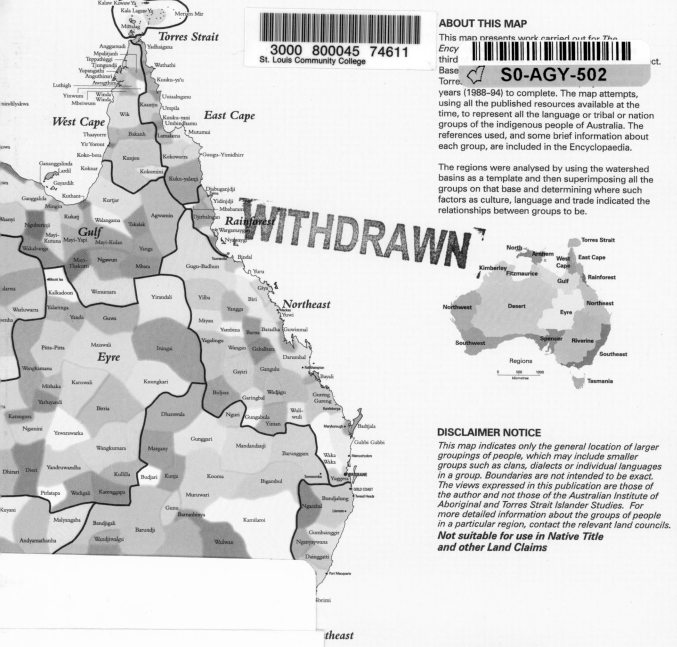

ABOUT THIS MAP

This map presents work carried out for *The Encyclopaedia* ... third ... ct. Base ... Torre... years (1988–94) to complete. The map attempts, using all the published resources available at the time, to represent all the language or tribal or nation groups of the indigenous people of Australia. The references used, and some brief information about each group, are included in the Encyclopaedia.

The regions were analysed by using the watershed basins as a template and then superimposing all the groups on that base and determining where such factors as culture, language and trade indicated the relationships between groups to be.

DISCLAIMER NOTICE

This map indicates only the general location of larger groupings of people, which may include smaller groups such as clans, dialects or individual languages in a group. Boundaries are not intended to be exact. The views expressed in this publication are those of the author and not those of the Australian Institute of Aboriginal and Torres Strait Islander Studies. For more detailed information about the groups of people in a particular region, contact the relevant land councils.
Not suitable for use in Native Title and other Land Claims

ACKNOWLEDGEMENT

Names and regions as used by Dr D. R. Horton in his book *The Encyclopaedia of Aboriginal Australia* published in 1994 by Aboriginal Studies Press for the Australian Institute of Aboriginal and Torres Strait Islander Studies (PO Box 553 Canberra, ACT 2601).

The Oxford Companion to
ABORIGINAL
ART AND CULTURE

WARNING

It is customary in Aboriginal communities not to mention the name or reproduce images of the recently deceased. All such mentions and images in this book have been negotiated with the express permission of the appropriate authorities and family members. Nonetheless care and discretion should exercised in using this book within Arnhem Land, central Australia and Kimberley.

Many of the Indigenous authors whose texts appear in the following pages have expressly asked that permission be sought from them, as well as from the publisher, for reproduction of any part of their texts.

THE OXFORD COMPANION TO
ABORIGINAL
ART AND CULTURE

General Editors:
Sylvia Kleinert and Margo Neale

Cultural Editor:
Robyne Bancroft

Editorial and Research Assistants:
Tsari Anderson, Victoria Haskins, Bernadette Hince, Katherine Russell,
Lani Russell, Lia Szokalski, Helen Skeat, Christine Watson,
and Christine Winter

OXFORD
UNIVERSITY PRESS

OXFORD
UNIVERSITY PRESS

253 Normanby Road, South Melbourne, Australia

Oxford University Press is a department of the University
of Oxford. It furthers the University's objective of excellence
in research, scholarship, and education by publishing
worldwide in

Oxford New York

Athens Auckland Bangkok Bogotá Buenos Aires
Calcutta Cape Town Chennai Dar es Salaam Delhi
Florence Hong Kong Istanbul Karachi Kuala Lumpur
Madrid Melbourne Mexico City Mumbai Nairobi
Paris Port Moresby São Paulo Shanghai Singapore Taipei
Tokyo Toronto Warsaw

with associated companies in Berlin Ibadan

OXFORD is a trade mark of Oxford Unversity Press
in the UK and in certain other countries

National Library of Australia
Cataloguing-in-Publication data:

The Oxford companion to Aboriginal art and culture.

 Bibliography
 Includes index.
 ISBN 0 19 550649 9.

 1. Aborigines, Australian—Arts. 2. Aborigines,
 Australian—Art. I. Kleinert, Sylvia. II. Neale, Margo.

700.899915

Edited by Frances Morphy
Indexed by Max McMaster
Text designed by Derrick I. Stone
Cover designed by Karen Trump
Typeset by Desktop Concepts Pty Ltd, Melbourne
Printed by McPherson's Printing Group, Australia

the centre for cross-cultural research
AN AUSTRALIAN RESEARCH COUNCIL SPECIAL RESEARCH CENTRE
THE AUSTRALIAN NATIONAL UNIVERSITY, CANBERRA, ACT 0200

THE GETTY
GRANT
PROGRAM

GORDON DARLING FOUNDATION

ATSIC

Preface

In undertaking this *Companion* it has been our paramount concern throughout to give a voice to the people whose culture is being represented. We have been afforded a golden opportunity to break a mould, to emphasise the Indigenous voice in a way that accords with the desire for self representation that has been the major thrust of Indigenous cultural politics over the past decade. In our efforts to transmit something of the art and culture of Aboriginal and Torres Strait Islander peoples—the First Australians—we have been guided in every aspect of the project by the principles of collaboration, consultation, and shared ownership that govern Indigenous practice. While it is well known that colonialism has had an enormous impact on Indigenous societies, this *Companion* reveals the other side of the coin—the significant influences that Aboriginal and Torres Strait Islander cultures have brought to bear on Australian history and society. This recognition of Indigenous agency will hopefully be one of the *Companion*'s most important contributions to the existing literature on Indigenous art and culture.

In the first part of the volume particularly, we have deliberately juxtaposed the personal and the vernacular to the academic and literary, giving weight to the position occupied by Indigenous narrators, and to an essentially narrative representation of culture. This has allowed us to draw upon a broad field of Indigenous contributors, from elders and senior custodians to artists, poets, and oral historians, as well as an emerging generation of Indigenous academics.

Despite a long history of interest in Aboriginal religion, society, and material culture among scholars and the wider public, Australia's Indigenous people have often been positioned ambiguously in relation to the nation state—even erased from settler narrative myths of national identity. It is only now, after three decades of political struggle for equal opportunities and recognition, and the official acknowledgment of Indigenous people as citizens in their own country, that a publication such as this *Companion* is possible. Australia's Indigenous people have mobilised in ingenious ways. The Freedom Ride of the 1960s called for social equality, the establishment of a Tent Embassy outside Parliament House in the 1970s demanded political recognition, and in 1980s the decade of Australia's bicentennial saw Indigenous calls for the insertion of black Australian history into the white colonial narrative under catch-cries such as: 'Australia has a Black History', and 'We have Survived'. The 1990s saw Indigenous people engaging in every aspect of the cultural, political, social, and economic life of the country, and achieving new levels of visibility. They have asserted their right to self determination in many contexts: in ongoing debates concerning native title and land rights emanating from the historic Mabo decision of 1993, in the exposure of the existence and social ramifications of the stolen generations, black deaths in custody, the government's reluctance to apologise for past wrongs, the rhetoric surrounding reconciliation, and the centenary of Federation. Black responses to white Australia's exploitation of icons of Aboriginal

identity for major international events such as the Olympic Games take the form of threatened boycotts or claims for greater Indigenous representation.

That this *Companion* could be compiled at all is a reflection both of the resilience of Indigenous Australians in maintaining their cultural traditions in the face of a recent and often oppressive history of colonial domination, and of the radical shift in attitudes towards Aboriginal people and their culture that has occurred in recent decades. For most of Australia's colonial history Aboriginal culture was invisible to the majority of Australians—viewed at best as a past way of life that would soon be gone. Unquestionably the production of art and the performance of ceremony was made difficult in many areas by the invasion of Aboriginal lands and the destruction of the people. But invisibility was created as much by the ways in which Europeans viewed Aboriginal culture as by the realities of Aboriginal cultural practice. The evolutionist's eye failed to see the richness of Aboriginal cultural production, which contradicted the idea that Australia was terra nullius—a land without people or culture—ripe for exploitation. In response, Aboriginal political action to gain recognition of their rights has involved a simultaneous assertion of the value of their culture and of their way of life.

Recent writings on Aboriginal art have transformed Euro-Australian understandings of the place of art in Aboriginal society and have worked in harmony with this process of value assertion and creation. In the 1940s and 1950s researchers such as Ronald and Catherine Berndt, C. P. Mountford, and T. G. H. Strehlow helped build the foundations of a better understanding of Aboriginal art. The 1970s brought a broader understanding of the role of art in Aboriginal society that has continued to the present. Research demonstrated the complexity and subtlety of Aboriginal systems of representation, and the important role they played in the transmission of knowledge and values across generations. As understanding of the close relationship between art and landscape grew, it was realised that Aboriginal art provided alternative perspectives on the land and its history. The aesthetic properties of the art began to be understood as Aboriginal ways of capturing the beauty and spirituality of their world. Recent decades have also seen an increasing exposure of Indigenous art through exhibitions and publications, and just as importantly through its availability in the market place, where the artists themselves are able to enter into dialogue with their audience.

New research areas have been opened up in response to Indigenous people's engagement in the process of reclamation, retrieval and revitalisation, and the need to redress historical imbalances and imposed silences. The inclusion of primary research by Indigenous and non-Indigenous contributors writing on Victoria, Tasmania, South Australia, and the south-west of Western Australia stresses the strength and continuity of Indigenous culture in the southern part of the continent, and challenges the common assumption that it was sullied, or erased, by colonial contact. Entries on south-eastern and northern Queensland, and the Torres Strait Islands augment the discussions of the better-known art traditions of the north, centre, and west of the continent, such as those of the desert, the Kimberley, and Arnhem Land. Western artistic hierarchies tend to privilege painting and sculptural traditions, and to focus on the work of male artists. Indigenous practice is more inclusive, and the *Companion* reflects this through the many entries on fibre arts, body ornament, the visual production of women and children, and Indigenous interventions in new sites of cultural practice.

The Indigenous value systems reflected in the generic title *Aboriginal Art and Culture*, and the concomitant emphasis on visuality, have led us to depart from the standard format and approach of most Oxford Companions. The indivisibility of art and culture in Indigenous societies is embodied in the expression 'art is culture made visible'. There is no exact equivalent for the Western term 'art' in any of the hundreds of Aboriginal languages studied. The closest equivalents are terms with the core meaning of 'impression', 'mark', or 'track', which refer primarily to traces left by the ancestral creator beings

in forming the country—they are physical manifestations of the omnipresent ancestors indelibly imprinted upon the land, and its flora and fauna. It is these marks that have been recalled by artists, in dynamic visual and oral forms, and in song and ceremony, over millennia. In the present, 'Indigenous art' is also about the maintenance and affirmation of Aboriginality—an identity derived from continuing traditions that have their genesis in relationships to land and place.

The Indigenous experience of time is not linear: rather it is multi-layered, expanding in an ever-lengthening time frame categorised—in Western thought—as 'past', 'present', and 'future'. As Howard Morphy (1998) has said: 'The concept of the Dreaming, a uniquely Aboriginal way of placing people in time and space, forces one to think differently, and in a less linear way, about the relationship between form and creativity in art.' But how to reflect these apparently opposed cultural views of ordering and time in the structure of a publication that purports to reflect Indigenous values, but must also be comprehensible and accessible to a broad audience of mostly non-Indigenous readers? How to convey a sense of the vastness of the time-depth—currently estimated at 60 000 years by scientists and referred to as 'time immemorial' by many Indigenous people—of the Indigenous cultural presence in Australia? How to transcribe the recording of history since European occupation, and the rapid socio-political developments of recent decades, in which a chronological sequencing of events, of cause and effect, is critical to understanding?

It is clear that Australia's Indigenous people have used 'art' to reaffirm their autonomous concerns, and they have deliberately sought to engage in dialogue with the colonising society. In turn, Western ideas of 'art' have adjusted to accommodate an ever-expanding Indigenous cultural practice: well-established art forms such as hollow log coffins (once relegated to relative obscurity) are now venerated, Western art forms—watercolour, acrylic painting, photography, and film—have been accepted and developed by Indigenous Australians, undercutting colonial stereotypes of the primitive, unchanging 'Other'. Indigenous people have gone to great lengths to correct perceptions that define—and therefore confine—their cultural values in terms of binary categories: 'traditional' versus 'urban', 'high art' versus 'popular culture', 'art' versus 'artefact', and 'written' versus 'oral' history. Some readers may encounter a wider frame of ideas and values than those to which they are accustomed. As one example, the idea of the landscape—once thought of in purely Western artistic terms as a scene drawn from nature—is now understood in broader, more complicated ways. From an Indigenous perspective, landscape is 'country'—a locus of identity and a political idea. It embodies 'inside' and 'outside' meanings belonging to systems of knowledge that are fundamentally religious. It is, simultaneously, a contested site of colonial conflict.

Such questions and considerations have informed a Companion that is multi-dimensional in its structure. In some respects we have followed the tradition established by Honderich's *Oxford Companion to Philosophy* and Gregory's *Oxford Companion to the Mind* in allowing for broad and detailed coverage of complex topics. At the same time we wanted to incorporate an encyclopaedic section that offered both to scholars and to the wider public a range of concise and authoritative reference entries. In this respect we have followed the model pioneered by Iain McCalman's *An Oxford Companion to the Romantic Age: British Culture 1776–1832*, which is structured around two separate, yet interconnected sections. Part One of this present *Companion* comprises a complex array of material covering many aspects of Aboriginal and Torres Strait Islander culture. Part Two is an alphabetically-ordered reference section; it covers major institutions, key issues, concepts, and events, and contains around 300 newly-commissioned biographies of artists.

Unlike other Companions, this volume is not restricted to a single academic discipline, a discrete historical period, or a particular field of endeavour. The dynamism and

diversity of its multi-faceted subject-matter has demanded a radical and innovative approach that is both pluralist and inclusivist. Part One relies on a broad chronological framework. It provides a familiar and accessible progression encompassing four major themes: an introduction to the founding framework of Aboriginal and Torres Strait Islander society in religion, land, and culture; an exploration of continuities and discontinuities as they have emerged through post-colonial historical and regional developments; a wide-ranging consideration of the renegotiation of tradition through contemporary cultural practice; and finally an exploration of the issues raised by the public face of contemporary Aboriginality, the reception of Aboriginal art, and the process of cultural commodification. Bracketed at the beginning and at the end by Indigenous voices, Part One concludes with some projections into the future.

Within this essentially linear chronology, each section in Part One divides into chapters which juxtapose longer and shorter essays, 'voices', boxed texts, and 'storyboards' (photo essays). Thus clusters of entries circle around a central theme such as 'religion' or 'cultural brokerage'. The distinctive 'voices' complement and enrich the essays by illustrating the lived cultural experiences of those whose existence is defined outside Western institutionalised spaces. The mix of these components offers a multi-layered and multi-vocal literary and visual text, reflecting the extraordinary richness and complexity of Indigenous history and participation in every field of human endeavour—from politics and religion to sport and entertainment, from the arts and architecture to economic and marketing activities. Historical voices, such as those of prominent writers and activists Oodgeroo Noonuccal (Kath Walker) and Kevin Gilbert, are available alongside the contemporary voices of leading artists, writers, and political figures such as Sally Morgan, HJ Wedge, Fiona Foley, Bill Neidjie, Michael Jagamara Nelson—who designed the mosaic on the forecourt of Parliament House, Canberra—and Mandawuy Yunupingu, one of the nation's most powerful and distinctive voices.

The entries in Part Two—the alphabetically-organised reference section—can be used to extend and build on the interpretative essays in Part One. They also function as independent entries, as an easily accessible reference source. Readers will find extensive cross referencing within and between both parts of the *Companion*. The reference section includes a number of longer entries focused on key ideas and issues, and on major events and cultural organisations which have contributed to the development of contemporary Aboriginal art and culture. The biographies highlight the contribution and cultural significance of individual artists such as Rover Thomas, Emily Kame Kngwarreye, Tracey Moffatt, and Gordon Bennett, and many lesser known historical figures such as Dick Roughsey (Goobalathaldin) and Ronald Bull. They include artists working in media such as fibre—traditionally associated with women's work—and emerging artists such as Jody Broun and Clinton Nain.

The visual component of the book, comprising over 400 images in black-and-white and colour, is greatly expanded in comparison to other similar publications. It affirms both the didactic and the aesthetic nature of Indigenous cultural production: it is not simply included as an adjunct to, or illustration of, the written text. The images function as visual texts equivalent to written entries—especially in the case of the storyboards. These two forms of communication—image and text—are seen to inform one another directly. The growing critical acclaim for and widespread popularity of Aboriginal and Torres Strait Islander art, both nationally and internationally, is attributable in large part to the depth and complexity of its visual imagery.

Our commitment to giving space to the Indigenous voice has dictated not only the style and structure, but also the methodology of the *Companion*. Indigenous people are represented at all levels: on the editorial team, on the editorial board, and as contributors—in their capacities as artists, curators, writers, dancers, actors, and musicians. The

Indigenous presence on the editorial board and team has ensured that the preparations for publication have proceeded in a manner sensitive to the protocols of Indigenous cultures, entailing a painstaking and often lengthy process of negotiation with communities and individuals, and flexibility in responding to their needs and in proceeding in accordance with their wishes. As one example, the Warburton community, which is committed to a collaborative approach to art-making, wished to be represented through a single entry rather than in individual biographies. Our selection of artists involved a range of considerations: we chose key artists who have been represented in major exhibitions and publications, historical figures, artists working across a range of media, and emerging artists. Reflecting the regional diversity of Australian Indigenous art was a prime concern. In commissioning the reference entries, we approached experts in the field, or art coordinators who had established relationships with communities, or we invited artists to nominate a writer familiar with their work, thereby returning to them the right to represent themselves. These distinctive biographies, individually commissioned, offer fresh insights into the lives of the artists as well as the details of their professional careers.

We consider ourselves fortunate to have been involved in the development of this exciting and groundbreaking project, and we trust that readers will gain much enjoyment, as well as knowledge, from this *Companion to Aboriginal Art and Culture*.

Sylvia Kleinert and Margo Neale

Morphy, H., *Aboriginal Art*, London, 1998.

Acknowledgments

It is not possible, with a project of this scale and depth, to acknowledge individually the debts owed to the many people who have assisted towards its publication. They come from many different walks of life: elders and senior custodians within Aboriginal communities, individual artists, writers, actors, and dancers, the many scholars writing and researching in the field, curators attached to collecting and cultural institutions both in Australia and overseas. As anyone involved in similar projects will be aware, this *Companion* represents far more than the ideas and initiatives of two people. Our Indigenous–non-Indigenous partnership as art historians established the parameters, but the whole process of conception, production, and publication has relied upon the collaborative synergy of a dedicated and dynamic editorial team and on the hard work of our many contributors. In addition, we had an ever supportive Editorial Board comprising William Jonas, Joan Kerr, Marcia Langton, Iain McCalman, Henry Reynolds, and Nicholas Thomas

Conceived by Iain McCalman, Director of the Humanities Research Centre (HRC), at the Australian National University, following an approach from Peter Rose, then commissioning editor for Oxford University Press, *The Oxford Companion to Aboriginal Art and Culture* represents the flagship publication of the recently-formed Centre for Cross-Cultural Research (CCR) at the Australian National University in Canberra. It would not have been possible to bring the *Companion* to fruition in 2000, from a commencement date in mid 1996, without the expertise, infrastructure, and support provided by the CCR. Thanks are due to present and former staff of the CCR: the Director Howard Morphy, the founding Director Nicholas Thomas, Iain McCalman, Joan Kerr, the Executive Officer Julie Gorrell, and Centre Administrator Anne-Maree O'Brien, for their unstinting support. Mid way through the project, additional resources generously provided by the Australian Research Council, The Getty Grants Program, the Gordon Darling Foundation, and the Aboriginal and Torres Strait Islander Commission kept the project afloat and able to meet its publishing deadline despite escalating costs.

In a project of this scale is also imperative to give due recognition to the contribution made by the editorial and research staff to the editorial process. It would not have been possible to produce such a publication without the dedication and enthusiasm of all those involved as editorial and research assistants, including Tsari Anderson, Robyne Bancroft, Gavin Bertram, Ian Bryson, Hilary Erickson, Victoria Haskins, Clive Hilliker, Bernadette Hince, Jodi Neale, Hugo Peterson, Katherine Russell, Lani Russell, LiaSzokalski, Helen Skeat, Christine Watson, Kathryn Wells, and Christine Winter. We particulary wish to thank Robyne Bancroft and Katherine Russell for their unfailing support and commitment to the project. The quality of the final publication reflects the wisdom and advice provided by two copy editors, Christopher Cunneen and Frances Morphy. The real enjoyment has come from working together on such an extraordinary project.

Contents

Notes to readers

The structure of the *Companion*

The *Companion* is divided into two separate, yet interconnected parts. Part One is structured broadly on a chronological framework, in four main sections. Within each section separate numbered chapters offer a cluster of longer and shorter essays, 'storyboards', boxed texts, and 'voices'. These offer a multi-perspective view of the diversity of Aboriginal and Torres Strait Islander art and culture, in both time and space. They are numbered by chapter and section, thus: 1.1, 1.2, etc. The entries in Part Two, the reference section, can be used to amplify and extend the interpretative essays in Part One or they can function independently as encyclopaedic entries. Each entry has a headword, and entries are in alphabetical order, according to their headword.

The 410 images in the *Companion* are central to its conception, and are intended to be used in conjunction with the text. There are four sections of colour plates, and these are numbered together in a single sequence with the black and white in-text illustrations.

In Part One we have tried to avoid rigid categorisation of the type that would confine entries on regional or thematic issues within a single section or chapter. The entries are intended to be read in many different ways—as single elements, or in clusters, or as a block of entries. The Index to Part One, located at the end of Part One, will assist readers to track key ideas, events and individuals. It also indexes all the illustrations in the volume. Readers will find extensive cross referencing, both between Parts One and Two and within each Part. In Part One, cross referencing occurs within the text, as appropriate. Words which are headwords in Part Two are emboldened at their first occurrence in the text, for example: ' . . . Albert **Namatjira**, the . . . '. References to related entries or themes in Part One are given by section number, for example [see (also) 6.1]. References to Part Two entries, where the headword does not appear in the text take the form [see (also) **Namatjira**]. The illustrations are referenced by their number, in italic if black and white, or in bold italic if in a colour plate section, thus: [*5*, ***24***]. Multiple cross references follow the order Part One; Part Two; illustration. For example: [see also 2.1, 4.5; **acrylic painting**, Albert **Namatjira**; *5*, ***24***].

Part Two contains concise and authoritative entries that examine key issues and events, the contribution made by leading cultural organisations to the development of contemporary Aboriginal and Torres Strait Islander art, and biographies of individual artists (or families of artists). From the thousands of practicing artists we have identified major figures whose work is widely represented in exhibitions, prizes and publications, a selection of lesser-known artists working in a diverse range of media, and historical figures. We have also aimed at regional coverage. 'Notes to Readers' for the Part Two entries appear at the beginning of that section. Readers will also find the illustrations cross referenced in the Index to Part One.

There are no footnotes or endnotes in the *Companion*. Nor will readers find a consolidated list of Further Reading. Given the scope, depth, and diversity of the volume, as the first multi-authored reference work of its kind in the field, we have decided to provide references directly underneath the entries in Part One and Part Two. The maps on the endpapers and in the Appendix will allow readers to track the cultural and language groups of Aboriginal Australia, geographic elements, place-names, and regional areas.

Pronunciation of Indigenous languages

Words in Indigenous Australian languages usually have stress on the first syllable, whereas in English it is usually the second to last which is prominent. So **Pin**tupi is correct rather than Pin**tu**pi, which is more natural for English speakers. Words of four or more syllables may have a second stress on the third syllable, for example **Ja**ka**ma**rra, which sounds more like the English pattern where the main stress would be on the second to last but there would be a secondary stress on the first syllable.

Most Indigenous languages have only three vowels: /i/ as in *pit*, /u/ as in *put*, and /a/ like the sound of *putt* (note that English uses the letter **u** to indicate two different vowel sounds). Some languages have a further set of long vowels, which may be spelled double, **ii, uu, aa**. In the Yolngu languages these are spelled **e, o, ä**. The long vowels are pronounced something like the vowels of English *pear*, *pour*, and *par* respectively.

Further vowel sounds may be heard in Indigenous languages, but they function as mere variants of the smaller set of distinctive vowel 'phonemes'. Absent from Indigenous languages are diphthongs, or gliding vowels, such as occur in English *boy*, *bite*, *bait*, *boat*, *about*. Some languages of Central Australia use the letter **e** for a distinctive vowel that sounds like that of English *the* or *about*; for example *merne* 'tucker' in Arrernte and Anmatyerre.

Totally absent from most Indigenous languages are 'fricative' phonemes such as English /f/, /v/, /th/, /s/, /z/, /sh/, /h/. 'Stop' consonants something like English /p/, /b/, /t/, /d/, /k/, /g/, /ch/, /j/ are present. However, in many Indigenous languages the pairs **p** and **b**, **t** and **d**, **k** and **g**, **ch** and **j** do not function as separate phonemes and are therefore spelled the same; some spelling systems uses **p**, **t**, **k** whereas others use **b**, **d**, **g**. These stops are rarely pronounced with the aspiration (or puff of air) that accompanies the English sounds; an Indigenous-language word spelled **papi** or **babi** will therefore sound like *buppy* or *bubby* rather that *puppy* or *pubby* to the native-speaker of English.

Most Indigenous languages have some consonants not found in English. Many languages have a set of 'retroflex' sounds that are pronounced like /t/, /n/, /l/ but with the tongue tip further back in the mouth; similar sounds occur in American English *barter*, *barn*, *barley*. The spelling conventions for these sounds are discussed in the next section.

Another set of characteristic Indigenous-language sounds are the 'alveo-palatal' stops. These sound something like the underlined letters in English <u>ch</u>uck or <u>j</u>u<u>dg</u>e, ca<u>ny</u>on, mi<u>lli</u>on; however they are pronounced with a different tongue configuration: the tongue tip is behind the lower teeth and contact with the gums or palate is made with the blade of the tongue. The spelling conventions for these are discussed in the next section. Some languages have a second set of tongue-blade (or 'laminal') sounds spelled **th** (or **dh**), **nh**, **lh**; for these the blade touches the back of the upper teeth (so even for /th/ the effect is a little different from English /th/).

Most Indigenous languages have two kinds of 'r' sounds. The first, usually a 'retroflex', sounds like English /r/ of *red* or *baron*; the second is either a 'trill' as in Scottish *very* or a 'tap' as in casual English pronunciations of /d/, as in *paddock*. They are distinguished in the orthographies of Indigenous languages, as described in the next section.

Some languages of Arnhem Land have a phoneme consisting of a 'glottal stop', which sounds like the catch that occurs in the middle of English *oh-oh*. It is spelled either with the apostrophe or with the letter **h**.

There are differences in the combination of sounds permitted in Indigenous Australian languages and English. One that causes difficulty for English speakers is the frequent occurrence of /ŋ/ at the beginning of words (English has it only in the middle or at the end of words, e.g. hanging). Combinations of /np/ and /nk/ occur in Indigenous languages, the latter being pronounced differently from /ŋk/.

Orthographies for Indigenous languages

Prior to European colonisation, the 200 (or more) distinct languages of Australia and the Torres Strait had no written tradition. Since they contain sounds and sound distinctions that are unknown in European languages, attempts at transcription by early settlers were inconsistent, idiosyncratic, and in most cases very approximate. For many languages in the south and east of Australia, the only surviving written records are therefore imperfect, and fragmentary. Professional linguists (including missionary linguists), did not begin work in earnest in Australia until the 1930s. Although today there are still some languages that remain undescribed (in the linguistic sense), it is broadly true to say that the languages of the areas most remote from the initial sites of colonisation, around twenty of which are still the first languages of their speakers, do now have written forms which accurately reflect their sound systems. For some of the languages of the south and east—where more extensive records exist, where languages survived against the odds in the minds of a few elderly speakers, or where the early recorders were possessed of an unusually good 'ear'—it has been possible to reconstruct their sound systems and provide a 'modern' orthography.

Not all people who have transcribed words and names from the well-described languages have been aware of the existence of a standard orthography. Over the years, many 'non-standard' spellings have made their way into print, and several well-known artists (for example, Uta Uta Tjangala) are best known by a non-standard spelling of their name. Some research predated the existence of a now-accepted orthography, as in the case of Spencer and Gillen, who rendered Arrernte as 'Arunta'. Sometimes an old or a simplified spelling has made its way into the public domain as a part of a person's own rendering of their name, and must therefore be respected even if an alternative exists in the form of a modern orthography. A case in point is Oodgeroo Noonuccal, whose second name is a rendering of the language name Nunugal.

In their orthographies, linguists—and speakers—have made differing choices about how to represent particular sounds: the /ŋ/ sound (as in English 'sing') is variously represented by **ng** or ŋ. For some languages where ŋ has been chosen for the orthography, words with the alternative spelling **ng** have entered the public domain (and dictionaries of Australian English). An example that will be found in many places in the *Companion* is the name Yolngu: in the orthography devised for the languages of the group this should properly be Yolŋu. The alveo-palatal stops may be represented by **tj** or **j** (or **ty, dy, ch**) the palatal nasal by **nj** or **ny**, the retroflex stop by **rt** or **t**, and the retroflex nasal by **rn** or **n**. Even more confusingly, the two 'r' sounds found in many languages are variously rendered as **r** (retroflex) and **rr** (trill), or as **r** (retroflex) and **r** (trill). Sometimes different communities who speak the same language, or related languages which have a lot of vocabulary in common, have made different spelling choices. No better illustration of this could be found than in the many ways of spelling the subsection names of the desert regions of Australia. The 'same' names are found over a vast area, but are spelled differently according to whether the person concerned is based at Yuendumu, or Papunya, or Balgo. For example, Tjapaltjarri and Japaljarri are alternate spellings of the same name. Finally, linguists change their minds about how best to represent a language and throw out established orthographies in favour of new ones—thus Gunwinggu becomes Kunwinjku (and Eastern Kunwinjku becomes Kuninjku). Readers

will note that the spellings used on the AIATSIS map which features on the front end-papers differ in come cases from those adopted in the *Companion* itself.

At this stage, the reader will have some inkling of the difficulties faced by the editors in deciding how to represent words and texts from Aboriginal languages. There is no 'right' way to proceed, except to aim for a consistent scheme that is maximally intelligible to the reader, while at the same time respecting conventions that have been established for particular languages, or communities. Accordingly, the following conventions have been adopted.

1) Extended texts in Indigenous languages are in italic, and are followed by a translation into English, in roman. The standard orthography of the community, if it has one, is used, including conventions relating to capitalisation of the initial letters of proper names (these vary between orthographies).

2) Proper names that occur within the main text appear in roman, with an initial capital letter. The sound /ŋ/ is always written as **ng**, even if this is not the convention of the orthography for the relevant language. In addition to names of people and places, the following categories of word have been treated as 'proper names': Indigenous-language terms which refer to the concept known popularly in English as 'the Dreaming' or 'Dreamings' (the most commonly occurring is Jukurrpa, also spelled Tjukurpa or Tjukurrpa), names of ceremonies (e.g. Mardayin, Pukumani, Yawulyu), and words for 'white' or 'non-Aboriginal' people (e.g. Kartiya and Balanda). The designation of the status 'proper name' is based on the conventions of English, and is therefore not always congruent with Indigenous linguistic structures. For example *yawulyu* is a widespread word for a type of women's ceremony, but is also used to describe the style of the songs and the paraphernalia used in such ceremonies. When being used as a proper name for the ceremony it is written as Yawulyu, and where it is descriptive of items associated with the ceremony it is written *yawulyu*.

3) Other Indigenous words that occur within the body of the main text are given in italic, following the orthographic conventions, where established, for the language or community in question.

4) The Kriol language now spoken across vast areas of the north and west presents special problems. Because much of its vocabulary comes originally from English, it is easy to think of it as a non-standard form of English, and this impression is compounded if it is transcribed in the standard orthography of English. For the benefit of the English-speaking reader we have kept an English orthography for lexical items of Kriol, many of which mean 'the same' as their English counterparts, but we have used Kriol orthography for the 'little words'—the grammatical particles—which, although derived from English originally, have very different meanings and functions in modern Kriol (see **Aboriginal English** entries in Part Two of this volume).

5) Quotations from written sources follow the spelling conventions of those sources, even where they differ from the conventions of the *Companion*. And, finally, where more than one spelling of a name has become established in the literature, the reader may find that alternatives are given at some points, thus: Uta Uta (Wuta Wuta) Tjangala. A swung dash is used where two alternative spellings or two different words are used for the same thing, as in *dari~dhoeri* (head-dress).

Glossary

Anangu:	regional term used in the area of Uluṟu–Kata Tjuṯa National Park and surrounds for some people of the Western Desert region, including Pitjantjatjara-speaking people.
Balanda:	Arnhem Land (mostly Yolngu) term for white people. Regional variants include Gub~Gubba (south eastern Australia); Kartiya (~Gadiya) (Kimberley); Munanga (southern Arnhem Land); Piranpa (central Australia).
bark painting:	the art practice of applying natural pigments to straightened lengths of bark with various forms of adhesive.
Bradshaw:	a style of rock painting found in the Kimberley region depicting small, red figures. Originally named after the explorer Joseph Bradshaw, who first sighted the paintings in 1891, Bradshaw represents three broad regional styles known by their local names: *Gwion Gwion*, *Kiera Kirow* and *Jungaroo*.
business:	as in 'women's business', 'men's business'. Ceremony, ceremonial activity.
clan:	a group of people with a shared ancestor. In Australia, where clans exist they are patrilineal, tracing descent through the male line.
Djang'kawu sisters:	the main protagonists in one of the major mythological cycles of north-eastern and central Arnhem Land.
dot painting:	an art movement recording traditional Aboriginal designs in acrylics on board and canvas which began in Papunya, NT in the early 1970s and has subsequently spread to other desert communities.
Dreaming:	a period beyond living memory in which ancestral beings were responsible for the genesis of the spiritual, physical and moral world, and for providing the laws and ceremonies which sustain contemporary existence.
Gub:	see Balanda.
Kurrir-Kurrir:	also Krill Krill. The new ceremonies dreamt by the Walmajarri artist Rover Thomas and translated into a new form of contemporary Kimberley art.
Jukurrpa:	see Tjukurpa.
Kadaitja:	also kadaitcha. An Arrernte term used to refer to secret killing and associated rituals.
Kartiya:	see Balanda
Koori:	also Koorie. An Aboriginal word of New South Wales origin adopted by south-eastern Aboriginal people to distinguish themselves, as a counter to the generic term, Aborigine.

Kriol:
the English-based creole language that is now spoken across large areas of the Northern Territory. It has replaced (and is still replacing) the languages once spoken there.

Law:
the body of spiritual, social and cultural knowledge, and the attendant social and religious prescriptions, derived from the Dreaming.

*ma*d*ayin*:
a Yolngu term for sacred.

Mardayin:
also Marrayin~Maraian. The name for a type of ceremony in central and western Arnhem Land.

mimih:
also Mimi. A rock spirit. The name was also used by to describe a style of early western Arnhem Land rock art attributed to *mimih*.

Munanga:
see Balanda.

moiety:
a form of identity and social organisation in which all people, songs, ceremonies and natural phenomena are assigned into two mutually exclusive categories. For further details see 3.1.

Murri:
Aboriginal people of New South Wales and southern Queensland.

Nyungah:
also Nyoongar. Aboriginal people of south-west Western Australia.

outstations:
small settlements established as the result of the movement off government-established reserves and missions back to homelands, which occurred from 1960s onwards in many outback areas.

pandanus:
Pandanus spiralis, a species of palm, the leaves of which provide the main raw material for the fibre-work of Arnhem Land.

Piranpa:
see Balanda.

rarrk:
cross-hatching in bark painting which signifies the spiritual power of ancestral beings. The term is in use widely in western and central Arnhem Land.

skin name:
see subsections.

subsections:
a form of identity and social organisation in which all people are assigned into one of eight named groups. See 3.1 for further details.

Tjukurpa:
also Tjukurrpa, Jukurrpa. The Dreaming, the Law.

Wägilak sisters:
also Wäwilak, Wagilag. The main protagonists in one of several major mythological cycles of Arnhem Land.

Yawulyu:
also Yawelye. Women's ceremony among Warlpiri and neighbouring peoples.

Yolngu:
Aboriginal people of north-eastern Arnhem Land. Also their languages.

Abbreviations

ABC	Australian Broadcasting Corporation
ACCA	Australian Centre for Contemporary Art, Melbourne
ACP	Australian Centre for Photography, Sydney
ACT	Australian Capital Territory
AETA	Australian Exhibitions Touring Agency
AGDC	Art Galleries Directors' Council
AGNSW	Art Gallery of New South Wales, Sydney
aGOG	Australian Girls Own Gallery, Canberra
AGSA	Art Gallery of South Australia, Adelaide
AGWA	Art Gallery of Western Australia, Perth
AHC	Australian Heritage Commission
AIATSIS	Australian Institute of Aboriginal and Torres Strait Islander Studies (formerly AIAS)
AIDT	Aboriginal Islander Dance Theatre
AM	Australian Museum, Sydney
ANCAAA	Association of Northern and Central Australian Aboriginal Artists (replaced by Desart and ANKAAA)
ANKAAA	Association of Northern and Kimberley Australian Aboriginal Artists
ANMM	Australian National Maritime Museum, Sydney
ANU	The Australian National University, Canberra
ARIA	Australian Record Industry Association
ArtspaceSA	Artspace, Adelaide Festival Centre, Adelaide
ATSIAB	Aboriginal and Torres Strait Islander Arts Board (formerly AAB)
ATSIC	Aboriginal and Torres Strait Islander Commission
Berndt Collection	R. M. Berndt Collection, Berndt Museum of Anthropology, University of Western Australia, Perth
BIMA	Brisbane Indigenous Media Association
BM	British Museum
CAAMA	Central Australian Aboriginal Media Association
CACSA	Contemporary Art Centre of South Australia, Adelaide
CCAS	Canberra Contemporary Art Space
CCBAG	Campbelltown City Bicentennial Art Gallery, Campbelltown, NSW
CCCC	Craftwest Centre for Contemporary Craft, Perth
CPAC	Casula Powerhouse Arts Centre, Casula, NSW
CRG	Cairns Regional Gallery, Cairns, Qld
EVTV	Ernabella Video and Television
FAC	Fremantle Arts Centre, Fremantle, WA

FCAATSI	Federal Council for the Advancement of Aborigines and Torres Strait Islanders
FUAM	Flinders University Art Museum, Adelaide
GCCAG	Gold Coast City Art Gallery, Surfers Paradise, Qld
GRAG	Goulburn Regional Art Gallery, Goulburn, NSW
HCC	Holmes à Court Collection, Heytesbury, WA
IAD	Institute for Aboriginal Development
IDG	Ivan Dougherty Gallery, University of New South Wales College of Fine Arts, Sydney
IMA	Institute of Modern Art, Brisbane
IPMA	Ian Potter Museum of Art, University of Melbourne
MAGNT	Museum and Gallery of the Northern Territory, Darwin
MCA	Museum of Contemporary Art, Sydney
MoS	Museum of Sydney
MV	Museum Victoria (formerly National Museum of Victoria)
NAIDOC	National Aboriginal and Islander Day of Observance Committee (formerly NADOC)
NATSIAA	National Aboriginal and Torres Strait Islander Art Award (formerly NAAA)
NGA	National Gallery of Australia, Canberra (formerly ANG)
NGV	National Gallery of Victoria, Melbourne
NIHAA	National Indigenous Heritage Art Award
NLA	National Library of Australia, Canberra
NMA	National Museum of Australia, Canberra
NSW	New South Wales
NT	Northern Territory
NTU	Northern Territory University, Darwin
PICA	Perth Institute of Contemporary Art
PM	Powerhouse Museum, Sydney
QAG	Queensland Art Gallery, Brisbane
Qantas	Queensland and Northern Territory Aerial Services Ltd
Qld	Queensland
QM	Queensland Museum, Brisbane
QVMAG	Queen Victoria Museum and Art Gallery, Launceston, Tas.
SA	South Australia
SAM	South Australian Museum, Adelaide
SBS	Special Broadcasting Service, Australia
SHEG	S. H. Ervin Gallery, Sydney
SLNSW	State Library of New South Wales, Sydney
SLQ	State Library of Queensland, Brisbane
SLV	State Library of Victoria, Melbourne
SSA	ScreenSound Australia (formerly National Film and Sound Archive)
SU	University of Sydney
TAFE	College of Technical and Further Education
Tandanya	Tandanya National Aboriginal Cultural Institute, Adelaide
Tas.	Tasmania
TCG	Tamworth City Gallery, Tamworth, NSW
TMAG	Tasmanian Museum and Art Gallery, Hobart
TPS	The Performance Space, Sydney
UCMAA	University of Cambridge Museum of Archaeology and Anthropology
UM	University of Melbourne

Abbreviations

UNSW	University of New South Wales
UTAS	University of Tasmania, Hobart and Launceston
UWA	University of Western Australia, Perth
Vic.	Victoria
WA	Western Australia
WAM	Western Australian Museum, Perth

Contributors

Contributors to Part One

Mr Kim AKERMAN, curator and archaeologist.

Mr Michael AIRD, Curator, Queensland Museum.

Professor Jon C. ALTMAN, Director, Centre for Aboriginal Economic Policy Research, The Australian National University.

Associate Professor Ian ANDERSON, Director, VicHealth, Koori Health Research and Community Development Unit, University of Melbourne.

Mr Geoffrey BARDON, artist, film-maker and writer.

Ms Mary BANI, Curator, Gallery of Aboriginal Australia, National Museum of Australia.

Mr Johnny BARRARRA, clan elder.

Dr Linda BARWICK, Research Consultant and Honorary Research Associate, Music Department, University of Sydney.

Emeritus Professor Jeremy BECKETT, anthropologist.

Mr Gordon BENNETT, artist.

Dr Roger BENJAMIN, Senior Visiting Fellow, Centre for Cross-Cultural Research, The Australian National University.

Mr Peter BIBBY, writer.

Dr Maggie BRADY, Research Fellow (health and drug abuse), Australian Institute of Aboriginal and Torres Strait Islander Studies.

Associate Professor Wendy BRADY, Director, Aboriginal Research and Resource Centre, University of New South Wales.

Mr Robert C. BROPHO, writer, film-maker, and elder.

Mr Jack BRITTEN, artist.

Ms Dulcie BRUMBY, artist.

Mr Ian BRYSON, anthropologist, writer, and film-maker; and Research Assistant, Centre for Cross-Cultural Research, The Australian National University.

Mr John BULUNBULUN, artist.

Dr Margaret BURNS, linguist and writer.

Ms Margaret CAREW, linguist.

Mr Wally CARUANA, Senior Curator of Aboriginal and Torres Strait Islander Art, National Gallery of Australia.

Ms Franchesca J. CUBILLO, Curator of Anthropology, South Australian Museum.

Ms Witjawara CURTIS, artist.

Mr Nugget DAWSON, artist.

Ms Karen DAYMAN, Arts and Crafts Adviser, Mangkaja Arts, Fitzroy Crossing.

Ms Jennifer DEGER, anthropologist and PhD candidate, Macquarie University.

Associate Professor Kim DOVEY, Department of Architecture, University of Melbourne.

Professor Françoise DUSSART, Department of Anthropology, University of Connecticut, USA.

Mr Wesley ENOCH, actor, director, and writer.

Ms Irene ENTATA, artist.

Ms Hannah FINK, writer and independent curator.

Dr Judith FITZPATRICK, Australian Centre for International Tropical Health and Nutrition, University of Queensland.

Ms Fiona FOLEY, artist and independent curator.

Mr Stephen FOX, Arts and Crafts Adviser, Maruku Arts via Uluṟu.

Dr Maureen FUARY, School of Anthropology, Archaeology, and Sociology, James Cook University.

Associate Professor Elizabeth FURNISS, Department of Anthropology, University of Calgary, Alberta, Canada.

Mr Murray GARDE, Cultural Officer, Maningrida Arts and Culture.

Associate Professor Ken GELDER, Department of English with Cultural Studies, University of Melbourne.

Ms Kelly GELLATLY, Curator, Heide Museum of Modern Art, Melbourne.

Mr Kevin GILBERT, artist, writer, and activist.

Ms Carroll GO-SAM, architect.

Ms Julie GOUGH, artist and writer.

Dr Andrée GRAU, Senior Lecturer in Anthropology, Rockhampton Institute, London.

Ms Lee-Anne HALL, Lecturer, School of Leisure and Tourism Studies, University of Technology, Sydney.

Ms Louise HAMBY, anthropologist and PhD candidate, The Australian National University.

Professor Annette HAMILTON, School of Behavioural Sciences, Macquarie University.

Dr Chris HEALY, Lecturer in Cultural Studies, Department of English, University of Melbourne.

Ms Anita HEISS, writer.

Mr Steve HEMMING, Department of Australian Studies, Flinders University.

Dr Anita HERLE, Senior Assistant Curator, Anthropology, Cambridge University Museum of Archaeology and Anthropology, UK.

Dr Jennifer HOFF, anthropologist.

Ms Jennifer ISAACS, writer and independent curator.

Ms Clara INKAMALA, artist.

JAMPIN, resident of 'No. 3 Island'.

Mr Hector JANDANY, artist.

Ms Carole Y. JOHNSON, dance teacher, consultant, and writer.

Dr Dianne JOHNSON, anthropologist.

Dr Vivien JOHNSON, sociologist, Senior ARC Fellow, Centre for Cross-Cultural Research, The Australian National University.

Dr Philip JONES, Senior Curator, Division of Anthropology, South Australian Museum.

KANGINY, artist.

Ms Doreen KARTINYERI, elder and artist.

Ms Maggie KAVANAGH, Director, Ngaanyatjarra-Pitjantjatjara-Yankunytjatjara Women's Council, Alice Springs.

Mr John KEAN, Producer, Australian Studies, Museum Victoria.

Dr Ian KEEN, Department of Archaeology and Anthropology, The Australian National University.

Professor Joan KERR, art historian, Centre for Cross-Cultural Research, The Australian National University.

Ms Kate KHAN, Project Officer, Australian Museum.

Mr Richard G. KIMBER, historian and anthropologist.

Dr Eric KJELLGREN, Oceanic Art, Metropolitan Museum of Art, New York, USA.

Dr Sylvia KLEINERT, Post Doctoral Fellow, Centre for Cross-Cultural Research, The Australian National University, Canberra.

Ms Yvonne KOOLMATRIE, artist.

Mr Mick KUBARKKU, artist.

KUNBRY, artist.

Ms Ruby LANGFORD, writer.

Professor Marcia LANGTON, Department of Geography and Environmental Studies, University of Melbourne.

Mr Gary LEE, writer and PhD candidate, College of Fine Arts, University of New South Wales.

Mr Greg LEHMAN, Head, Riawunna, Centre for Aboriginal Education, University of Tasmania.

Ms Donna LESLIE, artist, writer, and PhD candidate, University of Melbourne.

Ms Pat LOWE, writer.

Mr Koiki MABO, writer and activist.

Professor Isabel McBRYDE, Department of History, The Australian National University, and Visiting Fellow, Australian Institute of Aboriginal and Torres Strait Islander Studies.

Ms Hannah McGLADE, Law School, Murdoch University.

Dr Ian S. McINTOSH, anthropologist and independent consultant.

Ms Queenie McKENZIE, artist.

Mr Chips MACKINOLTY, writer and graphic artist.

Professor Julie MARCUS, Department of Anthropology, Charles Sturt University.

Dr Margaret MAYNARD, Department of Art History, University of Queensland.

Dr Lisa MEEKISON, anthropologist.

Dr M. Ruth MEGAW, Visiting Scholar, Department of Archaeology, School of Cultural Studies, Flinders University.

Professor R. Vincent S. MEGAW, Professor of Visual Arts and Archaeology, School of Cultural Studies, Flinders University.

Ms Doreen MELLOR, writer and independent curator; manager of 'Bringing them home', an oral history project of the National Library of Australia.

Dr Paul MEMMOTT, Aboriginal Environment Research Centre, Department of Architecture, University of Queensland.

Ms Nancy MILLER, artist.

Professor Sally MORGAN, writer and artist; Director, Centre for Indigenous History and the Arts, University of Western Australia.

Professor Howard MORPHY, Director, Centre for Cross-Cultural Research, The Australian National University.

Mr Philip MORRISSEY, Lecturer, Department of English, University of Melbourne.

Dr John MORTON, Lecturer in Sociology and Anthropology, LaTrobe University.

Mr Tom MOSBY, independent curator and conservator.

Mr David MOWALJARLAI, artist.

Mr Djon MUNDINE, Senior Curator, National Museum of Australia.

Mr David NATHAN, Visiting Research Fellow, Australian Institute of Aboriginal and Torres Strait Islander Studies.

Ms Margo NEALE, Manager, Gallery of the First Australians, National Museum of Australia.

NAANGARI, resident of 'No. 3 Island'.

Mr Bill NEIDJIE, elder and storyteller.

Mr Michael Jagamara NELSON, artist.

Mr Paddy NEOWARRA, elder.

Ms Oodgeroo NOONUCCAL (Kath Walker), poet and artist.

NYAWURRU, resident of 'No. 3 Island'.

Mr Michael O'FERRALL, freelance writer and curator.

Ms Kathleen OIEN, musicologist.

Ms Alison Joy PAGE, architect, Merrima, the Department of Public Works and Services, Sydney.

Ms Nellie PATTERSON, artist.

Ms Frances PETERS-LITTLE, musician and film-maker.

Ms Jude PHILP, Research Associate, Cambridge University Museum of Archaeology and Anthropology, UK.

Ms Roslyn POIGNANT, freelance historian and writer.

Ms Shirley PURDIE, artist.

Mr Anthony James REDMOND, Cultural Officer, Kamali Land Council.

Mr Brian ROBINSON, artist and independent curator, Cairns Regional Gallery.

Dr Deborah Bird ROSE, anthropologist and Visiting Fellow, The Australian National University.

Dr Andrée ROSENFELD, archaeologist and independent writer.

Dr Helen ROSS, Centre for Resource and Environmental Studies, The Australian National University.

Dr Gaye SCULTHORPE, Director, Indigenous Cultures Program, Museum Victoria.

Mr Vic SHARMAN, elder.

Ms Naomi SHARP, Coordinator, Hermannsburg Potters.

Dr John E. STANTON, Director, Berndt Museum of Anthropology, University of Western Australia.

Ms Ann STEPHEN, Curator, Powerhouse Museum.

Dr Roberta SYKES, writer and artist.

Dr Franca TAMISARI, Department of Anthropology, University of Sydney.

Dr Luke TAYLOR, Director of Research, Australian Institute of Aboriginal and Torres Strait Islander Studies.

Mr Freddie TIMMS, artist.

Mr Tony TJAMIWA, senior traditional owner Muṯitjulu councillor and Aboriginal Liaison Officer.

Ms Barbara TJIKATU, artist.

Ms Kathy TOZER, linguist, Mutijulu Community.

Ms Ellen TREVORROW, artist.

Ms Jakelin TROY, linguist, Aboriginal and Torres Strait Islander Commission.

Dr Ilaria VANNI, art historian and curator.

Dr Penny VAN TOORN, Lecturer, Department of English, University of Sydney.

Mr Paddy Fordham WAINBURRANGA, artist.

Ms Mingli WANJURRI-NUNGALA, elder.

Ms Christine WATSON, Visiting Fellow, Department of Archaeology and Anthropology, The Australian National University.

Mr Harry (HJ) WEDGE, artist.

Ms Margie WEST, Senior Curator, Museum and Art Gallery of the Northern Territory.

Dr Diana WOOD CONROY, Faculty of Creative Arts, University of Wollongong.

Ms Winnie WOODS, Chairwoman Ngaanyatjarra-Pitjantjatjara-Yankunytjatjara Women's Council, Alice Springs.

Mr Bangana Wunungmurra, elder, former Chairperson, TEABBA (Top End Aboriginal Bush Broadcasting Association).

Ms Lena YARINKURA, artist.

Dr Frank YORK, musicologist, School of Education, James Cook University.

Mr Mandawuy YUNUPINGU, musician and teacher.

Contributors to Part Two

Wherever possible, the initials of a contributor's first name and surname have been used to identify them uniquely. The last letter of the shortened forms listed below therefore represents the first letter of the surname, with the exception of surnames beginning 'Mc' (e.g. Ian McIntosh becomes IMcI), or double-barrelled surnames (e.g. Diana Wood Conroy becomes DWC). For those authors who prefer to have one (or more) of their other initials cited, these have been included in the shortened forms (e.g. Jon C. Altman becomes JCA). Readers are therefore advised to start at the end of a set of initials when seeking to identify an author from the list below. There remain some cases where more that one author has the same set of initials. Here, the first person listed has been assigned the shortest possible set of initials. For the second and subsequent contributors the second letter of their first name is inserted (or even the third or fourth letter if need be) to differentiate them (e.g. Jay Arthur becomes JA and John Avery becomes JOA). Lastly, in cases where a diagraph represents a single sound, the second letter of the diagraph is inserted in lower case (e.g. Djon Mundine becomes DjM).

Kim Akerman	KA	Carol Cooper	CAC	Rosita Henry	RH
Jon C. Altman	JCA	Council for Aboriginal		Melinda Hinkson	MH
Allison Archer	AA	Reconciliation	CAR	Christopher Hodges	CH
Jay Arthur	JA	Franchesca Cubillo	FC	Ingrid Hoffmann	IH
Bain Attwood	BA	Ann Curthoys	ANC	Jo Holder	JOH
John Avery	JOA	Claudinia Daley	CD	Lisa Horler	LIH
Bronwyn Bancroft	BB	Nick Davies	ND	Jack Horner	JAH
Robyne Bancroft	RB	Karen Dayman	KD	Jennifer Isaacs	JI
Mary Bani	MB	Jennifer Deger	JD	Terri Janke	TJ
Kim Barber	KB	Ian Dunlop	ID	Jenuarrie	J
Fran Barker	FB	Anna Eglitis	AE	Vivien Johnson	VJ
Kathy Barnes	KAB	Ute Eickelkamp	UE	Mary Ellen Jordan	MEJ
Jeremy Beckett	JB	Bruce Elder	BE	John Kean	JK
Huey Benjamin	HB	Raymond Evans	RE	Ian Keen	IK
James Bennett	JAB	Hannah Fink	HF	Duncan Kentish	DK
Dorothy Blair	DB	Lucienne Fontannaz	LF	Joan Kerr	JAK
Nerida Blair	NB	Stephen Fox	SF	Richard G. Kimber	RGK
Andrew Blake	AB	Skye Fraser	SKF	Jonathan Kimberley	JNK
Rachel Boyce	RAB	Virginia Fraser	VF	Victoria King	VK
Wendy Brady	WB	Ursula Frederick	UF	Sylvia Kleinert	SK
Anne Brewster	ANB	Blair French	BF	Grace Koch	GK
Richard Broome	RIB	Murray Garde	MG	Harold Koch	HK
Robert C. Bropho	RCB	Kelly Gellatly	KG	Frances Kofod	FK
Ian Bryson	IB	Benjamin Genocchio	BG	Gary Lee	GL
Gordon Bull	GB	Heather Goodall	HG	Greg Lehman	GRL
Roger Butler	ROB	Phillip Gordon	PG	Donna Leslie	DL
Denis Byrne	DEB	Chrissy Grant	CG	Pat Lowe	PL
Anita Callaway	AC	Ian Green	IG	Gillian McCracken	GMcC
Liam Campbell	LC	Jenny Green	JG	Fiona Macgowan	FM
Shirley Campbell	SC	Paul Greenaway	PAG	Ann McGrath	AMcG
Margaret Carew	MC	Lola Greeno	LG	Ian McIntosh	IMcI
Wally Caruana	WC	Helena Gulash	HLG	Kevin McKelson	KMcK
Anna Clabburn	AAC	Mary Guthrie	MAG	KimMcKenzie	KIMcK
Kathie Cochrane	KC	Louise Hamby	LH	Chips Mackinolty	CM
Carolyn Coleman	CC	John Harding	JH	Ian McLean	IMcL
Susan Congreve	SUC	Victoria Haskins	VH	Charlie McMahon	CMcM

Contributors

Vanessa McRae	VMcR	Michael Parsons	MP	Ann Stephen	ANS
Raymattja Marika	RM	Louise Partos	LP	Roberta Sykes	RS
David Martin	DM	Frances Peters-Little	FP-L	Lyn Syme	LS
Kathryn Matthews	KM	Nicolas Peterson	NP	Paul Taçon	PT
John Maynard	JM	Gary Proctor	GP	Colin Tatz	CT
Philip Mead	PM	Peter Read	PR	Paul Tatz	PAT
M. Ruth Megaw	MRM	Anthony James		Luke Taylor	LT
Vincent Megaw	JVSM	Redmond	AJR	Kathy Tozer	KT
Doreen Mellor	DOM	Joseph Reser	JR	Gerry Turcotte	GT
Joanna Mendelssohn	JAM	Una Rey	UR	Paul Turnbull	PUT
Tjalaminu Mia	TjM	Edwin Ride	ER	Ilaria Vanni	IV
Thomas Middlemost	TM	Brian Robinson	BR	Patricia Vinnicombe	PV
Diane Moon	DIM	Tim Rollason	TR	Graeme Ward	GW
Sally Morgan	SAM	Tim Rowse	TIR	Alan Watchman	AW
Howard Morphy	HM	Katherine Russell	KR	Christine Watson	CW
John Morton	JOM	Lani Russell	LR	Ken Watson	KW
Dan Mossenson	DAM	Judith Ryan	JUR	Brad Webb	BW
Anna Moulton	AM	Fiona Salmon	FS	Alan West	ALW
Stephen Muecke	STM	Andrew Sayers	AS	Margie West	MW
Djon Mundine	DjM	Kath Schilling	KS	Stephen Wild	SW
Margo Neale	MN	Nalda Searles	NS	Eleanor Williams	EW
Karl Neuenfeldt	KN	Adam Shoemaker	ADS	Nancy Williams	NW
Christine Nicholls	CN	Mike Smith	MS	Clare Williamson	CLW
Maria Nugent	MAN	Mark St Leon	MStL	Diana Wood Conroy	DWC
William Nuttall	WN	Tom Stannage	TS	Felicity Wright	FW
Michael O'Ferrall	MO'F	John E. Stanton	JES		

Part one

Contents: Part one

Contents: Part one

RENEGOTIATING TRADITION

Contents: Part one

THE PUBLIC FACE OF ABORIGINALITY

Contents: Part one

8

Foundations of being

1. Religion

1.1 Aboriginal religion today

When my father was alive this is what he taught me. He had taught me traditional … designs … He taught me how to sing song for the big ceremonies. People who are related to us in a close family they have to have the same sort of jukurrpa Dreaming, and to sing songs in the same way as we do our actions like dancing, and paintings on our body or shields or things … My Dreaming is the kangaroo Dreaming, the eagle Dreaming and budgerigar Dreaming so I have three kinds of Dreaming in my jukurrpa … [This] is what I have to teach my sons, and my son has to teach his sons the same way my father taught me, and that's the way it will go on … and no other families will come along and take it away from us, it is going to be really strict … That is what my father taught me and this is what it will carry on to the future, and no-one knows when the jukurrpa will ever end (Paddy Japaljarri Stewart 1994).

The land, for Aboriginal people, is a vibrant spiritual landscape. It is peopled in spirit form by ancestors who originated in the Dreaming, the creative period of time immemorial. The ancestors travelled the country, engaging in adventures which created the people, the natural features of the land, and established the code of life which is today called 'the [D]reaming' or 'the [L]aw'. The [L]aw has been passed on through countless generations of people … Song, dance, body, rock and sand painting, special languages and the oral explanations of the myths encoded in these essentially religious art forms have been the media of the Law to the present day … The ancient and enduring ideology and philosophy of the Dreaming is today challenged by the insidious encroachment of white ideology … These two systems co-exist … [but] are fundamentally incompatible … The difference between the two peoples is clearly defined in that the origins of white Australia are materially based, as opposed to Aboriginal society which has no concept of materialism and is spiritually based (Michael Anderson 1987).

When I stopped drinking I said the serenity prayer … That little prayer dug deep into me and made me feel at peace. I went to the church service for the very first time in a long time … Inside that church this light came, very bright, but beautiful. It blurred the vision … After a while, the light started fading. It was all happening in me now … and I felt really good, and I never want to ever go back to that part of my life that did all those horrible things … I am starting to pull … the stories from the Bible, into our way of living, and that is important. Interpreting the stories that were told by Jesus and that were told by the old prophets, pulling those stories and relating them to our way of living, our lifestyle, our

culture, our language, putting those pieces together. Both give me that peace. I cannot separate this from this, I've got to have them together (Agnes Palmer, cited in Rintoul 1993).

Paddy Japaljarri **Stewart**, Michael Anderson, and Agnes Palmer share an Aboriginal heritage, but they come from different parts of Australia and have experienced different histories. To read what they have to say about their religion is to be struck by diverse, yet closely connected, events and themes. Japaljarri is a Warlpiri–Anmatyerre man who belongs to the Mt Allan–Mt Denison area about 250 kilometres north-west of Alice Springs. He is a well known artist with an international reputation [*221*]; his work was represented in the 'Dreamings' exhibition which toured the USA in 1988–89. Anderson, whose Gamilaraay country is in northern New South Wales, has had a prominent career in Aboriginal education and politics, and was among the leaders of the group which erected the **Tent Embassy** in Canberra in 1972. Palmer is an Arrernte woman whose country is just north of Alice Springs, although she grew up at Santa Teresa, about 70 kilometres south-east of the town. She is involved in alcohol rehabilitation schemes in Alice Springs. Stewart, Anderson, and Palmer all believe in something known as the **Dreaming**. But they seem to want to tell us different things about it.

Paddy Japaljarri Stewart's account of Jukurrpa or 'Dreamings' resonates most closely with anthropological and popular portrayals of traditional Aboriginal society. He was born about 1940. While he has never known a life free from the influence of colonisation, he has lived at least part of that life in times when the influences were relatively slight. Consequently, his narrative style is close to the old ways. In the main, he speaks of Jukurrpa in the plural: kangaroo Dreaming, eagle Dreaming, budgerigar Dreaming— these are the stories that he and his 'close family' hold to the exclusion of others. He has inherited these from his father and will endeavour to pass them on to his sons. In this way, and in spite of the fact that they are not common property, Stewart assumes that the Dreamings—the 'traditional designs' and the 'song for the big ceremonies'—will continue forever. He also assumes that his Dreamings have existed since the very beginning of time. They are eternal and transcendent, which is why the idea of the Dreaming has been memorably described by anthropologist W. E. H. Stanner as 'everywhen'. But Stewart does not speak of *the* Dreaming, for the Dreaming in the singular sense is largely an Anglo-Australian translation of a general idea that he would call the Law.

The phrase 'the Dreaming' has its origins in the late nineteenth century when the postmaster of the Alice Springs telegraph station, Frank Gillen, in his research with Baldwin Spencer, coined the term 'Dream times' to capture in English the Arrernte word Altyerrenge. 'Dream times' underwent a number of transformations to become the Dreaming or the Dreamtime, both of which came to be applied on a continental scale to the fundamental religious conceptions of all Aboriginal groups. Altyerrenge, derived from the word Altyerre, is found only in dialects of Arrernte, the language spoken throughout a large area of semi-desert in central Australia, although in the form rendered by Gillen—'Alcheringa'—it has passed into widespread usage. While other Aboriginal languages use terms with meanings similar to that of Altyerre—including Jukurrpa in Warlpiri—Arrernte is one of the few languages that make an explicit link to dreaming. In Arrernte, the phrase *Altyerre areme* is used to describe the process of having a dream. It literally means 'to see Altyerre'.

But dreams are not the only road to Aboriginal religion. The core meaning of Altyerre in Arrernte lies somewhere else, in the idea of the ongoing creation of the world and all that it contains. Altyerre, Jukurrpa, and similar terms are fundamentally cosmologies, although they may have other meanings as well. For example, the Arrernte phrase *Altyerre ileme* describes the process of telling a story. While not all stories are regularly

referred to as Altyerre, stories are nevertheless fundamental to the entire cosmology that Altyerre describes. As is well known, Aboriginal people throughout Australia tell stories of the creation of the world by totemic ancestors—marvellous beings, essentially human (yet also superhuman) in form, but often also associated with particular species of animals and plants or other phenomena. These are the kangaroo, eagle, budgerigar, and other Dreamings spoken of by Paddy Japaljarri Stewart. The totemic beings are original in every sense of the term. They were the first to exist in the world and the first to institute a global regime of cause and effect. It was the totemic ancestors who created an ongoing dynamic field relating features of the landscape, the heavenly bodies, all living things, rules of human association, and religious observances.

These things are only marginally associated with dreams. Particular ancestors and their creations may well be referred to as 'Dreamings', but this term is a gloss on what we might otherwise call 'totems' or 'stories'. When Aboriginal people allude in English to the complete field of ancestral precedent, they speak not so much of the Dreaming, but of 'the Law'. The Law governs the world of all Creation. It encompasses not only the rules and regulations by which people live, but also the laws of nature. Without the Law, nothing would exist or persist. In that sense, the Law is the Constitution, a charter of all that was, is, and shall be. By the same token, the Law is everywhere, binding the whole world together in a systematic way. Hence, as we delve deeper into the complex associations of 'the Dreaming', it begins to appear as something much, much more than 'dreaming'. It is, in effect, a First Cause, a synthetic principle to which all minor causes are subordinate. While manifested through the material world, it is not in itself a material entity. It has been described by anthropologist T. G. H. Strehlow (1971) as 'eternal, uncreated, sprung out of itself'.

Nym **Bandak**'s painting *All the World*, 1958–59 [*34*] illustrates the way in which traditional Aboriginal religion reconciles the synthetic cosmology of the Law with the plurality of Dreamings. Bandak, a Murrinh-patha man from Port Keats, depicts the world as a unified totemic cosmos, made up of four strata. The outer band illustrates distant stars and the passage of the sun, which takes totemic and gendered forms. The next band depicts the Milky Way, while the next shows the planets, the morning star and the phases of the moon, also totemic in form. The final, earthly band of the universe is carefully represented with highly differentiated forms. Bandak had good reason for doing this, because different parts of the landscape were created by particular totemic beings. Moreover, these landscape parts remain more or less exclusively associated with particular ancestral beings, so that one cannot really speak of a single moment of earthly creation, but rather of many independent ancestral moments. While one may rightly say that there is a single Law, each totemic ancestor was effectively 'a law unto itself'. Totemic beings have something in common with Judaeo-Christian notions of power, since, like the Christian God who is sometimes referred to as the Word, they called or 'sang' the universe into being so as to make it consubstantial with themselves. If a totemic being is said to have created a particular place, that place, or 'sacred site', cannot be separated from the ancestor, and people refer to it in personal terms as 'him' or 'her'. Clusters of such sites coalesce to form estates or 'countries' held by particular family groups who likewise see themselves as consubstantial with the ancestors. Hence there is a threefold identity between people, places, and ancestors. As Paddy Japaljarri Stewart implies, no family surrenders its Dreamings or its country lightly. Ancestral knowledge is owned and jealously guarded. Each country is protected from intrusion under a regime of 'really strict' Law. Hence Bandak's care in differentiating place from place.

There is a profound relationship between an ancestor and the material entity created through his or her agency. A hill or tree might be an ancestor's body, or some part of it,

such as an arm or leg. A shallow depression or saddle on a range might have been caused by an ancestor making an impression there, either through direct bodily agency or through the operation of some tool [see 2.2]. Alternatively, it might be said that part of the country has been formed by the ancestor externalising something, a complex idea that is in many ways the key to understanding the general process of ancestral creation. For example, while an ancestor might create a pile of rocks by, say, vomiting, other forms of externalisation are essentially non-corporeal in nature. Sometimes an ancestor dreams a landscape feature before it is projected into reality. More regularly, the ancestors create such places by giving them names. But these names are not those of ordinary language: they are sung as verses of a song. Indeed, ancestral existence is essentially captured by songs which systematically describe journeys, activities, and creations as mythic cycles.

Uta Uta **Tjangala**'s *Woman at Yumari*, 1990 [1] illustrates something of these dynamics of creation, revealing how they are conditioned by a notion of visceral expression. The painting shows a number of landscape features that are part of a larger site complex in Pintupi country known as Yumari, near Lake Mackay. Uta Uta in this painting represents the 'mother-in-law' lying in a sexually provocative way. The roundels, which are also conventionally signs for places in the landscape, represent her breasts, vagina, and knees. Other paintings done before his death in 1990 depict different features of the place, particularly the 'old man' whose body was transformed into the main rock hole there. Yumari was part of Uta Uta's own country. It is associated with his family, and Uta Uta himself most strongly identified with the old man of the Yumari story. He is known to have painted the story in strategic fashion, using it as a statement of his power and authority in laying claim to his country, so that his expression of his Dreaming was at the same time, as Fred Myers has described it, 'an expression of his personal identity'. In

1. Uta Uta Tjangala, *Woman at Yumari*, 1990.
Acrylic on canvas, 112 x 75 cm.

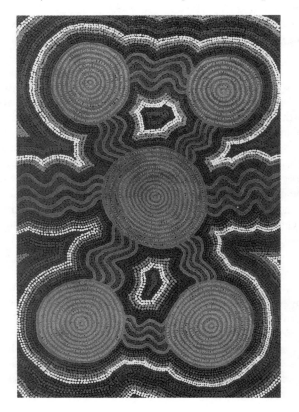

Arrernte, the language from which the Dreaming comes, one word that describes ancestral composition of songs, and therefore the very process of creation itself, literally translates as 'to call by name'. Strehlow (1971) demonstrates that the same word also means 'to trust' or 'to believe' and, in its reflexive form, it also carries the sense of 'to boast'. Indeed, all ancestral creation begins in the proud boast of calling oneself by name, with the ancestor conforming to the maxim 'know thyself'. After that, the ancestor names the place where he or she first came into existence, thus creating a major sacred site. Then the ancestor names all the other places, things, and creatures that are the outcome of his or her potent intervention—these are forever after bound to ancestral will. Those who come after the first beings, and are identified with them, inherit this very same potential. Uta Uta activated one local instance of that potential when he laid fresh claim to his country and re-created Yumari as a vehicle of his power, authority, and self-expression.

Virtue in Aboriginal religion lies in the obligation to follow ancestral precedent, which involves keeping the stories and countries alive as part of a living tradition steeped in ritual sensibilities and regulations. As Uta Uta's relationship to Yumari shows, the obligation is not disinterested: the traditions should repay the interest of the living and they are the very stuff of political competition. Stories are there for the telling, but they are communicated in a number of different ways to different people. Some 'outside' versions are public and known to all. Some of these are especially suitable for children, while others may be 'just so' stories or moral tales. The most important versions of stories, generally called 'inside' knowledge, tend to be restricted to senior men, although in many places women also deal in restricted knowledge. Moreover, each person's life has it own unique trajectory marked by characteristics of age, gender, and family affiliation which determine which stories, and which versions of those stories, will be revealed to them. The revelation may come through ritual drama—particularly during the commemorative events which re-enact the lives of totemic beings. Aboriginal rituals can consist of public dances and healing and mortuary practices, but these are usually subordinate to or articulated with male initiation, or other elements of 'men's business', or 'women's business', which are the primary means of sustaining countries in the form originally instituted by the totemic ancestors. Looking after country can fairly be said to be a kind of supreme good. But Aboriginal people do not really follow 'the Dreaming'. Rather, they follow particular Dreamings and build ritual careers out of unique clusters of totemic association.

In certain respects this care for Dreamings merges into economic maintenance and a kind of ecological consciousness. Looking after country enlivens it and makes it productive. But in other respects the care has more in common with nationalism. When the ancestors called the environment into existence, they sang songs steeped in sentimental biases towards the particular countries to which they were thereby bound. Each and every country was the most beautiful, the most bountiful, the most inspiring of all. Initiation rites induct novices into similar regimes of spatial commitment, while rituals designed to care for country repeat the very same songs and sentiments that originated with the totemic ancestors. Obligations towards ancestors and countries mean that Aboriginal people are in one sense owned by the land: they belong to it; they are identified with it. But this is not a denial of human ownership and agency. Religious identification with country is a negotiable matter that can lead to a sense of mutual possession and belonging. For example, Ian Keen shows that Yolngu people in north-eastern Arnhem Land refer to connections between countries, ancestors, and living people through the metaphor of *ḻikan,* which literally means 'elbow', but signifies a more general notion of conjoint existence. When people become 'conjoined' with ancestors and country, their own agency and power of possession are enhanced. As one Yolngu man, Wurrpan, once said in relation to his Dreaming: 'The big paperbark fell at honey bee

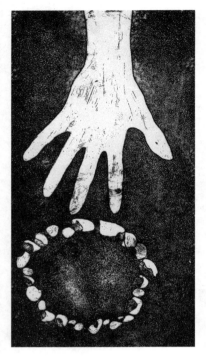

2. Fiona Foley,
Sacred Land, 1985.
Aquatint etching, 38.4 x
20.4 cm.

country. I called that. It is my knee or elbow … and I called the *l̲ikan* name … This, the knee or elbow, is power. I have a lot of power; no one gets the better of me, white or black. I have the law for everyone. I am the elbow. I have … the power.'

It is a fact, however, that many Aboriginal groups in Australia have not always been able to make such confident assertions. Many Aboriginal people have had their 'elbows' dislocated since the European invasion of Australia began in 1788. Many were unable to sustain connections with country in the wake of urban and rural development. And many were unable to sustain connections with Dreamings in the wake of the battle for hearts and minds that accompanied the battle for land. While Aboriginal people were not entirely powerless in their exchanges with settlers, on balance their history is one of a sense of dispossession and, for those who survived the onslaughts, a renegotiation of identity. Michael Anderson has said that 'the most important characteristic which distinguishes [Aboriginal people] … is that they have refused to surrender identity.' They are 'survivors of the traditional form'. While the 'balance and harmony [of the traditional way of life] was lost … the strength of it lived within the survivors, and it gave rise to the identity that Aborigines will carry with them into the 21st century and beyond.'

Not surprisingly, that identity is framed with reference to religious sensibilities. Anderson speaks of the 'ancient and enduring ideology and philosophy of the Dreaming' and of the 'vibrant spiritual landscape' that is Indigenous Australia. He also speaks of Aboriginal society being 'spiritually based' and having 'no concept of materialism'. This account echoes Paddy Japaljarri Stewart's concern with continuity and descent from original beings who were at one with the land, but its emphasis is different. It is first of all a general account. The identity spoken of is a broad Indigenous one, specific to the colonial situation that characterises the Australian nation state. While Stewart speaks only of his own family's Dreamings, Anderson employs the Dreaming to signify the religious and historical grounds for Indigenous Australian identity as a whole. Hence something new has been added to the 'ancient and enduring' philosophy. The Dreaming has almost become pantheistic, a singular spiritual essence belonging to all Aboriginal people and connecting them to one Aboriginal country—Australia.

Most non-Indigenous Australians know the Dreaming in this light. They are aware that Australia is a country with an extensive history and a land which has been honoured for countless generations. They believe there is an Australian Dreaming and that its secrets are held by Indigenous people. The recent upsurge of interest in Aboriginal art, both 'traditional' and 'urban', is in part testimony to Australia's fascination with the 'sacred' underpinning of the nation. The land, and its Dreaming, have come to be signified in many ways—not only by familiar Indigenous motifs, but also by introduced styles of representation. For example, Fiona **Foley**'s *Sacred Land*, 1985 [2] depicts the artist's hand reaching to connect with evidence of an ancestral past exposed upon the ground. Hence the work depicts the same connection between people, ancestors, and place that is central to all Dreamings and to the practice of holding country. Along with countless other Aboriginal paintings (or images thereof), *Sacred Ground* has entered into widespread circulation, illustrating to all an ongoing honouring of Aboriginal heritage and the land, and thereby affirming that the Dreaming will never end. For many Australians, Indigenous and non-Indigenous, this affirmation is reassuring, and Foley's image of an anonymous hand reaching respectfully to sacred land is something with which they can identify.

If interest in the Dreaming is no longer restricted to Indigenous Australians, this raises the question of the relationship between Indigenous and non-Indigenous religious ideas. After many decades of missionary influence, a great many Aboriginal people are now Christians, and even combine Christian tenets with those embodied in Indigenous

religion [see 1.2]. But they have often rejected or reworked the most fundamental biblical ideas. Ancestral beings are not, like God, distant figures. There is no story of the Fall consistent with ancestral creativity, nor any notion of sin that would require the intervention of a Saviour to reconcile human beings with the far flung reaches of heaven. There is no myth of a past or future Golden Age, no Utopian vision, and no hint of an outcast Devil, whose function is to bear responsibility for the cracks in God's erstwhile heavenly kingdom. In Aboriginal religions, not only do people live in close proximity to their totemic ancestors, but those beings also synthesise contradictory qualities within themselves—not least insofar as they are the paradoxical embodiment of all that is both good and bad. As Strehlow (1947) has written, ancestral stories tell of men and women whose lives were 'deeply stained with deeds of treachery and violence and lust and cruelty'. In central Australia I have encountered one Aboriginal synthesis of Christianity with traditional religion that teaches, without the vaguest hint of shame, that Satan was the origin of all totemic ancestry. While this can be interpreted as a direct response to Christian teaching about traditional forms of worship being the work of the Devil, it has taken a specifically Aboriginal genius to turn a denigrating statement into a myth that contains virtue.

Yet the typically Christian struggle between good and evil is now often used to measure the Dreaming. Michael Anderson speaks of an Indigenous world of 'harmony' and 'balance' before the coming of Europeans, who broke 'this circle of perfection'. Aboriginal history is therefore marked by a fall from grace and an eternal spiritual struggle against the materialist influences of Euro-Australian society. The land is honoured for being a paradise, much as it is in ancestral song. But while totemic verses are projected onto the landscape of the here and now, this paradise is projected onto an ideal past sensed as being potentially out of reach. There is, however, a promise of redemption since, if people recognise the failings of colonial history, both Aboriginal and non-Aboriginal people will be able to move forward to share a common bond with the land—a common Dreaming. As Anderson says:

We seek only what is ours, and the land is ours ... We do not wish to make refugees of those descendants of the invaders ... We will walk beside them in friendship and in goodwill, but we will not be subjugated nor will we allow this land to be subjugated to alien demands or greed. This is our world. We are prepared to share it, but not to give it away.

This redemptive vision has now come to be known as **reconciliation**. Like traditional Aboriginal religion, it is a fundamentally political project.

But to what extent do Aboriginal people assent to the view that Euro-Australian society lacks spiritual depth? Agnes Palmer's own story of redemption suggests an alternative path to reconciliation. Palmer is just one among thousands of Aboriginal Christians. As an alcoholic, she experienced her own version of a fall from grace, but her redemption lay partly in a religion that had been introduced by invaders and partly in a uniquely Aboriginal way of life. In reconciling differences, it is important to remember that the invaders were not exclusively materialist—they have had their own spiritual orientations and Aboriginal people have often sensed this and taken it to heart. Furthermore, colonial intrusion is not exclusively bad. The 'stories that were told by Jesus' and by 'the old prophets' can participate in the old ways and become inseparable from them. The life and artistic career of Jarinyanu David **Downs** [*35, 317*], a Wangkajunga Law man who converted to Baptist Christianity in the mid 1960s, demonstrate his conviction that it is necessary to 'make-em whole lot family'. Jarinyanu saw parallels between the ancestral and biblical heroes, who each travelled the desert; he linked the floods of his ancestor Piwi and of Noah, and equated the *Wati Kutjarra* (Two Men) with Moses and God.

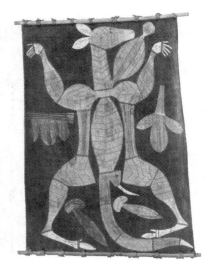

3. Namerredje Guymala,
Dismembered Kangaroo,
1974.
Natural pigments on bark, 68
x 43 cm.
The artist shows a kangaroo
divided into important food
parts. The liver is shown on the
left-hand side of the body and
the heart and lungs with part of
the trachea on the right. The
kidneys, attached to sections of
fat, are shown below the
figure. The tail and back meat
have been sectioned from the
body. The stomach and gut are
attached to the neck.

The habit of mind that radically separates good from evil, the spiritual from the material, and self from other seems quite alien to this conception, just as it is absent from Dreamings. One could argue that the genius of Aboriginal religion has long lain in its capacity to reconcile believers to unity and harmony without denying the forces that create divisions. Namerredje's *Dismembered Kangaroo*, 1974 [3] illustrates the metaphor of the divided body, commonly used in western Arnhem Land as a means of giving visual form to the paradox of the one and the many. This symbolism of division is as fundamental as any contrary idea of unification, and the former is not thought to spoil the latter. Rather, true harmony and balance obtain in a world where one cannot fully 'separate this from this'; where one cannot hastily distinguish good from evil, spirituality from materialism, or black from white; where Indigenous and other Australians can possess their own stories, yet recognise the potential of each other's Dreamings within the scope and principles of a more general Law.

JOHN MORTON

Anderson, M., 'Aboriginal philosophy of the land', *Empire Times,* vol. 19, no. 11, 1987; Keen, I., *Knowledge and Secrecy in an Aboriginal Religion: Yolngu of North-East Arnhem Land*, Oxford, 1994; Kentish, D., 'Jarinyanu David Downs', in A. M. Brody (ed.), *Stories: Eleven Aboriginal Artists,* Sydney, 1997; Myers, F. R., 'Aesthetics and practice: A local art history of Pintupi painting', in H. Morphy and M. Smith Boles (eds), *Art from the Land: Dialogues with the Kluge–Ruhe Collection of Australian Aboriginal Art,* Charlottesville, VA, 1999; Rintoul, S., *The Wailing: A National Black Oral History*, Port Melbourne, 1993; Spencer, W. B., 'Through Larapinta Land', in W. B. Spencer (ed.), *Report on the Work of the Horn Scientific Expedition to Central Australia,* London, 1896; Stanner, W. E. H., *White Man Got No Dreaming: Essays 1938–1973*, Canberra, 1979; Stewart, P. J., 'Dreamings', in D. Horton (ed.), *The Encyclopaedia of Aboriginal Australia,* Canberra, 1994; Strehlow, T. G. H., *Aranda Traditions,* Melbourne, 1947; Strehlow, T. G. H., *Songs of Central Australia*, Sydney, 1971.

1.2 Religion and art from colonial conquest to post-colonial resistance

It is not coincidental that the centres of the most highly prized genres of Aboriginal art, purported to be 'traditional', are former missions and settlements—the sites of contest between two religious or cosmological systems. In such locations as **Yirrkala**, **Papunya** [see also 9.4, 9.5], **Ngukurr**, **Balgo**, **Yuendumu**, **Maningrida**, Alice Springs, **Hermanns-burg** [see also 9.1, 9.2, 9.3], and **Fitzroy Crossing** [see 10.1, 10.2], in a milieu of increasing liberalism, the 1960s and 1970s saw perhaps the final flowering of the Enlightenment on the frontier.

For some art historians and anthropologists, it is self-evident that many works of 'Aboriginal art' are rather artefacts of the colonial encounter. But there remains the difficulty of mapping out the detailed world of Aboriginal religious life and culture proper—the world which lies behind the encounter—and of acknowledging the density of signs, of knowledge, and of images that Aboriginal people bring to this encounter.

Two religious systems, two knowledge systems

My principal argument is that between proselytising Christianity and Aboriginal religion lies the discursive location of the invention and construction of Aboriginal art and culture in modern Australia—the messengers of the first asserting Christ's Kingdom as the One Way, and the practitioners of the second eluding conversion and then finally protesting against the assumption of their irreligious state by revealing their secrets of

the sacred. Christians held that Aborigines were either pagans or heathens. In any case, they lived outside of Christendom. Seen as incapable of being civilised they could not be shepherded into the fold of the Kingdom of Christ. It was necessary, however, to contend with their threat to Christian values and to regard any sympathy for their ideas as heretical. The unresolved conflict between two fundamental views among Christians—that Aborigines either had no religion or a lower form of religion—informed the ambiguous and difficult appreciation of Aboriginal material culture, especially religious sacra, by Europeans. The failure to decide which stance was the more appropriate has been an ongoing cause of debate in Australian life.

Churches, missionary societies, clergy, and missionaries played a significant role on the frontier, some spreading an expedient message concerning the status of Aborigines to the marauding frontiersmen, and some devoting themselves to the amelioration of Aboriginal suffering or to the denunciation of violence and brutality. Mission settlements provided a safe haven for beleaguered Aboriginal people. Death rates would have been much higher without the presence of missionaries, and a debt is also owed to them for their role in ensuring the survival of traditions that continue to inform Aboriginal artistic endeavours.

A survey article on the role of religion in Aboriginal art and culture since colonisation cannot cover the many ideas and debates which have circulated in theological, anthropological, and other schools of thought. One scholar stands out from the crowd of curious observers. In 1976 W. E. H. Stanner, an Anglican and the outstanding anthropologist of his day, delivered the Charles Strong Memorial Trust Inaugural Lecture, which he commenced in this way:

There may still be some who question the rightness of including Aboriginal beliefs, acts and objects within the scholarly scope of Comparative Religion … I will contend that all the intellectual requirements can be, and long have been, amply satisfied.

If, for the purpose, I adopt William James's dictum—that the word 'religion' cannot stand for any single principle or essence, but is rather a collective name—it will not be in deference to the sceptics, but rather in acknowledgment of two things: the Aboriginal materials are too various and subtle for our present stage of professional insight, and we cannot yet make powerful general statements on a continental scale.

The situation remains much as Stanner described it; and with the changes that have since taken place in much of the traditional religious life, much that we might have learnt even then cannot now be discovered. The cultures and social ways of Aboriginal people have changed constantly and remarkably since settlement, and the archaeological record of human life on the continent from the late Pleistocene bears witness to change on a continental scale for over 40 000 years. Stanner's view of how Aboriginal religion—and its dynamism—could have been so misunderstood by Europeans bears repeating: 'only a blindness of the mind's eye prevented Europeans in the past from seeing that "the ritual uses of water, blood, earth and other substances, in combination with words, gestures, chants, songs and dances, all having for the Aborigines a compelling quality" were not "mere barbarisms" but had a sacramental quality.'

Aborigines also came into contact with peoples of the Islamic faith: the Macassans [see 6.4], from what is now Sulawesi in Indonesia, until their annual visit to harvest trepang was suppressed by customs officials in 1907; the Afghan camel drivers in many parts of rural and central Australia; and the Malay pearlers in northern Australia. On Thursday Island, a dance which syncretises Torres Strait and Islamic traditions is still performed, involving small, white, hand-held flags, while in Broome (and also in other remote centres where the peoples of Islamic Asia played a role in the frontier society)

there is an Islamic cemetery, the last resting place of some Malay-Aboriginal descendants. Although some intermarriage or cohabitation between Afghans and Aboriginal women occurred and some Aboriginal men were employed as 'camel boys' by the Afghan cameleers, any impact of Afghan traditions on Aboriginal art and performance is now imperceptible. Nor is there any evidence, despite some intermarriage with Chinese and significant employment by Chinese traders and shopkeepers, that Aboriginal people were influenced by Taoism, Confucianism, or Buddhism.

Following increased scholarly interest in Aborigines, artefacts became emblems of the discourse between two religious systems and, later, two knowledge systems. These include the sketches and drawings executed or collected by explorers and their companions, the much later ethnographic collections, and finally the work of the modern and postmodern curators who manufactured 'genres' and 'styles' as Aboriginal artists and craftspersons created more and more works for their audiences. Once these were the missionaries and their patrons in Europe, but increasingly a global art market, hungry for emblems of 'primitivism', came into being.

Andrew Sayers has described the complex relationships between Aboriginal artists and Europeans in the nineteenth century. His documentation of Black Johnny's drawings and the works of William **Barak** [see also 11.1; *289*] Tommy **McRae** [*140*], and **Mickey of Ulladulla** [*272*] alerts us to the difficulty of assessing their art merely as the result of 'white influence'. He rejects the simple idea that these works are 'halfway along some imagined continuum, away from traditional culture and towards the forms of the colonising culture', and notes that the respective bodies of work of these artists have two major, insistent themes: ceremonies and traditional hunting and food-gathering.

In the literature on Aboriginal religion, the influence of Christianity is a consistent theme: its incorporation and ownership by ceremonial leaders occurred widely. Ronald and Catherine Berndt wrote in 1988 that in their professional careers of over forty years, almost all their field research had been under the shadow of one mission or another: 'there were, and are few Aborigines who have not been exposed in some degree, at first hand or otherwise, to some form of proselytization.'

Anthropologists have alerted us to the privileged position of 'religion' in Aboriginal life, inasmuch as religious belief underlies Aboriginal social structures and interpretation of the world. When we look at the imagery of Aboriginal art, the religiosity of the work is often evident because of the presence of emblems which we have learnt to recognise as religious symbols, and often as symbols of the dialogue with Christianity. Ironically, the engagement between two religious systems on the Australian continent since the eighteenth century is as much a source of Aboriginal 'art' today as is the millennia-long engagement of the peoples called 'Aboriginal' with this continent.

A major justification for the expansion of European interests into most parts of the globe was an evangelical one—to bring the Word of God to the heathens and the pagans—and representations of other cultures were therefore sent back to the centres of the imperial world. It was necessary that heathen and pagan art and culture be depicted as degraded works of the Devil, and proof of the need for missionary work. All society, as Europeans perceived it, was Christian; beyond the borders were 'heathens', and beyond them, in turn, were 'barbarians' and 'savages'. The highest and most valued forms of art of the European societies, until the Enlightenment of the late eighteenth century, had been religious art. Thus, it was inconceivable to the explorers who came to the shores of the Great South Land, or Terra Australis Incognita—whether Catholic Spanish or Portuguese, Calvinist Dutch or Protestant English—that the Aboriginal people they observed were fully human, devoid, as they appeared to be, of religion and religious art. The first written report, published in English in 1697, was William

Dampier's *A New Voyage Round the World*. Dampier all but dismissed Aboriginal people, their land, and its resources as worthless, and noted: 'I did not perceive that they did worship any thing.'

The earliest British settlement was military; its purpose was to house convicts. No missionary accompanied the first fleet, and Governor Phillip was not instructed to preach to the Aborigines. But, as Jean Woolmington writes, the great evangelical revival in Britain led to the founding, between 1793 and 1813, of major Protestant missionary societies, three of which were to send missionaries to New South Wales: the London Missionary Society, the Church Missionary Society and the Wesleyan Missionary Society.

The enthusiasm displayed by successive colonists in the collection of Aboriginal objects belied the contempt in which they were held; the objects were appropriated for purposes of study only. There was little or no reference to their beauty or to the technical and aesthetic complexity of their manufacture. They were not perceived as 'art', or viewed in any way aesthetically, until the twentieth century. The failure of the British evangelists, and others sympathetic to the Aboriginal plight on the frontier, to convince their colleagues of the humanity of Aborigines—or, perhaps more correctly, of the inhumanity of their treatment of them—and the failure of the ideas of the Enlightenment in the Australian colonies were as much causes of the frontier brutality as was greed for the land. French visitors, imbued with Enlightenment ideas, such as François Péron who came in 1802, were sure that Aborigines could be civilised; but as the process of colonisation progressed, historian Manning Clark writes: 'less and less is heard of the early aspirations to civilise the aborigines as a preparation for their becoming members of the mystical body of Christ's Church. Experience was … convincing more and more people that violence and reprisals were the only methods the aborigines could understand.'

Anthropologists assessing the impact of the Christian missions report that few Aboriginal people were converted, and those that were refused thereby to reject their own religion. One successful missionary sect in colonial Australia was that of the Moravians in the Port Phillip district—eventually successful that is, in inculcating in the Gurnai allegiance of a sort to institutional practices which ran counter to their cultural traditions, and in suppressing the Indigenous traditions.

Bain Attwood's study of the nineteenth-century mission at Ramahyuck [4] in Gippsland (Vic.), and of the assertion by Aborigines of a different spatial and temporal sense from that imposed by the Moravians, is an insightful reconstruction of relations between Aborigines and the newcomers, providing a rich account of the changes which Aboriginal culture underwent in its negotiation with the missionaries. Here Friedrich and Louise Hagenauer constructed an architectural plan as the key to a system they

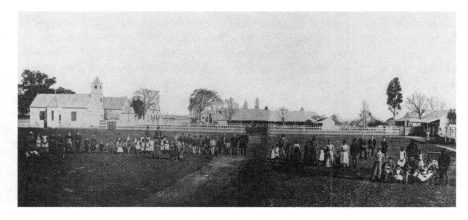

4. Ramahyuck Mission, 1883.

described as 'the machinery'. This aimed explicitly at socially engineering the whole population into a hierarchy, with each individual conscious of his or her place in the new ordered system. Attwood writes: 'Fundamental to their reconstruction of Aborigines was a plan to produce a carefully defined and ordered social space. In this Hagenauer wanted to create a didactic landscape, an instrument to transmit Christianity and "civilisation", mould the conduct of Aborigines, and express a conception of what he wished the Aborigines to become.'

Despite the attempts by the Moravians to impose a strict, Christian, European order, Gurnai continued to challenge their rule, although only within the missionary system. In a number of important aspects of mission life the Aborigines forced the missionaries to compromise, ensuring that a certain reciprocity became deeply embedded in a way which suited both parties. The paternalistic system was accepted by Aborigines insofar as it overlapped and was compatible with the social ethic of their traditional culture. As the years went by, the missionaries and the Aborigines were bound together ever more closely by the complex dyadic relationship which had developed, and a delicate social equilibrium existed which generally constrained the manner in which the rulers and ruled acted towards one another.

One of the challenges to the mission came from Tulaba (Billy Macleod) and his companions. A Brabiralung man, born near Bruthen in the early 1830s, Tulaba was taken as a boy and raised on a pastoral run, where he worked for Archibald and John Macleod. The Brabiralung asserted their traditional principles of reciprocity and tried to incorporate the whites into their kinship system. Attwood describes how the Brabiralung men sought to strengthen the bonds by selectively revealing their spiritual beliefs to the Macleods, whom Tulaba appears to have regarded as the equivalent of initiated Brabiralung men.

When A. W. Howitt and his wife settled on the Mitchell River in Brabiralung country to grow hops, Tulaba and his wife struck up something resembling the traditional Aboriginal relationship of kinship and reciprocity with them. Howitt, the amateur anthropologist, benefited from this relationship, since Tulaba and others regarded providing information about their culture as part of their reciprocal obligations. Howitt's anthropological inquiries were perceived, according to Attwood, 'as a means of sustaining' their beliefs and practices 'and passing on to other Aboriginal men some of their knowledge'.

Howitt had been impressed by a ceremony he had witnessed in the 1870s. His description, as reported by Attwood, indicates his belief in its authenticity: 'The actors were in their parts *con amore*. The past seemed to revive in them. They were no longer the wretched remnant of a native tribe dressed in the cast-off garments of the white men, but Kurnai [Gurnai] … performing a ceremony handed down to them through their ancestors.' At Howitt's suggestion, some Aboriginal men came together in 1884 for an initiation ceremony, despite the opposition of the missionaries, one of whom 'ridiculed the notion that Aborigines on Ramahyuck had any knowledge of traditional culture'.

The missionaries arranged marriages between young Aboriginal men and women in the European tradition, disregarding Aboriginal marriage rules. Attwood suggests that the traditional leaders may have regarded the missionary-arranged marriages as 'the only means of perpetuating their people'. Tulaba had no descendants, and the men and women who joined him in celebrating the church rituals were unable effectively to pass on their knowledge to the mission Aborigines. But they conveyed it to Howitt and so it entered European anthropological discourse, 'where', Attwood suggests, 'it remained alienated from Aborigines until they recently began to seek the riddle of their identity in his ethnographic texts'.

Despite the loss of population and land, Aboriginal traditional relationships with their country and the ritual expressions of these affiliations were difficult to suppress.

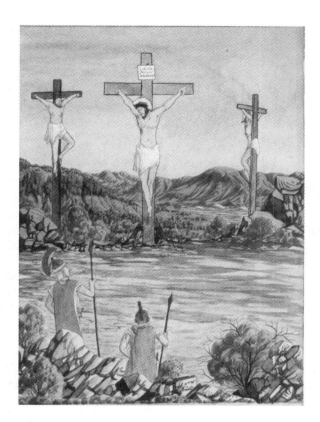

5. Oscar Namatjira,
The Lord Jesus on the Cross,
c.1960.
Watercolour, 52 x 38 cm.

Initiations were still being performed in many districts of south-eastern Australia at the end of the nineteenth century. Even the desire to own land had a partly traditional emphasis both in terms of where it was sought and its intended use. Henry Reynolds (1990) quotes a government official in southern New South Wales writing in 1883: 'I have known blacks in Braidwood and coast districts very intelligent, who have been and now are excellent farm labourers, and whose aspirations at all times were to be allowed some land they might call their own … where aborigines of surrounding districts might meet periodically for the purpose of holding corroborees and other exhilarating games.'

Missionaries were active in central Australia by the 1870s. In Western Arrernte country, German Lutheran missionaries established the Hermannsburg mission [see 9.1] on the banks of the Finke River. In 1932 Rex Battarbee and John Gardner, two artists from Victoria, visited the mission, drawing portraits of Aboriginal people and painting landscapes of the spectacular features of the land. They returned in 1934 and held an exhibition of their work in the Hermannsburg schoolroom. Jennifer Hoff has argued, however, that the Hermannsburg watercolour art movement did not originate, as the orthodox view has it, in the work of Battarbee and Albert **Namatjira** [*36, 42, 111, 115*] but 'emerged in the drawings of children during the early 1930s and was shaped by the environment of Hermannsburg mission.'

Suppression of traditional Aboriginal culture at the mission and the secret element in some art forms had resulted in the emergence of a new vehicle of expression at Hermannsburg. A transitional landscape style appeared which was not merely copied from the work of white Australian artists but was a reordered system of schemata depicting the central Australian environment [*5*]. Through their art, the children resolved the contradictions surrounding them.

In 1949 the Australian Presbyterian Board of Missions proffered accounts of the Presbyterian mission settlements at Mapoon, Weipa, Aurukun [see also 8.2], Mornington Island [see also 8.2], Bentinck Island, **Ernabella**, and Kunmunya and, in glowing terms, their purported success in conversion. Yet, their booklet admitted that the Aborigine already had a religious life: 'He knows which parts of the country are sacred and which are believed to be linked with various ancestors in the mythical past ... Much time is spent, especially by the older men, in religious discussion, and much of their most beautiful work is to use in religious ceremonies.'

Sacred art: Revelation and protest

The second part of my argument is that mission oases on the frontier provided the conditions for the reassertion of Aboriginal religion through the revelation of its most sacred and secret meanings, in the presentation of the physical symbols of these meanings.

In 1957 Yolngu clan leaders at **Elcho Island** (NT), in full view of all the residents of the mission—Aboriginal and mission staff alike—prepared a demonstration of sacred poles to protest to the missionaries the existence of their own religion [see 1.4; 7]. The event has been described by Ronald and Catherine Berndt as an expression of attempted syncretism, emphasising traditional religious equality with Christianity: 'To provide a visible, tangible focus for this, a memorial was set up near the old mission church at Elcho Island. A small, open enclosure held a display of formerly secret–sacred religious emblems that were being made public for the first time: the central traditional post had a Christian cross at its apex.' This display became known as the Elcho Island Memorial.

The motto of the Arnhem Land adjustment movement, as this unique demonstration has become known, was: 'We give ourselves and our *rangga* and *maḏayin* to God.' Revealing the *raŋga* (sacra) was a skilful means to get local support. Ronald Berndt described it as an attempt to unite people in religious ideology and friendship, as well as to re-establish leadership and maintain Elcho Island as a centre of government. He reported Badanga, who with Burrumarra was seen as the spiritual leader of the movement by virtue of his traditional authority, as saying: 'We believe in the old law and we want to keep it and we believe in the Bible too. So we have selected the good laws from both and put them together.'

Ian McIntosh argues that the movement leaders were aware of the need for the two laws to overlap and entwine, with neither taking precedence. Finding a place for Christianity in the Yolngu worldview necessitated a complex re-working of existing beliefs. Given that Yolngu Law determines links to country, inter-group relations, and marriage procedures, if the Christian *mala* (group), or any one *mala*, dominates, there is the threat of complete social chaos and loss of authority by the leaders.

Much of the knowledge encoded in the *raŋga* is, however, held by only a select few elders, and Berndt writes that, while all the women were invited to view the secret–sacred emblems on the Memorial, they were not told the significance of their shapes and designs. Presumably this applied to the missionaries too. Moreover, as McIntosh has pointed out, these *raŋga*, having been revealed, were never to be made again. This is a perfect example of the Yolngu economy of knowledge and information, and of how knowledge can go out of circulation.

In the early 1960s there was an indigenisation of Christian space in churches at several missions. At Yirrkala, in 1962–63, the Yolngu clan leaders of north-eastern Arnhem Land created two panels of the clan emblems: one for each of the moieties (Dhuwa and Yirritja) [*31, 32*]. These were placed on either side of the church altar, and represented the most sacred and secret of the clan Wangarr (ancestral beings), never before revealed in such depth in public. These events involved months of region-wide negotiation between the

clan leaders and represented a turning point in the relationship between Aboriginal people and the missionaries and other Australians. A different form of indigenisation occurred at the Daly River Catholic Mission (NT) in 1961. Miriam-Rose Baumann **Ungunmerr** painted, in acrylic, scenes of the Stations of the Cross. Stylistically these paintings are Aboriginal but their subject is the life of Christ.

In the south-eastern Kimberley (WA), in the mid 1980s, large banners were installed at the Catholic church at Balgo. Some depicted Christian themes, such as Easter or the Prodigal Son; others were 'assembly banners' following traditional mythological lines. The Berndts argued that these: 'do not represent syncretism *per se*. There would seem to be no place, or not yet, for material of this kind as far as the Lutherans, Presbyterians and Anglicans are concerned. With the Catholics and Methodists there was at least limited acceptance of Aboriginal ideology; among the Methodists there was more scope for an interchange of ideas, and more flexibility for cross-religious adaptation.'

In the early 1970s an art teacher sent to **Papunya**, a remote Aboriginal settlement in central Australia, found himself the exponent of what was to become a major Australian art form of international repute [see 9.5, 9.6; **acrylic painting**]. Geoffrey Bardon [see 9.4] assisted the Luritja and Pintupi elders to transfer their religious art to the readily available materials of a settlement: acrylic paint on scrap wood and Fibro, and later on canvas. The symbols of the sacred were disguised by incorporating designs in, or erasing them from, the final works. Nevertheless, these images, seen only before as sand paintings in ceremonies, sent a clear message that here was a religion with meanings and explanations as deep and as relevant as any that Christian missionaries might purvey.

The revelatory origins of the 'Aboriginal art' movement can be seen as events of resistance and as public announcements of a renaissance of Aboriginal belief. Some of the most significant developments in Aboriginal art took place in the late twentieth century. Central to much Aboriginal art production in the 1990s was a new permissiveness, atypical of the old traditions. A decade before, only properly qualified Law men and Law women—religious exegetes—had the authority to execute the sacred designs. A harsh discipline and physicality were involved in achieving that status and upholding it along with its rights and responsibilities.

There are two fields of Aboriginal knowledge which are exemplified in the historical process of making Aboriginal designs available to non-Aboriginal people: the inner and the outer, or the secret–sacred and the mundane, although they are not entirely absolute and distinct [see 1.4, 6.1]. The revelation of inside knowledge occurred formerly only during specific status-changing ritual ordeals. Today, anybody can see at first hand an Aboriginal design depicting outside knowledge. They may also see, in some paintings, the 'brilliance' (*bir'yun*) described by Morphy in *Ancestral Connections*—the 'flash of light' from the aesthetic effect of the fine cross-hatching that covers the surface of an 'inside' painting. But they will not apprehend its 'inside' significance.

Peter Sutton suggests that knowing more about Aboriginal culture might help others to understand these works, but that this cannot 'guarantee a rich grasp of the art … Sacred understanding largely comes from seeing, and particularly from seeing performances and the execution of designs, together with listening to the often cryptic glosses offered by elders at such events.' Yet the outside knowledge, such as the common representations of Dreamings, can now be grasped, if only distantly, because of the increasing body of scholarly and critical literature and exhibition catalogues.

The concealment of the sacred under the strictures of Aboriginal Law provides a clue to the interest in Aboriginal art, as does the troubled history of relations between Aborigines and the settler nation. It is, perhaps, from a double effect of the forbidden in the meaning of Aboriginal art that its strangely attractive power emanates. On the one

hand, its sacred qualities, if perceived at all, have been suppressed as pagan heresy by missionaries throughout much of Australian history, although not without Aboriginal protestation. On the other hand, its sacred content has been restricted under Aboriginal Law to those—both women and men—who have undergone particular ritual ordeals. To those who have studied the literature on Aboriginal art, this double enclosure by religious proscription, and the revelatory power of art to intimate both the idea of the sacred and unconquerable belief must be doubly seductive.

Aboriginal artists have intended since earliest colonial times to reveal their vision and to assert its power. The devaluation of the Aboriginal symbolic world as a precursor to the destruction of Aboriginal societies is a colonial strategy against which Aboriginal people of high degree have defended their beliefs, ideas, and values. They have done so by using their symbolic repertoire, especially their artistic traditions, to convey the integrity and dignity of their religion.

<div style="text-align: right">MARCIA LANGTON</div>

Attwood, B., *The Making of the Aborigines*, Sydney, 1989; Australian Presbyterian Board of Missions, *Friends from the Walkabout: Brief Studies of the Australian Aborigines and of the Work of Presbyterian Missions in Their Midst*, Sydney, 1949; Berndt, R. M., *An Adjustment Movement in Arnhem Land, Northern Territory of Australia*, Paris, 1962; Berndt, R. M. & Berndt, C. H., 'Body and soul: More than an episode!' in T. Swain & D. B. Rose (eds), 1988; Clark, M., *A History of Australia*, vol. 1, *From the Earliest Times to the Age of Macquarie*, Carlton, Vic., 1963; Hoff, J., 'Children's art at Hermannsburg: Emergence of the traditional style', paper presented to the Australian Institute of Aboriginal Studies Conference, 1984; McIntosh, I., 'Can We be Equal in Your Eyes?' A Perspective on Reconciliation from North-East Arnhem Land, PhD thesis, NTU, 1996; Morphy, H., *Ancestral Connections: Art and an Aboriginal System of Knowledge*, Chicago, 1991; Reynolds, H., *With the White People*, Ringwood, Vic., 1990; Reynolds, H., *This Whispering in our Hearts*, St Leonards, NSW, 1998; Sayers, A., *Aboriginal Artists of the Nineteenth Century*, Melbourne, 1994; Stanner, W. E. H., 'Some aspects of Aboriginal religion: The Charles Strong Memorial Trust Inaugural Lecture', *Colloquium: The Australian and New Zealand Theological Review*, vol. 9, no. 1, October 1976; Sutton, P. (ed.), *Dreamings: The Art of Aboriginal Australia*, New York & Ringwood, Vic., 1988; Swain, T. & Rose, D. B. (eds), *Aboriginal Australians and Christian Missions: Ethnographic and Historical Studies*, Bedford Park, SA, 1988; Woolmington, J., '"Writing on the sand": The first missions to Aborigines in eastern Australia', in T. Swain & D. B. Rose (eds), 1988.

1.3 The Pleiades in Australian Aboriginal and Torres Strait Islander astronomies

Prior to the European invasion, there were probably as many Aboriginal and Torres Strait Islander astronomies as there were discrete language or cultural groups. Since the Australian land mass straddles some thirty-three degrees of latitude, from 10° south in the Torres Strait to 43° south in Tasmania, there is a great variation in the portion of the night skies actually visible at any one time across the continent, and, in addition, a variety of dynamic ecological environments from which they can be viewed. The contexts in which knowledge about the stars was produced differed from one locality to the next and was sustained and modified in response to changing circumstances and social contingencies. Astronomical knowledge was considered to be extremely important, and was often held and owned by individuals, and passed on according to strict rules. Astronomical observation and enquiry were not separate areas of knowledge; they were, rather, integral parts of everyday life and were reflected in storytelling, song, dance, art, and ritual.

The night sky is still significant to Indigenous people. It is viewed as being a series of multi-layered interconnecting maps, and its meanings operate at many levels simultaneously. When, for example, the night sky is viewed as a seasonal calendar, this does not exclude meanings it has in mythology or social relationships—indeed these meanings frequently elaborate the seasonal symbolism, representing simply a shift in emphasis. The use of stars for seasonal voyaging does not exclude their meanings in the context of a terrestrial landscape. Knowing them as belonging to the place of the dead does not preclude seeing them also as celestial campfires. In addition, the celestial landscape is intrinsically linked with the terrestrial one: most of the myths that involve the stars have their dramatic starting points or episodes on the earth. Thus many sky-based ancestral heroes and heroines are also associated with particular places in the earthly landscape.

Despite the variation in cosmologies, it is occasionally possible to identify commonalities. Across the continent, the sky-world is seen as the dwelling place of many ancestral spirits and creation heroes and heroines, those personified sources of energy which inform and give meaning to natural and cultural life. The sky-world is a vast, bountiful, and lively place, from which the sky-people can travel along shamanic pathways. Earth-based men and women of high degree (traditional healers), whose great powers are seen to be connected to these energies, can also access the sky-world, usually by climbing or pulling themselves up a connecting cord, variously pictured as string, hair, rainbow, spear, grass rope, tree, or flames.

Very few European constellations have direct Aboriginal or Torres Strait Islander equivalents. The prevailing idea underpinning European astronomy, that of joining the brighter points of light to form patterns, is barely followed in Indigenous astronomies. The very dark patches between or beside the points of light are frequently distinguished, creating awesome black constellations that spread out and cover much of the night sky. Coloured and moving stars are distinguished, and in the case of the Boorong of the Victorian Mallee, a star's lineal relation to the horizon marks its significance. A star's position in relation to the Milky Way is significant to many groups because the Milky Way delineates moiety equivalences on the basis of which sky-based marriage classes and kin categories are assigned.

There is one star cluster that is significant both to Indigenous people across the length and breadth of the continent and to many Europeans. The Pleiades are distinguished by all Indigenous groups and, with the exception of the cultural areas of northern Arnhem Land, Groote Eylandt, and the Torres Strait Islands, they are seen as a group, seven in number, of related women [see 2.2]. In the majority of narratives the central motif involves the Seven Sisters running away from the unwelcome and usually illicit advances of a man (or men), usually represented by the constellation named Orion (by Europeans), although there is some variation in the celestial object assigned the role of the assailant.

Isobel White observed the dramatisation of the Seven Sisters narrative by Andagarinja women from Yalata and Indulkana (SA). The narrative is associated with the celebration of first menstruation performed by women for a girl during her seclusion away from the main camp. White was told a version of the story by the acknowledged ritual leader of the women, who was also the designated 'boss' of the ceremony. This particular woman recited and acted the part of Njiru (Orion) who chased the seven ancestral women across vast tracts of (Western Australian) country, through Meekatharra, Wiluna, Laverton, and Kalgoorlie to Cundeelee, where the women hid in a cave. But Njiru caught one of the women and raped her. Because she was Njiru's (classificatory) father's sister, this act was incestuous, and the woman sickened and died. The other six women continued on, with Njiru in hot pursuit, until they reached the Musgrave Ranges where they set up

camp. Njiru sent his penis underground to rape another one of the women. But this time the women set their dogs onto the penis, which was severed in the ensuing fracas and became a separate entity, Jula.

This version of the story extends from west of the Warburton Range over the Rawlinson, Mann, and Musgrave Ranges, reaching Glen Helen Gap in the Western MacDonnell Ranges, where the women clustered together in fright in the rocks at the side of the Finke Gorge. The vertically embedded rocks at the mouth of the gorge are believed to have been created by the feet of the dancing Pleiades as they performed a women's ceremony before escaping into the sky-world. Accounts collected by N. B. Tindale show that this version also extends south to Ooldea (SA) and north to **Haasts Bluff** and **Yuendumu** (NT). There are variants of this narrative in many other places across the continent and, in essence, they traverse thousands of kilometres of country as several separate narratives. Hundreds of localities feature in great song cycles which are still maintained and performed regularly, particularly in the Central and Western Deserts. White indicates that men's versions of the narrative differ from the women's, but the myths generally concern gender relations and reflect the open antagonism between the sexes in cultures whose values are primarily male dominated.

The Pleiades are significant indicators of weather change, so that in many areas, their appearance signals the onset of the coldest nights. C. P. Mountford (1939) and later, Dorothy Tunbridge relate that, for the Adnyamathanha people of the Flinders Ranges, the icy weather of the Pleiades women also indicates the *malkada*, the time of initiation for boys. The Adnyamathanha see the Pleiades women as having (kangaroo) pouches filled with fine white crystals which stream from them as they cross the sky. From the account provided by Jimmie Barker, people in areas around inland New South Wales and the Queensland border areas conceptualised the Pleiades women as frequent urinators who left a trail of ice (or frost) before dawn. In the Western Desert, the rising of the cluster (in late autumn), indicates the coming of the dingo pups and also the beginning of a new seasonal cycle. The dingo pups arrive earlier in Arnhem Land, and Orion rising at dawn (in about June) signals this propitious event.

In Arnhem Land and on Groote Eylandt, the Pleiades women are seen as partners of their fishermen-husbands who are represented as stars in the constellation of Orion. At the top of the bark painting by Minimini Mamarika of Groote Eylandt [6], the Pleiades (the Wutaringa women) are the small circles within the larger round form which represents a grass hut. Orion is a man (or several men) called Burumburumrunya, depicted as three circles across the T-shape of Orion's belt. The vertical form includes four circles that represent three fish caught by the men and the fire on which they were cooked. The Pleiades and Orion are part of an Arnhem Land constellation known as Djirulpuna (also known as 'the canoe stars', thus indicating the significance of voyaging by canoe) which includes the Hyades and many of the bright stars north and south of these groups. It is visible during the wet season, when the fishermen (Djirulpuna) paddle their canoe along the sky-river—the Milky Way—while their wives paddle a separate canoe. According to Mountford (1956), both groups have caught fish out at sea, but when they are nearing Cape Arnhem a heavy storm swamps both canoes, and all the occupants drown. The two canoes and their occupants, along with turtle, fish, and a whale they had caught, are now in the night sky. Knowledge of tides and winds as well as seasons indicated by stars are obviously significant for the successful preparation and undertaking of fishing and canoeing.

Torres Strait Islanders identify with the sea and much energy goes into the preparation for voyages between the islands and the mainland coasts of Australia and Papua New Guinea, undertaken for the purpose of exchange. In the eastern Torres Strait, the

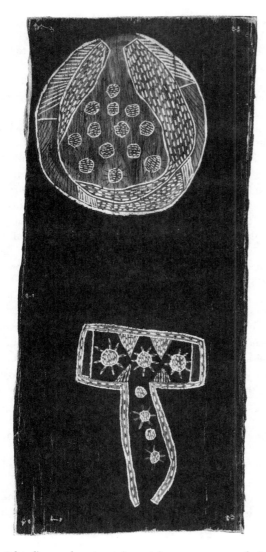

6. Minimini Mamarika, *Orion and the Pleiades,* 1948. Natural pigments on bark, 76 x 32 cm.

Meriam (Murray Island) people set out in outrigger canoes on their long sea voyages when the Pleiades appear (around mid October) as a sign of fair weather. Packed into the canoes are shell armlets (*wauri*), which are ritually given between exchange partners, and also yams, bananas, and sweet potatoes mixed with turtle fat, roasted, dried, and placed in sealed bamboo tubes. Having reached Papua New Guinea, Meriam exchange these goods for bird of paradise and cassowary feathers, and necklaces of dogs' teeth. Red and white ochres, emu feathers, and emu leg bones (for making into digging sticks) are sought in exchanges from the island of Mori (Mount Adolpus) and Cape York (Qld). These expeditions are exceptionally dangerous and follow a path from east to west as taken by the stars.

The Tagai (or Togai) is a mythical ancestral hero who belongs to all Torres Strait Islanders. He is represented in the night sky as an Island man standing in a canoe. Nonie Sharp (1993) records the significance of the immense constellation of the Tagai which consists of Sagittarius, part of Telescopium, Scorpio, Lupus, Centaurus, Crux (part of the Southern Cross), Corvus (Crow), part of Hydra and one star of Ara. In his left hand

27

Tagai holds a fish-spear, the three pronged head of which is represented by the Southern Cross. In his right hand he holds an apple-like fruit, represented by the European constellation of the Crow. There are twelve crewmen, six of whom are represented by the Pleiades group (known as Usiam) and the others by the stars in the belt of Orion (Seg). The narrative tells the story of Tagai, and how his twelve crew stole the food and drink which had been prepared for a voyage. As a result, they were all thrown overboard into the sea by Tagai, and their images set into star patterns forever. The stars of Tagai usher in seasonal and ceremonial changes and act as a guide to navigational voyaging, cultivation, and fishing. In addition, the Tagai represents the charter for the Meriam people, bidding them to follow their own cultural traditions—inherited from their forebears—which, in the course of time, they must pass on to following generations.

During the **Mabo** Case, extensive evidence was taken by the court about traditional law concerning the continuity of land ownership as set down by Malo, an ecologically-oriented spirit ancestor. Sharp (1994) records that most of the plaintiffs delivered the allegorical invocation 'stars follow their own path' when asked about land tenure, succession, and trespass. The invocation is inspired by the constellation of the Tagai, and, as a corollary, the Meriam must not trespass or encroach on what does not rightly belong to them. As Sharp (1993) reports, Malo's Law follows the charter of Tagai: 'I cannot walk the path that is Usiam's [the Pleiades], nor can I walk the path that is Seg's [Orion]. I must follow *teter mek*, the footprints made by my ancestors.' For the Meriam people, the stars have their own pathways across the heavens. Each star has its own journey to make, as does everything in the cosmos—its own time, its own place and its own destiny to fulfil.

Despite broad cultural variations, the Pleiades star cluster, in combination with other single stars and constellations, shows intriguing continuities across Australian Indigenous cosmologies. It is clearly of major significance throughout the country.

DIANNE JOHNSON

Barker, J., *The Two Worlds of Jimmie Barker: The Life of an Australian Aboriginal, 1900–1972 as Told to Janet Mathews*, Canberra, 1982; Johnson, D., *Night Skies of Aboriginal Australia: A Noctuary*, Sydney, 1998; Mountford, C. P., 'An Anyamatana legend of the Pleiades', *The Victorian Naturalist*, vol. 56, no. 7, 1939; Mountford, C. P. (ed.), *Records of the American–Australian Scientific Expedition to Arnhem Land*, vol. 1, *Art, myth and symbolism*, Melbourne, 1956; Sharp, N., *Stars of Tagai: The Torres Strait Islanders*, Canberra, 1993; Sharp, N., *Malo's Law in Court: The Religious Background to the Mabo Case*, Adelaide, 1994; Tindale, N. B., 'Totemic beliefs in the Western Desert of Australia, Part 1: Women who became the Pleiades', *Records of the South Australian Museum*, vol. 13, no. 3, 1959; Tunbridge, D., in association with the Nepabunna Aboriginal School and the Adnyamathanha people of the Flinders Ranges, South Australia, *Flinders Ranges Dreaming*, Canberra, 1988; White, I. M., 'Sexual conquest and submission in the myths of central Australia', in L. R. Hiatt (ed.), *Australian Aboriginal Mythology: Essays in Honour of W. E. H. Stanner*, Canberra, 1975.

1.4 The politics of the secret

One of the central concepts in Australian Aboriginal anthropology, that of the 'secret–sacred' realm, is in need of critical examination. This concept has been fundamental within anthropological circles since W. B. Spencer and F. J. Gillen drew attention to the importance of *tjuringa* (sacred objects) in central Australia in the 1890s. Their subsequent publications attracted worldwide recognition for the richness of Aboriginal ceremonial and social life. The extent of this fascination with the secret–sacred is the subject of my discussion.

Early anthropological research portrays Aboriginal culture (including religion and religious practices) as having remained constant and static for thousands of years. Max Charlesworth perceives this as 'the standard view' in such research. The apparent major shifts in secret–sacred cultural practices were attributed to the influx and impact of foreign cultures on Aboriginal communities and taken as evidence of decline, deterioration, or decay. Very little consideration was given to the possibility that Aboriginal religious practice accommodates and makes provision for changing circumstances. Contrary to 'the standard view', the cultural practices related to significant restricted material have always been dynamic, and the potential for change lies within the Aboriginal community; that is, the community itself dictates and orchestrates the fluid nature of restricted material. In *Ancestral Connections* Howard Morphy argues that the concepts of *djinawa*, meaning 'inside' (secret–sacred, restricted), and *warraŋul*, meaning 'outside' (public) are:

crucial to understanding the Yolngu system of religious knowledge … [Although they] refer to a continuum of knowledge involving degrees of restrictedness which are defined in terms of context or access, inside:outside can also refer to an opposition. Inside things are ancestrally powerful and sacred whereas outside things are mundane; inside things are restricted whereas outside things are unrestricted. The contrast between inside and outside can be applied to all sorts of natural and cultural phenomena, and in every case it carries the same range of connotations.

The Djang'kawu [see 6.2; *33, 71*] and Wägilak Dreamings [*150, 257, 316, 325, 337*], which are important ancestral stories from the Yolngu-speaking area of Arnhem Land, highlight the fluid nature of ownership and responsibility for secret–sacred material, the possibility for shifts in the religious power base and the definition of male and female roles through this process. Both stories tell of two sisters who moved around north-eastern Arnhem Land identifying and naming clan countries, and the animals found there. The Djang'kawu created totemic wells with their yam sticks. While they travelled, creating features of the landscape, many things happened to them. The narrative culminates in the loss of the women's religious power base through the men stealing their *raŋga* (sacred objects) and associated rituals. The Wägilak narrative recounts the incestuous rape of the younger sister by a man in her own moiety, the pollution of the python's sacred waterhole by one of the sisters, and the python's swallowing of the two sisters.

Ian Keen argues that both the Djang'kawu and Wägilak myths 'set out reasons for male control of the ceremonies … The Djang'kawu sisters … met men who deprived them of their dillybag and sacred objects, forever gaining for men the right to control the religious law, according to Yolngu tradition.' The point that Keen highlights here is that the transferral of restricted material to men is a permanent arrangement: it will remain this way 'forever'. However, in relation to the transferral of restricted information, ceremonies and objects, these myths also reflect the mobile and fluid nature of Aboriginal social and ceremonial practices. They set a precedent for the transferral of restricted knowledge, ritual, and objects from one gender to another, or from an irresponsible custodian to a responsible candidate.

Power, authority, status, and prestige are established in the telling and retelling of ancestral stories. The identity of the narrator, the composition of the audience, the context, and the locality in which the myth is told—all these are factors that affect the extent and variety of information that is revealed. Keen acknowledges that 'the content of secret knowledge could change … Yolngu men sometimes "brought out" (or claimed to have brought out) former secret proceedings into the public arena, while others remained secret.' Similarly, Erich Kolig in his research on Aboriginal people from the Fitzroy River

region of the Kimberley notes that 'they have reshaped their religious heritage' through a process of 'reinterpreting and manipulating the myth'.

The Elcho Island Memorial of 1957 [7] is emblematic of the dynamic nature of the secret–sacred. And the debate engendered by its creation illustrates well the nature of anthropological interest in the subject. In 1957 Aboriginal restricted objects, including bark paintings, bark containers, ceremonial poles, and *raŋga* were placed on public display at the Yolngu community of Galiwin'ku (**Elcho Island**, NT) [see 1.2]. They were assembled at a central point in the community, alongside the Methodist church. Approximately nine men supported this event by attending and providing objects for display. Not everyone in the community participated: some people chose to withhold their important religious objects and some women left the community before the proceedings began.

Ronald Berndt set the parameters for the anthropological debate that was to follow. He stated: 'These few men, with a fairly substantial following, are grappling with the problems of social and cultural change as they envisage them, at the level of practical manipulation. The way in which they have set about this, culminating in what I have termed an adjustment movement centred about a Memorial, is fundamentally rational and logical, despite its marked concern with the super-natural or non-empirical.' Both the terms 'adjustment movement' and 'memorial' are problematic: the first because it implies 'a concern with bringing about basic changes in the social order'; the second because it too acts on the notion that something has passed and needs to be preserved as a memory.

Many other researchers have commented on this event, each one providing a slightly different interpretation. All commentators have perceived it as a significant cultural occurrence, a turning point in Aboriginal 'adjustment' to changing circumstances. Berndt himself offered many alternative explanations. Most importantly he suggested that it was a direct response to the activities of the American–Australian Scientific Expedition to Arnhem Land, led by C. P. Mountford in 1948. During the course of the expedition a large amount of ethnographic material was collected, including photographs,

7. The Elcho Island Memorial in 1958.

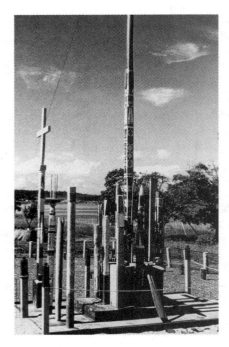

films, objects, and information regarding public and restricted cultural practices. When Yolngu people discovered how this material was being used they became extremely concerned and made attempts to gain back religious authorship and credibility. Berndt records that Burrumarra, one of the key initiators of the Elcho Island event, said of the anthropologists that they:

took pictures of our sacred ceremonies and raŋga, and we got excited. Why do they do this? We understood this when Warner, Thomson and the Berndts were here. But why do they come again and again to study us? They take photographs of sacred things and show them to all the people throughout Australia and other places ... We got a shock. We're not supposed to show these mareiin [maḏayin], these raŋga to just anybody.

At the time Berndt interpreted Burrumarra's concern as evidence that he wanted to receive something in exchange for the disclosure of information. He did not consider the impact of a large expedition arriving in the community, asking a range of questions, taking photographs, orchestrating performances and ceremonies, and collecting objects. Neither did he consider how the community might come to terms with non-Indigenous people being in possession of, and in control of, important restricted imagery, objects, and information. The erection of the Memorial can be seen as a response to these concerns, as the creation of a context in which Yolngu men were once again controlling the disclosure of restricted material.

Keen suggests that the event was prompted by the necessity to stabilise what was becoming a volatile situation. As a result of the radical change wrought by missionisation, many different clan groups were now living in close proximity to each other on Elcho Island. As Ian McIntosh observes: 'There remained a threat of clan warfare ... [due to] unending arguments over land, *raŋga* and women.' He quotes Burrumarra: 'There was little freedom ... There were many clans and too many secrets. Suspicion was draining the people of their energy.' Morphy is giving due weight to this statement when he argues that:

the leaders [of the adjustment movement] were conscious of this [tension] and saw the movement as a means of creating unity across clan boundaries. They saw the holding of sacred objects separately and in secret by the clans as a sign that the clans were divided against each other. It was thought that by displaying the objects in public, those barriers would be broken down and the Yolngu could act jointly in relation to the wider Australian society.

Another aspect highlighted by Berndt was the reinstatement of women as participants in restricted religious ceremony and the reversal of their loss of ancestral power as outlined in the Djang'kawu story. As Keen explains, 'two Yirritja leaders asked Ronald Berndt rhetorically, if the Djang'kawu were not women? ... In this way the leaders were ostensibly attempting to reverse the male appropriation of control of ceremony depicted in the Djang'kawu myth, and the secrecy and divisions inherent in that control.' One Yolngu man commented to Berndt that, through the public display of the *raŋga*: 'Now women as well as men can use the feathered string of the *raŋga*. Let all the men and women assemble as one. We shall bring everything into the clear [i.e. open, public] place: there will be no jealousies.'

As this comment reveals, the information, activities, and responsibilities passed on through the Dreaming (in this case the Djang'kawu and the Wägilak narratives) are very real and relevant to individuals and the community. By revealing the sacred and secret objects publicly, men were restoring part of the original female knowledge of the *raŋga*. Viewed in these terms, the event represented a reinstatement of, rather than a break with, tradition.

John Cawte describes the ultimate fate of the Memorial, in 1993: '[It is] rotting in the rain, fading in the sun, and nobody pays the slightest attention.' This raises the question of why, if the event was as momentous as anthropologists would have us believe, very few Aboriginal people take notice of the Memorial today. It should perhaps be seen as analogous to a commemorative burial site, that is, a set of objects placed at a particular location that had direct relevance to a particular individual. In this interpretation, the site and the objects are strong and powerful when they are initially placed in the open, because they are repositories of spiritual energy and power. But as the objects are left out in the open to decay, they diminish in power as their energy is dispersed into the spiritual and physical environment.

The Djang'kawu and Wägilak narratives illustrate how the mythology from this region provides flexibility in the fulfilment of significant ritual and cultural practice. The event at Elcho Island shows how this flexibility is enacted, how from an Aboriginal viewpoint it is possible—through 'mythological warrant'—to reveal restricted objects. In their fascination with the secret–sacred realm, anthropologists have often failed to acknowledge this mutability, and in so doing, have misinterpreted the Elcho Island 'adjustment movement' as a radical break with tradition. The display of *raŋa* at Galiwin'ku in 1957 is better seen as evidence of Aboriginal people's historical consciousness and their considered responses to the impact of radical change.

FRANCHESCA J. CUBILLO

Berndt, R. M., *An Adjustment Movement in Arnhem Land, Northern Territory of Australia*, Paris, 1962; Cawte, J., *The Universe of the Warramirri*, Kensington, NSW, 1993; Charlesworth, M., 'Introduction: Change in Aboriginal religion', in M. Charlesworth, H. Morphy, D. Bell and K. Maddock (eds), *Religion in Aboriginal Australia: An Anthology,* St Lucia, 1984; Keen, I., *Knowledge and Secrecy in an Aboriginal Religion*: *Yolngu of North-East Arnhem Land*, Oxford, 1994; Kolig, E., *The Silent Revolution: The Effects of Modernization on Australian Aboriginal Religion*, Philadelphia, 1981; McIntosh, I., *The Whale and the Cross: Conversations with David Burrumarra MBE*, Darwin, 1994; Morphy, H., *Ancestral Connections: Art and an Aboriginal System of Knowledge*, Chicago, 1991; Spencer, W. B., *The Native Tribes of Central Australia*, London, 1899.

1.5 Tarner the kangaroo: A source of Palawa spirituality

The kangaroo is a powerful metaphor for Indigenous knowledge and identity in Tasmania [8]. It was known to my people as Tarner, a creation spirit and ancestor of Palawa, the 'first man'; the sacred identity of the animal was rekindled in each generation as traditional creation stories were passed down. Tarner was a central character of the landscape in which Tasmanian Aborigines lived. Through kinship obligations, the kangaroo bound Palawa people to the land as descendants of a creation spirit. The values and beliefs of Tasmanian Aborigines were grounded in a mythology which provided the complex of obligations and practices of Indigenous customary law. The kangaroo was totemic to individual people and featured in ceremonial song and dance; the hunting, killing, and eating of kangaroo was conducted with elaborate ceremony; and its ecological requirements motivated many traditional fire-based land management practices.

When the British arrived, the kangaroo acquired a less sublime economic value. Sought by the newcomers as a source of meat and leather, the animal was exploited by the invaders and defended by the Palawa. In time, sheep replaced the kangaroo as a principal source of animal products. The Palawa, once considered by some British observers as lords of their 'native domain', were also transformed by colonisation. They were denigrated as the enemy of prosperity, and after the Black War—which raged

8. Eastern grey kangaroo (*Macropus giganteus*).

for seven years in Tasmania—they were pronounced extinct. Yet, like the kangaroo, the Palawa community did survive, albeit changed—the mythical identities of both were suspended in a new colonial narrative of history. The kangaroo is a *familiar*, a touchstone of Palawa spirituality. It is this spirituality which drives my people in their struggle to reclaim a place in the land.

Much has been written about Tasmanian Aborigines, but little about how we see the world. Lyndall Ryan provides a comprehensive account of early European attitudes to Palawa. The Dutch, who claimed Van Diemen's Land in 1642, did not meet an Aborigine, but concluded from the notches cut high in tree trunks that the island was inhabited by a race of giants. In 1772, anticipating a dialogue on the 'state of nature', Marc-Joseph Marion Dufresne sent naked sailors ashore on Bruny Island to liaise with the 'noble savages'. On the expedition's return to France, the philosopher Jean-Jacques Rousseau was horrified when told that his 'children of nature' had rejected the landing with a violent assault and had been killed.

This early conflict tarnished the European image of the 'noble savage'. A later French expedition, led by Bruni d'Entrecasteaux in 1792, included scientist Jacques-Julien Houton de Labillardière, who found the social organisation of the Aboriginal groups to be at odds with Rousseau's archetypal model of society. The native women, while appearing subordinate to the men, seemed to have sole authority for gathering shellfish, hunting seal, and providing many other essential resources. This challenged patriarchal notions of gender roles. Nevertheless, de Labillardière perceived a place for the Tasmanian Aborigines in republican ideology and imagined that these natives would be receptive to agriculture, that they would benefit from the more proper gender roles inherent in its practice. Notions of equality were not part of the British agenda, however. James Cook had read of the French experience, but on his arrival in Tasmania in 1777 he recognised no evidence of religion, cultivation of land, or settled law. Cook concluded, unromantically, that the land was 'practically unoccupied' and that the natives' way of life did not justify their continued enjoyment of their country. These early observations were heavily influenced by the naive, Enlightenment philosophies of the time and the imminence of colonial expansion. The British view effectively displaced Palawa from their land before the physical invasion began, and condemned them for their apparent lack of separation from, and dominion over, nature. For the British, terra nullius was confirmed.

The period of human occupation in Tasmania—at least 30 000 years—has provided ample opportunity for Palawa to engage with the geographic, biological, and climatic qualities of the region to a degree at least as sophisticated as in continental Australia. The use of fire in Tasmania provides a reliable indicator of the richness of other possible interrelationships. The bulk of historical material on Tasmanian Aborigines before invasion comes from George Augustus Robinson, who was paid to remove remaining tribal Aborigines from the mainland of Tasmania. N. J. B. Plomley's edition of Robinson's journals provides many references to plant and animal use and hints at the cultural associations which had developed around them.

Palawa languages also contain evidence of the complex interrelation of people and the physical world. Words for hills and mountains are metaphorical and often refer to the body parts of creation beings. The distinction between the living and non-living, so basic to Western ontologies, is less real. It was the identity of Aborigines within the land which bore the brunt of European invasion in Tasmania. The ethnocentrism of the British effectively blinded them to the quality of Palawa relationships with their home. These relationships constituted the identity which Indigenous Tasmanians struggled to defend against the invaders: it was Palawa identity, along with the land, which was colonised.

At first, while the kangaroo was vital to the fledgling economy, Europeans recognised Palawa knowledge as a valuable commodity in the new colony. Without it, expansion beyond the beachheads would not have been possible in the early years of Van Diemen's Land. The importance of the animal to the colonists at this time in some ways paralleled, yet profoundly contrasted with, its value to Palawa. The incomers recognised what Aborigines already understood implicitly: that a relationship with the kangaroo was a requirement of life in this land. But the relationship between Palawa and Tarner was much more than this. Robinson records the notable Palawa 'clever-man' Woorrady telling a story of how the kangaroo was an ancestor, transformed into Parlevar (Palawa) by the creation spirit Moinee. Before this transformation, Palawa had no knee joints. The spirit Droemerdeener broke his legs and cut off his tail, enabling him to sit down for the first time. According to Woorrady, as well as creating Parlevar, Moinee 'cut the ground and made the rivers, cut the land and made the islands'. This creation story provides a home for Aboriginal people, and a mythical genealogy which relates them directly to the kangaroo. The animal was also active in creation. Woorrady told Robinson: 'the TARNER … made the LY.MEEN.NE [lagoons], that he sit down and make it.'

By periodic use of fire, Aborigines maintained the country so it was favourable to the kangaroo, which provided meat and clothing. They invested in the continuation of this interrelationship through strict observance of ritual and ceremony. The hunt was a family event and was accompanied by song. Preparation and cooking were practised in accordance with ceremony, and song, dance, and storytelling would usually follow into the night. Tarner was a powerful presence in the cultural landscape of Tasmania, and a partner in life deserving the respect accorded to an ancestor spirit. The Europeans failed to establish a partnership with natural resources, which were exploited and then disregarded. A variety of native foods and cultural practices were treated in this way. Similarly, Indigenous knowledge was once essential to European survival in Van Diemen's Land, but was later disregarded as technology and capital accumulated. Simultaneously, the Palawa were being alienated from a land with which they had the most intimate of connections, a process which threatened their culture and identity, and their very existence.

The British, whether by design or default, oversaw the perpetration of genocide on the Palawa people. But a small number survived, mostly on the islands of Bass Strait. Furley Gardner, an Aboriginal woman who was born on Cape Barren Island, put the struggle in clear terms: 'We are claiming "Land Rights". What is so wrong with that? It is our ancestors calling from their graves: "Claim for what is rightfully yours"' (reported in the *Launceston Examiner,* 11 April 1977). A sense of deep injustice has motivated assertions of native rights to land and driven the renewal of a distinct Palawa cultural identity. Traditions such as muttonbirding, snaring, basket weaving, and shell-necklace making were passed down through successive generations [see also 11.5, 17.1; **shell necklaces;** *147, 168, 381*]. A few families located on the mainland of Tasmania, notably those of 'Fanny' **Cochrane Smith** and 'Dolly' Dalrymple Johnson, also maintained pride in Aboriginal identity and tradition. Families from Cape Barren Island joined them in reasserting this pride during the political activism of the 1970s.

The Aboriginal Information Service, established in 1973 and renamed the Tasmanian Aboriginal Centre in 1977, was the first State-wide, legally incorporated organisation to be established and controlled by Indigenous people in Tasmania. The focus of attention was firmly on the impact of colonialism and the issue of **land rights**. The centre recognised that the experiences endured through invasion and colonialism were valuable in maintaining Palawa cultural traditions and the expectation for justice which had endured since the early 1800s. The centre reinvigorated the struggle for land that had been maintained on Cape Barren and other islands of the Furneaux group by women

such as Dolly and Fanny. For the first time since Robinson completed his mission of dispossession, the control of Aboriginal homelands was again at stake.

As a result of this activism, a number of Private Members' Bills and Cabinet submissions were presented to governments during the 1970s and 1980s, but it was not until the *Aboriginal Lands Act* of 1995 that twelve areas were returned to the Aboriginal community. These included ceremonial **rock-art sites**, muttonbird islands and the site of the first official British occupation and massacre at Risdon Cove, and their return represented a symbolic victory for our community. One of them occupies a special place in Palawa culture as a monument to what colonisation had taken away. Karen Brown, in a poem written before its return, speaks of the spiritual loss that such sacred places embody:

> Kuti Kina is a cave,
> dark are its walls,
> permeated with an atmosphere,
> of men and women living,
> in the twilight of their dreamtime.

For Michael Mansell, a lawyer with the Tasmanian Aboriginal Centre, the campaign for the return of Kuti Kina was 'to get the dreaming back. We have been cut off from the past. Kutikina is the greatest physical connection with our past of any site in the State. It is as if we had finally returned to join our people, in our own environment, free from white dominance and oppression' (cited in Ryan 1996).

Before any of these developments, however, the centre had to establish in the minds of politician and voter alike that the identity of Tasmanian Aborigines in the twentieth century was valid. White Tasmanians had already closed an ugly chapter in their history. When **Trukanini** [9] died in 1876, she was farewelled as the last 'Queen' of her race. But her skeleton was displayed in the Royal Society of Tasmania's museum for over forty years, an obscene trophy of colonial conquest masquerading as a scientific curio [see 8.4, 11.8; **Burnum Burnum, repatriation**]. In 1976, her remains were finally cremated. This

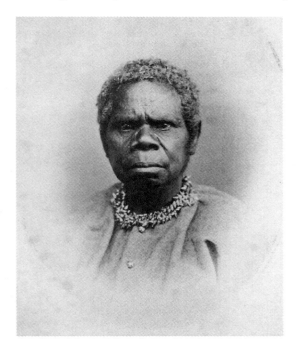

9. Charles A. Woolley, *Portrait of Trukanini*, 1866.

1.6 Tombstone ceremonies: Identity and political integration

Among Torres Strait Island people [see also 7.1, 7.2, 7.3, 7.4, 7.5, 12.1, 15.3] the Tombstone Opening is the central part of a flamboyant and elaborate ceremony at which the engraved headstone for a deceased relative is unveiled, providing a sign that the spirit has at last joined other ancestors and that mourning is finally over for the living. In the last few decades, this distinctive, secondary funerary rite has become a contemporary icon of Torres Strait Islander identity, practised both on the islands and among Islander people residing in Cairns, Townsville, and Brisbane.

The ceremony surrounding the Tombstone Opening incorporates many aesthetic components of performance art—dance, choreography, song, oratory—as well as textiles, decorative arts, and food preparation. Interpretations based only on the dynamic choreography, elaborate dance costumes, and paraphernalia, however, are inadequate for understanding the entire ceremonial complex: perspectives drawn from history, comparative religion, psychology, anthropology, economics, and politics are all pertinent.

History

'We saw a number of recent graves: two forked posts were set up at the head and two at the feet. Sand was neatly piled over the dead, and the top was ornamented with dugong skulls and ribs and large helmet-shells', noted the Revd William Wyatt Gill in his 1876 account of his travels in the Pacific. Descriptions of customary funeral ceremonies were collected by Alfred Cort Haddon when he visited Torres Strait in 1888 and 1898. He also obtained a sketch by Waria which illustrates the sara—a platform for the dead [10]. The Christian method of interment had begun to replace customary practice by the 1870s, fusing new practices with traditional elements.

Headstones and ornate iron fences, common among the grave sites of foreigners buried in Torres Strait in the late nineteenth century, together with the sara, provided a blueprint for twentieth-century graves. Lindsay Wilson argues that the remarkable concrete headstones and mortuary sculptures appearing in many Island cemeteries between 1900 and 1937 represent innovation under extreme conditions of political restriction. The deceased's lifetime achievements, former occupation, or totem were often symbolised in the sculptural elements, as well as incorporated in the inscription on the headstone. The expressive rituals and events surrounding death eventually developed into the Tombstone Opening.

Comparative religion

The death of one member of society provides for a reshuffling of position, status, and identity of all members, and sets in motion a process of transition. The goal in secondary funerary rites is to complete this transition period and finally to separate the living from the dead. The Tombstone Opening accomplishes this through the incorporation of the dead into their proper place in the hereafter and the reconciliation of the mourners with each other and within the larger community. The performance aspects, including dance and singing, allow all participants a role in the final ritual.

The origins of funerary ceremonies in Torres Strait are conveyed in the legends of Waiat and Tiai. In Torres Strait culture (Ailan Kastom), obligation to ancestors plays a very significant part. This important cultural value, is thrown into relief by the event of death. Although Christianity now provides much of the theology, the old belief system still underpins ritual activity surrounding death; the living fulfil a cultural mandate to maintain connections with deceased relatives and, in so doing, ultimately help to keep Ailan Kastom alive. Torres Strait Islander people living elsewhere sponsor the ceremonies on the home islands as well as in local towns on the mainland, thereby affirming links with the ancestors.

The event of death

The theme of transition dominates funeral symbolism worldwide, but the period of transition is unusually long in the Torres Strait Islands because of the cultural practices surrounding death. Normal life is suspended and a liminal

11. *Marigetal* carrying a coffin, Badu Island, 1980.
The deceased person was a member of the local Mother's Union of the Church of England, and the *marigetal* are wearing the characteristic blue and white uniform of the organisation. Male relatives stand behind them. In the past the coffin was carried from a boat to the family home. Today it is often carried from an aeroplane to a waiting vehicle and transported home. All the relatives follow the procession to the family home where they view the body and say their farewells. After some hours a church ceremony takes place, followed by the burial.

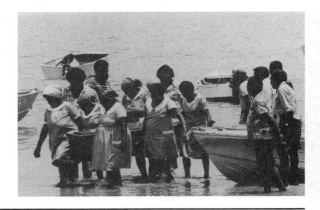

10. Waria's sketch of a *sara*, Mabuiag, 1898.
In Torres Strait customary practice following a death was for the body to be placed on an elevated platform, shaded by pandanus mats, to decompose. The platform edges were decorated with young coconut leaves. Coconut water containers and food were left at the front of the structure to keep *mari* (ghosts) from troubling the relatives of the dead. A fire, burning at the rear, kept the body warm.

state, mandated by custom, is imposed on certain individuals (e.g. the spouse of the deceased).

In the small communities, most people are intimately involved in the plans for this cultural event, being related to one another either through marriage or by descent. When a death occurs, however, a decreed individual becomes the 'ghost hand' (*mariget*, pl. *marigetal*), and takes on the role of primary organiser and planner for all subsequent activities. Assistants (*marigetal*) will be named, and together they will perform all the necessary duties—the formal announcement of the death, caring for the dead, and planning the funeral. After the burial, the coordination and financial management of the upcoming Tombstone Opening are the responsibility of the *marigetal*, including construction of the grave, ordering the headstone, arranging the celebration for its arrival and installation at the grave site, and the final unveiling event. [11].

Once a date is selected for the Tombstone Opening, immediate tasks must be completed: cleaning the graveyard, practising dances, sewing clothes, fashioning items for decorations, constructing the cooking and feasting area, organising transport and accommodation for guests, and purchasing goods. Just before the day itself, ritual foods must be harvested, containers used to cook food in the traditional earth oven (*amai*) must be woven, and the presentation of the feast completed. The day of the Tombstone Opening brings excitement and tension, and, ultimately, fulfilment; it is the culmination of a long period of sorrow and emotional distress. Honour and respect for a loved one who has passed away are finally to be shown publicly. Hundreds of people in colourful Island dresses and *lava-lavas* attend the graveside ceremony. Inside the *sara* (enclosure)is the grave, usually constructed of concrete and tile, and now occasionally of marble, with a headstone wrapped in cloth [12]. It is a monument to preserve remembrance of the deceased. Envelopes containing cash may be pinned to the cloth, or the entire grave may be covered in purchased textiles—cloth, blankets, and bedclothes—which will be distributed among the *marigetal* after the ceremony.

Once the crowd is assembled, a short prayer and a testimonial are spoken by the officiating clergy. Hymns are sung, important guests are invited to cut the ribbon across the entrance, and the relatives enter the *sara*. The unveiling discloses the headstone, usually with a framed photograph of the deceased in the corner and an engraved epitaph composed by close relatives. The latter is read by the officiating clergy and more prayers are recited. There is weeping, especially during the reading of the epitaph, but the sentiments are not expressed with wailing or other strong emotions, as they would have been at the funeral. The transition has been completed; the deceased is in a final resting place with other ancestors and the living resume normal life. People are joyful and often there is Island singing accompanied by guitar music or the beat of a customary drum. Each guest in turn enters the *sara* area to say a last goodbye and to admire the unveiled tombstone. The crowd returns in procession from the cemetery to the feasting area where a festive evening of dancing, singing, eating, and socialising lasts into the early morning [13].

Social relations, economics, and politics

Most Torres Strait Islanders are involved in some phase of the ritual exchange of labour surrounding this ceremony throughout their lives. There are always families who have not yet completed the obligation, and plastic flowers mark the sand-covered graves of their relatives. Emotional stress and sizeable financial debt are incurred in order to fulfil the obligation; social pressures are put on politicians invited to be honorary *mariget*; and migrant Islanders maintain links with their culture and relatives through contributions and visits specifically planned to coincide with an unveiling. It has become common for Tombstone Openings to take place during school holidays, at Christmas, or on long weekends in order to allow time for relatives to make the long journey to the islands or mainland.

Local politics and relations of power are channelled through this cultural performance, and regional identities are maintained. The symbolism of the ceremony amalgamates cultural constructions from diverse origins, including assorted customary decorations, songs and dances from local groups in the South Pacific and varied imported traditions (such as Christian hymns and prayers) from the colonial encounter. Contemporary identity in the Torres Strait Islands is mediated within the Tombstone Opening ceremony, and ritual symbols are ultimately crucial to political integration.

JUDITH M. FITZPATRICK

Gill, W. W., *Life in the Southern Isles, or, Scenes and Incidents in the South Pacific and New Guinea*, London, 1876; Haddon, A. C. (ed.), *Reports of the Cambridge Anthropological Expedition to Torres Straits*, 6 vols, Cambridge, 1901–35; Wilson, L., *Kerkar Lu: Contemporary Artefacts of the Torres Strait Islanders*, Brisbane, 1993.

12. Grave decorated with *zazil* (strips of plant material—in this case split coconut-palm fronds) and flowers, Townsville Cemetery (Qld), 1990.

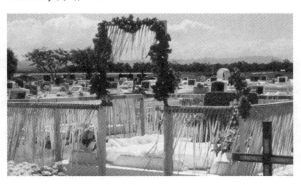

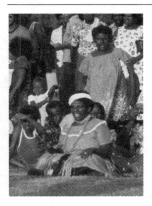

13. People singing, Badu Island, 1980.
After completion of the ceremony at the graveside, members of the community return to a feasting site or community centre where feasting, dancing and singing take place.

action was pivotal in reasserting the survival and transformation of our identity. It countered the neat dismissal of any need for further engagement with Palawa—constructed by the colonial narrative of Trukanini's death—by demonstrating that Tasmanian Aborigines were still to be reckoned with.

The Tasmanian Aboriginal Centre challenged vestigial public expectations that real Aborigines should somehow be like the deceased 'Queen'. It brought to prominence blonde-haired and blue-eyed activists such as Michael Mansell, who espoused a Maoist ideological framework, and challenged the sovereignty of the oppressor nation by establishing links with Muammar Kaddafi of revolutionary Libya. This association with a foreign leader, represented by Western powers as an international terrorist, revived old fears for many white Tasmanians: it represented the first tangible and defiant resistance since the end of the Black War. It was suggested that there were links (through Kaddafi's Mathaba movement) with groups which included the Irish Republican Army and the Palestine Liberation Organisation. In 1987 Mansell rejected a terrorist intent but stated that 'Australia was invaded by a bunch of terrorists from England, and the fruits of that terrorist activity are now vested in the Australian government who refuse to give it up to Aboriginal people' (cited in Ryan 1996).

The chaotic response from government, **media** and the public made it clear that the gulf between black and white cultures in Tasmania had widened: an increased sophistication had given the Tasmanian Aboriginal struggle an international context [see 4.1]. But the decades of missionisation [see 1.2] and urbanisation had withered much of the community's previous mythological association with the land. Whereas the kangaroo once served as a measure for the divergence of British and Palawa ways of knowing and living, Tarner appeared to have retreated from the Palawa world. Aboriginal identity in Tasmania had been transformed and colonised into a manifestation of modern ideological resistance [see 1.1]. Without the key figure of Tarner, or 'clever-men' such as Woorrady, we were left in spiritual disjuncture.

Most accounts of Tasmanian history have, according to historian Henry Reynolds, been pitying, patronising, and belittling. Their authors—almost exclusively non-Aboriginal—describe the Palawa experience in the language of ethnocentrism and classify the Palawa as defeated. These accounts have reinforced a long-held view that Tasmanian Aborigines disappeared along with native speakers of Palawa languages. The Aboriginal view of the changes of the past two centuries is scarcely represented in written sources. What has been recorded from, or written by, us has been mostly about the struggle against colonialism—a successful one in terms of survival. Aboriginal people will play a vital role in a new history of Indigenous Tasmania by contributing to narratives informed by their own political and mythological settings. Much of our writing to date has been dominated by ideologies of political struggle. Contemporary expression of Palawa culture has been restricted to a small number of works, by authors such as Jim Everett and Karen Brown, which have looked beyond politics and into the dimensions of spirituality.

If the future holds promise of progressive decolonisation of Tasmanian Aboriginal identity and history, it may be through the expression of a contemporary culture grounded in Woorrady's mythological text. The profound cost of two centuries of struggle has been a massive fracture in the continuity of Woorrady's mythology. The world of Tasmanian Aborigines is constructed around political assertions and cultural revival. We have a land-based identity which is informed by the past, and proceeds from a base which is completely different from that of Euro-Tasmanians. The separation between the two is enduring because, in part, it is this separation—born of conflict—which has contributed to the construction of the contemporary Palawa identity. This identity has a supernatural

origin: it refers to the powers of animals, plants, rivers, mountains, spirits, and ancestors. These often blur into one another, and are embedded in the practice of Palawa culture. The relationship of Tasmanian Aborigines with the land consists in what we do, what we see, and what we believe. The presence of Aboriginal sites in the landscape is how we know our land. Creation myths weld us to a sacred landscape in Tasmania which is our home in a profound sense. The land itself collapses the past and the present.

Here is the essential difference between Indigenous and colonial Tasmanians. The latter could have been taken away from their Tasmanian context and become what they were again, perhaps in another colony with another history. When the tribal Palawa were taken away from their land, they ceased to be what they were. The cost to Palawa culture of this dislocation has been evident, throughout the twentieth century, in the dominance of political ideology over spirituality. While Palawa languages no longer have native speakers, a revitalisation program is today being undertaken by our community. Its success will provide the hope that the community can also revitalise meanings in the mythical landscapes of Tarner. In the future, the political campaigns of the last thirty years will be seen as necessary steps in the journey toward reunification with the land. If the creation beings of Woorrady's mythology have slept since Law and ceremony were almost expunged by genocide, then the revival of language is certain to reawaken them. In the next millennium Tarner and the many other spiritual figures in the Tasmanian landscape may have the opportunity to re-empower us with a knowledge and spirituality which could never be won in battles fought on the Western political stage.

GREG LEHMAN

Archer, M. & Flannery, T., *The Kangaroo*, McMahon's Point, NSW, 1985; Everett, J. and Brown, K., *The Spirit of Kuti Kina: Tasmanian Aboriginal Poetry*, Hobart, 1990; Plomley, N. J. B. (ed.), *Friendly Mission: The Tasmanian Journals and Papers of George Augustus Robinson, 1829–1834*, Hobart, 1966; Reynolds, H., *Fate of a Free People: A Radical Examination of the Tasmanian Wars*, Ringwood, Vic., 1995; Ryan, L., *The Aboriginal Tasmanians*, 2nd edn, St Lucia, Qld, 1996.

2. Ritual and sacred sites

2.1 The power of place

Place

A site is a place. The power that created the world is located here, and when a person walks to this place, they put their body in the locus of creation. The beings who made and make the world have left something here—their body, their power, their consciousness, their Law. To stand here is to be *known by* that power.

The conquest of the 'new world' was accomplished by people who were convinced that they had both the ability and the right to go anywhere and to claim anything. In their arrogance and violence they walked into and on top of the sacred places of the worlds they claimed, without even knowing where they were. Anzac Munnganyi, a Bilinara man of Pigeon Hole (NT), is quoted in *Nourishing Terrains* as saying: 'White people just came up blind, bumping into everything. And put the flag; put the flag.' His imagery of white people stumbling around in unknown country and yet having the effrontery to 'put the flag' and claim the land exactly captures the arrogance of the act of conquest.

The significance of sacred sites lies in the connections between the life of today and the creation of the conditions and purpose of that life. That connection may be sustained through a great number of means, but in places damaged by colonisation few connections may remain. The degree of significance does not expand or contract depending on the variety of means of connection; rather, immense significance can be carried on the thinnest of connecting links, and knowledge of loss can heighten the significance of that which remains.

The sacred

The power that created the world is neither dead nor past. In Aboriginal Australian cosmologies, creation is the work of ancestral beings, or Dreamings [see 1.1]. In the foundational moments, Dreamings walked this earth, making this place, this country, this culture, and the people who belong here. All across the land the Dreamings made a world of form and difference: this place, another place, this country and its language, the next country and its language, and people for the different countries. In the words of Mussolini Harvey, reported by John Bradley in *Yanyuwa Country*:

White people ask us all the time, what is Dreaming? This is a hard question because Dreaming is a really big thing for Aboriginal people. In our language, Yanyuwa, we call the Dreaming Yijan. The Dreamings made our Law or narnu-Yuwa. *This Law is the way we live, our rules. This Law is our ceremonies, our songs, our stories; all of these things came from the Dreaming. One thing that I can tell you though is that our Law is not like European*

Law which is always changing—new government, new laws; but our Law cannot change, we did not make it. The Law was made by the Dreamings many, many years ago and given to our ancestors and they gave it to us.

Dreamings are foundational, but the work of sustaining the world is ongoing. It encompasses both **Dreaming** presence or power and all the work that people do to sustain the connections, and the Law, that were established by Dreaming. The French anthropologist Barbara Glowczewski, drawing on her work with Warlpiri people, states that 'the Dreaming appeared to me not like a mythical time of reference but as a parallel space-time, a permanency in movement, with which the Warlpiri have a relation of feedback.' The sacred is a hinge between orders of being; a sacred site is an enduring connection between foundational creation and current life. Where such connections are made, so places become sacred, and where sites are destroyed, so another connection between creation and the life of today is lost.

Dreaming action is interaction: a site is part of a living network of other sites. And while Dreamings are in sites, sites are not the whole of creation. Dreamings brought into being the differences that matter: the different countries, languages, peoples, species, cultures, landforms, plant communities, fresh water. There is sea country and land country; 'countries' include the people, animals, plants, Dreamings, the earth, soils, underground minerals and waters, surface water, and air. The sacred connects orders of being, and in Aboriginal cosmology these orders are all right here. Rather than pointing away from this world and the local, Aboriginal sacred sites intensify the experience of this world, placing ultimate value in the living systems and life processes that sustain this, the created world.

Knowledge

A site is informed by the knowledge of the location of the place, the stories and songs that are part of it, restrictions that surround the place and the correct forms of approach to it, the practices of care and the people who are responsible. In Aboriginal societies knowledge is land-based; personal authority, personal achievement, the authority of seniors, and the integrity and autonomy of local groups depend on the control of knowledge through restrictions on its dissemination [see 3.1]. Knowledge is graded by age, some of it is demarcated by gender, and almost all of it is identified with country [see 3.2, 3.3]. It points to country and to relationships between the possessor of knowledge and the country to which it refers. Performance of knowledge (through song, dance, story, history, and use of country) is a performance of identification and responsibility: it marks the person as one with rights and responsibilities to that country. Countrymen share rights. Non-countrymen do not have the same rights. To quote Harvey again: 'The Dreamings named all of the country and the sea as they travelled, they named everything that they saw. As the Dreamings travelled they put spirit children over the country, we call these spirit children *ardirri*. It is because of these spirit children that we are born, the spirit children are on the country, and we are born from the country.'

Stories of origins, often called myths, carry the knowledge of sites from generation to generation. Songs for a site sustain the connections between Dreamings and today, between the living and the deceased, the present and the past [see 15.1]. To sing a sacred song is to vitalise that connection.

Conquest has been both violent and destructive, and yet for the people who belong to and 'own' a site, their responsibilities are undiminished. Wherever there is a sacred site there are the people who look after it. Anyone today who walks to a place and stands there, is known. If this is not your place, and if you have not been introduced by people

who belong here, then you are recognised as a stranger, and you are not welcome. In Indigenous Law, sacred sites are not 'world heritage'. They connect local country and local people to the creation that brought them into being and for which they continue to be responsible.

Gender

Dreaming women and men imprinted themselves on the earth, and left the traces of their activities and their specific presence at the sites of their actions. Thus they created terrains that are both sacred and gendered. The created world does not privilege women to the exclusion of men, nor does it set women in opposition to men, although it does acknowledge the competitive quality of desire. Rather, and far more profoundly, in many parts of Australia the creative beings, women and men, establish complementary and dialogical relations in gendering the land. There are places which are managed jointly; other places to which men may go but about which they do not know the full meaning; and yet others where men can never go. A similar continuum exists for men's sites. Sacred geography articulates women's space and men's space—absolutely. In 1996 Ann Thomas, an elder of the Biripi and Yuin peoples of New South Wales, said: 'There are separate teachings and places for men and women … The men and women have separate, independent teachings and they are not told each other's teachings. Women determine their own lifestyles and spiritual traditions.'

Aboriginal women and men are subject to the Law that brings them all into being. Dreaming women and Dreaming men created the world, and in so doing created sites of power, some of which are gendered and exclusive. Women and men from generation to generation produce their social power, their histories, their communities, their spiritual and philosophical growth as they carry out the work of the world in the many domains that are shared as well as in those that are kept separate.

Victoria River Dreamings in the rock

The Victoria River district of the Northern Territory is part of the savanna region of the monsoonal north. White settlers established broadacre cattle stations here just over a century ago. Overrunning the homes of the original peoples of the region, they first shot and hunted away the local peoples, and later pressed them into service on the cattle stations as an unfree and unpaid labour force. In this region in the mid 1960s Aboriginal people at Wave Hill Station went on strike against the appalling system of oppression which ruled their lives, and as support for them was manifested throughout the nation they began to articulate what to them had been an underlying purpose in all their forms of resistance: to regain control over at least some portions of their traditional homelands [see 340]. Although **land rights** benefited some far more than others in the 1990s, people continued to participate in national and international struggles for equality, and cultural survival continues to be contested locally and nationally.

Victoria River people's accounts of the origins of the cosmos begin with the existence of earth and water. In the beginning, water covered the earth. When it withdrew it left the earth exposed and soft. Dreamings emerged from the earth and walked in the shape of humans, but they were not confined to that shape. As they walked they marked into the earth the signs of their travels and their activities. The earth is its own history, a living record of the creation and organisation of life; or, in Daly Pulkara's words, 'the Earth got a culture inside'.

In the bed of the Victoria River at Pigeon Hole, there are marks made by the Nanganarri, or Nangarrijpan women. These Dreaming women carried Law, ceremony, song, and language; they made the country and the people who are for that country; they put

resources in place, and they ended up sharing some of their Law with men. As they came singing and dancing, they left the tracks of their dance in the stone all through Bilinara country. These tracks are similar in shape (but not size) to the marks women now make as they dance [see 2.2]. There is a story for this place concerning where the Nanganarri women came from and where they went, what they did here; what they left that is not visible here, and how this site relates to others along the track. There is secret and gendered knowledge for both men and women, and there are other sites which only women visit. As well, there are sites and knowledge which are visible to all, and known at an open level to those who care to know.

Dreamings walked and changed: they were in human form, and they were in the form of the species which they would become. The emu Dreaming was a woman, and she came out of the west, walking across Bilinara country to the south of where the Nanganarri women travelled. One of the oldest people for this country, Jimmy Manngayarri, speaks in the *Bilinara Land Claim Report* of the complex of people, language, and Dreaming in terms of 'Law from beginning day'. Sites mark the emu's track over an extensive area; in places where she spoke Bilinara language, there she initiated that language, and there she placed those people. In Jimmy's words, emu 'bin give it tribe, language, country'. And of course she also kept travelling. This site is one of many; some are hills and some are trees, and all of them connect to other sites, countries, peoples, languages, rituals, and responsibilities along the track of this great Dreaming.

Visual evidence of Dreaming may show a human or non-human form. Only people who own the knowledge know the inner meanings of visual evidence, and there are many gradations of knowledge, and numerous modes of interpretation. The black cockatoo people are half and half, a rare instance in which the fact of shape-shifting is manifested visually [*14*]. More commonly, Dreamings appear either in animal or in human form.

Victoria River people say that many of the marks that outsiders call '**rock art**' are not representations, but rather are the actual Dreaming beings. Because the presence at a sacred site is Dreaming, it is alive: it is conscious, it can be spoken to, it acts and reacts. Where the Dreamings travelled, and where they placed themselves in the country, there they are still, a living presence. Not confined by conventional laws of time and space, they exist in many places at once, and in the past, present, and future time. Images on the surface of rocks are Dreamings; so too are many other marks, as well as many stones, trees, geomorphological features, and major celestial bodies. There is no necessary distinction between what Europeans refer to as art and all the other marks and things which are understood to be Dreaming presence.

While many figures are held to be the visual evidence of Dreaming, others are identified as being of purely human origin. Paintings of introduced species, for example, are identified by Victoria River people as teaching devices. People who had seen a new animal or item painted it to show it to those who had not seen it. An elaborate bullock, located in Ngaliwurru country on Victoria River Downs station, is shown with the VRD bull's-head brand on its rump.

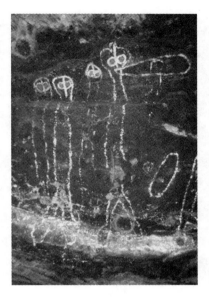

14. Black cockatoo people, Victoria River Downs District (NT).

Ritual

Visual evidence of Dreaming geography, of the tracks and sites, and actions and interactions, is created on the ground through ritual action. For example, in Victoria River country the non-secret portions of young men's initiation ceremonies take place within a carefully prepared ceremony ground called a 'ring place', formed by marking concentric circles into the earth. As the dancers bring their bodies into the ring place, their feet make a track into the circle [*15*].

15. Dancers in the 'ring place' at Yarralin (NT), 1981.

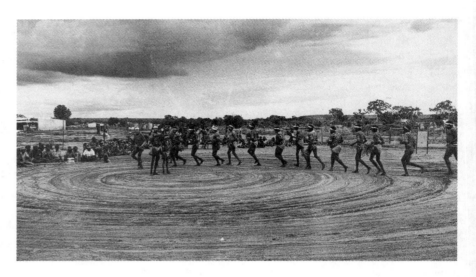

When people sing the Dreamings through the country today, they sing the sites and the events that brought the sites into being. In ceremonies people celebrate, articulate, and regenerate the travels of the extensive Dreamings, bringing together in a defined context the tracks and the localised Dreamings, local groups, and local countries. One of the major song cycles in the Victoria River country was instituted by the Nanganarri women, and when now the women dance into the ring place at night they form tracks that travel into the circle which are identical to those of the Nanganarri women.

For all the fixity that seems to inhere in geography, Aboriginal cosmologies mitigate against stasis, engaging in what Nancy Munn calls 'dynamic relations between spatial regions and moving spatial fields'. Thus, in a fixed site the ancestral presence is there not just as a body, but as a body in action; and that action, fixed in place, is extended through time. In a similar dynamic interplay of space, time, and person, sites can be 'detached from fixed locations and reproduced in iconographic designs' which 'can be transposed onto actors' bodies (through paintings) and onto different terrestrial spaces (as in ground paintings or drawings).'

Ritual, then, opens connections between Dreaming and today, and creates places where frozen motion is made active, where fixed sites are transposed onto people's bodies and onto the ground of ritual action. In these ritual places Dreaming maps are sung and danced into the terrain of the ceremonial ground. Thus the regenerative work of the world is performed and experienced in site and ritual, body and mind, Dreaming and the life of the country.

Decolonisation in New South Wales

Captain Cook [see 4.2, 4.3] came sailing up the eastern coast of Australia in April 1770. He saw 'a pretty high mountain' that looked to him remarkably like a camel, and so he named it—Mt Dromedary. According to the local Aboriginal people, Captain Cook discovered neither their mountain nor them. They had been advised of his journey, and many of their compatriots from the inland had joined them at the coast to watch him sail by. These people call their mountain Gulaga [*16*]. The Aboriginal people responsible for this mountain are the Umbarra people (people of the black duck) of the Yuin nation.

The mountain is an extinct volcano, linked geologically to Little Dromedary and Montague Island, and was the site of a brief period of intensive mining in the period 1877–1910. Human disruptions opened areas that were subsequently swept by violent

fire. In spite of these impacts, the mountain supports three different types of rainforest in addition to eucalypt forest. Anglo-Australian recognition of its unique concentration of different plant communities led to the designation of the eastern side of the mountain and the summit as Mount Dromedary Flora Reserve under the *Forestry Act* of 1968. The significance of the reserve led to its inclusion in the Register of the National Trust, and listing by the Australian Heritage Commission. In 1986 the New South Wales State government nominated the flora reserve for inclusion in the World Heritage list.

The people, like the mountain, have experienced the full gamut of colonisation since the 1840s, when white people first settled in the grassy plains around Narooma. The devastating impacts of **massacres**, epidemics, and dispossession were followed by a period of adaptive coexistence with white settlers in the late nineteenth century. In the twentieth century people experienced further dispossession and confinement under the rule of the Aborigines Protection Board, and by the 1950s assimilation policies and practices sought to move people indistinguishably into 'white' society [see 4.1]. More recently, Umbarra people have seized the opportunity for cultural and economic renewal. Through all of these years the mountain has remained a constant: visible, present, sacred, a place of refuge, memory, and hope.

In 1989 the Umbarra women and their relatives sought to ban logging on that portion of the mountain that was not already protected as a flora reserve. The basis of their action was that the mountain is a sacred place, one of a series of sacred mountains along the south coast of New South Wales. Gulaga is a Dreaming woman; the mountain is her body. There are portions of the mountain where men can go, and portions where only women can go. The main division is into two sides—east and west—one of which is exclusively for women. The mountain is ringed with tall standing stones called guardians, some of which are male, some female.

The oft repeated statement 'the mountain calls me back' conveys a sense of being called to be in the presence of this mountain, to put one's body in the place where the mountain dominates the sky, and where one's eyes and conversations constantly turn toward it. One man explained to me that the feeling of being called is like homesickness. When you are away your thoughts begin to wander, and they wander to Gulaga and you want to go home. In another way, it is like a magnet. No matter how far you go, you feel a pull that draws your thoughts and your feelings back to the mountain. This man and others define this calling as a power that is exercised by the mountain. It exerts its influence out of the

2.2 Ngantalarra, on the Nakarra Nakarra Dreaming track

The Nakarra Nakarra song cycle from the **Balgo** area of the Great Sandy Desert (WA) is part of a web of Seven Sisters narratives which traverse Australia and the Torres Strait [see 1.3]. It tells the story of a group of women who travel through the land, creating landforms and holding ceremonies. The sisters are constantly pursued by a man who, though not eligible to be their husband, attempts to divert them from their ceremonial activities and seduce them. The Nakarra Nakarra is an important part of the women's tradition of which a local Law woman, Marti Mudgidell, says: 'We've gotta hold-em tight. We can't chuck-em away.'

As the research of Isobel White and Ronald and Catherine Berndt has shown, the sisters' names vary from area to area, while custodianship of the song cycle can rest with men, or women, or be jointly held by both. The Nakarra Nakarra is held by the women of the Ngardi and Kukatja, two of the local language groups now referred to as Kutjungka ('at one') to express their common cultural heritage. The women transmit the story and its associated songs, designs, and dance performances, together with all-important rights to country, through matrilineal descent lines to their daughters and granddaughters. This female custodianship is interwoven with male custodianship of particular sites along the route travelled by the ancestral women, and male narratives which provide a somewhat different version of ancestral events.

Ngantalarra is a key site on the Nakarra Nakarra Dreaming track because of its connection with ceremony. Two verses from the Nakarra Nakarra song cycle dealing with the site tell of ancestral women putting digging sticks in the earth to mark out a ceremonial ground:

> *Ngantalarra, Tirriny karrinyanta*
> *Ngantalarra, Tirriny karrinyanta.*

Ngantalarra stands underneath Tirriny

> *Kanampiya juratinyanta*
> *kanampiya juratinyanta*
> *kanampiya juratinyanta*
> *kanampiya juratinyanta.*

a digging stick is standing up here.

Tjama Napanangka, the senior Ngardi–Kukatja woman who translated these verses, in her commentary links these words with ceremonies for the initiation of young boys: 'The women sometimes put two fire sticks or nulla-nullas in the ground for

dancing. The mothers after singing looked at a fire a long way away. They had a ceremony, all the mothers. Boys after ceremony bring food back to the mothers.'

Ngantalarra and the linked site of Kirrimangka ('all the women') are located in relatively flat, lush-looking country. The mythologically significant physical features of Ngantalarra are two soaks. Kirrimangka is a large group of white-trunked gum trees stretching down to Ngantalarra. The trees are said to be the metamorphosed bodies of the Nakarra Nakarra women, and the path of soft grass linking the two sites is said to have been created by their dancing feet [*17*]. The ancestral women once danced around the two soaks. The power of those women is located here, in the waters, the trees, and the path. They instigated the practice of performing ceremonies around two digging sticks inserted in the ground, and this is encoded in the two soaks, bearing witness of that knowledge to those women who have been taught the song cycle. Such elements in the land are important to contemporary Kutjungka women as physical proof of the authenticity of their ceremonial practices and designs.

Just as ancestral beings wrote upon the earth, imprinting the marks of their bodies as they danced, rested, or were transformed into it, so contemporary Kutjungka people make marks on the land which replicate the movements of the ancestors on the earth. Such designs are called *kuruwarri* ('ancestral power') designs. The *kuruwarri* sand-drawing and body-painting designs for Ngantalarra are made up of the same features as those contained in the landscape: a central line or lines between two concentric circles surrounded by arcs of dancing figures.

When contemporary Kutjungka women inscribe this design in the land, or on their own bodies for ceremony, or paint it on canvas for the art market, they are not just drawing an empty form. Fred Myers has shown that *kuruwarri* designs are 'dear', providing knowledge of the foundations of existence established in the Dreaming [see 6.1, 9.5]. In the case of Ngantalarra, the design reveals women's roles in performing

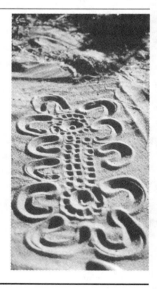

17. (*l.*) The path of soft grass created by the Nakarra Nakarra women as they danced to Ngantalarra.

18. (*r.*) *Kuruwarri* sand drawing of Ngantalarra.

ceremonies within this order. The designs reproduce the form of the ancestors' bodies as they entered and now exist within the earth. Thus the *kuruwarri* for Ngantalarra are believed to share in the form and power of the Nakarra Nakarra women themselves, and to be redolent of the power of the land where these events took place.

Just as the earth is marked by and saturated with the bodies and power of the ancestors, the bodies of living human beings can be symbolically linked to sacred sites, and saturated with ancestral power in ceremony. Frank Dubinskas and Sharon Traweek show that the outlining of designs in body painting replicates the play of sun and shadow on designs drawn in the sand [18]. The use of this outlining technique has the effect of bringing the meeting of sun and earth onto the women's bodies for ceremonial performances, symbolically uniting them with the land as they re-enact the deeds of the ancestors in ceremony.

For the Kutjungka, visual designs and touching are both part of sacred practice. In tracing with their fingers the path of the ancestors through the land, by drawing designs on the body of the land or on the human body, living people are following the footsteps of ancestral beings, touching the power they left when they metamorphosed into forms within the land. In the Balgo area, as in many other parts of Aboriginal Australia, people touch their paintings as they tell or sing the stories of the ancestors, and touch sacred objects in ceremony. This is done as a way of communing with ancestral power and of taking that power into themselves.

Sound is also an integral part of this complex. Among the Warlpiri, the word for a 'mark'—*jiri*—also means 'name' and 'song'. A similiar concept is held by the Kutjungka. As Nancy Munn states, there is a sense in which the ancestors singing their way from place to place implies that marks and names were 'put' at each place.

When women draw the designs in the land, they speak of the deeds of the Nakarra Nakarra women. When they paint their bodies for ceremony [19], they sing words from the song cycle containing ancestral power. The singing is led by the women executing the body painting, who aim a volley of sound vibration into the designs on the woman's torso as they paint and sing. The sound 'opens up' the body of the performers, and at the same time imprints the sacred words of the song cycle upon them.

Although the women do not usually sing the words of the song cycles when they paint for the art market, *kuruwarri* designs are 'strong' (*marrka*). They resonate with ancestral power, a power which is reinforced by the optical brilliance of the dotting and outlining techniques.

Contemporary Kutjungka women play an important role in joint male and female ceremonies for the initiation of boys in the Balgo area, dancing all night for their brothers, sons, or grandsons as the case may be. The mothers give the boys lighted firesticks and food to take with them on their journey to the surrounding country. At the end of the ceremonies, the women must turn their backs on the boys who later return to them as men, bringing their mothers gifts of food. Just as the initiation ceremonies mark a decisive step in the lives of the boys, Kutjungka women say that they are initiating themselves into a new life where the care of young boys is no longer their concern. Thus both the boys and their mothers pass into a new life stage; their relationship continues, but on a different plane. The dance performances for Ngantalarra include a re-enactment of the Nakarra Nakarra women giving food to young initiates in the Dreamtime. When senior Kutjungka women perform the same movements as the ancestral women they embody and become one with the ancestors.

The painting *From Parrakurra to Ngantalarra*, 1993 [20] by Millie Skeen, pictures women painted up for ceremony with a coolamon full of food for the initiates, dancing their way from Ngantalarra to Parrakurra where the Nakarra Nakarra ancestral women transformed themselves into a range of hills. The *kuruwarri* for Ngantalarra is in the centre of the painting. The mood of the work is vibrant, joyous, and celebratory.

CHRISTINE WATSON

Berndt, R. M. & Berndt, C. H., *The Speaking Land: Myth and Story in Aboriginal Australia*, Ringwood, Vic., 1989; Dubinskas, F. A. & Traweek, S., 'Closer to the ground: A re-interpretation of Walbiri iconography', *Man* (n.s.), vol. 19, 1984; Munn, N. D., 'The transformation of subjects into objects in Walbiri and Pitjantjatjara myth', in R. M. Berndt (ed.), *Australian Aboriginal Anthropology: Modern Studies in the Social Anthropology of the Australian Aborigines*, Nedlands, WA, 1970; Myers, F., 'Truth, beauty, and Pintupi painting', *Visual Anthropology*, vol. 2, 1989; White, I. M., 'Sexual conquest and submission in the myths of central Australia', in L. R. Hiatt (ed.), *Australian Aboriginal Mythology: Essays in Honour of W. E. H. Stanner*, Canberra, 1975.

19. Women's body painting of Ngantalarra.

20. (*r.*) Millie Skeen, *From Parrakurra to Ngantalarra*, 1993.
Acrylic on canvas, 105 x 105

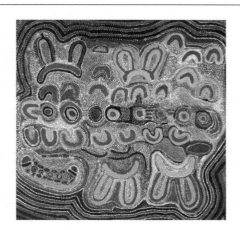

past, and into the present as current power. One of the women I interviewed about logging put it this way: 'They should not log the mountain. If they keep on logging there'll be nothing there. We'll have nothing to show our kids. It will be just a legend.'

Many local white people respect the fact that the mountain is sacred to Aboriginal people, and acknowledge its powerful presence. Other local white people hold the mountain to be significant without believing that it is sacred. European landscape values such as those of natural beauty, social history, biodiversity, research potential, ecologically sustainable water systems, and rest and recreation are part of the significance of the mountain to many of the people in the region, as well as to visitors. Some local white people have worked with Aboriginal people to protect the mountain, and many of them continue today the shared work of protecting this and other places in the region. At the same time, local Aboriginal women and men have organised teaching opportunities for non-Indigenous people, enabling them to bring themselves into the presence of this mountain under the guidance and guardianship of its traditional owners. In addition they remain supportive of a variety of spiritual disciplines which people in the area bring to the mountain.

For some white people in the area, living under the mantle of the mountain has caused them to rethink their own values and their own relationships both to the place and to the Indigenous people. Mal Dibden, a local dairy farmer, expressed his views eloquently:

I can see now, I couldn't see it a couple of years ago, that most of that mountain country should never have been cleared in the first place ... When you get down to the nitty-gritty economics of it and work out just how much money they made out of it, and how much they destroyed, what magnificent areas of bush they might have destroyed in clearing it and making a farm out of it, and how much soil they sent down the creeks and into Tilba Lake and Wallaga Lake by their farming practices and ploughing hills, and kidding themselves that they were being good farmers ... you'd have to say it was a waste and a shame ... I don't own this land. Soon someone else will have it. I'm the silly galoot trying to hold it together as a place to live. If you think you own it, you think of values and that's upsetting because it's worth a heap of money, but you love it so much you don't want to sell any. So what's the point of it being worth a heap of money? It only makes it harder to hang on to.

My work with the Indigenous and settler women and men who hold this mountain to be sacred led me to an appreciation of how human life is lived when it is open to the call of the sacred. The immensity of the significance of the living Dreaming presence is conveyed in the forceful statement of an Umbarra woman: 'You've got to understand—I'd give my life for this mountain.'

Reconciliation

Frontier ideology asserts that might makes right, that the war of conquest is waged not only against the people but also against the environment—the 'wilderness'—of the 'new world', and that those who conquer have the right to fulfil their destructive destiny. The rule of conquest, however, is a poor guide to settlement, for settled life is not warfare. It requires justice, and to the extent that it is built upon principles of war and conquest it must fail to establish its own long-term viability. It follows that while contests over sacred sites are often portrayed as racially inspired, they are, more profoundly, contests between the radically different principles of conquest and justice.

Indigenous peoples and settler peoples of Australia all know that the continent is made up of places that are wounded in war. We know that sites hold different meanings for different people, and we can see that many of these meanings are complementary. The experience of many settlers assures us that even newcomers can be touched by the

places of this land. The promise of sacred sites includes the prospect that conquest can be turned into peace, and that conquered lands can become what Richard Howitt terms 'decolonised homelands'. The power of place sustains the Indigenous people of this land, and inspires the descendants of conquerors to discover caring and respectful social and environmental values. At Gulaga and other places where sacred sites focus and conjoin the care and respect of Indigenous and settler peoples, the regenerative work of decolonisation shapes and reshapes the lives of contemporary Australians.

DEBORAH BIRD ROSE

Bradley, J., *Yanyuwa Country: The Yanyuwa People of Borroloola Tell the Story of Their Land*, Richmond, Vic., 1988; Glowczewski, B., 'Australian Aborigines: A paradigm of modernity?' in M. Blackman (ed.), *Australian Aborigines and the French*, Kensington, NSW, 1990; Howitt, R., 'Recognition, respect and reconciliation: Steps towards decolonisation?' *Australian Aboriginal Studies*, no. 1, 1998; Munn, N. D., 'Excluded spaces: The figure in the Australian Aboriginal landscape', *Critical Inquiry*, vol. 22, Spring 1996; Rose, D. B., *Nourishing Terrains: Australian Aboriginal Views of Landscape and Wilderness*, Canberra, 1996; Rose, D. B. & Lewis, D., *Bilinara (Coolibah–Wave Hill Stock Route) Land Claim*, Darwin, 1989; Thomas, A., in 'Interview with Ann Thomas', *The Mirror* [newspaper of the International Gzogchen], no. 34, Jan–Feb, 1996;

2.3 Arrernte land and the Todd River in Alice Springs

The Arrernte peoples of central Australia were by no means the last to feel the violence of colonisation, but it came later to them than to most. When it came, those affected by the establishment of the town of Alice Springs, where Lhere Mparntwe (the Todd River) cuts through the MacDonnell Ranges at Ntaripe (Heavitree Gap) [*111*], bore a special burden. Once the railway line arrived in 1929, trade and tourism developed, the town grew more quickly, Aboriginal people were excluded from it, and new housing submerged the Arrernte landscape and its ancestral **Dreaming** sites. As the landscape has disappeared under the new map of the settlers, the Arrernte of Mparntwe have become more determined to hold onto their Law and to the land and landscape upon which it is built, even though the town of Alice Springs now stands upon much that was previously in the heart of their country.

There have been three broad arenas of struggle: the gaining of access to the town and the establishment of housing areas within it [see 19.1]; finding ways of returning to traditional lands outside the town; and the documentation and protection of the sacred sites of the ancestral beings who created both the world and the customs of the people living in it. Nowhere has Arrernte determination been more evident than in the twenty-year-long campaign to preserve the Todd River.

The river, which now runs through the centre of the town, was always central to Arrernte life and well-being. Its soakages and waterholes provided a good supply of water, and its swampy flood plains were rich with the foods that supported the elaborate ceremonial cycles of Arrernte peoples. This land is known as Mparntwe and was created by the ancestral caterpillars moving out from Anthwerrke (Emily Gap). Arrernte interest in the river comes not only from its centrality to local religious beliefs and land claims but also from the linkages forged by the ancestors with the great, pan-continental song-cycles, and the ceremonies of their neighbours [see 1.3, 15.1]. Those ancestors pass over the MacDonnell Ranges and travel along and across the river. The pre-colonial walking tracks between reliable waterholes followed the Dreaming tracks of the ancestral beings (and became the basis for the camel roads used by pastoralists, prospectors, and explorers).

As the Arrernte were pushed off their lands and banned from the town, the riverbed of the Todd became one of the few public spaces in which their presence was tolerated. People moved along it, rested in it, visited its sites of religious significance, and camped there overnight. When children were removed and sent to the Bungalow home, near the Old Telegraph Station, their families lived in the riverbed to stay in touch and provide them with nutritious, gathered foods to supplement the unhealthy rations offered by the government and missions. While the colonial encounter disrupted both the social and cultural fabric of daily life and its economic base, the Todd River, its lands, and the important ritual places along and around it have been remembered, maintained wherever possible and, despite high levels of desecration, remain part of an Aboriginal landscape and Law of great vitality. It is not surprising, then, to find that the Arrernte people have fought to protect the Todd River from further desecration. The story of Arrernte resistance to the damming of the river shows not only the tenacity of a people under terrible pressure to give up their land and disappear into history, but also the ways in which successive governments and their agencies resist Aboriginal claims to land and justice.

In a climate which European settlers found debilitating, dreams of a permanent lake and reliable water supply quickly emerged. As soon as Alice Springs began to grow, Europeans wanted to dam the Todd to retain the abundant floodwaters for later use. Government plans to dam the river were prompted by the need to provide water to the town, but the proposals of the 1950s and 1960s were eventually overtaken by the discovery of the Mereenie Basin reserves, and plans for the reservoir were abandoned. In the 1970s, however, the idea of a recreational lake on the Todd River at the Old Telegraph Station became very popular, and the Northern Territory government carried out some preliminary studies of possible sites. In 1979 it was announced that a recreational lake, costing $2 million, would be built 300 metres north of the Old Telegraph Station. This created an immediate problem for the Arrernte and heralded the beginning of twenty years of struggle to preserve the river and the sacred sites connected with it.

Following a feasibility study, the government established the Aboriginal Sacred Sites Protection Authority. Governed by an independent board with a majority Aboriginal membership, the authority was charged with documenting and registering sacred sites, a task made particularly urgent in Alice Springs by rapid growth and the opening up of new suburbs in which rocky outcrops and small soakages were popular building sites. The information gathered by the protection authority was regarded as confidential. Its staff, often in conjunction with the Central Land Council and other Aboriginal organisations, were to act as brokers in negotiations between the traditional owners and those wishing to use the land for development, pipelines, mining, tourism, and such projects. In this way, the secret elements of Aboriginal religious beliefs were to be safeguarded and traditional owners were to be protected from direct negotiations with corporations and government departments—negotiations in which the opposing parties stood in a very unequal power relationship.

While the Northern Territory government had received early reports that Aboriginal sacred sites were unlikely to be a problem for the building of the dam, they anticipated opposition from environmentalists as well as Aboriginal owners and took steps to limit it. The plan of the 92-hectare lake was put on display for a few hours for each of four days during January 1980—the holiday period when most non-Aboriginal people go south. The government had allowed just eighteen days for public comment. Anticipating public protest against the dam, the *Centralian Advocate* of 24 January 1980 hinted that failure to build it would lead to greater risk of flooding. In the month that followed, it began to emerge that the sacred sites that would be submerged were important to Arrernte women. The government always claimed that agreement to proceed with the dam had

been reached with a small group of traditional owners under the auspices of the Central Land Council. Arrernte women, however, had not been included in the initial round of negotiations and their demands that the sites be protected posed a major problem. In the years that followed, more and more women were drawn into the struggle to protect the important Welatje Therre site, a segment of the important pan-continental Two Women Dreaming track. In the process, much important work in teaching and transmitting the songs, painted designs, and dances to younger women was accomplished.

The Territory government was determined to proceed with the lake and tried to find ways during 1982 of overcoming Aboriginal opposition and environmental criticisms. The debate was acrimonious and more and more government departments became embroiled in it. By March, the Chief Minister (Paul Everingham) had announced that $10 million was to be allocated to build the dam in the coming financial year and that he hoped for a resolution to the matter by the end of June. As relations between the Territory government and the Aboriginal Sacred Sites Protection Authority became strained almost to breaking point, a local campaign in favour of the dam was launched, Town Council funds were allocated to the beautification of the river, and a progress association was formed to organise a petition.

A counter-petition provoked considerable resentment until Aboriginal custodians for Mparntwe, including Charles Perkins, Rosalie Kunoth-Monks, and the traditional owners of the Welatje Therre site set up a protest camp at the Old Telegraph Station in 1984. The camp was successful in attracting national and international publicity and led to a federal board of inquiry. But it cost the Arrernte dearly. The difficulties of maintaining family life without proper water and food supplies, and five years of pressure on a group of people who were largely dispossessed, had led to social dislocation and interpersonal tensions. In a tragic, accidental fire, two lives were lost and the protest disbanded as people moved away into mourning camps.

The board of inquiry recommended that the lake at the Old Telegraph Station be abandoned, but local (non-Aboriginal) support for it never faltered. Accordingly the Territory government drafted new legislation which would effectively dismantle the *Aboriginal Sacred Sites Protection Act* and move control of the protection authority from its Aboriginal board to a government minister. With the authority's right to protect sacred sites from desecration under attack, the land councils called for public support and federal intervention. In 1989 the Arrernte peoples and the Northern Territory land councils conducted a strong political campaign against the new legislation. Aboriginal protest camps were set up in Darwin, Tennant Creek, and Alice Springs, and traditional owners suspended all negotiations with the government over sacred sites. These activities bought time and resulted in some amendments to the legislation, but during the process the government developed a new plan to dam the Todd, this time identifying Junction Waterhole as the most appropriate site.

Initially, consultations led to approval for a minimalist approach. But now, not only were women's sites at risk, but also important men's sites. Despite the protests and further Aboriginal demonstrations in Alice Springs in February 1991, the Territory government decided to proceed, and preliminary construction work at the dam site began. When the Aboriginal custodians of Junction Waterhole saw the destruction caused by even these preliminary works, they were appalled. The 'minimal' destruction and 'low' walls that had been discussed translated into unimagined devastation.

The custodians set up a new protest camp near the dam site [21]. The gates were locked against them and the site was patrolled by security guards. Access was eventually granted, however, and in April nearly a hundred Arrernte traditional owners met with the new body, the Aboriginal Areas Protection Authority, at Junction Waterhole. As a

2. Ritual and sacred sites

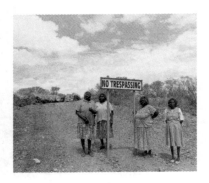

21. On the Road to Niltye–Tnyerte, (Junction Waterhole, NT), 1996. In the background are boulders blocking access to the site. The women in the foreground *(l. to r.)* are Ruby Rabuntja, Theresa Webb, Myra Hayes, and Rosie Ferber. The photograph was taken at the request of traditional owners.

result of the wishes of the people expressed there, the authority withdrew its construction certificate, the construction company's plant and equipment were withdrawn, and the contractors were paid out by the Territory government. The Aboriginal land councils then approached Robert Tickner, the Federal Minister for Aboriginal Affairs, who, following further investigations, made a declaration on 17 May 1992 halting construction work in that area for twenty years. Junction Waterhole is one of few areas in Australia to have been protected by a declaration under the Commonwealth *Aboriginal and Torres Strait Islander Heritage Protection Act 1984.*

For the Arrernte of Mparntwe the consequences of their action have been the protection of Lhere Mparntwe and its Dreaming tracks and the safeguarding of the sacred sites of their country. In their resolute response to racist scare campaigns and destructive legislation they have grown stronger and more determined. But the dream of a dam on the Todd has not gone away. In Alice Springs, twenty years is no time at all.

JULIE MARCUS

2.4 Uluṟu–Kata Tjuṯa National Park

An Aboriginal place, with Aboriginal Law

Aṉanguku ngura nyangatja, Aṉangu Tjukurpa tjuṯatjara.
This is an Aboriginal place, with Aboriginal Law.

Kamilu, tjamulu tjana panya tjukurpa kunpu, kanyiningi aṟa kunpu kanyiningi munuya Aṉangu tjuṯa kunpu nyinangi.
Our grandmothers and grandfathers held the Law strongly, and held our culture strongly, and they lived strongly and happily.

Ka kuwari nyanga nganaṉa tjungu nyinanyi, piṟanpa tjuṯa munu maṟu tjuṯa.
Now we are living together, white people and black people.

Nganaṉa tjungu waakaripai, piṟanpa munu maṟu, palu purunypa.
We are working together, white and black, equal.

Uwankara Uluṟula munu Kata Tjuṯala tjukaruru ngaranyi.
Everything at Uluṟu and Kata Tjuṯa still runs according to our Law.

Ranger tjutangku patji kanyini, patji panya pulitjara. Tjukaruru nyangatja.
All the rangers wear a badge carrying the image [of Uluṟu]. That is as it should be.

Nganaṉa national park tjukarurungku atunymankupai.
We are protecting this national park according to our Law.

Aṉangu tjutangku ranger munu scientist tjuṯangka nintini kuka tjuṯaku munu punu tjuṯaku.
Aboriginal people are training rangers and scientists about the animals and plants of the park.

Aṉangu tjuṯangkuya tjakultjunanyi yaaltji mingkiri tjuṯa nyinapai, munu piti tjanampa nyaangka ngarapai, munu mai nyaa tjana ngalkupai, uwankara.
We are telling them where to look for animals, where their burrows are, what food they eat, everything.

Aṉangu kutju ninti Tjukurpa panya palumpa.
Only Aṉangu know all these facts.

Ka kulila, ngayulu kuwari Tjukurpanguru wangkanyi.
So listen, I am speaking from the Tjukurpa now.

Nganaṉala tjilpi munu pampa tjuṯanguru Tjukurpa nyangatja.
We learn this Tjukurpa from the old men and women.

Nintiringanyi ka nganana kulira munu pulkara witira kanyini.
We listen to them and hold onto our Law really strongly.

Aṉanguku Tjukurpa kunpu pulka alatjitu ngaranyi.
There is powerful Aboriginal Law in this place.

Inma pulka ngaranyi munu Tjukurpa pulka ngaranyi kala palula tjanalanguru kulini, munu uti nganana kunpu mulapa kanyinma.
There are important songs and stories that we hear from our elders, and we must protect and support this important Law.

Miiḻ-miiḻpa ngaranyi, munu Aṉanguku Tjukurpa nyanga pulka mulapa.
There are sacred things here, and this sacred Law is very important.

Governmentaku law nyiringka ngarapai.
Government law is written on paper.

Aṉanguku Law katangka munu kurunta ngarapai.
[We] Aṉangu carry our Law in our heads and in our souls.

Nganaṉa Tjukurpa nyiringka tjunkupai wiya.
We don't put our Law onto paper.

Kuwari malikitja tjuta tjintu tjarpanyangka nyakula kutju munu puḻingka tatilpai.
Now a lot of visitors are only looking at the sunset and climbing Uluṟu.

Puḻi nyangatja miiḻ-miiḻpa alatjitu. Uti nyura tatintja wiyangku wantima!
That rock is a really important sacred thing. You shouldn't climb it!

Tatinyanka aṟa mulapa wiya. Aṟa mulapa ngaranyi pulkara kulintjaku.
Climbing is not a proper part of this place. There is a true story to be properly understood.

Iriti tjamu munu kami nganampangku kaltja kunpungku atunymanangi. Kuwari kutju, minga munu park ngaranyi.
A long time ago our grandparents looked after the culture really strongly. It's only recently that visitors and the park have been here.

History

We Aṉangu have always managed and cared for our ancestral land as taught through Tjukurpa. But when Uluṟu was made a National Park in 1958 and commonly called 'Ayers Rock' our ownership and responsibility for this land was ignored.

Ernest Giles and William Gosse were the first Piṟanpa (white people) to see Kata Tjuṯa and Uluṟu. They named them Mt Olga and Ayers Rock. They decided the land was too dry for cattle and sheep.

In 1920 the region was included in a reserve, which was established as a sanctuary for Aboriginal people. Our first experiences of Piṟanpa were with missionaries, Native Welfare Patrol Officers, prospectors and adventurers. We traded dingo scalps for food, implements and clothes. Some of us still remember Lasseter when he came looking for gold.

During the 1930s pastoralists began to graze cattle in the area. Conflict increased as our food sources disappeared and police patrols became more frequent. Some of our people were taken away in neck chains and leg irons [see **prison art**]. Many Anangu left the area at this time in fear and because of a bad drought. We went to missions and pastoral properties where we were given rations and water.

In 1948 a dirt road made Uluru accessible to tourists and in 1958 it was decided to create a national park here [see 18.1]. Then motels and an airstrip were built. As the park became a popular tourist attraction, damage began to occur to the environment and our sacred sites. In order to help stop the damage, a resort was opened at Yulara and the motels in the park closed in 1984.

For many years our traditional interest in the national park was ignored. But in the 1970s more Anangu moved back to live at Uluru, and our leaders began a long negotiation process to ensure that our cultural ties to the land were protected.

The *Aboriginal Land Rights (Northern Territory) Act 1976* made it possible for us to prove a claim to our land. In 1979 the Land Commissioner, Justice Toohey, accepted that 104 traditional owners had been formally proven for Uluru and 57 for Kata Tjuta. We were given title to what is now known as the Katiti Aboriginal Land Trust north and east of the park.

Our claim to Uluru and Kata Tjuta was unsuccessful because the land was being used as a national park. We then petitioned the Commonwealth government for freehold title.

Eventually in 1985 the Commonwealth government agreed to grant us title on condition that we lease the park back to the Australian National Parks and Wildlife Service (Parks Australia) for 99 years. The Uluru–Kata Tjuta Land Trust was granted inalienable freehold title to the park in a public ceremony on 26 October 1985 [*22*].

22. Chips Mackinolty,
Nyunta Anangu Maruku Ngurangka Ngaranyi—You are on Aboriginal Land,
1985.
Colour screen-print,
70.4 x 95.8 cm.
This poster, known popularly as the 'Uluru handback poster', commemorates the handing back of 'Ayers Rock' to its traditional owners.

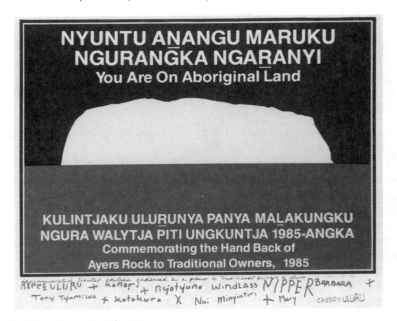

Nellie Patterson said at the time:

I've been talking about this place for a very long time and at last my whole spirit is relieved, that finally we've got Ayers Rock back! Uluru. Uluru and Kata Tjuta are safe at last! The elder women and the elder men are completely happy. The children and

dogs are happy. Everything is happy because we Aṉangu have been given back our Aboriginal land. We've been given back our Aboriginal spirit.

We, the traditional owners of Uluṟu, call it home. We are Pitjantjatjara and Yaku-nytjatjara people. We call ourselves Aṉangu and we welcome visitors to Uluṟu–Kata Tjuṯa National Park. Aṉangu want visitors to their land to learn that Tjukurpa is very important as it is the basis of the social, religious, legal and ethical systems of Aṉangu culture.

Tjukurpa

This is our Tjukurpa and we understand it. It is everywhere, all across the country … We make sure the park is run according to Tjukurpa (Tony Tjamiwa).

Tjukurpa [see 1.1] tells about the creation time and how physical things came to be. It also teaches how we should behave toward each other, and how and why things happen. Tjukurpa is very complex, and under our Law only some aspects of it can be shared with visitors to Uluṟu–Kata Tjuṯa National Park.

Tjukurpa is the basis of Aṉangu life. It explains the relationship between people, plants, animals, and land. It records the creation of all living creatures and the landscape. Tjukurpa teaches Aṉangu the proper way to relate to each other and the environment. Tjukurpa is Law.

Tjukurpa teaches that in the beginning the world was flat and featureless. Tjukuritja (the ancestral beings) emerged from this void and travelled widely across the country, shaping the landscape as they went. Trees and mountains and living creatures were all created by Tjukuritja on these journeys, and some of their spirit remains behind in each. The spirit of the Tjukuritja remains in the landscape through which they travelled.

Aṉangu are the direct descendants of the Tjukuritja creation ancestors. We are linked to the Tjukurpa of our birth place or country. The place to which we belong is very important to Aṉangu, as we share with it a part of our spirit. We Aṉangu are responsible for the protection and management of our country. We learn, through Tjukurpa, the proper way to care for the land and each other.

We are linked through Tjukurpa to many other places beyond Uluṟu and Kata Tjuṯa. Tjukurpa knowledge is passed from one generation to the next through story telling, song, dance, painting, and ceremony. The responsibility for teaching particular parts of Tjukurpa is given to specific people. They have responsibility to pass this on in the correct way to appropriate people. This ensures that no details of the ancestral journeys are lost. Responsibility for passing on Tjukurpa is linked to the rules of land ownership.

As Aṉangu grow older, we are taught more knowledge and skills. We also take on greater responsibilities for Tjukurpa and for looking after our country. Our grandmothers and grandfathers are treated with great respect because of their knowledge of Tjukurpa. It is through their teaching and wisdom that the culture is kept alive.

The countryside which surrounds us is covered with *iwara* (tracks) made by ancestral beings on their journeys. This network of tracks links Uluṟu and Kata Tjuṯa to many different people and places.

In the Tjukurpa a *kuniya* (woma python) man was killed by a *liru* (king brown snake) war party. Then a battle between the *kuniya* man's aunt and a *liru* warrior took place near the Muṯitjulu waterhole. The evidence of this battle remains in the features on the rock today.

The kuniya woman was really wild. She was so angry and upset that she made poison inside herself and was throwing magic poison out of herself. Then she hit that wati *(man) liru over there. She was trying to make him sorry because her nephew was dead.*

The liru war party had killed kuniya. When Anangu are sorry they cut themselves and that's what kuniya did to that liru. She cut him with a sharp stone. You can see the two marks now on Uluru. She was so angry she was building up this magic poison inside herself and she was trying to throw it away as she was coming in but she was really wild and she smashed him with that sharp stone twice and killed him. And when she turned around, she was still full of poison and that's when she vomited. This path here is going through a dangerous place because if people touch the plants here they get really big sores on their hands, because that poison is in the plants here. (Barbara Tjikatu)

Tjunguringkula waaakarinytjaku—Working together and joint management

We know this place—we are ninti (knowledgeable). The rangers and the Board of Management run this park. We run the Tjukurpa and we run the park. Our stories and our culture are really important. (Nellie Patterson)

Working together means making sure Tjukurpa comes first in park planning and management. Anangu and Piranpa talk together on a day to day basis about the proper way to do things. This means sharing our skills and learning each other's languages. We work with the rangers to make sure that sacred sites are protected and that the land is managed in the proper way. Anangu also show scientists where the small and scarce animals, birds, and reptiles can be found and what their habits are. Working together also means caring for visitors and teaching them the true meaning of Uluru and Kata Tjuta.

Anangu want to share some of our knowledge with visitors to the park. The walks we have developed with the rangers allow us to talk directly with visitors about our understanding of the land. We also train tour operators so they can give out accurate information about Uluru and Kata Tjuta.

The cultural centre is another way for us to tell you about Tjukurpa and our relationship with the land [see 18.2; **Maruku Arts and Crafts**]. Anangu have made paintings, burnt designs, carvings, tiles, and glass panels for the cultural centre. We also worked with the designers to make sound and video recordings. Through these you can see us perform *inma* and hear us talk about the way we have lived for a very long time.

Inma, or ceremonies, can last for several days and nights of music, songs, and dances. We are painted with ochres to represent the ancestors of Tjukurpa. We become *mala* (rufous hare wallaby), *kuniya* (woma python) or other animal ancestors to relive the events of Tjukurpa.

You might see some of the symbols used during *inma* painted in caves at Uluru. These are of great significance to us as they represent Tjukurpa. They show us one way that our culture has been passed on for generations.

The cultural significance of this place, which is for Anangu the embodiment of Tjukurpa, has gained national and international recognition. In 1977 Uluru was accepted by the UNESCO 'Man and the Biosphere' program as a valuable example of a unique arid land ecosystem. In 1987 Uluru received World Heritage listing for its natural and cultural elements, and in 1994 Uluru was listed as a World Heritage Cultural Landscape having powerful religious, artistic, and cultural associations and showing the successful relationship between humankind and the environment. In 1995 Uluru won the UNESCO Picasso Gold Medal for outstanding management and conservation of a biosphere reserve and World Heritage site.

2.5 The stand of the Nyungah people [23]

In 1989, at the height of Nyungah protests against the redevelopment of the old Swan Brewery site in Perth, elder, writer, and film-maker Robert **Bropho** spoke about the struggle for survival of the Nyungah people and their spiritual beliefs in that land.

23. Protesters block the entrance to the Swan Brewery site in Perth, 18 April 1989.

Us, the Aboriginal people, who are here on protest on the north side of Mounts Bay Road, on the south side of Kings Park across the road on the old Swan Brewery. The area where we are now, in a southerly direction, a west direction, north direction and an easterly direction is the Sacred Area to our ancestral grandfathers and grand-mothers. This is the First Grandmothers and the First Grandfathers since the Beginning of Time, Spiritual Beings.

Why is the area sacred, because across the road in the area where we are now, is where our ancestral grandfathers and grandmothers and their families lived in harmony with the land which is our Mother, our beginning.

Under the building is the sacred spring. Under the building is the Waugal, our Rain-bow Serpent. He is the creator of all waterways, of rivers, of creeks and it is through our ancestral grandfathers and grandmothers at the time when they walked and lived closely with the land, that is the law of the land, their beliefs. We have been here since the second or third of January—day one or day two when we the fringe-dwellers came here on site from the Swan Valley that's nine miles in an easterly direction from the ter-mites' home which is Parliament House—and the termites are the politicians who sit down there, which is old men and old women making decisions on Aboriginal issues. They're blackfellas—they are making decisions on our ancestral grandfathers and grandmothers on all the land which has been here since the Beginning of Time, long time ago, way back there, not just yesterday, long time before the whitefella came here.

Since we've been here, things have not been good for us. When the blackfellas was on protest, the whitefella gets narked, gets jealous, he says things like 'go home you black bastards, go home you rock apes, go home you black c s, why don't you get a job?' Well we can't go home, because we are already home, who wants a job anyway, it's white man's terms, to him the white man, the job is a god, or some big thing that he idolises, he's got to get up in the morning half past seven or whatever time it is and he goes to work and he comes home and he sleeps and he eats, he goes to the toilet, he sits down and he watches TV, he might read a book and he might sit down and talk about the poor old blackfellas in the big company of blackfellas.

Fling a bit of shit here and a bit of dirt there and a bit of dust here and a bit of bull-shit there, then he'll have a good old sleep and get up in the morning and go to work again. He'll do it from Monday to Friday—Saturday he'll go around doing his shop-ping—he might go to the football, he might go to the pub and have a drink and have a game of darts, Sunday he might go to church and pray for his forgiveness of the sins he created in the six days leading up to the seventh day, or he might get in his car and he might drive for miles looking for scrub, bush so that he can have a picnic and then race home again ready for work on Monday. If anybody should go home, it should be them because for 200 or more or less years that he has been here, he did nothing but pollute our waterways, tear our trees down, dig big holes in the ground looking for gold and coal and silver and diamonds and uranium, then he backtracks behind where the holes he's dug and he starts sifting through the big heaps of dirt that he's dug out with cyanide trying to get the last little grains of gold or whatever it is out of the dirty big heaps of dirt.

Anyway, we've been here since as I said, the third of January. When we first came here, there were two people sitting with their backs to the sandhill, Lionel and Trevor sitting there looking in a southerly direction out across over Mounts Bay Road where the river stretches out down towards Canning Bridge—we drove in and passed them and set up camp preparing ourselves for the shades of the darkness. The sun was set-ting, we made a fire and started to make tea and the police arrived. They came in, pulled up where Lionel and Trevor was, I walked over and asked them what was the trouble. They said 'Oh—no trouble. We had a phone call at the East Perth Police Sta-tion that fires were burning on the south of Kings Park near Mounts Bay Road.' This was a complaint that the person rang the East Perth Police Station about. I, in turn, explained to them that we was here for a purpose, I mentioned to prove a point, that point meant that we as Aboriginal people through our ancestral grandfathers and grandmothers, that we was here to protect our ancestral grandfathers and grand-mothers' beliefs that's under the ground—I didn't explain this in that way to these police officers, I just mentioned that we was here to prove a point and that point meant exactly what I said.

Anyway, as the days turn into weeks and the weeks turn into months, reinforce-ments of people started to come. Pat, Norman, Ronald, their daughter, this is Trevor and Pat, son and daughter, Trevor, Ronald and I don't know the daughter's name, people like Lyn supported, Julie and Lionel at the time. Lenny Culbong, never failed to be standing with us, straight and strong, a strong believer in the Old Fellas' culture, keeping it on the straight. Hospitals couldn't keep him in, a Vietnam soldier, a forward scout.

Graham Merritt fine figure of a man, big and strong walk like a *bungarra* (goanna) savage fella, strong supporter, Clarrie Isaacs always on the scene, strengthy fella, Big Dam, strong, lot of woman, Margaret, always behind buried in paper work supporting in the only way she can support, the rest of the fellas, don't know their names, I know them by face, gutsy, gutsy mob of people all putting up with the abuse, the cold, the wind, the rain, the day and the night, the pressures of the government, Peter Dowding and his ministers, everlasting criticising us on **radio**, **television**, in papers, they never stop, but we'll always be fighting against things like this where sacred sites are con-cerned.

This sacred site fight, you can say that we are all lawyers representing on behalf of what is under the building which has had a death sentence put on it, we the lawyers, men, and women, boys and girls, everyone that camps here and comes here is part of the fight, they are all lawyers, standing up against the pressure of the government, its

progress always threatening, dominating Aboriginal people since the Beginning of Time. The hardships that the women put up with here, the hardships of what us the men put up with, no woman and man's lib in this camp, we are all here for the same purpose and the same call and the same reason and that is to stand and support and be responsible to one another, that's why we're here.

I met a lot of people since I have been here, different characters and I'm going to miss all this mob when the day comes for us to roll up our swags and go our different ways, but it's strange because this fight has brought a lot of people together here on site, on protest on the sacred grounds and living in the homes, scattered in and out of the metropolitan area in different suburban areas. I'm going to miss all this mob but I'll put them all down in the diary of my mind, in the hall of fame where they are going to be; the people I've met here. They will all have their tags and their medals and their praise. For me, for bastards like me there's no medals for I'm too far up front and I haven't got time to accept medals, because the plains of my youth where I crossed, the plains of your youth each and every one of you that stand here today, you've crossed your plains of youth. This is the old people, the old men and women here and the middle aged and the good looking ones and the bad looking ones, you've all crossed your plains of your youth, you've experienced life to some extent in the happenings back there in the past.

Well this is what I mean, I've crossed the plains of my youth and I went up darkened roads and I've found a lot of things, blackfellas' problems here and there. I don't want no medals. I'm me and I have a duty to perform, and my duty is to be who I am and what I am and fight against what I think is right and wrong. If there's been wrong been done against the right … that's where you'll find me. This is the way, the only way that I want to be. The same applies to you; you are master of your own destiny, each and every one of you. It's no good you saying you're not.

This is what the protest is all about: it brought us together, us mob, little weird mob but we're strong and gutsy mob. All of you. That's where you'll stay in the diary of my mind in the six months or whatever how long we're going to be here. I'll remember you, all of you, as you are and as you were. You got any deep secrets; well I don't want to know about them. I know Big Dam's got some and I know Silent Trevor has got some, my brother, Pat, all of you. We can't bring back yesterday. The fight is here and now and the challenge will always be at the breaking of the dawn each day up the track which is tomorrow and becomes today, the present moment, then yesterday.

So you've crossed the plains of your life up until now and used the happenings of what you encountered back there down along the ways as an experience and guideline for what you're going to face tomorrow. The documentary film says that all, *Always Was Always Will Be* [1989] that's us, you and all of us, blackfellas, we're standing on behalf, for all Aboriginal people, Australia-wide not just state-wide.

You've got an audience unseen, unheard, silent, that is your ancestral grandmothers and grandfathers all around you on a day to day, week to week, month to month, year to year basis. Day and night, you can't see them, you can't hear them. That's your audience, the people you represent. As I said before, the voice of this person it really doesn't matter. Because I'm me, I can't be anything else but what I'm born to be, shit stirrer, activist, bludger, it doesn't hurt me.

<div align="right">ROBERT C. BROPHO</div>

3. Kinship and gender

3.1 Kinship, family, and art

Labels at exhibitions of Aboriginal art often provide information about the artist's social group or kin category. In the case of Western artists the label for a painting may include where and when it was painted, the nationality of the artist, and the artist's dates; in the case of an Aboriginal artist the person's clan, or language, or sometimes their social category will be identified. For example, the artist may be described as a member of the Manggalili clan, of the Wiradjuri or Djinang language group, of the Yirritja moiety, or of the Japaljarri subsection.

Kinship in Aboriginal Australia involves relationships between people and relationships with land. While the complex systems of kinship and marriage that are a central feature of social life in northern and central Australia have been transformed in many parts of southern Australia as a consequence of colonialism, kinship remains important everywhere. The European history of the south of Australia has seen the dispersal of Aboriginal people, their decimation through disease and **massacre**, and the break up of families through the removal of the children [see 11.1, 11.2, 11.3, 11.5, 11.6, 11.7, 11.8]. These themes emerge in the works of artists such as Julie **Dowling** [24] from south-west Australia, whose evocative paintings deal with issues such as the **stolen generations**. This process of disruption has not reduced the importance of the principle of kinship, but has changed the scale of its operation.

Kinship exists wherever people use links of descent and marriage to establish connections with others. In Aboriginal Australia the presumption is that such a connection will be found, and that finding it will establish a basis of communication. When people meet for the first time, one of the first things they do is establish their relationship by finding out where the other comes from, which family each belongs to, and whether they have shared relatives. The web of kinship which spreads across huge areas of south-east Australia forms a space mapped by the relationships between people, creating places where people can feel welcome and be part of a network of reciprocity. Kinship as an ideology institutes values of loyalty, obligation, and community support. In south-east Australia kinship continues to be a factor in many marriages. Marriage between relatives who are considered too close is discouraged, and this reinforces links between people of different regions and families.

In recent years kinship has, if anything, become more central as people try to reconnect themselves with their history [see **life stories**]. Artists from south-east Australia frequently identify with the language groups from which they are descended. Identification with a language is a means of reasserting identity and difference, a reaction against the lumpen-category 'Aborigines' into which Europeans have placed them. By identifying

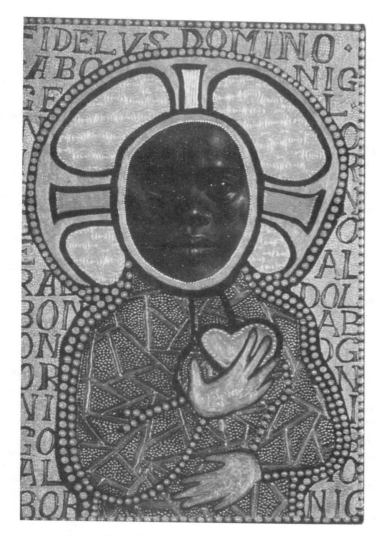

24. Julie Dowling, *Icon to a Stolen Child: Faith*, 1998. Acrylic, red ochre, and gold on canvas, 40.5 x 27.5 cm.

with a group, people are able to become individuals again. Difference and identity as a Wiradjuri, Gurnai, Ngunnawal, or Yolngu person is part of the process of reclaiming place and reclaiming one's relatives as one's own.

Judy Watson [*40, 402*], descended from the Waanyi people of north-west Queensland, has created works redolent with the emotion of personal history as reflected in land and objects. She visited her grandmother's country with her relatives, listened to their stories and became immersed in the land. As she says in the *Wiyana/Perisferia (Periphery)* catalogue: 'I listen and hear these words a hundred years away, that is my Grandmother's Mother's Country, it seeps down through blood and memory and soaks into the ground.'

Hetti Perkins recounts how later, while researching collections of material culture in European museums, Watson reflected that: 'those twined with human hair might include her own great grandmother's ... [she] remembers being told that old people used to be able to tell where a person was from by touching their hair. Accompanying her sketches and notes, listing materials such as stingray barbs, dingo's tail, plaited cane, and woven blankets are questions like "Would Nan's mother have worn one of these?"' [see **cultural heritage, repatriation**].

Metaphorically, her sense of kinship extends across the world, linking together people who find themselves the victims of colonial history or global power struggles as she reflects through her work on the tragedy of Bhopal, or on French nuclear testing as symptomatic of recent Pacific colonial history [see 23.3].

In many areas of Australia kinship not only provides information about the individual artist's group membership but also establishes the artist's relationship to the ancestral past or **Dreaming**. Kinship is a sign of the artist's entitlement or authority to produce a particular painting. In many cases paintings are owned and rights in them are distributed on the basis of kinship and group affiliation [see **rights in art**]. Kinship confirms permission to produce and reproduce designs and in the contemporary context has an important role to play in the exhibition of Aboriginal art and in the **copyright** of works [see 22.1].

In Aboriginal art the primary link of kinship is to the ancestral beings. Art is one of the ways in which relationships between people, place, and the ancestral past are established and maintained. Art was created by ancestral beings as part of the process of the creation of landscape; paintings are both records of the creative acts of the ancestral beings and a manifestation of them. The ancestral beings also created the human beings who succeeded them in the landscape, in a process of continuing descent from the ancestral past [see 1.1].

Kinship linkage with ancestral beings involves both individual and group relationships. The ancestral beings gave the rights to occupy the land to the people that they left behind on condition that the people continued to perform the ceremonies and produce the paintings that are a record of ancestral creative powers. The first humans who occupied the land are thought of as the ancestors of the people who live in the country today. Knowledge of ancestral designs establishes the right to occupy land and the ability to maintain connections with the ancestral forces in that landscape. For this reason knowledge of paintings, and the right to produce them, are closely regulated: they may only be produced by those who are acknowledged to have the right to do so.

Each generation re-establishes its links of kinship with the ancestral past through the process of spirit conception. In north-eastern Arnhem Land, when a women knows that she is pregnant the conception spirit is identified from among the ancestral spirits associated with a sacred place in the father's country, the mother's mother's country, or that of a closely related group. The pregnancy is connected with some unusual happening which is thought of as a sign of the ancestral being concerned. For example, the woman's husband may have narrowly escaped the jaws of a crocodile or may have been unusually successful in hunting kangaroo. The crocodile and kangaroo ancestors will be deemed the agents of conception. In the Yolngu languages of north-eastern Arnhem Land, people are said to be born into place: one word for being born is *dhawal-wuyaŋirr*, literally meaning to 'think of a named place'. In other parts of Australia variants of these conception beliefs reflect the particularities of the kinship systems in each case.

Kinship terms can be applied alike to people, ancestors, and land: people can refer to their actual mother, their mother's country, or the ancestral being of their mother's country by the same word (in the Yolngu languages *ŋä̱ndi* and in Kunwinjku *karrard*). People's rights in paintings and knowledge of paintings extend outwards from their own clan to those of other clans on the basis of kinship and ritual links. People gain rights to paintings of their mother's clan and of their mother's mother's clan, as well as to paintings belonging to clans along the path of shared ancestral tracks.

Individuals accumulate rights and knowledge over paintings as they move through life. In eastern and central Arnhem Land, they begin with knowledge of their own clan's paintings and then their mother's clan's paintings, learning first from their father and

mother's brother, and gradually accumulating other rights as they participate in ceremonies and take on a fuller role in the life of society. People's knowledge of paintings depends partly on individual factors such as their interest and aptitude as well as the position they have in their family. Eldest children often have more authority than others and take a leading role in ceremonial life. In western Arnhem Land, artists such as Peter Marralwanga [353] and Yirawala accumulated knowledge of paintings from a wide geographical region on the basis of the networks of ceremonial and kinship links. Clan relations in eastern and central Arnhem Land are a little more formally structured than in western Arnhem Land and clan identities are strongly marked in the art. Nonetheless, the rights that people exercise in mother's and mother's mother's clans' paintings vary greatly according to the individual concerned.

Social organisation and kinship differ widely across Australia, and the relationship between people, art, and land varies accordingly. In many parts of northern Australia and in the well-watered and more densely peopled parts of central Australia, people are members of descent groups which hold rights over defined areas of land and the religious knowledge and sacra associated with the land. In the more arid and sparsely populated areas of central Australia, links with the land are just as strong but a greater variety of criteria are used in establishing membership of a group. In parts of southeastern Australia, where the system of social organisation has been badly disrupted by the death of much of the population and by years of dispersal and relocation, kinship and descent nevertheless continue to be important criteria for group membership and for exercising control over land and property [see 11.2].

Over much of Arnhem Land the primary land holding group is a clan or a segment of a clan. People usually belong to the clan of their father (by patrilineal descent), though in some cases individuals can become members of a clan by adoption. Both men and women belong to the clan of their father and on marriage they keep their own clan identity. The clans are exogamous, which means that a person must marry someone of a different clan to their own. The clan members have rights in the 'sacred Law'—the paintings, ceremonies, sacred objects, and songs—associated with their land. In north-eastern Arnhem Land each clan speaks its own dialect of one of the Yolngu languages. The ancestral beings are said to have given a unique language to each place and language is one sign of people's spiritual identity. Often the same word (for example, Manggalili) refers to both the clan and the language. Some of the dialects, for example Gumatj and Manggalili, are linguistically very similar to each other, whereas another such as Rirratjingu differs markedly from them. In western and southern Arnhem Land, although there are different dialects of languages such as Kunwinjku and Mara, some clans speak the same dialect.

Clan members are entrusted to keep alive the memories of the ancestral beings who created their land and in turn they have access to the spiritual power embodied in the objects and in the landscape to ensure their health and well-being. They look after the land as they would look after a relative and in turn the ancestral forces nurture them. People are descended from the ancestral beings who created the landscape and on their deaths they will merge again with them. Kinship and clanship relations in Australia are classificatory so that a person will call other women besides their actual parent 'mother', and certain other clans will also be counted as 'mother' clans.

In much of Arnhem Land clans are classed as belonging to one of two patrilineal moieties. Moiety simply means a division of society into two halves. In Arnhem Land there are two main bases for moiety divisions. In a society with patrimoieties a person belongs to the same moiety as their father, while in a society with matrimoieties a person belongs to their mother's moiety. Throughout Arnhem Land today patrilineal moieties are widespread. In north-eastern Arnhem Land, for example, the Manggalili, Gumatj, and

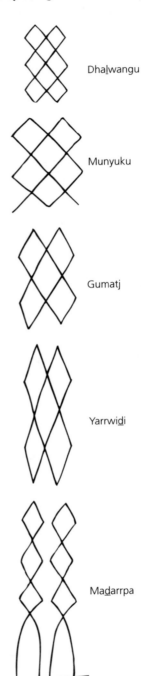

Dhalwangu

Munyuku

Gumatj

Yarrwidi

Madarrpa

25. Yirritja moiety clan designs, north-eastern Arnhem Land (NT).
The 'diamond' design is found only in paintings belonging to clans of the Yirritja moiety. Each clan owns a distinct variant of the design.

Madarrpa clans belong to the Yirritja patrimoiety and the Rirratjingu, Marrakulu, and Djapu clans to the Dhuwa patrimoiety. The patrimoieties have spread quite recently from eastern Arnhem Land to western and southern Arnhem Land, and because of this tend to be named after variants of the Yolngu language terms, Dhuwa and Yirritja. The division into moieties applies to the whole universe, so that ancestral beings, plants, and animals likewise belong to one moiety or the other—never to both. Ancestral beings created the landscape of clans of one moiety only. Shark (mäna) for example is associated with Dhuwa moiety land and crocodile (bäru) with Yirritja. The moieties, like the clans, are exogamous, meaning that a person of the Dhuwa moiety must marry a person of the Yirritja moiety and vice-versa. Moieties are very important in the social and ceremonial life of people since ceremonies and the roles people take in their performance reflect the moiety to which they belong. Named matrimoieties occur in southern and western Arnhem Land and are significant in ritual life and marriage arrangements. The two other most important divisions of society in Arnhem Land are semimoieties, which occur mainly in southern (though more recently in western) Arnhem Land, and subsections, which occur throughout. A subsection system divides people into eight classes which reflect their kinship relation to other members of society—a person will belong to a different subsection from their father and mother, but will belong to the same subsection as people whom they classify as brother and sister.

Kinship identity is reflected in the form of paintings across Arnhem Land. Each clan has its own set of paintings that reflect its unique relationship with the ancestral beings who created the landscape. Sometimes this takes the form of combinations of figures that refer to myths associated with particular areas of land, or stages of the journey of a set of ancestral beings—the place where the crocodile was burnt, or where the Wägilak sisters encountered the olive python [150, 257, 316, 325, 337]. But clan identity is also reflected in geometric designs that are associated with particular places. In eastern and central Arnhem Land there is an elaborate system of geometric clan designs which differentiate one place from another and one set of people from another. In western Arnhem Land the system is less formalised but each group also has sets of geometric rarrk designs linked to ancestral beings. Major ancestral beings, such as the Djang'kawu sisters [see 6.2, 6.5; 33, 71] or bäru in eastern Arnhem Land, and Lumaluma in western Arnhem Land, travelled great distances and connect many different clans. Designs show similarities along the ancestral track but each clan also has unique features that differentiate it from the rest. The journey of the wild honey ancestor of the Yirritja moiety, for example, is a diamond pattern that varies in its details from place to place, clan to clan [25]. It is as if the landscape is clothed in a tartan of clan designs, each of which represents the unique identity of the people and the place.

The Wanjina paintings of the Kimberley [see also 5.1, 10.1; 60, 153, 154] are, similarly, integrated within a system of clanship. In this case the system comprises the speakers of three languages—Worora, Wunumbal, and Ngarinyin—who are linked together in a pattern of ceremonial exchange known as the Wunan. Each clan is associated with a set of founding Wanjina ancestors who established the country and are manifest in the form of the paintings. The paintings were until quite recently ritually repainted as a means of maintaining spiritual continuity with the Wanjina. Although it is not known precisely which set of kin were responsible for the act of repainting, the group centred on the landowners, and descent from the ancestral being itself, in the form of spirit conception, were important factors in the repainting.

In central Australia kinship is just as important as in Arnhem Land. The close connection between groups based on descent, designs, and land that is found in northeastern Arnhem Land occurs in a somewhat more flexible form in the better watered

areas of central Australia, among groups such as the Kaytej, Warlpiri, and Arrernte. In the more sparsely populated regions of the Western Desert, in the lands of the people such as the Pintupi and Pitjantjatjara, relationships with land are often formed on a broader set of principles. People gain rights and knowledge over land through their father or their mother, or by links established in the grandparental generation, by long term association with areas of land, and by ritual and ceremonial links. People are still recognised as having stronger rights to some areas of land than others, and rights in paintings and land are guarded just as closely as they are in areas where rights are primarily based on descent. All these alternative bases for making connections with place are relevant elsewhere in Australia, but the accompanying rights are usually more precisely allocated and differentiated.

In many parts of central Australia subsections (colloquially, 'skins') are an important component of people's identity, though not so much among the Pitjantjatjara. Subsection terms are incorporated as part of people's names as in the case of Clifford **Possum** Tjapaltjarri, Paddy Japaljarri **Sims**, or Jeannie Egan Nungurrayi. It would be quite misleading to interpret these as surnames in the ordinary sense of the term. Subsection terms are ordered in patricouples or father–child pairs, so that children are called by a different term from their father but by the same term as their father's father. The equivalent to the surname in this case is often the penultimate name—Possum, or Egan. Paddy Sims' children will be of the J~Nungarrayi subsection not the J~Napaljarri subsection. There are eight subsection terms organised into four father–child pairs. In the table below, only the Warlpiri terms are listed—there are many different terms employed by different groups across Australia. The Warlpiri terms are the most widespread and have been adopted widely in central Australia (subject to minor variations of pronunciation and orthography). The terms differ for male and female: for example Napaljarri is the female equivalent of Japaljarri.

Warlpiri subsection terms

Male	Female	Male	Female
Jangala	Nangala	Jungarrayi	Nungarrayi
Jampijinpa	Nampijinpa	Japaljarri	Napaljarri
Jakamarra	Nakamarra	Japangardi	Napangardi
Japarrula	Naparrula	Japanangka	Napanangka

Subsections are closely associated with the marriage system. In the table above the subsections are ordered in their patricouple pairs, and each subsection term is placed opposite the subsection into which its members marry. Subsection terms are referred to as sociocentric kinship terms, because people are born into them and everybody refers to a person by the same term. Thus Clifford Possum can be addressed as Tjapaltjarri (i.e. Japaljarri) by everyone, irrespective of their individual relationship to him, whereas the term *wabira* (father) will only be used by a limited number of people who stand in the relationship of 'child' to him.

The importance of subsections in religious and artistic life varies across Australia. In much of central Australia subsections are associated with particular Dreaming tracks and hence the body of ancestral law associated with them. This gives subsections a central role in ceremonial organisation, and people's rights to produce certain designs may therefore be associated with subsection membership. In a painting such as Clifford Possum's *Yuutjutiyungu*, 1979 [*220*], the different sites are associated with different subsections or kin groups, and the responsibility for managing the site varies accordingly.

Thus the sites around Kapatala are associated with the J~Napangardi subsection, as it was a Japangardi man who gathered the caterpillars, whereas the main site of Yuutju-tiyungu belongs to the J~Nangala subsection.

Throughout Australia, rights that people gain in paintings and other forms of ritual knowledge extend beyond their own group. Indeed, rights and obligations are incorporated within networks of reciprocity and responsibility in which tasks are shared and roles are allocated on a variety of different bases. Over much of Australia people have a managerial role in ceremonies of groups other than their own. Usually the rights are related to the mother–child relationship, people having rights in their mother's group and responsibility to help them prepare for the performance of a ritual. Sometimes the division of responsibility can operate on a society-wide basis, with members of one moiety helping to organise, manage, and ensure the correct performance of ceremonies associated with the opposite moiety. In central Australia, among groups such as the Warlpiri, moiety divisions based on descent and generation are of crucial importance to the ceremonial life.

In Arnhem Land, the rights that a person gains in another clan's paintings are very important, and require the person to exercise those rights on behalf of the other clan by helping them in ceremonies or in decisions about important matters. Throughout Arnhem Land, people are called upon to participate in the rituals of their mother's clan and to help them in ceremonial preparation. In eastern and central Arnhem Land, people are referred to as the 'workers' for their mother's clan, though the role is one of considerable authority. In western and southern Arnhem Land, people take on an almost managerial role (*djuŋkay* in western Arnhem Land or *djuŋgayi* in the south) over their mother's clan's land and paintings and often have to be consulted over their use. In the case of mother's mother's clan paintings, the rights are exercised less frequently. The mother's mother's clan belongs to the same patrimoiety as a person's own clan. It is spiritually very close, and the extension of rights is a reflection of this.

The art of western Cape York Peninsula (Qld) shows both similarities and differences when compared with that of Arnhem Land and central Australia. The ritual art of the Wik-speaking peoples of the region of Aurukun also reflects the mythological events that are associated with particular sites. Elaborate carved and painted sculptures are used in initiation rituals and ceremonial events such as house openings to represent events in the lives of mythic beings [see 8.2; *100, 366*]. As elsewhere, the relationships between groups and land are mapped out in art, myth, and ritual. However, the right to produce the sculptures and body painting designs associated with the regional cults is not exclusively vested in the membership of particular clans or totemic groups, nor does production imply proprietorial interest. Although senior owners of the site are likely to come to the fore in producing sculptures and singing songs associated with the mythology of a place, other people can use the songs and designs. In a detailed analysis of a painting by Angus **Namponan** [26], Peter Sutton has shown how the artist uses themes from different places belonging to different clans along the Wik coast of Cape York Peninsula to weave a story of seasonality, of relations between people, and of the movement through life into death and the spirit world. The artist draws widely from the inventory of regional designs to create something that is essentially his own individual construction.

Principles of kinship are pervasively reflected in the practice and symbolism of Aboriginal art. They may focus society on groups of people linked together by descent—clans whose members hold rights in paintings in common. On the other hand ties of kinship can be the basis for the extension of relationships, providing points of connection between people. Kinship can be created through shared history and shared identity. People can be transformed into kin through marriage and by adoption. Ancestral beings

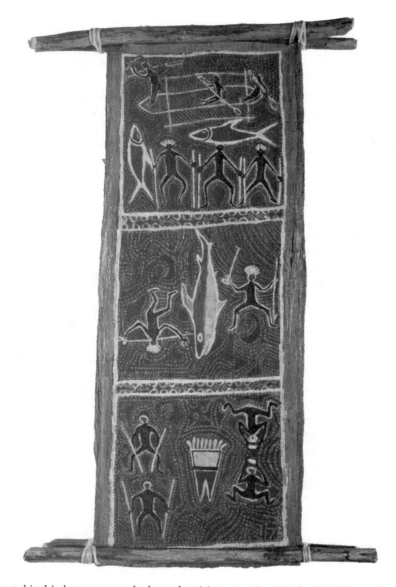

26. Angus Namponan *Three-panel bark painting, Aurukun, Cape York Peninsula,* 1976. Natural pigments on bark. 500 x 200 cm.
Panel 1: *(top)* 'Spearing milkfish by night'; panel 2 *(centre)*: 'Mother shark at Man-yelk'; panel 3 *(bottom)*: 'Two thirsty spirits at Moolench'.

can create kinship between people through spirit conception. In Aboriginal Australia art maps onto kinship: it follows the contours of relationships among people just as it traces the relationships of the ancestral beings to land.

HOWARD MORPHY

Morphy, H., *Ancestral Connections: Art and an Aboriginal System of Knowledge*, Chicago, 1991; Myers, F. R., *Pintupi Country, Pintupi Self: Sentiment, Place, and Politics among Western Desert Aborigines*, Canberra, 1986; Perkins, H., 'Judy Watson: Our skeletons in your closets', in R. Coates & H. Morphy (eds), *In Place (Out of Time): Contemporary Art in Australia*, Oxford, 1997; Perkins, H. & Correa, L. E., *Wiyana/Perisferia (Periphery): A Collaborative Temporal Art Installation by Aboriginal and Latin American Artists*, Sydney, 1992; Sutton, P., 'Bark painting by Angus Namponan of Aurukun', *Memoirs of the Queensland Museum*, vol. 30, no. 3, 1991; Taylor, L., *Seeing the Inside: Bark Painting in Western Arnhem Land*, Oxford, 1996.

3.2 Gender, aesthetics, performance

The consideration of gender in Aboriginal Australia was long dominated by a nineteenth-century model which posed 'men' as a group against 'women' as a group. This model assumed a relative power-relation which operated between 'men' and 'women', such that the former were dominant and the latter subordinate. Many missionaries, administrators, and influential colonists accepted evolutionary concepts and depicted Aboriginal life in negative and disparaging terms. Such terms provided a moral justification for practices which were aimed at destroying Indigenous social orders, in order to neutralise an Indigenous presence which, in accord with the doctrine of terra nullius, should not have been there. Accounts of cruelty to wives, of old men claiming young girls in marriage against their will, of the burdens carried by women from place to place while their 'lords and masters' strode free can be understood partly as a misunderstanding of the significance of common Aboriginal practices, and partly as a projection of a fantasised desire so common in the colonial imagination.

As anthropologists and others came to understand Indigenous social life somewhat better, these lurid distortions could no longer be sustained as 'scientific fact'. Detailed studies of Aboriginal groups and relationship networks, particularly across the north and centre of the country, began to reveal more complex patterns of connection between people, kinsfolk, and country [see 3.1]. But the question of 'gender' remained obscure. In the ethnographic texts of the 1930s to the 1960s, issues of gender, if they appeared at all, did so largely in relation to questions of marriage rules, that is the management of Indigenous kinship orders requiring betrothal, the observation of preferential marriage rules such as cross-cousin marriage, the management of jealousy, adultery, and its penalties, and so on. The framework remained focused on formal regulation and the relations between men, for whom, following the influential work of Claude Lévi-Strauss, women functioned as signs of exchange. There had been some studies of Aboriginal women, by women anthropologists, most famously Phyllis Kaberry's *Aboriginal Woman: Sacred and Profane*. Other women had worked in Aboriginal communities but did not focus particularly on women or on gender as an organising principle, for example Ursula McConnel in Cape York (Qld), and Marie Reay at Borroloola (NT). Catherine Berndt worked closely with her husband Ronald in many parts of Australia and contributed through her own work, and jointly with him, in many publications. By the 1960s, however, what seemed to be gaps in the ethnographic record were being noticed, and increasingly calls were heard for female researchers to work with women.

A number of male anthropologists were aware of the very limited contact they were able to have with Aboriginal women. By 1969 the interest in women had grown to the point where a special conference session was devoted to the topic, resulting in *Woman's Role in Aboriginal Society*, edited by Fay Gale. Most, although not all, of the papers were given by women. Over the next decade questions of gender grew steadily in importance, but the issues raised still derived largely from previous paradigms and interests. Had the importance and significance of women been undervalued or downplayed in **anthropology**, more particularly in the way Aboriginal society had been constructed by male ethnographers? Was a preoccupation with male authority and especially male control of ritual and religious life doing a disservice to the participation of women in the sacred domain? If women contributed substantially to the economy of their communities, for instance by gathering and hunting on a reliable daily basis, did this mean that they had more independence and control of their lives than did, say, middle-class Western women? Was the patrilineal principle really the basis of social organisation all over the continent, or did people obtain important rights and obligations from their maternal

relatives? What kinds of rights were these, and how were they recognised? How did men and women understand paternity, procreation, and childbirth, and did their attitudes and understandings differ? What significance should be given to 'women's business' which seemed to refer both to the physical and the spiritual world?

These questions were projected into a radically new context with the recognition of Aboriginal rights to land, resulting in the Commonwealth's *Aboriginal Land Rights (Northern Territory) Act 1976* and subsequent recognitions of **native title**. The Land Rights Act established precedents and practices for the demonstration and proof of Aboriginal affiliations to land [see **land rights**]. Throughout this process, what had been rather arcane debates in anthropology took on unprecedented importance. Aboriginal Law now had to be aligned with a specific form of Australian law if rights were to be conferred and recognised, and matters such as conservation of sites of significance were to proceed. Rights to land not only conferred authority and responsibility but had potential economic consequences as well. The structures set up to manage land rights had been overwhelmingly dominated by men: by Aboriginal men, as senior custodians, but also by non-Aboriginal male lawyers, anthropologists, field officers, and judges.

Diane Bell published *Daughters of the Dreaming* in 1983, and also participated actively in a variety of Northern Territory claims. She, and others, argued that Aboriginal women must be recognised as full and legitimate traditional owners and must be fully included in preparation and presentation of land claims. Land councils were obliged to extend their claim preparation to include women, and it became customary for both male and female anthropologists to prepare materials for claims, and organise their presentation to the court.

The question of 'gender' had come to mean the question of 'women'. As happened in the broader response to feminist calls for gender-awareness in research and scholarship, it was assumed that the way to ensure this was to have women research 'women's issues'. This left the traditional structure of masculinist understandings untouched; male researchers could continue to focus on the aspects they believed were important, while the other aspects, those of interest to women, could be dealt with separately and need have no necessary implication for the accepted forms of knowledge. But the question of gender underlies so many aspects of Aboriginal life, both in more traditional fields of enquiry, such as ritual and initiation practices, and in the contexts of everyday life, that to fail to consider it as a dynamic field affecting both men and women is to fail to grasp a fundamental principle of cultural existence and continuity.

'Gender', then, is not simply 'about women'. It is about the way in which socially and culturally significant modes of behaviour and interaction are inscribed in the subjective awareness of people in constant interaction with others who are of importance to them; it is about the way certain forms of behaviour and thought are brought forward in accordance with cultural schema, attributing positive and negative values to signs based on bodies; and it is about the way those bodies are allowed to reflect those meanings and their complex lived effects. Judith Butler has developed the idea of gender as a kind of performance: it is not an inherent or natural set of attributes resulting from an individual possessing one or other biologically-determined sexual characteristics, but rather a set of processes and practices which operate through conventionally accepted distinctions in appropriate behaviour in any given socio-cultural context.

Though Aboriginal social formations do rest explicitly on cultural divisions marking men from women, there is no equation with some more basic natural form of masculine and feminine. What it means to be a 'man' or a 'woman'—terms which exist in all Aboriginal languages as markers of gender—is not simply embedded in biological difference. Most notably, it is not enough to be an adult person with specific sexual characteristics.

3. Kinship and gender

There are many ways in which the different phases or aspects of womanhood, for instance, are named. Terms refer to life-cycle characteristics: a young, nubile girl is different from an adult woman; women who have never had children are not the same as women who have had children. In some Aboriginal communities, certain rituals mark a girl's first menstruation, and sexual experience is expected to follow, if not precede, this event. Young women are often married long before this, due to the operation of betrothal rules. 'Old woman' is a term of appreciation and approbation which refers not to chronological age but to breadth of experience and understanding: it is an honorific. The many terms used in Western societies to describe older women (old bat, old hag, old biddy), referring to the loss of primary physical characteristics associated with male attraction and desire, are not found in Aboriginal languages I am familiar with.

For men, the question of being a man is especially marked, due to the pervasive practices of male initiation [27]. The gender category 'man' is reserved only for those who have undergone the often protracted, painful, and frightening rites which mark boys off from men. In many Aboriginal groups, the achievement of manhood is marked physically on the body, in the form of penile modifications such as circumcision and sometimes also subincision, tooth extraction, and scarification. To be a man is not something arising from a particular anatomical configuration and the passage of time, rather, it means an integration into a community of knowledge, involving the necessary separation of boys from the world of women, and their submission to the authority and power of their male elders. However, boys are not initiated by just anybody. The framework of initiation ritual itself derives from a balance, expressed in ritualised performance over many days, months, or even years, involving the maternal and paternal relatives of the boy, his father's and mother's people and their countries. Initiation marks manhood on the body, but the mind is equally marked, through periods of withdrawal, deprivation, learning, submission to authority, support, exposure to secret events and objects, language, song, and oratory. A person who is biologically masculine but has not undergone these rites is, in traditional Aboriginal thought, not a man at all.

31. (*facing page, left*) The Yirrkala Church Panels, 1962–63: the Dhuwa moiety panel. Natural pigments on Masonite, 317 x 106 cm.
These monumental works were produced to explain the relationship Yolngu have with their land, at the time that a large area was being excised from the north-eastern part of the Arnhem Land Reserve for the mining of bauxite.
The artists represented in this panel (*refer to key shown opposite*) are: Wandjuk Marika (1), Mawalan Marika (2), Mathaman Marika (3), Gungguyama Dhamarrandji (4), Larrtjannga Ganambarr (5), Munaparriwuy Wanambi (6), Mutitjipuy Manunggurr (7), and Mithinari Gurruwiwi (8). The Marika artists of the Rirratjingu clan depict episodes from the narrative of the Djang'kawu ancestral beings. (1) shows the Djang'kawu at Burralku (the island of the dead), with the morning star above. From there they travelled east to make landfall at Yalangbara (2), before moving inland (3), creating waterholes in other Dhuwa clan countries and disseminating their Law. (4) shows a place near the salt water in Djambarrpuyngu clan country, and (5) shows freshwater sites in the countries of the Ngaymil and Dätiwuy (the artist belongs to the Ngaymil clan). In (6) the Marrakulu clan areas of Manybalala and Gurka'wuy are depicted. (7) shows the shark ancestor (mäna) and other ancestors at Dhuruputjpi in Djapu country. Finally, (8) represents Gälpu clan country.

See also: 1.1, 1.2, 4.6, 6.1, 22.1; Larrtjannga **Ganambarr**, Mithinari **Gurruwiwi**, **Marika family**, **Manunggurr family**.

32. (*facing page right*) The Yirrkala Church Panels, 1962–63: the Yirritja moiety panel. Natural pigments on Masonite, 317 x 106 cm.
The artists who feature in the Yirritja moiety panel (*refer to key shown opposite*) are: Birrikitji Gumana, Gawirrin Gumana, and Yanggarriny Wunungmurra (jointly responsible for A1–4); Munggurrawuy Yunupingu, Djarrkudjarrku Yunupingu, and Wätjung Manunggiritj (jointly responsible for B1–4); and Nänyin Maymuru and Narritjin Maymuru (jointly responsible for C1–3). The paintings in (A) show major ancestral beings of the Yirritja moiety at Gängan in Dhalwangu country: Barama (A1), Galparimum (A2), and Lany'tjung (A3). They met there (A4) before setting out to give the Law to the Yirritja clans. The paintings in (B) represent the Gumatj clan ancestors Wirrili (B1) and Murrirri (B2), and Gumatj inland stony country (B3) and saltwater country (B4) estates. Finally, the paintings in (C) refer to Manggalili clan country at Djarrakpi, showing the ancestral *guwak* (koel cuckoo) in his human form, after his death at sea (C1), the ancestral woman Nyapililngu, above the saltwater and cloud designs that link Manggalili to other saltwater Yirritja clans (C2), and the *guwak* and *marrnu* (possum) ancestors (C3) whose journey from the west, ending at Djarrakpi, links the Manggalili to Yirritja clans of the inland.

See also: 1.1, 1.2, 4.6, 6.1, 22.1; **Gumana family**, **Maymuru family**, Yanggarriny **Wunungmurra**, **Yunupingu family**.

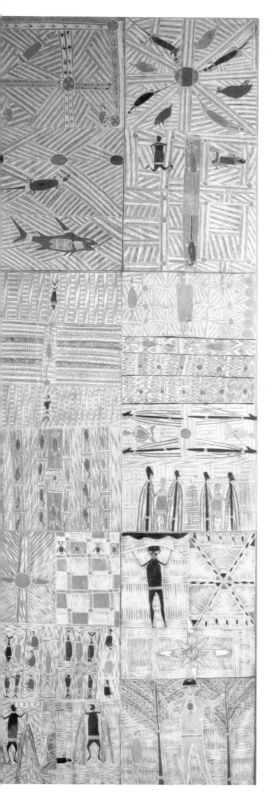

31. (*l.*) The Dhuwa moiety panel.

7	8
5	6
	3
4	1
2	1

32. (*r.*) The Yirritja moiety panel.

C3	
C1	C2
B4	B3
B1	B2
A4	A3
A1	A2

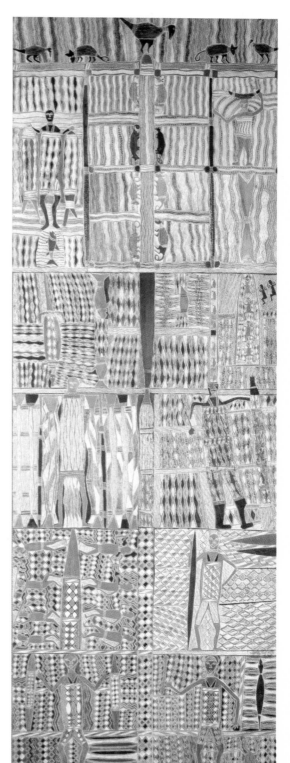

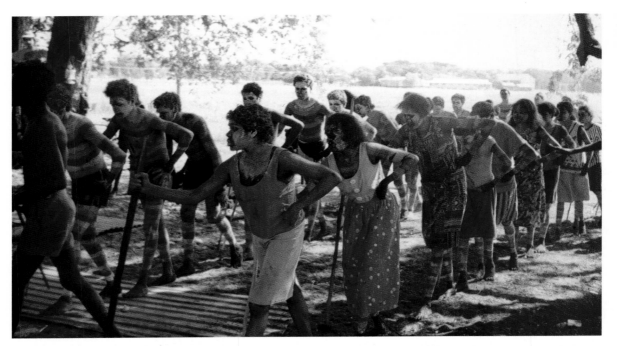

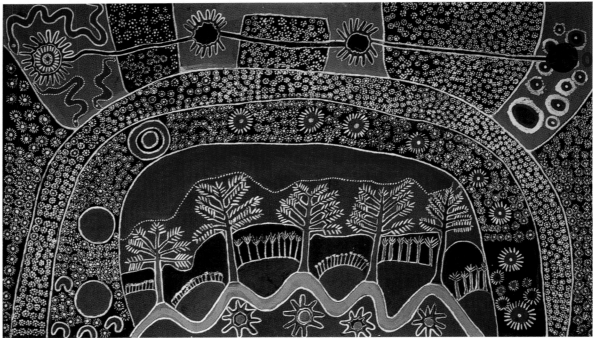

33. (*upper*) The dance of the Djang'kawu sisters, Milingimbi, north-eastern Arnhem Land (NT), 1991. Following in the footsteps of the ancestors, the dance re-enacts the creative journey of the sisters who strode across long distances with their yam sticks (*ŋal'gam*), shaping the country as they went.
See also: 1.1, 3.1, 3.2, 3.3, 6.1, 6.2, 6.5.

34. (*lower*) Nym Bandak, *All the World*, 1958–59. Natural pigments on Masonite, 102 x 167.5 cm.

See also: 1.1, 1.2, 6.1, 10.1, 10.2; Nym **Bandak**.

35. Jarinyanu David Downs, *Moses Belting the Rock in the Desert*, 1989. Natural pigments and acrylic on canvas, 152 x 106 cm. Jarinyanu first began painting the Moses story cycle after attending a bar mitzvah in Adelaide. This is second painting in the series. Jarinyanu tells the story:

After crossing the Red Sea, Moses was leading all the Jewish people in the Desert. Everyone became thirsty for water. Lots of people were close to dying. Alright, Moses came up to a big rock and belted it with his stick—broke it open. Inside was a spring—a living water. All the thirsty people drank and went away with Aaron, Moses' younger brother. A little bit later they made the gold bull and took off all their clothes. Moses went a different way— up the mountain to work with God and get the Ten Commandments.

The painting relays every aspect of the story cycle: Moses' journey with the Jewish people, the wielding of the stick, and the flowing water. The artist represents the people dying of thirst by chaotic footprints, and their renewed strength after drinking by ordered footprints.

See also: 1.1, 1.2, 10.1, 10.2; Jarinyanu David **Downs**.

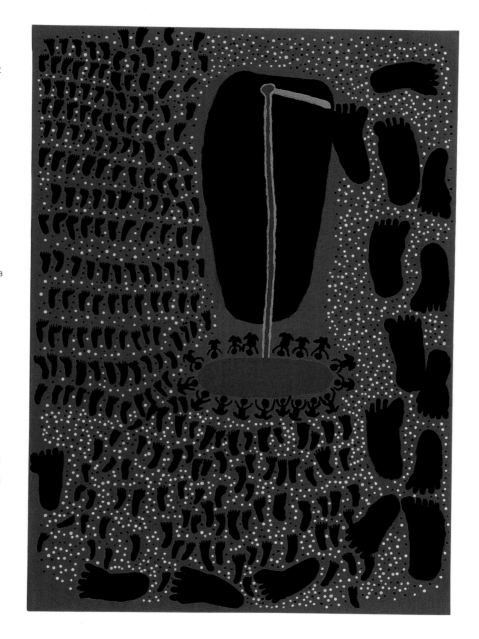

36. Albert Namatjira, *Ghost Gum,* 1942.
Watercolour on canvas, 53 x 42 cm.

See also: 1.1, 1.2, 2.3, 4.1, 9.1, 9.2, 9.3, 11.1, 12.1; Albert **Namatjira**.

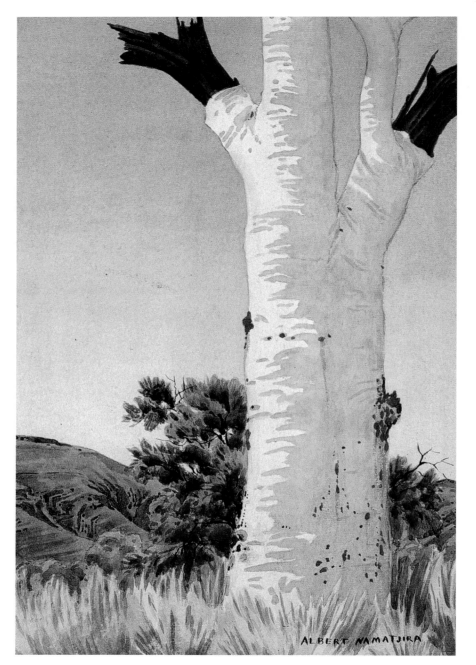

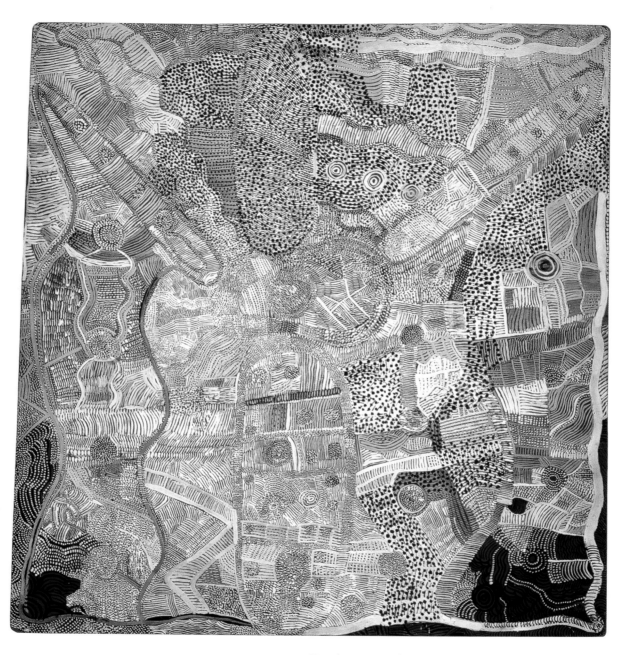

37. Johnny Warangkula
Tjupurrula, *Water Dreaming
at Kalipinypa*, 1972.
Acrylic on composition board,
80 x 75 cm.

See also: 1.1, 9.4, 9.5, 9.7,
21.2; Johnny **Warangkula
Tjupurrula**.

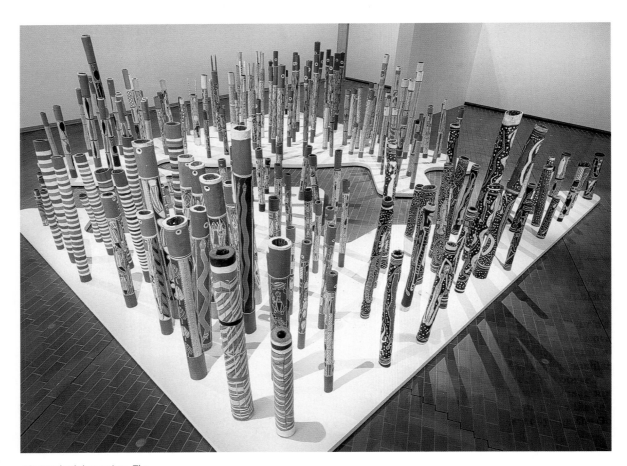

38. Ramingining artists, *The Aboriginal Memorial*, 1987–88.
Natural pigments on wood, max. height 327 cm.

See also: 1.1, 3.1, 4.6, 6.1, 6.3, 6.5, 21.1; David **Blanasi**, Paddy **Dhathangu**, Albert **Djiwada**, Dorothy **Djukulul**, Tom **Djumburpur**, Robyn **Djunginy**, Elizabeth **Djuttara**, David **Malangi**, John **Mawurndjul**, George **Milpurrurru**, Paddy Fordham **Wainburranga**, Jimmy **Wululu**.

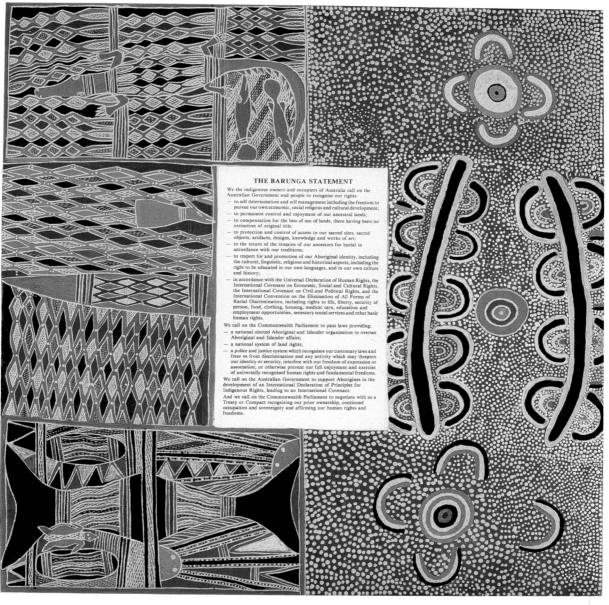

THE BARUNGA STATEMENT

We the indigenous owners and occupiers of Australia call on the Australian Government and people to recognise our rights:

— to self determination and self management including the freedom to pursue our own economic, social religous and cultural development;
— to permanent control and enjoyment of our ancestral lands;
— to compensation for the loss of use of lands, there having been no extinction of original title;
— to protection and control of access to our sacred sites, sacred objects, artifacts, designs, knowledge and works of art;
— to the return of the remains of our ancestors for burial in accordance with our traditions;
— to respect for and promotion of our Aboriginal identity, including the cultural, linguistic, religious and historical aspects, including the right to be educated in our own languages, and in our own culture and history;
— in accordance with the Universal Declaration of Human Rights, the International Covenant on Economic, Social and Cultural Rights, the International Covenant on Civil and Political Rights, and the International Convention on the Elimination of All Forms of Racial Discrimination, including rights to life, liberty, security of person, food, clothing, housing, medical care, education and employment opportunities, necessary social services and other basic human rights.

We call on the Commonwealth Parliament to pass laws providing:
— a national elected Aboriginal and Islander organisation to oversee Aboriginal and Islander affairs;
— a national system of land rights;
— a police and justice system which recognises our customary laws and frees us from discrimination and any activity which may threaten our identity or security, interfere with our freedom of expression or association, or otherwise prevent our full enjoyment and exercise of universally recognised human rights and fundamental freedoms.

We call on the Australian Government to support Aborigines in the development of an International Declaration of Principles for Indigenous Rights, leading to an International Covenant.

And we call on the Commonwealth Parliament to negotiate with us a Treaty or Compact recognising our prior ownership, continued occupation and sovereignty and affirming our human rights and freedoms.

39. The Barunga Statement, 1988.
Natural pigments on composition board, with collage of printed text on paper, 122 x 120 cm.
The artists represented in this work are: Galarrwuy Yunupingu, Djewiny Ngurruwutthun, Bakulangay Marawili, Terry Djambawa Marawili, and Marrirra Marawili (all from north-eastern Arnhem Land); and Wenten Rubuntja, Lindsay Turner Jampijinpa, and Dennis Williams Japanangka (all from central Australia).

See also: 1.1, 2.1, 4.6, 6.1, 23.2; **Aboriginality, cultural heritage, land rights, Marawili family, native title, Ngurruwutthun, rights to art,** Wenten **Rubuntja, Yunupingu family**.

40. Judy Watson, *Blood Vessel*, 1997. Pigments and pastel on canvas, 159 x 113 cm.

See also: 1.1, 3.1, 4.1, 8.2, 12.1, 21.1; **Judy Watson**.

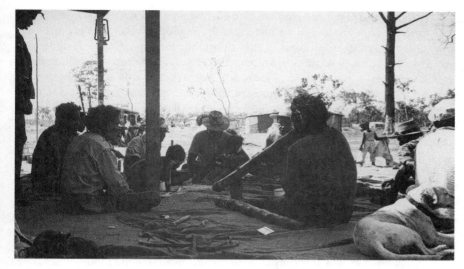

27. Male initiation at Maningrida (NT), 1968. The men are performing song cycles of country during a public phase of the ceremony.

From general descriptions and ethnographic accounts, we might think that everything pertaining to male initiation is a secret to men, something held aside and promulgated as a gender-confirming experience specific to its own category. But, if we go to an initiation ground somewhere in northern Arnhem Land (NT), we find instead a complex conundrum of arrivals and departures, presences and absences, in which women are fully involved. It is sometimes said that women are made present by their absences. This is a neat expression of a much more complex series of connections. When boys are seized for initiation, and taken away from the world of women and children, it is known in advance: the event to come is recognised by everybody involved, mothers and sisters especially. On the day, it is a time of silence, absence of normal life; as in death, everyday life is abated, reduced to its minimum. Maternal relatives of the initiate-to-be may daub their bodies in white ochre—image of death—or trace Dreaming designs on their bodies which make them incarnations of loss and absence. Female relatives may scarify parts of their bodies in accordance with their relationship with the initiate: for example on the upper arm if a sister, on the abdomen if a mother.

The men come, they seize the boys, the women wail and suffer in an orchestrated concert of loss. During the nights and weeks and months which follow, paint is placed on bodies, songs are sung [see 15.1], the bamboo-man (**didjeridu** player), usually a relative of the mother, drones out the ritual sounds of the boy's **Dreaming**. On the day of the operation itself, an air of hushed excitement prevails. 'Don't look up', the women say, 'there are men coming. They might spear us.' At the initiation ground, material items of exchange are piled up: in the late 1960s they were mattresses, blankets, cloths, drums of flour. The ceremony itself is accessible to all concerned, but women and children are clustered at the rim, the boundaries of a ritual space. During the rite, female relatives of the father dance in their designs at the edge of the proceedings.

The event unfolds: boys are carried into the ground, dazed, painted, decorated with their countries and Dreamings, on the shoulders of men. The rite is carried out in a public space, but designed so it cannot be seen, behind a screen. Nevertheless, around the outside perimeter of this invisible space of suffering, paternal aunts and grandmothers, wearing designs of the Dreaming they share with the initiate, trace the ancestral movements onto the ground, and with stylised movements of hands, arms, bodies, and feet contribute to writing the new identity of the boy—as a man of the country—into the ground. Their voices trill out a series of stylised wailings as the operation is performed.

Later, the women of the maternal line, daubed in white, attack with small spears (symbolic expressions of the loss of the matriline) those who have claimed the boy in the name of the father. Wild and dancing, they thrust their little spears towards those who have given the boy away to the world of men. In the waning of the day, people sit silent around their fires. It is a sad time: boys are now lost to the space of women, women are sorry for their sons, nephews, and brothers, feeling their physical pain located in their genitals, with the designs of their countries traced on their bodies. But they know too that only in this way can their male relatives enter into the world of men, defined around country, place, song, and continuity.

This is only a summary sketch of the way in which women and men are drawn into an infinitely complex web of physical and bodily expression around the idea of gender. In the Central Desert another space of gender expression is found, where practices both in everyday life and in ritual reflect a more interdependent yet more autonomous form of relationship between the genders. Why this should be so is not apparent within the understandings of ethnographic research. Research with Aboriginal women across the Central Desert indicates the existence of a restricted and autonomous space for women's rituals, sometimes known as Yawulyu. These performances indicate an idea of separate gender-based expressions of land, ownership, connection, and companionship.

Two very important processes in the past twenty years have brought out the deeper meanings of gender and association with land, future, past, space, design, and beauty. The first is the context of presentation of Aboriginal land claims. The second is the valorisation of **Aboriginality** in the world of art.

Women in land claims

The land claim process, under the *Aboriginal Land Rights (Northern Territory) Act 1976*, required for the first time specific demonstrations of certain kinds of relations between people and land. The critical tests involved the definition of 'traditional Aboriginal owner' and required that a traditional owner be a member of a 'local descent group' and have 'primary spiritual responsibility for a site on the land'. The two issues were connected. A person had to be a member of a group on the basis of descent and, further, required a spiritual connection to sacred sites arising from membership in that group. Aboriginal communities had long been thought of as practising patrilineal descent, even though it was also recognised increasingly that rights to sites, land, and ritual were distributed in much more complex ways, and included those deriving from matrilineal ties, or from the maternal grandmother. While such issues may have been important to anthropologists, and of course to Aboriginal people themselves, the reality underlying Aboriginal descent systems had no broader implication. However, with the 1976 Act, these questions came into a legal domain which required certainty and definite answers. The assumption that patrilineal descent alone gave rights to land, understood in Western legal systems as real property [see **land rights**], was readily grafted onto the Aboriginal case. Even when Aboriginal evidence at times clearly contradicted this, the model remained as the default or template on which land claims were constructed by those charged with producing the legal verification required by this new system, so alien to Indigenous concepts of time, space, ritual, and meaning.

These arguments remain intensely contested. The critical issue, however, is the question of gender in the claim process itself, and the way the expression of connection to land came to be enacted on a gendered basis within the conduct of claims. In early claims, women's involvement was extremely limited: they were often restricted to providing information about kinship. They were seldom called to give evidence in their own right. Soon, however, the inclusion of women both as 'Traditional Owners' and as

participants in the claim process became customary [*28*]. From the late 1970s, a certain style of presentation in claims emerged in central Australia. Many of these were concerned with Warlpiri and their neighbours, who shared elements of a distinctive desert culture which already displayed sophisticated and deeply significant mechanisms for the expression of gendered relationships in the ritual domain, especially the sacred contexts where Yawulyu were performed.

The expression, by women and men, of their ritual entitlements regarding sites and land came to involve specific distinguishing features. Land claims moved outside the court and into the bush; successive land commissioners heard evidence on or near the land being claimed, where Aboriginal people were far more able to express their perspectives and relationships than in the formal Western court system. While direct question and answer, and cross-examination, continued (both in the formal court setting and in the bush), a parallel set of processes emerged in which each gender undertook to explain its connection to country through highly structured performances. These were clearly based on traditional ritual displays, but they were being brought forth in an entirely new and distinctive context. Male claimants took the non-Aboriginal participants (notably, judges and lawyers, with their advisers) into secret–sacred contexts, where they were able to convey their proofs of entitlement. Evidence taken in these contexts was identified as restricted and removed from official and accessible court records. The physical and material processes involved clearly came to carry heavy significance in the legal context: groups who were unable to mount similar displays, or whose evidence in relation to their songs, rites, and country did not fall readily into the formal frameworks laid down in earlier claims, had a more difficult task in convincing the court of their legitimate entitlements. The world of the secret–sacred, partially and contextually revealed in the land claim context, became the statement of men's evidence *par excellence*.

Women, however, also gave evidence in similar ways. While there has been a long and sometimes acrimonious debate about whether or not Aboriginal women really have 'secret women's business', a large corpus of distinctive women's rites exists in certain areas and has powerful significance for women's relation to the land and the spiritual powers within it. Where earlier thought had consigned women to the profane context and treated 'women's business' primarily as an expression of physical body processes (menstruation, birth, love magic), it now became clear that, in the context of land and

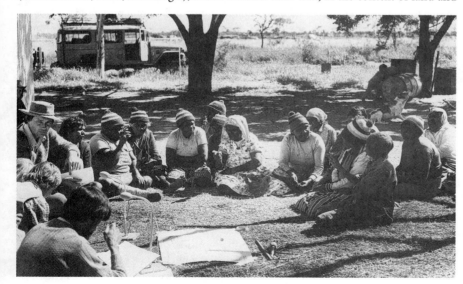

28. Women giving their evidence at the Barkly land claim hearing, Mt Barkly (NT), c.1984.

relationships, women had a complex framework of cultural performance through which they expressed themselves as 'women of the country'. Using intricately painted body designs associated with totemic species of the country, and performing sequences of dance and song each with their own distinctive meaning, wearing head-dresses and carrying symbols of their womanhood (digging sticks and coolamons), groups of women performed for the judge and the lawyers, and for other claimants, and in so doing laid out their evidence for inclusion in their own right.

The negotiations which determined who performed which ritual, in what context, wearing what design were not simple, and in the case of both men and women they included persons who were not patriline members. There is much argument over the resolution which came to be accepted in claim after claim, that both patriline members *and* matriline members had specific and distinctive rights to be accepted as claimants: one set, *kirda* (patriline members), as 'owners', and the other, *kurdungurlu* (children of the women of the patriline), as 'managers'. In this way the performance of gender in ritual displays came to constitute a basis for a re-evaluation of paternal and maternal links to land.

Women and art

During the same period, a separate but related phenomenon appeared. Aboriginal people, most notably in central Australia, began expressing their cultural identity in novel and extraordinary ways. With assistance and support from many non-Aboriginal people working as art and craft advisers in communities [see **art and craft centres**], a dramatic new form of identity began to take place. Using canvas or board as support (rather than ground or body), and new materials such as acrylic paints and brushes (instead of traditional ground ochres and emu fat), a rich visual culture began to express itself across the desert zones [see 2.2, 9.4, 9.5]. Designs were based on what appear to the Western eye to be abstract representations of the landscape and its Dreamings: waterholes, resting-places, animal tracks, human and heroic imprints on the landscape [*37*, *120, 121, 122, 220, 221, 222, 223, 224, 226*]. These took their places on works small and large, from cheap paint-boards to vast, epic canvases. The issue here is the way in which Aboriginal women in many communities seized on the opportunities that painting brought them, and developed it in distinctive ways which have produced an extraordinary array of styles, approaches, and expressions. Emily Kame **Kngwarreye**'s work is among the best known, but talented women are painting in remote communities all over central Australia and beyond [see 9.6; *123, 225*].

Women's painting has developed through the translation of design elements, colours, shapes, and forms (closely associated with the forms of a woman's body) onto the two-dimensional support. Generally using a black or brown-black ground (human skin being the model) as support for the design, and retaining both tracks across space and marks which would have appeared, in traditional ritual contexts, upon breasts, thighs, and other body surfaces, women's painting did not duplicate the formal elements of men's painting, although it shared some common elements. The tracing of space onto the body, rather than directly onto the ground, seems to have been particularly important. Colour, too, is treated much more freely, elements of the restricted palette being allowed to blend and connect across the space of canvas, or to glow against one another in intricate conjunctions. Women, in painting, are performing a gendered embodiment which connects them to time and landscape, just as they do in dance and song. The possibilities arising from contemporary cultural circumstances have opened up these domains of gendered expression, and permitted outsiders an insight (albeit partial and fragmentary) into the kinds of things Aboriginal people have been trying to explain to witless observers for decades. These things cannot be explained using words, sentences,

and paragraphs, because they involve a totally different metaphysics of appearance and being. The body itself, always a gendered body, provides the framework through which relationship to time and space can be expressed, and it is in the design, the paint, the mark, the movement of hand and foot, the track in the sand, or the trembling of the thigh that meaningful statements are made. The repetition of movement, of design, and of music and song calls forth the distinctive relationships of men and women, and of links between the living generations and ancestral time. Gender, then, and its performances, provides the basis for a mutuality through which people and land can continue in identity through time. Today, of course, many powerful forces have erupted into the space of the Indigenous metaphysic. Among the destructive aspects, which have had particularly devastating effects on women, has been the frequent loss of security resulting from the demands created by Western concepts of individual agency and autonomy. The expression of Indigenous gender relations are not readily mapped onto Western forms. Nevertheless the astounding creativity and expressiveness which seem to have been, if anything, enhanced in recent years show the possibility and power of Indigenous forms of relationship, and the continuity of an idea of gendered embodiment which marks Aboriginal life, culture, and art so distinctively. ANNETTE HAMILTON

Bell, D., *Daughters of the Dreaming*, Melbourne, 1983; Butler, J. P., *Gender Trouble: Feminism and the Subversion of Identity*, New York, 1990; Gale, F. (ed.), *Woman's Role in Aboriginal Society*, Canberra, 1970; Kaberry, P. M., *Aboriginal Woman: Sacred and Profane*, London, 1939.

3.3 The politics of representation: Kinship and gender in the performance of public ritual

Ritual performance at **Yuendumu**—the Aboriginal settlement where I have conducted fieldwork since 1983—has always been characterised by interconnected forms of competition and negotiation. A performance of a **Dreaming**, which can involve dance, painting, and song [see 15.1], requires a complex process of engagement within one's family as well as with other members of the settlement. Issues of kinship, seniority, gender, and less tangible expressions of human agency all come into play when myths from the Dreaming are presented.

By tracking the changing nature of public ritual at Yuendumu from the early days of forced sedentarisation (the collective resettlement of Aborigines by Australian governments a half-century ago) up to the present, a profound realignment of social structure may be clarified. Although Warlpiri ceremonial life has been sustained, public ritual, which was once the province of senior males, is now overseen by senior women.

Yuendumu is a Central Desert settlement, established by government in 1946, located some 300 kilometres north-west of Alice Springs. The Aboriginal people who live there organise themselves into discrete residential units of close kin that I will call kin groups. Given the mobility of the Warlpiri—many move between Yuendumu, various outstations, and other Warlpiri settlements—the size of any kin group varies greatly over time. Less susceptible to fluctuation, but still by no means static, is the number of kin groups at Yuendumu. Warlpiri comprise the majority of the 800 or so residents, and because they possess ownership rights over all the land [see 1.1, 2.1, 3.1; **land rights**] on which they and other Aboriginal people have been resettled, they dominate the ritual life of the settlement.

The right to perform a Dreaming publicly carries many of the obligations that accompany restricted ceremonies [see **rights in art**]. For each Dreaming there are owners (*kirda*) and managers (*kurdungurlu*); the latter monitor the fidelity of the

performance. And both must be present for an enactment. This is true regardless of the medium in which the Dreaming is represented, be it singing, sand painting, the painting of ritual objects, body painting, or dance.

The forced sedentarisation of Central Desert Aborigines imposed inter-group residency on various Aboriginal societies: the Pitjantjatjara, Pintupi, Anmatyerre, Arrernte, in addition to the Warlpiri. These groups that had previously existed in small bands of ten to twenty now inhabited a space that brought together hundreds of people. This confinement generated dramatic increases in the number of fights and 'sorry business' (ceremonial activity surrounding funerals) and made new demands on kinship relations. Sedentarisation also undermined the status of senior men and women by denying them the socio-political role they held prior to forced settlement. Concomitantly, the Warlpiri were forced to compete with other linguistic groups resettled at Yuendumu in order to perform and thus represent their culture in the large domain.

One major forum in which that representation emerged was public ritual, which served as a useful tool of both intra-Warlpiri and inter-Aboriginal engagement. While such performance supplied entertainment, it provided a context in which a newly pluralised community could declare kin group prestige. By its public nature it obviated many—but not all—of the burdens that attended restricted events. For public ritual still required various preliminary ceremonies, some elements of which were restricted, before a performance could take place.

There has been much debate over how women fitted into public ritual life of the Warlpiri during this early period of contact. Because the nature of Central Desert ritual practices appears to vary, both territorially and temporally, it would be ill-advised to project current practices backward in time, or to assume one settlement's practice will match the patterns of another. My interviews with Yuendumu's senior Warlpiri (men and women) who endured collective settlement in the 1940s confirm the observations of Nancy Munn and Mervyn Meggitt, two anthropologists who conducted extensive fieldwork with the Warlpiri in the 1950s. Both researchers noted that public ritual was, at the time, the exclusive province of men; equivalent ceremonies performed by women did not exist. Catherine Berndt, in her studies of other societies of central Australian women (1950, 1965) notes that women's ceremonies (Yawulyu) were either restricted or secret ceremonies.

In the first decades of sedentarisation, before the Commonwealth's *Aboriginal Land Rights (Northern Territory) Act 1976*, public events served as a vehicle for staking territorial and ritual claims, proclaiming rights, and the general declaration of identity *vis-à-vis* other Warlpiri kin groups and non-Warlpiri groups settled at Yuendumu. Performances for non-Indigenous viewers (apart from the occasional researcher) were rare. An explosion of events linking ritual performance with political activism followed the passage of the Act. The legislation required proof of genealogical and religious connection to land. For the Warlpiri and other Central Desert Aborigines such proof could only come through the performance of Dreaming rituals that tied them to their parents' and grandparents' country. Public performance became a kind of legal tool. Song, dance, and design were the Warlpiri's property deeds to land that had been taken away and was now in small part restored. In a way, the land rights movement prompted movement of a very different kind—of body, brush, and voice. To dance, to paint, and to sing the Dreaming was the most potent and legal way for the Warlpiri to reclaim from the federal government the lands from which their culture sprang.

This legislation brought with it profound changes in all social domains, and in the very nature of public ritual. The content of the Dreaming stories themselves did not

change, but most other elements associated with their performance did: the actors, the setting, the audience, the repertoire. The public events, redirected from non-Warlpiri Aborigines towards Kardiya (loosely translated, 'light-skinned people'), had a new urgency. The audience now frequently consisted of representatives of the innumerable government entities who required performance as a gauge not only of territorial claims but of broader, vaguer notions of Aboriginal culture [see also 3.2].

The earlier years of land rights and associated policies of self-determination were ones in which the ritual life of the settlement came under renewed observation and, at times, assault. These policies often required or compelled the Warlpiri to provide proof of multi-generational traditions. To that end, the Warlpiri were urged to have younger members of the settlement perform public Dreamings. These junior members had little expertise in the re-enactment of Dreaming stories (and felt embarrassed at their inexperience and at exposing it to outsiders). The Warlpiri eventually rejected this assault on long-standing age-based patterns of ritual display, although occasional gestures to placate government authorities are still made.

Access to religious sites was now dependent upon enacting Dreamings for a government audience. As might be imagined, this added pressure on top of the already stressful obligations than inhere in such performances. During this period, one influential elder refused to organise or perform a men's public ceremony (Purlapa) with his male relatives. He explained that he had witnessed ritual performances in which men improperly transmitted restricted information and now felt more comfortable having his sisters and daughters perform a public version of the women's restricted ceremony (Yawulyu) to avoid further transgressions. He noted that none of the women drank alcohol, and thus there was little chance they would present more than the public version of the Dreaming. Furthermore, he praised the manner in which they guarded restricted information while dancing in public contexts. This new-found deployment of women was, in other words, a regulatory response to new social conditions that had threatened the long-standing distribution (and, just as important, *non*-distribution) of ritual knowledge.

The gender shift within activities of the senior population was dramatic. Warlpiri women came to play a vital and enlarged role in the years following the 1976 legislation. *Yawulyu warrajanyani*—the public version of women's restricted ceremonies—emerged as the principal domain in which ritual knowledge was revealed to the outside world. By the early 1980s, women became the near-exclusive performers of public rituals at Yuendumu. While this fact makes it tempting to construct a model of Indigenous feminism, such ideological schematics are disputed by the participants themselves (and by participants I mean both men and women). To be sure, land rights legislation and self-determination policies coincided with a rise of Western feminist politics; Warlpiri women were increasingly encouraged to perform 'Aboriginal Dreamtime stories' in various contexts, from local school programs to the national celebration of Australia Day [see 4.1]. But when Warlpiri elders, both men and women, are asked about this change they dismiss these external events as inconsequential and at times comic. In point of fact, they do not see a gender division at all, since men are still intimately involved in the pre-performance negotiations that foreshadow public events. They rarely express the essentially non-Warlpiri opinion that the men have abdicated their role in the public arena. When asked about changes in the public ritual life of Yuendumu, the Warlpiri inevitably focus their observations on the struggles among kin groups—struggles that increased significantly with the exponential increase in public ritual performances. Much of this performance activity can be tied to the worldwide interest throughout the 1980s in so-called 'dot painting'—the **acrylic**

29. Warlpiri women's dance performance of water Dreaming, from 'Yuendumu: Paintings out of the Desert' exhibition, Adelaide, 1988.

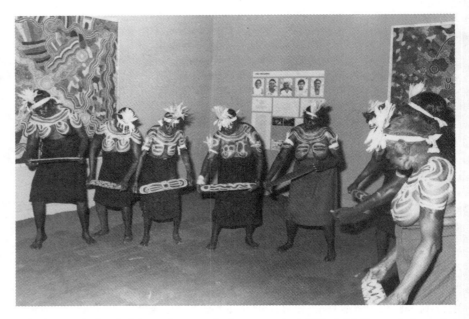

paintings and ritual objects that put the iconography of Warlpiri Dreamtime myths in the art galleries and into the consciousness of the public at large. Many of the more important exhibitions—'Women Artists' (AM 1982), 'Dream Maps' (MAGNT 1985), and 'Yuendumu: Paintings out of the Desert' (SAM 1988) [*29*]—were inaugurated with ritual performances. These performances significantly increased the economic and social significance of public ritual.

All this complicated and intensified the competition to paint and perform Dreamings back at Yuendumu. New questions arose because of the international explosion of interest in Aboriginal ceremonial life. Who should have the right to paint? Who should accompany the art to exhibition? Who should have the right to perform? Because of the new economic and social implications, public ritual performances at art exhibitions soon involved as much kin group politicking as did restricted rituals. With the sudden increase in the economic and political value of public ritual it is small wonder that kin group competition, so central to the restricted ritual life of the Warlpiri, entered the intercultural domain.

FRANÇOISE DUSSART

Berndt, C. H., 'Women's changing ceremonies in northern Australia', *l'Homme*, 1950; Berndt, C. H., 'Women and the "secret life"', in R. M. Berndt & C. H. Berndt (eds), *Aboriginal Man in Australia: Essays in Honour of Emeritus Professor A. P. Elkin*, Sydney, 1965; Meggitt, M. J., *Desert People: A Study of the Walbiri Aborigines of Central Australia*, Sydney, 1962; Munn, N. D., *Walbiri Iconography: Graphic Representation and Cultural Symbolism in a Central Australian Society*, Ithaca, NY, 1973.

30. Terry Milligan, *Portrait of Ruby Langford Ginibi,* 1997. Silver gelatin photograph, 21 x 26 cm. Ruby Langford Ginibi is an Aboriginal activist and author of four books including *Don't Take Your Love to Town* (1988). She is a member of the Bandjalang (Bundjalung) nation.

3.4 Don't Take Your Love to Town [30]

Coraki

I was born on Australia Day, the twenty-sixth of January 1934, at Box Ridge, Coraki, on the far north coast of N[ew] S[outh] W[ales]. It was a reserve or Aboriginal mission. My father was a log-cutter and later he drove trucks carting logs out of the Taloome scrub.

Dad was a tall and proud man, a family man, and he watched after my mother. They were married when I was six months old and my mother was sixteen.

A year later we moved to Stoney Gully mission near Kyogle, where Dad worked as a handyman for the manager. Sister Gwen was born when I was two.

In the afternoons Dad sat four or five of us on Bonnie, the mission horse, and we took her to the creek. One of the older kids sang 'My Bonnie Lies over the Ocean'. In the mornings Dad hitched a slide behind the horse and went under the culvert to the dairy for milk cans and delivered them to the mission houses.

The houses were four-roomed, no lining, open fire for cooking, and the windows were wooden slats that you prop open with a stick. Mum looked after old man Ord, who we called *nyathung* [grandfather]. I sat on the step and watched his grey beard moving as he talked, he was telling me stories in Bundjalung. Sometimes he sang …

As you came through the main gate of the mission there was a church and then, in the shape of a square, a school and about ten houses. This was our place, this was where the [K]ooris lived, about fifty of us. We stayed with some people called Breckenridge. In the middle of the square was a tennis court.

Out the back was Uncle Ernie's hut, which he'd made from a few pieces of galvanised iron and hessian bags, with a single bed in it and his tin trunk with all his belongings. There was a fire-bucket too. To keep warm he sat in front of the fire-bucket and told us stories about bush animals: *binging* [turtle], *jarahny* [frog], *guyahny* [possums], *burbi* [bear], also kangaroos, cranes, emus …

He started to doze and we poked him in his big belly and woke him up. He went on with the story. One night he told me my totem was the willy wagtail. Years later I think about that small bird. I am a very large woman with a bird singing inside me, good news and bad …

Redfern

Hundreds of smoking chimney stacks; rows of houses squeezed together; a neon sign showing a man in a little aeroplane and some musical notes and then the words lighting up, 'I like Aeroplane Jelly'. We ran from one carriage to the next, looking out the windows. We seemed to be travelling miles and miles to get to Sydney, and didn't realise we were already on the outskirts.

Dad and Mum Joyce had a one-bedroom flat at 22 Great Buckingham Street in Redfern. Gwen and I shared a three-quarter bed on the balcony and at the other end was a kitchenette. The main room had a fold-out table, the big bed, double bunks for the boys, and the wardrobe where Dad kept his money.

I went to work as an apprentice machinist at Brachs' clothing factory in Elizabeth Street. It was a long room with a bench running down the middle and about twenty-five women sitting at their machines on either side of the bench, facing each other. The owners were Jewish people and their daughter Topsy Brachs, who was a model, was sent to show me my job …

Friday and Saturday nights in Redfern everyone met at the picture theatre in Lawson Street. Those days, you hardly saw [K]ooris in pubs, because liquor was prohibited. People who did go to pubs had to show a Dog Licence ('Citizen's Rights') and if a white person was caught supplying liquor to blacks he was given six months without the option of a fine. Aboriginals were all right to join the services and fight for the country that we had no say in, but you couldn't breast a bar with your mates for a beer. The Dog Licence was a product of the Aborigines' Protection Board [see 4.1; *41*]. And now I understood why Dad was so against the idea of the Board funding me to go to teachers' college. The main function of the Aborigines' Protection Board was to discriminate against Aborigines.

Palms Milk Bar in Botany Road was a place for all the [K]oori teenagers. There'd be heaps of kids there. He had pinball machines and made the best milkshakes in Sydney, or so we thought. Many a love affair started at the Palms Milk Bar.

Some Sundays in summer the Aboriginal population of Redfern hired buses to go on picnics to the National Park, loaded up with cameras and swimming gear. You could catch the bus in front of the Lawson Picture Theatre.

The All Blacks [Aboriginal football team: see **Rugby League**; *378*] held dances and Presentation Balls in Redfern Town Hall. Gwen was Belle of the Ball once, when she was a telephonist, in a borrowed dress. I still have the photo of the ball. I nicked it from her a long time ago …

I'd heard about the Aboriginal Progressive Association [APA] and I decided to go to the meetings. Charlie Perkins was there, and the Bostocks, Eadie and Lester, also Bertie Groves, Charlie and Peggy Leon, Joyce Mercy, Ray Peckham, Helen Hambly, Allan Woods and Isobel McAllum whose father was Bill Ferguson, a member of the Aborigines Protection Board. We elected Charlie Perkins spokesman—he was still at university—and we met at the Pan Hellenic Club rooms in Elizabeth Street. Charlie organised that because he played soccer for the club. I was elected editor for our newspaper *Churinga* (meaning message stick). Ever since school and the long stories I'd wanted to do some writing, so I was happy.

It was about 1964 when we formed our first Sydney APA. We heard some dancers were coming down from Mornington Island to perform a **corroboree** at the Elizabethan Theatre in Newtown. At the next meeting we decided to apply for concessions. I'd never seen a corroboree or been in a big theatre before. Our seats were upstairs overlooking the stage.

When the lights went out we could see the glow of a fire on centre stage, with bodies huddled around it, and we could hear a didgeridoo [see **didjeridu**] in the background and clapping sticks and then the chanting. In a while the whole stage was aglow with the light from the fire, and the corroboree began.

A narrator talked over a microphone, explaining the action as the dancers performed. After each performance we clapped and clapped. Something inside me understood everything that was going on. I had tears in my eyes and I could feel the others in the group were entranced like me …

Afterwards, we asked permission to visit them backstage. It was strange because they were dressed in khaki overalls and they were so tall, big rangy warriors all over six feet. Only one of them could speak English, a bit pidgin and they were wary as they looked at us, until the one who could speak explained that we were part of them, and then they gave us big toothy grins and we were shaking hands all round. I can remember almost every detail from that night.

I went to a meeting of the APA on National Aborigines' Day in Martin Place. The Governor General and several other dignitaries (black and white) were going to speak. I wore a fur stole over my dress. I put my stilettos on and did my hair up. At Martin Place I met up with the others and found a seat. The Police Band sat behind us. A man on the dais was singing in the lingo and I listened closer. It was Bundjalung language, words and sounds I hadn't heard for a long time. It was an eerie feeling in amongst the skyscrapers.

RUBY LANGFORD

These passages are extracted from Ruby Langford's *Don't Take Your Love to Town*, Penguin Books, Ringwood, Vic., 1988. They are reproduced with permission of the author and Penguin Books Australia Ltd.

Colonial and post-colonial scenes

4. Colonial continuities and discontinuities

4.1 Art and culture in unsettled Australia

The European settlement of Australia had the effect of *un*settling the Indigenous inhabitants, often by displacing them, but also in the sense of turning their worlds upside down. Ever since, they have been coming to terms with the new and continually changing circumstances, while holding on by whatever means to a sense of their own social and cultural integrity. But for settler Australia, too, the problem of the Indigenous presence remains unsettled and unsettling. Even though more than 200 years have passed since the first settlers arrived, one has only to pick up a newspaper or watch a **television** bulletin to realise that the distinction between Australians of settler origin and those descended from the original inhabitants is a continuing preoccupation. And this although the census estimates the Indigenous population at a mere 2.1 per cent of the total.

This difference does not have the total character that it had at the moment of first contact, when 'native' and 'settler' confronted one another as distinct and sovereign peoples. Indigenous Australians—now officially known as Aborigines and Torres Strait Islanders—have many things in common with the predominantly European majority population: they share the same physical space and participate in the same political and economic processes. Many speak the same language, listen to the same music, and eat the same food, and most of the rest do so some of the time. The settler group remains dominant, however, not just numerically but politically and economically, so that Indigenous and non-Indigenous tend to experience and utilise what is shared from differing perspectives. Moreover, Indigenous Australians maintain to a greater or lesser degree practices which they do not share with the majority, and which give them a different perspective on life. Some of these practices are recognised as continuous with the life before settlement, particularly in the case of certain art and musical forms. Others were devised in the course of adapting to the settler presence, such as the various forms of English which Indigenous people speak among themselves [see **Aboriginal English**]. As in this case, Indigenous people have at times appropriated settler practices, making them their own. In a rather different way, the settler society has appropriated elements of Indigenous culture in the process of imagining an Australian nation [see 20.1].

Throughout the history of settled Australia, there has been a tendency to select particular differences as a means of suggesting differences of greater but undefined dimensions. The right and power to define Indigeneity, and to give it effect in everyday life, has for much of Australia's history been the prerogative of settler officials and experts; though this is not to say that Indigenous people have accepted their rulings. Official definitions have been based on a combination of skin colour, descent, and association, with the emphasis shifting to the latter in recent years. Indigenous opinion prefers

4. Continuities and discontinuities

41. Sally Morgan, *Citizenship*, 1987. Silk-screen print, 76.3 x 56.8 cm.

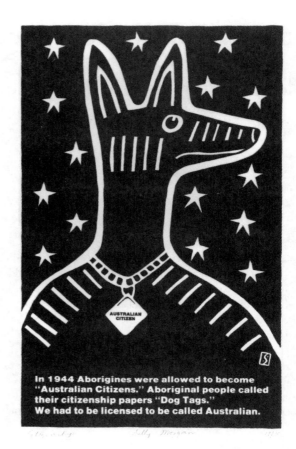

In 1944 Aborigines were allowed to become "Australian Citizens." Aboriginal people called their citizenship papers "Dog Tags." We had to be licensed to be called Australian.

membership of particular families to the abstract notion of descent, with the implication that the family is the site of Indigenous qualities, and that certain of these qualities are continuous with the life before settlement, and are in this sense traditional [see 3.1].

Phases of unsettlement

This much we can say in general terms about Australia since 1788. But the impact of European settlement was not immediate throughout the continent, nor was it uniform. The settlement at Port Jackson was but a beginning in a process, which is still going on, of transforming landscape and people. The densest settlement has always been along the southern, eastern, and south-western seaboards, while a sparser population based around farming, and sheep and cattle raising characterised the interior, and ephemeral settlements formed and dissolved around the extraction of finite resources such as gold. At the end of the nineteenth century there were no Indigenous people who had not felt some effects of the European presence, though some thousands were able to live more or less as their ancestors had done. As the twenty-first century begins, apparently no one lives independently, though the degree of involvement in mainstream Australia still varies.

Indigenous dependence on the settler society has taken different forms. Indigenous populations have had to give settlers access to whatever land and resources they wanted, but this did not always entail displacement, at least not immediately. Torres Strait Islanders [see 7.2, 7.3, 7.4] even now remain in occupation of their island homes, but they have been more or less dependent on the cash economy for more than a century,

and since the 1960s more than half their number have emigrated to the mainland in search of jobs. Most Arnhem Landers [see 6.1, 6.2, 6.5] are able to live on or near their country, and although they too have become dependent on the money economy over the last fifty years, they have not had to emigrate to survive. Other Aboriginal people had their country taken over for sheep and cattle raising, and were allowed to stay only on the condition of providing services to the pastoralists. When they ceased to be useful or became too costly they were driven off, to live wherever they could [see 10.1, 10.2]. Over the years, the number of Indigenous Australians displaced from their own country for one reason or another has increased steadily. A majority now live in towns and cities, though some of these maintain links with rural and even remote communities.

From around the middle of the nineteenth century, Christian missions [see 1.2] and governments began to play a part in the process of dislocation and relocation. In due course special legislation was enacted, ostensibly for the protection of, but in practice for the control of, 'wandering natives'. The principal strategy of these institutions was to concentrate their charges in supervised settlements, segregating them, except insofar as their labour was required for the settler economy.

Not all Indigenous people lived in such settlements, but before the 1960s most had experienced them at some time in their lives, and all but a few were what they called 'under the Act' [41]. This meant that they were subject to various forms of control including harassment from officials and police. Those subject to the Act could rarely appeal against these authorities, and although they became skilled in the arts of evasion, and sometimes dared open defiance, a degree of compliance was unavoidable. Nevertheless, situated on the margins of settler society, they were able to reconstitute Indigenous society along new lines. After several generations, the inmates of the official settlements came to regard these places as home, resisting when the authorities wanted to move them again.

While some members of governments and missions may have been concerned by the destitution to which settlement often reduced the Indigenous population, they were mainly concerned with keeping these supposed remnants of a 'primitive race' out of the way of a developing white Australia. Around the turn of the century, scientists asserted that such races were bound to disappear before the superior European, so that there was no need to plan a future for them. Similarly, although land might be reserved for Indigenous use, this was for the time being. According to the lawyers, the Indigenous population had been too 'primitive' to own the land, which could thus be regarded as terra nullius prior to the arrival of the British. This kind of thinking lay behind the Australian Constitution of 1901, which scarcely acknowledged the Indigenous presence.

In reality, by this time, the Indigenous population was beginning to recover from the catastrophic decline of the previous century, and although even by the 1930s it remained a minute percentage of the total population, governments and missions were becoming aware that the Indigenous population was not going to disappear, and must be accorded some kind of place in the future of the nation. As if to reinforce the point, the Indigenous presence began to impinge on international events. As war loomed in the Pacific, the country's leaders, worried about national security, and particularly the loyalty of the Indigenous communities living along the vulnerable northern coastline, devised a new policy.

The stated goal of what became known as the assimilation policy was eventual Indigenous participation in all aspects of national life, but as individuals rather than as a group. However, only a handful were regarded as 'ready' for this, and the rest were to be subjected to an intensive program of re-education to hasten their 'advancement'. Among the measures employed was the removal of children [see **stolen generations**], particularly those of lighter complexion, from supposedly unsuitable family environments, to

children's homes and in later years to white foster families, from which it was believed they would move more readily into the general community. Needless to say, there was no place for Indigenous culture, even for **language**, in this project. If it were to be preserved it must be in the museum or archive.

The goal of assimilation assumed new urgency as Australia entered the cold war and found its treatment of its Indigenous population attacked in international forums such as the United Nations. At the same time, urban and suburban Australians, who rarely if ever saw an Indigenous person, and were unlikely to know one as a friend or colleague, were nevertheless beginning to concern themselves with Indigenous affairs. Through the 1960s, there was an increasing clamour for all Australians to become equal, culminating in Indigenous–non-Indigenous collaboration in the **Federal Council for the Advancement of Aborigines and Torres Strait Islanders**.

With the 1970s, Indigenous people were becoming visible as never before—not, however, as candidates for assimilation. Joining a predominantly Indigenous mobilisation, which used the rhetoric of Black Power, they demanded not just citizenship, but the right to exist as a distinct group in perpetuity. **Land rights** became the focus of this mobilisation, gradually involving communities from all around the country. The *Aboriginal Land Rights (Northern Territory) Act 1976* (Cwlth) returned substantial tracts of land to their Aboriginal owners, but elsewhere gains were limited. In 1992, the so-called **Mabo** case, brought by four Murray Islanders from the Torres Strait, resulted in the High Court dismissing the doctrine of terra nullius [see **native title**]. After the passing of the *Native Title Act 1993* (Cwlth) hundreds of claims were made, but by 2000 few had been settled.

Sovereignty [see 4.5] was another of the demands of the 1970s, but so meagre were the resources of the Indigenous population that even local bodies required government funding and outside expertise. Nevertheless, non-government organisations delivering educational, legal, housing, and medical aid, as well as support for the arts, were formed through the decade, providing Indigenous people with the opportunity for administrative and political experience. Torres Strait Islanders had had charge of local government since the 1930s; now Aboriginal communities started to take on similar responsibilities. The federal government meanwhile experimented with various kinds of elected advisory bodies, before establishing the **Aboriginal and Torres Strait Islander Commission (ATSIC)** in 1990. This national body is situated at the apex of a local and regional structure, with responsibility for a variety of important services.

Art and the colonial experience

Indigenous practices broadly corresponding to what we call music, dance, poetry, storytelling, and drama, as well as painting, engraving, and sculpture, are embedded in social and cultural life, to which they make their own special contribution. These are the ways people remember the past and think about the future, the ways they identify with others like themselves, in distinction from others defined as not like themselves. This was true among Aboriginal people and Torres Strait Islanders when they were sovereign peoples, and it remains true for them now that they are Indigenous minorities in a settler society. Aboriginal art and culture is not a window into some tribal past. Artists and performers live within the same social and cultural milieu as other Indigenous people; thus to tell their story is to tell other people's stories as well.

I begin with the Aboriginal watercolourist, Albert **Namatjira** [see 1.2, 9.1; *36, 42, 111, 115*]. His career is of particular interest in that it straddled significant historical changes; he was affected by them, and to a considerable degree he effected them, if only because he was the first Aboriginal person to become a national celebrity. His story opens up a much broader set of questions, some of which still have meaning today.

Today Australia recognises a number of Indigenous celebrities, including artists whose names are nationally and even internationally known. At the beginning of the century one of the few names to be nationally known was that of Jimmy Governor, the outlaw. There were numerous Aborigines and Torres Strait Islanders creating and performing for their own communities and perhaps also for whites living in their localities, but metropolitan Australia, looking to Europe for its art and culture, regarded the idea of an Indigenous 'artist' as a contradiction in terms. In the idiom of the period, 'savages' were capable only of repeating what had been formed in the dim and distant past.

Such notions were not publicly challenged until Namatjira's exhibition in southern cities in 1944. In the discourse of the time, here was a 'full blood' Aborigine, only a generation removed from the 'stone age' who could paint 'like a white man'! The story can be quickly retold. Albert Namatjira, an Arrernte, born on Hermannsburg Lutheran mission in central Australia in 1902, discovers an aptitude for landscape painting through an association with the Australian artist, Rex Battarbee, in 1934. Supported by the mission and by Battarbee, he first exhibits in southern capitals shortly before the war, but his career takes off with his third metropolitan exhibition in 1944, and he comes to the attention of the national government. Official sponsorship reaches a climax in 1954 when he is presented to Queen Elizabeth in Canberra, wearing a white suit. He has further exhibitions in the southern cities, and having earlier been deterred by mission advisers from attending the openings, he now goes, meeting other Australian artists and patrons. The success story begins to turn sour when the press discovers that, though liable for tax on his by now considerable earnings, Northern Territory law does not permit Namatjira, as an Aborigine, to lease grazing land, or to buy land in Alice Springs. Following an outcry, he is removed from the register of government wards, to which all 'full bloods' have until now been consigned at birth, and declared an Australian citizen. This also entitles him to drink alcohol, which is normally forbidden to Aborigines. Subsequently, he is reported as being harried by the demands of relatives who are not citizens, and in 1958 he is imprisoned for supplying alcohol to one who is subsequently involved in a killing. The sentence is reduced after further public outcry, and he returns to the mission in 1959. The same year he dies, amid public outpourings of grief and an unsettling suspicion that white Australia is not without responsibility in the matter.

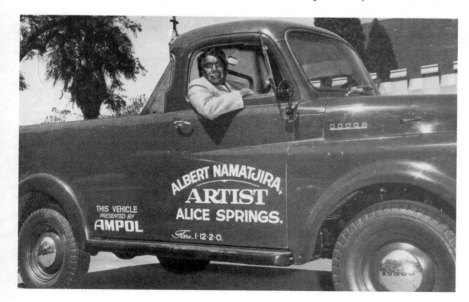

42. Albert Namatjira in the truck presented to him by Ampol, 1956.

Namatjira was born just after Australia became a Federation, but Aborigines like him scarcely figured in its plans. However, by the time of his first exhibition in the late 1930s, official attitudes to Indigenous Australia were changing. The federal government was working on the assimilation policy, and cultural nationalists, such as Xavier Herbert, were talking of a place for Indigenous people in Australia's future.

Following World War II, the assimilation project assumed international as well as domestic importance. The authorities needed Indigenous people who excelled in some area of approved endeavour to show the world that they were sincere about their advancement. They assembled a band of Indigenous achievers, including artists such as concert singer Harold **Blair**, and Rosalie Kunoth-Monks and Robert Tudawali, stars of the 1955 Australian film, *Jedda* [43]. Up to the time of his death, however, Albert Namatjira remained the best known and the most popular Aboriginal person in Australia. This striking figure, whose seeming silence could be coded as 'dignity', was ideal for the government propaganda machine, and for the growing body of Australians who felt sympathy for their Indigenous countrymen.

But as Namatjira's celebrity grew, the cracks in the official story began to show. Could a man whose earnings were matching those of some white Australians be denied the right to live in town and own property? Could the artist be denied a glass of wine at his own art show, when everyone around him was drinking? Should an Indigenous citizen be expected to sever connection with kin? And if he did, were white Australians ready to receive him?

43. Publicity poster for *Jedda* by Charles Chauvel, 1955.

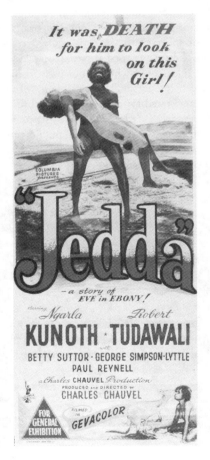

Namatjira's disgrace and death sparked off a debate between those who blamed discriminatory laws and those who blamed official assimilationism for trying to achieve in one lifetime what would take many generations to achieve —this had also been the message of *Jedda*. The former view prevailed, if only because it was more in keeping with the international and domestic currents of the time. There followed a dismantling of discriminatory legal restraints, and the piecemeal conferring of the various rights of citizenship; soon, all Indigenous people were also free to drink alcohol, own property, and live in town.

Artists and patrons

Who is an artist working for? One can answer this question in material terms—who provides the resources for the production—or in social terms—whom does he or she have to, or want to, please? On the first count, Namatjira was dependent on his patrons—Battarbee, the mission, and later the dealers—without whom he could not have afforded the materials. At least in the first instance he was painting to please these same patrons; his watercolours were a new departure for the Arrernte.

The story is different in the case of the Arnhem Land **bark paintings**, which became popular in the southern cities not long after Namatjira's death, and for a while eclipsed his work, and the **acrylic paintings** from **Papunya Tula** [see 9.4, 9.5] which achieved an international market in the 1980s. Mission and government agencies, in collaboration with dealers, provided the wherewithal, but the value of the paintings lay in their representation of myths using traditional iconography. The artists drew on the skills and knowledge of their seniors, and had to respect clan ownership of particular designs and stories, as well as rules of secrecy. Dealers and sponsors were in a position to enforce what they regarded as quality control, but to intervene too heavily would be to jeopardise the 'authenticity' which gave the work its legitimacy for the 'primitive art' market.

Before World War II there was no such market in Australia. Here and there around the country, individuals decorated **boomerangs** [*232, 228, 276, 364, 377*] or incised **emu eggs** [*141, 318*], to sell as souvenirs to tourists. Once in a while, museum or private collectors would visit the more remote areas, in search of primitive 'artefacts', but this did not amount to regular traffic.

Under favourable circumstances, this lack of interest left Indigenous people free to carry on as they had previously done, making ground paintings for ceremonies, which they destroyed immediately afterwards, or performing dances for their own sacred or secular purpose. Settlers of a scientific inclination, such as the explorer and ethnologist A. W. Howitt, might even sponsor such events, hoping to catch a glimpse of the 'primitive' before it vanished forever [see 1.2].

Settlers, for the most part, were not interested in preserving Indigenous cultures, but neither were they particularly interested in erasing them. On the other hand, the missionaries and officials who ran the settlements had a reforming brief, which in greater or lesser degree involved eradication of the old ways. Missionaries and officials varied in the extent to which they would tolerate Indigenous practices, and their regimes generally became more liberal from the 1960s, but it was by no means unusual for **languages** to be suppressed, not to mention dances and ceremonies.

Suppression did not turn the Indigenous population into imitation settlers, but rather directed their energies in directions which did not offend the authorities. Thus, Torres Strait music and dance [see 7.3, 15.3], which had been integral to religious life, were suppressed by missionaries towards the end of the nineteenth century. But having adopted other styles from the South Seas that the missionaries found acceptable, Islanders were

able to reconstitute a distinctive Torres Strait culture, which has carried them through to the present as well as providing an alternative form of cultural expression for their Aboriginal neighbours on Cape York (Qld).

The Islanders have been more fortunate than some in that they have been able to retain a considerable degree of control of their community affairs. Singing and dancing may be deployed to entertain visiting dignitaries, or—rarely—in performing for tourists. Yet what sustains them in the cultural repertoire is their central place in a festive complex, particularly the Tombstone Opening [see 1.6], which now brings together Islanders from all over the continent. White people watching such performances have little sense of what is good or bad, in terms of the Islander canon; Islanders remain the composers and choreographers, and being intensely competitive where such things are concerned, they remain the arbiters of excellence.

Elsewhere, in more closely settled areas of mainland Australia, Aboriginal people have had to make a more radical adaptation to an environment that has been culturally and at times physically hostile. Settlement or camp communities might be made up of different language and cultural groups, but if nothing else they shared an ethos of opposition to the authorities that generated a clandestine lore of subversive stories and sayings. The artistic forms, principally musical, that they adopted were much the same as those their white neighbours performed—fiddle and accordion music and, later, **country and western music**. These might be performed for the entertainment of whites, but the site of their creation was distinctively Aboriginal: the clay-pan dance, the bush camp, or the illicit drinking party. Dougie Young [*44*] parodied the jukebox hits of the 1950s and 1960s, composing songs about his friends in the small bush town where he lived, and exposing the hypocrisy of the local whites. Later he recorded some of his songs, but before this the bush telegraph had carried them to Aboriginal communities throughout the region.

44. Dougie Young, c. 1989.

In the less repressive and more affluent climate of the period since the mid 1970s, Aboriginal performers have had to be less circumspect about their choice of music and the sentiments expressed; indeed these have played an important role in political mobilisation. Rock music [see 15.2; **Yothu Yindi**] is now the preferred form among young Aborigines, even in central and northern Australia, and is marked as Aboriginal by the clothing and appearance of the performers [*192, 193, 408*], the lyrics of the songs, and the use of **didjeridu** and clap sticks. Those who have toured nationally and internationally have needed non-Indigenous financial backing, like any other band, but the Indigenous accoutrements are part of the appeal.

By comparison, 'traditional' Aboriginal music and dance [see 6.5, 7.3, 15.1, 16.3] are mainly performed in the remote communities of northern and central Australia. Where the setting is ceremonial, the owners are now able to exclude non-Indigenous people on the grounds of secrecy, and increasingly take this option. For non-Indigenous audiences, there is the folkloric setting of the state-funded dance theatres, offering a selection of material intended to be representative of Indigenous Australia as a whole [see 16.5, 16.6; **corroborees**].

There are now professional Indigenous performers [see 16.1], just as there are professional Indigenous painters and film-makers [13.1], but their careers usually require some kind of sponsorship and management. Even if this is in the hands of Indigenous people, it has in some degree to be responsive to the dictates of the market. Here we have an illustration of the paradox of Indigenous Australia in the late twentieth century: the value of this artistic production, both for the nation and for the consumers, lies in its Indigeneity, and there is a further value placed on the Indigenous producers having the freedom to express themselves; yet the conditions under which these activities occur limit what is done and how it is done.

Redefining the Indigenous

Until the 1960s, it was the settlers who decreed who was Indigenous and what this meant for their colonising project; Indigenous people may have thought otherwise, but their voices were seldom heard outside their own communities. As we have seen, until the 1930s, most settlers believed that 'natives' were constitutionally incapable of participating in the affairs of the nation. By the end of World War II, the official, and to a considerable degree the popular, position had changed, to the extent that Indigenous people were to be included, if not their **cultural heritage**. Thus, while Namatjira was hailed for 'painting like a white man', it was still important that he was an Aboriginal person and, since most Australians thought of Aboriginality in terms of descent, that he was what was popularly and officially termed a 'full blood' (as distinct from 'mixed blood' or 'half caste', whose authenticity they were uncertain of). This same desire for the 'authentic' Aborigine expressed itself in a vogue for images, whether of Namatjira himself, or other—often anonymous—'dignified' elders, or frolicking 'piccaninnies'. These, along with wildlife, were becoming the staple of Australiana, a category of artefact made possible by the innovations in cheap, colour reproduction, and a growing tourist industry [see 18.1]. The government also found it appropriate to put the image of a senior Anmatyerre man, One Pound Jimmy Tjungurrayi, on a postage stamp [45].

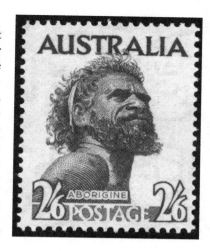

45. *One Pound Jimmy* stamp, Australia, issued August 14, 1950.
Charles H. Holmes' photograph of One Pound Jimmy Tjungurrayi, father of Clifford Possum Tjapaltjarri, first appeared on the cover of *Walkabout*, September 1950.

Yet, within a little more than a decade after Namatjira's death, art connoisseurs were dismissing his work as a travesty of **Aboriginality**, his physical appearance notwithstanding. For the official patron and the collector, this quality was now to be found in Arnhem Land art, painted on bark in 'natural' pigments, and grounded in 'traditional' mythology. By the 1980s, however, connoisseurs of Aboriginal art were hailing the Papunya Tula artists, even though their 'traditional' iconography was painted in acrylics on large sheets of Masonite and canvas. These might not be as 'traditional' as the bark paintings, but the painters were known to belong to groups such as the Pintupi, who had been among the last to leave the desert. The realisation that these paintings, with their iconography of country, were virtual title deeds, which might be used in land claims, enhanced the aura of authenticity.

In yet another irony, the acceptance of desert acrylics as 'authentic' resulted in a rehabilitation of Namatjira's work which, after all, had depicted Aboriginal places, even though he did not use the traditional iconography. The notion of what constituted Indigeneity was becoming increasingly pluralistic, among Indigenous and non-Indigenous alike. The essential criterion was that the creator or performer be of Indigenous descent—though mixed descent was no longer a disqualification—but the definition had broadened from genetic inheritance—all-important in Namatjira's day—to include the by now diverse experience of being Indigenous in settled Australia.

An Indigenous, urban, graphic art also emerged in the early 1980s, with the work of artists such as Trevor **Nickolls** [315], Bronwyn **Bancroft** [287] and Fiona **Foley** [see 23.3; 2, 63, 164] This also received official recognition and patronage. It drew on the experience of Aboriginal people who had lived around country towns, and on government settlements, and who since the 1960s had come in large numbers to live in rundown neighbourhoods in the cities [see 3.4, 12.1]. Some of the artists had trained in art schools which encouraged them to work with Indigenous themes and forms. However, the movement also drew on the developing cultural and political awareness of people whose link with the knowledge of their ancestors had been ruptured, but who were now discovering the possibility of learning from the 'traditional' artists of central and northern Australia. The dance troupes, which brought together performers from all over the continent, attempted a similar recuperation [see 16.5, 16.6].

Certain difficulties attend the development of a pan-Indigenous art. Designs, dances, and songs often belong to particular clans and communities, and cannot simply be appropriated, even by people from the same local community [see **rights in art**]. Use requires an elaborate etiquette of acknowledgment, and even then it is not always permissible. Some prefer to work in an explicitly non-traditional style, marking their work as Indigenous by including icons which are not specific to a particular group, such as the rainbow serpent. As these designs become signs of Indigeneity, there is increasing resistance to their use by non-Indigenous artists.

As compared with Namatjira's time, when white experts explained Indigenous art while the artists went unheard, artists of today have the space to explain themselves; indeed their voice is integral to the Indigeneity of their work. As well as talking to the non-Indigenous world, they have also to explain themselves to one another. The at times acrimonious debates among the burgeoning Indigenous intelligentsia explore the new dimensions of being Indigenous at the end of the twentieth century and beyond.

Art and politics

At the beginning of the twentieth century, settled Australia saw no future for its Indigenous people, but it did have a use for them in representing the past, for example in historical pageants celebrating its civilising achievements. Thus, when a community wanted to mark some anniversary, it summoned Aborigines to erect a gunyah or perform a corroboree, to represent the ways things used to be. In 1938 the government of New South Wales, to celebrate the 150th anniversary of the landing of the First Fleet, staged a re-enactment, in which Aboriginal 'warriors' would briefly challenge the white men, before fleeing before superior force. Australian film-makers had usually been content with white actors wearing black paint for such performances, but the government, intent on realism, arranged to bring down a party of 'full bloods' from the far west of the state. However, the Aborigines Progressive Association (APA)—one of the early civil rights organisations—was active in Sydney, and the authorities felt it advisable to isolate the performers prior to the performance, for fear that the radicals would 'get at' them and spoil the show. The APA countered by mounting a **Day of Mourning** [*186, 312*], which received some attention in the local press. Fifty years later, in the year of the Australian Bicentennial, there was no possibility of staging such a pantomime, and there was official apprehension that Aboriginal activists would spoil the celebration. Instead, there was an Indigenous 'anti-celebration', and this time it was the activists who brought down 'full blood' Aborigines from the Northern Territory [see **Survival Day**; *387*]. Mourning for the victims of colonisation was once again a theme, with Tiwi Pukumani poles planted at La Perouse, but it was not the only one. In the words of Yirrkala elder and political leader Galarrwuy **Yunupingu**:

We said we would come here to show our solidarity with Aboriginal people from all over Australia, to show our culture has survived, to mourn the people, the languages and the cultures which have died since the invasion began. At Kurnell, the spirits of the old people who belonged there are troubled, so we must put them to rest, let them know there are still people around who know how to care for country. So we will dance and sing the songs of the Dreamings and bring together all our people.

This event provided colourful footage for the international **media**, and an ironic comment on the travelling exhibitions of Aboriginal art and culture which Australia officially sponsored overseas during the bicentennial year. The 'anti-celebration' was an example of the politics of embarrassment, a characteristic tactic of Fourth World people, who, lacking the numbers and conventional resources to influence the political process,

perform their protest [46]. Deploying the signs of indigeneity, they assert their presence and call into question the self-image of the nation. In this kind of politics, official recognition of prominent Aborigines empowers them. Thus, in 1993, when, despite the High Court's decision on the **Mabo** case, the Commonwealth government seemed to be failing to bring in land rights legislation, Michael Jagamara **Nelson** symbolically defaced the mosaic which he had designed for Parliament House in Canberra [see 22.3; *264*]. Namatjira had done the same kind of thing almost unintentionally, simply by showing that even an officially sponsored Aboriginal achiever could suffer discrimination. Thirty years on, there was an Aboriginal movement which had learned how to catch the public eye, and **television** was that eye.

In the mid 1960s, Australian television viewers were been stirred by the dramatic footage from the African-American struggle against segregation in the American South, and the anti-apartheid movement in South Africa. The **Freedom Ride** which Charles Perkins took through rural New South Wales showed that Australia too had apartheid, and its own 'Deep North', providing dramatic television footage for domestic audiences.

The **Tent Embassy** [*49, 206*], erected on the lawn of Old Parliament House in 1972, similarly performed the idea of an Aboriginal nation, flying the new black, red, and yellow flag [see **flags**], while the tent was a discomfiting reminder of the kind of housing in which many Aboriginal people lived [see 19.1, 19.3]. The government's clumsy attempts to disperse the assembly provided further material for cameramen already seasoned in the filming of demonstrations against the war in Vietnam. These events, taking place on the government's doorstep, and where the ambassadors of countries such as Indonesia could not but see it, embarrassed the government sufficiently for it to reach a face-saving compromise. Not, however, before the leaders of the Opposition, who would soon take power, could be filmed talking to the demonstrators.

'Protest', as it was known around the late 1960s and early 1970s, became very much part of the urban Aboriginal scene of the period, and its was integral to groups such as the National Black Theatre of Redfern, particularly with shows such as *Basically Black* (1971). It became rather less important as Indigenous political institutions, such as ATSIC, took over the political process, and certain spokespersons could command press and television attention. The form was revived in **Mudrooroo**'s 1993 play, absurdly titled *The Aboriginal Protesters Confront the Declaration of the Australian Republic on 26 January 2001 with the Production of 'The Commission' by Heiner Müller*, in which a team of Aboriginal actors are commissioned to perform a German play about a slave revolt in the Caribbean. After performing a few scenes from Müller's play, they, in Brechtian manner, step out of this frame and start talking about their situation, decide to abandon the project, and end by chanting a variant of a familiar slogan:

What have we got?
SOVEREIGNTY.
When did we get it?
NOW, NOW, NOW.

The Governor and Premier of New South Wales were among the mainly non-Indigenous people attending the performance.

The political economy of Indigenous art

The gesture of the 'Aboriginal Protesters' can be understood as a refusal to stay within the positions defined for them, even by their friends—in the case of Mudrooroo's play, to identify with a long past uprising in a distant place—rather than enacting their own situation in the here and now. They are thus exercising sovereignty [see 4.5], within this tiny space. More generally, it might be understood as a protest against the tendency of

settler Australia to aestheticise the Indigenous presence, defining it in terms of creative and spiritual artists—who also contribute to the country's export earnings—while obscuring the grim statistics on health, income, and incarceration.

Indigenous artists and performers are situated in a field of complex and shifting forces. Like non-Indigenous artists, they are subject to the demands of patrons and the public, but, unlike them, they are representing some kind of Indigenous constituency. Just how that relationship works out varies a good deal. Torres Strait dancers, for example, are still primarily answerable to the Islander constituency, unless they are performing for one of the dance companies. Namatjira, by contrast, seems not to have considered his community in his choice of subject or his way of executing it, although he was responsive to the claims of his kinsmen on his earnings. The bark and acrylic painters have to reconcile the demands of relatives with those of patrons and the public in their deployment of traditional icons. 'Urban' artists tend to be answerable to the growing Indigenous intelligentsia around the continent who may themselves have conflicting opinions on what Indigenous artists should be doing.

In this respect, Indigenous artists and performers are like other Indigenous people in Australia, caught between the demands of a non-Indigenous majority which controls the money and the strategic institutions, and an Indigenous constituency which commands little in the way of resources, but can at moments exert pressure through unconventional means. The sovereignty which the activists of the 1970s demanded exists only in tantalising moments, not unlike that in which 'the Aboriginal Protesters' decided to do their own Indigenous thing.

JEREMY BECKETT

Amadio, N. (ed.), *Albert Namatjira: The Life and Work of an Australian Painter*, South Melbourne, 1986; Beckett, J., *Torres Strait Islanders: Custom and Colonialism*, Cambridge, 1987; Beckett, J., 'Aboriginality, citizenship and nation state', in J. Beckett (ed.), *Social Analysis*, special issue no. 24, *Aborigines and the State*, 1988; Beckett, J., '"I don't care who knows": The songs of Dougie Young', *Australian Aboriginal Studies*, no. 32, 1993; Beckett, J. (ed.), *Past and Present: The Construction of Aboriginality*, Canberra, 1988; Fischer, G. (ed.), with Behrendt, P. & Syron, B., *The Mudrooroo/Müller Project: A Theatrical Casebook*, Kensington, NSW, 1993; Stanner, W. E. H., *White Man Got No Dreaming: Essays 1938–1973*, Canberra, 1979; Yunupingu, G. & Bandirriya, L., 'Words from Kurnell', *Land Rights News*, vol. 2, no. 7, March 1988.

4.2 Captain Cook: Between Black and White

For a long time Aboriginal **history** in Australia was an impossibility. Aborigines were allowed to have myths, for myth is one of the markers of the primitive, but they had no history. True knowledge of the past was knowledge of White Australia reserved for white Australians. Now this is changing. There has been a huge expansion in the range of texts produced by Aboriginal people: histories [see **life stories**], Aboriginal language publishing ventures, **fiction**, critical writing, **radio, television**, video, drama [see 16.1], and a great deal more. One effect of this cultural production by and about Aborigines is that a number of Aboriginal narratives of Captain Cook [see 4.3; *46, 47, 172*] have appeared in writing, painting, **film** [see 13.1], and oral testimony.

Captain Cook is a name common to Aboriginal and non-Aboriginal histories. He has been celebrated by white Australians as foundational. Australia becomes historical only when Cook inscribes the continent within the known world of Europe. His name provides an answer to the question: 'Where have "we" come from?'—Australia makes an appearance within Western culture when it is discovered. Though Cook did not bring Aboriginal people into history, his name has also been used by Aboriginal people as a

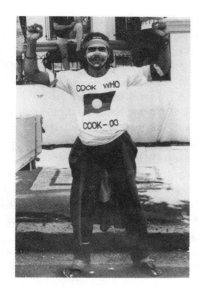

46. Brenda L. Croft, *Michael Watson in Redfern on the Long March of Freedom, Justice and Hope, Invasion Day, 26 January, 1988*, Sydney, 1988. Gelatin silver photograph, 50.4 x 40.5 cm.

means of accounting for certain kinds of change and as a metaphor for ethical dilemmas. In these ways Cook can be considered as a term which creates a possibility of dialogue between Aboriginal and non-Aboriginal ways of making histories.

Indigenous histories of Captain Cook have been publicly circulated as oral history, myth, and legend and have come from south-eastern Australia, and the north and far west of the continent. Roland Robinson relays Percy Mumbulla's story of Captain Cook on the south coast of New South Wales:

There was a terrible tall woman who lived at Ulladulla. Tungeei, that was her native name. She had six husbands, an' buried the lot. She was over a hundred, easy, when she died. She was tellin' my father, they were sittin' on the point that was all wild scrub.

The big ship came an' anchored out at Snapper Island. He put down a boat an' rowed up the river into Bateman's Bay. He landed on the shore of the river—the other side from where the church is now. When he landed, he gave the Kurris [Koories] clothes, an' them big sea-biscuits. Terrible hard biscuits they was.

When they was pullin' away to go back to the ship, them wild Kurris were runnin' out of the scrub. They'd stripped right off again. They was throwin' the clothes an' biscuits back at Captain Cook as his men was pullin' away in the boat.

Percy Mumbulla's very concise rendering of 'Captain Cook' includes a number of structural characteristics used in many Aboriginal histories of Cook. One problem for those immersed in European histories is that Mumbulla's history of Cook does not rely on the evidential systems which written European history has used since it began borrowing citation methods from jurists and priests in the sixteenth century. These other histories are born as tradition, not built up from Western source materials; Percy Mumbulla himself is source, document, and validation. The proof of the story, its regime of truth, is very precisely in its telling, its performance, and its lineage.

Mumbulla organises the telling of his history around place rather than time. As with many other Aboriginal histories, the conventions of space are what codify, position, and orient the entire dialogue. It is spoken and heard in and through a very precise place: 'She was tellin' my father, they were sittin' on the point that was all wild scrub.' This association is not a matter of memory triggers or techniques. Rather the authority of the history

is established because place and its meaning are continuous. In the terms of a non-Aboriginal sense of history, it is not really clear whether the 'historic' event of Cook's arrival was observed from the point or whether the history was told from the point. This generates a whole series of ostensibly unsettling questions for settler Australians: Who was sitting in the wild scrub? When was the scrub wild? When was the boat seen? Who saw the boat and from where? Perhaps an interrogation of Mumbulla along these lines might have resolved these positivist questions, but more important is the way that different systems of history 'solve' the distinctions between event and telling.

Many Aboriginal histories of Cook, including those of non-coastal people, introduce Cook as he arrives from the sea. Cook must come from the sea because he is always and everywhere a disruption to order and life. He cannot come from the land because land is the source of all order. In some Aboriginal histories the beach is a place of exchange: of useful goods, axes, and cloth, or of food which is memorable for its strangeness, or of information. But the exchanges are an ominous sign because, whatever their material substance, they are initiated by Cook. Yet Cook is always outside of culture: he cannot make a valid exchange, only one riddled with confusion or transgression. In European history the act of distributing trinkets on the beach is the classical index of an explorer's good intentions and kindness, but the response to such gift giving was often unexpected, as Captain Cook recorded in his journals. Mumbulla's history of Cook makes it absolutely clear that exchange was impossible in the absence of a shared framework. The exchange is explicitly rejected because the goods themselves are without value; the sea biscuits are 'terrible hard', a promise without nourishment. The goods are also rejected by 'wild Kurris' who refuse the garb of civility and consign the invaders to the sea. Cook, a figure from beyond culture, is rejected by Kooris who have the law because they come from the land.

There are other Aboriginal histories of Cook which might appear to a European historical sensibility as a real and recognisable history; with a little change of the language they present a very solid account of 'the other side of the frontier'—to use Henry Reynolds' phrase. In this sense, the narrative of Hobbles Danayari—a Yarralin man from the Victoria River district (NT)—could be understood as a grand history of 'race relations' in post-1770 Australia.

Hobbles Danayari's story of Captain Cook has been recorded by Deborah Bird Rose [see **Aboriginal English structure**]:

Right. Well, I'm speaking today, I'm named Hobbles Danayari and I got a bit of troubling.

Long way back beginning, I think, right back beginning. I don't know but this the biggest troubling.

Ah when that Captain Cook bin (past tense) come from big England and come through down to Sydney Harbour.

And lot of Aboriginal people, I don't know, but people bin down to Sydney Harbour, Aboriginal people.

And when that Captain Cook bin come through down to Sydney Harbour, well he's the one bin hit the Sydney Harbour.

Should have ask-em him one of these boss for Sydney, Aboriginal people.

People bin up there, Aboriginal people, he should have come up and 'hello', you know, 'hello'.

Now asking him for his place to come through, because Aboriginal land.

Because Captain Cook didn't give him fair go, to tell him to 'good day' or 'hello', you know give-em a people fair go.

We all men.

Because Captain Cook got his land, big England, and Aboriginal people got the Northern Territory.

Now Captain Cook didn't give-em fair go people all over Australia today ...

Hobbles Danayari's story explains a historical process that began with Europeans colonising pockets of the east coast and making their way around the continent. Eventually Europeans came to the Victoria River district during the 1880s and killed as many Aboriginal people as was necessary to establish a base for pastoral operations. Europeans continued to kill Aborigines when they presented a threat. At the same time young men and women were captured and put to work on the stations. The confinement lasted until armed resistance was defeated, dependency was secured, and Aborigines were integrated into the cattle industry. Despite these regimes, secular and sacred knowledge was not extinguished but was continually refurbished during the wet seasons when work came to a halt. The saga concludes with a statement of the results of this history; it also affirms the continuity and vitality of Yarralin culture.

Paddy Fordham **Wainburranga** [see 4.3; *47*] of the Rembarrnga people in central Arnhem Land has also circulated histories of Captain Cook. Each of these Aboriginal narratives is a product of colonial exchange and confrontation. Because I can appropriate them here by quoting from books, transcribed tape recordings, and films these histories are necessarily part-product of colonialist discourse: melded articulations of knowledge in a world of power. They are both products of Aboriginal historiographical traditions and available because of non-Aboriginal historical visions. Aboriginal people make expert use of positivist histories; from judicial proceedings, to land claims [see **land rights**], to 'stolen children' [see **stolen generations**] reclaiming their genealogy through the scriptural record of state institutions. Nothing in my discussion of Aboriginal histories of Cook should be taken as implying that Aboriginal people lack capacities in this sphere. What I have suggested i that Aboriginal histories of Captain Cook document a different form of social memory.

These accounts provide a powerful sense of the limits of non-Aboriginal social memory, a sense that the historical imagination of European modernity which we all inherit (although in distinctive ways) is not the only valid way of understanding the past. Aboriginal narratives are a contribution to historical understanding because they explore the fissures and absences in the European systems of history. They do not rely on the convention that history should imitate 'the historical process', but perform histories in ways which foreground social memory as appropriations of the past in the present. Aboriginal histories of Cook interpret the past as forms of analogies and structural correspondences with the hopes and tribulations of the present. These histories refuse to make categorical distinctions between the past and the present, explicitly speaking the affective and symbolic dimensions of history, and acknowledging the audience of the present. In these histories we hear a whole range of alternative forms and plots which handle time space differently, experiment with identity differently, juggle continuity and discontinuity differently, and take as their structures not progress or heroism but morality, protocols, culture, land, and law. These histories remember Captain Cook as posing a continuing problem for Black and White Australia, how to both acknowledge and rewrite the plot of ongoing colonisation. CHRIS HEALY

Haddon, A. C. (ed.), *Reports of the Cambridge Anthropological Expedition to Torres Straits*, vol. 5, Cambridge, 1904; Healy, C., *From the Ruins of Colonialism: History as Social Memory*, Cambridge, 1997; Robinson, R. E., *The Shift of Sands: An Autobiography, 1952–62*, South Melbourne, 1976; Rose, D. B., 'Remembrance', *Aboriginal History*, vol. 13, no. 2, 1989.

4.3 Too Many Captain Cooks [*47*]

The subject of a major painting and a film, the Rembarrnga–Ngalkbon account of Captain Cook by Paddy Fordham Wainburranga is one of a number of Aboriginal histories of the invasion of the white man that stand in stark relief to European accounts of Cook as the progenitor of discovery and settlement. In the film *Too Many Captain Cooks*, Wainburranga, in his typical style, recounts a narrative that contrasts the story of the 'old' Captain Cook 'from a million years ago' with that of the 'new Captain Cooks' who came after. The old Captain Cook 'was never a bad man' and, indeed, held ceremonies from central Arnhem Land to Groote Eylandt and upheld 'the good Law'. According to Wainburranga, ceremonies continue to be held to this day throughout Arnhem Land for the old Captain Cook.

His account has Captain Cook coming from 'Mosquito Island', east of Papua New Guinea, and arriving in Sydney where his 'business' was to build a boat. 'He made Sydney Harbour. He never made the [Sydney Harbour] bridge. He made a blackfella bridge from planks first time. Later they made the [Sydney Harbour] bridge.' On the other side of the harbour, at Wanambal, lived Satan—or Ngayang. In an attempt to steal Captain Cook's two wives, Ngayang attacks Cook; the ensuing heroic struggle is finally won by Cook when he kills Satan and throws him into a hole in the ground now represented by the Cahill Expressway tunnel. On Cook's return to Mosquito Island, he was attacked by his 'relations … his own tribe'. He returned to Sydney where he died from his wounds and was buried on an island in the harbour, said to be Garden Island, just across the water from the Captain Cook Graving Dock.

Then, Wainburranga tells us, 'people started thinking they could make Captain Cook another way', which led to the killing times:

Too many Captain Cooks … have been stealing all the women and killing people. They have made war. War makers, those new Captain Cooks [after World War II] … And then they made a new thing called 'welfare'. All the Captain Cook mob came and called themselves 'welfare mob'. They were new people now. They wanted to take all of Australia. They wanted it, they wanted the whole lot of this country … They could shoot people. New Captain Cook mob!

The old Captain Cook was a good man who didn't 'interfere', and was responsible for the introduction of things of use to Aboriginal people such as steel, material, and clothing. The new Captain Cooks represent all the bad things that came with the white man: killings, theft of country, and of women. Even in the guise of the 'welfare mob', they wanted to 'take over the whole country'. It was only after the introduction of **land rights** legislation—'now we've got our culture back'—that some sort of balance has been achieved against the new Captain Cooks.

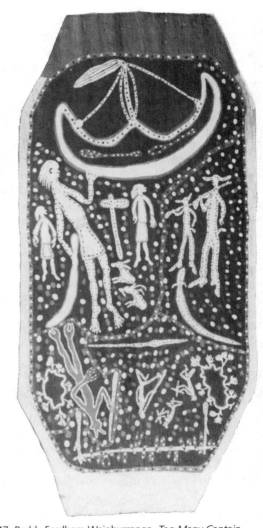

47. Paddy Fordham Wainburranga, *Too Many Captain Cooks*, 1987.
Natural pigments on bark; 151 x 71 cm.
In the painting Wainburranga depicts Captain Cook (the large white figure on the left), Satan (the dark figure, lower left), and 'Too Many Captain Cooks' (the two white figures on the right wearing cowboy boots and hats, with guns over their shoulders).

PADDY FORDHAM WAINBURRANGA, WITH COMMENTARY BY CHIPS MACKINOLTY

Mackinolty, C., & Wainburranga, P., 'Too many Captain Cooks', in T. Swain & D. B. Rose (eds), *Aboriginal Australians and Christian Missions*, Bedford Park, SA, 1988; McDonald, P., *Too Many Captain Cooks* [video recording], 1988.

4.4 *Physiological Adaptation to Cold* and other true horror stories

Medical Series is a body of work completed in 1994 which investigates how racial difference was represented during the 1950s and 1960s within supposed scientific studies that were either carried out in or readily available for reference in Australia. I decided to make work which questioned the notions upon which particular documents were based; primarily the idea that physical intrusion and experimentation can determine a person's identity.

I was startled to encounter many shelves of pseudo-scientific books which fixate on race in the BLISS catalogue section of the university library in Hobart. This cataloguing system has allowed for the survival of these questionable texts in a separate floor of outdated and now 'difficult' publications. These publications provide evidence about the forms of social, scientific, and government policies that affected earlier generations, and about the many outdated 'procedures' that were undertaken in the guise of science. These apparently impersonal studies reveal to the viewer (several decades later) the racist underpinnings of such research.

I constructed ten medical 'case studies'. They were entitled: *Intelligence Testing—the Porteous Maze Test, Physiological Adaptation to Cold, Skull Dimensions, Fingerprint Patterning, Earwax Consistency, Body Odour, Tooth Avulsion, Eyeball Weights, Brain Weights,* and *Hair Differentiation.* I decided to create one sculptural piece for each of the chart-based racial 'tests' located in separate publications. By incorporating portions of the texts in the sculptures I sought to bring them out of their shelved obscurity. The use of familiar and inviting materials encourages a closer investigation of the work, whereupon the viewer becomes aware of the humour and horror of the relationship created by the unexpected juxtaposition of objects and text. A destabilising flux has been achieved.

The piece *Physiological Adaptation to Cold*, 1994 [*48*] is a 'medical case' comprising a souvenir male Aboriginal doll in a miniature polystyrene esky, both placed in a folded tin case. Text printed on the acrylic frontispiece of the open case quotes from publications which describe in detail physical 'testing' imposed on Aboriginal people in the late 1950s in the Central Desert. According to the documentation, a research team 'placed' Aboriginal people in 'refrigerated meat-vans' overnight, to ascertain how their physical reactions to cold exposure compared with those of the researchers themselves.

All ten 'cases' reveal equally distasteful and initially unbelievable treatment of (mostly) Indigenous Australian 'subjects'. Taken together, these pieces have an illogical and ludicrously funny–awful presence which subverts their supposed scientific value as singular entities, and defeats their original impersonal intent: to collect, collate, and label. I have focused instead on the one aspect the scientists ignored—the inhumanity of their actions.

I believe that no single element of our body can reveal our true identity, and would argue that this ordering, classifying, and separating of the non-European body into sections was a means of control and containment prompted by fear of the Other—the fear that the Other may not actually be easily defined and packaged. This anxiety is a reality which I embrace, and which I direct through my work at an audience. In so doing I hope to encourage dialogue and a questioning of our belief systems about ourselves and the Other, and about the potentially debilitating framework which sets up difference as a measurable and quantifiable entity.

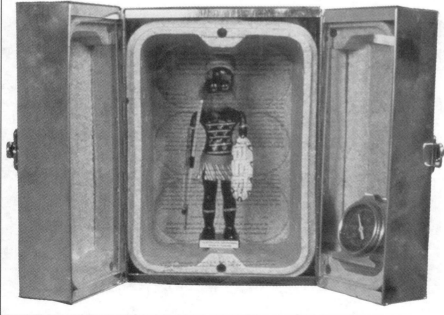

48. Julie Gough,
Physiological Adaptation to Cold, 1994.
Tin, mixed media, and text,
27 x 19 x 15 cm.

JULIE GOUGH

4.5 Aboriginal sovereignty

Artist, writer, and activist Kevin Gilbert gave this speech at the Aboriginal **Tent Embassy** in Canberra, on 27 May 1992, to mark a day of protest and mourning for the twenty-fifth anniversary of the **referendum of 1967** [*49, 206*].

It's twenty-five years since we Aboriginal People have had Australian citizenship imposed upon us, very much against the will of the Aboriginal People, for we have always been Australian Aborigines, not Aboriginal Australians.

We have never joined the company. We have never claimed citizenship of the oppressor, the people who have invaded our country.

Twenty-five years after this citizenship, which was supposed to give us some sort of rights and equality, we see that instead of lifting us to any sort of degree of place or right it has only given us the highest infant mortality rate, the highest number of Aboriginal people in prison, the highest mortality rate, the highest unemployment rate.

And after twenty-five years we still have Aboriginal children and people dying from lack of clean drinking water, lack of medication, lack of shelter.

We have still had twenty-five years of economic, political and medical human rights apartheid in Australia. And it hasn't worked for Aboriginal People.

At the end of the twenty-five years, we have seen the Australian Government and the Australian people try to get off the hook of responsibility by saying, ten years down the track, we'll have **Reconciliation**.

And Reconciliation doesn't promise us human rights, it doesn't promise us our Sovereign rights or the platform from which to negotiate, and it doesn't promise us a viable land base, an economical base, a political base, or a base in which we can again heal our people, where we can carry out our cultural practices.

It is ten more years of death! There must be something better.

49. Robert Campbell, Jr, *Aboriginal Embassy*, 1986. Acrylic on canvas, 88 x 107.3 cm.

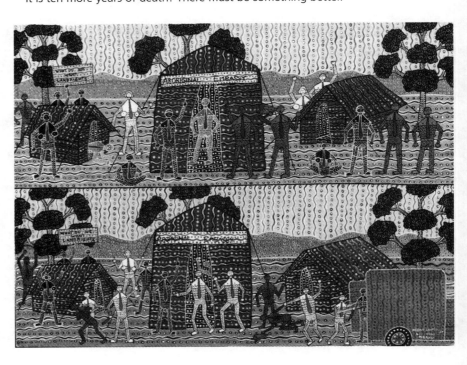

Australia is calling for a Republic and a new flag, a new vision. It cannot have a vision. It cannot have a new flag. It cannot have a Sovereign nation until it addresses the right of Aboriginal People, the Sovereign **Land Rights** of Aboriginal people.

You cannot build a vision, you cannot build a land, you cannot build a people, on land theft, on **massacre**, on continuing apartheid and the denial of the one group of Aboriginal people.

We have committed no crime, we have done no wrong except own the land which the churches and white society want to take from us.

It must change.

And we can never become, and we never will become, Australian citizens. For we are Aboriginal People. We are Sovereign Aboriginal People.

We fly the **flag** at half mast, in respect for Alice Dixon, the mother of the boy who died in custody, Kingsley Dixon; and for all the Aboriginal people who have died in custody and been murdered in custody [see **deaths in custody**]. And for all the Aboriginal people in gaol [see 12.1; **prison art**]. And for all of the children who are dying. A mark of respect and mourning for those who have died in the struggle. Because Australia still has not had the maturity, or the vision, or the guts, or the will, or the humanity, to come to justice, to come to terms, with our rights, as Sovereign Indigenous People.

Today is not a day of rejoicing, not a day of pride for Australia. It's a day when we hold our flags at half mast, in respect for Alice Dixon, and all the people who have died in custody, all the children who continue to die, even as we talk, through economic and political apartheid in this country.

We are still dying. Nothing has changed.

And white Australia and the politicians, are trying to avoid the responsibility, by pushing it off ten years in the future, where it promises nothing.

It has to change.

The Aboriginal vision for this country, Aboriginal Land Rights, is right for everyone. It means you cannot build any nation without integrity. You cannot build it without justice. You cannot build it without humanity. You cannot build it without compassion.

These are things that have to be addressed. We have to go forward with a vision. We have to go forward with a justice for everyone. That vision, that justice, that integrity, must address Aboriginal Sovereign rights, reparation, so we can have an economic and political voice.

We can't be done to anymore. Australia is not going to get away with killing us anymore. This type of apartheid has to be addressed.

If the Referendum hadn't been passed, we would have been further advanced, because white Australia would not have fooled the world into thinking that something positive was being done.

The international world would have looked much more closely at us, much sooner. They are now, but it would have advanced our cause by at least fifteen years.

We are now going to light our international distress flares … and we are going to signify with these distress flares the position Aboriginal People are in, and we want to signify to the world, that we need international aid, that our arms and legs have been taken from us, and we ask the International World to help restore our legs … and we need our arms.

KEVIN GILBERT

4.6 Art and politics: The Bark Petition and the Barunga Statement

There is a political side to Aboriginal art, as there is to most art. Much of the politics resides within the image itself—the message it contains and the way it is represented. Art encodes the Law of the ancestral past or **Dreaming** [see 1.1, 1.2], it marks the ownership of land and often the divisions between groups [see 3.1]. Politics is enacted through the production of art in context: factors such as who has the right to produce a painting, whether it can be seen in open or closed contexts, and restrictions based on age and gender [see **rights to art**]. The politics of art can be largely internal to the group, being the expression of feelings of identity and difference. Art production can even be an individual act of attachment or alienation. But often art has been used by Aboriginal people in external relations, as a means of political discourse and of widening the polity. Exchange ceremonies such as the Rom and Baṉumbirr (morning star) [see *407*] ceremonies of Arnhem Land are in part rituals of diplomacy which cement alliances between sometimes distant groups. In times of crisis, ceremony, or death, 'ambassadors', carrying with them their credentials in the form of message sticks and sacred objects, will travel to distant and sometimes hostile groups. Likewise in many parts of Australia young men before circumcision go on long journeys to introduce themselves to neighbouring groups.

From the beginnings of colonisation art has been used by Aborigines as a means of establishing relations with Europeans in trying to 'get them to understand' the values and laws of Aboriginal society. Early on, members of the First Fleet were invited to witness ceremonies—'**corroborees**'—at Sydney Cove, and people of the region exchanged art and artefacts with the invaders of their land. The significance of these exchanges was lost on the early colonists, as was to be the case for most of Australia's colonial history [see 11.1]. We have few detailed accounts of such events and can only reconstruct the motivations and frustrations of the times. But in Arnhem Land we have a detailed record of the last fifty years of engagement with Europeans and of the ways in which art and ritual have been part of the discourse.

The Bark Petition [*50*] of 1963 has become almost an icon of Indigenous political art. In the late 1950s the Yolngu people of Yirrkala in north-eastern Arnhem Land became aware of the threat to their land posed by mineral exploration. A crisis was reached when the government proposed to lease an area of their land to the French mining company, Pechiney. Following the visit of two parliamentarians—Kim Beazley, Sr and Gordon Bryant—to Yirrkala, members of the community sent a petition to the parliament in Canberra. As the accompanying letters made clear, it was a plea for the recognition of their title to their land. The petition was reproduced a number of times in English and Yolngu, and copies of it were fixed to sheets of bark bordered with paintings produced by members of the clans whose lands were threatened by the excision. The painted borders were an integral part of the petition, as Galarrwuy Yunupingu, the son of Munggurrawuy Yunupingu, one of the painters [see **Yunupingu family**], makes clear: 'It was not an ordinary petition; it was presented as a **bark painting** and showed the clan designs of all of the areas that were threatened by mining … [It was] not just a series of pictures but represented the title to our country under our law.' The Bark Petition did not immediately achieve the results that Yolngu wanted but it proved to be an important stage in the struggle for **land rights**. For Yolngu, land rights were eventually achieved in 1976 with the passage of the *Aboriginal Land Rights (Northern Territory) Act* (Cwlth).

The Bark Petition is part of a longer **history**. Yolngu have used art for hundreds of years as a means of asserting their rights and engaging outsiders. Arnhem Landers had entered into relationships of trade and exchange long before Europeans invaded their land. They

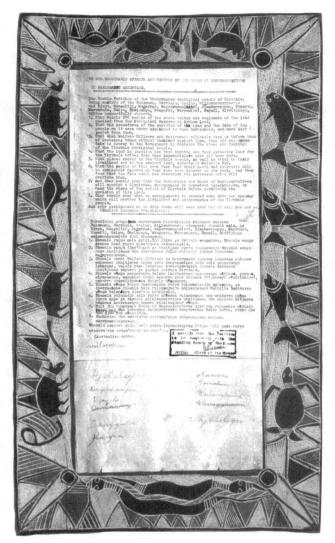

50. Yirrkala Artists, The Bark Petition, 1963.
Natural ochres on bark, with collage of printed text on paper, 59.1 x 34 cm.
The petition was presented to the Australian House of Representatives, Canberra, by the people of Yirrkala (NT) on 28 August 1963.

established close relationships with the Macassan traders from South Sulawesi [see 6.4] who came on an annual basis to collect trepang for 300 years, until the government stopped them in 1907. Aboriginal people of the coast incorporated the Macassans within their religious and social life, exchanging paintings and sacred names and establishing a modus vivendi. When the missionaries arrived in the 1930s Yolngu made paintings for sale and to facilitate understanding of their way of life. In the 1950s and 1960s this activity developed into the construction of what were, in effect, major community artworks. The Elcho Island Memorial of 1957 [see 1.2, 1.4; 7] consisted of a display of sacred objects and paintings outside the Galiwin'ku (**Elcho Island**) church. Partly an assertion of the value of Yolngu Law, it was accompanied by written demands for equality of rights and the recognition of customary law. In 1962—the year before the Bark Petition was made— two huge painted panels were produced, at the suggestion of Narritjin **Maymuru**, to be placed on either side of the altar in the Yirrkala church [*31, 32*]. The panels were a collaborative work and represented respectively the paintings of clans of the Dhuwa and Yirritja moieties. These paintings came out of the syncretic relationship that had

developed between Yolngu religious leaders and Methodist missionaries since the 1930s [see 1.2]. And the Bark Petition was a logical development of this history.

So too was the Barunga Statement [39], which was produced in 1988 and presented to the then Prime Minister Bob Hawke at a ceremony at Barunga (NT) by the two major land councils of the Northern Territory. Like the Bark Petition it consisted of a text bordered by paintings. These included equally designs from Arnhem Land and central Australia, representing the provinces of the Northern Land Council and the Central Land Council. In Galarrwuy Yunupingu's words: 'It was meant to be a follow-up to the Yirrkala Petition … Prime Minister Hawke promised to hang the painting in Parliament House, and that there would be a treaty between indigenous people and the government.' The text of the Barunga Statement calls on the government to negotiate a treaty 'recognising our prior ownership, continued occupation and sovereignty and affirming our human rights and freedoms'.

In recent years the art of Arnhem Land has moved from the local political arena— from the politics of clanship and discourse with missionaries—to the national and international stage. Art has been a major means of advocacy, a way of opening up to outsiders the values of Yolngu society and of seeking recognition for the systems of Law and title that underlie the representations [see also 23.2]. Yet as the art moves it also remains, in some fundamental ways, the same. To Aboriginal people their art is an expression of a way of life and of a view of the world: it is a gift of immense value that is very close to their sense of being in the world. It is offered in exchange. In the words of Galarrwuy Yunupingu: 'This is our painting, where is yours?'

HOWARD MORPHY

Attwood, B. & Markus, A., *The Struggle for Aboriginal Rights: A Documentary History*, Sydney, 1999; Morphy, H., ' "Now you understand": An analysis of the way Yolngu have used sacred knowledge to retain their autonomy', in N. Peterson & M. Langton (eds), *Aborigines, Land and Land Rights*, Canberra, 1983; Morphy, H., *Ancestral Connections: Art and an Aboriginal System of Knowledge*, Chicago, 1991; Wild, S. (ed.), *Rom: An Aboriginal Ritual of Diplomacy*, Canberra, 1986; Yunupingu, G., 'Indigenous art in the Olympic age', *Art and Australia*, vol. 35, no. 1, 1997.

5. Rock art revisited

5.1 Rock art: A multifaceted heritage

Rock art, or art on natural rock surfaces, is arguably the most enduring of Aboriginal artistic productions. It is the only source of evidence for Aboriginal art predating the collection of Aboriginal objects by European observers. It is evidence for a long tradition that shows strong continuities in its essential forms and structure throughout the entire continent. Two distinct strands are widely recognised: one focused on a set of relatively standard schema for the depiction of humans and a limited range of animals, and the other mainly employing a small range of graphically simple forms (circles, arcs, zigzags, and the like) and animal and bird tracks.

A regional overview

The rock art of simple forms and tracks is best known from engravings on exposed rock surfaces throughout much of the continent south of the tropics. Because they are often deeply weathered they are thought to be 'ancient' and to precede figurative art in many regions. Circles and tracks dominate, and superficially the tradition appears extraordinarily uniform. Few such sites have been studied in detail, but those that have reveal local character in some unique motifs and, importantly, a degree of patterning in the dispersal of motifs across an area. The apparent homogeneity of these sites may well lie in the fact that there is little room for stylistic variation in the dominant motifs used. Local stylistic expression is found in the rarer motifs and in the integration of the natural topography of the rocks into the overall organisation of the site.

In eastern and south-eastern Australia, this tradition was replaced by figurative motifs probably during the mid-Holocene period c.4000–3000 years ago. Although the basic animal and human schema vary little, medium and elaboration of detail give rise to regional styles. The often large-scale engravings on horizontal rock platforms through much of the Hawkesbury sandstone country north of Sydney mostly rely on simple outline forms, while the use of paints in rock shelters of the Laura region of Cape York Peninsula (Qld) [51] facilitates the addition of detail and infill to the same schema using contrasting colour, dots, or grid patterns that enliven these otherwise static images. Further simplification of the painted human schema, to almost linear form, allows the depiction of movement and gives rise to a lively imagery, as in the small-scale paintings in shelters on the Cobar plain in western New South Wales, and in much of south-eastern Australia. In the Pilbara region (WA) the use of lines of tracks to evoke the travel of animal figures remains important, but a greater freedom in the elaboration of figurative images of animals and especially the human form again gives rise to regional styles. In this region the technical skills for engraving tough and intractable rocks are

5. Rock art revisited

51. Laura elder George Musgrave guides tourists to Giant Horse Rockshelter, Laura (Qld), 1999.
Quinkan Aboriginal rock art of Cape York Peninsula is one of the most extensive bodies of rock art in the world. Indigenous knowledge and archaeological research testify to the great antiquity of rock art and Aboriginal settlement in the region. The paintings, stencils, and engravings in thousands of sandstone rockshelters represent the most recent phase of a continuous art tradition dating back many millennia. Colourful images of human and spirit figures, animals, plants, tracks, and artefacts are often multi-layered, indicating successive art episodes over many generations. The image of the 'giant horse' provides a spectacular example of rock art of the post invasion stage.

Indigenous land owners of this region, multilingual peoples who belonged to several discrete cultural groups, were brutally dispossessed of their lands following the Palmer River gold rushes of the 1870s. However freehold title of the Quinkan Reserves is now held by groups of Indigenous Trustees who are implementing innovative cultural heritage management strategies for cultural maintenance, community development, and cultural and eco-tourism.

Noelene Cole

particularly well developed, leading to quite complex imagery, as in the enigmatic 'climbing men' compositions of the Dampier region.

In the northern, monsoonal regions of the Kimberley (WA) and Northern Territory there is an early body of rock art that differs fundamentally from the rest of the continent in its aesthetic, in its conceptual themes, and in the graphic schema employed. These are conventionally known as Bradshaw (*Gwion Gwion, Kiera-Kirow, Jungardoo*) [*52*], and Mimih or Dynamic styles [*53*]. While there are stylistic differences between these two regions, both are characterised by detailed and finely executed images in compositions consisting mainly of men in elaborate attire of head-dresses, belts, tassels, and other orna-ments. They often carry weapons, but these are boomerangs and hand-thrown spears no longer used in these regions, and they lack the spear-thrower of the recent past. In Arnhem Land they are often shown in lively action, running, fighting, or hunting. The more recent rock art of these regions, however, conforms largely to continent-wide con-ventions, although their elaboration gives rise to very distinctive styles. In the Kimberley [see 10.1], large, dramatic images of creation beings known as Wanjina [*60*, *154*], and their animal or plant creations, are boldly executed, mostly in finger painting in red and black on a prepared white background. These striking images nonetheless rely on the same characteristics of a static frontal schema for the human figure as the art of the Hawkesbury (NSW) [*54*] or Laura (Qld) regions. The recent rock paintings of western Arnhem Land are more restrained in execution than the preceding Mimih figures, often employing clearly defined outlines in red or white, with fine line infilling in different colours for different sections of the human or animal form. On some animal images skeletal elements and some internal organs are rendered schematically, giving rise to the term x-ray art [see 5.2; *152*]. These x-ray images also employ the human and animal schema that underlie most other regional styles, but show greater freedom in their varia-tions, including the occasional depiction of movement in human figures. While much

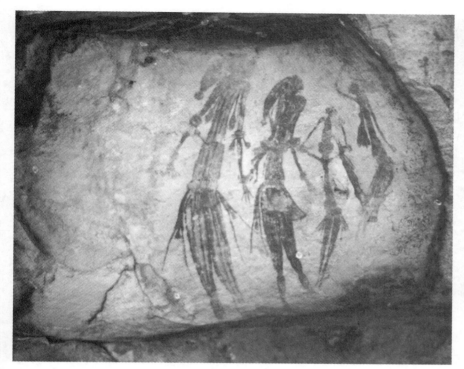

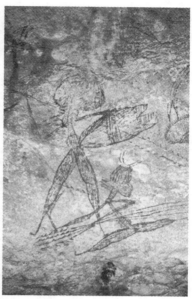

52. (Above left) *Gwion Gwion* (Bradshaw figures), King Edward River, North Kimberley (WA), 1997.

53. (Above right) Dynamic figure, Kakadu National Park (NT).

detailed work is available on local developments within each of these regions, the formal and developmental relationships between the earlier monsoonal art and the wider body of Aboriginal rock art is a question that has not yet been investigated. One key problem in approaching this question is the very contentious one of chronology.

The dating of rock art

It has become commonplace to say that rock art is notoriously difficult to date [see **rock art dating**], and how far back Aboriginal artistic tradition can be traced through rock art is much debated. There is some agreement among specialists on the general trends of development and on the time-scales involved for the more recent past, that is for the last few thousand years. Estimates for the earliest appearance of rock art range from Margaret Nobbs and Ronald Dorn's figure of at least 40 000 years ago or more, to Andrée Rosenfeld's figure of probably no more than some 12 000 to 15 000 years ago. Some of the more speculative claims, such as those of Grahame Walsh who argues that the finely executed Bradshaw paintings in the Kimberley are too fine to be Aboriginal, and must be the work of earlier peoples some 75 000 years or more ago, have no archaeological basis and are informed by racist perceptions of what Aboriginal people are capable of. Ongoing research on dating these paintings is yielding widely differing age estimates, ranging from perhaps little more than 4000 years to as much as 17 000 years, but this research is still in its early stages. There is indubitable evidence for the use of ground ochre pigments at least 20 000 years ago, for example at Nauwalabila in western Arnhem Land and at Puritjarra in central Australia, but what was painted remains unknown. The antiquity of the beginnings of painting and engraving on rock remains uncertain.

In most regions painting or engraving on rock is no longer practised, at least not on a regular basis, and the artists of this vast heritage remain anonymous. Najombolmi [*152*], who painted in western Arnhem Land from the 1930s to the 1960s, is one of the

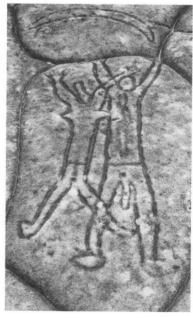

54. Spirit figures at the Basin track, Ku-ring-gai Chase National Park.

exceptions. Heritage management [see **cultural heritage**] and protection agencies have generally discouraged Aboriginal people from adding to the 'protected' sites [see **rock art repainting**], but with increasing Aboriginal control over their heritage, some rock painting has been revived (or more openly continued).

Meaning in rock art

For all its seeming durability, rock art is widely considered a very fragile cultural resource; it is subject to deterioration by natural weathering processes, and even more so by irresponsible practice at rock-art locations. Much surviving rock art is faded, partial, and it can be quite difficult to see. Yet it is by far the most visible cultural heritage of Aboriginal people, and as such is one of the few visible monuments to their long affiliation to the land. Rock art also tends to attract wide public interest despite the fact that much of it has little immediate visual impact. Nor does it conform closely to public taste in art. It seems one aspect of its appeal lies in the unique qualities of rock art: it is integral to its setting in a natural environment and cannot be divorced from its intended locational context [see **rock art sites**]. It cannot be reified in the somewhat intimidating atmosphere of an art gallery, and as such may seem more approachable, less the preserve of the 'expert'. Yet this very quality also enhances its exotic appeal, and in some respects removes it further from our understanding, for the meanings of rock art are bound up with meanings of landscape and of temporality that differ fundamentally from Western perceptions of place and time.

Meaning, in rock art, is a subject largely avoided by archaeologists. In the first instance, since the identity of the artist is generally not known, an account of Indigenous meanings for rock art is dependent on the involvement of informed Aboriginal viewers. More significantly, for rock art of some antiquity the style or content of the imagery may differ quite substantially from contemporary practice, and Aboriginal people can be as reluctant to guess at meaning as other researchers. Even for recent or contemporary rock art the perception of meaning is necessarily coloured by the identity and experience of the viewer. From a textual perspective, meaning can be understood not as inherent in the imagery, but rather as emerging from the interaction between viewer and image. Thus, especially in such an enduring art form, meaning is dynamic, contextual, and temporal, and is not something that can be resolved in any one statement. Archaeologists, therefore, are not so much concerned with any specific contemporary explanations as with a general sense of the range of conceptual concerns that are conveyed through the medium of rock art and with *how* meanings are conveyed through imagery.

In some parts of Australia it is possible to explore the role that rock art plays in Aboriginal culture—the contexts in which it operates, and the manner in which it is viewed and understood. The first thing to emerge from an overview of Aboriginal perceptions and attitudes to rock-art sites is their diversity of function. Rock-art sites range from highly sacred locations with restricted access, to casual expressions of secular concerns, and may cover the full gamut of intermediate situations. The art at a site may be a central feature of the significance of the area, it may be pertinent but not central, or even quite peripheral to its significance. It seems the term 'rock art' cannot be glossed precisely in Aboriginal languages; the concept is a construct of the Western discipline of **archaeology**. Rock art is defined by its materiality in much the same manner as other archaeological categories such as stone artefacts or pottery, each of which also cross-cuts many cultural categories. While such categorisation can be a useful device for archaeological practice, it is limiting when exploring questions of the past role of rock art in social practice for times, or in regions, with no existing Indigenous knowledge.

Present Aboriginal practice does allow some investigation of the relationship between the context of rock art and the nature of the art expressed [see 5.2, 5.3, 5.4; David **Mowaljarlai**]. For example, Robert Layton has pointed out that the Wanjina rock art sites of the Kimberley are central foci for the patrilineal clan territories, and for the rituals that ensure the arrival of monsoonal rains that annually revive the land. Since each ancestral clan Wanjina is associated with the creation and maintenance of a particular animal or plant species, the totality of Wanjina cults also symbolises the interrelatedness of the several clans [see 3.1]. In western Arnhem Land certain rock-art sites are also a focus for the expression of patrilineal clan affiliation through ritual and art, but many are wet-season camping sites. Many of the spectacular x-ray paintings of fish, animals, and birds in these camping sites do not have mythological referents, but commemorate the bounty of the country by recording successful hunting or fishing incidents. The cross-hatching invokes colour, and especially the colours of the rainbow, and the brilliance of light on water which is also seen in the iridescence of the scales of fish or the skin of snakes. It is thus evocative of the life-renewing powers of water and the continuance of the creative power of ancestral time. Thus, Taçon shows that while these images are essentially secular and anecdotal in their referents, the cross-hatching alludes to the essence of life and to the pervasive potency of ancestral power.

In central Australia rock art relies largely on 'simple' graphic forms in which circles and various track motifs dominate, while figurative images, which became the dominant form of expression in many other regions, are very rare. Some petroglyph sites such as Puritjarra (west of Alice Springs) have a deep patina and are clearly ancient. Elsewhere formally similar engravings appear much fresher, and in such situations may also include a small number of graphically more structured motifs such as 'feathered' motifs or the 'head-dress' motif at Ewaninga (NT). Rock paintings are mostly recent, and many are on unstable rock surfaces. But rock art at Puritjarra indicates a sequence of painting episodes which probably spans several millennia. A broad twofold division of painting sites is possible. One, an informal body of paintings often associated with habitation debris, consists largely of animal and bird track alignments, including long meandering lines of macropod tracks and many hand stencils. The other tends to contain more formally structured designs including the 'feathered' or 'head-dress' motifs also found among less weathered engravings, or designs based on patterns of alternate red and white stripes, or formal arrangements of circles sometimes joined by bands of parallel lines. It seems these more formally structured motifs evoke the Tjukurpa (Dreamings), and the designs of parallel stripes in particular mark sacred and restricted areas, or formerly restricted locales such as Emily Gap and Jesse Gap, just east of Alice Springs.

In desert regions the practice of painting or engraving on rock, both secular and sacred, seems to have been largely replaced by contemporary painting in acrylics—the widely practised 'dot' paintings [see 9.5; **acrylic paintings**]. The form of these derives from the sand paintings of the region rather than from rock art. In the ground painting and artefact painting tradition, too, the dominant graphic structures are the circle, arc, line, meander, and bird and animal tracks. While the antiquity of such a tradition cannot be known, it is clear evidence that the art of the circle, track, and line was not limited to painting on rock.

Such a continuity of basic motifs through space and time clearly testifies to an enduring graphic tradition which has proved sufficiently flexible to accommodate the requirements of change in cultural expression over many millennia, with relatively few graphic additions and elaborations. By contrast, in regions where more complex figurative and hence explicit motifs developed, changes in cultural requirements have led to significant changes in the range and style of motif construction.

'Markings' versus 'art' in rock-art sites

There is a range of ambivalent features commonly included under the term 'rock art' since they modify the rock surface and frequently occur at rock-art sites. In some shelters they are the only artificial modification of the rock surface. The most common of these are pits and abraded grooves. Shallow pits of around five centimetres in diameter have been pounded out of the rock surface, sometimes in very large numbers and covering quite extensive areas. They are commonly concentrated on large boulders in rock shelters, but no particular patterning in their arrangement can be discerned. Pitted rock surfaces occur particularly in northern parts of the continent. Short, narrow grooves abraded into the rock, ranging from a few centimetres to around ten centimetres long, are most common in central regions of Australia. These grooves are sometimes identified as 'spear-sharpening grooves', but they frequently occur in such restricted recesses of rock shelters that this technological explanation cannot hold. They can occur in large clusters, on boulders, or cut across projecting ridges of the rock surface. Very occasionally, sets of three short, abraded grooves seem to simulate a schematic arrow or bird-track motif, but most show no regularity other than that dictated by projections of the natural rock. Markings such as pits or grooves show no variation in form, nor any identifiable patterning. These marks on rock differ from other rock art insofar as their form, being mechanically determined, cannot vary: pits are identical the world over, unlike schema for human, animal, or other referents, or the choice—always culturally constrained—of abstract forms. The same, of course, applies to the hand stencils that are another widely occurring feature at rock-art sites. Unlike other paintings or engravings, these mechanical marks cannot be subjected to cultural conventions of style that are identifying hallmarks of authorship and context. It is arguable, therefore, whether they should be considered 'rock art', or be treated as resulting from a different cultural practice, sometimes found in the same locations as rock art—that is, as the visual consequence of a meaningful gesture rather than a practice aimed at a specific, visual product. The practice of making rock markings has some antiquity, and many pits and grooves are deeply patinated. Others, however, are clearly more recent and are contemporaneous with rock art.

Consideration of hand stencils is a little more complex, for although the form of the human hand is essentially invariable there are areas of possible choice: of colour, of how the fingers are held, or of the extent to which the wrist, or even forearm, is included [*375*]. In central Queensland, hand stencils show a variety of finger positions which presumably convey different meanings. Stencils of objects mostly show men's artefacts, especially **boomerangs** and spear-throwers, but in central Queensland a wider range of artefacts is commonly stencilled. Indeed, this region is characterised by the high development of the technique of stencilling, with the use of either small objects or spaces created between the fingers to construct quite elaborate designs. Clearly this mechanical means of image creation can be elaborated for stylistic expression, thus creating rock art, in the strict sense of the term. In most regions, however, hand stencils show little variation of form beyond that of the natural variation of size and slenderness among a group of people. When Aboriginal people comment on hand stencils, it is always with reference to their authors, either known individuals or, in general terms, the 'old people'. Unlike rock art of images or formal motifs, hand stencils are not referred to with reference to mythological features or stories.

The right to create imagery of mythological significance at a locality (or indeed anywhere) is subject to constraints of the mythologically defined affiliation of the artist [see **rights to art**]. Authorship of such art is an expression of an artist's social identity, of their mythologically sanctioned relation to the area and through that of their formal relationship to the wider community [see 3.1]. The semantic imagery and style of

mythological imagery at a rock-art site express and mediate mythologically structured relationships between persons through their affiliation to place. The hand stencil is a more personal statement of presence at a locality. Only insofar as legitimate presence is culturally constrained, and this will vary according to the sacredness or the secular nature of the locality, does it refer in a general sense to an individual's social situation. Even very young children, who as uninitiated individuals have not fully attained their social identities, could identify their affiliation to place with a hand stencil. In the recent rock art of western Arnhem Land where imagery can also be used for the commemoration of individual presence, hand stencils or other markings are notably absent. Here, the outsider would not be able to distinguish these two different levels of identity expression. It seems likely that pits, abraded grooves, and related marks are also participatory marks of an individualised nature, since their formal invariance prevents their use to express differentiations according to formalised cultural identities. With the passing of the generations, individualising markings or stencils will lose their identities, and may pass into the generality of group ancestry and into remote mythological time.

Art in place

Rock art comprises several forms of visual expression, and a diversity of social contexts and cultural meanings: the heritage of rock art is a variable category. The one, unifying theme is its inextricable relation to place. Rock art and rock markings visibly transform a natural place into cultural locale. They visually enhance the enculturation of landscape that is embodied in its naming, and in the narrative of history–mythology that links places into the web of meanings that constitute 'country'. The addition of rock art to place gives permanence to the more elusive meanings embodied in oral tradition, yet in the transformations of each reading of this cultural text, new meanings may be constructed. The central role of the site in structuring meaning is given permanence by means of rock art and rock marking. The art then legitimises the accounts of affiliation to country by passing into the remote and sacred time of the 'beyond human memory'.

ANDRÉE ROSENFELD

Nobbs, M. & Dorn, R., 'New surface exposure ages for petroglyphs from the Olary province, South Australia', *Archaeology in Oceania*, vol. 28, no. 1, 1993; Layton, R., *Australian Rock Art: A New Synthesis*, Cambridge, 1992; Rosenfeld, A., 'A review of the evidence for the emergence of rock art in Australia', in M. A. Smith, M. Spriggs, & B. Fankhauser (eds), *Sahul in Review: Pleistocene Archaeology in Australia, New Guinea and Island Melanesia*, Canberra, 1993; Rosenfeld, A., 'Archaeological signatures of the social context of rock art production', in M. Conkey, O. Soffer, D. Stratmann, & N. G. Jablonski (eds) *Beyond Art: Pleistocene Image and Symbol*, Memoirs of the Californian Academy of Sciences, no. 23, 1997; Taçon, P., 'Art and the essence of being: Symbolic and economic aspects of fish among the peoples of western Arnhem Land, Australia', in H. Morphy (ed.), *Animals into Art*, London, 1989; Walsh, G. L., *Bradshaws Ancient Rock Paintings of North-west Australia*, Carouge-Geneva, 1994.

5.2 Rock art as inspiration in western Arnhem Land

Artists in western Arnhem Land live in a landscape marked by the activity of ancestral beings. These beings have the power to form the shape of the land, and they have left traces of their bodies on the rock in the form of paintings at important sites. Only the most recent styles are said to be the product of human activity. For Aboriginal people living in this region, ideas about paintings are intrinsically merged with ideas about country. Contemporary artists draw on a tradition that stretches from Pleistocene times

to create sublime images of their religious beliefs, in the context of selling the resulting works to the non-Aboriginal market.

The tendency to market Aboriginal arts as the continuation of a long-standing tradition [see 21.1] can have both positive and negative effects. Sometimes marketing of Aboriginal art slips into the familiar tropes of a 'stone age culture' with all the social-evolutionist resonances that accompany interest in 'primitive' art. The market has exhibited a strong fascination with **rock art** as a feature of the primitive, but western Arnhem Land artists have a different interest in their rock art, and have drawn on other artistic traditions and employed new techniques to create an appropriate means of communicating with a Western audience.

The meaning of rock art

Tourists [see 18.1] can now easily visit the escarpment country of Kakadu National Park and see the rock art among the towering cliffs at Nourlangie or at Ubirr. Later they may visit the Aboriginal art shops in the park or **Injalak Arts and Crafts** at Oenpelli (Gunbalanya) in Arnhem Land to purchase examples of art painted by Kunwinjku people. The paintings on paper or on bark are strongly reminiscent of the rock art they have just seen and tangible evidence of the continuance of this tradition.

When we try to think of 10 000 or more years of art inscription practice—the sheer bulk of images, the numbers of generations of people involved, and the potential influence of the older paintings on successive generations of people—it is hard not to be in awe of the western Arnhem Land artistic tradition. For the Aboriginal people of this region, the rock-art tradition is an important cultural focus. Learning the stories associated with rock paintings is a key element of social reproduction. In other parts of Australia too, such as the Kimberley region in Western Australia and the Laura area in north Queensland, rock art also continues to be a major influence on contemporary art.

In western Arnhem Land most of the artists who came to prominence in the 1960s and 1970s first learnt to paint on rock [see 5.2]. It is well known that **Najombolmi**, who features in the Dorothy Bennett collection of bark paintings, painted rock shelters in the Kakadu region up until 1964 [*152*]. Wally **Mandarrk** [*351*] learnt to paint on rock in the country between the upper reaches of the Blyth and Liverpool rivers, first produced bark paintings for the American–Australian Expedition to Arnhem Land in 1948, and was a prolific bark painter for many years for Maningrida Arts and Crafts. Bobby Barrdjaray **Nganjmira** [*363*] learnt to paint on rock at Injalak rock shelter at Oenpelli around 1930 and in his country at the head of the Goomadeer River, and went on to become one of the leading artists at Oenpelli. Bardayal **Nadjamerrek** [*55*], who painted rock shelters in the region of the upper Mann River in the 1940s and touched up some of these paintings in 1994, was a prolific painter at Oenpelli, employing a style very similar to that of the rock-art tradition. That artists should be inspired to touch up these earlier works and regularly visit shelters reveals that rock art is still very much a part of contemporary culture. These men were active in communicating their knowledge about the meaning of rock paintings to younger generations.

Contemporary Kunwinjku recognise a number of kinds of rock-art sites, and the paintings in these sites are interpreted in different ways. Some of the larger, more comfortable shelters were visited by whole families for an extended period during the wet season. These sites have numerous paintings of overlapping images of different kinds of species. They are public shelters, and the stories about the subjects were shared freely with children. Artists such as Barrdjaray and Samuel Manggudja Ganarradj have described a number of different purposes for these paintings. They might illustrate events that occurred in daily life or public versions of mythological events.

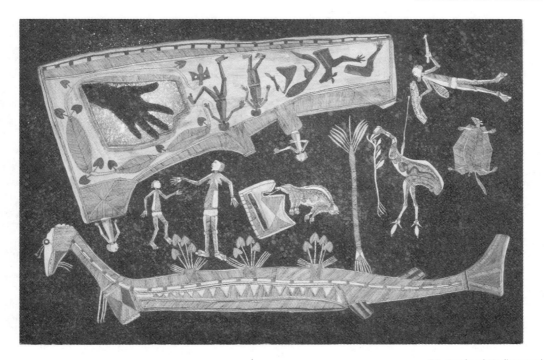

55. Bardayal Nadjamerrek,
*The Female Rainbow Serpent
Beneath Waterlilies in Her
Sacred Billabong*, 1991.
Natural pigments on paper,
101.6 x 151.2 cm.

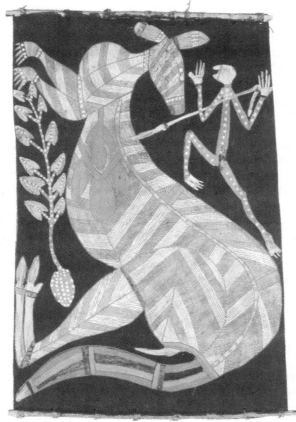

56. Spider Namirrkgi
Nabunu, *Mimi Hunter and
Feeding Kangaroo*, c.1977.
Natural pigments on bark,
76 x 48 cm.

111

The paintings of stories were to 'make children happy' or were painted 'for fun'. That is, the stories were told in a relaxed atmosphere but served an educational purpose. Sometimes the children were encouraged to paint as part of their apprenticeship as young artists—many sites have inexpert and unfinished works alongside the more expert, completed ones. Other images such as hand stencils served to personalise the space. They are a record of individuals having visited the site. Such images may become a memorial if the individual dies and viewers of these images feel 'sorry' for people they knew and loved.

Some images are said to have been produced not by humans but by the *mimih* spirits that inhabit the rock country. *Mimih* are not considered creator beings, they are more like trickster spirits; long and thin, they have powers that allow them to disappear inside the rock face, where they have their own, unique land and live much like humans [53, 56]. Occasionally they trick humans, steal them away, and take them to this world. *Mimih* are said to have taught humans many of their cultural skills, such as how to hunt, butcher, and cook game, and how to paint. Paintings of *mimih* are taken to be representations by the *mimih* of scenes of their own cultural life which continues inside the rock. Contemporary Kunwinjku often say they 'copy' *mimih* pictures in order to represent the activities of these humorous and slightly malevolent spirits.

Other, more secluded, sites display images which show human beings in unnaturally twisted postures, sometimes with dart shapes representing stingray spines stuck into their genitals or joints. These images are the result of sorcery practices, where artists painted their victims with afflictions that they hoped would magically transfer to them. As Peter Sutton notes, the representation of inversion, malformation, and undesired penetration in such images connotes the malevolent energy and heat of sexual jealousy that underlies sorcery practices. Elsewhere, humans are shown in the act of copulation. These images are identified as 'love magic' designs; the representation of the act is believed to bring about the consummation of the artist's desire.

There are also paintings which are said not to have been produced by humans or by *mimih*; here the ancestral beings (*djang*) 'made themselves rock'. The image on the rock surface is considered to be the trace and actual bodily presence of the ancestral being which ended its creation journey at this place by entering the rock. For example, at Injalak rock shelter at Oenpelli there is an image of a rotund human figure who people believe escaped a cyclone by running across the rock, leaving his footprints as impressions, and jumping up and into the rock face, where his image remains. The image is said to be much too high up for humans to have produced it. Elsewhere, images are the focus of ceremonies designed to increase the numbers of food animals associated with the particular *djang*. While such sites may be viewed by all in the community, behaviour in the vicinity is highly controlled to constrain activity that might anger the ancestral being.

Rock art and bark painting

Painting on bark shelters was a practice continuous with painting on rock shelters. If people wished to camp for the few months of the wet season where there were no suitable rock shelters, they could make shelters from stringybark (*Eucalyptus tetradonta*). Abandoned after the rains had ceased, these usually decomposed after a season or two. Paintings were sometimes produced on the inside of these shelters and, as in rock shelters, served to amuse and inform children and liven up the space [57].

The style and subjects apparent in early collections of bark paintings reveal strong continuity with contemporaneous rock-art styles; they are paintings of animal figures sometimes infilled with x-ray details [*152*]. In rock art, the outline of the figure is

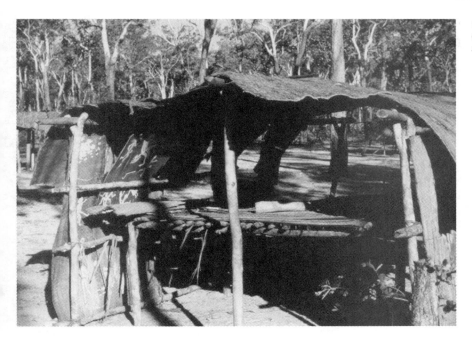

57. Bark hut at Manggalod on the Mann River, central Arnhem Land (NT), 1974.

generally completed as a silhouette of brilliant white paint against the darker background of the rock. Internal decoration of this silhouette may consist of joint marks and representation of the internal organs such as the optic nerves behind the eyes, the heart and lungs, liver, and stomach. Dots or hatched lines may highlight certain body parts. These paintings were described by artists as images of animals which showed the essential sweetmeats and prime cuts of meat or fat of the species [3]. The division of game has important symbolic overtones in this part of Arnhem Land, and x-ray art can also be used to emphasise notions of ancestral creation. The shape etched by the silhouette of the figure is of crucial importance in indicating the particular species, and young artists may take many years to learn how to produce the correct figure shapes for a range of species. Similarly the elegance of outline etched against the background is a prime aesthetic consideration. It is common to see senior artists overpainting and correcting the work of younger artists who have erred in failing to represent essential details of outline or who have not achieved an overall balance in the expression of figure shape.

Paintings on the walls of bark shelters were much more collectable than rock art. The first examples of the art from this part of Arnhem Land, collected around the coastal fringe of the region, were bark paintings taken from bark shelters. In 1878, J. C. Cox presented a set of paintings from the Port Essington region (Iwaidja language group) to the Australian Museum in Sydney. The first barks that Baldwin Spencer collected at Oenpelli in 1912 were taken from the walls of bark shelters. As late as the mid 1970s Dan Gillespie collected an image painted by Mandarrk on a bark shelter he had made for his family south of Maningrida. This is now in the collection of the National Museum of Australia. More recently George Chaloupka encouraged Dick Nguleingulei Murrumurru to paint a bark shelter at Malgawo, south of Maningrida, and later collected it for the Museum and Art Gallery of the Northern Territory.

Recognising the continuity between the hut paintings and the rock art, Spencer was keen to obtain the former and commissioned the production of paintings on bark as a means to analyse the rock-art tradition. He paid the artists with tobacco, which was highly valued, and encouraged the use of small rectangles of bark that could be easily

transported. Spencer may have reinforced the connection between bark painting and rock art, and set a pattern of collecting that was to be emulated in subsequent years.

There were strong points of connection between the artistic traditions of western Arnhem Land and those of the colonisers. Western Arnhem Land secular art is iconic in character and collectors such as Spencer could understand the iconography relatively quickly. It would seem that the artists perceived, in the context of this exchange, that the use of the more figurative secular motifs was most appropriate. Thus Spencer was able to collect images that had a relatively transparent narrative intent, such as a hunter spearing a kangaroo, and to establish this particular image as one of the key icons of Aboriginal artistic culture, intelligible to the non-Aboriginal population [56]. The early interest of researchers such as Spencer in the art of western Arnhem Land was prompted by images of primitivism. Describing the artistic culture of a group considered to be at the lowest rung of civilisation, Spencer's books of 1914 and 1928 fuelled a worldwide fascination with social evolution.

Spencer did not appreciate at the time, however, that such imagery has a multiplicity of associations in western Arnhem Land thinking. For example, ancestral episodes that involve the killing of various kangaroo species are central to a number of western Arnhem Land ceremonies. It has taken many more years of research to understand the complexity of Aboriginal systems of knowledge and the layering of symbols that occurs. Spencer was able to read only the most 'outside' or patent meanings of the core images [see 6.1]. It now seems ironic that he developed his theory of the 'primitive' nature of Aboriginal culture on the basis of this superficial knowledge.

New infusions

While the initial impetus for collecting was stimulated by interest in rock art, contemporary bark paintings also exhibit strong connections with body painting styles. This development is the result of Kunwinjku choosing to reveal more of their sacred (as opposed to secular) art to outsiders. Artists were in part encouraged to do this by collectors with an anthropological interest [see **anthropology**]. However, the Kunwinjku, like other Arnhem Land groups, also used anthropological researchers and later the art market as a means of revealing the strength of their culture to outsiders; as Howard Morphy suggests, this was in part designed to modify the relationship with non-Aborigines and put it on a more mutually respectful footing. Geoffrey Bardon [see 9.4] sees a similar trend in the decision by Pintupi artists to paint their more ceremonial images for the market in the early 1970s.

The collections of art made after the 1940s reveal something of these changes. C. P. Mountford visited Oenpelli in 1948 and 1949 as part of the American–Australian Scientific Expedition to Arnhem Land, and made an extensive collection of paintings on bark and on cardboard. He distributed his collection among all Australian State art galleries and for some institutions this became the first Aboriginal art in their collections [see 21.1. Ronald and Catherine Berndt conducted extensive and long-term anthropological research at Oenpelli in the late 1940s, and their research interests were more broadranging than Mountford's. They documented a number of rock-painting styles, such as sorcery and love magic, which had not been collected before and in addition collected paintings of ceremonial subjects which show ancestral beings painted with crosshatched designs.

The style of infill characterised by multicoloured bands of cross-hatched lines is called *rarrk* by Kunwinjku. It derives from body paintings made on the chest and thighs of dancers in the Mardayin ceremony [58]. Kunwinjku say that the ancestral beings once wore these designs on their bodies, and gave them to humans for use in ceremony.

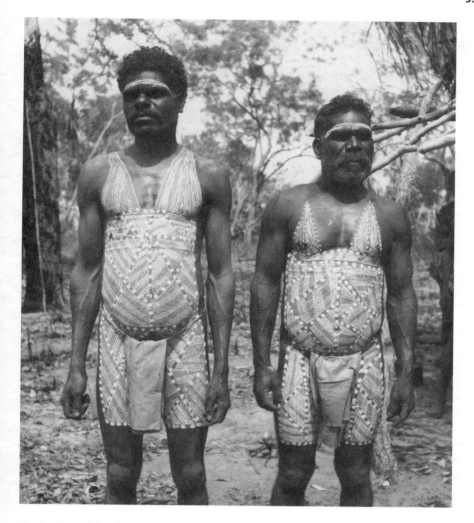

58. Bundubundu and Lamilami returning to public camp wearing *rarrk* body paintings after participating in a Mardayin ceremony at the mouth of the Liverpool River, central Arnhem Land, 1952.

Production of the design in a ceremonial context releases ancestral power and helps to ensure the plentiful supply of the particular species. The wearing of the design in ceremony by initiates communicates this power to them; regular performance helps to build up an individual's perceived stock of personal power, a progression that also derives from the gradual acquisition of knowledge about the ancestral realm. At one level these designs are interpreted as the body parts of the particular ancestor: they are imagined as a kind of x-ray painting. Another level of interpretation, however, relates the design to the ancestral lands created by the being; it is conceptualised as a kind of map, and confers recognition that the individual upon whom it is painted is intrinsically spiritually related to these lands. Initiation thus promotes a sense of personal and bodily identification with ancestral creativity.

Rarrk patterning became increasingly prominent in bark paintings during the 1960s and 1970s. The famous Kunwinjku artist, Billy **Yirawala**, was particularly adept at using ceremonial designs from Mardayin and Wubarr ceremonies in bark paintings. He painted extensive sets of images which depict the ancestral beings associated with the major Kunwinjku ceremonies, and in *Yirawala, Painter of the Dreaming* Sandra Le Brun Holmes documents that he was concerned to educate non-Aborigines about them.

Kunwinjku artists note that there was increased market demand for ceremonial imagery at this time as well as a demand for more bright and 'colourful' pictures. Senior artists established the incorporation of *rarrk* in paintings as the most culturally appropriate way of dealing with this market demand; the paintings depicted important ancestral stories and the use of cross-hatched designs was appropriate for representing the power of these figures.

Artists including Barrdjaray, Yirawala, and Peter **Marralwanga** [*353*] went on to show others how to develop the cross-hatching component in paintings in a way that was creative but that did not necessitate the revelation of ancestral designs. The *rarrk* used by them and the artists that they taught is described as 'half secret one, half ordinary one', that is modified to be appropriate for public consumption. Much of the dynamism of current Kunwinjku art derives from the adventurous way the artists use cross-hatching without necessarily sticking to rigid ceremonial rules of execution. In the work of the contemporary artist John **Mawurndjul** [*151*], the figurative outline is pushed to the edges of the bark to make a broad figure whose body is filled with a field of vibrating designs. The distinctive elements of the body are sometimes barely discernible against this strong patterning, and different figures are often woven together as part of the overall design. Mawurndjul is using *rarrk* in this new way to express ideas about the transformational power of the ancestral beings.

Another group of artists at Oenpelli, including Bardayal, Nguleingulei, and Jimmy Kalarriya, who identify themselves as having stronger affiliations with the more southern Kunwinjku and Kundedjnjenghmi clans of the Arnhem Land plateau, did not follow this trend. Rather, their art is characterised by a much greater use of rock-art motifs such as x-ray elements and internal hatching of the figure with red lines. The artists emphasise the uniqueness of their style and are explicit about its associations with their 'stone country' and 'freshwater' origins.

The current picture of artistic development in western Arnhem Land reveals strong regional variations. Artists undergo a fairly long-term apprenticeship and it is usual for younger artists to adopt the innovations of their senior teachers. This picture must be understood in relation to the new settlement patterns that developed in the contact situation, where senior artists have often formed their own camp within a town or established themselves as the 'boss' of a particular outstation. The clustering of junior artists around senior men located at different communities results in the development of 'schools' within the broader stylistic continuities characteristic of the region. Clan affiliations may influence these associations of individuals, but the sharing of knowledge about ancestral matters is much less focused upon clan ties in the west than it is in eastern Arnhem Land.

New developments

Mountford and the Berndts had occasionally given paper or cardboard to artists for the production of paintings. Paper was introduced to Oenpelli in a more concerted way in 1990 by an Adelaide-based dealer collecting on commission for a major American collector, J. W. Kluge. This paper was artist's archival-quality material made from 100 per cent cotton, manufactured by the French company, Arches. The availability of paper for commissioned work solved the problem posed by the seasonal availability of bark. It also provided a stable art medium, and was relatively easy to transport, to mount and frame, creating a highly saleable finished product.

David Cossey has described how dealers and the then arts adviser at Oenpelli experimented with gouache watercolours to create background effects similar to those found on cave surfaces. The paper is moistened, and layers of different colours are used to

create a texture of gradual surface variations similar to a rock surface. The artists complete the paintings on top of these prepared backgrounds. At Injalak Arts and Crafts Association today, some young men specialise in the preparation of paper, as a matter of preference, leaving other artists to complete the work at a later date.

Sporadic attempts to introduce media such as cartridge paper, Masonite, and canvas to Arnhem Land artists have rarely been a market success. The resulting works are generally too flat in appearance; the regularity of the work and the predictability of the surface fail to create the tensions needed to sustain interest. By contrast the current works on paper come alive partly through the interactions between the background texture of the work and the figures painted over it. The method by which these backgrounds are developed can result in unpredictable and surprising results. The texture of the background may affect the artist's positioning of figures and contribute to the overall dynamic balance of the work, and thus the work is strongly influenced by the new medium on which it is being produced

The use of Arches paper has led to some spectacular and complex works, particularly by the artists Barrdjaray and Bardayal [55]. The format of the prepared background appears to have encouraged the development of intricate compositions that create a frieze-like effect similar to the impression gained when viewing a rock-art shelter. In this vein Barrdjaray and his son and nephews have produced elaborate representations of the ancestral associations of their clan lands at Malworn that are more detailed that any previous bark painting. The frieze provides an opportunity for depicting a multitude of overlapping and interlocking figures in dynamic expressions of movement and life. Similarly Bardayal has for the first time produced large works that reveal scenes relating to old ceremonies such as Wubarr, and detailed compositions incorporating the variety of **Dreamings** associated with his stone-country home.

Artists in the contemporary context

Now that Kunwinjku do not generally live near rock-art sites, bark painting and painting on paper for the market have come to have an important role in circulating religious knowledge in the secular realm. The development of the market has seen Kunwinjku draw from a number of traditional arts to construct a medium that is appropriate for themselves and for the communication of religious ideas to audiences beyond their country. Kunwinjku have controlled and negotiated market demand for their work and met this demand in a manner that is also, in their view, culturally appropriate. Paintings now have two uses and two audiences; they are used in a didactic way within Kunwinjku society, and to promote the power of the culture further afield.

Artists can readily articulate the differing artistic interests of, for example, itinerant contractors who visit the region only sporadically and have little extended appreciation of the art, missionaries who may disapprove of certain subjects, and serious collectors who return on a regular basis and are interested in more important cultural themes. Some artists have seen their works hanging in major galleries in southern cities and have developed strong personal relationships with influential curators and dealers. Some of these non-Aboriginal agents have been drawn into Aboriginal systems of alliance, and have had the power of ancestral subjects revealed to them in ceremonial contexts and through visits to important creation sites. This is the Aboriginal counter to attitudes that are denigratory to their culture.

As a background to these developments, market linkages have been developed by missions and by government agencies to ensure some protection of Indigenous structures of authority and control. Kunwinjku contact history, in Jon Altman's view, has been framed by relations with a relatively benign welfare state. Kunwinjku are afforded

117

the protection of living within Arnhem Land, which has been a reserve for Aborigines since 1931, and Aboriginal land since the passing of the Commonwealth *Aboriginal Land Rights (Northern Territory) Act 1976* [see **land rights**]. A good deal of anthropological advice was incorporated in the development of the marketing framework for Kunwinjku art and, since the early 1970s, the federal government has financially supported the marketing infrastructure through such measures as grants for the employment of arts advisers by community arts co-operatives [see **art and craft centres**]. At Oenpelli, on the edge of Arnhem Land, artists have confronted heavy pressure from private sector enterprise that would have them compromise their art for commercial purposes. Yet Kunwinjku religious motivations are extremely resilient; they have met these pressures and transformed the circumstances into opportunities for promoting the depth of their culture.

Certainly it is important to capture the very important connections between rock art and arts produced for the market in Arnhem Land. These connections exist, and they are continually renewed. Yet it is also important to be aware of the traps posed by appeals to tradition as a means of authenticating culture. It is important that contemporary artists do not find themselves boxed in by market demand for a 'primitive'-looking product. My concern is that the market should remain responsive to new modes of expression, helping in turn to educate broader audiences about the variety of Aboriginal artistic expression.

LUKE TAYLOR

Altman, J. C., *Hunter-Gatherers Today: An Aboriginal Economy in North Australia*, Canberra, 1987; Bardon, G., *Papunya Tula: Art of the Western Desert*, Ringwood, Vic., 1991; Cossey, D, 'Introduction to the commission', in C. A. Dyer (ed.), *Kunwinjku Art from Injalak, 1991–1992: The John W. Kluge Commission*, North Adelaide, 1994; Le Brun Holmes, S., *Yirawala*, Milton, Qld, 1972; Le Brun Holmes, S., *Yirawala, Painter of the Dreaming*, Sydney, 1992; Morphy, H., '"Now you understand"—an analysis of the way Yolngu have used sacred knowledge to retain their autonomy', in N. Peterson & M. Langton (eds), *Aborigines, Land, and Land Rights*, Canberra, 1983; Spencer, W. B., *Native Tribes of the Northern Territory of Australia*, London, 1914; Spencer, W. B., *Wanderings in Wild Australia*, 2 vols, London, 1928; Sutton, P., 'Responding to Aboriginal Art', in P. Sutton, (ed.), *Dreamings: The Art of Aboriginal Australia*, New York & Ringwood, Vic., 1988; Taylor, L., *Seeing the Inside: Bark Painting in Western Arnhem Land*, Oxford, 1996.

5.3 Mick Kubarkku and the rock art of the Mann River district (NT)
[59]

Aboriginal **rock art** in Australia has always been fascinating both for its aesthetic values and the historical evidence [see **history**] it provides of an artistic tradition stretching back thousands of years. Elderly speakers of the eastern Kunwinjku language in western and central Arnhem Land still remember their childhood days living in the rock shelters of the Arnhem Land plateau outliers and watching new layers of artwork being superimposed over the numerous existing layers which have always decorated their living spaces.

Mick **Kubarkku** from the Mann River district in Arnhem Land has lived all his life in the rocky escarpment country where there are thousands of ochre pigment images on the walls and ceilings of sandstone shelters and overhangs. Since 1994 Kubarkku and his kin have been participating in a rock-art research project coordinated by the Bawinanga Aboriginal Corporation, a **Maningrida**-based Aboriginal land and community resource centre [see 13.5]. Using photographic, video, and audio recording, the eastern Kunwinjku have been documenting the contemporary cultural significance of the rock art within their clan estates along the Mann and Liverpool rivers.

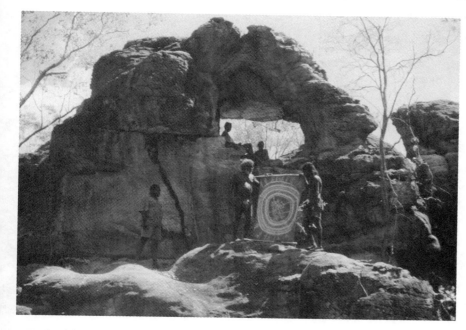

59. Mick Kubarkku and family at Dird Djang, moon Dreaming site, 1994. They hold a painting of this very site, depicting the circular hole that is said to have been created by the rainbow serpent piercing the rock.

In the following narrative in the eastern Kunwinjku language, Kubarkku discusses a number of aspects of rock art at sites near his home at Kubumi.

Bengkayi kumekke ya. Nakudji dolobbo birri-bimbom.
People painted whatever they thought about, yeah. Mostly they painted on bark.

Kureh yerre maneh bo-wam bo-rayi la naneh birri-niwirrinj birri-bimbuyi konda ku-warddewardde la kondah Kabadyorrkbun birri-bimbuyi namekke.
After the time when there was a great drought and water flowed again, people lived here and painted on rocks here at Kabadyorrkbun [on the middle Mann River]. That's where they painted.

Mayh nungka ke birri-djal-kurrmeng, minj rarrk ka-karrme, kayakki rarrk-yak yoh.
They painted animals or they just painted anything, but not cross-hatching, there was none of that *rarrk* [a form of cross-hatched infill common on bark paintings made today for the art market].

Minj ngalyod mak ka-yo njalehnjale ka-yo minj birri-bimbuyi larrk.
And there are few paintings of rainbow serpents or anything like that, they didn't paint those, no.

Birri-bimbom mayh, bininj, kunj, mimih ya.
They painted animals, people, kangaroos, and *mimih* spirits, yeah.

Djangkayi yameninj nakka wanjh namekke birri-bimbom ba minj birri-rarrkwemeninj ya.
Someone would go hunting and spear something and then that's what they would paint but they didn't use cross-hatching.

En ngalyod yiman njalenjale birri-bimbuyi la ben-nguyi, ya ben-nguyi bedberre wanjh ku-ronj birri-yuwurrinj ya birri-bawong ngalekke ngalyod.
They thought that if they painted anything like a rainbow serpent that it would

119

consume them, because serpents lived in the water [close by], and so they left those rainbow serpents alone.

Mayh birri-kurrmekurrmeninj rowk kunj nungka ke but marrek ngalyod birri-kurrmeninj ya ku-wardde marrek ka-bimyo wardi birri-bimbuyi wanjh ben-nguyi, wardi ka-yo Kubumi en Kabarrebarre en Dilebang en Milmilngkan en kabolkdadjerren ya ngalyod, konda wanjh kam-re yiman birri-bimbuyi wanjh ben-nguyi.
So they painted all kinds of animals such as kangaroos but not rainbow serpents on rock, they didn't paint them and they didn't want images of them otherwise they might have been consumed because there were rainbow serpents at Kubumi and Kabarrebarre and Dilebang and Milmilngkan and up to where that area finishes, yes, places where there are rainbow snakes. If they came here then and painted them they would be consumed [by the serpent].

Birri-keleminj wanjh birri-bawong dabbarrabbolk.
They were frightened and so the old people left that alone.

Birri-yolyolmeng dabbarrabbolk nakka ben-nguneng berrewoneng en bene-nang birlmu nawu ka-bimdi.
The old people also told stories about how those two women were eaten when they saw the barramundi, like in the rock painting there.

Bene-nang en djenj, djenj, bene-yimeng wanjh bene-kom-mey.
They saw the fish and they called out, 'there's a fish, a fish', and they pulled it out by the neck.

Ngalengman yerrkang ngalengman yerrkang, wanjh ben-wayhkeng berrewoneng ya, wanjh djang yimerranj.
One sat on one end and the other did likewise and it lifted them both up yes, and they turned into **Dreaming**.

Namekke djang ka-yime. Ngarr-bimbun en ngan-wayhke ngarrwoneng. Dabbarrabbolk konda birri-keleminj birri-bawongbim marrek wanjh birri-bimbuyi ya.
That's how that Dreaming goes. If we paint it, it might lift us up too. That's the way the old people thought and they were frightened and so they didn't paint some things.

Nangale bimbuyi minj mimih but bininj birri-bimbom, yo Kamarrang Kamarrang, Kela, Kela birri-bimbom kun-red Wamud.
Who painted here? Well it wasn't *mimih* spirits but people who painted them, yes, my father and his brothers and the fathers of Wamud [Anchor **Kalunba**; *212*].

Yo bedberre, mimih larrk.
Yes, these paintings are theirs, and not done by *mimih* spirits.

Nabe yerre, yerre bimbom la nani bininj 'Aboriginal' ya nani nawu ku-wardde and namekke ngamed Marrngunj ya bininj kun-red.
They [the *mimih*] painted over there [the western side of the Mann River] but here it was Aboriginal people who painted, those people who lived in the rock shelters such as at the place called Marrngunj, which is a place humans occupied.

Yo, kudjewk. Kudjewk nawu birri-djal-di kondanj birri-bimbuyi.
Here in the wet season. In the wet season they just stayed in these shelters and they would paint [*57*].

*Dabbarrabbolk na-karrngburk and Kela, Kela, Kela kun-red bedberre ya. Wamud,
Wamud and bedberre kun-red ya and wurdurd bindi-bidkuykmerrinj kondanj kun-red
a birrih-diwirrinj.*

All of my ancestors, my father and his brothers, and Wamud [Anchor Kalunba] and
his older brothers. When they were here they made hand stencils of their children [by
blowing ochre over their hands], here where they used to live.

*Yoh nga-yoy konda bu ngandi-bukkang and njamed kurrambalk bolkkime dolobbo ya
nakka nga-yoy but nani dabbarrabbolk birri-yoy na-karrngburrk and Kela yo birri-
niwirrinj birri-yuwurrinj.*

I camped here when I was young and the old people showed me this place. Today we
live in houses but then we lived in bark houses [see 19.1], me and my father and his
brother, they all lived [like that].

*Birri-yuwurrinj la mak kun-kod birri-buyi kureh birri-kodbarrebuyi kunukka
kuberrkbeberrk ya la birri-bimbuyi wanjh nani bim ya nani nawu.*

They also made houses from paperbark out in the open [not in rock shelters] and
would go off to paint on rock such as these paintings here.

*Nani and mimih and njalehnjale and birrih-bimbuyi nanih, nanih birri-bimbuyi Kela,
Kela, Wamud birri-bimbuyi. Birri-bimbuyi birri-bidkuykmerrinj bininj duninj nakka
bininj duninj.*

They would paint all kinds of subjects such as *mimih* spirits or they would spray their
hands with ochre to make a stencil. That was people doing this, men.

*Nani nangamenani wardbukkarra-wardbukkarra yo nanih. Yo, daluk, kaluk nawu
kun-ngarlabak nguyi ngarrku, kan-ngarlabaknguyi.*

This painting here is what-d'you-call-it, *wardbukkarra-wardbukkarra*, yes here. Yes,
this one is a woman, and they eat our cheek flesh, they eat our cheeks.

Nakka nani ka-bimdi, kun-ngarlabak nguyi ngarrku wardbukkarra-wardbukkarra.

That's what those paintings are, they eat our cheeks those *wardbukkarra-
wardbukkarra* spirits.

*Birri-nayinj dabbarrabbolk wanjh birri-bimbuyi, birri-bimbuyi nungka wardbukkarra-
wardbukkarra ben-ngarlabak-nguyi birri-yuhyungki, ya.*

They would have seen them and then painted them, they painted the *wardbukkarra-
wardbukkarra* spirits who ate the cheeks of the first people, yeah.

Nameke nungka wardbukkarra-wardbukkarra yo.

That's the *wardbukkarra-wardbukkarra* spirits, yes.

Ngal-dahdaluk na-rangem na-buyika nani wanjh konemkuyeng nungka.

And there are female ones, male ones, and that other one with the long neck.

Wayarra birri-nayinj birri-bimbuyi 'magic man' nawu bimbuyi.

They saw spirits and a clever man, a 'magic man', would have painted them.

*Ya birri-bimbuyi dabbarrabolk. Ya birri-rayinj la wayarra birri-bimbuyi. Birri-kordang
birri-bimbuyi.*

Yes, the old people painted like that [on rock]. Yes, they'd go about and paint spirits.
'Clever people' would do such paintings.

<div align="right">

MICK KUBARKKU

INTRODUCTION AND TRANSLATION BY MURRAY GARDE

</div>

5.4 Our paintings are our life: Ngarinyin Aboriginal Corporation and UNESCO [60]

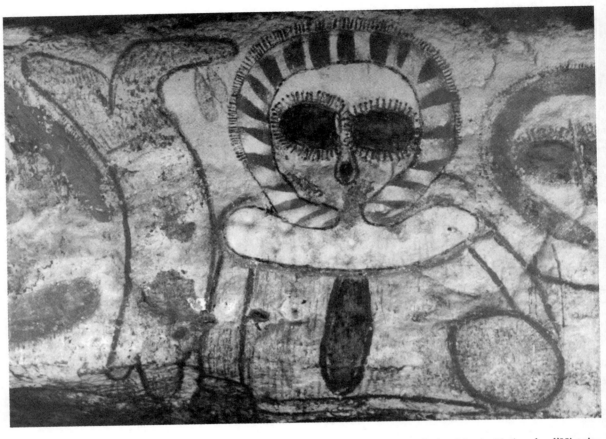

60. Wanjina at Ngawerri, in Wajingongo clan country, central North Kimberley (WA), 1977.
The forked figure on the left of the Wanjina represents a cyclone formation which is strongly associated with Wanjina.

In June 1997, at the invitation of UNESCO and the Musée Nationale d'Histoire Naturelle, a group of senior Ngarinyin Law people gave a speech at the launch of the Pathway Project, a joint archiving venture documenting the cultural significance of Wanjina images from the Kimberley, consisting of a film (*Le voie secret du Ngarinyin*) and an exhibition of photographs. The Ngarinyin elders took this opportunity to draw international attention to the dispossession of the Ngarinyin people and the danger to their **cultural heritage** resulting from the Wik High Court decision of 1996.

Wulun gurruru, Gurramalarr mingirr ganda Ngarinyin. Wulu ngarrun ganda Wanjina ganda, ngulamu Kamali-ngarri.
We bring you greetings from the Ngarinyin people. We are the Wanjina people from the north.

Nyarrun ganda jugul nyadi nirrigu dambun nyadaga way banjali manyirr-go.
We are very happy to be on your country, we don't go this far away from our land usually.

Nyarrun ganda wurramay nyadmanurrugu. Nurrugu warda wunow wunowud narriyali ganda nyadi nurrugu. Boror gajin dali ganda.
Thank you for inviting us to tell our story. Now is a very historic moment for us.

Balbaj bidi nyarrigu wuladibidi, yirrgal ngarlanunggadir. Jariwonunggu, mulmudbirri.
We under heavy pressure from our government, from pastoralists [*yirrgal*, lit. 'fence mob'] and mining companies, and tourist operators [*mulmudbirri*, lit. 'novices'].

Bundu gala mungu budmeri. Bada mungor budmeri dambun mindi.
They are trying to block us off from our country. They are trying to extinguish our **native title**.

Maba nyadirri beja, julu bina ngarawun guban mindi Duna wurwunari julu birri, duna ngadji nyanan.ga, ije anangga, gaingi-ananga, garndingi ananga.
This is our last chance to keep our young generation alive with knowledge of our country, with feeling for our country, with feeling for our mothers, our fathers, our grandmothers, and uncles.

Oyoljiri jowad wuranunga wira widni igalnun.ga gajin.ga budmara bada mugor dambun mindi.
At the beginning of the last wet season, [in December 1996] the Australian High Court decided that pastoral leases do not extinguish native title.

Wandi wudni, wuladi gulangi wunembu emeri.
Now after that decision, the Australian government is trying to reverse that decision.

Waij unem bundu emeri.
They are trying to reject the High Court decision.

Illaygajin, dambun oroy gajin budma nyarrigu.
This will make us orphans and refugees in our own country.

Gagande yalibada nyordon melbara. Wadi bulgu nyadu mirrerr nyurrun ganda wula.
This will kill us off forever. We need your help now more than ever before.

Digu gandaranilu maman.galgu nyurru. Ordeden nyarrigu, Wunggurr jiri.
The reason we come to you is because you are the professionals in your field of **rock art** [*Wunggurr*, lit. 'the life source represented by the rainbow serpent' and, by extension, physical manifestations of that force in the form of rock art].

Nyarrun galguwangarri Wunggurr nungga-gu.
We are the professionals for our own images.

Brrodeden nyarragu dambun duna wurrwun.
Our paintings are the title to our land.

Ari wangara barun-ngarr, brrodedeni burray nunga-gu, mal jubaran.
If we lose our title, the paintings are empty.

Wunggurr nyadaga dimu Wunggurra dambun nyadaga ginyadma-ngarri.
Our paintings are our life because *Wunggurr* and the land and people are all connected [see 2.1, 3.1].

Gajin.ga wuramura nyarrun Wungurrnangga. Wurlan buror gajin. Umbalgan gajin. Ngowan ganda umbalgan gajin. Umbalgun di gajin.ga yobi wandi wanyilgor.
Nobody can live outside of *Wunggurr*. Language makes the foundation of our life. Water is the source of our life. The foundation is made, we can't change it.

Wilinggin jari wulwunngarri birri, nyarrun dambun ni manyid bundan willin.gindi nyadaga. Burru ngadngali ngadmiri, duna maru dambun mindi ngarrawun ngarri gu gandamu, duna waru wurnan-di.

Archaeologists think about life in the past, we are thinking about our living country. If we join our knowledge together, we can protect art, life, and country.

Burrada alyi babiyalu gulingi, malngirri, burruru. Alyi nen.ge barrij birrinya arrungu munawalu yerij burabalu. Nulimal arrungu alyi narrun dali duna banyurun dali buna. Nurrun li wunan weringa nyaru mejerri ling wanyilwun. Ganda alyi wandu arungu mejerri. Maman.gal buno arungu bandu narun alyi ganda.
Everything comes from underneath the ground, the rain, the lightning, the people. They go up to the sky and come back down, but everything starts from underneath. They reflect each other, the top and the bottom. We are the people with the story and the feeling from underneath the ground. You people have one view, the scientific view, but we can reflect each other. You are neighbours at the top, we are your neighbours from underneath.

Wurnan wandi wu-ingga. Wali galumandi angga minyi gulangi-gu. Diralgi-gu wandi uwingga. Wanyid jilan ngarawun-gurde. Nyarrun ganda wul wanyid ningan nurrugu, gurramalada. Gurrama mingirr.
Our relationships come from the table of the *Wurnan* [the traditional sharing system where items were exchanged with different Aboriginal groups along a trade route]. The sharing system formed itself at that table. Before this table turned to stone it was a coolamon made of stringybark for carrying black plums (*gulangi*). We keep it as a living thing. We are here now, are reaching out to you, to your forehead. We thank your kind hands.

<div align="right">

SPEECH COMPOSED AND GIVEN BY PADDY NEOWARRA
TRANSCRIBED AND TRANSLATED BY ANTHONY JAMES REDMOND AND PADDY NEOWARRA
EDITED BY THOMAS SAUNDERS AND DICKY DADAYA

</div>

5.5 'Play about': Aboriginal graffiti in central Australia

Although numbers of European explorers and early travellers in central Australia commented on discoveries of trees, rock shelters, and rocky outcrops decorated with Aboriginal art [see 3.1, 5.1, 5.2, 5.3, 5.4; **rock art**], the first scientific study only began in the 1890s. E. C. Stirling, having learnt something of the meanings of the art at a limited number of sites in 1894, further commented: 'Probably some of them are merely idle scribblings without real meaning.' This was no advance on the speculative comments by explorers such as Alfred Giles and William Gosse in the 1870s, even though the comment was made in the context of the beginnings of a framework of understanding. It does hint, however, at the existence of a genre that might be termed **graffiti**. Baldwin Spencer and Francis Gillen confirmed this when they reported that there were two 'quite distinct sets of rock drawings made by the Central natives' in the late nineteenth century. Those of greatest significance were 'of a sacred nature', and only to be seen by initiated men, whilst the others were 'made for amusement during idle hours—"play about", as the natives say—and can be seen by men, women and children.' Included amongst these works were 'stencilled hand or, as it is commonly called, the "red hand"' [*375*]. In addition there were naturalistic sketches which were both traditional and also inspired by the establishment of permanent European settlements in central Australia in the 1870s. Thus the schoolteacher, Maise Chettle, whose father owned a station near Oodnadatta and who taught at 'The Bungalow' in Alice Springs in the mid 1930s, noted:

The Aborigines' talent and urge to draw things observed in their lives extended far beyond The Bungalow's environment. On the cattle stations far and wide, including our own horse

breeding station near Oodnadatta, all the round squatters' tanks, painted black to reduce evaporation, were canvases for aboriginal art. They bore realistic reproductions of motor trucks, camels and donkey teams, even aeroplanes, as well as wallabies, perenties [large lizards] and snakes.

On paler surfaces charcoal, readily available from campfires, was the favoured sketching 'pencil'. It was sometimes used to draw an outline round the ancestral red hand-stencils, or to add fingernails to them. From the 1880s to the 1970s depictions of cattle station life were also favoured: the rider on a bucking horse, free-running horses, and long-horned cattle were universal favourites [61]. During the 1970s and 1980s a number of water tanks bore images of the popular martial arts, and sexual activity became a more constant, but still relatively rare, element in the 1980s and 1990s. Overt political statements, common in urban Australia, remain virtually non-existent in central Australian Aboriginal graffiti.

The expression 'play about', first recorded almost a century ago, has remained in use through to the present, and may refer to art, dances, or certain activities at kindergartens and primary schools. Aboriginal children of both sexes are particularly perceived as likely to be involved in 'play about'. The expression is used for almost any kind of artistic endeavour by any age group that is undertaken in a light-hearted, instructional way—without serious intent—or that incorporates Western, manufactured items, **Aboriginal English**, or the exaggerated imagery of popular music and magazines. Textas are by far the most highly favoured media, and the smooth bark of street trees, iron fences, white and other pale coloured, painted walls, water tanks used for stock or at roadside stops for tourists [see 18.1], and bridge supports are the favoured art surfaces. Identification of person, home locality, and date are the most common forms of graffiti today, with 'true love' messages also very common, and the association of young males with **Australian Rules football** teams probably next in significance. A continuation of traditional 'play about' is found in the use of fine, brown mud to make hand prints on surfaces such as bridges or white motor vehicles, or in the use of manufactured paints to make bright hand prints on otherwise pale surfaces.

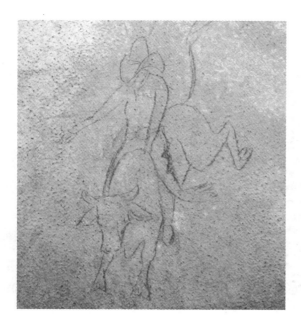

61. Stockman riding bull, on a water tank at Tarrawarra Bore, west of Haasts Bluff (NT), 1985.

5.6 Writing on walls: Reflections of rock-art traditions in 'urban' Aboriginal art

Visual representations stencilled, painted, engraved, or pounded into rock surfaces mean many things to Indigenous urban and rural artists, depending on their family background and the areas from which they come. In some areas, the stories of the ancestors encoded in **rock-art sites** have been handed down from generation to generation, and the sites themselves are redolent with the power of ceremonies held there. In more urbanised areas, Indigenous forebears were all too often separated from their country by encroaching European occupation. Here, rock-art sites act as a potent reminder of a cultural heritage to which living people yearn to belong, but from which they have been locked out. Rock-art sites are tangible evidence of the past achievements of Indigenous cultures; they have often been of pivotal importance to communities and to individual artists in connecting to and rebuilding their links with their heritage.

The Wiradjuri artist, poet, and activist Kevin **Gilbert** [see 4.5; 62] who between 1965 and 1969 produced a series of black-and-white linocuts in various New South Wales prisons [see **prison art**], is the first known Aboriginal printmaker. In *My Father's Studio*, 1965, the viewer is placed inside what appears to be a cave, close to the entrance, surrounded by myriad designs ranging from a hand stencil [see 375] and images of tools, bush food, and anthropomorphic depictions of spirits, to what looks like a Christian grave-marker. Beyond the dark walls of the cave is an Aboriginal man seated on a rock, spear in hand, a stream at his feet, staring at a sky swirling with spirit life.

The print contains a number of spatial ambiguities and conceptual counterpoints. Which is the studio: the cave interior or the inspirational space of nature from which Gilbert's ancestor gains nourishment? The form seen through the cave entrance is evocative of the space of the cranium itself, suggesting that the whole scene may be imagined from somewhere else. If we read Gilbert's studio as analogous to the interior walls of the cave in which his 'father' worked, he is in a sense mingling their two identities and gaining strength in the process. Following this reading of the work further, the confining prison becomes a space filled with knowledge and with a living heritage that sustained the artist throughout his imprisonment. Other prints in the series—*Boothung and Mirrigarng*, *Lineal Legend*, *Wahlo: Tribal Lore*, *Eaglemen Legend,* and *Marbung*—show that the inspiration of Wiradjuri culture was with him at that time, and throughout his life.

Rock-art subjects feature among the images of loss, survival, connection, and reinstatement of cultural heritage explored by the Nunugal artist, Avril **Quaill**, in the 1980s. She left home on Stradbroke Island to study at Sydney College of the Arts (SCA). Through her part-time job at the Aboriginal and Islander Dance Theatre [see 16.5], Avril was invited on an excursion to Ku-ring-gai Chase (NSW) in late 1984 with Parks and Wildlife Service rangers, Aboriginal and Islander Dance Theatre students, and prospective students [54]. The trip was a catalyst, introducing her to the Aboriginal culture of the Sydney region through its rock-art heritage, and demonstrating the possibility of connection with that heritage as the dancers performed near the rock-art site of Baiami. Between 1985 and 1988, Avril produced a series of drawings based on the event.

At that time there was a growing sense of community among urban Aboriginal people [see 12.1]. Young Koori and Murri art students who had felt isolated within mainstream institutions became aware that there were a number of other Aboriginal people studying and working in Sydney, and began to connect with them. In 1985 Janet Mooney, an Aboriginal teacher of art at Cleveland Street High School, asked Quaill to lead a mural project with Fiona **Foley** [see 23.2; 2, 165], who was also studying at SCA. Following extensive discussions between the artists, staff, and Indigenous and non-Indigenous students, it was decided that the mural should make local Aboriginal heritage visible to the students, and link the student population, across time, to that rich cultural heritage [63]. In the final design, the image of the rainbow serpent and footprint motifs connect contemporary Indigenous people—a young man working at Radio Redfern [see 13.4; **radio**], and two students at the school—with the ancient ancestral creator being, Baiami [see 11.1]. The mural project embodied the non-Indigenous students' knowledge of the rainbow serpent, and the Aboriginal students' knowledge of Baiami. By linking three contemporary young people with depictions of ancestral beings it suggested that living people can be sustained and nurtured by their own cultural heritage.

62. Kevin Gilbert, *My Father's Studio*, 1965. Linocut, 30.2 x 61.8 cm.

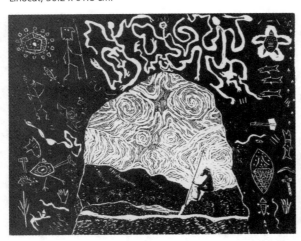

63. Avril Quaill and Fiona Foley, Baiami figure on New Cleveland St High School Mural, Alexandria (NSW), 1985.

The rock-art figures from the Laura area of Cape York Peninsula [51] have become a source of a profoundly personal imagery for Arone Raymond **Meeks**. Arone's grandfather's country, between the Palmer and Mitchell rivers in Cape York Peninsula, was devastated by the Palmer gold rush in 1872 [see 8.1, 8.2]. Hundreds—if not thousands—of the local Kokomini were massacred [see **massacres**], rivers polluted, and drugs and disease were introduced. Despite this destruction, the rock paintings of the Kokomini, located in hundreds of caves in the Laura sandstone belt, some 160 kilometres inland from Cooktown, lay undisturbed.

As a child, Arone had learnt from his grandfather about the bush, the spirits that lived there, and their Law. He moved to Sydney in the late 1970s, studying at the Alexander Mackie College of Advanced Education and City Art Institute in the 1980s. Images came to him in dreams, and began to infiltrate his art. In 1988, he visited Laura with the senior Napranum artist, **Thancoupie**, and the students of the Cairns TAFE. There he was formally given the name of Arone (black crane) by Thancoupie and members of the Napranum community, in a traditional Aboriginal naming ceremony.

Arone commemorated this important event in a series of *Laura Dreaming* works (1989–90) [64]. The first work in the series, a classic black-and-white linocut, became the basis for a large **acrylic painting** of the same year, as well as a colour linocut. Although delicately rendered and small in scale, the first linocut is a powerful depiction of creation, coupling, fertility, metamorphosis, and archetypal dream imagery. At the left of the work, a 'child' figure spreads its arms to receive knowledge and experience. This figure, like the yam below, is common in the Laura galleries and occurs in a number of Arone's works—a symbol of himself, and his emotional and spiritual growth. In *Laura Dreaming*, Arone as the child figure, newly named, reaches out to embrace his heritage. Similarly, in *Common Ground*, 1997 the artist appears as an adult reaching out to connect with a white figure. The background of archetypal imagery suggests the possibility of shared human experience.

Interest in rock art has been an unconscious rather than conscious aspect of the work of Tasmanian Aboriginal artist Karen **Casey**. In early works such as *Eternal Vigil*, 1988 and *Hot Fitzroy Night*, 1989, where she expresses her personal views on social and environmental issues, figurative images are often used as metaphors of the land, and of life itself. This interest in the essence of the land resurfaces in her paintings, sculptures and installation work from 1992 when she began a process of 'earth awareness'. Her multi-sensory work, *Transformation*,

1993, installed in the National Gallery of Victoria for the Fifth Australian Sculpture Triennial, evoked the sense of an underground cavern complete with a large earthenware maternal vessel. Sound, smell, and lighting were combined to induce a meditative state and to bring the viewer into tune with the rhythms of the earth, creating a sense of unity between person and the environment.

Recent installation work, such as the *Dreaming Chamber*, 1999 [65] for the Asia–Pacific Triennial at the Queensland Art Gallery, further developed her explorations in experiential art, combining the elements of sound, light, and water. The rock-like canvas surfaces appeared animate when lit from behind, and images, figures, and patterns seemed to emerge from the walls. The sound of Papua New Guinea Highland flutes resonated through the space as synchronised pumps in the water choreographed an increasingly complex series of patterns on its surface. These ripples, reflected onto the walls of the chamber, produced evanescent, *raark*-like patterns. The artist's intention was to capture layer upon layer of the earth itself in order to communicate a sense of timelessness—an imprint of the land's memory, recording all things, including rock art, which have taken place upon and within it. The cumulative effect of the action of light, water, and sound, dissolves the matter of the 'rock' walls.

Thus rock art has been, and no doubt will continue to be, an important subject for urban and rural Aboriginal artists, representing as it does the deep layers of artistic, emotional, cultural and spiritual expression to which they are heirs [66, 67]. In many ways, rock art has acted as a lifeline to these artists, connecting them to their heritage, to other Aboriginal people, to deeper parts of themselves and their potential, and to the substance of life itself.

CHRISTINE WATSON

Gilbert, K. & Williams, E., *Breath of Life: Moments in Transit towards Aboriginal Sovereignty*, Canberra, 1996; Queensland Art Gallery, *Third Asia–Pacific Triennial of Contemporary Art*, Brisbane, 1999; Sever, N., *Arone Raymond Meeks: Common Ground*, Canberra, 1997; Watson, C., *Najanooga: Paintings and Prints by Aboriginal Artists*, Paddington, NSW, 1989.

65. Karen Casey, *Dreaming Chamber*, 1999.
Installation with canvas, pigment, water, and synchronised sound and lighting (detail). The work was installed for the Third Asia–Pacific Triennial at the Queensland Art Gallery.

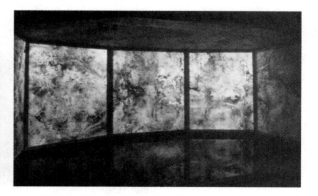

64. Arone Raymond Meeks, *Laura Dreaming*, 1989.
Linocut, 30.2 x 61.8 cm (print), 56.4 x 76.8 cm (sheet).

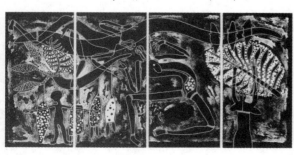

Graffiti is often said to be a means of expression used by the oppressed. There is an inherent element of this in much of the Aboriginal graffiti in central Australia, but there is also a continuum in individuality of artistic expression that relates to pre-European contact traditions.

RICHARD G. KIMBER

Chettle (née Robb), M., *Just Me*, Henley Beach, SA, 1997; Spencer, W. B., & Gillen, F. J., *Across Australia*, London, 1912; Stirling, E. C., 'Part IV: Anthropology', in W. B. Spencer (ed.), *Report on the Work of the Horn Scientific Expedition to Central Australia* [facsimile reprint] Bundaberg, Qld, 1994.

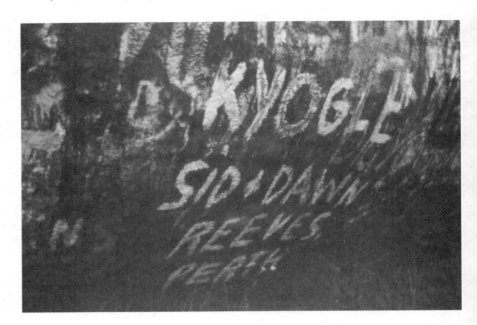

66. Destiny Deacon, *Koori Rocks Gub Words,* 1990. Black and white photograph.

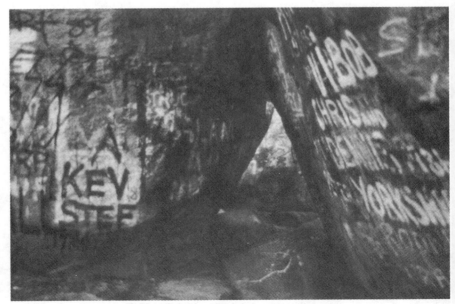

67. Destiny Deacon, *Koori Rocks Gub Words*, 1990 Black and white photograph. Destiny Deacon writes: 'Perhaps these rocks (The Sister Rocks near Stawell, Victoria) define Koori female darkness, values, secret knowledge—yet the Gub words show graffiti of fear and disconnection.'

6. Arnhem Land

6.1 Inner landscapes: The fourth dimension

Landscape is both the meeting place and the point of division between Aboriginal and European art. Painting has been a European way of understanding place since the time of the Enlightenment. In the seventeenth and eighteenth centuries the artists of the 'voyages of discovery' used art as a means of analysis and description. Their intention was to bring home images that would provide information about exotic environments and their peoples. A particular mode of representation was required: one that conveyed the scale and proportion of the topography, and provided information about climate and fertility in a recognisable idiom. The emphasis was on surface form and on panoramic views that included as much as possible of what was visible. Art was part of descriptive science: it both imposed itself on the landscape and revealed it. The requirements of the expedition sponsors influenced what features were recorded, and the technique of perspectival representation affected how they were represented. Yet at the same time art was exploring the unknown. Imposition and revelation continue as parallel trends in European-Australian landscape painting well into the twentieth century. At different times the landscape was tamed and domesticated, made romantic or picturesque, or shown to have characteristics of light and colour that conveyed a sense of its unique qualities. Aborigines appeared in this art as figures in a landscape, but it was no longer their landscape. European art distanced the land from Aboriginal conceptions of it: representing the landscape as it was seen by Aborigines was never part of the agenda. And yet Aboriginal art, too, was all about land.

Exhibitions of Aboriginal art have often stressed the connection between art and land, or place [see 2.1, 21.1]. Paintings are associated equally with ancestral being and place. Elements of their design often represent features of a landscape—a waterhole, a claypan, a range of hills. Designs are part of the specificity of place, since each place has its own associated set of designs. These designs are also redolent with the memories of people— those who had the designs painted on their bodies [58] or inscribed on their souls. Art marks the journey of ancestral beings who, through their actions, created features of the landscape. They became embodied in the land, and when people moved they walked on the bodies of the ancestors. The ancestors also took the land and made it part of themselves in the form of art—paintings, sculptures, songs, and dances—that became a record of their creative acts. Landscape is an externalisation of the ancestral beings; through paintings and sacred objects their human descendants reinternalise landscape in the form of a living and transforming code. Aboriginal art represents (and re-presents) a journey inside the land: it reveals the underlying creative events and gives access to the powers that continually regenerate life. But through its portability art also provides

a means of moving place—through space and time. The painting on the body of an initiate makes him into the ancestor and associates him with the place that the painting represents. Sand sculptures [279], though ephemeral in form, contain the essence of place. They re-contour the ceremonial ground, making it into an arena for ancestral action. In Arnhem Land, paintings on bodies and coffin lids have the power to transport the soul of the dead from the place of death to that of burial. Paintings have been used in court cases to demonstrate land-ownership [see 4.6, 23.2]; paintings are the title deeds to land [see **land rights**].

Like European art, Aboriginal art is characterised by its diversity. Since the Renaissance, perspective has been a normative technique in European landscape painting. Perspective and other techniques of illusion reproduce the landscape as it is seen, or more often, as it is constructed as seen in the imagination of the artist. It is modified through the inclusion of some things and the exclusion of others, through changing relative proportions to create dramatic effect, or even by moving features to fit the conventions of the genre. The overriding principle has been the representation of a vista, distributing things in space, and conveying the surface impression of things. The emphasis in Aboriginal art has been different. There is no single viewpoint, there is less emphasis on surface appearance, there are fewer horizontal views. Landscape is often represented from above, and the relative scale of the features represented reflects their mythological or social significance more than their topographical proportions. The key difference, however, is that Aboriginal art contains a fourth dimension—the 'inside'. Aboriginal art is as conceptual as it is perceptual. It is concerned with ideas and processes more than with appearances, and the perspective that it illuminates is that from the inside.

'Inside' is an important metaphysical and logical concept in Aboriginal systems of knowledge. The opposition between inside and outside encompasses other contrasts, some material, others metaphysical. Inside is below the ground, restricted, within the ceremonial ground, underlying, generative, ancestral. Outside is above ground, open, public, surface, produced. The journey from inside to outside is a movement from more restricted to less restricted forms: the journey from outside to inside is a movement towards deeper understanding. It would be quite wrong to make a simple association between inside forms and secrecy even though, as in most societies, there are secrets. Inside forms are better viewed as truths that have to be approached in a particular way in order to be understood. There is an order in the world, generated from within. To understand it a person must move from the outside to the inside, from surface forms to inner meanings and understandings. In Aboriginal societies art takes the viewer below the surface to reveal the underlying structure of things, the causes of surface form, relationships that are otherwise obscured. And because an Aboriginal world-view is centred on a belief in spiritual forces connected to the land, the perspective from the inside brings people in contact with the spiritual dimension [see 1.1].

Aboriginal art represents the inside in many different ways: by showing the internal organs of animals or the burrowings of creatures beneath the ground, by encoding meanings in abstract designs that belong to no particular dimension and which can be interpreted to refer to both outside and inside things, and by interweaving representations in such a way that the boundaries between representation and abstraction are dissolved. While elements of all these representational processes can be seen across Australia, the emphasis varies from place to place. In looking at four paintings from different regions of Australia I will show how they share common themes beneath their surface differences and how, in very different ways, they contribute to an understanding of the relationship between the inside and outside.

The first two paintings are *Djarrakpi Landscape*, 1976 [*68*] by Narritjin **Maymuru**, the Manggalili artist from Yirrkala in north-eastern Arnhem Land, and *Yuutjutiyungu*, 1979 [*220*] by the Anmatyerre artist Clifford **Possum Tjapaltjarri**, from the Central Desert. Paintings from Arnhem Land and the Central Desert have more in common than their stylistic differences suggest. Both paintings are representations of areas of land, almost maps. Neither represents the geographical features in 'true' topographical space; nevertheless, both relate directly to features of the landscape.

Narritjin's painting represents the mythological topography of Djarrakpi, a peninsula jutting out into the Gulf of Carpentaria. Djarrakpi centres on a shallow lagoon that is separated from the sea by high sand dunes. The inland margins of the lagoon are defined by a long gravel bank. It is an area of great natural beauty, and some mystery. The morning mists over the lagoon keep the sap in the surrounding stringybark trees flowing longer than elsewhere, allowing bark to be removed for painting and building huts well into the dry season. The lagoon is slightly salty, and fresh water has to be fetched from the springs that bubble up at low tide on the beach-side of the dunes. The painting can be interpreted both as a representation of myth and as a 'map'. This double frame, this switch of reference, gives art its power to reveal the inside, linking in a single form things which on the surface appear separate.

The painting shows a number of ancestral beings who journeyed from Donydji in central Arnhem Land to Djarrakpi. The leader of the group was the koel cuckoo (*guwak*), accompanied by possums and an emu. Each night the *guwak* would roost in a native cashew tree. The elongated figure on either side of the painting represents the head and body of the *guwak*, dividing at the bottom into legs and wings. The *guwak* is depicted eating cashew nuts which hang in bunches from the tree in the centre. After it had eaten, the *guwak* asked the possums to spin their fur into lengths of string. The possums spent all night climbing up and down the tree, spinning their fur. The body of the *guwak* now also represents the trunk of the tree, as does the central figure where the possums climb up and down. In the morning the *guwak* would give out lengths of string to the Aboriginal people who lived in the place for them to use in manufacturing sacred objects. He would then fly on to his next destination, taking a length of string with him in his beak. The body of the *guwak* now also represents this length of string, known as *burrkun*. Sometimes the *guwak* would let go a length of string and where it fell on the ground it would be transformed into a natural feature. As they travelled, the emu found water for the others by scratching in the ground with its foot, creating waterholes.

Djarrakpi was the final destination of the *guwak*, and in the painting the mythical action is shown transformed into landscape. The painting is oriented from north to south. The left side represents the high sand dunes and the beach, the centre represents the lagoon, and the right side represents its inland margins. The *guwak* landed first at the foot of the lagoon on the inland side. The possum spun lengths of fur string. Some of it was transformed into gullies in the sand dunes, another length was stretched out to form the low gravel bank. The *guwak* then flew on to the head of the lagoon where he ended his journey on a cashew tree, represented by bunches of nuts. The lagoon was created by the emu digging in the ground. The central feature—the tree-trunk and the climbing possums—now represents the bed of the lagoon itself. On the other side of the lagoon lived two women, the shy Nyapililngu. They were naked and did not know how to make string for baskets or pubic aprons. However, they learnt by observing the possum. They spun and spun, and the piles of string were transformed into the high dunes that separate the lagoon from the sea.

We have only begun to explore the possible interpretations of the painting, but already it should be clear how it moves us inside the landscape. The multiple interpretations

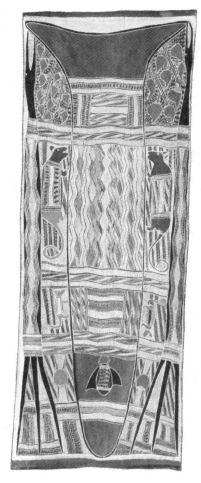

68. Narritjin Maymuru, *Djarrakpi Landscape*, 1976. Natural pigments on bark, 120 x 75 cm.

associated with each element allow the forging of associations as we switch reference from the myth to the landscape—from the tree-trunk, to the possum, to the gravel bank. Over time the individual viewer develops a complex understanding of the mythical history of the place.

Clifford Possum's painting covers a larger area of land than Narritjin's, representing an area of some forty by sixty kilometres on Mt Allan cattle station. It illustrates a number of separate and interrelated mythical events. Yuutjutiyungu is the hill represented by a large oval shape in the centre of the painting. To the right the sinuous line with alternating tracks marks the route of the possum ancestors. One story concerns a Kadaitcha man (a ritual assassin) who journeyed around searching out sacred boards. He had stolen some of those in Alyawarre country and had heard about a set held by two women who lived on the top of Yuutjutiyungu, but he failed to capture these. The women are the U-shaped figures sitting beside a sacred board at either end of the mountain; the Kadaitcha man's footprints can be seen tramping around its base. A second myth involves the journey of a man from Tjunykurra (in the lower left of the painting) to Yuutjutiyungu. This man saw a storm cloud forming, and to escape it hid in a cave below the hill, or, in another version, built a shelter. However, this was to no avail: lightning struck the cave–shelter and blew it to smithereens, scattering pieces of his body far and wide. The explosion is represented by the star-shaped figure underneath the hill.

A series of episodes of the myth of the two goanna brothers are illustrated to the right of the possum tracks. The footprints of the brothers are seen coming into the region. They made camp and while the exhausted younger brother rested, the other went on an unsuccessful hunting expedition. In the next episode illustrated, the elder brother chases the younger, trying to hit him with his axe. Their footprints lead to a rocky outcrop, Warriwarri, shown at the top right of the painting. There the goanna ancestor's eggs can be seen, transformed into round stones. Above the hill a series of scenes represent hunter-gatherer activities. A man is sitting by his campfire, cooking a mass of wriggling green caterpillars (*kapatala*). To the right the footprints of another man lead to a *yakatji* bush fruit. He is represented sitting down with his hooked boomerang beside him. Above this to the right another man is digging edible roots out of the ground.

On the left side of the painting, balancing the images of the goanna men, is a site associated with honey ants. The Warlpiri honey ant ancestor design consists of many elements: curved lines and dots representing the ants themselves, parallel lines that stand for the tunnels linking the separate chambers of their nests, circles representing entrances to the nest, and U-shaped signs and straight lines that can signify women using digging sticks to excavate the nest. At Yuutjutiyungu an ancestral woman is seen sitting on the ground to the left of the hill with her digging stick in front of her. She is represented by the black U-shaped sign and her digging stick by the line of white dots immediately in front. Beside her lies her discarded hair-string belt with its beautiful feather tassel. In front of her are the marks in the ground made as she sweeps her digging stick forward looking for the entrance to the nest, which leads in turn to the hole into the ground and the chambered homes of the big, fat honey ants. This design becomes a refrain for the entire left side of the painting, where the circular motifs repeat themselves and are superimposed on one another to represent the spread of the honey ants' nests.

The painting illustrates superbly the way in which perspective shifts in the representation of landscape in Central and Western Desert paintings. It creates a structure of relationships in the landscape by repeating the same set of geometric elements—a circle, a U-shaped sign, and a straight line—to mark the presence of different ancestral beings at key sites. These elements act as a mnemonic for place. In each site the characters are drawn as if larger than life: giants in the landscape seem to shrink the spaces between.

And in the case of the honey ant woman there is a further shift—from a macro- to a micro-perspective—as the interpretation of the circular motifs moves from above the surface of the earth to the underground chambered passages. Viewed as floating above the surface, the broken circular motifs can be interpreted as clouds spreading out across the landscape from the lightning strike. Viewed as on the surface they represent the many sites around Mt Allan where the ancestral honey ants emerged from the ground. Viewed as below the surface they represent the structure of the honey ants' nests. This switch of reference, which involves dramatic changes of scale, is one of the key characteristics of Aboriginal art.

While Narritjin Maymuru's *Djarrakpi Landscape* and Clifford Possum's *Yuutjutiyungu* seem to belong to very different representational traditions, the more one looks into the paintings the more the similarities emerge. In both cases there is an underlying structure, or template, which marks the passage of ancestral beings across the country and links their journeys to transformation of the landscape. Both paintings contain switches of perspective and scale: the tree that the *guwak* sits on becomes a length of string, impressions on the earth's surface become the entrances to the honey ant's nest. Both are concerned with a move from above to below the surface of the earth. In both there is an interplay between geometric and figurative motifs. The figurative motifs fix for a moment the process of ancestral transformation, revealing the footprints of the goanna man, the ceremonial hair-string belt, the possum climbing the tree; the geometric elements mark in a more general way the sites where the events occurred.

The two paintings considered so far reflect a broad perspective on landscape. The imprint of ancestral journeys is masked by the apparent concreteness of surface form, but moving inside the form of the landscape reveals the forces of ancestral creativity. *Yuutjutiyungu* and *Djarrakpi Landscape* place the landscape in the context of journeys which connect places distant from each other. I now turn to a second pair of paintings which are more narrowly focused—not so much on the land as on the ancestral beings themselves, and on natural species. Whereas the first two paintings are concerned with how ancestors are embodied in landscape, the second pair relate more to how ancestors become embodied in people, and to experiential aspects of the ancestral past or **Dreaming**.

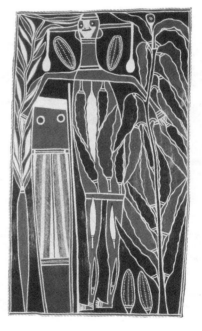

David **Malangi** lived by a lagoon at Yathalamarra in central Arnhem Land. While some of his work has map-like properties similar to Narritjin's *Djarrakpi Landscape*, his paintings of the ancestral spirit Murayana, such as *Murayana*, 1989–90 [69] convey the relationship between the inner spiritual dimension of the landscape and surface form in a more conceptual way. Murayana is a *mokuy* ancestral being associated with mortuary rituals. *Mokuy* spirit beings exist in space between the ancestral world and the world of living human beings, and play a role in mediating between the two domains. They live in the forests and provide companionship to the ghosts of the recently dead; they can also exact vengeance on the living. On the left of the painting is a representation of a hollow-log coffin in which the bones of the deceased are placed in the final burial ceremony. The 'eyes' of the hollow log stare luminously out of the darkness—a sign of the ghost looking for spiritual salvation and a reminder to the viewer of the constant presence of death in life.

69. David Malangi,
Murayana, 1989–90.
Natural pigments on bark,
103 x 57.5 cm.

Murayana is portrayed with multiple ambiguity. Looked at from one perspective he is stretched out on the ground as a corpse, with designs representing leaves of the *warri* tree painted on his chest. From another perspective he appears to loom over the coffin, perhaps offering a protective arm. When people die their chests are painted with sacred designs to link them directly with the spirit world. The designs emanate from the ancestors—from the Dreaming—and are a means of reincorporating the spirit of the person within the spiritual dimension. The leaves are repeated as a motif within the legs of

Murayana. Clan designs, such as these, are referred to as ŋaraka waŋarr ('bones of the ancestors'), and represent the core of the clan's identity. By representing the bones as leaves Malangi refers to this connection but simultaneously alludes to the fate of the dead body. In the past Arnhem Landers practised a form of tertiary burial. A person was first buried in the ground for a few months. The body was then dug up, any remaining flesh was removed, and the bones were placed in a cylindrical bark coffin. Finally, after several years, the bones were placed in a hollow-log coffin [see 6.3; *38, 69, 74, 269, 406*] which was their final resting place. The designs in the painting also represent features of the landscape including trees and plants. The leaves on the body join the leaves of the trees, creating a link between the present and the ancestral past, the living and the dead, the mundane and the spiritual. The transparency of Murayana's body and the inter-weaving of the leaves are metaphors for the interpenetration of the spiritual world and the world of surface form. While focusing on a spatially restricted image, the painting of Murayana, like the other two paintings so far considered, allows shifts of perspective and multiple layers of interpretation, creating a movement between different dimensions of existence, linking the inside with the outside.

The final painting, by Jimmy **Midjawmidjaw**, *Nadulmi in His Kangaroo Manifestation, as Wubarr Leader*, 1950 [*70*] takes us right inside the body of an animal, though once we are inside the body we come to the landscape again. The painting depicts a kangaroo in the x-ray style characteristic of western Arnhem Land [see 5.2; *3, 55, 56, 151, 152, 351, 363, 375*]. The 'shock' of x-ray art is that it combines naturalistic representations of the outer body-shape of animals and fish with often detailed representations of internal organs and some skeletal features. Some organs, such as the heart, lungs, and liver, seem to be represented more frequently than others and more often than not the only part of the skeleton which is shown is the backbone. In referring to x-ray art as 'seeing the inside', Luke Taylor is alluding to its symbolic significance. It is a form of naturalism that delineates the characteristics of the represented animal while revealing the underlying similarities that cut across species. The depiction of the internal organs reveals what animals have in common with each other and with humans. It asserts the unity of nature, which is the basis for the spiritual connections that result from ancestral transformations. The ancestral beings continually change from animal to human shape, from animate to inanimate states. X-ray art reveals the features that remain constant under conditions of transformation.

Although all x-ray art has this link with the spiritual aspect of life, its context is usually secular. X-ray paintings record the animal species associated with particular places, reflect on the success of a day's hunting, or teach the characteristics of certain animals and how they might be divided up for cooking [*3*]. However, x-ray art can also be linked to the ceremonial life of western Arnhem Land, and the form of Midjawmidjaw's painting makes that connection explicit. The internal bodies and internal organs of ancestral beings in their animal form are directly linked to the process of world creation. The ancestral kangaroo, for example, created features of the landscape of western Arnhem Land out of his body parts. His liver, his backbone, his dismembered and distributed body can be seen in the hills, waterholes, and rivers of the Arnhem Land escarpment. The forms of sacred objects used in the Wubarr and Mardayin ceremonies [*58*] reflect these events, and each participating group is associated with a different body part.

While Midjawmidjaw's painting contains representations of the kangaroo's lungs and backbone, it also includes a pattern of circular designs and cross-hatched segments which bear no direct formal resemblance to particular organs of the body. These designs refer to body paintings used in the Wubarr that are associated with the ancestral kangaroo, and to the places that were created by the kangaroo out of its own body. This

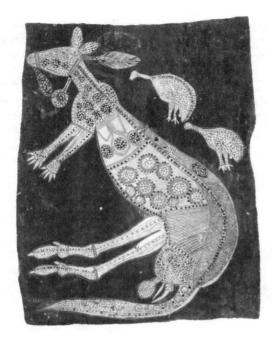

70. Jimmy Midjawmidjaw, *Nadulmi in His Kangaroo Manifestation, as Wubarr Leader*, 1950. Natural pigments on bark, 76 x 58 cm.

painting is not the recording of a successful hunting trip, and this kangaroo is no ordinary, mundane beast. He is Nadulmi, the ancestral being who created the Wubarr for the initiation of young men. In this ceremony the young men, painted with designs similar to those on the body of the kangaroo, participate in re-enactments of the foundational events that resulted in the creation of the landscape in different places across western Arnhem Land. They become the ancestor, they dance the landscape. Midjawmidjaw's painting thus condenses mythological history within the body of the landscape in such a way that, through a process of interpretation and ritual enactment, it reveals the complex chain of events that occurred along the ancestral track of Nadulmi. The landscape that will become a projection of the kangaroo is positioned within the body of the kangaroo as if at the beginning of its creative engagement with the world.

We have looked at four apparently very different paintings from different regions of Australia and have been able to see features that they share in common. To a limited extent the similarities reflect shared representational practices—for example a subtle interplay between the use of figurative and geometric systems of representation. But equally the similarities flow from common ideas about the nature of the world, in particular about the relationship between the inner world of spiritual existence and the outer world of surface forms; and from the way in which art across Australia is integral to systems of restricted knowledge, in which meaning is hidden as well as revealed. In considering Aboriginal art systems it is futile to try to understand the social relations of art independent of the metaphysical understandings communicated. It is equally unproductive to focus on the metaphysics and neglect the social context in which art objects are produced and reproduced. On the one hand, the particular connotations of the relationship between the inside and outside to individual Aboriginal people will be influenced by their experience of social relations, by the existence of systems of clan organisation [see 3.1], by the integration of art within hierarchical systems of knowledge and so on. On the other hand, the social meanings encoded in art in turn become incorporated within the metaphysics of spiritual journeys and become as if generated by the interior order of the landscape. The structure of systems of representation reflects the

contexts of presentation and the variety of audiences—the fact that, for example, some contexts and some meanings are restricted, and that there are multiple bases for restriction. In eastern Arnhem Land there is a movement from geometric to figurative forms as art moves from closed to public contexts. Yet, as we have seen, the relationships between geometric and figurative art and the different ways in which they are combined in the various regional systems of representation are integral to communicating an understanding of the landscape quite independent of any social function that they might have. Aboriginal art is part of a discourse in which the social and spiritual meanings of landscape are revealed by moving the viewer beyond the surface form of things, in order to understand the outside world from within.

HOWARD MORPHY

Johnson, V., *The Art of Clifford Possum*, Sydney, 1994; Lendon, N., The Meaning of Innovation: David Malangi and the Bark Painting Tradition of Central Arnhem Land [unpublished ms], n.d.; Morphy, H., *Ancestral Connections: Art and an Aboriginal System of Knowledge*, Chicago, 1991; Morphy, H., 'Manggalili art and the Promised Land', in L. Taylor (ed.), *Painting the Land Story*, Canberra, 1999; Smith, B., *European Vision and the South Pacific*, 2nd edn, Sydney, 1985; Taylor, L., *Seeing the Inside: Bark Painting in Western Arnhem Land*, Oxford, 1996.

6.2 The Djang'kawu story in art and performance

A myriad of ancestral stories fill the landscape with meaning for the Yolngu people of north-eastern Arnhem Land (NT). Some recount relatively short journeys, while others concern the epic travels of ancestors (Wangarr) from one side of north-eastern Arnhem Land to the other, and beyond. Among the best recorded of these are the journeys of the Wägilak sisters [*150, 257, 316, 325, 337*], from the south, and the Djang'kawu (also two sisters in some variants of the story) from the east [*33, 71*]. The story of the creative journey of the Djang'kawu links the countries of a string of clans of the Dhuwa moiety. A basic narrative, about which people of all participating groups more or less agree, recounts the course of the journey, the places visited, the nature of the creative acts, and other beings encountered. Detailed stories belonging to particular clans tell of events in their own countries. Tellers are more guarded about these, for the details of one clan's stories are in many cases incompatible with other versions.

The narrative

The variants told by members of different clans have features in common. Long ago the Djang'kawu travelled from the east across the sea from Burralku, an island in the east, a land of the dead, to the Arnhem Land coast. They paddled a bark canoe or a raft made of a roll of paperbark (*djutu*) and travelled overland on foot, following the course of the sun from sunrise to sunset. Each carried a pair of digging sticks (*gaṉinyiḏi*) or walking sticks (*mawalan*), one in each hand, with which they gathered food, pierced the ground to make wells and freshwater springs, and paddled the canoe. Each also carried a dilly-bag (*bathi*), and a conical *ŋanmarra* mat [*72*] also filled with sacred objects (*raŋga*) in some versions of the story, used as a cradle and shade for their babies, and as a net for catching fish. Hanging from the sisters' arms and from the dillybags were many fluffy, tasselled cords (*waṉa*, 'arms'), made from the orange breast-feathers of the red-collared lorikeet. As they travelled the Djang'kawu saw and named places, plants, animals, birds, fish, and other creatures, meeting rather different creatures and other phenomena at each clan's country. The Djang'kawu saw other Wangarr on the way, including some of the Yirritja moiety such as Lany'tjung.

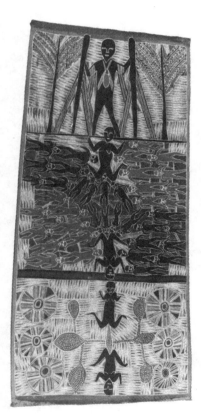

71. Wandjuk Marika, *The Birth of the Djang'kawu Children at Yalangbara*, 1982. Natural pigments on bark, 147.5 x 66.0 cm.

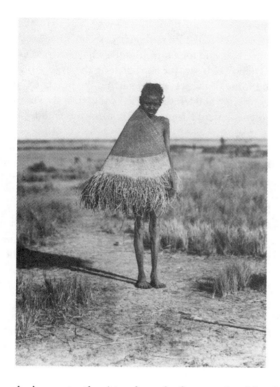

72. D. F. Thomson, *Conical Ngänmarra [ŋaṉmarra] mat, Mandialla Ceremony, Diagallauwumirr Group, Djinang Territory, Arnhem Land*, June 1937.

At each Dhuwa clan's country the sisters bore the first people of the clan in great numbers, named the group, and gave them their language. They created freshwater springs in the salt flats and mangroves, and on the beaches, by piercing the ground with their sticks. The Djang'kawu gave each clan its sacred objects, designs, songs, and ceremonies, putting them in the waterholes and in the ground, and created trees and other things by planting their sacred objects or their digging–walking sticks. On the way the Djang'kawu women lost their dillybags full of sacred objects, forever giving men the right to control the religious Law. Finally, their journey took them out of Yolngu country to the west towards the setting sun. Thus the central themes of the Djang'kawu mythology are of creation and fertility, the giving of sacred objects and knowledge to the various Dhuwa moiety clans, and the sisters' loss of the dillybags and hence of control of esoteric knowledge to men.

Certain features of the stories mark the identity of each clan. They differ about how the loss of the dillybags occurred: in one version recorded by Ronald Berndt, the sisters hung the bags in a tree when they went to gather shellfish, and men stole it; in another, documented by W. Lloyd Warner, the men burned the bushes where the baskets had been so the women would believe that they had been consumed in a fire. The location of this event varies too, for some clans centre the crucial loss in their own country. Most contentious is the identity of the Djang'kawu. From the perspective of the Rirratjingu, Gälpu and other clans in the east of the region, two sisters and a brother travelled together. In the Liyagawumirr version, however, no brother was involved. Some narrative details are secret: men recount ancestral actions and the 'inside' meaning of symbols that women are not supposed to know, and women also share esoteric knowledge and symbolism.

In the Rirratjingu clan's stories, the brother called Djang'kawu, his two sisters and a male companion began by crossing the sea from the east to the island of Burralku, and thence to the east coast. They paddled north along the coast to Yalangbara, near Port

Bradshaw. Here they sang about the birds they saw, such as red-collared lorikeet, black cockatoo, and pigeon. Details of the Rirratjingu stories tell of encounters with fish such as giant threadfin, butterfish, and long tom, and the whale, likened in form to a dillybag [see 17.1, *209*]. The Djang'kawu saw the sun catching the orange breast-feathers of the lorikeets, and the pounding of the waves and surf on the beach. On the mainland they saw and named many species, and left the marks of their travels. For example, at Yalangbara the Djang'kawu encountered *djanda* (goanna) in the parallel sandhills, and they planted an ironwood tree.

Liyagawumirr people relate how the two sisters (or in some versions an ancestor called Garrawurra) heard their mother's mothers and mother's mother's brothers (*märi*), people of the Gunbirritji clan, singing at Burarrgapu on Galiwin'ku (**Elcho Island**). The sisters crossed over the channel in their canoe, and taught the Gunbirritji the clap stick (*bilma*) songs with the slow beat for the Ngärra ceremony [see 15.1]. There the Djang'kawu made spring waters with their digging–walking sticks. Liyagawumirr artists depict the springs at Burarrgapu in separate images, or together with images of springs at Gärriyakngur. Markers of clan difference and identity surface again in the performance of ceremonies, although the design of ceremonies enables people of several different clans to cooperate in their performance, subsuming their differences in common forms.

The stories in performance

Stories such as these bear a complex relationship to songs and ceremonies. Yolngu perform several genres of songs (*manikay*), and within these, many different individual songs and song cycles. Singers perform the public *garma* songs about ghosts (*mokuy*) and totemic ancestors during initiation and mortuary rituals, exchange ceremonies, and for entertainment. Men tap out rhythmic patterns on ironwood *bilma* as they sing, usually accompanied by a **didjeridu** player. The themes and texts of men's songs are similar to women's mourning songs which they sing in a weeping style (*ŋäthi*, 'weep').

Men's songs for the Djang'kawu story differ from others in not being accompanied by the didjeridu, but by large *bilma* alone, struck with a regular, slow beat. Only certain clans have the right to sing them. The topics roughly follow the ancestral journey through a particular clan's country, but with allusions to the journey of the Djang'kawu as a whole, and to other clan's places.

Bariya became the leader of the Liyagawumirr clan in the mid 1970s. An extract from his performance and transcription of the song of *worrutj*, the red-collared lorikeet, conveys something of the way in which a singer projects images and evokes emotions about places and ancestral events.

Buŋan lithanmarraŋala Bakarrawu Marrawuŋgu Litjilitjiwu Burralka Datayana;

Red-collared lorikeet warmed her breast-feathers in the sun at Bakarrawu, at Marrawunggu, for the Litjilitji, group, for Burralka people, for the Datayana;

Buŋan lithanmarraŋala Bakarrawu Marrawuŋgu Litjilitjiwu; Bulukmana Garayalmana Yalabutjiŋu Gundjurrpurr Buliyaŋu Dawuminydjarrpirr Lirrabakthuna; Leda Galaŋurruŋal Garrawurrawu Djidida Malawurrpurr.

Feathers warmed in the sun at Bakarrawu, [for Burralka,] Marrawunggu, Litjilitji people on the same river; for Bulukmana, Garayalmana, Yalubutjingu, and Gundjurrpurr people, for Buliyangu, Dawuminydjarrpirr, and Lirrabakthuna groups far to the east; Lorikeet up above, the leader, the Garrawurra people, the Djidida, the Malawurrpurr group.

Bariya's comments on the songs explained how the lorikeets are identified with the sisters.

Songs may stand alone, or people may dance to them [see 6.5]. Women sometimes perform as the Djang'kawu, standing in a sand sculpture working their digging sticks as if creating the spring waters [*33*]. To 'visit' the dead at a funeral, or an initiate in a circumcision ceremony, men and women dance together in line, their bodies painted with horizontal stripes of red and yellow ochre and white clay, every person holding a long stick in each hand representing the sisters' *ganinyidi* sticks, following the journey of the Djang'kawu. The pattern signifies the forest (or azure) kingfisher (*djirrididi*) who, like the Djang'kawu, collects grubs and crustaceans in the mangroves. The dancers weave in line through the camp, from time to time forming a great circle, working their sticks as if piercing the ground to release the spring waters, and move on to form the final circle and perform the last creative act around the place where the dead person or the initiate lies.

The Ngärra ceremony

This same dance forms the climax of a ceremony called Ngärra. Several clans of the Dhuwa moiety, and the children of women of the groups, cooperate to perform the Ngärra every few years. In the ceremony, older men reveal secret men's dances and sacred objects to young men, while men and women dance in the public phases to re-enact the creative acts of the Djang'kawu.

Every day for several weeks men march in line from their secret dance-ground to a tree called Riyawarra which stands in the camp. There, women adorned like the Djang'kawu sisters, with a *ganinyidi* (digging stick) in each hand and dillybag decorated with red-collared lorikeet feathers, re-enact the loss of the bags and the sacred objects, as men chase them from the tree to call the sacred clan names that the sisters first uttered. Young men then dance various species of fish that the Djang'kawu saw, named, and caught on their journey, finishing with the kingfisher dance. These dances connote both the creation of new life through conception, and the return of spirits of the dead to the waters from whence they came.

On the final day, women hide under *nanmarra* mats or blankets, and after the men have formed a great circle, working the digging sticks back and forth, the women burst out of the mats to dance the kingfisher, signifying the birth of children to the clans. The symbolism of the ceremony has manifold implications of creation and fertility, of death and ancestral spirits, of kinship relations between intermarrying groups, and of aggression as well as cooperation in social relationships.

The stories in art and design

Yolngu people create designs related to the Djang'kawu stories in a variety of forms: on the body, on bark and other media, on sacred objects, and as sand sculptures. And they make a wide variety of objects connected with the story.

A pattern of horizontal red ochre, yellow ochre, and white stripes adorns the bodies of male and female dancers who re-enact the ancestral journey in public mortuary and initiation ceremonies, and during the public phase of the Ngärra ceremony. The public meaning of these at Milingimbi is kingfisher. A similar pattern on the hollow log coffins of the Liyagawumirr clan designates the marks of the rising tide [see 6.3; *38, 69, 74, 269, 406*].

A class of largely geometric designs called 'elbow designs' (*likanbuy miny'tji*), painted by men on the bodies of initiates and the dead, and on sacred objects, have layered meanings, from public ('outside') to secret ('inside'), connecting the ancestors' actions to a clan's country and its sacred objects which they deposited there [see 6.1]. The paintings include areas of cross-hatching (*rarrk*) in white clay, and red and yellow ochre.

Bark paintings (and more recently works on Masonite and paper) that are made for sale include representations of various key elements of the Djang'kawu narrative. Many show versions of the geometric designs, made open by the inclusion of more easily recognisable images, or combine geometric and figurative elements. In other representations of the story, figurative elements predominate, and depict the Djang'kawu, their canoe, items they carried, features of the country through which they travelled, trees which they planted, and the children the sisters bore. Men are the main painters, but women are taking an increasing role in making paintings on bark [see **bark paintings**] and in other media for sale. Banduk **Marika** is probably the best known woman artist with rights in the Djang'kawu story.

The various creatures and plants which the Djang'kawu saw, named, and sang about, and gathered on their journey, as well as other totemic ancestors encountered, are the topics of both songs and paintings. Each clan has a rather different set, but frequent topics include several species of goanna, bustards, whistle ducks, and pygmy geese, wild banana leaves and lilies, shellfish and sand crabs, and many species of fish.

Clan designs

Like the daily dances at the Riyawarra tree in the Ngärra ceremony, the painted designs and sand sculptures belonging to the various clans who count the Djang'kawu among their ancestors bear a family resemblance to one another, with telling differences. Images of fish tend to distinguish the paintings of different clans, although there is some overlap. Some species link clusters of clans; various species of shark, for example, link Djapu, Dätiwuy, and Djambarrpuyngu clans, while representations of wild banana are found in Djapu, Ngaymil, and Dätiwuy paintings. Species of goanna (*djanda*), frequently identified with the Djang'kawu, link all the clans.

Many paintings include the clan's *miny'tji*, a characteristic group of related geometric patterns, each associated with a particular country, that identifies it and differentiates it from others with varying degrees of clarity. Some are shared by several clans, but even when they are quite distinctive, the designs of clans with the same or related Wangarr ancestors bear a family resemblance [see *25*].

Rirratjingu clan *miny'tji* are variants of alternating panels of vertical and horizontal cross-hatched bars, sometimes rotated about 45 degrees. One version forms the background of Wandjuk **Marika**'s painting *The Birth of the Djang'kawu Children at Yalangbara*, 1982 [*71*]. The painting is divided into three sections. In the upper panel the Djang'kawu brother stands holding his *mawalan* walking sticks. Either side are *djota* trees planted by the Djang'kawu, a major symbol in the Djang'kawu stories. In the middle panel the two sisters give birth to many children. The lower panel shows the sisters with six *ŋaṉmarra* conical mats, used by women as cribs, sunshades, aprons, and working surfaces. Here, as in the Ngärra ceremony, they are symbols of fertility.

Dhuwa moiety clans of Galiwin'ku (Elcho Island), Langarra (Howard Island), and the adjacent mainland possess a family of clan *miny'tji* which share the spring waters (*milminydjarrk*) design. The minimal form is of a single vertical bar crossed by a horizontal bar, with a circle at the intersection. Two or more such figures may be joined in a row of two or more crosses and circles, or grouped in several horizontal and vertical rows to form a grid with square interstices. Most clans' *miny'tji* in this style are distinguished by the infill, dividing each square in different ways. A similar design placed within a circle represents the *ŋaṉmarra* mat in Wandjuk Marika's painting. The main Liyagawumirr clan design is also of this kind.

Sand sculpture designs, drawn with ridges of sand or soil, follow the painted *ḻikanbuy* designs in outline. They may incorporate other objects and materials however, such as

sticks to represent the ancestors' walking sticks, a dillybag adorned with strings of lorikeet feathers, and leaves to lend greater verisimilitude to the springs or waterholes depicted in the sand sculpture. Following a death or serious bloodshed, people stand in a sand sculpture in order to purify themselves with water.

As well as painted designs and sand sculptures, then, other items of material culture pertain to the Djang'kawu stories. Like the feathered cords, decorated baskets are an important, though public, sacred object belonging to a clan, looked after by a senior member. Women are the most active makers of twined baskets and mats [see 17.1]. Initiates, dancers, and leaders carry and wear these objects in performances of Djang'kawu dances and ceremonies [see **body adornment**]. Hollow log coffins associated with the Djang'kawu, used for the final interment of the bones of the dead, can be seen in the *Aboriginal Memorial* [see 6.3; *38, 74*] at the National Gallery of Australia.

Changes in designs and ceremonies

Changes in Yolngu rituals documented this century include deletions and elaborations of traditional forms as well as the incorporation of Christian elements [see 1.2]. However, strong continuities are evident between bark paintings from the 1950s and more recent work. The use of new materials such as glue as a binder instead of orchid juice, and of artist's brushes rather than human hair, have resulted in subtle stylistic changes. Other innovations are more radical. Among recent stylistic innovations the following are especially striking. Rather than placing images within the discrete panels of a large subdivided painting, in *The Sacred Resting Place of the Djang'kawu*, 1982 and *The Clans: Djang'kawu Children*, 1982, Wandjuk Marika placed a large image centrally, with the subdivisions radiating outward from it. In other paintings in the same series, large images of goannas spread across a panel to breach the outer border in a way not apparently characteristic of paintings by, for example, Wandjuk's father Mawalan, or by Mawalan's classificatory brother Milirrpum. Related stylistic innovations have appeared in paintings of the Wägilak sisters story.

In an interesting development, Micky **Dorrng**'s recent work in bark painting and on paper, associated with Liyagawumirr clan country at Gärriyakngur, omits the usual cross-hatching in the characteristic cruciform representation of spring waters. His *miny'tji* (designs or patterns) are composed solely of blocks of red ochre, yellow ochre, and white bars. *Miny'tji (Body Paint Design) for Djang'kawu Ceremony*, c.1990 [*73*] consists of a series of horizontal bars within a frame of vertical and horizontal bands, similar to the design painted on the body for the kingfisher dance and placed on the clan's hollow log coffin where it represents the marks of the rising and falling tide. Geometric designs such as this encode many secret or 'inside' meanings.

The Djang'kawu complex of stories, songs, and ceremonies, designs and material culture, is just one of many in the rich religious traditions of north-eastern Arnhem Land. The story and ceremonies create and maintain links between distinct Dhuwa moiety groups across Arnhem Land, while differentiating them. Yolngu people are able to draw on this tradition not only for the purpose of initiating the young, mourning and remembering the dead, and mediating social relationships within Arnhem Land, but in creating and maintaining links with other Australian communities and peoples of other countries, not least through the creation of art for the market, and the display of their work in galleries and museums [see 21.1, 21.2]. Paintings of the Djang'kawu story thus partake in the vital tradition which is Yolngu art, adapting to new materials and maintaining a dialogue between local religious practice and the arenas of national and international art.

IAN KEEN

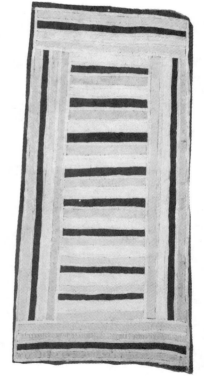

73. Micky Dorrng, *Miny'tji (body paint design) for Djang'kawu Ceremony*, c.1990. Natural pigments on bark, 154 x 70 cm.

141

Berndt, R. M., *Djanggawul: An Aboriginal Religious Cult of North-Eastern Arnhem Land*, London, 1952; Lendon, N., 'A narrative in paint', in W. Caruana & N. Lendon (eds), *The Painters of the Wagilag Sisters Story, 1937–1997*, Canberra, 1997; Morphy, H., *Ancestral Connections: Art and an Aboriginal System of Knowledge*, Chicago, 1991; Warner, W. L., *A Black Civilization; A Social Study of an Australian Tribe*, New York, 1937.

6.3 Two hundred burial poles: *The Aboriginal Memorial* [*38*, *74*]

*The article on which this essay is based was written in 1988 by Djon Mundine, former Art Coordinator of **Bula'bula Arts** at Ramingining, central Arnhem Land. It vividly recalls the climate of political protest which inspired the Aboriginal Memorial—an installation of 200 hollow log coffins by forty-three artists from Ramingining and the central Arnhem Land region. Intended as memorial to all those Indigenous people who lost their lives defending their country, the installation represents a map of the Glyde River estuary with the hollow log coffins placed in relation to the relative locations of the countries of the various land-holding clans who live along the river and its tributaries. The Memorial was first displayed in Sydney at the 1988 Biennale and is now in the collection of the National Gallery of Australia where it is prominently displayed. In 1999 the Memorial was shown at the Olympic Museum, Lausanne, before travelling in 2000 to St Petersburg [271] and Madrid.*

Since 1788 at least several hundred thousand Aboriginals have died at the hands of white invaders. Some time ago an elder artist in Ramingining brought me several videotapes belonging to his dead son. Not having a video cassette recorder, he wanted to play the tapes and show me. The son and the artist were and are very close to me. The tapes were battered and dust-ridden. I hesitated to run them through my machine but our relationship and my curiosity made me play them. His son had been a member of the Northern Land Council Executive and, in the course of his work contracts, had been given some more 'political' videotapes as background briefing for himself and the community. One of these was a copy of a John Pilger documentary called *The Secret Country* [1995]. In the opening précis of the programme Pilger talked of the decimation of a

74. The opening ceremony of the *Aboriginal Memorial* by Ramingining artists at the Sydney Biennale, with David Malangi and Johnny Dhurrikayu playing the didjeridu.

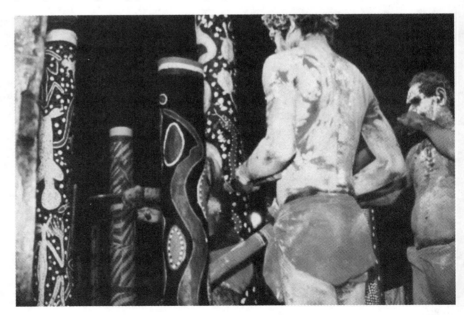

tribal group who owned land on the Hawkesbury River in New South Wales and who died 'to the last man, woman and child defending their country'. He continued that, throughout the land in every country town, there was an obelisk to those who had fallen in this war or that, but nowhere was there a memorial to these first Australians who died defending their country.

In the course of my work as art adviser, the major role is to make the outside world more aware and appreciative of Aboriginal art and culture [see 21.2; **art and craft centres**]. Some works of art are visually accessible to 'white eyes'; however, others aren't and are difficult to place. The hollow log bone coffin was one of these. During the sixties, when Aboriginal art was 'discovered', installations of so-called 'totem poles' were popular, though rarely placed in the prominent places which they deserved. Then, although a gradual growth in Aboriginal art appreciation crept up during the seventies, this was in the main to do with paintings, with the Western Desert school of 'dot and circle' leading the way [see 9.4, 9.5; **acrylic painting**]. Sculpture, generally referring to bird and other animal life pieces, was also sought after; however, works as uncompromising as the bone coffin were still hard to place. The problem was to change people's perceptions of Aboriginal sculpture and art in general. A *tour de force* was needed.

This cynically commercial venture lurked in the back of my mind until the Pilger programme crystallized these thoughts. During the day-to-day business of the Art and Craft Centre in Aboriginal communities, a series of regular exhibitions is planned and run. Art is a way of recording history, aspirations and feelings of the period. Art is a communication medium that often transcends language barriers. The aim is that themes, concepts and ideas of Aboriginal culture are carried within each exhibition, which is visually accessible to the general viewing public. During the bicentennial year most Aboriginal organizations and many white ones boycotted the celebrations [see **Survival Day**]. Many white artists withdrew their works from Bicentennial shows. As a commercial enterprise set up to ensure returns to artists, it was realized that any boycott decisions would have strong economic consequences. The bind was to present Aboriginal culture without celebrating—to make a true statement.

In north-eastern Arnhem Land present-day Aboriginal people carry on many age-old ceremonies and rituals [see 6.1, 6.2, 6.5]. One of these is the Hollow Log or Bone Coffin ceremony. When a person dies, the body is washed, painted with relevant totemic designs, sung over and mourned. Some time later the bones of the deceased are recovered and distributed to relatives in a small ceremony. After a period, which may be years, the relatives hand over the bones to ceremonial leaders for them to hold a Hollow Log ceremony [*269*]. A log hollowed out naturally by termites is found, cleaned and painted with relevant designs, like the body, amidst singing and dancing in a special camp for those completing the ritual. The bones are cleaned, painted with red ochre and placed in the log in special dances. When a set series of songs and dances has been completed, the log is carried and danced into the main public camp and stood upright. It is then left.

Full-size versions minus the bones are made and sold today as sculptures. These works are art pieces in their own right. Originally being living trees, the *Memorial* installation is like a forest—an Aboriginal artistic vision of the forest and landscape. In the original ceremony each pole would contain the bones of deceased people, embodying the soul. Each tree in this new forest would contain symbolically the spirit of a deceased person. The forest, the environment, is us; we are the environment [see 2.1]. Each hollow log is ceremonially a bone coffin, so in essence the forest is really like a large cemetery of dead Aboriginals, a war cemetery, a war memorial to all those Aboriginals who died defending their country [see also 8.3]. Two hundred poles were commissioned to represent the two hundred years of white contact and black agony.

6.4 Sacred memory and living tradition: Aboriginal art of the Macassan period in north-eastern Arnhem Land

The sale of the exotic delicacy, trepang, to Chinese entrepreneurs was Australia's first international enterprise. Indonesian fishermen from Macassar (Ujung Pandang) collected and processed the bêche-de-mer *Holothuria scabra*, sometimes in cooperation with Australia's Aborigines. The thriving industry continued from the early seventeenth century to 1907, with activities concentrated along the Arnhem Land coast of what is now the Northern Territory.

For Macassans, the trip was a business venture. 'Marege', as they called it, was the farthest coast, and the location of their most lucrative sojourns overseas. The significance of this era of first contact for Yolngu is evident in the many Indonesian influences in economic, social, and ceremonial life. The era heralded the emergence of new **Dreamings**, and protracted interaction with Macassans enabled Aborigines to better deal with ensuing contacts with Europeans in the twentieth century. Despite episodes of violence and bloodshed, with the passing of time and the blurring of memories, the seafarers are remembered with great fondness, particularly when compared with the European missionaries [see 1.2], miners, and bureaucrats who came in their wake.

Contact was not uniform throughout north-eastern Arnhem Land. Marketable varieties of trepang are scarce where seas are clear and rough, and coral abounds. But where the waters are shallow and protected and the sandy beach is lined with mangrove trees, *Holothuria scabra* flourishes. All along such beaches are traces of the presence of Asian traders: stone lines which once supported cooking pots; pottery shards and fragments of glass; and tamarind trees, which acted as place markers for the seasonal travellers. The differing nature and intensity of contact along this vast coast is reflected in the range of ways that Yolngu account for the past. Members of a majority of clans in both the Dhuwa and Yirritja moiety will speak of the Macassans as being the only group of outsiders involved in the trepang industry. However for several clans in the Yirritja moiety (for example Warramiri, Golpa, and Gumatj), the Macassans are spoken of as coming at the tail-end of a number of waves of visitors, beginning with dark-skinned people who respected Aboriginal rights and traded as equals with them. These were the people of Badu, said to be an island to the north. They were followed by the golden-skinned Bayini, who introduced Aborigines to trepanging, and who also had the skills of iron manufacture, pottery production, and weaving, but kept these secrets for themselves. Then came 'light brown' Macassans, and 'white' Japanese and Europeans. A change in skin colour from black to white corresponds to a change in the nature of relations with Aborigines, from reciprocity to a complete absence of it. This is a sacred reading of the past, and accounts of this nature centre on the ancestral being Birrinydji, who drew all outsiders onto the coast with his *märr* or desire.

Designs by Yolngu reflecting a Macassan theme are generally of two types: 'outside' (public) and 'inside' (esoteric or sacred) [see 6.1]. Depictions of praus (sailing craft), trepang-processing sites, the goods obtained through trade with the visitors, the mistreatment or abduction of women by Macassans, or the slaughter of Aboriginal men by firing squad, are 'outside'. Images such as golden-skinned women working on weaving looms, the performance of corroborees in honour of Allah, and an Arnhem Land creational being who directs Aboriginal men in the making of iron in kilns are 'inside'. 'Outside' art deals with specific historical episodes; 'inside' art refers implicitly or explicitly to Birrinydji.

Another way of distinguishing between 'outside' and 'inside' designs is to consider the purpose of a bark painting's manufacture: 'outside' bark paintings depicting a kidnapping or an execution are produced for sale to non-Aborigines, 'inside' paintings are generally produced for instruction purposes—for teaching young people the nature of the Law and guiding anthropologists [see **anthropology**] in their understanding of the significance of the Macassan past in the Yolngu present. Members of any clan in either the Dhuwa or Yirritja moiety can produce a painting of praus or of the long knives, or any other products of the trade. Such 'outside' bark paintings are statements of historical fact, posing no real challenge to the viewer. Some, however, inspire the same sense of pride and defiance as do 'inside' works, which concentrate on the nature and meaning of Aboriginal life in times of social upheaval. Commentaries on the design of 'inside' bark paintings emphasise Aboriginal autonomy and resistance in the face of outsider domination.

75. (*r.*) Charlie Matjuwi Burarrwanga, *Lul'warriwuy Leaving Elcho Island*, 1994. Acrylic on bark, 146 x 52 cm. This painting depicts the abduction of the artist's aunt (his mother's sister) by Macassans. Above the boat are articles of trade and a trepang processing camp typical of those along the Northern Territory coast.

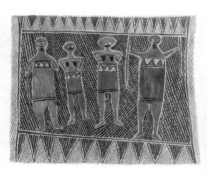

76. (*above*) Munggurrawuy Yunupingu, *Bayini, Men and Women of Port Bradshaw,* 1948. Natural pigments on bark, 46.0 x 58.7 cm.

The conventional view of the Aboriginal–Macassan past is one in which the visitors and Aborigines co-existed largely in peace and harmony, and where, while there was some impact on Aboriginal ceremonial practices, settlement patterns, and hunting practices, no significant changes took place in the Aboriginal way of life. We could call this an 'outside' perspective, because it conceals from the listener any reference to the 'timeless' Dreaming or ancestral themes which originate from this period of first contact.

However the view from within suggests that the impact of Macassan contact on Aboriginal lives was profound. Before the arrival of the trepangers on north-eastern Arnhem Land shores, Aborigines had little or no experience with outsiders. In the words of the Galiwin'ku (**Elcho Island**) leader David Burrumarra, contact with people from across the seas turned 'the Aboriginal world upside down', leading to endemic infighting and antisocial behaviour in the territories of the Warramiri, Golpa, and Gumatj. The memory of this often turbulent experience has been transformed by Aborigines over time into a body of Law centred on the creational being Birrinydji. Belief in Birrinydji empowers the listener–viewer to transform the nature of relations between cultural groups and to regain what was deemed to have been lost at the 'beginning of time'.

Paintings by Yolngu reflect upon the significance of the Macassans' annual visits, and the valuable exchange which occurred, as it has come to be integrated into an Aboriginal cosmology. The first two paintings are 'outside' depictions of actual historical events. The painting by Gumatj leader Matjuwi [75] shows the kidnapping of an Aboriginal woman, Lul'warriwuy. The second, by Munggurrawuy Yunupingu [76], depicts the golden-skinned Bayini referred to by some Yolngu as either the wives or workers for Birrinydji. They are framed with wedge-shaped cloud symbols associated with the Yirritja moiety. In some paintings, women are shown weaving, allowing the Aboriginal viewer to understand that those skills, now possessed by whites, were originally part of an Aboriginal cultural domain.

In George Liwukang's 'inside' bark painting of *The Hero of Iron*, 1976 [77], Aboriginal men learn to make iron from the 'red rock' (haematite) on the Arnhem Land coast under the direction of the creational being, Birrinydji. Macassan symbolism also forms the thematic core of Johnny **Bulunbulun**'s painting *Ganalpingu Cosmology*, 1994 [78] [see also 22.2]. In this painting Bulunbulun depicts the clan ceremony of the Ganalpingu and its central symbolic token, the *murrakundja* pole, represented as the mast of a Macassan prau with the Macassan goods exchanged: *djambaku* (tobacco), *märriyan* (gun), *mangaritj* (axe), and *manydjawa* (soldier knife). Other aspects of the painting show patterns of seasonal change such as *lungurrma* (the wind) and *djarrapun* (the cloud), associated with the arrival of the Macassans in the mid to late dry season.

Many people now view the heroic times of trade and travel to and from Macassar aboard the praus as a sort of golden era. Even though some Yolngu were sold into slavery in Indonesian waters, and some died en route, there are a number of accounts of Yolngu marrying in Macassar and Timor and raising families, while others were gainfully employed in the homes of the trepang industry entrepreneurs. After a year or more, they would take the voyage back home to Arnhem Land, and there were many stories to tell.

Contemporary Aborigines from Arnhem Land are now retracing the voyage to Macassar by plane, and renewing links with their old trading partners. In 1988, a replica of a Macassan prau sailed to Arnhem Land and was greeted with great excitement. At Galiwin'ku, the sailors were met by 500 Yolngu performing the ceremonies of Birrinydji, and were carried ashore shoulder-high. Groups have travelled from the central Arnhem Land community of **Maningrida** to Macassar, to perform a rite expressing inter-cultural unity, and a number of visits were made to Macassar by Yolngu from Galiwin'ku wishing to make contact with relatives still living there. In a reciprocal visit in 1997, performers from Macassar executed a series of dances on the Galiwin'ku shore, mimicking earlier cross-cultural exchanges. From an 'inside' perspective, Aborigines acknowledge a debt to Macassans. Through them, the 'truth' of Birrinydji and their own past was revealed. For other Yolngu, the tales of Macassans are an exotic part of their own past, and the stories of the exploits of their distant relatives in the islands of the Indonesian archipelago offer a positive image of an earlier bygone era. IAN S. MCINTOSH

McIntosh, I., 'The Birrinydji legacy: Aborigines, Macassans and mining in north-east Arnhem Land', *Aboriginal History*, vol. 21, 1997; Cawte, J., *The Universe of the Warramirri: Art, Medicine and Religion in Arnhem Land*, Kensington, NSW, 1993; Macknight, C. C. *The Voyage to Marege: Macassan Trepangers in Northern Australia*, Melbourne, 1976.

77. George Liwukang, *The Hero of Iron*, 1976. Natural pigments on bark, 55

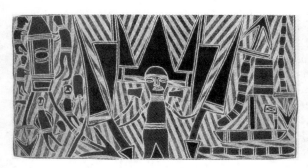

78. Johnny Bulunbulun, *Ganalbingu Cosmology*, 1994. Natural pigments on canvas, 129 x 272 cm.

In south-east Australia many well-documented **massacres** of Aboriginal people occurred since 1788. Many of these were covered up and forgotten (buried), as reported in Pilger's programme, and thus the name *The Secret Country*. In northern Australia present-day distortion of history continues still. It is widely touted that Aboriginals there were and are treated differently and did not suffer as other Aboriginals did from white contact. Thus they have no reason to feel betrayed, deprived, and angry as those southern blacks and Queensland Aboriginals are. Though many benevolent acts were carried out, massacres were occurring in Arnhem Land around the turn of the century, about the time of similar incidents in other parts of Australia. This is still 'secret history' for most of Australia.

There is currently an upsurge in interest in Aboriginal art among the Australian public and overseas visitors. A large part of this is a result of the tourist boom [see 18.1] sweeping the country. In other parts of the world where the particular indigenous art has become the flavour of the month, it has often led to attempts to exploit it commercially to the nth degree. The resultant pressure on artists to produce has led ultimately to a collapse or emasculation of the art form. Aboriginal art is now under incredible strain to fulfil white demands on Aboriginal culture. Certainly different factions have tried to lead the art this way and that. Whether they truly represent Aboriginal cultural aspirations is questionable. Beyond these schisms and distractions, Aboriginal artists and art have sustained their resilience in the face of these demands and continued to survive, convert the white community and make real statements.

Djon Mundine

A longer version of this article first appeared in *Australian and International Art Monthly*, no. 10, May 1988. It is reproduced with permission of Art Monthly Australia.

6.5 Knowing the country, holding the Law: Yolngu dance performance in north-eastern Arnhem Land

Aboriginal painting [see **bark painting, acrylic painting**] has been the subject of a rich body of research and popular writing, and there has been much interest in the varied forms of Indigenous music and songs [see 15.1]. By comparison, some genres of Australian Indigenous performance, particularly dance, have not received the same attention or close scholarly consideration. Despite the numerous and detailed descriptions of ceremonies in early anthropological monographs, the glossy coffee-table books and the occasional video recording of ritual events, the role of dancing in Aboriginal Law, in the assertion of knowledge, the claiming of rights [see 3.1, 3.2, 3.3, 22.1; **land rights, rights in art**], and the legitimisation and negotiation of authority over specific countries, has largely been neglected. This may be partly explained by the fact that paintings and songs have often been considered in isolation from their ceremonial contexts; this is especially so with their recent appreciation by, and consequent commercialisation in, the world's music and art markets. What is narrowly referred to as dancing—in reality a multi-dimensional activity—remains strongly linked to the local social contexts for which, and political purposes in which, it is performed.

Whereas dances, like paintings and songs, connect ancestral events, places, and people, they also complement, contain, and orchestrate other media into a harmonious whole [see 7.3, 16.3]. As A. P. Elkin, Catherine Berndt, and Ronald Berndt found, 'in the ritual dance, we have the ballet, singing and poetry … and the visual arts of painting, engraving, moulding or building up of objects, and even carving'. As in other parts of Indigenous Australia, dancing in any of the ceremonies of the Yolngu people of north-

eastern Arnhem Land is not merely a sequence of body movements composing more or less intricate patterns and choreographies. It is primarily a complex event which binds the land and time of the ancestral actions to the present context, the performers to their audience, language to movement, and music to space. As many Yolngu people explain, participating in dancing is 'knowing the country', 'holding the Law', and in circumcision and mortuary ceremonies it is showing one's love for the boy who is circumcised or the deceased and their family.

Ancestral footprints

The Yolngu believe that everything in the physical and phenomenal world they inhabit is the result of the journeys of ancestral beings who, by roaming through the sky, earth, seas, and waterways gave shape to the country and the environment as it appears today [see 6.1, 6.2]. It was during their travelling over long distances across the shapeless land that ancestral beings transformed their bodies into landscape features, and named places which they bestowed upon the groups of people they also created. Places, phenomena, names, stories, and people are thus the embodied manifestations of these beings' creative powers, the visible and tangible marks, or as Yolngu would say, 'footprints' (*djalkiri*) that the ancestral beings left behind. As this term indicates, these visible and permanent marks on the land, imprinted by the ancestral beings, and the stories recounting their life-giving and shape-making activities constitute the 'foundation' (as it is often rendered in English) of Yolngu Law and culture.

In the staging of Yolngu ceremonies the ancestral footprints are followed—retraced by embodying the ancestral power of trajectory, movement, and naming—in the songs, dances, designs, and sand sculptures. Ancestral trajectories are re-evoked in the journeying narratives of the songs which, like road maps criss-crossing the land, connect land and people; the creative power of naming is condensed in the chanting of ancestral names; ancestral places are energetically recharged through the polymorphic plasticity of visual media such as designs, sculptures, and ground patterns, and the ancestral beings' particular, creative transformative actions are embodied by the dancers' movements and choreographies.

Dance, knowledge, and the Law

The unitary nature and inseparable dimensions of performance as an event including music, song, designs, and dance, and the significance of dance as a unique aspect of ceremonies in north-eastern Arnhem Land is indicated in the use of the term *buŋgul*. At a more inclusive level the term refers to the ceremony as a whole, the combination of song, designs, and dancing. Often, however, the term *buŋgul* is used at a more exclusive level and specifically refers to the participation in dancing in contrast to singing and other activities.

Dancing, like painting and song, is a means by which knowledge is learnt, accumulated, and transmitted. To dance as a virtuoso, or even as an ordinary dancer, is to show oneself to be knowledgeable about the ancestral creative events and journeys which connect countries over which one has or may claim rights of ownership, and exercise responsibility. However, in contrast to the highly specialised performance of songs and the execution of paintings which, in ceremonial contexts, are almost exclusively the province of mature men, dancing is learnt at an early age and offers an opportunity for women and younger men to legitimise, or at least claim their rights to a particular body of knowledge in front of large audiences.

Despite its less specialised nature, levels of style, skill, and virtuosity in ceremonial dancing draw important distinctions between the sexes and the generations. The men

usually dance directly in front of the singers, and the women in a line or a group on one side of the singers, or further back behind the men. Whereas the men's movements are dramatic, women's movements are more modest and contained. Men's and women's arm movements are often the same, although in some dances the arm movements of men, and often those of old women, are more emphasised and elaborated [79].

Children learn to dance at a very young age by first looking (*nhäma*) and then copying (*yäkarrman*) the stepping of their adult relatives and older siblings. The process of learning the dances of related groups, or secret versions of public dances continues especially for young boys, who are gradually introduced to the highest and most secret levels of Yolngu knowledge. The dancing proficiency of the young performers is often taken as a sign that they are learning the Law. When the watchful elders comment that the young dancers' 'knees are talking' (*bon-waŋa*), meaning that they are moving with agility and skill, the youths are considered ready to be entrusted with further knowledge and ritual responsibility.

Style and virtuosity in performance also indicate the rights that individuals hold in the dance performance of groups which are related to them through specific kinship relationships [see 3.1]. People have the strongest rights to perform the dances of particular groups, namely those of their mother's group (the group who calls them *waku*, i.e. sisters' children, and whom they in turn call *ŋäṉḏi*), of their mother's mother's group, and of their own group, in that order. The people who are in the relationship of *waku* to the singers lead the dances and often indulge in virtuosity. One of the senior male *waku* has the strongest right to the knowledge of his mother's group, and he is said to be their manager (*djuŋgayi*) and boss (*ŋäṉḏi wataŋu*, literally 'mother's owner'). The man occupying this position in any given ceremony not only leads the group of dancers by performing at the front, closest to the singers, but is also responsible for emitting the dance calls and, by means of these, for directing the singers. The *djuŋgayi* always dances with energy and passion and his performance often outshines the others. The jumping is higher, the movements more dramatic, the interpretation theatrical and emotional. Being a virtuoso is his right and duty, a way in which he displays and asserts his legitimate claim to the knowledge of his mother's group and the fulfilment of his rights and

79. Knife dance of the Yirritja moiety, Elcho Island (NT), 1992.
Yolngu dance performances draw important distinctions between the sexes (the author is seen with other women dancers in the top left corner). The men usually dance in front of the singers, while women dance behind or beside the men. While the movements are the same, the men's execution of them is more dramatic and elaborate.

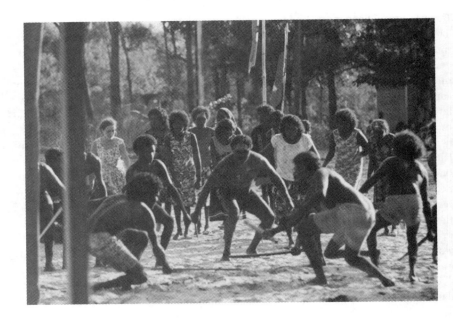

responsibilities. It should be noted that such claims made through performance are brought into and displayed in the public arena, usually in front of a large seated audience who observe, comment upon, acknowledge, or ridicule the performers' dancing statements. Furthermore, if dancing is the display of one's embodied knowledge of ancestral events, as well as the exercising of one's rights and duties of kinship, failure to dance is often criticised as demonstrating a lack of knowledge and Law. On many occasions the man responsible for organising the ceremony will stand up and address the seated audience with an accusatory tone: 'What's the matter with you lot? Are you people sitting without the Law?'

'Big dances' and 'small dances'

In Yolngu ceremonies the force of creation, which is fused in the footprints of the ancestral beings, is revealed and made present through songs, designs, and dances. The unified nature of performance, the revelation of ancestral power through the bringing together of its visual, musical, and verbal aspects, is reflected in the fact that each design, song, and dance is distinguished as having two or more versions expressing different levels of intensity and embodiment. Just as geometrical designs are considered more sacred and secret than figurative representations, an elaborate musical form, which accompanies the singing of major creative actions, is juxtaposed with an informal one marking less significant events, and big dances (*yindi buŋgul*) are contrasted with small dances (*nyumukuṉiny buŋgul*). Ancestral power is thus made present and is finally fully revealed when all these dimensions of embodiment are brought together in their most elaborate and charged forms during critical phases of Yolngu ceremonies such as the arrival of the deceased's body, at its transportation, and at the moment of the circumcision of an initiand.

The gradual embodiment of the manifestation of ancestral power in performance is well illustrated in the distinction between small and big dances. Whereas small dances are characterised by stylised and abstract movements which represent only a part of the ancestral body in motion, big dances performed either by individuals or a group are characterised by more complete mimetic actions in which the ancestral body is revealed in its full shape, action, and movement. The former are re-enacted by both men and women, the latter are often restricted to men. The following example is illustrative.

One of the dances embodying the serpent ancestor has both 'big' and 'little' variants. In the small dance the movement of the individual dancers consists in holding a stick at one end and moving it across the chest. In the big dance the representation of the serpent is also achieved by choreographic means. The dancers form a long line which advances in zigzag fashion to the centre of the dancing ground. Here the line transforms itself into two concentric circles rotating in opposite directions. While the little dance represents only the tail of the serpent swaying from one side to the other and may be performed by women, the big dance, performed to the elaborate musical form accompanied by the chanting of the names of the ancestor, visually reveals the coiling movement of the snake and is usually dominated by mature men.

The sacredness of such dances derives not only from the coming together of the elaborate music form and the chanting of ancestral names, but also from the fact that the whole body of the ancestral being in its shape, action, and movement is visually embodied in the choreographic patterns. Although it is not unusual for older women to join the men in the performance of big dances, people explain that these dances are too sacred to allow the participation of women. It is in these big dances that the men are referred to as ancestral beings (Wangarr). By embodying the ancestral power, they claim knowledge of the countries with which the cosmogonic events are associated.

Similarity and difference in movement variation

Movements and choreographies of small and big dances distinguish a more or less embodied knowledge of country and thus distribute performance rights between the sexes and the generations. They are also central in negotiating the shared yet unique knowledge associated with different countries belonging to different groups and individuals. Groups whose countries are positioned along the track of one or more ancestral journeys share songs and designs which narrate the creative deeds of those particular ancestral beings, and their songs and designs differ insofar as they stress significant details of ancestral actions associated with their respective countries. In the same way, each group performs distinctive dances. As with painting and songs, similarities and differences in dance movements and choreographies are performed to emphasise either unity or differentiation, association or separation, among groups.

An example of movement variation is provided by the big dance of cloud ancestors who travelled across the adjacent countries of two closely connected groups. Individual dancers—women holding a stick, and men a spear on their heads—may start by arranging themselves either in one or two lines or a circle, according to the ancestral events which took place in their respective countries. The dancers in parallel lines visually embody the clouds at a particular place on their country from which the long black monsoon clouds stretch along the horizon. Just as the clouds advance slowly across the sky just before the downpour, so the dancers proceed on the dance ground in line formations. However, upon reaching the country of a closely related group, the dancers form a circle and lower the spears from their heads to the ground in a searching movement. This is the place where cloud ancestors gathered to look for another ancestral being hidden in the shining sea water.

In ritual contexts such as mortuary and circumcision ceremonies, when several closely related groups participate in the performance, the execution of a particular dance version becomes crucial: these different forms allow the performers to negotiate their rights to country according to specific circumstances. If a particular—political—context requires groups or individuals to stress their unity and their shared knowledge of an event associated with a particular place, all differences are erased by performing the same variant of the dance. Conversely, the details which distinguish particular dance versions are emphasised in performance in order to claim, re-assert, or legitimise a group's unique association, knowledge, authority, and identity with a specific place. In the case of the two groups mentioned above, when the connection between them needs to be stressed in relation to another group, the dancers will unite by performing 'cloud' in either line or circle formation [80]. However, when these closely related groups need to establish their unique identity associated with their own countries, they will stress their difference by performing their specific dance choreography. Given that dance allows the participants to stress their links with each other, their overlapping or unique rights, or their differences, according to the position they occupy in particular political circumstances, ceremonies may be considered the most significant occasions at which knowledge of country, and the authority consequent upon such knowledge, are negotiated.

Dance as work, love, and play

Dancing is not only performed to legitimise one's knowledge and authority over country. Participation in performance is also considered as work, as the demonstration of love and compassion towards close relatives, and as an occasion to entertain and to be entertained. As in other parts of Indigenous Australia, the two main participants in a ceremony, two groups in the relationship of mother and sister's children, are often referred to respectively (in English) as the 'owners' and the 'managers' (or 'workers') of a

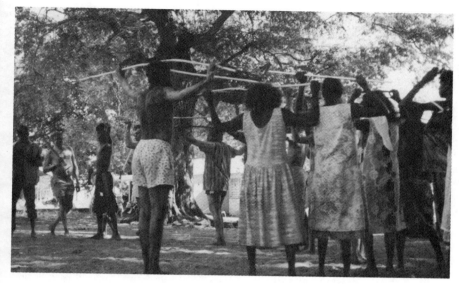

80. Cloud dance of the Dhuwa moiety, Milingimbi (NT), 1992.
This dance re-enacts cloud ancestors which gather in a circle formation. Different choreographies or dance movements serve to stress the unique identities of particular ancestral events at specific places belonging to closely related groups.

ceremony. It is by dancing that the workers (*djämamirr*, literally work-having) help the owners of a ceremony and through this work show their love and care for their kin. It may not be immediately obvious how participation in dancing can be considered as work which is physically and emotionally demanding, and so it is important to make two observations. First, despite the apparent effortlessness of Yolngu double stepping, the quick foot-shuffling in a semi-crouched, backward-leaning stance requires a continuous tension of the leg muscles. Moreover, performances are often carried out over a period of one or two weeks in the strong heat of the tropical sun throughout the day, and into the night. In addition, if relatives do not participate in the dancing and they do not help in other ways they are often publicly criticised, or disapproved of in private for their lack of compassion and care for their relatives.

Although dance performances, especially at ceremonial climaxes, are often characterised by seriousness, concentration, and tight co-ordination, and are charged with strong emotions of duty and love, they also take place in a relaxed atmosphere which is partly animated by the welcome presence of visiting relatives from other communities. Performances are occasions at which dancing statements about knowledge are laughed at as well as recognised. Young men who have recently begun to lead the less important songs and dances, and very young children in particular, are subjected to continual observation, encouragement, and joking. The audience often expresses its appreciation by shouting the kinship or subsection term of the performer while the singers often tease one another about their skill and virtuosity.

'Yolngu dance because Yolngu people hold the Law'

A detailed analysis of the complex nature of participation in performance points to the important role that dance plays in Yolngu Law [see 1.1, 2.1]. The meaning of particular dance movements cannot merely be considered as the manifestation or presencing of ancestral power, or as the maintenance and renewal of the sociophysical and religious links between people, land, and ancestral beings. The identification with country embodied in dancing is a statement—at once religious, political, and emotional—which reveals the multidimensional and dynamic aspects of Yolngu Law. Dancing in any Yolngu ceremony should therefore be understood not just as a form, but as an event in which knowledge associated with country is transferred, judged, asserted, and negotiated,

and through which obligations are fulfilled by offering help to, and demonstrating love and compassion towards, one's relatives. In this way, Yolngu Law is seen to be immutable yet changing, maintained yet renewed, replicated yet reinterpreted in matters of knowledge and authority as well as of morality.

As a Yolngu man once explained: 'Yolngu dance because they hold the Law', and he continued: 'Ancestral beings do not dance. They taught us how to dance and now it is Yolngu people who dance to show that we have *rom* (Law and culture).'

FRANCA TAMISARI

Elkin, A. P., Berndt, C., & Berndt, R., *Art in Arnhem Land*, Melbourne, 1950; Tamisari, F., 'Body, vision and movement: In the footprints of the ancestors', *Oceania*, vol. 68, no. 4, 1998.

6.6 Larrakia artists

The Larrakia people are the traditional owners and the original inhabitants of the Darwin and Cox Peninsula region of the Northern Territory. Their country extends from the mouth of the Adelaide River in north-western Arnhem Land around to the mouth of the Finnis River and includes all the coastal foreshores, adjacent islands, and inland waterways. Therefore, it is no surprise that the Larrakia generally describe themselves as 'saltwater people' whose strong coastal and sea affiliations are clearly demonstrated in the major **Dreaming** tracks and totemic and clan Dreamings—although Larrakia people have always used their inland country too. But no matter where their main connections and affiliations may be, all Larrakia have full access to, and the responsibility to care for, their country: their special places form a part of who and what they are, their Larrakia-ness.

In the period between 1801 and 1818, two centuries after the Dutch ship *Arnhem* gave its name to Arnhem Land, British and French seafarers began charting the Northern Territory coastline. The first British settlers began arriving in Larrakia lands in the 1820s. But it was not until 1869, after a few unsuccessful attempts, that a permanent settlement was established. First named Palmerston, it was later called Darwin. As more and more Europeans came to stay, Darwin literally grew up around the Larrakia people. Around 100 years ago the neighbouring Wogait people began to drift onto Larrakia country and many stayed on the Cox Peninsula, continuing a long association which has been cemented through marriage and ceremonial links. Darwin is now a thriving city of between 80 000 and 90 000 people. Many Larrakia were displaced and forcibly removed as Darwin grew. Yet many families remain, contributing as they always have, and sharing a unique place that is both their home and their country.

The Larrakia people were one of the first to lodge a claim for the return of their traditional lands, in 1979; but more than twenty years later there is still no resolution. The **Mabo** and Wik decisions have not necessarily been of benefit to the Larrakia or many other Aboriginal nations. Yet through the long years of fighting for land, the social and cultural disruption and upheaval, the bombing of Darwin and even Cyclone Tracy in 1974 [see 10.1, 10.2; *219*], not to mention the imposition of 'settled life', the Larrakia people themselves have been documenting and commenting on their country, their histories [see 4.2; **history**, **life stories**], and their own stories. Art is one of the media they have used.

There is very little information about traditional Larrakia painting and artistic expression, and few examples survive today. Larrakia society and culture have suffered great disruption through successive pieces of government legislation and other destructive restrictions, and Larrakia people were actively discouraged from participating in

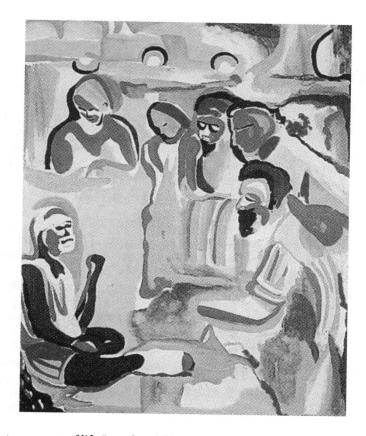

81. Koolpinyah, *Gwalwa Dorennage (This is Our Land)*, 1995.
Acrylic on canvas, 163.5 x 422.5 cm (complete).
This painting forms the third panel from the triptych *The Judge Inspects the Witness*. During an important stage of the Kenbi land-claim hearing the court visited Kulaluk, where a number of people gave evidence. A principal witness was a Larrakia man who fitted the requirements of the *Land Rights Act* to the Judge's satisfaction. The witness being inspected by the Judge has taken a strong confident pose. He knows who he is and is not overawed by the attention he is being given.

their customary way of life. Introduced diseases and the availability of alcohol and even opium destroyed much of the fabric of Larrakia society, so that people had very little incentive or encouragement to paint anything at all. Nevertheless, Larrakia people have maintained an artistic tradition which has evolved and transformed, particularly in the past twenty years with the emergence of artists who have been taking their work to a wider audience.

The Northern Territory's 'Dawn of Art' display in the 1888 Centennial International Exhibition, Melbourne, was one of the earliest recorded cases of the display of Larrakia art to a wider audience. Curated by John George Knight, this exhibition featured drawings by Aboriginal artists, four of whom—Davie, Jemmy Miller, Paddy, and Wandy Wandy—were inmates of Darwin's Fannie Bay Gaol, while the fifth, a Larrakia man called Billiamook, worked as an interpreter for the Darwin police [see **prison art**]. The inclusion of their work in this exhibition was unusual; previously only a few Larrakia artefacts and weapons had been collected by a handful of early explorers and some travellers. In the mid nineteenth century there was little interest in paintings by Larrakia: the early settlers and government officials were more intent on taking over Larrakia land and either dispersing or controlling the people. Aboriginal artworks were still regarded as artefacts or ethnographic curiosities, rather than as 'art' [see 2.1]. By the 1950s, however, Aboriginal art was starting to gain recognition and it was at this time that Larrakia artists were mentioned by anthropologists Ronald and Catherine Berndt, who noted the 'naturalistic figures' of Larrakia wood carvings.

Larrakia artists are today exhibiting their works both nationally and internationally. In the 1980s and 1990s a number of Larrakia artists began to make an impact and are raising

82. Prince of Wales, *Bodymarks*, 1996. Acrylic on canvas, 75 x 50 cm.

awareness about Larrakia people and culture through their art. Among the more prominent artists are **Prince of Wales** (Mitbul), Anthony Duwun Lee, Daniel Roque Gulawan Lee, Des Kootji Raymond, Peter Garamanak Browne, Marjorie Bil Bil, Naomi Briston, Nadine Lee, and Allyson and June Mills. What these artists have in common is their pervading interest in presenting not only Larrakia culture and spirituality but also their own histories, including their long struggle for the return of some of their traditional lands through the Kenbi (Larrakia) land claim [see **land rights**]. Duwun has been commenting on the Kenbi land claim for a decade or more. Prince of Wales and Duwun held a joint exhibition, 'Calling the Rainbow', at Hogarth Galleries in Paddington, Sydney, in early 1998. Prince of Wales is a senior Larrakia elder who had previously held his first solo exhibition, 'Bodymarks', at Gallery Gabrielle Pizzi in Melbourne in 1996 [*82*]. Duwun has been painting and creating art since his early adolescence and has also exhibited in solo and group shows in Canberra.

Koolpinyah, whose triptych *Gwalwa Dorennage (This is Our Land)*, 1995 [*81*] was purchased by the Museum and Art Gallery of the Northern Territory (MAGNT) in Darwin, is an acknowledged senior Larrakia elder and a keeper of cultural knowledge who has been painting for over forty years.

Roque Lee is another emerging Larrakia artist who is known for his fine three-dimensional spirit figures and painting. His spirit figures (one of which has been purchased by MAGNT) incorporate finely wrought cross-hatching with wood carving and natural objects such as short-neck turtle shells and bird bones. Kootji Raymond works both as a painter and film-maker [see 13.1]. His works on canvas depict his concern with the preservation and maintenance of Larrakia natural heritage, such as the mangrove foreshore environments now threatened with destruction in the cause of progress. Kootji mixes Larrakia earth and other media, such as the blood of the magpie goose (a highly-prized Larrakia staple), onto the canvas with the acrylics; these paintings have been exhibited in Darwin and Perth. Peter Garamanak Browne produces prints which show his long-term interest in the diversity and importance of Larrakia totemic animals and birds. His work illustrates the multi-skilled expertise of Larrakia artists who are taking advantage of new techniques and media in which to explore their art.

By contrast with the male artists, the recognition of Larrakia women artists has tended to concentrate in the areas of weaving [see 17.1], design, and music. The senior Larrakia elder, Topsy Secretary, who passed away in the late 1990s, paved the way for younger women to enter the art world. Marjorie Bil Bil is a well-known artist, weaver and storyteller. Naomi Briston and Nadine Lee work as artists and designers. Allyson and June Mills have received considerable recognition as musicians; Allyson adds acting to her repertoire [see 16.1] while June is also a visual and textile artist.

All art and artists evolve and transform over time. Larrakia artists, such as those mentioned here, are not only working within their own culture but are also creating within external artistic traditions. They are pushing boundaries and widening the awareness of Larrakia culture, society, and issues in such areas as video and **film**, sculpture, design, **printmaking**, weaving, fabric printing, and music. While Larrakia artists are still comparatively few in number, they are providing examples which younger Larrakia people and other artists may follow and take into the new millennium.

Gary Lee

Berndt, R. M., & Berndt, C. H., with Stanton, J. E., *Aboriginal Australian Art: A Visual Perspective*, Sydney, 1982; Sayers, A., *Aboriginal Artists of the Nineteenth Century*, Melbourne, 1994.

7. Between islands

7.1 Custom and creativity: Nineteenth-century collections of Torres Strait art

Torres Strait Islander art has undergone many transitions over the last two centuries. Yet, despite regional differences within Torres Strait and the similarities with some material from the neighbouring coast of Papua New Guinea, certain types of object, methods of production, and design elements combine to form a distinctive and dynamic Islander style. We will focus on the art of the nineteenth century, drawing on the wealth of material housed in Australian and British museums, with particular attention to a number of types and styles of objects which are characteristic of the region. An overview of the encounter between the Islanders and British explorers, missionaries, and researchers will provide a brief historical background to these early collections and illuminate innovations related to particular contact situations. Of particular importance are the comprehensive and well-documented collections made by the ethnologist Alfred Cort Haddon during his two expeditions to Torres Strait in 1888 and 1898.

Long before Europeans visited the region, Islanders were skilled navigators. In canoes up to 15 metres in length with double outriggers, twin mat sails, and decorations intended to assist difficult voyages and attract valuable sea creatures, they travelled long distances across the treacherous waters of the Strait and along the coasts of New Guinea and Australia. Indigenous trade was a material representation of family and cultural links, uniting people from different communities and forming the basis of what is often now described as *Ailan Kastom*. The diverse ecologies of the different islands provided a variety of natural resources. Foodstuffs and objects such as stone clubs were important in inter-island trade. The most valuable exports were pearls, trochus and *wauri* shells, and shell ornaments. In turn, many Islander artefacts incorporated materials acquired through more distant trade: ochre, javelins, and spear-throwers from Australia; and half-modelled wooden canoe hulls and drums, and cassowary and bird of paradise feathers from Papua New Guinea.

Torres Strait was named in 1767 after the first European explorer in the region, Spanish navigator Luis Vaés de Torres, who sailed through the Strait in 1606. The voyages of Cook (1768–71), Bligh (1787–89, 1791–93), and Flinders (1801–03) gradually charted a safe route for colonial expansion through the reef-bound waters. Contact between Islanders and early European explorers was intermittent, variable, and often traumatic. From the mid nineteenth century an increasing number of traders and divers from Europe, Polynesia, Malaysia, Japan, and elsewhere, came to exploit the riches of the Strait: bêche-de-mer, sandalwood, turtle shell, and, by the 1860s, pearl shell [see 10.4]. British colonial forces established a station at Somerset in 1864 which officially moved

to Thursday Island in 1877. In 1879 the whole of the Torres Strait region was annexed to the colony of Queensland.

The interests of early collectors focused on weapons, such as stone clubs (*gabagaba*) and arrows, as well as on objects made from rare and valuable materials, such as turtleshell masks and pearlshell ornaments. Many of these are now scattered throughout the world in museum collections, the most extensive of which is at the Museum of Mankind (British Museum). Although little is known about the specific provenance of most of these objects, or the Islanders who made them, brief comments can be found in the records of surveying expeditions or in the popular journals of officers such as Joseph Beete Jukes, on HMS *Fly* (1842–46), and Thomas Huxley, a naturalist on HMS *Rattlesnake* (1846–50). The records of early encounters with European explorers indicate that the Islanders were adept traders, and appeared keen to acquire materials such as iron and cloth: Jukes recounted that:

two or three went and brought a large roll of matting, at least 12 feet by 6, which they spread for us to sit down on. These really well-made fabrics greatly surprised us … They gave us cocoa-nut water, without waiting to receive anything for it, but for the other things they would only accept tobacco and iron implements, paying no regard to our beads and gaudy handkerchiefs.

Between 1871 and 1910 important collections of Torres Strait material were made by members of the London Missionary Society (LMS), a large, privately-funded, Protestant organisation. The missionaries Samuel McFarlane and Archibald Murray first landed on Darnley Island on 1 July 1871; this event has now been incorporated into Islander history as 'the Coming of the Light'. LMS teachers from the South Seas were settled on numerous islands under the protection of the local headman (*mamoose*). In the 1870s a training institute and missionary school were established on Mer (Murray Island). From such encounters came subtle changes in Torres Strait Islander material culture: the inclusion of calico in personal ornaments and dress; the incorporation of wood from tea and sugar chests into the construction of masks and dance ornaments; the use of tin and iron in place of turtle shell. LMS teachers and boat crews from the South Seas brought with them new styles of house construction, weaponry, basketry, and mat-making which

83. Men dancing on Mer, 1898.
The feathered head-dress (*dari~dhoeri*) and waisted drum (*warup*) continue to be important symbols of Torres Strait Islander identity. As a result of the influence of missionaries, colonial officers, and anthropologists, many Torres Strait dances were modified for new events and audiences. This photograph is one of a series showing 'secular' dances performed for Queen Victoria's birthday on May 24, 1898.

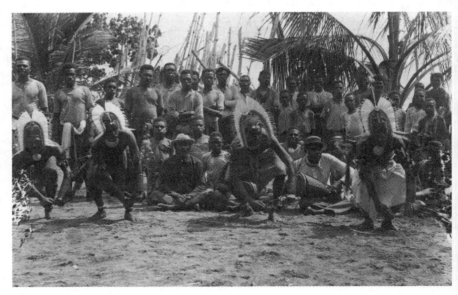

influenced local production. Colonial officials and missionaries imposed numerous changes through the suppression of ceremonial practices once connected with cult initiation, headhunting, warfare, gardening, and fishing magic, which led to a decline in the production of objects such as masks and sacred figures. Islander impressions of the outsiders were recorded through oral history, dance, and song [83], and on items such as stone spinning tops [84] and bamboo vessels.

Missionaries also commissioned artefacts intended for sale in Europe. The most noteworthy missionary collection was made by McFarlane between 1874 and 1888, the bulk of which was subsequently sold at Gerrard's Auction in London and purchased by the British Museum, Museum für Völkerkunde, Dresden, and the Royal Museum of Scotland, Edinburgh. Most of the McFarlane collection was obtained from the islands of Mabuiag, Naghir, Yam, Tudu, and Saibai. Many of the pieces he commissioned were remarkably elaborate and highly decorated—they reveal the technical skill and imagination of their producers while reflecting the interests of the collector.

The best known collections of nineteenth-century Torres Strait material remain those made by A. C. Haddon. The material is housed at the British Museum and the University of Cambridge Museum of Archaeology and Anthropology, with smaller collections at the National Museum of Ireland, Dublin, the Pitt Rivers Museum, Oxford, and the Queensland Museum, Brisbane. Haddon first went to Torres Strait to study marine biology, but his focus soon shifted to the stories and activities of the local people. Concerned with preserving a past he feared was disappearing, he organised the 1898 Cambridge Anthropological Expedition to Torres Strait. Its members included scholars in the fields of psychology, physiology, medicine, and linguistics, with expertise in photography, film, music, and art. The expedition documented Islanders' knowledge and material culture through photographs, field notes, sound recordings, and collections.

Haddon spent most of his time on the islands of Mer and Mabuiag where he developed close personal relationships with some of the local people. His journals include lively descriptions of everyday life and the people with whom he worked:

Shortly afterwards friends drop in to have a chat—from two or three to as many as two dozen, and I endeavour to find out all I can about what they did 'before white man he come—no missionary—no nothing'. We have very pleasant times together laughing and talking. They are greatly pleased when I show them pictures out of books, or in my sketch books, or rough prints of my photographs of themselves … They quite understand for what purpose I am making these enquiries and are very ready to tell me all they can (Haddon 1888).

Expedition members were privy to some aspects of Islander knowledge expressed through objects, stories, and re-enactments of sacred practices. Islanders seem to have made clear decisions about what to give and what to withhold. For example, Haddon tried without success in 1888 and 1898 to buy the sacred ceremonial drum, Wasikor [194], from the people of Mer. Similarly he was denied information about the secret ceremonial figure of Waiat in eastern Torres Strait. It was only from accounts given by William McFarlane and A. O. C. Davies that he was able to include descriptions of these ceremonies. Davies' collections, including the figure of Waiat, are now housed in the Queensland Museum.

The objects collected by Haddon illustrate a broad range of social and cultural activities at the turn of the century. The accompanying documentation also records the encounters between Haddon and specific Islanders. In addition to collecting existing pieces, he commissioned the production of numerous replicas and models, which, as with the material commissioned by Samuel McFarlane, resulted in much creative improvisation. With the assistance of elders, Haddon also recorded information about

a)

b)

c)

84. Stone spining tops, Mer, Collected in 1898.
a) Tracing of a man in European dress, and snake; 15.1 cm diam, 4.4 cm thick.
b) Illustration from the story of Keigi and Nageg; 13 cm diam, 4.5 cm thick.
c) The legendary Kalnut wearing a feather head-dress, using his long arm to steal food; 14 cm diam, 6.1 cm thick.

Stone spinning tops, used by men in the eastern islands of Torres Strait for competitive sport, were one of the few media on which illustrative designs appeared. The subjects were often taken from stories.

objects from earlier collections, using photographs, drawings, and descriptions of material held in European museums. His attribution of information to named sources was an extremely valuable aspect of the expedition's work. The expedition's *Reports* contained numerous stories, often quoted verbatim, and drawings from individual Islanders. While this information is incomplete, and contains inaccuracies, it remains an invaluable source of knowledge about the past:

Naga of Nagir [Naghir] knew how to make the urui krar, *or masks in the form of animals, he instructed the men in singing and dancing and in everything relating to the* kwod … *Waiat of Mabuiag came to Nagir to learn how to beat the drum and Naga taught him. Then Waiat stole a famous mask. After this Naga gave a mask to the men of Tutu [Tudu], another to those of Waraber, a third to those of Moa, and he kept one mask in Nagir. Naga gave akul shells to all the islands, Muralug, Waraber, Tutu, Yaru, Moa, Badu, Mabuiag, Masig, Paremar, Aurid, so that the men in these islands might in future make their own masks (Reports vol. 5, 1904).*

This is part of a story related to Haddon by Kuduma of Naghir. It alludes to a long history of mask-making in Torres Strait. Masks were worn in harvest festivals and in ceremonies related to initiation and honouring and appeasing the dead. While many were specific to ceremonies on particular islands, for example the Malu-Bomai initiation ceremonies associated with Mer, many common elements were found throughout the Strait. The most distinctive type of object historically associated with Torres Strait is the elaborate turtleshell mask, first mentioned in the 1606 log of de Torres. Nineteenth-century examples of these masks are truly exceptional pieces in terms of their detail, complexity, and skill of composition. Plates of moulded shell were carefully bound together with fibrous stitching and beeswax, often producing an apparently supple, leather-like appearance. Broadly, there were two types of turtleshell masks: those representing human faces (*le-op*) which appear to have originated from the eastern islands; and elaborate composite forms (*krar*), combining human and animal imagery, associated with the western and central islands. Both types were often further decorated with pearlshell eyes, tufts of cassowary feathers, shell, and goa nuts.

The anthropomorphic masks (*le-op*) often included a wide flange around the sides with detailed, incised decoration. The face tended to be elongated with a long, thin nose. Human hair was usually attached to the top of the head and around the mouth and chin, through perforations in the turtle shell. Only a few examples have hair remaining. The masks are often further decorated with lime-filled incisions and ochre. The large, composite masks (*krar*) were made by superimposing one creature on top of another. A mask made by Gizu of Naghir, collected by Haddon in 1888, has a crocodile head surmounted by a human face and outstretched hands. When worn on the top of the head, only the crocodile is clearly visible—the human figure is suddenly revealed when the wearer tilts his head downwards. One of the most complex examples of this type was commissioned by Samuel McFarlane from Mabuiag and includes a stingray, crocodile, fish, and birds [85]. In these multi-layered compositions, dramatically different aspects of the mask are revealed as the wearer changes position. Such masks highlight themes of surprise and transformation that continue to be an important aspect of Torres Strait performance.

Wooden masks (*buk*), depicting stylised human faces, appear to have originated in the northern islands, which had access to timber traded from New Guinea. There are numerous examples of these in British, German, Australian, and New Zealand museum collections which are either unprovenanced or attributed to Saibai. The two examples collected by Haddon, also said to originate from Saibai, were purchased on Thursday Island, which, being the administrative and commercial centre of Torres Strait, was an

emporium for goods collected on the various islands. The elongated faces have characteristically large, thin noses, extended chins, and grimacing mouths. When viewed from the side the masks have a pronounced bow shape, reminiscent of the curve of a canoe. The creators of these masks skilfully depicted subtle details of facial structure—the shape of the cheekbones and the rise of the squared forehead. Elongated ears portrayed the results of the once common practice of distending pierced ear lobes with decorative wooden weights. Many of these masks were originally painted. Those on which the paint survives tend to be black, either with a white band running from forehead to chin and widening out into a triangular design at each end, or, alternatively, with dotted white lines that divide the face into similar sections. In both types the contrast between light and dark highlights the angularity of the facial structure. As with the turtleshell masks, many of these pieces were once decorated with human hair or wigs of plaited fibre and pearlshell eyes. Both turtleshell and wooden masks were often worn over the face by positioning an interior crossbar between the teeth—a feat which required great skill and strength.

With few exceptions, the production and use of ceremonial masks declined during the last half of the nineteenth century as a result of the suppression of many traditional beliefs and practices by missionaries and colonial officials. Yet the collection made by the Haddon expedition in 1898 contains a large number of objects related to dance and performance [83, 194, 195] which are a testimony to the creative innovation of a distinct cultural form. Dances from pre-colonial times were presented in new ways as Islanders responded to and selectively incorporated outside influences. Dance paraphernalia from Haddon's 1898 collections include hand-held ornaments [86] and storyboards, many of which relate to a detailed knowledge of the movement of the stars, the currents of the sea, and the changing seasons [see 1.3]. A hand-held ornament from Mer, in the form of a wooden carving of a crab perched on the edge of a branch, shows great attention to anatomical detail. As the ornament is raised the detail of the underbelly is revealed. A large number of carved and painted staffs show the stories related to *muri*, small spirits

85. (*below left*) Unknown Torres Strait Islander (Mabuiag) artists, stingray mask, collected by Samuel McFarlane on Mabuiag in the 1880s.
Composite turtleshell and paint, length 122 cm.
The mask shows a large stingray superimposed over a crocodile. Small fish are attached to the side and birds' heads project from the base. This extremely elaborate mask is also notable for the unusual yellow paint on the fins and tail of the stingray.

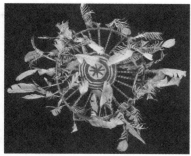

86. (*above*) Unknown Torres Strait Islander artists, hand-held dance ornament, collected by Alfred Cort Haddon on Mer in 1888.
White sea bird feathers (probably Torres Strait pigeon), painted wood, and cane, 50 x 8 cm.
The ornament has a central star motif and radiating feathers, recalling the natural world and seasons. Ornaments of this type were normally used in pairs.

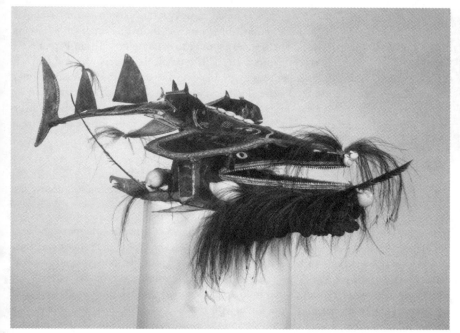

which use waterspouts for fishing. Many dance objects are constructed to highlight the multi-layered meanings expressed through dance performances; the dramatic characteristics of the overall form are crafted with the intention of surprising and captivating the audience. These objects, collected over a hundred years ago, are the precursors of the articulated, mechanical dance machines—the elaborate and distinctive objects in which contemporary Torres Strait artists excel [see 7.5; *92, 93, 94, 157*].

Dances and songs from recent and historical events were also incorporated into dramatic performances. The improvisation of Island dance to include new fads and fashions (such as a ferris-wheel ride at Thursday Island in 1898, recorded by Haddon) was also noted by Frank Hurley in *Pearls and Savages* (1924): 'Their dances constantly change in plot and character, since they bring into them incidents of the community which have attracted popular notice. One of the most amusing witnessed by the party was a pantomime satirising the white military authorities. In this the dancers mimicked with genuine artistic exaggeration the stiff walk, the manners and the pomposity of the ruling white men.' More recent performances have included a number of head-dresses which refer to Islanders' participation in the Australian defence effort during World War II. For example, the Horniman Museum, London, has two head-dresses collected in the 1990s which are constructed of a painted oil-drum base surmounted by a carved wooden aeroplane with the markings of an American F2 bomber. These originated from Badu where a wartime radar unit was based [*95*].

One head-dress which has changed little is the ubiquitous *dari~dhoeri* (feathered head-dress), although it continues to have distinctive variations associated with different Islander communities [see 7.3; *83, 89*]. Originally worn by warriors, it was also used by men for dances and numerous ceremonial occasions. It was made of white, radiating feathers, attached to an inverted, U-shaped, cane frame. The feathers, from Torres Strait pigeons or white herons, were often cut into fine, zigzag patterns towards the tips. The whiteness and fullness of the feathers were sometimes highlighted by the insertion of long, black, spindly cassowary feathers, creating a contrast of colour and texture. The frame was often ochred or painted. An unusual example collected by Haddon in 1898 includes stylised eyes and a long, thin, wooden nose. Another has a woven, triangular frontispiece, decorated with thick, reddish-brown ochre and white lime, with feathers projecting along the top edges. The frame is similar to ornaments worn in Papua New Guinea and was probably traded from there. This type of head-dress was and is worn differently across the Strait, sometimes at an angle on the top of the head, sometimes almost like a mask fixed to the forehead. An Islander song, collected and translated by Margaret Lawrie, recalling the similarity between the water spray thrown up from the rock, *waidemua*, and the shape and appearance of *dari~dhoeri* is indicative of the layers of meaning contained in the visual imagery associated with dance:

Malu kula, malu kula, dari waidemua

The waves breaking over a stone at the edge of the reef throw up foam, it looks like *dari*.

Dance and song were often accompanied with drums, shell trumpets, clappers, and rattles. There are three types of drum in nineteenth-century collections: the distinctive, hourglass-shaped drum (*warup*) found only in Torres Strait; the bow-shaped wooden drum (*buru buru~boro boro*) [*389*] also used across the south-west coast of Papua New Guinea; and the small, cylindrical bamboo drums (*marep*) made in the Strait. The *warup* are perhaps the most elegant of the three, with pinched waist opening out to an open mouth or 'jaw', often decorated with cassowary plumes and goa nuts and with lime-

filled, incised decoration around the edge. The lizard skin for the tympanum was traded from Papua New Guinea and often painted with red ochre and dotted with beeswax balls, essential for tightening the skin of the drum before playing. Some *warup* have small, personal decorations on their surface, most usually an animal, a bird, a fish like a shark, a cassowary, or a turtle. These designs probably related to the totem of the owner of the drum and were similar to personal signatures. Most *warup* have a small, triangular motif at the corner of each jaw, reminiscent of a *dari~dhoeri*. The *buru buru~boro boro* are waisted, with a large rectangular handle at the centre. Decoration is usually confined to the open end and consists of a series of painted and carved triangular motifs. The *marep* is usually plain. One example collected by Haddon has a jaw-like end and a small, red-ochred design of a turtle. It is probable that large, rough drums were traded from New Guinea into the northern islands where they were re-fashioned and decorated in a distinctive Islander style, allowing for personal expression.

The use of the figurative decoration often found on drums extends to other types of objects, such as the bamboo tobacco pipes common throughout the Strait, or the stone spinning tops [84] of the eastern islands. Pipes were often covered with incised decoration including geometric designs, images from stories, and totems. The range of styles and designs is indicative of the individual creativity expressed in decorating these personal objects. The flat upper surface of stone tops, used in competitive sport, provided a medium for painted subjects such as men wearing ceremonial masks, scenes from stories, and images of European men and ships. Some figurative designs appear to have been employed as a method of specific instruction. For example, a shell knife collected by Haddon from Mabuiag has the incised figure of a dugong with detailed lines showing the proper cutting places for butchering.

Many of the features of the anthropomorphic turtleshell and wooden masks are also seen in smaller, wooden carvings. Head-dress decorations, canoe-prow ornaments [87], models of ancestral figures, and figures placed in the garden to encourage productivity, all portray the pronounced nose, ears, and chin, and the distinctive m-shaped hairline. This style appears to have predominated in the nineteenth century throughout Torres Strait. The various degrees of stylisation are best illustrated by highly decorative face (*le-op*) or crocodile (*koedal*) arrows which range from easily recognisable to highly abstract, three-dimensional representations. Following Darwinian notions of species differentiation, Haddon arranged these arrows into a series based on increasing abstraction which he believed demonstrated principles of evolution and degeneration in art. These arrows are perhaps better understood as illustrative of the range of stylistic elements employed by individual artists.

The majority of nineteenth-century Torres Strait objects collected by Europeans were produced and used by men. A valuable aspect of the Haddon collections, however, is the number of perishable, domestic pieces associated with women, such as skirts, mats, and the tools used to make them. These objects are illustrative of gender relationships within families: women made baskets and mats for their brothers and husbands; small tools made by men, such as turtleshell fishing hooks and piercers, were used by women for weaving and were also incorporated into female ornaments. Both men and women wore fibrous skirts (*nesur, zazi*), notable for delicate and complex workmanship which combined three or four different textures, such as banana-leaf twists, and sago fibre bound with coconut palm and red calico. Finely woven mats made from pandanus and banana-leaf were often finished with over-painted detail in red, blue, and white—some of the most intricate examples were made for babies to lie on.

Many of the objects described here continue to be made and used by Torres Strait Islanders. The feathered *dari~dhoeri* has become a symbol of the unity of Torres Strait—

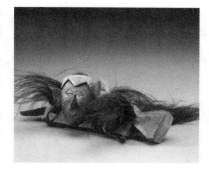

87. Unknown Torres Strait Islander artists, canoe prow ornament (*dogai*), collected by Alfred Cort Haddon on Saibai in 1888.
Wood, pearl shell, and cassowary feathers, length 36 cm.
The projecting wooden head with pearlshell eyes, typically elongated ears and m-shaped hairline, is decorated with tufts of cassowary feathers. The *dogai* was attached to a canoe to assist with fishing and navigation.

a stylised version is the central image on the **flag** of the Torres Strait Regional Authority, founded in 1994. The *warup* and *buru buru~boro boro* drums [*389*] are also used to represent Islander identity, although the latter, often brightly painted, are much more common today. Woven mats continue to be an integral part of *Ailan Kastom*, as a symbol of welcome in churches and homes in the Strait and on the mainland. The production and use of certain types of masks and cult figures declined towards the end of the nineteenth century and they are no longer made. Yet, many of their formal, stylistic features, such as the manner of depicting the human face, have remained in use, while notions of surprise and transformation have been incorporated into objects associated with secular dance. Images of historic objects now in museum collections have also been incorporated into printmaking and sculpture by contemporary artists such as Dennis **Nona** and Alick **Tipoti**. Nineteenth-century collections remain a testament to the skills and vibrant artistic traditions of Torres Strait Islanders. These historic objects embody the social relationships between individuals and communities within Torres Strait, as well as those between Islanders and outsiders. In the words of Pedro Stephen, Mayor of Torres Shire, to the Council for Australian **Reconciliation**, in 1997: 'The island mat binds many leaves (of different shades and textures) together, just as a community of individuals and families are bound together, sharing their strengths and their weaknesses.'

ANITA HERLE AND JUDE PHILP

Australian Reconciliation Convention, *The People's Movement for Reconciliation: Proceedings of the Australian Reconciliation Convention, 26–28 May 1997*, Canberra, 1997; Haddon, A. C., Journal, 1888 [unpub. microfiche], National Library of Australia; Haddon. A. C. (ed.), *Reports of the Cambridge Anthropological Expedition to Torres Straits*, 6 vols, Cambridge, 1901–1935; Herle, A. & Philp, J., *Torres Strait Islanders: An Exhibition Marking the Centenary of the 1898 Cambridge Anthropological Expedition*, Cambridge, 1998; Jukes, J. B., *Narrative of the Surveying Voyage of HMS Fly, Commanded by Captain F.P. Blackwood, RN, in Torres Strait, New Guinea, and Other Islands of the Eastern Archipelago, During the Years 1842–1846: Together with an Excursion into the Interior of the Eastern Part of Java*, 2 vols, London, 1847; Lawrie, M. E., *Myths and Legends of Torres Strait* [sleeve notes to recording accompanying publication], St. Lucia, Qld, 1970; Moore, D. R., *The Torres Strait Collections of A. C. Haddon: A Descriptive Catalogue*, London, 1984; Mosby, T. & Robinson, B. (eds), *Ilan Pasin (This is our Way): Torres Strait Art*, Cairns, Qld., 1998.

7.2 Connections to the past

We people who call ourselves Torres Strait Islanders maintain that identity whether we live in Torres Strait or in mainland communities. Our connections to the past and one another through a shared history and culture make this possible.

The physical and material representations of our traditional culture, made by our direct ancestors, can be found all around the world—but not in Torres Strait. The Strait was once a short cut to Australia and the Pacific, and objects were collected there by visiting traders and travellers and later deposited in foreign museums. The most comprehensive and publicised collection of traditional Torres Strait Islander material culture was systematically gathered by Alfred Cort Haddon during the 1898 Cambridge Anthropological Expedition to Torres Strait [see 7.1]. Following the expedition, the six volumes of reports were published. Despite the eradication of many traditional practices due to the introduction of Christianity [see 1.2], many Islanders still hold the objects collected by Haddon in high regard. They do not represent a forgotten past but signify an untapped source of strength and unity that can only make Torres Strait Islander culture stronger in the future.

Islanders who sat and talked to Haddon during his visits in 1888 and 1898 are still remembered by their descendants. How Torres Strait Islanders interact with one another today bears directly on who we are related to. Traditional knowledge of kinship systems, language, and customary practices were formally maintained on the islands through a strong oral history tradition. Stories told by elders ensured the continuity of customary practices. These stories were usually accompanied by a genealogical history which contextualised the listener's position within the kin system. This has been made more complex by the distribution of Torres Strait families and communities throughout Australia. The knowledge is, however, still available to individuals when suitable occasions arise for sharing it.

While conducting research on the Haddon Collection, I was given a photograph of Haddon's key informants on Mabuiag Island. When I showed it to an uncle (*awthe~aude*) he was able to tell me how I was directly related to the men in question. If I had not shown him this photograph, these people would not have meant anything to me except in their role as Haddon's informants. My limited knowledge of my ancestors is a result of growing up in mainland Australia: if I did not see these people I did not need to know about them. The more Torres Strait Islanders interact with one another, the more this knowledge of ancestry is maintained. This in turn strengthens our connections to one another and to the past.

Ailan Kastom is the term used to describe the strong sense of culture shared by Islanders. *The Aboriginal and Torres Strait Islander (ATSIC) Act 1989* (Cwlth), defines it as: 'the body of custom, traditions, observances and beliefs of some or all of the Torres Strait Islanders living in the Torres Strait area, and includes any such customs, traditions, observances and beliefs relating to particular persons, areas, objects or relationships.'

This definition, although intended to be comprehensive, does not recognise the significant Islander population living on the mainland. In many satellite communities there are Islanders who are highly involved in the promotion of their culture. With the establishment of Torres Strait Islander organisations and increased access to services and resources, mainland communities are developing rapidly. Apart from the occasional dance performances at public celebrations such as NAIDOC week, Torres Strait culture has not been strongly promoted in a formal way until recently. Increasingly, these 'mainland' Islanders have felt the need to present their culture in forms that are distinct from the forms found in Islander cultural contexts such as Tombstone Openings [see 1.6], weddings, and church celebrations.

The promotion of works of art to the wider public is a recent phenomenon that has grown from the increased interest in Torres Strait culture on the part of museums and art galleries. However, many Torres Strait Islanders, and Australians in general, have had little exposure to historical collections of traditional Torres Strait objects. The Australian community is generally not aware, for example, that the cultures of the Torres Strait are the only ones in the world that constructed composite turtleshell masks [85]. In the past, Torres Strait works were often placed under the broader heading of Aboriginal art and culture. This however is changing with the promotion of Torres Strait culture at large cultural institutions such as the National Museum of Australia, and as more interest in Torres Strait culture is generated, the call for traditional objects to be returned to the Torres Strait grows stronger. Once they are returned, both Torres Strait Islanders and the broader Australian community can celebrate them together.

The Islanders' need to reconnect with the past through the return of these objects cannot be overstated. In 1997, film director Frances Calvert documented an instance of reconnection in *Cracks in the Mask*. In the film, Islanders Ephraim **Bani** and his wife Petharie visit many international museums that have Torres Strait collections. On one

occasion, while viewing a turtleshell mask on display at the Cambridge University Museum of Archaeology and Anthropology, Ephraim is able to provide important cultural information about the object from Torres Strait oral history. Thus the Torres Strait Islander perspective can improve the current level of knowledge about objects, and this further supports the argument for repatriation. Even though many collections of Torres Strait material are distributed around the world, Islanders continue to have rights to their cultural heritage. As long as Torres Strait culture exists, so will the need to connect to the past.

Visual and material expressions of culture have long been commonplace in Torres Strait society, but when these objects are collected, they tend to be presented either as ethnographic artefacts or as 'art', with little regard for their original function and cultural context. One notable case is the display of dance machines and head-dresses constructed by Ken **Thaiday**, Sr [see 7.5; *157*]. Because few art gallery visitors have been exposed to Torres Strait culture, and there is limited information provided with gallery exhibits, the misconception has arisen that Thaiday's use of *beizam,* or shark head-dresses, is a recent development unconnected to a rich and diverse set of cultural traditions. Formerly used to represent the different clans and as symbols associated with ancestor worship and warrior cults in Torres Strait, the representation of totemic animals in the form of masks and head-dresses has continued in contemporary dance forms.

Traditionally artistic expression in various forms was a means of promoting one's identity within a clan system, focusing on connections to totems and ancestry. Cicatrisation, such as the scarring of totemic dugongs onto the lower back, reported by Haddon, was practised by women to express clan identity. This, of course, does not necessarily constitute the basis of all traditional artistic expression, but the importance of identity through connections with totems and ancestry continues to be illustrated in contemporary Torres Strait Islander art.

Ellen **José** [*158*], originally from Cairns and now based in Melbourne, is one of the longest-practising Torres Strait Islander artists. As well as working as a painter, printmaker, photographer, and installation artist, she is an art teacher. *Did They Beat the Drum Slowly When They Lowered You Down*, 1992 places Torres Strait Islander soldiers of World War II within an earlier tradition of the Indigenous warrior. The work depicts an Islander dancer in traditional costume holding a drum, integrated with images of warfare: the flash of gunfire, an Islander soldier, and the long winding road of the Kokoda trail edged with barbed wire. The Islanders' contribution to the defence of Australia was a turning point in government administration of the Strait. Exposure for a limited period to equal rights, further supported by the camaraderie shared by soldiers, led to a major push for better conditions and self-determination for Islanders.

Alick **Tipoti**, a Badu Islander, has also attained international recognition. He has moved into the area of children's literature by publishing traditional stories told to him as a child. In *Mura Uruiau Danaka*, 1996 [*88*], which translates from the Kala Lagaw Ya language as 'For the eyes of every creature', he depicts a triumphant headhunter drawing strength from his *augud* (totem) as he prepares to avenge the death of his six brothers in battle. Tipoti likens his use of the linoprint technique to the style of carving and etching practised by traditional artisans. While much of his work draws on the myths and legends of older, darker times, it still provides a medium for cultural maintenance in a popular form.

The year 1998 was significant in the celebration of both traditional and contemporary Torres Strait culture, with the centennial celebrations of the 1898 expedition and the promotion of Torres Strait art nationally in the 'Ilan Pasin' (This is our way) **exhibition** at the Cairns Regional Gallery. The first exhibition of its kind, 'Ilan Pasin' toured nation-

ally, providing a forum for both historical and contemporary works. This first step is now being followed up by the National Museum of Australia, which has dedicated special exhibition space for Torres Strait. Once in place, this exhibition space will allow Torres Strait culture to be presented at a formal level, to promote awareness and understanding to justify the need for traditional material to be returned to Torres Strait, and so that Islanders can continue to strengthen their connections to the past.

MARY BANI

Bani, M., 'Torres Strait Islander collections in Australia and overseas museums,' in T. Mosby & B. Robinson (eds), 1998; Haddon, A. C. (ed.), *Reports of the Cambridge Anthropological Expedition to Torres Straits*, 6 vols, Cambridge, 1901–1935; Mosby, T. & Robinson, B. (eds), *Ilan Pasin (This is Our Way): Torres Strait Art*, Cairns, Qld, 1998.

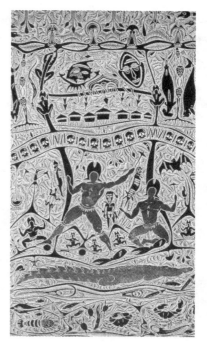

88. Alick Tipoti, *Mura Uruiaw Danaka (For the Eyes of Every Creature)*, 1996. Linocut, hand-coloured à la coupe, 100 x 54.5 cm.

7.3 Dancing in Torres Strait

Torres Strait Islanders believe that the practices which they call *Ailan Kastom* distinguish them from other peoples and link them to ancestors who inhabited their islands before the coming of Europeans. Dance is an important part of this *Kastom*, as the main outlet for creativity and the principal source of aesthetic satisfaction. At the same time it is a means by which people present themselves—as individuals to their fellows, communities to other communities, and Islanders to the world.

Torres Strait Islanders are connoisseurs of dance and have long been so. Originally an integral part of religious practice and a vehicle for expressing transcendent meanings, dance was also a source of amusement or play (*plei* in Broken, the Torres Strait Creole). This does not mean that it is not taken seriously. The dancer strives for what Islanders call 'style' in personal decoration and performance, to catch the eye of the spectators and perhaps of a particular member of the opposite sex. The dance both permits such display and sets limits upon it. Competence is within the capacity of most, but even minor physical defects are a disqualification and clumsiness draws a withering fire of female laughter. On the other hand, age and obesity do not diminish the person of the dancer provided that the performance is in order. Some dancers drink alcohol to give 'strength' to their performance, but they run the risk that it will be exaggerated. Much the same constraints operate with respect to personal decoration. There is room for individual preference in the wearing of a flower or feather in the hair, or the affectation of a cigarette between the lips; but there are conventions regarding what is appropriate for any particular kind of dance.

The region, including Cape York and the coast of western Papua New Guinea, sustains a rich variety of styles. The majority are specific to particular local traditions, but everyone knows and performs Island Dance. Properly presented Island Dance is accompanied by a combination of voices, hand-beaten Papuan drums, and a bamboo or tin beaten rapidly with two sticks. On Boigu, guitars are used. Voices may include both male and female, singing in a basic two-part harmony. The drums contribute a steady 4/4 beat with occasional rolls, the bamboo or tin sounds a rapid tattoo, the song's words add further syncopation. The musicians sit in front of the spectators, facing the dancers, who also sing and accentuate their movements with hand-held rattles.

The posture of the dancer is stooped, the men almost crouching, with head erect, elbows flexed, fists clenched, and knees apart. The basic steps consist of stamping—Islanders say 'kick'—on alternate feet, with occasional double steps and jumps. Men stamp more heavily than women, and may also kneel or fall prostrate, before leaping up again. Accompanying this are arm movements. Quick, graceful head movements are the

distinguishing features of an accomplished dancer. Women wear knee-length dresses; men a knee-length *lava-lava* and singlet, usually white. Over the dress or *lava-lava* is a kilt of pale green coconut-palm fronds. White wristlets, anklets, and head-kerchiefs allow the audience to pick out the movements in the half-darkness. On Saibai and Boigu, dancers adopt a posture that is nearer erect, and sway from the hips, 'hula style'. To show off this movement a long raffia or bark skirt is worn, preferably decorated with horizontal bands. Saibai men have a variety of head ornaments, and long scarves hanging from their wrists.

Each Island Dance consists of a selection from the limited range of movements that makes up the genre, set to a musical composition. There are hundreds of pieces in the repertoire, constantly augmented by new compositions, though depleted by the forgetting of others. A team of men, or women, or both, selects pieces in anticipation of a **festival** and spends nights practising. Each dancer must control the exact sequence of movements, for coordination is fundamental to the form. Island Dance is essentially an abstract form. Most songs have only the most general reference, for example to the movements of sea and sky, with no attempt to convey a narrative message. Some dances represent a particular activity such as turtle-hunting, kite-flying, fighting with bow and arrow, and signalling by semaphore, but the meaning is considered unimportant. The 'gear' is rather an extension of the dancer's body, its success measured in terms of the ingenuity of its devising. Mabuiag, for example, is noted for folding contraptions that open to reveal a cluster of stars.

The performance begins with the dancers emerging from, and ends with their returning to, a place of concealment. The dancing ground is a defined space. The team marches on in single file and, fronted by two leaders ('field bosses'), forms ranks facing the spectators. Dancers then go through their sequence a number of times, after which they take a break, and women sprinkle them with baby powder and perfume. Presently they resume, finally leaving as they came, followed by their musicians. Although each performance is a discrete event, it is always given in the company of other performances. The teams that follow one another onto the dancing ground are implicitly competing with one another.

Island Dance occupies a privileged place in the festive complex, but Euro-American touch dancing, known as 'Waltz' or 'Slow Drag', dating from World War II, and recent styles in the rock mode, also exist. 'Hawaiian' films of the 1940s started a fashion in 'Hula' displays, performed by women for fund raising purposes. There are also longer established dances associated with the Pacific Islands. 'Sit Down' dances, attributed to Samoa, are the most popular of these, particularly among the elderly and obese. Less commonly performed and more distinctive in character are the dances known as Taibobo, attributed to Rotuma, which are quite different from other Island music not only in words, but in structure and voice tone.

Islanders also recognise another style which they call 'Old Fashioned Dance' and attribute it to the time before the coming of missionaries. Rarely performed, the style is nevertheless remembered by the older generation as the 'real' Torres Strait dance. It is performed to 'Old Fashioned Songs' and accompanied only by drums and the dancers' rattles [195]. The musicians precede the dancers onto the ground and build up a sense of expectation with a slow prelude. Two dancers emerge, adopt a crouching posture and perform skipping steps on the tips of their toes; arm movements show off the decoration on the left forearm, and head movements, the white feather head-dress. The head-dress, known as *dari~dhoeri*, is distinctive to Torres Strait and commonly used by Islanders as their emblem [see **flags**]. A flat halo of feathers, it frames the face rather than conceals it. A characteristic movement is a turn of the head so that the *dari~dhoeri* becomes momentarily invisible. Another optical illusion is achieved by mounting a long black feather on

the frame and attaching a tuft of white feathers to its tip. In the darkness the tuft appears to float above the dancer's head. The forearm ornament is mounted in a gauntlet, from which protrudes a loop and a long cane tipped by another tuft of white feathers. Again, the tuft appears to float about the dancer's arm. A white-on-black effect is a recurring motif. The dancer may put streaks of paint on his face, blackening his trunk with soot so as to show up the flat white shell pendant worn from the neck. The Old Fashioned Dance is recognised as the most difficult, and thus a test of the performer's skill.

Meriam (Murray Islanders) also perform a series of dances derived from the old pre-Christian cult of Malu-Bomai. But of the original objects that played a central part in the rites, only the drum Wasikor survives. The shark head-dress, symbolising the ferocious aspect of Malu, was destroyed early in the mission era; the Bomai mask, once hung with the jawbones of war victims, disappeared around the same time. Latter-day performers make do with plywood and cardboard replacements. The right to wear the mask or head-dress, usually a black cassowary-feather coronet fronted by segments of dry coconut husk, is particularly coveted. Certain dancers wear a half-mask, called a 'shark-mouth'. Gripped in the teeth and decorated with white feathers, it partially conceals the face. Faces and bodies are painted with black mud and red lead. The skirts are of dark leaf or bark, and the background is a screen of coconut leaves into which crotons have been woven. The dance runs for about an hour.

The Malu-Bomai dances are all that has survived missionary repression of a rich ceremonial culture. Since the 1920s, however, Islanders have represented their mythical and legendary past in dance pageants, with warfare as a favourite theme. From the 1950s Saibai has achieved prominence in this genre with a number of brilliant presentations, the most notable of which was *Adhi Buiya*, which told the story of the luminescent stone that gave power and protection to their fighting men [89]. These dances are performed to drumming and singing, and have been composed for the occasion. The costuming is intended to suggest olden times and draws heavily on materials from neighbouring Papua, but there is room for imaginative embellishment. The head-dress may consist of a cassowary-feather coronet and bird-of-paradise plume, with a light wooden feather mounted on a flexible cane so that it nods over the dancer's head. It may also be fronted by a white cardboard mitre. The traditional feather *dari~dhoeri* is occasionally used, but

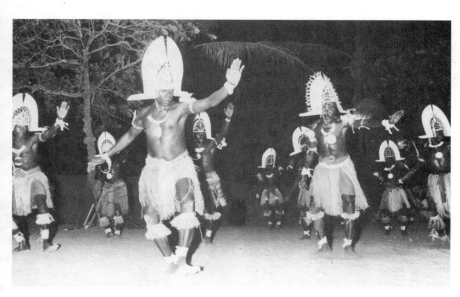

89. Performance of the Saibai *Adhi Buiya* dance at the enthronement of Bishop Matthews, 1960. In the foreground (left to right) are Kala Waia, Mebai Warusam, Asuela Aniba, and Francis Abai.

there is some preference for much larger ones that can be made with cardboard and other European materials. Skirts may be of shredded bark, imported from Papua, or teased out manilla rope. The warrior-dancers may carry the traditional bow and arrow, or use a combined spear and paddle that has no counterpart in the traditional inventory.

All Islanders are aware of the richness and diversity of their dancing heritage, but differ as to the use they make of it. Island Dance is not only the most favoured style throughout the Strait but the only one performed in the majority of communities. Mer (Murray Island), however, is unusual, maintaining a cultural pluralism; within recent memory the staple fare of Island Dance has been varied by performances of Taibobo, Old Fashioned Dance, and the Malu-Bomai cycle. There has been no sustained attempt to modify any of these styles or combine them; the Meriam prefer to keep each style distinct.

This cultural conservation is all the more remarkable because Meriam tradition has suffered severe interruptions. The Malu-Bomai dances were among the earliest targets of missionary repression: all but one of the sacred objects were destroyed or lost, and the songs and dances were forbidden, until the visit of Haddon's Cambridge Anthropological Expedition in 1898 provided an opportunity for their revival [see 7.1]. It was not until the mission regime had undergone a liberalisation in the 1920s that the dances could be restored to the regular repertoire, although with a selection of elements recombined to form a continuous performance. No attempt was made to reproduce the Bomai mask in turtle shell, either because the technique had been lost or because this would have brought the replica too close to the actual 'fetish'. The new Bomai was made of plywood, with painted bars taking the place of the open-work original. In other respects the Meriam went to great lengths to maintain the authenticity of the presentation, with particular respect to costumes and regalia. Moreover, having effected the reconstruction, they kept it virtually unchanged thereafter. Regarded with a seriousness tinged with awe, the new Malu-Bomai dances have come to stand for the old cult that once gave the Meriam their power and prestige among other Islanders. As such their integrity is inviolable. The Meriam have brought the same conservatism to the other dances. Even Island Dance has remained virtually unchanged. Those who have found their creativity restricted by the conventions of the established forms have found an outlet in the devising of elaborate dances in the 'Hula' mode.

In Saibai, tradition has been harnessed to creativity and spectacle in a style that is unitary but dynamic. The forms known to the oldest generation have been discarded or adapted without any feeling of impropriety. Choreographers go to Papua for plumes and grass skirts for historical pageants, but also add items that are obvious anachronisms. The past is imaginatively recreated rather than faithfully reproduced. Over the last decade or so, Islanders on the mainland have begun performing dances at multicultural festivals, while parties from Torres Strait regularly represent their tradition at the annual Pacific Islands dance festivals [157]. There have been a number of improvisations, such as the use of dari~dhoeri for Island Dance, of which traditionalists disapprove.

Some of the younger generation have joined the Aboriginal and Islander Dance Theatre [see 16.5], which includes traditional and Western dance in its repertoire. Island and Old Fashioned Dance are included and have not as yet been subjected to changes beyond those dictated by the exigencies of a continuous performance requiring quick changes of costume. The example of Mexican and Filipino folkloric companies suggests, however, that traditional dances will undergo modifications to meet the requirements of professional performance. If the Torres Strait tradition is to escape this fate it must be maintained within the Islander community and continually subjected to its judgment.

KOIKI MABO AND JEREMY BECKETT

Beckett, J., with musical analysis & transcriptions by Jones, T. A., *Traditional Music of Torres Strait* [gramophone record & pamphlet], Canberra, 1972; Beckett, J., with translations & transcriptions by Bani, E., Townson, S., Mabo, K., & Ober, D., *Modern Music of Torres Straits*, Canberra, 1981; Haddon, A. C. (ed.), *Reports of the Cambridge Anthropological Expedition to Torres Straits*, vol. 4, Cambridge, 1912; Holmes, C., *The Islanders* [documentary film], Film Australia, 1968.

7.4 Contemporary Torres Strait Islander art

Contemporary art of the Torres Strait Islands is flourishing. It is an art that brings together ancestral thinking and tradition, modern philosophies and evolving ways. An artistic tradition has been present in the Torres Strait for many centuries, playing a vital role in everyday life [see 7.1]. Utilising natural materials, Torres Strait Islanders produced functional objects, ceremonial items and implements. With the introduction of Christianity in 1871 (known to Islanders as the 'Coming of the Light'), came the demise of a traditional lifestyle. The production of ceremonial icons was tabooed and eventually ceased. Researchers in the 1960s and 1970s aimed at salvaging remnants of knowledge from the older Islanders and consciously contributed to the revival of interest in the old way of life. Links to traditional work and access to the visual documentation of scholars have prompted new artistic energy: contemporary artists draw upon earlier traditions and the input of Christianity and colonisation to reaffirm their identity [see 7.2].

With the introduction of Christianity came Western attitudes, influences, and implements, and new media, with painting and **printmaking** emerging as dominant art forms. In the late 1960s and early 1970s, a large group of works on paper were produced by Islander artists. These were commissioned by Australian historian [see **history**] Margaret Lawrie, who was employed at the Queensland State Library. Lawrie travelled widely through the Strait, often spending large amounts of time at island communities, interacting with local people and recording their stories of the creation of Torres Strait. Each of the regions making up Torres Strait has its own creation stories and culture heroes: these are Kuiam in the western islands, the Four Brothers (Malu, Sigai, Siu, and Kolka) in the central islands and Gelam, Waiet, and the Malu-Bomai cult in the eastern islands.

In preparation for her book *Myths and Legends of Torres Strait*, Lawrie approached several local craftsmen, one from each island group. These men—Ephraim and Ngailu **Bani**, Segar Passi, Locky Tom, and Kala Waia—were skilled practitioners with extensive knowledge of island life and culture encompassing ceremony, language, dance [see 7.3] and music [see 15.3], mythology, and arts and crafts. Seeking illustrative art that would encourage interest in the Torres Strait mythology that was being recorded, she supplied the men with watercolour paints and paper. Their illustrations were representations of the landscape and human form. Painting in wildly vivid colours, the artists visualised certain aspects of traditional island culture, focusing on land-forms, supernatural beings and mythical warriors as they interacted with an altered island society. These two-dimensional works represent the first reinterpretations of Western artistic tradition by Islanders, and represent one of the largest collections of early modern Torres Strait art.

Mosby divides contemporary Torres Strait art into three groups: traditional community, traditional urban, and urban. Yet he is fully aware that 'such a division necessarily perpetuates the categorisation of Indigenous art and artists into neat packages' and may be an oversimplification. As leading artist Ellen **José** comments,

For every Islander who lives in the Torres Strait, five live on the mainland. Wave upon wave of Islanders have been forced to leave their islands. Dispossession is not just a matter of losing

your land, it's much more. It's a matter of losing your cultural roots and ultimately your very identity. My journey is the same journey that thousands of mainlanders have embarked on. Some rediscover their culture, others hold onto and expand vestiges of culture that make them people. Some do it through family, others through art, religion, work, sport or history. Each journey strengthens their individual and group identity.

Traditional community artists such as James Eseli and Richard Harry [*94*], who are renowned for their dance machines [see 7.5], and weavers like Mary-Betty Harris and Jenny Mye reside in Torres Strait and produce artwork in accordance with established aesthetic protocols. The objects that they make are still used in communities throughout the islands: these are dance paraphernalia (including musical instruments), dance machines, and domestic items such as woven fans, mats, and basketry. Dance machines are generally manufactured by individuals who have no formal Western art training. Although any community member can produce such objects, those who do are invariably the composers and choreographers of the dance and song which accompanies the machine, as well as lead singers and lead dancers. Eseli lives on Badu (Mulgrave Island). With his knowledge of island lifestyle and culture he translates his ideas into dance-related objects. For example, his *USAAF Fighter*, 1988 dance head-dress [*95*] interposes history and lifestyle. The plane on the top of the head-dress recalls fighter planes flying overhead during World War II: in a dance context, it reflects upon Islanders' involvement in the war.

The positioning of artists within a traditional urban domain is flexible, with some artists gradually moving from a traditionally oriented community to an urban situation while others experiment with new ideas while remaining close to the realm of the traditional community. At one end of this spectrum is the group of Torres Strait resident artists who are senior figures living within their home communities. These artists—Ephraim and Ngailu Bani, Segar Passi, Locky Tom, and Kala Waia—briefly experimented with Western art techniques when producing illustrations for Lawrie's *Myths and Legends of Torres Strait*, but have not continued to explore in that direction. The development of a contemporary Torres Strait art tradition has been primarily led by island artists residing on mainland Australia. Over the past twenty-five years these artists have reinterpreted the visual history of Torres Strait through their use of modern media and techniques, working within Western art frameworks while referencing their community roots. These artists seek traditional knowledge from community elders and through individual and personal research. This group of artists includes Tatipai Barsa (printmaker), Joseph Dorante (painter and carver), Annie Gela (printmaker and dancer), Dennis Nona (printmaker), Brian **Robinson** (printmaker and sculptor) [*90*], Ken Thaiday, Jr (painter and dancer), Alick **Tipoti** (painter, printmaker and illustrator) [*88*], and Andrew Williams (painter and printmaker). Most of these artists are graduates of the Visual Arts Department of the Faculty of Aboriginal and Torres Strait Islander Studies at the **Far North Queensland Institute of TAFE** in Cairns.

Many of these young artists experiment with several media, including engraving and painting. Their traditionally derived carving skills, evident on ceremonial masks as etching and fretwork, have led to the production of intricate relief prints on paper, which have created intense interest throughout Australia and overseas. In Torres Strait Islander engravings, one senses a relaxed mastery that allows the artists to realise complex, often geometric, highly expressive designs. Background colours are varied, ranging from tints of blue and green, through to various shades of red and natural ochre colours. Finely engraved, elegant lines with rhythmic movements and varying strokes carry the eye with them and combine with flat tints and shaded areas to create spectacular effects. Often

90. Brian Robinson, *Ilan Coke*, 1995.
Acrylic on canvas, 121 x 112 cm.

themes from the legends and myths of Torres Strait form the narrative, with inspiration taken from marine creatures or elements that assume animal shapes. There is a clear connection with tradition which lends a strength to all the works, an affirmation of cultural beliefs and affiliations. The creators of these engravings are working in union with their culture, traditions, and history, and they are also responding to their contemporary environment; urbanisation, Western influences, and new techniques influence their art.

Other artists in this group—Rosie **Barkus** (textiles) [*91*], Victor McGrath (engraver and carver) [*346*], Ken **Thaiday**, Sr (sculptor, artefact maker and dancer) [*157*], and Edrick **Tabuai** (artefact maker, carver, and dancer) [*389*]—have little or no formal art training, but utilise their traditional knowledge and skills to develop distinctive contemporary styles. Barkus is a textile artist residing on Thursday Island who is developing a unique style of hand-printed fabrics. She derives her imagery from the inspiring seascape, the interaction between marine life and island people, and growing *kai-kai* (bush food). McGrath is a leading visual artist, writer, and entrepreneur who specialises in turtle shell and pearl shell. He learnt to work in these media by watching elders and pearlers at work. Over the years he has refined and perfected his style which includes turtleshell mask-making and pearlshell scrimshaw.

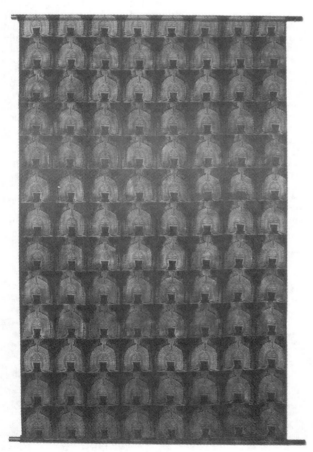

91. Rosie Barkus, *Dhoeri* (head-dress) design, 1991. Linocut on satin, 200 x 100 cm.

Ken Thaiday, Sr and Edrick Tabuai are leading Torres Strait artists. They possess the traditional knowledge and skill for making *dari~dhoeri* (head-dresses) and also choreograph dance performances using head-dresses. Thaiday is a sculptor, and also founder of

7.5 Dance machines from the Torres Strait Islands

The development of contemporary art in the Torres Strait Islands is still at a relatively embryonic stage: active collecting by art institutions began only in the last few years [see 21.1]. Collection of traditional Islander objects as 'art' currently centres around a specific type of sculptural form unique to the Torres Strait Islands—objects loosely termed 'dance machines' or, in the vernacular, 'playthings'. These hand-held dance accessories, head-dresses, and masks are used in dance performance and are created by individuals according to traditional knowledge and conventions [see 7.1, 7.2, 7.4]. Although these objects pre-date colonisation, their continued production has seen an evolution in form, responding particularly to external influences and to the need for cultural maintenance within a contemporary Australian and global community. Such innovation indicates that these objects are not inert aesthetic creations but are the representation of a flourishing cultural industry that reflects the uniqueness of Torres Strait cultural practices.

Dance machines are used in such inter-island cultural activities as church festivals, weddings, Tombstone Opening ceremonies [see 1.6], and other important events in the Islander cultural year. As cultural objects they cannot be separated from this dance performance context, and dance in contemporary Torres Strait Islander society is an important component of cultural life [see 7.3]. The suppression of traditional ritual and religion during colonisation changed the emphasis of how Islanders expressed tradition. Secular cultural practices, which were allowed to continue after colonisation, led to the emergence of dance as the pre-eminent cultural practice around which other cultural activities revolved.

The survival of secular dance also allowed the knowledge of pre-colonial traditions to persist under the guise of a secular activity. Important traditional practices that were suppressed following colonisation, such as inter-island wars, continued to be expressed in dance, with war instruments and associated paraphernalia such as bows and arrows, clubs, spears, and the warrior head-dress and costume used extensively in dance performances. Further, the traditional enmities which existed

between the various islands now take the form of dance competitions between different islands and dance teams.

Dance machines may be divided into several classes. The most important distinction is that between male and female types, with certain machines being used exclusively by the appropriate gender. The *zugub* [92] and the *comet* [93] are examples of male machines, and the *sik* [94] is an example of a female machine. Another division is that between machines that contain moving mechanical parts, which are manipulated during the course of the dance, and those machines which do not. Generally, the moving parts in the male dance machines tend to be more complex.

A third distinction occurs between those objects that are abstract in design, and those that reproduce physical aspects of the environment, such as cloud formations, sea creatures, or celestial bodies. An example of an abstract design is the *sik* dance machine from Yam Island made by Richard Joeban Harry. The design represents foam whipped off waves during stormy weather. The white feathers represent the sea spray, and the star in the centre of the bottom panel is the morning star. The fish-tail ends and multicoloured patterns are purely ornamental. The black and white diamond pattern of the fish-tail ends is also ornamental, although it is a traditional Island design known throughout the Strait. Examples of dance machines depicting realistic elements include the *zugub* and *comet* designs made by Patrick Thaiday. During the course of the *zugub* dance the machine is manipulated to display the rising and setting of the Southern Cross constellation. The *comet* dance machine represents a comet which is said to appear, according to Yam Islander tradition, only once every seven centuries.

A fourth division is made between objects that are regularly used with a variety of songs and choreography, and those that have specific songs and choreography. A final division is between objects that are hand-held and those that are worn on the head. The *sik*, *zugub*, and *comet* are hand-held dance machines.

Aesthetic appreciation of a dance machine is not limited to its physical appearance, as the object cannot be separated

92 .Patrick Thaiday, *Zugub* (dance machine), c.1993. Wood, paint, tin, and twine, 78 x 72 x 10 cm.

93. Patrick Thaiday, *Comet* (dance machine), c.1993. Wood, paint, tin, and twine, 50 x 120 x 6 cm.

from its cultural context. A dance centres on rows of participants, each with a machine, all moving their objects in unison. The important aspect of the performance is the uniform movement, and so solo performances are rare. The ultimate success of a dance machine is a combination of its physical appearance, the choreography of the dance, the song rhythm, and the relationship between the meaning of the song and the design and movement of the object.

Dance machines are both communal and individual objects. They are communal in that they represent their island of origin; that is, it is possible to identify from which island the dancers come by the machine used. The creator of an object's design remains anonymous, with attribution and recognition belonging to the island as a community. However, at a village level, specific designs are readily identifiable with individuals, who are invariably the composers of the song and dance that accompanies the machine, as well as lead singers and dancers.

The majority of creators of dance machines are male. Although this is an established convention, the reason for male dominance is based on access and knowledge of tools, as well as the predominance of male choreographers and dancers. Currently, once a new design is created the knowledge of construction is passed on to other male members of the dance troupe, who are then responsible for constructing objects for future performance.

Following performances, dance machines are usually stored or displayed in people's houses, and are rarely reused. New machines are made when required for specific events. Because of this continuous production of dance machines, the possibility of innovation is always present, and designs and materials used for construction are continually evolving. An example of this is the development of the *sik* machine. The design dates from the 1950s when the song and dance were first composed and performed. Originally the machine was made from the frond of a coconut palm. In the 1970s the frond was replaced with Western-manufactured, found materials such as tin from metal drums, plywood, and house paint. Since the 1970s the design and type of material used for the *sik* have continued to develop. The present interpretation is made from a sheet of plywood as the bottom panel, with the fish-tail ends and the star in the centre cut from tin sheets nailed to the plywood. The rods attached to the top of the bottom panel are made either from dowels purchased from hardware stores or strips of bamboo. The feathers are either synthetic, or from birds captured on the island. These are usually attached to the rods

with tape. Recently, the use of feathers have been superseded by synthetic raffia.

Despite these innovations, there are certain conventions which govern the making and the use of a dance machine. For example, the basic shape and the colours used never change, particularly the dominant use of white. The reason for the importance of white is its luminosity at night when dance performances usually occur.

In one respect, the use of Western materials may be seen as compromising the cultural integrity of the objects. However, the aesthetics of the design and the machine's use in dance performance is the ultimate intent, and access to Western materials allows this intent to be achieved faster and more efficiently. The time saved allows for the development of new dances and songs, which ultimately results in the continuation and evolution of Torres Strait tradition.

The danger exists that the collecting and exhibiting of dance machines in a fine art context may result in a corruption of their cultural value. At present, design ideas and innovations originate locally, with the evolution of various types of objects being guided by Islander aesthetics. It is possible to argue that the collecting of Islander cultural objects by state institutions, such as metropolitan art galleries, may lead to an increase in the production of the objects for sale. This may also result in a decline in quality at the expense of local needs. The design of dance machines may eventually be dictated by the art market and be subject to the purchasing power of collectors. Ultimately, the cultural function and importance of dance machines to cultural development must be appreciated and be a consideration in their collection. TOM MOSBY

A longer version of this article originally appeared as 'Play things: Dance Machines from the Torres Strait Islands', *ART AsiaPacific*, no. 14, 1997. It is reproduced with permission of the author and *ART AsiaPacific*.
Mosby, T. & Robinson, B. (eds), *Ilan Pasin (This is Our Way): Torres Strait Art*, Cairns, 1998.

95. James Eseli, *USAAF fighter* (dance head-dress), 1988. Hibiscus wood, paint, nails, adhesive resin, aluminium, and battery operated lights, 49 x 63.5 x 32 cm.

94. Richard Joeban Harry, *Sik* (dance machine), 1996. Wood, paint, feathers, aluminium, and tape; 12 pieces: 58 x 66.5 x 2 cm each.

the Darnley Island dance troupe which introduced the cassowary head-dress, and leader of the Torres Strait Islander Loza dance troupe based in Cairns. During his childhood on Darnley he learnt that sharks, frigate birds, sun, stars, and flowers are celebrations of life and markers of important activities like fishing and ceremonies. After moving to Cairns, he worked on the railway but kept up his dance performances. He started producing dance machines and head-dresses for his troupe, eventually refining his craftsmanship and skills to develop a contemporary style of mask. These constructions are primarily made from plywood, with additional materials such as feathers, black bamboo, lawyer cane, and other natural materials that maintain a link with the original artefacts of his forefathers. Edrick Tabuai is a consummate artist and craftsman. Lindsay Wilson has written that 'his understanding of the visually spectacular is instinctive, yet his artefacts are, above all, functional and superbly designed for his rigorous style of dance.' Tabuai's *dhibal* (head-dresses) are recognisably in the Saibai Island tradition. His personality is stamped on all his art and he 'shows few scruples about sidestepping tradition where it hinders creativity'.

Urban [see 12.1] Torres Strait artists such as Ellen José (painter, installation maker, and multi-media artist) [*158*], Destiny **Deacon** (photographer and multi-media artist) [*66, 67, 277, 314*], Clinton **Nain** (mixed media artist, installation maker, and dancer) [*173, 300*], and Lisa Martin (painter) are descendants of migrant Islanders living on mainland Australia who left the islands mainly in search of work. These artists have acquired extensive knowledge of Western art practices, and art institution training. They are driven by the need to search for identity and to engage with the effects of the changes wrought by colonisation in the political and religious life of Torres Strait Islanders and other Indigenous people. Torres Strait art provides key components in the construction of their identity, both for themselves and for others. It also provides a base from which they can confidently negotiate the minority status which has been the distinguishing feature of Torres Strait Islanders throughout history. We can be optimistic about the future of Torres Strait Islander arts. With the establishment of art centres around the country and the emergence of a contemporary Islander practice, this unique culture will remain distinctive even as it continues to evolve in response to contemporary circumstances.

BRIAN ROBINSON

José, E., 'Cultural identity', in T. Mosby & B. Robinson (eds), 1998; Lawrie, M. E., *Myths and Legends of Torres Strait*, St. Lucia, Qld, 1970; Mosby, T. 'Torres Strait Islander art and artists', in T. Mosby & B. Robinson (eds), 1998; Mosby, T. & Robinson, B. (eds), *Ilan Pasin (This is Our Way): Torres Strait Art*, Cairns, 1998; Wilson, L., *Kerkar Lu: Contemporary Artefacts of the Torres Strait Islanders*, Brisbane, 1993.

7.6 Tiwi graveposts

Death is a traumatic event in all human communities and for the culturally distinct Tiwi people on Bathurst and Melville Islands (approximately 100 kilometres north of Darwin) it is especially momentous. The death of an important man or woman begins a sequence of dramatic funeral rituals that have been re-enacted over many generations. At the climax of these ceremonies, large carved and painted posts [*96, 205, 336*] are placed around the grave as a final gift to the dead person and a lasting memorial.

Older Tiwi relate a story central to their ancient religious traditions which describes how death came to the world and why Tiwi carvers still create graveposts for major funeral ceremonies. Andrée Grau [see 16.3] has recorded the story as follows:

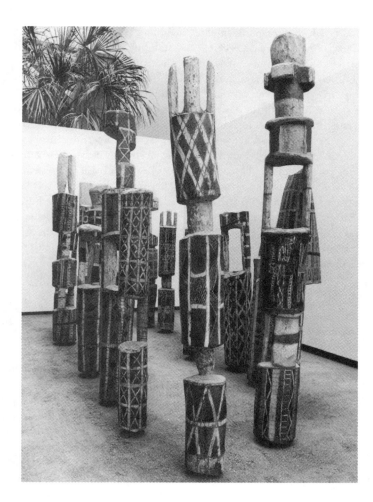

96. Laurie Nelson Mungatopi, Bob One Apuatami, Big Jack Yarunga, Don Burakmadjua, Charlie Quiet, and an unknown artist, *Pukumani Grave Posts,* 1958.
Natural pigments on ironwood, 147.3 to 247.2 cm (heights).

Long ago when all the animals lived as human beings everyone was happy and no one died. Purukupali, the leader of the people, went hunting leaving his wife Wai-ai to gather food. Wai-ai left her baby Tjinani in the camp and sneaked into the bush with her lover Tapara who was Purukupali's brother. She stayed away too long and the hot sun shone on her baby and killed him. When Purukupali found out he fell into a rage. Tapara offered to take the dead baby and bring him back to life in three days but Purukupali refused and fought with Tapara until he killed him. He then walked to the sea shore carrying his dead son and called out to the people 'Go, all of you! You must make cemetery poles, and then you will have to dance.' Then he walked backward into the sea saying 'We will follow my son. No one will ever come back, every one will die.'

All of the people living on the island in that Palaneri (**Dreaming**) time gathered at the place where Purukupali had drowned himself and performed the first Pukumani or funeral ceremony. Purukupali's detailed instructions for his own ceremony have remained the model for Tiwi funeral ceremonies ever since. Old men say that they still carve and paint *tutini* (graveposts) according to the dictates of form and meaning laid down by Purukupali during the Dreaming. Purukupali was the archetypal 'big man' for the Tiwi—a resourceful and strong hunter and fighter, and a leader with great prestige and influence. Since that time Tiwi 'big men' have amassed wealth and power in life, and

have received lavish Pukumani ceremonies including especially large graveposts after death. Young men have increased their social standing by carving *tutini* and actively performing in Pukumani ceremonies before appreciative audiences.

Because of their handsome appearance and reputation as skilful fighters, young Tiwi men were captured as slaves by early raiders, including the Portuguese, who periodically visited the islands. Although the Tiwi came to fear European visitors, their desire for metal tools and other prized objects overcame their suspicion. Intermittent contact was marked by treachery and bloodshed on both sides. By the nineteenth century when large Macassan trepang fleets sailed southward to the Australian coast, their captains were given strict instructions to avoid Melville Island. When the British established a military settlement, Fort Dundas, on the island in 1824, they found the Tiwi fiercely hostile.

Until the twentieth century, the Tiwi continued to repel intruders by ambushing expeditions, spearing castaways and looting wrecked ships for valued items including weapons, tools, and cloth. This period of isolation ended suddenly with the arrival of Joe Cooper, a buffalo shooter, and his group of Yuwatja (mainland Aborigines) who established permanent camps on Melville Island. With Cooper's protection, researchers including Hermann Klaatsch and Baldwin Spencer were able to observe and record the dramatic extended funeral ceremonies of the Tiwi.

After the death and burial of an adult man or woman, surviving relatives assume obligations and restrictions determined by the closeness of their relationship with that person. Their duties are said to imitate those of the Pukwi people who enacted the first Pukumani rites during the Dreaming. In Pukwi ceremonies held early in the twentieth century, distant male relatives were formally presented with tools and materials by members of the bereaved family who specified the number and size of graveposts required. Each stage of the Pukumani rituals was regulated by the requirements of these 'workers' who, after carving and painting the graveposts, were paid in the final stage of the ceremony. On the last day of the funeral large numbers of mourners gathered at the burial site and the decorated posts were carried onto the ceremonial ground and erected in rows. During the singing and dancing that followed, the surviving relatives viewed the posts carefully, assessing their size and complexity, the quality of their carving and painting, and the correctness of their 'story' (that is, the meanings conveyed through their painted designs). Payment for each post and its placement adjacent to the grave were supervised by middle-aged men of high status known as 'bosses'. Artists who created graveposts of outstanding quality and originality received higher payment and acquired great prestige among the assembled mourners. Occasionally, disputes broke out when the bereaved family refused to accept an unsatisfactory gravepost or the artist demanded higher payment. In the days before widespread European influence, an artist who produced a gravepost displeasing to close relatives could be speared.

For many generations of gravepost carvers, the potential rewards—tools, wives, prestige, money—outweighed the potential penalties of disgrace and physical punishment. Even now, carvers of great experience regard the creation of graveposts for a major Pukumani ceremony as a physically and intellectually demanding task. They must illustrate their technical skills using difficult media such as ironwood, display their ritual knowledge, and cope with changeable weather conditions within the limited time available before the final ceremony.

Experienced carvers prepare for their task by locating a suitable hardwood tree in the bush and meditating on the 'story' for the carved and painted motifs. According to Holder Adams, an important contemporary carver, Purukupali had said that newly erected graveposts should 'bleed' into the ground, so Tiwi carvers must cut living trees for ceremonial commissions. From the time that the chosen bloodwood or ironwood

tree is felled and the carver begins 'taking off skin' (de-barking the log) work must proceed quickly because the timber hardens progressively as it dries. For this reason, most graveposts are carved during or immediately after the wet season when periodic storms and high humidity slow the drying process.

Carving techniques have altered considerably over the years. In the distant past, Tiwi carvers used ground or flaked stone axes, mussel shells, and fire to fashion graveposts. Later, metal tools became available. Today, chainsaws are used to fell trees and to define the major sculptural elements of ceremonial graveposts. Certain parts of *tutini* including the 'crest' or 'head' become areas for painted decoration, so their surfaces are smoothly finished. In the past, artists smoothed these areas using sharkskin or by rubbing with stones; contemporary artists use steel chisels, sandpaper, and emery paper to achieve a uniform surface.

During important funeral ceremonies in the past, the group of workers who had finished carving sent word to the head of the bereaved family and obtained permission to 'cook' or scorch the posts. Small fires were lit and the posts rolled through them to dry the timber and prevent cracking, and to provide a ground surface for painted designs. For about twenty years from World War II, Tiwi artists maintained a popular local style by heavily charring their graveposts to achieve a dense black ground colour. This blackened surface symbolised the human skin which also received painted designs during the Pukumani rituals. As this heavily charred surface provided an unstable base for paints, the style gradually lost favour and recent graveposts are scorched carefully to dry the timber without changing its colour. Contemporary artists apply black paint to the surface of their post if they wish to create a dark ground for brightly coloured designs.

Tiwi painters have remained constant in their preference for a limited range of natural pigments obtained from specific locations on Bathurst and Melville Islands. Baldwin Spencer recorded: 'So far as colours are concerned, they only recognize four, white is tuteingùni; red is yaringa; yellow is arigèninga; black is tuniwinni.' Although some graveposts were painted with ground ochres and clays mixed with water, most painters added binders to their 'colours' to ensure that their designs lasted for as long as possible. Until the 1960s, natural substances including turtle eggs, honey and beeswax, and juice from the stems and leaves of local plants were added to pigments as fixatives. For ceremonial commissions and paintings made for sale, Tiwi painters now prefer to use a solution of polyvinyl acetate glue mixed with ochres, charcoal or clay to make their paints brighter and more resistant to water damage.

Experienced artists know the painted designs before they finish the carving process and, as innovation is considered desirable, they may modify or add to existing patterns if a new idea inspires them. Some artists receive a mental picture of the designs while contemplating the 'story' of their prospective *tutini* while others dream of their chosen patterns. Decorated posts created during Pukumani rituals symbolise human figures and are positioned around the grave to physically contain the *mopaditi* (the dead person's spirit). Alone and insecure, this newly created spirit seeks to rejoin its family and is potentially dangerous to surviving close kin. The Tiwi believe that the *mopaditi* remains near the ceremonial ground to watch the events during the dramatic singing and dancing by close relatives that follow the display of painted graveposts. At the climax of the final ceremony the mourners converge on the grave where they lean on the graveposts or beat themselves with sticks, crying and weeping as a last farewell. When the mourners finally leave the grave site, the satisfied *mopaditi* also departs to join other relatives in the spirit world.

Tiwi people regard their graveposts as having a spiritual dimension that is absent from other art objects including ceremonial spears, paintings, bark baskets, and *pukumani*

ornaments. They say that graveposts possess *imunga* (life essence), which they share with all living things. At the final ceremony the newly completed posts with their bright decorations achieve their most perfect (and 'living') form which soon deteriorates as the grave site is abandoned and rain, bushfires, and termites take their toll. Within a few months their painted designs fade and eventually the weathered posts disintegrate and fall, to disappear under vigorous wet season vegetation.

According to knowledgeable Tiwi artists, the carved forms and painted motifs on graveposts symbolise the transition from life to death. Each gravepost represents a newly dead human body beginning to decay. Certain motifs depict male or female forms—Paddy Henry, an old man in 1986, specified that a gravepost with a 'head' on top represented a woman and a post with projecting 'arms' was a man. Sculptured elements have specific meanings according to the 'story' chosen for that commission, the territorial and family affiliations of the dead person, and the relationship and totemic connections of the artist. The 'crests' or carved motifs surmounting graveposts often illustrate these meanings; as well as signifying gender they may represent a hat, native pumpkin, or ceremonial bundle. Two distinctive projections may symbolise the raised arms of a man, buffalo horns, ears, or the jaws of a crocodile.

Painted designs contain meanings independent of those expressed in the carved forms. These paintings are wrapped around the cylindrical form of the post, embellishing its surface in the way that painted body designs beautify the mourners at a funeral ceremony, or patterned garments enhance the body of their wearer [*204*]. Certain painted motifs called *pukumani* designs were created for important ceremonies long ago and remain unchanged whenever they are used. According to old men, some of the *pukumani* motifs reputedly used for Purukupali's funeral are especially sacred. *Pukumani* designs may refer to the markings on *pukwi* people who lived during the Dreaming and changed their form to animals or birds, or to natural features remaining on Bathurst or Melville Island. Other motifs still described as 'body scars' represent the fine parallel scars once cut on the bodies of Tiwi men and women. Acquired over several years after their first initiation, these body scars symbolising spear heads or zamia palms conferred high status on those men and women who were fully marked on chest, back, and arms [see **body adornment**]. Because no two patterns were alike, these scarified designs served to identify important individuals. Similar designs of fine parallels scratched over painted decorations on early grave markers identified the resting places of important people for many years after their deaths. As Paddy Freddy explained in 1986, '*pukumani* designs are to make posts like people.'

Although the ritual importance of graveposts for the Tiwi remains undiminished, major stylistic changes have taken place over several centuries. As wooden grave markers, these posts probably form part of an archaic sculptural tradition that spread from south-east Asia through Indonesia to the northern coast of Australia. Tjamalampua, a knowledgeable elderly man in 1954, may have seen the last examples of this simple monumental style. *Tutini* displayed at ceremonies when Tjamalampua was a young man were solid hardwood posts topped by a rounded 'cap' or incised bands and painted with meandering lines or dotted patterns. Along the northern coast of Melville Island a new sculpturally complex style emerged. These graveposts contained distinctive elements—'hats, horns' and 'windows'—in what became the dominant Tiwi style known today. Unlike earlier graveposts, these *tutini* were profusely decorated with geometric motifs reminiscent of textile patterns and were probably inspired by Macassan contact. Although Tiwi artists assert that *tutinis* have always symbolised human beings, representational carved figures and human-headed graveposts did not appear until the 1920s. At that time an innovative carver named Kado produced representational images as spe-

cial commissions for funeral ceremonies. Although decorated with *pukumani* designs, these images were remarkably similar to small human forms carved by men in north-eastern Arnhem Land to distract a dead person's spirit at the grave site. This stylistic likeness can be attributed to contact with Arnhem Landers after the 1920s, which led to knowledge of their major ceremonies and beliefs.

Because small human figures quickly became popular with collectors and tourists, several younger Tiwi on Melville and Bathurst Islands began producing them. By introducing narrative elements within a distinctive geometric style, one younger artist, Harry Carpenter (Ilinjau Marikulu) created unique carvings which made important Tiwi historical themes accessible to a wider audience. Carpenter restricted his imagery to the *palaneri* heroes Purukupali, Tapara, Tjinani, and Wai-ai, illustrating their stories with details including birds, false beards, painted *naga* (loincloths), and body designs. He added European features such as circular bases and extended arms carved separately and attached. Carpenter's familiarity with votive statues in the local mission church may have influenced him to believe that such ingredients were attractive to European buyers. In large figures of Purukupali and Wai-ai, Christian elements blended with older ideas: *tutini* supports were carved beneath their circular bases.

Along with carved birds, painted bark baskets and textiles, carved and painted human figures retain their popularity in the Tiwi art and craft industry [see **Tiwi Designs**; *285*]. However, the Tiwi still hold their graveposts in special regard and hundreds of people attend major funeral ceremonies held on Melville Island.

JENNIFER HOFF

The above text is taken from *Tiwi Graveposts*, a brochure published by the National Gallery of Victoria in 1988. It is reproduced here with the permission of the National Gallery of Victoria, Melbourne.

Grau, A., Dreaming, Dancing Kinship: The Study of *Yoi*, the Dance of the Tiwi of Melville and Bathurst Islands, North Australia, PhD thesis, Queen's University, Belfast, 1983; Spencer, W. B., *Native Tribes of the Northern Territory of Australia*, London, 1914.

8. Queensland

8.1 Adornments and design in north Queensland: A view from the nineteenth century

The cultural life of Indigenous peoples in north Queensland at the turn of the century is known through oral history handed down by Aboriginal people, the observations of early explorers, and in the works of the first Protector of Aboriginals for North Queensland, Dr Walter Edmund Roth. From 1898 he travelled the countryside, talking to Aboriginal people, collecting artefacts, taking notes on what he heard from people about the objects, and recording what he saw using sketches and photographs. Roth deposited most of these records and artefacts in the Australian Museum in Sydney in 1905. The collection has importance for Aboriginal people in Queensland today.

At the time Roth was collecting, Cape York Peninsula was a vibrant area. There was close contact between communities across the Cape and with people from Papua New Guinea (PNG) and the Torres Strait Islands. Crocodile masks, grass skirts, and drums incorporated in ceremonies held in Aurukun reflect a PNG influence, as do dugout canoes found down the east coast of the Cape. At Laura [see 5.1], **rock art** depicting a horse and man, a pig, and a policeman recorded European contact [51].

The rock art of north Queensland was first seen by the British in 1803 when Matthew Flinders visited Chasm Island in the Gulf of Carpentaria and saw drawn figures outlined with a burnt stick. While surveying the coast of Australia in 1821, Captain Phillip Parker King also found extensive rock art on Clack Island, off the east coast of Cape York Peninsula at the entrance to Princess Charlotte Bay. Among the more than 150 figures were sharks, porpoises, turtles, lizards, starfish, clubs, canoes, water-gourds, and kangaroos, outlined in white on a red-ochred background. In 1899 Roth visited Clack Island and found the red-ochred site and also other outline drawings not recorded by King. According to Roth, several caves were so small that the artists must have lain on their backs to carry out the work. Roth recorded rock art at Mt Cook near Cooktown, where charcoal figures and crocodiles painted with charcoal and yellow pigment were outlined in white clay. Hand stencils were also in evidence. One of Roth's informants reported many paintings on vertical or overhanging rocks in the Bloomfield River region, where human figures, cassowaries, turtles, and kangaroos were depicted, using charcoal and red and white ochre. Stencilled hands again were present.

While explorers, prospectors, and settlers had moved into most of north Queensland by the mid nineteenth century, dispossessing the local Aboriginal people of their lands, they had left the rainforest region alone. This area, stretching along the east coast from Cardwell to Cairns and inland to Mt Bartle Frere and Bellenden Ker, was regarded as inhospitable. Its dense canopy of heavy-foliaged trees entwined with

prickly climbers and thick, claustrophobic undergrowth made movement through the forest almost impossible. It exuded a dank, gloomy atmosphere and its floor was slippery underfoot.

The rainforest people, who did not share the European perception of their forest home, led a rich cultural life, making and decorating objects which are found nowhere else in Australia. In the wet season, from about December to March, they led a fairly settled life, sheltering from torrential rains in domed huts which were up to 135 centimetres in height and heavily thatched with leaves [see 19.1; *234*]. Fires were always burning in the huts and Aboriginal people wrapped themselves in bark blankets to keep warm.

These blankets, which were also used as mats on the earthen floors, were unique to the rainforest. They were made from the hammered inner bark of the fig tree and could only be made in the wet when the bark was pliable and soft. The blankets were not decorated. Roth saw one being made at Atherton; it took five or six hours of work to produce the soft sheet of bark, which could be folded into a package about 30 centimetres square. This was a good size to fit into a woven bag or basket. Roth reported that during initiation ceremonies on the Tully River young boys wrapped a bark blanket around themselves when women were nearby. By the time Roth was in the area, government blankets were being given to local Aboriginal people and the art of making bark-cloth blankets was dying out. Possum-skin cloaks and kangaroo-skin rugs also were no longer made.

Another unique and essential item of rainforest life was an elegantly constructed, crescent-shaped, woven basket [see 17.1; *97*]. These beautifully crafted baskets were made from lengths of split lawyer cane, a prolific climbing plant found throughout the rainforest. Strips of cane, with the prickles skilfully removed, were brought back to camp. The lawyer cane was not collected until needed because the basket-maker had to complete the task within five days—after this time the cane could no longer be made pliable by soaking. The distinct crescent shape of the basket was formed by stringing the ends of a length of split lawyer cane like a bow and attaching it by top-stitching to the inner surface. Baskets were strengthened during manufacture by rings of cane attached at regular intervals to the inside by top-stitching. Two handles, one small, one long, were fitted to the mouth and held there by tightly woven thin strips of split lawyer cane.

Undecorated crescent-shaped baskets were used to gather and leach foods, especially the Moreton Bay chestnut. Part of the process of rendering this nut edible was to put sliced nuts in a basket and place it overnight in a stream of running water to leach out the bitter taste. In flood times women caught large quantities of small fish with these baskets. When rivers were swollen, fish travelled upstream close to river banks in columns about thirty centimetres wide and deep. It was a simple matter to dangle a basket into this shoal of fish and scoop up a basketful, wrap them in wild ginger leaves and set them aside to be baked. Very large baskets were used to ferry goods—and also children—across rivers. Crescent-shaped bark baskets were also made for carrying honey or water.

Painted baskets were used by men for various purposes: to carry ritual objects, for trading purposes, or as a gift to a friend. The outer surface of a crescent-shaped basket was painted with traditional designs using locally obtained red and yellow ochres, charcoal, and white clay. Carl Lumholtz, a scientist writing about his experiences with Aboriginal people in north Queensland in 1882–83, noted that baskets painted red, yellow, or white sometimes had stripes and dots of human blood which the maker would take from his arm.

The large, painted, softwood shield, of a type found only in the rainforest, and the single-handed, ironwood sword, a weapon unique to the rainforest, are two objects which need to be considered together [*98*]. The shields were cut from the natural buttresses of

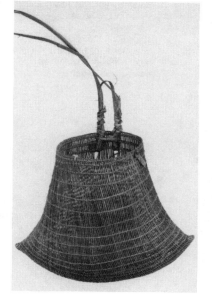

97. Crescent-shaped (bicornual) woven basket, collected Atherton, 1898. Height 23.6 cm, mouth 15 x 13 cm, outer handle 37 cm long, inner handle 9 cm long.

giant fig trees and taken back to camp to be shaped with an axe or tomahawk. The wood had a high moisture content and needed about two weeks to dry out. Hot coals were used to burn into the back of the shield and the wood was chiselled out to make a hand-grip. After the outer surface was smoothed with a wooden rasp, designs were painted with lawyer cane brushes in earth pigments and charcoal, using human blood as a fixative. A shield was not considered finished until it was painted. Of over fifty rainforest shields in the Australian Museum collections, no two have the same decorative surface. It is thought that these individual designs acted as a means of identification in situations of ritual conflict.

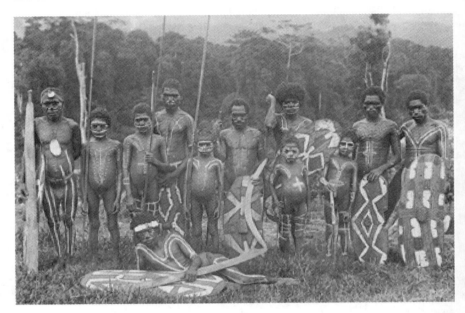

98. Yidinjdji rainforest people and Burumbu (*right*), a leading man of Mulgrave River, near Babinda (Qld), c.1893.
Burumbu is holding a wooden sword club. The design on the shield held by the man standing in the centre relates to a species of fruit, and the second shield from the left bears a frog design.

There is no doubt that these beautifully painted shields were used in battle. One shield in the Australian Museum collection has sixteen slash marks, and seven spear holes with six spear points still embedded. There is a rounded depression where a stone may have been thrown, and two bullet holes. An early settler, R. A. Johnstone, reminiscing in the *Queenslander* in 1901, recorded an attack on his property by a group of Aboriginal men, advancing like a Roman phalanx: 'When the blacks attacked the house at Bellenden Plains, they used ... [shields] as a movable barricade, about one hundred of them crouching behind them, holding the shield in one hand and their weapons in the other. Nothing could be seen ... but this line of painted shields moving slowly towards the house ... I could see nothing but shields to fire at.'

The heavy, hardwood sword, used only with the painted shields, was a difficult weapon to manage and its sole use within Aboriginal communities was in ritual fighting. The shape of the sword followed the shape of the tree from which it was cut—the straighter the better. One edge was usually sharper than the other. The small handgrip, designed to be grasped in one hand only, was bound with hand-spun, bark-fibre twine and gum to afford a firmer grip. It was always carried with the hand stretched over the shoulder so that the sword hung behind the back. With a highly decorated shield in one hand and an ironwood sword in the other, two men would stand facing each other when settling disputes in a traditional manner. The massive blade and small handgrip made it difficult to swing the sword over the shoulder and hit one's assailant. At Cape Grafton,

in the late 1890s, Roth saw future husbands clash swords in mock warfare with the relations of their future wives before a marriage could be consummated. After European settlement, men started to use discarded, cross-cut saw blades as swords, painting the blade and shaping the handgrip to fit one hand. These proved lethal, and the use of swords in ritual fighting disappeared early in the twentieth century.

Ornately painted cross-**boomerangs**, sometimes used in ceremonies and also to entertain children, were only found in the rainforests. Two pieces of light wood, about thirty centimetres long, were held together crosswise with strips of the ever-useful lawyer cane threaded through a hole in the centre. Designs, similar to those found on the shields, were painted on both sides of the cross-boomerang in yellow and red ochres, white clay, and charcoal. Roth described them being thrown by men and boys in 1898. Writing nearly forty years later, anthropologist Ursula McConnel recorded them being used in a dance, by which time they were commonly referred to as windmills or aeroplanes. She says a stick was fastened to the back of a cross-boomerang and twirled between the hands to revolve as does a boomerang in flight. This was done as men danced in a circle. McConnel also mentions that live coals were attached to the arms of a cross-boomerang and thrown in the air at night to amuse children.

Many people in north Queensland had elaborate body decoration [see **body adornment**] and head-dresses, such as the conical bark and human hair-string hats from Mornington Island, and the crocodile dance masks from Aurukun. Again the rainforest people had their own elaborate, feathered head-dresses, although much of their body decoration was similar to that worn by men and women in other parts of Queensland and in Arnhem Land.

Feathers from the body, wings, and crest of the sulphur-crested cockatoo formed part of some elaborate head-dresses worn by men for ceremonial occasions and when going into battle. One was made by placing beeswax over the hair and sticking feathers into the warm wax until it set like a cap; another, worn at the back of the head, used the crest feathers and white fluffy feathers bound together at the quills with twine and beeswax. Another version was made from radiating feathers, with those of the yellow sulphur-crested cockatoo forming the centrepiece. In addition, white wing feathers were tied to a wooden handle with twine and beeswax and stuck in the hair. Mr R. Hislop, owner of a property called Wyalla, on the Bloomfield River in the 1890s, reported to Roth that when combat was under way, the leader wore a cockatoo crest feather-tuft head-dress, which made him stand out in the group of warriors.

There was a profusion of forehead bands and necklaces to choose from for both daily and special occasions. At Cape Grafton, Cairns, Atherton, and Tully, Roth recorded that small oval-cut pieces of pearl shell [see also 10.4] were fixed with beeswax to the beard and forelocks of the men. Rectangular-shaped pieces of nautilus shell were strung together on hand-spun, bark-fibre twine to make delicate forehead bands for men and necklaces for women. Occasionally, oval-shaped shell pieces were used, probably traded from the Gulf of Carpentaria. Sometimes a single pearl shell, nautilus or bailer shell was used, suspended on a hand-spun, bark-fibre string and hung down the back of a man, or between the breasts of a woman. At times the single shells were used as spoons. After European contact, these shells were sometimes suspended on strips of fabric rather than on bark-fibre string.

Elegant necklaces consisting of hundreds of short segments of grass reed threaded on bark-fibre string and tied at the ends, were made and usually worn by women. Some of these necklaces were up to 480 centimetres long. They could either be wound round and round the neck or rolled into a thick loop and worn with their ends tied with string. Such necklaces were popular all over Queensland.

Pandanus palm armbands, sometimes with burnt decoration, were worn by men when attending ceremonies. Men and sometimes women wore bird bone, shell, or reed nose pins. Women wore bark-fibre skirts made by forming loops over the top-string to form tassels between 7 and 10 centimetres long [*99*].

Before European settlement there was a great deal of barter and trade between the different communities up and down the Queensland coast and inland across to the Gulf of Carpentaria. Objects and ideas travelled great distances, yet local creations remained distinct.

In 1872 the rainforest people suffered an unprecedented onslaught on their way of life when the British discovered gold in the Palmer River area, inland from Cooktown, and at the Mulgrave nearby. Suddenly, 20 000 Europeans and Chinese rushed to the gold-fields and spread their tents over land held by local Aboriginal people. By 1874 Cook-town was a prosperous community with some 4000 inhabitants. Aboriginal people came down from the hills to challenge the right of strangers to travel through their country without permission. The track to the goldfields subsequently became known as Battle Camp. At about the same time, tin was found on the Atherton Tablelands. Permanent settlements and ports were established along the coast and inland. Many Aboriginal people, forced off their lands, lived and worked on the fringes of the settlements, and were often paid in opium and alcohol. Measles and influenza killed many who lacked any protection against these introduced diseases.

In this tragic manner, a way of life that had existed for thousands of years came under great threat. Objects collected in the late nineteenth and early twentieth century stand as an enduring testimony to the creativity and artistic imagination of the rainforest peoples of that time. Their creativity was embodied in the refined manufacture and decoration of items—sometimes for use in daily living, sometimes imbued with protection from an ancestral design—found nowhere else in Australia.

Today that creativity continues, in a mixture of tradition and innovation. It can been seen in a delicate image etched in a bowl at Yarrabah, in a finely curved basket in a craft shop in Cairns, or on a painted, ornate shield hanging on a wall in a private home near Tully. It may also be seen in the work of such artists as Heather Walker and her sister **Jenuarrie** (Judith Warrie) [*333*], Mundabaree (Jennifer Green), and Zane **Saunders** [*379*].

KATE KHAN

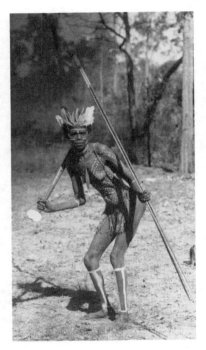

99. D. F. Thomson, *Woman painted for mortuary ceremony, Wellapan. Wik Munkan group, Archer River area, Cape York Peninsula (Qld)*, April 1933.

Berndt, R. M. & Berndt, C. H. with Stanton, J. E., *Aboriginal Australian Art: A Visual Perspective*, Sydney, 1982; Johnstone, R. A., quoted in F. S. Colliver & F. P. Woolston, 'The rain forest sword and shield in Queensland', *Occasional Papers in Anthropology*, Anthropology Museum, University of Queensland, 1980; Loos, N., *Invasion and Resistance: Aboriginal–European Relations on the North Queensland Frontier 1861–1897*, Canberra, 1982; Lumholtz, C., *Among Cannibals: An Account of Four Years' Travels in Australia and of Camp Life with the Aborigines of Queensland*, London, 1889; McConnel, U. H., 'Inspiration and design in Aboriginal art', *Art in Australia*, no. 59, 1935; Roth, W. E., *North Queensland Ethnography*. Bulletins 1–18, Brisbane, 1901–1910.

8.2 Flash marks: A brief history of twentieth-century Queensland Aboriginal art

At the time of European contact, Queensland's boundaries encompassed an estimated 70 000 people belonging to around sixty linguistic groups. They occupied a diverse range of environments, from tropical Cape York to the more arid regions of the south-west. As in other parts of Australia, the people expressed their cultural identities through a unique range of artefacts and ceremonial art styles. The ensuing colonial period placed tremen-

dous pressure on these groups and their cultural practices, as the effects of disease, dis-possession, and campaigns of so-called 'dispersal' [see **massacres**] took their toll. It is esti-mated that during this time the Indigenous population of Queensland was reduced dramatically, by at least half. Despite this, Indigenous people in Queensland have shown remarkable resilience over the years. Their spirit of determination has found expression in many forms, including the maintenance or revival of customary practices, and the creation of completely new idioms to express their individual identities and histories.

As far back as the early settlement period there were spirited individualists who nego-tiated the boundaries between black and white culture through their art. One of the first Indigenous artists to record life on the northern frontier was Queensland cattleman Charlie Flannigan [see **prison art**]. His sketches of cattle station work in Queensland, the Northern Territory, and the Kimberley, made in 1892 and 1893, indicate how suc-cessfully Aboriginal people had adapted to the developing rural economy in the north. There was, however, a darker side to Aboriginal–settler relations that was graphically captured by his contemporary, another cattleman known only as Oscar [*365*]. His sketches done in 1899 document the brutality of the Native Police who, between 1849 and 1897, are alleged to have massacred thousands of Aboriginal people throughout Queensland. Several works, titled from the artist's own descriptions, *Dispersing Usual Way. Some Good Shooting,* and *Police Boys Doing Duty (Lynch Law),* showing Aboriginal people being shot, flogged, and hanged, remain the most shocking images from this time. Oscar's other sketches of ceremonial performance show that despite these depre-dations people were still pursuing customary lifestyles on the boundaries of cattle sta-tions and new settlements.

The first recorded female artist, from a later contact period, was a Pitta Pitta woman, Kalboori **Youngi** [*409*] who would occasionally bring her innovative stone sculptures into Springvale station near Boulia, on her periodic visits from out bush to obtain rations. R. H. Goddard collected a series of these sculptures in 1938. They depict a fully clothed stockman leading a draught horse, along with male and female figures wearing an array of traditional dress and ornaments just like those recorded by ethnographer W. E. Roth. It is possible that Kalboori taught other women how to make these sculp-tures, or that some of hers were traded north, because similar carvings were collected by the artist Margaret Preston, probably in 1941, at Dajarra just south-west of Cloncurry. Preston attributes these carvings to Linda Craigie and Nora Nathan.

The imagery of this genre of sculpture may have been new but the process for making it was based upon the traditional way of moulding widow's caps out of kopi—a form of gypsum rock that could be manipulated when softened, or carved when hardened. Other customary forms of sculpture were still being produced in the Gulf region before World War II. Even the rainforest groups, who had suffered the worst impact of the gold-rush period, were still making their characteristic decorated weaponry, though Ursula McConnel predicted that these traditions would not survive into the next generation. In the northern region, there was an efflorescence of certain sculptural forms in the 1950s. Peter Sutton suggests that this was possibly due to the ceremonial exchanges that occurred between the various groups who had settled at the Aurukun mission. These decorated sculptures of ancestral figures and animals continue to be an integral aspect of funeral and other ceremonies, and apart from a brief period in the 1990s when some were made for sale, their use has been strictly confined to the ritual sphere [*100, 366*].

Certain other ceremonial practices survived in the remote communities of the north, along with their attendant art forms including masks, sculptures, ornaments, and the 'flash marks' or ceremonial designs that people applied to the body [see 8.1]. However, modifications to such practices were inevitable under the strict policies of the missions

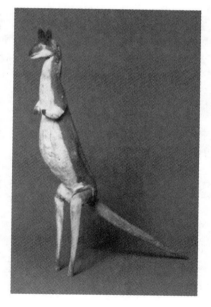

100. Attributed to George Ngallametta, assisted by MacNaught Ngallametta and Joe Ngallametta, *Wallaby from Thawungadha,* Western Cape York Peninsula, 1962. Wood, adhesive, black, white, and red pigment, 68.3 x 90 x 12cm.

and new government reserves established throughout Queensland at places like Palm Island, Yarrabah, Thursday Island, Woorabinda, and Cherbourg. People here were isolated and their movements and actions were often strictly controlled. They had neither individual rights nor property rights: most artefacts made for sale had to be sold via the station shops, which then retained all the profits. Even so, there is evidence that enterprising individuals were also marketing their work independently from a very early period. By the 1950s, the opportunities for individuals wishing to pursue careers as artists were beginning to improve, prompted in part by the unparalleled success of Albert **Namatjira** [*36, 42, 111, 115*] and the Hermannsburg School of watercolour painters [see 8.1]. Namatjira's significance as a role model for other Indigenous artists of the time should never be underestimated. At the same time he was also regarded as an important symbol of success by the promoters of assimilation.

It was in this climate that the self-taught artist Joe **Rootsey** [*101*] rose to prominence, with watercolour landscapes of his home country around Barrow Point on Cape York Peninsula. During his short career he was hailed in the local **media** as the next Namatjira, and was the first Indigenous artist promoted by the Queensland government locally and overseas. Rootsey was followed in his success by Mornington Island artist Dick **Roughsey** (Goobalathaldin) [*102, 376*], who embarked on his artistic career by first attempting Namatjira-style landscapes. He soon abandoned watercolours in favour of bark painting, and then painting with acrylics, in order to record the ancestral traditions and everyday activities of his people, the Lardil. Family members who followed his example established a school of innovative painting that is still practised on Mornington Island today. Goobalathaldin and his family set the precedent for the adoption of bark painting in the north of the State, and subsequently a number of artists started recording their stories on bark. **Thancoupie** was one of those artists who took up bark painting before she did a pottery course and branched into making ceramics [*103*] in the 1970s.

At the time many Queensland artists including Joe Rootsey, and Dick, Elsie, and Lindsey Roughsey, marketed their work through the Department of Native Welfare's

101. Joe Rootsey, *(Landscape with Rock Formation)*, 1958.
Watercolour on paper, 40 x 58 cm.

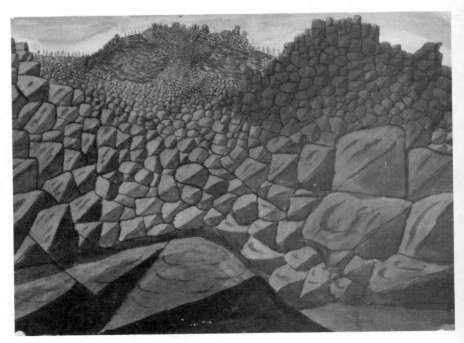

Queensland Aboriginal Creations shop (QAC) in Brisbane. Indeed, QAC were the sole promoters of Rootsey's work after he was brought to their attention in the late 1950s. The establishment in 1959 of this centralised wholesale–retail marketing outlet for Indigenous artwork was part of the department's plan to develop Indigenous business and employment opportunities at missions and government reserves throughout Queensland [see 21.2]. As the first and only State government agency to market Aboriginal art, QAC was extremely influential in directing the course of commercial art and craft in the State for decades to come. However, while QAC provided an outlet for traditional items made in the remote regions of the State, it also set up government-controlled workshops for the mass production of tourist 'curios' [see 18.1]. Many of these were not even based on artefacts that were indigenous to the State. Items like bullroarers, **didjeridus**, returning **boomerangs**, and **bark paintings** were produced in bulk in communities like Cherbourg and Hope Vale, and the blanks were then distributed to Murri artists in Brisbane and Cherbourg for decoration. Artists were usually instructed by the department to copy classic images from Arnhem Land and the Kimberley onto their artworks in the bid for 'authenticity'. Apart from being culturally inappropriate, such a directive mode of operation was not sympathetic to the nurturing of individual talent. It did however result in a distinctive genre of souvenirs, for example the 'shadow boxes'—a type of letter rack made from miniaturised weapons. These were once made in a number of communities throughout Queensland and New South Wales, although they are now especially identified with the Cherbourg artists. Shadow boxes are highly regarded in the southeast region of Queensland, where they are still widely made. Other items made for QAC over the years have included stuffed koala bears, shell-encrusted and painted glass bottles, ashtrays made from Torres Strait Island pearl shells, decorated emu eggs, and ceramics from the Yarrabah and Cherbourg potteries. QAC significantly revised its policies in the mid 1980s, and is still one of the few Brisbane-based retail outlets that cater for artists in Queensland as well as other States.

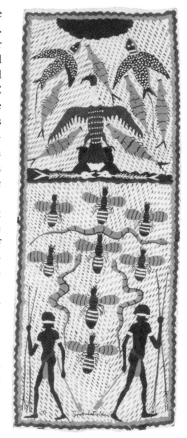

102. Dick Roughsey (Goobalathaldin), *Wild Honey Bees and the Fish-Hawk*, 1971.
Natural pigments on bark, 77 x 29 cm.

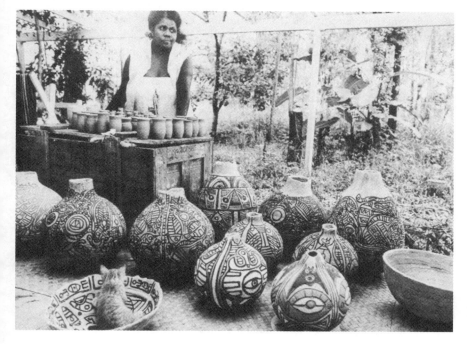

103. (*l.*) Thancoupie with a collection of pots ready for glaze firing, Trinity Beach, Cairns, 1981.

Despite its chequered legacy, QAC provided many artists with an outlet for their talents and helped launch the careers of a number of successful contemporary artists [see 12.1]. Prime examples are Roslyn Kemp and her brother Vincent **Serico** [*380*], who started off as teenagers decorating QAC artefacts at home with their family. Brothers Marshall and Richard **Bell** [*294*] also worked for QAC before branching out on their own and forming new alliances with other artists. This generation of Murri artists was influential in the new wave of political art activism emerging around the country in the 1980s. Perhaps as a result of its particularly bitter colonial history, Queensland has produced a high proportion of well-known practitioners of art with a political edge . These include Gordon **Bennett** [see 22.5; *265, 267, 275*] and **Judy Watson** [*40, 402*] who were the first Indigenous artists to achieve mainstream recognition when each won the prestigious Moët & Chandon Art Award [see **art awards and prizes**].

While Bennett has explored the broad issues of identity and the ways in which it is culturally constructed, Fiona **Foley** [see 23.3; *2, 63, 164*], Judy Watson, and Ron **Hurley** [*331*] tend to look at political themes from a more personal perspective: individual journeys of discovery and recovery underpin much of their work. They and other contemporary artists have contributed significantly through their work to the repositioning of Indigenous people in the history of Queensland.

Like Judy Watson, Fiona Foley also believed in social change through grassroots community action, which led to her creative exchanges with artists in central Arnhem Land. In 1987 Foley used her experience with the Arnhem Land community-based art cooperatives to found the **Boomalli Aboriginal Artists Co-operative** in Sydney together with a dynamic group of young artists that included her fellow Queenslanders Avril **Quaill** [*63, 161*] and Arone Raymond **Meeks** [*64, 175*]. The Boomalli artists' collective was extremely important in spearheading the promotion of mainly east coast artists who were part of the emerging phenomenon of 'urban' art.

Most of these artists were graduates from mainstream art colleges, because until the **Far North Queensland Institute of TAFE** established its Associate Diploma in Aboriginal and Torres Strait Islander art in 1984, there was no other option available. This course became a focus for people living in northern Queensland and attracted a vibrant mix of students whose diverse cultural backgrounds—Torres Strait Islander [see 7.2, 7.4], South-Sea Islander, and Aboriginal—very much reflected the influence of colonial policies of removal and the infamous blackbirding trade. These artists forged new interpretations of their ancestral idioms or drew upon familiar imagery provided by the **rock-art** [see 5.1, *51*] galleries of the Laura region. Many well-known practitioners are graduates of this course: they include Zane **Saunders** [*379*], Heather Walker, **Jenuarrie** [*333*], Pooaraar Bevan Hayward, Anna Gela, and Dennis **Nona** and Harry Nona. Younger artists like Samantha Meeks and Andrew Williams have returned in recent years to attend mainstream college courses. The resourcing of artists at remote communities, a development of the 1990s, has also brought forth some very talented individuals in the Cape York region, the most successful being Rosella **Namok** [*343*], Sammy Clarmont, and other artists at **Lockhart River**. Their prints and paintings coexist alongside certain customary art forms in the region, such as the Aurukun sculptures [*100, 366*] or the more experimental dancing masks by Ken **Thaiday**, Sr [*157*] and other Torres Strait Islander artists [see 7.5].

The bicentennial year and the staging of Expo '88 in Brisbane brought new opportunities for local artists, who were starting to achieve some recognition. In 1990 the diverse artistic output of Queensland was brought together in 'Balance 1990'. This was the first exhibition of predominantly Indigenous art to be curated by the Queensland Art Gallery, and it profiled many local practitioners. The exhibition provided a forum for

the artists to voice their concerns, particularly on the issue of their economic survival and the dearth of significant State arts funding and infrastructure support at the time. The burgeoning tourist industry [see 18.1], centred mainly in the Cairns–Kuranda region, had already led to the foundation of the successful Tjapukai dance group in 1987, the Tjapukai Cultural Centre [see **corroborees**], and the Laura Aboriginal Dance and Culture Festival [see **festivals**]. These developments vindicated the view expressed in the 1989 Altman Report, that there was greater potential for artists than was currently being realised in the market place. In an attempt to empower and service struggling artists around the State, an independent artists' collective, the **Campfire Group**, was established in 1990, largely as a follow-on from the 'Balance 1990' exhibition [*248, 301*]. Campfire's aims were similar to Boomalli's: to initiate new links between emerging artists, remote communities and the market place in order to provide better resources for those struggling on the margins of the industry. Some of the members—Marshall Bell, Michael Eather [*227*], and Laurie Nilsen [*227*]—with the assistance of Michael Aird [see 8.5], seeded the independent association of State-wide artists, Queensland Indigenous Committee for Visual Arts (QICVA). The aims and objectives of QICVA were defined during an important series of artists' conferences staged in Yarrabah in 1992 and Woorabinda in 1993 and 1994. Although not all of the recommendations have been realised, important legacies of these initiatives were the establishment of the Bachelor of Visual Arts in Contemporary Australian Indigenous Art at the Queensland College of Art, and continued support for south-eastern Queensland artists by what is now the Queensland Indigenous Aboriginal Artists Corporation (QIAAC).

These new developments arose from the same independent spirit that was evident in the work of nineteenth-century artists like Flannigan and Oscar. When Ravenshoe artist Michael **Anning** [*284*] won the Wandjuk Marika Memorial Three-Dimensional Award at Darwin's National Aboriginal and Torres Strait Islander Art Award in 1998, he also symbolised this spirit in his individual efforts to revive the artistic traditions of his rain-forest people, the Yidindji. His success was particularly heartening in view of Ursula McConnel's pessimistic prediction of 60 years before that these very same traditions would not survive into the next generation. Given the recent developments around the State and the high profile achieved by a number of Murri artists, there is a renewed sense of optimism about the future. It seems highly likely that with the proper infrastructural support, Queensland will emerge as the next important frontier for Indigenous art.

MARGIE WEST

Department of Aboriginal Affairs, *The Aboriginal Arts and Crafts Industry: Report of the Review Committee, July 1989* [the Altman Report], Canberra, 1989; Goddard, R. H., 'Aboriginal sculpture', in M. Walkom (ed.), *Report of the 24th Meeting of ANZAAS*, Glebe, NSW, 1939; McConnel, U. H., 'Inspiration and design in Aboriginal art', *Art in Australia*, no. 59, 1935; Neale, M., *Yiribana: An Introduction to the Aboriginal and Torres Strait Islander Collection at the Art Gallery of New South Wales*, Sydney, 1993; Roughsey, D. (Goobalathaldin), *Moon and Rainbow: The Autobiography of an Aboriginal*, Adelaide, 1977; Sayers, A., *Aboriginal Artists of the Nineteenth Century*, Melbourne, 1994; Sutton, P. (ed.), *Dreamings: The Art of Aboriginal Australia*, New York & Ringwood, Vic., 1988.

8.3. The Kalkadoon memorial

The Kalkadoon people are widely portrayed in Australian popular **histories** as one of the few Aboriginal tribes that engaged in collective, armed resistance against Europeans [see **guerilla fighters**]. The spread of the colonial pastoral industry into north-western

104. The Kalkadoon Memorial at Kajabbi near Mount Isa (Qld), 1998.

Queensland between the 1860s and 1880s resulted in protracted and increasingly violent conflict between the Kalkadoon and the settlers for control of land and waterholes. In September 1884, having retreated for protection into a rugged, hilly region now known as Battle Mountain, a large party of Kalkadoons fought desperately against an armed contingent of Native Mounted Police and settlers. Many Kalkadoons were massacred [see **massacres**]. The story of the 'last stand' has long been recounted in regional popular histories that are otherwise largely silent about Aboriginal–European relations and colonial frontier violence. Since the 1970s, the stand of the Kalkadoon has gained even greater historical prominence, challenging the myth of Australia's peaceful settlement and highlighting forms of Aboriginal resistance to the colonial invasion. In seeking to honour the Kalkadoon, some historians, such as Robert Armstrong, and Al Grassby and Marji Hill, have assimilated the Kalkadoon story within a conventional Australian historical narrative—the Anzac legend—in the process transforming the Kalkadoon into 'honorary Anzacs'.

In the 1980s Aboriginal leaders in Mount Isa initiated a project of public memorialisation to draw attention to the Kalkadoons' resistance to European invasion and their cultural survival into the present. To mark the centenary of the massacre, in 1984, leaders of the newly-formed Kalkadoon Tribal Council erected a memorial cairn in the tiny settlement of Kajabbi, twenty-two kilometres from Battle Mountain [*104*]. Unveiled by the Secretary of the Department of Aboriginal Affairs, Charles Perkins, and Kalkadoon elder George Thorpe, the memorial plaque presents a counter-hegemonic formulation of Kalkadoon history resonant with Anzac symbolism:

THIS OBELISK IS IN MEMORIAL TO THE KALKATUNGU TRIBE, WHO DURING SEPTEMBER 1884, FOUGHT ONE OF AUSTRALIA'S HISTORICAL BATTLES OF RESISTANCE AGAINST A PARA–MILITARY FORCE OF EUROPEAN SETTLERS AND THE QUEENSLAND NATIVE MOUNTED POLICE AT A PLACE KNOWN TO–DAY AS BATTLE MOUNTAIN—20klms SOUTH WEST OF KAJABBI. THE SPIRIT OF THE KALKATUNGU TRIBE NEVER DIED AT BATTLE, BUT REMAINS INTACT AND ALIVE TODAY WITHIN THE KALKADOON TRIBAL COUNCIL

In 1986, the tribal council erected the Kalkadoon Memorial Keeping Place [see **keeping places**], in order to instil a sense of pride in Kalkadoon people and to promote Aboriginal culture to non-Indigenous audiences. At the opening ceremonies 150 Aboriginal artefacts were handed over for display and safe keeping. The keeping place is currently one of the most high-profile Aboriginal facilities in Mount Isa and has cultivated positive relationships with civic leaders, mining companies, local schools, and tourism [see 18.1] promoters.

In 1988, as part of the bicentennial year celebrations, long-time area resident Dr David Harvey Sutton designed and financed the erection of a monument to the Kalkadoon and Mitakoodi peoples. Situated on the Barkly Highway about sixty kilometres east of Mount Isa, on the purported tribal boundaries of the Kalkadoon and Mitakoodi, the memorial was intended to draw public attention to Aboriginal history and to Aboriginal ownership of the land before Europeans arrived. On either side of a brick wall were displayed images of a **boomerang**, spears, Aboriginal warriors, the Aboriginal **flag**, and brass plaques bearing poems and texts. Aboriginal people were portrayed sympathetically, but in a romantic colonial narrative as primitive, noble savages inevitably but regrettably cut down in the path of European civilisation. The central plaques on each

side of the wall included a plea for reconciliation on behalf of the Kalkadoon (to the west) and the Mitakoodi (to the east):

> YOU WHO PASS BY
> ARE NOW ENTERING THE ANCIENT
> TRIBAL LANDS OF THE KALKADOON/MITAKOODI
> DISPOSSESSED BY THE EUROPEAN
> HONOUR THEIR NAME
> BE BROTHER AND SISTER TO
> THEIR DESCENDANTS

Local public response to the memorial was mixed. Leaders of the Mitakoodi Aboriginal Corporation fully endorsed the monument, and many other Aboriginal leaders still support its intent as a positive expression of Aboriginal identity and culture. Other members of the public were less supportive. Since its erection the memorial has been repeatedly vandalised with racist graffiti, spray paint, and bullet holes. In 1992 it was destroyed with explosives. Rebuilt, within months it was again vandalised. Significantly, a memorial commemorating the Burke and Wills expedition of 1861, just one kilometre down the road, has remained undefaced.

Public memorials are among the most powerful, and contentious, forms of public history; powerful in that by claiming public space they assert an authoritative legitimacy; contentious in that their visibility often triggers debate and controversy. The attacks on the Kalkadoon–Mitakoodi memorial reveal the extent to which positive representations of Aboriginality are contentious in the context of a mounting Aboriginal **land rights** movement, a Queensland government long opposed to **native title** and with a long history of brutally repressive Aboriginal policies, and the lingering anti-Aboriginal racism that pervades the Australian outback.

Yet public memorials also afford powerful means for challenging official histories. In engaging in a process of counter-memorialisation, Kalkadoon leaders are challenging the prevalent notion that their tribe was eliminated at Battle Mountain. Instead, they are using public memorials to demonstrate their cultural survival, to advance claims to native title, to foster Aboriginal people's pride in their culture and identity, and to secure a more respected position for Aboriginal people in regional Queensland society.

<div align="right">ELIZABETH FURNISS</div>

Armstrong, R. E. M., *The Kalkadoons: A Study of an Aboriginal Tribe on the Queensland Frontier*, Brisbane, 1980; Grassby, A. & Hill, M., *Six Australian Battlefields*, St Leonards, NSW, 1998.

8.4 Tambo: Race and representation

In October 1993, news flashed round the world that the mummified body of a north Queensland Aborigine called Tambo had been found in the basement of a recently closed funeral home in Cleveland, Ohio. Two months later, the brothers Walter and Reg Palm Island—senior traditional owners of the islands whose name they bear—arrived in Cleveland to repatriate the remains of their ancestor [see 11.8; **Burnum Burnum**, **cultural heritage**, **repatriation**]. Accompanied by Kitchener Bligh, a senior elder representing the other Aboriginal peoples who make up the present-day Palm Island community, they performed a ceremony to release Tambo's spirit, assisted by a Native American within whose Seneca tribal domain Cleveland is situated. On 23 February 1994, the 110th anniversary of Tambo's death in 1884, he was finally laid to rest in his own land.

105. Tambo and his companions, photographed before 23 February 1884. (*Rear*) Bob, ?Wangong and Billy from Hinchinbrook Island, and their Manbarra kin from Palm Islands. (*Front*) Jenny, Toby, their son little Toby (aged seven), Jimmy Tambo, and his wife Sussy.

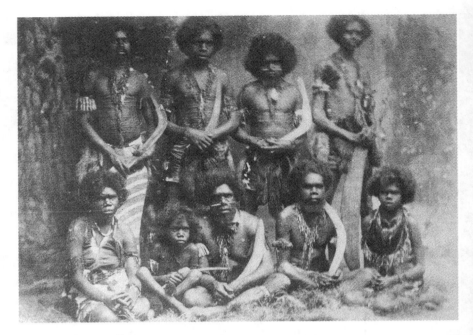

Tambo was one of nine Aborigines from the Palm Islands and Hinchinbrook Island who were removed overseas in 1883 by the showman R. A. Cunningham, acting as agent for P. T. Barnum's circus. In 1892, Cunningham—by then notorious for his maltreatment of a group of Samoans—returned to the same area and persuaded another eight Aborigines from Mungalla station, near Ingham, to go with him to the 1893 World's Columbian Fair in Chicago. Cunningham exploited both groups of Aborigines over several years, touring them throughout the show-places of the USA and Europe, where they were also examined, measured, and photographed by anthropologists. Their personal stories intersected with another narrative concerning the links between popular culture and the new 'science of man'—**anthropology**—with its social-evolutionary notions about a hierarchy of race that legitimised the dispossession of the 'savage' races that were 'doomed to disappear'. The same rationale fuelled the objectifying and commodifying processes by which the personal identities of the Aboriginal performers were obscured, and their numbers steadily reduced by death.

It has been impossible to unravel their stories chronologically. Until the survivors of the first group reached Europe only three had been mentioned by name in newspaper reports: Billy and Jimmy, who tried to escape from Cunningham in Sydney, and Tambo, who was the first to die after only a year abroad. In Europe the seven survivors were examined and interviewed in Brussels by two anthropologists, E. Houzé and V. Jacques, and it is largely from their 1884 report that information can be gleaned about the first group as individuals, as well as about their culture and languages. By relating the only known photograph of all nine of the first group to anthropological reports and later photographs of the seven survivors, it has been possible to identify them, mainly by their given English names [105]. The six Manbarra from Palm Island are Jenny, her son (Little Toby), and husband (Toby), seated left, Tambo and his wife (Sussy) seated together, right, and behind them Jimmy, standing a little apart. The three Biyaygiri men from Hinchinbrook Island, Billy, a man whose identity is uncertain but who may have been called Wangong, and Bob, stand together, distinguished by their horizontal body marks. According to Houzé and Jacques, these three left wives and families behind. Recruited to

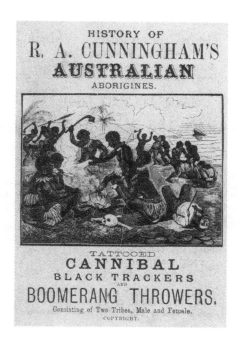

take part in Barnum's *Ethnological Congress of Strange and Savage Tribes of 1883*, they are dressed in their show clothes. Together with other indigenous performers—Zulu, Nubians, Toda, and Sioux—similarly dispossessed on other colonial frontiers, Tambo and his companions were absorbed into the emerging modern world of spectacle, where they were cast in the role of savages. Particularly in the touring circus, *The Greatest Show on Earth*, they joined a cast of thousands and played to daily audiences of tens of thousands throughout the season [see **circus life**].

From the 1870s Barnum led the way in developing the travelling circus as an industrialised form of mass entertainment. Before the cinema, the circus was probably the most influential form of popular culture in shaping public attitudes. The cover illustration Cunningham used for his pamphlet about the 'Australian Boomerang Throwers' also appeared in newspaper advertisements for the show [*106*]. It pictures not Aborigines but 'savages' of the late nineteenth century Western imagination—in this instance, vaguely Fijian-looking. In the circus and other popular literature, whatever their supposed racial origins, 'savages' were said to be 'ferocious' and 'treacherous', with their bodies self-mutilated; they were said to lack language and to eat people. This graphic representation of the group is generically related to a number of others produced both then and much earlier. By the 1880s, Tambo and his companions had become entrapped in an already powerfully constructed stereotype of 'savagery', and stories from Queensland's shifting frontiers, such as that of Eliza Fraser and the wreck of the *Stirling Castle*, had played a part in its formation.

Of the seventeen people removed abroad by Cunningham, only two of the second group are known to have made their way back home, in 1898. They immediately came under Queensland's *Protection Act* of 1897, and seemingly were lost to trace. Under the Act, removal became the main punitive instrument of control over Aboriginal lives, and after 1918 Great Palm Island became, in effect, a penal settlement. For the present-day Palm Islanders and their Aboriginal neighbours, the return of the ancestor, Tambo, and the recovery of his story, however fragmentary, has a particular resonance: it symbolises the return of other 'lost ones'. It has quickened the processes of cultural revaluation.

8.5 'Portraits of Our Elders'

In Portraits of Our Elders, curator, photographer and writer Michael Aird … [gathered] together images of his and others' ancestors taken by studio photographers in the Brisbane district … Some photographs are from public institutions such as the Queensland Museum but many others are from private collections, and it is this last factor which makes the material different to previous collections (Bruce 1993).

The photographs in the exhibition 'Portraits of Our Elders' (1993) offer a glimpse of the transition that Aboriginal people of southern Queensland experienced from the 1860s through to the 1920s. The early photographs document a time when Aborigines had little control over the way in which they were portrayed by photographers; the later images are of subjects who have chosen how they wish to be seen.

In the early photographs, the subjects have clearly been posed; they appear uncomfortable and possibly had little control over the setting in which they were placed. The camera can be seen as the tool of a dominant society—the powerful photographing the oppressed. But if we look past the props and awkward poses, the personality and strength of the individuals emerge. Regardless of the props and stereotypes, they look beyond the situation they are in—*they* are looking at us.

The more recent photographs in the exhibition, dating from the 1920s, were obviously of paying customers with total control over the situation—well-dressed, confident Aborigines in photographic studios. These photographs were a part of the political process that some Aboriginal people were going through. These people sent their children to schools to be educated, to improve their credibility or acceptability within the European society. They bought expensive clothes, they had photographs taken wearing these clothes, they paid for copies of photographs to display in their homes, and to give away to relatives. These actions can be interpreted as tactics of survival.

They reflect the absolute confidence and dignity of people who have succeeded, who have earned the respect of the community.

The photographs featured in 'Portraits of Our Elders' demonstrate the contrast between Aborigines portrayed as the 'exotic' or the 'noble savage' and confident Aboriginal people posing how they choose. In particular, the photograph of Katie, Lilly, and Clara Williams [*107*] gave me the idea for the exhibition. I was struck by this photograph; the beauty of the women, the confidence they demonstrated, inspired me to put together a series of studio portraits of Aborigines.

Many photographs of Aborigines from the nineteenth century were produced for a general market rather than a specific patron. The souvenir trade created a market for both individual prints and entire albums. Series of photographs featuring Aborigines were popular amongst Europeans, since they offered a glimpse of people who were thought to be quickly vanishing. In documenting this 'disappearing lifestyle', photographers saw no need to attach names to the images they produced. In some cases the title 'Australian Aboriginal' was the only information included with the photograph. The names of the individuals, or where they lived, seemed to be unimportant. They were reduced to nothing more than black faces.

John William Lindt was one of the first photographers to attempt seriously to portray traditional Aboriginal lifestyles [*108*]. While working in Grafton, northern New South Wales in the early 1870s, Lindt decided that he could more accurately portray Aboriginal life from within his studio where conditions could be controlled. He began to organise typical Aboriginal camp scenes with typical European backdrops of mountain ranges. Photographs such as these may seem extremely removed from reality, yet they were a very popular series which sold around the world to those wanting images of the exotic.

107. Unknown photographer, *Katie, Lilly and Clara Williams from Tamrookum, Beaudesert Distric*t, c.1925. Studio photograph, 14 x 9 cm.

108. (*r.*) John William Lindt, *Grafton,* 1873. Studio photograph, 19.7 x 14 cm.

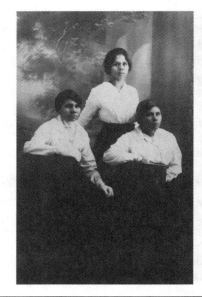
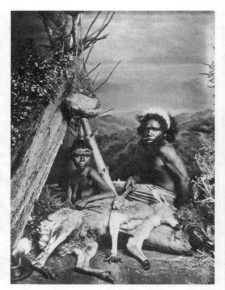

Many photographers took studio portraits of Aborigines throughout southern Queensland and sold the images as cabinet photographs. These were a popular type of postcard from the late nineteenth century and many of the images included bare-breasted Aboriginal women. As popular sellers they were a source of income for the photographer, which the viewer could scrutinise without restraint. This was a reflection of the dual moral standards of the time, where nudity was acceptable as long as it was not European nudity. An example, held in the Queensland Museum, is the photograph of Rosie Campbell [109] posed by Brisbane photographer Paul Poulson in the 1890s. She is shown bare-breasted, with no indication of her name or where she was from.

At Stradbroke Island, however, where several of her grandchildren live today, they hold many photographs of her. In these images not only is she fully clothed, but also the families can attach information and personal memories of Rosie as a person [110]. As Candice Bruce has observed, in contrasting the Poulson photograph and one of the family photographs, 'the Campbell family gather with family members, from the eldest to the youngest: an image collected and handed down with love and pride, in the same manner as any other. The image at once defeats the stereotype … This is the politics of dominance amply described by the simple positioning of the two photographs side by side.'

One of the aims of 'Portraits of Our Elders' was to look at the ownership of photographs, and how Aboriginal people relate to them today. Bruce comments that, like many members of the dominant society, 'Aboriginals … own large collections of early photographs—but perhaps they perform more complex functions. As well as their significance as objects of sentiment and memory … many were indeed knowingly used by different Aboriginal families, as a means of defeating the institutionalised abuse and manipulation sanctioned by government authorities under the various Aboriginal Protection Acts.'

Aborigines felt a very real need to state their successes in the European community to ensure protection from the oppressive 'protection' policies. Photographs were just one way to seek protection from the legislation. For example, the expensive European clothing worn by some individuals is evidence that they have made an effort to obtain them. The expense involved may have been prohibitive to many Europeans of the time, yet some Aborigines managed to afford them. This indicates a degree of success within the European economic system. At the same time, it tells the wider community that the wearers were exempt from the Aboriginal legislation.

Held within the collections of my relatives are photographs of my great-great-grandparents, William Williams and Emily Jackey, taken around 1910. Thanks to family photographic collections, my family can take our photographic **history** back to this point, which I am grateful for. But because family members have gone into institutions to carry out research, we can now take our photographic history back that one more generation. The photograph that I am most grateful to have is of my grandfather's grandmother's father—to have photographs of my great-great-great-grandfather is quite a privilege. This photograph, *Jackey Jackey—King of the Logan and Pimpama*, c.1890, takes my family history back to the beginning of Aboriginal relations with the first European people coming to the area.

I have often seen Aboriginal people look past the stereotypical way in which their relatives and ancestors have been portrayed—they are just happy to be able to see photographs of people that play a part in their **family history**. I have watched as a woman viewed photographs, taken in the 1890s, of her grandmother posing bare-breasted in a photographic studio. This image contrasted with the way this woman remembered her grandmother, as a woman who was always fully clothed. Yet she seemed undisturbed that the photographer had portrayed her grandmother in such an uncharacteristic manner and was simply grateful for the opportunity to view a photograph of her taken so long ago. After working with photographic collections for over ten years, I have been able to experience myself, as well as share with numerous Aboriginal people, the joy and excitement of finding images of ancestors and relatives. In all of these photographs, the people command our attention with their strength and vulnerability. They are people who have lived through a period of enormous change. We should be proud of these people for they are 'Our Elders'. MICHAEL AIRD

Aird M. (ed.), *Portraits of Our Elders*, South Brisbane, 1993; Bruce, C., 'Portraits of Our Elders', *Photofile*, no. 40, November 1993.

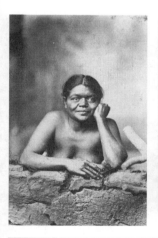

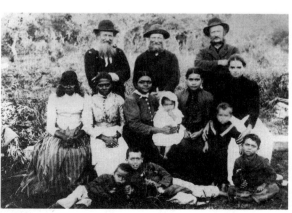

109. (*l.*) Paul C. Poulson, *Rosie Campbell from Myora Mission, Stradbroke Island*, 1890s.
Studio photograph, 14.6 x 9.5 cm, on card 16.5 x 10.5 cm.

110. (*r.*) Photographer unknown, *Campbell Family and Friends at Amity*, May 1891.
Photograph, 8.3 x 12 cm.

Tambo's special circumstances required new forms of ritual, both for the release of his spirit in Cleveland, Ohio, and for his funeral on Palm Island, and the production of images has played a dynamic role in these processes.

A graphic image, that of a brooding Aboriginal face merged with the outline of Great Palm Island, came to symbolise the returned ancestor. Produced earlier as a sarong design, it was reproduced on the shirts worn by the male pallbearers and ushers, and on the aprons worn by the women serving at the funeral feast. Executed in a Western figurative style, the surrounding emblems of turtle, dolphin, and drum may appear to non-Aboriginal eyes to be merely decorative, but they refer both to site-specific myths and to historical associations with Torres Strait Islanders removed to Palm Island early this century. Through its iconic form, the design is accessible to both an Aboriginal and non-Aboriginal public. It reflects the Palm Islanders' simultaneous accommodation of, and resistance to, the pressure of the dominant culture. As for the central mythic image, the ancestral figure *is* the island. Such a visualisation of Aboriginal space signals the resilience of core beliefs that celebrate the spiritual connections with the land.

ROSLYN POIGNANT

Dixon, R. M. W., 'Nyawaygi', in R. M. W. Dixon & B. J. Blake (eds), *Handbook of Australian Languages*, vol. 3, Canberra, 1983; Houzé, E. & Jacques, V., 'Communications de MM. Houzé et Jacques sur les Australiens du Musée du Nord, Séance du 28 Mai, 1884', *Bulletin de la Société d'Anthropologie de Bruxelles*, vol. 3, 1884; Poignant, R., 'Captive Aboriginal lives: Billy, Jenny, Little Toby and their companions', in K. Darian-Smith (ed.), *Captive Lives: Working Papers in Australian Studies*, no. 87, London, 1993; Poignant, R., 'Looking for Tambo', *The Olive Pink Society Bulletin*, vol. 9, nos 1 & 2, 1997.

9. Central Australia

9.1 Painting country: The Arrernte watercolour artists of Hermannsburg

There are many stories concerning Albert **Namatjira** [*36, 42, 111, 115*], Australia's best known, indeed until comparatively recently, only internationally known Indigenous artist; almost all are seemingly contradictory. Was Albert Namatjira the victim, the 'wanderer between two worlds' as his biographer Joyce Batty suggested in 1963, or the individualistic artistic genius, exploiter of a changing environment? In his own lifetime Albert Namatjira had popular and commercial success as an artist. Yet outside his own community, for whom he has become a hero and role model, Namatjira's work has since been generally ignored or viewed as a sign of assimilation rather than as a form of survival and adaptation.

The historical moment

Whatever Albert Namatjira was—and he has been many things to many people—he cannot be understood outside the political, social, and historical realities of his time. The Hermannsburg School of landscape painting which came out of the desert in the 1930s, and which Albert Namatjira initiated, was the result of a conjunction of circumstances. White settlement in central Australia had begun in the 1870s at the time of the building of the Overland Telegraph between Adelaide and Darwin. Pastoralists moved in to establish a cattle industry, and gold seekers flooded in to search the MacDonnell Ranges. In 1877 the first Finke River Mission had been established at Hermannsburg, by German-speaking Lutheran missionaries who had made a twenty-two-month trek from Bethany in the Barossa Valley (SA). And by the 1880s, the little town of Stuart, which became Alice Springs in 1933, came into existence.

This expansion of non-Aboriginal settlement was achieved at the expense of the Indigenous peoples, who were increasingly excluded from traditional lands, and particularly from water resources. As epidemic and other diseases took their toll, compounded by malnutrition, dispossession, and violence, the plight of Indigenous inhabitants became increasingly desperate. In the 1920s this process accelerated sharply. The railway line from Adelaide was extended northwards from Oodnadatta, reaching Alice Springs in 1929, and the first aeroplanes had landed at Hermannsburg the previous year. With these new types of transport available, increasing numbers of scientists, artists, and tourists visited the Centre [see 18.1].

Pressures on the Indigenous Australians were mounting steadily. Drought added to dispossession in the 1920s, displacing many Indigenous groups. People were begging for food along the railway line as it approached Alice Springs, and were often forcibly

111. Albert Namatjira, *Heavitree Gap*, 1952. Watercolour, 34 x 52 cm. Painting 'from memory', Namatjira has omitted the railway line to Alice Springs which had been there since 1929. Heavitree Gap appears pristine, as it may have looked before the iron hand of colonial progress.

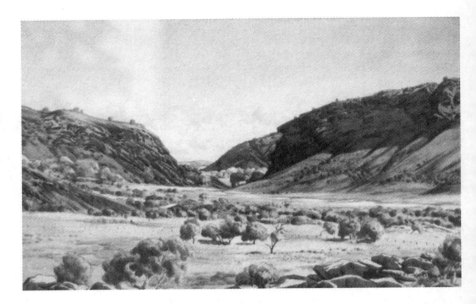

driven off. Many died of starvation or deficiency diseases such as scurvy. Frontier violence, never totally absent, flared again in the **massacres** of Warlpiri people in August and September 1928, near Coniston Station, some 255 kilometres north-west of Alice Springs. Sheer terror gripped the survivors and many sought shelter with missions such as Hermannsburg.

Missions and Christian churches in general have not always been sensitive to the social customs and spiritual beliefs of indigenous peoples around the world. Compared to European settlers, come to make their fortunes or just to earn a living from land which once belonged to the indigenous inhabitants, however, many missions made greater efforts [see 1.2]. At its most basic, a desire to save souls meant that people must at least be kept alive in order to be converted: this was the case in central Australia. Despite a feeling of antagonism to the Lutherans on the part of some Arrernte, which continues among several of the community today, the good intentions of the Mission cannot be denied. Successive superintendents were concerned to keep alive at least some aspects of Aboriginal culture. From the outset, a school for the children, operating in both the Arrernte and German languages, was established at the Finke River Mission. Another aim was to document the local people's language: it was recorded faithfully by Pastor A. H. Kempe, one of the first two pastors at Hermmansburg, and later by Carl Strehlow and his son T. G. H. Strehlow.

Albert Namatjira and the Hermannsburg Mission

Born into the relative anonymity and poverty of the Hermannsburg mission (Ntaria) in 1902, Albert Namatjira was originally called Elea by his parents. He was baptised in 1905 and given the name Albert—an Anglicisation of a German Christian name like so many names given to the Arrernte at Hermannsburg. Drawing in a European way was already well established among the schoolchildren of the mission, influenced by illustrations of biblical stories and primary school texts. Early drawings by Namatjira and other members of the community reveal an interest in figurative depictions of people and animals, ceremonies, and hunting scenes not evident in the later landscapes. Influential too, were the many artists who visited Hermannsburg from the later 1920s onwards, using 'the Centre' as a new icon in the definition of Australia's national and artistic identity. The

basic inspiration for what was largely something new in Arrernte society was a little known illustrator and artist, Rex Battarbee, born in Warrnambool (Vic.). Barbara Henson describes the excitement generated among the Arrernte, when they saw the work of Rex Battarbee and another Victorian artist, John Gardner, exhibited in 1934 in the schoolroom at Hermannsburg. Afterwards Albert Namatjira approached Pastor Albrecht, asked how much money such paintings might fetch, and stated that he could paint such scenes. An outstanding craftsman who had worked as a stockman, blacksmith, and camel driver, Namatjira also produced artefacts such as **boomerangs** and woomeras carved or painted in watercolours, and poker-worked mulga-wood plaques, which were sold in the mission store. He now embarked on a career as an artist.

Once he had been shown by Battarbee how to use watercolours, Albert Namatjira rapidly mastered the medium. In 1937 Pastor Albrecht took ten paintings by Namatjira to a Lutheran conference in Nuriootpa (SA), and the same year Battarbee included three of Namatjira's paintings in his own exhibition in Adelaide. In December 1938 Namatjira's first one-man exhibition was held in the Athenaeum Gallery in Melbourne. At first Namatjira's works were unsigned, then signed only ALBERT. It was only when he was told that it was common to add a surname as well that he adopted the original, pre-baptismal name of his father as the second half of his signature. In 1938 he began to sign his name NAMATJIRA ALBERT. Thereafter, he recorded his name as ALBERT NAMATJIRA.

From 1938 onwards Albert Namatjira was celebrated as an Aboriginal folk hero, lauded as the first Aboriginal Australian to paint in watercolour and have his work exhibited and sold widely to white Australians [see 4.1]. In choosing to paint in a European style Namatjira had apparently abandoned the traditional Arrernte forms of visual expression associated with ceremonial life. However there is some doubt whether he was ever fully initiated amongst his own people, and his 'wrong way' marriage may also have precluded him from seniority within Arrernte Law. His decision to paint in watercolours occurred at a time of crisis, when the mission, with the aid of Arrernte evangelists like Moses (Tjalkabotta), embarked upon a deliberate attempt to consolidate Christianity through the sale of *tjuringa* (sacred objects) and the deconsecration of sacred sites. In some ways, this new style of painting was probably safer psychologically than other forms of artistic production. Philip Jones argues that Albert Namatjira's own role was that of one who lived dangerously, '[h]is transition from highly sanctioned depictions of … sacred art to the precise techniques of European landscape painting was not achieved cleanly or without compromise', and seemingly transgressed both Aboriginal and non-Aboriginal norms of visual language.

Namatjira's small-scale watercolours were mostly bought by private, non-Aboriginal, individuals. Art critics and art institutions largely refused to accept that work done in a 'borrowed' style by an Aboriginal could have any value as art, or any meaningful place in Indigenous Australian culture. Thus, in the 1950s neither the National Gallery of Victoria nor the Art Gallery of New South Wales owned a work by Albert Namatjira. The Deputy Director of the Art Gallery of New South Wales, the painter Tony Tuckson [see 21.1], who had almost single-handedly established a public presence for Indigenous art wrote, 'Namatjira gained greater recognition than any of the [other Hermannsburg painters], because in Western eyes he was the least Aboriginal.' Even today, relatively few of his paintings hang in public institutions and none of those have represented major purchases. Recent re-evaluation has, however, led to two works by Namatjira being hung in the new Parliament House in Canberra in 1988.

Until recently, then, it has been hard to get an overall impression of the nature and scope of this first modern painting movement by Aboriginal people—a movement which, paradoxically, not only preceded that of the **acrylic painters** of the Centre but

influenced many of the key members of that group, several of whom were related to and shared cultural ties with the Arrernte community of Hermannsburg. The first major retrospective exhibition, 'Albert Namatjira', curated by Mona Byrnes, was held in 1984 at the Araluen Centre in Alice Springs, twenty-five years after Albert's death. The foreword to the exhibition catalogue by Elwyn Lynn, artist and curator, is written with a painter's eye but is still slightly apologetic in tone. Another major exhibition, 'The Heritage of Namatjira', which positioned Namatjira and the other Arrernte painters both in 'traditional' central Australia and in later developments in Indigenous Australian painting, toured Australia from 1991 to 1993; it revealed no such inhibitions and led to the publication of the first in-depth study of the Hermannsburg watercolourists, past and present (Hardy et al. 1992). It is now possible to argue that Namatjira and the other watercolourists have, on the one hand, formed and transformed popular ideas about the landscape of the heart of Australia and, on the other, given new expression to the fundamental relationship of Aboriginal people to their land and to their past and their future.

The heritage of Namatjira

Namatjira's success led to others in the community following his example in the early 1940s. First came his close male relatives many of whom had close ties to the Arrernte evangelists—Moses and others. Among these were Albert Namatjira's older sons Enos, Oscar [5], and Ewald, and the **Pareroultja brothers** Otto [112], Reuben, and Edwin who had the same grandfather as Albert. This emerging group of painters was taught by Albert Namatjira himself and by Battarbee, who gave instruction to Otto and Edwin Pareroultja and Ewald Namatjira. Walter Ebatarinja was taught by Albert Namatjira and indeed was supported by him for some period of time since, according to Arrernte kinship rules, Albert was Walter's classificatory uncle and thus owed him help and indulgence. Occasionally he even signed Walter's work with his own name. One of Walter's two characteristic styles is very close to that of Albert Namatjira's landscapes. It is worth observing, however, that although many of the Hermannsburg painters depicted animals or humans, often in hunting scenes, such paintings in particular have rarely been purchased by institutions, exhibited, or even published. For example Walter's wife Cordula **Ebatarinja** (née Malbunka) did a series of portrait studies of people in the mission dressed in European clothes, but these have never been reproduced.

112. Otto Pareroultja, *James Range Country*, 1966. Watercolour, 54.5 x 74.8 cm.

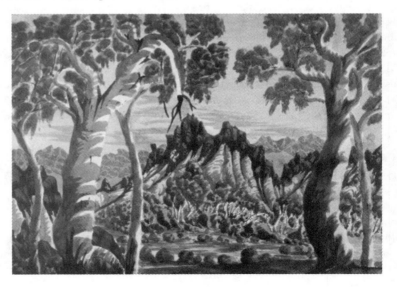

Cordula was prominent amongst a handful of female painters who often produced delightful genre scenes replete with people and animals [*113*]. But she was not encouraged to paint and instead produced embroidered linen and the like. Another early woman artist was Gloria Moketarinja (née Emitja), wife of Richard Moketarinja. Arrernte tradition tended to deny the existence of women painters and assert that at most they were taught by and aided their husbands.

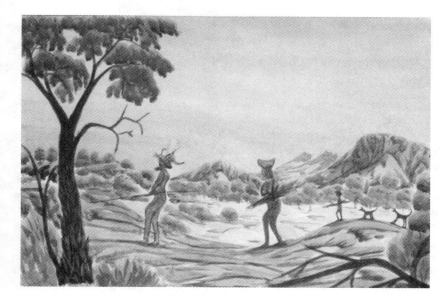

113. Cordula Ebatarinja, *Untitled*, no date. Watercolour, 36.5 x 53.5 cm.

The paintings of Otto and Edwin Pareroultja are often far more geometric in structure than those of Albert Namatjira himself, or those of his sons Oscar and Enos. The latter's pencil studies, made as a boy of fourteen, of scenes around Hermannsburg rival those done by his father at the same time. Ewald Namatjira, the frailest of Albert's children to survive infancy, and the one with the most variable style, produced some very stylised work—'cubist' was Battarbee's description. Following a shooting accident at the age of nineteen, Ewald suffered from severe headaches which have often been cited as the reason for his highly coloured, violently swirling, and almost abstract compositions. Battarbee thought that Ewald Namatjira and Otto and Edwin Pareroultja were the most able and interesting of the painters, and saw Otto's work as incorporating the concentric circles and wavy lines of traditional Arrernte sacred objects. T. G. H. Strehlow also noted the embedding of sacred *tjuringa* decoration and aspects of secret–sacred ceremonies in European-style landscape in the work of Namatjira as well as that of Ewald Namatjira, Otto Pareroultja, and Walter Ebatarinja.

Other artists with family ties to Albert Namatjira include Gerhard Inkamala and his cousin Adolf, who were of the same age as the Pareroultja brothers. Henoch and Herbert Raberaba were also closely related to Albert. Clem and Douglas Abbott were classificatory 'nephews', though of a younger generation, and had watched him painting. Clem's painting are vividly coloured, geometrically textured 'traditional' landscapes. Three members of the Luritja-speaking Pannka family, Claude, Ivan, and Nelson, also became landscape painters; their sister Epana married Albert's son Maurice Namatjira, and their sister Gloria married Richard Moketarinja who accompanied Battarbee on painting trips in 1940 and 1941. Moketarinja's later powerful landscapes are notable for their strong verticals and the curved geometry of the mountains [*114*].

114. Attributed to Richard Moketarinja, *Sacred Objects Above Landscape*, no date. Watercolour, 24.8 x 35.3 cm.

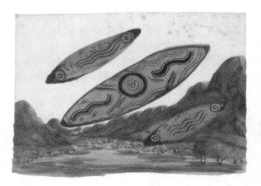

Claude Pannka's strongly delineated landscapes, in traditional Hermannsburg style with a framing gum tree in the foreground giving depth of perspective to the view of the land, often depicted the area round one of Albert Namatjira's major painting camps at Areyonga. In his youth, Claude Pannka's work attracted the interest of the child-art educator Frances Derham when she visited Hermannsburg in 1938. Another artist who caught Derham's attention was Reuben Pareroultja who, in the 1950s, was one of a small group of artists to undertake Christian subjects. These were a fascinating amalgam of traditional Arrernte scenes and the images which the artists had seen in the Lutheran Bibles and religious tracts used by Moses and others of the 'native evangelists' at the Hermannsburg Mission.

Some of the older generation of **Papunya** painters can also produce Arrernte landscapes in the watercolour style. In this informal art, they have adopted the standard iconography of the Hermannsburg landscape—gum trees in the foreground, hills in the distance—as a kind of visual lingua franca. One such person is the Pintupi artist Turkey **Tolson Tjupurrula**, who was born at Haasts Bluff where he met Albert Namatjira, who often painted there. In the early 1980s, the Anmatyerre–Arrernte painter, **Kaapa Mbitjana Tjampitjinpa** [*120*], one of the first of the Papunya artists, who was related through local kinship lines to Namatjira, produced 'Hermannsburg' watercolours, adding his name in the lower right hand corner in the manner of the true Hermannsburg painters. On the other hand, the Anmatyerre painter Clifford **Possum Tjapaltjarri** [*220, 227*] declined an invitation from Namatjira, who was his classificatory father, to teach him the new technique. As Vivien Johnson has pointed out, this attempt by Albert Namatjira to teach the young Clifford Possum how to paint in the manner of the Hermannsburg School represents an early breaking out beyond the traditional tribal affiliations. While Clifford Possum took up carving and painting **boomerangs** early on, and still occasionally does 'Namatjira-style' signed landscapes in coloured pencils, his assertion that 'I got painting job to do' has taken him in other directions.

The early 1980s saw the adoption of 'dot painting' by several of the Arrernte painters, notably by Wenten **Rubuntja** [*39, 377*], who developed fluency in both styles. The Papunya-based artist John Peter Stewart Tjungurrayi used acrylic paints to produce landscapes whose swirling lines echo the stylised watercolour paintings of Walter Ebatarinja and Albert's son Keith Namatjira. Douglas Abbott in 1988 produced a remarkable series of paintings combining acrylic dot painting with the Hermannsburg watercolour tradition. One such work contains a realistic landscape enclosed within a map of Australia, while outside the map is a stylised depiction of the **Dreaming** tracks connected with the site; 'the hegemony of the dot' described by Jenny Green in 1992 is not yet complete.

In central Australia, watercolour landscapes have established themselves as part of a traditional system, a self-referential pattern-book of Aboriginality. Arrernte people continue to paint in watercolour, some still working in and around Hermannsburg, many in Alice Springs. At **Santa Teresa** Catholic mission (Ltyentye Apurte), established to the east of Alice Springs in 1935, Eastern Arrernte children attending the mission school were encouraged to paint by a white teacher. But the predominance of women artists at Santa Teresa, working now as members of **Keringke Arts**, only serves to emphasise the different nature of this tradition from that of their western Arrernte neighbours.

Eastern Arrernte have developed their own landscape tradition. Therese Ryder, Kathleen **Wallace** [396], and Gabriella Wallace are amongst the most significant painters in one of the few successful attempts to establish a self-governing artists' cooperative. Therese Ryder and Kathleen Wallace recall that their own work first went on public display in the 1960s before they had seen any paintings by Albert Namatjira. Though equally concerned with the land, the art of the Santa Teresa painters differs stylistically from that of the Hermannsburg or Alice Springs painters. It is usually less geometric in the way that the features of the natural landscape are outlined, more concerned with painting effects in the sky such as sunsets and, like Albert Namatjira's own work, it uses a feathery delicacy to show vegetation. But since 1971 at Santa Teresa, too, the critical and economic success of the Papunya acrylic 'dot painting' has affected the watercolour painters, and made their art seem less 'authentically Aboriginal' to buyers. Once more the response has been to develop their own dotting style, which employs a raised impasto.

The latest development at Hermannsburg has been the making and painting of pottery [see 9.2, 9.3], particularly by women closely connected by family and marriage ties to the Inkamala family. The senior men are also involved, since they are the custodians of many of the Dreamings painted on the ceramics. The style incorporates modelled clay animal and bird figures on the lids of pots, which often have landscapes like those of the watercolour painters on their rounded bodies [116]. To an outsider, the pots have a freshness and spontaneity lacking in many of the contemporary watercolours. Thus topicality, or rather a further manifestation of adaptability as a form of cultural survival, is a keynote of the work.

Through his achievements as an artist and the status he attained as Australia's best known Aborigine, Namatjira's influence extended far beyond central Australia. The landscapes of the Ngukurr artist Ginger **Riley Munduwalawala** [156] and of the Melbourne-based **Lin Onus** [163, 266, 274], the **boomerangs** of Bluey Roberts, and the trays and tins of Donny Smith all acknowledge the inspiration of Namatjira. The South Australian painter Trevor **Nickolls** [315] paid tribute to him in a series of four *Namatjira Dreamings* which he exhibited during the 1990 Adelaide Festival. These works capture precisely the colour tones of Namatjira's watercolour landscapes.

In the 1970s and 1980s the watercolour tradition continued, but many western Arrernte, such as Namatjira's granddaughter, Elaine [115], began working in the acrylic dot painting style. This development was largely prompted, as the artists themselves perceive it, by the higher prestige and prices awarded to the 'Papunya' paintings, which are still generally regarded by the artists themselves and by the art-market as more genuinely Indigenous. It is certainly noticeable how in recent years the major auction houses, such as Sotheby's in their now regular Aboriginal and Tribal Art sale, have largely excluded Hermannsburg watercolours. An exception is made for works by Namatjira which routinely fetch between $5000 and $15 000, and occasionally higher figures still: *Ghost Gums, James Range, NT*, part of the collection of the late Sir Garfield Barwick, was sold for $25 300 at Lawsons in Sydney on 22 July 1997.

Painting country

Whatever he may have been and, for that matter, may still be for white Australians, to his own people Namatjira is most emphatically not a victim. His watercolours and the work of his relations and followers may have become commodities and relegated to the status of products for the up-market art tourist [see 18.1], but as Ian Burn and Ann Stephen argued in 1986, the watercolours remain 'popularly read in terms of conveying a love of the land, necessary in order to reveal its beauty'. The contemporary artists are unanimous in stating that their work gains its strength being grounded, literally, in the landscape of which they themselves are a part. There is still a pride in 'showing the whole world what a beautiful country Central Australia is', as Douglas Abbott has said, while Wenten Rubuntja, perhaps the most successful of the Arrernte artists who have engaged in the cross-over of styles between watercolour landscape and acrylic painting, is quoted by Jenny Green as saying: 'Landscape is not just trivial, pretty or decorative. This is worship work, culture. It's all Dreaming.' Namatjira himself had no doubts about his position in life, both within his own society and that of non-Indigenous Australia. Following a visit to Sydney in 1956 with his son Keith, Ampol presented him with a new truck; to his own name on the driver's door he had added the one word: ARTIST [*42*]. With his truck he could travel in search of new locations to paint far beyond his own traditional country—a risky business and the mirror image of the travels of the displaced Western Desert painters of Papunya in the late 1970s and 1980s who used their hard-earned, four-wheel-drive Toyotas to revisit their own lands, from which they had been taken as a result of the misguided government policy of centralised settlement.

Despite everything, Namatjira's achievement, and by extension the achievement of all the Arrernte painters and potters, was 'in appropriating a space of cultural practice for himself—and for subsequent Aboriginal artists—which allowed transgressions of cultural, racial and historical boundaries' (Burn & Stephen 1992). While the ultimate fate of the watercolour movement itself is uncertain, its power and significance for the community which produced it remains strong. In what was her last proud statement to her people Albert's granddaughter Jillian Namatjira is recorded by Jenny Green as saying:

Itye aparlpiletyeke, akwetethe itelaretyeke, akwetethe mparetyeke 'landscape'. Pmere nwerneke ikeltarle irrkwetyeke, itye aparlpiletyeke. Kele.

You must not lose it, you must always think about it, and always paint landscape. So that our country will be held strong. You must not lose it.

The heritage of Namatjira is indeed still strong.

J. V. S. Megaw and M. Ruth Megaw

Batty, J. D., *Namatjira: Wanderer Between Two Worlds*, Melbourne, 1963; Burn, I. & Stephen, A., 'Traditional painter: The transfiguration of Albert Namatjira', *Age Monthly Review*, vol. 6, no. 7, November 1986; Burn, I. & Stephen, A., 'Namatjira's white mask: A partial interpretation', in J. Hardy et al., 1992; Green, J., 'Country in mind: The continuing tradition of landscape painting', in J. Hardy et al., 1992; Hardy, J., Megaw, J. V. S., & Megaw, M. R. (eds), *The Heritage of Albert Namatjira: The Watercolourists of Central Australia*, Port Melbourne, 1992; Henson, B., *A Straight-out Man: F. W. Albrecht and Central Australian Aborigines*, Carlton, Vic., 1992; Johnson, V., *The Art of Clifford Possum Tjapaltjarri*, East Roseville, NSW, 1994; Jones, P., 'Namatjira: Traveller between two worlds', in J. Hardy et al., 1992; Megaw, M. R. (ed.), *The Heritage of Namatjira*, Melbourne, 1991; Strehlow, T. G. H., *Rex Battarbee: Artist and Founder of the Aboriginal Art Movement in Central Australia*, Sydney, 1956; Tuckson, J. A., 'Aboriginal art and the Western world', in R. M. Berndt (ed.), *Australian Aboriginal Art*, Sydney, 1964.

9.2 Hermannsburg Potters

The emergence of a pottery tradition at Hermannsburg in the early 1990s initially met with a mixed response: audiences frequently found it difficult to evaluate the innovative ceramics which had begun to appear in exhibitions. A closer study of the Hermannsburg potters, however, reveals that they have built on and extended a complex cultural heritage, paying homage both to the watercolour tradition established by Albert Namatjira and to a more recent history of ceramic figurines. This vital and vigorous combination led Western Arrernte to innovate a new genre for their creative expression, reaffirming their connections to country whilst actively incorporating elements from a wide range of contemporary influences [see 9.3].

The historical origins of the Hermannsburg pottery tradition can be traced to the work of Victor Jaensch, an employee of the Lutheran Mission at Hermannsburg. Possibly inspired by an Australian figurative ceramic tradition, Jaensch introduced pottery to Hermannsburg in the early 1960s as part of an economic initiative to supplement income from tourism. Margie West recorded one of the original artists, Joseph Rontji, a senior Arrernte man, who said:

It started out really weekends. Old man Vic Jaensch was interested in pottery. He was the gardener we used to work with and he asked me and Nahasson Ungwanaka, that was our pastor, and the other one was Melvin Malbunka. He was making native figures and he tried to show us what to do because he knew about it. Then he built a kiln at the back of this house here. We were really happy to do it more but that old man Jaensch was sick. He went back to South Australia. That's why we stopped.

Examples of the small, hand-modelled emus, kangaroos, humans, and other figures produced at the time can be seen today at the Historical Precinct Museum at Hermannsburg and the South Australian Museum.

This brief foray into ceramics established the precedent upon which the contemporary development of the Hermannsburg pottery is based. Pastor Nahasson Ungwanaka always remembered his earlier experiences with clay, and when the possibility of developing a new enterprise at Hermannsburg emerged he suggested pottery as a potential resource. In 1989 the Northern Territory Open College appointed Naomi Sharp, a ceramicist and teacher, to develop pottery at Hermannsburg. She chose not to follow the Anglo-Japanese models adopted in other Aboriginal communities; she drew instead upon Native American Pueblo pottery as a fruitful precedent. Adapting this model to suit the constraints imposed by climate and the limited technical and financial resources, she introduced simple, coil-built terracotta containers and a style of decoration in keeping with the complex artistic traditions of the region.

Initially pottery was produced at three outstations: Arrkapa, Tjamakura, and Intjarrtnama. These outstations were established as a result of the homeland movement of the 1970s when Aboriginal people decided to return to their traditional areas of land. The Arrernte artists worked on a tarpaulin under a tree, using clay and glazes which had been brought in by car, and Sharp would return with the pots to the studio established at Hermannsburg to fire them. In these early years both men and women participated in making pots on the outstations. The men preferred to remain on their outstations, however, rather than travel to the pottery studio in Hermannsburg. When Sharp could no longer visit the outstations, due to the growing number of women in the town who wanted to make pots, the men eventually stopped coming as they felt uncomfortable working in the studio with women from outside their family.

The Hermannsburg potters today are women—daughters and nieces of the original watercolourists. Most grew up with the experience of their relatives painting around

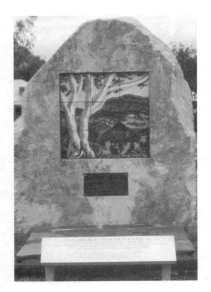

115. Albert Namatjira's gravestone mural, 1994. Albert Namatjira's grand-daughter, Elaine Namatjira, produced this gravestone mural working in collaboration with her cousin, Elizabeth Moketarinja. They moulded mountain ranges and trees in relief on the nine tiles, and then glazed the scene. At the ceremonial unveiling of the gravestone, Elaine Namatjira said that she paid respect to her grandfather through the mural and hoped he 'would be pleased'. Today the mural, set in the sandstone headstone of Namatjira's grave in Alice Springs, is a symbol of the love that the Arrernte people have for their country and a sign of the continuity of their art.

them. As children, they spent hours watching members of their family sketching and laying down the translucent colours on paper, and they often accompanied the painters on their visits to particular painting sites. By the time they were adults they were practised in recording what they saw. They had a good grasp of perspective and the ability to build up depth in a painting from the background to the foreground; and they had also developed an ability to portray the subtleties of the colour and tones of their country bathed in the strong light of the desert. Today they are using clay to build the vessels that they paint on. They hand-build their round pots using the coil method and take great pride in the making and shaping of the pots and in moulding little figurines on the lids. The following comments are typical: 'I like holding that little pot' (Carol Ebatarinja); 'I like the feel of clay in my hands' (Ida Enalanga); and 'Now the little birds on top finish the story' (Elaine Namatjira).

The women do not always paint what is found in their own country; they are visually excited by all that they see on television and in magazines. They love to depict penguins or polar bears, African animals such as zebras, leopards, and tigers, or tropical birds and fish. One visit to Darwin's Indo-Pacific Marine aquarium inspired many of the artists to depict fish and other marine life. Such wide-ranging interests are a reflection of a basic fascination with patterns and pattern-making, but these images are not always well received by an audience which wants to see traditionally-oriented Aboriginal art. As Carol Rontji (quoted in West & Kean 1996) recalls: 'I always think what I'm going to do [on the pot], what I'm going to draw on it, I think first, it's my own idea. I do what I see out bush, like gecko, skink and goanna. I did a lion once, nobody would buy it.'

Hermannsburg Potters has also produced many large, tiled murals depicting in relief Dreaming stories, landscapes, and the animals, birds, and bush tucker found in Arrernte country [115]. These are now to be found in private and institutional collections in Australia and overseas. The involvement of senior men, who play an important role as the ritual authorities for an area, has contributed significantly to the development of the pottery. Denis Ebatarinja, the son of the watercolourist Walter Ebatarinja, the owner of Roulpmaulpma and *kwertengerle* (custodian) of Ntaria, designed the logo for the pottery and authorised the first Dreaming mural produced by Hermannsburg Potters. It tells the story of the twins Renkaraka and Ratara associated with the Palm Valley–Ntaria area. For Ebatarinja, the Hermannsburg pottery is important in maintaining cultural knowledge: 'I don't want them kids forgetting their stories and the names of those places' (quoted in Irvine 1991).

Involvement in the pottery gives the women an economic return and the chance to travel and participate in workshops like the one held with Pueblo potters in New Mexico in March 1994. It also provides the women with the opportunity to enjoy elements of their traditional lifestyle—sitting together, doing a task, and chatting about their families. In the right season all go out and gather wild bush tucker and take some of it back to the studio to look at while they work. Seated together around a large table they watch each other's works in progress and comment and admire. There is no feeling of competition between the women nor any assertion of artistic ego. Cooperation has always been essential, not only for the success of their rich and varied social life and religious culture, but also for their very survival in a harsh and demanding environment. Participating in the production of the pottery is part of a traditional lifestyle. It is intertwined with, and enhances, the daily life they and their ancestors have always known: it is a successful integration of the old and the new.

NAOMI SHARP

Irvine, J., 'The Hermannsburg potters', *Ceramics: Art and Perception,* no. 6, 1991; West, M. & Kean, J. (eds), *Hermannsburg Potters,* Darwin, 1996.

9.3 Irene Entata, *Mission Days*, 1998

'When I'm painting my pots I am just painting with my ideas, my country' (Irene Entata 1997).

In preparing a large exhibition to be shown at Parliament House in 2000 to mark the turn of the century, the women potters of Hermannsburg began to make works which recorded themes or ideas of particular personal significance. *Mission Days*, 1998 [*116*], a painted ceramic piece made by Irene Entata for the exhibition, is one of the largest pots yet produced in the Hermannsburg tradition. This major work records many sequences of life at Hermannsburg during the old mission days. The vignettes painted around the surface of the pot are reminiscences of activities still current during the artist's childhood, and others which have become part of family history and memory. Most show activities which her relatives undertook under the direction of the Lutheran mission.

Discussing the pot on its completion, Irene Entata remarked:

That is the old horse corral where the big supermarket and petrol is [now]. The ironwood tree is still there from when we were small. On the top [the figure] might be my father—he used to dress up like that and ride the camel. Why I made that big pot was I remember in olden days I used to see my cousin Gwendoline milking cows at missionary time. The ladies used to milk them. There was only a fence of petrol drums—no proper yard.

Other scenes painted on the surface include young women shepherding sheep, carrying milk in buckets, feeding the chickens, and the famous Hermannsburg church which still stands in the historic mission precinct: 'The new church used to be a chook yard. We had smaller drums cut in half for egg, *guarda*. My mother Millicent used to get them and take them to Pastor Gross. They used to have sheep on both sides where the houses are now.'

The watercolour artist Albert **Namatjira** is shown in his famous car [see 20.5; *42*] in which he travelled between Hermannsburg and Alice Springs conducting his art business. Irene Entata recalls him painting and the circle of artists which grew up in response to the interest in Arrernte watercolours

Irene Entata is one of the original potters of Hermannsburg, and her work has become well known. It exhibits a charming fresh and direct painterly technique of surface decoration; she has a preference for well modelled figures on the lids of the circular lidded pots, and ascribes this to the skills she learnt modelling plasticine at school: 'When I was ten or eleven there were cattle, horses, donkeys, camels, plenty of dogs and plenty of pussy cats. I went to school and we made things with plasticine—birds, eggs, wagons, birds and nests, little people.'

116. Irene Entata, *Mission Days*, 1998.
Terracotta with underglaze painting, vinyl acetate copolymer sealant; max. width 47 cm, height 36 cm.

Known for their adaptive and creative ways with new materials and concepts since earliest times, the Arrernte of Hermannsburg have now become as famous for pottery as they are for watercolour painting. Following the great Albert Namatjira's lead, numerous artists continue the watercolour tradition. Elements of that painting tradition and ease with adaptive materials are evident in Hermannsburg pottery. As Clara Inkamala says: 'Arrernte people like to learn and work in new things. My grandmother learnt to crochet for the church; my uncles learnt watercolour painting … and now in this generation we are the first in pottery and we are travelling the world.'

When *Mission Days* was removed from the kiln and displayed for the first time, Irene Entata's close friends, sisters and relatives showed great communal pride in their reactions. In the words of Clara Inkamala: 'When we see a really good pot we say "you done a really good work, nice, standing out. *Maranthurra*, like the sun on it."'

TEXT PROVIDED BY JENNIFER ISAACS
FROM INTERVIEWS WITH IRENE ENTATA AND CLARA INKAMALA

Isaacs, J., *Hermannsburg Potters*, Roseville East, NSW, 2000.

9.4 The Papunya Tula movement

On my arrival at **Papunya** Special School (NT) in early 1971, I taught elementary Western knowledge to approximately 160 children aged from five to sixteen. There were many basic study activities, magazines, music, and **sport** in the European manner, and a hot meal for lunch every day. Initially I was ignorant of Aboriginal culture at Papunya, but I was continually conscious of a presumption among most of the whites that the Desert culture was vestigial at best—doomed, insubstantial, and vanishing.

As time passed, there was a gradual emergence of children's patterns [*117*] in the classroom and I saw young people drawing games in the sand itself, demonstrating afresh the intelligibility and significance of Western Desert cultural meanings. I welcomed the children's patterns and imaginative line drawings, hoping they would reveal an Indigenous sign language and its attendant perceptions. I often played games with my classes, drawing with my fingers in the sand a variety of tracks, circles, and spirals, for I had noticed patterns and various configurations on ceremonial objects by this time. By asking Obed Raggett, the Arrernte interpreter and assistant at the school, and others in the community what different designs meant, I learned many social customs and sometimes the sacred–secret strictures of the representations. At ceremonies I saw body decoration and thereby increased my knowledge of the graphic and painted representations of the various language groups at Papunya. Constantly encouraging the children, I studied the patterns that emerged in their work [see 9.5]. After May 1971 many diverse styles began to appear in their puppetry, **batik**, silk-screening, and ceramic decoration. Obed Raggett greatly enjoyed these new-found expressions of Aboriginal identity in art work. I endeavoured to speak Pintupi with him and the artists. Because of my interest in the considered repetition of patterns on the blackboard during my lessons, I came to be known by the children as 'Mister Patterns'.

From early 1971 to August 1972 I made every effort to interest and encourage senior men in the community to use traditional patterns in their paintings. Johnny **Warangkula Tjupurrula** [*37*] and Mick **Namarari Tjapaltjarri** [*360*], two members of the Papunya Council of that early time, became my friends and hunting companions. Showing interest in my classroom activities with children, both men enthusiastically painted many small images and designs of travelling stories or **Dreaming** tracks. Occasionally, they found idle hours to work quite intensely with me, conceptualising and reconceptualising the motifs. I also had contact with other men such as Charlie **Tjararu Tjungurrayi** [*394*], Old Walter Tjampitjinpa, Old Mick Tjakamarra, Old Tom Onion Tjapangati, Old Bert Tjakamarra, Don Ellis Tjapanangka, and **Kaapa Mbitjana Tjampitjinpa** [*120*], who first watched me from under the elevated floor of my classroom or from the abandoned old settlement office before beginning to paint with me. Traditional motifs had already been attempted at the settlement before my arrival; I first became aware of them when I began to lend brushes to men working at the old settlement office. Painting independently, Kaapa Tjampitjinpa was sometimes authorised by senior men to depict tribal motifs of considerable cultural significance which I had not seen before. In July 1971 he won the important Alice Springs Caltex Art Prize [see **art awards and prizes**] in open competition with European artists—an achievement that gave an enormous boost to Aboriginal cultural identity. Because of the general lack of respect for Aboriginal culture among whites at Papunya, my intense interest in their designs and images brought about a reaffirmation by senior men such as Kaapa Tjampitjinpa of what they were attempting. I realised that the designs I saw had a significant cultural meaning, but at first there was a considerable reluctance among the artists to discuss this with me. That a white man seemed capable of understanding something of traditional design was for Old Mick Tjakamarra, in particular, quite extraor-

117. Thea, *Line design*, 1971.

dinary. His wonderment was apparent on his face that autumn morning when I provided new paint and suggested regular changes of water to keep the colours clean and fresh. It seemed I could help these quiet and seemingly obscure senior men, for I was the art teacher who had access to government supplies. Such encouragement of traditional art styles was quite unprecedented in this brutalised and impoverished settlement. It clashed with all preconceived European ideas, and with many of the racist and hierarchical assumptions of the nation. To encourage men in non-secret art with family and children's themes seemed to me to give Aboriginal perceptions substance as a new visual art form.

Part of the lower school building with its colonnade and school walls, squalid and sterile, was greatly enhanced and restored at my suggestion by some of the children, with assistance from Obed Raggett and the yardmen Billy **Stockman** Tjapaltjarri and Long Jack Phillipus Tjakamarra. The earlier murals we completed inspired the major *Honey Ant Mural* of August 1971 [*118*]. All the money used for the school murals came from the profit we made from the selling of food in the Aboriginal camps every pay fortnight, with assistance from Val Petering, the daughter of the Lutheran pastor, and occasionally one or two others. My negotiations with the senior men began on the site of the proposed mural and continued in the school art room and at my quarters. Kaapa Tjampitjinpa's interest in the project reassured me of the importance of the design finally agreed upon with the senior men. The major school wall facing the central lawn area was prepared by cement rendering, then sealed. With the authorisation of the head teacher, Fred Friis, I provided the men with their painting materials. The senior men of the community, in particular Old Tom Onion Tjapangardi, were giving an unprecedented gift to the white man's system of schooling in return for the new respect shown to Aboriginal identity and self-esteem, but at first I did not know of the gift, nor of the far-reaching tribal negotiations which were necessary before the project could take place.

Ordinary, school-quality powder paints in traditional colours, mixed with PVA (polyvinyl acetate) glues were applied on the special wall, mostly with standard issue painting brushes. As assistant to the painters, I found myself running up and down school stairs with materials for weeks. The making of the murals gave enormous pleasure to the painters, and brought great happiness, pride, and hope to the Papunya community. These murals embodied stories of great significance to all the Papunya people. Sacred–secret issues were discreetly avoided. European illustrations of realistic honey ants with legs and wings were attempted by Kaapa Tjampitjinpa, but at my request were

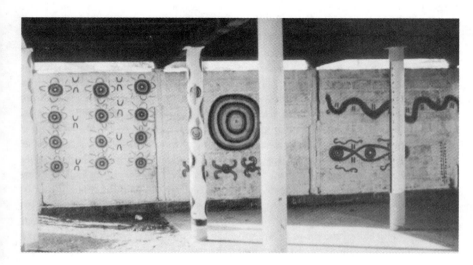

118. Papunya school colonnade, with murals at east end-wall, 1971.

modified to the traditional 'U' shape for honey ant spirit figures. During those weeks, young Pintupi tribesmen would stop off in quite considerable numbers when returning to camp and sit on the lawn in groups to sing and chant the spirit Dreamings of the murals. Their laughter and singing brought forth a sense of glory to all the Aboriginal people on those crisp, blue-purple, desert afternoons, for the work was an affirmation of cultural integrity and meaning.

My fellow schoolteachers also admired the principal mural for its commanding position and visual strength. Significantly, it could be seen by all the Aboriginal people in the community for whom its design linked the entire continental Aboriginal world. The fidelity of the work for people who believed in a Dreaming 'eternity' caused the artistic ideas developed at Papunya to spread to other Aboriginal communities throughout the Western Desert and Central Desert [see 9.5].

Yet at the time the mural was not acknowledged, except among its proponents, for its significance. Being traditional, it was the last thing an unaware and unresponsive government administration welcomed. It was seen by visiting cabinet ministers, an entire committee of federal parliamentarians and senior cultural bureaucrats, as well as by education officials. The mural designs meant nothing to them, however—not even as a mere refurbishment and enhancement of a wretched school building. The designs were dismissed as something pretty but obscure, and presumed to be as incomprehensible as most Aboriginal matters, of no significance or cultural importance. They were not considered art and suffered the fate of **graffiti**: all the murals were destroyed when the school was repainted in 1974.

After the mural was completed, I continually offered help to any man wishing to paint and arranged for Obed Raggett to explain that anyone who wished to paint traditional designs could do so and receive every assistance through my teaching role at the school. The many 'new' Pintupi young men who visited my quarters added tremendously to the number of painters working. Designs on fibro, tin, or fruitbox ends, salvaged and brought to my verandah by unknown Pintupi men, produced images unlike any, to my knowledge, ever seen before. Even the Arrernte men from Hermannsburg, who had good jobs in the office and kitchen, would sometimes paint in the classroom. These designs depicted dots in various combinations of half circles and spiralling lines. At first radiating circles were used, but later only concentric circles. Some configurations embraced two or three meanings depending upon the interrelationship of the constituent parts. Each man had his own personal images. Any insuperable language barrier between the men and me was circumvented by a nodding of heads, smiles, hand-signs, and much laughter. I became friends with these Pintupi men—but only slowly. The Pintupi were very happy to have paper, crayons, and European art materials; they seemed to take an immense pride in their enigmatic patterns. Men would regularly visit my quarters, before and after work, and many tribesmen spent hours painting and drawing on my verandah. We all enjoyed billycans of tea, and biscuits. These times were the quiet beginnings to that immense sharing of affection and generosity which so marked the early dynamic of the Papunya painting movement.

The senior custodians now established a company of their own, Papunya Tula Artists Pty Ltd. This commercial outlet overcame quite profound and institutionalised obstacles to ensure the survival of the Western Desert culture. The opportunity to make money interested all these senior men, mostly Anmatyerre–Arrernte, who desperately needed some material assistance and who had a good understanding of business procedures. Following many 'business' meetings in my schoolroom in late 1971, with Obed Raggett translating on behalf of the Papunya Art and Craft Council, the 'painting group' began to realise their common interests by working in the painting room at the east end of the

'Town Hall' (a euphemism for the galvanised-iron storage shed assigned to the painters) [*119*]. This group of more than thirty men of many cultural groups, ages, and extremely varied experience worked together until I left Papunya in August 1972. Such was the enthusiasm of the artists that about a thousand works had been created during my time at Papunya. Obed Raggett and painting men from different tribal groups who understood my advice translated my perpetual refrain: 'We can beat the whitefella artist with really "good stories" painted the "proper" Aboriginal way, whitefella *wiya* … nothing whitefella.'

GEOFFREY BARDON

Bardon, G., *Aboriginal Art of the Western Desert*, Adelaide, 1979; Bardon, G., 'The gift that time gave', in J. Ryan, *Mythscapes: Aboriginal Art of the Desert*, Melbourne, 1989; Bardon, G., *Papunya Tula: Art of the Western Desert*, Ringwood, Vic., 1991; Bardon, G., 'Reminiscences for Obed Raggett of Papunya', in D. Mellor & J. V. S. Megaw (eds), *Twenty-Five Years and Beyond: Papunya Tula Painting*, Adelaide, 1999.

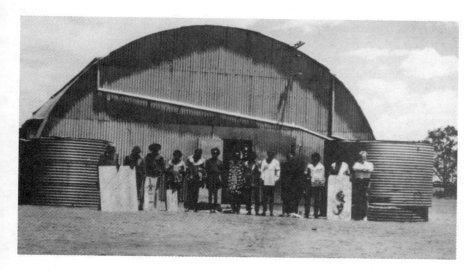

119. Papunya Tula artists in front of the painting shed, 1971.

9.5 Desert art

That Dreaming been all the time. From our early days, before the European people came up. That Dreaming carry on. Old people carry on this law, business, schooling, for the young people. Grandfather and grandmother, uncle and aunty, mummy and father, all that—they been carry on this, teach 'em all the young boys and girls. They been using the dancing boards, spear, boomerang—all painted. And they been using them on the body different times.

Kids, I see them all the time—painted … Everybody painted. They been using ochres— all the colours from the rock. People use them to paint up. I use paint and canvas—that's not from us, from European people. Business time, we don't use the paint the way I use them—no, we use them from rock teach 'em all the young fellas (Clifford Possum Tjapalt-jarri 1992, quoted in Johnson 1994).

Ask the artists of the Western Desert, and they will tell you that their paintings come from the **Dreaming**. Like the trees, caves, and monoliths which mark out the journeys and stopping places of the ancestral land-forming beings, like the ceremonies in which the ancestors' exploits are relived, their paintings are part of the Dreaming. Through their imagery of ancestral passage in the landscape, they provide an immediate insight

into this fundamental concept of contemporary **Aboriginality**. By painting the designs and stories which identify their particular Dreaming places, the artists also assert their rights [see **rights to art**] and obligations as Western Desert landowners, entrusted with the ritual re-enactment of the events which occurred at these sites during the Dreaming. The focal points of these ceremonies are elaborate sculpted mosaics known as sand paintings, the ancient form on which the contemporary artists of the Western Desert base their renditions on canvas of the Dreaming stories. When the surface of the ground has been cleared and firmed, the custodians of the Dreaming site work with spinifex down dyed with pigments—red and yellow ochres, charcoal and white lime or pipe clay brought from mines and beds sometimes hundreds of kilometres distant—and with daisy petals, emu feathers, and eagle-feather down. Using the traditional visual language of the Western Desert peoples—U-shapes, concentric circles, and journey lines—which also forms the dominant iconography of Western Desert paintings, they encode in their sand paintings the ancestral narratives celebrated in the accompanying songs and dances. The procedure which the artists typically follow in producing their canvases mirrors this ceremonial context: on a dark, even ground, usually red ochre or black like the traditional surfaces of skin or earth, the artists inscribe the Dreaming designs, outlining and then surrounding them with massed fields of dots like the balls of spinifex down which typify the ritual style.

If Western Desert art came from the Dreaming as the artists have always insisted, it came also out of the network of Aboriginal settlements established across the desert region by successive Australian governments under the now infamous policy of assimilation. The nomadic peoples of the Western Desert had gradually been gathered into these places, whose official purpose was, as one Department of Territories Report of 1977 stated, 'to bear the initial brunt of the burden (of overcoming the divergence of social customs between the Aboriginals and the white man) and, by training and precept, render the native acceptable to every day Australian social life and, as an individual, attracted to it' [see 4.1]. Bureaucrats call them 'remote settlements', but for their older Aboriginal residents it was only their relative proximity to the things that mattered to them—country and Dreamings—that made bearable their memories of forced relocation to these places. For the generations born on them, the settlements have the major Dreaming significance that one's birthplace has for all Western Desert peoples. They are not 'remote' from the community's spiritual centres—only from the rest of the world. The title of **Ernabella** artist Makinti Minutjukur's painting *Aṉangu waltjapiti ngura waltjangka nyinantja*, 1989–90, meaning in Pitjantjatjara 'A group of Aboriginal people living together as a community in one place', perfectly encapsulates the complex concept of the 'remote community' in the contemporary social order of the Western Desert peoples. Highly individualised as the painting movement and many of its most committed artists have become under the influence of the white art systems of marketing and display, it was from just such a community of people and place that the **acrylic painting** movement originally sprang in 1971.

Indeed, it started in the 'worst' settlement in the Western Desert by the sort of 'performance indicators' imposed on their Aboriginal Councils in the 1990s. Long before anyone put paintbrush to canvas, **Papunya** was one of the most publicised Aboriginal settlements in Australia. Its proximity to Alice Springs (250 kilometres due west on the eastern fringes of the Western Desert region) may have contributed to the settlement's notoriety. It was here that the 'remnants' of the so-called 'lost tribe' of the Pintupi, presumed to be the last of the Western Desert peoples still pursuing their traditional nomadic lifestyle, were brought in from 1963 onwards by the Northern Territory Welfare Branch patrols. Officially opened in 1960, Papunya was the last of the settle-

ments to be established, and boasted a range and scale of facilities superior to what was on offer elsewhere across the network, testifying to the government's undying determination to extract from the minds and bodies of 'the last wild blackfellas' the proof of its normalising vision. It is painful now to be reminded of that not so distant past when the rest of the world looked down upon the people of the Western Desert as the most primitive on earth. But it is necessary, if we are to understand the impact of the amazing works of art that began to emerge from Papunya within a few years of the controversial 'trucking in'—and that have been pouring out of the Western Desert ever since. The story of Western Desert art is one of the most extraordinary in twentieth-century art, and pivotal to the fortunes of Indigenous artists in Australia today. It begins in that moment of courageous defiance when the founders of Papunya Tula Artists, including some of those 'wild blackfellas' brought in from Pintupi country, took up their brushes and opposed the might of the assimilationist regime with their exquisitely painted boards, proudly proclaiming the living culture of the Western Desert peoples.

What was happening in Papunya in 1971 to set in motion this remarkable art movement? The unhappy truth for the government was that by the beginning of the 1970s the last great assimilationist experiment had become an embarrassingly public failure. Numbers at Papunya had risen to just over a thousand, swelled by the influx of unemployed stockmen and their families from surrounding cattle stations after the introduction of award wages in 1968. More than half the Aboriginal residents were under sixteen. Delinquency had become the pastime of the young. Acts of vandalism, car stealing [see 20.5], and violence against Europeans were apparently commonplace—certainly they were always newsworthy if they happened at Papunya. The media attention prompted a string of official inquiries which all reported gloomily on the settlement's future prospects. But in the midst of this scene of outward devastation, something was happening beneath the very classrooms in which the next generation of Western Desert children were being inculcated with the concepts of the colonising culture. Geoffrey Bardon [see 9.4], the new art teacher at Papunya School, had assembled a team of older Aboriginal men including **Kaapa Mbitjana Tjampitjinpa** [120], Billy **Stockman** Tjapaltjarri and Long Jack Phillipus to create a mural on the blank three by ten-metre wall under the classrooms [118]. The end result was galvanising: a powerful collective assertion that the cultural traditions of the Aboriginal people at Papunya would *not* be erased from the assimilationists' world [see 1.2].

Mainstream Australian culture is now so saturated with the imagery of dot, line, and circle derived from Western Desert painting that it is easy to overlook how radical a step this was. The giving of permission by the elders for the painting of the Papunya school mural represented a complete reversal of the hitherto resolutely isolationist attitude of Western Desert people. Until then, the ceremonial designs had been jealously guarded from the prying eyes of the world. But the head tribal educators grasped the didactic potential of the enthusiastic art teacher's project—for winning back the hearts and minds of the younger generation to their responsibilities under the Dreaming. In the re-education camp of their colonisers they instituted their own re-education program—in Aboriginality. The first paintings done at Papunya after the mural were layouts of ceremonial grounds and dancers' paths, and depictions of sacred objects forbidden to the sight of the uninitiated. These were an accurate record of their own cultural traditions and perhaps also an externalisation of their acute longing for the Dreaming places whose stories they told. These elements were eliminated once the paintings began to be sold outside the settlement, but the rumoured contents of the earliest works, and the similarity of the Dreaming designs on later 'censored' works to those of neighbouring groups who still held fast to the traditional bans on disclosure, provoked strong

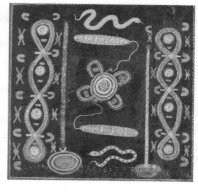

120. Kaapa Mbitjana Tjampitjinpa, *Untitled*, 1971. Acrylic powder paint on composition board, 91 x 91.5 cm.

condemnation of the Papunya painters from the rest of Western Desert society for many years. Responding to these pressures, the pioneers of Papunya Tula Artists began the development of a visual language which their Western Desert critics would consider appropriate to the paintings' expanding encounter with the outside world: a radically simplified iconography whose ritual references were accessible only to those with inside knowledge of the artists' Dreamings.

As the years went by after Geoffrey Bardon's departure in 1972, pictorial motivations became more prominent. The most tangible sign of this was the distinctive dotted backgrounds which for the next two decades would be the hallmark of the 'Western Desert' style [37]. The classic desert painting of the second half of the 1970s depicts ambiguously the actual geographical locations, the narrative lines of the Dreamings associated with those places, and the contemporary ceremonies in which these connections are reaffirmed by the Dreamings' custodians. These contents are fused into a coherent image using a code of abstract symbolism that makes modern Western experiments with abstraction look naive. The auto-ethnologists reverently creating 'authentic' records of their esoteric knowledge had transformed themselves into sophisticated artists, using their inherited visual culture to invent an art language in which they were free to arrange the elements of their paintings 'according to their aesthetic judgement' (Papunya Tula Artists 1975). Clifford **Possum Tjapaltjarri** [*220, 227*] and his brother Tim **Leura Tjapaltjarri** [*224, 262*] pioneered a new genre in Papunya painting with their 'topographical' representations of the totemic landscape, of which *Warlugulong*, 1976 was the first. By the end of the 1970s Papunya paintings had become vast compendiums of Western Desert culture, mapping out the artists' custodial responsibilities over vast areas, like personal deeds of title. The inclusion of several of these monumental works in 'Australian Perspecta 1981' at the Art Gallery of New South Wales marked the beginning of the end of the long denial of Aboriginal art by the Australian art establishment [see 21.1].

The implications of Papunya Tula's subsequent success in the world of contemporary art go further than the development of individual artists—or even the transforming effects of exposure to the paintings on mainstream Australian audiences. The 1980s marked a turning point in the history of the Western Desert peoples which might not have been reached had not the entire community been galvanised by the painters' success. A movement for the resettlement of tribal lands was gaining momentum [see 9.7]. Just as the arrival of the Pintupi, with the strength of their immediate, practical continuity of connection with country, may have precipitated the painting movement at Papunya (rather than at any of a dozen other communities from which painting enterprises have since emerged), so the Pintupi exodus from Papunya a decade and a half later spearheaded the homelands movement in the Western Desert. In 1981 they travelled some 300 kilometres west back to where they came from and established a Pintupi township, 200 strong, at Kintore. By 1985 they had pushed another 200 kilometres further west to Kiwirrkurra. The changes in Pintupi painting which corresponded with this exodus reflect the alteration in the artists' relationship to country. As the Aboriginal term 'homelands' (rather than the European 'outstations') implies, the focus of those who led this movement was not withdrawal from the ravages of settlement life, but calculated assertion of the fundamental importance of connection to country for the survival of Western Desert society.

The self-repatriation of the Pintupi had only been possible because of the independent income generated by their paintings—a lesson not lost on their countrymen and women at other settlements across the network. Many who had originally opposed the Papunya painters' decision to allow their Dreamings into Western art began to rethink their position, and the art movement started to spread from settlement to settlement

along the lines of kinship and family which connect all the desert peoples. Communities close to Papunya were the first to be affected, but as the 1980s advanced, community after community would fall like dominoes before the painting movement's seemingly irresistible advance. The education in the inherited visual language of the Dreaming designs which is the passage to adulthood in Western Desert culture creates the potential for every tribesman—and woman—in central Australia to embrace the vocation of artist; and the way things were going in the late 1980s, it looked as though they just might. The Western Desert approach to artistic vocation was wryly summarised by one of its most eminent practitioners, Clifford Possum Tjapaltjarri, in answer to a question about why he became an artist: 'More better than digging holes for fencing post!' (Quoted in Johnson 1994.) The amazing proliferation of painting communities confirms the richness of the cultural base from which Western Desert art draws both longevity and inspiration.

The painting movement spread first to **Yuendumu**, a settlement 100 kilometres north of Papunya established in the early 1950s to accommodate the southern or Ngalia Warlpiri people, whose traditional lands lie further to the north-west. In contrast to Papunya, where for the first decade painting was almost exclusively a male domain, here it was a group of older women who initiated the process, in the mid 1980s. Encouraged by the interest of a visiting French anthropologist, Françoise Dussart [see 3.3], in their body painting designs, the senior ceremonial women of the community produced a sequence of large, collaborative canvases. Flamboyantly coloured and painted, as if glowing with pride in the artists' cultural heritage as Warlpiri women, they quickly drew the art world's attention to the arrival of a new force in Western Desert art. A separate project, organised by the headmaster and adult educator at the Yuendumu school, precipitated the men's involvement in the art enterprise. A group of senior men, including Paddy **Sims Japaljarri**, Larry Spencer Jungarrayi, Paddy Nelson Jupurrurla and Paddy **Stewart Japaljarri**, was commissioned to paint the thirty doors of the school with their Dreaming designs [*221*]. In 1983 the *Yuendumu Doors* project was carried out with official sanction and support, whereas the Papunya school mural had been painted over by the Northern Territory Education Department a few years after it was created. But irrespective of how the activity was perceived by non-Aboriginal authorities, it had the same effect in each case on the Aboriginal residents of the settlements: an upwelling of communal identification and pride, followed by an eruption of paint and canvas. The **Warlukurlangu Artists Aboriginal Association** was originally incorporated in 1986 in the wake of the Yuendumu painters' successful exhibition in Sydney in December 1985 at Hogarth Galleries. Both men and women paint for the association, though women are in the majority and also paint more regularly than the men—a pattern which has been repeated in many other painting communities since the mid 1980s. Calculations of gender imbalance do not seem to be an issue among the artists, perhaps because the Dreaming so richly endows both men and women [see 3.2, 3.3]. They have now worked harmoniously together for more than a decade as Warlukurlangu Artists, an organisation characterised, like the Warlpiri people themselves, by a very strong sense of collective purpose and cultural pride [*121*].

Sentiments of community pride also surrounded the establishment of a painting enterprise at Napperby Station. Situated midway between Mt Allan Station and Yuendumu, it was one of the original pastoral leases in the region, on which the local Anmatyerre people had worked for several generations as stockmen and domestics. With the support of the station owner's wife, who made paint and canvas available to the painters and marketed their work through exhibitions in the eastern states, Napperby joined the art movement about the same time as Yuendumu.

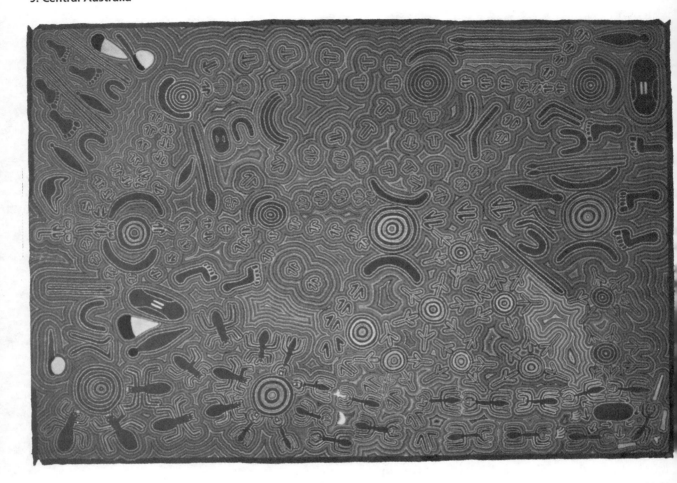

121. Warlukurlangu Artists, *Yanardilyi (Cockatoo Creek) Jukurrpa*, 1996.
Acrylic on linen, 300 x 400 cm. The four Dreamings represented in the painting are *marlu* (kangaroo), *Wati-jarra* (Two Men), *ngatijirri* (budgerigar), and *pingi* (meat ant).

In the *Sydney Morning Herald* (11 July 1987), Napperby artist Cassidy Tjapaltjarri expressed his hopes for the 'new artists' community: 'We will make our people the number one painters ... We make plenty of money. We have plenty of good painters here. It is something my people always do well. Even the young fellas are getting interested in this. We can do work for ourselves for a change and not just take your government money.'

Painting was also under way in a more haphazard fashion in the Anmatyerre community of Mt Allan, centred around the community general store which, in the early 1980s, started a modest sideline selling art materials and buying paintings from all comers for resale in Alice Springs. By 1988 the community identified with this enterprise as its own project. The aspirations of the Yuelamu Artists of Mt Allan were given form by the construction with bicentennial funds of the Yuelamu Art Gallery and Museum. This remains the focus of art-making in the community today.

As the decade advanced, the inventors of the painting language on which the contemporary forms of Western Desert art are based saw their achievement recognised at the highest levels of Australian culture—perhaps best symbolised by the commissioning of Papunya Tula artist Michael Jagamara **Nelson** [see 22.3; *226, 227*] to produce a design for the forecourt mosaic of Parliament House in Canberra [*264*]. The rise of Papunya paintings in the national and international art market was also having a dramatic impact on art and craft production in the 'town camps' around Alice Springs [9.7]: the

popularity of dot paintings with tourists [see 18.1] encouraged greater participation in art-making from all levels of the local Aboriginal community. Experience with other media, including **batik** and watercolour landscape painting [see 9.1], is evident in the work of some Alice Springs-based painters but, for most, acrylic on canvas was the first medium in which they had produced any kind of art for sale. The desire to become an artist motivated individuals in Alice Springs to learn more about their Dreaming stories and designs—and how they should paint them to avoid offence to the senior custodians. Just as the Papunya tribal educators had seen the paintings as a way of teaching children their Dreamings, so now the art movement was functioning like an adult education program for the town-based generations raised under the old policies of assimilation. Many were now actively seeking out their affiliations with country and Dreaming from older relatives on the settlements. Several of the highest profile Papunya artists moved into Alice Springs to take advantage of the greatly increased opportunities opened up by the thriving local trade in dot paintings. Artists' organisations were springing up all over town, and art materials were readily obtainable. This situation produced much that was dross, but it also nurtured the development of a group of ambitious and determined artists, who would play a role in the 1990s in shifting the centre of gravity of Western Desert art from community art enterprises towards individual artistic careers.

However, the art world's interest was still focused primarily on painters and paintings from the remote settlements, to judge by the response which two of the remotest communities received to their entry into the market for Western Desert paintings in the late 1980s. These were **Lajamanu**, situated 700 kilometres north-north-west of Alice Springs, and Balgo, 850 kilometres west-north-west across the Western Australian border. Both communities had expressed strong reservations about the painting movement in the early years, but right across the Western Desert, groups of elders were doing the only thing they could in the face of mounting evidence that the painting movement was there to stay: they threw the weight of their authority behind it and began to imagine new futures for their people—and themselves—arising from the exposure of their culture to the world in this form. As in Papunya and Yuendumu, community painting projects provided the impetus for a wave of individual painting endeavour across both settlements. Helpers coordinating the distribution of materials found themselves caught up in a frenzy of painting activity, working into the night preparing cheap calico canvases with whatever they could find for undercoat. When the canvas was used up, people went on painting—on roller blinds, on anything they could find. Older men and women worked together in a communal atmosphere where some sang and danced for the Dreaming while others painted. Like many of the original Papunya and Yuendumu painters, the senior members of the Balgo and Lajamanu communities were born and grew to adulthood in the bush, before their first contact with white society. People of this generation, with the strength of their uninterrupted connections to the Dreamings and the places depicted in their paintings, have exerted a profound influence on the painting movement. Their bold, expressive painterliness defines the 'Balgo style' of linked dotting and blurred forms and edges seen in the work of artists like Susie **Bootja Bootja**, Bai Bai **Napangarti**, Eubena **Nampitjin** [*361*], Donkeyman **Lee Tjupurrula** [*155*], Bridget Mudjidell, Njamme Napangarti, Sunfly **Tjampitjin**, and **Wimmitji Tjapangarti**, and also produces the loose, ebullient iconographies of Lajamanu artists like Abie **Jangala** [*223*], Ronnie Lawson Jakamarra, and Louisa Napaljarri Lawson [*122*]. **Warlayirti Artists** was established at Balgo in 1987 and the company has since pursued an ambitious international marketing strategy. At Lajamanu the artistic energies released by the primal act of communal self-assertion were dissipated by the lack of any organised attempt to promote or distribute the work to remote metropolitan markets, leaving artists to struggle on alone.

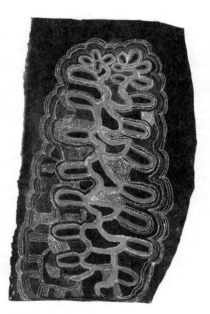

122. Louisa Napaljarri Lawson (Pupiya), *Ngalyipi (Medicine Vine) Dreaming*, 1987. Acrylic on canvas, 125.5 x 73.5 cm.
The artist has depicted *ngalyipi*, the medicine vine which entwines itself around trees and is used in traditional medicine and for ceremonial arm-string. The whole of the plant—roots, stem, and flowers—is boldly represented, in the manner of early Lajamanu paintings.

The Pitjantjatjara peoples are justly feared and respected across the Western Desert for the strength of their adherence to the Laws of the Dreaming and their vigilance over unauthorised disclosure of matters forbidden to the uninitiated. Until the late 1980s, no-one painted acrylic paintings in the Western Desert style on the Pitjantjatjara lands, and apart from William Sandy at Papunya there were no Pitjantjatjara painters of note anywhere else. Certainly no-one painted at **Ernabella**, where the redoubtable Winifred Hilliard, craft adviser for almost three decades, was dismissive of the sweeping advance of the painting movement into communities to the north and west of Papunya as 'band-waggoning'. Some of the first dot paintings to be produced in Ernabella were painted for the Healthy Aboriginal Life Team (HALT). HALT approached Ernabella Arts in 1988 about a book to present Pitjantjatjara perceptions of health through the medium of acrylic paintings, and offered to make paint and canvas available to the artists at Ernabella [see 20.6]. There was a rush for materials and a burst of painting activity in the community while they lasted. As often happens in the history of Western Desert art, HALT's health education experiment became something else in the artists' hands. The idea that the proper use of the language of Western Desert art is to present the artists' Dreamings remains intrinsic to the acrylic art enterprise at Ernabella, where a small core of artists have continued to work with acrylics, producing large canvases explicitly based on ceremonies (*inma*) and sand drawing (*milpatjunanyi*). That acrylic painting was to be found at all in Ernabella represented an important milestone in the Western Desert history of the art movement.

The painting movement was still spreading, meshing at the fringes with other regional styles to a point where it was increasingly impossible to say where Western Desert art ended and something else began. But its eastward advance had halted in Alice Springs. Batik-making following Ernabella's example had been under way among women on **Utopia** Aboriginal lands north-east of Alice Springs since 1977, providing a pool of artists experienced in this medium and ready to try their hand at dot painting as soon as the opportunity arose. It did in CAAMA's 'Summer Project' of 1988–89, producing a dramatic and almost instantaneous alteration in the perception of the Utopia artists by the Australian art world—and in their own perception of themselves. The influence of the previous decade of batik production was evident in the works which the painters produced on their first canvases, not only in the designs they used but also in considerations of scale and form pertaining to the nature and uses of fabric. The artists' experimentation with the act of painting itself led to the emergence of a free-wheeling 'Utopia style' radically different from all the other painting communities in the Western Desert—and stunningly successful in the market place. Nowhere is this more plainly illustrated than in the career of Emily Kame **Kngwarreye** [see 9.6; *123, 216, 225*] who quickly established herself as the leading woman painter in desert art—now re-named 'Central Desert' or simply 'Desert' art to include the Utopia artists—with the production over the next few years of a series of paintings beneath whose richly textured and boldly dotted surfaces could be glimpsed partially hidden Dreaming designs. Official recognition at the highest levels followed—as did frenzied acquisition of her work by public galleries and private collectors. She paved the way for other Utopia artists like Gloria **Petyarre** [*367*] and Ada **Bird Petyarre** [*222*], who have established careers based on their own variants of the theme of scaled-up body painting announced in Emily's first painting. But Emily has no equal for the inspired recklessness of her last 'stripes' series, in which rough uneven brush strokes identified by the artist only as 'body paint' are inscribed along plain black or red ochre grounds. No-one took greater risks, or greater liberties, than she did, while still remaining true to herself—and to the spirit of the Dreaming embodied in her work.

Ever since Desert art began, it has held in creative suspension the tension between the communal agenda of the movement and the individual aspirations of the artists who carry out that agenda by painting their Dreaming places. There have always been those who painted in pursuit of their personal ambitions and those who remained focused on the more anonymous, collective meaning of their work as a homage to the Dreaming ancestors—though more often than not these motivations were combined in the same individuals. In the late 1990s the movement seems in some danger of bifurcating into two distinct camps: the 'no names' and the 'big names', as more of the most committed painters embark on individual careers. But alongside this tendency others express a reassuring determination to carry on what their fathers and mothers—or grandfathers and grandmothers—began. Painting has started up again in Haasts Bluff [393]—or **Ikuntji** as it is now known—after almost a decade in decline following the deaths in the early 1980s of the artists who painted there for Papunya Tula Artists. This time it is a community-based enterprise rather than just an offshoot of Papunya Tula Artists, led by several painters with close family ties to the original Haasts Bluff painters. Also since the early 1990s, Warlukurlangu Artists has been producing vast collaborative canvases, contributed to by those who have claims to the country and Dreamings depicted on them—both young and old. Together, these paintings comprise a comprehensive collective record of the artists' culture—echoing the achievement of the pioneer Papunya painters. Projects like this attempt to subvert the star-making of the contemporary art world with works whose processes of production and circulation actively reinforce the core values of Western Desert society. The painting movement has outlived many of the founding group of artists at Papunya in 1971: gone now are Old Mick Tjakamarra, Kaapa Tjampitjinpa, Tim Leura Tjapaltjarri, Old Walter Tjampitjinpa, Old Tutuma Tjapangati, Charlie Tarawa **Tjararu Tjungarrayi**, Uta Uta **Tjangala**, Anatjari Tjakamarra, Anatjari Tjampitjinpa, Old Mick **Namarari Tjapaltjarri**, and Pinta Pinta Tjapanangka. Gone too are some of the 'second generation' of Papunya Tula Artists who began working in the early 1980s: Dick Pantimus Tjupurrula, Simon Tjakamarra, and **Maxie Tjampitjinpa** [392]. But like the collective spirit of the movement they helped to found, the surviving pioneers of Western Desert art have also come through the challenges of the last decade, maintaining creative momentum despite the blandishments of the art world.

Before the events at Papunya at the beginning of the 1970s, Aboriginal settlements were virtually indistinguishable to the outside gaze—and designedly so. The drab uniformity of these places served their purpose of destroying all vestiges of their Aboriginal residents' distinctive cultural identities. But the Western Desert peoples have transformed the *dis*culturation facilities provided by the white authorities into a network of communities of Aboriginal people 'living together in one place', painting pictures to show the rest of the world their distinctive cultural identities—as Western Desert people, but also as members of their particular communities. Community after community has found a way of asserting its collective identity: through the distinctiveness of its artists' paintings within the overarching visual language of Desert art. The remote communities, where the connections to country proclaimed in the paintings are constantly renewed in the ceremonial lives of their members, are the cultural base of Western Desert art, on whose maintenance may depend the well-being not just of an art movement but of Western Desert society itself.

It was the late Tim Leura Tjapaltjarri who said that 'The money belongs to the ancestors' (Johnson 1996). They would surely approve the reoccupation of Dreaming countries and the re-establishment of their ceremonies which the art movement has helped to finance. And if the dots are truly, as some have suggested, the breath of the subterranean ancestors rising to the surface of the land and encircling the spirit places, this is

an uncannily apt metaphor. The dots breathed life into the art movement, the radical simplicity of the technique made possible the wildfire speed of its diffusion across the whole societal grid of the Western Desert. The dotting technique was what made the paintings look like abstract art to the unknowing eyes of Western art audiences, and cleared a passage for them into the wider world through the gateway of high art. From this stepping-off point, a vast army of artists has carried on the work of the pioneers, capturing the imagination of mainstream Australia with the visual forms of their culture and inspiring a greater measure of respect for those who have bestowed such a gift on their fellow Australians—and the world. May their art—and the social order of the Western Desert peoples which constantly replenishes it, long continue to 'survive the white man's world' (Willoughby 1979).

VIVIEN JOHNSON

Davis, K. & Hunter, J., Papunya: History and Future Prospects, A Report for the Ministers of Aboriginal Affairs and Education [unpublished], July 1977; Johnson, V., *The Art of Clifford Possum Tjapaltjarri*, Sydney, 1994; Johnson, V., 'A history of Western Desert art 1971–1996', in J. Hylton & C. Chapman (eds), *Dreamings of the Desert: Aboriginal Dot Paintings of the Western Desert*, Adelaide, 1996; HALT (Healthy Aboriginal Life Team), *A̲nangu Way: Iriti pukulpa pika wiya nyinantja munu pukulpa pika wiya kunpu nyinantjaku ngula = In the past we were happy and free from sickness; and in the future we will become strong and healthy again*, Alice Springs, 1991; Willoughby, B., *We Have Survived*, 'No Fixed Address' [various recording releases], 1979.

9.6 Emily Kame Kngwarreye, *Utopia Panels*, 1996 [*123*]

Emily Kame Kngwarreye, a senior eastern Anmatyerre artist from Utopia (NT), was renowned for her extraordinary adventurousness, individuality, and energy [*216*]. 'No-one took greater risks than Emily', according to Vivien Johnson [see 9.5].

The *Utopia Panels* comprise eighteen separate works covering fifty square metres of painted surface. Produced in February 1996 during the final year of Emily Kame Kngwarreye's life, they exhibit a degree of muscularity, boldness, and rawness that defies her advanced years. Emily lived and worked in an Aboriginal camp on the edge of the Gibson Desert some 250 kilometres north-east of Alice Springs. In 1996 she was in her eighties and in failing health. Her willingness to extend herself in terms of scale was matched by her prodigious output—an estimate of between 2000 and 3000 works in an eight-year period of working in Western materials. She departed radically from the classical and familiar dot and circle style of Desert painting [see **acrylic painting**], introducing a gestural, more abstract style, and using an unlimited palette.

Kngwarreye is distinctive for her practice of working in series, on large-scale canvases in a diversity of styles. Her image-making underwent discernible stylistic changes. Her first works on small canvases in 1989 echo her previous work in the batik medium. Later that year she produced her limited series of 'seed' paintings. Through 1990 and 1991 a fine tracery of lines or animal tracking overlaid with dots finally gave way to larger works with fields of dots of varying sizes, followed by large,

vigorously executed 'dump-dump' dots which take on the character of the brush. Her expansive canvases exploded with colour in 1992 and 1993 when the dots merged to become swirling masses of interconnected shapes, described as images of country [*225*]. From 1994 there was a radical departure to bare, bold linear structures usually in one or two colours and devoid of dots, culminating in the *Utopia Panels* series.

This culmination of her oeuvre reveals three linear variations in a vigorous expression executed with rapidity and confidence. Horizontal black stripes vibrate as they sear the canvas and map the body painting used in women's ceremonies called Awelye. Body and country converge and resonate in other panels of broad vertical lines in ochre and green tones that blend at the edges. The exuberant growth of the yam roots is depicted in a third set of panels as random woven masses of oranges and purples.

Despite the stylistic variations Emily's entire oeuvre is about one story—Alhalkere—her country and her Dreamings. When asked about her paintings, be they elegant black lines, or veils of fine dots over delicate traceries of special markings, her response was always the same, 'it's whole lot, everything'. For Kngwarreye, as for many desert artists, every painting is a celebration of country. So profound was her identification with her major yam totem that her second name—Kame—refers to the seed of the yam, and her nose was pierced in homage to the ancestor Alhalkere, a pierced rock on her country of the same name.

9.7 The first Pintupi outstations

The first Pintupi outstation was created in 1968 at Waruwiya and the second at nearby Alumbra Bore in 1970. Their establishment preceded the election of the Whitlam government, and the radical changes to government policy in relation to Aboriginal affairs that were to mark the 1970s. These outstations were the early signposts for the return of the Pintupi from Papunya (NT) to their lands in the west—an exodus that gathered force over the next two decades.

The emergence of the **Papunya Tula** painting movement in 1971 coincided with the election of the Whitlam government and occurred at a time when the Pintupi were living at the Piggery Camp on the western edge of Papunya. About half of the Papunya Tula artists were Pintupi-speakers from the Gibson Desert, many of whom had had their first contact with Europeans just a decade or two before. Several of the more outgoing Pintupi men—Nosepeg Tjupurrula, **Uta Uta Tjangala** [1], and Shorty Lungkata Tjungurrayi—introduced other men into Geoffrey Bardon's painting shed [see 9.4].

The Pintupi were powerless in the political environment at Papunya, which was dominated by Arrernte people educated at Hermannsburg Mission and committed to the Lutheran faith [see 9.1]. Resentment toward Pintupi increased with the redirection of resources to the outstations. There can be no doubt that the enforced proximity of previously estranged tribal groups at Papunya exacerbated the tension, but it also contributed to Papunya becoming a seedbed for the accelerated development of Western Desert art. While, at the time, I saw both the outstation and the painting movements as a testimony to Aboriginal creativity, they were in fact bicultural constructions. Both relied on the cooperation, expertise, commitment, and resources of black and white alike for their development.

The *Utopia Panels* were commissioned by the Queensland Art Gallery to coincide with its major national touring retrospective, 'Emily Kame Kngwarreye. Alhalkere: Paintings from Utopia', 1998–99.

MARGO NEALe

Neale, M., *Emily Kngwarreye: Alhalkere Paintings from Utopia*, Melbourne, 1998.

123. Emily Kame Kngwarreye, *Utopia Panels*, 1996.
2 of 18, Acrylici on canvas, each 263 x 86.5 cm.

9.8 Drawing the Dreaming: The Berndt collection of drawings from Birrundudu (NT)

In 1944–45, during the course of fieldwork [see **anthropology**] with his wife and life-long collaborator Catherine Berndt, Ronald Berndt collected a large number of crayon drawings on brown paper from Aboriginal men living at Birrundudu, then an outstation of Gordon Downs station (WA), south-west of Wave Hill on the northern border of the Tanami Desert. The artists were of the Nyining, Ngardi, Kukatja, Wanayaka, and Warlpiri-speaking groups whose original homelands extended from north-west to south-east of Birrundudu. These people maintained cultural ties to localities later known as the settlements of **Papunya**, **Yuendumu**, and **Balgo** Hills. Their drawings foreshadow the desert art movement of later years.

In these drawings, strong stylistic variation within northern and Western Desert influences are typified by, in particular, the mixed use of both 'map'-like and lateral perspectives, including figurative imagery, and the introduction of alien elements such as the windmills and pastoral fences of Europeans. The artists' explanations of their works, recorded at the time of collection, are found in the captions to the illustrations accompanying this essay [125, 126, 127, 128]. The essay itself serves to describe the context in which the drawings were made.

In *End of an Era*, the Berndts described Birrundudu as the 'most extremely shocking' environment that they had experienced in of all their anthropological fieldwork with Aboriginal communities over almost fifty years. Conditions there were 'harsh' at the very least: gripped by a long-term drought, the outstation was suffering severe environmental degradation as a result of overstocking and inappropriate pastoral activity. The Soak, a central feature of life at Birrundudu and the resource that traditionally provided the

means of sustenance in this otherwise largely inhospitable place, was almost dry and filled with the rotting carcasses of long-dead cattle. The stench was, as Ronald Berndt put it, 'unforgettable'. And yet this was the sole supply of water at that time for the station, and for all its inhabitants, Aboriginal and non-Aboriginal alike.

A substantial community of Aboriginal families, local custodians of this country, had been attracted to Birrundudu station from the 1930s, in search of reliable water and food supplies. And yet the scene that confronted the Berndts in 1945 was one of great suffering. It was not only the stench of the carcasses in the Soak (really a large rock hole), but more the treatment of the Aboriginal stockmen and their families that shocked them. Many of these people were quite literally starving yet, according to Ronald Berndt, there were plenty of undistributed rations in the store. The alcoholism of the non-Aboriginal staff, and the abuse of some Aboriginal women, created for the Berndts a singularly dreadful environment. This was the time that Ronald referred to, many years later, as 'the most trying of our lives'.

Nights were spent secretly trying to 'fish' (with a hook on the end of a line and stick) cans of bully beef, treacle, and so on out from behind the screen barricade at the store to give to the local people. Days were spent arguing with the overseer, pleading for much needed food for the people. On many occasions, Ronald reminisced that 'for the only time in my life, I thought, if I'd only had a gun, I would have shot that bastard [the white overseer].' And he was not one for overstatement. At one stage, too, when the overseer was tiring of their constant criticisms, he tried to encourage them to travel south, to 'better country'. Certain death is what it really would have been, for both the Berndts and their Aboriginal guides.

125. Badawun, *Non-secret Yurami Ceremony from Sunday Island, near Derby*, 1945.
Crayon on brown paper, 45 x 61 cm.
This ceremony is carried out by intermediate groups eastward to Birrundudu (NT). Dancers wearing head-dresses and holding whittled sticks perform the ceremony at Wonggu-Bililunga waterhole (*left*) on Sturt Creek.

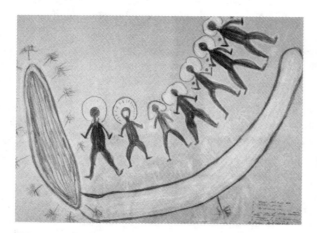

126. Nipper, *Nyining Tribal Country*, 1945.
Crayon on brown paper, 40 x 61 cm.
This is country belonging to *djulama* and *djangala* Dreaming subsection groupings. It depicts Ngugadu water hole, a *djimberi* (covered rock hole or *gnamma* hole) near Flora Creek, running towards the fence of Flora Valley Station.

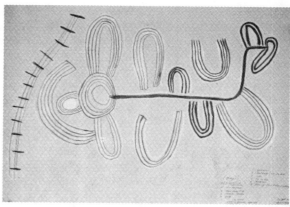

These comments set the scene for this extraordinary artistic record, demonstrating that, in the midst of atrocious conditions, local Aborigines maintained the richness of their cultural knowledge and their certain and specific associations with the landscape within which they lived.

Ronald Berndt was encouraged very early on in his professional career as an anthropologist by both N. B. Tindale (honorary ethnologist at the South Australian Museum during the war years) and C. P. Mountford (also living in Adelaide) to use crayons and brown paper to record, in a permanent medium, Aboriginal narratives and statements of cultural experience. At Birrundudu (unlike at Ooldea (SA) in 1941) Ronald Berndt did not seek to restrict the repertoire of coloured crayons used by the Aboriginal men to document their world, the 'country' within which they lived, and the mythic associations that enlivened this landscape. The resulting imagery remains a forceful commentary on the ways in which ritual custodianship over land is maintained, albeit in the most difficult physical and emotional circumstances.

As Ronald and Catherine Berndt (1950) noted:

We see … how important it is to know the significance of a particular drawing. This we must know, for through their art manifestations we can come to understand the people themselves … without its meanings an object, however beautiful, however well executed, is dead, absolutely and irrevocably dead. Allocated to some museum which concerns itself largely with relics of the past, a past which can be re-created only from the imagination of aliens, or ripped from its cultural context to serve an alien purpose, its death is just as definitely assured … Aboriginal art need not be allocated to the shelves of the past, nor lose its context when removed from its indigenous and traditional setting. It can, and should, take its place alongside other great schools of art, and be incorporated in our general appreciation of it for its own worth … , aboriginal art exists as a virile expression of a particular way of life, dictated by certain codes of behaviour and activity and limited by its cultural perspective.

Crucially, then, these drawings provided a vital means for Aboriginal owners to image and imagine the landscape of their country around Birrundudu. It is a landscape pregnant with meaning and energised sources. The living manifestations of the **Dreaming** beings permeate the landscape to provide a continually unfolding charter within which the living world of the present and the past are immutably and inextricably entwined.

But this is not only a world of Dreaming beings. The increasing influence of external imagery, of innovative devices which might be thought of as belonging primarily to the world of the European invaders can be seen in the Birrundudu drawings. Images of the outsiders are not limited to these drawings. They also may be found engraved on the surfaces of pearlshell pubic pendants [see 10.4], on weaponry, and in **rock art**. But their presence in these early drawings is persuasive testimony to both the adaptive, and the creative, forces that lie behind the Dreaming, and the world (now vastly different in so many respects) in which these people were living at that time.

These images are 'snapshots on the Dreaming': they provide a temporal locator of knowledge and thought that is uniquely Aboriginal, unambiguously situated within the contemporary experience of their creators.

JOHN E. STANTON

Berndt, R. M. & Berndt, C. H., 'Aboriginal art in central-western Northern Territory', *Meanjin*, vol. 9, no. 3, Spring 1950; Berndt, R. M. & Berndt, C. H., *End of an Era: Aboriginal Labour in the Northern Territory*, Canberra, 1987; Berndt, R. M. & Berndt, C. H., A Preliminary Report of Field Work in the Ooldea Region [unpublished], Western South Australia, Sydney, 1945.

127. Djambu 'Lefthand', *Dreaming Men Climb the Cliff at Killi Killi*, 1945.
Crayon on brown paper, 42 x 61 cm.
Killi Killi is far south of Birrundudu and west of Tanami. The standing men (drawn full length) walk around telling the two climbers (with bent legs), who are novices, not to climb as they may fall.

128. Bogi', *Gadanggadang*, 1945.
Crayon on brown paper, 40 x 61 cm.
This place is an element of a mythic track, where the Dreaming crow tied his hair up like bushes into a head-dress called *mudera*, depicted by a line of stones going up to the peak of the hill. The hill itself is the crow.

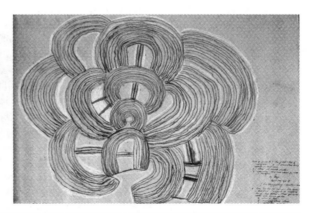

124. At Karrku on the way to Johnny Warangkula's country, 1978.
Artists Johnny Warangkula Tjupurrula (*top left*), Dick Pantimas Tjupurrula (*bottom left*), David Corby Tjapaltjarri (*centre, with beanie*), art adviser John Kean (*centre top*), and others.

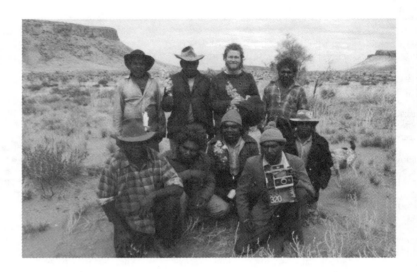

By 1973 the Pintupi had mustered government support for another move, this time to Yayayi some forty-two kilometres west of Papunya, and it was this camp that firmly established the agenda for the outstation movement. Over the next decade a constellation of a dozen outstations sprang up and these were supported by Papunya. The outstation network emphasised ideological schisms between the white support staff at Papunya, many of whom still supported the assimilationist aims of a centralised community. These tensions paralleled those between the established Arrernte and Luritja power brokers of Papunya and those such as the Pintupi, whose country was further afield, and who wished to establish independently-resourced communities. But there were few tensions between the artists of the newly-created company of Papunya Tula Pty Ltd and the outstation movement.

By 1977 most of the Pintupi artists who had emigrated to Papunya between the late 1950s and the early 1960s were living at either Yayayi or Waruwiya. With the appearance of the 'artists' truck', Uta Uta Tjangala and Shorty Lungkata Tjungurrayi would both appear from their corrugated humpies, emphatically demanding the biggest canvas. A couple of paces back, less assertive artists like Yala Yala Gibbs Tjungarrayi, Willie Tjungurrayi, and John Tjakamarra would also press their claims. Even with little market demand, there were never enough canvases for all the artists. All of these middle-aged men at Waruwiya were keen painters with large families to support. Their work was powerful but at the time even the finest Pintupi paintings sold slowly and it seemed that the transport of family members, meat, and news in the painting truck was as significant to the community as the income from a few paintings. Most of these artists also produced artefacts—**boomerangs**, incised shields, and painted wooden vessels—all of which were sold for what would now be regarded as ridiculously low prices. However, these artefacts and paintings formed part of a cash economy that was supplemented by bush tucker, giving a baseline income on which the families on out-stations could survive.

Yayayi was the base for Freddy West Tjakamarra, Anatjari Tjakamarra, Anatjari Tjampitjinpa, Willie Tjapanangka, and visiting men from Docker River, to the south. Pintupi/Luritja artists George Tjangala, Turkey **Tolson Tjupurrula**, and occasionally Mick **Namarari Tjapaltjarri** [*360*] and Ray Inkamala were then living at Kungkayunti, another outstation on the site of a women's Dreaming track that led to their country to the west. Kungkayunti was a very quiet camp, in the desert oak country. In the spring of 1978 Johnny **Warangkula Tjupurrula** [*37*] and his brother Dick Pantimas Tjupurrula,

together with Alan Jenkins, an inventive young outstation coordinator from South Australia, established a remote outstation at Ilypili in the Ehrenberg Ranges, 200 kilometres west of Papunya. Warangkula had left the area as a boy and travelled overland with his family to Hermannsburg. His return to Ilypili symbolised the potential for Luritja and Pintupi people to overcome the conflict, ill health and powerlessness of Papunya and assert some autonomy by returning to their ancestral country [124].

During the late 1970s, the outstation movement was the most dynamic aspect of life at Papunya. The painting industry was still relatively tiny with an annual turnover of around $30 000. Its significance could not be compared with the introduction of the bilingual literacy programs at Papunya school, the handing over of the Haasts Bluff Reserve to Aboriginal control, the Aboriginalisation of the health service [see 20.6], or the creation of new outstations. At that time there were about fifty artists wanting to paint whenever the opportunity was provided, but Papunya Tula relied on a small Aboriginal Arts Board grant, one exhibition a year (at Realities Gallery in Melbourne), occasional government commissions, a single corporate customer (Lord McAlpine), and a minute local market for smaller paintings [see 21.1, 21.2]. As arts adviser I was professionally ill-equipped—and far too isolated—to create a market that would support the artists' desire to produce new work. The largest canvases at that time earned the artists $1000—the cost of a second-hand Holden. The proceeds of almost every large work resulted in the immediate purchase from the ever-ready second-hand dealers in Alice Springs. Most of these cars headed immediately west to an outstation: many never made it and were abandoned by the side of the road. Even the better cars lasted just a few weeks.

The late 1970s and early 1980s were also a time of increasing movement between the conflicting attractions of ancestral lands and Alice Springs. By the time of my employment as art adviser in mid 1977, about 80 per cent of the Papunya Tula artists were living (for at least part of the year) on outstations. **Kaapa Mbitjana Tjampitjinpa** [120], Tim **Leura Tjapaltjarri** [224, 262] and Billy **Stockman Tjapaltjarri** were the artists who lived most consistently in Alice Springs, where they found that their small boards were saleable on the tourist market. It followed that, if artists (as shareholders of the company) wanted to get back to their country, then it was essential that the resources of Papunya Tula be used to support those living on outstations or those attempting to establish outstations far to the west.

To the young southern 'lefties' who worked in increasing numbers in central Australia, the push for Aboriginal control of land and community resources was bound up with and manifest in Papunya Tula painting. To me, as manager of the company, the policy of dedicating these resources to the community development aspirations of the artists who had led the outstation movement seemed incontestable, especially when seen against the resource-intensive, centralised community at Papunya and its attendant social problems. Despite the difficulties, the majority shareholders—the Pintupi and Luritja artists at their isolated outstations—continued to receive their monthly supplies.

By the mid 1980s, the Pintupi had established further communities at Kintore and Kiwirrkura, while several artists and their families were spending more time in town than at Papunya. As the market was beginning to respond to Western Desert art, the population of Papunya was only one-third of what it had been a decade before.

JOHN KEAN

Myers, F, 'Aesthetics and practice: A local art history of Pintupi painting', in Morphy, H. & Smith Boles, M., *Art from the Land: Dialogues with the Kluge–Ruhe Collection of Australian Aboriginal Art*, Charlottesville, VA, 1999.

10. The Kimberley

10.1 The traditional Aboriginal art of the Kimberley region (WA)

Prior to 1975, interest in the art produced by the Indigenous peoples of the Kimberley was restricted, in the main, to those conducting anthropological studies [see **anthropology**] in the region and to a handful of dealers. The painting of pictures was rare, and creativity was channelled into dance forms and the production of artefacts for the then small tourist industry. Paintings, when they were produced, were considered to be of little artistic merit and were regarded more as ethnographic curiosities with minimal commercial value. Indeed, this opinion of the traditional art of the region is still held by many Australian dealers and critics; interest in works made before the mid 1970s appears to be generally restricted to the international art arena.

Five distinct cultural areas, with their concomitant expressions of creativity, are to be found within the Kimberley. The central and northern Kimberley region of the Worora, Wunumbal, and Ngarinyin is the primary location of Wanjina and Bradshaw (*Gwion Gwion*, *Kiera-Kirow*, *Jungardoo*) **rock-art** styles [see 5.1, 5.4]. The other four are the western area of the Dampier Land Peninsula and the coast south of Broome; the Ord River basin and drainage basins leading east into the Northern Territory; the southeastern region, the home of the Jaru, that lies generally to the east of Halls Creek; and the southern area, lying along the Fitzroy River and south to the adjacent Western Desert regions of the Great Sandy Desert. Naturally the peoples of these areas did not live in isolation, and religious and economic ties mesh the region into a broader entity. As elsewhere in Aboriginal Australia, people are generally multilingual.

Cultural identifiers (apart from language) are found in the suites of material culture that existed within the different cultural areas. The people of the Dampier Land Peninsula did not, for example, use the spear-throwers or stone-tipped spears found in other parts of the Kimberley. They engraved pearl shell [see 10.4] with a distinctive range of geometric designs and their principal weapons for hunting and fighting were **boomerangs** and hand-held spears; protection was afforded by the use of softwood shields. In the north of the peninsula, mangrove-wood catamarans were used to hunt dugong and turtle and to occupy or exploit offshore islands and reefs. The eastern neighbours of the raft-using Dampier Landers, the coastal Worora, also used rafts, but otherwise were very different in language, social organisation, material culture, and religion.

The Worora are akin to the Wunumbal and Ngarinyin-speaking people, sharing a cosmology focusing on Wanjina beings, the rainbow serpent (*Wunggud* or *Galaru*) and the totemic nightjars (*Wodoi* and *Djingun*) who instituted the principles of social organisation. Here in the North and Central Kimberley people used long, light-wood spear-throwers to hurl long, slender spears, tipped with delicately serrated stone points. Honey

was collected in sewn-bark buckets by women who also made the ground-edged axes used to open the hives. Economically, and in terms of material culture, these groups were very similar to the Miriuwung and Gajerrong people of the north-east who occupied the Ord River basin, with links running east to the lower reaches of the Victoria and Fitzmaurice rivers. The Gajerrong, however, did not possess the Wanjina cult and their cosmos was organised according to a different kinship system.

The land of the Jaru lay south of the Ord River basin, across broad grasslands and an adjacent, arid zone. In terms of material culture—hooked boomerangs and broad soft-wood shields for example—this group shared common elements with people of the arid zone of northern central Australia. Within the riverine environment of the Fitzroy basin, which separates the rugged ramparts of the central Kimberley from the northern margins of the Great Sandy Desert, lay the southern cultural area. The people of this zone possessed material culture derived from both desert and northern sources as well as implements, such as ground-edged chisels, that were more akin to the shell tools of Dampier Land. Boomerangs, spears, and spear-throwers similar to those of the desert, as well as the northern forms, were used in the Fitzroy region, as were boomerangs and shields resembling those of the Pilbara or the Dampier Land Peninsula.

While the Kimberley, as a whole, has not been known for more ephemeral art forms, it has long been famous for its **rock art**, specifically the Wanjina paintings [60, 154]. Discovered by the explorer Sir George Grey in 1837, these paintings became synonymous with the whole region although, in fact, they are generally found in the north-central area.

Wanjina are round-headed, anthropomorphic figures, with the head surrounded by a broad band of colour, usually red, which in turn has a fringed or sometimes rayed margin. They are sometimes shown wearing a pair of red-tailed black cockatoo feathers in their hair. The eyes are round pools of solid colour, usually black, with prominent eyelashes. The drop-shaped nose is well defined, with the tip often enhanced by a solid infilling of paint. There is no mouth. The image may be restricted to a bust-like form showing only head and shoulders or upper torso, or be more complete, showing the body and limbs. Usually a band of colour runs across the upper chest and separates the shoulders from the upper arms. From this hangs a black oval form, variously described as the sternum or a pearlshell ornament. While the head and upper chest are a solid white colour upon which the features are painted, the remainder of the body, below the shoulder girdle, is usually filled in with stripes or is irregularly hachured, suggesting to some observers that the figures are clothed. In some, a band across the waistline represents a hair-string girdle, the basic dress of traditional days.

Although usually painted with black and red pigment on a solid white ground, bicolour Wanjina—red on a white ground—do occur. In some instances, yellow ochre is used to dramatic effect, either in conjunction with red or substituting for it entirely. Many Wanjina show signs of repeated repainting, a practice that was once an annual occurrence.

Size may vary from less than forty centimetres to massive figures more than three metres in length. Regardless of size, the Wanjina paintings found in the caves and shelters possess a monumental presence coupled with a sense of impassivity—the owlish eyes stare out with stolid curiosity at the world beyond.

Wanjina are culture heroes who, along with the ubiquitous rainbow serpent, controlled the elements and instituted the laws governing much human behaviour. Many of their actions, and their physical presence, are manifested in features of the contemporary landscape in the form of striking geological features, impressive boab trees, and in their painted images staring from cave walls. Their presence was invoked and their creativity highlighted during the last months of the year, when clan elders would retouch the paintings to ensure a bountiful wet season and the commencement of a new and

fruitful seasonal cycle. Inappropriate behaviour could bring down their cataclysmic retribution—violent storms, lightning strikes, earth tremors, and floods. Their association with the cyclical nature of the seasons links them also to that of the human cosmos—birth, death, and rebirth of the eternal spirit.

Wanjina are not the only entities depicted in this monumental manner. Within the style are found images of many natural species: snakes such as the black-headed python, crocodiles and goannas, fish of many types, and hives of the native bee. Paintings of plants and fruits also occur. The Wanjina also coexist with other supernatural forms such as the rainbow serpent, evil spirits (*argula*), and spirits of the fruits or honey and flowers (*wurrala-wurrala* and *ngarra-ngarra*).

While the art of the Wanjina is found mainly on the rock walls of caves and shelters there is some evidence that they were once painted on sheets of bark for ceremonial purposes. Paintings of Wanjina on bark and plywood board were produced at the instigation of missionaries and anthropologists from the late 1930s.

The curiosity created by the Wanjina paintings appears to have blinded many researchers to the presence of a multitude of elegant, generally monochromatic figures. Known in archaeological literature [see **archaeology**] as Bradshaw paintings [52] and to local Aboriginal people as *Gwion Gwion*, *Kiera-Kirow*, or *Jungardoo*, these works were first noted by the explorer Joseph Bradshaw in 1891. In the last decade a number of researchers have made extensive recordings of this art and have developed several typologies. Some theories about the origin of the paintings have provoked an intense reaction from Aboriginal peoples in whose country they are to be found. Grahame Walsh has suggested that the paintings were produced by non-Aboriginal people. This view is based on the fact that, in ethnographic accounts collected over the past sixty years, Aboriginal people stated the paintings to be the works of spirits or of a particular bird. Other arguments presented by Walsh in support of a non-Aboriginal origin for the Bradshaws do not stand up to scrutiny, particularly if the stylistic sequences of the Kimberley are compared with those of western Arnhem Land. There, radically differing art styles supersede one another without any suggestion of other than Indigenous origin. Parallels between Bradshaw art and the Dynamic art style of the Alligator Rivers region [53] suggest that these may be regional reflections of a homogeneous cultural group. Elements such as the extensive depiction of boomerangs, the forms of hair and head ornamentation, the presence of elaborate forms of dress—belts, skirts, and sashes—the depiction of multi-barbed spears and the absence of spear-throwers, all reflect an archaic cultural similarity between the regions.

The corpus of works recognised by archaeologists as Bradshaw paintings contains a number of distinct styles. While all display an extraordinary elegance, distinctions can be made on the basis of hair styles, dress, and the presence or absence of items such as boomerangs, spears, wands, and dillybags. The posture of the figures can also be used as a stylistic marker.

As in Arnhem Land, the presence of the ancient record of human artistic activity in the Kimberley permits a much richer glimpse into the past than is afforded by the archaeological record alone. The generally very simple stone tools provide no evidence of the organic materials which may have been associated with their use, and which are reflected in the early art; nor do they allow glimpses of social life, the apparent complexities of which are, however, reflected in the tantalising images on the sandstone walls.

Until the mid 1970s, when a few enlightened dealers and collectors joined with anthropologists to purchase or commission works on bark, stone, or canvas, painting across the region occurred sporadically and was mainly confined to the decoration of artefacts such as sewn-bark honey buckets and coolamons (*angkam*) [129], or wooden

spear-throwers and shields. In 1975 Mary Mácha of the Aboriginal Traditional Arts gallery in Perth, recognised the talents of artists at Kalumburu, such as Alex **Mingel-manganu** [*153*], Manila Kutwit, and Rose, Lily, and Jack **Karedada** [*335*]. This led to the first regular creation of two-dimensional works from the region.

The production of paintings, usually of Wanjina beings, supplemented an existing economy focused on the production of small craft objects for the limited tourist market of the time. This market was firmly based on an art form which was unique to the Kimberley, the engraving of **boab nuts** [*295*]. The boab tree (*Adansonia gregorii*) is principally found in the Kimberley region, extending to the Victoria River basin in the Northern Territory. It bears flowers and sets fruit in the last months of the year. The fruit are large nuts, enclosing seeds held in a pithy matrix. Both the shell, covered with a velvet-like fluff, and the pithy interior harden as the fruit matures.

Along with the beating of clap sticks, the dry nuts, with their desiccated pith interiors, were occasionally used as maraca-like rattles to accompany the chorus of singers at dances. From the earliest contact period, the dried nuts, their fluffy exteriors rubbed off and the hard shell decorated with fine engraving, were curios, popular with visitors to the region. Decoration consists either of a fine linear scoring of the dark epidermis or of tremolo engraving, which creates a thin, zigzag line that reveals the lighter inner hue of the shell. Occasionally shells are painted with simple geometric designs and in rare instances they are both carved and painted.

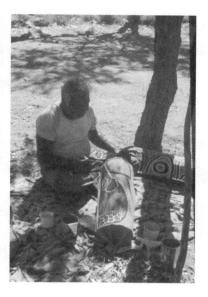

129. Jack Wheera painting *angkam* (bark coolamons), Mowanjum Kimberley, 1975.

Engraved decoration embraces a range of styles including a naturalistic style reminiscent of painted rock-art forms, a geometric style, and a representational, naturalistic style akin to European art traditions. Engraved elements may stand alone or combine to create a thematic whole. In some instances of representational-style boabs, the narrative pictures vividly depict bush or pastoral life. Conflict, ceremonial life, and mythology are also sources of inspiration, and on the coast marine life, watercraft, and pearl-diving are common themes. Some individual artists, taking advantage of nuts of suitable form, create animals and birds from them, skilfully engraving features such as fur or feathers with realistic detail. Wanjina figures are not commonly engraved on boab nuts, but they often feature on painted and engraved slates, an art form prominent in the 1970s at Kalumburu and now practised widely in the region. As well as Wanjina, other human forms derived from the painted Bradshaw figures are common on these slates, as are often delightfully naive scenes of bush and camp life.

Slates, decorated boab nuts, and bark or wooden artefacts—particularly didjeridus—delicate, flaked-glass and stone spear-tips, engraved pearlshell ornaments [see 10.4], and the occasional painting on bark or board represented the tangible elements of Kimberley art familiar to most people prior to 1970. There was, however, another form of expression which, possessing an internal focus, was generally not as accessible as the objects enumerated above: a significant body of contemporary Kimberley fine art can be shown to be directly derived from objects associated with dance forms.

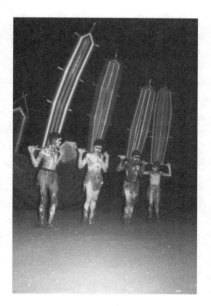

Early records of Kimberley performing arts, sacred and secular, indicate that associated objects, sculptural forms, and paintings other than body painting played significant roles in some dances. These included wooden, anthropomorphic carvings of ancestral beings, often adorned with engraving, and miniature ornaments in the form of fibre and shell attachments. Other three-dimensional constructions included anthropomorphic forms and animals made by binding tussocks of grass with finely spun hair, fur, or plant-fibre string.

130. Alan and Peggy Griffiths, thread-cross dance frames, used in performance at Kununurra, August 1997. Sticks, commercially spun wool, bark, and ochres.

String dyed with ochre or left in natural shades, and later commercially produced wool, were also used to make thread-cross constructions [*130*]. These were developed into increasingly complex forms woven onto wooden frames, particularly in the Pilbara,

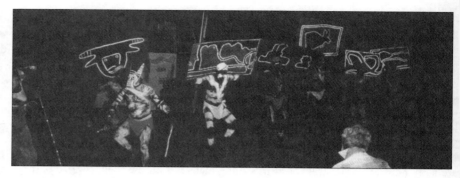

131. Men dancing with *balga* boards during a Kurrir-Kurrir ceremony, Warmun, 1979.

the south Kimberley, and on the Dampier Land Peninsula. Thread-cross work was used to create head-dresses, hand-held dancing wands, and imposing emblems, three metres and more in height, which were either carried ponderously by a dancer or embedded in the ground to dominate the setting. Bardi Artist Roy **Wiggan** creates thread-cross forms called *ilma* which are derived from these forms [*404*]. These are sought-after sculptural pieces.,

Thread-cross work is also sometimes used to border large, painted panels used in public ceremony (*balga*) performances [*131*] in the north and central Kimberley and in the Ord River basin. Paintings on the boards refer to places, events, and characters featured in the associated songs. The threading in these cases is a mark of the supernatural content of the performances. In the 1970s, large painted boards, carried on the shoulders and behind the heads of dancers in the Kurirr-Kurirr (Krill Krill) ceremony [see 10.2], caught the attention of the wider art community and exposed the creative potential of the region. These boards were originally painted mainly by Paddy **Jaminji** [*332*], although other men at Turkey Creek also contributed to their creation. The interest in Jaminji's paintings encouraged **Rover Thomas** [see 10.2; *136, 219*], the composer of the Kurirr-Kurirr, to commence painting in his own right in 1982. By the time of his death in 1998 Thomas was recognised as an artist of international standing.

It was not long before works by artists from across the region were being actively promoted. Some communities set up their own art centres and workshops manned by local coordinators, others dealt with regional agencies. Some individual artists, such as Jimmy **Pike** [*133, 270, 369*], Jarinyanu David **Downs** [*35, 317*], and Rover Thomas, preferred to deal with a single agent or agency dedicated to the promotion of their work. By 1985 the Aboriginal artists of the Kimberley were not only a major force in the Australian art world, they were also significant contributors to the overall economy of the region.

KIM AKERMAN

Crawford, I. M., *The Art of the Wandjina: Aboriginal Cave Paintings in Kimberley, Western Australia*, Melbourne, 1968; Ryan, J. with Akerman, K., *Images of Power: Aboriginal Art of the Kimberley*, Melbourne, 1993; Thomas, R. with Akerman, K., Mácha, M., Christensen, W., and Caruana, W., *Roads Cross: The Paintings of Rover Thomas*, Canberra, 1994; Walsh, G., *Bradshaws Ancient Rock Paintings of North-West Australia*, Carouge-Geneva, 1994.

10.2 Aboriginal artists in the Kimberley: New developments from the 1980s

Much of the art that emerged from the Kimberley region of Western Australia during the 1980s was directly related to the social and political fomentation that had started in the previous decade. For newly forming independent Aboriginal communities, whether

in established towns such as Kununurra, Broome, **Fitzroy Crossing**, and Halls Creek, or on small areas of land excised from cattle station leaseholds, issues of land ownership, self-determination, and the recovery and projection of distinctive cultural identity formed a potent focus across the whole region. In the volatile political environment of State politics, the recovery of traditional land and maintenance of language were specific, primary strategies within the wider struggle for effective **land rights** and for a level of self-management and for instituting effective processes for ensuring cultural continuity [see **cultural heritage**]. There were many challenges to be met: establishing facilities and housing programs in new centres and on small outstations, forging appropriate education systems for the younger generation, and developing effective negotiating strategies in the face of mineral exploration activities, as well as responding to the growth of State and federal government agencies charged with Aboriginal health, education, employment, and economic development.

The rejuvenation of an active ceremonial life underpinned artistic developments in the 1980s. The *balga* ceremonies created at **Warmun, Mowanjum**, and Kalumburu in the late 1970s, most notably the Kurrir-Kurrir, had taken part of their inspiration from the events specifically relating to the destruction of Darwin by Cyclone Tracy on Christmas Day, 1974. By the early 1980s these performances functioned in a much wider context. As vehicles for articulating both localised identity and inter-community cultural exchange, *balga* dance performances united people in the common task of strengthening ties with sacred sites and Dreamtime mythologies. The new mobility of the early 1980s enabled social, political, and ceremonial relationships to be reformed and reconfigured. The strengthening of direct community interaction as, for instance, between Warmun and Mowanjum, was frequently enacted through cultural exchanges where dance performances [see 10.1; *131*] and the creation of dance paraphernalia figured prominently. Under the aegis of the Darwin-based Aboriginal Cultural Foundation, Warmun dancers performed the Kurirr-Kurirr ceremony at several cultural gatherings in the Kimberley and the Northern Territory in the early 1980s, and their performances were often a critical ingredient in early land-rights meetings such as those held out bush by the newly formed Kimberley Land Council.

By the 1980s, the Warmun Creek Kurirr-Kurirr ceremony had already evolved from its original funerary commemorative function into a vehicle for a wider cultural expression. Its performance during the 1979 Noonkanbah mining protests was recorded in the Film Australia documentary, *On Sacred Ground* (1980). Performances at the growing Warmun community also provided a key backdrop to negotiations which took place in 1979 and 1980 for the development of the Argyle diamond mine, where a proposed new dam involved the destruction by submersion of several sacred sites.

In the early 1980s, Kimberley three-dimensional artistic expression followed the pattern of earlier decades: traditional items such as spears, incised shields, **boomerangs**, fighting sticks, incised **boab nuts** [*295*], hair-string belts, and **didjeridus** were produced for local use and exchange, and also for sale to Aboriginal Traditional Arts, the Perth-based outlet operating as a branch of the national Aboriginal Arts Australia gallery network.

Two-dimensional art production focused on the Wanjina bark paintings from Kalumburu, particularly those of Jack and Lily **Karedada** [*335*] and pearl shells [see 10.4] incised with figurative imagery by Broome-based Butcher Joe **Nangan** [*362*]. An exhibition in Perth in 1980 of large Wanjina paintings on canvas by Alex **Mingelmanganu** [*153*] resulted from a collaborative workshop conducted by Aboriginal Traditional Arts field officer Mary Mácha and her artist husband Václav in association with the Adult Aboriginal Education unit of the State government. Mimi Arts and Crafts, an Aboriginal community-based sales and marketing organisation located in Katherine (NT), also operated

231

as an agency for Kimberley craftsmen and craftswomen: a field officer visited Kununurra, Warmun, Halls Creek, and Fitzroy Crossing two or three times a year. The Mimi field officer was instrumental in supplying Warmun artist Paddy **Jaminji** [*332*] with his first canvases in 1983. The early painted plywood boards used by both Warmun and Mowanjum *balga* dancers were first seen by a wider public at the 1983 Aboriginal Arts Festival at the Western Australian Institute of Technology (later Curtin University of Technology).

The catalyst for the transposition of these ceremonial boards into the art market was Mary Mácha, who began to operate as a private dealer in Perth in 1983. She worked with various artists in the Kimberley area, in particular Paddy Jaminji and **Rover Thomas** [*136, 219*] at Warmun, and Joe Nangan in Broome. In the 1990s she oversaw the marketing of Roy **Wiggan**'s *ilma* dance emblems [*404*]. Nangan's line and colour pencil drawings depicted the extensive Dreamtime stories of the Broome area and represented an often whimsical but highly informed insight. Although rarely exhibited in public, sets of drawings from his sketchbooks are held in several public collections. Through Mácha's agency, paintings by Jaminji and Thomas were acquired by the National Gallery of Australia (NGA) in 1984 [see 21.1]. Several examples of the early boards were also acquired by the Berndt Museum (at the University of Western Australia) in 1982 and 1983, and by English private collector Lord McAlpine; the boards from the McAlpine collection were acquired in 1990 by the National Museum of Australia. As a collector and major property developer in Broome during the early 1980s, McAlpine also encouraged the short-lived production of stone carved heads by Big John **Dodo** [*132*] and others from Lagrange, south of Broome. Until the end of the 1980s a commercial Aboriginal art and artefact outlet operated at his privately established Broome Zoo. Aboriginal artefacts and paintings from the McAlpine collection were also prominently displayed in the foyer of the company's head office in Perth, representing an early example of the corporate collecting of Aboriginal art. McAlpine was followed by Perth-based businessman Robert Holmes à Court, who acquired a substantial collection of **Papunya** paintings in 1981 and later made large collections, from 1985 onwards, of the works of Kimberley artists Rover Thomas and Jarinyanu David **Downs** [*35, 317*] in addition to works from leading Aboriginal artists across the country.

The Kurirr-Kurirr ceremony boards of the 1970s were quite minimalist in conception, being mostly simple, two-colour, linear or dotted compositions defining tracks or hill ranges. By the mid 1980s Paddy Jaminji was extending his subject matter into more complex depictions of landscape features with **Dreamtime** associations. From 1983 onwards his works show a more detailed schematisation of landscape, blending vertical imagery such as boab trees and hill ranges within more abstracted and patterned renditions of river beds, roadways, and intersecting horizon lines. Progressively, his larger boards and canvases incorporated references to many sites, often shown between dividing lines. The use of yellow, white, and red ochres in the a single composition also allowed Jaminji to develop a series of diagrammatic schema for decoratively embellishing solid land masses such as hills, or to employ contrasting colour striping in hitherto empty areas.

Some of Rover Thomas's early works from the period 1983–86 focused on the familiar single subjects of the Kurirr-Kurirr and their related distinctive topography. He soon extended his subject matter more widely across the whole Kimberley landscape to include references to historical events. He depicted several early twentieth-century **massacre** sites [see 10.3], mixed Dreamtime sites with cattle station references, and painted the Argyle diamond mine dam. This breadth of coverage was informed by his extensive familiarity with the whole region, gained during his career as a travelling stockman. By comparison with Jaminji's compositions, Thomas's were less defined by vertical landscape forms, figurative references, or any sense of a horizon line. Instead, landscape

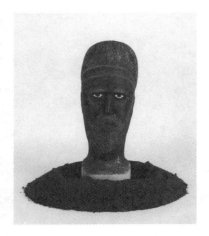

132. Big John Dodo, *Maparn (Doctor Man)*, c. 1985. Natural pigments on carved sandstone, 35.5 x 14 x 21 cm.

features were suggested by flat, intersecting, fluid spatial masses divided by areas of contrasting colour with a suggested overhead viewpoint reminiscent of the conventions of the Central Desert artistic perspective. Where Jaminji included literal figurative references, Thomas's paintings projected a strong sense of an emptying-out of extraneous details and a minimalist reduction of the landscape to its barest features. Nonetheless, the compositions, their titles and their descriptive annotations clearly show that Thomas was referring to physical features of the landscape and its associated symbolic spiritual references. For a short period he produced highly figurative works incorporating a Dreamtime owl and the rainbow serpent. As his works began to be displayed from the late 1980s in public gallery exhibitions, their strong textural quality of gritty ochre surfaces and broad, uneven brush strokes evoked an immediate comparison with the more generalised, loosely structured formulations of the Abstract Expressionist movement, especially as defined by artists such as Mark Rothko. They were positioned in terms of the aesthetic of minimal art, with its emphasis on the reduction of complexity to simple forms, colours, and composition.

In the Kimberley, the process of transformation from the largely anonymous, 'traditional painter–craftsperson' to named 'artist' was, to a large degree, tied to the emergence of the community artists' centres which were progressively established across the northern part of Western Australia in the mid 1980s, and to the parallel emergence of new, specialist galleries in Perth and interstate. Between 1985 and 1987 cultural centres were set up at Balgo Hills, Kununurra, Fitzroy Crossing, and Broome, facilitated by local community Aboriginal corporations, the **Aboriginal Arts Board** of the Australia Council, and by funding support from a new Aboriginal section in the Western Australian Department for the Arts. In the face of a changing market, the emergence of specialist galleries, and the gradual shift from the confines of museum settings into a contemporary art forum, the community-based agencies provided a critical, professional interface between the artists and an evolving art world.

In the early 1980s, painting activity throughout the Kimberley was sporadic. It took place mainly in ceremonial contexts and sales were local, and intermittent. In some places, for example at Balgo Hills and Warmun, artistic activity was often closely allied to school programs: artists were irregularly marketed through a Catholic Church network and only later experienced direct interaction with the commercial market. The exhibition 'Traditional and Contemporary Aboriginal Art of the Kimberley' at the Broome Art Gallery in April 1986 was the first to show new paintings by Jarinyanu David Downs, Mervyn Street, Jimmy **Pike** [*133, 270, 369*], Paddy Jaminji, and George **Mung Mung** [*358*]. The exhibition mostly comprised traditional craft items such as boomerangs, clubs, spears, shields, dillybags, didjeridus, and decorated boab nuts. Paradoxically, this exhibition was probably the last to show these traditionally oriented craft works alongside drawings and paintings. In 1986 the inclusion of Rover Thomas's work in the 'National Aboriginal Art Award' at the Museum and Art Gallery of the Northern Territory, and of works by Thomas and Jaminji in the 'Second Survey of Contemporary Aboriginal Art' at the Blaxland Gallery, Sydney, brought the region's emerging painters to national attention and, importantly, presented them as modern—as 'contemporary'. Two new Perth venues, Birrukmarri Gallery and the Dreamtime Gallery, further transformed perceptions of Aboriginal arts and crafts by emphasising their contemporaneity, and divorcing them from the 'craft' context. The first commercial exhibition of Turkey Creek artists was presented at the Birrukmarri Gallery in August 1987.

Pike and Thomas were featured in both major national 1988 bicentenary touring exhibitions—'The Face of Australia' and 'The Great Australian Art Exhibition 1788–1988'—alongside several other Aboriginal artists, reflecting the curatorial perception

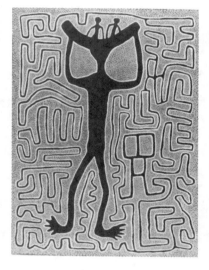

133. Jimmy Pike, *Woman Carrying her Two Boys*, 1991. Colour screen-print, 76 x 55.7 cm.
Jimmy Pike elaborates on the meaning of this work: A woman was bringing her two sons from the south. One day she left them at a waterhole. She went hunting. A big mob of women were chasing the two men, and made them very sick. The mother of the two men came back and found them lying there worn out. She picked them up and carried them in a coolamon, carried them all the way to Junyuwarnti, on top of her head. She was watching her two sons. All the women came and asked for the two men. At that waterhole Junyuwarnti you can see all the trees where all the women came out of the scrub. The mother told them to go back, and took off with her sons. There are double waterholes all along that way. The two boys died later, at Pukapuka and Kujinuru, two waterholes close together. That's in my country. Parnarnytu Pinya Kangani Walakujarra. (O'Ferrall 1995)

that their work was in the contemporary idiom. This recognition was confirmed by the artistic and market response to the 'Art from the Kimberley' exhibition at the Aboriginal Artists Gallery, Sydney in 1988, and the 'Turkey Creek: Recent Work' exhibition at Deutscher Gallery, Melbourne in 1989. Both shows, organised through Waringarri Aboriginal Arts, Kununurra, included large-scale works on canvas by Rover Thomas, Paddy Jaminji, George Mung Mung, Freddie **Timms** [*391*], and Jack **Britten** [*297*]. These exhibitions constituted the first considered presentation of the Warmun painters' movement to the national audience. They brought together a number of individual painters who had been working sporadically since the early 1980s. Mung Mung, Timms, and Britten, along with Hector **Jandany** and Paddy Williams, through their association with Mirrilingki Spirituality Centre founded near Warmun in 1979, had occasionally produced paintings that covered both descriptive Dreamtime subjects and Christian themes, but their work had not previously appeared in commercial gallery settings.

The work of Fitzroy Crossing artist Jarinyanu David Downs, with its compositional exploration of Wangkajunga Dreaming heroes and biblical themes, and the evolution of Pike's oeuvre, which spanned **printmaking**, painting, and the commercial world of applied fabric design through his association with Desert Designs, further challenged outdated perceptions and the pigeon-holing of Aboriginal artists. From the early 1980s, working in Fitzroy Crossing, Jarinyanu (who, like Rover Thomas was originally from the Great Sandy Desert) had begun to produce a range of small, figurative paintings depicting ceremonial scenes from his Walmajarri and Wangkajunga backgrounds. By the second half of the decade, he was abandoning this essentially illustrative and narrative approach and focusing on Kurtal, a major desert storm being, and Piwi, another ancestral being. Simultaneously, he began a series of works dealing with Christian topics, informed by his intense biblical studies and role as a lay preacher. This intersection of Aboriginal and Christian spiritual subjects set in specific landscape settings (such as the Red Sea crossing, Moses accepting the Ten Commandments on the mountain top, and the Garden of Eden) produced a series of powerful graphic works converging, from two distinct cultural viewpoints, on the sacredness of place and the personification of natural forces. Another Fitzroy Crossing artist, Pijaju Peter **Skipper** [*134, 270*], also rose to prominence at this time, producing several exhibitions of intense, colour-dotted compositions inspired by the Great Sandy Desert. Pike's early lino prints were constructed around traditional Walmajarri linear designs incised into ceremonial dancing boards and pearl shells, that referred to the topography of the sand-dune ridges and sacred waterholes of the Great Sandy Desert. Produced in 1983 and 1984, the raw intensity of these works attracted instant critical interest. Subsequent suites of colour prints, produced by Pike in 1986 and later, were notable for their vibrant, high contrast colours, reflecting partly his use of luminous textacolour pen in his sketch books, but equally the inspiration he drew from the actual colours to be seen in the Great Sandy Desert, particularly in the early morning and evening light and in the effects of the rainy season on the flowering vegetation and waterholes of the desert.

The seminal developments of the previous decade were consolidated, for Kimberley artists, in the 1990s. Through exhibitions organised by **Waringarri Aboriginal Arts** at Kununurra and **Mangkaja Arts** at Fitzroy Crossing, Kimberley artists regularly appeared in exhibitions across the country in the early part of the decade. Artists at Warmun, including Britten, Jandany, **Queenie McKenzie** [*135, 268*], and Henry Wambiny, evolved a new subject matter and a wider stylistic range. The major Kimberley retrospective, 'Images of Power', presented by the National Gallery of Victoria in 1993, gave substance to the profile and highlighted the diversity of Kimberley Aboriginal art. The 1994 'Roads Cross' exhibition at the NGA, featuring a retrospective of Rover Thomas's work and

134. Peter Skipper, *Jilji*, 1988. Acrylic on linen, 182.5 x 121.5 cm.
This painting depicts the *jilji* (sandhills) lying in parallel ridges.

early Jaminji paintings, and the 1995 Thomas solo exhibition, 'Well 33', at William Mora Gallery, Melbourne, further consolidated the status of contemporary Kimberley art.

In Kununurra, Waringarri Aboriginal Arts also expanded its support to painters from Kalumburu, notably Rosie, Lily, and Louis Karedada, and to Paddy **Carlton** [*302*] from Kununurra. Several exhibitions from the **Port Keats** area were also organised. Through Mangkaja Arts, artists Pijaju Peter Skipper and Mona Skipper Jukuna [*270*], Janangoo Butcher **Cherel** [*305*], Jimmy Nerima[*270*], Hughey Bent [*270*], and Jinny Bent Ngarta [*270*] exhibited in solo and joint exhibitions at Artplace Gallery, Perth. The 1991 exhibition 'Karrayili Ten Years On' featured established artists and several new women artists. The profile and productiveness of the Warmun artists, in particular, was extended by the opening in Melbourne in 1993 of Kimberley Art, a commercial gallery which predominantly featured the work of the more established Warmun painters but also newer artists such as Birimbi and Henry Wambiny. These developments marked a distinctive shift from the 1980s, when most Kimberley artists had worked exclusively through community organisations, toward a closer convergence with the mainstream art world and a more open-ended relationship between individual artists and galleries. During the 1990s artists also travelled overseas and interstate, widening their experience of the dynamics of balancing cultural and commercial interests.

The 1990s saw a progressive maturation of the regional art scene with a mix of options for artists, who could either work independently and directly with individual gallery dealers or maintain their primary association with the established community artists' cooperatives. The opening of the private Ochre Gallery in 1994 in Kununurra, where the community-run Waringarri Aboriginal Arts continues to operate, indicated the significant growth of regional tourism in the Kimberley region. This growth particularly affected Broome, where heavy national and international marketing saw a dramatic increase in short-term visitors, facilitating the opening of several new galleries. In a further development, the Warmun community artists established their own cooperative, Kelarriny Arts. Its first Melbourne exhibition, in March 1999, showcased the work of both established and emerging artists including Patrick Mung Mung [see George **Mung Mung**], Shirley **Purdie, Madigan Thomas**, and Goody Barrett. Similarly, artists at the Crocodile Hole outstation have exhibited through their own Jirrawun organisation.

At one level, this continuing emergence of artists and new cooperative groupings reflects the diversity of the different sub-regions and distinctive communities of the Kimberley. This diversity is, however, defined in no small measure by the work of particular individuals such as Paddy Jaminji, Rover Thomas, Jimmy Pike, and David Jarinyanu Downs who, through their seminal work in the 1980s, dramatically defined new artistic parameters and visions. The key directions plotted by such pioneers continues to provide a foundation for other Kimberley artists to follow in future years.

MICHAEL O'FERRALL

Akerman, K., 'Big John Dodo and Kimberley stone sculpture', in J. Kean, F. Alberts, M. Mácha, & K. Giles (eds), *Paper Stone Tin*, Adelaide, 1989; Akerman, K., 'The art of the Kurirr-Kurirr ceremony', in L. Taylor (ed.), *Painting the Land Story*, Canberra, 1999; Brody, A. M. (ed.), *Stories: Eleven Aboriginal Artists*, Sydney, 1997; Crumlin, R. (ed.), *Aboriginal Art and Spirituality*, Melbourne, 1991; O'Ferrall, M. A., *On the Edge, Five Contemporary Aboriginal Artists*, Perth, 1989; O'Ferrall, M. A., *Jimmy Pike—Desert Designs 1981–1995*, Perth, 1995; Ryan, J. with Akerman, K., *Images of Power: Aboriginal Art of the Kimberley*, Melbourne, 1993; Stanton, J. E., *Innovative Aboriginal Art of Western Australia*, Occasional paper, Anthropology Research Museum, University of Western Australia, 1988; Stringer, J., *Material Perfection, Minimal Art and Its Aftermath: Selected from the Kerry Stokes Collection*, Perth, 1998; Thomas, R., with Akerman,

K., Mácha, M., Christensen, W., and Caruana, W., *Roads Cross: The Paintings of Rover Thomas*, Canberra, 1994.

10.3 Painting history at Warmun: The killing times

The colonial history of the east Kimberley was often marked by violent encounters between Kartiya (white) stockmen and local Aboriginal peoples. Stockmen frequently massacred whole encampments of Aboriginal people in reprisal for incidents of cattle-spearing or on similar pretexts. Aboriginal people were shot or poisoned, and the bodies burnt to destroy the evidence. But Aboriginal people were not always passive victims. Some, dubbed 'outlaws' in mainstream histories [see **guerilla fighters**], took up arms against the invading settlers. Largely unwritten, these stories of **massacre** and resistance are preserved in Aboriginal oral tradition and are being retold by the contemporary artists of the Warmun community.

Artists **Queenie McKenzie** [*135*] and **Rover Thomas** [*136*] embed these histories within the sacred geography of the Kimberley landscape. In depicting the brutal killings at Lajibany each follows a unique vision. The events at Lajibany began when a group of Aboriginal people killed a bullock for food. The massacre was witnessed by a man who hid inside the carcass to avoid discovery. At the climactic point, an Aboriginal woman hands the stockmen a bullet she has been saving in her bag—and is shot with it. McKenzie tells the story [see11.5; **Aboriginal English structure**]:

[Stockmen] bin (past tense) come from Old Texas [Downs station]. They bin camp. Make-em (transitive marker) dinner camp la (at) One Mile bottle tree. They bin look round blonga (for) allabout (them) [i.e. for Aboriginal people] and see kill-em one bullock. They bin saddle-em up horse. Get-em rifles ready, everything. Bullet. Gallop up la them.

And this one boy bin go in long (into the) bullock guts. When they bin gallop up he bin see-em allabout, comin' up. He bin go in under guts. They never see him. That old man bin lookin' out from bullock. Just a eye him bin lookin' out, you know. Kartiya bin walk around look that bullock. 'Ah, we go.' All the [Kartiya] talk. Well, that old man know little bit English. 'We go now.' They bin drive-em up [the Aboriginals]. 'Come on! Come on!', they talk. Crack him whip la allabout. Make-em go.

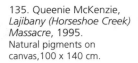

135. Queenie McKenzie, *Lajibany (Horseshoe Creek) Massacre*, 1995. Natural pigments on canvas,100 x 140 cm.

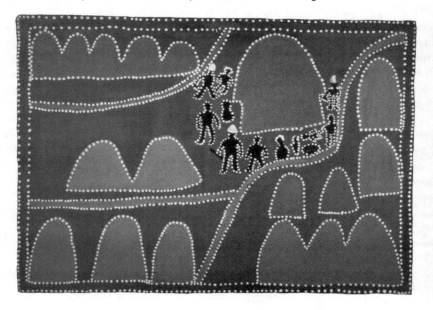

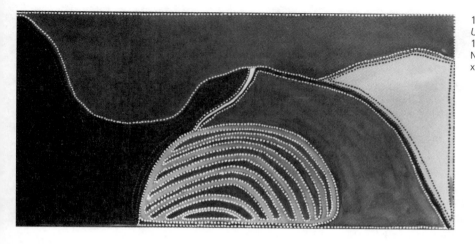

136. Rover Thomas, *One Hid Under the Bullock's Hide*, 1991.
Natural pigments on canvas, 90 x 180 cm.

They bin go down la creek. Finish [claps to imitate gunshots]. Went away. [The man who hid] bin go round la that place where he bin lookin' out allabout. [He saw the stockmen] tie-em up that lot boy, belt-em allabout. Do everything now allabout. That white men bin kill-em that blackfella. Whoa! Knock-em back allabout again everywhere. That one reckon put-em coolamon like a that [mimes a woman holding up a coolamon to shield herself]. Want to stop-em that bullet. He go through la him. Shoot-em allabout. Kill-em and knock-em baby la that hill every way. Him bin see that. Pick-em up baby. Get him by the leg and hit la [rock].

[The man who hid] bin see-em big smoke get up. Burn-em. Killer [the dead bullock] and all that lot [the bodies]. Big blow allabout where they bin take-em. And there's 'nother old woman they [stockmen] bin look. No bullet. Well, this 'nother woman now he bin alive. 'I got-em bullet here onefella la bag', him bin talk him. Silly bugger him bin give it. Bang! Bang! Knock-em him. Sad, poorfella.

This one old man bin look from this bullock. They're gone him bin see. Get up and run! Run! He bin find-em this baby. Him bin pick-em up. He bin find-em [the baby's] right mother. He bin give it to him. That old woman bin ask him: 'You bin see my little boy there. I bin chuck him la water, gottem (in a) coolamon. I bin leave him.' 'Him here', he said. And him full of blood, that old man, where he bin go in la bullock guts. Hair, everything, they's just like a wet. Him bin sit down like a that. That's what massacre where they bin do-em. That's all. That's the Horseshoe Creek [Lajibany]. Finish now. I bin already paint it already, painted that.

The date of the massacre is unrecorded. The child rescued at the end is now one of the oldest men in Warmun.

Other contemporary paintings depict places associated with 'Major' [*391*], a Queensland Aboriginal stockman from Texas Downs station, near Warmun, who took up arms against the Kartiya (white people) in 1905 and gathered a small group of followers. After killing several people, Major retreats to a high hill to elude the police but finally comes down to face his pursuers. McKenzie describes the events:

That Major him bin run away from Old Texas [Downs]. Him bin run away from [manager]. First Kartiya he bin shoot-em la Banana Spring … He bin go la Blackfella Creek. He bin sittin' down top of the hill. He see-em this white man ridin' along, gotta (on a) horse. He bin lookin' at-em white man. All right, wide place [Kartiya] bin come up [to].

He bin blow the hat la that Kartiya! He never shoot him but he bin blow that hat! Just missed him. No hat! Hat bin keep that way, behind!

From there that Major bin follow-em Blackfella Creek. 'I'll go la these two Kartiya longa (at) Blackfella Creek,' he said. He went there. He bin wait there till get dark. He bin try-em night time. He couldn't get-em that two Kartiya.

All right, morning time now. Early in the morning. He bin woke up now. Two girls bin milkin-em goat. Him bin ask them two: 'Where manager? Where cook?'

'Cook work, manager sleep yet,' they bin tell him.

He bin walk up la kitchen now. Soon as that cook come out ... Bang! Knock him down. This Kartiya bin hear-em shot now, this manager. He bin run from his place. He bin run look la his mate. Bang! Knock him down. Two of them ... Major bin go la Mount Clyde now. Climb up la that hill. Policeman bin after him. Him go round la him there. Can't get him. Him top of the hill. Can't climb up la that hill. He's long way up! Four days they bin try [to get] him. Nothing. Couldn't get him. They bin go 'way. They bin come back [to Warmun].

All right, they bin get-em policeman for Halls Creek, policeman from Wyndham, policeman from Fitzroy, policeman from Derby. They bin get him all the policeman ... [Major and his party] bin have-em big corroboree that night. [Major] bin tell-em [the others] all about that night: 'Don't come near me, please. Early in the morning, tomorrow, don't come up near me. Policeman here somewhere la ridge. You stay here and don't come near me. I can stand up myself and they can shoot me down. You twofella stay.'

Him bin sittin' down there lookin' out for a policeman. Him bin see policeman come out. Policeman bin come up ... They bin shoot-em bout (repeatedly) that Major from foot to head! From foot right up la head. Cut-em him neck. Cut-em [his head] off and take-em away ... But that old man I don't know what happened to him. That's all that story blong (about) Major. Short story Major bin have-em. Finish now.

<div align="right">

QUEENIE MCKENZIE

COMMENTARY AND INTERVIEW BY ERIC P. KJELLGREN

</div>

10.4 Engraved pearl shell from the Kimberley

Materials that shine or sparkle, that are iridescent or nacreous, play an important part in both the spiritual and secular life of Aboriginal people. The quality of brilliance that can be seen on the freshly oiled and ochred body of a dancer [see **body adornment**], the dazzling shimmer of well-executed cross-hatching in a bark painting, the play of light in crystals of quartz, cleavage fragments of gypsum and calcite, and the pearly hues or porcellaneous surfaces of marine and freshwater shells all indicate the presence of power derived from the creative period or **Dreaming**. This power is positive and life-enhancing, however it can also be gathered and directed for malevolent purposes. In the Kimberley, plaques of pearl shell, either undecorated or engraved, are also perceived to possess such power.

Some shell pieces are small and were worn as head and neck ornaments, others are large and were worn suspended from hair-belts or around the neck at both secular and secret ceremonies and at other important functions. Some shells served as ritual emblems and power objects, capable of attracting rain or divining the presence of a murderer.

Originally, pearl shells were engraved with stone tools and the incisors of wallabies and kangaroos. Metal engraving tools fashioned from nails were observed in use in

Broome in the 1890s. Today screwdrivers, nails, windscreen wiper rods, and the tangs of rasps and files are commonly employed to engrave shell.

Many Kimberley pearl shells are plain: the natural iridescence—often presenting a subtle spectrum of colour that symbolised the rainbow serpent—was beautiful in its own right and did not require further embellishment. Other shells were carefully engraved with geometric designs or with naturalistic figures of people, plants, and animals. The engraving of shells appears to have been generally restricted to the Dampier Land Peninsula and adjacent islands, and south to the area of the Eighty Mile Beach. On the north-west Kimberley coast, shells were occasionally engraved with plants and animals, in a style similar to that found in the rock paintings of the area.

There appears to be a sequential development in the use of geometric designs on pearl shell. The earliest recorded shells have either simple, random mazes composed of sets of parallel lines incised on their inner surface, or they are covered with parallel rows of zigzag lines that may combine to create a herringbone effect. The engraved lines are usually infilled with red or yellow ochre, or crushed charcoal, so that the engraving contrasts starkly with the lustrous shell ground. By the 1920s, at Broome and on the Eighty Mile Beach, the maze design [137] had become much more regular, with angles tending to approximate 90 degrees and with the complex design itself laid out about a simple, often anthropomorphic, figure. At the same time, artists on the Dampier Land Peninsula to the north had developed a distinctive, open, bilaterally symmetrical style of anthropomorphic engraving which they applied to pearl shell.

Figurative engravings can be divided into two broad categories: the traditional figurative style, consisting of simple images of humans, fish, reptiles, birds, macropods, and plants, and the realistic style that includes compositions depicting both traditional and introduced themes. The latter motifs are often drawn from the artist's own pearling, mission, or pastoral experiences [see Butcher Joe **Nangan**].

Pearl shells from the Kimberley, initially injected into local exchange systems, ultimately filtered across the continent: their presence is recorded in all States apart from Victoria and Tasmania. Today few shells are engraved in those areas originally associated with their production; over the last two decades people of the Western and Central Deserts, who still employ them for a wide variety of purposes, have taken up engraving raw shell purchased at coastal centres in order to meet local demands. Shells engraved by artisans in the desert often show their origins iconographically, bearing motifs such as concentric arcs, spirals, or concentric rhombs or squares—designs not normally found on shells carved on the Kimberley coast.

KIM AKERMAN

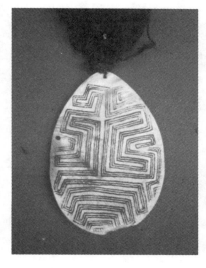

137. Artist unknown, pearl shell with maze design, c. mid 1930s. c. 22 x 15 cm.

11. The southern States

11.1 Art and Aboriginality in the south-east

The remarkably rich and complex artistic heritage of south-eastern Australia can no longer be overlooked. Although Aboriginal people in the southern States have experienced the longest and most intense history of colonisation, they have never ceased to remain in historical continuity with the past and to engage actively with a contemporary colonial reality. In the south-east, no less than elsewhere, Aboriginal art is highly significant as an expression of identity and difference and as a means of engaging in dialogue with settler society. The history of the dynamic Aboriginal presence in the south-east reveals a matrix of relatively independent regional traditions, reflecting the creative response of Aboriginal people to the opportunities and limitations presented by their particular historical experiences.

It is becoming increasingly evident that Aboriginal people have sought to use art as a means of cross-cultural exchange to persuade a settler society to respect their values and beliefs. Prior to colonisation Aboriginal people had well-established networks of exchange: items such as food, raw materials, weapons, and ornaments were exchanged as gifts, and so too were more intangible elements like songs, dances, and ideas. The intention of this activity was not primarily economic but served social, political, and judicial functions that assisted in negotiating relations of power, prestige, and goodwill. It is not surprising, then, that with the arrival of the first visitors to their shores Aboriginal people sought to incorporate them within the same relations of reciprocity and indebtedness. The Aborigines of Port Jackson bartered and traded services and items of material culture in return for particular European goods: bread, blankets, and clothing. Records of early encounters indicate that Aborigines displayed intense interest in the performance of military manoeuvres and memorialised these encounters in ritual performances. Of course this exchange of gifts and commodities was fraught with tension: objects lost the culturally discrete meanings which they held for Aboriginal people as they became entangled in a process of cross-cultural exchange that involved the uneven power relationships of a colonial context.

The 'voyages of discovery' to Australia and the Pacific region generated a wealth of images. In addition to recording flora and fauna, artists on board made portrait studies of Aboriginal people and depicted their lifestyle, material culture, and ceremonial life [*290*]. But the experience of cross-cultural exchange provided by these voyages also offered a 'creative space' for the curiosity and interest of Aboriginal artists. Within the archive resulting from Nicolas Baudin's expedition of 1801–03 are the first recorded drawings by Aboriginal artists. The six sheets of crayon drawings described as *Dessins exécutés par les Naturels des environs du Port Jackson* (Drawings Executed by the Natives

around Port Jackson) are apparently the work of Aboriginal artists who accompanied the zoologist François Péron on an expedition to the foothills of the Blue Mountains, west of Sydney. Whilst the tentative and halting—yet spontaneous—lines suggest the work of artists unused to handling crayons, in content and style the drawings bear a striking resemblance to the rock engravings of the Sydney region [54]. Andrew Sayers persuasively argues that within a colonial world shaped by various complex and contingent forces, drawing represented a vital, immediate, and direct means of exchange, marking crucial moments of early colonial encounter, for example at the signing of the 'treaty' between Kulin elders and John Batman in 1835 that effectively secured the settlement of Melbourne, and in the journals of George Augustus Robinson and William Thomas, among the first appointed 'protectors' of Aborigines in the colony of Victoria.

As Carol Cooper demonstrates, it is possible to establish links between the drawings of Aboriginal artists and the distinctive ceremonial life of the region. Through art Aborigines acknowledge their social and spiritual connections to a sentient landscape created by the actions of mythical ancestral beings and overlain with the events of colonial history. Throughout the south-east, religious beliefs focused on the 'All-Father' figures of Daramulun and Baiami who were believed to have returned to earth to act as mentors and guides for their descendants. Eyewitness accounts provided by early visitors, settlers, and ethnographers record Bora (initiation) ceremonies of great complexity with sculptures of considerable size representing various animals and ancestral figures [144] decorated with wood, shells, and quartz. Their descriptions record participants dancing in mimicry of totemic animals and holding aloft life-size effigies of people and animals in wood, bark, and grass. Surrounding the clearings were carved trees and saplings and stumps bound with cord.

But it was the elaborately carved, wooden weapons produced in the south-east which initially attracted considerable attention from private and institutional collectors—a fascination which reflected a general interest in weaponry but also an appreciation of their aesthetic form. Designs on the weapons reveal local variations within the overall unity of a regionally distinctive style. Whilst some weapons are left plain and undecorated, the majority are carved with intricate two and three dimensional designs composed of geometric elements—cross-hatching, herring-bone, chevrons, zigzags, diamonds, and rhomboids—used in conjunction with an equally rich array of figurative imagery. Although we have little detailed knowledge about the origins of these weapons and their connection to the societies who produced them, we can be certain that they did not simply fulfil an economic role but were broadly expressive of individual and collective identities in a variety of contexts. The evident parallels between the rock art, carved wooden weapons, possum-skin cloaks, carved trees (dendroglyphs) [138], cicatrices, and body designs of the region, make it likely that these graphic elements encoded restricted knowledge as they do elsewhere in Aboriginal communities today.

Because of the speed and intensity with which the frontier moved across the southeast in the early decades of the nineteenth century, Aboriginal people were unable to maintain ceremonial life. With conquest came dispossession from their land, the decimation of their populations through violence and disease, and cruel disruption to processes of cultural transmission. In Victoria alone, as Richard Broome notes, the Aboriginal population was drastically reduced in one generation from 10 000 people in 1835 to a mere 1907 in 1853. Christian missions established to give protection to surviving remnants fulfilled an ambivalent role [see 1.2]. In some instances missions sought to eradicate Aboriginal culture by ordering the destruction of weapons and the repression of ceremonial life. More generally, missions appear to have encouraged the continued production of traditional artefacts as training in the skills and industry required for

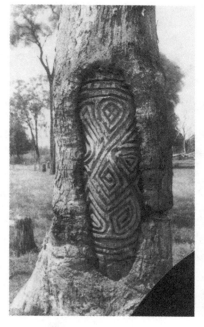

138. Dendroglyph (carved tree), New South Wales, c.1918.

assimilation. At Coranderrk Station near Healesville, sixty kilometres north-east of Melbourne, members of the Kulin nation, under the benign leadership of the Presbyterian lay preacher John Green, established an independent and flourishing community where the sale of traditional items such as wooden weapons, rush baskets, and possum-skin cloaks and the new skills acquired by Aboriginal women in embroidery and dressmaking augmented the income earned from agricultural and pastoral activities.

Conversion to Christianity did not necessarily erase Aboriginal culture, nor the political struggles of Aboriginal people for equality and restitution of traditional land [see 1.2]. In the well-documented history of resistance in the south-east there are many parallels with the strikes, walk-offs, and petitions [see 4.6, 14.2] staged across Aboriginal Australia during the twentieth century. In June 1863, for example, residents of Coranderrk, concerned that the mission might be lost to the greed of settlers, petitioned Queen Victoria through her representative, the Governor of Victoria. As Andrew Sayers records, the petition was accompanied by gifts including 'weapons, baskets and a collar of crocheted lace' made by a young girl of the community. Through such gifts—directly expressive of social and spiritual connections to country—Kulin sought to influence the course of future events by incorporating Europeans within their own exchange relations.

One of the most important objects preserved from the nineteenth century—the wooden headstone for Thomas Bungaleen [*139*]—highlights the increasing significance of art in the contested arena of colonial relations. Commissioned in the late 1860s from the Coranderrk community by Robert Brough Smyth, then 'protector' of Aborigines, the carved headstone was intended as a memorial to a young Gurnai youth, Thomas Bungaleen, who had died as the direct outcome of colonial violence. Concerned for the spirit of the young man who had died alone, away from his kin and wider community, the artist—possibly Simon Wonga, cousin of the artist William **Barak**—transposed forms from an Indigenous mortuary ceremony into a Christian context. Rows of intricately carved figures enclosed by repeating lines interpret the event in terms of an Aboriginal world view: they show the friends of the deceased appointed to investigate the cause of the death, the birds and animals who indicate that the deceased did not lack food, and the *mooroop* (spirits) believed to have caused the death of the young man. Reproduced in Smyth's *The Aborigines of Victoria* the memorial entered the collection of the Museum of Victoria as part of the **cultural heritage** of the south-east.

Significantly the three nineteenth-century artists for whom drawing was a major focus of their lives are all from the south-east: William Barak [*289*], Tommy **McRae** [*140*], and **Mickey of Ulladulla** [*272*]. While the work of all three artists offers extraordinary insights into the lifestyle of Aborigines in a post-contact era, stylistically the drawings are closely connected to the distinctive Indigenous art of the region, displaying repeated figurative and geometric forms within a continuous graphic space. William Barak, a long-term resident of Coranderrk, painted extensively in natural pigments, ochres, and charcoal on paper and cardboard, and with European watercolours. In scenes of ceremonial life recalled from childhood memories, Barak depicts rows of dancers dressed in possum-skin cloaks holding **boomerangs** aloft and, below, seated spectators accompanying the dancers. Frequently giant figures and animals form a central feature of his drawings. Likewise the finely-hatched pen and ink drawings of the Kwatkwat artist Tommy McRae are broadly descriptive of an earlier lifestyle concerned with corroborees, ritualised fights, and hunting scenes. McRae also provides a historical perspective, depicting relations between Aborigines and European and Chinese settlers. In one unique series he relays scenes from the life of the escaped convict William Buckley, who lived with the Aboriginal people of Port Phillip from 1803 to 1835. The

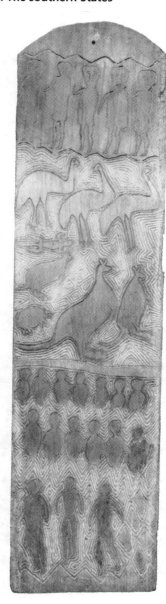

139. Grave marker made for Thomas Bungaleen, in the1860s
Carved wood, 130 x 35 cm.

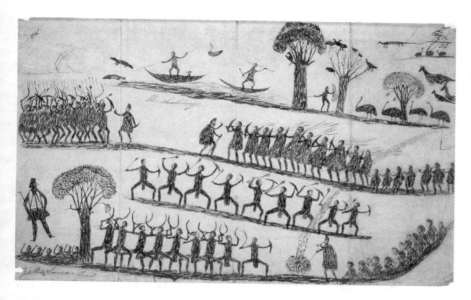

140. Tommy McRae,
*Scenes of Aboriginal life:
Squatter,* 1880s.
Pen and ink on blue paper, 21.5
x 34 cm.

drawings of Mickey of Ulladulla, who lived on the south coast of New South Wales, reflect the same abiding concerns with the ceremonial life of his people and their continuing involvement in traditional activities of hunting and fishing but, in addition, his evident curiosity about the colonial world of townships and coastal steamers.

Through their involvement in drawing and the production of artefacts, these artists achieved considerable recognition. However, we should not lose sight of the political dimension of their work. At a time when the lives of Aborigines were increasingly constrained by deteriorating race relations, Barak and McRae were leaders for their people. Barak, for example, led deputations that resulted in a Royal Commission in 1877 and a further inquiry in 1881; later he supplied the ethnographer A. W. Howitt with information about tribal lore, and he attended, as a guest of Howitt, a revival of a Gurnai Jeraeil ceremony held near Lake Victoria, in Gippsland, Victoria. Nevertheless, Barak was inevitably seen as a relic of a passing era. Memorialised as 'King Barak: The Last of the Yarra Tribe', he became emblematic of a dying race. Across the south-east, from the mid nineteenth to the early twentieth century, senior Aboriginal men and women were recognised by such honorific titles and by the gift of breastplates [*145*], modelled on military insignia, intended as a mark of respect and to gain their influence as allies. Whilst Aborigines may have originally appreciated the regal titles and tokens of colonial esteem bestowed upon them, their acceptance of them has come to be seen more ambivalently by their descendants as participation in settler narrative myths of 'fatal impact' that mask the destruction of Aboriginal culture.

For the better part of the twentieth century, Aborigines in the south-east lived under repressive and discriminatory legislation aimed at their integration and assimilation into mainstream society. Closure of missions and government reserves and the destruction of many flourishing, self-sufficient communities like that at Jackson's Track in Victoria, created bitterness and turmoil. At the same time government authorities, welfare agencies, and the church combined to implement the most destructive aspect of the policy—the relentless removal of children from their families [see 14.5; **stolen generations**]. Aborigines found ways of resisting these pressures: organising legal action and petitions, moving on and off remaining reserves and into fringe camps on the outskirts of country towns and, eventually, migrating into the capital cities [see 3.4, 12.1].

Thus despite this oppression Aborigines survived—and they never ceased to engage in the production of art. Indeed, for Aborigines in the south-east, the creative labour involved in making boomerangs, carved **emu eggs**, feather flowers, rush baskets [see 17.1, 17.2; *303*], and **shell necklaces** [*381*] assumed new importance, emblematic of their cultural pride and intransigence before oppression, racial discrimination, and government policies of assimilation. Contemporary south-eastern artists **Lin Onus** [*163, 266, 274*], Ian W. **Abdulla** [*282*], and Yvonne **Koolmatrie** [*159*] acknowledge that it was through the process of learning from family members how to manufacture and decorate artefacts and hearing the stories of their people that they established a strong and enduring sense of their **Aboriginality**. Reflecting a culturally distinctive use of space, Aborigines, in rural regions particularly, may decorate the interiors of their homes with displays of boomerangs, feather flowers, and wall hangings. Displayed openly and publicly alongside family photographs, such items become a locus for cultural memories associated with particular family members and a marker of cultural identity. Both the objects and the photographs are widely valued as a way of 'keeping culture'.

Within these commonalities, individual experiences differed. In more remote rural communities—among Dhan-Gadi in northern New South Wales and Paakantji in far-western New South Wales, many more aspects of traditional life survived than was formerly recognised. Men like George Dutton from Wilcannia, recorded by the anthropologist Jeremy Beckett in the 1950s, had gone through the Law and knew the myths, songs, and language of their people. Like the contemporary Kimberley artist **Rover Thomas** [*136, 219*], Paakantji were assisted by their incorporation within the pastoral industry: admired as 'smart men', they gained status for the invaluable bush skills they bought to the industry and new skills they learned, like horse riding. Travelling with stock from one waterhole to another, they retained knowledge of the *mura,* or **Dreaming** tracks of their people. Working alongside non-Aboriginal colleagues, Aboriginal stockman syncretised Indigenous skills in carving with Australian folk traditions to produce carved walking sticks, stock whips, and carved emu eggs. One surviving set of pastoral artefacts produced by Harry Mitchell—head stockman at Lake Victoria Station (NSW), from the 1920s to the 1940s—juxtapose intricate, *trompe-l'œil* designs carved in imitation of leather thonging, with popular European imagery such as the Turk's head knot, belt buckles, and hands linked in friendship.

The carved emu eggs widely produced by Aboriginal artists in the southern States were likewise appropriated from a vernacular art form popular among itinerant workers from the mid nineteenth century onward. But their makers also drew upon the cultural memories embodied in rock-art imagery, the skills acquired in carved wooden weapons, and made use of traditional economic resources. Stylistic differences between the carved emu eggs produced by the Paakantji and their neighbours the Wiradjuri people highlight the regional and historical distinctions within the south-east. Emu eggs carved by Gordon Mitchell in the 1920s, working in the traditions established by his father, typically form a continuous visual narrative around the egg [*141*]. Paralleling themes seen earlier in the drawings of Tommy McRae, Mitchell depicts vignettes of Aboriginal families travelling through a landscape rich in plant and animal resources: kangaroos, nesting swans, and families of bilbies are dwarfed by protective plants with hatched and dotted decoration. By contrast Wiradjuri artists like Joe Walsh and his son Hilton, and Sam Kirby and his daughter Esther [*318*], gain status among Aborigines and the wider community for their cameo-like illusions of reality achieved by carving through the many tonal layers of the thick, dark, granulated shell. An array of brilliant themes recur in the objects produced by these and other south-eastern artists: landscapes, flora and fauna, idealised images of Aboriginal people, the landing of Captain Cook in Botany Bay [see 4.2, 4.3], scenes from

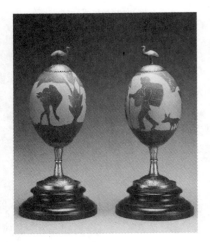

141. Gordon Mitchell, pair of carved emu eggs, c.1920, in earlier silver mounts (c. 1880s). Each 28.1 x 12.8 x 12.8 cm.

the pastoral industry and World War II, friendship hands, and heraldic symbols of the nation state: flags, coats of arms, and the continent of Australia.

Those Aborigines who were concentrated on remaining government reserves came under a repressive and restrictive regime as managers sought to gain control over their movements. However, the fascination which Aborigines held for mainstream Australians undermined government legislation aimed at isolating them from the wider community. In the early twentieth century, the many frequent visitors to Lake Tyers Aboriginal Station in Gippsland (Vic.), from nearby Lakes Entrance, were able to experience a form of cultural tourism [see 18.1], with demonstrations of fire lighting and boomerang throwing followed by a tour of the station, a vaudeville concert, and the opportunity to purchase a rush basket or one of the innovative poker-worked or painted boomerangs made specifically for sale. Aborigines here and elsewhere at **La Perouse** (NSW) [*232, 339*], and Raukkan (Point McLeay, SA), appear to have appreciated such visits as one of the few means of remaining in dialogue with mainstream Australians. And it seems Aborigines were able to maintain a considerable degree of control over their interaction with tourists. Far from representing a form of cultural colonisation, the production of weapons and crafts for sale to tourists might be seen as a form of strategic resistance that successfully disrupted the disciplined approach to regular, dutiful labour favoured by government authorities.

What is striking, then, is the vitality and diversity of cultural practices displayed in rural regions during this century. In some instances there was a remarkable continuity of form. For Aborigines and non-Aborigines alike, the boomerang represented an important symbol of Aboriginality, a part of the distinctive cultural heritage of the south-east and an icon of national identity for white Australians. Elsewhere traditional practices were partially or substantially transformed. Feathers, formerly used in various social and ceremonial contexts, were now transformed into delicate posies of feather flowers, introducing an Aboriginal aesthetic into Australian homes. And in some cases Aborigines embarked upon extraordinary forays into new territory, as in the verandah chairs of cabbage tree palm (a local version of a colonial design) made by members of the Aboriginal fishing community of Taree in northern New South Wales [see **furniture**; *320*]. But in all cases, whether the forms outwardly resemble earlier traditions or appropriate—in a form of bricolage—from a colonial genre, they do so from a culturally distinctive, Indigenous perspective.

From the 1930s onwards, momentous changes occurred in the south-east as Aborigines, by force, or by choice, left behind isolated rural reserves and fringe camps to migrate into the capital cities. Whereas previously legislation had excluded an Aboriginal presence from Australian cities and towns, the war years and postwar development offered Aborigines the possibility of greater freedom and opportunities for employment and education. At the same time, pan-Aboriginal organisations formed by Aboriginal leaders to fight for the restitution of traditional land and the return of civil rights provided a catalyst for cultural solidarity. In forging new, more public, and politicised affirmations of urban Aboriginal identity, Aborigines in the south-east drew upon a dynamic and distinctive history of public performance, which was first realised in the **corroborees** of the nineteenth century and then re-emerged in the concert parties which toured Aboriginal reserves and performed for tourists [see also **festivals**]. Relocated into the cities, concerts continued to fulfil both an economic and a cultural role, raising money for Aboriginal welfare and mobilising culture for political ends. In the program for the *Corroboree Season 1949*, staged at Wirth's Olympia in Melbourne, **Bill Onus** [*364*], entrepreneur, artist, and activist, and president of the Australian Aborigines League, made this deliberately cultural strategy quite explicit, arguing that the only way to circumvent an

institutionalised racism was to present to the public those Aborigines such as Albert **Namatjira** and Harold **Blair** who had achieved individual success in their own field.

In one such event, *An Aboriginal Moomba: Out of the Dark*, staged by the Australian Aborigines League at the Princess Theatre, Melbourne in 1951 in protest against the exclusion of an Aboriginal presence from the celebrations for the Victorian Centenary and the Jubilee of the Commonwealth, we see how Aboriginal leaders used performance to intervene strategically in the political struggle. Staged before a set design that combined one of Namatjira's famous watercolours with traditional designs from the southeast, the program, presented by an all-Aboriginal professional cast from Melbourne and interstate, included a hybrid mix of Indigenous and colonial genres with storytelling, song and dance, displays of boomerang throwing and fire eating, and more contemporary musical items starring Harold Blair and Torres Strait Islander, Georgia Lee (Dulcie **Pitt**). *An Aboriginal Moomba* revealed the historical consciousness of Aboriginal people, drawing upon the past as a source for cultural renewal while acknowledging the changes which had occurred within particular experiences of modernity.

While such performances met with acclaim from the wider public, critics were more ambivalent. For many white commentators, such evident links between culture and commerce were anathema. Indeed, from the late nineteenth century onward, private collectors and cultural institutions had denigrated as mere curios objects produced in the south-east, seeing their appropriation of colonial imagery, styles, and techniques as evidence of acculturation. More recently, such incorporations have come to be viewed more constructively, as expressive of Aborigines' creative and imaginative response to a changed historical reality. At Aboriginal Enterprises, the outlet for Aboriginal art and craft opened at Belgrave (Vic.) in 1952, Bill Onus marketed a range of work, from traditional bark paintings from Arnhem Land to smaller, tourist souvenirs, and he encouraged the use of motifs from Aboriginal culture as a means of regaining a strong and distinctive Aboriginal presence in Melbourne. It is noteworthy that during the Royal Visit of 1954, Arrernte watercolourist Albert Namatjira, and members of the **Timbery family** of La Perouse, whose work bridged the divide between high art and popular culture, were presented to the Queen. Such meetings between Aborigines and reigning monarchs operate in a discrete realm separate from the reality of everyday life. Participating Aborigines may appear as both exotic spectacle and a symbol of assimilation; nevertheless, they affirm the status of Aborigines as Australia's Indigenous people.

Namatjira's ground-breaking effort in pioneering a new, modern form of artistic expression was inspirational to Aborigines. Equally Ronald **Bull** [*142*], who had the opportunity to study informally with leading representational painters of the day, Hans Heysen and Ernest Buckmaster, established a legacy for south-eastern Aboriginal artists. His appropriation of a landscape genre taken as an icon of national identity by white Australians made it likely that his work, like that of Namatjira, would be interpreted as evidence of assimilation. However, just as the watercolours of the Hermannsburg School have undergone re-evaluation, so Bull's consummate landscapes of the settled southeast are seen to reaffirm his continuing connections to country—despite the trauma of dispossession. Indeed, his strategic placement of ancestral heads hidden within major works, such as his mural of a classic tribal scene painted on the walls of Melbourne's Pentridge Prison in 1961 [see **prison art**], imbues his work with another level of 'inside meaning' entirely appropriate to an Aboriginal perspective.

Albert Namatjira, the Nyungah artist Revel **Cooper** [*148, 364*], and Koori Ronald Bull influenced the young Melbourne artist Lin Onus, providing a historical context for an emerging generation of urban Aboriginal artists. Against a background of political protest, openly critical of the colonial regime, the landscape tradition they appropriated

142. Ronald Bull, *Yarra at Healesville*, 1977. Watercolour, 47 x 65 cm.

assumed symbolic importance as an expression of a wider pan-Aboriginal concern for country and as a commentary on colonial dispossession.

SYLVIA KLEINERT

Barwick, R. E. & Barwick, D. E., 'A memorial for Thomas Bungaleen, 1847–1865', *Aboriginal History*, vol. 8, no. 1, 1984; Beckett, J., 'George Dutton's country: Portrait of an Aboriginal drover', *Aboriginal History*, vol. 2, no. 1, 1978; Broome, R., 'Victoria', in A. McGrath (ed.), *Contested Ground: Australian Aborigines under the British Crown*, St. Leonards, NSW, 1995; Cooper, C., 'Traditional visual culture in south-east Australia', in A. Sayers, 1994; Goodall, H., *Invasion to Embassy: Land in Aboriginal Politics in New South Wales, 1770–1972*, St. Leonards, NSW, 1996; Howitt, A. W., *The Native Tribes of South-East Australia*, London, 1904; McBryde, I., 'Exchange in south-eastern Australia: An ethnohistorical perspective', *Aboriginal History*, vol. 8, no. 2, 1984; Sayers, A., *Aboriginal Artists of the Nineteenth Century*, Melbourne, 1994; Smyth, R. B., *The Aborigines of Victoria: With Notes Relating to the Habits of the Natives of Other Parts of Australia and Tasmania Compiled from Various Sources for the Government of Victoria*, 2 vols, Melbourne, 1878; Tonkin, D. & Landon, C., *Jackson's Track: Memoirs of a Dreamtime Place*, Ringwood, Vic., 1999.

11.2 Continuity and discontinuity: Wurundjeri custodianship of the Mt William quarry

Wil-im-ee mooring (tomahawk place) was the Woiwurrung name for the immense hatchet stone quarry on the slopes of Mt William in the ranges north of Melbourne [*143*]. It is one of the world's great archaeological quarry sites [see **archaeology**], established by a hunter-gatherer, non-urban society. Its stone travelled through complex exchange networks over a thousand kilometres beyond Woiwurrung lands.

This quarry, which was a major resource of great social significance in the country of Wurundjeri groups of the Kulin Woiwurrung of central Victoria, was still being used at the time of European settlement. Nineteenth-century ethnographic records give insights into its organisation. Access to the outcrops, and also the right to work their stone and negotiate exchanges for it, were strictly controlled by a select group of senior Wurundjeri group leaders (*ngurungaeta*) who held rights in relation to the quarry. Among them Billi-bellary had special responsibilities in relation to the actual working of the quarry, as had his father before him. These responsibilities were at times delegated to his nephew Bungerim. Custody of the quarry seems to have been subject to complex arrangements involving leaders of adjacent groups, each with a significant role and all interrelated by

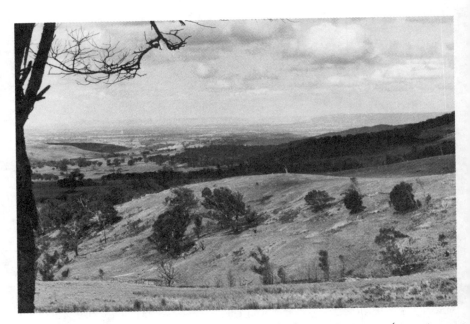

143. The Mt William quarry site.
The extensive quarried outcrops can be seen on the central ridge. The associated stone flaking areas show up as light patches when the covering grasses die off in the heat of early summer.

marriage. Important among these was Ningulabul whose name means 'stone toma-hawk'. The group also included Bebejern (father of the artist William **Barak** [*289*]) and Murrum Murrumbean. Such complex arrangements between those with rights in important resources are well known today in central and northern Australia. So within the Wurundjeri polity there were strict controls; outsiders had to observe even stricter protocols if they wished to acquire the prized stone.

Such direct records of custodial control of resources are rare for south-eastern Australia, where so many Aboriginal societies were destroyed, dispossessed, or relocated from their homelands without concern for their traditions. Our knowledge of Mt William's social importance to Wurundjeri people, and of its organisation, is the gift of William Barak. It results from the singular, fortunate circumstance of his meetings with Alfred Howitt in the 1880s and Howitt's recording of their discussions [see 1.2, 11.1]. There may well be further 'hidden histories' of the Aboriginal values attached to other quarries known archaeologically. Mt William, however, seems unique not only in its recorded social significance but also in its size, the extent of its exchange linkages, and the symbolic values of its products.

When Barak was interviewed by Howitt he was the sole surviving traditionally desig-nated Wurundjeri leader among the Woiwurrung. The remaining Woiwurrung had long been dispossessed of their lands and relocated to government-controlled settlements, first at Acheron and the Mohican Station, then from 1863 at Coranderrk. Yet by the end of the century even their hold on Coranderrk land became tenuous. Dianne Barwick has shown that Barak fought a sophisticated campaign to maintain it, especially in the diffi-cult years after the forced resignation in 1875 of John Green, the Superintendent who had supported the community's independent development.

Wurundjeri links to the quarry were broken with the death of Billi-bellary and others of the inner group in the 1840s and 1850s; or so it appears from the evidence available to us. There are no records of visits, no reference to Howitt's going there with Barak, in spite of the emphasis he gives it in his published account of 1904. Yet our evidence on such things is scanty. Certainly in the 1880s Wurundjeri still knew well who of the ear-lier group leaders held rights in the quarry.

From the 1880s the quarry was denied the care of its traditional owners. Its later history illustrates the pulse of changing scholarly stances and the attitudes of settlers and administrators towards Indigenous societies, the culture of hunter-gatherers, and national heritage. Attitudes—scholarly, official, and popular—at the turn of the century drew strength from Social Darwinism. Scholars showed an intense interest in Aboriginal culture as an exemplar of the past, of a former stage in human cultural evolution. Aboriginal people themselves were regarded as curious relics of this past, unlikely to survive contact with 'civilisation'. They were to be treated with kindly concern, as part of the region's natural history. In spite of the Woiwurrung's demonstrated success in social and economic adaptation at Coranderrk they were not considered capable of taking any active role in determining their future, or even of contributing to the continuing management of their own significant places, such as Mt William.

By the turn of the century loss of Aboriginal custodianship of the quarry seemed inevitable. Yet the site retained its power. It acquired new layers of meaning as various groups within settler or scientific society exerted control or claimed custodianship. In the early days of the colony, the scientific community of Melbourne made geological study of the outcrops as part of wider assessments of the colony's economic resources. The scientists noted evidence for extensive Aboriginal mining. Howitt's 1904 publication brought the quarry to the attention of an international anthropological audience. Mt William also became a focus of the late Victorian popular enthusiasm for natural history. Members of naturalist societies scoured the countryside recording and collecting specimens which were to be understood in novel ways through the disciplines of geology, zoology, botany, and the new study, prehistoric archaeology.

Educational opportunities also contributed. Informal programs supplemented new developments in state-funded education. By 1900, most country towns had their libraries and mechanics institutes: Kilmore and Lancefield were no exceptions. So local townsfolk learnt of Mt William's importance for archaeology and natural history. It soon became a significant educational resource, the object of excursions for residents and school pupils. These involved lectures on botany and geology as well as visits to the 'tomahawk workshops', to contemplate their 'silent relics'. Local histories document these activities, also the concern of residents that the quarry be protected. Unfortunately, not all local landholders were supportive and the initiative was blocked. Representations to government were renewed between 1917 and 1921 by Allan Cameron, a Romsey resident and member of the Legislative Assembly. He was supported by historical and field naturalist society members. Robert Paton reports Cameron as arguing that the government had a duty to protect this 'great historic landmark' with its unique 'proof … that this country was inhabited for hundreds of years before the white man came here'. He suggested a return of Aboriginal people to the proposed reserve where they could 'resume the making of their **boomerangs** and stone axes, and live to an extent the life of their ancestors'. It was envisaged that people from all over the world would visit this reserve and its Aboriginal exhibits, frozen in time in a living historical diorama.

Cameron's proposals illustrate well the ambiguities besetting even the sympathetic among contemporary decision makers. It is easy to hear in the argument, so ostensibly supportive, the assumption that Aboriginal people were locked onto that 'lowest rung' of the ladder of progress. One can hear also the denial of their demonstrated ability to adapt to new lifestyles. 'A great mistake was made in attempting to turn them into agriculturalists,' Cameron argued; 'my desire would be to take the aborigines back to the spot where their ancestors worked for hundreds of years.' The Aboriginal community of Coranderrk (forced in the 1920s to move to Lake Tyers in Gippsland) probably had the

more realistic view of its options. It wished to continue to farm the land that had long been its home.

In the years that followed, Mt William gained new values and new custodians from within the dominant society. The quarry became a place of pilgrimage and source of archaeological treasure for the collectors of stone artefacts. With minds focused on artefact classification, they rarely asked wider questions of cultural context, but adopted ethnographic frameworks provided by Howitt and his contemporaries. They did not seek information from the descendants of the quarry's traditional owners. In the 1960s archaeologist Dermot Casey, collector Stan Mitchell and anthropologist Donald Thomson emerge as individuals concerned with wider questions. Thomson visited the quarry in 1969. In his judgement Mt William held significance beyond its economic importance, also great research potential.

Isabel McBryde's research from 1974 demonstrated the immense archaeological significance of the site and of the evidence for the distribution of its products. Her ethnohistorical work documented the complexity of the site's original custodianship, organisation, and special values. Mt William's ascribed meanings thus acquired a new scientific layer. The 1970s saw heightened social awareness of environmental issues and of the need to protect **cultural heritage** places. Archaeologists argued strongly for protection of Aboriginal sites and the establishment of management and conservation programs. The States, including Victoria, introduced protective legislation and appointed heritage administrators. Significant Aboriginal places were among Australia's first nominations of places to the World Heritage list for their cultural values. In the 1970s the Mt William site was scheduled by the Victorian Archaeological Survey under State legislation. It was later entered on the Register of the National Estate by the Australian Heritage Commission. The area was fenced, its land reserved and management delegated to local government officials. Access to the outcrops was again strictly controlled. So the State acquired custodianship, and the heritage managers assumed control.

Recently further shifts have occurred. These have placed the Wurundjeri again as major players in the quarry's management. In the late 1970s and 1980s Aboriginal groups in south-eastern Australia argued strongly for involvement in decisions about their cultural heritage and places of significance. Aboriginal leaders asserted their rights to recognition of their continuing custodianship of places of significance, contesting the ownership of the past and its archaeological remains. This response has produced significant change. In Victoria, the Wurundjeri Tribe, Land Compensation and Cultural Heritage Council, and other bodies such as the Kulin Nation Cultural Heritage Organisation now play active roles in exciting new development for Mt William.

The Plan of Management, prepared in 1993–94, recognises Wurundjeri custodianship of the quarry, carrying special rights and responsibilities, in partnership with the Heritage Services section of Aboriginal Affairs Victoria. Other major interest groups, such as local government, landholders, tourism, educators, and researchers—all those who briefly assumed custodianship—are represented on the Committee of Management established under the plan to develop opportunities for a sharing of perspectives, for 'working together' with new understanding of why Mt William is valued by each interest group. Recently local government, which held title to the site, relinquished this to the Wurundjeri in the spirit of **reconciliation**. This accomplishes the closure of a century-long cycle in which the control of the Mt William quarry, appropriated by the dominant society, and within it contested by various interest groups, is returned to those whose prior, incontestable claims were long ignored. The process being developed, in a spirit of partnership, also seeks to recognise the values the site holds for others, especially local residents for whom it is part of their lives' landscape of memory. The 'silent relics of the

wil-im-ee mooring' will be cared for again by Wurundjeri custodians. The great quarry will resume its status of significance as an important Aboriginal place, as well as a remarkable component of the world's archaeological heritage.

ISABEL MCBRYDE

Barwick, D. E., Barwick, L. E., & Barwick, R. E. (eds), *Rebellion at Coranderrk*, Canberra, 1998; Howitt, A. W., *The Native Tribes of South-East Australia*, London, 1904; McBryde, I., 'Artefacts, language and social interaction: A case study from south-eastern Australia', in G. N. Bailey & P. Callow (eds), *Stone Age Prehistory*, Cambridge, 1986; Paton, R., 'Trading Places': A History of the Mt William Aboriginal Stone Quarry [unpublished report], Department of Aboriginal Affairs, Victoria, 1993.

11.3 Reclaiming Wailwan culture

When Charles Kerry photographed a Wailwan camp and men's ceremonial ground in 1898 [*144*], pastoralists had been in occupation of their country, which lay between the Macquarie and Castlereagh rivers of western New South Wales, for over half a century. The site had been recorded in 1895 by the surveyor and amateur anthropologist, R. H. Mathews, who struggled to find words appropriate to describe the 'mystic drawings … cut into the turf' on the *boorbung* ground, an oval area approached 'through a rustic archway, formed by pulling together and fastening the tops of a number of saplings'. Among the extensive ground designs, he noted 'the effigy of a man formed by stuffing a suit of European attire with grass and leaves [and beyond] … the outline of an immense snake'. Mathews reported that the ceremony had involved 'two hundred people of all ages and both sexes, including several half-castes … They came from Gulargambone, Coonamble, Trangie, Dandaloo, Dubbo, Brewarrina, and Conkapeak. From the time the

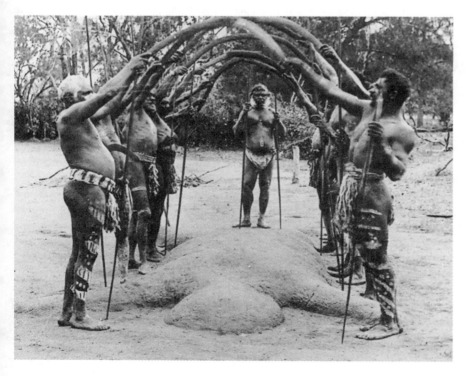

144. Charles Kerry, *Ceremony*, 1898.
R. H. Mathews (1901) recorded 'a colossal horizontal representation of [the Creator] … formed by heaping up the loose earth into human shape'.

145. Charles Kerry, 1898. The 'two worlds' occupied by the Wailwan are evident in this camp photograph. Two elders, a man and a woman, are shown in front of their bark shelter which is covered in a skin of sewn hessian wool-bags. She sits at the entrance dressed in a European dress and apron. He stands with spear and shield painted up for a men's ceremony, wearing a breastplate with the inscription, 'Billie King of the Macquarie'. Stock-work equipment is stored on the roof. The caption, written on the glass plate negative for the postcard trade, does not give their names or their country, but makes the ironic jibe: 'The King's mia mia'.

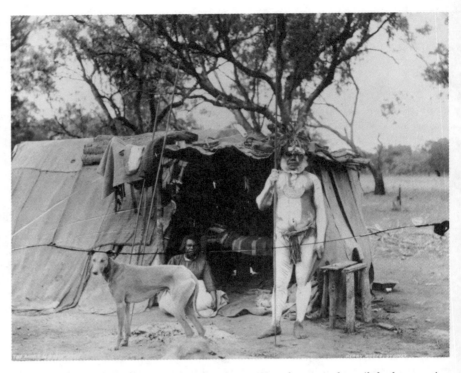

local mob selected the site and commenced preparing the ground, until the last contingent arrived, was more than three months … At this gathering nine youths were admitted to the status of membership in their respective tribes.' When Kerry arrived to take 'picturesque views' only about forty local people were left at the camp. He may have been alerted by the Aborigines Protection Board who in May 1898 had received a police report 'regarding the gathering of Aborigines at the Bulgregar Creek for the purpose of holding a Bora (ceremony).' Back in Sydney, Kerry spoke at the Royal Society of New South Wales in 1899 about being 'indebted to Mr. F. W. Hill, the owner of the adjoining station "Quambone", for the privilege of being present on the occasion. Many of the natives were in his employ, and all were under heavy obligations to him for protection and kindness extending over many years.' Kerry's files reveal that the eighteen photographs of the ceremonial ground were preceded by a group of thirteen camp photographs, showing families living in humpies on the outskirts of a pastoral station [145].

Subsequently, in the late 1920s, the Wailwan people were removed from their land at Quambone and taken to Brewarrina reserve. Meanwhile the thirty-one photographs, dispossessed of their Wailwan identity, circulated as postcards and then in popular and anthropological books [see **anthropology**]. For instance, Ronald Berndt, who reproduced fourteen photographs of the ceremonial ground in *Australian Aboriginal Religion*, had only the vaguest idea of the location. With the loss of their Wailwan identity the connection between the secular and sacred sites was broken and the subjects became generic 'Aboriginals' bearing Kerry's confusing captions.

To locate the descendants the Powerhouse Museum, Sydney, which holds Kerry's glass plate negatives, employed Joe Flick, a Yuwaalaraay man whose land borders Wailwan land. He described the process:

When I began taking the photos out and showing them to some Aboriginal people they were just so surprised that anything like that happened in their country … Charles Kerry

probably wasn't sure what he was seeing when he was looking through the lens yet through the power of the photographs and through the spirit of the Wailwan people they return to show us what their country meant to them.

When all the photographs are seen together the Wailwan in the camp do not appear the hapless victims of colonialism nor does their ceremonial life appear remote. The photographs reveal how they maintained their culture by adapting various European elements in a remarkable expression of cultural identity in the face of occupation.

One fact significant to the sacred aspect of the photographs emerged from Kerry's account. He expressed irritation at the restrictions imposed on him, writing that 'even when successful in gaining admittance to the scene of operations we were frequently requested, sometimes ordered to leave again … the final impression I gathered was that I was being wilfully misled.' One of the descendants, Merle Latham (née Carney), born at Gulargambone in 1916, was proud that her people had exercised such control and had not compromised their sacred knowledge. Other elders, who had known of the ground as children, felt that the access their people had given Kerry should be respected. No descendant requested any prohibition of the images, only the desire that they be recognised as Wailwan.

The identity of individuals in the photographs proved more difficult. One of the elderly landowners recalled 'a camp at Ringorah where King Billy resided with Davey Brown, Freddie Brown, Natti Brown, Frankie Booka, 'Crooked Toe Jackie', Peter Bob Flood, Hector Lee, Jimmy Cooper'. Some names recurred in conversation with Aboriginal elders like Robert 'Tracker' Robinson at Coonamble: 'I worked out at Quambone for sixteen years from 1952 to [19]68 along with Jimmy Cooper, Jack Murray, Fred and Hector and Johnny Lee and Frank Gordon.' He also saw that not much had changed for stockworkers since the photographs were taken: 'That bed would be made with sticks in the ground and it wouldn't have a mattress I can tell you, it'd be grass. The humpy would be bark.' Joe Flick describes the value of such accounts: 'For a lot of people in N[ew] S[outh] W[ales] there's not a lot of happy memories, but they're still custodians, custodians over those things that happened to them. I see that as important as sharing traditional cultures because that's what they actually lived through.' The most direct connection to family came from *New Dawn*, the State government magazine for Aborigines, which had a cover story in January 1974 about an elder, Davey Brown, born around 1870 on Sandy Camp station, just west of Quambone. Through the Coonamble Land Council we traced his great niece, Thelma Leonard (née Walsh), who recalled: 'Davey Brown, nothing would stop him … He was one of the oldest at Quambone. He knew the language and could sing.'

The Wailwan spoke a language that was close in grammar, and had a great deal of shared vocabulary with, the Ngiyampaa language of western New South Wales. Linguist Tamsin Donaldson has shown how some Ngiyampaa words were extended to encompass European objects. She writes that the word '*kurrumin*, already used for the shadow of something on the ground, or its reflection in water, could also be used for "photograph", by virtue of the fact that all three are images.' All *kurrumin* things are therefore effects of 'cast' light, whether on the ground, in water, or in glass, as distinct from sacred designs painted on the body, carved on trees, or formed out of the ground. So, the Wailwan may have seen the *kurrumin*, or photograph, as involving Europeans in an exchange that might gain respect for Wailwan country and culture. ANN STEPHEN

Berndt, R. M., *Australian Aboriginal Religion*, Leiden, 1974; Donaldson, T., 'From speaking Ngiyampaa to speaking English', *Aboriginal History*, vol. 9, no. 2, 1985; Kerry, C., 'Exhibits',

Journal and Proceedings of the Royal Society of New South Wales, vol. 33, 1899; Mathews, R. H., 'The Būrbūng of the Wiradthuri tribes', *Proceedings of the Royal Society of Queensland*, vol. 16, 1901; Miller, S., *Sharing a Wailwan Story*, Ultimo, NSW, 1999.

11.4 The Toas of Killalpaninna

The 400 Toas of Killalpaninna mission in north-eastern South Australia have achieved international prominence as Aboriginal art since the 'Art and Land' exhibition at the South Australian Museum (SAM) during 1986 [*146*]. These small sculptures, ranging in length from 15 to 57 centimetres, mostly feature a pointed wooden 'peg' onto which a gypsum knob has been moulded. The wooden base and the knob are usually decorated with ochred designs incorporating bands of colour or dots. The knob may also carry attachments of bone, shell, stone, wood, charcoal, hair, or feathers. The individual forms and cryptic symbolism of the Toas are rendered more potent by the existence of detailed explanations for each Toa. These link the symbolism of the Toas to the Aboriginal totemic landscape of the eastern Lake Eyre region, occupied by the Diyari, Wangkangurru, and related groups.

The Toas were sold to the SAM in 1907 by Pastor J. G. Reuther, three years after they came to his attention. His description of them as 'way markers', that were placed in deserted camps to indicate symbolically the destination of their sculptors, constitutes the only authoritative statement of their traditional function in Aboriginal society. Reuther's manuscript, also purchased by the SAM, includes a detailed explanation for each of the Toas, stating that the sites indicated by the Toas' particular forms and decorations correspond to named places within the documented itineraries of **Dreaming** ancestors, centring on the Cooper Creek region. Thus, for example, a Toa with a lizard foot attached to a red and white painted gypsum knob represents the site Kadniterkana, where the ancestor Pitikipana noticed a lizard climbing a sandhill overlooking a plain.

But there is cause for scepticism about the stated function of Toas. For the missionary Reuther, keen to begin a new career as an ethnographer, the Toas represented 'a picture script drawn in colour', a remarkable ethnographic discovery which he promoted vigor-

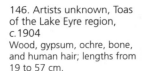

146. Artists unknown, Toas of the Lake Eyre region, c.1904
Wood, gypsum, ochre, bone, and human hair; lengths from 19 to 57 cm.

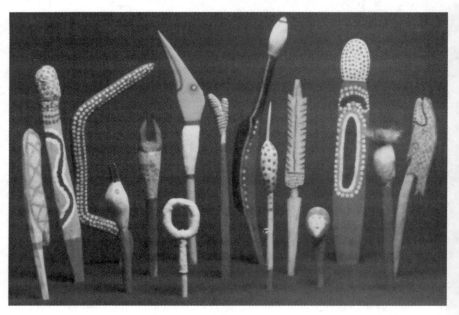

ously to museums in Europe and Australia during 1905. But none of the scientists and ethnographers who visited Killalpaninna in preceding years had observed Toas, and these objects were apparently unknown to Aboriginal people of the region in 1912. The Toas appeared after a decade of controversy over the function and significance of Aboriginal message sticks and the putative existence of a 'picture-script'. Nevertheless, while there is no ethnographic precedent for the existence of Toas as direction-markers, ethnographers have noted the use of marker-pegs to denote rights in local resources such as swan eggs, or to mark ceremonial ground limits. It seems likely that these forms provided a 'proto-type' for the Toas, which were probably made at Killalpaninna during late 1903.

The Birdsville Track ethnographer George Aiston wrote in 1938 of the 'great Toa hoax' perpetrated at Killalpaninna, but what is perhaps more likely is that Toas represent an innovative local response to a perceived demand for Aboriginal ethnographica, in which a small group of Europeans and Aboriginal people collaborated in an unprecedented artistic project, merging new forms and media with ancient traditional knowledge. In that combination, found also in Western Desert **acrylic painting**, lies their importance as part of the history of Aboriginal art. In recent years a series of Aboriginal art exhibitions and publications has raised the profile of the Toas. Not least has been the playfully ironic installation by Melbourne artist **Lin Onus**, *A Stronger Spring for David—Toas for a Modern Age*, 1994 [*266*].

PHILIP JONES

Jones, P. G. & Sutton, P. J., *Art and Land: Aboriginal Sculptures of the Lake Eyre Region*, Adelaide, 1986.

11.5 Cultural relevance and resurgence: Aboriginal artists in Tasmania today

Time ripples in Tasmania: like waves upon our island shore its rhythms serve to remind Aboriginal people of connections to place and to practices. For many Palawa artists the continuation of linkages to the land and its resources is an intrinsic part of cultural life [see 1.5].

It is practically impossible to separate Tasmanian Aboriginal art and artists from our cultural and political concerns. The links to traditional tribal lands belonging to certain bands (and thus families) are recognised and maintained and interconnect with our lives today. While some Aboriginal families associate most strongly with Cape Barren Island, Flinders Island and the muttonbirding islands, others have lived for generations in the Huon Valley and on the north-western coast.

Many government policies aimed to destroy the solidarity and spirit of the Aboriginal community by acts of disruption including forced enculturation, dispossession of land, and removal of children [see **stolen generations**]. Once dispossessed, our people were pressured to the degree that ongoing contact and close relationships between extended tribal groups (today's families) have, in some cases, been damaged or even lost.

The *Cape Barren Island Reserve Act 1912* exemplifies State-wide, bureaucratic intervention into Aboriginal lives. The government completely changed the rules for land occupation and ownership on Cape Barren Island that had been set up in 1881. Occupation now meant a 99-year lease at best. Ownership of land, considered by the Aboriginal people to be unquestionably their right, was not on offer. Mere occupation now depended on building a home and farming the land in the European sense—depending on the size of the grant. If inhabitants did not apply for and 'lawfully tend' their block of land from the age of twenty-one they were required to leave the reserve.

This Act was later supplemented by the *Cape Barren Island Reserve Act 1945* which was created to 'encourage' zero residency of Cape Barren Island Reserve by 1951. To this end the government terminated services on the island, closed the hospital, and ceased to pay unemployment benefits to Islanders, while promising housing and employment in Launceston. Despite these pressures to leave, there were still about 130 Aboriginal people living on Cape Barren in 1947.

Tasmanian Aborigines are still trying to come to terms with these enactments. When one talks about artists and cultural expression in Tasmania there is no separating out of **history** from the equation, regardless of the art form. History and connectedness may be evident in the processes and materials utilised, or in the issues and dialogue raised in artists' work. Daughters, sons, nephews, nieces are expressing personal (and family) experiences, hopes, and aspirations through art. Their art practice may be the means by which a healing process can proceed, and is perhaps a cathartic act showing relief and gratitude to elders for the survival of the culture in family stories and practices [see **family history**].

Within a lifestyle that has always required ingenuity and invention as part of daily existence, the Aboriginal community has maintained skills with no categorical borders. Tasmanian Aboriginal people are artists in the everyday, people who creatively respond to needs within themselves and their community. Some communicate their ideas through the visual arts, while most maintain traditional skills including woodworking, fibre-art, and **shell-necklace** making which have also been extended in the recent past into broom and limewash brush-making, the preparation of kangaroo sinew for snares and hide for moccasins, and collection of grass-tree resin sent to America for furniture varnish. Woodworking skills were adapted into a boat-building tradition by several Bass Strait families and translated by the Brown brothers into musical instrument-making.

Traditional gatherings, such as those during the annual muttonbirding season, provide many examples of the use and reuse of resources, dependent on season and place. The feathers and down of muttonbirds become filling for pillows and quilts, while the oil can be medicinally rubbed or swallowed; even the grasses near the sheds are reaped for floor cover. Auntie Ida West, a respected community elder, described this crossover of materials and culture: 'Dances used to be held on the mutton-bird islands. We would dance on the grass floors of the birding sheds.' The dance is thus specific to the time and place, as the grasses and shells collected at a certain time also remind their makers and the community of their own sense of place on the land, of the seasons and their own roles as makers and gift-givers. This is the big picture of interconnectedness.

Wood is a material in which Palawa adaptation, resourcefulness, and artistic skill find reflection. Traditional toolkits created by Brendan Brown and Vernon Graham include the spear, waddy, digging stick, and chisels of various kinds. In accommodation to the muttonbirding industry, spears have been adapted to operate horizontally as spits [*168*]. These are used to hold upwards of thirty *yolla* (muttonbird) by the beaks across the shoulders of the birder.

Intricate fibre baskets [see 17.1] are made by skilled Aboriginal practitioners in Tasmania. Lennah Newson, Eva Richardson, Yvonne Kopper, Dorothy Murray, Brenda Rhodes, and Fiona Maher not only create their own work, but pass on skills in community workshops. Contemporary artists' interpretations of traditional fibre and basketwork extend beyond the known and the 'practical' into the realm of personal expression, partly because there is no urgency today to make or repair a utilitarian item quickly for immediate use.

Tuttitell, 1994, a collection of fish traps created by Audrey Frost, represents a dialogue not only between past and present, but extends into a vision of shared cultural practices as being an integral part of our future. Audrey's visual work expresses her belief in the

need for communication between generations—between youth and elders—and in the supportive networks and cyclical responsibilities of community life.

Born on Cape Barren Island, Lola **Greeno** lived in Bass Strait until the early 1970s. Today she lives and works in Launceston where she makes work that is a response to historical and current issues which are central to her family and the Aboriginal community. She says: 'My art is influenced by my Aboriginal culture and especially the Cape Barren Reserve Act 1912–51. This [Act] placed considerable social discrimination and restrictions on my mother and her community … leaving many scars that remain today.' Using natural bush dyes, plant fibres, and other materials, Lola creates symbols to represent her culture and reflect the environment.

Traditional Tasmanian Aboriginal subsistence items included containers made of bull kelp [*147*]. These ingenious kelp water-carriers and baskets, which are made by Palawa artists including Lola Greeno and Brenda Rhodes, require the time and sensitivity to respond to the materials. Vicky West, who began weaving after attending a cultural workshop, describes her baskets as formed according to the will of the fibres.

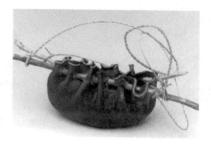

147. Lola Greeno, *Kelp Water-Carrier*, 1994. Bull kelp, tea-tree, and flax, 7 x 7 x 25 cm.

The shell necklace [*381*] has always been a central form of cultural expression for Palawa people. Complex and individual in threading design and choice of shell, these strands comprise approximately two metres of shells painstakingly collected and prepared from varieties including maireener, rye (or 'rice') shells, toothies, buckies, oat shells, yellow buttons, and cat's teeth. The significance of these strands reaches far beyond the category of mere 'necklace'. Usually only worn for special occasions and kept in a place of pride in the home, the necklaces are given as gifts to mark significant events—births, marriages, anniversaries, personal achievements—and have been presented, on occasion, to Aboriginal and other First Nations people visiting our land. Until the 1930s some were threaded and marketed specifically for the tourist trade [see 18.1], and some have been made for museum collections. Within the Palawa community are a handful of respected shell workers, most taught by their mothers and aunties, one by her father. These include Dulcie Greeno, Muriel Maynard, and Corrie Fullard. Joan Brown, an elder, lives on Cape Barren Island and has made the necklaces all her life. Palawa women shell-stringers meet to hold workshops; many are actively involved in teaching community or family members their craft.

Most Tasmanian Aboriginal artists working with fibre or shell-stringing maintain a strict personal code of excellence and include a signature of making. This is the individual's own mark, pattern, or means of working with the chosen material (such as secret recipes for bush-dye ingredients). Thus, within the circular form of community there is space for personal expression. Although always evident in Palawa households as forms of domestic art, techniques such as basketry, fibre-art, shell-necklace making, and woodworking have only recently been recognised by the dominant (white) culture as 'art' or even as Aboriginal culture. Aboriginal people themselves have not always used 'Aboriginal culture' to label the work and practices within the home that have been taught, passed on, and altered through time and circumstance.

Museums [21.1], **anthropologists**, the **media**, and popular culture have collectively managed to misrepresent our people, and to collect and determine our access to portions of our own culture. In response, Palawa people have maintained a long-term, private practice of self-determination and control of knowledge in order to protect our heritage [see **cultural heritage**]. To this end, we present our art forms in a variety of public places (not necessarily in 'exhibitions') as *living culture*, and the increasing visibility of Palawa art is, in turn, giving rise to adaptation. The adoption of these art forms within the home or as clothing represents cultural continuity, since they are adaptations of the ground and body markings used within the ceremonies of the past.

Only in recent years, through exhibitions such as the annual NAIDOC Art Show at the Moonah Arts Centre near Hobart, has it become obvious that there are cultural links between the long-term community practice of creating crocheted doilies and shell-edged milk-jug covers, and the practice of shell-necklace making; and between the bark paintings of Furley Gardner and the work of the fibre artists Lennah Newson and Eva Richardson. These art forms are all different means of engaging with the natural and the practical; different forms of expression linked to domesticity, gift-giving, and maintenance of skills. The Tasmanian Aboriginal community lacks regard for exterior art world agendas that encourage the definition of two discrete bands termed 'art' and 'craft'. Individuals proudly develop and maintain skills that interact within their practice regardless of categorisations such as art versus craft or traditional versus contemporary. Cultural practices have thus emerged again in diverse forms and media, linked to the past, yet forming around personal knowledge, family, and pride.

In Tasmania, alongside the return to traditional woodworking, basketry, and the continuation of shell-necklace making, alternative forms of artistic expression are surfacing as vital new means of connecting with the earth, in storytelling, or documenting. Artists including Ricky **Maynard**, Jennie **Gorringe**, Yvonne Kopper, and June Brown work with differing media to represent their cultural and spiritual ties to the land and people. In his 1986 *Moonbird People* series [168], Maynard photographically documented everyday lives. He portrayed the muttonbirding season in Bass Strait—the hard work and camaraderie, the cuts and blisters, the stories, and the maintenance of seasonal gathering for reasons beyond financial subsistence. Maynard's documentary photography focuses often on social and political issues and injustices, and his 1993 South Australian Prisons series *No More Than What You See* exemplifies his practice of challenging conventional photographic methods [see **prison art**].

Some Aboriginal artists connect directly with the land in their work through their materials. Jennie Gorringe, a Palawa ceramicist based in Hobart, makes large-scale, clay works [322], often incorporating the symbol of the serpent wrapping around her towering conical forms. Other pieces serve as water vessels whilst her installation at the Women's Karadi Aboriginal Corporation, Berriedale, near Hobart, is an earth ring several metres wide containing a formation of her fired and marked works. Jennie states: 'My work projects the feelings I have about Tasmania. It is important that I use symbolism that refers to the land and the spirit. It is an old place with an Aboriginal culture that is still surviving.'

Printmaking is also a vital emergent form of cultural affirmation in Tasmania. Yvonne Kopper uses printing and textiles as a means of conveying her ideas. The work *Family Ties*, 1995 incorporates layering of printed and sewn imagery, which suggests the interconnectedness of family and certain forces outside the home which enter to disrupt lives—such as war.

Personal variations of traditional Tasmanian Aboriginal rock carving are the basis for June Brown's pen and ink designs. As well as being accessible on the Web, Brown's drawings have been reproduced on highly visible bag and T-shirt prints through Palawa Prints, the only Tasmanian Indigenous screen-printing company.

Ironically then, we are creating, within a contemporary and complex art world and market, pieces that are now not used for subsistence collection—of bush foods, water, shellfish, and so on—but are rather, in themselves, a means of increased subsistence as saleable cultural commodities. This raises new questions within the community today regarding the means of manufacture and distribution of such physical renditions of our culture.

In the 1990s the Women's Karadi Aboriginal Corporation has been at the forefront of Palawa people's gaining of control of their cultural heritage by facilitating workshops on

basketry and fibre skills. Workshops have been held in the bush to ensure that participants can collect and identify plant materials as well as taking part in cultural exchange with other Palawa people. As Karadi's coordinator Kylie Dickson states: 'Traditional crafts are a vehicle for both conveying the artist's identity and creating a sense of shared culture within the community … In the atmosphere of the workshops the artists are always telling stories about what has happened to them—so we're not only linking ourselves to a form of culture that's almost been lost, but we're regaining other cultural skills, like the traditional way of storytelling.'

It is entirely appropriate that our community should both revere and rework our cultural past, especially when, in some cases, practices have continued to the present day uninterrupted. When Aboriginal artists in Tasmania connect to the past by means of creatively rendering what was, as what still is, we are embarking on a storytelling journey of affirmation and connectedness with the materials, ancestry, and land that is inherently ours.

JULIE GOUGH

A version of this article was originally published as 'Time ripples in Tasmania: Aboriginal artists in Tasmania today', *Art and Australia*, vol. 35, no. 1, 1997. It is reproduced with permission of the author and *Art and Australia*.

West, I., *Pride against Prejudice: Reminiscences of a Tasmanian Aborigine*, Canberra, 1984; West, V., 'Artist's statement', in University Gallery, University of Tasmania, *Nuini (Alive)*, Launceston, 1995; Westcott, L., 'Interview with Kylie Dickson', *ATSIC News*, Winter 1997.

11.6 Bush landscapes of the south-west of Western Australia: The child art of Carrolup

Carrolup, now known as Marribank, is an Aboriginal settlement near Katanning in south-western Western Australia. The late 1940s saw the emergence there of a group of Nyungah artists, aged between twelve and fourteen. This movement created considerable interest, and was heavily publicised at first. It later fell into relative obscurity, although the Nyungah landscape school continues productively to the present. Another generation of artists has emerged, many of whom have direct, kin-based associations with the original Carrolup artists. However, it was not until the development of a cultural resource centre at Marribank that this art movement was widely promoted within the contemporary context. A national travelling exhibition, 'Nyungar Landscapes' (1992), created a wider awareness of south-western art, demonstrating the development of the style in terms of both its historical origins and its significance in the contemporary context of Aboriginal urban art. The Edenburg Collection, now at the Berndt Museum of Anthropology, University of Western Australia, contains several works by the child artists, and the Phillips Bequest to the museum comprises the finest collection of their early works.

Carrolup was established in 1915 as a settlement where Aboriginal persons could be sent to remove them from the public eye. Accompanied by Annie Lock, of the Australian Aborigines Mission, who assumed responsibility for issuing rations, Aboriginal people of mixed descent were forcibly removed from customary camping places on the fringes of neighbouring towns. The erection of permanent buildings was completed by 1921: a school, dormitories, hospital, and staff residences were built from local stone, and most remain standing today. Land was cleared and stocked with sheep, but the settlement was closed by the Aborigines Department in 1922 as part of an economy drive, only to be reopened in 1940 as a technical training centre.

The appointment of Noel White as headmaster at Carrolup in 1945 was to have far-reaching significance. With the assistance of his wife Lily, he developed a teaching program well-suited to the children's interests and abilities. Lessons in music and drawing were intended to highlight their creativity and imagination. When he noticed one of the children, Parnell Dempster, drawing on scraps of paper, White provided paper and pencils. Within weeks the children were making complex designs of geometric shapes and naturalistic features of the local landscape. The children started by decorating the margins of their exercise sheets, but were soon filling full sheets of paper. White began taking the children on nature study walks in the adjacent bushland, after which they would return to the classroom and draw what they had observed, each hiding their work from the eyes of the others until it was finished.

Soon the children were asking to do drawings after school twice a week. Some of the works in pastel were subtle and subdued, echoing the softened colours of the night. But in other cases, the renderings of almost unbelievably rich sunsets, patterned by the silhouettes of trees on the horizon, show an extraordinary vibrancy. The animals of the bush and images of spirits of the night, and of body-painted dancing men, compete for prominence in many of the drawings. Imagined **corroborees**, far removed from the day-to-day institutionalisation of life at Carrolup, convey a yearning for the outside world, the cherished bush of the south-west. In correspondence with Florence Rutter, one of the child artists, Reynold Hart, reflected on his own experience:

He [White] saw that we had some talent, we practised on brown paper, night after night for about two years, and our drawing started to win the respect of the white people … The native children in the past wasn't given a chance to learn, but since Mr White took over the teaching at Carrolup we are now getting people to respect us and our drawings.

In October 1946 the children exhibited their art at the Katanning Agricultural Show. The *Great Southern Herald* (7 November 1946) reported:

The native children have been encouraged to give expression to their natural ability to picturise things close to their lives. No attempt has been made to impose Western principles upon their art and the result has been the presentation of brilliantly coloured work with bold and striking outline. The sense of balanced composition with which the boys fill their frame is remarkable, but even more notable is the sure handling of movement and the true sense of perspective.

In July 1947 the children sent a collection of twenty pastel drawings to the Lord Forrest centenary exhibition held in Perth. Three months later, some 450 drawings by several of the boys were exhibited at Boans department store, and Parnell Dempster, Revel **Cooper** [148, 364], Claude Kelly, and Reynold Hart demonstrated their skills at the exhibition, which received wide press coverage. Approximately £120 was raised from sales, and the money was held in trust by the Department of Native Affairs to purchase more materials for the artists.

Increasingly, the boys were encouraged to pursue their art: it was seen as a vocational training useful in seeking subsequent employment. Indeed, two of the boys, Revel Cooper and Parnell Dempster, later worked at Gibney Graphics, the only Perth company employing artists at that time. With few exceptions, the girls were discouraged from further developing their highly geometric art: the Department considered such skills to be irrelevant to their training as future domestic servants. Vera **Wallam**'s tapestry [397] remains the only extant landscape by a girl; it was based on a design drafted by Revel Cooper.

At a school of instruction held at Albany in 1948, a collection of exhibited works created great interest—amid some scepticism that the work was too good to have been

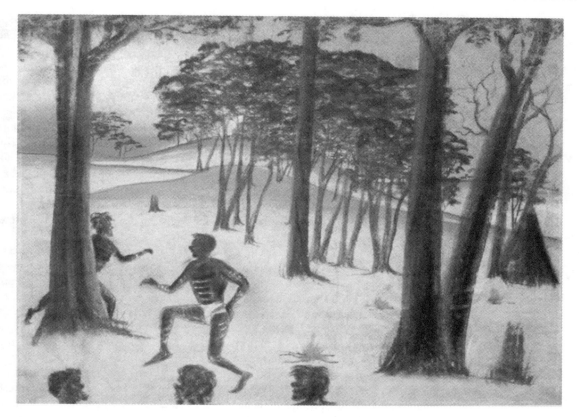

done by Aboriginal children unaided. So White promptly returned to Carrolup to bring three artists to Albany to demonstrate their ability in front of the doubters. The same year, a selection of crayon drawings and watercolours, and other handicrafts including painted wooden trays, decorated pottery, and sculpture, were sent to a UNESCO-sponsored seminar on rural education in Mysore.

These exhibitions did much to overturn preconceptions in the wider community about the work of child artists and to highlight the naivety of the notion 'primitive' art. Another exhibition was arranged in Sydney, with the support of Perth artist Beatrice Darbyshire. Yet it was the chance reading of a magazine article about the Boans exhibition that sparked a life-long interest in the Carrolup art on the part of Florence Rutter, an Englishwoman then visiting Perth. Travelling to Carrolup in July 1949, she wrote in her journal: 'I was very thrilled to see the work done by these children. Some unbelievably beautiful designs by the children under 7 years. The work by the older children is just marvelous ... I believe a good market can be found for some of their very original designs ... Altogether a very interesting, in fact thrilling, day.'

Rutter arranged for a selection of works by Carrolup children to tour Australia, New Zealand, Britain, and the Netherlands. Describing the opening of the exhibition at the Overseas League, London, the headline of the *Daily Graphic* was 'Can your child draw like this?' The *Illustrated London News* (12 August 1950) published five pictures over a full page, and on the occasion of a showing at Foyles Bookshop, London, *The Teachers' World*, an educators' magazine, made the following comments (7 February 1951), fascinating in hindsight: '*They were not taught!* These paintings run counter to all our current theories. These children ... living under desperately miserable conditions absolutely

148. Revel Cooper, *Dancer*, 1947–48.
Pastel on paper, 29 x 38 cm. This work was submitted as an exhibit at the International Seminar on Rural Education sponsored by UNESCO and held at Mysore, India in November 1949.

untaught ... given paper, produced *absolutely naturalistic pictures*. Form and movement of men and animals, landscapes of perfect perspective and even atmospheric perspective, colour beautifully blended: it was all here.'

But the success of Carrolup Native Settlement in promoting this new art form was also to be, in a sense, the cause of its destruction. The appointment of a new Commissioner of Native Affairs, S. G. Middleton, brought changing policies. At the same time, the Superintendent of Carrolup, V. H. Sully, increasingly criticised White's work among the children, claiming that it had no vocational value. Parnell Dempster wrote to Florence Rutter in July 1950: 'About this time last year we had about 300 drawings ready [but not this year] because we are not to work after school. New rules put out by Spt Mr Sully. Mr White cannot teach us or take us to the school room, after hours. Although we have lots of spare time with nothing to do.' Carrolup was closed in 1951, despite strong criticisms of Middleton by the Whites and Florence Rutter. Younger children were removed to Roelands Mission Farm, near Bunbury; many of the older children, having by then reached the minimum school-leaving age, left entirely.

The enforced movement of Aboriginal people to Carrolup had a profound impact on south-western culture, particularly among children, since it exposed them to elements of knowledge they might not have experienced elsewhere. For some, these insights provided an inspiration for the maintenance of Nyungah values and, in particular, the importance attached to the role of kin in survival. Carrolup's child art may be seen as part of a wider reaction against European authority, a clear statement of Nyungah social identity, and an affirmation of cultural solidarity. These children were not alone in that, but the acceptance of their art by many members of the broader Australian society has had a strong impact on the emerging social dynamics of the present-day south-west.

This style of painting cannot simply be viewed as an absorption and incorporation of European ideas of landscape drawing. Neither can it be regarded as derived from the Hermannsburg School of central Australia [see 9.1] and, in particular, the works of Albert **Namatjira** [*36, 42, 111, 115*]. It is entirely inappropriate to label contemporary south-western artists like Tjyllyungoo (Lance Chadd) and Yibiyung (Roma Winmar) as simple imitators of the central Australian style. Any evaluation of the Carrolup art movement and its significance to contemporary Nyungah art has to take into account the specific sociohistorical context within which it emerged. The development of the Carrolup settlement spanned thirty-five years; its successive closures and reopenings shaped the nature of Nyungah responses to changes in the patterns of institutionalisation over this period. The emergence of the Carrolup artists was undoubtedly a product of this social environment. Many of the artists continued to paint; some were at their most prolific during periods of further institutionalisation—a few as prisoners at Fremantle Gaol [see **prison art**].

That so few of the original child artists survive at the time of writing suggests something of the pressures contingent on the disempowerment that so many Nyungah people continue to experience. In some cases, their art careers faltered after their departure from Carrolup. Some viewed the closure of Carrolup as an act of betrayal—not by their teachers and their promoters, but by the coercive and unimaginative Department of Native Affairs and its commissioner.

Perhaps more importantly, though, the child artists have provided inspiration for another generation of Nyungah people to paint in 'the Carrolup style'. Tjyllyungoo recalls that as a young child he watched his uncle, Parnell Dempster, as he painted. Many others have responded to such inspiration, and the list is still growing.

JOHN E. STANTON

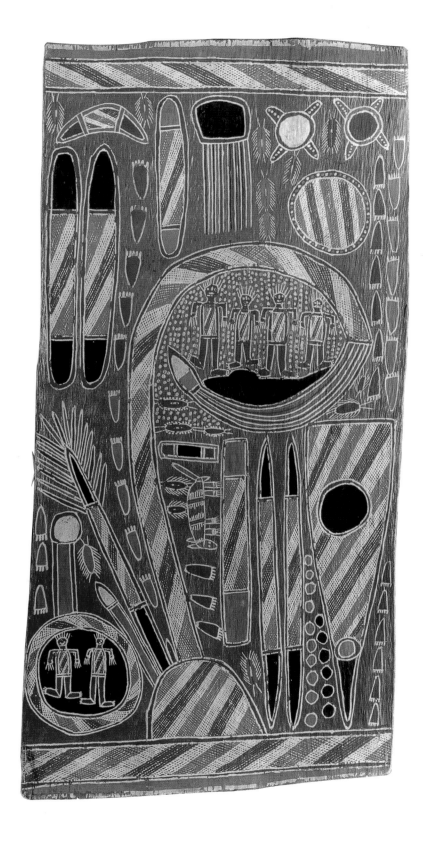

150. Dawidi, *Wagilag Creation Story*, 1956. Natural pigments on bark, 110 x 50 cm.

See also: 1.1, 2.1, 3.1, 6.1; **Dawidi**, Paddy **Dhathangu**, Philip **Gudthaykudthay**.

151. John Mawurndjul, *Rainbow Serpent's Antilopine Kangaroo*, 1991. Natural pigments on bark, 189 x 94 cm.

See also: 1.1, 2.1, 5.1, 5.2, 5.3, 6.1; John **Mawurndjul**.

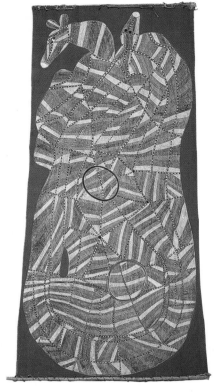

152. Najombolmi, *Bininy (people) and Mythic Beings*, Anbanbang shelter, Nourlangie Rock, Kakadu National Park, 1985.

See also: 1.1, 2.1, 5.1, 5.2, 5.3, 6.1; **Najombolmi**.

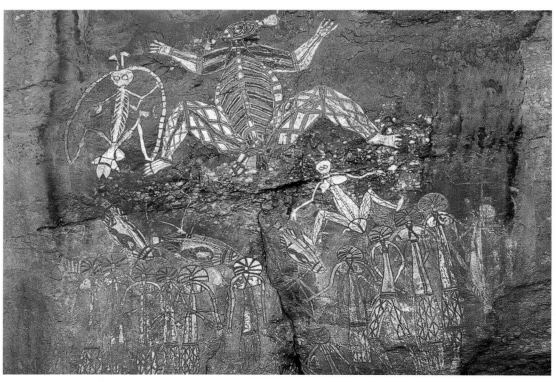

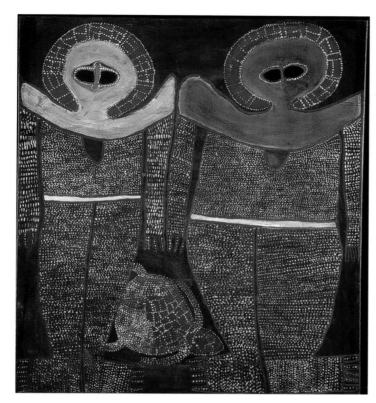

153. Alex Mingelmanganu, *Wanjina*, 1980.
Natural pigments and oil on canvas, 160 x 142 cm.

See also: 1.1, 2.1, 3.1, 10.1, 10.2; Alex **Mingelmanganu**, **Karedada family**.

154. Wanjina figures in Gunyirrngarri–Wargalingongo country, central North Kimberley.

See also: 1.1, 2.1, 5.1, 5.4, 10.1, 10.2.

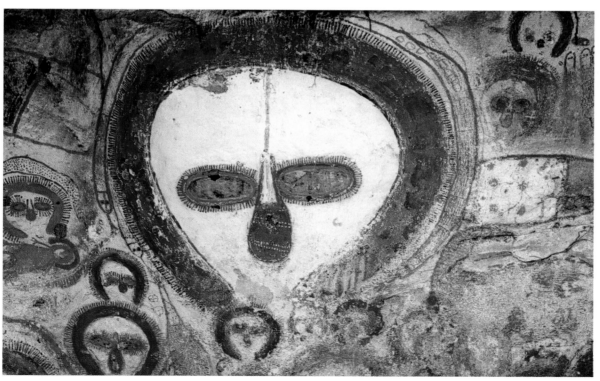

155. Donkeyman Lee Tjupurrula, *Yata Yata Tjarinpa, West of Lake Mackay*, 1991.
Acrylic on canvas, 150 x 75 cm.

See also: 1.1, 2.1, 9.5; **Balgo**, Donkeyman **Lee Tjupurrula**.

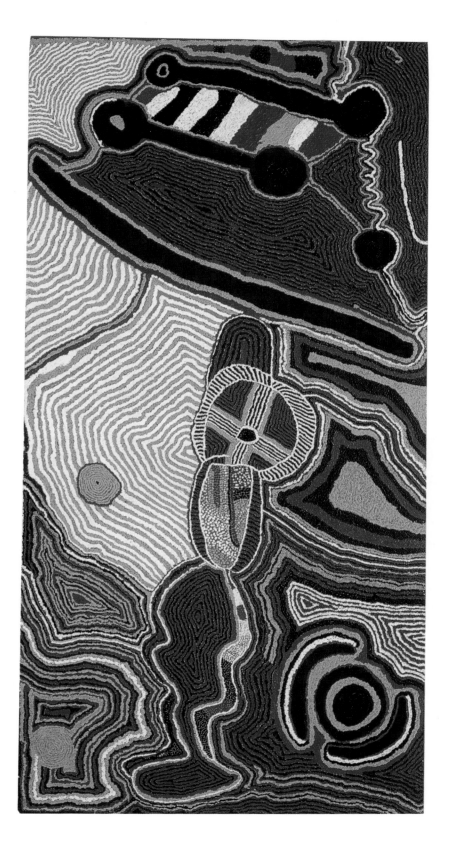

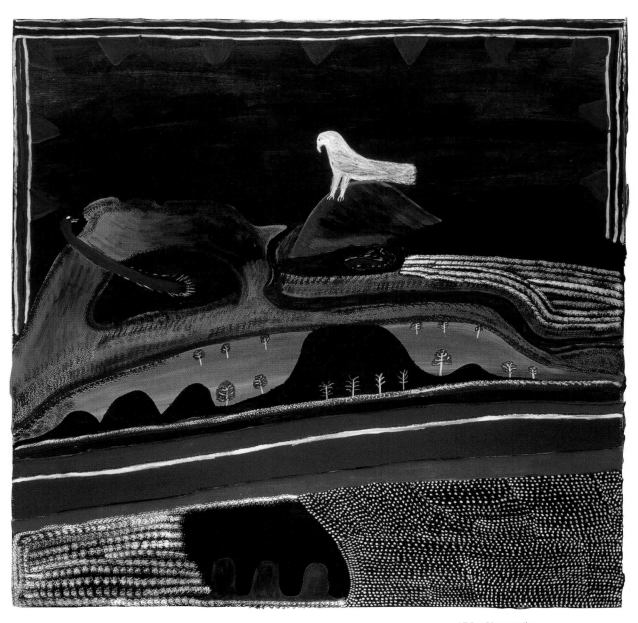

156. Ginger Riley
Munduwalawala, *Mara
Country*, 1992.
Acrylic on canvas, 244.0 x
244.0 cm.

See also: 1.2, 2.1; Djambu
Barra Barra, Willie **Gudabi**,
Gertie **Huddlestone**, **Ngukurr
artists**, Ginger **Riley
Munduwalawala**.

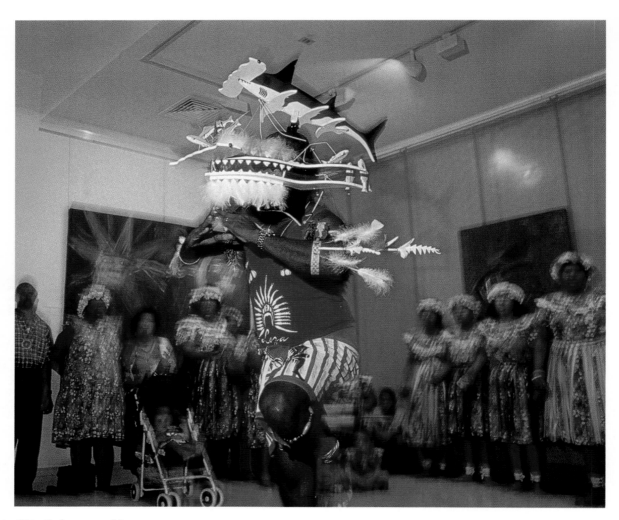

157. Performance of the
Shark Dance by Ken Thaiday,
Sr and the Loza dancers at a
Cairns Regional Gallery
exhibition opening in
February 1996.

See also: 1.1, 1.2, 1.6, 2.1, 7.1,
7.2, 7.3, 7.4, 7.5, 12.1, 15.3,
20.4; Ken **Thaiday**, Sr.

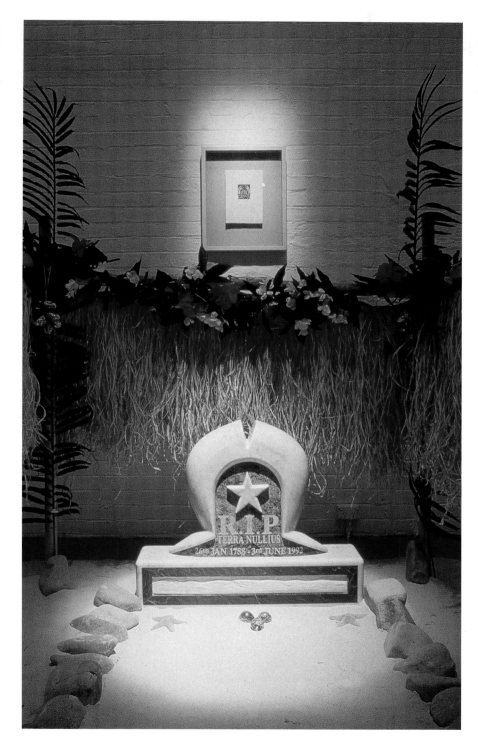

158. Ellen José, *RIP Terra Nullius,* 1996. Mixed media installation, 210 x 220 x 380 cm.

See also: 1.1, 1.2, 4.1, 7.1, 7.2, 7.4, 12.1; Ellen **José**.

159. Yvonne Koolmatrie, (*l. to r.*) *Duck Trap*, 1997, woven sedge grass, 5 x 520 x 186 cm; *Burial Basket*, 1997, woven sedge grass, 19 x 80 x 37 cm; and *Eel Trap*, 1997, woven sedge grass, 106 x 54 x 43 cm.

See also: 1.1, 1.2, 4.1, 11.1, 12.1, 17.1, 17.2, 18.1, 20.3, 21.1; Thelma **Carter**, Yvonne **Koolmatrie**, Ellen **Trevorrow**.

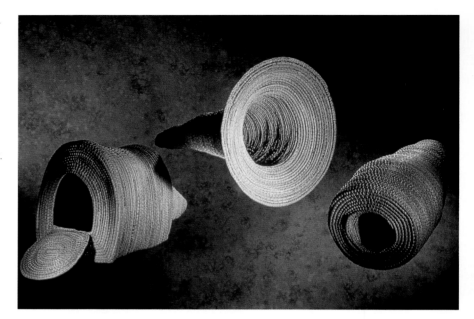

160. Elizabeth Djuttarra, *Woven Floor Mat*, 1991. Pandanus leaves and natural dyes, 270 x 372 (irreg.).

See also: 1.1, 2.1, 3.1, 6.1, 17.1; Elizabeth **Djuttarra**.

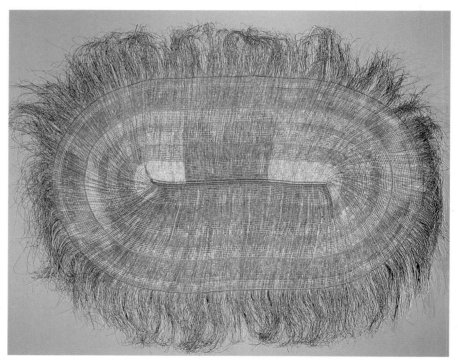

Dumbartung Aboriginal Corporation, *Nyungar Art from the South-West Region of Western Australia*, Waterford, WA, 1991; Miller, M. D. & Rutter, F., *Child Artists of the Australian Bush*, London & Sydney, 1952; Stanton, J. E., *Nyungar Landscapes: Aboriginal Artists of the South-West, the Heritage of Carrolup, Western Australia*, Nedlands, WA, 1992.

11.7 Language and identity

Aboriginal people are, and have always been, multilingual—extraordinarily adept at oral communication, and creative in their use of language for personal and group expression in a wide variety of contexts. Vic Sharman, an Aboriginal man whose country extends from Wreck Bay to Broulee on the south coast of NSW, explains that 'language is just part of us'.

It is not surprising, therefore, that Aboriginal people rose to the challenge of communicating with the invaders of 1788, by participating in the creative processes which led to the development of pidgin and creole languages, as well as other distinct forms of English now referred to as Aboriginal English [see **Aboriginal English structure, Aboriginal English vocabulary**]. In Australia, from 1788 onwards, there was the right kind of social and linguistic mix to create pidgins and creoles. In the Northern Territory and the Kimberley (WA), the language that developed from the early pidgin is called Kriol. Like any other language it has dialects spoken in different parts of the country—such as Cattle Country Kriol in the west, and Roper River Kriol in the north-east. In south-eastern Australia—where the invasion had its earliest impact—the maintenance of their own separate languages has helped people keep their cultures alive.

People assert clear distinctions between those aspects of their languages that are English and those that are distinctly of their own Aboriginal cultures. For example, Vic Sharman speaks about *mirri* and *mirrigan* when talking about dogs. In explaining weather changes, he notes the movements of *gunyu* (swan) and relates the importance of *djungar* (octopus) to his people. He explains that a *gabar* (non-Aboriginal man) or *wadjiman* (non-Aboriginal woman) would not understand him or his countrymen when they are speaking together and mixing these creolised English words with those of their own languages. In 1916 Coommee-Nullanga—one of Vic's ancestors who lived at Murramarang (NSW)—spoke to her friend Edmund Milne about the hardships her people faced and he wrote down what she had said to him:

Where my people? [pause]—dead all dead—Coommee soon die too—then all gone … Why my people die? Wha' for you wanter know? … Me tell you. Long tam ago me lil' picaninny, pblenty black feller sit down longa big camp. Him eat native food all same like old wild myall feller; him fat—what you call big, strong; him skin shiny, native food good, ver' good. You white feller come 'long—sit down—black feller him try lib it all same white feller; wear um clothes—eat white man tucker—drink white feller grog all tam he get him; lay 'bout camp; no clim' oller tree look for possum. Him skin get hard, what you call dry up; him get pblenty sick—tumble down—soon die—grog kill 'em ver' quick—ver' soon—all—die—me see'um never—no more.

To Sharman, this is the kind of English the older people he knows speak. It comes from a time when English was not the first language of his people. For him the words are very evocative and conjure up images of their faces lighting up as they speak, and the gestures and mannerisms that mark those people as his own elders. It is not just the words but the sound of the words and how they are delivered that are significant to Vic.

The language that Coommee used has many features common to the pidgin that developed after 1788 in New South Wales. These features are still present in the creole languages used elsewhere in Australia today. Characteristic of these languages is the use of *all same like* for 'like', the suffix *-em* on *kill 'em*, and *-fela* (from English 'fellow') on, for example, *old wild myall feller* referring to Aboriginal ancestors before the invasion (*myall* is a Sydney Aboriginal language word meaning stranger).

Language and culture are indivisible. Sharman remembers many Aboriginal people like Coommee who were around Wreck Bay in the 1950s doing 'business' (the word used by Aboriginal people throughout Australia for matters that are connected with their Laws). They used the kind of language that Coommee spoke to Edmund Milne—English in their eyes—for speaking with outsiders, and reserved their own languages for use among themselves. In the same way people today continue to use language to distinguish between themselves and outsiders. If Vic Sharman were referring to a friend among his own people, that person would be *mujil* or *mujilan*, but outside that circle the friend would be his *mate*.

<div align="right">Jakelin Troy and Vic Sharman</div>

11.8 Yagan and the London–Liverpool connection

Mingli Wanjurri-Nungala provides a vivid account of her journey to London and Liverpool in August 1997 with a delegation of Nyungah people from Western Australia to repatriate the preserved remains of the Aboriginal resistance leader, Yagan, who had been shot and killed near the Swan River settlement on 11 July 1833 [see 8.4; **Burnum Burnum, guerilla fighters, repatriation;** *149*].

On Tuesday 26 August 1997 I went shopping for several hours looking for a coat for the next winter. I joked that I should be looking for clothes to go to London as there was talk about the imminent trip to recover Yagan's *cart* (head).

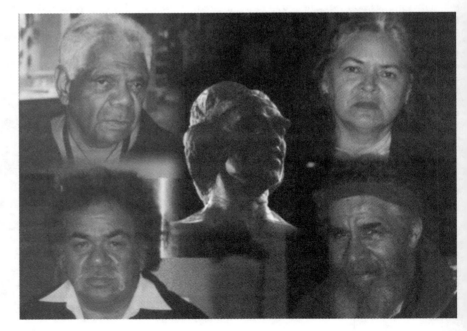

149. Christopher Pease (design) and Ken Boase (photographer), *Some of the People Who Are Trying to Unite the Nyoongar Nation over the Issue of Yagan's Kart*, 1997.
This photo-montage shows the Nyungah delegation which travelled to England in August 1997 to retrieve the *kart* (head) of the Nyungah warrior Yagan. (*Clockwise from top right*) Mingli Wanjurri-Nungala, Ken Colbung, Richard Wilkes, and Robert Bropho. In the centre is the head of the statue commemorating Yagan on Heirrison Island (WA).

Ken Colbung had been searching for Yagan's remains for many years, so too had Robert **Bropho** and others. In 1996 members of the British High Commission had come to Perth and had met with Nyungah people at the Aboriginal Advancement Council to discuss what to do with Yagan's remains, which had been in the Liverpool Museum [UK] until 1963 when the head was buried in the cemetery at Everton. Ensign Robert Dale had originally taken the remains from Australia, and through the efforts of a PhD student, Cressida Fforde, the grave had been located. There was also another person who used to send messages to Robert Bropho from his research at the Liverpool Museum. We seemed to have lost track of him but he was last heard of living in Ireland. He was an Aboriginal man who basically lived on the streets in London. He should have been with us when we went to Liverpool. I would like to acknowledge him. Thank you for your efforts, Ricky, and may you know that you helped the Nyungah people of the Swan Valley Community keep their hopes alive.

On Tuesday evening at 5 p.m. I rang home to be greeted with, 'Where have you been? You are going to London tonight'.

This was quite a shock but all I had to do was pack. After that statement the nerves set in as I remembered all the things people were saying about who was to go and who would not be going. I have travelled with Robert Bropho on other occasions and had no hesitation in doing so at this time. I am a Spiritual person and believe in the Ancient Law and Culture and relied on that to carry me through.

At 10.30 p.m. that night we were at the international airport to fly to London via Hong Kong. We waved goodbye with butterflies in our tummies but with well wishes from our family and supporters. This is History in the making I thought to myself. What a tremendous mission to be embarking on. My ticket was inside an envelope with someone else's name. 'I was meant to go', I heard myself say with my heart in my mouth. I was to go and bring Yagan's remains home. This was astounding. The Ancient ones were smiling at me and trying to calm me as my job was going to be one of the most important that I would ever do in my lifetime …

On to London where we were met by Cressida Fforde and Linton Burke, an Aboriginal student who was working with Cressida at the Southampton University. The trip from the airport to Leinster Gardens took quite a long time as it was their morning peak hour. It was interesting and amusing to be in another country driving along their autoways on a mission such as ours. This does not happen every day. I could not stop all these feelings and thoughts flooding over me. Sometimes I wanted to cry and other times I felt so high. I wondered what the other members of the group were feeling.

Discussions began almost immediately we arrived. We had little time. The court case in Australia was to be on Friday. It was now Thursday. Cressida, Linton, and Ken were working hard to organise the events to follow. We had to be ready to be in Liverpool. Yagan's remains were now with the Liverpool City Council. We were to find out later that the Australian High Commission would not do anything until after the court case [being brought by another person who claimed that he should be the one to collect the remains], even though the British High Commission had agreed to allow the remains to return to Australia. We went to Australia House to be told this was the case. They were most unhelpful and totally bureaucratic. That night we went back there to attend a function.

It was quite a walk from Leinster Gardens but Robert and I decided we would walk as far as we could and when we got tired we would call a cab. Yes call a London cab. That was another great experience. We walked past Piccadilly Circus where we strained our necks to see a column about the equivalent of eight stories high with a statue of Nelson atop. There were several statues around. They were all reminders of the wars of

Britain. Quite daunting to see such solid images decorating the streets. The buildings reminded me of the hardness and coldness which the first British people must have brought to Australia when they came and committed the atrocities they did. Now that I have seen the buildings and statues I can understand the feelings of that era.

On Heirrison Island looking west stands the only statue in Perth to remind the people that Aboriginal people lived here before the white people came. This came about because of the efforts of the Nyungah people who worked at the Aboriginal Advancement Council. Jack Davis, author, playwright, and well-known personality, was actively involved in Aboriginal affairs. Rose Pell, Sullivan and Lorna Hume, Ken Colbung, Elizabeth Hansen, and Eliza Isaacs were the main people involved in getting the statue of Yagan made. Rose Pell told me that she did not mind if the statue was moved after vandals hacked off the head shortly after we returned from England with the real head. She expressed the view of the time that the statue would be near the Swan River to watch who came up the river. This is what Yagan used to be doing when the first white people came. He was always watching who was coming up the river. When people were sighted Yagan would send someone to tell the others. Oral history tells us that Yagan was a very important man who was respected by all. He opposed white settlement when he realised to what extent they were taking the land from his people and becoming permanent squatters. Yagan observed the strangers digging up their land and growing crops. The white settlers just came and stayed. They did not ask any of the Nyungah people if they could stay and dig the ground. They caught fish and ate native animals out of season. Their behaviour was bewildering. Yagan and other members of his group could not understand the white man's ways of doing everything wrong. At first Yagan was friendly and used to share his food, especially fish if he caught too many for his needs. This feeling was not shared by the settlers as they did not like it when someone dug up their potatoes to eat. But they had been eating the bush food of the area; Yagan had shown a lot of people what to eat and what not to eat.

Midgigooroo was Yagan's father and Moyran was his mother. Moyran began to notice the friction that was brought about by the settlers who did not like to share. Her words, *Meenya djanga boomungar*, mean 'the smell of the white man is killing us'. Feeding stations were set up for the Nyungah people. There was one near the South Perth Mill and one up the river on Henry Bull's lease at Upper Swan. This is the place where Yagan's rather young life came to the end when William Keates shot Yagan after pretending to be friendly and delaying him. Heegan, known to be Yagan's brother, was found dead close by. William Keates's body was found down towards the river.

Ensign Dale smoked Yagan's head in a tree on the property for three months to prepare it for display. Yagan once said, 'You came to our country. You have driven us from our haunts and disturbed us in our occupation as we walk in our country. We are fired upon by the white man, why should the white man treat us this way?' (Colbung n.d.). So began the travels of Yagan's remains, until 1997 when his head came home. It is yet to be laid to rest.

I had the privilege to be the only woman in the group and this honour will stay with me until the day my Spirit returns to its resting place. I have made the Spiritual connection with Yagan now and that can never be changed. I honour that connection for the Nyungah women who came before us and for those who come after.

MINGLI WANJURRI-NUNGALA

Colbung, K., 'Yagan: The Swan River Settlement', Australia Council for the the Arts, Sydney, n.d.

Renegotiating tradition

12. Urban Aboriginal art

12.1 United in the struggle: Indigenous art from urban areas

The beginnings of visibility: 'Koori Art '84'

The exhibition 'Koori Art '84' at Artspace in Surry Hills, Sydney opened a new chapter in Australian art history. It created a new cultural space in an art mainstream dense with white, well educated, middle-class, predominantly male artists who evinced a strong preference for the minimalist internationalist style of the period. 'Koori Art '84' featured the work of twenty-five artists including Isobell E. Coe, Andrew Saunders, Avril **Quaill** [*63, 161*], Fiona **Foley** [see 23.3; *2, 63, 164*], Gordon **Syron** [*165*], Michael **Riley** [*373*], **Lin Onus** [*163, 266, 274*], Trevor **Nickolls** [*315*], Arone Raymond **Meeks** [*64, 175*], and Ian Craigie, and some visiting artists from the Central Desert region and Arnhem Land. They were black, many were self-taught, or students, they had no apparent interest in international styles, and a third of them were women. Their work was in the social realist mode, employing mostly figurative and sometimes heroic and confrontational imagery. It was described by some observers, disparagingly, as hybrid, amateurish, and 'not really authentic Aboriginal art, looking more like second-rate European art'.

These adventurous young artists had embarked on a mission that looked beyond the aesthetic to cultural and political concerns. Firmly grounded in country, in the land of

161. Avril Quaill, *Trespassers Keep Out!* 1985.
Poster, 50.9 x 76 cm.

the ancestors, and in the Aboriginal **land rights** movement, they had little interest in the styles that were currently fashionable in the countries of the colonisers. This 'aberration' could not penetrate the sealed world of the art intelligentsia. Although the exhibition was well-attended by the art literati, no reviews appeared in the mainstream art journals. Academic Vivien Johnson, who had been instrumental in the organisation of the exhibition, reviewed it herself—in the alternative magazine *Art Network*.

The exhibition inserted the word 'Koori' into the vocabulary of the art world. In its core meaning it is a collective term for Aboriginal people from the south-east but, as applied to art, it defined a new political position of unity, of struggle, and of reclamation, a self-assigned space separate from that allocated by the dominant culture as 'Aboriginal'—a space that comes with an insistence that art be defined and judged within its social and political context. Fiona Foley later said that she was told in her final year at art school that 'what you are doing is only a fad, and will only last 5 years' (Isaacs 1990). Challenges like this were met with determination and, ultimately, success. 'Koori' became a banner for a parade of exhibitions: 'Urban Koories' (1986), 'Koorie Perspectives' (1989) and 'A Koori Perspective Tour' (1990).

Just as importantly, 'Koori Art '84' introduced black artists to each other. As Arone Raymond Meeks, one of the exhibiting artists, said: 'it is only since 1984 that we realised that there were other Koori artists out there doing the same thing.' This sentiment was echoed by many others.

Before visibility

There is a hidden history: 'Koori Art '84' did not appear from nowhere. During the 1950s Australia was reassessing its position in the post-war era. Living proof of the success of the government's assimilationist policies were put on full public view: artist Albert **Namatjira** [see 4.1, 9.1; *36, 42, 111, 115*] and opera singer Harold **Blair** were held up as shining examples of how black men could become like white men—with the right training. By the late 1960s established attitudes were being challenged and terms like citizenship and human rights were being bandied about. In the 1970s Aboriginal Studies was introduced into Australian universities, and international calls for the promotion of understanding between peoples created a climate in which Indigenous people and their cultures started to move out of the realm of **anthropology** and into popular consciousness.

However, the gaze was directed northward. A network of government-funded art centres was established in remote communities through central and northern Australia in the 1970s. The Australia Council funded the establishment of Aboriginal art galleries in Melbourne and Sydney in the 1980s for the exhibition and marketing of 'traditional' art, while in Perth the Native Trading Fund set up shop at the East Perth division of the Native Welfare Department in 1971 [see 10.2]. There was no economic or cultural imperative to buy from city-based artists in the south.

Resistance to this exclusion took many forms. Indigenous agency found cultural and political expression in the 1970s and 1980s in the formation of local and regional based community centres, land councils, medical centres, keeping places, and art centres, and through national government agencies. In the 1970s aspiring young artists from rural and urban areas were attracted to art training in the cities: at Swinburne College in Melbourne, out of which Koori Kollij emerged in 1986; or at East Sydney Technical School, Sydney College of the Arts, and Alexander Mackie College of Advanced Education in Sydney. Aboriginal-managed centres such as the Eora Centre and Tranby Aboriginal Cooperative College offered specialised training in the visual and performing arts for Aboriginal students. A takeover of the **Aboriginal Arts Board** under the chairmanship of Aboriginal **Tent Embassy** [*49, 206*] leader Chicka Dixon in 1983, in which activist Gary

Foley became its Indigenous Director, saw increased funding to Indigenous art including, for the first time, to urban artists.

Many artists continued to work in isolation, as they had done for decades before. Some received their training in the community-based tourist souvenir industry, and others in prisons [see **prison art**], or on the streets [see 12.2]. Tourist souvenir art had been the only outlet for artists of south-east and central Australia who wanted to engage in visual cultural production with some measure of economic independence [see 8.2, 11.1, 18.1]. In Queensland in the 1960s Percy Trezise encouraged **Thancoupie** (Gloria Fletcher) [*103*], later known for her ceramics, to learn bark painting. Mary Serico, who worked from Brisbane, also painted on bark. Vincent **Serico** [*380*] and Robin O'Chin from Cherbourg developed distinctive composite styles combining the figuration of Mornington Island, the cross-hatching of Arnhem Land and Western realism. Cairns-based artist Joe **Rootsey** (Alamanhthin) [*101*] worked in the landscape genre during the 1950s and 1960s, influenced by the watercolours of Arrernte artist Albert Namatjira. Mornington Islanders Lindsay and Dick **Roughsey** (Goobalathaldin) [*102, 376*] were also active.

In Darwin [see 6.6] Harold Thomas also worked alone in a landscape tradition, from the late 1960s, painting vast watercolour vistas of the Northern Territory wetlands. While there is an appearance of the Westernised in these 'Koori' landscapes, the essence, spirit and often the subjects are of Aboriginal spaces and places. In 1971, Thomas designed the powerfully political graphic image which was to become the Aboriginal **flag**.

A number of prominent artists whose works are now exhibited in major galleries did their training in their fathers' workshops (or in other community-based collectives). Among these were Lin Onus, Robert **Campbell**, Jr [*49*] and Badger **Bates** [*292*]. Onus, a Yorta Yorta artist from Melbourne, is a classic example of a Koori who made the journey from the tourist trade to the galleries over three decades. In the 1960s he worked with his father **Bill Onus** [*364*] in his business, Aboriginal Enterprises, producing tourist artefacts [see 11.1]. In the 1970s, following in the footsteps of Ronald **Bull** [*142*] and Revel **Cooper** [*148, 364*], he moved into the only other 'saleable' area of work for an Aboriginal artist—landscapes in the European tradition. By 1980s, in the wake of considerable political gains, Onus was establishing himself as a major national figure, exhibiting both in Australia and overseas alongside artists who had travelled the art school circuit.

Kempsey artist Robert Campbell, Jr began by doing pencil drawings of animals and plants on boomerangs and other artefacts for his father to finish with hot-poker work. By the late 1980s, after working in a range of manual, usually itinerant jobs, he was having solo exhibitions in mainstream Sydney galleries. Broken Hill artist Badger Bates worked as a carver of wood and emu shells and later in lino-cut prints.

Prison was a training ground for many artists for whom gaining visibility was doubly significant [see **prison art**]. Prison was a place for introspection, for reflection on the inequities of the justice system which then, as now, saw Aboriginal people incarcerated at a much greater rate than other Australians. In prison, art was a form of release. Poet, activist, and artist Kevin **Gilbert** [see 4.5, 14.1; *62*] started his art-making in prison in New South Wales in the 1960s, later becoming a pivotal figure in the political struggles of the 1970s and 1980s. During the 1970s he made and sold artefacts at his art gallery–service station on the Pacific Highway, where he also attempted unsuccessfully to raise a National School of Aboriginal Arts in 1971.

While he was in prison Western Australian artist Jimmy **Pike** [*133, 270, 369*] used his art to remain connected with his culture and country in the Great Sandy Desert. Northern Territory artist John Johnson, now living in Canberra, learnt his trade in Fannie Bay prison, Darwin, in 1980, an experience reflected in his art, with its use of barbed wire and corrugated iron as a commentary on the entrapment of Indigenous people. Gordon

Lindsay, a South Australian artist living and working in Perth, used a distinctive graphic style with a futuristic edge, while Leslie **Griggs** in Melbourne painted about the prison experience and related social problems in a style reflecting his Aboriginal heritage. Sydney artist Gordon **Syron** started painting in Long Bay during the 1970s. He was renowned for his prophetic work, *Judgement by his Peers*, 1978 [see 12.2; *165*] which was first exhibited at Murraweena, Redfern while he was still incarcerated. 'Graduating from "Her Majesty's Royal School of Art" with honours', is how Syron refers to his prison experience and his introduction to art.

Seizing the day

Artists like Bull, Onus, Rootsey, and Roughsey were called the 'new Namatjiras'. And like him they were simultaneously applauded and denigrated. The world of fine art, controlled by the dominant culture, was unreceptive. It viewed Koori art through the old assimilationist lens as derivative, as aping the Western pictorial system.

Coming at least a decade after these artists had begun to work, 'Koori Art '84' was more than an art exhibition. It became a symbolic space, a contested site of historic moment which drew into its ambit all the political, socio-cultural and artistic issues of the day. What was there about this year, this city and this location and those participants that seized the day? The location—an inner city Sydney contemporary art space where contemporary white artists were normally shown—was a radical departure. Since the 1920s Aboriginal art had been shown in department stores, or in town halls (where Namatjira had been shown in the 1950s and 1960s), or in community halls, or indeed in art society rooms run by benevolent societies. Its absence from commercial galleries and major public galleries reflected its marginal status. 'Koori Art '84' demonstrated the possibility of penetrating white art spaces and introducing the concept of urban art to the art world, 'from the site of the white'—to borrow a phrase from academic Annette Hamilton. The young cultural activists of the art world were claiming a space after decades of displacement.

Between two cultures? City-based art in the 1980s

Although Sydney was the major arena for the infiltration of the mainstream, the politics of recognition were being enacted as part of an assertion of identity around the country. Adelaide-based artist Trevor Nickolls, working in isolation, articulated themes that were typical of the time. He described his paintings as 'a marriage of Aboriginal Culture and Western culture to form a style called *Traditional Contemporary—From Dreamtime to Machinetime*'. This prophetic thesis continues to engage artists who are struggling to find a personal space in the contemporary art world outside the margins—now contested—of Aboriginality. Nickolls speaks of finding his own private Dreaming through works like *Machine Time and Dream Time*, 1984, and *Wrestling with White Spirit*, c.1980 and 1990. He has used his training and experience as an art teacher to draw on sources like Picasso's *Guernica*, 1937, Boyd's *Bride Series*, 1957–62, and Munch's *The Scream*, 1893.

Art-school-trained Queensland artist Arone Raymond Meeks attempted 'to explore and strengthen the existing links between urban and traditional Aboriginal thought and culture'. This theme has persisted in his work, finding reconciliation in a 1988 print *Healing Place*. It was found again in his spectacular laser light performance, in which spirit figures inspired by rock art were projected onto rock walls, at the cultural event 'Lineage and Linkages', in Townsville in 1993.

An unfinished painting by Terry Shewring, Jim Simon, Andrew Saunders, and others from the Eora centre, used on the cover of the *Koori Art '84* catalogue, encapsulates the sense of alienation and dispossession that powered this second wave of artists. A dualistic

and heavily symbolic narrative unfolds. A nostalgic representation of an arcadian past on one side of the picture plane is connected by an arching rainbow to the other side— a brutal view of a land ravaged by industrial activity and pollution. An Aboriginal man is seen travelling a snaking pathway with its origins in the past. He has a child on his shoulders, and together they face a cyclone fence which bars their access to the 'future'. Trapped in a marginal space between two worlds, their connectedness to the past is symbolised by the rainbow which, as rainbow serpent made manifest, tells of the cultural strength that is the basis for survival.

During this period, several women artists were focusing on the issue of identity in relation to place. In her early work, Sydney-trained Queensland artist Fiona Foley referenced the sea associated with her ancestral home, Fraser Island. Foley's sensitive and sophisticated spatial sense, which has continued as a strong characteristic of her work, is already apparent in her early work. Fellow Queenslander Avril Quaill recalled more specifically her mother's country at Stradbroke Island, in her *Wulula, My Mother's Land*, 1984.

Jeffrey **Samuels**' iconic work *A Changing Continent Series*, 1984 [*162*] was a prophetic statement about how Aboriginal art, in particular Koori art, was changing the shape of Australian art: 'I wanted to see if I could design the dot like an Aboriginal technique in pointillist style, combining European art and Aboriginal art' (interview with author, 25 March 1999). The pattern of repeated maps of Australia in this work introduced the interest in serialisation that he has maintained since that time: 'When I do a body of work I do it in series and paint out what is inside of me … series of maps, series of stamps, and now I am doing a dancing series in sequences.' *Changing Continent* was one of the first works of urban Indigenous art to be acquired by a public art gallery, when it was purchased by the Art Gallery of New South Wales (AGNSW). The author's performance prior to its exhibition there in 1984 resulted from his strong interest in acknowledging the integration between static and performative elements of Indigenous culture.

The politics of visibility

There were several notable exhibitions in the wake of 'Koori Art '84'. 'Heartland', the first exhibition dedicated to women artists, opened in 1985 at the Ivan Dougherty Gallery, Sydney and the first major photography exhibition of Indigenous photographers, 'NADOC '86 Exhibition of Aboriginal and Islander Photographers' was shown in 1986 at the Aboriginal Artist Gallery in Sydney. This show featured artists who were in a minority twice over, being both photographers and black. Michael Riley even dared venture into representing Aboriginality as 'high glam' in his portrait, *Christina*, 1986.

However, the 'literal, westernized and politicized' art style of the 1980s was summarily dismissed by the 'art intelligentsia' who 'wasted no time in insinuating the futility of such partisan gestures in the institutionalized and heavily symbolic spaces of the art world' (Johnson 1990). Access to visible exhibition spaces remained problematic. A committed band of young artists, some of whom had been associated with 'Koori Art '84', decided to take matters into their own hands. In 1987 they formed **Boomalli Aboriginal Artists Co-operative**. Tellingly, the name means 'to strike' or 'to make a mark' in several of the Indigenous languages of New South Wales. Boomalli provided a meeting place, support systems, and exhibition opportunities: it was probably the single most influential factor in the rapid rise to prominence of city-based art. Above all, it was about Indigenous agency and the right to define Aboriginality, for oneself, as a fluid and multiple identity, severing it from the colonial view of Aboriginality as something fixed and singular.

Boomalli exhibitions in those formative years were mission statements in action. They clearly asserted the members' intention to work as a community collective, and to

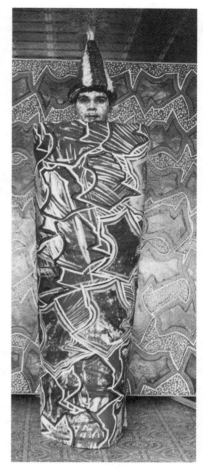

162. Jeffrey Samuels, *A Changing Continent Series*, 1984 (detail).
Acrylic earth pigment dye on composition board, 187 x 124.5 cm.
The photograph shows the artist performing the work in his studio at Chippendale, NSW in 1984. Samuels has wrapped himself in paper bearing the design, to represent the wearing of a traditional possum-skin cloak

control and manage their own careers. 'De Facto Apartheid' was mounted in 1988: its title was taken from Aboriginal academic and activist Marcia Langton's essay calling for the acknowledgment of the ill-treatment of Aboriginal people in the shadow of the impending bicentennial celebrations. 'Kempsey Koori Artists' (1988) featured the work of rural artists, declaring an intention to provide opportunities for those who were doubly marginalised. The exhibition featured, among others, the Kempsey-based artists Milton Budge, Robert Campbell, Jr, and David Fernando. 'Gomileroi–Moree Mob at Boomalli' (1989) included the work of South Australian artist Ian **Abdulla** [*282*] who, like Campbell, was later taken up by a major city gallery. In Adelaide another Aboriginal-managed centre, Tandanya National Cultural Institute, was established in 1989 as a multi-arts centre to provide a place for Indigenous people to express heritage, art, and culture through the arts and to promote harmony between black and white Australians. Kurwingie (Kerry **Giles**) and John Kean were the inaugural curatorial team who mounted the opening exhibition 'Look at Us Now' (1989). This survey of Indigenous art from South Australia demonstrated a refusal to conform to the Western distinctions between 'art' and 'craft', and 'high art' and 'popular culture'. In 1990 Tandanya's contribution to the Adelaide Festival program was the major exhibition 'East to West: Land in Papunya Tula Painting', designed to establish the institute's national profile as a cultural and visual arts centre.

The bicentennial year of 1988 [see **Survival Day**] sharpened the focus on Indigenous affairs and the arts. Thousands of Aboriginal people (and non-Indigenous supporters) from all parts of the country acted to stake a claim in the national psyche and reflect on their part in the building of the nation. In a spate of 'unofficial' exhibitions, publications, and other retrospective reflections, history was revisited, interrogated, and rewritten in this, the year of re-enactments. There was a proliferation of the most accessible and most democratic media of popular culture such as **printmaking**, **cartoons**, and photography [see 12.4] in exhibitions such as 'Right Here Right Now—Australia '88' which addressed issues avoided by the bicentennial, and '200 in the Shade' which traced the history of racism in Australian cartoons. 'Inside Black Australia' and 'More than Black and White' were photographic exhibitions which addressed issues of race and self-representation. Queensland artist Gordon **Bennett** [see 22.5; *265, 267, 275*], who described his work as 'history paintings' [see **history**], quickly found his place in this era of 'official' decolonisation with epic works that challenged the colonial accounts of Australian history being celebrated during the bicentennial. Other artists also challenged the morality and legality of actions taken against Aboriginal people. Sally **Morgan**'s *Taken Away*, 1989 [*384*] highlighted the plight of children removed from their families [see 14.5; **stolen generations**], and Fiona Foley's *Survival I, II, II, III, IV*, 1988, in a commentary on the removal of people from their country, juxtaposed images of Badtjala ancestors reclaimed from European archives [see **repatriation**] with shell middens bearing witness to centuries of Aboriginal occupancy of Fraser Island [see 23.3].

Connections, and reconnections
Many city-based artists exposed to Western art history felt a need, at this time, to round out their art education by exposing themselves to a more holistic Aboriginal art education. These excursions did not simply involve artists from the south going north to 're-charge' their Aboriginality—to re-Indigenise themselves through contact with the so-called 'real blacks'. A reverse flow, from north to south, also occurred: Banduk Marika [see **Marika family**] first ventured south from Arnhem Land in the early 1980s, as others have done since.

Robert Campbell, Jr, Avril Quaill, Michael Riley, and Gordon Bennett were among those who went north. Trevor Nickolls's association with Papunya artist Dinny Nolan Tjampitjinpa in 1979 had a long-term effect on his art: 'This encounter … convinced him that his vision of a truly Australian art drawing on both Aboriginal and western heritages was a real possibility' (Aboriginal Arts Australia 1987). Jeffrey Samuels, one of the earliest of these 'cultural' explorers, went to Mornington Island in northern Queensland in the late 1970s. He was followed a few years later by Raymond Meeks, who had been given the name Arone (black crane) by Thancoupie.

Lin Onus made the first of sixteen 'spiritual pilgrimages', as he described them, to Arnhem Land in 1986. Over the next ten years he was accepted into the family and the life of the late Jack **Wunuwun** [*407*]—now referred to as 'Big Wamut'. Out of these exchanges and his journeys across Lake Eyre to the Top End came the dingo installation *Dingoes*, 1989 at the National Gallery of Australia (NGA) and the installation *Fruit Bats*, 1991 [*163*] at the AGNSW. At **Maningrida** (NT) in 1986 he met Sydney-based Badtjala artist Fiona Foley, and a resident white artist Michael Eather with whom he shared many collaborations. For Foley this was one of many visits which not only inspired her

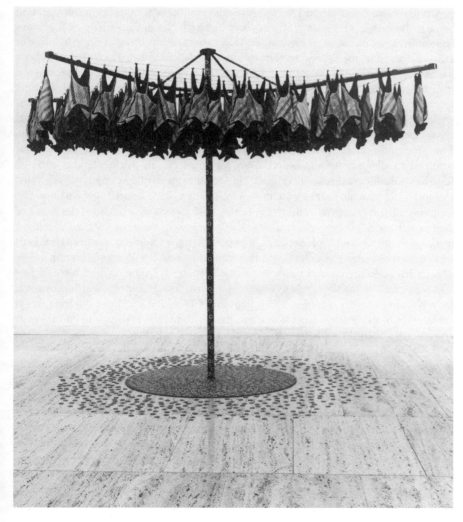

163. Lin Onus, *Fruit Bats*, 1991.
Polychromed fibreglass sculptures, polychromed wooden discs, Hills Hoist clothesline, 250 x 250 x 250 cm overall.

personally and artistically but also resulted in community exchanges between women weavers from Fraser Island and Maningrida, and collaborative weaving workshops in Sydney. Eather, in turn, organised exchange visits between Brisbane Murri artists from the **Campfire Group** [*227, 246, 301*] and Maningrida painters and carvers.

The Campfire Group had been formed in 1991 to encourage collaboration between Indigenous artists from around Australia—but also between black and white artists. Its activities culminated in innovative and monumental ground sculptures in King George Square, Brisbane for the Dah festival in 1998 and in 1999. Desert artists Michael Jagamara **Nelson** [see 22.3; *226, 227, 264*] and Paddy Carroll Tjungurrayi worked alongside Murri artists Bianca Beetson and Joanne Currie from Queensland, and with non-Aboriginal Leigh Hobba, a video artist from Tasmania. These art performance events rendered redundant the distinction between urban and traditional art practice.

Exchanges sometimes took the form of collaborative exhibitions. In 'Bulawirri–Bugaja: A Special Place', at the National Gallery of Victoria (NGV) in 1988, Melbourne and Maningrida artists exhibited together, clearly demonstrating their mutual influences. Of particular note is Les **Mirrikkurriya**'s bark painting *Petrol Sniffer*, 1988 [*254*], painted in response to Lin Onus's canvas of the same name, painted in 1986 following his first visit to Arnhem Land [see 20.6]. In 1993 in Sydney the exhibition 'Continuity', a collaboration between Boomalli, ANKAAA (Darwin), and Desart (Alice Springs) [see 21.2; **art and craft centres**] set out to show the continuity of cultural traditions that unite Indigenous artists across time, media, and regions throughout the continent. The Yiribana Gallery, which opened at the AGNSW in the following year, dedicated its space to Indigenous art. It dismantled the cultural apartheid between Aboriginal people of the north and the south through the use of multiple themes and non-chronological juxtapositions. Meanwhile the landmark exhibition 'Balance 1990. Views, Visions, Influences', held in Brisbane, expanded the definition of inclusiveness to incorporate all artists—black and white—who were guided by Indigenous themes and practices. Cultural and artistic equality was accorded to all forms of expression, from a painted Nissan truck [see also 20.5] by Jonathan Kumintjara **Brown** [*299*] and Lin Onus, to painted trays by Nyungah artist Donny Smith, a carved snake by South Australian artist Billy Coolwell, and a painting by Colleen Williams (now Wall), entitled *A Foot in Both Camps*, which echoed the theme of dual existence evident in works of the 1980s. These works, which may be read as cultural texts, assert the irreconcilable presence of two cultural art traditions, confirming a duality that does not need to be reconciled [see **reconciliation**]. They resist definition as low or high art, as decorative art or kitsch. 'Balance 1990' treated them as seriously as paintings on canvas by the more widely recognised artists also included—Gordon Bennett, Judy **Watson** [*40, 402*], and non-Indigenous artist Tim Johnson. The exhibition was 'a genuine historical breakthrough—an event that shattered the conventional practices of art museums', according to art academic and reviewer Rex Butler.

Indigenous art goes international

By the 1990s Indigenous art had moved from the relative obscurity of the 1970s through a decade of increasing visibility. The 1990s saw a proliferation of exhibitions, funding opportunities, and forays into the international arena. 'Tagari Lia: My Family. Art from Australia', held in Glasgow in 1990, has been described as the first international exhibition fully managed by the Indigenous people whose culture was being represented. Exhibitors included Pooaraar (Bevan Hayward), and many of the artists already mentioned. It was supported by the Australia Council. Cross-cultural interactions broadened to include indigenous artists from other countries. Boomalli now stepped into the international arena through exchanges with Native American Indian artists such as Edgar

Heap of Birds and black British artist Eddie Chambers, while the Campfire Group initiated cultural exchanges in Finland and Norway with Sami artists in 1993 and 1994. Individual artists—**Rea** [*174, 276*], Brenda L **Croft** [*46*], Judy Watson, Arone Raymond Meeks, and Gordon Hookey [*312*]—took up residencies in locations as far-flung as New Caledonia, Western Samoa, Hong Kong, China, Canada, France, India, Italy, the UK, and the USA. Public art institutions supported major international exhibition events with an urban Indigenous presence such as the Asia–Pacific Triennial of Contemporary Art at the Queensland Art Gallery in Brisbane in 1993, 1996, and 1999, at the AGNSW with the Sydney Biennale and Perspecta from 1989, at the Adelaide Biennale, and, from 1987, the Artist Regional Exchanges in Perth.

During the 1990s Australia was represented by five Indigenous artists at two separate Venice Biennales: in 1990 Trevor Nickolls and **Rover Thomas** [*136, 219*] were featured, followed in 1997 by Emily Kame **Kngwareye** [*123, 216, 225*], Yvonne **Koolmatrie** [see 17.1; *159*], and Judy Watson. Indigenous art also featured at the Havana Biennale, the first Johannesburg Biennale in 1995 (Destiny **Deacon** [*66, 67, 277, 314*] and Brenda L Croft) and Art Cologne (from 1993 onwards) and was included in exhibitions in Beijing, Oxford, London, Paris, Buenos Aires, Kyoto, Tokyo, Seoul, and New York.

The art of self-definition

The emphasis on **native title** precipitated by the **Mabo** case in 1993 kept issues of reconnection to land, spirituality, and kinship to the fore in the 1990s. Bronwyn **Bancroft** [*287*] and Sally Morgan depicted their relationship to country and family in generally high-keyed works, celebrating and commemorating through personal or collective stories in mainly figurative narratives. Judy Watson's more abstract and minimal canvases evoke strong spiritual connections with a retrieved past. Bendigo artist Gayle **Maddigan**'s [*350*] lush gestural works connect with the vitality of the ceremonial and spiritual life of the Dja Dja Wrung and surrounding clans of the Bendigo region. Installation artist Nicki **McCarthy** [*345*] addressed the metaphysical beliefs of her people through the use of test tubes, lights, feathers, and sand.

Other artists have retained connection to country and heritage through a reinterpretation of traditional forms and practices. Queenslanders Rick Roser and Laurie Nilson have used wood, found objects, and mouth-blown hand stencils in ochre. Torres Strait Islander Ken **Thaiday**, Sr [*157*] constructs mechanical dance machines [see 7.4, 7.5] and head-dresses from new and found materials. **Rock-art** motifs from the Laura region in Cape York [see 5.1; *51*] are referred to in the paintings of Cairns painter Zane **Saunders** [*379*] and inscribed in the ceramic surfaces of the pots of Thancoupie and **Jenuarrie** [*333*]. Sydney artist Euphemia **Bostock** is inspired by the traditional possum-skin cloaks of the south-east in her fabric designs, and her daughter Tracey Bostock adapts motifs from Bandjalang country in her paintings, as she explores her matrilineal links.

The work of some artists is more autobiographical in character. Elaine Russell and HJ **Wedge** [see 12.5; *171*] document stories of growing up on missions, and South Australian artist Ian Abdulla records life off the mission on the banks of the Murray River with a combination of image and text. Jody **Broun** [*298*] from Western Australia also deals with mission life and other contact situations; there is a sense of the surreal in her documentary style. The work of Julie **Dowling** [*24*], also from Western Australia, is distinctive: she connects with her heritage by exploring family history through portraiture. She deals in complex social and political commentary, narrating life stories by interweaving Western religious and commercial iconography with Aboriginal iconography and with historical and personal events. Her topics range from child abuse, to the stolen generations, and her own identity—the dilemma of looking white and being black.

Self-representation was brandished like a double-edged sword in the 1990s, countering negative stereotyping but also projecting images of the future. Richard **Bell** [*294*] waged war on what he calls the sanitisation and sterilisation of our **history** and 'wants to expose that, and the belief that says if you tell a lie often it becomes the truth' (cited in Chambers et al. 1994). In *Dreamtime/Nightmare*, 1993 (exhibited in 'Urban Focus', NGA 1994) he poses Aboriginal children as future Prime Ministers and Ministers, and himself in various roles as Minister of Armed Forces, Police, and White Affairs, offering new fictions that—if portrayed often enough—could become true. Describing himself as 'intellectual terrorist' he confronts racism in all its forms head on, firing images and words like missiles into the hearts of the guilty. He stands parallel to Gordon Syron, whose more literal confrontational style makes him a lone but known maverick, a 'visible invisible'.

Many artists in the 1990s have pioneered new conceptual spaces, and they have exploited new technologies to critique historical representations. They seek 'to enmesh non-Aboriginal viewers in a space of competing social, cultural and historical representations as a metaphor for the unequal power structures marking the relations between Australians' (Genocchio 1997–98). The observer becomes the observed in the work of multimedia artist–photographer Rea who deals with issues of invisibility and gender. In telling ethnographic reversals she turns the camera on the voyeur in *Highly Coloured O My life is coloured by my colour*, 1993. She expands this concept in the installation *Eye/I'mma Blak Piece*, 1996–97 in which grids of mirrors capture images of the viewer, mirroring the prejudices of non-Aboriginal viewers as displayed in the kitsch representations of the Aboriginal garden gnomes placed near by. Gordon Bennett had deployed mirrors and Black Sambo images in a similar way in *If Banjo Patterson was Black*, 1995, using the metaphor of narcissism to draw the viewer into self-reflection through competing representations of history. Other artists such as Brook **Andrew** [see 12.4; *170*], Gordon Hookey, Clinton **Nain** [*173, 300*], and Bianca Beetson use kitsch, as exemplified in objects such as tea towels and plastic toys, to reappropriate images of Aboriginal identity constructed by the coloniser. In recontextualising these images they return the gaze in a process of redefinition. Encased in the ironies of black humour, a new and surreptitious form of activism is unleashed.

Indigenous artists are now addressing global and abstract themes, in the light of localised experience. Melbourne-based artist Ellen **José** [see 7.2, 7.4] draws on her Torres Strait Islander heritage to express concern for the global environment by combining a bamboo construction based on the *nath* (dugong trap), computer-generated imagery, and paintings in her pivotal work *In the Balance*, 1994. In another installation, *RIP Terra Nullius 26 June 1788–3 June 1992*, 1996 [*158*], she creates a Torres Strait tombstone installation [see 1.6] to comment on the colonial concept of terra nullius. Tasmanian artist Karen **Casey** explores the spiritual aspects of water, light, sound, and movement across cultures, time zones, and place. These elements are combined in her installation *Dreaming Chamber*, 1999 [*65*] which employs state-of-the-art computerised systems to articulate wave patterns in symphony with the haunting sounds of wind instruments such as the Ainu harp, the **didjeridu** and highland flutes from Papua New Guinea, orchestrated by collaborating sound artist, Tim Cole [see 5.6]. In a re-creation of her lounge room at Brunswick Street, Melbourne, in the Second Asia–Pacific Triennial of Contemporary Art, 1996 in Brisbane, Destiny Deacon makes a statement of self-representation which reverses the museological representation of the 'primitive habitat'. In her installations Tasmanian artist Julie **Gough** [see 4.4, 11.5; *48*] critiques the scientific aspect of this containment, in which Indigenous people have been historically represented and defined using display cases, specimen containers, and instruments for classification and categorisation.

The *Aboriginal Memorial*, 1987–88 [see 6.3; *38, 74*], an installation of 200 hollow-log coffins from Arnhem Land, now in the collection of the NGA, inspired a number of urban artists to create memorial sites outdoors. A multi-media installation of used telegraph poles entitled *Edge of the Trees*, by Fiona Foley and Janet Laurence, marks a significant Eora site outside the Museum of Sydney, while Foley's engraved stone memorials entitled *The Lie of the Land*, 1997 [*164*] mark a site at the Museum of Melbourne. Brisbane-based painter Ron **Hurley**'s *Geerabaugh Midden*, 1995, comprising six, nine-metre carved ironbark poles placed on the banks of the Brisbane River, echoes the serpentine motions of the rainbow serpent and represents the six clan groups—from South Australia to Coolum in Queensland—who hold parts of the story. The creation of heritage walking trails [see **cultural heritage**] as public art by Koori artist Donna **Leslie** [see 18.4; *341*] and Murri artist Laurie Nilson [*227*] deals with concepts of 'caring for country'.

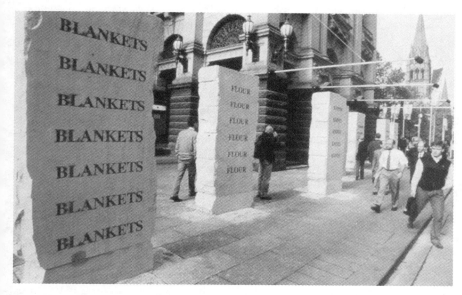

164. Fiona Foley, *The Lie of the Land*, 1997. Sandstone, 7 blocks, each 300 x 100 x 50cm.

The Indigenisation of Australia

In the new millennium, the voices of Indigenous artists are becoming increasingly heterogeneous, pervasive, sophisticated, and self-defining. Something which started in the politicised public spaces of the streets has now penetrated the interior white spaces of the establishment art world in Australia and overseas [see 21.1]. The multiple zones of production for Indigenous art reveal a mobile space of fluid identities that overlies and disrupts the Western concept of the postcolonial. Indigenous artists have colonised spaces once denied them—viewed from their perspective the postcolonial space contains the Indigenised Other. Lin Onus's *Fruit Bats*, 1991 [*163*], occupying pride of place in the institutionalised space of the AGNSW, symbolises an act of decolonisation. It appropriates the Hills Hoist, icon of the great Australian back yard, and Indigenises it—and the white Australian's 'sacred place'. Two Qantas jets [*280*]—flagships of the national airline—wing their way around the world bearing designs commissioned from Balarinji, an Aboriginal-managed company. On the approach to Sydney, the chief steward may be heard to announce, proudly, that 'You are travelling in the world's largest modern art work.' The marketing of Australia now rides on the back of contemporary Indigenous art: the Australian experience is Indigenised.

MARGO NEALE

Aboriginal Arts Australia, *Art & Aboriginality 1987*, Sydney, 1987; Boomalli Aboriginal Artists Co-operative, Special issue newsletter, no.3, Autumn 1996; Butler, R., 'The best painting in Brisbane? Emily Kame Kngwarreye at Fire-Works Gallery', *The Review*, September 1996; Caruana, W., *Aboriginal Art*, London, 1993; Chambers, E., INIVA, & Boomalli Aboriginal Artists Co-operative, *True Colours. Aboriginal and Torres Strait Islander Artists Raise the Flag*, Sydney, 1994; Croft, B. L., 'Boomalli: From little things, big things grow', in L. Taylor (ed.), *Painting the Land Story*, Canberra, 1999; Genocchio, B., 'Activism and Audience in Urban Aboriginal Art', *Eyeline*, no. 35, summer 1997–98; Isaacs, J., 'Urban Aboriginal art: Fiona Foley on Aboriginality in art, life, and landscape, from a discussion with Jennifer Isaacs', *Art Monthly*, no. 30, 1990; Johnson, T. & Johnson, V. (eds), *Koori Art '84*, Sydney, 1984; Johnson, V., 'Into the urbane: Urban Aboriginal art in the Australian art context', *Art Monthly Australia*, no. 33, 1990; Meeks, R. J., 'Artist statement', in T. Johnson & V. Johnson (eds), 1984; Morphy, H., *Aboriginal Art*, London, 1998; Neale, M., *Yiribana: An Introduction to the Aboriginal and Torres Strait Islander Collection, The Art Gallery of New South Wales*, Sydney, 1994; Nickolls, T., 'Artist statement', in T. Johnson & V. Johnson (eds), 1984; Ross, W., (ed) *Art Network*, vol. 1, no. 1, November 1979.

12.2 Aboriginal protest art

Which came first? Was it the crudely daubed 'Go Home Nigger' signs painted on wooden fences around Redfern and Surry Hills, Sydney? Or was it Gerald (Gerry) Bostock's razor-sharp confrontational comedy reply, *Here Comes the Nigger*, which opened at the National Black Theatre in 1975 and was later considered valuable material for a documentary by the well-known non-Indigenous actor Bryan Brown and the Australian Film Commission [see 14.1, 16.1]?

The early 1970s was a time of upheaval, but also of rapid progress in race relations in Australia. Aboriginal people were frustrated at the lack of action following the **referendum of 1967** which, for the first time, acknowledged Aborigines' citizenship in their own country. They were disenchanted at the white community's hypocritical stance against apartheid in South Africa, evidenced by large, well-organised, and often violent protests around the country against a touring all-white Springbok football team.

At the time, rural Aboriginal people, in the main, lived in the squalor of maladministered government reserves and missions, where they subsisted on basic rations issued by mission managers [see 4.1, 9.5, 9.8, 11.1]. These were sometimes withheld, plummeting whole families into starvation for petty misdemeanours or lack of adherence to ad hoc and arbitrary rules. Generally, urban Aborigines lived in overcrowded conditions under the aegis of slum landlords. They were subjected to special conditions—including the removal of their children [see **stolen generations**]—imposed by Aboriginal welfare departments, and lived under constant threat of now well-documented police harassment and imprisonment [see **prison art**]. Both urban and rural Aboriginal populations suffered appalling health [see 20.6], low life expectancy, high unemployment, and high levels of discrimination. Under pre-referendum government policies, Aboriginal people had been without legal access to schools, and consequently laboured under high rates of illiteracy and innumeracy. The emergence of the concepts of equal opportunity and human rights, and of anti-discrimination laws, were still a decade in the future.

The 1967 referendum, with its implied suggestion of equality, was somehow expected to alleviate some of these desperate and appalling conditions. When improvements failed to eventuate, Aboriginal people felt the need to articulate their anger and concerns. But how could a poor and completely white-dominated minority make their voices heard when access to the media was totally controlled by non-Aborigines?

The answer was in the arts! Unable to afford full-page advertisements in the daily newspapers, television commercials, or even basic canvas and oils, Aboriginal people

were compelled to improvise outlets to explain to the uninformed public their perspective on the country's history, the tragedy of their current situation, and their righteous rage and deeply felt passion for justice.

From the extreme 'Create Equality—Buy a Black a Gun' slogans painted on paling fences around Sydney's inner city, to the more moderate 'Aboriginal Family Reunion—Invite Your White Relations' car stickers printed and distributed in Cairns, north Queensland, each in its own way attracted a variety of violent repercussions from sections of the white society that had become comfortable with the racist status quo. **Graffiti** became a sort of 'newspaper of the streets', a way of publicising the names of many Aborigines unjustly imprisoned or killed by police. Cheaply produced 'Free Lionel Brockman' buttons helped alert the country to inequity in Western Australia where, at the cost of hundreds of thousands of dollars, this Aboriginal father of eleven was being hunted down across the desert, along with his brood, by hundreds of police in small planes, helicopters, and four-wheel-drive vehicles—for the theft of band-aids, powdered milk, and baby food.

Visual depictions of injustice began to emerge from the prisons, the most famous of which became Gordon **Syron**'s *Judgement by his Peers*, 1980 [*165*]. In this painting, the juxtaposition of a judge, jury, and legal representatives—all black—sitting in judgement of a lone, white offender produced much greater consternation among the viewing public than would have been occasioned by the more familiar, and therefore more acceptable, sight of an all-white court scene with a lone, black offender.

Aboriginal performing arts were played in the streets as well as in the theatre. The Aboriginal/Islander Dance Theatre's rendition of *Embassy* [see 16.5; *206*], based on the 1972 struggle between Aborigines and the police at the Aboriginal Embassy [see **Tent Embassy**; *49*] in Canberra, was a major tour de force, being performed overseas as well as across the nation. Robert Merritt's play [see 16.1], *The Cake Man*, a depiction of the mission lifestyle—of hope, despair, and imprisonment—was first performed at the National Black Theatre in 1975 while the author was still a prison inmate. The irony of the playwright's arrival under prison escort on opening night was not lost on the majority white audience. In 1977 *The Cake Man* enjoyed a season at the Bondi Pavilion Theatre, and was later broadcast on television on the ABC.

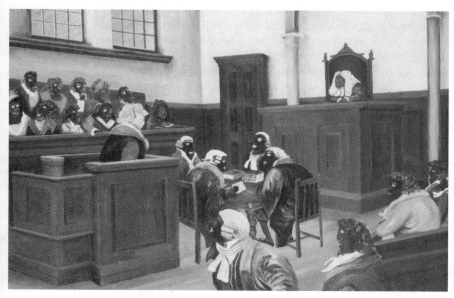

165. Gordon Syron, *Judgement by his Peers*, 1978. Oil on canvas, 75 x 105 cm.

It seems strange now, but the simple yet stunning black, red, and yellow Aboriginal **flag**, designed by Harold Thomas in 1971, was held in contempt and denigrated by many non-Aborigines for more than a decade after it first appeared. Some politicians and representatives of the media, including the *Townsville Daily Bulletin*, referred to it as the 'Black Power' flag, and, by implication, anyone who displayed the flag, or wore a flag patch on their sleeve or button in their lapel was considered both militant and subversive.

Equally inexplicable, in retrospect, was public reaction in the 1970s to the phrase '**land rights**'. Although the slogan 'Land Rights Now' was used as a common chant during demonstrations, it was considered to be so confrontational at the time that Aboriginal community leaders, some of whom veered right away from uttering the words in conversation, quietly suggested that its use be limited to demonstrations. For the phrase to become more acceptable, they said, it would have to be included in the graffiti 'newspapers' so the public could become familiar with it.

The impact of protest posters [see 12.3; *162, 166*] created for use in demonstrations was immeasurable. In 1966, for example, over a thousand kilometres from any of the urban centres, the Gurindji people staged a strike against their exploitative working and living conditions on Wave Hill station. The station, which is situated on land for which the Gurindji are the historical custodians, was leased by government at fifty-five cents per square mile to the wealthy London-based Vestey cattle and shipping empire. A research project conducted by the Australasian Meat Industry Employees Union revealed that, in the area, young girls were raped by stockmen (who considered this to be a way of avoiding venereal disease). Support for the strike and for action by the Gurindji to lay claim to nearby Daguragu (Wattie Creek) was forthcoming from a host of mainly left-leaning trade unions, university student groups, and Aborigines and their supporters around the country. It was, however, a simple placard, bearing the message 'Vesteys suck Black blood', strung around the neck of an urban Aboriginal demonstrator and carried further afield by newspaper coverage, that galvanised Lord Vestey into action to protect his family's name from the shame of such negative publicity. With his concurrence, Wattie Creek was handed back to the Gurindji people by Gough Whitlam and his Labor government in 1975 [see *340*].

Protest poetry informed the public's understanding of the dire condition of race relations, and the early examples of this genre, in particular, can be viewed as the logical extension of traditional Aboriginal songlines. Kath Walker, who changed her name in the 1980s to **Oodgeroo** of the tribe Noonuccal [see 14.3], was the first poet to break through the barriers and have her work appear in print with *We are Going* (1964) and *The Dawn is at Hand* (1966). She was followed by west coast poet Jack **Davis**, who later won international acclaim as a playwright, and by Gerry Bostock and Maureen Watson, both of whom have earned accolades for their poetry and storytelling presentations [see 14.1].

But public protest art was not just the domain of people whose names became famous over time. A small, anonymous hand-lettered sign painted on a stone set at ground level in a rockery near Redfern Post Office, just half a block from the Aboriginal Medical Service, became the focus of attention for thousands of Sydney inner-city dwellers who walked past it and pondered its significance:

> PLEASE GOD
> TAKE BACK
> BLACK

Was this message, as some thought, the work of a poetic racist—or, as most felt, a deep cry of pain from a very young Aboriginal person expressing his or her view of the negative reaction black skin so often attracts? The question remains unanswered.

The protest imagery and slogans of the 1970s continued as valuable currency for more than a decade. A later National Aborigine and Islanders' Day Observance Committee (NAIDOC) poster, as one example, carried a depiction of the Aboriginal Embassy which had been erected on the front lawns of Canberra's Parliament House in 1972. On the glossy paper, a few poorly-attired Aboriginal youths are seen standing beside the ragged tent of the embassy above which flies an Aboriginal flag, while beneath are emblazoned the words: 'Justice—Or Just This?'

More than a quarter of a century later, however, and despite enormous changes including the growth of white national support movements such as Women for Native Title and the creative Sea of Hands, thousands of Aboriginal people around the country are still forced to continue living in conditions which the embassy represented—without power, or access to clean water, or even basic environmental health facilities. Protest art in its many forms still has a major role to play, and it will remain an essential tool for a significant majority of the Aboriginal people who have few other means to convey their demand for equality and justice.

It is therefore both a wondrous and incongruous sight to many Aboriginal people who lived through those troubled times of the 1970s to see, now, the jam-packed audiences, predominantly composed of white Australians, many sporting the Aboriginal colours to demonstrate their solidarity, tapping their feet, clapping their hands, and singing along with **Yothu Yindi**'s *Treaty* and other Aboriginal protest songs of this new generation.

From small seeds, great trees grow.

ROBERTA SYKES

12.3 Indigenous political poster-making in the 1970s and 1980s

The 1970s saw a dramatic rise in the use of the political poster as a dynamic communicative medium. The screen-printed poster was attractive to artists and political activists of this era because of its potential rapidly to inform and galvanise the public on a range of social issues. Here was a creative medium which broke down the barriers between high art and popular culture through the use of bold and simple formats, with production values of relative speed and economy. Posters were destined for temporary display in the street environment. In this public space they competed with advertising, were subject to vandals, and risked being removed or replaced. Thus each poster had to grab the attention of the passer-by, using direct—and often witty—vocabulary [22, *161, 166, 252, 253*].

Political poster-making was in part made possible by the rise in community arts workshops across Australia from the mid 1970s to the early 1980s. The medium thrived on the desire of many young artists to practise collaboratively, and the implementation, in the early 1970s, of the Whitlam Labor government's policy of increasing community access to, and participation in, creative activity. The establishment of arts workshops, either independently run or attached to community centres, hospitals, and prisons [see **prison art**], led to new opportunities for individuals and organisations to make use of the poster medium.

Nindeebiya Aboriginal Workshop was an early example of a community-based art workshop serving an Aboriginal population. Based in Fitzroy, in inner Melbourne, Nindeebiya began operations in 1976 with small grants from several funding bodies. Offering a program of arts and crafts, the workshop sought to reduce the effects of social problems such as alcohol and drug abuse. Activities included screen-printing [see **printmaking**], mural design, and painting. From the outset, Nindeebiya worked closely with other local Aboriginal community organisations, applying creative skills to practical ends in the promotion of activities and services. As described by Sharon Firebrace, the

166. Byron Pickett, *Aboriginality,* 1986. Screen-print, 34.5 x 49.3 cm. In this image of three men set against a brick wall, Pickett comments on the changing life of Aborigines over the last two hundred years. On the left is the traditional elder, in the middle a station hand, and on the right an Aborigine of today, a self portrait of the artist.

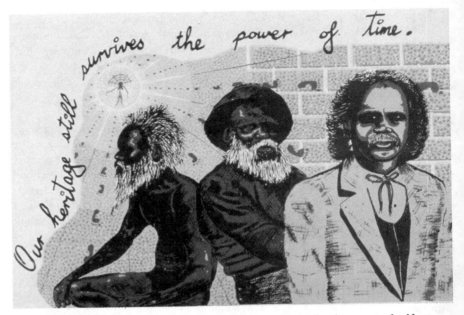

aim of the Nindeebiya program was to 'encourage the re-development of self-esteem and self-determination amongst our people and to re-establish pride in our rich culture'. Nindeebiya was supported in this venture by interested professionals, students, and tertiary institutions.

Notable creative partnerships between Indigenous individuals and organisations and arts workshops were to be found across Australia during the 1970s and 1980s. Initially, few of the posters were directly produced by Aboriginal artists or community members, rather they were the result of commissions or empathetic political and personal relationships which had developed between Aboriginal and non-Aboriginal bodies and individuals. This situation changed somewhat with increased Aboriginal access to formal and informal art education.

Poster collectives such as Earthworks and Lucifoil and workshops such as the Tin Sheds, Redback Graphix [see *252, 253*], and Garage Graphix Community Art Workshop in Sydney, Redletter Press and Another Planet Posters in Melbourne, Megalo Screenprints in Canberra, Community Media Association in Adelaide, and Jalak Graphix–Green Ant in Darwin were responsible for the co-production of posters which dealt with topical and long-standing Indigenous concerns such as **land rights**, justice, health [see 20.6], and welfare. Whilst many of these posters were immediately useful in protest actions and in raising awareness, some have come to be iconic in the definition of Aboriginal struggle and triumph: for example the 1985 Uluru 'handback' poster, *Nyuntu Anangu Maruku Ngurangka Ngaranyi—You Are On Aboriginal Land* [*22*], a joint production between Chips Mackinolty–Green Ant Design and the Mutitjulu Community.

Perhaps the best known Indigenous screen-print of this era resulted from community access at the Tin Sheds. Avril **Quaill**'s 1982 poster *Trespassers Keep Out!* [*162*] was originally produced for exhibition and sale to raise awareness of land rights. The use of a historical photographic image featuring North Stradbroke Island personality, the enterprising Tommy Nuggin, makes the resulting poster ambiguously rich—is the figure locked out from his lands, or is the European configured here as trespasser? The bold and strategic use of the colours and design of the Aboriginal **flag** in Quaill's poster quickly garnered the interest and sympathy of its audience. Indeed, the colour field of

black, red, and yellow has become a ubiquitous political sign in Indigenous posters. Beyond its initial exhibition the poster has enjoyed a second life. It has been both widely collected and reproduced in numerous publications, not only to exemplify the artist's work, or to represent Aboriginal printmaking, but also to illustrate Aboriginal pride in culture and determination in securing land rights.

In any consideration of the production of posters by Aboriginal artists, Garage Graphix Community Art Workshop, formed in 1981 in western Sydney, should perhaps be singled out for comment. Founded by feminist artworkers and activists, Garage Graphix sought to provide women and children in the local community with a venue to pursue creative activity and a means for voicing their concerns—domestic and other-wise. In its early years, an Aboriginal arts program encouraged community access to facilities, offered skills tutelage within community projects, and undertook the occasional production of commissioned posters. The availability of Commonwealth government employment programs enabled Alice Hinton-Bateup to train as screen-printer and designer. Community demand in the 1980s for access to this highly successful program led to the employment of other Aboriginal artists—significantly Gary Jones—and trainees on a project-by-project basis, the whole administered by a designated Indigenous staff member.

The poster work that emerged from Garage Graphix was diverse in style, but remarkably consistent in terms of the way social and topical issues were addressed. This had much to do with the close working relationships that were established. Collaboration did not only involve resolving aesthetic or technical problems; the politics presented were often discussed and argued around the table. Co-authoring of posters was acknowledged by members of Garage Graphix—indeed in printing their workshop's logo upon most pieces of work, they claimed each poster as a product of collective effort.

The poster work of Garage Graphix and its Aboriginal arts program is a significant historical record, revealing Aboriginal perspectives and voices of a particular era. Despite addressing broad-ranging social issues, the poster work is not without a deeply local flavour. Local issues and personalities have been used within posters to serve the community and generate discussion and debate. These are works which offer positive declarations of Aboriginal identity, activity, and possibility, where even the gravest of issues have been spared a melancholic or defensive treatment.

In regional Australia, the enthusiastic support of the Australia Council [see **Aboriginal Arts Board**], together with civic councils, tertiary institutions, non-arts government bureaus, and umbrella organisations such as the Print Council of Australia, made possible a range of innovative arts programs involving the provision of art workshop facilities, artist residencies, and the training and employment of Aboriginal artists. An individual who benefited and made a significant contribution to the poster medium was Byron Pickett. A Western Australian, Pickett had moved to Port Lincoln (SA), where in 1984 he was employed with the Eyre Peninsula Cultural Trust. Its training program equipped Pickett with skills in screen-printing and poster production, including drawing and photography. Subsequently he led poster-making workshops for interested members of the local Aboriginal community. The dozen posters and limited edition screen-prints which emerged from Pickett's traineeship and artist residency were made generally available through sale, local display, and a State-wide tour in 1985. Their content ranged across personal and political issues facing Aboriginal Australians, including racism, identity, place-relatedness, and the environment. For many Aborigines and non-Aborigines in the Port Lincoln community, Pickett's position as community artist and the posters which resulted were a point of pride; they were considered evidence of municipal progress. At another level his posters struck many as truly revelatory, not only

because they laid bare the contemporary experience of being Aboriginal, but because through the use of personal narrative they humanised the Aboriginal Other.

Distinct differences have emerged in the practice of Indigenous poster-making in urban and regional or remote settings. The environment, the artists, their tutors, and the purpose of production are all influential and form the basis of an encompassing political context. In remote communities poster-making has been largely subsumed by the production of printed fabric or limited edition prints which refer to or replicate traditional designs.

Urban Indigenous artists of the 1980s have used printmaking as both a preferred and supplementary expressive medium. Few, however, have engaged more than occasionally with overt political poster-making. Formally trained Indigenous artists such as Fiona **Foley** [see 23.3; *2, 63, 164*], Gordon **Bennett** [see 22.5; *265, 267, 275*], Arone Raymond **Meeks** [*64, 175*], Karen **Casey** [*65*], and Sally **Morgan** [*41, 384*] produce prints of a highly political nature, yet they are classified and distributed as limited edition fine art prints. But it might be argued that, far from diminishing their political impact, exhibition and collection by public and private institutions, where expert curatorship will allow each an expanded and reflexive life, enhances the status of these works as key historical documents.

Today, screen-printed political posters are produced with reduced frequency as, ironically, they have become too expensive and time-consuming relative to other media. For situations which demand large-scale distribution, the political poster now lives on through the enthusiastic embracing of technologies such as offset or digital reproduction, desk-top publishing, and colour photocopy. A key example from the late 1980s is the Northern and Central Land Councils' sponsored project 'We Have Survived', which saw the nationwide commissioning of twelve Indigenous artists to produce images for subsequent mass reproduction, reflecting on the theme of survival as a counterpoint to the 1988 bicentennial celebrations.

Indigenous political poster-making forms an integral part of the political actions and creative efforts of the many involved in the struggles of Indigenous Australians. Political posters leave a significant legacy: they are important social documents bearing cumulative witness to an era; they had a role in informing and educating the broad populace; and the medium has given form and very public expression to Aboriginal voices.

LEE-ANNE HALL

Butler, R., *Poster Art in Australia: The Streets as Art Galleries—Walls Sometimes Speak*, Canberra, 1993; Firebrace, S., 'Nindeebiya Aboriginal Workshop', in C. Merewether & A. Stephen (eds), *The Great Divide—An Ongoing Critique of Australian Culture Under Capitalism: Reviews of Oppositional Cultural Work and an Examination of Socialist Models*, Fitzroy, Vic., 1977; Hall, L. (au.); Brown, K. (ed.), *Who is Bill Posters?* North Sydney, 1988.

12.4 Is there an Aboriginal photography?

'Is there an Aboriginal photography?' asks Mervyn **Bishop** in his 1989 self-portrait of the same name [*167*]. In this witty photograph, Bishop holds a tiny, toy camera to his right eye in a gesture that questions the desire to narrowly define and experience his work as 'Aboriginal'. This visual gambit of title and image also refers to Aboriginal photography's relatively recent history—which Bishop's *oeuvre* pre-dates by more than twenty years. Through his work as a press photographer with the *Sydney Morning Herald* (where he began a four-year photography cadetship in 1962), and later employment with the newly established Department of Aboriginal Affairs in Canberra, he inadvertently

167. Mervyn Bishop, *Is There an Aboriginal Photography?* 1989.
Gelatin silver photograph, 50.8 x 61.0 cm.

excluded himself from areas of photographic practice deemed suitable for exhibition, research, and scholarly publication. It was not until his work was displayed in the 'NADOC '86 Exhibition of Aboriginal and Islander Photographers' (the first exhibition of the work of Indigenous photographers) at the Aboriginal Artists Gallery, Sydney, that it received exposure beyond the press and departmental publications.

Following the landmark 'Koori Art '84' exhibition [see 12.1], 'NADOC '86' similarly attempted to introduce both contemporary Indigenous artists and contemporary Indigenous issues to the mainstream, but focused on a medium that had been largely unrepresented in 'Koori Art '84'. Of the artists represented in 'NADOC '86'—Mervyn Bishop, Brenda L **Croft** [*46*], Tony Davis, Ellen **José** [*158*], Daryn Kemp, Tracey **Moffatt** [*169, 244, 326*], Michael **Riley** [*373*], Chris Robertson, Tony Shewring, and Ros Sultan—only Michael Riley was included in both. Not all of these artists have continued as exhibiting photographers, but the exhibition nevertheless signalled the diversity of practice that was to emerge in future years. Tracey Moffatt's *The Movie Star: David Gulpilil on Bondi Beach*, 1985 [*326*], for example, foreshadowed the manner in which she was to grapple with and interrogate the issues surrounding Indigenous identity and its photographic representation. Her postmodern style, already evident here, was to differ significantly from the various photographic responses by her colleagues to the politics of the late 1980s.

'NADOC '86' included Bishop's iconic *Prime Minister Gough Whitlam Pours Soil into Hands of Traditional Land Owner Vincent Lingiari, Northern Territory,* 1975 [*340*], a photographic 'record' of the theatrical climax of one of the first successful land claims [see **land rights**] by Australia's Indigenous peoples. However, the picturing of this symbolic triumph of the traditional landowners of Daguragu (Wattie Creek)—the culmination of a political battle that had commenced eight years earlier as a demand for equal wages by striking Aboriginal pastoral workers—was a restaged event. Bishop, ever-conscious of the perfect photo opportunity, invited the participants to step out into the bright northern sunlight from the bough shed where the ceremony had taken place. The result was the quintessential photographic text—a totally re-created scene that has been read in hindsight as photographic truth. The pathos of the photograph remains, however, in the contrast between Whitlam's conscious ministerial action and the very human, everyday touches of Vincent Lingiari's handsewn jeans and cataract-filled eyes.

An increasing number of Aboriginal Australians had access to an art school education during the 1980s, and this was an important factor in the arrival of Indigenous photographers onto the Australian art scene during the period. However, 'access' did not necessarily mean that the system accommodated the often different needs of Indigenous students. The increasing prominence of photography in contemporary art both in Australia and internationally may have influenced the students' choice of medium; yet their work was largely documentary, at a time when documentary practice had become both contested and unfashionable.

In some ways the very literal manner in which many Indigenous photographers first used the camera can be compared to the first wave of feminist writing of the 1960s. Theirs was a mission of re-presentation, of making Indigenous identity visible in ways in which they saw fit. While feminists rewrote patriarchal history, Indigenous photographers—now in control of the means of representation—were able to retake, re-present, reclaim, and largely reconfigure photographic representations of Aboriginality in ways that counteracted denigrating and stereotypical imaging. The predominantly documentary work of the artists in 'NADOC '86' (and others) was to be further stimulated by the activities surrounding Australia's bicentennial in 1988, which provided the impetus for a strong and compelling body of documentary photography that dealt very directly with the issues surrounding White Australia's celebration of its two-hundredth birthday.

The activities of this year culminated in a unique event that almost demanded, by its very nature, the directness of a documentary response. The Long March of Freedom, Justice, and Hope, attended by over 50 000 Aboriginal and non-Aboriginal people from around the country, protested the original invasion of Australia and its re-enactment in Sydney 200 years later, and celebrated Aboriginal Australia's cultural and spiritual survival in the face of that invasion [see **Survival Day**]. For artists like Brenda L Croft, Alana **Harris** [*387*], and Kevin **Gilbert** [see 4.5; *62*], the camera became a register of activities of resistance during this historical moment and was used to convey an overtly political message. Croft's *Michael Watson in Redfern on the Long March of Freedom, Justice and Hope, Invasion Day, 26 January 1988* [*46*] conveys the positive energy and exhilaration of this historic day while emphasising the importance of humour, both as a form of cultural cohesion, and as a necessary survival tactic in the face of adversity. Central to the composition of the photograph, the message on the subject's T-shirt functions as a lighthearted yet pointed reminder of the implications of terra nullius and Australia's history of invasion.

The support of older practitioners such as Mervyn Bishop and Kevin Gilbert for emerging photographers during this period was of utmost importance. The political awareness and strong cultural identity of Gilbert's work, particularly, was to influence an increasingly politicised younger generation of artists. A tireless campaigner for Aboriginal rights and sovereignty, Gilbert organised the 1988 touring exhibition 'Inside Black Australia' with unashamedly didactic intentions. Describing his work as 'tucker for the people', Gilbert employed the camera as a means to an end, subordinating aesthetics to content in an attempt to confront the predominantly white audience who would experience his images and, by extension, the exhibition. 'Inside Black Australia' was shown at Albert Hall, Canberra, and was timed to coincide with the opening of the new Parliament House, to which it was almost (and ironically) adjacent.

The inclusion of photographs by Torres Strait Islands artist Ellen José [*158*] in 'Inside Black Australia' speaks directly of the correlation between the immediacy of the camera and the increasingly politicised work of the Indigenous artists of this period. The activities surrounding 1988 prompted José (known for her far more lyrical work in other media) to produce and exhibit hard-hitting images of the Third World conditions in

which many Indigenous Australians continued to live. Fully aware of photography's exploitative past (and present), however, José's series of photographs from this period, of Lake Tyers in Victoria's Gippsland region and Fletchers Lake in south-western New South Wales, include a careful balance of sensitive 'environmental' portraits, where subjects display continuing connections to the land while living undeniably contemporary lives.

After 200 Years, edited by Penny Taylor, was also published in 1988. It was the culmination of a three-year photographic project that worked to overcome the problems associated with documentary photography and its role in the creation and perpetuation of negative images of Aboriginal people. While placing itself squarely within the documentary tradition, the project sought to invert the often negative perceptions (and outcomes) of documentary practice by insisting on a process of collaboration between the photographer and their chosen community. The twenty communities were selected to represent the diversity of contemporary Aboriginal life. A total of twenty Indigenous and non-Indigenous photographers worked in these communities for a period of up to two months. The project's strict guidelines ensured that participants were able to control and direct the work of the photographer, as well as determine the selection of images and accompanying texts for the associated publication and exhibition. The project aimed to overcome the polarising elements of the representation of Indigenous people—the romanticised Aboriginal person of the outback versus the down-and-outs in the city—leading the viewer to question widely held stereotypes (traditional, primitive, 'noble savage', victim) of Aboriginal life.

While *After 200 Years* was criticised at the time for its poor representation of Indigenous photographers and the fact that the project was jointly funded by the National Aboriginal and Torres Strait Islander Program and the National Publications Program of the Australian Bicentennial Authority, it did introduce, support, and continue to influence the work of emerging photographers such as Alana Harris and Ricky **Maynard** [*168*]. Harris's poetic *Rock and Reed*, 1991, for example, embodies a return to the subject of landscape that she focused on at the beginning of her career, and the power of Maynard's *Athol Burgess*, 1985 conveys the indelible mark left on his work by the experience of *After 200 Years*.

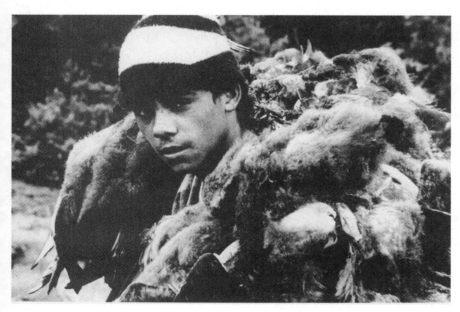

168. Ricky Maynard, *Jason Thomas*, from the *Moonbird People* series, 1985. Gelatin silver photograph, 19.4 x 30.2 cm.

The photo essay has continued to be a significant form of expression for Maynard, who has remained committed to documentary practice (and the related 'fine print' tradition). Following the consultative philosophy of *After 200 Years*, Maynard enables his sitters to tell their own stories through the use of their voices (more often than not) as titles for the images. As a result the photographs in his series *No More Than What You See*, 1993 depicting Indigenous experiences of imprisonment in South Australia and the later *Urban Diary*, 1997 convey a sense of trust and understanding in the relationship between photographer and subject that is essential to Maynard's working method and (political) intent [see **prison art**]. The notion of 'positive' images is particularly present in *Urban Diary*—photographs taken in the streets and parks of Melbourne's St Kilda and in Galliamble, an Aboriginal-run drug and alcohol rehabilitation centre—where the artist himself (like his subjects) was undergoing treatment at the time.

The very specific activities of 1988 thus stimulated a body of Indigenous photography which embraced documentary practice and in which the camera functioned largely as recording device. However, Tracey Moffatt's 'manipulated' images of this period (and earlier) show that Indigenous experience and identity could be explored just as successfully in the studio, reflecting the predominant practice of postmodern photography. Moffatt's *Some Lads* series of 1986, black and white photographs of male Aboriginal dancers cheekily playing up to the camera, revealed a unique and early artistic maturity that soon blossomed in *Something More*, 1989 [*244*]—a nine-part colour and black-and-white series that toyed with and contorted the notion of the visual narrative. Laid out like a storyboard for a B-grade film, *Something More* signalled Moffatt's ravenous appetite for incredibly varied source material, resulting in filmic treatments that remain open-ended. *Something More* plays tantalisingly with themes of race, sexuality, and gender that were to reappear in different guises in Moffatt's later works, and which led to the typecasting of the artist (as a contemporary, black, woman photographer [see 20.1]). As a result she refused for some time to allow her work to be included in exhibitions focused exclusively on Aboriginal or 'black' work. She has changed her position in recent years.

Moffatt's series of twenty-seven offset photolithographs *Up in the Sky*, 1997 [*169*] blurs the distinction between reality and fiction to the point that the images, as a body, present a bizarre, dreamlike vision in which narrative is thwarted and fantasy takes over. The audience's wonder and confusion at a melodrama—in which 'Sisters of Mercy' 'rescue' an Aboriginal child from an unidentifiable outback wasteland, the bodies of

169. Tracey Moffatt, *Up in the Sky* (detail), 1997. Offset print, 72 x 102 cm.

men are entwined, fighting in the dirt, and a community in pyjamas and bathrobes witnesses an undisclosed event—is further compounded by the unsettling camera angles, in which horizons tilt and perspectives are shifted. *Up in the Sky* was influenced both by American and European documentary photography of the 1940s to the 1960s, and by the 'grittiness' of black-and-white Italian films of the 1960s. Its international success is testimony to the fact that almost 'global' experience of Moffatt's sources and the cross-cultural ability to read them leads the audience to enact a visual role-play in which knowledge of the particularly 'Australian' threads of the story is not necessary.

The bicentennial year of 1988 was followed by a second wave of work by Indigenous photographers who had previously worked in the documentary tradition. In the years after the bicentennial Brenda L Croft adopted a very different style that travels two different but interrelated courses. The first, evident in series such as *The Big Deal is Black*, 1993 and *Strange Fruit*, 1994, focuses on producing photographs that extend the audience's understanding of Aboriginal identity through images that reflect Croft's close relationship with her largely female subjects. The second plunders her own family's photographic archive, reusing the humble snapshot to raise a variety of issues, including the role of photography in the shaping and interpretation of family history.

The title of Croft's series *Strange Fruit*—originally the name of song by Lewis Allen, made famous by Billie Holiday, about the hanging of blacks in the Deep South of the United States—immediately politicises the sumptuous colour photographs that comprise the work, making a direct link to Australia's own history of genocide and the related issues of grief, loss, and cultural destruction. Initially exhibited as an installation at the Performance Space, Sydney, the photographic component of *Strange Fruit* was displayed against wall panels of different colours labelled with their colour-chart names—'colonial beige', 'complexion', 'foreigner'—foregrounding the all-pervading nature of colonialism and the insidious relationship between racism and language. By titling her fragmented portraits of Aboriginal women with the names of well known and not so well known women 'of colour' from around the world, Croft refers to the collective nature of the battle against racism (as well as experiences of it), while reinforcing its specificity in an Aboriginal context.

The snapshot (that all-important record of family events) has, at the same time, become central to Croft's work. Her reuse of her family album in her contemporary images leads the viewer to ponder the difficulty of interpretation and the oft-raised question of photographic 'truth'. According to the artist, the use of the computer to combine text and archival imagery (something that she achieved earlier through collage in her 1991 *Family Album* series) is 'about trying to put [in] the bits that are missing out of the family album; the bits that we don't see'. Croft's use of language encourages the construction of various narratives: while intensely personal, the texts that overlay the images are also documents of broader, national issues, bearing witness to this country's chequered history of racial policies—such as assimilation—and their continuing impact on contemporary society.

Photography as archival record and the possibilities that emerge from the layering of time through images were also of concern to Leah **King-Smith** [*273*] in her 1992 series *Patterns of Connection*. In these large-scale colour images, King-Smith achieved atmospheric, almost dreamlike, effects by overlaying nineteenth-century photographs of Aboriginal subjects with her own contemporary painted and photographed images of the Australian bush. The artist's subtle layering, which is not unlike the ghosting created by double exposure in nineteenth-century spirit photographs, attempts to encourage the audience to 'activate their inner sight to view Aboriginal people'. King-Smith's stated intention also reflects the more contemplative mood of the work; an attempt, almost, at

'spiritual healing' rather than a call to action. Like the work of many Indigenous artists who use photography as their chosen medium, *Patterns of Connection* actively engages with the history of photographic representation of Australia's Indigenous people and its link to ethnography.

The early 1990s also signalled the arrival of a number of younger artists who burst onto the scene with work that readily embraced new technology and revelled in the influence of advertising and popular culture. The rough and ready aesthetic of Destiny **Deacon**'s bubble-jet prints [*277*; see also *66, 67*] and amateurish colour photographs, for example, stretches the boundaries of traditional conceptions of photography in a practice that deliberately flies in the face of the 'fine print' tradition. In fact Deacon's practice so reflects her experience as an urban Aboriginal woman living in the inner suburbs of Melbourne that it rarely extends beyond the parameters of her Brunswick living room–studio. As the artist says of the creative process behind *Eva Johnson, Writer*, 1994 [*314*], a work that not only appropriates but reclaims J. M. Crossland's painting of 1854, *Nannultera, a Young Cricketer of the Natives' Training Institution, Poonindie*:

I felt sorry for Nannultera when I first saw him at the NGA … A few years later I was stumped for image/s as an exhibition opening loomed days away. I looked about. Eva was at my place. Virginia Fraser too … From begging Eva (to pose) and Virginia (to make the set), it took less than an hour to get the image right. Improvising in the laundry. A couple of months later, the NGA and the National Library [who own Nannultera] both bought Eva's portrait. Now Nannultera won't have to be alone; Eva Johnson, writer, will keep him company.

In Deacon's work, explorations of race, sexuality, and gender are veiled in a humour which disguises, initially at least, its hard-hitting content. Not unlike her older peer Tracey Moffatt, Deacon choreographs constructed images that revel both in their artificiality and in a heightened sense of play. Female subjects are no longer victims of the lens. Fully aware of photography's power (and delight in the exotic), they are all too willing to 'play the game', but from a position in which they are now totally in control. For example, Deacon's mock video cover *Peach Blossom's Revenge*, 1995, a Mattress Actress Production, is a tongue-in-cheek satire on American war and action films that explores the positioning and objectification of the 'blak' female body in photography and film. Mass culture and the familiar codes of advertising, film, and television are among Deacon's diverse sources, resulting in images in which the domestic and everyday converge with fantasy.

Deacon's collection of 'Koori kitsch' and the use of her now renowned 'dollies' as protagonists in her work, speak of the desire to collect—and, by extension, control—Aboriginal people. As Juliana Engberg notes: 'These are the decorations and knick-knacks which helped to define the idea of "Aboriginal" in white Australia through the 1940s, 50s and 60s. Ashtrays with pictures of Aborigines, often grotesquely sketched, upon which cigarettes could be ground out. Decorative plates with Aboriginal children that could be hung up in the home as some exotic curiosity: like pets.' For the artist, however, this practice is something more: a rescue mission in which she retrieves these 'lost Koori souls', empowers them and restores their dignity and, by extension, the dignity of those they represent.

Rea [*174, 276*], another member of this next generation of Indigenous artists, launched her exhibiting career in 1992 with the series *Look Who's Calling the Kettle Black*, a vibrant body of ten images in which black-and-white photographs of Aboriginal women 'in service' are juxtaposed with the dictionary definitions used to define them. These 'archival' images of young women from the Cootamundra Girls' Home in New South Wales are then 'contained' in deliberately amateurish computer graphics of contemporary

domestic appliances, highlighting the destructive influence of Christian ideals that increasingly colonised the black female body by imposing morality in the guise of domestic cleanliness and bodily concealment. The role of the Church is also the subject of Michael Riley's atmospheric *Sacrifice* series (1993), which reflects upon the relationship between Indigenous Australians and Christianity. Through the use of symbols such as sugar, tea, and salt (mission rations), a Celtic cross inscribed with a dollar sign, and a crucifix on a necklace lying against black skin, we are able to feel, in this powerfully filmic work, Riley's personal struggle with the Church's doubly inscribed role as bodily protector (particularly of earlier generations) and destroyer of traditional culture.

Rea has stated (Carver 1996) that dying as a servant, as many of the women she depicted did, is simply another form of Aboriginal deaths in custody. This important issue is also the focus of her later large-scale colour work, *Definitions of Difference I–VI*, 1994. In pairs of images highlighting the difference between black and white experience, the artist juxtaposes symbols representative of these different race-related realities (and hence expectations) over different parts of her sister's body, representing both her own body and 'blak' women generally. An image of a hangman's noose draped down a young woman's back (blak experience) is juxtaposed to the same image with noose replaced by a string of pearls (white experience)—the audience is not permitted to read these images ambivalently. The sleek, sumptuous, and iridescent pink and blue surfaces of *Definitions of Difference* also serve to reinforce the message by squarely positioning the work within the contemporary realm. While the candy spectrum of Pop Art is an obvious influence, Rea's celebration of colour highlights the way in which it can function as a trigger for both memory and feelings—something very particular to her own, matrilineal family. The fragments of the black and 'white' body function as blank pages on which textual definitions are inscribed. These incongruous definitions link the work to the personal experiences of its creator (blak, lesbian, artist), and reference the visual symbol of the noose, while simultaneously highlighting the manner in which language continues to both dominate and control Indigenous (and particularly female) experience.

Sexuality and gender are also central to the work of cross-disciplinary artist Brook **Andrew**, who deals with queer issues in a deliberately celebratory (and as a result, to some, confrontational) manner. His *Sexy and Dangerous*, 1996 [*170*], for example, seamlessly blends symbols associated with various cultures in an image that both reclaims and reconfigures representation, while referencing the ethnographic tradition through a contemporary gaze that delights in the power and beauty of the male body. Interestingly, Andrew appropriated the Chinese characters that emblazon his subject's chest from a poster in Sydney's Chinatown—unconsciously branding his protagonist, through his lack of knowledge of the language, with script meaning 'a shifty female sort of person'—an action that speaks quite pointedly of the assumptions made about other cultures throughout the history of colonisation and the move towards an elision of difference in contemporary 'global' society. As the artist states in *bLAK bABE(Z) & kWEER kAT(Z)*:

Being Blak, Kweer, Gay with Fair Skin is a challenge, but there you go, we are not always the stereotypes of history. But … we are the sum of our ancestors. We are not yesterday, we are today, and with this we need to change … and become different all the time. This is to be rejoiced. Blak sexuality has had its role in Australian society as one caught in the dilemmas of issues surrounding white vs blak: race, ownership, desire of the 'exotic' and western Christian and political hierarchy.

In a brief period of just over ten years, the work of Indigenous photographers has covered a lot of ground. Yet regardless of the many and varied ways in which Aboriginal artists use the camera, their work displays a unity in its examination, interrogation, and

170. Brook Andrew, *Sexy and Dangerous*, 1996. Digital photograph printed on duraclear mounted on perspex, 150 x 80 cm.

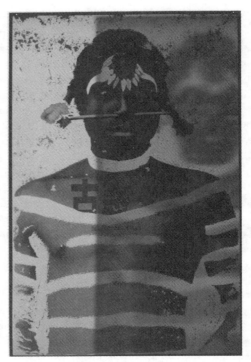

celebration of the issues surrounding Aboriginal identity, and in its central concern with imaging the history of photographic representation.

KELLY GELLATLY

Carver, A., 'Mind, body and soul: Picking up the pieces, fitting them together, making her-story … ', *Art and AsiaPacific*, vol. 3, no. 2, 1996; Croft, B. L., Transcript of artist's floortalk at 'Re-Take: Contemporary Aboriginal and Torres Strait Photography', NGA, 1999; Deacon, D., 'Artist's statement, "Image Bank"', *Artlink*, vol. 15, nos 2–3, 1995; Engberg, J., *Signs of Life: Melbourne International Biennial 1999*, Melbourne, 1999; *Patterns of Connection: An Exhibition of Photo-Compositions by Leah King-Smith, with an Environmental Soundscape by Duncan King-Smith*, Northcote, Vic., 1992; Perkins, H., 'Right beside you: Brenda L. Croft', in J. Kerr & J. Holder (eds), *Past Present: The National Women's Art Anthology,* North Ryde, NSW, 1999; Rea, Andrew, B., Chapple, M., Peer, R., & Brady, W., *bLAK bABE(Z) & kWEER kAT(Z)*, Chippendale, NSW, 1998; Taylor, P., *After 200 Years,* Canberra, 1988.

12.5 HJ Wedge: *Wiradjuri Spirit Man*

HJ Wedge's vibrant narrative art is founded in his experience of growing up on Erambie Mission in Cowra, New South Wales. He depicts the idylls of childhood and rural life—going yabbying, star gazing, singing hymns—but also the grim memories of colonial history and realities of contemporary life—invasion, **massacre**, alienation, alcoholism, domestic violence, and suicide. In Wedge's painted world outsize figures grimace and gesticulate under lurid skies, or stare from the canvas in open-mouthed grief and out-rage, irradiated with anger, or fear, or happiness, or sometimes simply energy. A seam of anger runs through the stories and images, and his vision is informed by a keen sense of injustice and loss. For Wedge, Christianity [see 1.2] is an ideology of oppression, and a weapon of colonisation, as he describes in *Wiradjuri Spirit Man*:

Over the centuries when the white man came and claimed this land as theirs they started to get the native people and split their families up and put them into homes and other missions and so on to stop them from passing their knowledge down to the young people who then cannot pass their knowledge down to their children [see **stolen generations**].

If they did try to speak their language some of them were removed from the mission, maybe even put into prison [see **prison art**] for speaking their language. Them days were very tough on the people—they made it very tough for them—they couldn't hardly go anywhere without permission from the white people. They were treated like kids, they weren't treated like grown-ups or they weren't treated with the rank from their tribes, they were just treated like all the others with no respect at all.

Some of the families were split up and when another family went to a mission to meet their relations they needed a pass to go onto the mission to see their family and friends or whatever. When they weren't allowed on there some of the people would sneak onto the mission to see their people and some of them were caught sneaking on and were sent to prison for how long I don't know. They made it very hard for us people to get around and we needed a pass to go here and to go there—I wonder why they didn't give us a pass to go to the toilet to have a shit.

Then in this painting [*171*] it shows a couple of women and children going over to the office to get their fortnightly ration—sugar, bread, flour, tea, milk—and whatever other stuff they got from the white manager … Today some people think there are still a lot of white managers around.

Judith Ryan compares Wedge's vision to that of William Blake in the *Songs of Innocence and of Experience*. Text and image are interdependent; as Wedge explains, 'that's why you got to have the stories beside them 'cause you wouldn't understand them and nobody else would, only me'. (Wedge cannot read or write, so the stories are transcribed by dictation.) The power of Wedge's art comes from the fusion of the discrete oral traditions of biblical and Aboriginal storytelling [see 14.1]. Ancestral lore, contemporary issues, and biblical mythology combine in the artist's idiosyncratic rendering, as for example in his telling of the story of Adam and Eve:

In this painting it shows Adam and Eve in this beautiful garden. God told them that this garden is theirs, all they have to do is to stay away from that tree, but Eve like a woman is curious. She nagged at Adam to have a look at the tree. Adam said, 'We were told to stay away from the tree', but she ended up persuading Adam to have a look at the tree. When they went over to have a look, they found a beautiful snake coiled around the fruit tree. Then the snake said in a cool soft voice, 'Pick the fruit and have a taste'. As Eve went to stretch out her hand for the fruit Adam said, 'No, we're not allowed to touch anything from this tree!' Then the snake said to Adam, 'Don't be a square' and Eve said to Adam, 'This fruit won't hurt us at all'. So Adam watched Eve put the fruit to her sweet soft lips. She really enjoyed eating the fruit. As she was eating it she passed it over to Adam, then the snake said to Adam, 'Take a bite of this lovely juicy fruit'. When Adam took a bite suddenly there was a big electrical storm then a big raving voice came to tell them to fuck off out of the garden. Adam told Eve they had to leave the place and never return. As they were walking away Adam said to Eve, 'Are you fuckin' happy now?' Then Eve said to Adam, 'Don't start now'. They left, and two dark people came into the garden as the garden was dying off. They came across this tree. The beautiful snake was still there. As they were walking to the tree they could hear two people in the distance rowing and fighting, then the snake attracted their

12.6 Alternative sexualities

The suggestion that homosexuality exists within Aboriginal culture often provokes strident opposition and argument, both within and outside Aboriginal society. For the most part such opposition is founded on fallacies—that homosexuality is not a traditional expression of sexuality, or, further, that it was introduced by Europeans. Such views could be considered laughable if they did not retain the currency that they do today. There is a wealth of data available which not only confirms the existence of homosexual practices and relationships, but also attests to cultural sanctioning for such activity in Aboriginal Australia at the time of first contact with Europeans.

Written accounts of homosexual practices among Aboriginal people in Australia date back as far as the mid 1880s. Many of these early accounts come from settlers, missionaries, and pioneers, and are problematic in that these people were not trained observers. They were also white, and male, and their accounts were often based on hearsay. It is also possible that the Aboriginal people who provided the information concealed or withheld particular kinds of knowledge or deliberately gave false information in an effort to deflect intrusive questioning about practices which could be considered sensitive. The few female European observers failed to recognise the diverse expressions of sexuality of Aboriginal women. Given that the Victorian era heralded a new wave of invisibility of women's sexuality, this is not surprising. The main concern of both male and female observers of Aboriginal societies was with male heterosexuality.

Doubts have been raised about the integrity of the early data because of the high degree of similarity between the available accounts. But the sheer number of early reports of homosexual practices in Aboriginal societies suggests that such practices did in fact occur. Reports from northern and central Australia, the Kimberley, northern Queensland and south-eastern Australia provide evidence of homosexual activity across Aboriginal Australia at the time of first contact.

Because of the wider society's prejudice against homosexuality, there was no improvement in the quality of information when trained anthropologists [see **anthropology**] began to carry out fieldwork in Australia. Anthropologists such as Ronald and Catherine Berndt were not immune to such prejudices when, for example, they referred to homosexual practices in western Arnhem Land by such terms as 'perversion' and 'sexual abnormality'. Aboriginal views on and understandings about homosexual practices were not sought by the majority of anthropologists.

Aboriginal men's sexuality has received more attention in the last twenty years. Unfortunately, this interest results from the health crisis which is afflicting the Indigenous gay male population. HIV and AIDS have deeply affected Australian society in general and the Indigenous Australian population, both homosexual and heterosexual, in particular. Aboriginal gay men are particularly concerned with their own issues and with increasing awareness of their problems, as never before. In 1996 the *Anwernekenhe 1* report highlighted their concerns and needs. By 1997 and 1998 Aboriginal researchers and anthropologists were increasingly writing about and giving a voice to Indigenous gay men.

There were Aboriginal participants in the first Sydney Gay and Lesbian Mardi Gras in 1978. In 1986 the Indigenous gay flag was carried in the festival parade. Designed by Gary Lee,

173. Clinton Nain, *The Long White Cloud* (detail), 1995–96. Mixed media installation, 31 x 31 x 20 cm.

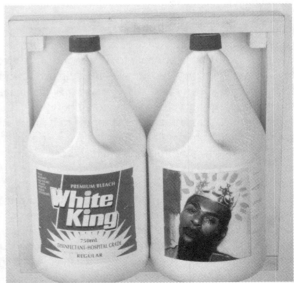

172. *Malcom Cole as Captain Cook in the 1988 Mardi Gras Parade.*
This photograph by William Yang appeared in the *Sydney Morning Herald*, 28 January 2000.

the golden or yellow sun was replaced by a yellow love-heart signifying love, pride, and respect. Indigenous Australian gays and lesbians led the parade in 1988 on a 'Captain Cook' float [172], further raising the profile of Aboriginal and Torres Strait Islander gays and lesbians. Artistic expression is evident in the costumes designed by Indigenous participants in the Mardi Gras and in other festivals which focus on sexuality. Indigenous transsexual and transgender performers often display a humour in their costumes which can make the underlying artistry of the design invisible.

Aboriginal gays and lesbians have seized upon the opportunities now available to them to articulate their own lives and stories through a wide range of media. Indigenous lesbian and gay voices are seen and heard in film, video, poetry, writing, the visual arts and, theatre. In *White King, Black Queen* [173], a small panel from a larger installation, *The Long White Cloud*, 1995–96, Clinton **Nain** reminds us that this freedom of expression has not always existed and can be challenged. In the work, Nain represents himself as a black queen in counterpoint to the chemical potency of White King bleach—a metaphor for white society and the pressure to be white, presentable, and acceptable that has impinged upon Indigenous people's lives.

Representations of Aboriginal women's sexuality are expressed in works such as *code VIII (I–VIII)*, 1998 [174] by the Gamilaroi [Gamilaraay] artist, **Rea**. She centralises the 'blak' body through subtle layers of physical and emotional meaning. In this work, the black female body lies in an imaginary watery medium shrouded by layers of delicate colour, reminiscent of fabric and lily fronds. She is at rest, but open to communicate with those willing to engage under those conditions. Arone Raymond **Meeks** has included images of homosexual and heterosexual desire in his works. In the early 1990s he was one of the first Aboriginal artists to express in his work his grief at the loss of friends through HIV-related deaths. Recent works such as *The Raft*, 1997 [175] emphasise the **Dreamings** as a matrix for the earthly lives of the male couples he images. This Indigenous, transgendered sexuality has been forged in new media by a new generation of Aboriginal and Torres Strait Islander artists who are not afraid to challenge the boundaries of sexuality and identity.

WENDY BRADY AND GARY LEE

Australian Federation of AIDS Organisations, *Anwernekenhe 1*, Report from the 1994 First National Indigenous Gay Men and Transgender Sexual Health Conference, Darlinghurst, NSW, 1996; Berndt, R. M. & Berndt, C., *Sexual Behaviour in Western Arnhem Land*, New York, 1951; O'Riordan, M., 'Walking through time: Indigenous lesbian and gay art', *National AIDS Bulletin*, vol. 11, no. 3, 1997.

174. *rea:code VIII, (I-VIII)*, 1998.
Digital Cibachrome print,

175. Arone Raymond Meeks, *The Raft*, 1997.
Acrylic on cotton, 80 x 98.5 cm.
The raft is a long brown skeletal boat. The two figures to the right bid farewell to each other. The traveller carries the seed of life while ascending figures to the left represent spiritual guides. The serpent links the transition between birth, life, and death.

12. Urban Aboriginal art

171. HJ Wedge, *The White Manager*, 1993. Acrylic on watercolour paper, 50.5 x 70 cm.

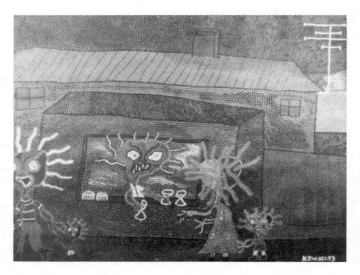

attention. He said to them to have a taste of this last piece of fruit on this tree. Then they started to look for something on the ground and the snake was getting curious and he asked them what they were looking for. One of them turned and said to the snake, 'We are looking for a bundi [heavy stick], and we're going to bundi you and eat you', and the snake said, 'It's time for me to cut out of here'. As the snake was talking a big black beautiful spirit popped out of nowhere and frightened the two dark people and he said to them, 'This garden is your home for the rest of your generations to come'. Over the centuries many children have been living in this garden of theirs with their own lore. Till the white people came along and destroyed the garden over two hundred years. They are destroying the rainforests to make toilet paper and digging up the land to mine and poison the land and water with chemical waste and if you don't fuckin' believe me you can get in your car and drive around this ruined garden of ours.

In Wedge's vision the Garden of Eden is allied with the Dreamtime, and the Fall with colonisation and environmental desecration. Like Trevor **Nickolls** [315], Wedge has a distinctly modern Dreaming, one built as much from the artist's inheritance as from his experience and imaginings:

So this way I try to paint what I dream, what I hear on *A Current Affair*, things you can even hear people talking about on the train. When you sit down with other blacks, have a little drink and that, especially when they're from other tribes. And they sit there and talk about what happened in their life and how their Dreamtime got destroyed as well—but not all of it because most of them really kept it. A lot of people on other missions was too scared to even speak it and even pass it down. I think maybe that one of the reason they didn't pass it down to us was 'cause maybe we wasn't worthy of our Dreamtime, so that's why they didn't pass it. They would have just been too frightened to do it. We might have lost some of it but now, through our dreams, we are sharing the past, the present, and the future.

HJWEDGE INTRODUCED BY HANNAH FINK

Extracts from Wedge, H. J. *Wiradjuri Spirit Man HJ Wedge*, Craftsman House in association with Boomalli Aboriginal Artists Co-operative, Roseville East, NSW, 1996. Reproduced with permission.

13. Film and communications

13.1 Painting with light: Australian Indigenous cinema

In remote, regional, and settled Australia, the 1970s witnessed a watershed in the expression of Indigenous agency in film. In 1971 what was possibly the first recorded instance of Aboriginal film occurred when the film-maker and journalist Cecil Holmes taught Robert Roberts and a young couple, Fred and Mavis Ashley, at **Ngukurr** (Roper River) how to make films with a 16 millimetre camera. Their films have not survived. Holmes had moved to the Northern Territory in 1964 and besides making ethnographic and documentary films about Aboriginal people was an advocate for their rights. He recognised the potential of film in Aboriginal hands when he concluded a paper given at the first Arts Council of Australia conference in 1973: 'And let us make no mistake, placing cameras and recorders in the hands of people will have a machine gun like effect. There may be pain and explosions here within the whole Australian psyche. Let it be so.' From such humble beginnings in Ngukurr, Indigenous 'painting with light' has continued to develop in collaboration with non-Indigenous film-makers in what has been the most participatory of all the representational modes in Australia.

The definition of Indigenous film is as complex as Aboriginal identity itself. Does content become Aboriginal when the camera is handed over to the Aboriginal person? Is a film about an Irish grandfather by an Indigenous person an Indigenous film? Can a film directed by a German woman about Torres Strait Islanders be called Indigenous? Such questions have been the subject of much argument in studies by Marcia Langton, Terence Turner, and others. Perhaps it is a futile exercise to attribute the authorship of these shadow plays of shared realities to a race, or even to a single person. Each production involves not only the person behind the camera and the camera—or machine— itself, but also those being recorded, sound technicians, editors, and many others. But that said, it is important to talk about Indigenous film-making because there is an ever-growing body of Indigenous film-makers and of representations of Indigenous people, and a history that defines it.

There is, too, the 'surplus enjoyment', the additional effect of the shadow play on, and the response it entices from, its audience. As in their production, so too in their watching, films about Indigenous people are seen by both black and white audiences. In 1999, Aboriginal novelist Archie Weller [see 14.1] described the power of the Indigenisation of cinematic media:

I wonder how many people really realize how absolutely special it is for an ordinary Aboriginal man or woman, not clever, not rich, not anything very much, to sit down alone among a crowd of whitefellahs and hear—even feel—the intimacy imparted by the largely white

audience as the magic of the White Man's Dreaming brings the story of the Blackfellahs' Dreaming to them, as well as making us laugh, cry and believe in ourselves.

The ethnographic

The first film recorded in Australia was ethnographic [see **anthropology**], made in 1898 on Mer (Murray Island) in the Torres Strait by the British scientist A. C. Haddon of the Cambridge Expedition [see 7.1]. He used a hand-wind camera, capturing a ceremonial dance by men wearing the masks of Malo, fire-making, and fish traps. Only four minutes remain of this historical record. Since the late nineteenth century, many thousands of hours of film and video have been recorded of the lives of Indigenous Australians. In terms of genre, the bulk of these hours, during the twentieth century, was made up of ethnographic and general documentary films with melodramas taking a lesser, yet not insignificant, place.

Naturalists, other scientists and their amateur collaborators—who believed that Aboriginal societies held the key to human evolution and thus practised salvage ethnography—filmed their subjects from early in the century. They included Baldwin Spencer, C. P. Mountford, Donald Thomson, and N. B. Tindale.

Working for Australia's government film-making organisation, the Commonwealth Film Unit, film-maker Ian Dunlop made the series *People of the Australian Western Desert* (1964, 1967) [*176*]. Essentially a reconstruction of daily desert life, the series is aesthetically stunning and continues to be popular among Western Desert audiences. From the 1970s Dunlop focused his attention on film-making with the Yolngu people at **Yirrkala** in Arnhem Land (NT). He made twenty-two films over a twenty-five year period, including *My Country Djarrakpi* (1981) featuring the artist Narritjin **Maymuru**, the detailed ceremonial record *Djungguwan at Gurka'wuy* (1989), and the award-winning personal portrait *Conversations with Dundiwuy Wanambi* (1995) [see D̲undiwuy **Wa̲nambi**].

The use of the cine-camera as a scientific recording instrument continued at the **Australian Institute of Aboriginal and Torres Strait Islander Studies (AIATSIS)**, Canberra, which holds the world's most extensive collection of Aboriginal and Torres Strait Islander films produced by Indigenous and non-Indigenous people. The ethnographic

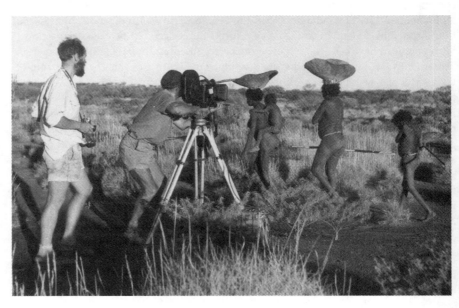

176. Ian Dunlop (*left*) and Richard Tucker (*behind camera*) filming Minma and his family in 1964 in the Western Desert (WA). The series, *People of the Australian Western Desert* (1964, 1967) and the film *Desert People* 1966, provide a valuable record of the activities of daily life during a period of transition for the Ngaanyatjarra-speaking people of the Western Desert. Filmed in silent black and white, this aesthetically beautiful film continues to be popular in the Western Desert, but has otherwise unfortunately dated very quickly: general audiences reacted negatively to not being able to hear the people's voices.

films produced by the Institute's own film unit between 1962 and 1991 form an important body of work within this collection. There are over one hundred films ranging from records of ceremonial events to complex collaborative projects with Aboriginal people. In 1965 anthropologists Roger Sandall and Nicolas Peterson began to produce films mainly of secret ceremonies but also of canoe building and camel herding. Fifteen of Sandall's seventeen films, such as *Camels and the Pitjantjara* (1969), were made in the Northern Territory. By contrast, independent film-maker Curtis Levy, who made five films for the Institute, was distinctly a television documentary maker. Levy is best known for *Sons of Namatjira* (1975), a portrait of ten days in the life of Aboriginal painters living on the outskirts of Alice Springs [see 9.1]. By 1975, David and Judith MacDougall, from the USA, had taken up the position of full-time film-makers at AIATSIS, replacing Sandall. The MacDougalls brought with them a new approach in participatory film-making that sought to go beyond the detached and problematic approach of the observational. This new style was developed in *Goodbye Old Man* (1977) when a recorded ceremony was transformed by the interpretation of one of the participants, Thomas Woody Minipini. Kim McKenzie's *Waiting for Harry* (1980) is another important film from AIATSIS recording the concerns of Anbarra people from **Maningrida** in Arnhem Land in the mounting of a mortuary ceremony.

Aboriginal people have achieved some success in negotiating their own representation in the films made under the auspices of AIATSIS. In effect, the power of the camera was incorporated into the rituals of Indigenous collaborators. Aware of the power of film, Aboriginal people from remote regions requested that the film unit record ceremonial events of great importance. This brought status and legitimacy to their own personal involvement and to the religious significance of the ceremonies themselves. Filming became a ritualised activity, with film-makers being taken to country and people's connection explained to camera. The revelation of knowledge, the telling of stories, being shown country, all allowed for the enactment of ritual through film-making. Indeed Peter Sutton has argued that Wik people [see **native title**] at Cape Keerweer (Qld), used filming by non-Indigenous people to validate their identity and to register their claims in the eyes of outsiders:

When filming is 'permitted', therefore, it is a mistake to see this permission as a passive acquiescence out of mere politeness, cooperativeness or desire for money. In a great many cases, film is being actively used. There is a naive view that doing ethnographic films is one-way exploitation by the film-maker of Aboriginal film objects. An extension of this view is that the only way to 'democratise' film-making is to have the Aborigines make all the films themselves. In the Cape Keerweer case, this would remove one of the most important functions of film-making as the use of the outsider for insider ends.

As an example of this idea in operation, in McKenzie's *Waiting for Harry* the central subject, Anbarra elder Frank Gurrmanamana, claims ownership of the film while making a public speech. Through collaborative methods and straightforward appropriation of authorial control by Indigenous people, these films become constructed as much by the Aboriginal hosts as by the trained film-makers. The Aboriginal performers make the explicit claim of their own agency and ownership of the content and form—they become as much the *auteur* as those behind the camera.

The maturation of the **television** medium and its demand, though limited, for local content, led to changes in film-making during the 1970s. These included a marked change in the style of films being made about or by Indigenous people as a result of the demand for self-representation, and the complicated empowerment of Indigenous people through limited bureaucratic and legislative means. Aboriginal calls for self-

representation had an indirect, but ultimately fatal, impact on ethnographic film-making. In effect, Indigenous people began making their own filmic records as the means of production became available to them. The other pressure on the ethnographic film style came from emerging problems associated with the ceremonial films. As communication with remote Australia began to improve, AIATSIS could no longer assume that people from remote Australia would not be affected by the screening of them. With more Aboriginal people visiting the cities in settled Australia, the possibility that uninitiated men and women might see aspects of ceremonial life forbidden to them became an issue. Scientific recording was thus brought face to face with the realities of the practice of Aboriginal religion [see 1.1]. Indigenous people themselves began to realise that they could control the documentation of their own culture and therefore created an ever-growing body of (mainly) video auto-ethnography.

Indigenous film

During the 1970s AIATSIS became the focus for Aboriginal scholars, students, and activists from remote and urban regions. Direct demands were made by some Indigenous people for the representation of Aboriginal people living in more densely settled regions of Australia. Both the MacDougalls and McKenzie met this demand by making films in regional New South Wales such as the MacDougalls' *Stockman's Strategy* (1984) about an Aboriginal-owned cattle station. Calls for self-representation from Indigenous people were met by the Institute through its film trainee program. Similarly Film Australia (formerly the Commonwealth Film Unit) broke with the tradition of focusing on remote communities through the production of films such as *Sister If You Only Knew* (1975), directed by Janet Isaac. Other ground-breaking films were Martha Ansara's collaboration with Essie Coffey, *My Survival as an Aboriginal* (1979), and Alessandro Cavadini and Carolyn Strachan's *Ningla A-Na!* (1972) about the **Tent Embassy** and the **land rights** movement.

In 1979 AIATSIS initiated a training program with a short course on video camera techniques for two Torres Strait Islander men, Trent and Dimple Bani, run by Bryan Butler. Out of this experience came a video, *The Importance of Torres Strait Singing and Dancing* (1979). Later the film unit took on trainees, first Coral Edwards, then Wayne **Barker**, Ralph Rigby, and Wally Franklin. Edwards made a film about tracing her own **family history**, *It's a Long Road Back* (1981). Barker, from Broome, Western Australia, who had started as a trainee in the sound section of AIATSIS before working in the film unit, went on to make the film *Cass: No Saucepan Diver* (1983) about his pearl-diving grandfather. By the late 1980s, training programs and Indigenous-identified positions were common in federally-funded **organisations** and institutions such as the Australian Film, Television and Radio School (AFTRS), Film Australia, the Australian Broadcasting Corporation (ABC), and the Special Broadcasting Service (SBS).

Aboriginal and Torres Strait Islander people began producing for their own **media** outlets on a large scale in the early 1980s, responding to a growing need to reproduce their own identity in what was becoming a multicultural and pluralist Australia. The late 1970s and the 1980s witnessed the rise of a pan-Aboriginal movement that focused on the recognition of certain rights—one of which was the right to self-representation. At the same time federal employment strategies and task force investigations on the potential of Indigenous broadcasting (Department of Aboriginal Affairs) allowed for the creation of localised **radio** [see 13.3, 13.4] and television stations in a scheme called BRACS (Broadcasting in Remote Aboriginal Communities Scheme) and media organisations such as Central Australian Aboriginal Media Association (CAAMA) Productions and the Townsville Aboriginal and Islander Media Association. These developments fuelled

a demand for broadcast material at the local level and for stations such as Imparja, in effect establishing an Indigenous television production industry. Indigenous people began to access equipment and funds to produce work that would counteract the stereotypes and misrepresentations of the past.

Cinematically, Indigenous Australians had previously been represented—none too successfully—in melodramatic feature films such as Charles Chauvel's *Jedda* (1955) [43], the quintessential story of savagery and assimilation. *Jedda* incorporated a history of Indigenous stereotypes, such as the inherent, uncontrollable, violent nature of 'tribal blacks' and the myth that all Aboriginal people lived in remote areas and none were urban dwellers. These representations persisted in filmed melodramas well into the 1970s and it was only with Ned Lander's *Wrong Side of the Road* (1981) that urban life was considered in a feature film [see 20.5].

The emergence of an Indigenous film industry, however, was not simply a reaction to earlier melodrama or ethnographic cinema, but a profound renaissance of Aboriginal visual arts in new media, including film and video. This cultural change was enabled by forms of technology and communication which moved the Aboriginal subject from the periphery of the colonial gaze to the centre of the post-colonial vision. Aboriginal people no longer wished to fill the role of ethnographic subject; moreover, the role itself became unstable in the rapidly changing world of the global entertainment industry.

The Aboriginal engagement with cinema and the new technology must be traced to the profound sense of discomfort induced in the Aboriginal audience by their representation in films. Film literacy was acquired by Aboriginal people who watched the scientific and fictional film canon as trainee film and media workers and as occasional audiences convened by those in the anthropological industry. A wider Indigenous audience had earlier consumed fictional representations from roped-off 'blacks only' areas of country cinemas and at the regular screenings at missions across Australia. As the dominance of film and television as a mode for representing Indigenous people became pervasive, audiences developed more sophisticated ways of reading these past representations and producers created new ways of seeing themselves. In the Aboriginal cinematic response, the scientific and fictional gaze is addressed in a variety of ways, not simply through a rejection of the Aboriginal person as subject of the European cinematic gaze, but by other aesthetic and political strategies as well.

During the 1970s Aboriginal activist and actor Gary Foley collaborated with Phil Noyce on the feature film *Backroads* (1977), a polemical statement about Aboriginal dispossession and racism in Australia. But control over production of films was wrested from non-Indigenous film-makers most obviously during the 1980s with the production of collaborative, political documentaries such as Alec Morgan and Lester Bostock's *Lousy Little Sixpence* (1982), about the experience of the forced removal of Aboriginal children [see **stolen generations**], and Robert **Bropho**'s *Munda Nyuringu* (1983) and *Always Was Always Will Be* (1989) [see 2.5], co-produced with Martha Ansara and others. The Indigenous units in the ABC and SBS were also producing programs at this time. The ABC production *Barbakueria* (1986) was of key importance: it was a parody of settlement in which inverted roles effectively unsettled the place of non-Indigenous people in Australia. While film-makers such as Frances **Peters-Little** [see 13.2, 16.4] and David Sandy were working at the ABC, community media organisations such as CAAMA Productions, established by Freda Glynn, were working towards the establishment of the Imparja television station and training Indigenous people to produce broadcast programs for it.

The most prominent independent film-maker during the 1980s was Tracey **Moffatt** [see 12.4] whose films *Nice Coloured Girls* (1987), and *Night Cries: A Rural Tragedy*

(1989), challenged established modes of representing Indigenous women. Through re-imagining the relationships that Aboriginal people, especially women, have had with white men and adoptive parents, Moffatt disturbed the pensive calm of established narratives about European settlement and Indigenous assimilation. In this disturbance Moffatt revealed something of the complex nature of contemporary **Aboriginality** and conjured the realisation in Australian audiences that everything was not as it seemed.

During the 1990s Indigenous media workers established themselves more firmly in the television broadcast industry at national as well as local levels. As a training ground, the local and national television industry provided many with the skills to venture into film production. The AFTRS too has contributed to the professional training during the 1990s of such film-makers as Rachel **Perkins**, Darlene Johnson, Catriona McKenzie, Erica Glynn, Rima Tamou, Pauline Clague, and Ivan **Sen**, and cinematographers Warwick **Thornton** and Allan Collins. It is important to restate that films, unlike paintings and photographs, are produced by teams. Indigenous directors and producers are managing the production of a vision that requires the skills of many individuals, some of whom may not be Indigenous. In a short time, Indigenous film-makers have achieved prominence in the industry but they constitute a very small minority. Film production has also been restricted by its necessary expense: because of this, investment in Indigenous film-makers has been predominantly funded by the federal government. While with a few exceptions, commercial backers have been reluctant to invest in feature films created by Indigenous directors, government funding requiring Indigenous creative control has allowed for the development during the 1990s of a substantial body of Indigenous-directed cinematic works.

While the national and regional television stations continued to support Indigenous media workers during the 1990s, the Australian Film Commission (AFC) in collaboration with the federal national broadcasters began a number of funding incentive programs, including the Indigenous Drama Initiative and the National Indigenous Documentary Fund. These programs have contributed to the production of over thirty short fiction films and documentaries directed by Indigenous people, all of which have been broadcast on national television. Fifteen of the short fiction films were aired in three programs on SBS, *Sand to Celluloid* (1996), *Shifting Sands* (1998), and *Crossing Tracks* (1999). *Sand to Celluloid* consisted of six films which covered Aboriginal **deaths in custody**, traditional payback, and race relations. Each broke new ground in dramatic fiction film-making. Of particular note were Warwick Thornton's prison cinematography in the chilling *Payback* (1996) and Richard Frankland's personal reflections in *No Way to Forget* (1996) about deaths in custody. In *Shifting Sands,* Ivan Sen's *Tears* (1998) [*177*] provided a contemporary insight to the idea of leaving the mission while Erica Glynn's *My Bed, Your Bed* (1998) similarly gives a modern account of a young couple and their promised marriage. The most recent drama series, *Crossing Tracks,* was made up of three shorts: *Harry's War* (1999) by Richard Frankland, *Saturday Night, Sunday Morning* (1999) by Rima Tamou, and *Wind* (1999) by Ivan Sen. Frankland and Sen directed actors in historical narratives about identity while Tamou took his audience into a pop culture thriller about stolen cars and kidnapping adapted from a short story written by Archie Weller. Each of these films employed production values comparable to the best Australian features and the quality of the screenplays was unquestionable. These initiatives have created a sense of confidence within the small community of Indigenous writers and directors and within Indigenous members of the industry more broadly.

Only two feature films by Aboriginal film-makers have been made and released publicly: Tracey Moffatt's surreal *Bedevil* (1993) and Rachel Perkins' *Radiance* (1998) [*178*]. This is not for a want of trying on the part of Indigenous writers and directors. Perkins

177. A still photograph taken during the filming of Ivan Sen's *Tears* (1998).
On crutches, Vaughan (played by Luke Carroll) follows Lena (Jamilla Frail) on their long walk away from the mission. *Tears* offers a bleak portrait of the empty lives of rural Indigenous youth and their attempts at breaking out. It follows on thematically from Sen's earlier documenary on Indigenous youth, *Shifting Shelter* (1997).

is one of the most experienced film and television producers in Australia, and her filmic adaptation of white playwright Louis Nowra's play about three sisters, their secrets, and their dead mother was successful locally and on the international festival circuit. The production team behind *Radiance* is illustrative of the collaborative nature of industry film-making for, apart from the three lead actors, the director, and the cinematographer, all key creative and production roles were filled by non-Indigenous people.

178. Mae (Trisha Norton-James), Cressy (Rachel Maza), and Nona (Deborah Mailman) in a publicity photograph for Rachael Perkins', feature film *Radiance* (1998).
United on the occasion of their mother's death, three sisters whose lives have followed different paths enter a maelstrom of guilt and regret when hidden histories are revealed. Perkins's sensitive direction of her three lead characters portrays common, yet largely untold, Indigenous experiences, and the hurt at the heart of these silences.

Along with the Indigenous Drama Initiative, the National Indigenous Documentary Fund has produced an exceptional body of short films that have also been broadcast on national television. Rachel Perkins's *Crim TV* (1997) observes Indigenous prisoners at Long Bay Gaol and their own production of a video aimed at making young offenders aware of the reality of prison life. *Shifting Shelter* (1997) and *Vanish* (1998) by Ivan Sen consider life in country New South Wales from the perspectives of children and women, providing insights not just through interviews but through close-up framing and time-lapse effects. The fund produced a number of community productions such as Varleri Martin and Pat Fiske's *Munga Wardingki Partu: Night Patrol* (1997), Timothy Japangardi Marshall and Graig Japangardi Williams's *Marluku Wirlinyi: The Kangaroo Hunters* (1998), and Belle Davidson and Pantjiti McKenzie's *Minyma Kutjara Tjukurpa: The Two Sisters Story* (1999). Each of these films is transcultural in form but made for local consumption in the area of their production—in these cases, central Australia.

Another style of film has become apparent in these funded documentaries—the personal journey [see **life stories, stolen generations**]. Examples are *Silent Legacy* (1998) by Debbie Gittins, *Glad* (1999) by Jill Milroy, and *Peeping Thru the Louvres* (1999) by Mark Bin Barker, all of which trace the journey of a parent of the director's back to their birthplace. There are also biographical and autobiographical portrait documentaries, such as Donna Ives's *A Memory: Grace Lenoy* (1999) and Louise Glover's self-portrait filmed by Erika Addis, *Black Sheep* (1999). Another film produced with support from this fund is the comedy documentary about Warlpiri people and cars, *Bush Mechanics* (1998) [*179*], directed by Francis Kelly and David Batty—also created in a collaborative manner. Kelly, the subject of Eric Michaels's (1989) monograph *For a Cultural Future*, on the establishment of the Warlpiri Media Association, co-directed this short film with Batty, a

179. A publicity still for *Bush Mechanics* (1998).
Co-director Francis Jupurrula Kelly shows his audience how to resuscitate a flat tyre with a generous stuffing of spinifex grass. Slapstick humour and serious reflection about the place of the automobile in Warlpiri life combine in an accessible and award-winning film that speaks to all audiences.

non-Indigenous film-maker with a long history of participation in Australian Indigenous media. A road movie with an ethnographic twist, it deals with the practicalities, aesthetics and philosophy of cars as used by Warlpiri [see also 20.5]. At the 1999 Australian Film Institute awards, Kelly won the award for original concept for this film. The benefit of these short film initiatives is that they have allowed Indigenous people to become full-time film-makers when previously many had been political activists who used film to communicate their discontent. Indigenous film-making for cinema release and television has been developing as a craft and as an art form; it is no longer simply a tool for change.

The 'gaze' in Indigenous film

When the subjects of film can be on either side of the camera, image making and dissemination involve keen imaginative engagement with a range of artistic passions that quickly dissolve the conventional boundaries of film-making and draw on deep reservoirs of hidden cultural resources. Ephemerality and nuance conspire to suggest realms of significance rather than to spell out perceived facts in the linear pedantic style of much earlier European-inspired documentary narrative. A multifaceted medium like film can do some measure of justice to the multidimensional realities of Aboriginal philosophy. Film, as a medium, opens up possibilities for a more rounded exploration of Aboriginal realities: it furnishes film-makers with the means to bypass the restrictions imposed, and the situations evoked, by the colonial language and its attendant institutions. In this, the medium helps to give voice to some of the immense, suffocating silences of a past laden with injustice.

This question of 'the gaze' is of central importance in any history of Indigenous involvement in film and video-making because of the troubling effect on Aboriginal audiences of the scientific and ethnographic authorship that once dominated cinematic productions concerning Aboriginal life. From the 1970s onwards, Aboriginal people began to make films and videos in their own right, as directors, as participants in community productions, and as collaborators with other film-makers. Even in many of the ethnographic productions, Indigenous people have been able to speak through the non-Indigenous film-makers, to direct the content and to make evident their rights over it. They have demanded the right to represent their own vision, and have produced a cinematic legacy of critical importance to the Australian film industry, to Australian artists and intellectuals, and to their communities.

Indigenous film and video production does not and cannot compete with the global film industry. Rather, it has taken up the task of challenging the hegemonic representation of Aboriginal people according to the stereotypes and tropes of the frontier, and of the colonial and neo-colonial Australian imagination: the Empire talks back. Mainstream film, as much as literature, has rendered its Aboriginal characters in particular formulaic ways to satisfy the ceaseless demands of national identity construction and nationalistic differentiation in the international arena. In the melodramatic fictional films made during the first period of the Australian national cinema (from 1901 to the 1960s), the tropes of the savage, noble or otherwise, the faithful companion, the criminal, the mendicant, the victim, are typically cast against the valorous white hero of the outback, and other landscape and location stereotypes. These are thought to typify the Australian experience, but they contrast starkly with the reality lived by the overwhelmingly urban, Anglo-Australian middle-class population. Filmic reflections of the Australian national imaginary have bolstered a nostalgic cultural mythology, only occasionally contradicting the prevailing colonial and national narratives. The historical trajectory of Indigenous cinematic work through this cultural domain is still under construction.

IAN BRYSON, MARGARET BURNS, AND MARCIA LANGTON

Bryson, I., *Bringing to Light: A History of the Australian Institute of Aboriginal and Torres Strait Islander Studies Film Unit*, MA thesis, Australian National University, 1998; Department of Aboriginal Affairs, *Out of the Silent Land: Report of the Task Force on Aboriginal and Islander Broadcasting and Communications*, Canberra, 1984; Holmes, C., 'Making films at Roper River', *Identity*, vol. 1, no. 5, 1972; Holmes, C., Aboriginal film makers, paper delivered at Aboriginal Arts in Australia conference, Arts Council of Australia, Canberra, 22 May 1973; Langton, M., *Well, I Heard It on the Radio and I Saw It on the Television: An Essay for the Australian Film Commission on the Politics and Aesthetics of Filmmaking by and about Aboriginal People and Things*, North Sydney, 1993; Michaels, E., *For a Cultural Future: Francis Jupurrurla Makes TV at Yuendumu*, Malvern, Vic., 1987; Sutton, P., Some observations on Aboriginal use of filming at Cape Keerweer, 1977, paper presented at the Ethnographic Film Conference, AIAS [AIATSIS], Canberra, 1978; Turner, T., 'Representation, collaboration and mediation in contemporary ethnographic and indigenous media', *Visual Anthropology Review*, vol. 11, no. 2, 1995; Weller, A., 'Aborigines in film', *Cinema Papers*, January 1999.

13.2 White people's homes

Before **television** came to the outback the only contact I remember of the outside world was at Conomos Picture Theatre in Walgett. Dazzled by images and sounds foreign to my own childhood experience I marvelled at Hendrix's flaming guitar and Truffaut's *Fahrenheit 451*. After my grandmother would finish cleaning the white people's homes in the town she'd pick me up after a matinée [*180*]. As we walked home together in the blazing heat of late afternoon I'd eventually return to the reality of my isolation of growing up in rural New South Wales during the 1960s. In 1979 the picture-theatre burnt down. Now a young mum, I drove past the black debris and puddles of water littering the street everywhere. I overheard from the locals that the fire brigade had driven over 240 miles [380 kilometres] to be there. Little was spared except for the Catholic second-hand store whose immaculate walls were saved from the inferno. As I drove on I guess I felt indifferent to the theatre's demise, perhaps because everyone had television nowadays.

180. *'Me and My Nanna'*, 1998.
Frances Peters-Little (*left*) with Doreen Peters (*right*), 1998.

The racism I experienced growing up as a young Aboriginal girl in outback Australia in the 1960s was invisible until thirty or more civil rights protesters from Sydney joined locals to pressure Conomos to permit Aboriginal people the same rights to sit upstairs in the dress circle as the white people in the town. My aunt and friends were arrested and the demonstration captured the national media's attention. Soon after, Aboriginal people began talking to the cameras and we began seeing ourselves on the little black-and-white screens. Religiously, all us black kids would congregate on Mavis Anderson's lounge-room floor after school to watch telly. It didn't matter what we watched, the fun was just being together laughing and impressing each other with how well we could jest with white fellas on television. On more serious occasions, the adults and kids would be glued to the screen whenever one of our locals appeared on TV. Deemed as 'political agitators' by journalists, they became our heroes, like Mavis's son Michael who flashed across the screen as the Black Panther radical of the outback, or the very hand-some Aboriginal elder and political activist, Harry Hall, who was noted for his hat, debonair style, and features. Finally it seemed that our isolation had ceased and our burning issues were affirmed on television, but indifference was yet to come.

It was a time when the world watched the Vietnam War and the assassinations of Kennedy, King, and Malcolm X on television, and somewhere in amongst it we saw our-selves from outback Australia as mixing it with the best of them. The 1972 **land rights** protests on the lawns of Parliament House in Australia's national capital city, Canberra,

were perhaps the most stirring scenes whites saw of Aboriginal people in Australian history. A tent was erected called the Aboriginal Embassy, as a declaration of Aboriginal sovereignty [see 4.5; **Tent Embassy**; *49*, *206*]. These demonstrations marked the first time Aboriginal people came together on a national basis encouraged by intense television coverage. Large numbers of white supporters had surprised everyone; even the media appeared to be onside. Meanwhile at home, our eyes fixed to the screen, we searched for familiar faces amongst the crowds. We were satisfied in the knowledge that black faces were appearing within the sanctuary of white people's homes, perhaps for the first time in history making sensational media news, not giving a damn whether middle Australia approved of them or not. It should be ironic, however, how audiences began tuning out and turning off only after our issues became safe and sophisticated.

To anyone who confesses to being influenced by television, and particularly to those who deny it, I would like to assure them that I too was briefly a non-believer in television, especially when I was going through my 'artistic' period which felt a bit haughty after a while. Yet television fascinates me and, like the angry young protesters, I knew the value of invading white people's homes via television. Lurking behind millions of closed doors, and as subliminal as the racism in this country, television quietly but confidently shapes viewers' white imaginings of who Aboriginal people are and what we need, so we needed to use it too. Fortunately though, I grew up with my family who became television critics by default, particularly when television misrepresented Aboriginal people, or excluded us from view.

The fact that I landed a job as a television documentary film-maker was accidental. I was an undergraduate media student sharing a house and a huge phone bill with six other communication students at the time. Just hours before the phone was disconnected, the series producer from *Blackout* called to offer me a fortnight's work researching for documentaries. Seven years later I left the Australian Broadcasting Corporation (ABC) as a producer and in that time it seemed only fair to me for blackfellas to invade mainstream television for a change. While I was there I missed the confronting images of unknown Aboriginal 'bushies' and noticed how they had been replaced by a more sophisticated generation of urban and traditional Aboriginal spokespeople. I also noticed that documentaries were becoming somewhat passé for some, but I'd insist that it wasn't documentaries which were boring, it was just the way they were made and that a good doco was more dramatic because they had 'real' people, as opposed to glossy actors with carefully written scripts.

In the space of seven years I'd worked on over thirteen documentaries for ABC television, three of which I produced. I guess there was never going to be any doubt that I'd want to make controversial television documentaries. Television meant getting into the home and making audiences confront their own issues in their own backyards, and while I must say I don't care too much about making audiences uncomfortable, it hasn't always been easy. But then again, it wasn't easy for my grandmother either, who'd listened to my fantastic stories on the long hot walk home after the matinée, after cleaning white people's homes.

FRANCES PETERS-LITTLE

13.3 Warrkwarrkbuyŋu media: Yolngu culture and Balanda technology

The following *raypirri* (a Yolngu term for a specific type of 'cultural encouragement' or disciplining traditionally used in ceremony) was recorded by Djapu clan elder Johnny Barrarra in 1995 for broadcast on the community **radio** in Gapuwiyak (NT):

This song that you've just heard. Whether you're the owner of this song or you call it mother, or you call it *waku* (child), this is our song. This is everybody's song and this is how our old generation lived. We are encouraging ourselves as Yolngu people now because of the involvement of the Western world. And that's why we are encouraging ourselves to be aware so that we will continue our *manikay* (songs), our culture. Starting from the eldest of our people and to the new generation. So when this generation now today start passing away, that tradition, that *manikay* (song) will be carried on by the new generation. *Yo* (yes). People should start respecting and really accepting this *rom* (Law) as their culture. Discos, guitars, *balanda* (non-Aboriginal) music is not to be taken as our number one priority. That's the white man's way of living. Sometimes *balanda* music can be good. Depends on people. Sometimes, *balanda* music can rule you. And that's how today we see kids, people losing their law, their culture because of committing themself to *balanda* music. So guitars, drums, *balanda* instrument is something that we can use. But to carry on that *rom*, that culture, we should carry on the *yiḏaki* (didgeridu) and the *biḻma* (clap sticks).

Johnny Barrarra voices a concern common amongst Yolngu (and other Aboriginal peoples) who live with the challenge of negotiating meaningful ways to be Yolngu in contemporary contexts, of constructing identities informed by both traditional forms of Yolngu knowledge and practice and Western cultural influences. **Television** and radio as particularly influential Western cultural forms came into focus in the late 1980s when the launch of the AUSSAT satellite first brought mainstream broadcast media directly into remote Aboriginal communities. Fears that exposure to 'inappropriate' Hollywood movies, Australian soap operas, and rock and roll would prove fatal to local cultures led to the establishment of the Broadcasting in Remote Aboriginal Communities Scheme (BRACS) in 1987 [see 13.1; **media associations**].

BRACS provides remote Aboriginal communities with basic radio and video facilities so that locally made programs can be broadcast within the community in place of mainstream, satellite-delivered, television and radio. From the outset, BRACS was hindered by a lack of resources for training, low wages, poor-quality equipment, and little technical support. Although conditions are improving, BRACS operators still face the challenges of becoming radio and video producers in difficult, dusty, and under-resourced circumstances. Perhaps the greatest challenge for these community broadcasters, however, is to make BRACS work within Aboriginal cultural protocols. Yolngu and other Indigenous information and communication priorities are often at odds with mainstream media practices.

In Gapuwiyak, a community of about 800 Yolngu people in north-eastern Arnhem Land, Bangana Wunungmurra, the cultural adviser to BRACS and former chairperson of the Top End Aboriginal Bush Broadcasting Association, takes an optimistic view of the ability of Yolngu culture to adapt to the changing times using BRACS:

The whole learning process is changing. Kids now watch a lot of TV, they are used to looking at a screen. So it's just a matter of putting the right information into it ... A lot of people are still isolated, they are still in a Yolngu world, and in a Yolngu world you only see *buŋgul* (ceremony) when it happens, you only hear *manikay* (song) when it happens. This is the kind of things that we're trying to introduce to the Yolngu. Saying we can go further with our ceremonies and our teaching culture. We can go further with this modern technology. Encouraging our people, our kids and saying 'listen to this'. That's what I'm trying to establish here is ... something for Yolngu culture. That's what BRACS is there for. If you're a 'DJ', it's your job to start thinking about this.

Encouraging our people to listen to our radio. People got to understand we've got radio now, same as television. It's just a matter of talking to them.

Bangana began working with the Gapuwiyak BRACS operators and community members in 1995, exploring the possibilities of broadcasting from a Yolngu perspective. As part of this strategy of 'Yolngu-ising' media content, Bangana recorded songs and *raypirri* from the various clan leaders of Gapuwiyak for broadcast on the local radio. The clan songs are a popular feature of Gapuwiyak's radio programming and are often requested. The BRACS operator, Frank Gambali, plays these songs and *raypirri*, such as the one by Johnny Barrarra set out above, alongside Western music, locally produced rock and roll, and community information. Frank also makes video recordings of local events such as public ceremonies, sporting contests and bush-tucker trips, and of Yolngu stories, broadcasting them at night on the local community TV channel.

Bangana comments further:

In the early days people used to carry letter sticks across Arnhem Land to let people know that there was a ceremony on. This was bloody hard work. These days we can just pick up a telephone or turn on the radio to notify other clans of a ceremony or a death and so on. But to our elders modern technology and its potential is still a foreign concept, so to make them really understand about modern technology I strongly feel that it should be introduced to them in a proper Yolngu way.

Bangana's emphasis on recording and broadcasting in a 'proper Yolngu way' means more than simply broadcasting in local languages. BRACS operators must follow local protocols with regard to both the right to speak and the right to hear songs, stories, and knowledge. These fundamental proprieties can make the recording of a song or story a complex matter for negotiation. As part of his strategy for convincing clan elders to become involved with BRACS, Bangana worked to change local perceptions of BRACS from a *balanda* entertainment medium to a technology appropriate for Yolngu cultural expression. A major step was taken in 1997 when Gapuwiyak BRACS was renamed Warrkwarrkbuyŋu Yolngu Radio and Video [*181*] in a ceremony that linked ancestral stories with contemporary communications technology. Bangana explains this development:

181. Warrkwarrkbuyŋu logo developed by Frank Gambali, Gapuwiyak, Arnhem Land (NT) 1997.

To Yolngu the word BRACS means nothing. We've changed the name so it can be understood as a concept and become a symbol of Yolngu culture. For our elders to really understand the concept we have used the *yidaki* or the didjeridu as an example for them … Let me tell you about Warrkwarrkbuyŋu and its ancient and modern meanings. At Gapuwiyak there is place called Warrkwarrkbuyŋgu that the Liyalanmirri Gupapuyŋgu clan own. At this place back in the time of creation lived what we call a *mokuy*, or an ancestral being. This *mokuy* had a *dhadalal*, a special type of *yidaki*, which it blew to give signals to other *mokuy* in other clan countries. This *mokuy* and his signal is very important to these clans. It is one of the things that connects Yolngu across Arnhem Land. And so we're using this story to communicate to Yolngu our vision for Yolngu radio. Today at Gapuwiyak we tell our elders that the Warrkwarrkbuyŋu Yolngu Radio and Video is like the *dhadalal* signalling for other Yirritja *mokuy*.

In this way Yolngu are using ancestral frameworks to assert the place of their *rom* (Law) and culture in the twenty-first century. Access to the airwaves enables Warrkwarrkbuyŋu

and other Indigenous media organisations across the country to communicate on their own terms, and in their own voices, to both Indigenous and non-Indigenous audiences. And, as Bangana emphasises, cameras, microphones, and satellites can transmit songs and stories without compromising traditional values or ways of thinking:

We aren't getting the *balanda* technology and just forcing it. I sit down and talk to the Yolngu leaders first. And then they make their own decision and understand it their way as a Yolngu concept. When they see the name Warrkwarrkbuyŋu Yolngu Radio and Video or hear the sound of the *dhaḏalal* on the radio, they know that this is all about Yolngu communications. In this way the BRACS can always remind us that we are Yolngu and using this technology for supporting our culture and linking us up in Yolngu ways.

JOHNNY BARRARRA AND BANGANA WUNUNGMURRA
COMMENTARY BY JENNIFER DEGER

Barrarra, J., 'Raypirri', unpublished speech for radio, trans. Bangana Wunungmurra, 1995; Wunungmurra, B., Warrkwarrkbuyŋu Yolngu radio: Combining Yolngu culture with balanda technology, unpublished speech delivered at the Fulbright Symposium Indigenous Cultures in an Interconnected World, Darwin, 1997.

13.4 Indigenous arts and media: Gadigal in profile

In 1994, the Sydney suburb of Chippendale, on the fringes of Redfern—one of the oldest surviving urban Aboriginal communities in Australia—became home to Gadigal Information Services (GIS), a community-based media–arts and information service for the 36 000 members of Sydney's Indigenous community [see also **media associations**]. Named after the traditional owners of the inner Sydney area, it grew out of the need for an Indigenous-controlled and operated media organisation in the city with the largest Indigenous population in Australia. For too many years mainstream media portrayed Indigenous Australians through negative stereotypes; Gadigal was, and remains, a means to amend this.

Gadigal's charter is to collect, collate, and disseminate any information that concerns Indigenous people. It operates mainly through Koori **Radio**, but also through publishing, literature, entertainment, promotions, and public relations. It provides an information service for members of the general public who want information on Indigenous people and their lifestyles. Gadigal's management committee includes representatives from government agencies such as the New South Wales Department of Aboriginal Affairs and the Australian Broadcasting Corporation (ABC), and community agencies like the New South Wales Aboriginal Land Council and **Boomalli Aboriginal Artists Co-operative**. A number of local individuals with a background in the arts or media have also assisted. The committee, and Gadigal's membership and volunteers, are representative of the local community. With three full-time staff the organisation relies heavily upon voluntary support from the community. In 1998 there were some sixty volunteer broadcasters and about fifty non-Aboriginal members, affectionately referred to as FROGS (Friends and Relatives of Gadigal).

Koori Radio, through which GIS is licensed to give Kooris in Sydney a voice on the airwaves, is a significant part of the service. Currently existing on test transmissions, it is a successor to Radio Redfern of the early 1980s. Its programming covers a diverse range of issues, styles, and audiences, ranging from news and current affairs, to shows for children and teenagers, and programs designed to raise issues relevant to Aboriginal communities. There are also specific broadcasts relating to other marginalised Indigenous

peoples including Torres Strait Islanders, East Timorese, Burmese, and Palestinians. The music played ranges from rock to hip hop, to jazz and blues to Koori country [see **country and western music**]. One of Koori Radio's main priorities is to promote Koori music—be it country, rock [see 15.2], reggae, ballads, or even opera. Broadcasters are instructed that a third of their program must be Indigenous music.

In 1996 GIS–Koori Radio won the Community Broadcasting Association of Australia's (CBAA) Indigenous Program of the Year award for the series *Arts Yarn Up,* designed to promote the richness and diversity of Indigenous art, culture, music. Each week for twenty-six weeks, listeners across the nation, via 250 community radio stations, took in the energy of Aboriginal and Torres Strait Islander arts, hearing from a number of voices and communities around the country. Following the national award, GIS received funding from the Australia Council [see **Aboriginal Arts Board**] to produce another series of *Arts Yarn Up* in 1997. Koori Radio has produced a number of educational documentaries including three by youth representatives, a series on women, and three radio plays. In 1998 GIS completed two documentaries on gambling for the CBAA.

Off the air, Gadigal is supporting music through Klub Kooris events at local Sydney venues. It also acts as an advocacy, referral, and arts management agency, and sometimes as a booking agency for many Indigenous musicians and bands, both Sydney-based and national. In 1998 it released the compilation CD *Yabun,* showcasing new and emerging artists in Sydney. In conjunction with Metro Screen Ltd, it ran its first multimedia training program in 1998, providing training for ten young Kooris in multimedia, designing Web pages, and using the Internet. While currently offering their services to helping other Indigenous organisations design their Web sites, GIS also hopes to produce for the Internet, as part of their Web site, a walking tour of Sydney.

Gadigal has organised and sponsored spoken-word events at Spring Writing Festivals at the NSW Writers' Centre each year, and has been responsible for performances as part of Pacific Wave Festival and other one-off happenings in the suburbs. These events generally involve the Aboriginal writers' group established through, and working out of, GIS, and include not only Sydney-based authors and communities, but also others from around Australia. GIS has acted as a consultant for the Sydney Organising Committee for the Olympic Games on the literary program of the Festival of the **Dreaming**, and has organised two successful writers' workshops in Sydney. Three works developed as part of the workshops have been selected by the ABC for production in their drama programs. In 1998, GIS also held the first masterclasses for Aboriginal writers at the NSW Writers' Centre and brought together many Aboriginal writers from around Australia, including Kerry Reed-Gilbert, Bob Maza, Owen Love, Lisa Bellear, and Ruby Langford **Ginibi** [see 3.4].

Committed to raising awareness of the Indigenous communities of Sydney, Gadigal worked with the Redfern community to collect information and material for the exhibition 'Guwanyi: Stories of the Redfern Aboriginal Community', at the Museum of Sydney in 1996–97. This was a photographic exhibition with theatre, song, and dance. In 1998, the manager of GIS, Cathy Craigie, wrote and workshopped the play *The Other Side,* as part of the Urban Theatre Projects. Featuring the talents of Leah Purcell [*200*], with support from local Kooris from the western suburbs of Sydney, it was performed at venues in Liverpool and Campbelltown.

In the future, Gadigal will move to the Earth Exchange at the Rocks as part of a consortium called Tullagulla. From this location Koori Radio will be able to broadcast to Sydney using the latest digital equipment, with its own multimedia studios.

ANITA HEISS

13.5 The World Wide Web

The Internet has become host to a significant amount of material about Aboriginal arts and culture. The strong graphic styles and diverse art forms found in the majority of Indigenous web sites are proving extremely popular with the World Wide Web's growing international audience.

While many of the early Aboriginal-oriented web sites came from non-Aboriginal sources, Aboriginal sites are now at the forefront of Australian web publishing. These include **Yothu Yindi**'s site, which always uses state-of-the-art graphics and was one of the earliest Australian sites to use streaming sound (spoken and sung in an Aboriginal (Yolngu) language), and the site of Tandanya, the National Aboriginal Cultural Institute. It was clear from the beginning that the Web could present a different range of view-points from conventional books, newspapers, **radio**, and **television**. Materials tended to be new, and much of the colonial flavour of standard sources was absent. Further Aboriginal web publishers quickly appeared, especially during 1996–97. As many Aboriginal people took up an interest in browsing the Internet, the stage was set for them to take an unprecedented share of publishing about themselves and to themselves in a medium that was emerging into the mainstream.

For the visual arts, these developments meant that galleries were no longer the only 'artspaces'. Audiences for Aboriginal art were no longer restricted to the choice between urban galleries and 'authentic' off-the-beaten-track art centres. For example, the Maningrida (NT) site run by the Bawinanga Aboriginal Corporation [*182*], set up in early 1995 as one of the first Aboriginal web sites, quickly established an innovative and successful web art catalogue with an international clientele [see also 15.4]. Indigenous web sites are also challenging the boundaries between culture and politics, offering diverse Aboriginal viewpoints about **history**, culture, and social issues.

The rapid growth of the Internet has not been without problems. Aboriginal people have expressed fears about new forms of exploitation of their cultures and creativity;

182. Maningrida (NT) web page, early 1997.
The Bawinanga Aboriginal Corporation at Maningrida set up one of the earliest Indigenous Australian web sites. The site continues to evolve. The home page links through to the pages of Maningrida Arts and Culture, which feature an illustrated and annotated gallery of works for sale direct from the community.

doubts about appropriate representation of their many distinct groups and cultures; and disquiet about their level of access to network resources. Other problems (not confined to Aboriginal-related materials) include lack of conventions for assuring quality and authenticity; insufficient means of distinguishing between information providers, indexing services, and network service suppliers; and preoccupation with technology rather than social and cultural value.

In most cases, however, the identification of problems has helped to crystallise discussion about long-standing issues, such as protection of intellectual property [see 22.1], or has highlighted the Web's greater ability to present Aboriginal viewpoints, as compared to conventional publishing. Of well over 200 web sites that have Indigenous content, around one-third have been created by Aboriginal organisations or individuals. While this figure may overstate the number of Indigenous individuals who are performing the technical procedures of web publishing, there is no doubting the Web's ability to foster more equitable access to publishing than ever before.

What has driven Indigenous groups, who have long had limited participation in publishing and **media**, to take advantage of this novel technology? It seems that pre-existing Aboriginal experiences and cultural knowledge have helped to demystify the Web. Some Aboriginal people say that the Web has much in common with their own social systems: both consist of networked networks where information transmission is rapid and an individual's participation depends on his or her identity as expressed in terms of the network. Many Aboriginal people have high skill levels in areas relevant to good Internet practice, for example communication and graphics, and have experience with precursors such as two-way radio and video production.

Advances in human rights have also played a part: an increase in provision of education to Aboriginal people has given many access to computers and institutional support. The major drive, however, has come from Aboriginal communities, where organisations such as cultural centres and land councils have propelled a solid Aboriginal presence onto the Internet.

Many Indigenous people are also enthusiastic users of email and mailing lists. They have pioneered innovative distribution methods, for example conveying Web and email content between a resource centre and community members using more traditional media such as the telephone or fax.

In the future, the Web will offer opportunities for developing links between artists and their audiences in the northern hemisphere, where Aboriginal exhibitions and performances have recently been so popular. Internet publishing has arrived at a time when Indigenous issues are prominent in Australia; and so the Web will continue to focus discussions about the roles and representation of Aboriginal people and their knowledge.

While Aboriginal participation in Web development has been vigorous, the diversity of Aboriginal lifestyles, identities, aspirations, and skills means that there is no unified or pan-Aboriginal Web presence. Aboriginal peoples' participation on the World Wide Web is truly a rich network of diverse messages.

DAVID NATHAN

14. Literature

14.1 Aboriginal writing

The complexity of Aboriginal literature demands attentive reading, and an understanding of the political and social contexts in which the works are produced. These are the preliminary requirements for doing justice to the texts.

Aboriginal society is founded on narrative. The journeys of the **Dreaming** beings who created the landscape and established the norms for mankind [see 1.1] are recalled in song cycles [see 15.1] and read in the landscape [see 2.1, 6.1]. Since 1788 Aborigines have used narrative to make sense of the impact of European settlement and to perpetuate Aboriginal knowledge and cultural traditions. Hayden White suggests narrative is an answer 'to a problem of general human concern, namely, the problem of how to translate knowing into telling'. While Aboriginal writing is a comparatively recent phenomenon it has its origins in oral tradition. This tradition of yarning, of telling stories which maintain cultural continuity and provide the hearer with interpretations and analyses of contemporary social reality, is the basis for Aboriginal writing.

There is also the political aspect of cultural representation: settlers have used negative representations of Aborigines to justify dispossession and continuing repression [see 4.1; **history**]. Through these settler narratives, both official and popular, racism is normalised and rationalised, passed on to future generations, and justified to an international audience. Aboriginal writing is part of a wider movement in the Aboriginal arts community which contests the veracity and integrity of these representations.

Suspension of disbelief and imaginative absorption are critical elements in reader enjoyment, but if this is to go beyond self-projection and sympathy for Aboriginal concerns it must include critical thought. As Ian Reid has pointed out, messages cannot just be beamed from one person to another—understanding requires interpretation. No text can be understood apart from the information, expectations, or preoccupations that readers bring to a text and which frame their understanding of it. A full appreciation of an Aboriginal text requires some knowledge of Aboriginal society, its history, and its political and social context.

The politics of Aboriginal writing

Aboriginal writing is political, but its politics relates to a range of concerns and is expressed in a variety of ways. These expressions include resistance to settler repression, **reconciliation** with settler culture, celebration of Aboriginal culture, a reconfiguring of aspects of traditional culture and **language** in the print medium, and testifying to community and cultural survival. In order to keep in mind this diversity we might use the broader categorisation suggested by Anthony Giddens (Cassell 1993) and consider

Aboriginal writing as advocating emancipatory politics (the overcoming of systemic injustice, discrimination, and exploitation) or life politics (the creation of ethical patterns for living and coexistence) or a combination of both. The important point is that Aboriginal politics is multi-faceted in its concerns, something inattentive reading can fail to register. Finally, there is the social context of Aboriginal writing. Edward Said has noted of criticism generally that if it is to remain true to itself it must not be reducible to either a doctrine or a political position. While our understanding of Aboriginal writing is inflected by an awareness of Aboriginal political issues, these do not limit the range of possible readings of a text nor do they foreclose on the possibility of re-readings of those texts over the passage of time.

A politics of Aboriginal writing can be tracked through the careers of Colin Johnson (**Mudrooroo**) and Kath Walker, two key figures. In 1964 Walker (who later changed her name to **Oodgeroo** Noonuccal) [see 14.3] published a volume of poems, entitled *We are Going*, which was an immediate success with the Australian reading public. 'Its success was inevitable', she said in 1988, 'not because I'm a good writer, but because for the first time the Aboriginals had a voice, a written voice.' In the same interview Oodgeroo cheerfully agreed with the critics who dismissed her writing as propaganda, responding that it '*was* propaganda' and deliberate propaganda at that.

A consequence of the success of *We are Going* with the settler reading public was that the Aboriginal writer was expected always to fulfil a role as representative and voice for the Aboriginal people. Some of Oodgeroo's successors actively sought out this responsibility, others had it forced on them. Whether deliberately sought or not, Aboriginal authors have continued to find that Australia's structures of race impose a representative role, and that to decline such a role is in many ways to risk being perceived as culturally inauthentic. Pressures on Aboriginal artists to conform to whatever definition of Aboriginal authenticity currently holds sway, and to represent the Aboriginal community, are enabling when claimed by Aboriginal writers but limiting when imposed or demanded. Oodgeroo's influence in defining Aboriginal writing and the manner of its reading has been immeasurable—from her early rejection of aestheticist conceptions of writing, to her address at the inaugural Aboriginal Writers' Conference in 1983 when she proposed Eleven Commandments which summarised the social and political responsibilities of the Aboriginal author.

Johnson, the other seminal figure, changed his name to Mudrooroo Narogin in 1988 and has since published under the names of Mudrooroo Nyoongah and Mudrooroo. His first novel, *Wild Cat Falling*, was published in 1965. Mudrooroo's distinction as the first Aboriginal novelist is now contested, with doubts raised about his **Aboriginality**. The later controversies notwithstanding, *Wild Cat Falling* was prophetic in the manner in which the author developed Indigenous themes relating to land, tradition, identity, government, and community and devised a narrative resolution which involved a remaking of self and culture through a return to cultural origin. Without necessarily being directly influenced by *Wild Cat Falling*, later Aboriginal writers explored identical themes and adopted similar narrative closures [see also **fiction**].

Shortly after the publication of *Wild Cat Falling*, Mudrooroo left Australia and spent an extended period in Asia. When he returned to Australia in the late 1970s he regularly published fictional works to general critical acclaim. But of greater influence than any of his fictional works was *Writing from the Fringe*, Mudrooroo's book of critical essays on Aboriginal writing which was released in 1990. Its central thesis made use of a simplified version of Frantz Fanon's identification of stages in the development of a literature by a colonised people. Fanon's periodisation—visionary and rhetorical in conception rather than empirical—identified the stages as proceeding from assimilated and culturally

alienated forms of writing to an activist literature. Mudrooroo contended that Aboriginal writing had entered an activist phase in which many Aboriginal people, who had previously never thought they could be authors, were writing. He believed, however, that much of this writing was derivative rather than an authentic Aboriginal literature, and singled out Lionel **Fogarty**'s poetry, which combined Indigenous speech patterns and expressions with political commitment and the techniques of modernist verse, as an example of authentic, de-colonised Aboriginal writing.

Another of Mudrooroo's theses was that authentic Aboriginal writing possessed a distinctive Aboriginal textuality. He identified the mixing of tenses by Aboriginal writers as one example of this. But the mixing of tenses is not a uniquely Aboriginal phenomenon: it is common in conversational narration and is textualised when these narratives are written down unedited. In a review of *Writing from the Fringe* Simon During said pertinently: 'Those discursive elements that a writer or critic may isolate as being properly "Aboriginal" … can always be mimicked or repeated by anybody.' Seen in historical context, however, Mudrooroo's critical output during the late 1980s and early 1990s was instrumental in representing the interests of Aboriginal writers and Aboriginal society in a critical field dominated by non-Aboriginal intellectuals. Mudrooroo's interest in international figures such as Fanon, Malcolm X, and Bob Marley encouraged critics to think of Aboriginal writing as part of a global phenomenon and endorsed the adaptation and use of post-colonial theory in its interpretation and analysis. While issues relating to Mudrooroo's Aboriginality were widely reported in the popular press, it is a measure of his influence that there have been few scholarly considerations of its implications for Mudrooroo's status as an Aboriginal writer or for the understanding and interpreting of Aboriginal literature.

Although Oodgeroo and Mudrooroo were influential in defining the politics of Aboriginal writing, Jack **Davis** was clearly the most important figure in Aboriginal theatre in the 1980s. As well as being a playwright, poet, and editor, Davis inspired and encouraged a generation of Aboriginal actors, directors, and playwrights. While Davis is probably best known for his trilogy *The First Born*—comprising his first play, *Kullark* (performed in 1979), *The Dreamers* (1982) [*183*], and *No Sugar* (1985)—two of his later plays, *Barungin* (1988) and *In Our Town* (1992), deserve special comment. In his introduction to *Barungin*, Bob Hodge wrote that Davis was the most important dramatist writing in Australia at that time, 'the kind of writer that every nation needs and so rarely gets.' *Barungin* is a Nyungah word meaning to 'smell the wind' in order to locate game, and Davis, Hodge suggested, was 'a hunter-writer with a superb nose', one who did not flinch from 'smelling the wind' in a contemporary sense, identifying those elements that make up post-contact Aboriginal life. In this play Davis took as his subject matter Aboriginal **deaths in custody**, concluding with a roll-call of recorded deaths.

In Our Town looks at the anxieties which develop when an Aboriginal war hero returns to his home town and begins a love affair with a non-Aboriginal woman. The affair disturbs the uneasy racial coexistence in the small town of Northam (WA), and tensions are further inflamed through the misrepresentations of gossip. The love affair falters in the face of general disapproval and one of them leaves, but in the final scene the lovers refuse to let the gossips and racists claim the town, and return together. While rigorous in his portrayal of the strategies and effects of racism, Davis consistently stresses that the human aspirations which settler and Aboriginal communities have in common make an ethical coexistence possible. Uncle Herbie, an Aboriginal elder, stresses the values which are a feature of Davis's writing: 'Everybody finishes up going down Cemetery Road. Kia, everybody.'

183. *The Dreamers*, by Jack Davis, in performance by the National Theatre Company, Octagon Theatre, Perth, July 1983.
The actors are (*l. to r.*) Ernie Dingo, Jack Davis, Allan Kickett, and Luke Fuller.

Reclaiming the past

How people remember the past is part of the way they create cultural meaning [see **family history**], and in the tradition of humanism Aboriginal authors have found the life-narrative genre [see **life stories**] an effective vehicle for reconnecting with valuable aspects of the past and re-creating an Aboriginal self in spite of the dislocations of colonialism. Sally **Morgan**'s *My Place*, the most famous of these works, was first published in 1987 and the manner in which it was received owed something to the imminent bicentenary of European settlement in Australia. Public debate at the time reflected heightened concerns about Aboriginal–settler relations, a reassessment of Australia's past and the manner in which it was settled, and a desire, on some level, for reconciliation with the Aboriginal community.

My Place fulfilled some of these needs: it allowed a poignant but not embittered exploration and revisioning of Australian post-contact history and suggested possibilities for Aboriginal–settler coexistence. Its lack of bitterness also encouraged an empathetic manner of reading. As such it anticipated the official rhetoric of reconciliation (as it was later shown to have been prophetic in recognising the far-reaching harm the State policy of child abduction [see **stolen generations**; *384*] had caused Aboriginal society). On a deeper level it dealt with the circulation and exchange of Indigenous women in colonial Australia. As a significant text it also attracted strong critiques, which, without diminishing the book's importance, problematised aspects of its reading and reception.

The testimonial aspect of *My Place* was taken further in Ruby Langford **Ginibi**'s *Don't Take Your Love to Town* (1988) [see *3.4*; *30*]. In an interview published in 1994, Langford said that she wanted her book read in schools as history, and an idea of its density can be grasped when we catalogue some of its themes. Langford documented the existence of large parts of traditional Aboriginal culture in rural, non-traditional, Aboriginal communities in New South Wales; she showed the importance of rural work for Aboriginal men and how it was used to maintain a measure of autonomy and independence in relation to settler society; she chronicled the movement of rural Aborigines to the city and the resultant changes in values and social structures. In depicting these economic conditions Langford also identified a sense of anomie, people moving because they are disoriented without a sense of 'belongin'. We should note that this loss of 'belongin' created the

conditions for meeting other displaced Aboriginal peoples. Finally she raised gender issues such as the connection between Aboriginal men, colonisation, and prison [see **prison art**]; the ways in which the extended family shapes a sense of self; and the agency of Aboriginal women as carers and protectors. An important point to be drawn from Langford's book is the arbitrariness of the distinction between creative writing and social comment or analysis.

The most compelling example of the diversity of Aboriginal writing can be found in *Paperbark* (1990). Jack Davis, Stephen Muecke, Mudrooroo Narogin, and Adam Shoemaker, *Paperbark*'s editors, provide a major history of Aboriginal writing, with contributions which range from the petition of the Kaurna (Gaurna) people to Governor Gawler in 1841 to Patrick Dodson's address to the Catholic Commission for Justice and Peace in 1986. In spite of an introduction which works to homogenise Aboriginal writing and reduce its subtlety, the multi-faceted nature of the collection is clearly evident. There are many outstanding pieces in the collection which repay careful attention and emphasise that the close reading of Aboriginal writing can never be divorced from context. Jack Davis's 'White Fantasy—Black Fact' delineates the de-masculinising of Aboriginal men under colonisation, the agency and labour of Aboriginal women caring for their families, and the complex, possibly complicit, relationships this gives rise to with settler men. A superficial reading sees this as nothing more than a sentimental story telling of a bus driver's racism and the kindness of a motorcycle gang. In another example, Hyllus Marus's 'The Concrete Box' is a parable on welfare colonialism, showing the connection between money and governmental control of Indigenous people. Marus presents this cryptically and in a manner which textualises the complexity of the process of welfare colonisation and the uncertain political consciousness of the Indigenous community. Sally Morgan's 'The Letter' [see 14.5] is the tale of a woman fulfilling her dead sister's charge to find her daughter. As well as being about the re-establishing of contact after a child abduction it illustrates how a text—in this case the dead mother's letter—functions as an essential medium of communication in her absence. Thus the non-Indigenous medium of writing can be used in re-establishing community.

Addressing the settler society

The best introduction to Aboriginal **poetry** to date is Kevin **Gilbert**'s *Inside Black Australia* (1987). His impassioned preface speaks of the truth of Aboriginality and justice as being the only principles on which Australia can survive. He presents contemporary Australia as a battleground between two opposing forces—good and evil—represented by Aboriginal and settler respectively. Gilbert's introduction functions as an effective means of cautioning readers who may have been inclined to a depoliticised, aestheticised reading of the collected poems, but in some respects he succeeds too well. Some prominent reviews politicised the work to the extent of minimising the diversity and variety of concern and utterance, and the quality of individual works in the anthology.

The fact that the collection is distinguished by exceptional poems from Frank Doolan, James Everett, Mary Duroux, Rex Marshall, and Julie Watson Nungarrayi, none of whom are widely known as poets and some of whom have higher profiles as community workers and political activists, prompts an examination of the role of the poet in the Aboriginal community, where occasional poets are common. And while in the Western literary tradition to be a poet is a matter of consistent self-designation, in a primarily oral tradition, with the right circumstances, anyone can be a poet. The result is a poetry inspired by profound and immediate feelings, written simply, with an emphasis on content and communication rather than formal innovation. Such poems are often more effective when embodied by the poet in oral performance.

Stephen Muecke's transcriptions of Nyigina elder Paddy Roe's [*184*] teaching stories were published in 1983 with the title *Gularabulu*. Reflecting the diversity of Aboriginal political strategies, Roe's narrative style might be contrasted with Gilbert's racially loaded introduction to *Inside Black Australia*. Roe's text is distinguished by its sobriety and absence of rhetorical gestures, Gilbert's by its passion and hyperbole. The political strategy varies as well, with Roe taking pains to emphasise Aboriginal sovereignty and the power of the *maban* (clever man) and by implication pre-contact forms of Aboriginal culture; and Gilbert working to emphasise Aboriginal dispossession and settler brutality and hypocrisy [see 4.5]. Though both writers have had to respond to the impact of racism and colonisation, their education and experiences have been quite different. Muecke for instance outlines the extent of Roe's knowledge, which covers subjects such as 'history, botany, medicine, biology, meteorology, religion, sociology, politics'.

The Roe and Muecke collaboration challenged the accepted relationship between a settler author–academic and an Aboriginal 'informant'. In revising the protocols and ethics of settler–Aboriginal collaboration, *Gularabulu* highlighted the need for reciprocity and exchange: as such the text is a paradigm of social and linguistic convergence. As well as the ethics of the relationship between Muecke and Roe, readers were introduced to the special qualities of Kriol [see **Aboriginal English**] which, as a 'language of bridging', less tied to place than are classical Aboriginal **languages**, represents social convergence.

184. Paddy Roe, Broome, 1976.

Some of the most exciting contemporary Aboriginal writing is a 'writing in process', marked by generic instabilities and verbal excesses and not submitting to any received ideas about form and content. Two 1990s texts, Sam Watson's *The Kadaitcha Sung* and Philip McLaren's *Scream Black Murder*, deal with sadism and violence in ways that are both confronting and uncontrolled. In opening up new subjects and styles for fictional writing, both texts avoid being scripted by the genre, and neither author writes in subservience to readerly expectations.

Like a number of earlier Aboriginal writers, Watson depicts settler power as fundamentally illegitimate and identifies the brutality of the colonial regime as a necessary element in maintaining settler status and privilege. But rather than remaining content with a simple racial and cultural dualism Watson introduces impurity and conflict into those categories. Ambiguity is an element of the social world: some settlers are really transgressive Aborigines and some of the more villainous characters in *The Kadaitcha Sung* are Aboriginal. Change, conflict, cynicism, and transgression are found in his

representation of the **Dreaming**—a representation which is neither romanticised nor Utopian. Watson is thus able to make the problem of colonisation, and its solution, an intra-Aboriginal one, just as pre-temporal transgressions in the Dreaming have created the conditions which have allowed the European incursion in the first instance.

Scream Black Murder is on one level a generic crime novel—complete with detailed descriptions of forensic procedures—and on another, a psychopath's monologue. But McLaren introduces the state policy of child abduction and includes an excursus, in powerful and affective writing, which tells the story of David Gundy, an Aboriginal man wrongfully killed by New South Wales police. Less protean than Watson in his ability to recombine and reconstitute cultural symbols, McLaren provides specific and detailed information on the dynamics of contemporary Australian racism and presents modern Aboriginal subjectivities, that is individuals who are creating new Aboriginal identities as a result of changing social conditions. Just as Ruby Langford Ginibi chronicled the drift to Sydney by Aborigines in the 1950s and 1960s, McLaren represents a contemporary Aboriginal population flow, showing how the different sub-communities intermesh; the relations between rural, traditional, and metropolitan communities; and contemporary dialogic **Aboriginality**.

Kim Scott's *True Country*, published in 1993, is in many ways a reprise and reconfiguration of themes developed by earlier Aboriginal writers. It is also a text which has wrong-footed reviewers and reading public alike in that the key to understanding it lies not in popular discourses such as reconciliation or post-colonial theory (though they are important contextual frames) but in a consideration of its formal structures. Scott writes in the preface that the 'novel began with a desire to explore a sort of neglected interior space, and to consider my own heritage'. Like Bill Neidjie in *Story About Feeling* (1989) [see 14.4; *187*], Scott speaks of nurturing through story: 'If you believe it, and talk it, then it becomes real.' While the novel is centred around Billy, a Nyungah whose cultural affiliations are with the settler world rather than the Aboriginal, it is not an unproblematic tale of returning to one's origins. Scott acknowledges the power of the traditional Aboriginal ways but rejects traditionalist perspectives on Aboriginality. Insanity and turpitude in Scott's novel coexist with knowledge of traditional culture. Like Sally Morgan's *My Place*, Scott's novel is composed of other people's stories but while the stories of Morgan's relatives are subsumed into her quest for truth, *True Country* does not privilege its central character Billy. It is a text in which ideological evaluation is not carried out from what Boris Uspensky has called a 'single, dominating point of view'; the authorial position is supra-personal, not limited to the perspective of Billy in that it accompanies Billy but does not merge with him.

The fact that the text follows Billy but does not describe the community of Karnama and surrounding land solely from his point of view enables Scott to show the importance of land independently of any given subjectivity. Initially Billy surveys the country by plane, collects historical information, studies maps, and describes views from the air, but ultimately he needs an experience to take him beyond that subject–object relationship. In this interest in spatiality Scott's narrative method suggests some of the paintings of Ginger **Riley Munduwalawala** [*156*] which depict the topography of the Limmen Bight from the viewpoint of majestic Dreaming beings (most often Ngak Ngak the sea eagle). *True Country* ends with Billy delirious, seeing a vision he is unable to relate and it is in that vision that he comes to the same knowledge as the mysterious narrator who oversees everything. The confluence of tradition and modernity is found in knowledge, rather than an adoption of ritual, or emotional identification, or spatial return to origins, and the forward-looking nature of the text is affirmed by Scott who has said that he intended Billy's state to be interpreted as the continuation of a tradition, not as a precursor to death.

Scott continues his investigation of the historical and contemporary meanings of Aboriginal and settler identities in his most recent novel *Benang* (1999). The respectful but sometimes puzzled reception of *Benang* indicates that the challenge to Aboriginal writing at the present moment lies in the type of reader waiting to receive the book. The vigorous polemics of Oodgeroo, Gilbert, and Mudrooroo were motivated to some extent by the desire to create appropriate conditions for reading Aboriginal literature—conditions which at the time did not exist. The dominant mode of reading has continued to be one of empathy and identification, but the critical challenge for Aboriginal writers is always to call new readers into existence. An Aboriginal text must make use of what Rimmon-Kenan terms 'codes, frames ... familiar to the reader', but at the same time it must prompt the reader to use these codes to discover what they *don't* know. Our final author, Kim Scott, is an example of someone disadvantaged by the fact that reviewers have not found an adequate frame in which to situate texts which propose new ways of thinking about profoundly Australian issues. Aboriginal writing is 'situative' in that it deals with the situations of Aboriginal people in Australia, and the diversity of these situations highlights, rather than de-emphasises, the thematic continuities of Aboriginal literature.

PHILIP MORRISSEY

During, S., 'How Aboriginal is it?', *Australian Book Review*, no. 118, 1990; Cassell, P. (ed.), *The Giddens Reader*, London, 1993; Michaels, E., 'Para-ethnography', *Art & Text*, no. 30, 1988; Narogin, M., *Writing from the Fringe: A Study of Modern Aboriginal Literature*, Melbourne, 1990; Reid I., *Narrative Exchanges*, London, 1992; Rimmon-Kenan, S., *Narrative Fiction: Contemporary Poetics*, London, 1983; Roe, P. (au.); Muecke, S. (ed.), *Gularabulu: Stories from the West Kimberley*, Fremantle, WA, 1983; Said, E. W., *The World, the Text and the Critic*, London, 1984; Turcotte, G., '"Recording the cries of the people": an interview with Oodgeroo (Kath Walker)', in A. Rutherford (ed.), *Aboriginal Culture Today*, Sydney, 1988; Uspensky, B., *A Poetics of Composition: The Structure of the Artistic Text and Typology of a Compositional Form*, trans. V. Zavarin & S. Wittig, Berkeley, CA, 1973; White, H., 'The value of narrativity in the representation of reality', *Critical Inquiry*, vol. 7, 1980.

14.2 Early Aboriginal writing

Aboriginal societies have used sophisticated visual signifying systems for many thousands of years. It is therefore not surprising that Aboriginal people were quick to recognise the value of alphabetic writing—a visual code for spoken utterances. The earliest Aboriginal writings were produced by dictation and other collaborative modes. In 1796 Bennelong dictated a letter to Lord Sydney's steward, Mr Phillips, whom he had met while visiting England three years previously. From the 1820s onwards, Aboriginal people collaborated with whites to produce written translations. John Harris has shown how Biraban, an Awabakal man from the Lake Macquarie area north of Sydney, assisted missionary Lancelot Threlkeld in his translations of the Gospel of St Luke into the Awabakal language, and how James Unaipon worked with the missionary George Taplin translating Ngarrindjeri oral narratives into English at Raukkan (Point McLeay, SA).

The first school for Aboriginal children was opened at Parramatta in 1815. Individual Aboriginal children were also taken into white people's homes and taught to read and write. As Aboriginal literacy gradually spread during the nineteenth century, Aboriginal people began writing their own letters, acting as scribes for one another, composing petitions to government officials, and writing for newspapers. From September 1836 to December 1837, two young Tasmanian Aboriginal men, Walter George Arthur and Thomas Brune, wrote the *Flinders Island Weekly Chronicle*. This hand-copied newsletter

was closely vetted by the Flinders Island commandant George Augustus Robinson, but the authors managed nevertheless to convey a picture of day-to-day life on the island where the people lived, sick and dispirited, far from their traditional country on the Tasmanian mainland [see 1.5, 11.5]. Arthur and his wife Mary Anne wrote a number of letters of protest to government officials during the 1840s and 1850s. In February 1846 Arthur and seven other men—'free Aborigines of Van Diemen's Land'—signed a letter to the Flinders Island superintendent, Joseph Milligan, requesting that Mr Clark, the catechist, draw up a petition to Queen Victoria on their behalf. Clark duly drafted the petition, Arthur and seven other men signed it, and Earl Grey presented it to the Queen in March 1847. In the process of complaining against the return of an unpopular superintendent, Henry Jeanneret, the petition articulates the Aboriginal signatories' own understanding of their social identity, their political rights, and their historical circumstances.

Prior to the late 1920s, Aboriginal writing was largely political and personal rather than literary. While government officials used writing as an instrument of colonial administration and control, Aboriginal people used it as a means of resistance and political negotiation, as well as for communication with one another. The Barwicks' and Heather Goodall's research has revealed how, from the 1870s onwards, Aboriginal residents of a number of reserves in New South Wales and Victoria wrote letters and petitions asking for land, complaining about cruel or inefficient reserve managers, and objecting to the plans and policies of the two Boards for the Protection of Aborigines [185]. The Aboriginal protesters clearly understood that by putting their complaints

185. *Coranderrk Petition*, 19 February 1882.

321

AUSTRALIAN
Aborigines Conference

SESQUI-CENTENARY

Day of Mourning and Protest

to be held in

THE AUSTRALIAN HALL, SYDNEY

(No. 148 Elizabeth Street — a hundred yards south of Liverpool Street)

on

WEDNESDAY, 26th JANUARY, 1938

(AUSTRALIA DAY)

The Conference will assemble at 10 o'clock in the morning.

ABORIGINES AND PERSONS OF ABORIGINAL BLOOD ONLY ARE INVITED TO ATTEND

The following Resolution will be moved:

"...senting THE ABORIGINES OF AUSTRALIA, assembled in Conference at the Australian ...ey, on the 26th day of January, 1938, this being the 150th Anniversary of the whitemen's ... our country, HEREBY MAKE PROTEST against the callous treatment of our people by ...whitemen during the past 150 years, AND WE APPEAL to the Australian Nation of today to make new laws for the education and care of Aborigines, and we ask for a new policy which will raise our people to FULL CITIZEN STATUS and EQUALITY WITHIN THE COMMUNITY."

The above resolution will be debated and voted upon, as the sole business of the Conference, which will terminate at 5 o'clock in the afternoon.

TO ALL AUSTRALIAN ABORIGINES! PLEASE COME TO THIS CONFERENCE IF YOU POSSIBLY CAN! ALSO SEND WORD BY LETTER TO NOTIFY US IF YOU CAN ATTEND

Signed, for and on behalf of

THE ABORIGINES PROGRESSIVE ASSOCIATION,

J. T. PATTEN, President.
W. FERGUSON, Organising Secretary.

Address: c/o. Box 1924KK, General Post Office, Sydney.

into writing they made them official and powerful [see also *186*]. Written documents and press releases carried their words over the heads of the managers and the boards, and conveyed them to the attention of the general public and to higher government authorities. So effective were the written complaints of Aboriginal residents of the Coranderrk Reserve outside Melbourne that the Board hired police detectives on more than one occasion to try to prove that their letters were forgeries penned by white trouble-makers. In every case, they were found to have been authored by the Aboriginal residents. These petitions led to a major official inquiry into Coranderrk in 1881. As well as testifying orally, Aboriginal witnesses also presented written evidence to the inquiry. In doing so they raised issues not addressed by their questioners, and ensured that their views were accurately recorded in the minutes of evidence.

While using writing to deal with the foreign institutions of colonial government and law, the people of Coranderrk were also assimilating writing into their own traditional protocols of communication. On the petitions, for example, the order of names reflected the community's traditional social hierarchy, with the local clan-head William **Barak** [see 11.1; *289*] and other senior men at the top, followed by the younger men (including the principal scribe Thomas Dunolly), then the women and the children. For Barak and the other men, writing did not obviate the need for face-to-face dialogue. They walked to Melbourne to present their petitions personally to the Chief Secretary. Spoken words and written documents authorised each other. The physical presence of the men verified the authenticity of the petitions; conversely, the petitions were symbolic objects that functioned, in the manner of message-sticks, to identify the delegated speakers and authorise their spoken words.

PENNY VAN TOORN

186. (Facing page) Day of Mourning Poster, 1938. This hand bill was produced by the Aborigines Progressive Association for a protest meeting held on 26 January 1938. Handbills like this were distributed on Aboriginal reserves. The resolution of the meeting was passed unanimously.

This photograph shows the treasured copy of the hand bill pasted by Pearl Gibbs, the Aboriginal activist, at the beginning of her extensive collection of press clippings that document her political activities.

Barwick, D. E., Barwick, L. E., & Barwick, R. E. (eds), *Rebellion at Coranderrk*, Canberra, 1998; Goodall, H., *Invasion to Embassy: Land in Aboriginal Politics in New South Wales, 1770–1972*, St. Leonards, NSW, 1996; Harris, J., *One Blood: 200 Years of Aboriginal Encounter with Christianity— A Story of Hope*, Sutherland, NSW, 1990.

14.3 *The Past*

Let no one say the past is dead.
The past is all about us and within.
Haunted by tribal memories, I know
This little now, this accidental present
Is not the all of me, whose long making
Is so much of the past.

Tonight here in suburbia as I sit
In easy chair before electric heater,
Warmed by the red glow, I fall into dream:
I am away
At the camp fire in the bush, among
My own people, sitting on the ground,
No walls about me,
The stars over me,
The tall surrounding trees that stir in the wind
Making their own music,
Soft cries of the night coming to us, there

Where we are one with all old Nature's lives
Known and unknown,
In scenes where we belong but have now forsaken.
Deep chair and electric radiator
Are but since yesterday,
But a thousand thousand camp fires in the forest
Are in my blood.
Let none tell me the past is wholly gone.
Now is so small a part of time, so small a part
Of all the race years that have moulded me.

OODGEROO NOONUCCAL

This poem appeared in Kevin Gilbert's edited collection *Inside Black Australia: An Anthology of Aboriginal Poetry,* published by Penguin Books Australia, Ringwood, Vic., 1988. It is reproduced with permission of Penguin Books Australia.

14.4 *Story about Feeling* [187]

Well I'll tell you about this story,
about story where you feel ... laying down.

Tree, grass, star ...
because star and tree working with you.
We got blood pressure
but same thing ... spirit on your body,
but e working with you.
Even nice wind e blow ... having a sleep ...
because that spirit e with you.

Listen carefully this, you can hear me.
I'm telling you because earth just like mother
and father or brother of you.
That tree same thing.
Your body, my body I suppose,
I'm same as you ... anyone.
Tree working when you sleeping and dream.

This story e can listen carefully, e can listen slow.
If you in city well I suppose lot of houses,
you can't hardly look this star
but might be one night you look.
Have a look star because that's the feeling.
String, blood ... through your body.

That star e working there ... see?
E working. I can see.
Some of them small, you can't hardly see.
Always at night, if you lie down ...
look careful, e working ... see?
When you sleep ... blood e pumping.

So you look … e go pink, e come white.
See im work? E work.
In the night you dream, lay down,
that star e working for you.
Tree … grass …

I love it tree because e love me too.
E watching me same as you
tree e working with your body, my body,
e working with us.
While you sleep e working.
Daylight, when you walking around, e work too.

That tree, grass … that all like our father.
Dirt, earth, I sleep with this earth.
Grass … just like your brother.
In my blood in my arm this grass.
This dirt for us because we'll be dead,
we'll be going this earth.
This the story now.

Stone e never move
Rock e don't move round,
e got to stay for ever and ever.

E'll be there million, million … star.
Because e stay, e never move.
Tree e follow you'n'me,
e'll be dead behind us but next one e'll come.
Same people. Aborigine same.
We'll be dead but next one, kid, e'll be born.
Same this tree.

BILL NEIDJIE

Extracted from Bill Neidjie's _Story about Feeling,_ edited by Keith Taylor, published by Magabala
Books, Broome, 1989. Reproduced with permission of Magabala Books, Broome.

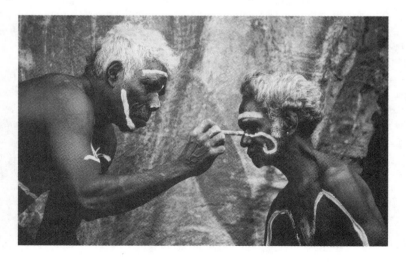

187. Bill Neidjie painting
Iyanuk (Felix Holmes) for a
Mordak ceremony, Cannon
Hill, East Alligator River (NT),
1983.

14.5 *The Letter*

The bus swayed back and forth making my tired old head hurt even more.

Really, I wanted to cry, but no-one cried on a bus. I glanced down sadly at the old biscuit tin sitting on my lap. Scotch Shortbreads, they weren't even her favourites, but she'd liked the colour of the tin so I'd given them to her.

I sighed and wiped away the tear that was beginning to creep down my cheek. She was gone, and I felt old and lonely and very disappointed.

My fingers traced around the lid of the tin and slowly loosened it.

Inside was all she'd had to leave. A thin silvery necklace, some baby photos, her Citizenship Certificate, and the letter. I smiled when I remembered how it had taken her so long to write. She'd gone over and over every word. It was so important to her. We'd even joked about the day I would have to take it to Elaine. That day had come sooner than we both expected.

I've failed, I told myself as I lifted out the necklace. It'd been bought for Elaine's tenth birthday, but we hadn't known where to send it. Now we knew where Elaine lived but she didn't want the tin or anything in it.

I placed it back gently on top of the photo.

Elaine had said the baby in the photo wasn't her. She'd said it was all a silly mistake and she wished I'd stop pestering her.

It was the third time I'd been to see her and it looked like it would be the last. I picked up the letter. It was faded and worn. I opened it out carefully and read it again.

To my daughter Elaine,

I am writing in the hope that one day you will read this and understand. I suppose you don't want to know me because you think I deserted you. It wasn't like that. I want to tell you what it was like. I was only seventeen when you were born at the Settlement. They all wanted to know who your father was, but I wouldn't tell. Of course he was a white man, you were so fair, but there was no love in his heart for you or me. I promised myself I would protect you. I wanted you to have a better life than me.

They took you away when I was twenty. Mr Neville from the Aborigines Protection Board said it was the best thing. He said that black mothers like me weren't allowed to keep babies like you. He didn't want you brought up as one of our people. I didn't want to let you go but I didn't have any choice. That was the law.

I started looking for you when I was thirty. No-one would tell me where you'd gone. It was all a big secret. I heard they'd changed your last name, but I didn't know what your new name was. I went and saw Mr Neville and told him I wanted to visit you. That was when I found out that you'd been adopted by a white family. You thought you were white. Mr Neville said I'd only hurt you by trying to find you.

For a long time I tried to forget you, but how could I forget my own daughter? Sometimes I'd take out your baby photo and look at it and kiss your little face. I prayed that somehow you'd know you had a mother who loved you.

By the time I found you, you were grown up with a family of your own. I started sending you letters trying to reach you. I wanted to see you and my grandchildren, but you know all about that because you've sent all my letters back. I don't blame you and I don't hold any grudges, I understand. When you get this letter I will be gone, but you will have the special things in my tin. I hope that one day you will wonder who you really are and that you will make friends with our people because that's where you belong. Please be kind to the lady who gives you my tin, she's your own aunty.

From your loving Mother.

My hands were shaking as I folded the letter and placed it back in the tin. It was no use, I'd tried, but it was no use. Nellie had always been the strong one in our family, she'd never given up on anything. She'd always believed that one day Elaine would come home.

I pressed the lid down firmly and looked out the window at the passing road. It was good Nellie wasn't here now. I was glad she didn't know how things had turned out. Suddenly her voice seemed to whisper crossly in my ear. 'You always give up too easy!'

'Do not,' I said quietly. I didn't know what to do then. Nellie was right, that girl was our own flesh and blood. I couldn't let her go so easily. I looked down at the tin again and felt strangely better, almost happy. I'll make one last try, I thought to myself. I'll get a new envelope and mail it to her. She might just read it!

I was out in the yard when I heard the phone ring. I felt sure that by the time I got inside it would stop. It takes me a long while to get up the back steps these days. 'Hello,' I panted as I lifted the receiver. 'Aunty Bessie?' 'Who's this?' I asked in surprise. 'It's Elaine.' Elaine? I couldn't believe it! It'd been two months since I'd mailed the letter. 'Is it really you Elaine?' I asked. 'Yes, it's me. I want to talk to you. Can I come and see you?' 'Ooh yes, anytime.'

'I'll be there tomorrow and Aunty … take care of yourself.'

My hands shook as I placed the phone back on the hook.

Had I heard right? Had she really said, take care of yourself Aunty? I sat down quickly in the nearest chair and wiped my eyes.

'Well, why shouldn't I cry?' I said out loud to the empty room, 'I'm not on the bus now!' Nellie felt very close to me just then. 'Aah sister,' I sighed, 'did you hear all that? Elaine will be here tomorrow?'

'Did you hear that sister? Elaine's coming home.'

<div align="right">SALLY MORGAN</div>

This text originally appeared in *Paperbark: A Collection of Black Australian Writings,* edited by Jack Davis, Stephen Muecke, Mudrooroo Narogin, and Adam Shoemaker, published by the University of Queensland Press, St Lucia, Qld, 1990. 'The Letter' is reproduced with permission of Sally Morgan.

15. Music

15.1 Song as an Indigenous art

Song is one of the primary means by which Aboriginal Australians, of whatever background, express and maintain their identity and culture. As David **Mowaljarlai,** eloquent spokesman of the Ngarinyin people of the northern Kimberley, once commented [see 15.5]: 'song was the first idea, the principle of sharing which underlies our system.'

Both Indigenous and adopted song genres are sites of constant creativity for contemporary Aboriginal people, and new hybrid forms are constantly emerging. This survey focuses on Indigenous song genres and their central role in Aboriginal culture (including their relationship with other art forms) because relatively little is known about them. Many distinctively Aboriginal characteristics and practices in music-making within adopted musical styles (such as rock and reggae [see 15.2]) can be better identified if the listener has an understanding of the significance and forms of Indigenous song genres. The valorising of 'world music' in the global commercial music market has made the quotation of Indigenous genres increasingly possible in the hybrid popular musics being developed by many Aboriginal musicians today.

A multiplicity of different Indigenous song types continues to flourish across Australia, incorporating and adapting new media, audiences, and expressive possibilities. In those areas of central and northern Australia where Indigenous languages have continued to be spoken, these Indigenous genres generally continue to be practised alongside adopted music, while in southern and eastern Australia, where the impact of European invasion has more strongly disrupted Indigenous cultural practices, adopted styles predominate. Even in these areas, however, the resurgence in public expression of Aboriginal identity [see **Aboriginality**] has generated revivals of long-dormant Indigenous genres, often with cultural exchange and inspiration from northern and central Australia.

The wider context of song

All Indigenous performance genres are associated primarily with religious ceremony [see 1.1, 2.1, 6.2]. Although performance can, and often does, take place in non-ceremonial contexts, ceremony remains the most fundamental and potent context of Indigenous song, dance, and visual representation. Ceremony is marked by dense layerings of signification and formal patterning in numerous media, some of which, like song and the visual depiction of the marks of the **Dreamings,** may also be enacted and circulated in non-ceremonial contexts. These abstracted artefacts of Aboriginal culture circulating globally as commodities have been framed as Western genres—'music' and 'art'—but if we wish to appreciate them in terms of an Indigenous aesthetic, it is important to remember their interdependence as parts of a complex whole.

Catherine Ellis (1970) was one of the first musicologists to draw attention to what we would today call the multimedia aspects of central Australian ceremony. She argued that performances needed to be recorded and explained in several media, because different aspects of the myth being represented were presented in different modes of formal patterning—the song text, the body design [see 2.2], the dance movements [see 6.5, 7.3, 16.3]—as well as in the musical structure itself and in the spoken exegesis of the myth.

The ancestral forces evoked in ceremony through the interlocking of these various modes of formal patterning can be wielded for good (healing or increase of food species), but they are potentially highly dangerous in their power to unleash excessive and undisciplined natural energy (freak storms, bushfires). Great care is taken not only in instilling respect for Dreaming power, but also in teaching the formal patterning and its significance. The blurring of one aspect of the patterning—the smoothing over of the tracks left by the dancers, or rubbing out the body designs—may be enough to defuse these dangerous aspects of Dreaming power. But all cultural activity is instilled with Dreaming consciousness.

The extent to which song is inextricably intertwined with other artistic and linguistic media is indicated by the multiple meanings of words for 'song' in many Aboriginal languages. For example, in the Warumungu language of northern-central Australia, the word used for women's songs, *yawulyu*, may also refer to women's ceremonies in general, to the associated dancing, to body designs, and to the objects used in performances. Each part evokes the whole complex.

To those inculcated in ceremony, each song, like each design, marks a particular aspect of or a particular moment in a larger story. They are indexes—the scent, or the track—of the ancestral myths that organise the physical and social environment. They stand for, but do not encapsulate, the relevant Dreaming. The elusiveness of a neat explanation for any one song is attributable to this quality of metonymy: song texts are always pointing outwards to organisational principles, and cannot be encapsulated in simplistic translations. In central Australia, each of the many song texts making up a song series—or 'songline' as it is sometimes termed by Aboriginal people to convey the mapping of the country through song—commemorates a particular action of a Dreaming ancestor as it passes through a particular tract of country. It is in ceremony that the accumulation and superimposition of mimetic detail evokes the power of the Dreaming left dormant in the sites visited by the ancestor.

Despite the great variability between Indigenous genres of different areas, certain common underlying principles and formal features can be identified. Songs are locally specific: they make sense in relation to a particular geographical, cosmological, and social context. Thus, song texts typically refer to specific features of the local environment, or to characteristic movements of a particular animal species, or to a specific occasion. For example, the text of one *yawulyu* sung by Warumungu women refers to a particular dried-up mulga tree that stands by itself near the road north of Tennant Creek (in northern central Australia):

wakiriji larrana wakiriji larra
wakiriji larrana wakiriji larra

mangkkuru larrana mangkkuru larra
mangkkuru larrana mangkkuru larra

In their most important and sacred contexts, in ceremony and ritual, songs may extend this quality of specificity to naming, thereby evoking the power of the Dreaming.

188. Peter Manaberu, painted clap sticks, 1988. These clap sticks were used by Alan Maralung, a Ngalkbon singer and 'clever man', to accompany his *wangga* songs at the time of their recording by Allan Marett in 1988. The designs depict the two spirit beings from whom Maralung received songs while in a dream state: the bird *Bunggridj-bunggridj*, and the spirit of a deceased songman named Balinydyirri.

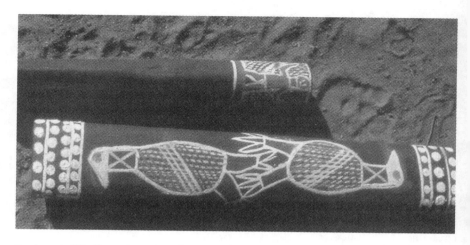

In almost all Indigenous genres, the songs themselves are regarded as having non-human origin. Old songs, the most powerful Dreaming songs, were created by Dreaming beings, often as part of the process of differentiating and creating the country and the social world in its present form. Thus songs, like language and other forms of culture, reside in the country. New songs may be found by individuals while in an altered state of consciousness (typically while dreaming). In such cases the songs usually emanate from country-based spiritual power, often with the assistance of a spirit intermediary such as a deceased relative. For example, it was in recognition of the non-human origins of his songs that the Ngalkbon songman Alan Maralung accompanied his *wangga* songs using a pair of clap sticks upon which were painted the figures of his two song-giving spirits *Bunggridj-bunggridj* (a small bird) and Balinydyirri (a deceased songman) [188].

The Warumungu women's song mentioned above was received in dream from the Mungamunga women (Dreaming women associated with the country around Tennant Creek and other places). In describing her dream encounter with the Mungamunga, Nappanangka reported that as she was being taught the song in her dream, her daughter heard her singing in her sleep. Today this particular song text takes its place within a larger series of Mungamunga *yawulyu* songs. Dreamt by a number of different women over the last fifty years, all these songs bear the mark of their source in the Dreaming world of the Mungamunga through their distinctive melody and rhythm.

The language of song

The language of song texts is often difficult to understand, because singing styles entail phonetic changes and the introduction of ambiguities, as well as the use of a specialised song vocabulary. As Dixon has noted, song texts often include old words, words in other languages (including languages spoken only by spirits), meaningful words that are 'just for song' and vocables (meaningless syllables that may serve a purely rhythmic function).

For example, the Warumungu song cited above includes two words *larrana* and *larra*, described as *wirnkarra-kari* (belonging to the Dreaming) and 'just for song', and two words in Warumungu: *wakiriji* (mulga) and *mangkkuru* (black soil plain). Without extensive and specific local knowledge of the country and of the Dreamings that inhabit it, the learner would find it impossible to make sense of this song text. For those steeped in knowledge of the country and its culture, however, the song participates in and evokes a dense web of associations and meanings. The very obliqueness and lack of specificity in the song text point to the necessity for authoritative elucidation and exegesis by knowledgeable elders. Stephen Wild has eloquently discussed the ways in which song

knowledge and transmission participate in networks 'recreating the *jukurrpa* [Dreaming]'. Bearing in mind that a performance of a central Australian songline may consist of hundreds of different song texts, the depth of knowledge it embodies and that is required for its decipherment is staggering. Truly the long song series of Australia are among the most impressive monuments of human culture.

Rhythm and melody

Linguistic complexity is only one dimension of song. Let us now turn in some detail to the ways in which the aural patterning of the song—its rhythm and melody—reflect the ethos of the Dreaming, and how these patterns are integrated with other forms of kinesic and visual patterning in dance and design.

Fred Myers has characterised two central qualities of the Dreaming as 'timelessness and segmented extension in space'. The formal structure of a songline—the succession of individual song texts, each set to the same melody associated with a particular Dreaming—is metaphorically linked with a track. The Dreamings are encoded in country through the marks they left at particular sites along their track. The sites are encoded in musical structure through the succession of distinct song texts, each set to the same melody. Each song in the series is like an individual footprint in the track: self-sufficient but, to those who know how to read it, encoding a wealth of information about the being who created it and its activities in that particular context. A unifying meaning is given by the melody (often referred to in central Australian languages as the 'scent' or 'taste' of the Dreaming ancestor). The melody expands and contracts to accommodate texts of different lengths just as the precise form of a footprint is determined by the nature of the terrain upon which it is left.

The timelessness of the Dreaming is indicated by the cyclical patterns found in both rhythm and melody. The song text is set to an invariant rhythm with percussion beating. This text with its associated rhythm is repeated over and over until the end of the item is reached. The song performance may begin and end at any point in the text cycle. For example, one performance of the *yawulyu* Mungamunga song text we have already discussed presents the following sequence:

wakiriji larrana wakiriji larra
mangkkuru larrana mangkkuru larra
mangkkuru larrana mangkkuru larra
wakiriji larrana wakiriji larra
wakiriji larrana wakiriji larra
mangkkuru larrana mangkkuru larra
mangkkuru larrana mangkkuru larra
wakiriji larrana

In abstract, the text cycle consists of a repetition of each of the two lines:

A: wakiriji larrana wakiriji larra

B: mangkkuru larrana mangkkuru larra

In this particular performance, the singing starts and ends at different points in the cycle: ABBAABB(A), with the final A being truncated. The conventions of performance create the sense that the song text is cycling endlessly, occasionally surfacing to manifest in audible form, then resubmerging.

The melody too is cyclical: a song performance typically presents two or three repetitions of a particular series of pitches. The start and end points of the melodic cycles do

not necessarily coincide with the text cycles: indeed, because different songs in the series have text cycles of different durations, the number of repetitions of a text cycle needed to present a whole melodic cycle may vary from as many as fifteen to as few as two. The fitting of the text onto the flexible melodic contour is a process improvised or negotiated in performance by song leaders who are not only musically knowledgeable but also endowed with the authority to explain the texts and the associated myth.

The simultaneous presentation of independently cycling temporal structures has an iridescent quality, where first one structural aspect, then another, may be in the foreground of our consciousness. Grasping the whole requires abandoning analytical listening and may be a profoundly disorientating experience. How much more overwhelming when to the independent auditory patternings of melody, rhythm, beating, and text are added, in ceremony, the simultaneous presentation of information through dance and design, sometimes partially obscured by flickering firelight and smoke!

The Warumungu Mungamunga *yawulyu* series presents two different forms of the melody—termed *warlinginjji* (slow, quiet) and *kulumpurr* (fast, loud, happy)—the selection of which depends on the rhythmic patterning of the particular song text. This patterning in turn correlates with particular dance movements—termed *martta* for slow dancing, and *ngappajarra* for fast dancing—used by the Mungamunga women and re-enacted in ceremony by Warumungu women today. The strokes of the percussion accompaniment refer to the footsteps of the Mungamunga women, and call forth the matching movements of today's dancers. Thus, ritual actions, called forth and synchronised by the performance of song, confirm the intimate and ongoing relationship of Aboriginal people with country and Dreamings.

Song and visual representation

To knowledgeable Aboriginal people, seeing the designs associated with a particular Dreaming may immediately call to mind the relevant songs, and vice versa. There are many reported instances of Western Desert painters singing as they execute Dreaming designs in **acrylic paintings** destined for the international art market. These paintings may serve local purposes, too. For example, during a session to record a Warlpiri men's *ngapa* (rain) Dreaming *yilpinji* (love song) series at Alekarenge (NT), in September 1996, an acrylic painting executed by Linda Wilson Nangala, the granddaughter of Jangala, one of the song leaders, was brought out [189].

The painting, described by the other song leader, Japaljarri, as a 'map', served as the focus for his exegesis of the *ngapa* Dreaming at the site Kurlpurlunu: as he named distinctive features of the painting, he sang snatches of the song texts associated with them. Explanations of the song texts often evoked the execution of designs, too. The distinct responsibilities of 'owner' (*kirda*) and 'manager' (*kurdungulu*) in holding and looking after the Dreaming are evident in the roles taken by the two senior men in explaining the songs. Here the owner, Jangala, dynamically executes the large-scale design—representing raindrops, the rainbow, and sheets of rain—as he talks enthusiastically about the power of the thunderstorm sweeping along through the country. The manager, Japaljarri, whose duty to care for and uphold the Dreaming was inherited through his mother, has drawn a more restrained and stylised depiction of the *wirliya* (footprint or track) of rain. Both men executed individual strokes in their drawings rhythmically, in time with singing of snatches of the relevant song text [190].

The tight interconnectedness of song, dance, and design relates the creative actions of the ancestors, as revealed in their marks left on present-day landscapes, to the creative actions of contemporary Aboriginal people. Dreaming songs, stories, and designs may now be created by Aboriginal people for a global market, but this does not necessarily

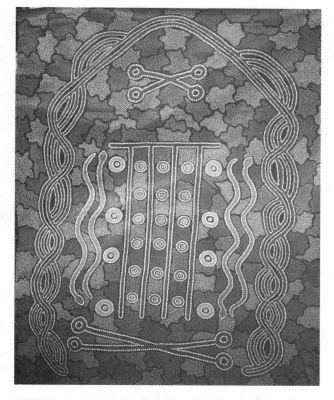

189. Linda Wilson Nangala, *Ngapa (Water or Rain) Dreaming at Kurlpurlunu*, 1996.
Acrylic on canvas, 132 x 93 cm. During a break in recording of the *ngapa* songline at Alekarenge in September 1996, this painting was used by the senior songmen Japaljarri and Jangala to explain features of the songline. They sang the songs associated with each feature of the site represented in the painting.

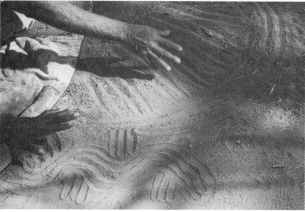

190. Jangala and Japaljarri's sand drawing executed in the course of explaining the *ngapa* (rain) Dreaming song texts, Alekarenge, September 1996.

negate their use for more localised purposes. At Mandorah, near Darwin, **didjeridus** created and decorated for the international tourist market [see 18.1] are on sale in the local pub; this does not prevent their being reappropriated on occasion for an impromptu *wangga* performance held on the nearby beach for the benefit of researchers documenting a **land rights** claim [*191*].

The commodification of Indigenous song

We may perhaps think of the paintings, recordings, instruments, and video clips relating to Indigenous ceremonial genres as 'tracks' of Aboriginal ceremony. Now that these 'footprints' circulate in their own right as commodities in the global market place, the

191. Nicky Djarug plays didjeridu to accompany Kenny Baranjuk's *wangga* singing on the beach at Mandorah (NT) in 1997.

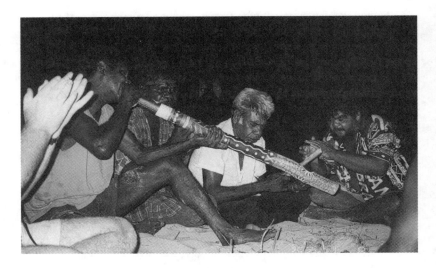

didjeridu, painting, sound-bite, or video clip may be the first or only means of contact with Aboriginal culture for a vast international audience. It is little wonder that, without the benefit of an Aboriginal education to point to some of the richness and subtlety of the religious practice that generated these 'traces', the first response of the middle-class Westerners who make up the majority of this global audience is to treat the visual and aural footprints of the Dreaming as 'art' and 'music'.

Thousands of didjeridu players in Seattle, Amsterdam, and Dublin are more interested in asking technical musical questions about performance techniques and the like than in engaging with difficult political and cultural questions about social meaning [see 15.4]. The seemingly value-free dissemination of Aboriginal 'music' as equivalent to African or Sardinian or Tuvan 'music' creates a market place for musicological explanations as keys to understanding.

It is noteworthy that despite the 1990s boom in world music, very few recordings of Indigenous genres of Aboriginal song have become available. Many recordings marketed internationally as 'authentic' and 'traditional' Aboriginal music are actually recently-composed examples of tourist-oriented didjeridu 'relaxation' music, often recorded and produced by non-Aboriginal or even non-Australian performers. Just as worrying in their own way are the field recordings of Indigenous ceremonial genres, which were typically made in the 1960s, and are being published internationally in the 1990s with inaccurate and misleading notes, and no return of royalties to the communities of the performers [see 22.1]. These are even more objectionable when material is included that communities have requested be withdrawn from public circulation. Fortunately, more and more Aboriginal communities are now taking charge of their own representation in the global market place, and asserting control of their cultural property. Nevertheless, there seems to be much scope for misunderstanding and slippage between the Aboriginal economy of knowledge based on face-to-face duty of care, and the desires of producers and many consumers of the global musical product for snappy, easily-digested, politically neutral explanations—sugar-coating for the sound-bite pill.

LINDA BARWICK

Dixon, R. M. W., *The Languages of Australia*, Cambridge, 1980; Ellis, C., 'The role of the ethnomusicologist in the study of Andagarinja women's ceremonies,' *Miscellanea Musicologica: Adelaide Studies in Musicology,* vol. 5, 1970; Ellis, C., *Aboriginal Music: Education for Living,* St

Lucia, Qld, 1985; Maralung, A., Manaberu, P., & Marett, A., *Bunggridj-bunggridj: Wangga Songs by Alan Maralung* [CD, notes by A. Marett & L. Barwick], Washington, 1993; Myers, F. R., *Pintupi Country, Pintupi Self: Sentiment, Place, and Politics Among Western Desert Aborigines*, Canberra, 1986; Wild, S. A., 'Recreating the *Jukurrpa*: Adaptation and innovation of songs and ceremonies in Warlpiri society', in M. Clunies Ross, T. Donaldson, & S. A. Wild (eds), *Songs of Aboriginal Australia*, Sydney, 1987.

15.2 Aboriginal contemporary music: Rockin' into the mainstream?

Today I tried to reach somebody
From Yuendumu, Chicago too
There's only one news receiving my ear,
It's a song of love and a song of fear.

Could you reach somebody, somebody today?
There's one more story to tell.
Could you reach somebody, somebody today?
There's one more story to tell.

ONE MORE STORY TO TELL, APAAK JUPURRULA (PETER MILLER) AND ALAN MURPHY
FROM THE ALBUM *BLEKBALA MUJIK* (1995)

Contemporary music is integral to Indigenous community life, often easily co-residing with more traditional forms of expressive culture. The marginal space occupied by Indigenous musicians in the mainstream music industry of Australia parallels their marginality in the mainstream media. For example, negative stereotypes of urban Aborigines have meant that touring Indigenous bands often experience difficulty getting bookings, because pub owners are afraid they will attract the 'wrong sort' of audience. This is depicted in Ned Lander's semi-fictional film [see also 13.1], *Wrong Side of the Road* (1981), which features two Indigenous rock bands, No Fixed Address and Us Mob.

At the same time, pressure is put on musicians to produce Indigenous, expressive culture in particular, prescribed ways. For instance, the **didjeridu** has become, in Karl Neuenfeldt's words, 'the major musical symbol of **Aboriginality**', even though it was originally restricted to Arnhem Land and the north-east of Western Australia. Richard Micallef, former music manager of the Central Australian Aboriginal Media Association's (CAAMA) music label, has commented on the demand for the didjeridu in Indigenous recordings, regardless of whether it is culturally or aesthetically appropriate to the music. According to Micallef, didjeridu has taken on new meaning to overseas, alternative lifestylers as 'the new *Stairway to Heaven*', and he is concerned that this new market for didjeridu recordings could lead to appropriation and copyright infringement [see 15.4, 22.1].

Indigenous musicians may or may not be ready and willing to enter the mainstream music industry. Although some bands aim for national and international success, others are interested in producing their own music with, and primarily for, their own communities. Prominent Yolngu band, **Yothu Yindi** [408], from north-eastern Arnhem Land, has sought a position within the mainstream, believing it provides a stepping-stone to **reconciliation**. Its early 1990s song, *Treaty*, was the first Indigenous rock song to hit the top of the charts. Since then, the band has gained international recognition and produced several albums with a major Australian record label, which has helped to increase awareness and appreciation of Indigenous popular music. However, the marginal space allowed for Indigenous expressive culture in the mainstream has encouraged the expectation that all Indigenous rock bands should look and sound like Yothu Yindi. David

Hollinsworth describes the manner in which Yothu Yindi has been viewed—and marketed—in mainstream Australia as the 'privileging of representations of essentialised and exoticised Aboriginal culture'. This, he says, has made it more difficult for bands from 'less exotic settings' to establish themselves in the public sphere as musically worthwhile, culturally interesting, or even authentically Indigenous.

In 1995, the Alice Springs band Amunda, while on tour, was playing a gig in a small venue in the Canberra suburbs. As a friend and I chatted with band members between sets, the lead singer was approached by a drunken man: 'Hey, can you play that song that's on the radio? What's the name of it … oh yeah, Treaty.' This man persisted, convinced that Amunda, as the only Indigenous rock band he'd ever seen, should be able to play the only Indigenous rock song he'd ever heard. When I asked Amunda's lead singer how he felt about the encounter, he shrugged his shoulders, and said that sort of thing happened all the time.

The Central Australian Aboriginal Media Association (CAAMA)

CAAMA, as an Indigenous media organisation based in Alice Springs [see **media associations**], deals with the tensions and ironies of working simultaneously within and outside the mainstream commercial broadcasting and recording industries. Consisting of a **radio** station, **television** services, video productions unit, and music label—CAAMA Music—with its own recording studio, CAAMA has produced more Indigenous album titles than any other label in Australia. It began recording Indigenous music in the early 1980s, to fulfil its commitment to broadcast Indigenous content on its radio station. CAAMA's music studio has always considered the promotion of community and cultural development as a primary goal. Accordingly, it provides regular recording services for local community bands at reduced rates, acts informally as agent or advocate for these bands, conducts regular music workshops in Indigenous communities, and acts as sponsor and consultant for local Indigenous community festivals.

CAAMA Music is keenly aware of the difficulties and paradoxes facing Indigenous musicians. Even though it has a state-of-the-art recording studio, and produces high-quality albums in a variety of popular genres, ranging from **country and western** to rock and world music, CAAMA has found that mainstream broadcasters are reluctant to air or market its products. Micallef attributes this to several factors: CAAMA's physical distance from what is considered the 'centre' of the industry in Sydney and Melbourne makes it easy to overlook; there is an assumption in the mainstream industry that any Indigenous music label will be less professional, and its product inferior; and Australian musicians in general (Indigenous and non-Indigenous alike) have difficulty achieving commercial success in Australia, because the industry here favours overseas imports over supporting its home-grown talent.

CAAMA feels it is ultimately answerable to its own community. The high level of cultural sensitivity required in producing and marketing local musicians means that CAAMA frequently makes decisions which it knows will result in reduced commercial and financial success. For example, in Indigenous Australia it is generally the case that, after someone dies, mention of their name, sight of their image, or the sound of their voice will cause great distress to family members and those close to them. Thus, if a musician dies, CAAMA feels obliged to pull that person's commercial recordings off the local market, and to recall posters or advertisements with that person's photograph. It ceases to broadcast the musician's work for as long as the family feels it is suitable—and this could be for a number of years.

CAAMA produces a number of local community bands who are not particularly interested in 'making it' in the mainstream music industry. Many community musicians

are unwilling to pay the price for national or international recognition, which may include touring commitments which will take them away from their families and community for long periods of time. They are more interested in producing a small number of cassette albums which will be disseminated locally, and in following a touring circuit limited to Indigenous communities in central Australia. CAAMA produces these albums, sometimes making as few as 200 copies, knowing that it will probably lose money on them.

CAAMA does produce albums specifically targeting mainstream markets. For example, *Red Sands Dreaming: A Global Cultural Collective* (1998), is an 'ambient' album, designed for the world music market. However, this album, was in production for three years, and meanwhile other rival world music albums with an Australian Indigenous flavour were produced and launched in a quarter of the time. The CAAMA album, which features twenty separate Indigenous performers—from community members participating in traditional song ceremonies, to Indigenous school children—required two separate contracts (publishing and recording) with all these individuals to ensure that they received the recognition and royalties they were entitled to. Further, CAAMA was not willing to enter into final production on the album until Indigenous community members could be fully consulted, in order to ensure that any traditional material on the album was presented in an appropriate manner. Thus CAAMA, having produced this world music album in a culturally sensitive and conscientious manner, has only a small corner of the market because there are non-Indigenous producers putting out albums which, although they contain Indigenous traditional music, do not cite the performers or attribute any copyright to them.

Identifying contemporary Indigenous music

To view contemporary music genres as being in opposition to traditional ones would be misleading: many people are equally conversant with, and regularly perform, both. Further, as Catherine Ellis has shown, for some Indigenous Australians, 'traditional' music may include early twentieth-century Scottish, English, and Australian folk songs, black American songs, music-hall songs, or hymns. Many Indigenous communities in central Australia have church choirs who sing 'traditional' Christian hymns in both English and local Indigenous languages. For example, the Hermannsburg [see 1.2, 9.1, 9.2, 9.3] Ladies Choir has recorded albums in the local language, such as 'Arrente [Arrernte] Christmas Carols' (1988); and the Titjikala Desert Oaks Band, a country-rock band from central Australia includes selections of gospel music performed by the Titjikala Maryvale Choir on its album, *Titjikala* (1989), citing them as 'traditional'.

Virtually universal access to mainstream media has meant that all Indigenous people are familiar with a variety of musics, and are regularly exposed to Australian and American popular genres. Contemporary Indigenous musicians often utilise, and experiment with, the harmonic and rhythmic structures of Western popular music as well as those of traditional Aboriginal music, creating a synthesis of genres. For example, Steven Knopoff has described how Yothu Yindi features contemporary rock songs, Yolngu clan songs, and a Yolngu recreational song form (*djatpaŋarri*) in its albums and live performances, and includes discussions of traditional Yolngu culture in its album liner notes for *Homeland Movement* (1989), *Tribal Voice* (1992), and *Freedom* (1993).

Blekbala Mujik, a band from central Arnhem Land, includes both contemporary and traditional songs on its album, as well as artwork by the lead singer which is 'painted in a traditional manner'. When permission was requested for use of one of its traditional songs on an educational CD-ROM, the band granted permission with the proviso that one of its rock songs be included as well, because it wanted to make it clear that it performs both traditional and contemporary music.

As Paul Ah Chee, lead singer of the Alice Springs band Amunda, told me in 1995, 'Aboriginal people know that they were the original inhabitants of this land, and they've got a very strong culture. And that culture allows us to be experimental with what we do. Because we know that we can always return to home base, you know. We know we're going to get around it. Someone's going to hit a home run and we'll touch first, second, third base and get home.'

Stylistic traits

Some Indigenous contemporary music has textual and musical attributes that make it unmistakably 'Aboriginal', including lyrics in local Indigenous languages, references to local place names and sacred sites, and use of Indigenous instruments (didjeridu, clap sticks). Other more subtle stylistic traits, some strictly musical, others performance-related, distinguish Indigenous popular music from its Western counterpart.

Vocal production, which differs regionally, is often distinctive in quality. For example, the slightly nasal, husky vocal quality often present in the voices of Arnhem Land singers is evident in the performances of Mandawuy Yunupingu [see 23.1; **Yunupingu family**] (Yothu Yindi), George Djilaynga (Warumpi Band [*192*]), and Keith Lapalung (Wirrinyga Band). Central Australian performers sing with light, clear, and sometimes sonorous voices, exemplified by Rex Patterson (North Tanami Band), Ron Watson (Areyonga Desert Tigers), and Frank Yamma (a Pitjantjatjara singer from Alice Springs).

The treatment of text in relation to melody, and the use of additive rhythms and phrases, show characteristics which Ellis, Brunton, and Barwick describe as 'unconscious remnants of traditional performance practice'. For example, the song *Kapi Pulka* (Big Rain) by Coloured Stone, a band from Koonibba, South Australia from its album *Koonibba Rock* (1985), is a synthesis of Western and Indigenous musical and cultural elements. Utilising reggae, country-western, and rock genres, it employs a standard country-rock format with alternating verses, refrain, and instrumental interludes each six to twelve bars long, but plays with standard rhythms by adding and subtracting beats from bars, changing phrase lengths, and unexpected placement of text and syncopation. Further, the song makes use of didjeridu, and uses Indigenous language words.

192. Warumpi Band performing at the Adelaide Arts Festival, March 2000. The band members (*l. to r.*) are Neil Murray, George Djilaynga, Bill Heckenburg, Stanley Satour, and Stephen Teakle.

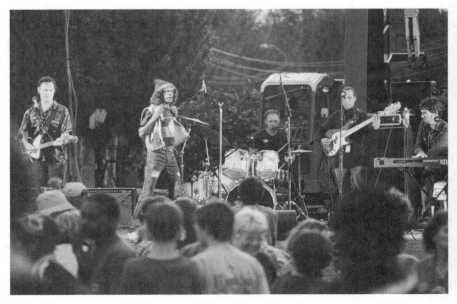

Performance practice, which also differs regionally, may also be distinctive. Central Australian Indigenous bands tend to perform in a quiet, retiring, passive manner, even when the music is lively rock. Neil Murray, a former member of Warumpi Band [*192*], from Papunya, in his fictionalised account of his years with the band, describes performing in communities in the Centre:

I felt like an idiot standing out in front facing the audience while the others played with their backs turned and Geoffry played drums with his head bowed, looking at the floor. I learnt that this was 'kurnta', they said 'shame'.

'Wiya kurntarrintjaku! [don't be ashamed]' I learnt to say but it did no good. My bold position out front facing the crowd must have just confirmed people's opinions that whitefellas have got no shame.

Bands from Arnhem Land tend to be more outgoing on stage, and often include dancing, traditional costumes, and body painting in their performances.

Indigenous community audiences tend to respond in a more subdued manner to live musical performances than their European counterparts, out of respect for the performers. This in turn affects the relationship of the Indigenous band to its audience.

Andrew McMillan's account of Midnight Oil's 1986 'Blackfella/Whitefella' tour of outback Aboriginal communities describes the puzzlement of the band when community audiences failed to applaud or dance to their music, and got up to leave as soon as the last chords of the last song were done:

Over by the store, bunches of women and children stand and squat by the fence, curious but giving little away, shy of these shameless whitefellas jumping around and making such a racket … when he says 'Thank you' the people by the fence get up and quickly disperse, figuring the whole gig's over and that, in the interests of politeness, it's time to go home.

Song lyrics

Indigenous popular musicians tend not to write straight love songs. They are more likely to deal with topics important to their communities, such as relationship to the land, community issues, and protest against historic and current injustices.

Songs relating to land cover a range of themes: love of country (*Heart of Kakadu*, Mimi Band), identification with country (*Our Home, Our Land*, various artists), **land rights** (*Land Rights*, Sunrize Band), loss of land (*We Shall Cry*, Warumpi Band), identification of important sites (*Yolngu Boy*, Yothu Yindi), and exhortations to get back to one's country (*Mardaka Nyanu* (Keep it for yourself), North Tanami Band).

Community issues addressed in song include: alcohol (*Woma Wanti* (Drink Little Bit), Areyonga Desert Tigers), AIDS (*Inipanya AIDS Ngku* (The Name is AIDS), Isaac Yamma and the Pitjantjatjara Country Band), taking care of the community (*Chairman Blues*, Bevan Young & Victor Tunkin), and keeping culture strong (*Tell Me Stories*, Lajamanu Teenage Band).

Protest songs, composed in anger or sorrow, cover a wide range of topics: the **stolen generations** (*Took the Children Away*, Archie **Roach** [*193*]), Aboriginal **deaths in custody** (*Justice Will Be Done*, Les Shillingsworth), destruction of culture (*Angerwuy* (Why We're Angry), Raven), racial discrimination (*Genocide*, Us Mob), and environmental degradation (*Stricken Land*, Blackfire). As Paul Ah Chee says: 'They're singing about the land, singing about alcohol, and how it affects the community, singing about AIDS, singing about a whole wide range of different issues that only an Aboriginal person can sing about, really. We're dealing with authenticity.'

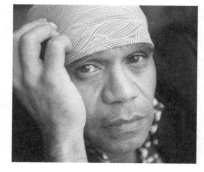

193. Singer and songwriter Archie Roach, 1997.

An expression of culture

Urban-based and remote community-based Indigenous music (and musicians) may be distinguished from one another in some respects, but regional stylistic differences must be considered as well. Urban-based musicians are less likely to write songs in Indigenous languages, they may incorporate more (and more varied) musical styles, their lyrics may be less tied to specific localities, and they are more likely to address non-Indigenous audiences in anger or protest. Archie Roach, for example, has incorporated his own personal experiences into his music. His powerful lyrical songs deal with a range of topics including the dispossession of Indigenous Australians, the stolen generation, alcohol, and homelessness.

Nonetheless, many urban-based musicians have roots in regional Australia, and this is reflected in their music. Christine Anu, a singer and performer based in Sydney, is originally from Thursday Island in Torres Strait. The songs on her 1995 hit album *Stylin' Up* contain allusions to Island life and culture, and make reference to local Torres Strait Island languages, including Torres Strait Creole, as well as to urban life. Joe Geia, a Melbourne-based musician originally from the Guugu Yimidhirr people of north-east Queensland, includes rock and roll, reggae, and Black American soul and funk musical styles on his album *Yil Lull* (1988). His songs deal with issues important to Indigenous people throughout Australia, but also make reference to his specific language, culture and family: the title of his album translates as 'Uncle Willie'.

Kev Carmody says, in the 1993 documentary film *From Little Things Big Things Grow*, 'I'm trying to express that music is something else. It's an expression of bloody culture, and the reality of a certain place and time ... To this day, I find it a pain in the rear end to get up on stage. I'd rather play around the campfire, do it like that. That's where the music's created.'

The story contemporary Indigenous musicians have to tell is rich, varied, and complex, often painful, yet ultimately optimistic. Elements from the past, both Indigenous and European, as well as present struggles, at both local and national levels, are helping to inspire and shape an oral—and aural—history which attests to the continuing viability of Indigenous expressive culture in Australia.

KATHLEEN OIEN

Ellis, C. J., 'Developments in music education among Aboriginals in central and South Australia', in J. Isaacs (ed.), *Australian Aboriginal Music*, Sydney, 1979; Ellis, C. J., Brunton, M., & Barwick, L. M., 'From the Dreaming rock to *reggae* rock', in A. D. McCredie (ed.), *From Colonel Light into the Footlights: The Performing Arts in South Australia from 1836 to the Present*, Norwood, SA, 1988; Hollinsworth, D., '*Narna Tarkendi*: Indigenous performing arts opening cultural doors', *Australian–Canadian Studies: An Interdisciplinary Social Science Review*, vol. 14, nos 1–2, 1996; Knopoff, S., 'Accompanying the Dreaming', in K. Neuenfeldt (ed.), 1997; McMillan, A., *Strict Rules*, Sydney, 1988; Murray, N., *Sing for Me, Countryman*, Rydalmere, NSW, 1993; Neuenfeldt, K., 'The didjeridu in the desert', in K. Neuenfeldt (ed.), 1997; Neuenfeldt, K. (ed.), *The Didjeridu: From Arnhem Land to Internet*, Sydney, 1997.

15.3 Torres Strait Islander music

The significance of music in Torres Strait culture [see also 1.6, 7.1, 7.2, 7.3, 7.4, 7.5] is neatly summed up in Darnley Islander James Thaiday's words: 'Music is an important aspect of Torres Strait life style. Our whole identity, our culture and tradition revolve around music'. Islander identity and music have both changed in response to varying influences, possibly not more so than in the past century, but the link between the two is

as close as ever. Music remains integral to the negotiation, affirmation, and maintenance of Torres Strait Islander identity. Music and the dance which almost invariably accompanies it are so important to Torres Strait society that many behavioural conventions are suspended during performance, including strict restrictions on conduct between in-laws of the opposite sex that are normally sacrosanct.

Today's Torres Strait music and musical practices are the products of a musical tradition that was interrupted by the 'Coming of the Light' (Christianity) in 1871 [see 1.2]. The gospel was predominantly spread by South Sea mission teachers who relentlessly disrupted all connection with the Torres Strait Islanders' past, including the singing of traditional songs and performance of traditional dances. The ancient Torres Strait 'wailing chants' and light, high-stepping dances were systematically replaced by South Sea melodies and heavy-footed, stamping dances. But while mission teachers were successful in destroying much of the detail of traditional musical practice in Torres Strait, they could not compete with the adaptability and inventiveness of the Islanders. Following a period of experimentation, new styles evolved, combining elements of South Sea music and movement with features of traditional Torres Strait music and dance. These new styles, now known as Island Song and Island Dance, are viewed by today's Torres Strait Islanders as their musical heritage.

Torres Strait music is predominantly vocal, with percussion accompaniment. Island Songs generally originate with known individuals. The words and music are usually created by the same person—in Western terms, a poet–composer. Islanders speak of music as being 'found', not 'composed'. The words are a response to an inspiration, and the melody is then 'chosen' to suit the text. Torres Strait music is not notated, but passed on by oral transmission. A song's melody undergoes surprisingly little variation over time: efforts are made to maintain authenticity by honouring the song-maker's original intentions as faithfully as possible from performance to performance. For this reason, the melody is sometimes referred to colloquially as the 'straight voice'.

Island Songs are performed in two-part or three-part harmony. Harmony parts are not determined by the song-maker, but are improvised by the singers. Once established, these harmonisations become comparatively standardised, but they do undergo continuing variation. The essence of the harmony is retained, with singers free to provide embellishments within the agreed harmonic framework. The quality of the harmonies used is of particular interest. Consecutive fourths and fifths are common, lending a regionally distinctive character to the music which affirms a unique musical identity.

A beat is always maintained for singers and dancers on a large, waisted drum (*warup~buruburu~badara*), a metre or more in length, with one open end [389]. The drum's membrane is local goanna skin, or snake skin imported from Papua New Guinea, upon which small beeswax mounds are affixed to enhance resonance. The instruments are usually decorated with traditional, brightly coloured, geometric designs.

While most waisted drums are imported from PNG, a few are crafted in Torres Strait. A remarkable example fashioned by Samuel Auda of Yam Island is an example of *kago*, an instrument similar in style and proportions to the old traditional *warupa*, and made from local timber. The drum has no decorative carving and was originally unpainted. It was once elaborately adorned with bird of paradise feathers and seed pods, but these were removed from the instrument long ago. Much like Wasikor, the sacred drum of Mer (Murray Island), *kago* is not just a musical instrument, it is an important local emblem of identity.

A large, horizontal, bamboo slit-drum (*lumut~thrum~taram*) subdivides the *warup* beat into fours or eights in duple time, and into sixes in triple metre. Waisted drums and bamboo slit-drums are the principal musical instruments of Torres Strait.

194. Bundle rattles are frequently used in both men's and women's dances throughout Torres Strait. They are carried by the dancers as a sound-producing dance prop. Depending on the island of origin, the rattle is variously known as *goa*, *guwa*, *gua*, *gor*, *kulap* or *kolap*. The instrument's name derives from the Indigenous name of the material used to make it: *goa* (Pangium edule) and *kulap* (Entada phaseoloides). The nut-shells (seeds) average about 4-5 cm in diameter, and are split in half for use. Instruments vary in size from 8 to 40 whole shells. Traditionally, natural fibres were used to tie the half-shells together, and the twine was then tied or woven together in a handle with a loop or club shape. Today, synthetic strings are used more often. The *guwa* in the photograph is made with nylon twine. 1998.

195. Yam Island elder Eric Mareka tests a newly crafted notched flute. Two further instruments under construction rest on his lap. Notched (end-blown) bamboo flutes are found infrequently in Torres Strait, based on the availability of specific varieties of bamboo (*ipypus, Bambusa forbesii*). They are used soley for personal recreation, playing dance songs. The skill of flute making is currently held only by a few elders.

Bean-pod rattles (*gor~goa~guwa*) [194] or split bamboo clackers (*marap~marup*) are sometimes carried by dancers to reinforce the pulse or add rhythmic punctuation. Other hand-held dance props such as bows and long sticks are exploited for occasional sounds. The ubiquitous guitar is now used to accompany singing in informal circumstances on some islands, but not during dancing. Guitar-based 'string bands' have not enjoyed wide popularity. Side-blown, conch shell trumpets (*bu*) are occasionally used for signalling and in association with specific dances. Melody instruments exist, but are rare, and are limited to bamboo flutes [*195*]. Pan-pipes appear occasionally, but are thought to be introduced rather than indigenous. Recent evidence indicates intermittent periods of notched flute playing on a few islands. No discrete flute repertoire exists—it is limited to dance tunes played for personal entertainment.

Musically, cultural identity is achieved through the powerful shared experience of music production. The characteristics of Islander singing and dance both reflect and shape the collective spirit. There are no solo songs or dances, or solos within these forms: Island Song is choral, and Island Dance is performed in ranks, with common movements. Performance contexts provide unique opportunities for the promulgation of collective identity by everyone present. Within this collective framework, individuals generate opportunities to display their excellence and assert their personal identity.

In public performance contexts, percussion instruments commence first, setting the tempo of the music. Songs usually begin this way even in informal settings, often with someone tapping out a *warup* beat or the *thrum* part on a tabletop or other handy surface. A lead singer then begins alone to 'strike' the song, establishing the tonality. Other singers take up the song mid-phrase, joining in almost immediately. The beginnings of songs are never synchronised: they always follow this phase-in procedure. Songs are almost invariably short, rarely more than thirty-two bars long, and use only one verse of text. They are repeated as many times as necessary to accommodate the sequence of dance movements, or until the singers are satisfied.

Island Songs vary from lullabies to war songs, and include work songs, nonsense (*geman*) songs, farewell songs, and a range of other types. Personal emotion is expressed predominantly in farewell songs, for Island protocol does not allow public display of personal sentiment in love songs or partner dancing involving close physical contact. Song texts speak mainly of the environment, the weather, marine travel, and other similar topics related to daily life, many of which are also concerned in one way or another with place. In this way, the songs evoke a sense of 'being there' by situating Islanders within familiar physical surroundings or conditions. 'Place' is as much a construct of the imagination as it is a geographical fact, so that locations are cultural symbols. Songs of the sea, of the pathways of the winds, of significant locations not only evoke mental images of specific places but also recall events and feelings associated with living in that space.

Song texts rarely concentrate on a single topic, but combine two or more images in a two-part or three-part structure. Normally the text moves from background to foreground, or from the general to the particular. For example, weather songs typically describe general weather conditions, narrow to the action taking place to nearer the observer, then describe the immediate effect. Richard Harry's song, *Ina ngalmunia maza guraridha e*, is a good example of a three-part weather song, ending with an image of the breakers on the reef's edge appearing like a white lace border on a lava-lava. Despite their brevity, the songs are thus rich in contrasting or complementary images.

Part 1, location:

Ina ngalmunia maza guraridha e, ngalmun zageth naki.
Here past us [lies the] reef backbone, our work [is] around here.

Part 2, weather and conditions in the distance:

Koei gubau mazaka, Wapa breika napaiki paruya.
Big wind to the reef, Wapa [name of the reef] breaker along ahead there in front.

Matha bauau nurnur ulaik'e.
Only waves' noise going on.

Part 3, near conditions and resultant image:

Siksik napaipa, mura ngade bulu kaliko leisad yuka gaar e.
Foam (white water) ahead there, all just like blue calico [lava-lava] lace lying around.

A strong sense of cultural ownership prevails in Islander society. In Torres Strait custom, custodianship of knowledge is based in the family. Proprietorship of songs is treated with such importance that the name of the song-maker is passed down with the song from generation to generation. Ownership of a song is initially vested in the song-maker, although tacit rights of use reside with the community. After the death of a song-maker, ownership remains perpetually with their family or clan.

Just as some families are known for producing excellent dugong hunters, others are recognised for producing exceptional singers, song-makers, dancers, dance-makers, or craftsmen of instruments or dance paraphernalia. The talents of particular families are viewed as comparatively static by the community (a family of singers usually produces quality singers, not expert dance-makers). It is not uncommon, in instances when uncertainty regarding ownership of a song arises, for a person to be dismissed as its possible creator because they belong to a family of dance-makers, not song-makers. Substantial prestige is accorded to artistic families, who weave important threads of cultural continuity through the community.

Periodically, gifted individuals emerge within families. Their talent, which is invariably recognised and nurtured, usually evolves in the special area for which the family is noted. It is the norm for one person to create the text and music, for another (in another family) to devise the dance movements, and often for another (in yet another family) to design the paraphernalia carried by the dancers. The cooperative, interdependent nature of Islander society is reinforced through this familial division of cultural responsibilities.

Talented individuals lead the community in their areas of aptitude and may become custodians of the tradition in their area of expertise. Thus the best singers become the authorities on the song repertoire. They acquire the duty to commit the repertoire accurately to memory and consequently accept responsibility for ensuring faithful performance of the songs. At times, a particular repertoire may come to rely on a single individual not only for its accuracy, but for its maintenance—sometimes even for its very survival. Some songs and dances may be for the exclusive use of a particular clan, may have well defined religious or spiritual connections, or may be secret songs. Whole rituals and repertoires are known to have been lost on the death of a custodian who has deemed it inappropriate to pass on valued knowledge to people who are not yet ready to receive it, or when the custodian was the last of the group to which the music belonged. Preservation of the material is regarded as irrelevant in an inappropriate context, and the right of ownership is expressed with finality.

Respect for specific song ownership rights has become more strongly demanded in recent times. This partly reflects a desire to negotiate, affirm, and maintain a specific identity, not only within Australian culture at large, but also within Islander culture. While Torres Strait Islanders share an overarching Islander identity, various regional and

even island-specific identities are distinguishable. Dance characteristics and singing styles differ between geographic and linguistic island groups, and individual islands, and act as markers of specific island identity. For example, Yam Islanders declare their language, manner of speaking, and consequently their singing style as 'lighter' than that of their neighbours in Mabuiag. They also regard their dance movements as lighter and more graceful. Even minor differences are highlighted as emblematic of separate identity, and are cultivated in the interests of reinforcing identity with a specific island.

The preservation and maintenance of Islander culture against the effects of Western commercial and popular culture are viewed today as priorities by the elders. It is no wonder, then, that although the exchange of material and cultural commodities (including songs and dances) is rooted in centuries-old bartering traditions, this exchange is now undergoing an internal cultural reassessment. The performance of particular song or dance material by those who are not the traditional owners provokes annoyance or even anger. Islanders tend deliberately to reserve a special portion of their repertoire for their own exclusive use, preserving a unique set that is not only representative of familiar people or particular families, but is also specific to the most fundamental place in which identity resides, the home island.

Islander culture is dynamic. New songs are constantly being created, just as they were in the past. These are no less a record of Islander culture than pre-colonisation music. Together, the songs of the past, the present, and those yet to be found are the markers and carriers of Torres Strait Island culture and Islander identity. FRANK YORK

Beckett, J. (compiler), *Traditional Music of Torres Strait* [sound cassette, Australian Institute of Aboriginal Studies], Canberra, 1972; Beckett, J. (compiler), *Modern Music of Torres Strait* [sound cassette, Australian Institute of Aboriginal Studies], Canberra, 1981.

15.4 Maningrida, the didjeridu and the Internet

One side-effect of the new genre in popular music, now known as 'world music' or 'world beat', has been a phenomenal interest in the **didjeridu**, the Australian Aboriginal wind instrument from the Top End of the Northern Territory and north-eastern Western Australia [see *191, 196, 330, 351*]. Towards the end of the 1990s it became a global fad, centred mainly in the USA and in a number of European countries. The use of the didjeridu amongst Australian Aboriginal people, too, has recently spread from its traditional range to Aboriginal groups in southern and more settled parts of Australia. The instrument has become a pan-Aboriginal icon and more generally an Australian cultural symbol. It is also now common to see young, foreign backpackers at Australian airports, preparing to leave Australia with a didjeridu under their arm. This fascination with the didjeridu has, however, produced some unfortunate side effects. Karl Neuenfeldt's research into the new didjeridu 'industry' in Australia has revealed that thousands of didjeridus are being cut annually from the Australian bush and exported in a commercial frenzy, with little thought as to the effect on the environment or the politics of cultural ownership.

Aboriginal people at **Maningrida Arts and Culture** in Arnhem Land have been able to observe the development of this global fascination with the didjeridu through the use of the Internet [see also 13.5]. The community, through the Bawinanga Aboriginal Corporation, has its own Internet site on the World Wide Web which includes, amongst many other topics, information about traditional music in the region. Recordings of this music are made available for purchase. There is also a detailed description of how the didjeridu is made and used as an instrument of accompaniment in the many musical

genres of the Maningrida region. Staff at the cultural centre made this information available in response to the large number of incoming email enquiries relating to the didjeridu, and the large amount of misinformation discovered on didjeridu Internet sites. Much of this emanates either from New Age devotees or from those seeking to take commercial advantage of the high level of interest in the didjeridu.

Internet communications sent to Maningrida Arts and Culture have often revealed some bizarre perceptions about the didjeridu and Aboriginal culture in general. The following unsolicited email to the managers of the Bawinanga Internet site is a good example:

I am a German aboriginal planetary citizen, a didgeridoo player and sound artist for 7 years. I've been experiencing and exploring the healing effect and aspects of the harmonic vibrational sound of the didgeridoo—'the mother of all flutes'. I have the greatest respect for this sacred instrument ... I experience the didgeridoo as an important tool for us, especially in the Western 'civilized' world for reconnecting with Mother Earth and all our relations on this planet. It is a bridge to communicate with sacred Mother Life in her manifestation of the creation and her expression as living sentient beings ... The vibrational sound of the didgeridoo can be used to reconnect with one's own and inner source of power, healing and knowing, as well as to explore other dimensions of life and consciousness. Through the didgeridoo a vibrational sound can be created which everybody, every soul can feel and relate to. It is in resonance with the sound of all sounds—the sacred OM—the sound of Oneness. The possibility for carrying information makes it perfect for healing purposes.

Since Maningrida's Internet site was established in 1995, staff at the cultural centre have been receiving several messages each week concerning the didjeridu. Messages like the one above are usually dismissed as bizarre nonsense and too strange to deal with, but the New Age reconstruction of Aboriginal culture and the extraordinary popularity of the didjeridu amongst New Age acolytes requires some kind of explanation. This topic has been explored in detail by Patricia Sherwood, who explains how traditional music of Indigenous peoples can be transformed as part of the selective appropriation process and application of the New Age world-view to Indigenous cultures:

Didjeridu is used extensively to produce and reproduce alternative lifestylers' Eurocentric dreams of a better world based on the four key elements of holistic meaning, of co-operative community, sustainable lifestyle and spiritual vitality ... Parkhill (1993) notes how this utopian view transforms traditional music practices: 'Complexes of social meaning originally associated with time-honoured musical traditions are now endowed with a non-specific, non-directional "depth" by the cover-note writers' Eurocentric dreams.'

A number of other factors are pertinent to an explanation of how the didjeridu has been taken out of its original musical context, as an instrument of song accompaniment, and raised to the dizzy heights of the 'sacred OM ... sound of oneness' in New Age belief. There is a dearth of commercially available recordings of traditional Aboriginal music, which makes it difficult for those interested to hear how the didjeridu is actually used in its usual role as accompaniment to song. Aboriginal rock bands [see 15.2] are the focus of commercial attention at present, while traditional Aboriginal music is often relegated to the pigeon-hole of 'the ethnographic', in a manner reminiscent of the way Aboriginal art was treated until quite recently.

Outside of academic ethnomusicology and anthropology, traditional Aboriginal music is not promoted in a way which conveys its location within diverse, complex, and culturally regulated contexts in Aboriginal communities. Instead, it is often misrepresented and marketed as a fleeting encounter with a form of exotica, endowed with

shades of Eastern religious spirituality and various tenets of New Age belief. Maningrida's Internet site attempts to redress the myth-making associated with the didjeridu and Aboriginal culture in general. It embraces technology that allows Aboriginal people in remote Arnhem Land to publish globally a more realistic presentation of their culture and their music, using their own words, sounds, and images. For example, the latest addition to the site is an illustrated essay describing the place of the didjeridu in Maningrida music and ceremonial life [196].

Tom Djelkwarrngi Wood, former assistant Aboriginal heritage officer with Maningrida Arts and Culture, describes the value of the Internet site with the following observation, in Kunwinjku:

Ngabin-nang Balanda birri-buhmeng, minj njaleman-dule karrmeninj makka djal dule-yak 'no meaning'. Mako konda behngad ngarri-karrme minj bedberre walem-beh, la Balanda ngandi-nangngadberre wanjh ngandi-ngundjikang ngadberre bedda. Ngabin-nang Balanda sort of like hippies, ngal-kudji daluk yimarnekborrkkemeninj djal larrk 'no meaning'. Ngad mako ngarri-karrme mulilken, djabbi, kun-borrk, daluk mararradj man-dule-ken. Ngadberre makoreykurrmeninj minj bedberre walem-beh. Balanda bu birri-mey mako but bale ka-yime bu kabirri-bengkan. Bu kabirri-nan Internet ngadberre karewanjh kabirri-bengkan.

I've seen non-Aboriginal people playing the didjeridu and the way they play there's no tune, no song, and no meaning. The didjeridu is from here [Arnhem Land] and non-Aboriginal people have seen us and tried to copy us. I've seen some non-Aboriginal people, sort of like hippies and there was this one woman trying to dance [to their didjeridu playing] but it had no meaning. We use the didjeridu in ceremony such as circumcision ceremonies, for dancing, and for love songs. The didjeridu placed itself here for us, for Aboriginal people from all around this area [the Top End of the Northern Territory], it doesn't belong to those down south. Non-Aboriginal people have tried to take hold of the didjeridu but they just don't seem to be able to understand it. Maybe if they look at our Internet site they might understand.

Comments such as these reflect two concerns: that there should be some acknowledgment of the ownership that Top End Aboriginal people have of the instrument, and that the didjeridu plays a much more sophisticated role in traditional Aboriginal music than is generally appreciated.

MURRAY GARDE

Neuenfeldt, K. (ed.), *The Didjeridu: From Arnhem Land to Internet*, Sydney, 1997; Parkhill, P., 'Of tradition, tourism and the world music industry', *Meanjin*, vol. 52, no. 3, 1993; Sherwood, P., 'The didjeridu and alternative lifestylers' reconstruction of social reality', in K. Neuenfeldt (ed.), 1997.

This essay is a condensed version of 'From a distance: Aboriginal music on the Maningrida Internet site', a paper delivered at the Fulbright Symposium Indigenous People in an Interconnected World, Darwin, 1997.

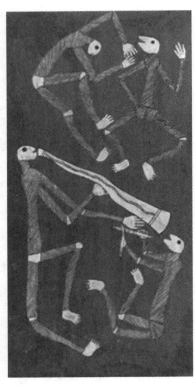

196. Curley Bardkudubbu, *Mimih Spirits Performing Music and Dancing*. c.1985. Natural pigments on bark, 62 x 27 cm.

15.5 The origins of dance and song in the Ngarinyin world

Songs, dances, and images all come from the time when everyone was lawless, when all the animals and birds were humans, in the Lalan-di (**Dreaming**). This is the time when Wodoi (spotted nightjar) and Jun.gun (owlet nightjar)—the two moiety heroes—took objects from the maker of the sacred boards, Wibalma. This person was hoarding all the sacred things for himself. Wodoi and Jun.gun did the right thing to steal these

boards and share them out amongst the clans. They sang this song after getting the boards:

gunyanadma wule monjon nyi
what shall we do, talking here as a council of all people?

gananya wule
what shall we decide in these discussions?

You can see that song was the first idea, the principle of sharing which underlies our system [*197*].

All these animals who created ideas are our ancestors. They started ceremony, song, and the *wunnan* (exchange system) which gives us our marriage system and a network for sharing out resources to all the different clans in our country. This is a system of promises which links everyone through the exchange of *mayangarri* (sacred boards).

The birds and animals who brought these songs to us are Law people who come out in the night and sleep all through the day. During Walungarri (initiation cycles) we act out the part of the animals who are our relations in the kinship system, all our family. Humans become dancing animals through the Walungarri, just as they became animals with the introduction of Law in the Lalan-di. The very first verse in this song comes from acting out the part of the emu who stole the ceremonial food, the *gulangi* cakes, from the *wunnan* table. That's why the first song is Dududungarri, the place where the emu stamped her feet to make a pass in the ranges.

A composer, *banman*, gets songs from these animals. The spirits start teaching him songs from Wunggurr (rainbow serpent [see also 5.4]), the source of all our lives. *Banman* are people who pull Wunggurr out of the gorge waterholes and are then given quartz stones by her. These stones are soft, like jelly, but become hard when outside of the body. They become soft again when immersed in water. Wunggurr might deposit her egg in the belly of the *banman* and this egg will breed and grow inside the composer's body, as though the stomach of the composer is a pouch. Sometimes a male and female Wunggurr will mate inside the body of the *banman* and breed inside him in order to give him power. This power is easily lost and many people have seen the

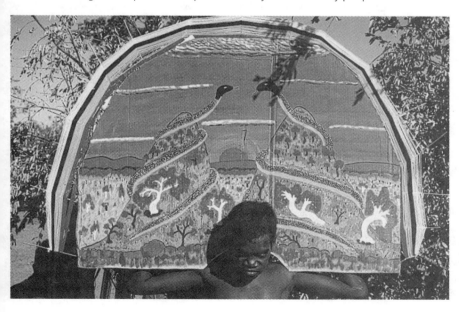

197. *Balga* board depicting the Wunggurr serpents, carried by a boy from the Gibb River school, 1997. Usually used in *balga* performances, this board was used in 1997 at Bijilli for a performance of the *galinda junba* Wanalirri.

198. Boys and young men performing *wangga* dancing, at Bijili (on Mount Elizabeth Station) in 1977.
Women and young girls are executing their more restrained style in the background. The performers are Ngarinyin from North Kimberley, but the songs have been learnt from *wangga* singers of the Port Keats (NT) area.

snake leave their body and can point out the marks on their skin where the snake left their body. After this a person will lose the power to be a composer. Hot drinks or food can also kill this snake inside the body. The Wunggurr is a blind snake, *nyambiliji*, but when it opens its eyes inside the body of the composer–doctor then he or she [the host] is given clear vision and a shining eye and is able to look into the spirit realm.

We call the top degree doctormen *morororra*. They are able to travel through the air or under the ground and under the water. They can breathe underwater because this is where their power comes from in the first place, from Wunggurr. When a composer visits Dulugun, the island of the dead, in order to find new songs and dances, the tune sticks in his mind like a stain, it can't be forgotten—we say *nyambalug*—he doesn't have to think about it any more because it is fastened on to him, like a wife to her husband. This composing we call *yari-yari* which is like a dream but different again. When a composer has that clear vision he has two minds working at once—one which is asleep and one which is awake, one eye looking inside and the other looking out. He is asleep but awake at the same moment.

The art of the great *banman* is being lost to us now. There are only very few left. In earlier times we had the great Balbungu who died near Kunmunya. He taught his art to Wattie Ngerdu who died in the 1970s. Also we had Wirrijangu, my cousin brother who composed Gullawada, the 'Captain Cook *junba*', which we performed at Mowanjum in 1996. Now we rely on Nyalgodi, the composer at Dodnan, to find new songs for us. Some of the different types of *junba* dance which come to us through the *banman* are:

balga, which is performed with string crosses which we now weave from coloured wool and previously were made with spun kangaroo and possum hair coloured with ochres [see 10.1; Roy **Wiggan**, Peggy and Alan **Griffiths**; *130, 131, 404*]. These are called *waranggi* and are public totems—different to the secret ones in the desert side which are called *waninggi*. [Then] *jadmi*, which is performed with the long paperbark caps and green leaves at the elbow and knee joints. The word *jadmi* imitates the sound of the dancers stamping on the ground—*jad jad jad jad*. [Finally] *gullawada*, which are love songs.

Some of our dances also use painted song-boards, *balmara*, such as we saw at the Wanalirri performance at Bijilli in 1997. This type of dance we call *galinda* and [it] comes from the Western part of the country, like Wororra or western Ngarinyin country. *Galinda* we call a female style. *Balga*, which uses string crosses, we call a male style, because the framework of the crosses is the bone, *ornad*, of the ancestor–dancer, while the wool is the flesh of the ancestor–dancer's body [*198*].

When we perform our songs, when we live our lives, we have to *bujerat*, 'stretch out', 'get tight or right', the meaning which lies in our works and our lives. Otherwise we are left stranded, sitting nowhere. We have to have *werull-di*, power or passion, in the way we live, the way we dance, the way we sing.

DAVID MOWALJARLI
IN CONVERSATION WITH ANTHONY JAMES REDMOND

16. Performance

16.1 Indigenous performance

The history of Indigenous performance in Australia is both long and broad, with a traditional record spanning millennia and a growing contemporary practice which intersects urban, rural, expatriate, and sacred sites. My experience of being a Murri artist is in the area of theatre and this is my focus here. Any written chronicle of an endeavour attains a sense of legitimacy and puts a responsibility on its author; both these facts give me an uncomfortable feeling. Indigenous theatre is an amalgam of experiences, specific to regions, and to people who have focused on creating their work rather than recording it. Hence, any one person can only reflect what they have heard about, seen, or been part of. What follows should be viewed as a starting point for further research, a testimony to those artists and their work, and to the collective nurturing of our voice in performance. I define Indigenous theatre as performance in a structured actor–audience relationship created by Indigenous artists with the express wish to reflect our political struggle, lifestyle, cultures, and people.

The birth of Indigenous theatre

It is hard to pinpoint the moment when Indigenous theatre leapt into being. It follows on from the smooth and dynamic growth of our traditional performance structures: the purposes of our storytelling have not changed. Lydia Miller, prominent actor and advocate for Indigenous artists, once said to me that an important connection between our traditional and contemporary arts practice was that before 1788 our peoples had to think *survival*. Art and culture were inseparable; hunting, family structures, genealogy, Law, geography were reflected in the art, and so they are today. Though the world has changed and the role of our performance may have as much to do with political *survival*, social awareness, and the need for systematic change, the power and role of the artist is to think *survival*.

Maureen Watson, elder and storyteller, once spoke about the need to tell the stories of the world around us. She said the traditional role of stories was to provide meaning and shape to the world, to explain why the world is as it is, and what our connection is to it. As the world changed so did the media in which meaning was made. In visual arts it can be best seen with the move to canvas and acrylics [see **acrylic painting**]. New skills and techniques are spliced and absorbed by artists to maintain the unbroken line of our cultures. The coming of new elements to our lives needed new stories; the coming of Christianity [see 1.2], of the horse, Toyotas [see 20.5], money, AIDS, and alcohol—all needed stories, dances [see 7.3, 16.5, 16.6], paintings, and songs [see 15.2; **country and western**

music]. If we cannot tell the story of it, how can we ever get a handle on it? How can we ever accept it, reject it or use it?

The Cherry Pickers [*199*], written by Kevin Gilbert, is held up as the first Aboriginal play ever published. In a world where the written word has the power to live on and supersede a normally robust oral tradition, any history of Indigenous theatre relies on such milestones. Written in 1968, *The Cherry Pickers* follows the fortunes of Aboriginal seasonal workers and their struggle for survival. Themes of infant mortality, discrimination, exploitation, abuse, and hope are told through an unfolding of the human spirit and a remarkable sense of humour. Kevin Gilbert is quoted as having said 'You sharpen your axe on the hardest stone', which for me has come to mean that the best arguments can be shaped against the greatest hardships, the strongest voices can grow against the greatest oppression, and that our stories are our best weapon against the most damning discrimination. Kevin Gilbert was an activist, a man of passion, a philosopher, a bureaucrat, a poet, and a playwright. *The Cherry Pickers* had several readings and workshops, and a 1971 performance by the Nindethana Theatre in Melbourne, but was not professionally produced until 1994, after the death of its author, mainly because he refused to allow his play to be performed by a non-Indigenous cast.

199. Kevin Gilbert, *The Cherry Pickers*, in performance at the Metro Arts Theatre Space, Perth, in 1994.
The actors are (*left*) Billy Macpherson and (*right*) Marilyn Miller.

Explorations in content and form

Through the writing of our Indigenous playwrights we observe the growth of our consciousness as a nation of people, still in all our diversity but united in a political struggle. The plays of Jack **Davis** [see 14.1; *183*], Eva Johnson, Robert Merritt [see 12.2], Bob Maza, Richard Walley, Roger Bennett, and more, reflect the need to project an image of ourselves in the playhouses of our country. Contemporary playwriting is searching out new ground to investigate; new performance practices have emerged out of a postmodern, bowerbird approach. As Indigenous artists wrestle through training institutions and gather experiences unheard of by our forebears, there are developments in form and intent. The traditional practice of integrating art forms is being reinstated: a sophisticated rendering of design, and the use of body as the site for performance are replacing the conventions of earlier works which traded in the currencies of naturalism and biography. *Box the Pony* (1999) by Leah Purcell [*200*] and Scott Rankin, *White Baptist Abba Fan* (1997) by Deborah Cheetham, *Stolen* (1998) by Jane Harrison, *Up the Road* (1997) by John Harding, *Bran Nue Dae* (1991) [see 16.2; *202*], and *Corrugation Road* (1997) by Jimmy Chi, have all pushed earlier stylistic advances to the brink. My own interest in creating contemporary performance and in the manipulation of form led me to write and direct *The 7 Stages of*

Grieving (1996, co-written with Deborah Mailman) [*201*], *The Little White Dress* (1996), *A Life of Grace and Piety* (1998), and *The Sunshine Club* (1999). Music, agitprop, direct address storytelling, stand-up comedy, visual theatre, and singing are all now strongly part of our artistic arsenal. Contemporary Indigenous artists think nothing of massive stylistic changes midstream or of assuming knowledge in their audience. Our plays are no longer merely about the education of non-Indigenous Australia—they can celebrate and explore our voice, assuming a general level of understanding amongst the viewers.

I was once told the story of the crow and the well which goes something like this:

The crow comes to the well to drink but cannot because the water level is too low. The crow is thirsty and needs to drink and so it picks up a small stone in its beak and drops it into the well, and the water level rises very slightly. The crow takes another small stone and again drops it into the well. The water level rises again. The crow continues knowing that each stone is building on the last. It is content to work through this slow process in the knowledge that one day the water level will be high enough to drink.

This is how I see Indigenous performance: every new work, every artist, each endeavour, is a small stone building on the one before.

200. Leah Purcell in her play *Box the Pony*, Belvoir Street Theatre, Sydney, 1999.

201. Deborah Mailman in *The 7 Stages of Grieving*, directed by Wesley Enoch, 1994.

351

Theatre as life-narrative

Much of the work of Indigenous theatre-makers has focused on the telling of our stories to the broader community. Biographical and autobiographical works [see **life stories**] fill our theatres. The personal is political. Each Indigenous person's life is a record of the socio-political **history** of our treatment. Growing up on missions, being taken away [see **stolen generations**], incarceration [see 12.1; **prison art**], lack of education, our treatment as workers, the class divide, our role as activists and bureaucrats, access to travel and money, these are all played out in the stories of our lives. Each generation has a story to tell which reflects the political changes in Australia—life under the Protection Act [*41*], the repercussions of the **referendum of 1967**, the **land rights** movement. The work of Jack Davis, the growth of one-person shows like *Ningali* by Josie Ningali Lawford, performed internationally in the 1990s, the works of Roger Bennett—*Funerals and Circuses* (1995), *Up the Ladder* (1997)—and the numerous community arts events which set out to celebrate the people of our communities are testimony to this.

Inherent in this need to tell the stories of our lives is the searching for a validation of our experiences. Once I was working with young people in detention—most of whom were Aboriginal—and tried everything to keep the sessions from deteriorating into chaos. Having talked to the staff of the centre I had decided to build a cubby house with the group. On its completion the group went inside, proud that they had created their own space. They proceeded to tell stories of their lives and the reasons why they were sent to a detention centre; what page their 'crime' had made in the papers, the **television** crews, how they were followed by a news 'chopper'. I realised, maybe for the first time, what they were doing—by telling these stories they had a way of connecting, of explaining the world around them. I realised that all people want this form of validation or reflection through story; most Australians get this through the television [see 13.2], magazines, and films [see 13.1] that surround us every day, but Indigenous Australia must fight for its stories; otherwise, when they are told, they are negative. These young people just wanted their stories to have an outlet; when you no longer think a society has space to reflect you and your story, you create the space, sometimes violently. Indigenous theatre has always had a political voice. The works of Vivien Walker, Brian Syron, Kath Walker (**Oodgeroo** Noonuccal) [see 14.3], Jimmy Everett, Gary Foley, Glenn Shea, Robert Crompton, Cathy Craigie, all carry a strong politics.

Themes in Indigenous theatre

In my reading of Indigenous theatre texts there are three main themes—death and loss, family, and isolation. Death and loss are often interconnected: they are played out with the death of a old person and the subsequent loss of knowledge and **history**, the loss of freedoms, or the search for the missing past. Funerals feature heavily in our lives and in our theatre. The strong emotional energy and ritual which surround death give Indigenous theatre a cathartic and cleansing quality while providing a well-defined dramatic seam. Family and community are the lifeblood of most stories; given the biographical nature of many works this is no wonder. Indigenous social structures, with their strong family matriarchs, large extended families, and elders, provide an intricate pattern of respect and obligations to explore. Many plays require three generations on stage, or discuss the interplay of history and people. Isolation as both a personal and a political phenomenon is a constant: communities within communities, the struggle for individuality against the pressure to conform to community norms, physical and the spiritual isolation of trying to deal with an issue by yourself, searching for connections and continuity. Despite the inherently tragic qualities of these themes, Indigenous theatre is above all celebratory. The use of

humour and the inclusion of an audience through the relaxation of formal theatrical conventions provide a counterpoint, highlighting the humanity of the work.

Essentialism and its aftermath

Gary Foley once talked of the need to express our differences not through colour but through culture; that what makes Indigenous Australians different from non-Indigenous Australians is not what we look like but how we go about what we do. In our theatre we give insight into a cultural perspective, a view of the world and our political struggle. But there are other movements afoot. 'Colour-blind casting' has arrived in the Australian theatre from Britain and the USA—essentially challenging an audience to ignore the colour of an actor's skin and allow them to create a role, and to see beyond preconceived notions of dramatic relationship. This is an ongoing debate in Australian theatre—can an Indigenous actor, writer, director, depoliticise their presence in a performance? Do we want this? Given Australia's political and social history, can an audience see beyond the identity of an Indigenous artist to listen to the universality of a story? Or, as I would argue, does an audience read the identity of an Indigenous artist into the whole picture, seeking out relevance, resonance, and meaning?

Neil Armfield, director of Company B (Belvoir Street Theatre, Sydney), has often cast Indigenous performers in his shows—Leah Purcell in *Marriage of Figaro,* Kevin Smith in *The Tempest,* Deborah Mailman, Bob Maza, Irma Woods, Bradley Byquar in *As You Like It.* Instead of trying to ask an audience not to see their **Aboriginality**, he allows their performances to resonate with the text: Purcell as Susanna the maid, Smith as Caliban, Maza as the outcast Duke. A group of performers led by Rhoda Roberts and Lydia Miller asked Louis Nowra to consider writing a piece where their Aboriginality was not the focus. The result was *Radiance* (1993), a story of three sisters returning for the funeral of their mother [see 13.1].

Many Indigenous theatre artists do not want to be pigeon-holed: they fight for recognition simply as artists of calibre. Leah Purcell, Deborah Mailman, Justine Saunders, Aaron Pedersen, Rachel Maza, Lydia Miller, Kylie Belling, Rhoda Roberts, Tracey **Moffatt** [*169, 244, 326*], Tony Briggs, and Laurence Clifford are some of the artists who have worked across the board, from commercial musicals, to new adaptations of French classics, to Shakespeare, to specially commissioned works which do not centre on their Aboriginality. Members of this generation are struggling to be seen as artists in their own right with skills to equal those of their non-Indigenous peers.

The institutional framework

In recent years, Indigenous theatre has been given a boost through the recognition of State and federal funding bodies [see **Aboriginal Arts Board**], special events and the tourism infrastructure [see 18.1; **corroborees**]. Companies, festivals, projects, and support networks have sprung up, led by a thirst for exposure and knowledge among the Australian people and the international community. Most of the major theatre companies and **festivals** maintain support for Indigenous artists and projects. A turning point for Indigenous performance was the Festival of the Dreaming—the first of the arts festivals held as part of the lead-up to the Olympic Games in 2000. Like the 'bicentennial celebrations' of 1988 [see **Survival Day**], it provided an opportunity to showcase the diversity of Indigenous works and artists, from contemporary performance projects and exhibitions to Lingo renditions of European classics. New works by Noel Tovey, Michael Leslie, Sally Riley, Andrea James, Stephen Page, and Raymond Blanco were featured in the festival, which displayed the depth and scope of Indigenous theatre-making and all

the possible permutations of relationships—white writers working with Indigenous performers, black writing being performed by white actors, the roughness and charm, the polish and sophistication. For the first time there was a sense that Indigenous artists were no longer working in isolation; seeing the diversity and regionality of Indigenous theatre renewed a sense of what we were trying to achieve. Rhoda Roberts, artistic director, issued a challenge to the critics and audiences attending Festival of the Dreaming events, saying that the time had passed for treating Indigenous arts as a special case, immune from the rigour of artistic judgement and criticism; that Indigenous arts had come into the mainstream and could hold their own in discourse and artistic delivery.

Through the early days at the Australian Content division of the Elizabethan Theatre Trust, at the Aboriginal National Theatre Trust, and the National Black Playwrights' Conferences funded through the Australia Council's **Aboriginal and Torres Strait Islander Arts Board**, the ad hoc development of Indigenous theatre has seen many attempts to flourish. The mix of skills and support needed to go to the next step has either not been present or could not be sustained, with rapid burn-out and too few mentoring and training opportunities.

Kooemba Jdarra Indigenous Performing Arts (Brisbane), Yirra Yaakin Noongar Theatre (Perth) and Ilbijerri Aboriginal and Torres Strait Islander Theatre Co-operative Ltd (Melbourne) are just three of the surviving Indigenous theatres; each is the product of a long history of struggle and development. Indigenous theatre is in a constant process of being reborn. The negative consequence of this is the lack of recorded history; the virtue is the sense of fluidity and the avoidance of definition. If a show is being created by Indigenous artists, then it is Indigenous theatre. The people named here are a few of those who have contributed to making Indigenous performance what it is today. The next generation will write a new chapter, with new names.

WESLEY ENOCH

Davis, J., Johnson, E., Walley, R., & Maza, B.(au.); Saunders, J. (ed.), *Plays from Black Australia*, Sydney, 1989; Gilbert, H., 'Reconciliation, Aboriginality, and Australian theatre in the 1990s', in V. Kelly, (ed.), *Our Australian Theatre in the 1990s*, Amsterdam, 1998; Langton, M., *Well, I Heard it on the Radio and I Saw it on the Television: An Essay for the Australian Film Commission on the Politics and Aesthetics of Filmmaking by and about Aboriginal People and Things*, North Sydney, 1993; Narogin, M., *Writing from the Fringe*, Melbourne, 1990.

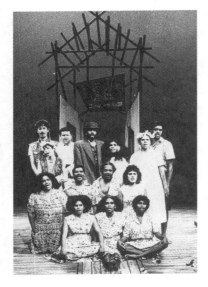

202. Jimmy Chi, *Bran Nue Dae*, (theatre still) Octagon Theatre Perth, 1990. Back row: Alan Charlton, Robert Faggetter, Ernie Dingo, Maroochy Barumba, Michelle Torres, John Moore. Middle row: Lynda Nutter, David Sampi, Stephen Aramba Albert, Decla Morrison. Front row: Sylvia Clarke (kneeling), Ali Torres, Josephine Ningali Lawford, Rohanna Angus.

16.2 Power country

Six light aircraft ran their fleet shadows over the glistening land like a flight of birds, a plateau land streaming with watercourses in the Wet, the special time, electricity in the air, time of gatherings, dancing, and Law. And to this place, protected, preserved by distance, the original country, owned and cared for by Kwini, Wunambal, Worora people, a play was coming the only practical way it could, by plane.

Distributed over six Cessnas were the cast, costumes, sets, and band instruments; from one plane, the author of the play looked down at the vivid maze of patterns, the lichen-stained sheets of rock, the waterfalls and chasms, and called it 'power country'. *Bran Nue Dae* [see 16.1; *202*] had toured, but never like this, to a far community with a mission in its past. Jimmy Chi wanted to tour the play everywhere through the furthest country, and this was symbolic of that purpose, to bring the healing back to its roots, to people easily overlooked when talking 'box office'.

So from a soggy sky to a dirt runway in the furthest place you could get from the capitals of urban, seaboard-bound Australians, where the show and its music were a hit, the

story and songs of Willie and Rosie, Uncle Tadpole and Auntie Theresa came down to red earth. Came to spark the spontaneous, carefree enjoyment which you get in less than wealthy places, the volleys of exuberant laughter which surprise and delight seasoned actors, and a still kind of tremulous wonder that 'only truth remains' as the final song, *If I Gave My Heart to You,* has it. The song also says: 'Understand me when you really see me.'

It was the laughter and silence of an audience that recognised itself, the drama and beauty of what is equally its own history, as it is in different ways all Australia's. Here a tradition was observed, unknown in a city theatre: a troupe of local performers gave a welcoming dance, to warm the grass stage in front of the school, and make a stirring point of its own. This was their place, to which the great show was as an invited guest. That is how *Bran Nue Dae* played Kalumburu, on the grass, in the high days of December 1991.

Jimmy Chi grew up in Broome, the son of James Joseph Chi and Mary Bernardine Bell. His formal education began at the local Catholic school, a place of dusty bare feet and St John of God nuns, women who rebelled against their order to stay and serve this community. He boarded later at Rossmoyne, Perth, an experience that fed wit better than body, to judge by the play, with its archetypal characters like tuckshop-raiding Willie, the priest of frailties Benedictus, and the drinking-droving displaced parent Uncle Tadpole, a resounding role first defined by Ernie Dingo and brought to an ultimate pitch by Broome actor, Stephen Albert. Like his creation, Chi is to this day himself a tour-de-force performer with resonant delivery, humour, energy, and passion.

His development along the parentally desired and more sedate career line of engineer came to a halt when a car crash terminated his studies at the University of Western Australia in the early 1970s. He already carried the childhood scars from a kitchen accident with fire. The serious car accident and long period of hospitalisation precipitated a breakdown and ongoing nervous disorder—no easy street for this composer, in work or family life. The return from city and university was a shattering reversal and yet, paradoxically, it led Chi back to music, through the mending, fertile ways of a small, self-contained town, as Broome then was, with understanding instilled into its veins by its own history of conflicts and survival.

That history involved a partial insulation from one of the great shames of the continent's recent human history, the White Australia policy. Partial, because although the paranoid policy was applied in Broome, and with cruelty, it could not be successful, for the town's pearling economy depended on a majority Asian population, just as the cattle and sheep battler-empires of the whole, vast Kimberley always rode on the shoulders of its Aboriginal majority. Like a door open to the world, being a port, having the impertinence to be a capital in its pearl trade, Broome pointed to what might have been, and yet may be, a more balanced Australian social pattern. Certainly a more interesting, lively and cosmopolitan one. Certainly a town of tides that come and go majestically. A confluence of sounds.

After studying at the Centre for Aboriginal Studies and Music at Adelaide University, with Broome musicians Michael Manolis and Arnold Smith, Chi helped to start the Kuckles band [see 15.2], which built a national following, recording and touring once to Europe, performing original music by members who comprised Manolis, Steve Pigram, Peter Yu, John Sahanna, Patrick bin Amat, and Gary Gower. They were not the first musicians to emerge here, they had parentage in the evenings and verandahs of the Chinatown that was for much longer called Japtown, they grew up hearing town stars like harp and banjo duo Micky Matthews and Kiddo Taylor, and the rock'n'roll era's Broomebeats. Kuckles was the tree under which a number of the songs, later to be the mainstay of a show, sprouted like a tamarind's offspring: 'The seeds that you might sow.' Chi talked for years of a story to be told with the music, episodes of which were well

known to the group. The songs were many. Which would make it to the stage? Some that did not, like *Cold Cup of Coffee* and *Acceptable Coon*, are sublime and virtually unknown.

Bran Nue Dae (1991) is the biography of a generation, and a way to understand not just the history of an era of dislocation but its reverberating effects [see 4.1, 20.1]. It shows how to accept and to deal with the ongoing tingle, the visions, with humour and grace, and how to reconcile an inner conflict—and find a partner in life. Similar themes generated more music, more drama in *Corrugation Road* (1997), though its main subjects—sexual destiny and the difficulties our society cheerfully adds to mental disorders—are different, the treatment more satirical, fluid, and surreal, with a rollicking energy and a plot that finally clicks out of pure chaos.

Both of these works stand as bold landmarks in Australian theatre but stand is about all they are allowed to do, rather than run in any sense of having regular seasons anywhere. After chalking up for Chi and his collaborators a Myer Foundation National Award, a Jill Blewett Drama Award, for Chi individually a Human Rights Award, and successful Black Swan productions directed by Andrew Ross, which toured nationally (*Bran Nue Dae* three times, *Corrugation Road* twice), these rich works have still not played in some Australian cities. Neither has their potential on the world scene been tested. Their exemplary energies are under wraps, although CDs from both shows exist in the market place, permeating sub-mainstream their half-impress of sound, somewhat commercialised when compared to earlier tapes of the original band and first production which are, predictably, preferred by the composer(s) and are now collectors' items. The 1992 Tom Zubrycki documentary *Bran Nue Dae* brought to light early footage of a Kuckles band session, trying something out. It is the quintessential song of an epoch: *Listen to the News*. At once heartening and searing, the news is yet fresh.

Chi has been wary of publicity and often tried to shun its transforming intrusions, but the reason his two completed works are not out there doing their stuff, as on that stand-up opening night of the Festival of Perth, 1990, and that moving day in Kalumburu, could lie with the state of original Australian theatre. Strange, but not so difficult to explain, is the country that refuses its own. That seems not to wish upon itself the power they call, in the Kimberley, 'country', a power of music and story.

PETER BIBBY

16.3 Land, body, and poetry: An integrated aesthetic among the Tiwi

Long ago when Purukuparli was alive, there was dancing, and we shall never give up our dancing. We shall keep on dancing. We shall never give it up because we are not white people. We are Tiwi. We are black people (Allie Miller, cited in Osborne 1974).

Ceremonial performances are at the core of Tiwi life. Through participation in the Pukumani mortuary rituals and the Kulama yam increase ritual Tiwi people gain their identity. These performances bring together all aspects of Tiwi art—song, dance, body decoration [see **body adornment**], sculpture [see 7.6], and painting—but, more than this, as forms of social and symbolic actions they bring together complex sets of ideas and feelings that the Tiwi have about their world, and provide a space in which they reflect on and elaborate their culture. Through them the Tiwi world-view and the Tiwi landscape find embodiment: dancers manifest as representations of cosmology and spiritual beliefs, of gender and power relationships, and occasionally of historical events. By bringing together different modes of thought—aesthetic, symbolic, intellectual— and by enacting knowledge from different realms of life, ceremonial performances

produce a heightened sense of being. They allow the Tiwi to link different strands of experience, creating a site where cultural coherence, ambiguities, and contradictions can be played out. Ceremonies often reinforce ties between individuals and the group, while providing an arena where different agendas can be put forward and conflicts expressed—and sometimes resolved—publicly [203].

Language, dance, and fire are the three most important symbolic domains, and all three come into ceremonial performances. Classical Tiwi, the poetic language of song, encapsulates in its very structure a quality of being-in-the-world that is dear to Tiwi. It is telling, for example, that even though hours were spent discussing 'dance', I was always introduced to newcomers as 'she comes to study language'. Discussing their attachment to their traditional culture, Tiwi people often say 'we will never give up our dancing', equating dancing with their way of life. Fire is central to Tiwi life both practically and spiritually. Indeed its aesthetic dimension is the weft upon which the Tiwi world-view is woven.

A world torched by fire

People caring for and managing the land have a duty to burn dry grasses. This is to ensure that there is no build-up of flammable material which would be dangerous in case of accidental fire, and it allows certain seeds to germinate. Clearing the land means that animal tracks are more visible: thus hunting is easier, and snakes can be avoided. Through shared fires, commitments between individuals are reinforced. During the night, fire protects humans from snakes or crocodiles and during the day it transforms natural products into consumable items: meat, for example, but also certain cycad nuts as well as the *kulama* yams that are naturally toxic but made edible through treatment involving fire. *Kulama* yams are masculine when dug out of the ground, but become feminine once they have been baked (Goodale 1982; Grau 1993). Fire is purifying: during Pukumani dancers walk through smoke to be cleansed and objects polluted by death are passed through smoke to be decontaminated. Smoke rising on the horizon is always commented upon: it is a confirmation that all is well in the land of the Tiwi. Fire is significant to all aspects of life; it symbolises the relationship between human beings, between humans and the spiritual world, and between humans and land [204].

Dance as embodied world-view

Traditionally, Tiwi dance was performed almost exclusively as part of mortuary rituals (only playing a small, albeit important, part of Kulama). *Pukumani*, the label given to describe the special status of bereaved relatives, is often used by the Tiwi as a generic term to encompass all the activities linked to the mortuary rituals: from the commissioning and production of mortuary posts [96, 205, 336], bark baskets, and other ritual paraphernalia to the rituals themselves [see 7.6]. In the late twentieth century, however, celebrations for birthdays, marriages, graduations, and so on, started to take place, and most of them involve dance. The Tiwi chose to model the more recent ceremonies on the older ones. Instead of dancing for someone who is dead (almost all Tiwi dance events are performed for someone specific) dancers perform for someone sitting in front of them.

Traditionally there is no separation between the body and the self. Indeed bodily, social, ecological, and spiritual worlds are all interconnected, a single cosmological universe finding a physical reality in the dancers' bodies. This unity is articulated in part in the Tiwi world-view. The Tiwi say that the world was made up by Pukwi or Imunga, the Sun-Woman. She came out of the sky, transformed herself into a turtle and walked the earth. As she moved, fresh water appeared behind her and the Tiwi islands were formed. During her journey she changed her physical shape, appearing sometimes as a turtle,

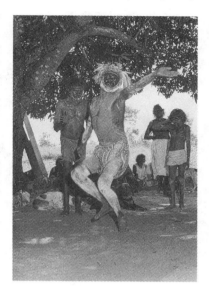

203. George Norm Purimini is highly respected for his painting and dancing, and for his cleverness with words and his ritual knowledge. He is seen here dancing at Pirlingimpi, Meville Island, in 1983.

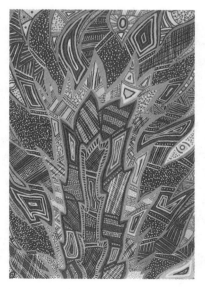

204. Thecla Puruntatameri, *Yikwani (fire) painting*, 1991. Gouache on paper, 100 x 70 cm.

205. Big Jack painting a Pukumani gravepost, with Laurie Nelson on the right, Melville Island, 1958.

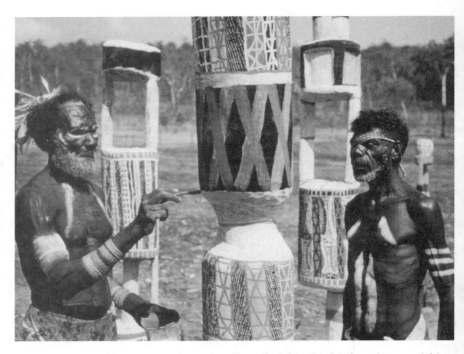

sometimes as an old woman, and occasionally as the jabiru bird. When she was a jabiru, a hunter, seeing her wading through the water, mistook her for a barramundi. Pleased with the prospect of a good meal, he threw his spear but missed her. Imunga was terrified and in her fright she urinated for a long time. Her urine rushed into the sea and turned the water salty.

In her journey Imunga left her daughters along the way, and to this day they can be seen sitting in places where the spirits of children yet to be born dwell. These women are said to be the ancestresses that founded the Tiwi matrilineal descent groups (*imunga*) into which every Tiwi is born. Tiwi also 'come out' of their father's *imunga*, and use the term *irumwa* to refer to it. Thus an individual would say 'I belong to the people of X', naming their mother's *imunga* and 'I come out of the people of Y', naming their father's. The *irumwa* is directly connected to **Dreamings**: the species, geographical features, and places connected with the *irumwa* are a person's Dreamings. At birth Tiwi also receive a 'country' from their father, which entitles them to the resources of the land. Countries too, tend to be associated with specific characteristics: in one place there may be a lot of dingos, or jungle fowls, or a deposit of ochre. All these are additional Dreamings that an individual receives.

The Tiwi universe is divided into three parallel worlds: the world of the unborn, that of the living, and that of the dead. Tiwi people are adamant that the three worlds have to remain distinct and that the unborn and the dead have no right to interfere with their daily lives. They argue, for example, that one of the roles of the mortuary rituals is to ease the passage of the deceased into the world of the dead and to make sure that they remain there. Nevertheless, the spiritual beings are never far away, and there is a great deal of overlap between the worlds. Fathers have to find the spirits of their children in their dreams before conception can take place. and some individuals are known to see ghosts. Furthermore, it is important that during ceremonial performances the three worlds come together, recreating the unity of the time of creation. Indeed it is through participating in these events that the Tiwi keep in touch with the power inherent in the Dreaming.

The Tiwi dance repertoire is composed of a number of different dance types, each comprising many dances. The Dreaming dances are one type: these link individuals with their Dreamings. These may be the spirits of animals, such as crocodile, dingo, or shark; or natural phenomena, such as rainbow; or geographical features, such as certain rock formations. Each individual manifests as a representation of these things. When they dance shark, or crocodile, they are not mimicking them, as is often believed; rather they are showing another facet of their personalities. The Tiwi talk about 'marking' their Dreamings when discussing what is happening in these dances.

Another group of dances, the kinship dances, embody the social world. Relatives are associated with body parts: the legs represent a certain kind of sibling, the cheek another, the abdomen represents a woman's children or a man's sisters' children, the shoulder represents the in-laws, especially a man's mother-in-law, and the big toe the husband. When individuals feel a pain in their bodies, they immediately interpret it as a warning of the illness or even the death of specific relatives. During mortuary rituals, dancers use the bodily connections to show specific kinship relationships between themselves and the deceased. The kinship dances are thus public statements that emphasise, strengthen, but also occasionally deny, kinship ties. The Tiwi use them not only to reinforce kinship practices and ideology but also to reflect upon them. Through the dances, youngsters learn a complex system by having it encoded into their bodies. Occasionally individuals are allowed to renegotiate kinship relationships. A mother, for example, could use dance in a way that would protect her daughters from men she did not want them to marry. Dancing, she could transform the social reality by reinventing kinship relationships in order to send a message, sanctioned by the participants, and accepted by the recipients. Thus the dance floor is also a space where conflicts can be approached and resolved.

Through performance, Tiwi men and women can imagine as well as reflect their social reality. In ritual life at least, gender is irrelevant. In dance, both men and women perform impossible roles, women finding spirit children and men being pregnant or breastfeeding. In dance, individuals can be spouses or potential spouses to both men and women, regardless of gender. They can also be parents of much older individuals. In a sense they can become 'other', experiencing a larger world than the everyday one that is limited by their age and gender.

Embodied landscape, embodied language

In the Tiwi environment different spaces are seen as important for different reasons. Countries are where one can exploit the resources, and where one's ghost goes back after death; sacred sites are where spirit children are found; and the home–camp is where one sleeps overnight and where one can daydream. The camp is important emotionally. It would be abnormal for an individual to camp alone in the bush, and at home a great deal of time is spent congenially after work, often outside the house, playing cards, just sitting, or watching **television**. Although many people prefer to keep their audiovisual equipment indoors, very long extension leads allowing outside viewing are common. Similarly, beds are often taken outside and modern kitchen facilities do not preclude outside cooking fires—often more convenient for the type of food enjoyed.

Tiwi refer to their countries and to sacred sites as if they were human beings [see 1.1, 2.1, 3.1, 6.1]. Looking after one's country is important. Care is both practical—ensuring that resources are renewed—and spiritual and psychological—establishing emotional links between individuals, their physical world, and their cosmology. In ceremonial performances Tiwi often situate their bodies in space by facing sacred places and countries that may be miles away. Their spatial intelligence is thus highly developed: they are physically aware not only of their immediate space but also of their whole geographical

environment. Their abilities demonstrate the non-universality of the Western assumption that space is, in Henri Poincaré's terms, 'a system of axes invariably bound to the body' perceived primarily egocentrically. Tiwi perceive space as much, if not more, topocentrically and geocentrically.

In performance, when they face specific locations, dancers often call out the names of places, or the names of the people or the Dreamings associated with them. The quality of the voice, and the clarity and rhythm of the calls are important and often commented upon. Sound reverberates through space, linking dancers and sacred spaces, bringing an aural dimension and adding to the poetic experience of the land as well as to the beauty of the song text. Language has great aesthetic significance: Tiwi often talk about the importance of, and great pleasure derived from 'big words'.

There are three different levels or styles within the Tiwi language. One is 'classical' Tiwi which is the language of poetry, of great discussion, and of declamation. The second style is somewhat simpler in structure and is used in more mundane contexts. The third, yet more simplified, style could be labelled 'children's' Tiwi. In the Tiwi language, all the elements of a sentence may be combined in a single, highly complex morphological structure. This is especially true of classical Tiwi which few adults master before middle life. The Tiwi verb is, in effect, potentially a sentence in miniature. It may contain within its bounds not only pronominal reference to subject and object, and markers of tense or mood (which are fairly common features in the world's languages), but also many other types of information. The verb is made up of four main sections (prefixes, insertions, stems and suffixes) and eleven grammatical categories can be expressed within it (person, number, gender, tense, aspect, mood, voice, location–direction, time of day, stance, and emphasis). For example, any verb can have a suffix or prefix to indicate whether the activity is done standing still or moving along, whether it has a durative quality or a repetitive quality, or whether it is just about to start or has just begun. It can indicate whether the activity is carried out in the morning or in the evening as well as in a variety of spatial locations, that it has been attempted but not completed, that it could have been achieved if the person had really wanted it, or that an action has not only been carried out but has been done in the most complete manner possible.

The Tiwi enjoy the formal structure and the morphological complexity of their language, because it is both direct and evocative. Furthermore, they enjoy clever images and metaphors in song texts. These are sometime used because of avoidance relationships. A man is forbidden to name his mother-in-law, yet he has to sing about her, during Kulama for example. Using the body connection representing her as the shoulder, he may sing about an aeroplane with a broken wing ('shoulder'). The aeroplane may fall into a tree, and this image links it to a sea eagle making its nest, a bird connected to the mother-in-law. Metaphor is not necessarily prompted by avoidance; mourners may sing about having faces that look scarred like stones, referring both to rock formations found at specific sacred sites connected to the deceased, and to the fact that as patrilineal siblings to the deceased their 'cheeks' have been damaged.

Creativity as a way of life

The Tiwi greatly value creativity and originality. Each person, for example, has a number of names especially coined during their life. Tiwi use singing, carving, painting, choreographing, and dancing to express their personal thoughts and experiences and to distinguish themselves from each other and from outsiders. When a man from **Maningrida**, in Arnhem Land, came to live in Pularumpi in the 1980s, Tiwi people were respectful of his customs and appreciative of his dancing. Nevertheless, they often made comments such

as: 'These people on the mainland, they repeat the same old songs. We Tiwi don't, we make new ones all the time.'

Every ritual has old and new elements. Creating a new song cycle, for example, is intrinsic to the annual Kulama ceremony. Similarly, each of the ceremonial leaders must create a series of songs and an accompanying dance as part of the preliminary mortuary rituals. If successful, these dances will become part of the repertoire referred to as 'just-a-song dances'. Unlike the kinship dances, which were choreographed by the dreaming hero Purukuparli, they are humanly choreographed and as such may be discarded. Sorrow songs are often composed and performed in parallel to mortuary rituals. The themes may have a direct connection with the deceased, they may be historical, or about the natural world, but often they are about contemporary reality, allowing people to explore cultural changes symbolically. In earlier centuries there were songs and dances about the new dugout canoes (as opposed to the older traditional bark canoes) and about the types of boats used by the British when they established a settlement on Melville Island in 1823. In the twentieth century there have been songs and dances about aeroplanes, houses, cars, electricity, beer, the big house of the Queen of England, and the bombing of Darwin during World War II. The topics are as varied as their creators. In 1998, a woman despaired in a sorrow song that young people did not participate in Kulama, and many saw this as a reference to the plague of suicides among young men that was devastating the islands. The incorporation of new elements, an intrinsic part of the Tiwi creative system, is analogous to the incorporation of complex nuances into the Tiwi verb.

An integrated aesthetic

When the land is burned, Tiwi people comment on how clean everything has become, and on how the new growth—the delicate green shoots—stands out on the black. When Tiwi paint either themselves or objects they always start with charcoal. Painters talk about highlighting clear lines and patterns. After fire the verticality of trees is also reinforced and in some ways it is comparable to the uprightness of the human body. Tiwi people are generally very straight in their bearing. This posture gives a distinct quality to their walking, which is often commented upon and praised in songs, sometime ironically, as 'walking flash'. In dance, gestures too have to be clear. They are often simple reversals: the limbs use the same path moving away and returning to the body. They have to be directly in time with the beat. Good dancers are said to 'punch the ground properly', whilst mediocre ones with unclear gestures are said 'to dance like a baby', because their movements have the uncoordinated look associated with toddlers. Similarly, song texts have to be 'lined up' in the head before being sung and the voice of a good singer must be clear so that the complex poetry can be clearly understood.

Ceremonial performances are microcosms of Tiwi society. Past, present, and future are collapsed into one; the different spaces of sacred sites, countries, and home are brought together; and participants vibrate with their world. Dance represents the elementary aesthetic principles of fire and of landscape in their most perfect embodiments. It is a crucial medium of enculturation, integrating the Tiwi into their world.

ANDRÉE GRAU

Goodale, J., *Tiwi Wives: A Study of the Women of Melville Island, North Australia,* Seattle, 1971; Goodale, J., 'Production and reproduction of key resources among the Tiwi of north Australia', in *American Association for the Advancement of Science, Selected Symposium*, Boulder, Colorado, 1982; Grau, A., 'Gender interchangeability among the Tiwi', in H. Thomas (ed.), *Dance, Gender, and Culture*, Basingstoke, UK, 1993; Grau, A., 'On the acquisition of knowledge: Teaching kinship

through the body among the Tiwi of Northern Australia', in V. Keck (ed.), *Common Worlds and Single Lives: Constituting Knowledge in Pacific Societies*, Oxford, 1998; Osborne, C., *The Tiwi Language*, Canberra, 1974; Poincaré, H., *The Foundations of Science*, trans. G. B. Halsted, Lancaster, PA, 1946.

16.4 High art and the humour of the ordinary

While white tourists and townsfolk of Echuca (Vic.) celebrated its cultural **festival** in recognition of its colonial history, it was clear to Aboriginal audiences watching the Indigenous dance troupe just when to engage with the humour of the traditional ceremonial dancers. The small town of Echuca, on the Murray River, boasts a long history of bushrangers and pioneers, and a spectacular fleet of large steam paddle-boats. I was filming the festival in September 1989 with a television crew. The traditional dancers on this day were dramatising a small group of honey collectors, who occasionally were chased and stung by the bees. The second dance was of spirits returning from the dead, imitating living ancestors, taunting and teasing their fellow hunters with branches and leaves. During the performances the **didjeridu** player, who alternated between microphone and his instrument, announced the significance of the dances. It was apparent that he and the other dancers were accustomed to white audiences, frequently appealing to them for their participation and sharing with them the humour of Aboriginal people and culture. The white tourists [see 18.1] eagerly participated.

Later, a small group of Aboriginal people stayed behind to watch the dancers' second set. This dance was different to the earlier set which, just a few moments before, had clearly been a performance for outsiders, an almost censored version for the white public. The second set of dances, with a predominantly Aboriginal audience, eventually turned into a game among ourselves. The jest was for the dancer to cajole an Aboriginal onlooker out of her shyness, but the onlooker's role was to test the dancer's ability to persist. It was a flirt, a tease, and a dare of sorts. The humour that was now in play seemingly dealt on a more personal and clandestine level which was shared amongst ourselves, so our cameras were turned off.

Stephen Page, Aboriginal choreographer for the Bangarra Dance Theatre [see 16.6], once commented that he used to love the opening nights at the Belvoir Street Theatre, Sydney, because it had a predominantly Aboriginal and Islander audience. He said that, as a performer, you always knew when there would be a lot of Kooris there because they were often very noisy and knew just when to laugh. For Page it was as if the actors and audience in Aboriginal performances were connected through an acknowledgement of their shared ownership of culture. If there is one significant feature which distinguishes the way Aboriginal people perceive Aboriginal performances it is the relationship between audience and performer, and the humour we share. White culture, it seems, disconnects audiences from performers, and the finer or higher the art, the more absent or distant the humour becomes.

While there have been several attempts to bring Aboriginal humour into the performing arts and to a wider audience on television over the past decade, for some reason they were not successful. **Television** programs like the ABC's *Blackout* series (1989–94), with Paul Fenech's black comedy skits, never lasted longer than one season, and the short comedy sketches on SBS's earlier ICAM program, *The Masters* (1996)—a dark satire on Aboriginal families living in suburbia—was quickly axed from the network. Ernie Dingo, Australia's most prominent Aboriginal comedian, shocked audiences at the Belvoir Street Theatre in 1988 when he used a vacuum cleaner hose to simulate a didjeridu. Aboriginal comedienne Destiny **Deacon**'s dark parody of a destitute Aboriginal

mother in *High Art* on the ICAM program in 1993 was apparently far too unvarnished for the high art scene [*66, 67, 277, 314*]. Yet Aboriginal people choose to make such works and obviously enjoy watching them. So why were they axed? Perhaps the answer could lie in the way white Australians have yet to appreciate the merits of humour as art, or perhaps, like the tourists at Echuca who eagerly participated with the Aboriginal dancers, they are incapable of applauding and revering anything that smacks of everyday life and much prefer to invent art as a way of distancing themselves from the humour of the ordinary.

FRANCES PETERS-LITTLE

16.5 NAISDA: Reconciliation in action

The seeds of NAISDA—the National Aboriginal and Islander Skills Development Association—were sown in the late 1960s and early 1970s, when Indigenous Australians were beginning to identify as part of the international world of black peoples and Australian government attitudes and policies relating to Indigenous people were changing. The establishment of the Australian Council of the Arts [see **Aboriginal Arts Board**] promoted traditional art and stimulated development of new art forms in Aboriginal communities. Contemporary creative expression by urban Indigenous people was shared mainly through music [see 15.2], performance [see 16.6], and poetry [see 14.1, 14.3]. In dance, urban Aboriginal peoples were looking at revitalising their culture through the establishments developed by Pastor Don Brady (Yelangi Dancers) and Steve Mam (Torres Strait Islander Dance Group) in South Brisbane.

The visiting Eleo Pomare Dance Company from New York (of which I was a member), performing at the Adelaide Arts Festival and the Sydney Conservatorium of Music in 1972, opened the way for modern theatrical dance to become a form of expression for urban Aboriginal and Islander peoples of Australia. Indigenous community leaders saw Pomare's predominantly African-American dancers perform choreographic works relevant to Aboriginal experiences. Just as Kevin Gilbert's play *The Cherry Pickers* [see 16.1; *199*] presented in 1971 by Nindethana Theatre in Melbourne, portrayed Aboriginal social issues, Pomare created dances on American themes that were exciting and visual, that heightened emotions, and challenged the intellect. The black Australian audience experienced the power of non-verbal dance images portraying dispossession, racism, cultural heritage, and aspiration.

Following the performance, I was invited by the Australian Council of the Arts to remain in Australia. With encouragement from Aboriginal community members, the Australian Council of the Arts provided a grant for me to introduce modern dance to Aboriginal people. Dance classes began later that year in a dusty, seldom-used church hall in Redfern, Sydney. Wayne Nicol, Euphemia **Bostock**, Tracey Bostock, Norma Ingrim, JoAnne Vesper, and Elsie Vesper formed the core of the dance workshop. Much of its philosophy encapsulated Indigenous attitudes of the period. Performing and teaching work were practical measures that enhanced dance training and encouraged community commitment. This purposefulness was crucial to the acceptance of contemporary dance as a medium for raising national and international awareness of Indigenous social issues.

The group's first performance was at a political demonstration in front of the Sydney Town Hall at the Moratorium for Black Rights on 14 July 1972, NADOC day. Several weeks later we were asked to participate in the **Tent Embassy** demonstrations in Canberra [*49, 206*]. Performing for this, the group explored ideas of confusion, despair, confrontation—themes parallel to the events of real life. Developed for the concert stage

206. Aboriginal Tent Embassy demonstration, Canberra. 1972.
Carole Johnson, representing death of people, is carried by Michael Anderson and Bob Maza in the first performance of the NAISDA dance group.

by 1978, this semi-improvised dance reflecting Aboriginal historical perspectives [see **history**] made contemporary dance a major force in Indigenous performing arts activities.

After our first public concert at Surry Hills in 1972, I returned to America. Following that, the group had a chequered existence. Pivotal in maintaining group cohesion, Wayne Nicol and Euphemia Bostock combined dance activities with the Black Theatre Arts and Culture Centre. They arranged for David **Gulpilil** [see *326*] to teach traditional dance and found both space and a contemporary teacher, Lucy Jumawan, who in 1973 rebuilt the modern dance workshop before she returned to the Philippines. Regular contemporary dance classes restarted in late 1974, when I returned to Sydney. People who identified as black and coloured, from many different cultural backgrounds, gravitated to the dance classes. By the time Careers in Dance (the original name of NAISDA's full-time dance training course) started, contemporary dance in Sydney's Aboriginal community represented black multiculturalism—the students were traditional and urban Aborigines, Torres Strait Islanders, South Pacific Islanders, Maori, South Africans, West Indians, Asians, and Europeans.

In February 1975, the Aboriginal Arts Board's Urban Theatre Committee planned a dance concert at the Black Theatre to engender support for existing activities. The Yelangi Dancers, Torres Strait Islander Dancers, and the Sydney Contemporary Dancers demonstrated the scope of urban Indigenous dance. The concept of presenting and training in three styles—traditional Aboriginal, traditional Torres Strait Islander, and contemporary interpretive dance—to ensure a comprehensive picture of Indigenous Australia had its origins with this concert. Inclusive dance training began with a six-week performing arts workshop in mid 1975 at the Black Theatre. The Aboriginal Arts Board's approval of this workshop structure for developing urban performing arts initiated the revolutionary practice that permitted urban Indigenous students to study traditional culture from traditional owners.

The workshop created a demand for ongoing professional training. Five participants (Wayne Nicol, Cheryle Stone, Dorathea Randall, Lillian Crombie, and Daryl Williams) wanted to become professional dancers but the work experience needed for Australian professional theatre was unavailable to them. A three-year course, designed so that students would work closely with the Aboriginal community to gain practical performing and teaching experience, was developed. The Aboriginal Arts Board and Common-

wealth Department of Education provided funding for a three-month preliminary course in October 1975; and so Careers in Dance, a three-year professional course, was born.

More than any other art form, dance was regarded by most government funding bodies as recreational. Government thinking was that trades (skilled and semi-skilled) provided appropriate jobs for Indigenous Australians. NAISDA—which aimed to provide intensive, long-term training and experience essential to gain professional arts employment—rejected such ideas. To achieve permanent funding from the Department of Aboriginal Affairs (DAA), the course required a structure and a name that made its purpose clear. Though it would be eight years before DAA funding was achieved, the name Aboriginal/Islander Skills Development Scheme (AISDS) was invented. It delineated the cultural heritages of the Indigenous students, who were intent on building a professional career for themselves and future generations. Dance was taught as a way of life, an employable skill that required absolute dedication. Common experiences of racism and oppression connected dancers from different traditional heritages. The students enjoyed learning and sharing each other's traditional dance. With their imagination and physical bodies stimulated, the dance training unleashed exciting creativity. Most urban students demonstrated increased self-confidence as their knowledge of traditional and modern forms increased. The dance was a practical way to celebrate their diversity and unite to promote a single, yet multifaceted, objective. Their goal, a contemporary professional dance company that incorporated traditional cultures, would project internationally a new dance technique and an image of contemporary, self-managed Indigenous Australian peoples.

From the outset, Aboriginal and Torres Strait Islander elders representing traditional dance owners embraced and strengthened this urban dance training program. They welcomed the opportunity to pass on their knowledge to eager students [207]. **Yirrkala** sent dancers to perform overseas with the students. Mornington Island and Torres Strait Islander [see 7.3] elders sent their young people to the course as students. The traditional study trip to distant communities evolved from the relationship with Mornington Island elders, who wanted their people to experience and provide feedback to the students' work in the city. On the second trip to Mornington Island, elders requested that when AISDS students performed Lardil dance publicly there should always be a representative from their community performing with the students. Until 1988 the policy was very strictly adhered to for all traditional dance, regardless of the community. It was so firm that at one time there was friction with members of Redfern's urban Aboriginal community who accused AISDS management of favouring Torres Strait Island dance. The course had a continuous enrolment of Islander students who could support the urban Aboriginal students with Island Dance. Aboriginal critics would not accept that when there were no traditional owners (or students) the course policy of presenting three styles publicly had to be abandoned out of respectful necessity.

The students, who presented only what was permissible, understood that it would take time to achieve a contemporary style as unique and identifiable as traditional dance styles. A first step was to have meaningful choreography to contemporary Aboriginal music. Initially songs by Bobby McLeod, Bob Randall, and Harry Williams's Country Music Outcasts [see **country and western music**] provided the musical foundation for dancing about the dilemmas of their urban experiences. Harold **Blair**'s Aboriginal songs in operatic concert style provided the base to which Lucy Jumawan applied Aboriginal movement motifs with classic modern dance lines. Roslyn Watson (Queensland Ballet Company), while working with David Gulpilil in the Dance Company of New South Wales, looked at the traditional Brolga Dance of central Arnhem Land and fused classical

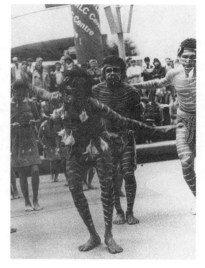

207. NAISDA students performing traditional dance with Yolngu teachers, Magungun Wanambi and Nuwandjali Marawili, during NADOC week at Martin Place, Sydney, 1981.

ballet with traditional dance to create her version. This body of creative, contemporary theatre dance enabled the Aboriginal Arts Board to support both urban black dance and traditional dancers at international festivals. The first of these was the Festival of African and Black Culture in Lagos, Nigeria, in 1977. For this festival the group, which included Roslyn Watson and four students, adopted the name Aboriginal/Islander Dance Theatre (AIDT). From then on the course became known by the name of its performing group, which often included traditional guest artists, graduates, and students. The dance course, originally designed for three years, was extended to five years in 1980. Assisted by the Aboriginal Arts Board, Careers in Dance developed and took advantage of real work opportunities so that its students could expose the contemporary Indigenous experience nationally and internationally. NAISDA was incorporated in 1988. As Indigenous choreographic expertise was developed, programs included more Indigenous choreography. At Bangarra Dance Theatre, which was established in 1989 [see 16.6], creative leadership came from trained Aboriginal and Torres Strait Islander dancers. By 1992 AIDT (as a professional company) had followed suit.

Practical work experience programs such as the annual season in Sydney, the Queensland remote area tour, the traditional study trip, and international and national tours, while serving the larger Indigenous community and the nation as a whole, had the underlying purpose of preparing the students for professional work. Students, seen on **television** in major shows such as the *Lyre Bird Fashion Awards*, brought pride to the Indigenous community. They participated with mainstream dance companies such as Kai Tai Chan's One Extra Dance Group and the Sydney Dance Company. They were also involved in dance programs, for example Norman Hall's Dance Umbrella at the Seymour Centre, Sydney, and the Shell Folkloric Concert at the Sydney Opera House, and in numerous community events.

From its inception, the wider Australian community had approached NAISDA for Indigenous representation in community programs and local festivals. The success of this work created a demand for employment of Aboriginal dancers. NAISDA dancers, disciplined and trained in both traditional and modern forms, were comfortable presenting positive images of Indigenous peoples. Importantly, the students gained performance skills and determination to make the course work so that future generations would have dance career opportunities. As the government saw results, NAISDA became a national institution, a grand experiment that had worked. It had come into existence at a time when 'Black was expansive' and urban Aboriginal people encouraged blacks who identified with them to participate fully. NAISDA created excitement. Its founding students were determined to show black people achieving excellence in the major Australian dance styles—Aboriginal and Torres Strait Islander dance, Western contemporary styles (ballet, tap, jazz), European folk, and African. NAISDA's practices, in harmony with Indigenous goals, were reconciliation in action. NAISDA evolved through the active participation in creative dance of people from urban, rural, and traditional communities and of friends representing multicultural Australia. People from traditional communities participated fully and provided leadership to urban Aboriginal people. The Australian dance community and the multicultural community interacted with the dancers. Through dance, Indigenous Australians are recognised as providers. Their skill in fusing ancient and modern dance forms empowers them to lead in building a new, Australian, modern dance technique. In bringing together urban and traditional experiences, NAISDA's philosophy grew pragmatically. It survived by initiating practical projects to benefit both the students and their Indigenous communities and, as a result, Australia as a nation.

CAROLE Y. JOHNSON

16.6 Bangarra Dance Theatre

Bangarra Dance Theatre is one of Australia's leading dance companies, best known for its fusion of traditional Aboriginal and contemporary Western dance movements. Its style has developed under the artistic direction of Stephen Page. His influences include time spent as a principal dancer with Graeme Murphy's Sydney Dance Company, as well as the dances and movements of the Yolngu people at **Yirrkala**, in north-eastern Arnhem Land. Bangarra principal dancer Djakapurra Munyarryun, from Dhalinybuy near Yirrkala, also works as a cultural consultant to ensure the integrity of the dances and the appropriateness of their use in various contexts (others have aided him in this task over the course of Bangarra's life). Page and Munyarryun in turn work very closely with in-house composer, David Page, ensuring that Bangarra's music is as original and innovative as its dance. Bangarra is based in Sydney, and in 1997 moved into new premises at the Wharf, alongside the Sydney Theatre Company and the Sydney Dance Company.

Bangarra was formed in 1989 by staff and graduates of the Aboriginal/Islander Skills Development Scheme (now known as NAISDA: the National Aboriginal and Islander Skills Development Association [see 16.5]). Although Bangarra's subsequent success makes it difficult to remember now, at the time there were few mainstream venues available to Indigenous dancers. Its founders' principal goals, therefore, were to create a distinct, professional performing body for Indigenous artists, one which would offer employment opportunities for NAISDA graduates and which would allow them to continue to work in the rich context of their own cultures. In its first two years Bangarra survived mainly by touring schools, a not unwelcome beginning since another of its goals was to use dance to educate people about Indigenous cultures and issues. The company also sought and obtained corporate sponsorship.

In 1991 Bangarra won a creative development grant from the Australia Council [see **Aboriginal Arts Board**]. This award was strong recognition of Bangarra's early success and future promise, and gave practical support for planning a major production. It allowed the group to hire Stephen Page, first as principal choreographer and then as artistic director.

Page's first production as Bangarra's artistic director was *Praying Mantis Dreaming* in 1992, the first full-length Aboriginal and Torres Strait Islander ballet composed in Australia. Inspired by a traditional dance Page witnessed on a visit to Yirrkala, the ballet is about a young woman who has an Aboriginal mother and a white father; she inherits the Praying Mantis Dreaming from her mother and the spirit watches over her as she struggles to reconcile the two traditions and cultures in which she lives.

Australian critics received the production with enthusiasm: Page was described as a choreographer of 'awesome' potential and the show itself was immediately hailed as a classic. Significantly, critics suggested that Bangarra represented the emergence of a unique, Australian genre of dance. *Praying Mantis Dreaming*, and Bangarra itself, were thus to some degree appropriated by non-Indigenous Australians, who seemed to believe that the incorporation of **Aboriginality** into mainstream arts gave them an imprimatur of antipodean authenticity and at last made the Australian arts distinct from the European traditions from which they had sprung. Simultaneously, Bangarra's work was placed alongside Jimmy Chi's play *Bran Nue Dae* (1991) [16.2], and the music of **Yothu Yindi**, as part of a renaissance of Indigenous culture which appealed to both Indigenous and non-Indigenous audiences.

Bangarra spent much of 1992 and 1993 touring *Praying Mantis Dreaming* and other shorter pieces of dance. The company performed in China, Hong Kong, the USA, and at London's South Bank Festival. In Australia it played in all the major centres as well as

conducting a 'Backyard Top End' tour to Western Australia and the Northern Territory. A highlight of this tour was Bangarra's visit to Yirrkala, their first company tour to the area from which so many of their styles and stories are adapted. Financial support for this tour and Bangarra's continuing operations came from further grants from the Australia Council and the **Aboriginal and Torres Strait Islander Commission**, and from corporate sponsorship.

Also during this period, Bangarra performed for the International Olympic Committee, at the 1993 Australian Football League Grand Final [see **Australian Rules football**], and at the opening ceremony of the 1993 World Youth Soccer Championship Cup. These events secured Bangarra live audiences in the thousands and televised audiences of millions. In 1993, Stephen Page and Pam Young were artistic directors for *Black Vine*, a concert cum variety show of Indigenous talent organised through Bangarra and commissioned by the Sydney City Council to celebrate the Year of the World's Indigenous People. In 1994, Bangarra was joint winner of the Sidney Myer Performing Arts Award.

Bangarra's next full-length production was *Ninni*, first performed at the Enmore Theatre in Sydney in May, 1994. *Ninni* was to some extent an experiment in form: the traditional cultural consultant, Guypunura Munyarryun, taught lead actor Rachel Maza and guest composer La Donna Hollingsworth traditional dialogue and gesture to produce a show that was as much drama and storytelling as it was dance. Thematically, it continued an exploration of some of the topics introduced with *Praying Mantis Dreaming*, including the personal and familial dislocation many Indigenous people have endured through the process of colonisation, the negotiation of multiple identities faced by Indigenous people who have links to both urban and traditional lives, and the strength and endurance of traditional values associated with land, spirit, and sense of cultural identity. Overall, however, *Ninni* was much less well received critically than *Praying Mantis Dreaming*, largely due to a perceived lack of success in combining dance and dramatic forms.

Ochres, created in 1995, rocketed Bangarra back to national and international attention [*278*]. If the critics enjoyed *Praying Mantis Dreaming*, they positively rhapsodised about this new production. Stephen Page and Bernadette Walong co-choreographed it, and once again David Page composed original music. *Ochres* takes place in four sections: Yellow, Black, Red, and White. Each section corresponds to an aspect of human relationships, to each other, and to land. Yellow is birth and women's business (ceremony) [see **Aboriginal English vocabulary**], black is initiation and men's business, red refers to relationships between men and women, and white is the culmination of the life-cycle and a return to earth.

Audience and critical reaction to *Ochres* was significant, not just because the show was uniformly admired, but because of what was said and the implications for Bangarra. In a repetition of the response to *Praying Mantis Dreaming*, *Ochres* prompted some to suggest that Bangarra had created a new Australian dance. Because *Ochres* got significantly more press, however, this message was carried further than in earlier write-ups about *Praying Mantis Dreaming*. People also responded overwhelmingly to the principal theme of *Ochres*—the spiritual importance of land to humanity in general, and to Indigenous Australians in particular. Press and audiences enthused about the 'spiritual' qualities of the work, and non-Indigenous critics were not immune from romanticising Bangarra as an exotic company offering a peek at an ancient, reverential, and somehow more primal culture. In some respects, the audience response to the theme of spirituality was precisely what Page, Walong, and others were trying to invoke. Yet there is also an unpleasant possibility that spirituality is somehow a 'nicer' topic for Indigenous performers, more palatable than, say, the overt treatment of some of the far-reaching

consequences of colonisation, such as family or social breakdown. Nevertheless, *Ochres* was a canny production to mount in the era of **native title** and awareness of Indigenous **land rights** for it provided a poetic and beautiful acting-out of affective relationships to land—relationships that are not always well understood by non-Indigenous people [see also 2.1].

Bangarra toured *Ochres* extensively in 1995 and 1996, travelling to Berlin, Tokyo, New Caledonia, India, and again throughout Australia. With their accessible style, beauty, and undoubted power, they were hailed as a force for reconciliation. Further, they were called 'cultural ambassadors' for Indigenous culture within Australia, and for Australian culture abroad. While touring *Ochres* around the world, Bangarra also continued to perform cameo pieces for events such as the closing ceremony of the 1996 Atlanta Olympics, which was beamed to a vast **television** audience.

In 1997 Bangarra opened a new work, *Fish* [*208*], which received its world premiere at the Edinburgh Festival and its Australian premiere at the Festival of the Dreaming in Sydney in 1998. In three sections—Swamp, Traps, and Reef—*Fish* continues the exploration of human relationships to the natural world that began with *Ochres*. It looks at humanity's connections to water: in the dances, fish are unborn souls anxious about birth; ancient cycles of fishing and regeneration are disrupted by Western carelessness; and the many beings or 'cultures' of Australia's reefs live side by side in beauty.

Although critical reaction in Edinburgh was mixed, by the time *Fish* reached Sydney it was taut and thrilling; it proved one of the most popular of the Festival of the Dreaming entries and was once again well reviewed. Further, its thirteen packed performances at the Sydney Opera House proved Bangarra's ability to access, and fill, space usually reserved for non-Indigenous performers.

By virtue of being a successful Indigenous arts group, Bangarra Dance Theatre has assumed, or has had thrust upon it, a role out of proportion to its size and youth. Members of Bangarra are expected to be agents for reconciliation, educators, cultural ambassadors, role models, and, above all, innovative dancers. As Stephen Page has acknowledged, everything they do as Indigenous artists has political import. They thus have their critics. Some in the Indigenous community have accused Bangarra of commodifying Indigenous culture, serving it up and selling it to non-Indigenous audiences. Others have suggested that Bangarra has been spoiled by success and attention, that it has veered too far from its original mandate, such as when it hired non-Indigenous dancer Jan Pinkerton (no longer with the company). Others have accused them of misrepresenting Indigenous experience, or of drawing too much on the traditions of Indigenous people at **Maningrida**, Yirrkala, and Dhalinybuy in particular. Further, in the dance community, Bangarra is occasionally accused of shallowness, or of failing to resolve dualisms in its themes and form, where the urban–contemporary and rural–traditional dichotomy feeds both story and style.

While these criticisms are no doubt valid, and important within the contexts from which they are made, they cannot diminish Bangarra's extraordinary achievements to date. Nor does Bangarra try to avoid dealing with these, and other, challenges. It has successfully combined contemporary and traditional styles, values, and stories. In its vitality and success, by virtue of the venues it commands, and in its bold expressions of themes, it is a convergence of art and activism. Its political force is in the quality and excellence of its dance.

LISA MEEKISON

208. Bangarra Dance Theatre, *Fish* (publicity image), 1997.

17. Fibre-work and textiles

17.1 Fibre tracks

Fibre has always played a major part in the productive activity of Aboriginal Australia. All areas of the continent had fibre traditions, many of which are continued today. Where plant fibre was plentiful, it was spun, twined, coiled, and transformed into a diverse range of functional structures which supported daily activities. In other areas—notably in desert country where plant life was less abundant—animal-based fibre played the main role in the construction of equivalent objects. The current range of new initiatives in the field of textiles provides a hint of the diversity which once existed; some of the innovative practices now being carried out, especially by women, attest to the lively creativity which undoubtedly existed through those centuries of activity unseen by Western eyes.

In former times, fibre objects and their creation were crucial to the sustenance of life in both material and spiritual ways. Like other items of material culture, those made from fibre provided protection from cold, rain, wind, and other extremes of the natural environment. In some cases they personified spirit forces which were directly and personally connected with groups of people and intimately involved in their connections with land. Such fibre connections varied from one culture to another, and still do. Some continuing traditions clearly encompass and demonstrate these spiritual links; other links now being created by fibre practitioners, in areas where culture was ravaged by white settlement, are both contemporary statements and echoes of past achievements.

In examining Indigenous fibre practice in Australia, it is particularly instructive to observe the quality of life and the particular environment so eloquently encapsulated in the objects. This is not to deny that there is a process of transformation at work, but to imply that the carefully chosen elements reflect the life and context of the maker. Without exception in Aboriginal fibre work, textured surfaces invite the viewer to touch. Often a shift in texture signals a change in technique or a structural variation in the work. Apart from the markers of sight and touch, the sense of smell is an integral part of the appreciation of the piece, especially with some fibres and especially when the work is fresh. This is so, whether it is a traditional bi-cornual basket from north Queensland [97], where the use of lawyer-cane strips endows the work with its particular precision and clarity, or a coil-bundled spinifex basket—broad, shallow, and generously proportioned—from central Australia [see 17.4; 215].

From Arnhem Land to the Coorong

Space precludes a description of the many fibre traditions in Australia. Instead we focus on two areas that are geographically distant, and culturally separate, yet which were

linked through early missionary activity, when a traditional technique from the Coorong and the lower reaches of the great Murray River in the south of the continent became part of accepted fibre practice in Arnhem Land and other related areas of the north. Despite the connection, these two traditions provide many contrasts, both in the objects created and the environments and situations which have resulted in the continuing of fibre practice today.

The northern part of the Northern Territory, incorporating Arnhem Land and often referred to as the Top End, is the home of several styles of fibre work, which are characterised by their use of natural materials and warm colours. Although there are diverse forms, most work is produced by the techniques of coiling, twining, and looping. Coiled basket forms that stand without support are currently the dominant items made for sale, while twined conical forms are more often associated with the classic (traditional) period [72]. The works vary from large, flat mats [160] to small, coiled earrings.

In Arnhem Land, fibre containers are closely associated with major creator figures and other ancestors. The Djang'kawu sisters [see 6.2] are ancestral beings from eastern Arnhem Land who carried a variety of sacred objects including conical mats and bathi [209], often called dillybags. As they travelled across the land their actions changed the landscape, and they gave birth to many children, often drawing them from the inside of their baskets or conical mats. The present-day models of these ancestral containers are important ceremonial objects, which vary in design from group to group. Some ancestral beings have actually taken the form of fibre objects. Margaret Carew documented two examples. A triangular skirt of the Gun-nartpa speakers, called Djinggabardabiya, travelled across the land creating sacred sites and Law for the people of central Arnhem Land. In the cosmology of the Rembarrnga people, two sacred dillybags travelled from the east, making springs and waterholes as they went. The dillybags (kunmadj) are of the Dhuwa moiety and were brought by Dhuwa parrots from Mirrngatja, a site near Gapuwiyak (Lake Evella), to a waterhole across the Blyth river at Jerrma Gornirra. They resided there in the billabong together with the bamagora (traditional conical mat).

Ancestral beings may also be represented as fibre objects. Twined and painted representations of a honey spirit have been made by Robyn **Djunginy** [210], a Ganalbingu woman from Ramingining. Referring to her mother's **Dreaming**, these three-dimensional bottle forms, and painted images of the bottles, are connected with a water site near the Ramingining airstrip where a similarly shaped rock is located.

In the south, during the nineteenth and early twentieth centuries, the Ngarrindjeri [see 17.2] people of the Murray River and Coorong regions in South Australia were subjected to indiscriminate colonisation, and much of the layered, cultural, and ceremonial meaning of traditional woven forms was lost. However, basic fibre techniques of the area continued to be communicated to family members. This situation was typical of many southern Australian communities, but in eastern areas where settlement first occurred both ceremonial knowledge and material techniques were often lost [see 1.2, 4.1, 11.1].

The two traditions meet

There was unexpected contact between north and south when coiling, a technique of fibre construction used by Ngarrindjeri people of the Lower Murray area, became popular as a way of making of baskets in Arnhem Land. Gretta Matthews, a young woman born in 1877, was most probably responsible. Her family worked with Ngarrindjeri people on the Lower Murray River at the Maloga Mission, where she became involved with Aboriginal women and their fibrework. They coiled bundles of rushes and formed them into baskets. When her father died in 1902 the mission closed, and Gretta Matthews eventually continued her work on Croker and Goulburn Islands (NT). In 1922 she began

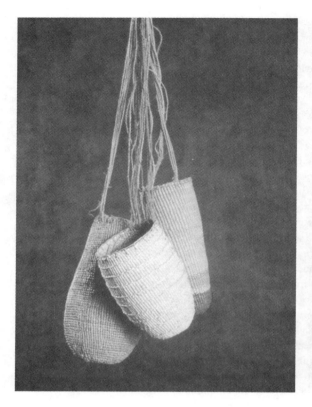

209. Group of *bathi* (pandanus dillybags) from Maningrida, in the 'Language of Weaving' exhibition, MAGNT, 1995. *Left to right*: Minnie Manarrdjala, *Napiya* dillybag; Elizabeth Mipilangur, *Burlupurr* dillybag; and Nancy Gabirama, *Gonborlpon* honey-collecting bag.

210. Robin Djunginy, *Untitled*, 1992, and *Bottles*, 1992. Twined pandanus bottles, 38 x 13 cm, 41 x 14 cm, and 33 x 17.5 cm, and natural pigments on bark. Both the bottles and the painting are associated with a site connected with honey

her work as a mission teacher on Goulburn Island and the influence of the Ngarrindjeri technique spread. S. A. Luck hypothesises that Maung people took this style of working from Goulburn Island to the Liverpool River area on the mainland, when they joined a group of Maung people already living there. The technique was soon to spread across Arnhem Land. Gretta Matthews, and other missionaries to follow, considered the making of baskets to be of economic benefit to the Aboriginal people and it was also seen as a means to fulfil the mission's desire to have Aboriginal people doing 'constructive' work. The time spent on the new forms, however, meant less time for the construction of the more classic forms that were used for ceremony and as trade items.

In more recent times, the coiling technique has continued to be a catalyst for connecting artists from the north and the south. A contemporary and visible result of the earlier connection was the exhibition and series of workshops held in 1992, 'Two Countries, One Weave', where Diane Moon from **Maningrida Arts and Culture** in Arnhem Land and Kerry **Giles**—a Ngarrindjeri artist working from Tandanya Aboriginal Cultural Institute in Adelaide—were the co-curators who brought together the Maningrida and Ngarrindjeri artists. Both groups of artists exhibited what Giles describes as traditional work from their area as well as more innovative pieces drawn from recent experiences and materials, and participated in workshops at Tandanya and at Camp Coorong. The Ngarrindjeri women brought locally gathered rushes and the Arnhem Land women brought pandanus and roots for dyes from their country. During the workshops, artists had the opportunity to use unfamiliar materials and some also produced collaborative pieces with a mix of techniques and materials.

It is not only the coiling technique itself which has spread to Arnhem Land. Variations of one of the traditional forms, the Two Sister basket (also known as the Sister basket and

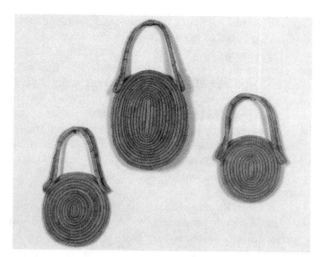

211. Ellen Trevorrow,
Ngarrindjeri Sister Baskets,
1995.
Freshwater rushes, (*l. to r.*) 56
x 27 x 10 cm, 42 x 23 x 6 cm,
39 x 21 x 5 cm.

so named because the two flat sides, sewn together, were likened to sisters) are made occasionally in an area stretching from western Arnhem Land as far east as Elcho Island. A recent basket by Ellen **Trevorrow** [*211*] from the Coorong and one made by Elsie **Milindirri** [*355*] from Galiwin'ku (**Elcho Island**) illustrate the possible connection despite some differences in style. The front, back, and handles of both baskets have a similar structure, produced by the coil bundle technique. Trevorrow's basket retains the spaced buttonhole stitch of older forms which allows the central bundle of sedge grass to be visible, while the Arnhem Land basket is densely stitched, allowing no visual access to the central core. Whilst the Trevorrow basket provides little internal area, the space between the sides of Milindirri's form is expanded by the addition of a wide band of looped string. The sides are coiled outward in a conical form, sometimes called a Madonna basket—the allusion being to the rock star, not the original mother figure. As Crompton has noted, past examples of the Sister basket made by Ngarrindjeri elder, **Milerum** (Clarence Long), in the 1930s [see 17.2] display a conical form similar to Milindirri's.

Fibrework in south-eastern Australia

Generally speaking, in south-eastern Australia the quality of fibre objects which has an immediate impact on the viewer is their density. As with the Sister baskets, the works are usually coiled, using a central, solid core of fibre which is wrapped and tightly wound in spiral forms to create a thick layer of material. When this technique is used to fashion a shelter, it provides a degree of protection from the elements which might not be necessary in warmer parts of the country—although the density may reflect the availability of materials as much as the need for ensuring protection. In any case, the compacted substance associated with fibre objects across southern South Australia and Victoria has an aesthetic which is closely related to form and structure. The decorative elements incorporated within woven objects of these areas mostly relate to the ways the coils are positioned. The hypnotic, spiral form is repeated over and over again, occasionally leavened by a looped bundle which produces an opening—usually repeated so that a stiff lacy pattern appears.

That the works were originally functional in no way diminishes their aesthetic and artistic qualities. Eel traps, fish scoops, gathering baskets, mats, and weapon holders they may be, but they are also part of a ceremonial and creative reality which is interwoven with and inseparable from practical needs, in the view of the cultures which created them. Today, the market provides another context within which to frame such objects,

without any lessening of the ceremonial and cultural meaning attached to the object archetypes and sometimes even to the objects themselves. Layers of meaning are permitted to coexist, as they always have been in Aboriginal cultures. Thus it is possible to describe the characteristics of the fibre objects as they relate—now or in the past—to usage, without diminishing the expressive power of fibre as media or the intrinsic power of the objects as art works.

Although there is little recorded about Ngarrindjeri fibre practice from former times, there are bodies of knowledge which have survived and have been transmitted orally, if incompletely. These have been extended through the existence of early fibre objects held in museums, which have provided clues for contemporary practitioners and facilitated the retrieval process, inspiring the work of Ngarrindjeri weavers Ellen Trevorrow and Yvonne **Koolmatrie** [*159*].

Ngarrindjeri elder Doreen Kartinyeri decided in 1982 that the time had come to pass on her skills, and with the help of government funding she instigated a workshop to do this. She taught a great deal of what she knew to a group of younger Ngarrindjeri women from her local community at Raukkan (Point McLeay) and Meningie. Both Trevorrow and Koolmatrie took part in the workshop and continued to work with fibre as a vocational task, teaching it to others, including non-Aboriginal people, in order to keep the craft alive. They also continued their own practice, deriving much personal satisfaction from fibre work as an artform. Trevorrow and her husband Tom spent time at the South Australian Museum examining a number of early fibre objects in order to trace the fibre processes. With these inputs as a basis for her own practice, Ellen uses her knowledge and experience as part of her work at Camp Coorong, the cultural centre which she runs with Tom. She teaches the techniques to visitors and shows, in video form, the 1930s film about Ngarrindjeri elder, Milerum [*213*]. The film shows him as a strong and compact man, working with swiftness, precision, and grace to pick sedges from the sand dunes near the Coorong. He chooses the sedge *Cyperus gymnocaulos* which appears to have been an important material for people from the Lower Murray, Lakes, and Coorong area and on the Murray River from Murray Bridge to the South Australian border. Milerum places his harvest in a gathering basket which he carries on his back. Later, he sits and coils the fibre, using a water bowl fashioned from a skull, and a pointed piece of bone as a tool. This film is a research resource for all, including, importantly, contemporary Aboriginal fibre artists; it gives clear indications of the movement patterns of the maker, as well as the materials used. Combined with oral transmission of knowledge and some of the actual completed objects held in the South Australian Museum, the film provides valuable information about traditions which might well have been completely lost. The actions of Milerum, a close relation of many Ngarrindjeri people active in the arts today, highlight the importance of fibre practice to men, as well as women, of the area. It is satisfying to Koolmatrie that male members of her family are continuing to engage with Ngarrindjeri fibre traditions. Her son, John Koolmatrie, has made a speciality of the knotted-grass duck net, a fragile item which would be placed above and across a waterway to snare ducks. These were first startled into flight, then directed downwards into the net by the whirring of boomerangs.

Many of these traditions have formed the basis for innovative fibre practice. Moandik artist **Janet Watson**, as early as the 1920s, used the coil bundle technique to create a basketry monoplane and a biplane [*401*], after seeing real ones in Kingston, South Australia. The Two Sister basket was the basis for Yvonne Koolmatrie's *Turtle*, 1994—a sculptural and figurative work which demonstrates the divergence from traditional forms which individual fibre artists are willing to embrace. The major art collecting institutions in Australia now recognise the art and craft practice from which *Turtle* has come as one of

the most significant movements to emerge in recent times. Aboriginal fibre artists are now often included in contemporary exhibitions. The Goulburn Regional Gallery initiated a project, 'Below the Surface' (1996), which featured collaboration between Indigenous and non-Indigenous curators and textile artists, and included works by both Trevorrow and Koolmatrie. Koolmatrie produced a mat in which she incorporated for the first time narrative elements and coloured fibre. Trevorrow used the traditional Two Sister basket form to make reference to the Seven Sisters Dreaming [see 1.3]. From the late 1980s, both artists have had work included in groundbreaking exhibitions. Both are still active, and involved in a number of exhibition projects.

For Aboriginal fibre artists, departure from tradition is not new. In the late nineteenth century fibre practitioners from mission settlements such as Coranderrk, in Victoria, used traditional techniques to produce baskets which were strongly related in form to those made and used in England at the time. Shallow, coiled baskets with decorative edges and handles, held in the collection of the Museum of Victoria, are reminiscent of the fruit bowls or cake plates used in European homes where Aboriginal women worked as domestic servants. Decorative elements incorporated into such work were often inspired by European culture and some of the materials were imported. Raffia work-shops were held in Victorian mission settlements, and this material was sometimes used for binding coils. Later, coloured raffia was used to create patterns. Although some subtle use of colour—such as the dye from the red basal sheaths of the sedge *Lepidosperma canescens* from the Kingston area of South Australia—was traditional in southern areas, strong patterning created with chemically dyed raffia was a significant divergence [*303*].

In the south, as far as can be discerned, no ochres or other strong externally applied colouring were used traditionally, although little is known about ceremonial practices connected with fibre, which might have occasioned such use. Certain aspects of secret–sacred knowledge were, and perhaps still are, held by a very few women elders of the Ngarrindjeri people, but it is known that at least some of these women preferred secret matters to remain untold rather than have them diffused by dispersal into the fragmented cultural situation of the present day. Nevertheless, objects which have obvious ceremonial connotations, such as the woven shrouds made by Koolmatrie, continue to be produced [see Pinkie **Mack**; *347*].

The ease with which Aboriginal women have continued to innovate, and to incorporate new materials, functions, and forms into their weaving repertoire, underlies the continuing strength and increasing diversity of fibre crafts in Australia. Tasmania [see 11.5], regarded for many years as a place where Aboriginal peoples and cultures had been completely destroyed, is the scene of a revival of fibre crafts by groups of women who have worked with collective memories and collected objects, and have made contact with people in other States to re-establish their traditions. In early 1995, a group of Tasmanian women travelled to South Australia to work with Trevorrow at Camp Coorong. Various techniques were compared and experiences shared.

Fibre-work in northern Australia

Baskets from the south generally maintain the colouring of the dried reeds and grasses from which they are constructed. In the north, by contrast, the undyed, pale, wheat colour of dried pandanus is used mainly to contrast with the dyed, natural material in baskets made for sale today. Although Aboriginal people have always known of plants that produce colour, there is little evidence that dyes were used in Arnhem Land before the coming of the missionaries. Essential items for dyeing with plant matter are water and a container in which to put all the ingredients (including the fibre to be dyed) over

the fire to boil. Metal containers were probably first introduced when Macassan fishermen [see 6.4] came to the north coast of Arnhem Land but were more readily available after Europeans arrived. S. A. Luck states that from 1922 Gretta Matthews at the Goulburn Island Mission encouraged women to find and use local dyes for their fibre products. In western Arnhem Land and the **Daly River** area a magnificent range of reddish purple hues is obtained from plants such as *Haemodorum corymbosum* that are not found in the east. This colour is almost a trademark of fibrework obtained from western Arnhem Land and as far east as Maningrida. Throughout Arnhem Land an array of yellows is produced from the outer bark of the roots of two small trees, *Pogonolobus reticulatus* and *Morinda citrifolia*. Ashes from particular wood types, such as the cocky apple *(Planchonia careya)* may be added to change the yellow to a range of oranges, reds, and browns. Black can be produced from the quinine tree, *Petalostigma pubescens*.

Fibre objects made for ceremonial use in these northern areas are particularly colourful. The surface images are obtained by the use of ochres, with which clan designs are painted on to the finished objects. These may also have additions of feathers, fur, or spun hair depending on moiety and clan affiliation. The materials and designs link the objects to the land and to their ancestral connections. Bob **Burruwal**, a Rembarrnga painter and fibre artist from Maningrida, makes public versions of ceremonial wearable objects [see **body adornment**]. His *lokngarru* (dancing belts) incorporate feather pendants and ochred surfaces. Men wear this type of belt in certain ceremonies.

Parallel developments

Across the Top End, flat mats, predominantly made from pandanus, have remained an important aspect of fibre production and mainly find their way to gallery walls. Today's flattened mat form is a development from an older conical form which served both everyday and ceremonial uses. Julie Djulibing and Barbara Wurrgitjpa from Ramingining, Elizabeth Mipilanggurr from Maningrida and Gubiyarrawuy Guyula from Gapuwiyak still make the twined conical forms. Although the makers of mats now are women, in the past both men and women made pandanus mats. Donald Thomson photographed Wonggu of Blue Mud Bay [see **Mununggurr family**] in the 1930s twining a flat mat.

Elizabeth **Djuttarra** [*160*] from **Ramingining** has won major art awards for beautifully crafted large flat mats up to three metres in diameter. The colour banding is varied by producing a spiralling movement created by careful colour contrasts in the core elements and the selection of twining. Minnie **Manarrdjala** from Maningrida also employs a creative spiralling design created not by the original core elements but by manipulation of the twining elements. Banding patterns are produced with relative ease in twining, but breaking the band to create a pattern such as the one seen in Manarrdjala's work requires careful planning and skill. Regina Wilson, a Peppimenarti artist from the Daly River area, extends the techniques and materials normally employed in the Top End, using finer, softer fibre from the sand palm, *Livistona humilis*, which the Ngan'gikurrunggurr people call *merrepen*. After its preparation she braids the fibre into long lengths which are coiled around each other and then stitched together with fibres of *merrepen*. A fringe of loose *merrepen* fibre is attached around the edges.

Flat, circular mats are also an important part of the repertoire of Ngarrindjeri fibre work. The bundles of sedge are coiled to produce a strong, sculptural object, unsoftened by added colour or fringed fibre. On occasion, the bundle is looped at intervals to form a decorative, open-spaced band, which is sometimes used as a basis for varying the circular form. Large, flat, circular pieces were once used as cloaks and personal shelter, as well as for carrying children, but are now more often displayed on walls—they have become ceremonial objects of a different kind.

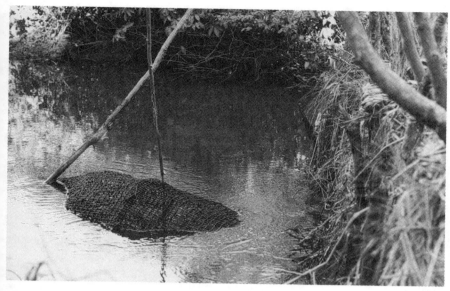

212. A fish trap made by Anchor Kalunba in use at Bulgai, central Arnhem Land in 1980.

Various styles of traditional collecting baskets were made by Ngarrindjeri women following the 1982 workshop. Many of these were shown in the exhibition 'Two Countries, One Weave', and others included in a later Tandanya exhibition 'Nunga, Yura, Koori' (1992) co-curated by Kerry Giles and John Kean. The coiled cockle basket made by Laura Agius was a type used for collecting cockles along the seashore of the Coorong Peninsula. Flat bottomed and cylindrical, it had a knotted-string handle which was worn over the shoulder. The men's weapon basket was a larger, more rounded variation of this style. Smaller, flatter gathering baskets would have been used for collecting small berries and fruits such as *muntharri* (wild apples). Waterways were an important source of food in Ngarrindjeri culture, and various fibre traps and scoops were used for catching eels, fish, and yabbies, the most recognisable now being the elongated eel trap form. This form has a counterpart in Arnhem Land with the conical fish trap from the Maningrida area which is made from *Malaisia* vine. Anchor **Kalunba** was the senior ceremonial leader of the Kunwinjku people and held the authority and knowledge to make the conical trap [*212*]. It was only made by men in the past, but is now sometimes made by senior women. It is not only a successful tool for catching fish, but holds symbolic meaning for its connection with the spirits of Aboriginal people at birth and death.

Fibre practice within contemporary Aboriginal culture is alive, and as vigorous as ever. As in any cultural setting there is innovation, building upon traditions which form a rich foundation for present and future activity. The continuing use and retrieval of techniques allow practitioners to engage with the profound and esoteric meanings underlying this material activity. Both the objects and their meanings have sustained Aboriginal cultures for millennia.

LOUISE HAMBY AND DOREEN MELLOR

Carew, M. & Hughes, A., *Maningrida: The Language of Weaving*, South Melbourne, 1995; Crompton, R., *Milerum: Whose Story?* [film], Bluestone Pictures, 1997; Giles, K. & Everett, P., 'Two countries, one weave', *Artlink*, vol. 12, no. 2, 1992; Hemming, S., 'Aboriginal coiled basketry in South Australia', *Journal of the Anthropological Society of South Australia*, vol. 27, no. 5, 1989; Isaacs, J., *Australia's Living Heritage: Arts of the Dreaming*, Sydney, 1984; Luck, S. A., 'Traditional craftwork at Goulburn Island school', *Special Schools Bulletin [Darwin]*, vol. 5, no. 4, 1968;

Museum of Victoria, *Women's Work: Aboriginal Women's Artefacts in the Museum of Victoria*, Melbourne, 1992; Spencer, W. B., *Native Tribes of the Northern Territory of Australia*, London, 1914.

17.2 Binding the rushes: Survival of culture

The Ngarrindjeri people of the Lower Murray, the Coorong, and Lake Alexandrina in South Australia first came into contact with the British in the early 1830s. The explorer Sturt, proceeding down the Murray River to its mouth, had been helped and guided by members of the eighteen loosely confederated groups who once formed the Ngarrindjeri nation. Despite a painful history of colonisation, the descendants of those Ngarrindjeri still know the web of family histories since contact, and recognise close ties with specific places in landscape. Fibre from the river sedges has become a key element in tying together the past and the future [see 17.1]. According to contemporary basket-maker Ellen Trevorrow:

We do think about the cruel past. But let the past be, we need to make things better for young people, while not forgetting about it.

The European artist George French Angas visited the colony in the 1840s and in a series of remarkable watercolours documented the seaweed cloaks, possum-skin cloaks, nets, and the wealth of artefacts in everyday life and ceremony. The South Australian Museum collection includes nets, war baskets, capes, fish scoops, Sister baskets, and coffin baskets, together with a documentary film made in the 1930s [see 17.1]. This film, which has had a great influence on Ellen **Trevorrow** [*211*] shows a Ngarrindjeri elder, **Milerum** (Clarence Long) [*213*], collecting the rushes and weaving a basket on the sand dunes, with a container of water beside him made from half a skull. Trevorrow comments:

With weaving a basket, you make it like that, it's yours absolutely, it's your hands shaped it that way. In the old video of Clarence Long making a basket, he has a water dish made of half a human skull and bone awls. The handles were made of twisted string like the Tasmanian ladies showed me. The sister basket is like a turtle, the old war baskets had a handle of human hair.

In early 1995 a group of Tasmanian women travelled to Camp Coorong to work with Ellen Trevorrow. Basket-weaving as a money-making activity had been encouraged in the mission at Raukkan (Point McLeay) founded by George Taplin in 1859. Woven items made there filled the Adelaide Town Hall in 1898. Tourists came by boat to visit the mission and purchased woven souvenirs such as baskets, mats, feather dusters, and ornaments in the first decade of the twentieth century. Memories of mission life at Raukkan go back a hundred years, distanced but still vivid. The naming of formidable 'aunties' and 'grannies' evoke that time. In the 1920s the craft of fibre was still strong, as seen in the innovative *Airplane*, woven by **Janet Watson** [*401*]. Sixty years later, Aunt Doreen Kartinyeri initiated a workshop in 1982, when traditional techniques seemed about to die, in order to pass on the skills. Notable contemporary weavers Ellen Trevorrow and Yvonne **Koolmatrie** [*159*] attended. Ellen Trevorrow says:

Family is so important. Coming back from the Festival Theatre on my birthday we called in to see Nanna [her great aunt] on the way home. I had some rushes for them from the Festival Theatre demonstration, that they could carry on weaving with. Nanna Laura is 94. They're our elders and special.

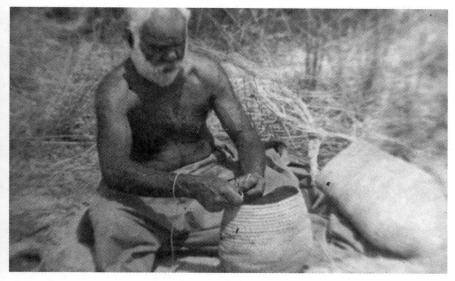

213. Milerum (Clarence Long) making a basket from sedge stalks, using the 'coiled bundle' technique, 1937.

The skill of basket-making is identified with the knowledge of specific sites for gathering the special sedges that have a flexible, not brittle, consistency. Knowledge of the location of special sites is handed down through families. Ellen Trevorrow recounts that:

I used to take Tanya my daughter to netball and pull into the river and pick rushes. I really feel that Nanna would be smiling today, at me picking rushes where she used to pick them. When we get the feeling we need to do something—then we'll go and see how the rushes are growing. The heart is in it all, the whole process, you know you get the feeling of it just by being there and doing those things, the beauty of it.

The Ngarrindjeri perception of country is an intertwined geographic and cultural landscape, where spirit realms above and below the ground intersect with human territories. Particular animals, especially the pelican and swan, can act as direct messengers from the spirit world through their close relationships with humans. For Ellen Trevorrow:

My special creature is the Murray cod, see I'm from the river. Tom [her husband] is from the Coorong and he's a blue crane.

For many Ngarrindjeri, beliefs about the **Dreaming** ancestor Nurrunderi who formed the landscape are not incompatible with Christianity [see 1.2], strong since early missionary days. Although the Sister baskets and mats of Ellen Trevorrow are not identified with specific myths, Yvonne Koolmatrie has incorporated a Dreaming component into her sculptural pieces, reflecting her mother's stories. Myths are not static but change to reflect changing situations, incorporating elements of trauma associated with dispossession. Yvonne comments:

It's not easy to go out at night in the Coorong because so much is going on, out there in the dark country. Sometimes a woman comes holding a baby, wailing, wailing. I never saw her, but friends did. There's too much sadness.

Drawing on ancient knowledge of the attributes of plants, the Ngarrindjeri weaving method is a coiled basketry technique, where a bundle of the thin reedy leaves of the

spiny sedge *Cyperus gymnocaulos* or the flat sedge *Cyperus vaginatus* is twisted by a looped strand that ties the bundle in a continuous coil. The leaves of the flax lily *Dianella revoluta* were used to provide strong thread for tying. Ngarrindjeri fibre is distinctive for its formal simplicity and minimal use of pattern or colour, but influences between northern and southern Australia are recognised by contemporary Aboriginal weavers. Ellen Trevorrow talks of intercultural experiences:

It's beautiful to sit and yarn while you weave together. I like weaving with old people because they yarn about things, the past which is the future for their children. I loved the **Maningrida** women sharing with us in Camp Coorong. The place feels like home to them, they feel safe with us. I want to share things across cultures.

The craft of making feather flowers, displayed in clusters in Ngarrindjeri living rooms, uses mainly the feathers of the pelican. An animal is found dead by the road, and quills from the echidna, or feathers from the pelican, are gathered for craftwork. Feathers have had strong spirit associations.

The revival of traditions such as basket-weaving is underscored by painful historical divisions between Aboriginal and European, and the overwhelming impact of European law and language. Tom Trevorrow recalls:

The last of the fringe camps didn't go until 1964 or '65. We were put out there in the fringe camps because we weren't allowed to live in towns. I remember saying to my father, 'What are we doing out here? Why are we living like this?'

Some Ngarrindjeri people, such as Mrs Lola Rankine of Raukkan, refused to pass on knowledge of culture and language in the face of such changes. Tom Trevorrow explains:

You see, she'd seen all the children taught Christian ways at the Mission, and all the land laid waste. In those days you couldn't have two ways, nobody was interested in Aboriginal culture, there was strong racism then. When I went to the Meningie School in the 1960s I was punished for talking Ngarrindjeri language.

An alternative is to acknowledge the profound changes of post-European times and incorporate them into an understanding of a living Aboriginal culture, a philosophy widely known across the national Aboriginal spectrum as 'Both Ways'. Doreen Kartinyeri perceived, like Ellen Trevorrow, that elements of the old culture could be revived to give choices to the Ngarrindjeri in challenging present-day conditions. She stated:

In some ways the past, present and future are one. You can see why Aboriginal people are confused, mixed up, angry, wild. But someone has to sit down and see the whole history, know the full extent of what's happened.

Ellen Trevorrow adds:

If we don't look ahead, us women felt we wouldn't be able to set it straight for our children. A lot of our work is about preserving heritage.

Ellen Trevorrow's artistry is linked to the transmission of the basket-weaving heritage through education. Yvonne Koolmatrie's acclaimed sculptural development of Ngarrindjeri weaving reflects a contemporary emphasis on the psyche of the artist. Her

insight as a woman who has lived by seasonal work along the Murray leads to an individual interpretation of landscape and artefacts. She transforms tradition for the non-Aboriginal art world in her icons of the land:

I just go with the flow of the weaving, ideas start when I start weaving. It's the structure of the weaving I find powerful, not the decorative part. The way life was structured in older times was powerful.

For Trevorrow and Koolmatrie the continuation of sedge weaving has other resonances than the usefulness of selling woven items: they recognise the economic value of heritage to tourism. The production of objects for exhibitions at a national and international level is significant because of the continuing negotiation of power and cultural knowledge between the Ngarrindjeri and the wider Australian society.

ELLEN TREVORROW, YVONNE KOOLMATRIE, TOM TREVORROW, AND DOREEN KARTINYERI
INTERVIEWS AND COMMENTARY BY DIANA WOOD CONROY

17.3 Lena Yarinkura and her mermaids

In 1994 Lena **Yarinkura** from Bolkdjam in central Arnhem Land (NT), caused a sensation at the 11th National Aboriginal and Torres Strait Islander Art Award (NATSIAA), held at the Museum and Art Gallery of the Northern Territory, with her entry of life-sized paperbark figures [*214*]. While a few **Maningrida** craftswomen before her had experimented in whimsical basketry shapes, none had developed their craft in such a dramatic way into the realm of mythological representation. Before this time, Lena was a respected weaver with a proclivity for making baskets with unusual technique combinations and shapes. After her marriage to Rembarrnga artist Bob **Burruwal** in the 1980s, she branched into bark painting and figurative carving. Never content to remain with one idea for long, Lena fused the narrative possibilities of such artwork with her weaving skills to produce innovative and highly original pandanus sculptures. These stand as a testament to her originality and the vitality of the contemporary fibre arts in Arnhem Land. Of her work she says:

From school days I learnt [weaving] from my mother … Her surname is Djaymarrangu, old lady living at top camp. I started 1981 painting and weaving and carving. Doing many ways. Sometimes I'm helping Bob, or I'm doing myself, and Bob does something else. Bob's been teaching me painting—one story—and also I'm teaching to my son and daughter. I'm helping him [Bob]. He's not helping me to make basket, it's too hard for him. I'm helping him do carving or painting, bark painting, no worries, but he can't help me with pandanus or string bag or thing like that.

The collaborative nature of their partnership and the significance of the ancestral stories told to her by her father and husband are emphasised in Lena's discussion of her very first paperbark figure group entered into the 1994 NATSIAA. A similar figure group was also entered later that same year in the Canberra Indigenous Heritage Art Award. Both groups illustrate the same important crocodile story from the region:

Yes I made it that paperbark one. That crocodile—Bob made it with paperbark, but I made the husband and wife and two kids. Well that's my idea. My father used to tell me that story long time ago, all the stories. *Mimih*—rock country, he used to tell me that story. I used to put it in my mind. I used to think, 'I'll make anything.' He's got story, so I make bark or basket and made it paperbark. That's the old time story.

214. Lena Yarinkura, *Family of Yawkyawk, Mermaids*, 1997.
Pandanus fibre, paperbark, feathers, and natural pigments, (*l. to r.*) 115, 160, 185, and 109 cm long.

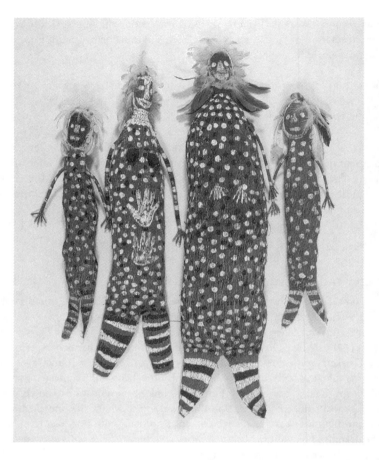

Lena goes on to discuss another important sculptural group of *yawkyawk* (mermaid spirit beings) that won the Wandjuk Marika Memorial Three-Dimensional Award at the 14th NATSIAA in 1997. These were not, like her previous paperbark figures, overwound with fibre, but were made with bodies of pandanus twined like the conical bags of the area, stuffed with paperbark, and painted:

My father used to tell me all that story. That *yawkyawk* story. One man went hunting and he saw a *yawkyawk*—sharp milk [pointy breasts], in that water and picked 'im out from that water and take it away [home]. He use to make his wife, before, *yawkyawk*. Like Bob's father. He used to go and take 'im out of the water and use[d] to take her [to] desert country. She married him. He make his own wife. Bob's father he was really clever.

Yes I started [making the *yawkyawk*] one day, just start always making [like a] dilly bag. I always do like that, start first then go and then join it [the fibres] and make big one. That's my own idea, nobody knows only by myself. My mother always telling me, 'Show me how to do it.' 'You know, you should copy.' 'No, I don't know how to make.' My mother try to copy, but nobody knows, only myself.

The little baby one and mother one [*yawkyawk*] I started, just made a little head, just leave it open and then paperbark—put it in [for stuffing] and join it [the fibres] and just make big one, bigger and bigger, and just put paperbark all the way, all the way and then finish up and make the tail, then the arms.

While acknowledging the influences of various people and ideas upon her work, Lena clearly views her innovations as the result of personal inspiration and continues to produce a range of woven basketry figures, fibre artefacts, bark paintings, and wooden carvings:

I'm the only lady at Bolkdjam doing the weaving, the painting anything, just myself there's nobody. When I finish off this mermaid then I'll make other different things. I'll try think about it, that's my idea, just to think myself, to learn about and make different weaving. No use the same thing, I'll do different thing. Somebody said, 'Who made this mermaid?' 'That's the girl from Bolkdjam, she's got a lot of mind, always thinking, not just one thing, but all different way, painting, carving, weaving, all different way.'

<div align="right">

LENA YARINKURA, WITH INTRODUCTION BY MARGIE WEST

INTERVIEWS WITH LENA YARINKURA BY MARGIE WEST

BIOGRAPHICAL NOTES BY MARGARET CAREW, MANINGRIDA ARTS AND CULTURE

</div>

17.4 Weaving baskets in the Central Desert

Basket-weaving [*215*] is relatively new to Central Desert people, though Ngaanyatjarra women have always made three main items from fibres: hair rings for carrying loads; shoes from bark, vines, and feathers; and hair-string skirts or face coverings for ceremonial purposes. Ngaanyatjarra communities started weaving in 1995 after the Ngaanyatjarra Pitjantjatjara Yankunytjatjara Women's Council initiated a training program funded by **ATSIC**. This program ran until funding ceased in September 1996. During its existence local artist Thisbe Purich taught weaving and craft skills to the Ngaanyatjarra women of six communities in the Warburton area. Workshops were also held with other weavers–Nalda Searles, Philomena Hali, and Renita Glencross. Women have continued making baskets and spread the craft themselves to other communities up to 1000 kilometres away.

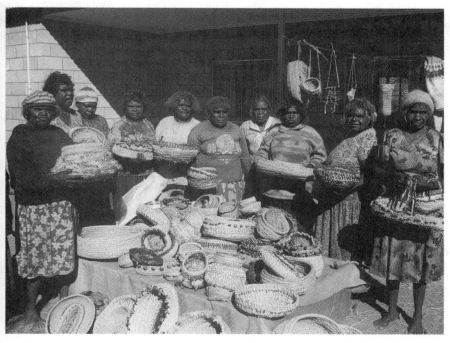

215. A group of Ngaanyatjarra women with baskets they have made at a workshop at Warakuna with Thisbe Purich, central Western Desert (WA), 1998.

The materials used to produce the baskets include *wangurnu* (woollybutt grass), *nyanturra* and *minari* (also local grasses), *yininti* (bat's-wing coral tree beans), and *nganurti* (bush turkey feathers), hand-spun human hair, sheep wool, and scraps of contemporary materials. The weavings have featured in several exhibitions, including one large touring exhibition. Baskets by Ngaanyatjarra communities have been exhibited in many local and national exhibitions. Winnie Woods, Chairwoman of the Council, says:

Basket-weaving is a wonderful new desert craft that offers women another way of making money. We like doing the basket program because it is something to learn and do in and around the community.

Firstly, materials are ready and found easily in the bush anywhere, anytime and cost nothing. We use many kinds of grasses which grow in the desert and we decorate them with animal fats, ochre, emu and turkey feathers, seeds and beans. Sometimes we sew them together with thin strips of bark, vines and creepers, or just use jute string, coloured wool or scraps of string found around the camps. All you need are needles and string and you can even make a needle from a tinned meat key.

Secondly, they're really easy to make and you can take them everywhere with you: indoors, outdoors, picked up and carried around on your travels. The women have been teaching each other, you don't need special teachers.

The baskets have been really popular. In 1997 we entered some baskets in the Central Australian Aboriginal Art and Craft Expo in Alice Springs and they all sold out. Later Araluen Centre for Arts and Entertainment bought a couple of our baskets for their collection and also told the National Gallery of Victoria about us. Some baskets from Wingellina and **Warburton** went to the Leonora Art prize [1997]; one came first in the craft section and the rest sold out. More baskets from Tjukurla have been sent to the Artists in Residence Gallery in Perth.

Basket-making has been really good for us women. We can make them easily in the bush. While you're digging for *maku* (witchetty grubs) and *tjala* (honey ants), you can collect seeds and grass as well. It also gives us more money.

It's good for the young women too, we can show them sacred sites, special grass and the best time to go and get them. We can tell stories while we're collecting the grass and making the baskets. Doing the baskets has made a big difference to our lives.

WINNIE WOODS
INTRODUCTION AND INTERVIEW SUPPLIED BY MAGGIE KAVANAGH

17.5 Indigenous dress

Dress and body markings are redolent with meaning in Aboriginal culture. In its essence, Aboriginal dress today still acknowledges the ancient territory of the ancestral body. A playful photograph [*216*] of Emily Kame **Kngwarreye** [see 9.5, 9.6; *123*, *225*], standing between Barbara **Weir** [*403*] and Gloria Tamerre **Petyarre** [*367*], all in T-shirts imprinted with her painting of ritual body marks, makes explicit these links between the ancestral body and the modern. Whether Indigenous attire is used to signal social status, community affiliation, ceremonial adornment, or political resistance, or simply as practical bodily covering, it simultaneously accepts and disavows the Western clothing system. While Europeans regard the adorned and shaped body partly as a commodity, to be used for the display of power, prestige, and status, we cannot assume the same things about dress and identity with Indigenous people. Clearly, clothes encode entirely different meanings for non-Europeans, and within cross-cultural relations that take place

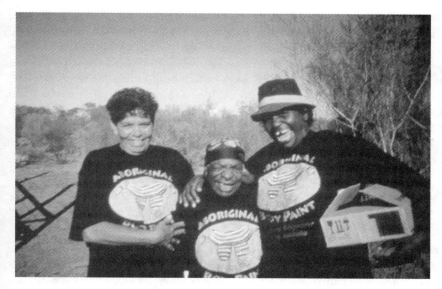

216. Emily Kame Kngwarreye (*centre*), Barbara Weir, and Gloria Petyarre wearing Emily body-paint T-shirts with her Emu Dreaming from Utopia Body Paint Collection. Alice Springs, April 1994.

between colonisers and colonised. It all depends on the occasion, and on who wears what and who observes them.

Before contact with Europeans, the skin of Aboriginal bodies was largely unclothed and open to the elements. People adorned their bodies [see **body adornment**] with warm, earth-based pigments, used ornamental headbands, armlets, anklets, and belts made of fibre, shells, teeth, feathers, bark, and leaves, and they scarred their skins with special markings. They performed **corroborees** and religious rituals wearing body paint, head-dresses, and accessories. The hair of participants was sometimes matted with earth, twisted, and plaited. Coverings and marks varied with region, social grouping, season, age, and gender. Skin cloaks [see *289*], for instance, worn in the south-east and south-west, gave way to fibre cloaks in the warm north-eastern rainforests. In some regions such as Arnhem Land and Bathurst and Melville Islands, women used short skirts of bark or woven leaves, or skins sewn together. Bark sandals were worn in the Western Desert, bark hats on Mornington Island and dillybags of fibre were carried in many communities [see 17.1]. For ceremonies such as initiations, burials, and rain making, marks were and are still inscribed onto the body, the design varying according to the person's social group and the subject of the ceremony and song cycle. This symbolic mapping in traditional pigments was and is connected with sand sculptures [2.2, 6.2] or **bark paintings**, or the designs on carved trees [see 11.1] and other ceremonial objects, speaking of restricted knowledge.

Confusions on both sides about the meaning of appearances occurred from first settlement. The sight of 'naked' black bodies was profoundly problematic for Europeans. Conversely, Aborigines were apparently perplexed about European body coverings and the sex of the wearers, and seemed at times unclear exactly where clothing ended and flesh began. In some senses this indeterminacy about dress has continued to operate across the two cultures. Some clothes like knitted caps (beanies) that were European working-class garments have now been incorporated into Indigenous cultural traditions, and are characteristic of both men's and women's dress in some areas. There are many other instances where Western dress was and is accommodated into ritual attire, such as at Taroom, south-western Queensland, in the 1920s, when men's ceremonial body paint was streaked over their shorts, a widespread contemporary practice in performances and Indigenous celebrations in the south.

Clothing has been implicated in unequal power relations between the races. Early colonists assiduously sought to cover unclothed Aboriginal bodies, for 'naked' black bodies were believed to be uncivilised and tainted, contradicting the view of the noble savage as pure, innocent and childlike. In an interview with Vivien Johnson in 1986, the artist Banduk **Marika**, who grew up in north-eastern Arnhem Land, remembers vividly the clothing of her younger days. For Marika, dressing up in European dress had dual significance: it was pleasurable and playful, but also had far more problematic subtexts in terms of black–white relations.

[A]ll these tribal people, every Sunday—church bells, dress themselves in the missionary clothes going to church … It was sort of a fun time for me—when I was young. It was great to have your father dressed up in white shirt and tie, every Sunday going down to church … They were good times, happy times, but I don't think that any of those old people really understood what it was all about … they were brain-washing my people, and doing a big stab in the back.

The supposed progress of Indigenous people toward civilisation was believed to be discernible by the degree to which they submitted to wearing European dress. Missionaries and pastoralists employed dress as a technique of acculturation, and commonly as a reward system. They were aided in this by official policies, such as the issue of government 'slops' (ready-made clothing) and blankets, beginning from the time of Governor Macquarie in 1815. Dressing up Aboriginal people at Oyster Cove as northern European peasants was a specific project of Tasmanian authorities in the 1850s, and similar interventions continued throughout the century. Payment for work was often by means of standard issue clothing.

Indigenous people, too, exploited access to Western dress in furthering their own purposes. Crinolines were popularly sought by Aboriginal women in the mid nineteenth century, for they seemed to find these large, wired structures appealing. Similarly attractive to Aborigines were European station clothing and paraphernalia [*217*]. This was a status-endowed but also cost-effective garb that allowed black stockmen to move between two opposing cultural territories at the frontier—the bush and the station. Typical dress was R. M. Williams riding boots, Akubra hats, stockmen's trousers, and shirts. Station hierarchies and rivalries were spelled out by the size, the shape, or the relative flashiness of the various hats worn. Today the Akubra of the outback stockman has evolved into a powerful symbol for black activists, often accompanied by a brilliant red headband. In the outback there were also economic imperatives in the choice of station dress, for firms like Wayne's stores stocked cheap clothing, producing special hard-wearing lines, with minimal styling, for their local black customers.

Dress has been the site of struggle and engagement since the last century, and continuing cultural exchanges and negotiations about clothing have been implicit in relations between blacks and whites. Aborigines have responded to outside impositions with accommodations and resistances. In 1952 the photographer Axel Poignant, on a trip to Nagalarramba on the north coast of central Arnhem Land, filled with preconceptions, and in search of 'authentic' tribal life, recorded dismay at the ragged and dirty clothing of the local people. Exerting pressure on one occasion, he asked a woman to change for him and 'she swapped a "terrible looking dress" for a "beaut red skirt".' He acknowledged: 'I would have preferred nothing—but settled for that.'

Today, subtle regional differences continue to be displayed in outback Aboriginal styles. These are now constituted by a mixture of T-shirts, head scarves, and garments made from Indigenous and imported batik, and patterned fabrics. Common attire for Island women is a flowery print dress with puffed sleeves. In the outback, a plain or

217. Bull ride. Kim Hudson (Kokoberra language group), receives a reassuring hand from Simon Luke (Kokoberra language group) as two other men working the chute prepare him for the Bull Ride event at the 1994 Kowanyama Rodeo. Kowanyama is an Aboriginal community on the west coast of Cape York Peninsula, Far North Queensland. Photograph by Peta Hill, June 1994 for the project *Shadows in the dust— a contemporary portrait of Aboriginal station life.*
© 1996 Peta Hill

patterned T-shirt and loose skirt are worn at ceremonial times to allow the women to sit comfortably on the ground and be painted up as circumstances dictate. At the same time, professional Aboriginal women in urban areas have developed a particular and distinctive flair in their outfitting, using bold colours, snappy hats, dramatic scarves, and beads. This, too, signals a special identity for Aboriginal people.

Since the late 1960s Aborigines have been empowered by the development of their own fabric design, which has also entered the realm of fashion design. T-shirts, scarves, and leisurewear, produced primarily in art centres across the country, resonate with significance. These garments link back to traditional designs and to popular cultural styles. Nor is this clothing always consumed by Aboriginal people. A subtle distancing from the goods is at work, allowing space to be reserved for private, as well as public, forms of Aboriginal identity. Stephen Muecke (discussing the 'writing' on cloth by Walmajarri artist Jimmy **Pike** [*133*, 270, *369*]) describes Aboriginal dress as one that is 'carried around, nomadically, on people's bodies'. The 'diffusion' of Aboriginal design can be identified in many places, and in a variety of ways, for clothing is designed in numerous Aboriginal environments, from community art centres to designer workshops.

Most commonly, Aboriginal designers work at community art centres and produce on a modest scale, favouring portable and relatively inexpensive items like T-shirts, scarves and fabric lengths. Production is disparate and pluralistic. Aboriginal artists are committed to surface in dress—they seldom restructure. Pattern is described onto fabric and images are fixed by screen printing or hand painting. This is not mere pattern making. Rather, it is a sign that most remain distanced from Eurocentric concepts of fashion which traditionally concern complexity of shape, cut, and fit.

By the end of the 1960s, the Australian government and other agencies were encouraging Indigenous designers and craftspeople to design and make everyday dress, partly

as a route toward self-sufficiency and cultural reclamation. This marked significant changes in the dynamics between Europeans and Aboriginal people in the realm of dress. The government believed the encouragement of traditional crafts and design would create employment for Indigenous people, and that Aboriginal communities could be revitalised through the increased marketability of their products.

In 1965 an influential report on the tourist industry (Harris et al.) identified a need to establish an Aboriginal arts and crafts industry. Numbers of community craft organisations began to be funded. But in 1981 a shift in official policy sought to maximise, through self-management, the benefits of cultural products to Aboriginal people. It also signified a move from cultural support to encouragement driven by the needs of a tourist economy [see 18.1]. Tourists wanted well-made products that were uniquely Australian. They had to be distinctive, portable and with the potential to be manufactured in large quantities. Thus, the tourist economy shapes the parameters of the types of commodity—small, bright, portable items—that yield the best income for Aboriginal clothing designers.

An Aboriginal marketing staple is the T-shirt, a functional, informal garment, on which the marks of group identity may be easily displayed. Other staples are scarves and the sarong, both rectangular strips of cloth. The sarong, now a mainstream leisurewear item, is an item of dress for Torres Strait Islander men, worn tucked about the waist. The T-shirt can be a throwaway, mass-produced garment, ideal for a cash-and-carry form of popular Aboriginalia. For some it seems the ultimate, low-cost tourist souvenir. But mass produced T-shirts, with unauthenticated replica designs, were the site of a battle in the 1980s over Indigenous ownership of design. The final outcome, in 1989, was some entitlement to protection under the *Copyright Act* [see 22.1]. The very marketable popularity of T-shirt designs is synonymous with their capacity for exploitation. Thus they represent the equivalent of **land-rights** claims in fabric, and are key sites of Aboriginal struggle for autonomy over their culture.

The T-shirt is a deeply politicised garment which readily bears the inscriptions of resistance. One could cite shirts with schematic red, yellow, and black images at the hand-over of title to Ulu̱ru in 1985 [*22*], those at the Australia Day anti-bicentenary march in Sydney in 1988 [see **Survival Day**; *46*], and the Balarinji shirt worn by the athlete Cathy Freeman [see 20.1, 20.2; *281*] as a proud statement of her **Aboriginality**. Destiny **Deacon** [*66, 67, 277, 314*] also used a series of T-shirts, *Not Another T-Shirt*, in her installation for the 'Lawyers, Guns and Money: Art, Artist, Law and Power' exhibition at the Gabrielle Pizzi Gallery in Melbourne in 1997, thus making a strong political statement about black encounters with the law.

Today, there are community craft centres, urban-based outlets, advisory centres, and marketing endeavours promoting Aboriginal dress and fabric design. Centres like **Keringke Arts** produce handpainted T-shirts, dress lengths, scarves, and jewellery in contemporary designs with motifs based on the regional landscape. Others, like Jilamara, started by using old traditional designs copied from published images; some, like Pertame, use both traditional and more modern motifs.

Perhaps the most important early community centre for textile design was **Ernabella**, a Pitjantjatjara community in the Musgrave Ranges in north-western South Australia. It evolved from mission craft outlet in 1948 to a sophisticated urban marketing enterprise. In 1971 **batik** was introduced by an artist from New York, Leo Brereton, and the women began to translate the striking, fluent sand *walka tjuta* (meaningful marks) onto silk, cotton, and silk organza. These were sold as lengths of cloth but also made into scarves, hats, and bags. Ernabella Arts continues to produce lustrous, glowing batiks with designs of organic abundance. The practice of batik spread to Fregon, to an associated

community Amata, and in 1977 to **Utopia**. The women at Utopia first made skirts for themselves and for children's clothes. Julia Murray, who arrived in 1978, established the Utopia Batik program allowing the artists to work with silk, and she also obtained bulk containers of T-shirts and jeans from the south to transform into batik clothes. Today the designs are visibly different from those of Ernabella, and derive from personal totems or **Dreamings** or replicate the linear designs applied to the body in *yawelye* ceremonies [see 2.2, 3.2, 3.3].

Tiwi Designs at Nguiu on Bathurst Island was, and remains, one of the most important community-based fabric design companies in northern Australia. Textile subjects include fish, lizards, and birds, and translated body art designs from Kulama and Pukumani ceremonies. Tiwi Designs have supplied well beyond the tourist market. A related industry on Bathurst Island is the independent clothing and fabric design workshop, **Bima Wear**. More recent community enterprises are Yurrampi Crafts at **Yuendumu**, north-west of Alice Springs, set up in 1990; Yurundiali Aboriginal Corporation near Moree, who specialise in distinctive screen-printed fabric and leisurewear; and Tobwabba Art Group at Forster, on the central north coast of New South Wales, who produce clothing and accessories, all under licence from individual artists. One of the most lively is Spirit Lines of Moree, set up in 1992, originally run by Ann Johnson of the Gamilaraay people and non-Aboriginal Janelle Boyd. Spirit Lines produce delicate photo-screen textile designs, with a contemporary and local focus: 'work drawn from experiences as women, wives and mothers living on the edge of the desert.' The high profile Desert Designs began in Perth in 1985. This company works with Aboriginal artists such as Jimmy Pike [*133*, 270, *369*] and Doris Gingingara. Its practice is for all designs to have an Indigenous name and to provide information on the artist, a copyright notice, and information on the design and its meaning. Even more successful is the Aboriginal and non-Aboriginal team of Jumbana, established in 1983 and led by John Moriarty who draws upon his Yanyuwa heritage from Booroloola (NT). The company, now known as Balarinji, draws on aspects of both Western and Indigenous cultural processes. It employs Western business strategies for accessing new markets, and Indigenous processes in cultural design for the product and in the employment of Aboriginal people. While the company continues a long tradition of using Indigenous motifs for leisurewear, its best-known commissions are to be seen on two Qantas 747 aircraft [*280*].

White artists and designers, beginning with Margaret Preston in the 1920s, have admired the strong designs and abstract depth of Aboriginal art. In the 1930s and 1940s, Aboriginal motifs with catchy titles like *Rock Carving*, *Corroboree*, and *Emu Track* became increasingly popular for household and fashion textiles. Designers of these fabrics gave important new visibility to Aboriginal design, though few were much troubled by issues of appropriation. Interest in Aboriginal motifs and in 'primitive' design intensified in the 1970s and early 1980s. The work of Jenny Kee and Linda Jackson for the shop Flamingo Park between 1973 and 1983 capitalised heavily on Indigenous art (as part of their wide-ranging interests in the designs of other cultures). Whilst these non-Indigenous artists were stimulated by the earthy colours and 'mystique' of Aboriginal design, both promoted Indigenous design. Kee first interpreted the Mimi motif in 1977 with her *Mimikee* scarf and Aboriginal theme fabrics, and the following year produced Aboriginal art sweater dresses. She repaid the **Maningrida** community with unused fabric; they were delighted, and made it into bags and items for their own use. Similarly, Yuendumu women admired the bush symbols in Jackson's fabrics and the brilliance of her *Rainbow* colours, when they visited her studio. They made it into clothing and also purchased her designer T-shirts for their own use. Jackson and Kee both looked to

218. Aboriginal models, Christine Power (*left*) and Michelle Clark (*right*), showcasing two of Ron Gidgup's creations at the Marr Mooditji Gnuni fashion parade, NAIDOC week, 1998, Lawrence Wilson Art Gallery, University of Western Australia.

Aboriginal (and indeed African and Indian) motifs for inspiration, but importantly, they also worked comfortably alongside Aboriginal designers and used Indigenous fabrics, for example from Tiwi Designs.

Kee's productive collaborations with Banduk Marika are of particular interest. Kee printed bold, lino designs by Marika onto cotton fabric, and included Marika's portrait on her *Black and White Unity* scarf of 1987–88; Marika also produced fine designs with bird and snake symbols for Kee fabrics. In 1983 she screened a black-and-white fabric print for herself and, with Kee, co-designed an outfit for her own use, appearing in this dress on the cover of *Aboriginal Employment News* in March 1984. Marika also modelled fashions for Kee, and can be seen in a flamboyant advertisement in the early 1980s for Flamingo Park.

The Gamilaraay designer Lawrence Leslie and Euphemia **Bostock** both worked with Jackson in her studio, and Leslie fabrics were used by Jackson in some of her fashion shows. After meeting Utopia women in Sydney, Jackson visited Utopia station in 1982. In that year Jackson designed her sonorously rich wrapped and draped *Utopia Costume*—a loose fitting dress, poncho, and four lengths of textile—made from earthy coloured batik lengths, hand painted by the women of the station. At the same time, she sent made-up tops, leggings, skirts, and coats to Utopia which the women decorated in batik designs, and these were then sold in Sydney. These cross-cultural references and associations in the 1980s were complex, diverse, and at the time seemed mutually enriching. Stylistic character moved fluidly between these designers and Aboriginal communities, although today we might regard these borrowings as more problematic.

In the mid 1980s, some Aboriginal artists became fashion designers in their own right. Bandjalang artist Bronwyn **Bancroft** [*287*] is probably the most important of these in bridging the gap between white and black cultures. Between 1985 and 1990, Bancroft was proprietor of Designer Aboriginals in Rozelle, Sydney, one of the first retail outlets for quality one-off printed and painted clothing and jewellery by Aboriginal designers. Bancroft began showing fashions using Koori models in 1982, and later joined with Euphemia Bostock and Mini Heath to show her clothes at the Printemps store in Paris in 1987. Ron **Gidgup** [*218*] works from a base in Perth, and has been actively involved in designing for Aboriginal fashion parades. Fashion parades have been recurrent features of NAIDOC weeks since the 'Yurandiali' fashion performance in Canberra in 1991, and build on earlier attempts in the 1980s to raise the self-esteem of young Koori women. 'Fashion the Indigenous Way', directed by Lenore Dembski, was a musical fashion event (and fashion expo) shown as part of Melbourne Fashion Week in 1997, with the express purpose of foregrounding the high-fashion potential of Indigenous designers. More recently an emerging group of young Indigenous designers have begun to offer a brilliant counterpoint to modern, mainstream fashion.

MARGARET MAYNARD

Harris, Kerr, Forster, & Stanton Robbins & Co., *Australia's Travel and Tourist Industry: A Report Prepared for the Australian National Travel Association*, Sydney, 1965; Johnson, V., 'Banduk Marika, interviewed by Vivien Johnson', in C. Moore (ed.), *Dissonance: Feminism and the Arts 1970–1990*, Sydney, 1994; McGrath, A., *Born in the Cattle*, Sydney, 1987; Muecke, S., 'Mainstream of consciousness', *ALR Magazine*, no. 148, 1993; Poignant, R., with Poignant, A., *Encounter at Nagalarramba*, Canberra, 1996; Reynolds, H., *The Other Side of the Frontier*, Townsville, Qld, 1981; Rowse, T., 'Interpretive possibilities: Aboriginal men and clothing', *Cultural Studies*, vol. 5, no. 1, 1991.

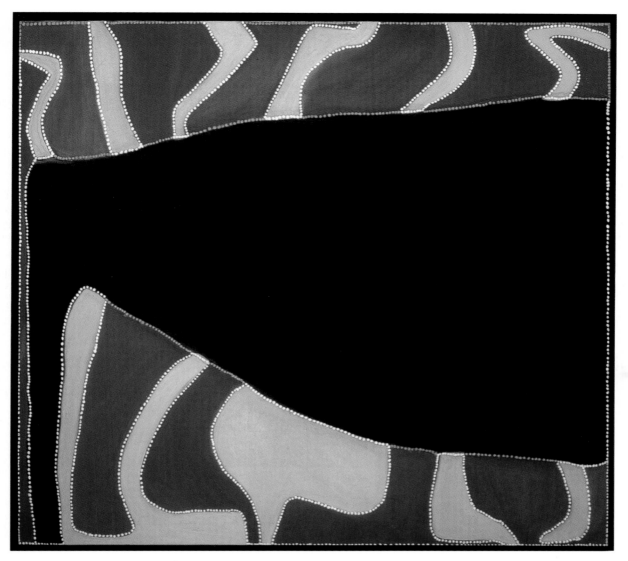

219. Rover Thomas, *Cyclone Tracy,* 1991.
Natural gum and pigments on canvas, 183 x 168 cm.

See also: 1.1, 1.2, 3.1, 10.1, 10.2, 21.1, 22.6, 23.2; **Dreaming**, **Rover Thomas**, Paddy **Jaminji**.

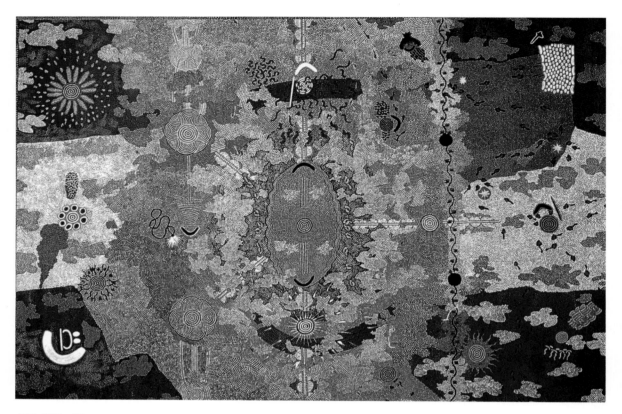

220. Clifford Possum
Tjapaltjarri, *Yuutjutiyungu*,
1979.
Acrylic on canvas, 231 x
365.5 cm.

See also: 1.1, 2.1, 3.1, 4.1,
6.1, 9.1, 9.4, 9.5, 9.7, 21.1,
21.3; Clifford **Possum
Tjapaltjarri**.

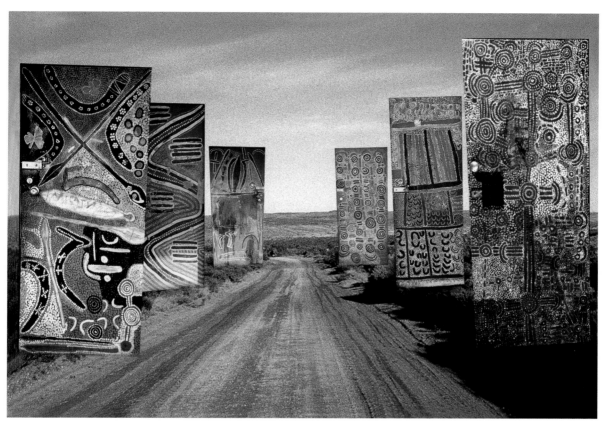

221. *Unhinged! The Yuendumu Doors*, 1983. Acrylic on wooden doors; (*l. to r.*) Paddy Japaljarri Stewart, *Two Men (Watijarrakurlu)*, 90.7 x 204 x 4.5 cm; Paddy Japaljarri Stewart, *Rain (Ngapakurlu)*, 80.5 x 204 x 4.5 cm; Paddy Japaljarri Stewart, *Two Men (Watijarrakurlu)*, 91.2 x 204 x 4.5 cm; Paddy Jupurrurla Nelson, *Big Yam (Yarlakurlu)*, 90.5 x 204 x 4.5 cm; Larry Jungarrayi Spencer, *Women (Kantakurlu)*, tapers to base, top 81, bottom 80.5, x 208 x 4.5 cm; Paddy Japaljarri Stewart, Paddy Japaljarri Sims, Paddy Jupurrurla Nelson, and Roy Jupurrurla Curtis, *Small Yam and Big Yam (Ngarlajiyikirli manu Yarlakurlu)*, 91.2 x 204 x 4.5 cm.

See also: 1.1, 2.1, 3.1, 6.1, 9.5, 9.7; **Dreaming**, Paddy Japaljarri **Sims**, Paddy Japaljarri **Stewart**, **Warlukurlangu artists**.

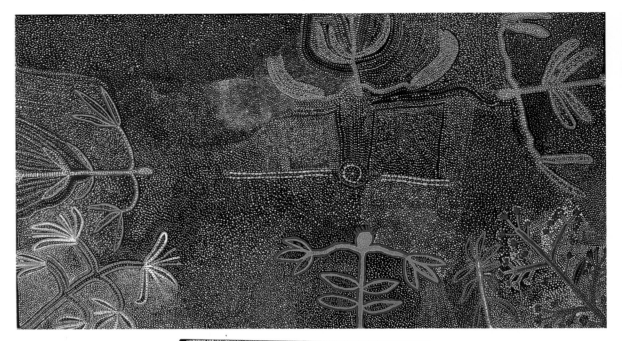

222. Ada Bird Petyarre,
Sacred Grasses, 1989.
Acrylic on canvas, 130 x
230 cm.

See also: 1.1, 2.1, 6.1, 9.5,
9.6; **acrylic painting, batik,**
Emily Kame **Kngwarreye,**
Ada **Bird Petyarre, Utopia**.

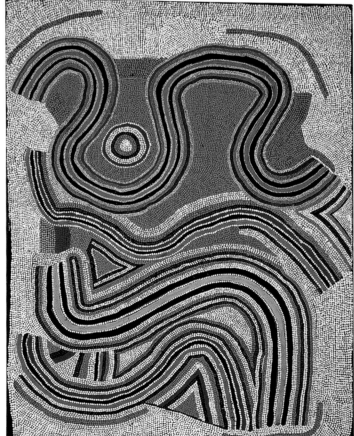

223. Abie Jangala, *Water
Dreaming*, 1987.
Acrylic on cotton duck;
122 x 91.5 cm.

See also: 1.1, 2.1, 6.1, 9.5;
acrylic painting, Abie
**Jangala, Warnayaka art
centre**.

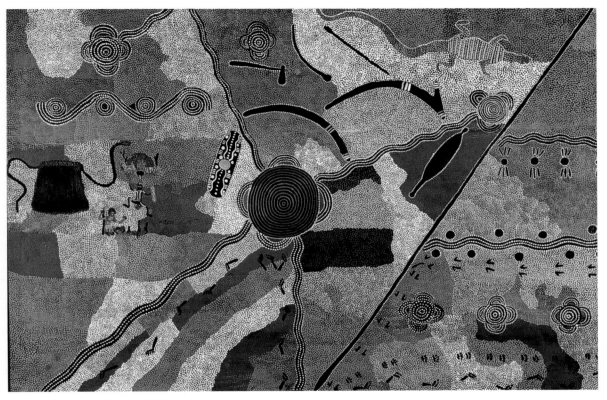

224. Tim Leura Tjapaltjarri,
Rock Wallaby Dreaming,
1982.
Acrylic on canvas, 120.8 x
179 cm.

See also: 1.1, 2.1, 4.1, 6.1, 9.4,
9.5, 9.7; **acrylic painting**, Tim
**Leura Tjapaltjarri Papunya
Tula**.

225. Emily Kame
Kngwarreye, *Untitled*, 1990.
Acrylic on canvas, 210.9 x
121.6 cm.

See also: 1.1, 2.1, 6.1, 9.5,
9.6, 9.7, 17.5, 21.1, 21.3;
acrylic painting, Emily Kame
Kngwarreye, **Utopia**.

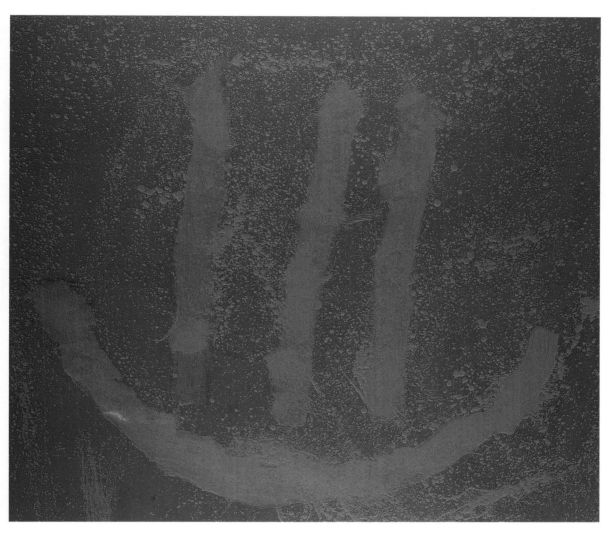

226. Michael Jagamara Nelson, *Lightning*, 1998. Acrylic on linen canvas, 201 x 176.5 cm.

See also: 1.1, 2.1, 6.1, 9.4, 9.5, 9.7, 22.1, 22.3; Michael Jagamara **Nelson**.

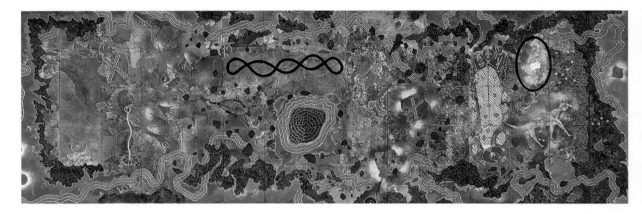

227. Michael Eather and friends, *Two Worlds*, 1995–97.
Acrylic, natural pigments, shellac, and maps on 75 boards in 15 panels, 956 x 300 cm. (installed); 2 curtains 325 x 335 cm, 325 x 340 cm, 4 curtain rods 3 x 75 cm (each).

This dramatic collaboration involved fifteen Indigenous and non-Indigenous artists mainly associated with the Fire-Works Gallery in Brisbane: Bianca Beetson, Karen Casey, Joanne Currie, Michael Eather, Stephen Gawulku, Leigh Hobba, Christopher Hodges, Ruby Abbott Napangardi, Michael Jagamara Nelson, Laurie Nilsen, Lin Onus, Rick Roser, Clifford Possum Tjapaltjarri, Simon Turner, and Barbara Weir. The mural, which is concerned with displacement and identity, encompasses two vast maps: from Tasmania on the left to Arnhem Land and the region around the Arafura Sea on the right.

See also: 1.1, 2.1, 6.1, 8.2, 9.5, 12.1; Richard **Bell**, **Campfire Group**, Karen **Casey**, Michael Jagamara **Nelson**, **Lin Onus**, Clifford **Possum Tjapaltjarri**, Barbara **Weir**.

18. Cultural meeting places

18.1 When whitefellas go walkabout

Tourism has grown to become Australia's largest industry. Until the 1980s, tourist promotion relied heavily on images associated with an outdoor lifestyle, beach culture, and the beauty of Australia's natural environments. Then with an increasingly sophisticated tourist market came an emphasis on cultural attractions, including Australia's unique Indigenous **cultural heritage**. This trend coincided with the bicentenary of European settlement of Australia in 1988 and an explosion of interest in Aboriginal art [see 21.1, 21.2]. Since the 1980s the range and number of tourist ventures based on Indigenous culture have rapidly increased. These now encompass promotion of significant Aboriginal places, cultural centres, guided tours, performances, walking trails, production of Aboriginal art and craft, and **festivals** celebrating a broad range of Indigenous arts. Although many commercial marketing enterprises have focused on marketing Aboriginal culture, the most significant recent development has seen an increasing involvement of Indigenous organisations and individuals in the initiation and management of such ventures. The diversity of Aboriginal people's experience with tourism throughout Australia makes generalisation difficult, but a number of common issues arise from Indigenous involvement in the industry. This essay provides a brief historical survey of 'Aboriginal' tourism, examines tensions between private and public knowledge and presentations of culture, and discusses emerging trends in the Indigenous tourism industry.

The historical context

The origins of a form of tourism focused on Aboriginal people and culture can be traced to the nineteenth and early twentieth century. Government policies led to the concentration of Aboriginal people on reserves such as Coranderrk [see 4.1, 11.2, 14.2; *228*] near Melbourne, **La Perouse** in Sydney [see 18.3; *232*, *339*], and Lake Tyers in Gippsland. These locations often became popular places for tourists to visit. In the 1870s and 1880s, day trippers from Melbourne would visit Coranderrk and buy mementos made by Aboriginal residents such as **boomerangs**, baskets, and possum-skin cloaks [*289*]. In the 1920s and 1930s visitors to Lakes Entrance would travel by boat to nearby Lake Tyers, buy artefacts, and take photographs of the Aboriginal people [see 11.1].

In more remote locations the development of railways and roads led to regular contact between Aboriginal people and travellers. With the opening of the transcontinental railway across southern Australia between Adelaide and Perth in 1917, the railway sidings became important places for trade between Aborigines and train travellers. After World War II, with improved roads and an increase in air travel, Alice Springs in central Australia became a major focus for Australian tourism. This coincided with the popularity in

228. *Boomerang throwing,*
Coranderrk Station, Vic,
c.1900.

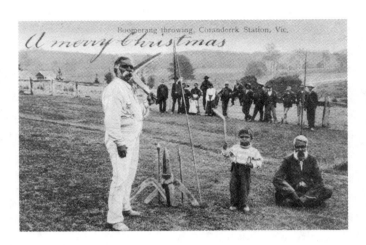

southern cities of the watercolour paintings of the famous central Australian Arrernte artist, Albert **Namatjira** [see 9.1; *36, 42, 111, 115*], and watercolours and prints in his style became popular tourist souvenirs.

In 1958, after pressure from tourism operators, Uluru and Kata Tjuṯa (then popularly known as Ayers Rock and Mt Olga) were excised from the Petermann Reserve of the Northern Territory for the purpose of developing new tourist enterprises [see 2.4, 18.2; **Maruku Arts and Crafts**]. Local pastoralists, who were suffering the effects of a prolonged drought, opened dining rooms for tourists as a way to obtain income. Stations such as Angas Downs and Curtin Springs, on the way to Uluru, became important sites for trading between Aboriginal people and tourists.

This early period has often been regarded as one in which Aborigines were only passively involved, and in which they were vulnerable to exploitation. Maggie Brady has shown that, at Ooldea, the Protector of Aborigines believed bartering was detrimental to Aboriginal people as it encouraged 'shiftless habits'; similarly, welfare officers in the Uluru region in the 1960s tried to keep Aborigines away from tourists and from Uluru itself. In this, they sought assistance from tourism operators: it was considered that the money earned by trading artefacts was, as anthropologist Robert Layton has reported, 'an adverse effect in our attempt to teach the natives the principle of work for pay'. Such a perspective failed to recognise the ways in which Aboriginal people used the advent of tourism to their own advantage. Aborigines from Ooldea used the train to attend ceremonies, and trading artefacts at Uluru freed local Aborigines from dependence on missions and settlements and allowed the continuance of a mobile, autonomous lifestyle, necessary to the conduct of important ritual business. This trade was particularly important when seasonal conditions led to difficulties in living off the land. Selling artefacts was an important source of independent income in these contexts.

The potential of Aboriginal culture as a major focus for tourism was recognised in a report on Australia's travel and tourism industry in 1965 by Harris et al. Tourism was seen as a way to promote economic development in remote Australia and, for Aborigines, as a way to make a living while preserving the integrity of their customs and way of life, which at that time were popularly considered unique and 'primitive'. The election of a Labor government in 1972, and the formation of the **Aboriginal Arts Board** in 1973, led to the creation of mechanisms of support for Aboriginal art and culture: Aboriginal people in remote Australia were encouraged to produce art and craft for external sale [see 21.2]. This policy could be justified not just in its own right as support for unique forms of Indigenous art and craft, but also in the context of increasing demand for

Aboriginal cultural products, both from tourists and from Australian society at large. A range of commercial outlets was established, with government funding, to market Aboriginal art and craft with the aim of promoting high quality and maximising returns to Indigenous producers.

Tourism to and within Australia continued to expand rapidly in the 1970s and 1980s, with major promotions occurring in association with the bicentenary celebrations in 1988 [see **Survival Day**]. Distinctive—and commodifiable—forms of Australian culture were in high demand. Aboriginal art and culture occupied a unique market niche, and it was during this period that tourism which focused on Aboriginal culture began to be formally marketed.

Until the early 1980s, 'Indigenous' tourism was largely centred around Aboriginal culture in remote Australia. This was a legacy of the belief that 'real' Aboriginal people lived in these locations. Urban Aboriginal people were popularly perceived as lacking 'authentic' culture. As Ann McGrath has shown, this romanticised concept of **Aboriginality** was fostered by travel magazines such as *Walkabout* and was associated with more general myths about the nature of outback Australia [see 4.1, *45*]. The emphasis began to shift in the 1980s and 1990s with the establishment of a variety of Indigenous tourism ventures in other parts of Australia.

Tensions between public and private values

Aboriginal societies are characterised by varying degrees of restriction on access to knowledge. Concern for maintenance of private knowledge is paramount in decision-making about what are appropriate forms of culture to make accessible to outsiders. This concern is reflected in choices about the types of Aboriginal places which are made accessible to the public, the forms of art and artefacts made for sale, the types of cultural performances mounted, and in the development of Aboriginal cultural centres [see 19.4] and **keeping places**. Some Aboriginal groups choose to participate in tourism ventures, others may have little choice, and some decline to be involved, preferring not to share their knowledge, culture, living space, and special places with outsiders.

The tension between public and private knowledge and values may be illustrated by reference to several significant Aboriginal cultural sites. The development of a site museum of desert culture at Cave Hill (SA) in the early 1970s incorporated a proposal to open to tourists a cave containing rock art. The aim was to provide employment and economic benefits for Aborigines from the increasing tourist trade to central Australia. This well-meaning proposal had unintended consequences. Because of concern among some members of the community about outsiders seeing important religious images, the art work was deliberately painted over by senior men. Similarly, Aboriginal people's concern about control and access to sites at Mutawintji National Park [*229*] in western New South Wales led to a campaign which resulted in closure of the park in 1983. It has since been reopened, but access to certain sections is only permitted if tours are accompanied by a guide. In some tourist locales where it has been impossible to restrict entry to the whole area, such as at Uluṟu–Kata Tjuṯa National Park, certain sections, which are registered sacred sites, have been fenced off and have legal prohibitions on entry. In other parks, some significant places are deliberately left unsignposted so that visitors remain unaware of their existence. While some groups such as the Tiwi people of Bathurst and Melville Islands are able to control tourism because of their geographic isolation, for other groups, such as those at Uluṟu and Kakadu, conditions of land title require continued tourist access. To meet the demand to visit Aboriginal places, Aboriginal people are now commonly using Aboriginal-led guided tours and carefully considered interpretive signage to make tourists more aware of the significance of particular places.

229. New South Wales National Park and Wildlife Service rangers talk to tourists at Mutawintji Historic Site, 1994.

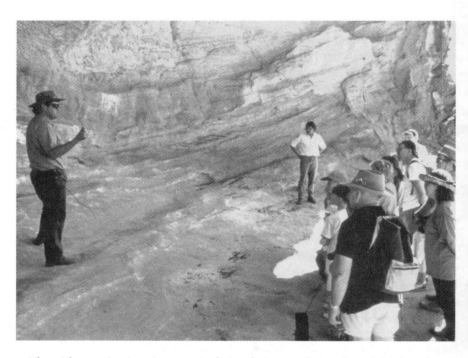

The wish to maintain privacy, not only in relation to religious knowledge but also to be beyond the tourist gaze in everyday life, has led many communities to impose restrictions on entry to living areas, often causing disappointment for tourists. Access is more easily controlled in some contexts than others. For example, the Tiwi control tourist access by requiring permits for all visitors and through their ownership of Tiwi Tours. At **Hermannsburg** (Ntaria) [see 9.1, 9.2, 9.3], the visitor to the central area of the community, which has fine historic buildings from the mission era, does not require a permit for a day visit to what is now a tourist precinct. At Uluṟu the impact of tourism was particularly acute prior to 1984: a small community of less than 100 people had over 200 000 tourists per year staying in the adjacent camping ground. This was one reason for the creation of the resort of Yulara outside the park in 1984 and the closure of the Aboriginal community to outsiders. As a result, however, the local Aṉangu people have little control over the range of tourist enterprises offered at Yulara. Consequently they have established their own tour company—Aṉangu Tours—to attempt to obtain greater economic advantage from tourism.

Because of prior experience with tourists and general levels of racism in Australian society, many Aboriginal people are reluctant to be directly involved in tourism ventures which require constant, face-to-face interaction with tourists, preferring to establish mechanisms which allow them to obtain economic benefits without direct contact. Responses to tourist demand for access to 'behind-the-scenes' areas range from carefully controlled, high-quality, small-scale tours such as those run by Desert Tracks [230] through the Pitjantjatjara homelands, to more mass-tourism, high-turnover products such as the Tjapukai Aboriginal Cultural Park [see **corroborees**] established in Cairns in 1996.

The tension surrounding the control of restricted knowledge in changed circumstances receives graphic expression in the forms of art that are produced for sale. For example, the early paintings of the now famous Papunya Tula school of Western Desert art [see 9.5; **acrylic painting**] were often characterised by the inclusion of symbolism

relating to the restricted religious knowledge of senior men. These paintings were not well received in the market place; nevertheless concern about the widespread circulation of the paintings led the men to restrict the use of these images and produce paintings with a distinctive dotted background. While the later popularity and success of this style of painting led to the rapid adoption of 'dot' painting techniques by many communities in central Australia, other groups continued to worry about depiction of important images and places and were reluctant to enter the acrylic painting market. Ironically, the early paintings from Papunya are now among the most highly sought-after works among private collectors of Aboriginal art, and are beyond the economic reach of most tourists.

Production of carvings for sale to tourists [see 18.2] has become an important part of the local economy in the Pitjantjatjara lands in northern South Australia and in adjacent areas of the Northern Territory and Western Australia. With increasing numbers of tourists visiting Uluru, there is a high demand for robust, low-cost souvenirs. Since the beginning of the tourist trade to Uluru in the late 1950s, pokerwork animal carvings (*punu*) have been developed to meet this demand, and have become a characteristic feature of the local artistic repertoire. Through time, these works have become more complex, more highly decorated, and increasingly diverse in form [*231, 354, 399*]. Thanks to the existence of a regional arts organisation, **Maruku Arts and Crafts**, carvings can be either retailed locally or wholesaled to outlets in capital cities or other tourist areas. Through the production of such works for tourists, Aboriginal people can maintain a lifestyle which allows them to carry out important cultural responsibilities such as visiting sites and conducting ceremonies. While the local demand from tourists for low-cost, sturdy, small-sized items has led to increased production of items such as *punu*, Maruku's diverse marketing strategy includes wholesale agreements with outlets in other locations where larger items such as spears and wooden dishes are in demand. In addition, Maruku promotes sales through special exhibitions and at international trade fairs.

The construction of Aboriginal **keeping places** and cultural centres [see 2.4, 19.4] is a growing trend, arising in part from the desire of local communities to take advantage of increased tourism and to educate the wider community about Aboriginal **history** and culture. The first was built at Shepparton (Vic.) in 1980, and many new centres in other locations have since been created, particularly in the eastern States. This trend has been associated with the drive for **repatriation** [see **cultural heritage, Australian Indigenous Cultural Network**] of cultural collections from major museums, and such centres are a means of encouraging pride in local cultural history, and a way of developing economic enterprises in Indigenous communities. The displays of local history and culture allow tourists and other visitors to appreciate the diversity of Aboriginal culture throughout Australia. Often the 'Aboriginalist' architecture of keeping places such as Brambuk Living Cultural Centre at Halls Gap (Vic.) [*241*], or the Uluru–Kata Tjuta Cultural Centre, becomes a tourist attraction in itself.

While Aboriginal cultural centres and keeping places are often established with tourist audiences in mind, the costs of staffing and ongoing operations can rarely be met from self-generated funds. Efforts to increase income through enterprises such as provision of conference facilities and restaurants selling Indigenous food have not made these institutions economically self-sufficient. Their continuing existence thus depends upon government support except in the areas of highest tourist visitation. In eastern States, government funding bodies often sponsor these enterprises by providing a building and funds for initial exhibits, but their continuing viability remains problematic because of lack of coordinated funding to provide for trained staff and changing exhibits.

Although much Aboriginal dance and music is performed in private ceremonial contexts [see 6.5, 7.3, 15.1, 16.3], a wide range of public performances is undertaken

230. Nganyinytja grinding woollybutt seeds, 1989.

Ngalya pitjalaya, ngayuku ngura nyakunytjikitja. Manta nyangatja miil-miilpatjara! Ngayuku kamiku tjamuku ngura iritinguru. Pitjalaya! Pina ala, kuru ala, kututu alatjara!

Come and see my country. This land is sacred! This has been my grandmother's and grandfather's country from a long time ago. Come with open ears, open eyes and open heart!

Nganyinytja and Ilyatjari, Pitjantjatjara elders of Central Australia, invite people from all over the world to come and visit their country. Since 1988 their family have been running Desert Tracks, a cross-cultural tour business, at Angatja in the Mann Ranges. Nganyinytja says; 'People need to understand that Aboriginal Law–Tjukurpa is in the land. We live on the land and are keeping it alive, looking after it as our grandmothers and grandfathers did, following the Law.'

throughout Australia, from contexts of mass tourism to specially commissioned and choreographed works performed in major capital city theatres. The Tjapukai Dance Theatre [see **corroborees**], part of the Tjapukai Aboriginal Cultural Park, is highly successful, presenting Aboriginal and Torres Strait Islander dance and theatre to international and local tourists. Through daily performances, it provides significant economic and cultural input to an important mass-tourism enterprise. The Bangarra Dance Theatre [see 16.6], based in Sydney, has grown since its establishment in 1989 to provide an important, contemporary dance experience. It reaches a large audience through national and international tours and via regular television coverage.

Local tourism is also encouraged through special Indigenous arts **festivals** and events such as the Aboriginal Dance and Cultural Festival at Laura (Qld), the **Survival Day** concerts in Sydney on 26 January, and the Yuendumu Sports Carnival and the Barunga Festival in the Northern Territory. These special events attract significant numbers of Indigenous visitors as well as tourists.

Contemporary issues and trends

Indigenous tourism is now formally encouraged through national tourism strategies, developed by the **Aboriginal and Torres Strait Islander Commission**, with an emphasis on Indigenous business ventures that can be economically viable and self-sustaining. Tourism, much of it Indigenous tourism, remains a key economic base for State and Territory governments, particularly in northern Australia. It is ironic then that, at the same time, Aboriginal culture is threatened by policies and practices which aim to reduce the ability of Aboriginal groups to lay claim to land through **native title** processes.

Policies designed to encourage Aboriginal involvement in tourism are not always matched by economic benefits. In 1994, tourists could choose from fifty-two tours advertised as part of the Northern Territory's 'Come Share Our Culture' campaign, yet only twenty-two were partly or wholly Aboriginal-owned. While emphasis is being placed on promotion of Indigenous tourism, the employment of Aboriginal people in the private tourism sector remains negligible.

Two of Australia's most significant places for Aboriginal tourism—the national parks at Uluṟu–Kata Tjuṯa and Kakadu—are managed jointly by Indigenous custodians and government agencies. This is a recent phenomenon which, while having many benefits, is not without unresolved problems. Arrangements with federal agencies create tensions with a Territory administration which is anxious for increased control; any desire on the part of traditional owners to reduce tourist numbers is unrealisable, since continued public access is a condition of the lease.

Commercial success stories in Indigenous tourism are few. Apart from individual Aboriginal artists whose paintings may receive high prices (and these are generally not sold in tourism contexts), the most successful individual Indigenous enterprise is probably Balarinji, a designer and retail label created and marketed by Jumbana Design Pty Ltd, whose directors are John and Ros Moriarty. Using designs drawn from John's Aboriginal heritage, this company produces a wide range of clothing and textiles aimed at the tourist market. Balarinji was commissioned in the early 1990s to paint two Qantas jumbo jets with their designs [*280*].

The tourist market is the backbone of many Aboriginal arts and crafts organisations. These provide Aboriginal producers in remote areas with the opportunity for some limited economic benefits and support the continued production of important cultural items. In the mid 1990s, sales of Indigenous art and craft were estimated to be worth $200 million a year, with about half of this from sales in tourist contexts. At Uluṟu, the presence of over 300 000 tourists per year underpins a local art industry worth over $1 million in

sales. Infrastructure support for art centres comes from federal funding and remains vulnerable to changes in policy or altered priorities: art centres may be forced to compete for funding with housing projects or other forms of community infrastructure development.

The increased demand for Aboriginal products in the tourist industry has expanded opportunities for Aboriginal artists, but it has also led to unscrupulous business practices. Many items sold in tourist contexts feature Aboriginal designs but are not in fact made by Aboriginal people. Aboriginal designs on T-shirts, tea towels, coasters, and other products are often fabricated without permission by non-Indigenous people (either in Australia or overseas), or are executed in what is perceived as a generic 'Aboriginal style'. Legal action has been taken against several operators who have copied Aboriginal designs without permission, and the industry is seeking ways to provide indicators of authenticity so that buyers may not be unwitting participants in these practices [see 22.1].

Tourist demand for Aboriginal cultural products has resulted in changes to certain art and craft forms. Often the most well-known forms of Aboriginal artefacts, such as the **boomerang** or **didjeridu**, are sought. This demand is sometimes met from areas where such items were not previously made. Didjeridus were traditionally found only in certain parts of northern Australia, but there is such a high demand for them that they are now made by Aboriginal people in many areas of Australia [see 15.4]. Similarly, many tourists remain unaware that boomerangs were not used in all parts of Australia and that they could be either returning (i.e. of a type that comes back when thrown) or non-returning. Returning boomerangs have captured the public imagination and are commonly produced for sale, while relatively few people buy functional non-returning types.

Indigenous individuals and communities are establishing increasingly diverse tourist enterprises. These include emu farms [see **emu eggs**], commercial design studios, cultural camps and cultural centres, dance and performance groups, safari tours, and commercial tour companies. Such new ventures are not only important economically to their host communities, but also serve to renew, or reflect new expressions of, Aboriginal cultural identity.

The tourist potential of Aboriginal culture has also been recognised by major museums in Australia. Public collecting institutions are increasing their focus on Indigenous heritage [see 21.1], and using Indigenous art and culture as a drawcard. New galleries of Aboriginal art and culture have opened in Adelaide, Melbourne, and Canberra. These provide an important introduction to Aboriginal culture in a form which could be further explored in local, Aboriginal-managed, contexts.

In the 1950s and 1960s, Aboriginal items were regarded as little more than curios for tourists. However, Aboriginal and Torres Strait Islander culture now fills a unique niche in the marketing of tourism in Australia. The promotion of Indigenous culture as part of a distinctive, Australian, national identity is being re-emphasised with the Olympic Games in Sydney in 2000 and the centenary of the Federation of Australia in 2001. The expression of Indigenous culture is becoming more widespread in tourist contexts: in designs painted on jumbo jets, in 'Aboriginalist' architecture, in the use of Indigenous foods in gourmet Australian cuisine, and in advertising images. With careful balancing of economic and cultural requirements, Indigenous tourism can develop in ways which serve to strengthen aspects of Indigenous culture. By buying 'authenticated' Aboriginal art and craft, tourists can support Indigenous artists and their dynamic and evolving art traditions. Through support of tourist ventures controlled by Aboriginal people, the tourist industry can actively support the cultural and economic aspirations of Australia's Indigenous people.

GAYE SCULTHORPE

Brady, M., 'Leaving the spinifex: The impact of rations, missions, and the atomic tests on the southern Pitjantjatjara', *Records of the South Australian Museum*, vol. 20, 1987; Harris, Kerr, Forster, & Stanton Robbins & Co., *Australia's Travel and Tourist Industry: A Report Prepared for the Australian National Travel Association*, Sydney, 1965; Layton, R., *Uluru: An Aboriginal History of Ayers Rock*, Canberra, 1986; McGrath, A., 'Travels to a distant past: The mythology of the outback', *Australian Cultural History*, no. 10, 1991.

18.2 Cultural tourism at Uluru: *Ananguku Tjukurpa*

Nganampa punu tjuta ngarinyi nyangangka, malikitja tjutangku nyakula nintiringkunyt jaku.
Our craft is here for all the strangers to look at and learn from.

<div align="right">NELLIE PATTERSON, MUTITJULU</div>

Maruku artists at Mutitjulu Community [*231*] and their relatives from other places share working in the Uluru–Kata Tjuta National Park. Carving since the Tjukurpa (**Dreaming**) and for 'tourists' since the 1940s, they now have a cultural centre where visitors can watch them work [see 2.4; **Maruku Arts**]. Some of the craft workers have spoken about working with tourists. They are Witjawara Curtis (WC), Nancy Miller (NM), and Kunbry (KU) from Mutitjulu, Dulcie Brumby (DB) from Docker River, Kanginy (KA) from Ernabella, and Nugget Dawson (ND) from Mutitjulu and Wingellina.

WC: Okay I'm burning, burn and burn and work again on another piece. Burning it with the wire. It's good work. There are two of us and we don't get up for hours, coming early in the morning, sitting down, burning, burning, burning, never stirring. And you know the little black ants we call the tourists come and stand for a little while and we sit there burning.

231. Cultural Tourism at Uluru, 1994.
Witjawara Curtis, Nancy Miller, and Nellie Patterson (*l. to r.*), with tourists.

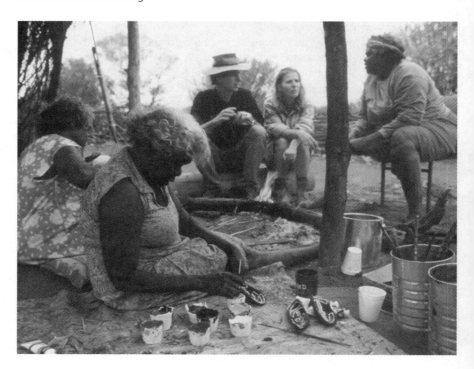

NM: And they go like this: 'Allo, Allo'.

WC: Yes! And they come every day, 'I want to buy this one', like that, 'let me buy that one'.

NM: 'What's this?' they ask like that. It's a *wira*, a small bowl, so I say '*Wira*', then: 'Your axe is important, always think about it. Use the axe to chop and afterwards, chisel and wood rasp, sandpaper. They're mine, like family.' That's how I explain it. Just like that.

But when someone looks like they want to take a photograph we warn them: 'Get out! Am I a dog or crow? I'm human!' Only speaking sharply, then they can understand. When it's time to go we put our tools and carvings away and get up stiffly.

DB: Us old ladies work making lots of good pieces, painting inside the bowls. The tourists are thinking and talking like this: 'Hey what story is this design? What are you doing on that one?' They don't know, they don't live with Aboriginal people, they're coming from the whitefella world. They can't understand.

They come on buses for the rock and they see Anangu person working and can't figure it. Someone asks 'Why are you doing that?' I always answer, 'This is *Minyma Kutjara*, Two Women. I'm thinking about Docker River', like that, 'I'm doing country far away. Mine, my Mother's and my Father's sacred one.' Living with Aboriginal people, white people can learn a lot. They know about *tjukurpa*. We can live together like this.

Okay. That's all I'm saying. Just that.

KA: Interested people are always asking, so I lift up the *piti*, the bowl you know, place the *manguri* (head ring) and the bowl on my head and show them. So they see: 'Oh, I get it, you made this then!'

Grandmother and mother always travelled like that, balancing the bowl on their heads. A woman always had a head ring and she carried the bowl on her head. She went for water, pouring it in the bowl. They weren't decorated then, we've made the designs. Really beautiful patterns.

KU: People are happy to have *punu*—lovely carvings, small wooden craft and animals carved by Anangu [399]. Their grandparents perhaps bought craft here and maybe they're finished up and now the *punu*'s their children's. That craft can never be made exactly the same again but the children of the Anangu who made those pieces are still carving and the white people's children, who've never seen this place, are still coming and taking home carvings—who knows how much *punu* has travelled over the seas!

And so it goes, linked together, white people follow in their grandparents' footsteps and Anangu follow their grandmothers and grandfathers in what to do.

Never let this work for our *punu* stop.

ND: I want to give white people a story they can listen to and learn from. Not all our descendants know these things. But, I guess if talk is opened and people listen they can learn. So really this story is for them.

We hold the Law, hold it, keep and respect it. The father has it, protects and follows it. The son has it, he holds it and passes it on when he's finished up. He's lost and gone but his young brother, his son, his daughter has it, the land too, the stories and the Law. Tjukurpa. It's alive and carried on. All right, this is for the white people to hear. Open, for them to understand.

NELLIE PATTERSON, WITJAWARA CURTIS, NANCY MILLER, DULCIE BRUMBY, KANGINY, KUNBRY, AND NUGGET DAWSON

INTRODUCTION AND INTERVIEWS SUPPLIED BY KATHY TOZER AND STEPHEN FOX

© Maruku Arts and Crafts

18.3 Bridging the gap: The production of tourist objects at La Perouse

At the end of the bus line to **La Perouse**, 15 kilometres from Sydney, among the monuments of European landings, stands a memorial to the life and work of Marjorie Timbery [see **Timbery family**]. It marks the place where she and her husband John used to sit at their stall and sell artefacts and other objects to tourists. On the weekends, in front of the monument, there is still a stall, where Laddie Timbery [*232*] and Greg Simms sell painted, carved, and burnt-in (poker-worked) objects, and sometimes Esme Timbery's shell-works [*339*]. The development of La Perouse as a tourist destination is entangled with the history of the production of objects, made by the people of the local Aboriginal community. Early in the twentieth century, the making and selling of tourist objects involved a comparatively large section of the community. Today the trading activity is continued mainly through the efforts of four artists—Greg Simms, and Esme, Jeff, and Laddie Timbery—who are members of two families responsible for the trade since the beginning of the century. Simms specialises in burnt-in objects, like **boomerangs** and boomerang-shaped necklaces and brooches. He learnt the craft as a child, 'when I started to walk'. As children, he and Laddie Timbery would collect the right mangrove wood in the bush around La Perouse to make boomerangs. The collection of wood, apart from providing the raw material for the manufacture of artefacts for the tourist trade, also offered the occasion to tell and exchange stories. After having carved the object he would start the decoration with a piece of wire heated on a drum.

There were three different kinds of wire, he says: first a round wire, then you would flatten one wire out and have a blunt edge and your third wire would be flattened and with a sharp end to draw the finer lines. The round wire was used to blacken areas of the surface, and the blunt one was for heavier lines.

As much as the technique, the designs, too, are passed down from generation to generation: the emu, for instance is a Simms design. The story of the arrival of Captain Cook [see also 4.2, 4.3] at Botany Bay, on the other hand, was painted and burnt-in on boomerangs by Joe Timbery during the 1930s, and it is carved and painted by Laddie and Jeff Timbery in barks and shields today. This story is central to the history of the Timbery family and of the community, and it validates the Aboriginal presence in La Perouse, tracing back the Indigenous existence in the area to the time before contact, contradicting the claim that Aboriginal people had totally disappeared from the La Perouse shore before the 1880s. The story tells of the landing of Cook at Botany Bay, and of

232. Laddie Timbery selling boomerangs at the Loop, La Perouse (NSW), 1998.

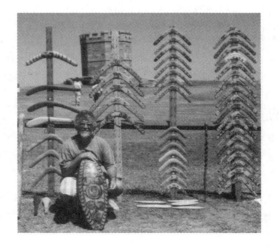

the subsequent killing of three men. The Timberys, the story goes, were fishing on the beach when Cook arrived, and saw the boat approaching. Other designs that have been used in the past and are still used to decorate the shields, the spear-throwers, and the returning boomerangs (the throwing boomerangs are generally not engraved) are koalas, kookaburras, kangaroos, and from the 1930s, the Sydney Harbour Bridge. As a shell-work, the Bridge, together with burnt-in artefacts, has become emblematic of La Perouse itself. Esme Timbery still makes shell-works for sale. She learnt the technique as well as the designs from her mother Elizabeth. As a child and as a young woman she used to collect shells with members of her family on the shores of La Perouse and Cronulla, as well as on the south coast of New South Wales. Today she receives her shells from family members living there, in Jervis Bay. Her products, apart from harbour bridges, include baby slippers and religious images framed in shells and boxes. These are first cut out in cardboard, then lined with bright coloured fabric, and finally glued and covered with shells in precise patterns. With her sister Rose, Esme used to have a stall at the Royal Easter Show. They sold their work to the visitors while the men were selling their boomerangs and shields [see 11.1, 18.1].

Looking back at the histories of the Timbery and Simms families it is possible to follow the changes and the success of the business from its beginnings in the nineteenth century up to the present. The trade in artefacts and objects was a way to supplement what was earned through fishing—the other occupation of the Kooris living on the coast. Trade seems to have been started by the women, who as early as 1882 travelled to Sydney and the suburbs selling shell baskets. Ten years later a larger section of the community was involved in the making of artefacts and objects specifically for the tourist trade, and we find the La Perouse men busy fishing, gathering honey, and making weapons, while women continued to produce shell-works, helped by the children. With the establishment of the official Aboriginal reserve in 1895 and the United Aborigines Mission the previous year, the production of artefacts became, in the eyes of the missionaries, a means to keep people busy and to exercise some control of larger groups. From 1884 to 1939 the policy promoted in the reports of the Aborigines Protection Board was one of segregation, and discouragement of any contact between Indigenous and non-Indigenous Australians [see 4.1, *41*]. The making of artefacts, which was thought to be a safe way to keep the Kooris who were living on the reserve occupied and to prevent contact with settler Australians, resulted in the opposite, and became an important factor in the defeat of the segregation policy. Catching the tram to 'the Loop' on the weekend, to go to La Perouse to buy boomerangs and shell-works, soon became a fashionable pastime, especially after 1905 when the area was declared a public recreational space. In the first decade of the twentieth century artefacts from La Perouse were so popular that they were granted a stall every year at the Sydney Royal Easter Show, where, as the *Australian Aborigines Advocate* reported on 28 April 1904: 'shell-works, native weapons, mats and carved walking sticks, looked very pretty and attracted a good deal of attention.' In 1910 the fame of the La Perouse shell-works had reached London, where, the *Advocate* of 28 February reported, an exhibition of Queen Emma Timbery's renowned work 'was almost fought for'.

In the 1920s La Perouse was included in the official tours of visitors such as the American Fleet and the Crown Prince of Japan. Later, in the 1950s and 1960s, both Joe Timbery and Bob Simms were engaged in practical throwing demonstrations and lessons, as well as in the manufacture of weapons, while the women continued to create shell-works and to exhibit them successfully at fairs and at the Royal Easter Show. The fame of the La Perouse mob was such that when Queen Elizabeth II visited Australia in 1954 she was met by Joe Timbery, who presented her with a boomerang [see 9.1]. The business was so

successful that by 1955 Bob Simms had started a small factory: the demand for boomerangs was so huge he could not cope by hand-making them. In 1956 he took part in the Australian World's Fair in Sydney, where Marjorie Timbery had a special stall to sell shell-works. This abbreviated list of successes demonstrates the essential continuity of the artefacts industry in La Perouse. This continuous tradition has ensured the survival of cultural integrity, since the making and selling of boomerangs and shell-works involves the handing down from generation to generation of both the technical knowledge necessary to the craft and the design, and the local knowledge of the bush, the beaches, and seasonal cycles. Furthermore, the production process itself, patterned as it is by kinship, seems to carry pre-contact practices through to the twentieth century and beyond. The families of La Perouse have taken the opportunity to secure the survival and the transmission of knowledge by incorporating it within the new form of the souvenir. Objects which were, and are, aimed specifically at the tourist market, have become the cultural markers of the community, which has represented itself and recognises itself in them.

ILARIA VANNI

Bell, J. H., The La Perouse Aborigines, PhD thesis, University of Sydney, 1960; McKenzie, P. & Stephen, A., 'La Perouse: An urban Aboriginal community', in M. Kelly (ed.), *Sydney: City of Suburbs*, Sydney, 1987; *La Perouse, the Place, the People and the Sea: A Collection of Writing by Members of the Aboriginal Community*, Canberra, 1988.

18.4 'Another View' walking trail: Pathway of the Rainbow Serpent

In April 1995 'Another View' walking trail: Pathway of the Rainbow Serpent was launched by the City of Melbourne during the National Trust's eighteenth annual Victorian Heritage Festival. 'Another View' consists of a series of sites which may be visited by walking from site to site, or at random, either on foot or by using the city circle tram which encircles the central business district of Melbourne. Seventeen sites, thirteen of which have public art work installations, offer—as their name suggests—'another view' of Melbourne's history. The Serpent provides a visual and symbolic link from site to site: as a universal symbol of birth and life, death and rebirth, it has always been part of Aboriginal cultural life. It can be seen appearing symbolically as if from the earth itself at some of the sites, visually incorporated into some of the art works.

The art works are placed in counterpoint to seventeen of Melbourne's monuments and sites of historical significance and remembrance. They are not meant to be interpreted as specific commentary on these: rather they express an alternative perspective. They were created in a process of cultural collaboration, chiefly by Gurnai artist Ray Thomas, non-Indigenous Australian Megan Evans (who is of Celtic ancestry) [233] and to a lesser extent by a number of other participants from the Victorian College of the Arts and Galiamble Men's Recovery Centre in Melbourne. Evans and Thomas were assisted by researcher–writer Robert Mate Mate from the Woorabinda and Berigaba people of Queensland.

'Another View' is a symbolic journey which is not intended to evoke only an intellectual response. It aspires to become an emotional and transformational personal inner journey for the viewer. The opportunity to see history from 'another view' positively promotes acknowledgment of the experiences of Indigenous peoples and therefore engenders a positive relationship between them and non-Indigenous peoples. Before this installation, Aboriginal and culturally collaborative perspectives had rarely been represented in the form of public monuments in Melbourne. The Skeletal Remains Rock in Kings Domain, next to the Queen Victoria Gardens, is one exception.

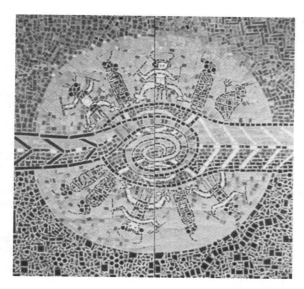

The walking trail has, however, a history of its own which points to the difficulties some Australians encounter in contemplating **histories** presented from Aboriginal or collaborative perspectives. Originally it was made up of eighteen sites. One of these was withdrawn as a result of censorship, following a newspaper article which described the walking trail as a 'guilt trail of white occupation'. Unfortunately, this led to a series of responses from people who expressed the wish not to be involved with something which had the potential—or so it seemed at the time—to be interpreted negatively and to generate conflict. Four other sites of the seventeen which remained were retained in the walking trail itself, but the art works intended for each were withdrawn, either because they were considered inappropriate or because they had met with funding difficulties.

White denial is present and pervasive. It is evidenced historically by the European monuments which tell the story of colonisation from a white perspective, without reference to the Aboriginal peoples who suffered and died as a result. The Kulin people of central Victoria have survived to give their perspective on that history. At Site One on the trail, for example, the place where Victorian Parliament now stands was a *wyebo bunnul* or small hill which was a traditional place of ceremony and a meeting place for the Kulin nation. The ceremonial ground is signified by reference to a painting by Wurundjeri artist, William **Barak** [see 11.1, *289*], titled *Ceremony* (from the late 1890s). This site is the beginning and the end of the walking trail, and this closure is symbolised by the serpent's tail entwined in a concentric circle and contained within its own head. The serpent swallowing its own tail symbolises the transformational inner journey which may be taken while experiencing 'Another View'. The eternal flow of the body of the serpent has its beginning and its end marked by the Aboriginal flag. Artists Thomas and Evans have inscribed this place with a pavement mosaic, whose subject interprets Barak's *Ceremony*. Barak's own remembrance of invasion was recorded by Shirley Wiencke with the words that white men 'will shoot you down like a kangaroo' and 'come here by and by and clear the scrub all over the country'.

'Another View' is about acknowledgment of the experience of Aboriginal people. It is also about owning up together as Australians to the implications of our many views of history. The viewer is reminded of our collective need to peel back the layers of the surface of things and consider more than one perspective. One of the censored art works was to have been a brass map inlaid into bluestone pavers. It would have shown tribal

boundaries of Victorian Aboriginal people and the places where **massacres** took place. The artists felt challenged to create art work communicating the complexity of colonial contact history. The process included consideration of how the viewer may personally interact with the depths of the realities exposed.

At some sites the artists aimed at providing 'an intimate experience of looking into the past' (Evans 1996). For example, the act of kneeling down to view box installations with glass lids placed level with the ground may reveal symbols which represent the relationship between the first white people and the Kulin people. But the act also provides the opportunity for a personal interaction between symbols and viewer. The use of lace as a symbol portrayed the 'refined and delicate surface of the colonial experience while underneath lies the hard reality of brutality and violence'. Red ribbons represent the lifeblood or sinews and veins of all people connected with the land. Beneath the skin, with the symbolic associations of 'black' and 'white' removed, we are connected as members of the human race.

We may bind together two views of our past without invalidating either the Indigenous view or the non-Indigenous view. 'Another View' gives us the opportunity for deeper comprehension, and the associated possibilities of further growth in cultural empathy and cultural tolerance.

DONNA LESLIE

Callick, R., 'Melbourne plans a guilt trail of white occupation', *Australian Financial Review*, 21 February 1995; Evans, M., *Another View* [unpublished slide list, supplement to published booklet], Melbourne, 1996; Wiencke, S. W., *When the Wattles Bloom Again: The Life and Times of William Barak*, Woori Yallock, Vic., 1984.

19. Living spaces

19.1 Aboriginal architecture

Australian Aboriginal architecture exists in the form of many regional styles that have undergone change and adaptation over thousands of years. The creators and users of these architectures have adjusted them as required to suit their lifestyles and changing needs. A growing body of evidence shows that Aboriginal architecture is not simply a material response to climatic and social circumstances; it is also generated by distinct spatial and cognitive rules, constructs, and behaviours. Cultural symbols encoded in the physical form provide another overlay of architectural meanings.

'Traditional' Aboriginal architecture, defined as that practised and adapted for many millennia prior to the arrival of the colonists, was largely domestic, comprising a range of shelter types used in residential camps. Most tribal or language groups employed a repertoire of up to eight shelter types, one of which was selected for use according to the prevailing circumstances of weather, availability of local materials, planned purpose and length of stay, and size and composition of the group to be accommodated. Each type had a regional distribution; particular regional styles were largely a function of the available structural and cladding materials and the dominant climatic influences. In pleasant weather, preference was generally for open living with minimal structures. Across the continent, a common shelter for dry, cold, windy weather was the grass, bark, or foliage windbreak, with warming fires. Shade structures were also widespread. Low, enclosed shelters provided protection in those many parts of the continent where rain fell for periods of only several days. In the relatively few areas of prolonged, continuous rainfall, sophisticated styles of strong, weatherproof shelters were developed [see 8.1; *234*]. These dwellings were tall enough to stand up in, and were sited near plentiful resources so that sedentary occupation was possible. In central Australia, where there are extremes of daily temperatures, the more durable styles were dome forms covered with a thick layer of spinifex and sometimes with mud or clay plastering. In the eastern rainforests, pliable saplings and canes were deployed to make lightweight, interconnected dome forms, sometimes covered with carefully thatched grasses or layers of palm leaves to deflect the heavy, continual rainfall. In the western part of Victoria where there are cold, wet winters, the tall conical houses were clad with earth sods for insulation and there is evidence for rock-wall cottages.

The mobile and flexible hunter-gatherer lifestyle resulted in campsites with impermanent or semi-permanent dwellings which were occupied for periods from a single day to several months. This apparent impermanence was often misread by early colonists as a confirmation of lack of connection or attachment to place. However, Aboriginal bands occupied a series of camps in a permanent pattern of seasonal rotation. The modesty of

234. Rainforest Aborigines building a *jimbara* (dome-shaped dwelling) of saplings, leaves, and grass, Atherton, 1918.

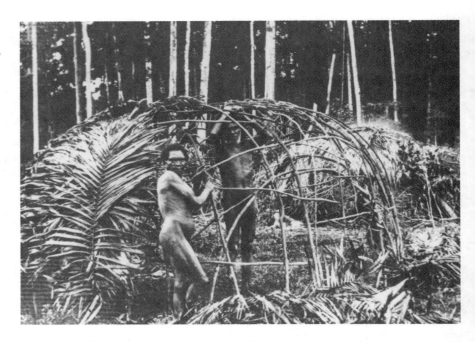

the camp architecture (as compared to that of other cultural groups) was supplemented by a highly structured use of space as well as a complex geography of place. Camp size varied from a single family up to several hundred people or more. The logistics of spatial organisation were generated and regulated by complex social structures and associated behavioural customs and moral codes. For example, in a typical larger-sized settlement, separate shelters were commonly used for diurnal and nocturnal activities. Men and women congregated apart during the day, while family groups resided together at night. Unmarried men and women slept in separate domiciliary groups. Nocturnal domiciliary groups were spatially arranged in clusters according to a variety of social principles: age and gender identity, tribal or language group identity, as well as close family relationship. These clusters were usually close enough for visual and aural communication, but at the same time there were kinship rules which forbade specific relatives from camping in proximity to one another. Movement around camps was also restricted by prescribed avoidance behaviours and the existence of gender-exclusive ceremonial grounds.

Examples of traditional Aboriginal architecture which do not incorporate Western material components are now rarely found. One outstanding house type, still in use in Arnhem Land in the hot, humid wet season, is a pole and platform structure with roofing made from curved stringybark sheets (*Eucalyptus tetradonta*) which are up to three metres long [235]. The roof covers a sleeping platform under which fires are burnt to repel the ever-present swarms of mosquitoes [see also 356]. The most sophisticated of these shelters have two (even three) platforms, one above the other, for different segments of the 'household'. Sloping poles are used for climbing to the higher platforms. These houses are occupied during the wet season from December to early April or so. They are located on high flood-free areas, in the tall, open forests where the stringybarks grow. People spend much time sitting, making artefacts, and socialising in their houses during torrential rain. In between cloudbursts, they collect a range of seasonal foods. In larger camps of this type, the households arrange themselves in clusters according to patrifilial groups oriented in the direction of their clan country.

Joseph Reser found that complex religious symbolism is associated with these types of houses in eastern Arnhem Land. Here, the significance of the forked post and ridge pole of the vaulted, platform dwelling derives from the mythological activities of the Wägilak sisters [see *150, 257, 316, 325*], ancestral heroines who built the first vaulted dwelling (*molk*) in the region. The Ḻiyagawumirr clan associates the forked post and pole with a waterhole on the Glyde River where the great python swallowed the Wägilak sisters. Here this distinctive stringybark house was first constructed when the rains began, either made by the python with its tongue according to some, or by the Wägilak sisters themselves according to others. A wider regional association links the the shelter, covered in rain in the wet season, with the sisters being covered in mucus in the stomach of the python, and with being in the womb. This classical structure is not only still used but remains a principal motif in painting, myth, and ceremony.

New cultural practices and types of architecture have arisen since colonisation through the synthesis of customary behaviours, meanings, forms, spatial scales, and layouts with acculturated materials and technologies. However, for such architecture to be truly Aboriginal architecture, there must be a retention of architectural control by the Indigenous builders and architects, and a continuity of traditional features, selected as part of the maintenance of **Aboriginality**. Unfortunately, colonisation led to the destruction or loss of many Indigenous architectural forms. However, the forces of cultural change varied from State to State and region to region, and in some cases traditional Aboriginal architectural elements persisted in various ways, albeit combined with new materials and artefacts to generate adapted styles.

One common colonial context is the mission settlement. In 1914 Presbyterian missionaries came to Mornington Island in the Gulf of Carpentaria to impose their religious ideology and provide Western material benefits which they believed would improve the morality and quality of life of the local people—the Lardil and Yangkaal.

235. Repertoire of seasonal shelter types used in eastern Arnhem Land during the early twentieth century.

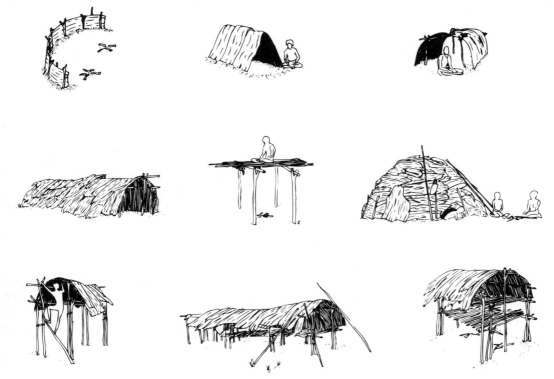

The missionaries decided to focus on the children, regarding it as too difficult a task to convert all but a small number of the adult population to Christian morality. Gradually, they persuaded the adults to allow the children to reside in dormitories on the mission, where they could be readily educated and indoctrinated. Adjacent to the mission compound was a large, customary, trading and ceremonial camp where at times up to several hundred people gathered. Over the next forty years this gradually became a sedentary village. The early missionaries did not interfere with the lifestyle or vernacular architecture of this camp. It was not until the 1950s that a new generation of missionaries began providing materials (milled timber and galvanised iron) to supplement the repertoire of the traditional architecture. Because these new materials were costly and scarce, residents were encouraged to continue using customary bark cladding for walls. Labumore Elsie Roughsey, reminiscing in her book *An Aboriginal Mother Tells of the Old and the New*, describes the gathering process:

When these huts were built, it was a very hard work to be done. We people went so many miles out bush to get all our barks, spent all day just collecting barks, making large fire to burn the barks to keep them firm and strong ... flattened them on the ground and put weight of logs and stones on them, until the evening came. We all came home with great loads of barks on our heads and on our sides, hung down from the shoulder by a string or belt. That's how we carried extra load more, was that way. The men had much heavier load on their heads. That's how we had to work hard to build a hut for ourselves. We had no other way to carry all the load. Some were lucky because they had dug outs [canoes] to go out to bring back all their barks. So you see, it was very hard to start to build a house of bush barks. Everything was done by walking.

By the 1970s some 500 or so people lived in this mission village in galvanised iron huts and cottages, with many acculturated artefacts such as buckets, blankets, clothing, cassette players, and other electrical appliances. However the village layout still reflected the social patterning of the trading camp of the early 1900s, with the distribution of tribal, sub-tribal, and clan groups in their same residential locations. Although the material environment had changed, the lifestyle and forms of domestic behaviour were largely unchanged, with an emphasis on external orientation of family groups, compact density, ease of visual and auditory communication, external cooking, and eating around fires.

The government-run Aboriginal settlements were in many respects similar to the missions. They were formed to service large centralised populations, forced together under a variety of official policies. Once again the emphasis was often on the delivery of education, health, and welfare services rather than housing, and sedentary camps sprang up around administrative centres. Even though some European-style housing has been provided since the 1970s, there still remain many remote centres that contain occupier-constructed sub-camps, with dwellings fashioned from acculturated materials.

Cathy Keys has recently completed an outstanding case study of contemporary Warlpiri single women's camps (*jilimi*) constructed of recycled Western materials [236]. *Jilimi* contain a range of categories of single women including widows, sick women, women with absent husbands, and divorcees. During the day the *jilimi* population expands and becomes the focus of social activity for both the married and single women of the community. The members of the household groups are mostly related matrilineally; widows who were co-wives and who live together are usually also related through the matriline. Warlpiri *jilimi* households were customarily located on the western side of camps. The architecture is laid out to create an effect of layered spaces that give increasing degrees of privacy from east to west. The domiciliary spaces of *jilimi* contain one, or more, of four shelter types (the combination depends on weather conditions): the windbreak (*yunta*);

the enclosed rainproof shelter (*yujuku*); the horizontal shade (*mulunba*) and finally the adapted tree shade (*yama-puralji*). The windbreaks and shades are designed to facilitate visual surveillance of the wider settlement during daylight. As households expand, *yunta*, *yujuku*, and *mulunba* grow to be characteristically elongated structures. For example, the enclosed *yujuku* is a 'snake-like' tunnel structure oriented north–south and up to twenty metres long but only two to three metres wide. It is used for sleeping, and warming fires are lit inside. Occupants observe a preferred sleeping orientation, with the head pointing east to facilitate reception of good dreams and prevent illness.

Movement of the camp occurs upon the death of a resident, and subsequent long-term avoidance of the site is observed even after a ritual site-cleansing. The building materials of the structures are redistributed to particular relatives according to the rules concerning the disposal of the deceased's possessions.

Other adapted settlement patterns of this kind are still found on remote pastoral properties and at outstations, where people pursue lifestyles that include traditional Aboriginal styles of architecture. But closer to the east coast another type—the town camp, or fringe settlement—was once common in rural Australia. Such settlements were

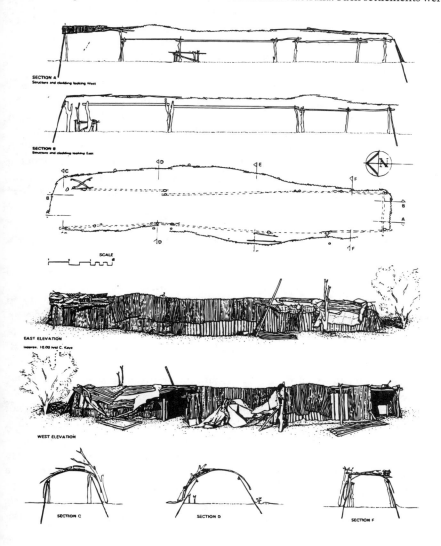

236. Sections, elevation, and plan of *yujuku* (shelter) in *jilimi* (single women's camp) located in North Camp, Nyirrpi (NT), May 1994.

originally established near many, if not most, towns in the eastern colonies during the nineteenth century. When the various Aboriginal Protection Acts were enforced around the turn of the century, protectors and protection boards had most of these camps dismantled and their residents moved on to reserves. A few remained untouched, and others re-formed in the 1940s and 1950s as people were displaced and moved many times over by the authorities. Town camps persisted until the early 1980s and even into the 1990s in a few places. These settlements were more familiarly known to their residents as *yumba* (Qld), 'tin camps' (NSW), or 'humpy camps'. They had an economic relationship with the town and the wider region, being a source of pastoral and town labour. The residents in turn sought access to desired services and goods in the town. Being a short distance from town permitted a degree of social privacy and autonomy sufficient to maintain aspects of Aboriginal culture and identity, such as ceremonies, public dancing, mortuary rituals, marriage practices, fights, and various forms of household and spatial behaviour which had been suppressed in the government settlements and missions during the era of assimilation.

Town camps contained dwellings made of second-hand materials, constructed by the residents without the approval of the local government authority, and lacking reticulated town services. The residents, following customary principles, also planned their location and spacing in relation to one another. These settlements occupied vacant crown land—often the town common reserved for the use of pastoral stock being moved by drovers.

One town camp that remained intact in the 1990s, although diminished in size, was at Goodooga on the Bokhara River in New South Wales, near the Queensland border. This tin camp, as it was known locally, was recorded in the early 1990s by Stephanie Smith. It contains a resident 'ethno-architect', who has designed and built fifteen or more humpies over several decades with distinctive design and construction methods. The humpies were distributed under shady trees near the banks and bends of the river. The layout of some of these humpies displayed a complex of cellular plan development. This organic architectural growth was probably the consequence of a long uninterrupted sedentary period which had lasted since 1950 (when a flood destroyed previous residences). 'Home improvements' observed in these long-term residences included glass louvres, window curtains, floor coverings, tyre buffer walls to the yard, self-installed electricity and gas, carports, and mown lawn.

The visual character of humpy architecture is dominated by second-hand sheet iron, both flat and corrugated. Its advantages as a cladding material are low maintenance, ease of shaping and bracing, durability, pliability, reusability, portability, and adaptability (in adding rooms or openings). Sheets are readily bent, cut, and shaped with minimal technology to provide weatherproof details. Post-to-beam and rafter-to-beam connections are made by drilling holes with a brace and bit and tying members together with galvanised wire, a technique adapted from fencing technology. Humpy floors are of compacted earth, sometimes covered with old lino or carpet. They may be eventually cemented in [see 19.3; *240*].

Town camp settlements typically displayed a strong sense of social boundedness, not through the use of fences or other territorial markers, but through the architectural character of the settlement and the distinct lifestyle of the residents, unified through a distinct social network and pattern of domiciliary behaviour. The Aboriginal identity of such settlements provided a cultural barrier to most of the town whites. There was a strong sense of privacy and mechanisms for control of access. The residents had a type of autonomy which, despite the attendant material impoverishment, conferred strong social mechanisms for coping with and resisting imposed change. This autonomy was

certainly not recognised by those local authorities who pressed for new housing and the assimilation of the Aboriginal people into the town. Thus one *yumba* resident from Cunnamulla, Hazel McKellar, writes:

I vividly recall life at the yumba, as I spent all my childhood and some of my married life there. Although conditions were very poor and hard, I nevertheless remember those days with fondness …

My father was … handy with a rifle and he used to ride his pushbike out to the common to shoot a roo. Dad was a very good cook as well. In fact, he had more home-making knowledge than Mum—he would make bread and butter puddings and, at Christmas time, jellies were a speciality. Until the early 1940s, the only tap we had was at the cemetery. As kids we were made to go and fetch water for washing and cooking. We used to carry the water in four-gallon kerosene tins. For our bath we needed two kerosene tins for enough water … There was no electricity of course at the yumba. Cooking was done on an open fire. To keep things cold we used a water bag with a hole cut in the top. Butter was kept cool by wrapping it in a wet tea towel in a dish. A few folk had charcoal coolers …

The camp was always kept very clean. We used to make brooms from a bush of hopbush. The branches were tied together with a piece of string or wire. This broom was much better than a straw broom because it didn't remove all the topsoil but just removed the rubbish. The women would keep a large area around the camp clean for the children to play on. On washing days, the women would always boil up their clothes in kerosene tin, or if they were lucky, in a copper.

By the late 1980s (earlier in eastern States), many town camps were gone—razed by council bulldozers as a result of assimilationist policies. Under more flexible regimes their facilities were upgraded, and in some cases they were allocated land titles. The negative aspects of town camps, in terms of health problems, and lack of services and amenities, were no different from those of the institutional mission and reserve settlements of the time. A key difference, however, was that outsiders, including journalists, were not allowed into reserves and missions, while town camps were in the public eye (and could be observed by passers-by), and thereby attracted criticism.

In the 1950s and 1960s the provision of conventional European housing became a political imperative for State governments, as part of the assimilation policy. However, there was no Aboriginal voice in the design or management of these housing projects. Following the **referendum of 1967**, the federal government became active in Aboriginal housing programs in the 1970s, introducing an Act that provided a simplified procedure for Aboriginal community groups who wished to form housing co-operatives and apply for Commonwealth (as opposed to State) funding. Many rural and urban-based groups exercised their rights under this new self-determination policy to take control of their own housing projects. Some projects, for example the Aboriginal Housing Company in Redfern, Sydney, have involved the renovation of existing, dense, city areas. Others are self-help projects in which groups of people build their own houses: examples are Bakandji Ltd of Wilcannia in western New South Wales, and Mitakoodi Aboriginal Corporation of Cloncurry in north Queensland.

The federal government's increasing role in Aboriginal housing in the 1970s brought some flexibility in architectural design but, taken overall, government housing programs tended to stifle or suppress the principles of Aboriginal architecture. There were some important exceptions, and these became increasingly common during the 1980s and 1990s as power continued to shift from governments to Aboriginal communities and agencies. The outstation movement [see 9.7] which emerged during the late 1970s led to a settlement type in which Indigenous control has been maximised. Movement to

411

outstations from many remote settlements came about as a result of government relaxation of centralised residential policies and the desire of Aboriginal groups to restore their spiritual and managerial connections with their homelands. Outstation development was accompanied by some revitalisation of traditional architectural forms and technologies, combined with the use of acculturated materials. However, limited funds were also made available for the employment of architects and builders, resulting in a range of collaborative projects.

An interesting architectural concept—the 'decentralised house'— emerged and evolved during the 1980s and 1990s on certain outstations of the Wakaya, Alyawarre, and Warumungu peoples on the Barkly Tableland, and in the Wik homelands of Cape York [237]. The decentralised house is generated by upgrading a traditional camp to satisfactory health and structural standards using Western construction and material technology, with the least possible disruption to the spatial fabric of the camp. This generic design type evolved as a result of a design process founded on observation of the subdivision of camp space, of gender-specific distinctions, and of household behaviours in their different settings—night and day, dry season and wet season, cold and hot weather. The process generates a design outcome comprising different types of structures, forms, materials, and degrees of enclosure for different activities at different times. The 'house' is a set of separate structures which combine with other site elements and services for outdoor living. It is quite different from the conventional Western house, with its single structure containing a range of internal subspaces for different activities. Such architectural developments embody the idea of 'collaborative Aboriginal architecture', which can be defined as architecture in which Aboriginal people retain conceptual, stylistic, and management control of the project. Certain aspects of traditional Aboriginal architecture persist, but in the context of a collaborative partnership with other non-Aboriginal personnel (funding agencies, architects, and tradesmen).

One of the best-known outcomes of collaborative architecture has occurred in the development by Tangentyere Council Inc. of nineteen multi-tribal town camps in Alice Springs [238]. This Indigenous housing organisation has been directed since 1977 through its executive body of camp representatives, who have always met very frequently to manage and regulate decision-making. The organisation has employed its own architects, builders, tradesmen, landscape architects, housing officers, and homemakers, many of whom have been Aboriginal people. In this transformation of the camps, many conflicts arose with the local and Territory governments. For example, the camp leaders and architects preserved the customary camp layouts, with separate clusters of households for each traditional social group separated by substantial buffer spaces for intergroup privacy. This practice attracted criticism for allegedly failing to make efficient use all of the lease area in the camps: the authorities of the time preferred a more geometric division of the land into single house lots. The Tangentyere architects developed a distinctive style of consultation aimed at overcoming cross-cultural communication problems, and emphasising resident participation and involvement. In this way a portfolio of over 150 house designs was generated, and all of the humpies in the camps were gradually replaced with houses in a program of town camp lease improvements. A distinctive architectural style emerged. It combined facilities suited to an externally oriented lifestyle, outdoor cooking, and constantly changing household sizes (because of visiting 'bush' relatives) with robust construction suited to town camp wear and tear, yet retained an architectural urban character that blended favourably with the Alice Springs townscape.

Aboriginal architecture—past and present— represents a cultural triumph. Through the millennia, camps, settlements, and outstations have provided settings compatible

with Aboriginal lifestyles. The recurring tasks—of regenerating the settlement, reorganising the spatial layout, recycling the old building materials, and rebuilding the shelters—reflect the recurring themes of residential mobility, changes in the population structure, births and deaths, climatic shifts, and natural calamities. One can see in this lifestyle a preference for a more essential, direct, and demanding relation with the environment than that favoured by the average Western urban dweller, who has little control over the shaping of his or her environment, and who prefers a safe and sealed retreat when the elements rage.

Just as Aboriginal art styles have undergone a change in value in Western eyes—from the so-called 'primitive' to internationally famous genres such as 'dot painting' [see **acrylic painting**]—so too is there a shift in non-Aboriginal perceptions of the architecture of Aboriginal Australia. 'Primitive huts' become legitimate, vernacular architecture, as their qualities are better understood. Meanwhile, just as Anglo–Aboriginal cultural fusions are occurring in such areas as religion, music, and art, so too the last two decades have seen the emergence of a collaborative style of architecture as a result of interaction between Aboriginal clients and non-Aboriginal architects and builders [see 19.4]. The mid 1990s saw the first Aboriginal graduates of architecture in Australian universities [see 19.5]; they will undoubtedly push the boundaries of modern Aboriginal architecture even further.

PAUL MEMMOTT AND CARROLL GO-SAM

237. (*Above left*) Outstation building, Lockhart River (Qld), November 1992.

238. (*Above right*) Tangentyere house, central Australia, 1988.

Keys, C., 'Defining single Aboriginal women's housing needs in central Australia: Dealing with issues of culture, gender and environment', *Architectural Theory Review*, vol. 1, no. 1, April 1996; Labumore, E. R., Memmott, P., & Horsman, R. (eds), *An Aboriginal Mother Tells of the Old and the New*, Fitzroy, Vic., 1984; McKellar, H. (au.); Blake, T. (ed.), *Matya-mundu: A History of the Aboriginal People of South West Queensland*, Cunnamulla, Qld, 1984; Reser, J. P., 'The dwelling as motif in Aboriginal bark painting', in P. J. Ucko (ed.), *Form in Indigenous Art: Schematisation in the Art of Aboriginal Australia and Prehistoric Europe*, Canberra, 1977; Smith, S. D., The Tin Camp: A Study of Contemporary Aboriginal Architecture in North-western New South Wales, MArch. thesis, University of Queensland, 1996.

19.2 'Slave buildings'

Western Australia's oldest building is a small prison in Fremantle known as the Round House. Built in 1830–31, it was the first permanent building to be erected in the Swan

River Colony. Strictly speaking, the Round House is a dodecahedron, with cells arranged around the walls and a well located in the centre. It was designed by the colony's first civil engineer, Henry Reveley. Situated high on the main street and backing onto the Indian Ocean, the Round House dominates the city.

Architecturally, the Round House is unusual: it stands in complete contrast to the rectangular-style prisons built shortly afterwards in Perth and Fremantle. It is similar to the Native Prison or 'quod' which was built thirty years later at Rottnest Island (known as Wadjemup to the Nyungah people), eighteen kilometres off the Fremantle coast. The labour performed by Aboriginal men included the construction and repair of buildings, quarrying stone, making lime, clearing land, fishing, and salt collection. Although the quod has a more complex design than the Round House, the *Chronological History of Rottnest Island* suggests that it is directly related 'in its plan form and general conception'. It was considered, as Neville Green and Susan Moon have noted, a 'bold experiment on a humanitarian model well ahead of its time'.

The Round House and Rottnest prisons were represented by the dominant society as correctional and humanitarian in design. There are stories and fragments of evidence in the Aboriginal and wider communities, however, which throw another light on the design and intent of these two structures. According to Nyungah oral tradition, Aboriginal men who had broken no law were forced to work in confinement for public benefit. This suggests to the Nyungah people that the Round House and Rottnest Island prisons might be interpreted as 'slave buildings'. Originally the Round House contained Aboriginal men who were rounded up from the surrounding area. After the establishment of the Rottnest Island quod, Aboriginal men from throughout the State of Western Australia formed the population and workforce of the island. It is conservatively estimated that between 1838 and 1931 more than 3600 Aboriginal men were imprisoned at Rottnest Island [*239*].

Slavery, as defined legally, did not exist in Western Australia. It had been outlawed by Great Britain since 1807, although the possession of slaves was legal until 1834. The Swan River Colony was proclaimed British territory in 1829. It was a free colony which experienced a severe shortage of labour, and there was a reluctance to transport British convicts to make up the workforce. The State colonial government was already transporting indentured coolie labourers from Singapore in the 1830s, but it was rebuked by the British government, who later arranged for convicts to be transported instead. Before the advent of the convict labour supply, an Aboriginal workforce was conveniently at hand.

The *Act to Constitute the Island of Rottnest as a Legal Prison 1841* was designed to ensure that the 'Aboriginal race … may be instructed in useful knowledge and gradually trained in the habits of civilised life'. R. J. Ferguson reports that the island was considered 'peculiarly suitable to their detention, inasmuch as a greater degree of personal liberty may be allowed'. However, the Aboriginal prisoners of Rottnest Island lived in deplorable conditions and were put to hard labour constructing roads in chain gangs, quarrying limestone, erecting buildings, collecting salt, and farming gardens and wheat fields. At one stage parliament even considered establishing plantations in the northwest, using the prisoners. In Western Australia, the various Native Protection Acts also established 'assignment systems' which ensured the enslavement of thousands of Aboriginal men, women, and children. Many European pastoral stations, agricultural developments, pearlshell enterprises, and domestic households relied on and exploited the Aboriginal labour provided under the assignment systems [see 4.1]. As Neville Green demonstrates, those who resisted were incarcerated at Rottnest Island, 'the final answer for holding those too wild and rebellious to submit to local service'. These practices were

exposed and condemned as slavery by the now famous Revd J. B. Gribble and the British Anti-Slavery Society.

Green and Moon report that in 1894 Fremantle politician Elias Solomon campaigned to close the Native Establishment and open Rottnest Island as a 'place of summer resort and recreation' complete with Aboriginal 'servants'—although the island had already been used as an exclusive summer resort by various governors and their invitees since at least 1864. Closure of the Native Establishment was recommended and approved in 1902, but 'prisoners' were kept at the island until 1931 to maintain and repair the holiday cottages, continue the roadworks, and assist passengers with luggage.

Today, the buildings that the Aboriginal men laboured on for nearly a century make up the main settlement on the island, and Stephen Mickler reports that their 'distinctive charm play[s] an important part in forming the character of Rottnest'. The quod, now known as the Rottnest Island Lodge, is a luxury holiday resort in which the old prison cells have been renamed 'settler cabins' [see 18.1]. Green and Moon estimate that at least twenty-one men died in each of these units, and the remains of the 371 men sent to the island who died as a result of disease, torture, execution, and murder lie in unmarked graves—the Premier, Richard Court, acknowledges that this is the largest Aboriginal deaths-in-custody burial site in Western Australia.

Since the 1980s Aboriginal people from throughout the State have called on the government to return the former Native Establishment to the Aboriginal community, so that they can turn it into a Museum of Remembrance [see **cultural heritage**, **repatriation**]. Successive governments have refused to excise the prison area from the privately owned lease and have limited their support to the establishment of an interpretive centre elsewhere on the island.

Wadjemup is a Nyungah site of the highest significance. The burial areas, protected by the *Aboriginal Heritage Act (Western Australia) 1975*, are cared for by the local Nyungah community and representatives of the Rottnest Island Aboriginal Deaths Group. Whilst the land is Nyungah, the men who were rounded up to work there, and who died there, were from the many lands and nations that make up Western Australia. We can still see them today, as the flocks of *wardung* (crows) who inhabit the island and who call out sadly. They are the spirits of the old and young men who never left.

HANNAH MCGLADE

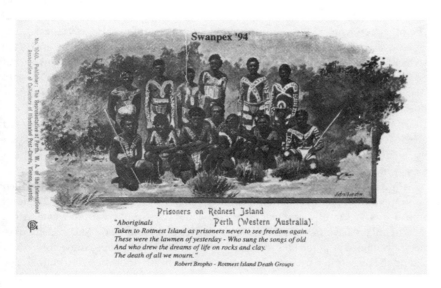

239. Prisoners on Rottnest Island, c. 1899.

This story is for Mindim, who was sent to Rottnest Island in 1897 as punishment for 'absconding' from the Hassell family in Jerramungup. Mindim escaped from the island and was never recaptured.

Ferguson, R. J., *Rottnest Island History and Architecture*, Nedlands, WA, 1986; Government of Western Australia, *Chronological History of Rottnest Island*, Perth, 1995; Green, N., 'Aborigines and white settlers in the nineteenth century', in C. T. Stannage (ed.), *A New History of Western Australia*, Nedlands, WA, 1981; Green, N. & Moon, S., *Far From Home: Aboriginal Prisoners of Rottnest Island 1838–1931,* Nedlands, WA, 1997; Gribble, J. B., *Dark Deeds in a Sunny Land, or, Blacks and Whites in North-west Australia*, Nedlands, WA, 1987; Mickler, S., 'Curators and the colony: Managing the past at Rottnest Island', *Continuum*, vol. 3, no. 1, 1990.

19.3 In the vernacular

Halls Creek town common, the Kimberley, 1980

The camp called 'No. 3 Island' was a desolate spot at the junction of two dry gullies. The name compared it ironically with the nearby 'No. 1' and 'No. 2' reserves, the run-down government settlements of transitional housing colonised by Kija and Jaru people respectively. One scrawny tree provided mottled shade, the only other shady place the gully floor in the shade of the steep banks. Here, when a senior Law woman visited from another camp, we enjoyed rousing *jarrarta* (women's ceremony) singing sessions, age being no deterrent to interest in love magic.

All of the residents had moved here recently from across the creek, to be nearer the shops. Elderly Naangari and her husband Jampin occupied an old, concrete-floored, corrugated iron shack, with the permission of its builder (a distant relative) who had long ago moved to the reserve. Its inside area was just over 9 square metres, and its height 2.6 metres. Clothes were stored inside on a wire strung between the walls, or in empty flour drums. The cracked and uneven concrete slab extended north to form a bare patio, on which stood an ancient, empty fridge. The windows did not work, nor did the door, which in any case was too narrow for its space. No matter. In the dry season Naangari and Jampin could sleep outside on their sagging wire beds. A few metres away outside, an open fireplace sat between two bricks, although as often Naangari and her husband shared their neighbour's more elaborate hearth.

The other residents of the camp, a cross-cousin of Jampin's (also a Naangari), her niece Nyawurru, and Nyawurru's husband, had made the main camp living-area. This was a neatly swept space under the tree, some metres away, where a carefully constructed camp oven—half a drum sunk into the ground with a grid over it at ground level—did regular duty cooking midday stew and boiling water for tea. Their food, like their clothes, was stored in empty white-flour drums, which doubled as stools. In the dry season, one or two swags were often near this fire. Here the women often sat, talked, and received visitors.

Nyawurru and her husband Jawan had built a 'tent' (they preferred not to call it a humpy) which exhibited the sophisticated climate control of Aboriginal camp construction [*240*]. The journalistic habit, so prevalent in the 1970s, of presenting photos of such 'humpies' as a symbol of Aboriginal disadvantage and white neglect does these dwellings an injustice as a form of vernacular architecture and pays scant regard to whatever the occupants might have thought about their homes and handiwork. Star pickets were strategically angled at both sides so that a canvas fly, with short rope connectors, could be slid up the pickets in a trice to allow a breeze underneath or down against rain. A few

240. Humpy construction, Warmun community, East Kimberley (WA), 1980.

sheets of corrugated iron could be shifted around the perimeter whenever a more substantial windbreak or rain guard was needed at the ends, or the sides. The enclosed area was 4.5 square metres, and the height 0.9 of a metre. Like Naangari and her husband, Nyawurru could choose to sleep outside or in. A single wire bed outside could be used for day-time naps, or have a swag thrown onto it. A discarded stove was used as an outdoor seat. The shelter was but part of their living space, which centred on the tree and outdoor kitchen. Water was carted by bucket from 'No. 1' reserve across one of the gullies, then stored in a flour drum. Toilet facilities? The bush across the creek or a longer walk to either reserve. Showers? Visit either reserve.

Naangari and her husband were content with their camp and its location, but dreamed (in vain) of having a more substantial dwelling, like those on a nearby outstation, built at their site. In the short term, they hoped to have water piped to them from one of the reserves. When interviewed about their preferences concerning a variety of housing options, Jampin said of humpies:

Yes. Very good you know, narrow humpy. Enough for me and wife and three dogs. Too many might come in big houses. Little humpy enough. Want a little bit of a light, electric light, enough to see the place dark time, and pipe running down, save me from carting [water]. Me and Naangari get tired *la* (in the) arm ... [A shack is] more better, so nobody can't come in. If they fix-em up properly, iron, all right. Kitchen or something like that, do-*em* up proper way.

This contrasts with typical views of people who have opted for government housing in the town itself, many of whom lived in camps earlier in their lives:

No. Too much wind and might blow the thing down. Too far from water and toilet and things. Can't put your food anywhere, white ants and cockroaches get it ... Bit too far. Hard for us to keep the place clean, for washing clothes. Too far to walk, if we've got no vehicle to bring us in.

Too dusty. No cement, anything like that. Rain time if you go to toilet, you have to go into bed with muddy feet ... I like somewhere to plug in the washing machine. I like electricity in a house.

Even if Jampin and Naangari had qualified for government housing, which was highly unlikely, it was not what they sought. Naangari said:

No. I don't like. Too high [off the ground] for me. If we drunk, old people drunk, break their neck. Cement house better, old man too blind.

Nyawurru, one generation younger, was also content to live in a humpy, at least for the time being:

Yes, on my own, me and my husband. Sometimes we feel … we like to stay in our humpy because it's cold. Hot time we like to stay in humpy. Like to stay on my own, no noise. Be quiet, no frightening and all this. Lot of drunkards coming in, I don't like it. If they want to drink, friends together, not fighting, they can stay for one week.

She preferred a tent to a corrugated iron shack:

No. You can't get wind in there.

Government housing was not her style:

No. You've got to spend a lot of money. I reckon this the better place to stay. Me and Naangari are full relations, we talk one language. Because we're real quiet. Sometimes we have good fun, but somebody else disturbing the peace when we sleep. Me and Jawan just sleep on our own, old girl got a lot of friends.

Her aunt amplified campers' reservations about moving to conventional housing:

No. Everybody coming up. You want your own place. You can have your own family. This mob [the camp members] have their own tucker, not just chasing one another [for food]. Too much for pay and thing, for water, everything you've got to pay. Bathroom, thing like that, too much.

What does this show? Campers are particular about their needs. Town camps fulfil a valuable role in the Indigenous housing 'market', providing the low-cost option vital as a fall-back for anyone who gets evicted, who wants to avoid the pressures of living in crowded conditions with relatives (and the related demands on their income), or for new couples who want privacy. They are not a permanent option for many people, but needed nevertheless.

Site considerations are important, in terms of fondness for a place, nearness or strategic distance from town facilities including water and shops—too close and you would attract too many drunk visitors trying to cadge food late at night. People might well stay at a favourite camp site rather than accept upgraded dwellings elsewhere.

Vernacular construction is not a disgrace—it may be quite ingenious, and well adapted to climatic conditions. The combination of introduced materials—canvas, corrugated iron, star pickets, wire, rope, flour drums—with a finely tuned climatic understanding and Indigenous construction techniques shows remarkable adaptation as well as making economic and environmental sense: reduce, re-use, recycle.

On the social side, camp life allows choice of one's living companions: on reserves and in town houses are allocated irrespective of disharmony between neighbours. Within a cultural context in which it is most unacceptable to exclude people explicitly, campers can use their living conditions to manage the likelihood of visitors in a subtle way. Living in a tiny camp dwelling is often a deliberate strategy to deter overnight guests, and to encourage homeless relatives to build their own shelters rather than

bunk in. Likewise, carting water to a distant location can be a price worth paying for one's privacy and for deterring unwanted (especially drunk) visitors. Provided there is no pressure, in the form of harassment, to leave the site (Halls Creek was unusual in this regard), camp life offers maximum personal control, freedom from having a government landlord, freedom from fixed expenses other than food, and freedom to choose one's companions.

<div align="right">HELEN ROSS, WITH THE VOICES OF NAANGARI, JAMPIN, AND NYAWURRU</div>

19.4 Aboriginal cultural centres

During the 1990s a range of Aboriginal cultural centres, museums, and other institutions were constructed or commissioned in various urban and rural locations. Almost invariably there is a strong call for the forms of such buildings to represent an Aboriginal identity in architecture. Yet the architects and many clients and users of these buildings are non-Aboriginal. My aim here is to open up some of the issues surrounding these new representations of **Aboriginality** in architecture, and to ask how architecture is being used in the ongoing discourse of **reconciliation**.

Although Aboriginal cultures traditionally invest considerable symbolic meaning in built form [see 19.1], Aboriginal people have rarely constructed permanent buildings. This lack of permanent architecture was a significant reason for the declaration that the continent was terra nullius—the legal legitimation for invasion. In colonial eyes, Aboriginal claims to the land were not legitimate or proper partly because Aborigines had not appropriated it architecturally. Such a characterisation of Aboriginality was, and remains, problematic, inadequate, and dangerous. Problematic because if embraced today it invokes a traditional model of Aboriginality which ignores the transformations wrought by 200 years of white domination. Inadequate because attempting to render the relationship between Aboriginal people and place transparent through the language of the colonising culture is fraught with problems. And dangerous because the stereotyping of Aboriginal dwellings has become part of a post-colonial discourse, complicit with new forms of domination. I have no desire to contribute to such stereotypes: there are a multiplicity of Aboriginal relations to place, landscape, and architecture. My concern is with the meanings of the newly emerging architectures of Aboriginality—with how those meanings are constructed, by whom, for whom, and to what effect.

Brambuk

One of the earliest of these new buildings was the Brambuk Living Cultural Centre, completed in 1990 at Gariwerd (the Grampians) in western Victoria [*241*]. The written brief called for the use of 'curvilinear forms and natural materials' and a participatory design process. The architect was Gregory Burgess whose work had long been characterised by non-orthogonal geometry, curvilinear forms, and the use of timber. With sources in both traditional Aboriginal forms of shelter and Aboriginal art, the plan is based on five rough circles which collectively represent the five clan groups of the region, but the internal divisions are functional, not social. The plan is centred on a large hearth in the foyer with a helical pathway leading upstairs to workshop and restaurant spaces. The materials are earth, timber, and rough stone with liberal use of bush poles for support. Hung off a serpentine ridge beam, the large, undulating roof opens into eye-shaped slits of windows. From the outside, this roof is highly suggestive of natural and biological forms; it is at once both zoomorphic and geomorphic, with metaphoric links both to the nearby mountains and to the shapes of birds. The plan is strongly connected with and oriented to two outdoor spaces—an entry courtyard and a meeting ground with fire-pit.

<div align="right">419</div>

241. Brambuk Cultural Centre, Gariwerd (The Grampians) Vic.

While this is a centre of living culture and a museum, it is also structured and funded to meet the demands of a tourist industry [see 18.1]—it is a site of both cultural production and cultural consumption. The museum display relates a shocking history of white domination and violence against Aboriginal people in the region. Aboriginal arts are taught and practised in the workshop areas and sold in the shop. In the restaurant 'bush tucker' is consumed while customers gaze at the mountains through the 'Aboriginal eye'. For the Aboriginal people involved the sense of ownership is strong and they see the architect's work as one part of its success. Comments in the visitors' book are infused with an uncommon passion for the building which has also won a major national architectural award. It is a wonderfully evocative piece of architecture, yet there is a criticism, put forward by Mathilde Lochert, that the use of natural materials and curvilinear forms too easily meets stereotyped preconceptions of Aboriginal culture, that the design reinforces a dominant construction of Aboriginal people as primitive, natural, and organic. In this view, Brambuk becomes a gesture of **reconciliation** which is at odds with unresolved colonial conflicts. On the other hand, this critique of 'primitivism' may be seen to carry the implication that representations of Aboriginal identity should be more 'modern' for their own good, and thus to contain echoes of assimilation and paternalism within itself.

Warradjan

The Warradjan Cultural Centre opened at Cooinda, in Kakadu National Park, in 1995. This was a collaboration between the National Parks Service and the traditional owners

(the Gagudju Association) with the aim of presenting the cultural tradition of the region for tourists. From its conception, the highly collaborative site selection and design process took over a decade. A Northern Territory government agency won the tender after the lowest tender was enforced. The traditional owners supported the idea of a building that represented a totemic figure—the freshwater, pig-nosed turtle (*warradjan*) —the use of which was authorised by the relevant clan.

The design was developed as a turtle-shaped building which is just discernible from ground level. The circular plan is formed of two D-shaped halves back to back, reflecting the moiety division which operates throughout the region. The separation between the two halves forms a landscaped gully, representing the nearby escarpment. These walls splay out, as legs, to flank the entrance area. The roof, which extends to create a verandah on all sides, represents the carapace of the turtle and the head is suggested by a fabric canopy over the entry foyer. The external fibro walls have a textured finish intended to suggest both the underbelly of a turtle and the sandstone rock walls of the park. The verandah walls have been 'signed' with ochre-coloured hand stencils, echoing some Kakadu **rock-art sites.**

The brief asked for '"live" exhibits and displays by traditional people' and these were intended for the verandah with its stencilled 'rock walls'. Yet there is little evidence of such use—traditional owners speak of feeling 'humbugged' by the tourist gaze. While this centre works well as a cultural museum, the architecture disappointed everyone concerned, and a decision was subsequently made to rebuild. The building draws its zoomorphic form from an authentic tradition but the literal interpretation of the form renders it inflexible both functionally and symbolically. Always and only a turtle, it is easily judged as kitsch. And yet, because it is designed with Aboriginal authorisation it unsettles the very category of 'architectural kitsch'.

Galeena Beek

The Galeena Beek Living Cultural Centre, designed by Anthony Styant-Browne, was opened in 1996. The site at Healesville, outside Melbourne, was part of the Coranderrk Aboriginal Station from 1863 to 1924 [see 11.1, *228*]. The centre has a brief to nourish and service the community activities of the local Coranderrk community; and to create, display, and sell Aboriginal culture to visitors. Thus once again we have a building that is called upon to represent Aboriginality and to frame a site of cultural production and exchange. It is located opposite the entrance to the Healesville Wildlife Sanctuary, one of Victoria's prime tourist attractions. The juxtaposition of Aboriginality with wildlife, on the same tourist menu, renders this a problematic project from the outset.

The building consists of a large meeting and performance space with a gallery, shop, and offices attached. The building plan, centred on the meeting room, is derived from a circular–spiral motif drawn from symbols of community in Aboriginal art. The beautifully-lit central room is a double height space which looks out into the forest landscape. It is enclosed by a ring of service rooms and offices on three sides, which are in turn encircled by a gallery–foyer. This design attempts to fuse the Aboriginal and the contemporary, avoiding any literal or organic metaphors. It also deliberately embodies some of the tensions that surround the construction of Aboriginality. On the street frontage, wall junctions are splayed in a manner that generates both the spiral motif and an edginess which reflects an unfinished process of reconciliation. The projecting, corrugated-iron shop contrasts with the wood-shingled, central room and can be read as both a segment expelled from the centre and a wedge inserted into it. With a calm and beautiful central space connected to the landscape and a jagged street frontage, the building becomes a metaphor for relations with both landscape and mainstream society.

This is the least collaborative of the projects described here. It is a finely composed building which establishes cultural identity while avoiding stereotypy. And the tensions which are coded into the design reflect real power struggles in the design process. This project was initially conceived as a community centre, sited deeper in the forest. Yet government funding became conditional upon moving the building up to the street, to meet the tourist market as a spin-off from the wildlife sanctuary. Very soon after completion the central meeting and performance space was appropriated and divided into segments to serve as a museum. This displacement of living culture by historic displays underlines the representation of the building as a place of ongoing struggle.

Uluṟu–Kata Tjuṯa

The Uluṟu–Kata Tjuṯa Cultural Centre was completed near Uluṟu in 1996, as a tourist visitor centre with a focus on both environment and culture [see 2.4, 18.2; **Maruku Arts and Crafts**]. A highly collaborative design process between architect Gregory Burgess and the Aṉangu community incorporated the commissioning of paintings of the rock and its major Dreaming story as a source of design. Aspects of Aṉangu Law (Tjukurpa) are embodied in this story of a struggle between two snakes. The plan of the centre is composed of two snake-like forms framing a central open space—a metaphoric weaving of serpentine pathways, walls, and rooflines rather than literal representation. The building appears in the desert landscape as a series of undulating roofs dwarfed by the rock of Uluṟu. The tourist pathway through the centre begins with a tightly controlled and darkened sequence of spaces which tell stories of Aṉangu Law. Beyond this display, pathways branch to the shops, restaurant, environmental displays, and craftwork and performance spaces.

From the point of view of both tourist and professional architect this is a highly successful design. It has won prizes and has been widely published in the international architectural press. From traditional owners there are two different responses. First, there is an appreciation of the form of the building and the manner in which the Tjukurpa stories have been represented, coupled with pride in the owners' role in this process. Yet there is also a tendency for Aṉangu to deflect questions away from the form of the building and onto the process of community development of which it was designed to be a part. This process generated strong expectations that the centre would be a space for genuine cultural exchange and economic development—results which it has largely failed to deliver. There is a perception that Aṉangu culture is displayed and consumed rather than understood. While the building wins prizes, in social terms it has not produced equality of recognition.

But is this asking too much of architecture, and too soon? Package tours form the major source of visitors, and these funnel their subjects through the centre on half-hour cycles geared to global schedules. Such schedules always allow the necessary two hours to climb Uluṟu, yet according to the Tjukurpa the rock should not be climbed. Indeed, the considerable success of the cultural centre might be measured by the declining number of climbers—visitors are beginning to see the landscape from perspectives other than that of the dominating Western gaze.

Constructing and authorising Aboriginal architecture

Architecture is a social art and buildings are social artefacts. Architecture constructs dreams and illusions, it frames new spaces for action, but it alone cannot deliver social change. The meanings of these cultural centres are subject to a complex web of competing interests: the commercial market views them as signature buildings for cultural tourism; the political market as signifiers of reconciliation; and the architectural market

as aesthetic objects. Most importantly, each building also marks a significant point in a community development process, but these broader interests are not under the control of either the architects or Aboriginal clients.

It is surely for Aboriginal people to decide how they are to be represented. But then what if they choose to exploit the market for cultural tourism by meeting its preconceptions? What if primitivist constructions of Aboriginality are used as a mask for economic interest? And what if Aboriginal people choose not to participate in any collaborative process where the imperatives of white politics and tourist desire remain dominant? In such circumstances, does architectural representation matter? I suggest that it does, and that within the context of current identity politics the identification of Aboriginality in architecture is unavoidable. While the apparent absence of a strong architectural tradition weakened the Aboriginal position under colonialism, it may now confer some advantages. Without any fixed tradition of Aboriginal architecture, authentication relies on a participation process within which a variety of identifications become possible. The zoomorphic figures which regularly emerge from such processes are the antithesis of the abstraction which has dominated twentieth-century architectural discourse. Metaphors of nature may stabilise Aboriginal identities as marginal to a mainstream which privileges the abstract, regular, straight, urban, civilised—the primitivist critique, as outlined earlier. Yet such a zoomorphic architecture also represents a challenge with the potential to reinvigorate mainstream architectural ideology.

Aboriginal cultural centres are replete with the complexities and contradictions of race relations in Australia. Torn between different audiences they slide seamlessly across categories—Aboriginal and non-Aboriginal, authentic and kitsch, difference and assimilation, culture and commerce. They show aspects both of the emergence of Aboriginal architecture and of the appropriation of Aboriginal culture. Many Aboriginal architectures—and Aboriginal architects—are emerging. These centres tell a story-in-process which has scarcely begun.

Kim Dovey

Dovey, K., 'Architecture and Aborigines', *Architecture Australia*, vol. 85, no. 4, 1996; Dovey, K., Jacobs, J., & Lochert, M., 'Authorizing Aboriginality in architecture', in L. Lokko (ed.), *White Papers, Black Marks*, London, (in press 2000); Lochert, M., 'Mediating Aboriginal Architecture', *Transition*, nos 54–5, 1997.

19.5 *Gurung gunya*: A new dwelling

In my final year at university, I was asked to design an Indigenous cultural centre for a group of women artists in Dubbo, New South Wales. For the first meeting alone with the group, I took all my formal design training, and my own culture, and was prepared to ask many questions to develop the design brief. For the week I was there, I did not put pen to paper. The women told me not to worry about the building and took me away to do women's business. I arrived back in Sydney with a strong understanding of their identity, their needs, and what my role was to be. It became clear to me that we were trying to make a *gurung gunya*, a new dwelling, and it would take more than design ability and the best intentions to succeed.

However, this is not a comparative essay on Western versus Indigenous architecture. This is *my* voice as an Indigenous designer working with, and for, Aboriginal communities. The way I see it, Indigenous architecture is not a style but a culturally appropriate process based on communication, trust, and community development.

Indigenous cultures all over the world have ordered their environment to a degree, using various functional shelters and defining places of ceremony. These were not objects placed on the landscape but were tools for living within it. The land, water, food, air, and shelter were treated as extensions of the body rather than as separate elements which make up an 'environment'. Most traditional dwellings in Australia were portable, kinetic, functional shelters made from readily available materials and found objects. Pursuing a largely nomadic way of life, families moved with the food and made temporary structures, which protected them from wind, sun, and rain [see 19.1].

Just as I was asked to abandon preconceptions derived from Western architecture, so too must anyone who wants to understand what Indigenous architecture is, and what it was traditionally. Buildings were used as a *skin,* as living and breathing extensions of the body. No matter what form they adopted, they were receptive, flexible, sensitive, and constantly renewing. This concept is still applicable today, and new technologies can be adopted in its service. This is what will make buildings clever, and uniquely Indigenous.

There is also in place an elaborate yet intangible organisation of space, which is marked geographically, with spirits, totems, and songlines. Understanding both the tangible and intangible aspects of culture lends clues to the interpretation of identity and place in the modern world.

Indigenous cultures are living cultures, and draw strength from the ability to adapt and evolve. Contemporary Indigenous identity is about expressing our ancient **Dreaming** and spirituality in new ways. As a contemporary Aboriginal person living in the city, I see my work as a valuable contribution to the struggle for self-determination, despite the fact that I don't hunt for my dinner. There is a place for new technology in a living culture: it adds to the diversity of expression, as well as consolidating our position in the present and the future.

More is needed than a standard designer–client set-up with a 'product' at the end of the day. Certainly this is a part of it, but the process needs to be built on respect, trust, and cultural sensitivity. From the moment a building idea is conceived to the moment it is realised, communication, in whatever form, and community involvement will determine the Aboriginality of the architecture. Within the process, there are many considerations which may not necessarily exist in a non-Aboriginal project. Designers are asked to consider culture, place, and identity as well as employment and training opportunities, social justice, and health issues. The failures in the past were not only due to misconceptions about culture, but to the coupling of this omission with a lack of community consultation.

In 1995, Dillon Kombumerri [*242*], a descendant of the Kombumerri people on the Gold Coast (Qld), took an important step in rectifying the problem of consultation, or lack of it, by setting up Merrima Aboriginal Design Unit. As part of the Department of Public Works and Services in New South Wales, Merrima (Bright Star) offers consultation and design services *by* Indigenous people, *for* Indigenous people. Since then, the group has grown to include Kevin O'Brien, an architect and descendant of the Meriam Mer people of Torres Strait and me, Alison Joy Page, an interior designer and descendant of the Tharawal people of **La Perouse**. As a team, Merrima endorses a fluid consultation process and encourages communities to be involved at every stage of the project. This is to allow maximum input and ensure ownership of the project.

Consultation is high on the agenda: it is about communicating with people, not clients. Building up a sense of trust is difficult for non-Aboriginal people, not just because of failures in the past, but also because of the subtle ways in which Indigenous people communicate with each other. Time and money cannot be viewed as con-

242. Denis (Dillon) Kombumerri with his design for a corrective services building shaped like a goanna, from an Aboriginal inmate's concept, 1997.

straints, which is why it may be more appropriate for a designer to appoint Indigenous consultants to liaise between the project team and the community. Merrima, which has successfully performed this role, believes that communicating with communities is not that difficult, if you are prepared to listen to the words unspoken. Communicating with Indigenous people is not a linear thing; you may have to sit through stories, songs, or sit silently for some time without even mentioning the project. Our advice is to listen to all of it, as all is of equal importance. Dillon explains:

Most projects we [Merrima] have undertaken involve reconciling factional groups, often from different tribal areas. In workshops conducted for the redevelopment of the Redfern Aboriginal Housing Company, it was interesting to see various people jockeying for a position that best suited their own interests. These people were important to the project, but sitting quietly in a corner were several elders who revealed to me critical information that an otherwise inexperienced consultant may have missed.

One way of dealing with conflicting interests within a community is to establish a working committee. Democratically elected, the committee represents a balanced cross-section of the community. In my experience, this has helped to alleviate personal–professional interests. It is very difficult to make everybody happy, you need to be a flexible person, not just a designer. The question of form and materials has been debated since Indigenous and architecture were both used in the same sentence. There is no one answer to what form and materials are appropriate. There are as many answers as there are communities. Some communities are struggling to meet their basic needs and cannot afford the luxury of continuing what critics perceive as being Indigenous architecture. A building which is designed around solid environmental systems and works well as a functional tool is as Indigenous as Brambuk Living Cultural Centre [*241*], which organically complements the Victorian landscape. It may be that all these ideas will help us evolve even better solutions, but it is ignorant to say that one is more real, or blacker, than the other.

When I was a young girl, the other kids at school would ask, 'How can you be Aboriginal when you have blue eyes and live in a normal house?' 'Real' Aborigines, according to such stereotypes, carried spears and spoke their own language [see **Aboriginality**]. Similarly, it is a common view that Indigenous architecture products be organic structures made from mud, bark, grass, and leaves. This may be appropriate for some communities, but Indigenous architecture will be as fluid and as adaptive to

identity as the culture is, which is why it cannot be confined to one style. In terms of employment and training opportunities, it may be more appropriate to use the skills which are existing within the community. This may determine which materials should be used, and affect the form of the building. Similarly, there is no point blowing budgets for a more vernacular architecture, if it means the community will have to leave essential needs unfulfilled.

My feeling is, there is too much talk about what Indigenous people should and shouldn't do in terms of architecture. Australian Aboriginals, like other Indigenous cultures, have been 'studied' for decades. Communities are fully aware of, and tired of, outsiders taking from their culture and giving little back. Understanding the uniqueness of each community, and cultural sensitivity, are best achieved by more Indigenous people penetrating the system, and working with their own and other communities. This is where universities can contribute, by using their resources to educate and encourage young Aboriginal people to take control. This will stop opportunists who have worked with a community once and then claim to be authorities on 'Indigenous architecture'. There are so many positive things that can be gained in terms of challenging existing stereotypes, and achieving economic sustainability, and reconciliation. By taking control of our future, we can create new patterns of meaning which are a true representation of our culture.

Alison Joy Page

Heppell, M. (ed.), *A Black Reality: Aboriginal Camps and Housing in Remote Australia*, Canberra, 1979.

The public face of Aboriginality

20. Aboriginalities

20.1 Post-colonial Dreaming at the end of the whitefellas' millennium

Aboriginal art has the potential to provide non-Aboriginal people with new or enhanced insights into Aboriginal people and their cultural history. Art allows us to reach beyond the immediate experience of the work to the world of the artist. However, in so doing, we draw upon our prior knowledge and cultural experience of Aboriginal Australia. Viewing cultural products such as visual art, film, or text can transform our emotional and intellectual engagement with Indigenous Australia. But the quality of this experience depends in part on how we critically receive and interpret these moments.

It is possible to deepen our understanding of the social context of the production and consumption of Aboriginal art in a number of ways. For instance, we might consider the entanglement of Aboriginal art production in a global market [see 21.1, 21.2] that extends from remote Australia to the fashionable art salons of Europe and the USA. Alternatively, we might broaden our understanding by exploring the place of art in the ceremonial and cultural life of its Indigenous creators [see 1.1, 1.6, 2.2, 3.3, 3.4, 6.2, 6.5, 7.3, 7.6, 15.1, 16.3]. In this essay, however, I examine Aboriginal art within a broader landscape of cultural experience made up of an apparently disparate set of public encounters and events.

In contemporary Australia, Indigenous people constitute a small minority: they were 2.1 per cent of the population in 1996. As a result, social and cultural phenomena that occur within the wider public context play a significant, if not pivotal, role in shaping how non-Aboriginal people know and understand Aboriginal peoples. Many experience Aboriginal art as one element of a complex set of social encounters in the public sphere—public phenomena which include, for instance, **media** representations of Aboriginal people in **sport** [see 20.2], the Aboriginal housing 'problem' [see 19.1, 19.3], or political protests [see 2.5, 4.1, 4.2, 12.2, 22.3], the social organisation of public spaces, and public debates on issues of **history** and culture.

In what follows, my intention is to map out some of the key dimensions of Australian colonialism and explore how these have shaped the cultural contours of public manifestations of **Aboriginality**, including art. With a new millennium and the centennial of Australian federation upon us, these issues are now no less important than they have been at any time during the colonial history of the continent. So my focus is contemporary—and forward-looking.

Consider recent controversial moments in Aboriginal history. At the 1994 Victoria (Canada) Commonwealth Games, the Aboriginal athlete Cathy Freeman [see 20.2; **athletics**; *281*], created a domestic furore when she carried the Aboriginal **flag** during

427

her gold medal victory lap. One of a growing number of nationally recognised Aboriginal athletes and sports-persons, Freeman was the first Aboriginal athlete to win gold in the Commonwealth arena. Despite this achievement, her gesture provoked some angry public responses, notably from her team's boss. It was as if a national moral crisis had emerged. The Australian news and current affairs media, active participants in the manufacture of this dispute, also recorded a range of public and elite views on the issue. Despite the negative criticism she received, Freeman's actions also generated public support and positive media commentary.

This particular incident occurred in the context of a recent historical tradition of Aboriginal social protest that gained political momentum in the late 1960s. Sentinel events of this era include both the 1967 constitutional referendum and the creation of the Aboriginal **Tent Embassy** [see 4.1; *49*, *206*] on the lawns of the national Parliament in 1972. The **referendum of 1967** is generally seen as a watershed in Australian colonial relations. Because of it, the race-specific clauses of the Australian constitution were deleted. This alone did not actually confer citizenship on Aboriginal people in a political or legal sense. Civic rights were attained through legislative and social reform in a number of contexts. For instance, the right to vote at a Commonwealth level was achieved with the passage of the Commonwealth's *Electoral Act 1962*. However, the 1967 referendum is often used as a symbolic marker for the social development of a new form of Aboriginal citizenship that challenged then dominant notions of an exclusive white Australian nationhood. In this social and political environment Aboriginal self-determination and sovereignty [see 4.5] emerged as key ideas which underscored and, to an extent, transformed Aboriginal political action, and which increasingly also began to take on a national focus. The creation of the Aboriginal Tent Embassy, as a part of this protest movement, dramatically symbolised both the social position of Indigenous Australians at this time and the emergence of this new political mood.

The decades since the Tent Embassy have been characterised by a number of symbolic and political crises in Aboriginal affairs. Conflict has centred on issues such as **land rights** and **cultural heritage** management, the distribution of government resources, and the provision of services such as education, health care [see 20.6; *250*, *251*, *252*, *253*, *254*], community infrastructure, and housing [see 19.1]. In a more abstract sense, these disputes have revolved around contested claims concerning the civic and indigenous rights of Aboriginal people. Aboriginal political and social action has also challenged perceptions of Aboriginal people, identities, and issues—perceptions rooted in Australia's colonial culture. It may be tempting to see this as part of an inevitable historical trend towards social reform. However, it is sobering to keep in mind the complex nature of these social processes.

A few years before Cathy Freeman morally challenged notions of Australian nationhood in front of a global sports audience, there had been controversy when cultural and geographic sites in a national park in the State of Victoria's Western District were renamed. A mountain range had its name changed from its colonial name—the Grampians to Gariwerd, a name appropriated from local Aboriginal languages [see 19.4]. The Victorian Minister for Tourism initially sponsored this action, co-opting some Koori (Aboriginal) community support for the initiative. The renaming exercise was a part of a broader tourism [see 18.1] marketing strategy that mobilised the region's 'Aboriginality', evident in a number of rock-art sites and other sites of Aboriginal cultural significance. Nevertheless, the renaming also carried deep symbolic resonances: it was a gesture of recognition of the original Aboriginal owners of this region. At the time, Koori writers, such as Tony Birch, were ambivalent:

The name restoration may be a beginning or an end. The tourist dollar chases the 'niche market'. The marketers may one day target a Western District town as a 'Sovereign Hill'— perhaps Stawell, which has a gold-mining history. Its citizens may become artefacts performing behind colonial facades, stuck in a local version of 'American Dreams' … But if the market moves away from 'Dreamtime legends', the money may well follow.

Not everyone was convinced by the minister's logic, and indeed many non-Aboriginal locals deeply resented the imposition of Aboriginal place names. This was the case even though most sites officially carried dual names as in Grampians–Gariwerd. The grist to the mill of public conflict was competing versions of history: the possibility of peeling back the cultural layers of colonial history of British exploration and colonial development, to accommodate an Aboriginal history and cultural present. Following the election of a new conservative State government in 1992, the decision of the previous Labor government was overturned. The Minister for Conservation claimed the dual names were confusing; in support he cited a petition of 57 000 signatures.

An Aboriginal woman carries an Aboriginal flag in celebrating a victory. A State government gives Aboriginal names to landmarks in a national park. On the face of it, these are seemingly unrelated incidents. Yet, they both generated crises—symbolic in nature—that captured considerable public attention. The moral power of these events and the subsequent social response point to colonial tensions that lie dormant, or are implicit, within Australian society. Periodically these tensions erupt in acrimonious public disputes that lay bare the social wounds of the colonial past. Both of the events referred to illustrate the multi-layered and dynamic quality of social relationships that shape the representation of Aboriginal people and subjects. A gesture of goodwill that recognises the Aboriginal history of a region is at the same time a marketing ploy that commodifies landscape and packages its cultural properties for a domestic and international tourist economy. The Aboriginal flag, which symbolises both Aboriginal survival and continuing anti-colonial action, can also be seen either as a gesture of **reconciliation** or one of separation, depending on the perspective of the viewer and the context of action. Interpretation of such events is necessarily complex. It requires, in part, a broader understanding of the sociology of race relations within a colonial context.

Colonial Dreamings: Imagining the colonised

Our challenge then, is to position the public phenomena associated with Aboriginal Australians as a part of a broader tapestry of cultural experience rather than as disconnected symbolic events, to produce a credible intellectual framework that accounts for their social and cultural interrelationship. The crucial issue is how the character or quality of social relationships shapes the representation of Aboriginal people and subjects. These relationships fuel the social dynamics that underlie both the production of Aboriginal 'art' and other public phenomena such as political discourse or media commentary.

In approaching this problem, some commentators have related the production of colonial symbols to the social context of Australian colonialism. For example, in her analysis of the representation of Aboriginal people and subjects in Australian film, Marcia Langton argued that:

The most dense relationship is not between actual people, but between white Australians and the symbols created by their predecessors. Australians do not know and relate to Aboriginal people. They relate to stories told by former colonists … 'Aboriginality', therefore, is a field of intersubjectivity in that it is remade over and over again in a process of dialogue, of imagination, of representation and interpretation.

Langton characterises three broad but distinct social contexts or experiences in which representations of Aboriginal people, identities, and related subjects are produced:

One category is the experience of the Aboriginal person interacting with other Aboriginal people in social situations located largely within Aboriginal culture ...

As a second category of cultural and textual construction of things 'Aboriginal', there are the familiar stereotypes and the constant stereotyping, iconising and mythologising of Aboriginal people by white people who have never had any substantial first-hand contact with Aboriginal people ...

A third category is those constructions which are generated when Aboriginal and non-Aboriginal people engage in actual dialogue, be it at a supermarket check-out or in a film co-production.

In other words, contemporary relationships between Aboriginal and non-Aboriginal are formed largely in the abstract. Rather than being sustained interpersonal relationships, social connections between Aboriginal and non-Aboriginal Australians are fleeting and ephemeral. For some, of course, this is not the case. For most non-Aboriginal Australians, however, cultural phenomena play a pivotal and significant role in the social reproduction of colonial values and identities.

Given this, it is perhaps not surprising that conflict in Aboriginal affairs often has a significant symbolic element. This is the case in the land rights political movement, although there are also material gains at stake. On the other hand, conflicts about the treatment of Aboriginal skeletal remains have been, at their core, disputes about the cultural meaning of human remains, and the consequences of this for the treatment of remains within scientific investigations. For some Aboriginal people, the past gathering and display of Aboriginal skeletal remains was intertwined with the production of colonial histories that rendered invisible Aboriginal survival and contemporary cultural experience [see 8.4, 11.8; **repatriation**]. For some archaeologists these political challenges to archaeological practice could be accommodated, although at times with difficulty; others found them more confronting [see **archaeology**]. John Mulvaney argued, for example, that 'past repressive colonialism does not mean that the present academic generation must pay the price, by never opposing strident claims and demands by radical Aboriginal leaders. Not to do so, will be to replace white violence and repression with black intellectual totalitarianism.'

The status of Indigenous Australians as a cultural minority is only one relevant social factor shaping non-Aboriginal knowledge or understanding of Aboriginal people and issues. We also need to consider the ongoing maintenance of colonial relationships within the fabric of Australian society.

Settler colonialism, such as occurred in Australia, involved both the actual dispossession of the Indigenous Australians from their land, and their natural and cultural resources, and the management of Aboriginal and Torres Strait Islander peoples by the settler state. Colonial relationships did not simply evaporate when European imperial powers withdrew from direct colonial rule, as when the Commonwealth of Australia federated in 1901. Rather, these relationships became woven into the social fabric of the emerging settler society. Since federation, government structures and processes have played a central role in these social developments.

In a formal sense, the Commonwealth did not become directly involved in Aboriginal affairs until after the constitutional reform of 1967. It did so indirectly, however, when it took over the administration of the Northern Territory from South Australia in 1910. Until 1967, each State jurisdiction independently pursued its own approach to Aboriginal affairs administration; consequently there was considerable variation in the detail

and extent to which programs directed at Aborigines were implemented. Broadly, however, the early history of federation was dominated by two distinct regimes in Aboriginal affairs policy: protectionism and assimilation [see 4.1].

Protectionist approaches to Aboriginal administration emerged during the nineteenth century as the frontier began to close in different regions of the continent. Colonial governments had sought to 'protect' the welfare of Aboriginal people by creating segregated reserves and missions within which systems of surveillance and colonial regulation were executed. These historical experiences have been significant in shaping the contemporary culture and identities of Aboriginal peoples. Today there is, for instance, quite a rich Aboriginal literature [see 14.1, 16.1] in different voices and genres, documenting the varied experiences of Indigenous Australians under protectionism. Examples are the autobiographies of Dick **Roughsey** [*102, 376*] and Labumore Elsie Roughsey (1971, 1984), *Auntie Rita* (Huggins & Huggins 1994) or Jack **Davis**'s play *No Sugar* (1986) [see also **life stories**]. Rita Huggins recalled the forced removal of her family to Barambah (later Cherbourg) Aboriginal reserve:

I will never forget how they huddled, frightened, cold and crying in their blankets. Some of our old relations were wrenched from our arms and lives that day and it is for them that I shed my tears. One old lady broke away from the others and screamed, 'Don't take my gunduburries! Don't take my gunduburries!' as the truck moved off, taking us away from her. After running a small distance she was stopped and held by the officials who wanted to keep 'wild bush Blacks' on these reserves.

These texts document both the suffering of mission or reserve life as well as memories of community survival and cultural development.

Prominent throughout this era were colonial cultural representations of Aboriginal people that emphasised cultural loss and perhaps inevitable 'passing'. In a political sense, missions and reserves were part of system of welfare that was to 'smooth the pillow of the dying race'.

By the late 1930s, however, the Aboriginal population in some parts of the country had begun to increase noticeably. In particular, the numbers of Indigenous Australians of mixed Aboriginal and non-Aboriginal ancestry were growing. As Jeremy Beckett argues, this gave rise to a growing moral panic about the so-called 'half-caste', who represented 'an anomaly if not a danger' within the dominant colonial cultural frameworks of the time. Increasingly administrations began to promote the biological or cultural assimilation of Aboriginal people into a category of 'almost whites'. Presumably, this would prepare Aboriginal people for the entitlements of white citizenship. In practice ideas of assimilation were implemented in a number of ways. In some regions, missions and reserves were closed. The removal of Aboriginal children from their families and their placement with non-Aboriginal families or institutions became common practice [see **stolen generations**]. In States with particularly authoritarian and invasive Aboriginal administrative systems, some Aboriginal people were granted 'passes'—legal exemptions provided to individual Aboriginal people from the conditions of the particular jurisdiction's Aboriginal Act [see 4.1; *41*].

Aboriginal life practices were expected to conform to the cultural values of white Australia. Consider, for example, Peter Myers's description of the non-Aboriginal social values attached to the assignment of Aboriginal housing in Wilcannia (NSW) in the 1970s:

The ethic of the game is that normality is associated with apparent order ... Being of a symbolic rather than functional origin, this factor of maintenance ... requires a shared

knowledge of what it can signify. To the society creating and maintaining such symbolic continuities—well dressed, a neat and tidy house, steady job, outward cheerfulness, etc.— these icons have some meaning, without whose belief or acceptance anyone can be stigmatised as asocial.

Under both protectionism and assimilationism, Aboriginal people were seen to be outside of, but dependent on, the white Australian nation. At best, citizenship for Aboriginal Australians was ambiguous, conditional on their biological or cultural transformation into white Australians. However, in the period following the 1967 referendum, political support for an exclusively 'white' Australia began to decline. Increasingly ideas of assimilation were dropped from Aboriginal affairs policy, and concepts of self-management and self-determination became more commonplace.

This shift in policy has undoubtedly been influential in shaping the provision of Aboriginal welfare and other government programs since the 1970s. Certainly, over this period these ideas—self-management and self-determination—have become dominant politically. To an extent this reflects broader social changes in the relationship between Aboriginal and non-Aboriginal Australians. However, it would be naive to claim that this social transformation is anything other than partial. Further, the quality of Aboriginal life experience remains poor relative to that of other Australians.

Continuing Aboriginal disadvantage in areas such as health, education, employment, income, and housing is well-documented. Periodically, when these issues are at the centre of policy debate, attention shifts onto the legacy of government action or inaction. During one such dispute concerning Aboriginal health the then Commonwealth Minister for Health, Graham Richardson, took a tour of Aboriginal communities in Australia's north, making a series of promises coated in political rhetoric. As a rejoinder a cartoonist positioned Richardson as just the last in a long genealogy of politicians with grand claims [243].

While colonial relationships have continued to mesh with the framework of Australian society, I do not wish to suggest that they are all-pervasive. Other social dynamics, such as class and gender, also significantly shape Aboriginal life experience and cultural production. Government structures directly responsible for the management of Aboriginal affairs have always had limited resources: this undermines their effectiveness in the implementation of colonial policies. Further, the scope and nature of state regulation and scrutiny of Aboriginal life have varied through time.

Us mob, them others

To this point we have considered how the public face of Aboriginal Australia is framed in broad terms by the social relations of colonialism. Here, I would like to explore these issues further and consider the contours and form of the colonial cultural tradition. In doing this I will draw upon critical concepts developed for this specific purpose. Some commentators have used the term 'Aboriginalism' as a descriptive gloss for Australian colonial cultural production (with obvious reference to Edward Said's Orientalism). One manifestation of 'Aboriginalism' is, in Bain Attwood's description, 'a style of thought which is based upon an epistemological and ontological distinction between "Them" and "Us"—in this form Europeans imagine "the Aborigines" as their "Other".

It is argued that within the context of colonial relationships, Aboriginal people are construed as the 'Other' in relation to an implicit settler 'self'. In this way social difference becomes culturally organised in a manner that attaches a particular set of values, ideas, or symbols to colonised peoples. This gives rise to what some have called the 'colonial imagination': the colonised 'Other' is uncivilised and embedded in nature, outside

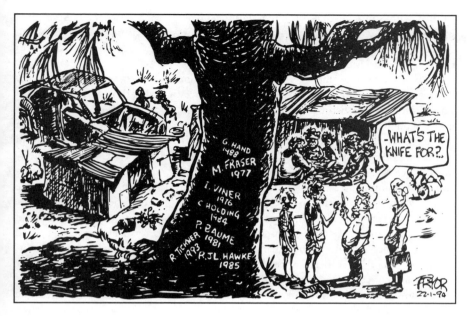

243. Geoff Pryor, *What's the Knife For? Canberra Times*, 22 Janurary 1994.

of history, wild and savage; but yet also noble and spiritual. By inference, the colonisers perceive themselves as masters of nature, civilised, and embedded in the material concerns of capitalism. The colonial representations of Aboriginal people are implicitly refracted from the 'self-understanding' of settler cultures.

Consider for instance one representation of Aboriginality which I have sometimes termed 'Jacky Jacky':

Most Australians are familiar with the figure of the Jacky. He is found in suburban garden kitsch, a three-foot black plaster miniature with a red lap-lap and spear, or perhaps inside the house as a cutesie receptacle for cigarette butts: the tea-towel image of Aboriginality. It is the Jacky who features in blokey bar discourse—as the butt of racist jokes. This derogatory representation of Aboriginality is a pitiful figure of the bewildered 'traditional' Aborigine who has wandered into modernity, yet at the same time also maintains notions of a pristine and authentic Aboriginality.

Jacky Jacky is a drunk. He is disadvantaged and trapped in a cultural void. Jacky is not an industrious or smart operator in a capitalist economy. He is a living fossil—a 'primitive' among 'moderns'.

As a cultural complex, the 'Other' is not necessarily internally consistent. Aborigines are, for example, both savage and noble. These complexes form through time out of multiple social encounters occurring in a diverse array of contexts. The 'Other' is transformed and recreated as colonial ideas become manifest in distinctive institutional and cultural frameworks through time.

Neither are such colonial representations necessarily entirely negative. New Age spiritualism has readily appropriated notions of a noble and spiritual Aboriginality, as a metaphor to emphasise the spiritual barrenness of contemporary Western cultures [see 15.4]. One advocate, Marlo Morgan, claimed that 'somewhere in the dry heat of the Outback there remains a slow, steady, ancient heart-beat, a unique group of people not concerned with racism, but concerned only with other people and the environment. To understand that pulse is to better understand being human or humanbeingness.' Goodwill notwithstanding, Morgan's book, *Mutant Message Down Under* (1994), is

riddled with some fairly astounding claims, and includes a chapter on Aboriginal mental telepathy titled 'Cordless Phone'. The book was a publishing success in North America. The Aboriginal public response was highly critical, accusing the author of cultural appropriation.

It is possible to detect the presence of the colonial imagination in other contemporary social encounters, for example in one of the cases investigated in the Royal Commission into Aboriginal **Deaths in Custody** (which was commissioned in 1987 in response to growing public pressure). Arthur Moffatt was a Koori from country Victoria. He died in police custody after a series of events in which a number of people including police and ambulance officers had treated him as if he were drunk. He had been in police custody one day before his death. On the day that he died, Mr Moffatt travelled by train between two local country towns. Prior to the journey, he had been seen drinking with some friends, yet was not reported to have displayed any signs of intoxication. However, by the time that he reached his destination, he was agitated, sweaty, and confused. Removed from the train, he was left semi-conscious on the station platform. Here a station guard called the police, who despite removing him to police custody also called for an ambulance. The ambulance officers assessed that Mr Moffatt was drunk, and took no further action. Later that evening Arthur Moffatt died in a police cell, alone and unattended.

The Royal Commission inquiry into the death of Arthur Moffatt concluded that he had most probably died because of a hypoglycaemic coma, a complication of his diabetes. Some symptoms of hypoglycaemia can reasonably be confused with drunkenness. Nevertheless, the police acted contrary to standing orders that require a medical assessment of anyone taken into custody who is unable to give their name and address. Further, it is not accepted practice for an ambulance officer to make a medical assessment and treatment decision, as happened in this case. The police and ambulance officers who assessed Mr Moffatt were apparently so confident in their own diagnosis of drunkenness that they failed to secure a medical assessment of his condition. This most probably cost Mr Moffatt his life.

We can only speculate about the extent to which notions of 'Jacky as a drunk' were influential in shaping the actions of those in authority on this occasion. At best, these colonial stereotypes probably reinforced a series of errors in professional judgement. The fleeting nature of interpersonal encounters between Aboriginal and non-Aboriginal people in this region, and colonial notions of Aboriginality, interplay in a way that underlines the continuity of the colonial imagination. We might indeed wonder how the outcome for Mr Moffatt might have differed had he been white, or perhaps dressed in a suit, on that day when he was found semi-conscious in a public place.

Making art in a colonised world

Not infrequently, Aboriginal art will directly engage colonial metaphors and symbols. This may be intended as frank critique. Artists, in drawing upon their lived cultural experience, may re-work or confront dimensions of the colonial imagination.

Take, for example, two photographic images by the artists Tracey Moffatt and Destiny Deacon. On one level Moffatt's series *Something More*, 1989 [244] can be read as a dramatic narrative of the beautiful young heroine who escapes a troubled rural home and heads for the bright lights of the city, with tragic consequences. Yet Moffatt is also concerned with issues of race, class, gender, and national identity. As the protagonist in this fictional tableau, Moffatt—clad in a startling red cheong sam—unsettles colonial representations of Aboriginal female sexuality. Deacon's *Last Laughs*, 1995 plays with colonial notions of a dangerous Aboriginal female sexuality—but the artist uses irony and a rapport with her subjects to capture a moment locked between a pose and discomposure

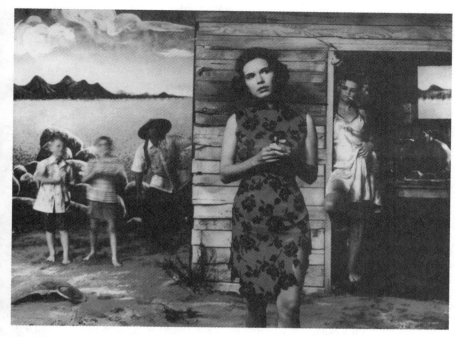

244. Tracey Moffatt, *Something More* (detail), 1998. Direct positive colour photographs, 100.6 x 127 cm (each sheet).

[*277*]. These women are at once mocking and flaunting: tarted up—but definitely not available. Their gaze mocks and directly engages the viewer. In different ways both these images challenge and re-present images of Aboriginal women.

However, while there is a history to the colonial sexual metaphors that provide an interpretative reading for these works, their creation is also grounded in the contemporary life of Aboriginal people. It would be a travesty to reduce Aboriginal art to simple cultural resistance. But it would also be a mistake to ignore the challenge it can provide to ways of understanding Aboriginal life experiences.

Histories and memories: Millennial tensions

Throughout the 1990s, Australian society underwent significant economic change in the context of equally significant cultural agitation. A period of economic adjustment, characterised by high levels of unemployment and a decline in industries such as manufacturing and primary production, caused some social upheaval and considerable uncertainty. The economic policy agenda continued to be dominated by rationalist values and programs deregulating financial and labour markets and privatising public assets. Concurrently, a number of events and realignments in social policy coalesced and provided some profound challenges to Australian national identities: these included the movement for an Australian republic, the development of a national program for Aboriginal reconciliation, the legal recognition of Aboriginal **native title** in the 1992 **Mabo** case in the High Court, and the development of international policy promoting closer economic and social ties with Asia. The public face of Aboriginal Australia was close to the symbolic heart of many of these controversies. In a speech in Redfern reported in the *Age*, 11 December 1992, the Prime Minister Paul Keating set the stage for this part of this agenda in saying:

We took the traditional lands and smashed the traditional way of life. We brought the disease, the alcohol. We committed the murders. We took the children from their mothers. We practised discrimination and exclusion. It was our ignorance and prejudice.

435

We failed to make the most basic human response and enter into their hearts and minds. We failed to ask 'how would I feel if this were done to me?' As a consequence, we failed to see that what we were doing degraded us all.

There was a moment in the early part of the decade in which it seemed as if a distinctly new set of national values were emerging and taking hold. The 'new nationalism' appeared to appropriate comfortably Aboriginal icons, such as the Aboriginal flag, to add to a broader array of symbolic images of Australian nationhood. This thinking challenged notions of peaceful settlement. It gave rise to a cultural attitude that was confident and multicultural. This Australia had dispensed with the cultural cringe of an antipodean, white, imperial enclave. There was a certain confidence about what this meant for Australia's cultural future. Consider Wanda Jamrozik's response to the Freeman incident:

The Keating generation, too, is open minded about who or what Australians are. Most of them, after all, attended schools with large enrolments of children from non-English-speaking backgrounds. For these people race, ethnicity, sexual orientation, gender, no longer come loaded with expectations. They welcome the promise of a republic as the perfect vehicle for severing the ties with Britain which for so long have reinforced a view of 'normal Australia' against which other streams were perpetually measured and found wanting ...

The floodgates have opened. What was political yesterday is an accepted part of life today. The old guard will have to wear it. When Cathy Freeman brandished the two flags in Victoria, she demonstrated that what was recently thought to be the future for Australia is here and now.

However, subsequent events suggested that while the 'new nationalism' had its supporters, a significant component of Australian society remained unconvinced and uncommitted. A growing caucus of critics derided some of these cultural developments as an uncritical 'political correctness'. Revisionist histories were labelled the 'black armband' view of history. Michael Warby, writing in the *Adelaide Review* (1999) under the by-line 'Our Stolen History', criticised 'progressivist' academics for whom '[a]ny sort of positive rendition of Australian history is just too gauche'. The return of a conservative coalition government at the national level in 1996 after thirteen years of Labor rule provided some momentum and political support for this growing counter-critique.

One particular political manifestation of these social developments was Pauline Hanson's One Nation Party. Originally, Hanson stood as a candidate for the Liberal Party. However, she was disendorsed during the 1996 political campaign that led to the election of the Howard government, following some racially provocative comments made by her during the election campaign on the issues of race and multiculturalism. Response from the Liberal Party machine was swift and ruthless. Despite the essentially socially conservative stance of Howard's government-in-waiting, the prospect of losing yet another winnable election in a media furore on issues of race was apparently too risky. Hanson was elected as an independent, and the political momentum that began with the initial controversy culminated in the formation of her own political party. She argued consistently that Indigenous Australians had been unfairly advantaged by previous governments, which encouraged the politics of separatism. As Jeff Archer comments:

Pauline Hanson's populist appeal depends on a number of symbolic arguments about economic nationalism, settler ideology, and rural ideology ... the enemy Hanson and her supporters demonise (in the manner of familiar anti-Semitic diatribes) is not so much Indigenous peoples or Asians but rather, is the chattering classes ... [Her appeal] involves

an intensely nostalgic recreation of an historical golden age of triumph for ordinary, unpretentious, hardworking, white Australians … The powerful symbols of Aboriginal Reconciliation and Land Rights are seen as particularly dangerous threats to this white Australian heartland. They are resymbolised as a dispossession and a subjection of the battling settler.

It is tempting to interpret some of this in terms of the colonial cultural politics of earlier eras. Notions of cultural exclusion, and the spectre of a dependent black Australia, echo uncomfortably the metaphors of Aboriginality prominent during the early years of federation. However, this would be to oversimplify considerably these cultural phenomena. This form of cultural politics is unique because it re-invents the 'Aussie battler' as the dispossessed. It emerged at a particular historical moment, following a decade of economic reform that deregulated trade and financial industry and occurred in parallel with the decline of Australian primary production. While colonial images of Aboriginal Australia can be remobilised in such historical contexts as this, the way in which it happens is unique to its particular context. How this part of Australia's colonial history will unfold is difficult to predict, but it will no doubt continue to transform the making and experience of Aboriginal art. As this art too can continue to transform us.

IAN ANDERSON

Anderson. I., 'Black suffering white wash', in *Arena Magazine* June–July 1993; Archer, J., 'Howard, Hanson, and the importance of symbolic politics', in B. Grant (ed.), *Pauline Hanson: One Nation and Australian Politics*, Armidale, 1997; Attwood, B. & Arnold, J. (eds), *Power, Knowledge and Aborigines*, Bundoora, Vic., 1992; Beckett, J., 'The past in the present, the present in the past: Constructing a national Aboriginality', in J. Beckett (ed.), *Past and Present: The Construction of Aboriginality*, Canberra, 1988; Birch, T., '"Nothing has changed": The making and unmaking of Koori culture', in G. Cowlishaw & B. Morris (eds), *Race Matters*, Canberra, 1997; Huggins, R. & Huggins, J, *Auntie Rita*, Canberra, 1994; Jamrozik, W., 'Flagging a new Australia', *Independent Monthly*, December 1994–January 1995; Langton, M., *Well, I Heard it on the Radio and I Saw it on the Television: An Essay for the Australian Film Commission on the Politics and Aesthetics of Filmmaking by and about Aboriginal People and Things*, North Sydney, 1993; Mulvaney, D. J., 'Past regained, future lost: The Kow Swamp Pleistocene burials', *Antiquity*, vol. 65, 1991; Myers, P., 'On "housing" Aborigines: The case of Wilcannia, 1974', in P. Foss (ed.), *Island in the Stream: Myths of Place in Australian Culture*, Leichhardt, NSW, 1988; Royal Commission into Aboriginal Deaths in Custody, *Report of the Inquiry into the Death of Arthur Moffatt* (Commissioner J. H. Wootten), Canberra, 1990.

20.2 Gesture, symbol, identity

In April 1993, after a Victorian football match [see **Australian Rules football**, **sport**] between Collingwood and St Kilda, the players were being showered with catcalls from the crowd. It was nothing unusual, just another Saturday afternoon of jubilation for some, frustration for others. Receiving more than his share of remarks, many of them racist, St Kilda player Nicky Winmar lifted his jersey and pointed to his black chest [*245*]. This simple gesture, made with pride and defiance, was eagerly captured by press photographers. Immortalised thus, Winmar's image delivered a clear message: here was one black athlete who was not cowed by his colour.

Winmar's gesture did not halt the abuse directed at players on and off field, but it did promote considerable discussion. It drew attention to the vilification suffered by players on grounds of race and challenged the cherished myth that, in **sport**, talent and skill

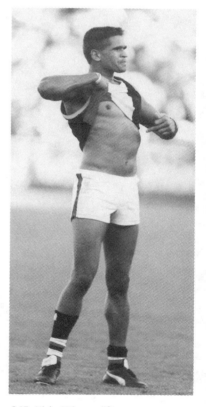

245. Nicky Winmar lifts up his jersey, pointing with pride to his colour and his Aboriginality, 1993.

were all that mattered. Importantly, it was an indicator of the wider Aboriginal determination to speak out against public displays of racism.

In the past a gesture such as Winmar's (and the reception it received) would have been improbable. Aboriginal participation in organised sport was manipulated and administered by white entrepreneurs and institutional frameworks. The wider social context of colonial paternalism in Australia ensured that the capacity of Indigenous athletes to protest against injustices was severely limited. To have done so would have been to jeopardise their ability to participate and be rewarded in their chosen field. For Aboriginal sporting fans and onlookers, a stellar performance by a black boxer [see **boxing**] or runner [see **athletics**] undoubtedly gave reason for community pride and joy. Moreover, the purse won by an individual would have been welcome in many close-knit communities.

There is little evidence, however, that a convincing win against a white counterpart in early Australia challenged established beliefs on race. Sporting fans did understand competition between blacks and whites as symbolic, but often this was felt in the rawest of terms as a kind of battle between cultures. The outcome inevitably provided confirmation, to some, of racial notions based in Social Darwinism: a win by a black athlete could be attributed to some natural advantage, often linked to 'animal' ability and cunning; conversely, a win for a white athlete might be interpreted as proof of the superiority of intellect and strategy over brutish instinct.

Not every fan saw Aboriginal sporting achievement through a reductionist looking-glass. Many truly enjoyed and were entertained by the feats of Indigenous athletes, yet this was an admiration largely limited to the field: there were few opportunities for social mixing or mechanisms which encouraged other expressions of appreciation. On occasion, Aboriginal athletes of exceptional merit were fêted off field—admitted to society through their athleticism—their colour perhaps momentarily forgotten.

The last three decades of the twentieth century saw significant changes in many aspects of the world of organised sport, in media control, patterns of play, audience consumption, product development (both games and players are 'products'), and sponsorship. These changes, coupled with social and political activism, legislative change, and shifts in community attitudes have played a large part in sports-loving Australia's embrace of some Aboriginal athletes. However, this is an appropriative embrace, whereby Aboriginal success is acclaimed by, and claimed for, all Australians: Aboriginal identity shifts from being a liability in general society to being usefully novel. At no stage does success serve to erase Aboriginal difference. On the contrary this difference becomes subject to heightened levels of attention. **Aboriginality** becomes a reason to be noticed, a journalistic angle, a sponsor's delight, and for the individual, on occasion, an enabling characteristic which may be positively asserted.

It may be argued that Aboriginal individuals who attempt to achieve success in the white world must engage with its rules and codes, and in so doing risk a separation from their Aboriginal fellows and their cultural identity. Tennis player Evonne Goolagong (now Cawley) has been criticised more than most: she was castigated by many Aboriginal activists for her naivety regarding political issues, and for her determination to make tennis her first priority. Goolagong's decision to tour South Africa in 1971, despite the existence of apartheid, met with a great deal of hostility. Many felt that she should have refused the invitation to play, as a gesture of solidarity with black South Africans. While the advice of her coach, Vic Edwards, was that 'sport and politics should not mix', Goolagong did not make her decision on those grounds. She saw herself as a potent symbol of black achievement and felt her presence in South Africa would be a display of resistance to the apartheid regime. By winning her matches she would prove the ability of black peoples both to white supremacists and to her black brothers and sisters.

For many years, Goolagong has been a target for her critics. She has largely chosen to keep her own counsel, despite the slurs on her character (one exception was her action for defamation against the publishers of the *Bulletin* in 1980). In her 1993 autobiography *Home!* she described the choices she made in her career in the context of having an Indigenous identity. This exceptional athlete maintains the belief that an Aboriginal person can aim for the top and have every chance to succeed. In her words, anything is possible when one's hand is stretched out 'not for pity but for the prize'. This somewhat controversial view has not been formed in ignorance of the degradation suffered by Aboriginal people, nor is Goolagong unaware of the ways in which her individual successes have been appropriated to suggest that Australia really is the land of opportunity for all. Simply, her views reflect formative experiences which have shaped her belief in possible pathways to the future. She is proud of her personal achievements and the position she holds as a widely respected public figure with an honoured place in the histories of Australian and international sport. Equally, she is confident that her Indigenous identity has been a source of pride for many Aboriginal Australians who have witnessed one of their own as the best in the world.

Goolagong's achievements deserve to be positioned as a part of a complex intersection of political, social, and cultural events, including Aboriginal activism, which precipitated great change in the national life with regard to race and opportunity. Importantly too, Goolagong's 1971 Wimbledon victory may be read retrospectively as a symbol of the changing relationship between Australia and Great Britain.

During her professional career, Goolagong served as a role model of athletic excellence—a first among equals—and other Indigenous athletes have sought to emulate her. Achievement remains important in challenging conservative or reactionary views about Aboriginal ability. It is not, however, the sole means by which Indigenous athletes now choose to communicate with the public. Increased media involvement and sponsorship in sport have offered celebrity status, wealth, and hence new freedoms to a select few among Indigenous athletes. Considered to be of public interest, their voice and their concerns about matters beyond sport may be advantageously amplified.

Most notable, perhaps, in the category of celebrity Indigenous athlete is runner Cathy Freeman. Since she first came to the public's attention at the Commonwealth Games in Auckland (NZ) in 1990, Freeman's steady rise in ability has been matched by the increasing affection of the Australian public. Her celebrity as an Indigenous athlete was enhanced considerably at the 1994 Commonwealth Games in Victoria (Canada), when she used the Aboriginal **flag** as a winner's cloak [281].

This gesture was a simple, but not a spontaneous, act. Freeman had packed the flag in her suitcase, intending to use it if she won. She had given it to a friend seated in the stands who handed it to her after her winning race. Freeman waved the flag to the assembled crowd and the millions watching the live telecast before also receiving and displaying the Australian flag on her victory lap after the 400 metre race. The resulting reports led to a very public debate about her right to use the Aboriginal flag at an international event. Three days later, Freeman again won gold, for the 200 metre event. Alert to the likely response to a repeat gesture, she accepted and displayed simultaneously both the Aboriginal and the Australian flag. Although many Australians delighted in her rapturous act, for some it was an uncomfortable sight.

Chef de mission of the Australian Commonwealth Games team, Arthur Tunstall, was particularly critical of Freeman's action. Although her actions were not in contravention of the Commonwealth Games Federation (CGF) Constitution, it was argued that, by using both Aboriginal and Australian flags, Freeman had embarrassed Australia by putting in question her representative position as an Australian national at an international event.

Some argued that she had unnecessarily introduced a political dimension to her achievements on the track.

Subsequent amendments to the Australian Commonwealth Games Association (ACGA) Athlete's Agreement 1998 now caution athletes about behaviour which may be interpreted as in breach of their obligations. Athletes are required to acknowledge and agree 'that statements or demonstrations (whether verbally, in writing or by act or omission) regarding political, religious or racial matters are contrary to the objects and purposes of ACGA and CGF and the spirit of the Games, and that sanctions may be imposed … for any such statement.' The Aboriginal flag has considerable resonance both as a political and as an ideological emblem. Hence, it will require a liberal interpretation and application of this agreement's provisions if we are to witness future, unsanctioned, exuberant displays of the flag in the context of the Commonwealth Games competition.

The International Olympic Committee applies its own conditions covering the behaviour of participating national teams and their individual athletes. Participants are warned against infringements of the Olympic Charter which may result in disqualification and possible loss of ranking or medals. Perhaps the best-known breach of the Olympic Charter and subsequent disciplinary actions centred upon African-American athletes Tommie Smith and John Carlos at the 1968 Mexico City games. Respectively first and third in the 200 metre men's track event, both stood barefoot on the winners dais, each raising a black, gloved fist as the national anthem of the United States of America played. Their act—both a salute to Black America and a potent reminder of the great inequalities in American life—was condemned as being against the Olympic spirit, and led to their removal from the village and from further competition.

Aware that display of the Aboriginal flag at the 1996 Atlanta Olympics might invite disciplinary action, Freeman did not flout the charter. She was, however, keen to make a positive statement regarding her Aboriginality and was encouraged by Australia's *chef de mission*, John Coates, to find a creative solution. The idea of a pair of Aboriginal 'flag' running shoes was suggested to Nike Inc.—the sporting footwear company that sponsored Freeman—and they were happy to produce them. A cheeky reference to Freeman's earlier use of the Aboriginal flag, the shoes offered Freeman an opportunity to distinguish herself as a proud Aboriginal competitor. It appeared that wearing a flag upon one's feet, rather than waving it in the air, would not be considered an inflammatory gesture—though Freeman's feet did indeed fly!

For some Aboriginal Australians her use of the 'flag' shoes was too subdued, particularly as she wore them only in the semi-finals at Atlanta. Charles Perkins, consultant to the Australian Sports Commission, argued publicly that Freeman should have risked the loss of her medal in favour of a gesture of solidarity with Aboriginal people, such as the display of the Aboriginal flag. In his view, Freeman was perhaps confused as to her future identification. He was reported as asking: 'Where does she go from here then? Is she going to be a black white person, is she, and pretend she's somebody else?' (*Sydney Morning Herald*, 1 August 1996). Perkins' comments drew a line in the sand for prominent Aboriginal Australians. Here was a demand for the unashamed display and celebration of cultural identity, before all other considerations. Here also was recognition of the importance of role models and symbolic actions to the Aboriginal community.

The criticisms of Freeman reflect the level of community expectation of individuals who hold positions of influence and respect within and beyond the Aboriginal community. Elite Aboriginal athletes cannot dissolve into the play as their team mates might do. Rather, as beacons of an identity which is ambivalently received, they find themselves incidentally, and of necessity, performing a political role. Their words, gestures, and

actions bear representative and symbolic weight: hence the delight expressed by many at Freeman's use of the Aboriginal flag in 1994.

Freeman's decision not to repeat the flag incident at the Olympic Games need not be interpreted as a denial of her Aboriginality. Indeed, there are perhaps no points in public life at which one may choose to step away from one's Aboriginal self. Like Goolagong before her, Freeman may have judged that a winning performance on the world stage was the supreme signalling of Aboriginal achievement. Furthermore, her win was shared by all Australians and thus may be recognised in the long term as a significant contribution to the transformation of relations between black and white Australians.

The ways in which prominent Aboriginal athletes respond to community expectations are a matter for their individual consideration and choice of expression. Whether Aboriginal identity is upheld in word, through sporting excellence, or in symbolic gesture and act, there will be many waiting, hungry for each new display.

<div align="right">Lee-Anne Hall</div>

Australian Commonwealth Games Association, *Commonwealth Games Federation Constitution*, Sydney, 1997; Australian Commonwealth Games Association, '11.2 Requirements Regarding Propaganda and Advertising', *Australian Commonwealth Games Team Athlete's Agreement*, Double Bay, Sydney, 1998; Goolagong Cawley, E. & Jarratt, P., *Home! The Evonne Goolagong Story*, East Roseville, NSW, 1993; International Olympic Commission, *Olympic Charter*, Lausanne, 1997; McGregor, A., *Cathy Freeman: A Journey Just Begun*, Milsons Point, NSW, 1998.

20.3 Hindmarsh Island (Kumarangk): Challenging Australian mythologies

Let me tell you something. That in my younger years when I was growing up the old people said the River Murray, murungi [Murrundi], is our life line to the Ngarrindjeri people. And they said where the river meets the salt water they said that's our spiritual place (Tom Trevorrow, in evidence to the Hindmarsh Island Bridge Royal Commission, 1995).

At the turn of the millennium, over 200 years after the establishment of British settlement at Sydney Cove, Australia was re-envisioning the frontiers of its dominant culture. It was reflecting on its status as a nation and its relationship to the continent through debates about the establishment of a republic and about **native title** rights arising from the High Court's **Mabo** and Wik decisions. In this unsettled, shifting ground, Hindmarsh Island (Kumarangk), at the mouth of Australia's longest river, provided a focus in the debate about the place of Indigenous people in the nation.

In the early 1990s developers planned to build a bridge across the Murray River about sixty kilometres from Adelaide, between the mainland town of Goolwa and Kumarangk, to support a marina development. In 1994 a group of Ngarrindjeri women, led by Doreen Kartinyeri [see 17.2], claimed that Kumarangk was associated with restricted women's knowledge and that the proposed bridge would desecrate that tradition. In July Robert Tickner, the Federal Minister for Aboriginal and Torres Strait Islander Affairs, used federal heritage protection legislation [see **cultural heritage**] to place a twenty-five-year ban on building the bridge.

These events were widely reported in the media and the phrase 'secret women's business' quickly became part of contemporary Australian language. Over many months the enormous **media** attention given to the Hindmarsh Island issue led to the questioning, Australia-wide, of the authenticity of Indigenous culture. The fact that the prime focus

of Kumarangk was women's knowledge also heightened media interest. The debate rapidly incorporated long-held popular concerns about the authenticity of Indigenous 'sacred sites' and the commonly held view that 'real' Indigenous culture does not exist in 'settled' Australia [see 4.1].

In April 1995 dissent, amounting to accusations of fabrication, emerged in the Ngarrindjeri community and was championed in the media. In the midst of this controversy, the South Australian government established a Royal Commission to inquire into the authenticity of the Ngarrindjeri claims. In December the Royal Commissioner, Iris Stevens, reported to the Governor of South Australia that the 'whole of the women's business was a fabrication', carried out to 'prevent the construction of a bridge between Goolwa and Hindmarsh Island'. A group of Ngarrindjeri women, labelled by the media as the 'dissidents', had given evidence to the commission that they did not know of the 'women's business' or did not believe in it.

Most of the Ngarrindjeri proponents of the women's business, however, refused to take part in the commission. Instead, they participated in a Commonwealth inquiry, instituted under the *Aboriginal and Torres Strait Islander Heritage Protection Act (Commonwealth) 1984*. Justice Jane Mathews conducted this inquiry in early 1996, and most importantly, with assistance and advice from several senior anthropologists [see **anthropology**], came to quite different conclusions from those of the State Royal Commission regarding the genuineness of the Ngarrindjeri traditions.

Many Australians agree with the Royal Commission's conclusions that the Hindmarsh Island claims are fabricated. What insight does this complex case give into white Australian culture? The survival of Indigenous people in 'settled' Australia challenges the legitimacy of the Australian nation, which is built upon a myth of 'settlement'. Settlement requires a frontier, which leaves behind a new conceptual space in which 'real' Indigenous people can no longer exist.

The Ngarrindjeri women who sought protection for the traditions associated with Kumarangk thus challenged the state through their very existence. By arguing that they have a strong, distinctive culture and a continuing association with their country they overturned all the stereotypes associated with south-eastern Aboriginal people.

Just before he died at Goolwa in August 1935, Reuben Walker, a Ngarrindjeri man who had lived a considerable portion of his life in camps in the Lower Murray Lakes region, wrote an account of his life story for the anthropologist N. B. Tindale, then a curator at the South Australian Museum. Towards the end of his account of Ngarrindjeri history and culture, Walker made the following heartfelt statement (which Tindale reproduced as it was written):

I always thought of my kind ald Grandfather and grand mother that took care of me never a child was cared so much as I was and being a half caste shame on the white race I would sooner be a full Blooded aborigine my blood boil at time I scorn the white man because I know I know He is the low wicked blaggard that took the country from my Grandmother ... my father or Grandfather on the white man side the European did He have any [th]ing that he got lawfully ... That day will come when the white man will have to account for what they have done God is Good the vengence of the almighty shall they reap.

Walker's is a strong statement, bordering on a curse, serving to remind Tindale, and other readers, of the dreadful impact of the European invasion of South Australia on the Ngarrindjeri people and the illegitimate nature of European 'settlement'.

Tindale was more interested in Walker's 'ethnographic' notes. He was concerned with recording what he saw as the almost extinct culture of the Aboriginal people in southern South Australia. He considered that the role of the anthropologist was to collect 'tradi-

tional' information from 'full-blooded' Aborigines. For Tindale, the museum was to be the last resting place of 'authentic' but dead Ngarrindjeri traditions, artefacts, and even human remains. The collections of the South Australian Museum were to become a bizarre cultural litmus test, used against Ngarrindjeri people in the Hindmarsh Island case. The Royal Commission took place at the frontier between Indigenous, oral accounts of culture and the Western empiricist tradition.

The frontier is a site of creation for the colonial state; Walker lost his country to the 'low wicked blaggards' in the moving path of the frontier of settlement. His son Arthur fought at Gallipoli and died at Pozières in 1916, in a war in which, many argue, Australia established its identity as a separate nation. Yet, as an Aborigine, Walker was not counted as an Australian. Aboriginal people who fought in and survived World War I returned home to little official recognition and to the inequalities of Australian society. That war reinforced the harsh reality of colonisation and dispossession for Ngarrindjeri people. Doreen Kartinyeri [see 17.1, 17.2] wrote about this in her book *Ngarrindjeri Anzacs*: 'I find it difficult to understand how so many Aboriginal men were allowed to enlist in the Army, as they were … not counted as human beings. Why did the government want them to enlist? Was it because they did not care who went to fight the War for them? I feel strongly that the then Protector of Aborigines should have stepped in and stopped them from enlisting.'

While affecting the credibility of all Indigenous people, Hindmarsh Island highlights a central problem for Indigenous people in 'settled' Australia. They have been effectively defined out of existence by Australian society and in particular by anthropologists. The Indigenous anthropologist Marcia Langton described this process as the 'social scientists' great deception' and identified what she described as the 'insidious ideology of tribal and detribalized Aborigines—the "real" Aborigines and the rest of us' [see 11.1, 12.1]. This ideology was presaged in 1951 by Ronald and Catherine Berndt. Of the Ngarrindjeri they wrote:

In this region [lower Murray] live the remnants of a once flourishing people. The tribes which once inhabited the Murray districts and the whole east and south-east of South Australia, as well as the district that we now call Adelaide, are now virtually extinct. Of the remaining handful of 'full-blood' aborigines, only a very few are at all well acquainted with the language and traditions of their forefathers; and these are old men and women, so that before long they and their knowledge will have passed beyond our reach.

When Veronica Brodie, a proponent Ngarrindjeri woman, gave evidence to the 1995 Royal Commission that the Australia-wide Seven Sisters Dreaming [see 1.3, 2.2] was associated with Hindmarsh Island, several expert witnesses argued that these traditions were imported from central Australia. Significant, then, in assessing the commission's findings is Justice Mathews's specific contradiction of this crucial misconception. She writes:

There is considerable material, much of it unearthed for the purpose of this Report, which directly refutes the Royal Commissioner's findings on this matter. References to the Seven Sisters Dreaming Story in Ngarrindjeri culture can be found in several sources, some of which go back a long time. Philip Clarke's PhD thesis quoted a 1960s account of the Seven Sisters Dreaming Story as recorded by Annie Rankine, a Ngarrindjeri woman whose father Milerum (Clarence Long) [213]was Norman Tindale's principal informant.

Historians have often written about the frontier of settlement in Australian **history**. Characterised as an early site of struggle between Indigenous Australians and Europeans, this frontier has been described as something that existed in the distant past. For many Aboriginal people the frontier has continued to exist throughout Australia's history. As

can be seen clearly from the debates surrounding the Mabo and Wik decisions of the High Court, Australia is a 'settler-state' and the struggle to dominate land and culture is still at the heart of the Australian ethos. For many Ngarrindjeri people, the Hindmarsh Island bridge represents a further assertion of settlement. For many Ngarrindjeri women and men, it threatens to desecrate a significant religious area. Kumarangk stands at the gateway to the Coorong and the heartlands of the Ngarrindjeri people. Doug Wilson, a senior Ngarrindjeri man, encapsulates the crucial cultural importance of areas such as the Coorong for the Ngarrindjeri: 'You know we got something special in the Coorong, the Ngarrindjeri … You feel when you go over the other side suddenly you got no worries in the world, you feel if a weight has been lifted off your shoulders, you feel free.'

The Coorong is symbolic of survival for Ngarrindjeri people. Although only 200 kilometres south of Adelaide, the area has resisted large-scale settlement. Jacob Stengle's paintings reveal the enduring Ngarrindjeri spirit that inhabits this apparently colonised space [246]. For Ngarrindjeri it contains the spirit of freedom from dispossession and oppression. They have continued to express their cultural identity and envision their relations to others (including the Australian state) through their artistic traditions. The Hindmarsh Island case has provided Ngarrindjeri artists with a potent icon through which to explore the frontiers between Indigenous culture and the state.

The Hindmarsh Island issue raises challenges for many Australian institutions—museums, universities, the legal system, Australia's official history, and the Australian nation itself. None are left unscathed by the questions it raises. The system of heritage legislation, the legal system, and the academic disciplines that claimed to specialise in an understanding of Indigenous culture generally failed to address adequately the popular assumptions of white Australia about culture, authenticity, and legal rights that were highlighted by the Hindmarsh Island controversy. The negative focus on Indigenous culture, central to the Hindmarsh Island debate, prepared the way for the conservative federal government's reaction to the High Court's Wik ruling and proposed changes to native title and Indigenous heritage protection legislation.

In raising questions about Indigenous culture, the Hindmarsh Island issue became part of a much broader debate about Australian identity and the legitimacy of the Australian state in relation to native title. The interface between Indigenous people, government, and development is a crucial site for the invention of Australian identity. The millennium, the native title debate, and specific issues such as Hindmarsh Island came together at a crucial time, when Australia was re-shaping itself in readiness for a possible republic and a new century. STEVE HEMMING

246. Jacob Stengle,
Hindmarsh Island, 1996.
Acrylic on board,
145 x 122 cm.

Berndt, R. M. & Berndt, C. H., *From Black to White in South Australia*, Melbourne, 1951; Kartinyeri, D., *Ngarrindjeri Anzacs*, Aboriginal Family History Project, Adelaide, 1996; Langton, M., 'Urbanizing Aborigines: The social scientists' great deception', *Social Alternatives*, vol. 2, no. 2, 1981; Mathews, J., *Commonwealth Hindmarsh Island Report*, Adelaide, 1996; Stevens, I. E., *Report of the Hindmarsh Island Bridge Royal Commission*, Adelaide, December 1995; Tindale, N. B., *Journal of Researches in the South East of South Australia*, vol 2, Anthropology Archives, South Australian Museum, 1934–37.

20.4 Tales of Torres Strait: The historical novel and localised memories

In 1933 the prolific Australian author Ion Idriess published *Drums of Mer*, a novel set in the Torres Strait Islands in the nineteenth century. This popular novel, I would suggest, has had greater impact on Yam Island people than its anthropological cousin, A. C.

Haddon's six-volume *Reports of the Cambridge Anthropological Expedition to Torres Straits* (1901–1935) [see 7.1], and constitutes an important source of cultural and historical information. It is, however, only one of the many means by which Yam Island people have been able to construct a strong sense of themselves as a unique people, and as members of the Australian nation state.

Some literary evaluations of *Drums of Mer* describe it as having limited merit, as being racist, and as representing Torres Strait Island people as savages, and whites as inherently adventurous and civilised. Despite being shunned by literary critics, many of its author's books were very popular; as late as the 1980s, Idriess remained the single bestselling author on Angus & Robertson's list. Referring to his popularity in Australia as a whole, David Foster quotes Idriess as saying: 'the public … liked my books, each year they could depend on getting life in some wild part of Australia they knew nothing about and was quite different from the other parts. That was one of the secrets of my success.' In my research in the Yam Island community, begun in 1980, I was many times directed to this book. Initially uncertain why people were equating a novel with 'history', I began to understand much later that the stories Yam Islanders tell themselves, and others, are their history, and that the storytelling component of *Drums of Mer* warranted exploration. The contemporary use of this novel by some Yam Island people, especially men, constitutes one of the many means by which they articulate to themselves and to others who they are and where they have come from. It remains an important document, through which they have come to know themselves, White Others, and their intersecting pasts in the nineteenth century.

As a story, the novel could be cast as '**history**', particularly since *Drums of Mer* is a colourful embellishment of known historical events and characters drawn essentially from Haddon's *Reports*. Before they were reprinted in 1971, the latter were virtually impossible for Islanders and non-Islanders alike to access, and remain difficult to acquire. The novel, on the other hand, has been reasonably cheap and quite accessible to Torres Strait Island people since the 1950s. While the *Reports* have had limited popular appeal on Yam Island to date, it is not simply the availability of *Drums of Mer* that accounts for its popularity. Rather, it is the form of narration that renders its contents a meaningful, believable, and authentic representation of tradition. Haddon's *Reports* and *Drums of Mer* are not competing representations of nineteenth-century Torres Strait— one as predominantly truth and the other predominantly fiction. Instead, one is the romanticised refraction of the scientific other.

Idriess was indebted to the *Reports*, and re-presents some of the material collected by the expedition. In this sense, his book is derivative: it can only exist in relation to the Haddon texts, which likewise can only exist in relation to Torres Strait Island people's culture and history—as recorded and recreated in the nineteenth century. Like Haddon and his team, Idriess drew upon the knowledge, experience, and interests of the resident missionary William McFarlane, to augment his material and facilitate his entrée into Torres Strait. In his Author's Note to the *Drums of Mer* Idriess says: 'This story is in all essentials historical fact … Ethnologically, too, the story is correct. Here, I am greatly indebted to the splendid *Reports of the Cambridge Anthropological Expedition to Torres Strait* and to that living mine of Torres Strait ethnological lore the Rev. W. H. MacFarlane [sic] … who put me in personal touch with the Island historians.' McFarlane himself says in the book's foreword that '*Drums of Mer* comes with very strong appeal. There are some who may think that Mr Idriess is giving us simply an imaginative picture, but the author has travelled the Strait with the discerning eye and contemplative soul of the artist who is satisfied only with first-hand colour, and who, while blending history and romance with subtle skill, at the same time keeps within the region of fact.'

It is precisely in the way Idriess blends and blurs, manoeuvring himself and his characters 'within the region of fact', that the full impact of his narration is felt. He re-presents the substance of the *Reports* in the genre of the historical novel, brimming with romance and adventure, while at the same time authenticating it with photographs of known individuals, places, maps, cultural objects, and regular references to explorers. These inclusions add to the level of uncertainty for the reader about what is purely imaginative as opposed to what is more firmly realistic. To add to this skilful blurring of artistic and historical conventions, the author's voice interrupts at regular intervals, bringing the audience back to the present. This device of collapsing the twentieth century into the nineteenth is a direct address to the readers, drawing upon their familiarity with the history of colonialism in Torres Strait. In addition, the hero Jakara, a white castaway, regularly anticipates the future by referring to historical events which are known to have occurred after the time of the novel.

Part of the success of *Drums of Mer* stems from Idriess's memorable storytelling. Moreover, his recounting of events and persons in the past closely approximates the traditions of Yam Island storytelling (*yan stori*), through which Yam Islanders are placed in the past and the present. In Idriess's narrative the same effect is achieved. While the novel is not about Yam Island—most of the action takes place on Mer (Murray Island)—there are enough references to significant places, people, and events to attract the Yam Island reader and to enable some to say their culture and history are represented in it. All Torres Strait Island people know about the two spiritually powerful drums of Mer, in the eastern islands, and a book with such a title is immediately enticing. From the outset, Torres Strait Islander readers can anticipate a story about themselves and their spiritual power.

During the nineteenth century 'semi-ethnographic' novels replaced the 'fabulous travel account'. The device of mixing historical realities with imaginary events allowed the difference between 'them' and 'us' to be exaggerated. This is certainly an effect of *Drums of Mer*, for both 'us' and for 'Torres Strait Islander' readers. The representation of the Islanders as fierce, beautiful in their physique, preoccupied with magical power and warfare, as a world unto themselves (albeit on the cusp of dramatic social change through the increasing incursion of powerful outsiders), is an image which delights a Yam Islander readership. They can see it as a portrayal of themselves, and their Meriam neighbours on Murray Island, as potent and impenetrable [*247*].

Yam Islanders, I suspect, see themselves as central subjects in this story. The novel tells of Kebisu, the iconic chief of the Yam-Tudu people (who have not lived on Tudu since the end of the nineteenth century), who engages in power plays with C'Zarcke the awesome Meriam priest, with their central island neighbours, and with the whites. Idriess renders Kebisu impotent in the face of change, but I do not think Yam Island people attend to this reading of the narrative. Tudu is never far away, and the inclusion of a photograph of Maino—a descendant of Kebisu—bridges this time of Kebisu to the recent past. In 1981, for instance, a woman explained that Idriess had visited Yam and referred me to the photograph of her great-grandfather, Maino.

In this story Yam Islanders, through their ancestral heroes, are cast as savage selves against savage yet fundamentally weak whites. They see the castaway Jakara as being so terrified of the power of the Meriam priests and of being forced to do the dance of death, that he escaped. And yet this semi-ethnographic novel does more than exaggerate difference; it transforms the Torres Strait Islanders of Haddon's *Reports* into individuals by breathing life into them. The text evokes the past through the senses, and celebrates it. Idriess fills out the characters with imagined intentions, emotions, powers, and sexuality, in a plot which borrows from the *Reports* and from his own imaginative repertoire. Individuals and events are created, embodied, and placed within a social landscape in which

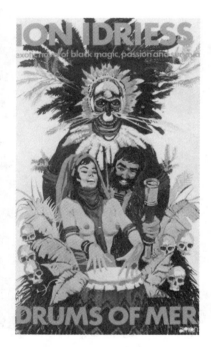

247. Cover of Ion Idriess, *Drums of Mer*, Angus & Robertson, Sydney, 1933.

Yam Island people feel at home. This physical and emotional anchoring of the novel's characters—black and white—authenticates the tale. By bringing some of the data from the *Reports* back home, *Drums of Mer* finds its mark, and this helps to account for the referential and authoritative position the text occupies for some Yam Island people. It operates as a mnemonic device, triggering memories and the imagination.

Torres Strait readers see *Drums of Mer* and its Torres Strait Islander protagonists C'Zarcke, Kebisu, the Pretty Lamar, and Beizam as standing outside, and in opposition to, European society. This particular past, with these places, these people, and these practices as related by Idriess, constitutes an important point of reference for Yam Island people. In this history, Yam Island people see themselves as opposing the increasing presence of white invaders from the sea, while being intrigued by and envious of their obvious power; they see themselves as actively incorporating some of the foreigners into their own society, but on their own terms.

The fact that Kebisu and others participate in a coherent story, in which people are accurately located in place and time, gives *Drums of Mer* an orthodoxy and authority. Idriess romanticises a particular era in Torres Strait history drawn from the *Reports* and from Torres Strait Island people themselves. In attending to the way in which Idriess uses *yan stori,* the impact of *Drums of Mer* for Torres Strait Islander readers can be approached. Edward Said reminds us that it is through stories that 'colonized people … assert their own identity and the existence of their own history'. Through this particular story, some Yam Island people can be seen to be doing precisely that.

MAUREEN FUARY

Foster, D. (ed.), *Self Portraits*, Canberra, 1991; Fuary, M. M., 'A novel approach to tradition: Torres Strait Islanders and Ion Idriess', *Australian Journal of Anthropology,* vol. 8, no. 3, 1997; Idriess, I., 'Ion Idriess: Self-portrait', in D. Foster (ed.), 1991; Said, E. W., *Culture and Imperialism*, London, 1993; Shoemaker, A., *Black Words White Page: Aboriginal Literature 1929–1988,* St. Lucia, Qld, 1992.

20.5 Aborigines and cars

As a potent symbol of modernisation, the motor car may have an ambiguous status for Aboriginal people. The car can be associated with the modern fact of dispossession, certainly; but it may assist in the repossession of country, too.

The Aboriginal road narrative—a genre constituted in some recent cinema [see 13.1] and literature in Australia—provides a focus for the ambivalent role of the car, especially in relation to the law, as in Phil Noyce's film *Backroads* (1977). In Ned Lander's film *Wrong Side of the Road* (1981), old Holdens are central to the lives of Aboriginal rock groups, No Fixed Address and Us Mob, as they go on tour [see 15.2]. The Aboriginal road narrative can end by having its characters drive away, as Lander's film does, or it can end abruptly—as in Archie Weller's novel, *The Day of the Dog* (1981) [see 14.1], based in Perth, which concludes with a high-speed police chase and a spectacular car crash. This Gothic, moralising account places Aboriginal youth firmly on the wrong side of the law and sees the heady freedom associated with the car as leading inevitably to arrest, closure, and fatality. Certainly this is an available narrative for expressing the misfortunes of modern life for young Aboriginal people. Steve Mickler has looked at newspaper reporting in Perth of Aboriginal youth gangs in the early 1990s, showing that the *West Australian*'s claim that 'more than half the young criminals caught in high-speed chases by the police are Aboriginal' is perfectly consistent with a **media**-orchestrated racism which scapegoats these groups as urban, joyriding terrorists. A lighter account of an Aboriginal man's relationship to his vehicle—still on the wrong side of the law—is given in Aleksi

Vellis's film, *The Life of Harry Dare* (1995). Harry recovers a submerged Kombi van in Adelaide, and nurses it carefully back to health. Possession and repossession work together here through this Aboriginal resurrection—and restoration—of a car.

Robert **Bropho**'s [see also 2.5] short tale, 'The great journey of the Aboriginal teenagers' also works as a road narrative. This story similarly places Bropho and his teenage friends on the wrong side of white Australian law. But the tale is never sensationalist; in fact, it unfolds mostly as a kind of matter-of-fact comedy. The boys begin their 'run' from the police by boarding a train from Perth into the country. The first stop is at 'my auntie's place': the country here is mapped in terms of the location of Aboriginal relatives. The boys later steal a Holden utility and drive down to the narrator's brother's place. The utility gets a flat tyre, so the boys jump a train. Arriving at Kalgoorlie, they steal another car and head north, later picking up a half-ton International truck: 'through Katherine Valley … we got to Wiluna … we went through Yandl station and Roy Hill and Bonny Downs … we headed for Port Hedland.' The boys are caught, however, and locked up at Port Hedland; but they escape, steal a boat and try to row 'to Singapore'. Caught again off-shore, they are taken back to Fremantle prison: 'And that's where the journey of the teenage Aboriginals—that's us—in the late forties through the fifties and early sixties ended up.'

The detailed mapping of this 'great journey', with places sometimes identified with other Aboriginal people including relatives, seems to amount to a practice of repossession in the context of dispossession. The boys are dispossessed enough to entertain the idea of leaving the country altogether by rowing to Singapore; at the same time, the journey makes their social group coherent through its shared opposition to 'white law' and its movement through a sequence of places which—in the retelling of the story to the granddaughter—become iconic. The route is a kind of modern 'songline', in other words. Certainly Bropho's road narrative 'ends up' with the Aboriginal boys in prison—but this is not a 'fatal' ending. In fact, it is quite the opposite: the prison itself becomes another in a sequence of places across country denoting Aboriginal self-identification [see also **prison art**].

The films and stories discussed so far each show their vehicles to be laden with Aboriginal passengers, as if the car is first and foremost a way of collecting people together (rather than, as in a more typical narrative about the car and modernity, alienating them from one another). The anthropologist Tamsin Donaldson has transcribed a song composed by a teenage Yolngu boy from north-eastern Arnhem Land. It seems, at first (in the English translation), as if this song is about pelicans:

> Two pelicans went along putting [fish] into their fishing nets.
> [They] went to Palmi putting fish in [their] pouches.
> [They] crept along
> putting [fish] into [their] pouches [as they went] to Palmi
> Come on! Away [you] go to Wankurr.
> [They] went along putting [fish] in their fishing nets.
> Then they went along scooping up water in their fishing nets.
> [They] run to take off … can't
> Hey! big brother, fix pelican for us!
> [They] went along putting [fish] in their fishing nets, dipping their pouches.

Donaldson notes that the song becomes problematic in the penultimate line: 'Who is big brother, and why is he asked to fix pelican?' It is necessary to know that the Aboriginal boy's father owns a yellow Toyota called *Gäḻumay* (Pelican): all the cars in this community are given names, the same names 'formerly given to canoes'. In fact, the song is about

a journey the composer made in the Toyota—and perhaps another car—with his older brother. The lines describing the pelicans filling their pouches are a metaphorical account of the way the Toyota stops to collect more passengers. The Toyota becomes central to the practice of repossession of country through 'adaptation' (the car-as-pelican; the easy translation from the canoe to the car), a feature which might allow us to think of the car in this respect as being 'Aboriginalised'.

In the art world there may be no better images of the Aboriginalisation of the car than **Lin Onus** [see 12.1; *266*, *274*] and Jonathan Kumintjara **Brown**'s [see *299*] *Cat on Nissan Dreaming*, 1989 and Michael Jagamara **Nelson**'s [see 22.3; *226*, *227*, *264*] BMW *Art Car Project*, 1989. In both cases, the metallic bodies of cars were covered with Aboriginal designs. Vivien Johnson sees the painting of the BMW as a complex entanglement of Western Desert iconography and the ideals (and nostalgias) of a modern, global corporation. The Aboriginalised car symbolises 'the collision of ... two realities'. Nelson is able to present traditional work on the body of the car, but he adapts his designs and practices so that they remain ascendant, and becomes modern in the process. Johnson notes that by the 1970s the car had potential for 'increasing contact between scattered tribal groups' and 'became a significant factor ... in the re-integration of Western Desert [see 9.5] society after the initial traumas of contact with European culture.'

In Nadine Amadio's book on Albert **Namatjira** [see 4.1, 9.1], there is a photograph of the artist sitting in a Dodge truck, a gift from the Ampol company in 1956 [*42*]. 'Albert Namatjira, Artist Alice Springs' is painted on the door. Although Namatjira's landscapes were utterly devoid of cars and trucks—or any other image of modernity, for that matter—the photograph speaks to his role in a modern world as an artist whose paintings circulate from place to place, sold here and bought there [see 9.1]. The Dodge thus offers an ambivalent image, signifying both the success of the artist and the industrialisation, and commodification, of his name and work. Forty years later, in 1996, at the Queensland Art Gallery, Aboriginal artists in the **Campfire Group** gave expression to this ambivalence through their *All Stock Must Go!* [*248*] performance installation at the Second Asia–Pacific Triennial of Contemporary Art. Here, a cattle truck stocked with Aboriginal art works both as a parody and as a reflection of the 'Aboriginal art industry' in the modern world. Margo Neale and Michael Eather note that this 'dysfunctional truck' is 'a token of a displaced people', having 'direct associations with a recent past

248. (*Below left*) Campfire Group, *All Stock Must Go!* 1996.
Installation and performance event comprising truck, tent, art works, merchandise, video, and mixed media. The Second Asia–Pacific Triennial, Queensland Art Gallery.

249. (*Below right*) Mavis Holmes Petyarre, *Untitled*, 1990.
Acrylic paint on car door, 99 x 105 cm.

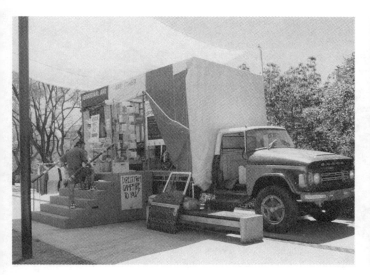

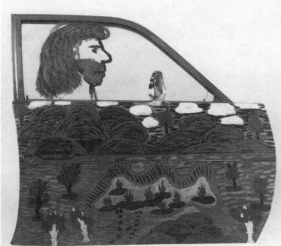

20.6 Aboriginal art in the social marketing of health

The use of art to communicate health messages has a long history in health improvement programs in developing countries. In Australia the use of Aboriginal art to promote communication in the field of health dates from the late 1970s. The first Aboriginal painting from the desert to be used in health promotion was Johnny Briscoe's caterpillar Dreamtime spirit painting *Anumarra—Working for Health*, 1979. This became the symbol for the Aboriginal health worker program in central Australia—a radical attempt to use local people as community health workers or auxiliaries, inspired by similar programs in developing countries and by China's barefoot doctor scheme. Encouraged by an Indian medical officer with primary health care experience, health workers at **Yuendumu** in 1979 made a traditional ground painting, *Napangardi Jukurrpa*, into their symbol for health, incorporating symbolic representations of family life, food, shelter, water, and warmth [*250*]. Other paintings followed: these were not only directed at an Aboriginal audience, but were also designed to elucidate Aboriginal understandings to uncomprehending, non-Aboriginal health professionals. They were early examples of social marketing—a strategy used by health developers to improve outcomes when introducing a new product or a new program. These days it often involves anthropologists [see **anthropology**] and is based on the idea that innovations will be more readily accepted if they accommodate to existing beliefs.

In the late 1980s a series of **acrylic paintings** by Aboriginal people associated with the Healthy Aboriginal Life Team (HALT) was made into posters featuring a variety of health issues—petrol sniffing, social health, and HIV/AIDS. HALT was a health intervention and promotion project in central Australia which began in 1986 as a petrol sniffing prevention team. Many of the paintings were by Andrew Japaljarri Spencer [*251*], a Warlpiri man from Yuendumu and member of HALT. He had previously been involved in the ground-breaking Warlpiri **Media** Association with Eric Michaels. The posters were mass-produced, with the explanation written alongside the painting. The use of written explanations alongside the art is also featured in *Anangu Way*, a book of primarily health-related messages painted by Pitjantjatjara-speaking people and published in 1991. Each painting is accompanied by its own explanatory story in Pitjantjatjara and English. The paintings refer to diet, processed sugars and alcohol, parenting, litter, the hunting and collecting of food, the categorisation of foods, and

ceremonial life. Some are mythological stories. Many paintings have candid and down-to-earth titles, such as *Living in Rubbish* and *Father and Mother Don't Know What's Going on*.

Another application of social marketing has utilised Aboriginal visual conceptualisations of particular messages which have been executed by non-Aboriginal artists. A team, funded through the National Campaign Against Drug Abuse in 1988, organised brainstorming workshops at different locations, in which the Indigenous health workers' ideas on recognisable health messages were sketched out on the spot by a professional graphic artist, reworked, and voted on. These were later finished and reproduced as brightly coloured posters by Redback Graphix [see 12.3]. The products included an x-ray style painting of the effects of smoking and drinking alcohol on two pregnant women, and others on the themes of drink-driving, domestic violence, and 'caring and sharing without grog' [*252*]. The most iconic of these posters was *Condoman*—the Phantom figure, with a black face, transformed into a health behaviour advertisement [*253*]. This device allowed condoms to be promoted without offence in communities that are conservative about sexual matters. The Phantom icon was first used in 1986 by the Kimberley Aboriginal Medical Services Council. Ironically, the Phantom is hardly a figure which would normally be thought of as 'culturally appropriate', since he bears no signifiers of Aboriginal cultural form. But with the colours of the image changed to red, black, and yellow—the colours of the Aboriginal flag—he was culturally recognisable to Indigenous youth in Australia.

The diagrammatic drawings and paintings of the 1970s at times sacrificed artistic design to the messages they promoted

251. Andrew Japaljarri Spencer, *Yapaku Kuruwarri (Warlpiri) (Altogether, past and present)*, c. 1987. Acrylic on canvas, 121 x 91 cm.
The written explanation for this image reads:
The painting has four parts. The first [*top*] part tells how Aboriginal people lived before white people arrived. The culture, the Dreaming, and family life were strong. The second part tells how white people came and made their camp, bringing flour, sugar, alcohol, and petrol. The third part tells how these things are used today in ways that harm Aboriginal people, who may catch AIDS, or other STDs, and suffer from family breakdown. The fourth [*bottom*] part tells of the future in which Aboriginal groups are thinking and talking about ways to solve their problems. They will keep the culture and family life, and use new Western things in healthy ways.

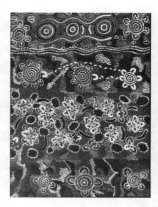

250. Health symbol for Yuendumu—Napangardi women's Jukurrpa or Dreamtime story, 1979.

in order to ensure that the message was unambiguous. They often incorporated annotations. As the health poster movement gathered pace, message was more often sacrificed to art. Eric Michaels observed that Warlpiri—and other central Australian graphics—'record ideas rather than speech, are evocative rather than denotative, and do not assure a given reading.' Michaels emphasises that Warlpiri and Central Desert 'symbols' are used as a kind of shorthand within a predominantly oral culture. Western Desert art requires explanation if particular meanings are to be communicated unambiguously to a wide audience. Realising this, Andrew Japaljarri Spencer and others have travelled the communities and 'workshopped' their art in small groups, explaining the health story it contains. Art remains a teaching tool.

Cultural identification with a health message, however, does not necessarily bring about behaviour change. Using Aboriginal art for the communication of health messages also raises issues of best practice and accuracy. It could be argued that HIV/AIDS material has particular requirements (for example presenting specific advice about condom use) which should take precedence over the art. There is undoubtedly a tension between an emphasis on art and the clarity of the communication when the theme is the improvement of Indigenous health. Certainly many Aboriginal health posters by well-known artists are used more as decoration than anything else; they may be seen on the walls of any government office, often far removed from the gaze of those whom they are intended to influence. Some argue that posters soon lose their initial power and become part of the visual furniture. Nevertheless, they have become the public and acceptable representation of Aboriginal health—an issue which is usually problematised. The Aboriginal health poster helps to soothe the harshness of the debate on premature death rates and preventable disease by implying that something is being done, that positive steps have been taken, that Aboriginal people themselves are engaged.

Individual Aboriginal artists have also used social and health problems as themes. In 1986 Koori artist Lin **Onus** [see 12.1; *266*, **274**] first visited **Maningrida**, where local painter Jack **Wunuwun** [*407*] became his mentor. Disturbed by the activities he witnessed among some of the young people, on his return to Melbourne he painted *Petrol Sniffer*, 1986, which is a stark example of this blending of styles. With its inverted figures of the youth and the skeleton, each with cans of petrol

to the nose, backgrounded by cross-hatching and the paraphernalia of sniffing, the painting has an unambiguous message. Onus showed the painting to Jack Kalakala, a senior man visiting from Maningrida; it was taken back and put up in the Maningrida Health Centre. In 1988 the Arnhem Land artists were invited to respond to Onus's paintings—just as he had expressed *their* influence in his work. Les **Mirrikkurriya** painted his own version of Onus's petrol sniffer; the boy in his painting was a particular boy [*254*]. This too is a remarkable painting, for its wholly contemporary theme is depicted on bark. Instead of the sniffer's cool-drink can Mirrikkurriya painted ceremonial dillybags which are highly significant to the Rembarrnga [see 17.1] (perhaps to warn that sniffing destroys culture and the relationship with land). Instead of chicken-wire, he used extensive cross-hatching. The youth is thoroughly modern, wearing army shorts. The skeleton evokes an x-ray image. United in their treatment of a contemporary theme these two artists, from very different backgrounds, demonstrate the resilience of Aboriginal art styles as well as an openness—and desire—to change.

MAGGIE BRADY

Devanesen, D. & Briscoe, J., The Aboriginal health worker training programme in Central Australia, Lambie-Dew Oration, Sydney University Medical Society, 1980; HALT (Healthy Aboriginal Life Team), *Anangu Way: Iriti pulkulpa pika wiya nyinantja munu pukulpa pika wiya kunpu nyinantjaku ngula = In the past we were happy and free from sickness; and in the future we will become strong and healthy again*, Alice Springs, 1991; Hill, P. S. & Murphy, G. J., 'Cultural identification in Aboriginal and Torres Strait Islander AIDS education', *Australian Journal of Public Health*, vol. 16, no. 2, 1992; Michaels, E., 'Hollywood iconography: A Warlpiri reading', in P. Drummond & R. Paterson (eds.), *Television and its Audience: International Research Perspectives—A Selection of Papers from the Second International Television Studies Conference, London, 1986*, London, 1988.

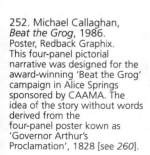

252. Michael Callaghan, *Beat the Grog*, 1986. Poster, Redback Graphix. This four-panel pictorial narrative was designed for the award-winning 'Beat the Grog' campaign in Alice Springs sponsored by CAAMA. The idea of the story without words derived from the four-panel poster kown as 'Governor Arthur's Proclamation', 1828 [see *260*].

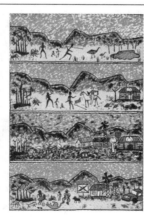

253. Cwlth Dept. of Community Services and Health, *Condoman*, 1987. Poster, Michael Callaghan and Redback Graphix.

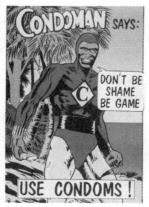

254. Les Mirrikkurriya, *Petrol Sniffer*, 1988. Natural pigments on bark, 165 x 107 cm.

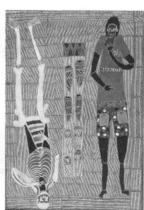

where cattle trucks were used to herd Aboriginal people onto reserves.' Dismantled and painted truck parts are then reassembled, 'causing a new form to appear, an identity altered by the journey of dislocation that preceded it … Today, Aboriginal people have repossessed these vehicles and adapted them for their own use.'

Michael Boulter describes how some artists from the Utopia community have also reclaimed car parts as surfaces for painting—turning them into a form of 'landscape'. An exhibition of painted doors and bonnets and boots, 'Art, Cars and the Landscape', was held at the William Mora Gallery in Melbourne in June and July 1990. Boulter highlights a car door painted by Mavis Holmes Petyarre [249], as well as Ada **Bird Petyarre**'s *Hub Cap*, 1991. This dot painting on a General Motors 'spare part' certainly illustrates the entanglement of traditional art work with modern industrial technology, where the latter remains distinctive and yet is Aboriginalised at the same time. 'The lion shape of the dotted centrepiece', Boulter notes, 'gives away the origins of the medium'.

When the car is taken as a symbol of modernity, some histories of early Aboriginal contact with the car can find themselves talking up Aboriginal naivety. Bill Edwards's transcription of a Pitjantjatjara Aboriginal story by Jacky Tjupuru titled 'Mutuka nyakunytja—Seeing a motorcar', for example, lifts the car out of its social context by focusing only on one Aboriginal man's surprised reaction to it. This account at least goes on to note that motor cars 'are now an ever-present and central part of Pitjantjatjara life'. These days, Aboriginal use of the car is neither naive nor enacted in isolation, as is well documented in Grayson Gerrard's fascinating article, 'Everyone will be jealous for that mutika'. Gerrard locates the motor car (*mutika*) right in the centre of contemporary Aboriginal social life. The car is a commodity; but in the Arnhem Land community Gerrard describes, 'an active process of *de*-commoditization is evident' in relation to it. This is because of 'humbugging', an Aboriginal practice directed at white Australians which means both to 'annoy' and to 'win something to one's own advantage'. This practice is used most strongly in relation to cars, not least because Aborigines own very few of them—they are broadly shared across families—compared with white people in the area. The introduction of the car and road systems in Arnhem Land has, for Aborigines, 'opened up the possibility of fast and relatively cheap movement between scattered kin and between ceremonial centres', as well as enabling goods to be easily transported. So there is a dependence upon the car as a means of repossession of country, but a scarcity of resources with which to realise this potential. Gerrard traces the means by which Aboriginal people 'humbug' whites in order to gain access to their cars: to win the car over to their advantage. She offers her own experiences as an example:

After first driving into this community, for many hours … I was descended on by people wanting lifts, angry that I was too tired to stand, let alone drive. The next day I was asked to drive back along that road for five hours to 'drop' someone at a particular destination. One woman asked me if I would 'drop' her at her outstation every barge night, over two hours of hard road. Another asked me to get up at 5 a.m. to take her to the airport. People who borrowed the car, sometimes leaving me to do my work on foot, complained that I had not put enough petrol in it.

The Aboriginal 'de-commoditization' of the car, for Gerrard, lies in this casual disregard for white 'schedules' and white notions of distance and directions for proper automobile behaviour. Her account thus works as a post-colonial allegory, describing a modern context where the white Australian relationship to the car (which may indeed be re-expressed as: the white Australian relationship to the nation) is liable to be interrupted time and again. This mode of interruption Aboriginalises the car, if only for a moment, to remind those white owners of the post-colonial fact that dispossession and

(re)possession are now thoroughly entangled. In this respect, it is worth noting the serendipitous acronym for the Council for Aboriginal **Reconciliation** in Australia, established by the Labor government in late 1991–CAR.

KEN GELDER

Amadio, N., *Albert Namatjira*, South Melbourne, 1986; Boulter, M., 'Spare part art', in M. Boulter, *The Art of Utopia: A New Direction in Contemporary Aboriginal Art*, Roseville East, NSW, 1991; Bropho, R., 'The great journey of the Aboriginal teenagers', in J. Davis, S. Muecke, M. Narogin, & A. Shoemaker (eds), *Paperbark: A Collection of Black Australian Writings*, St Lucia, Qld, 1990; Donaldson, T., 'Translating oral literature: Aboriginal song texts', *Aboriginal History*, vol. 3, nos 1–2, 1979; Gerrard, G., 'Everyone will be jealous for that mutika', *Mankind,* vol. 19, no. 2, 1989; Johnson, V., *Michael Jagamara Nelson*, Roseville, NSW, 1997; Mickler, S., 'Visions of disorder: Aboriginal people and youth crime reporting', *Cultural Studies*, vol. 6, no. 3, 1992; Neale, M. & Eather, M., 'Campfire Group: All Stock Must Go!' in *The Second Asia–Pacific Triennial of Contemporary Art*, South Brisbane, 1996; Tjupuru, J. & Edwards, B., 'Mutuka nyakunytja—Seeing a motorcar: A Pitjantjatjara text, Jacky Tjupurulu wangkanytja', *Aboriginal History*, vol. 18, nos 1–2, 1994.

21. Reception and recognition of Aboriginal art

21.1 Black art on white walls? Institutional responses to Indigenous Australian art

The response of Australia's leading public art institutions to Indigenous art is marked, with few exceptions, by decades of neglect. It was assumed that the artistic artefacts of Indigenous peoples could not be defined as 'works of art' by the dominant Western European standard. Thus Aboriginal art was not considered eligible for inclusion in collections which focused primarily on paintings and sculpture in the European tradition [see 6.1]. This attitude prevailed until the 1980s, when several factors combined to alter institutional perceptions of Indigenous art. Prominent among these was the sheer volume of work that was beginning to appear, from many parts of the country. This work was also being exhibited widely—primarily in private and commercial galleries, artists' cooperatives, and university galleries and museums. Simultaneously, Indigenous artists were beginning to gain ground in their struggle to have their work accepted as art, and to break into the art mainstream on their own terms. They were supported by a number of commentators, art historians, community art advisers, and curators who confronted the prevailing Eurocentric view of art, and who recognised that Aboriginal art could be appreciated not only in terms of Indigenous systems of artistic creation, but also as a major tradition of contemporary Australian art. As they argued, this tradition is not only the longest continuing tradition of art in the world, but it is also unique to Australia. Today, Indigenous art is a key component of the collections and **exhibition** programs of most major public art institutions in Australia.

A people without art?

Historically, the collection of Indigenous art, material culture, and even human remains [see 11.8; **Burnum Burnum, repatriation, Trukanini**], was the prerogative of museums of natural history and ethnography, particularly those attached to universities and their departments of **anthropology**. Collections such as that of the South Australian Museum (SAM) are vast: their objects may be counted in the thousands. The nineteenth-century presumption that Aboriginal culture was impoverished, and lacked art, continued to prevail into the twentieth century. Traditional Indigenous objects such as **bark paintings**, painted sculptures, and objects woven in natural fibres [see 17.1] were regarded primarily (or solely) as functional items, whether made for ceremonial or everyday use, and therefore as outside the definition of art in the European paradigm. Furthermore, these works were believed to be produced communally, as slavish replicas of age-old models without any possibility for the innovation, individuality, or personal expression so prized by the European art world.

Nevertheless, the early history of interest in Indigenous art contained the seeds that were to develop into the dramatic change of attitude in the 1980s. The first recorded exhibition of Aboriginal work as art consisted of a group of drawings made in Darwin in 1888 and shown in the Northern Territory pavilion of the Centennial International Exhibition in Melbourne later that year [see 6.6; **prison art**]. The drawings were listed as works of art, not ethnography, and aroused the interest of the director of the National Gallery of Victoria (NGV). In 1912, Baldwin Spencer collected bark paintings and other art objects in western Arnhem Land. A selection of these was shown in 1929 at the then National Museum of Victoria's exhibition 'Australian Aboriginal Art' [*255*], and again in 1943 in its 'Primitive Art Exhibition', which included work from Asia, Africa, and Oceania. The term 'primitive' reflects the Social Darwinism of the times, indicating a particular attitude to the development of art and to Aboriginal art's place within it. Aboriginal works were even occasionally included in exhibitions of Australian art such as 'Art of Australia 1788–1941' which toured the USA and Canada in 1941–42.

255. Catalogue cover, *Australian Aboriginal Art*, 1929.

Indigenous art as art: The beginnings

From the late 1940s, anthropologists Ronald and Catherine Berndt actively sought to collect and document works of art in the course of their research in several Aboriginal communities in Arnhem Land and the deserts of Australia. Through their extensive fieldwork, they made personal contact with many artists. In 1957 they organised 'Australian Aboriginal Art: Arnhem Land Paintings on Bark and Carved Human Figures' at the Art Gallery of Western Australia (AGWA). The exhibition is highly significant: it was the first to situate identified and named artists within regionally-based styles. An art-historical attitude towards Aboriginal art had begun to emerge.

In 1948 C. P. Mountford led the Australian–American Scientific Expedition to Arnhem Land which, *inter alia*, collected several hundred bark paintings, sculptures, and objects. During the 1950s many of these were distributed among several State art galleries, arguably to encourage the institutions to exhibit Aboriginal art, if not to build their own collections.

The interest of private collectors also contributed to the growing acceptance of Aboriginal art as a valid form of artistic expression, despite the fact that for several of them Aboriginal art represented the last collectable, so-called authentic, examples of the art of a stone-age society. The enthusiasm—and the purse—of one American collector, Dr Stuart Scougall, allowed the Art Gallery of New South Wales (AGNSW), in Sydney, to begin its own collection of Aboriginal art through the deputy director Tony Tuckson. In the main, Scougall and Tuckson collected works from Arnhem Land and Bathurst and Melville Islands [*96, 205*]. Thus Sydney's became the first State gallery to actively collect and display Aboriginal art—even though pieces were often shown in conjunction with the art of Oceania.

The eventual acceptance of Aboriginal art by public institutions owes much to the more general social and political advances of the Aboriginal community in the late 1960s and 1970s. After the **referendum of 1967**, the campaigns for **land rights**, social justice, and equality gathered momentum in the early 1970s, and Aboriginal people were successful in promoting their culture, aspirations, and values in the Australian public domain, where previously these had been ignored.

Indigenous people recognise that art is an essential component of traditional life, and therefore a force for change. In 1973 the **Aboriginal Arts Board** was established under the aegis of the newly formed Australia Council to support the production and distribution of Indigenous art. Art centres [see **art and craft centres**] were established in many Aboriginal communities to coordinate the making of art, to mediate between artists and

the wider art world [see 5.2, 8.2, 21.2], to protect artists' rights in terms of financial returns and **copyright** [see 22.1], and to promote and sell art and artefacts. The art centres took over the role formerly played by missions, which had encouraged the production and sale of art and artefacts to raise funds for their endeavours. The sale of these objects through mission shops in the major cities contributed to the visibility of Aboriginal art in Australia, and the Commonwealth government later assisted in the establishment of Aboriginal arts and crafts galleries in several Australian capitals to provide the outlets for art production. By the late 1980s this role had been taken over by private and commercial galleries, some dedicated solely to the sale of Aboriginal art.

The public art institutions enter the field

Against the backdrop of a burgeoning market for Aboriginal art, public art institutions began to take a proactive role in collecting and promoting Indigenous art and artists, thereby providing the Establishment's stamp of approval. Where they existed, public collections until the 1970s had tended to include only 'classical' examples of Aboriginal art: bark painting and sculpture from the north predominated. This changed during the 1980s (and at AGWA in the 1970s), when several institutions began to employ specialist staff and to develop policies to incorporate the acquisition of Aboriginal art as part of their collecting and exhibition programs.

In 1983 the AGNSW appointed Djon Mundine as curator-in-the-field; he was the first Indigenous curator to be employed by an art institution. Under his stewardship the gallery established a dedicated space for the display of Aboriginal art, to be followed by a permanent gallery, Yiribana, and the establishment of a department of Aboriginal art within the management structure of the gallery. In 1984, the Museum and Art Gallery of the Northern Territory (MAGNT) in Darwin, which had commenced collecting in 1970, inaugurated the annual National Aboriginal Art Award, and a collecting program which continues to be augmented by the acquisition of the prize-winning works. By this time, the NGV was actively building on its fledgling collection of Aboriginal art.

By 1984, the National Gallery of Australia (NGA), which had opened to the public in 1982, had recognised the need to focus on the collection of Indigenous art. It established a department of Aboriginal and Torres Strait Islander art with a budget dedicated to acquisitions, thereby guaranteeing that a minimum amount would be spent annually on Indigenous art. Whereas older collections were already housed in the major ethnographic and anthropological museums around the country, and State galleries had commenced to acquire Aboriginal art on a limited scale, the NGA's articulated policy was to seek out Indigenous art as it happened, and, through the addition of historical works when available, to build a national collection that was comprehensive and representative of regional styles, art forms, and materials.

As the 1980s drew to a close, public collections had broadened in scope to include the recent developments in **acrylic painting** in the desert [see 9.4, 9.5] (largely ignored during the **Papunya** movement's formative years in the 1970s), weavings and textiles [see 17.1], posters [see 12.3], and prints [see **printmaking**], and the work of urban-based artists [see 12.1]. It took until the 1990s for the remaining State galleries to establish programs and collections of Indigenous art; the Queensland Art Gallery was encouraged by the success of their exhibition 'Balance 1990' [see 8.2, 12.1] to commence a collection. The Art Gallery of South Australia began to collect Indigenous art, on a selective basis, to complement rather than compete with the extensive holdings of the SAM, situated next door.

Changing attitudes and approaches

The decision of public institutions to collect the art of Indigenous Australians precipi-

tated the adoption of new museum practices to manage, research, promote, exhibit, and make Aboriginal art accessible in ways which accorded with Indigenous customs and beliefs. It also entailed the involvement of Indigenous people in the development of programs and policies. The monolithic character of Australian art galleries began to disappear—no longer were they simply bastions of Western European culture, managed by white Europeans for a white audience. Today, most public institutions attempt to cater for the plurality of Australian society, in the recognition that art and gallery audiences are not homogenous. In the area of Indigenous art, most institutions employ specialist curators, many of whom are Indigenous, who facilitate the processes of consultation and collaboration with Aboriginal communities, traditional owners, and artists.

These curators have introduced changes to traditional museum procedures from the most fundamental level upwards. Until the early 1980s, for example, it was common to find Indigenous works exhibited in public institutions with labels which failed to identify the artist by name. Nowadays, most exhibition labels not only name the artist, but also the basic social affiliations (such as clan and language group) which make up their identity, much in the same way as European artists are identified by their country of origin or language [see 3.1]. Mourning customs are also followed. Acquisitions policies are developed so that they encompass all Indigenous art forms, especially where these may be gender-based: if weaving in Arnhem Land [see 17.1] and textile-making in the desert [see 17.4] are not collected, the work of women is largely eliminated. Regular consultation between museums and communities has become integral to the proper management of collections and to the provision of accurate and culturally sensitive public access to the works through exhibitions and publications.

In 1993, after much consultation with Indigenous communities and collecting institutions, Museums Australia developed a set of guidelines in a document entitled *Previous Possessions, New Obligations*, for the management, care, and maintenance of Indigenous collections. Although these guidelines cover all types of Indigenous material including art, material culture, and human remains [see 8.4, 11.8; **cultural heritage, repatriation**], to a large extent they have been adopted by all public institutions. The prominent features of the guidelines are consultation and shared custodianship.

One of the fundamental shifts in attitude concerns the ownership of Indigenous art: while institutions have legal title to the objects by virtue of acquisition, they share with the traditional owners, artists, and communities custodianship of these works. It has become common practice for galleries to consult these parties regarding the various contexts in which objects are used. In 1994 the Museum of Contemporary Art (MCA) in Sydney entered into an formal agreement with **Maningrida Arts and Crafts** concerning a collection of Maningrida weavings which were purchased by the museum, with MCA and the Maningrida art centre sharing custodianship.

New kinds of exhibitions

The changes in museum practice are perhaps most conspicuous in the curatorship of exhibitions. Institutions now stage a range of exhibitions which vary in type and purpose and which have developed over the years. Where once exhibitions tended to be surveys, they are now likely to be more specific and tightly focused. While Aboriginal art was included in survey exhibitions of Australian art such as the one organised by Mountford, and the Jubilee Exhibition of Australian Art which toured the State galleries of the Commonwealth in 1951, it was not until 1960 that the State art galleries arranged an exhibition dedicated solely to Indigenous art—'Australian Aboriginal Art'—which toured to most State institutions. The tendency for art galleries to treat Aboriginal art as a generic type, separate from the mainstream of art, continued. This was also true of touring

exhibitions such as 'Aboriginal Australia' in 1981–82. This exhibition was organised by the Australian Gallery Directors Council, but the curatorial input was from leading anthropologists.

While survey exhibitions continue to be staged, the 1980s marked the beginning of exhibitions on particular aspects of Aboriginal art. Although in the main these were based on the classic stylistic regions, they represent some of the first attempts at art historical analysis. In 1984 the NGV staged 'Kunwinjku Bim, Western Arnhem Land Paintings' and in 1985 'The Face of the Centre: Papunya Tula Paintings 1971–1984'.

Of several general survey exhibitions, the large exhibition 'Aboriginal Art: The Continuing Tradition' at the NGA in 1989 did much to establish the place of Indigenous art in the Australian artistic mainstream, coming as it did at the end of a series of major national survey exhibitions staged to mark the bicentenary. NGA's Aboriginal statement for 1988 had been the *Aboriginal Memorial* [see 6.3; *38*, *74*]; 'The Continuing Tradition' in the following year symbolised the resilience and strength of Indigenous culture. Drawn almost entirely from the NGA's own collection, the exhibition showed art from each region of Australia, including that of urban Indigenous artists who had been thus far largely neglected by the art institutions [see 12.1].

During the 1980s, the relationships being formed between art institutions and Aboriginal communities led to many collaborative ventures which heralded changes in curatorial policy, collection management practices, and the shape of exhibitions. In 1982 'Aboriginal Art at the Top' had been a collaboration between MAGNT and the art communities of Arnhem Land and its surrounds. The Power Institute (now MCA) at the University of Sydney acquired the entire collection, which went into the exhibition 'Objects and Representations from Ramingining' in 1984 (it was later shown at the MCA in 1996 as 'The Native Born') [*256*]. In 1987–88, in close cooperation with the community of Ramingining, the NGA underwrote the production of the *Aboriginal Memorial*, establishing a relationship which was to lead to the exhibition 'The Painters of the Wagilag Sisters Story 1937–1997' [*257*] which is widely regarded as a model of liaison between institution and community.

The 'Wagilag Sisters' exhibition examined the transfer of traditions over time, tracing the development of one genre of painting over four generations of artists. It was developed over seven years of negotiations between the NGA and the senior owners and custodians of the Wägilak narrative and its associated land, rituals, and paintings [see 6.2; *150*, *316*, *325*, *337*]. Paintings in this genre had started leaving the area as early as the 1930s and were now found in collections all over the world. The exhibition provided the means to locate these works and, in the form of photographs, to return them to the community. In essence, the Yolngu community of the **Ramingining**, Milingimbi, and **Yirrkala** area were rediscovering six decades of their artistic heritage. As a result, Yolngu interest in the exhibition was high; every stage of its development and of the accompanying catalogue was negotiated between the community and the National Gallery.

Issues which were of primary concern included the final selection of works, and the exclusion of those regarded as too sacred–secret for public display. On the advice of the community, the layout of the exhibition was determined according to the sequence of conception sites of the artists, and a clear division was made between those with primary and secondary rights in the associated rituals. The catalogue included contributions from artists, and traditional owners and custodians, who updated the documentation of the earlier works where the original documentation was regarded as inaccurate or irrelevant. One of the increasingly common features of exhibition catalogues is to give the artists the primary voice, rather than overemphasising interpretation by outsiders.

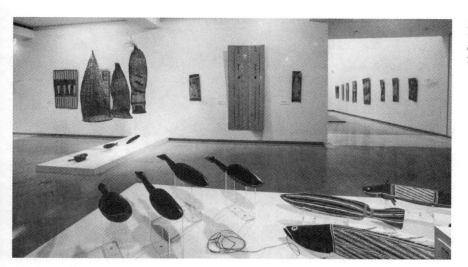

256. Installation view of 'The Native Born', Museum of Contemporary Art, Sydney, 1996.

With Aboriginal art becoming an essential part of art gallery collections and programs, and the appointment of specialist staff, the potential exists for exhibitions which reflect multiple and complex aspects of Indigenous art. The NGA's 'Flash Pictures', for example, examined the aesthetic qualities of paint and painting from the Indigenous perspective. In close collaboration with artists and their communities, galleries began to stage exhibitions of the work of individual artists. In 1989 MAGNT staged an exhibition focusing on a collection of work entitled 'Yathalamarra' by David **Malangi**. George **Milpurrurru** was the first to be honoured in this way at the NGA, in 1993.

Indigenous art goes international

Art institutions in Australia also recognise their responsibility to promote Aboriginal art and artists abroad so that Indigenous art no longer remains outside the mainstream in the world's art. Several survey exhibitions have introduced the overseas art public to the richness and diversity of styles, traditions, techniques and narratives encompassed by the phrase 'Aboriginal art'. 'Dreamings', organised by the SAM, opened in New York and toured the USA in 1988–89. The exhibition encouraged a small number of American collectors to collect Aboriginal art. Also in 1988, MAGNT toured 'The Inspired Dream' through South-East Asia, and in 1992 the AGWA took 'Crossroads: Towards a New Reality, Aboriginal Art from Australia' to Japan. 'Aratjara: Art of the First Australians', which successfully toured major art institutions in Europe in 1993–94, was organised substantially through the Aboriginal Arts Board but relied on the support of (and loans from) art institutions and museums. It did much to dispel the stereotype, still prevailing overseas, of Indigenous Australian art as merely 'ethnographic'. The NGA's overseas exhibitions such as 'The Eye of the Storm', shown in India in 1996, and 'World of Dreamings', at the Hermitage Museum in St Petersburg in 2000, have concentrated on a small number of artists. NGA's European tour of the *Aboriginal Memorial* in 1999–2000 [*38, 74, 271*] fostered a greater awareness of the scope and relevance of contemporary Aboriginal art in the modern world.

The involvement of art institutions in major national and international exhibitions, such as biennales, is a further strategy in gaining acceptance for Indigenous Australian art in the world context. Aboriginal artists made the first of their now regular appearances at the Biennale of Sydney in 1979, followed by the AGNSW's Australian Perspecta

257. The opening of the 'Painters of the Wagilag Sisters' exhibition, National Gallery of Australia, Canberra, 1997.
The Governor-General Sir William Deane is instructed in the implanting of *malawirr*, the lightning tongue of the ancestral spirit, by Gawirri<u>n</u> Gumana.

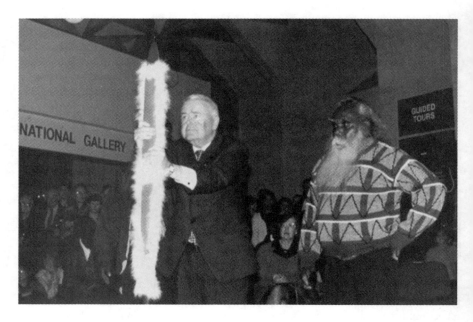

of 1981. AGWA supported the first Aboriginal artists—urban-based Trevor **Nickolls** [*315*] and **Rover Thomas** [*136, 219*] from the Kimberley—to represent Australia officially at the Venice Biennale in 1990. The MCA staged 'Tyerabarrbowaryaou II—I shall never become a white man', at the Fifth Havana Biennial in Cuba in 1994. In Venice in 1997, the AGNSW supported 'fluent', which was organised by a team of Aboriginal women curators and featured three women artists—Emily Kame **Kngwarreye** [see 9.6; *123, 216, 225*], **Judy Watson** [*40, 402*], and Yvonne **Koolmatrie** [*159*].

Since the 1980s, there have been dramatic changes in Australian art institution policies and strategies on Indigenous art. Stereotyped and outdated attitudes have been revolutionised, both within art institutions and beyond into the public domain. Solo exhibitions of artists show that individuality of style is not at odds with communal artistic endeavour. Exhibitions such as 'The Wagilag Sisters' are evidence that artistic traditions are dynamic, not fossilised, and allow for innovation. Indigenous Australian art is no longer regarded as 'primitive', but as a sophisticated reflection of the contemporary realities of its makers. Far from being neglected, it is now regarded as an integral part of institutional art collections and programs. The sweeping changes in institutional attitudes, policies, practice, and programs have promoted a better awareness, understanding, and appreciation of the realities and complexities of Indigenous Australian art, culture, and society.

WALLY CARUANA

Berndt, R. M. & Berndt, C. H., *Australian Aboriginal Art : Arnhem Land Paintings on Bark and Carved Human Figures*, Perth, 1957; Caruana, W. & Lendon, N., *The Painters of the Wagilag Sisters Story 1937–1997*, Canberra, 1997; Cooke, P., & Altman, J. (eds), *Art at the Top*, Maningrida, 1982; Cooper, C., Morphy, H., Mulvaney, J., & Peterson, N., *Aboriginal Australia*, Sydney, 1981; Lüthi, B., *Aratjara—Art of the First Australians: Traditional and Contemporary Works by Aboriginal and Torres Strait Islander Artists*, Cologne, 1993; Milpurrurru, G., Getjpulu, G., Mundine, D., Reser, J., & Caruana, W., *The Art of George Milpurrurru*, Canberra, 1994; Norton, F., *Aboriginal Art*, Perth, 1975; O'Ferrall, M. A., *Keepers of the Secrets: Aboriginal Art from Arnhem Land in the Collection of the Art Gallery of Western Australia*, Perth, 1990; Sutton, P. (ed.), *Dreamings: The Art of Aboriginal*

Australia, New York & Ringwood, Vic., 1988; Thomas, R., Akerman, K., Mácha, M., Christensen, W., & Caruana, W., *Roads Cross: The Paintings of Rover Thomas*, Canberra, 1994; Wallace, D., Desmond, M., & Caruana, W., *Flash Pictures by Aboriginal and Torres Strait Islander Artists*, Canberra, 1991.

21.2 Marketing Aboriginal art

Indigenous Australians have always produced art in ceremonial and secular contexts, and have made and traded artefacts and commodities for millennia. At times, such trade was conducted through elaborate and extensive ceremonial exchange networks. Since first encountering Aboriginal people, Europeans have been interested in Aboriginal culture, and a great many objects were collected in the past, as artefacts and curios, for museums [see 8.1, 11.1, 21.1]. The emerging art history of Indigenous art recognises that the product was always there, but that marketing was at times highly informal and sometimes suspect. Conditions varied from place to place: there were trading posts and church-run outlets and individual interactions between Aboriginal producers and visitors or tourists [see 11.1, 18.1]. The role of missionaries in encouraging the production of Aboriginal art for sale cannot be overestimated. It was viewed as a mechanism to introduce the cash economy into remote mission communities, and to demonstrate Aboriginal cultural vibrancy and the role of missions in 'protection and preservation'. Among the earliest commercial outlets for Aboriginal art in the 1960s were the missionary society shops in Sydney and Melbourne.

Many Aboriginal artists were in a bind which was not of their making: if they produced 'genuine' artefacts, this was ethnographica for museums; if they incorporated new media and production techniques, then this was at best tourist art. These values of the dominant society were reflected in early exhibitions, overseas and in Australia, that focused on Aboriginal culture as prehistoric or 'primitive'.

The emergence of formal marketing structures

An important turning point in the emergence of Aboriginal art onto the market can be dated to the early 1970s. In 1965 the first comprehensive study of the Australian tourism industry by international consultants Harris, Kerr, Forster, and Stanton Robbins and Co. had identified an important niche for Aboriginal people in the future of the emerging tourism industry. These consultants recommended the establishment of an Aboriginal arts industry and government intervention to create a marketing authority that would ensure quality control and authenticity. In 1971, the federal government sponsored the establishment of Aboriginal Arts and Crafts Pty Ltd. (AAC). This 'government company' played a major role in establishing credible and professionally-run outlets for Indigenous art in most State capitals for over twenty years.

The Australia Council for the Arts had an Aboriginal Arts Advisory Committee. When the Whitlam government came to power in 1972, public patronage of the arts escalated rapidly. In 1973 the **Aboriginal Arts Board** was created as a discrete and important element of the proposed Australia Council, a model that was established by statute in 1975. Since that time, the board has provided a supportive institutional and representative umbrella organisation for Aboriginal art, and provided funding for Aboriginal arts promotion, development, and marketing. The board's ambitious exhibitions program generated public interest in Aboriginal art both in Australia and overseas—purchases for exhibitions in the 1970s provided significant and strategic direct support to the embryonic arts movements in central Australia [see 9.4, 9.5] and Arnhem Land [see **Buku-Larrnggay Mulka, Bula'bula Arts, Injalak**] in particular. Grants were provided to individual

artists for professional development. The task of subsidising the AAC and its expanding network of retail outlets was transferred to the board, and a number of Aboriginal, community-based arts organisations were established and supported. These organisations, now usually called Aboriginal art centres [see **art and craft centres**], were mainly in remote localities and operated as collecting and marketing agencies. The senior staff, usually called 'arts advisers', were usually non-Indigenous. They operated as inter-cultural mediators and marketing agents between the producers and AAC, and also other commercial galleries and the producers. An efflorescence in Aboriginal arts production occurred quickly, with market demand following behind.

The fundamental shift in the early 1970s in the national approach to Indigenous Australians, from the policy of assimilation to that of self-determination and **land rights**, also had a major impact on Aboriginal arts production and marketing. Many Aboriginal people were provided an opportunity for cultural revival; others used artistic expression to make political statements about their rights in land to wider audiences; and those at newly-formed outstations on Aboriginal-owned land needed to produce art for sale to survive economically, but were also insulated from the wider society in a way that encouraged cultural reproduction. At the same time, the sudden emergence of Western Desert **acrylic painting** at **Papunya** generated excitement almost from the beginning. Arguably, the acceptance of Western Desert art was an important catalyst for the more widespread acceptance of other regional art styles as fine art.

The marketing of Aboriginal art has been a contentious issue, primarily because it has received a great deal of government financial support for the last three decades. As so often in Indigenous policy, this opened it up to relentless public, parliamentary, and media scrutiny. One unforeseen outcome is that attention has tended to focus on Aboriginal art in the remoter parts of northern and central Australia [see 12.1]. Part of the debate has been framed by the broad tension between the cultural and commercial imperatives of Aboriginal art marketing. On the one hand, there are pressures to view the marketing of Aboriginal art as commercial activity, with some expectation that demand will influence supply and that art production will enhance Aboriginal economic well-being (and even independence from state benefits). On the other hand, there is an Indigenous viewpoint, often strongly expressed, that Aboriginal art embodies living heritage [see **cultural heritage**], and its cultural integrity must be protected at any cost. Historically, the community-controlled Aboriginal art centre model has accommodated this ongoing tension well: the artists decide what is produced and the art centre has the opportunity to market work with integrity, and appropriate documentation. From the 1970s, there has been a tendency to differentiate Aboriginal fine art from tourist art, although the divide between the two broad categories is flexible (with many artists producing both) and is dictated to some extent by price. From the 1980s, Indigenous people have become more actively involved in manufacturing art for the tourist market.

The development of the market

In the 1960s, 'artefacts' were collected informally by expeditions sent by collecting institutions from overseas, and by tourists and non-Aboriginal residents of Aboriginal communities, often through bartering and haggling. Art from locations like **Yirrkala** and **Oenpelli**, sold by mission shops, was the exception. Much of the art collected in the 1960s, and even earlier, and a great deal that was sold through early retail outlets, is now finding its way onto the lucrative secondary arts market. In the 1970s Aboriginal art was 'discovered', but a high proportion, between 80 per cent and 90 per cent according to a review of the industry in 1981 (Arts Research, Training and Support Ltd), was destined for overseas.

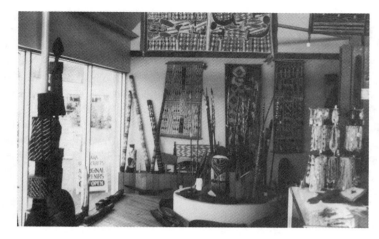

258. Aboriginal art display,
Yulara Village, Uluṟu, 1986.

The 1980s saw unprecedented growth in the fine arts segment of the industry, from an estimated value of $2.5 million in 1980 to $20 million a decade later. Much of this growth was fuelled by Australian public institutions, especially State art galleries and museums, which began to show a belated interest in the period leading up to the bicentennial in 1988.

With increased tourism in the 1980s and improved facilities at Aboriginal-owned destinations like Uluṟu–Kata Tjuṯa [see 2.4, 18.1, 18.2; *258*] and Kakadu national parks, there also came a heightened interest in authentic Indigenous tourist art. Indigenous participation in manufacturing increased markedly: items ranged from wooden, hand-crafted items to pottery, batik, jewellery, screen-printed textiles, and T-shirts, many of which are produced at central Australian communities. Indigenous and joint-venture manufacturing businesses like Balarinji [*280*] and Desert Designs were also established. The 1980s also saw the emergence of a small number of specialist commercial galleries alongside the AAC, which by this time was called Aboriginal Arts Australia Ltd (AAAL), and a greater involvement of agents acting for particular well known artists like **Rover Thomas** [*136, 219*], Jimmy **Pike** [*133, 270, 369*], Trevor Nickolls [*315*], and Robert **Campbell**, Jr [*49*].

The 1980s were a time of unprecedented Indigenous cultural revival all over Australia. Urban and rural Indigenous artists, many with formal art school qualifications, formed artists' cooperatives: the most renowned is **Boomalli Aboriginal Artists Co-operative** in Sydney where a number of important artists began their careers. Major regional art styles, like that of Torres Strait [see 7.2, 7.4, 7.5], made a re-emergence, facilitated in large part by the Cairns College of TAFE [see **Far North Queensland Institute of TAFE**] and other art schools.

The emergence of nation-wide strategies

A political dispute in the late 1980s over marketing between most art centres, represented by their lobbying organisation—then called the Association of Northern and Central Australian Aboriginal Artists—and AAAL, precipitated a national review of the industry by the Department of Aboriginal Affairs in 1989 that ultimately resulted in some major changes in the 1990s. Because art centres boycotted AAAL, the company started dealing directly with artists in Melbourne, Sydney, Perth, and Alice Springs. This revealed that there were even more producers than the estimated 5000 supported by art centres. After 1991, when AAAL lost government support, private sector commercial galleries became the lynchpins of the fine art industry. Most dealt directly with art centres, but also with their own stables of urban-based artists.

The 1990s saw consolidation of the Aboriginal arts industry, a new sophistication and knowledge among fine art collectors, who counted more and more Australians among their number, a growth in manufactured tourist art, and changes in marketing that reflected this new stability. The 1989 review of the Aboriginal arts and crafts industry resulted in growth of support for Aboriginal art centres, under the **Aboriginal and Torres Strait Islander Commission**'s (ATSIC's) National Arts and Crafts Industry Support Strategy. This program, with its annual budget of $6 million, provides grants to about forty art centres. These are mainly in remote regions, and disadvantaged in terms of marketing. Three Indigenous arts advocacy agencies—Desart for central Australia, the Association of Northern, Kimberley and Arnhem Aboriginal Artists for the north and the Kimberley, and the National Indigenous Arts Advocacy Association in Sydney—were also supported by government. The Aboriginal and Torres Strait Islander Arts Board of the Australia Council focused its support on arts promotion and advocacy and professional development for key Aboriginal artists. To simplify a little, ATSIC focused all its support on community arts organisations, whereas the Australia Council also supported individuals.

Structural changes in the 1990s

The late 1990s also saw the emergence of a number of marketing issues that reflected structural changes in the industry. From the mid 1990s a vibrant, secondary Aboriginal art market developed. The last two specialist Aboriginal art auctions of the twentieth century generated over $4 million in sales, an amount that exceeds the estimated value of the entire industry two decades earlier. The rapid escalation in prices, especially for Western Desert art of the early 1970s, raised the issue of payment of *droite de suite* (resale royalty) to Aboriginal artists or their estates. It also raised other questions that have yet to be answered: what the effect on primary sales will be of the quantities of early Aboriginal art collected in the 1950s and 1960s now resurfacing in the secondary market on primary sales, and the extent to which auction houses may be trading and investing in Aboriginal art.

Tensions have inevitably arisen in the commercial gallery sector as a result of such rapid change. A number of remote, community-based art centres are recognising that direct involvement in retailing could maximise financial returns to producers. Direct marketing to tourist outlets in high visitation destinations like Aboriginal-owned national parks is one of the resulting initiatives. Operational bottlenecks in packaging and transporting art to the market are structural, so rather than exporting the art, some centres are importing the buyers. Specialist art tours, where art is retailed at prices that correspond with the wholesale prices offered to commercial galleries, are on the increase.

The closure of AAAL facilitated the growth of a non-government, specialist commercial gallery sector in Aboriginal art. But it also meant that AAAL was not there to set and regulate standards. In Alice Springs in the 1990s there was an unprecedented growth in commercial outlets selling Aboriginal art, much of which was of questionable quality and integrity. Relations between art centres and commercial galleries have been strained by disagreements about issues such as slow payment and poor recording of stock on consignment. Some of the older, more established, specialists resented the late arrival and relative success of new entrants to the field who had previously failed to support the Aboriginal art movement. The Australian Indigenous Art Trade Association was established in 1998, with its own code of ethical practice, as an Indigenous art version of the Australian Commercial Galleries Association.

Patronage relationships between agents and key Aboriginal artists have also become more complex and there has been a growing competition to market those artists seen as

the 'stars'. While it is normal for mainstream Australian artists to have a number of agents (usually on a State-by-State basis) there seems to have been some market discomfort that major Aboriginal artists—like Emily Kame **Kngwarreye** [*123, 216, 225*]—choose to operate in this way. The issue of authenticity has been coupled with a small number of so-called 'art scandals' concerning dubious or joint authorship [see 21.3]. The popular media appears intent on sensationalising this issue, dressing up its paternalistic inquiries about 'dots for dollars' as concerns about the cultural integrity of art. In reality, Aboriginal artists often have no access to conventional forms of financial credit, and some choose to gain access to cash by producing art quickly for sale. While some people may dislike the idea of Aboriginal artists producing art mainly for financial benefit, it is a practice common to artists everywhere.

There are, however, genuine issues of authenticity and authorship [see 22.1]. Many of the long-established art centres recognise that their competitive advantage depends on market confidence in the product, and have developed relatively sophisticated computerised databases to document and authenticate their art. There is a growing recognition among art centres that they need to control the marketing of Aboriginal intellectual property rights in art, as well as the marketing of the art itself. In the aftermath of a number of successful **copyright** infringement prosecutions there has been a growing industry in imitations, particularly manufactured products. The response has been the establishment of an Indigenous authenticity label intended as an aid for the marketing of genuine Aboriginal product.

By the late 1990s the Indigenous arts market had a value estimated as approaching $200 million a year, most of which, perhaps 80 per cent, is made up of manufactured tourist art. Of this, only a small proportion is actually made by Indigenous manufacturers. The rest is produced by non-Indigenous businesses—either with or without appropriate licensing agreements with Indigenous creators of art. Important current debates focus on how an authenticity label might help genuine Indigenous tourist art establish a competitive market niche, and how appropriate commercial agreements might be struck to remunerate artists while protecting their intellectual property in art designs.

Recently, e-commerce [see 13.5] has entered the picture, with an auction house—Sotheby's—approaching a number of key art centres to participate. While the Internet undoubtedly provides a new mechanism for promoting and advertising Aboriginal art, it is unlikely to supersede the more traditional means of exhibition, sale in commercial galleries and tourist outlets, and art auctions. Almost all Aboriginal artists continue to live in remote locations, and as long as this is the case, community-based art centres will need to be maintained: they represent the proven, cost-effective, intercultural marketing formula. But there is no doubt that more artists in remote areas will start using agents in much the same way as do successful urban and rural Aboriginal artists. This diversification in marketing modes, and some healthy competition between agents, augurs well for those Aboriginal artists whose work is in high demand. However, community-based art centres express concern that while they undertake the nurturing and development of all artists, commercial outlets and a few top artists take most of the profits.

Changes in market perceptions of Aboriginal fine art may lead to the bifurcation of the current thousands of producers into a small elite of fêted fine artists, and a much larger majority producing lower status, tourist art. This can nonetheless be authentic, have integrity, and provide important financial returns to its producers. More effective marketing and enhanced assistance to unserviced regions may see the emergence of further new and vibrant Aboriginal art movements and forms. If marketing developments in the next thirty years replicate those in the last thirty, the future robustness of the Aboriginal art industry is assured.

JON ALTMAN

Altman, J. C., 'Aboriginal art centres and NACISS', in F. Wright & F. Morphy (eds), *The Art & Craft Centre Story*, vol. 2, *Summary and Recommendations*, Canberra, 2000; Arts Research, Training and Support Ltd, Improving Focus and Efficiency in the Marketing of Aboriginal Artifacts, unpublished report to the Australia Council, Sydney, June 1981; Department of Aboriginal Affairs, *The Aboriginal Arts and Crafts Industry: Report of the Review Committee, July 1989*, Canberra, 1989; Harris, Kerr, Forster, & Stanton Robbins & Co., *Australia's Travel and Tourist Industry*, report prepared for the Australian National Travel Association, Sydney, 1965; Jones, P., 'Perceptions of Aboriginal art: A history', in P. Sutton (ed.), *Dreamings: The Art of Aboriginal Australia*, New York & Ringwood, Vic., 1988; Morphy, H., 'Audiences for art', in A. Curthoys, A. W. Martin, & T. Rowse (eds), *Australians from 1939*, Broadway, NSW, 1987; Morphy, H. & Boles, M. S. (eds), *Art from the Land: Dialogues with the Kluge–Ruhe Collection of Australian Aboriginal Art*, Charlottesville, VA, 1999; Peterson, N., 'Aboriginal Arts and Crafts Pty Ltd: A brief history', in P. Loveday & P. Cooke (eds), *Aboriginal Arts and Crafts and the Market*, Darwin, 1983; Taylor, L. (ed.), *Painting the Land Story*, Canberra, 1999.

21.3 The brush with words: Criticism and Aboriginal art

The confluence of criticism and Aboriginal art has always been a turbulent meeting of unlike practices. The newspaper review—a mix of opinion and information that attempts to assess works on sale—has a long tradition in European print culture. However, the criteria by which remote community people assess their art differ greatly from Anglo-Australian value systems. Working among the Warlpiri in the 1980s, anthropologist Eric Michaels found that concepts of neatness or satisfying design might be entertained to help shape works for European audiences. But in determining whether works were 'good' or 'bad', rights of ownership over a specific story and depth of ritual knowledge on the artist's part were paramount.

Aesthetic rather than social or religious values take clear precedence in the European context. They are the stock-in-trade of art critics assessing Aboriginal and Torres Strait Islander art. In writing for a largely Anglo-Celtic audience and avoiding the rarefied language of cultural critique, many newspaper reviewers rely on descriptive criticism. This enumerates the visual properties of a work and usually aims to praise or otherwise evaluate it. 'Formalist' criteria are most often used to translate Aboriginal painting for non-Indigenous eyes. Formalism covers the whole range of critical registers, from untutored enthusiasm at a work's visual impact (in tabloid newspapers), to detailed decipherings of complex visual effects (in essays for major exhibition catalogues). With its historical grounding in twentieth-century European, American, and Australian modernist movements, the formalist lexicon is quite readily adapted to the appearance of Aboriginal art. A telling example is the way the work of Emily Kame **Kngwarreye** [see 9.5, 9.6; *123, 216, 225*] has been understood via comparisons with familiar modernist artists, from the 'all-over' paintings of Jackson Pollock (for her abstract fields of dots), to the expressionist brushwork of Franz Kline or Tony Tuckson (for her Yam series). Debates about the cultural inappropriateness of such epithets cannot alter the fact that they have smoothed the appreciation of Kngwarreye's work for a large Australian public (including urban Aborigines familiar with Western art styles). Her works, like virtually all Aboriginal art today, were created in a situation of dynamic exchange with non-Indigenous publics that provide both audience and market. There are many signs that they have been adjusted accordingly.

It is important to note the gulf between populist art criticism, which has helped sensationalise and construct the success of Aboriginal art, and two kinds of specialist writing. The enriching conceptions of cultural anthropologists [see **anthropology**] like

Nancy Munn, Howard Morphy, and Fred Myers have not yet filtered adequately into reviewers' practice. And texts of cultural critique that deliberately address issues of criticism have generated debates little known beyond academic circles (for example Vivien Johnson, Anne-Maree Willis, or Ian McLean in journals like *Art & Text* or *Third Text*). Whereas in anthropological texts great attention is given to the integration of Aboriginal religion with the social practice of art, in much populist criticism, religion is reduced to a kind of New Age spirituality. Similarly the communal basis of Aboriginal art has been frequently neglected or misunderstood. Since the Romantic era, only works of art by exalted individual creators have qualified for full scrutiny in the art criticism of the West. Much Aboriginal art, in contrast, is collaborative or communal in production, with artists often sharing the task of depicting stories with ritually appropriate family members or friends.

In the late 1990s, this discrepancy in value systems led to a succession of exposés of 'forgeries' of Aboriginal painting in newspaper journalism and populist documentaries for television. Scandal-based stories on Kathleen **Petyarre** or Clifford **Possum Tjapaltjarri** [*220*, *227*] have given Aboriginal art a prominence rarely accorded major non-Indigenous artists. Most notorious is the case of Kathleen Petyarre, awarded the National Aboriginal and Torres Strait Islander Art Award for her *Storm in Atnangkere Country II* [*259*], in 1996. When it was claimed in the press that large sections of this work had been executed by Petyarre's former partner, a non-Aboriginal man, a campaign was mounted for the prize to be withdrawn. In these debates, critics for leading newspapers failed to comprehend the ubiquity of collaborative work in Aboriginal Australia. Others, such as the Aboriginal curator Djon Mundine, undercut these debates to reaffirm Indigenous cultural practice: the right of artists as senior custodians of sites to authorise the inclusion of less experienced people and to direct their participation in the painting process.

The other great newsworthy issue that has often impinged on art criticism is the many **copyright** [see 22.1] infringements that Aboriginal artists have sustained (and sought redress for in the courts). In Aboriginal cultures, attitudes to authorship and ownership of images are more complex than the familiar Western notion of one artist, one handmade product, one legal right: as ownership pertains to the Dreaming story more than to the mere physical exposition of it in a picture, it may also be communally held.

Aboriginal art has a close relationship to politics in Australia, not least because works of art have been used as evidence in **native title** land claims [see 3.1, 4.6, 6.1; **rights to art**]. True to the Western tradition of Kantian disinterest, art criticism has seldom addressed this directly. Yet critics can act as cultural brokers in the nexus between the art market [see 21.2] and the museums [see 21.1] that purchase and display the art, serving as cultural banks to guarantee the value of works. Museum history helps track the movement of criticism from the 'ethnographic' context (in which museums staffed by anthropologists collected Aboriginal material culture as an index of beliefs and ritual practices) to the 'aesthetic' context provided by art galleries (where Aboriginal work enjoys consideration similar to European, Asian, or American works of art). Such 'art' collecting was initiated in the late 1950s at the Art Gallery of New South Wales with the support of deputy director (and abstract painter) Tony Tuckson. The acquisition of **acrylic paintings** became widespread in Australian State galleries in the mid-1980s—a ratification that did much to open Aboriginal art to assessment by written criticism.

Earlier in the twentieth century there had been isolated cases of the critical appreciation of Aboriginal visual practice. The Sydney artist Margaret Preston's familiarity in Paris with the new valuation of African and Oceanic 'primitive art' led her to call for the study and imitation of Aboriginal aesthetics in the mid 1920s. Preston proposed a new

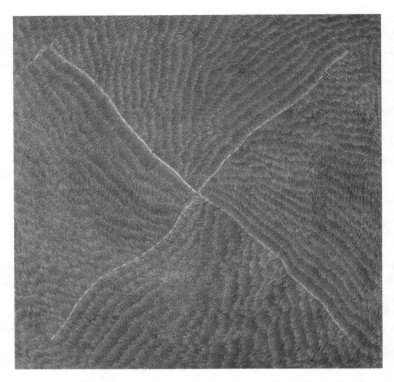

259. Kathleen Petyarre, *Storm in Atnangkere Country II*, 1996. Acrylic on linen, 183 x 183 cm.

national art inspired by Aboriginal petroglyphs, decorated shields, and rock paintings [see **rock art**]; her oils and prints of the 1940s and 1950s attempted the same. Ian McLean sees her identification with Aborigines as symptomatic of European efforts to think themselves into a land they invaded. Nicholas Thomas, in his study of European perceptions of Aboriginal art, notes that Preston's art drew a new level of attention to neglected Indigenous art traditions.

In a way different to Preston, the Arrernte artist Albert **Namatjira** [see 4.1, 9.1; *36, 42, 111, 115*], working in a Western landscape genre, staked a claim to Aboriginal artistry in the European sense—by proving that great technical skill and aesthetic sense were in the gift of Indigenous as well as settler Australians. Yet the great popularity of Namatjira's works with middle-brow Anglo-Australia only rarely resulted in entry into State art collections. He was not a member of the avant-garde, and for art critics and other arbiters of 'highbrow' taste, the literalism of Namatjira's work was read as aesthetic failure, and its apparent derivativeness as cultural contamination.

The case reveals a criterion of criticism regarding Aboriginal art that has never gone away: the idea of 'cultural authenticity'. For a decade after its appearance in 1971, **Papunya** School dot-painting in acrylic on canvas was considered by critics whose taste was formed on rock or **bark painting** as an unacceptable accommodation to Western modes of seeing [see 9.4, 9.5]. Similar arguments were used to obstruct the appreciation and purchase of urban art in the 1980s [see 12.1]. Urban Koori artists themselves have been influential in pointing to the confining notion of Aboriginality that drives such a criterion of an authentic, static culture. Combining with the emerging feminist attack on essences—be they gendered, racial, national—in definitions of identity, a model of dynamic cultural identity has come to replace older ethnographic fixities. This in turn opened the way to new appreciations of a much wider variety of Aboriginal art practice in the 1990s.

Yet the criterion of a traditional or authentic Aboriginality continues to add lustre to individual artists accepted as great by the mainstream: **Rover Thomas** [*136, 219*], Michael Jagamarra **Nelson** [*226, 227, 264*], Emily Kame Kngwarreye, and Ginger **Riley Munduwalawala** [*156*] all gain cachet through their evident connection with land and culture. The idea of arcane tribal knowledge as the invisible content of their paintings is a potent one. It is the legacy (within the European tradition) of painting as an art of the intellect, the trace of spirit or genius. While summary **Dreaming** stories dictated by artists routinely accompany works on sale, critical writing rarely enters such discussions of religious or narrative meaning. Indeed, given the status accorded Aboriginal art and its importance in the market place, the paucity of criticism is striking. Dozens of exhibitions in leading commercial dealerships are held each year without rating a comment from regular newspaper columnists. Only single-artist retrospectives or museum shows are likely to garner critical attention. This is a symptom of the disquiet some critics, curators, and dealers have with Aboriginal work: they prefer to give their attention to their own, non-Indigenous arts community. However, other newspaper critics of the 1990s like Christopher Heathcote, John MacDonald, and Susan McCulloch have given supportive exposure to acrylic and bark painting on formalist grounds. Their praise of Aboriginal art as authentic and original can be tied to their disillusionment with the local avant-garde art practice.

In the 1990s, urban Indigenous artists who had trained in art schools (and thus were familiar with conceptual art and new photomedia) have provided a challenge to assumptions about traditional Aboriginal art. The politically contentious nature of much urban art, which in the 1980s seemed to discourage the attention of art critics, in the 1990s attracted a vital stream of sophisticated writing. Photographer and filmmaker Tracey **Moffatt** [see 12.1, 12.4, 13.1; *169, 244, 326*] and painter Gordon **Bennett** [see 12.1, 22.4, 22.5; *265, 267, 275*] in particular have encouraged a minor industry of critical composition on the part of academics and curators. These have outdone one another in providing critiques using the fine tools of deconstruction, Lacanian analysis, and post-colonial critique. Both artists position their work to resist a fixed Aboriginal identity [see **Aboriginality**], rereading the history of race relations in Australia and positing marginal identities in a way that fascinates contemporary art audiences in Australia and overseas. Indeed, the cultural logic and visual techniques of younger urban Aboriginal artists find a match with the criteria of postmodern art criticism. Along with Fiona **Foley** [see 23.3; *2, 63, 164*], Destiny **Deacon** [see 12.1; *66, 67, 277, 314*], and Julie **Gough** [see 4.4, 11.5; *48*], Moffatt and Bennett reuse kitsch and historical imagery in vivid appropriations that interrogate Australian history and identity. For many critics, their formulations have a grand ethical resonance.

The fear of offending the Koori community that appears to have dissuaded potential critics of urban art during the 1980s has dissipated somewhat, although some urban artists complain that critiques which actually challenge their work are rare. Aboriginal academics and curators, still very few in number, have tended to adopt expository rather than critical stances in the texts they devote to new Aboriginal art (although Djon Mundine, Margo Neale, and Hetti Perkins are among those making a rich contribution to writing on Aboriginal art). Artists have also contributed to such writing: Gordon Bennett is unusual in composing intellectually elaborate artist's commentaries, focusing on the conflicted sense of self derived from learning at the age of eleven of his Aboriginal parentage. A politics of strategic essentialism—asserting their Indigenous identity and difference—is apparent in the works and writings of the 'blak' group of younger urban artists and curators gathered around Destiny Deacon. Tracey Moffatt on the other hand has refused the fixity of critical labels, and has largely refrained from commentary

on her own production. This silence on the part of the artist has often worked, like an enigma, to encourage the activity of interpretation. With such artists, and with the most prominent of the northern Australian painters, the written criticism of Indigenous art begins to come of age.

ROGER BENJAMIN

Bennett, G., 'The Manifest Toe', in I. McLean & G. Bennett, *The Art of Gordon Bennett*, Roseville East, NSW, 1996; Butler, R. (ed.), *What is Appropriation? An Anthology of Critical Writings on Australian Art in the '80s and '90s*, Sydney, 1996; McLean, I., *White Aborigines: Identity Politics in Australian Art*, New York, 1998; Michaels, E., *Bad Aboriginal Art: Tradition, Media, and Technological Horizons*, St Leonards, NSW, 1994; Morphy, H., *Ancestral Connections: Art and an Aboriginal System of Knowledge*, Chicago, 1991; Munn, N. D., *Walbiri Iconography: Graphic Representation and Cultural Symbolism in a Central Australian Society*, Ithaca, NY, 1973; Myers, F., 'Aesthetics and practice: A local art history of Pintupi painting', in H. Morphy & M. Smith Boles (eds), *Art from the Land: Dialogues with the Kluge–Ruhe Collection of Australian Aboriginal Art*, Charlottesville, VA, 1999; Thomas, N., *Possessions: Indigenous Art, Colonial Culture*, New York, 1999; Williamson, C. & Perkins, H., *Blakness: Blak City Culture!* Melbourne, 1994.

22. Cross-cultural exchange

22.1 Cultural brokerage: Commodification and intellectual property

The phrase 'selling the Dreamtime' has long served to articulate misgivings about the commodification of Australian Indigenous cultures as 'Aboriginal art' (and more recently 'Aboriginal and Torres Strait Islander art'). Many within Western Desert society at first opposed in these terms the **Papunya** painters' [see 9.4, 9.5] initiative in committing their **Dreamings** to the Western art world, but later recognised that the painting movement had become so widespread as to constitute a new form of collective expression, which could potentially strengthen (rather than undermine) its foundations in the Dreaming—and also provide cash-strapped Aboriginal communities with independent income. As the millennium approached, Western art analysts finally came to the same conclusion, proposing reconceptualisation of the industry in terms of 'cultural brokerage': that is to say, a sophisticated intervention in mainstream society in which artists are brokers, seeking to exchange non-Indigenous access to the iconography and narratives of the Dreaming for Indigenous economic, political, and cultural benefits, including recognition of their ownership rights in that culture [see **rights in art**]—and the land to which it is inextricably linked [see 21.2]. To consider the commercial application of Aboriginal and Torres Strait Islander artistic traditions only in terms of Indigenous motivation and agency, however, is in its own way as one-sided as the victim-oriented perspective of cultural colonialism that concepts like 'cultural brokerage' are intended to supplant. In this **history**, other players also figure—for better or worse [*260*].

The appropriation of Australian Aboriginal imageries by commercial and nationalistic interests is but the most recent chapter in a century-long history of plunder and involuntary hybridisation of Indigenous visual traditions ushered in by European colonialism and its artistic aftermath. The early twentieth-century pioneers of modernism enacted Europeans' fascination with the exoticism of the original inhabitants of 'their' far-flung empires, whom they regarded as primitive and uncivilised. Ethnographers and travellers, themselves pioneers of the contemporary global phenomenon of cultural tourism [see 18.1], brought back works of 'primitive art' from Africa and the Pacific to metropolitan Europe, as ethnographic curiosities [see 21.1, 21.2]. Western artists exposed to such objects borrowed heavily from the works of these Indigenous artists. But though they were artistic revolutionaries, the early modernists were also creatures of their colonialist times, treating the artistic traditions which were their inspiration like vacant territories to be exploited. Compounding the offence, the commercial design industry proceeded to plagiarise not only the modernists' work but also the Indigenous originals from which it was derived, thereby placing once culturally specific religious

260. *Proclamation of Governor George Arthur to the Aborigines*, 1 November 1828.
Oil on wood, 36 x 22.8 cm. This pictorial proclamation was issued by Governor Arthur in response to an Indigenous complaint that his proclamations were 'gammon' because Aboriginal people could not read them. '"Read then", said the Governor, pointing to a Picture.' The picture says that all the residents of the colony are equal before the introduced system of law—but for nearly 200 years it would be 'just a pretty picture'.

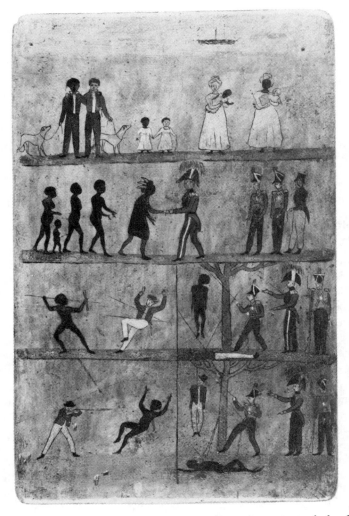

iconographies in circulation, in mass consumer culture, as empty symbols of romanticised Otherness [see 20.1]. It is by now a familiar scenario, but because the Australian chapter comes so late in this larger history, its action moves beyond both colonialism and modernism into the continuing struggle of Indigenous artists and communities to regain control of their collective destinies.

Aboriginal art was generally overlooked in the first flurry of modernist appropriation in Europe at the beginning of the century. The tribal custodians still jealously guarded the Dreaming imagery from the prying eyes of the outside world, which dismissed them as a 'people without culture'. In the local context, however, Aboriginal art was accessible enough to arouse parallel passions for the non-Western and 'primitive' in early Australian modernists like Margaret Preston, who in the 1920s proposed that all Australian artists adopt the traditional imagery and techniques of Aboriginal art as the basis of a distinctive, national art style. Preston has been criticised for her blithe indifference to the cultural significance of the design elements whose appropriation she advocated, but in her admiration for the aesthetic qualities of Aboriginal art she was a voice crying in a Social Darwinist wilderness. Moreover, the attempts by Preston and her handful of associates to popularise Aboriginal imagery and techniques, at a time when Aboriginal art

itself had received little public attention, may have contributed to the economic viability over the next twenty or thirty years of Indigenous **bark-painting** enterprises in Arnhem Land (notably at **Yirrkala**, where senior clansmen had been painting clan designs on bark for the museum and private collectors' market since 1936).

Only in central Australia, however, where the Hermannsburg School [see 9.1] of landscape watercolourists founded by Albert **Namatjira** [4.1; *36, 42, 111, 115*] had managed to tap into the increasingly lucrative tourist market [see 18.1], had Aboriginal art achieved anything like the kind of visibility and profitability which its 'classical' forms came to enjoy in the late 1990s. Critical acclaim was snobbishly denied this great pioneer of Aboriginal art in his lifetime. Nor was serious recognition extended to the bark-painting traditions of Arnhem Land until the final decades of the twentieth century. In the 1950s and 1960s the market for bark paintings was still largely confined to ethnographic museums, government departments, and private collectors of what the auction houses currently call 'tribal art'. However, a wave of 'Aboriginal-inspired' imagery, much of it directly copied from these Aboriginal originals (as reproduced in museum publications) swept through Australian fashion and design houses during this period.

These precursors of the contemporary 'imitations industry' began as cottage industries, supplying souvenirs for occasions like the Queen's visit in 1954 and the 1956 Melbourne Olympics. In their quest for a locally identified style, non-Aboriginal designers seized upon Aboriginal art as if it were a common Australian heritage which they could make use of as they saw fit. Copying elements of classical works of Aboriginal art, recombining them at will, mimicking effects like *rarrk* and x-ray, they effectively 'invented' the pseudo-Aboriginal look which was still with us in the late 1990s. No one gave a thought to the artists and communities whose designs were thus casually appropriated to create an aura of **Aboriginality**. Australian suburbanites consumed this merchandise as avidly as the overseas tourists. They were cheerfully wiping their dishes and stubbing their cigarettes out on it as the news came through of the overwhelming 90.77 per cent 'Yes' vote in the **referendum of 1967**.

The triumph of the referendum, which allowed the counting of Aboriginal people in the census and empowered the Commonwealth to make laws for them, belongs to all who campaigned so passionately and effectively through conventional political channels for the 'Yes' vote. But it also belongs to the elders of the various tribes and clans who at different times as the century proceeded had authorised exposure of their Dreaming designs to Western culture as 'Aboriginal art'. In most cases, they knew as little of the world to which they were consigning the ancient symbols of their cultures as it did of them, but from the treatment they had thus far received at the hands of these arrogant outsiders they understood the necessity of convincing them that they too were 'cultural people' (to use the words of Yirrkala elder Gawirriṉ Gumana [see **Gumana family**; *32, 257*], who participated in this process in north-eastern Arnhem Land as a young man). They believed in the power of their art to communicate the message of their humanity across language and cultural barriers—and the referendum result confirmed the wisdom of the course on which the elders' authorisations had launched Indigenous culture. Strengthened in their belief in the power of the Dreaming designs to speak to the outside world, the elders took another step away from cultural isolationism with the decision to use the voice of their art to explain to that world the Dreaming Laws which connect Aboriginal people with their land.

The first bark painting explicitly to petition for **land rights** had been presented to the Australian Parliament by the Yirrkala elders in 1963 [see 4.6; *50*], but had been met with incomprehension and denial. Aboriginal art had been incorporated into Australia's national symbolism long before Aboriginal people were symbolically incorporated in

the Australian nation through the referendum, but from the point of view of its originators this was an involuntary process over which they had no control. The design of the new decimal currency, introduced into Australia in 1966, indicates the terms in which Aboriginal art was being given the status of official Australian culture: a reproduction of a bark painting by Arnhem Land artist David **Malangi** [*261*] was used, without authorisation by the artist, on the back of the dollar note. The painting depicts one of Malangi's Dreaming sites at the mouth of the Glyde River and outlines in part the mourning rites which are performed at the death of a member of his clan. The design elements were recognised by a former teacher at the settlement where Malangi lived, who broke the story to the press. A deeply embarrassed 'Nugget' Coombs, then Governor of the Reserve Bank, ordered Malangi's contribution to the national currency to be acknowledged with the presentation of a silver medallion and A$1000, offering in explanation of the oversight that everyone had assumed that the design was the work of some 'anonymous and probably long dead' Aboriginal artist.

261. The Australian one-dollar note, (1964). Watermark: Captain James Cook; designer: Gordon Andrews; front design: Australian Commonwealth Coat-of-Arms and a portrait of Queen Elizabeth II; back design: interpretation of an Aboriginal bark painting by artist David Malangi, together with a representation of other bark paintings and carvings; designer's initials are to the bottom left of the tree.

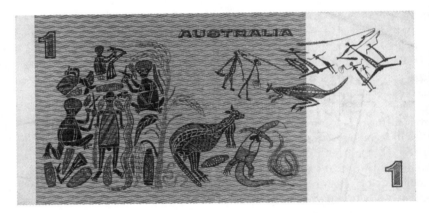

This was the heyday of 'scientific' museology in Australia. Teams of non-Indigenous experts pronounced on the 'authenticity' of Aboriginal art *vis-à-vis* their idealised versions of 'pre-contact' society. Displays of 'authentic ethnographic artefacts' by anonymous craftsmen—always men—were mounted, for the entertainment and edification of the general public. Bark paintings were exhibited in museums alongside other items of 'traditional material culture' all of which, like the Indigenous art brought into Europe at the beginning of the century, had been created to supply this market. However, the museification process mystified the historical circumstances of their production so that they appeared to their audiences to emanate impersonally from a space and time—and a society—unrelated to the contemporary world. Aboriginal art could not speak for the artists and communities who created it because it was already spoken for—by the ethnographers. Submerged in scientific objectifications and overlaid with nationalistic sentiments, Aboriginal art seemed to belong to no one. Nor, it seemed, did the land. The Yirrkala community's protest at the invasion of their lands by mining interests was as incomprehensible to the world at large as was their custodianship of the ancient iconography in which the demand for justice had been expressed. In 1970 the court to which the community had taken its battle for land rights declared under the doctrine of terra nullius that the system of law under which the community operated 'did not provide for any proprietary interest … in any part of the subject land'. So other Australians continued to dry their dishes on the unauthorised copies while the elders' proclamations of land ownership gathered dust in the museums of the colonising culture.

Enter Wandjuk Marika [see **Marika family**; *31, 71*], Yirrkala elder, artist, and musician, who in 1975 succeeded Dick **Roughsey** [*102, 376*] as chairman of the **Aboriginal Arts Board** of the Australia Council. It was Wandjuk who first laid the issue of copyright in Aboriginal art on the table—literally. He threw down a bundle of cheap tea towels decorated with images of his own and his father's paintings and challenged the assembled council members and the society they represented to do something about it. Wandjuk was one of the first of his people to become aware of the problem of unauthorised reproduction of Aboriginal art works because, in his capacity as board chairman, he was one of the first to travel widely and come into contact with mass-produced merchandise decorated with images copied from Aboriginal art. In the early 1970s few Indigenous artists had enough contact with the world of Western consumerism even to be aware of the existence of the 'imitations industry'. Their concerns about the extent of their culture's exposure through Aboriginal art were focused on the original works and the institutional contexts which they envisaged for their display. Their own world held no cultural precedent for taking someone else's design and using it to enhance the profitability of one's product in the market place. The realisation that this was happening was profoundly disturbing for Wandjuk—as it has been for all the other artists affected by the illicit trade in their imagery.

Wandjuk's agitation led in 1976 to the establishment of the Aboriginal Artists Agency with himself as founding chairman, to be 'responsible for protecting the **copyright** of Aboriginal artists, craftsmen and musicians'. But it was another seven years before Wandjuk's insistence on equal rights for Aboriginal artists under Australian copyright law produced any action in the courts. Viewed ethnographically, the very 'authenticity' of Aboriginal art was thought to rule out the 'originality' required of artistic works protected by the Commonwealth *Australian Copyright Act 1968*. In 1983, against this tide of opinion, the agency mounted the first ever case in the Australian courts in defence of an Aboriginal artist's copyright: this was *Yanggarriny Wunungmurra v. Peter Stripes Fabrics*. **Wunungmurra**'s [*32*] statement to the court stressed that he had learnt to paint the Dreaming in question from Gawirrin Gumana's father, who also had rights in the story, but that anyone could tell it was his painting of the Dreaming design on the manufacturer's fabric from the distinctive way the long-necked tortoises were drawn, which he likened to his signature. Yanggarriny's work thus satisfied the minimal condition of 'originality' required by the Act, in originating from the mind of the artist. Traditional educational practices require of initiates the creative reinterpretation of inherited designs within the basic parameters laid down in the Dreaming. This kind of individuality is differently motivated from Western-style innovation, but increasingly the work of even the most traditionally-oriented Aboriginal painters is an admixture of both as artists respond to market and critical demand. Yanggarriny won his case: the manufacturer was ordered to pay A$1500 damages to the artist and deliver up all the unsold, infringing fabric. One roll of the cloth was duly returned to Yanggarriny at Yirrkala, where the community performed a healing ceremony over it. The case was the talk of Arnhem Land, but it was not the turning point in the wider campaign for copyright protection for which Wandjuk had hoped; Aboriginal art remained effectively an artistic terra nullius.

Ironically, it was the ethnographers' and curators' initial refusal to confer the status of 'authenticity' on Papunya paintings, in judging them too like contemporary art to be suitably housed in museums, that precipitated Aboriginal art's escape into the world of contemporary art—a world which had initially regarded Papunya paintings as too like ethnographic artefacts to be suitably housed in art galleries! The awe-inspiring, large canvases produced by the Papunya artists in the late 1970s and early 1980s—vast 'deeds of title' to their personal Dreaming countries—were particularly significant in bringing

about the dramatic perceptual shift required for Australian art audiences to see the works of Aboriginal artists as both 'authentic' and contemporary art [see 9.5]. Support from major galleries and influential private collectors followed, and by the late 1980s Aboriginal works of art in general, and Western Desert paintings in particular, were highly priced and keenly sought after commodities in the contemporary art market. Paradoxical though it may seem, it was this commodification of Aboriginal art that finally made achievable Wandjuk's goal of preventing its unauthorised reproduction. As producers of increasingly valuable cultural commodities, the entitlement of Aboriginal artists to copyright protection would no longer be denied.

In the late 1980s, the boom in the production and consumption of Aboriginal art, which hugely increased its circulation and visibility, met the tourist boom sparked by the 1988 bicentennial celebrations [see **Survival Day**]; and the 'imitations industry' assumed its current proportions and its single-minded dedication to exploiting the popularity of Aboriginal imagery for commercial gain. Aboriginal art images were now vastly more accessible in (legal) reproduction to the wider audience in Australia and around the world—but in the process their exposure to potential copyright infringers had also been greatly increased. As stolen designs flooded onto the tourist market, Aboriginal artists commenced a series of court actions over infringements of their personal artistic copyright. In August 1989, Johnny **Bulunbulun** mounted a case for copyright infringement against Flash Screenprinters, manufacturers of a line of T-shirts bearing unauthorised reproductions of his works [see 22.2; *263*]. Bulunbulun was subsequently joined by thirteen other Aboriginal plaintiffs. *Bulun Bulun v. Nejlam Pty Ltd* (unreported) only went as far as an injunction preventing further production and distribution of the offending articles. The matter was subsequently settled out of court (with a court-ratified settlement of A$150 000 being paid to the artists by the company), but the injunction still meant that the principle of copyright protection for Aboriginal art, for which Wandjuk had fought for fifteen years, had finally been accepted by the courts. Coming as it did immediately after the bicentennial year, the case attracted considerable public attention and support for the artists' cause. Regrettably, Wandjuk did not live to celebrate this small triumph.

The bicentennial year also produced a revival of the elders' strategy of using Aboriginal art to communicate the message of land rights. Alongside the commodification of Aboriginal art had gone an equally intense politicisation. In the words of the mercurial Gary Foley, who initiated this process in his brief term as the first Indigenous Director of the Aboriginal Arts Board in 1984: 'All Aboriginal art is political because it is a statement of cultural survival.' As 1988 approached, the struggle to place control of Aboriginal art back into Aboriginal hands was taken up by articulate, young urban artists who, in their zeal, denounced as cultural thieves and colonialists all local non-Indigenous artists who so much as acknowledged the inspiration of Aboriginal art. The magnificent mosaic designed by leading Papunya Tula artist Michael Jagamara **Nelson** [see 22.3; *264*] in the forecourt of the Parliament House in Canberra became the focus of fierce debate between angry, city-based Aboriginal voices denouncing it as a whitewash of Australia's shameful treatment of its Indigenous peoples, and the leaders of more traditionally-oriented communities like Papunya and Yirrkala who saw it as an instrument in the negotiated resolution of these issues. In June 1988, the elders of northern and central Australian Aboriginal communities presented the Prime Minister of Australia with a second painted petition for land rights known as the Barunga Statement [see 4.6; *39*], and were promised a treaty which never eventuated. The elders' faith was finally vindicated by the High Court of Australia's historic decision in June 1992 in the case of Torres Strait Islander Koiki 'Eddie' **Mabo**, overturning the legal fiction of terra nullius and

provoking the dramatic changes in legal and social recognition of Indigenous land rights with which the name of Mabo is now synonymous. Thirty years after the original Yirrkala bark petition [see 4.6; 50], the relationships to land which had been patiently spelled out by generations of Aboriginal artists painting their Dreaming designs were recognised in Australian law under the Commonwealth's *Native Title Act 1993*.

The so-called 'Carpets Case' has been described in some circles as 'the Mabo decision of Aboriginal culture'. In December 1994 the Federal Court of Australia handed down a landmark judgment in a copyright case brought by George **Milpurrurru** [*356*], Banduk Marika [see **Marika family**], Tim **Payungka Tjapangarti**, and the Public Trustee of the Northern Territory acting on behalf of five other deceased artists against a Perth-based company, Indofurn Pty Ltd [see *262*]. The artists were assisted by Colin Golvan, also barrister in the Bulun Bulun case, and the Aboriginal Arts Management Association (AAMA), the Aboriginal Artists Agency's successor as government-funded Indigenous watchdog on copyright issues, which had been formed in 1990 in the wake of the T-shirt case. *Milpurrurru (and others) v. Indofurn* was the longest running and may yet be the most significant legal action involving Aboriginal art and copyright infringement ever to go to full trial. Over three weeks of detailed testimony, every aspect of the unauthorised reproduction onto carpets of the work of the eight Aboriginal artists was exhaustively examined. Justice Von Doussa's award of $188 640 damages to the Aboriginal artists

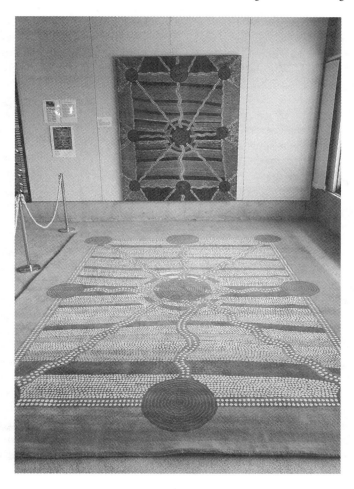

262. Tim Leura Tjapaltjarri, *Kooralia*, 1980.
The photograph shows the 'Seven Sisters' carpet produced by Indofurn Pty Ltd in the foreground.

made headlines as one of the biggest payouts in Australian copyright history. Of this, $70 000 was awarded to the living artists for the 'personal hurt and cultural harm' they had suffered within their own communities because they were involuntarily implicated in an offence against Aboriginal laws of intellectual property. The recognition of and respect for Aboriginal Law and custom which the concept of cultural harm implies has led to the case being compared to the Mabo judgment. As Mabo did for land rights, these rulings explode the fiction of artistic terra nullius. The court proceedings for copyright infringement have given artists a platform from which to draw attention to the Indigenous laws of intellectual property which have also been flagrantly disregarded in these cases. The court further determined that three 'adapted' designs produced by the carpet manufacturers, which used only very small sections of the original works simplified, enlarged, and distorted, were just as much copyright infringements as carpets which reproduced the entire original.

The redress which Aboriginal artists have obtained through the European legal system for infringements of their Aboriginal copyright undoubtedly advances the cause of their rights as creative individuals within mainstream society. In Aboriginal terms, however, their right to own and control certain uses of the intellectual property in question rests not in having originated their 'signature' versions of designs but in the tribe or clan having conferred custodianship of those designs on its individual members. Hence the lawyers' arguments in these court actions, designed to establish that the provisions of the Copyright Act are met by the stylistic individuality of the artists whose copyright has been infringed, were always accompanied by the case on which Wandjuk originally stood his ground: the communal sources of the artists' subject-matter and inspiration. This issue is central to the case of *Bulun Bulun and Milpurrurru v. R & T Textiles*, which commenced in the Federal Court in Darwin in 1997. A conventional case of copyright infringement, involving the unauthorised copying of one of Bulunbulun's paintings onto dress fabric, was transformed into one which attempted to push the boundaries of Australian intellectual property law by Milpurrurru's claim to be recognised alongside the artist as a legitimate applicant in the case on behalf of all the traditional owners of Ganalbingu country, without whose permission Bulunbulun could not have painted the original work. Milpurrurru's application was designed to produce legal recognition of the inextricable connection between rights in land and in art under Indigenous Law. In the event, the judge determined that no finding was necessary in this case concerning the legal rights of the other traditional owners to pursue a charge of copyright infringement against the manufacturer, since the artist had already successfully undertaken such action. However, the judge did acknowledge the traditional owners' right to proceed against the manufacturer in a similar situation in the future, should the artist be unable or unwilling to do so.

A second copyright case involving Aboriginal art which went before the Australian courts in 1997 was *Harold Joseph Thomas v. David George Brown and James Morrison Vallely Tennant*, in which the judge ruled that Harold Thomas [see 12.1], the Aboriginal artist whom history has long recognised as the designer of the Aboriginal **flag**, was legally the copyright holder of its design. This emblem has become, in the space of twenty-five years, a potent signifier of Aboriginal unity and self-determination, and its protection from cooption by nationalistic or commercial interests without its creator's consent is now guaranteed in law—at least for the artist's lifetime plus fifty years. In the early 1990s the AAMA had assisted urban-based artists Sally **Morgan** [see 12.1, 14.5; *41, 384*] and Bronwyn **Bancroft** [see 17.5; *287*] to negotiate out-of-court settlements with manufacturers who had illegally copied their work. Design piracy was originally confined to the classical traditions of Aboriginal art, but once post-classical expressions—

including the Aboriginal flag itself—became as much signifiers of Aboriginality to the general consumer as the traditionally Aboriginal-associated styles, the imitations industry wasted no time in robbing this rich, new image bank. While some sections of the commercial design industry habitually plagiarise all imageries available in reproduction, including the work of non-Indigenous contemporary artists, Aboriginal artists are triply exploitable in the Australian context (as will be Torres Strait Islander artists, once their work becomes more widely known and reproduced). Their high-profile images signify to the consumer gaze more than just art; they can also be used to stand for Australian-ness and Aboriginality. On the latter count, they are almost indispensable to the tourist industry [see 18.1]. Faced with the success of Indigenous challenges to the doctrine of artistic terra nullius, the manufacturers have begun exploring other ways of achieving, within the law, the requisite intimations of Aboriginality.

As copyright infringements of Aboriginal art were answered with legal proceedings, unauthorised reproductions of Aboriginal originals, which had been endemic in the tourist industry in 1988, virtually disappeared. They were replaced with caricatures of Aboriginal art: pastiches of generic motifs so thoroughly decontextualised as to be unrecognisable to contemporary custodians of the various Indigenous artistic traditions from which they had been plucked by 'in house' design teams. Manufacturers hid their usually non-Indigenous authorship under labels like 'Australian Aboriginal Art' or even 'Primitive Art Australia'. Copyright law affords no protection against this sort of bastardisation of Aboriginal artists' work: art styles like the x-ray forms of Arnhem Land or Western Desert 'dot' painting which are fused and confused by exponents of pseudo-Aboriginality cannot be copyrighted. Another response emerged among some manufacturers, however, as the message of the copyright campaign also began to get through to consumers of this merchandise. The customers were more interested than before in the 'authenticity' of what they were buying, not in the old-fashioned ethnographic sense, but in terms of the authentication bestowed by direct Aboriginal involvement in its production. Except at the 'cheap and nasty' end of the tourist market, producers have responded by entering into licensing agreements with Aboriginal artists for commercial application of their designs (often appended to their glossy catalogues alongside the older generic range). Swing tags stating the artists' Aboriginal credentials were added for consumers influenced by considerations of 'authenticity'—but all the while oblivious to the intra-Aboriginal controversies raging around the so-called 'out of area' uses of the popular classical styles by many Indigenous designers. Notwithstanding these still unresolved issues and the tokenism and opportunism of the manufacturers' moves, the positive response from consumers began to have an impact on industry practices, to the point where if no artist was credited, this was a fair indication that the design work was either some non-Indigenous commercial designer 'ripping off' Aboriginal art—or a copyright infringement. Counterfeit Aboriginal artists were unheard of in a market place still wrestling with the strange and unwelcome idea that Aboriginal art was the product of individual artistic effort. The appearance of these impostors in the late 1990s opened up the disturbing prospect of a flood of Aboriginal impersonators and other appropriators of Aboriginal artistic identity, but was also a back-handed acknowledgment of the ascendancy of Indigenous cultural expression both in the national psyche and in the projection of Australia's international image.

It would be ironic if the blatant piracy of the imitations industry should turn out to have paved the way for more productive relationships between Aboriginal artists and commercial interests. Nowadays most merchandise on the Australian market bearing Aboriginal designs does not involve illegal copying of the work of Indigenous artists. Although many items are still the work of non-Aboriginal imitators, the products of

Indigenous community enterprises are gaining an increasing share of the market, and the design ranges of the major non-Indigenous manufacturers reflect the increasing inclusion of Aboriginal art practices and artists in the mainstream fashion and design industries. It is to be hoped that their presence will have the same salutary effect on these industries' practices with respect to copyright that the actions of Indigenous artists have had in the contemporary art world. The 'black art scandals' which were trumpeted by the media throughout the late 1990s [see 21.2] suggest, however, that the imitation industry's attitudes are beginning to rub off on the contemporary art world—where there will be no shortage of notoriety seekers.

Aboriginal art's power to speak to such contentious issues as Indigenous connections to land, cultural and intellectual property rights, and the **stolen generations** has survived its admission to the rarefied atmosphere of the art galleries because it is more than just art—not only to the Aboriginal artists and communities who make it, but also to its mainstream audiences. Before its recognition in the mid to late 1980s as contemporary art, Aboriginal art had passed through a long phase of incarceration and objectification in the museums, as the plaything of the ethnographers [see 21.1]. The powers attributed to Aboriginal art works, as authentic artefacts bearing cultural witness to the societies which produced them, were already familiar to the audiences who now re-encountered Aboriginal art in the gallery context. But this was cultural witness of a new and profoundly political nature, its messages no longer subsumed and distanced by the experts' pronouncements on the 'ethnographic significance' of the works within their cultures of origin. The effect of highly publicised artistic and literary fraud has been to undermine the capacity of Aboriginal art to bear this potent form of cultural witness. The impostors subject the entire body of Indigenous art to cultural harm when they mock its ability to speak its own truths to mainstream audiences and to impart visions of Aboriginality. Non-Indigenous artists and writers who cynically claim the right to impersonate imaginary or real Aboriginal artists are perjurers using the forum of Aboriginal art to bear false witness. In asserting their right to engage in this form of artistic licence, they trample underfoot the rights of those with whom they claim to identify.

In the face of its own evanescence and inconsequentiality, mass consumer culture of the late twentieth century was fascinated with the durability and spiritual strength of indigenous cultures, none more than the Aboriginal and Torres Strait Islander cultures of Australia. Yet it refused to recognise that the maintenance of these cultural traditions was founded on the rule of law, in particular the Indigenous regimes of intellectual property which spell out the connection of Aboriginal and Torres Strait Islander peoples to their histories and heritage countries. Indigenous Australians never asked that others be obliged to obey these Laws, which are complex, and whose detailed operation is understood only by those initiated in the sacred knowledge which they encode. They do ask others, however, to respect the fact that these Laws are as important to them as Western laws are for members of mainstream society. Indeed, they are much more important, integrating as they do issues of individual identity, intellectual property, and land ownership with the transmission of culture from one generation to the next. People earn or inherit the right to paint certain Dreaming designs and the country they represent, title to which, under Indigenous Law, cannot be transferred to another. The theft of objects bearing someone else's designs carries a severe penalty under Aboriginal Law. As custodians of their designs, Aboriginal artists have a legal responsibility to protect them and pass them on undamaged to future generations. The destructive effects of theft of designs on the capacity of Indigenous artists to go on making art cannot be overstated. The special legislative protections which Wandjuk Marika also sought for ancient rock art at sacred sites, for ceremonial forms, and for other aspects of Indigenous visual

culture not at present covered by the copyright laws of Australia have yet to be devised. Although efforts continue, they have as yet yielded no tangible outcome.

VIVIEN JOHNSON

Gray, S., 'Aboriginal designs and copyright: Can the Australian common law expand to meet Aboriginal demands?' *Copyright Reporter*, vol. 9, no. 4, December 1991; Golvan, C., 'Aboriginal art and the protection of Indigenous cultural rights', *Aboriginal Law Bulletin*, vol. 2, no. 56, June 1992; Johnson, V., *Copyrites: Aboriginal Art in the Age of Reproductive Technologies*, Sydney, 1996; Kleinert, S., 'Drawing the line: Appropriation or inspiration?' *Object*, Winter 1992.

22.2 Copyright infringement: An artist's response

In August 1989, Johnny **Bulunbulun** mounted a case for copyright infringement against Flash Screenprinters, manufacturers of a line of T-shirts bearing unauthorised reproductions of his works [see 22.1]. This is his affidavit.

I never approved of the reproduction of any of my art works on T-shirts, and never approved the mass reproduction of any of my art works, other than reproduction of photos of my works in art books. None of the Respondents has ever spoken to me, or attempted to speak to me, about the matter. Had they sought my permission, I would not have given it.

This reproduction has caused me great embarrassment and shame, and I strongly feel that I have been the victim of the theft of an important birthright. I have not painted since I learned about the reproduction of my art works, and attribute my inactivity as an artist directly to my annoyance and frustration with the actions of the Respondents in this matter. My interest in painting has been rekindled by the efforts being made on my behalf to resolve this problem, and I am just starting to paint again, although I am doing so in anticipation that this problem will be resolved in the near future. If it is not resolved satisfactorily, I have considered never painting again.

My work is very closely associated with an affinity for the land. This affinity is at the essence of my religious beliefs. The unauthorised reproduction of art works is a very sensitive issue in all Aboriginal communities. The impetus for the creation of works remains their importance in ceremony, and the creation of art works is an important step in the preservation of important traditional customs. It is an activity which occupies the normal part of the day-to-day activities of the members of my tribe and represents an important part of the cultural continuity of the tribe. It is also the main source of income for my people, both in my tribe and for the people of many other tribes, and I am very concerned about the financial well-being of my family should I decide that I cannot go on painting.

My father lived at a mission settlement at Milingimbi where he sold works to the mission. He painted the **Dreamings** stories of our tribe, the Gunilbingu [Ganalbingu], including Waterhole scenes. He painted such scenes in his own way. I do not have any of his works, and I have never tried to copy any of them. His teaching was of importance in imparting to me the traditional techniques of bark painting, and the Dreamings traditions and images of our tribe. I am training my own son in the same manner.

Many of my paintings feature Waterhole settings, and these are an important part of my Dreaming, and all the animals in these paintings are part of that Dreaming. Many of the paintings include the long-necked turtle, called *barnda,* the magpie goose, or *gumang*, the file snake, or *bipuan*, and waterlily or *yarrman*. The bands of crosshatching or *rarrk* represent *marrawurrurr yiritdja* [Yirritja] site [*263*].

263. Johnny Bulunbulun,
*Magpie Geese and
Waterlilies at the Waterhole*,
1980.
Natural pigments on bark,
110.5 x 77 cm.

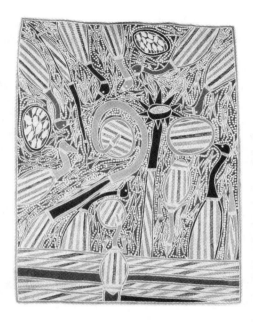

The story being told in my Waterhole works concerns the passage to Garmedi from my traditional land, and illustrates different ways of interpreting the same aspects of the story. The story is generally concerned with the travel of the long-necked turtle to Garmedi, and, by tradition, I am allowed to paint the part of the story concerning the travel of the turtle to Garmedi. According to tradition, the long-necked turtle continued its journey, and other artists paint the onward journey.

JOHNNY BULUNBULUN

This affidavit was originally published in Vivien Johnson's *Copyrites: Aboriginal Art in the Age of Reproductive Technologies*, National Indigenous Arts Advocacy Association & Macquarie University, Sydney, 1996. It is reproduced with permission of Maningrida Arts & Culture, Winnellie.

22.3 I am an artist, not a politician

Michael Jagamara **Nelson**, creator of the grand mosaic [*264*] which lies in the forecourt at the front of Parliament House in Canberra, stood beside it to make this speech at a critical moment in the Mabo **native title** campaign of 1993.

I am an artist, not a politician. I'm not used to standing up in front of everyone making speeches. I only speak for my paintings. And my paintings speak for me—and my culture.

You don't seem to understand. You look at my work, all you see is the pretty painting, a pretty picture. That's why they asked me to come to Canberra and explain this forecourt mosaic.

You the white people took this country from us. You must recognise Aboriginal people have our own culture, our Dreamtime, ceremonies, places where we held our corroborees for our Dreaming. It is what my paintings are about.

My painting for the mosaic in the forecourt of Parliament House represent all the Indigenous people in this land, the wider Australia. That's why I put all the different

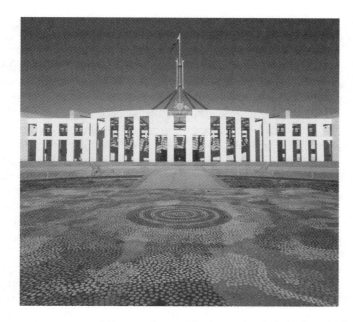

264. Michael Jagamara Nelson, forecourt mosaic pavement (possum and wallaby Dreaming), Parliament House, Canberra, 1986–87.

animals—represent to me all the peoples at this place. The circle in the middle is one of my **Dreamings**, a place back home. But it also stand for this place, where all the Aboriginal people come and meet together, just like we do in our ceremony, to discuss and work together. White people must understand that this land is Aboriginal peoples' homeland, we are still here keeping the laws of the Dreaming. We want to keep our culture strongly for our children's children. We cannot do this without our land because it is our life, that Dreaming, story, the paintings, our culture, it is all tied to our land.

This has all been changed. This is no longer a meeting place for Aboriginal people. The government of Australia are still not recognising our people and our culture. It is abusing my painting and insulting my people. It make my people sad that government does not respect my painting or my people. I want to take my painting back to my people.

<div align="right">Michael Jagamara Nelson</div>

The written version of this text originally appeared in Vivien Johnson's *Michael Jagamara Nelson*, Craftsman House, Roseville, NSW, 1997. It is reproduced with permission of the Aboriginal Artists Agency.

22.4 Appropriation art

'Appropriation art' normally refers to works in which images by other artists are embedded that must be recognised if the new work is to be properly understood. Appropriation art became a dominant fashion in Western art in the 1980s, when iconic European paintings were quoted everywhere—often ironically—and on everything from large canvases to pop-record covers. The Australian bicentenary [see **Survival Day**], which was full of ironic inversions (both deliberate and unwitting), provided a major incentive for urban-based Indigenous artists to appropriate Aboriginal and Torres Strait Islander subjects from white art. Their aim was to place these images of their people in less demeaning settings or else to highlight the inherent racism of non-Indigenous representation. New black perspectives on old subjects shattered other white stereotypes too. The definitive

example of Australian appropriation art may well be the Sydney Aboriginal artist and activist Malcolm Cole challenging the official bicentennial celebrations by leading the 1988 Gay and Lesbian Mardi Gras parade dressed as Captain Cook [see 12.6; *172*].

Gordon **Bennett** [see 22.5; *265, 267, 275*] was among the first 'high' artists to show that appropriating white images of Aboriginal subjects could effectively transfer meaning—even ownership—from the imperial maker to the colonised subject. In 1989 he produced a series of oil paintings based on well-known colonial images of Aboriginal people. Some replicated photographs taken in the early 1870s by the German-born J. W. Lindt, internationally esteemed during his lifetime as the best ethnographic photographer in the country even though his renowned Aboriginal family groups were invented in his Clarence River (NSW) studio [see 8.5]. By flatly reproducing Lindt's famous photo of an Aboriginal couple with hunting booty outside a bark hut above the title *Frame*, Bennett was reminding his predominantly white audience that the Indigenous colonial subject has always been framed, constantly reconstructed to make a white reputation. His many other appropriations include *Double Take*, 1989, a facsimile of a detail from a painted wooden board known as *The Proclamation of Governor George Arthur to the Aborigines of Tasmania* [*260*] attributed to Surveyor-General George Frankland, who initiated the idea of nailing these pictorial messages to trees in the Van Diemen's Land bush in 1829. Through selective quotation of this foolish and futile attempt to explain the equality of British law to an illiterate but artistic race, Bennett created an Indigenous reading of the invaders' image—a promise of death and destruction.

Re-presenting historic white images from the perspective of the Indigenous subject was not confined to photographs, drawings, and paintings from Australia's colonial past. While Bennett satirised colonial art, Tracey **Moffatt** [see 12.1, 12.4, 13.1; *169, 326*] quoted frames from *Jedda* (1955) [see also 4.1; *43*], the archetypal white Australian film about the clash of Aboriginal and non-Aboriginal lifestyles, both in her first solo photography show, 'Something More', 1989 [*244*], and in her first short film, *Night Cries* (shown officially at Cannes in 1989).

Such caustic commentaries were more controversial when transferred to the fashionable practice of appropriation art itself. In 1990 Bennett responded to a controversial bicentennial year painting, *I AM Aboriginal*, by Australia's appropriation star Imants

265. Gordon Bennett, *Big Romantic Painting: (Apotheosis of Captain Cook)*, 1993. Acrylic on canvas, 182 x 400 cm.

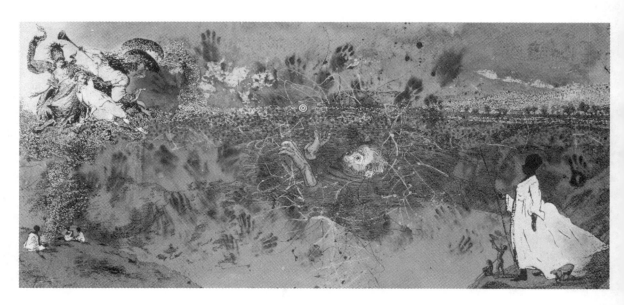

Tillers, a first generation Australian of Latvian descent. Tillers' provocative version of one of New Zealander Colin McCahon's large 1970s paintings made up of the letters *I AM* gave 'I' the form of an Aboriginal shield in front of a Papunya 'dot' painting, while 'AM' was painted on a black field covered with western one-point perspective lines. Bennett, raised in white Brisbane suburbia, incorporated a childhood photograph of himself in cowboy costume within his letter 'I', complemented it with a group of school textbook 'Aborigines' in 'AM', and satirically entitled his parody *Self Portrait (But I Always Wanted to be One of the Good Guys)* [*275*]. The following year he reclaimed Tillers's appropriation of the most famous 'dot painting' of the decade—Michael Jagamara **Nelson**'s [see 22.3; *226, 227, 264*] *The Five Dreamings*, 1985, now known as *Five Stories*. As well as echoing Tillers's *The Nine Shots*, 1985, Bennett's *The Nine Ricochets (Fall Down Black Fella, Jump Up White Fella)*, 1991 included an 1890 history textbook illustration of Queensland Native Police killing other Aborigines (under the direction of their white officer) and a Tillers *Pataphysical Man*, 1984 from a Latvian school text fleeing the scene. Ironically, the commentary won Bennett the 1991 Moët & Chandon fellowship for artists under 35—one year at a studio in France.

Tillers was not the only non-Indigenous artist appropriating Aboriginal images in the early 1990s in order to suggest that he too was 'Other', an outsider in the dominant Euro-Australian culture. The most spectacular result of this short-lived fashion was a large autobiographical installation entitled *Juanita Laguna*, 1994 by the Chilean-Australian Juan Davila. Its numerous floor paintings included a self-portrait as a bisexual 'white blackfella' adapted from Augustus Earle's portrait of the Sydney Aboriginal **Bungaree**, *c.*1828, while the surrounding wall frieze was made up of replicas of drawings by the nineteenth-century Murray River Aboriginal artist Tommy **McRae** [*140*]. After starring in the national touring exhibition 'Aboriginal Australia' in 1981, McRae's witty ink drawings became popular sources for non-Indigenous appropriation artists. In a subtle response, Fiona **Foley** [see 23.3; *2, 63, 164*] and Djon Mundine included a McRae frieze in their 1994 Havana Biennial exhibition 'Tyerabarrbowaryaou II—I shall never become a white man', the first exhibition by Aboriginal curators to be shown internationally. In the all-Indigenous context McRae was re-appropriated to become a respected ancestor, thus denying non-Aboriginal artists the right to claim him merely because of his Western technique.

By then, contemporary Aboriginal artists were being recognised as sophisticated stars of the local appropriation scene in exhibitions and publications. Lin **Onus**'s [*274*] hyper-real *Twice Upon a Time (Homage to von Guerard)*, painted in 1991, consists of a meticulously depicted living Aboriginal carved tree [see *138*] set behind a depopulated version of the most popular painting in the Art Gallery of South Australia, H. J. Johnstone's *Evening Shadows, Backwater of the Murray, South Australia*, 1880. (In fact, the precise source seems to have been a smaller version of the gallery painting that hung in Onus's childhood home, which he mistakenly believed to be by the earlier colonial painter Eugène von Guérard.) Both images depict lost views along the Murray River, the artist's own ancestral place. That one is Aboriginal and the other European exemplifies Onus's dual heritage.

A particular problem for all artists appropriating Australian images is that few are instantly recognisable to the general public. Most visitors to the Queensland Art Gallery recognise the Hokusai wave in Onus's *Michael And I Are Just Slipping Down To The Pub For A Minute*, 1992 but are unaware that the dingo and stingray surfing it are the personal totems of Onus and his great friend Michael Eather. And while the icons of US popular culture are familiar to everyone, far more ancient and valuable ones from Aboriginal Australia have had limited circulation in the Western world. Pintupi painter

Tjungkiya Wukula Linda **Syddick**'s *E. T. and Friends*, 1992 [*388*], which fuses the Steven Spielberg alien with her own ancestral figures, can be read as a metaphor of Australia's sad history of replacing the genuine home-grown product with the ersatz import.

Other Indigenous women artists such as Leah **King-Smith**, Julie **Dowling** [*24*], Fiona Foley and Destiny **Deacon** [*66, 67, 277, 314*] had compelling reasons for appropriating white colonial images of Aboriginal people. They found ways of dealing with the fact that the originals were often as little known as their Aboriginal subjects were. King-Smith makes metre-square cibachrome palimpsests of close-up details of Aboriginal people from old photographs overlaid on unspoiled natural landscapes. Her first major series, *Patterns of Connection*, 1991–92 [*273*], transformed mid nineteenth-century Aboriginal people in mission photographs taken by the German photographer Charles Walter at Coranderrk, Lake Tyers, and Ramahyuck, now in the State Library of Victoria. In *White Apron—Black Hands*, 1994, created with Lel Black and Jackie Huggins, she reworked images of Aboriginal women in domestic service from early twentieth-century photographs in the Queensland State Library. By reading against the grain King-Smith frees the historical subjects from the oblivion of the archive and the menial roles imposed by white society. Her glorious ghosts haunt natural landscapes that have always been theirs.

Destiny Deacon's aggressive 1994 photograph *Eva Johnson: Writer* [*314*] parodies an 1854 oil painting of *Nanulterra, a Young Cricketer of the Natives' Training Institution Poonindie* [*313*] by the South Australian portraitist John Michael Crossland. Identical in dress and pose, the chief difference between the two figures is neither age nor gender but the fact that the boy holds the cricket bat of conformity whereas the writer wields the anarchist's axe. In this devastating indictment of white social control, Deacon appropriates the role of the artist. The person she so memorably resurrects from the dead is not the painter Crossland but Nanulterra, the black subject [see also 12.4].

Fiona Foley's *Native Blood*, 1994, a sepia photograph of the artist as an exotic bare-breasted, grass-skirted beauty, reclaims the subject even more literally—although her platform shoes in the Aboriginal colours of red, black, and yellow suggestively subvert the historicism of the image. Despite the fact that the photograph is acknowledged as having been taken by a leading white Sydney photographer, Sandy Edwards, Foley simultaneously casts herself both as subject and creator. In setting herself up in this way for (mainly) white viewers, she specifically draws attention to the impossibility of any comparable agency for the subject in past generations of equally offensive 'ethnographic' photographs. This is not a quotation of a specific image but a blanket indictment of a society incapable of seeing young black women except in sexual stereotypes. It looks like a parody because most viewers have memories of such sirens from old movies, postcards, photographs, and advertisements. Through the deadly precision of her visual commentary, Foley locates the reference within the referent.

Julie Dowling's *Blind Justice*, 1992 adds a blindfold to a historic print of an Aboriginal woman wearing a kangaroo skin cloak and holding a spear, to create a Justice figure that is the obverse of the usual allegorical, Classical Roman blonde. The sole motif the two have in common—the blindfold—is also inverted, no longer a symbol of the impartiality of British law but of its blindness to the crimes carried out in its name. Dowling's *Goodbye White Fella Religion*, painted the same year in acrylic, red ochre, and blood, depicts a dead priest with the gruesome smile of rictus slung in a shroud in front of rows of Bathurst Island Aboriginal women and children. The figures, taken from an old photograph, are branded with tiny crosses but their background is made up of painted dots that serve as a reminder both of the photographic screen of white reproductive technology and of dot painting, an appropriate contemporary symbol of continuing links with

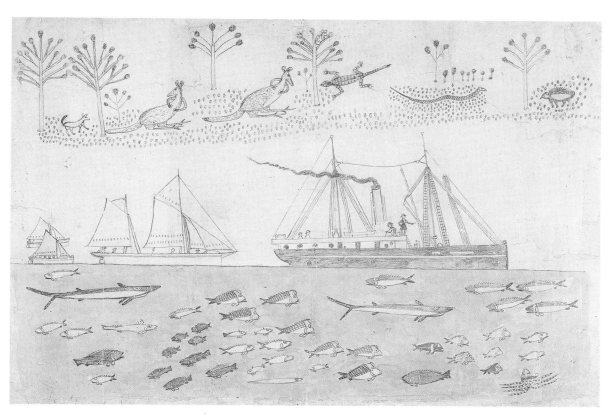

272. Mickey of Ulladulla,
Boats, Fish; Native Fauna and Flora, c.1880s.
Pencil and watercolour,
38 x 55.2. cm (irreg.).

See also: 1.1, 1.2, 2.1, 4.1,
4.2, 11.1; William **Barak**,
Mickey of Ulladulla, Tommy
McRae.

273. Leah King-Smith,
Untitled No II, from the series
Patterns of Connection,
1992.
Direct positive colour
photograph, 102.5 x 103 cm.

See also: 1.1, 2.1, 4.1, 8.2,
11.1, 12.1, 12.4; Leah **King-
Smith**.

274. Lin Onus, *Barmah
Forest*, 1994.
Acrylic on linen, 183 x 244
cm.

See also: 1.1, 2.1, 4.1, 6.1,
11.1, 12.1; **art awards and
prizes**, Lin Onus.

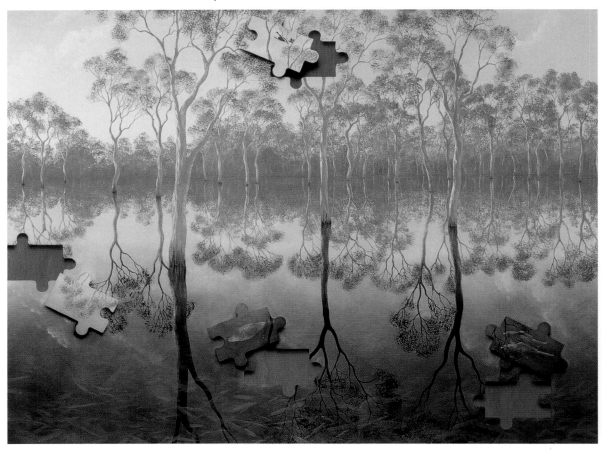

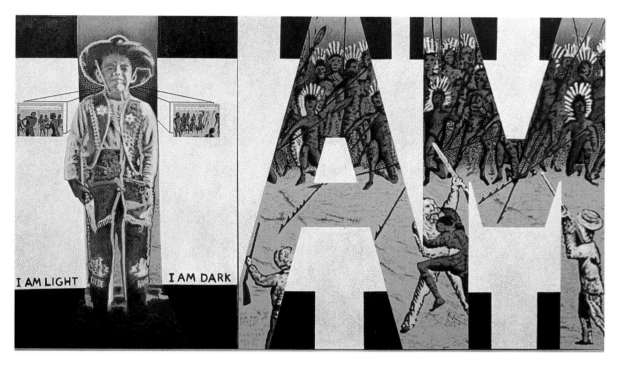

I AM LIGHT I AM DARK

275. Gordon Bennett, *Self Portrait (But I Always Wanted to be One of the Good Guys)*, 1990.
Oil on canvas, 150 x 260 cm.

See also: 1.1, 2.1, 4.1, 8.2, 11.1, 12.1, 22.4, 22.5; **Aboriginality**, **art awards and prizes**, Gordon **Bennett**.

276. Rea, *for 100% Koori (rea probe series)*, 1997. Photographic triptych, digital Cibachrome prints, 40 x 120 cm.

See also: 4.1, 12,1, 12.4, 12.6; **art awards and prizes**, **Rea**.

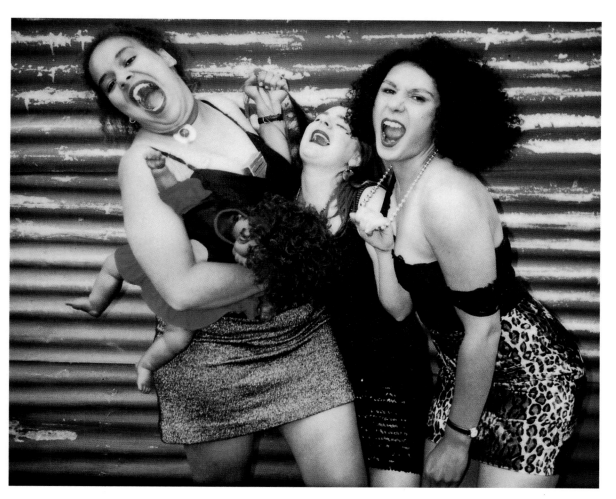

277. Destiny Deacon, *Last Laughs*, 1995.
Colour polaroid bubble-jet print on paper, 59.5 x 72.5 cm, edition of 5.

See also: 4.1, 7.4, 12.1, 12.4, 22.4; Destiny **Deacon**.

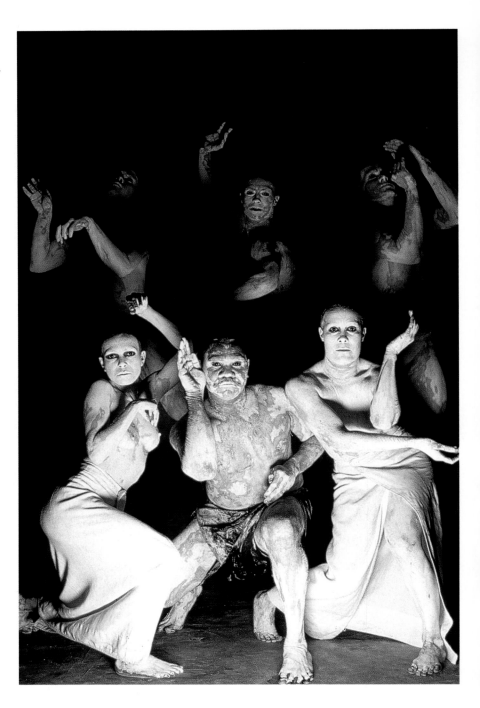

279. Various Yirrkala artists, *Yingapungapu Sand Sculpture*, in association with 'Native Titled', Museum of Contemporary Art, Sydney, September 1997.

See also: 1.1, 2.1, 3.1, 4.1, 6.1, 6.2, 6.3, 20.1, 21.2; **Yirrkala**.

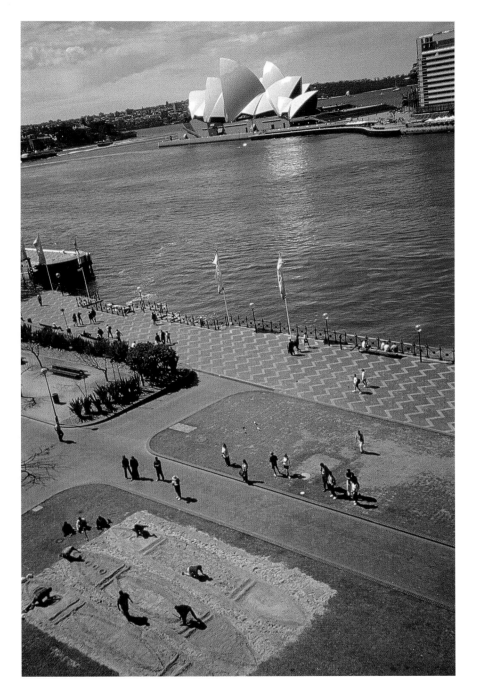

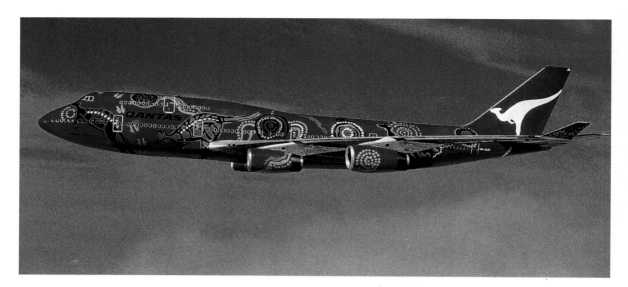

280. *Wunala Dreaming 747*
Qantas Aircraft design by
Balarinji Studios, Sydney,
1994.
See also: 4.1, 12.1, 17.5, 20.1,
20.2.

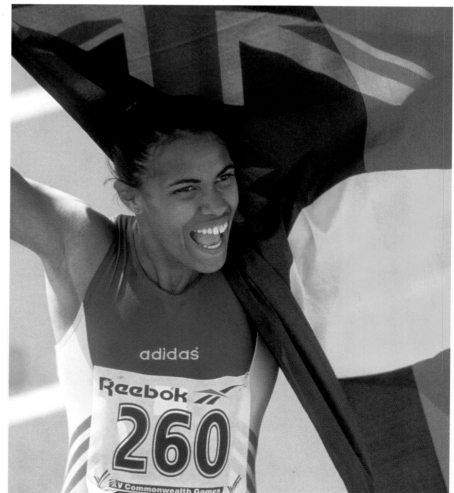

281. Cathy Freeman at the
Commonwealth Games,
Victoria, Canada, 1994.
Freeman runs her victory lap
with Aboriginal and
Australian flags held aloft.

See also: 4.1, 20.1, 20.2;
athletics.

traditional lands. Style, subject, and medium all highlight the artist's theme of destructive coexistence, past and present.

Mixing reclaimed European depictions of historic Aboriginal people and Indigenous motifs is one way of showing that Australian art history needs to include all its inhabitants as active participants if it is to be relevant to present interests and values. Many of Bennett's paintings exemplify this by amalgamating quotations from white and black images and motifs. Aboriginal art is a crucial presence in *Big Romantic Painting: The Apotheosis of Captain Cook*, 1995 [*265*], even though it mainly quotes white colonial images. The Aboriginal woman standing proudly erect in the right foreground is a copy of an 1868 sketch by a newly-married emigrant to north Queensland, Lucy Gray, intended only for the eyes of her English family. Bennett gives the amateur drawing equal status to a 1794 professional engraving of Captain Cook in glory from the transformation scene of a London pantomime by the renowned Philippe de Loutherberg. His sources are typically up to date; these come from revisionist art historical and history texts published in 1992. Then, in the centre of the painting hovering just out of reach of a school textbook explorer drowning in Australia's mythical Inland Sea, is one bright desert art dot. It evidently represents Aboriginal survival in the same location. The result is no boast about relative black and white survival in the Australian interior, however, but a critique of the ignorant romantic myth-making of old white Australian history books.

In a later series, *Home Decor (Preston + de Stijl = Citizen)*, 1995–98 [see 22.5; *267*], Bennett mixes more generic details from avant-garde European paintings and jazz-age popular culture with a '**corroboree**' dancer by Margaret Preston. This is no longer simple appropriation. Even Preston experts have difficulty identifying one overblown, isolated detail from an atypical work. Like much recent appropriation art, these paintings have nothing to do with identifying sources (the answers are already in the titles, where relevant). They have become autonomous satires on the sort of art that results when we cling to an art history with an exclusively white urban perspective on race.

Other artists have effectively turned the tables and made the Indigenous reference crucial to their work. Onus's *A Stronger Spring for David—Toas for a Modern Age*, 1994 [*266*] is a late twentieth-century version of the unique Reuther collection of early twentieth-century Lake Eyre Toas (message sticks) [*146*] in the South Australian Museum. Although undoubtedly enhanced by knowing the source, his witty new message sticks do not replicate forms that belong to Aboriginal people of a distant country. Onus realised (as few of his non-Indigenous contemporaries did) that the unauthorised appropriation of Aboriginal styles and motifs is improper because it inevitably results in the icons of the powerless being absorbed into the dominant culture. His lively tributes are created out of the rubbish of contemporary white society and highlight (with considerable affection) the ludicrous fetishes of the conqueror. Yet perhaps their wit also echoes the potentially parodic character of the enigmatic originals, similarly produced to satisfy the irrational lusts of the white collector.

In the 1990s Aboriginal artists increasingly quoted images and motifs from their own heritage. Icons like Wanjina (spirit figures) had already appeared in paintings by artists such as Robert Ambrose **Cole** [*308*] and Karen **Casey** [*65*] purely as respectful homage or, in the latter's work, as a telling contrast to urban decadence. But Jonathan Kumintjara **Brown**'s portrayal of Wanjina as white men in nuclear decontamination suits in one of his *Ode to Maralinga Nullius* paintings (*c.*1992–95) [*299*] is a bitterly satiric inversion. As well as being the notorious site of the 1950s British nuclear tests, Maralinga was Brown's traditional homeland. A **stolen generations** child and a forced refugee, his first remembered sight of this desolate landscape was as an adult. The series also includes a number of **acrylic paintings** in which Western Desert style dots are

266. Lin Onus, *A Stronger Spring for David—Toas for a Modern Age*, 1994. (detail: To supersede Camp Dogs on Cold Desert Nights) Installation at the second Asia–Pacific Triennial of Contemporary Art, Queensland Art Gallery, 27 September 1996–19 January 1997. Acrylic painting on electrical conduit and PVC tubing with wooden bases, a spring, a ball, feathers, string, found objects and sand; 10 pieces 150 x 162 x 150 cm (oval, installed, variable).

obliterated by large patches of black, symbolising that loss of land and culture. In order to appreciate these works, the viewer needs to recognise the Indigenous symbols of this shameful event.

Whispering hollow wooden posts, some carved with Sydney Aboriginal words, others filled with Indigenous materials like shells, feathers, and honey are set among the iron building stanchions and sandstone tombstones of white society in *The Edge of the Trees*, 1994–95, a large sculptural installation by Fiona Foley and Janet Laurence outside the Museum of Sydney on the site of the first Government House. With cool postmodern irony, they echo the form, function, and texture of Pukumani poles (*tutini*) [see 7.6, 16.3], an Indigenous reference accessible to most Australians. Our greatest contemporary icon is the *Aboriginal Memorial*, 1987–88 [*38*, *74*], made up of 200 modern burial poles by **Ramingining** artists, while the Art Gallery of New South Wales holds a renowned collection of Tiwi *tutini* [*96*] made in 1958. The latter inspired a group of poles (made in 1998–99) by the Tiwi artist Pedro Wonammeri, exhibited in the gallery as part of 'Perspecta 99' to assert the survival of this ancient tradition. The Museum of Sydney poles, however, are tributes to displacement not survival, key players in a memorial to the meeting of Indigenous and non-Indigenous Australians on 'the fatal shore' of Port Jackson by latter-day representatives of both sides of that encounter, the Badtjala Foley and the non-Indigenous Lawrence.

Art that reclaims the past through conscious visual quotation can come from both sides of the frontier. Yet when remote artists transform historic images for new audiences, the status of the source is often equivocal—both known and unknown. Emily Kame **Kngwarreye** [*123*, *216*, *225*], Ada **Bird Petyarre** [*222*], Bessie Liddle, and the many other women artists who transpose women's body designs onto **batik** and canvas—even the Tiwi Nancy Henry of Yimpinari, Melville Island, who refers to body ornament in her bark designs—do not divulge the original meanings of these motifs to outsiders. Nevertheless, they remain embedded in the work, giving it its power. Perhaps these translations from body to canvas, from ceremony to display, can be called quotation art, but they are not appropriations in the same way that reviving lost or forgotten traditional images can be.

In the early 1930s the Moandik **Janet Watson** wove two aeroplanes out of sedge [*401*] using the material and methods that her ancestors and contemporaries employed for baskets, mats, fish traps, and other useful objects [see 17.1, 17.2]. Her work inspired Ngarrindjeri Yvonne **Koolmatrie** [*159*] to make her own biplane in homage. Koolmatrie has also made eel and fish traps and other traditional Ngarrindjeri objects (mainly copied from originals in the South Australian Museum), always as art works for predominantly non-Indigenous viewers. Some were included in 'fluent', the official Australian entry in the 1997 Venice Biennale, where they attracted shoals of human admirers. In 1998 she reproduced another lost Ngarrindjeri art form—Pinkie **Mack**'s unique surviving ceremonial mortuary mat of 1943 [*347*].

Since the function of Koolmatrie's replicas is to evoke respect for and recognition of forgotten customs of her people, so these objects are as much political statements as Bennett's most explicit satires. An 'authentic' fish trap hanging in an exhibition may not look much like evidence for a Ngarrindjeri land claim, but it is. Like many forms of Indigenous art that take back the past for the present, its bite will be felt long after the pinpricks of most non-Indigenous artistic appropriation are forgotten.

JOAN KERR

Kerr, J., 'Past present: The local art of colonial quotation', in N. Thomas & D. Losche (eds), *Double Vision: Art Histories and Colonial Histories in the Pacific*, Cambridge, 1999; Cubillo-Alberts, F.,

'Janet Watson', in J. Kerr (ed.), *Heritage: The National Women's Art Book,* Roseville East, NSW, 1995; Marsh, A., 'Gordon Bennett: A menace in Australian history', *Eyeline,* no. 41, 1999.

22.5 Home Decor (Preston + De Stijl = Citizen), 1995–98 [*267*]

The development of these particular paintings was motivated by the 1940s and 1950s works of Australian modernist artist Margaret Preston—specifically the 'Aboriginal works'.

Initially I began by using the appropriated detail as a starting point for paintings that were primarily concerned with formal issues, but which also played with the possibility of a perceived narrative, a narrative that is suggested by the relationships of the various elements in the work but which did not actually exist. I am interested in the play between the figurative and the abstract in these works. I am also interested in exploring the cross-cultural issues that these works may provoke—particularly the issues surrounding Preston's advocacy of appropriating 'Aboriginal art' as a means to develop an 'Indigenous' style of Australian modern art while, at the same time, being dismissive of Aboriginal cultures and peoples. This is an obvious issue, which is extremely relevant to our times and our national identity, but not the only issue I am interested in [see 22.1].

The idea of style interests me also. *De Stijl* (The Style) was based on a multidisciplinary approach that embraced all aspects of formal creation and aimed at universality. I am also interested in Mondrian's theosophic concepts which led him to create an abstract visual language in order to represent the universal harmony that would result from the resolution of the antitheses between the masculine and the feminine, the static and the dynamic, and the spiritual and the material. While such a resolution would be nice, I am more interested in the dynamic/static interplay between the binary opposites of abstract/figurative, Black/White, good/bad, right/wrong, inclusion/exclusion to name a few. Here I am merely adding to Mondrian's list some of the binaries that preoccupy me at present.

Within the modernist grid of Mondrian's spiritual universality and Preston's stylistic utilitarianism, I hope to further explore a history of ideas, the history of events and the spaces between the binary opposites that form their foundation, and which form our sense of ourselves. After all there must be some utility in exploring the common ground between self and other.

What stimulates me most of all is the possibility of a meaningful dialogue in a visual language and the implications that may arise from this for contemporary life and society.

GORDON BENNETT

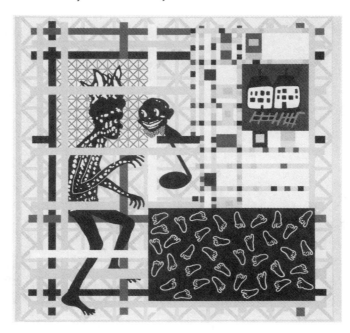

267. Gordon Bennett,
*Home Decor
(Preston + De Stijl = Citizen).
Dance the Boogieman Blues,*
1997
Acrylic on linen, 182.5 x
182.5 cm.

Thomas, N., 'Home Decor and dance: The abstraction of Aboriginality', in R. Coates & H. Morphy (eds), *In Place (Out of Time): Contemporary Art in Australia,* Oxford, 1997; McLean, I., 'Gordon Bennett's Home Decor: The joker in the pack', in C. Perrin (ed.), *In the Wake of Terra Nullius,* special issue of *Law, Text, Culture,* vol. 4, no. 1, 1998.

22.6 'They bin make us go artist now': East Kimberley painters on the art world

The contemporary art of **Warmun** and Kununurra in the east Kimberley developed from two sources: painted boards carried by dancers in a Kurirr-Kurirr **corroboree** 'found' by **Rover Thomas** [see 10.1, 10.2, 10.3; *131, 136, 219*] and paintings created for the Warmun school by elders to teach children Kija culture. The paintings, called 'boards' in Kriol [see **Aboriginal English**], were 'discovered' by white people (Kartiya) who encouraged the creation of works for sale.

The growing international recognition of artists from these communities has drawn both them and their work into the non-Aboriginal art world. This new encounter with Kartiya, who sought within living memory to eradicate Aboriginal culture but now often idealise it, elicits mixed reactions. While pleased with the greater respect for Aboriginal culture and the income that art brings, artists voice concerns about who mostly profits and about the appropriate display of Aboriginal art in museums and galleries. These are some of their perspectives [see also 21.1].

Hector **Jandany** recounts that:

[A dead woman's spirit] had to come to Rover. Tell him make a song of him. That's why he bin (past tense) make that Kurirr-Kurirr. And that old man 'nother one he bin painting all that story. Everything song, [a] painting, like that. And we had to get together and dance-em (transitive marker) for him la (at the) school. Teach-em kid through that board.

This painting he like a school book. Important for [Aboriginal] children. That's why we bin get them thing now. And he's an important thing this. Really important places there. And Kartiya bin come to find out what they can. They was ask-em why us in Turkey Creek [Warmun]: 'What you painting there?' 'Ah, we just make-em up here for school kid' and did everything. We didn't have-em money then. We just bin painting up here for school kid. All them old people not reading [or] writing. This the important thing for us, for Australia. That bin give us life all the time. This country.

Well now some white people bin come and look in the school. They bin see good lotta painting stop from the Aborigines. They had to make us painting for gallery now. All the Kartiya bin find out what. They bin see this and they bin make us do painting. And we bin keep going' then. Painting on. Every gallery. And they bin make us go artist now. From that painting. He from school this. Everywhere painting going. We had a painting all this. And they bin come around and make us artist now. We are artists today. Very clever, eh?

We got that memory always. Somebody want to buy him he gotta come buy him right here. Well, they bin long to come buy this painting. [Kartiya] gotta go 'Oh, I got-em money. I'll buy him off you. How much sell-em for that?' That's what he bin asking. [We said] 'Yeah, you can do that. Long as you get him mobs of money might be!'

How they bin come to love this [painting]? That Kartiya bin find out through the Aborigine in school. Because these kid in the school always painting. Painting and corroboree dancing. They bin come to love him. They good one. You bin say you [Kartiya] might be love-em this picture there. Well, I might love-em something you bring-em. I might be love-em that thing you got-em. Well, there. You see now? Him the same. You and me got same place. You love my thing. I love-em your thing.

After the initial success, others began to paint. **Madigan Thomas** takes up the story:

[My uncle] that's the one bin start. Then Rover bin start. And we bin start thinkin' about it: 'We'll have to start tryin' to do something like that. They might help us.' We bin start

doing all the painting. Some people when they come through they used to come around and look around. Askin' around for painting. We bin just go la house and grab-em and show-em to them people. And they buy-em off us. 'Ah, well, we'll have to start off more,' they [Aboriginals] bin start thinkin' about now. Get goin' now. Gettin' bigger and bigger. Till everybody bin come up and askin' us now 'Oh you do painting? You do painting!' Everyone. 'Ah, yeah. It's not very good,' we used to tell-em, '[We] just try.' They used to look at our painting and [ask] 'What story?' and they buy-em. We all havin' a go now.

Though cultural content remains the priority, most paintings are produced for sale. Aware of the prices their works command at urban galleries, some artists worry about exploitation. Jack **Britten** [*297*] explains:

Doing that painting, Kartiya one. You know what mean we put-em that country? Culture! That's our culture we doing. Kartiya don't wake up. What country and all that. This is our country. Before them Kartiya.

Somefella Kartiya came over. He said: 'This your culture. We got our culture. We pay you for that.' Well there, they pay you. Drawing the country. Kartiya love-em that painting what blackfella do. Kartiya take board. Blackfella take-em half. He send-em or he sell-em. 'Nother rich Kartiya come from that way he buy-em all that for another, might be, gallery. And that poor old blackfella bin make-em that place good and that boy can't get-em right price.

With the increasing popularity of their work, artists travel to exhibitions throughout the world. The journeys bring novel experiences, but also prompt concerns about the cultural appropriateness of the way in which Aboriginal art is displayed. Freddie **Timms** [see 10.3; *391*] recalls:

I went to Tokyo. But they never [bought] anything. I was there for a week. We had couple of bloke lookin' after [us]. Walk around there. Walk all over the city. Look around and all. Goin' to look at train underground. I just go around myself sometimes. Walk around. Meeting that many people. See that many people. Oh, very nice country. Very clean country. You can't see anything laying. Can't see rubbish. And they haven't gotta room much. No much room. They gotta house all along. No room to hang your clothes out. They gotta have it on the window all over hangin' up. Very jammed up. People gotta jammed up. Even the café. Very nice shop. Some up there, some underground. I met one [woman] there, [from] New York. He askin' me a lotta questions. He was like my painting too. And he reckon 'I hope one day you like to come to New York there.' I'm probably goin' sometime.

Queenie **McKenzie** [*135*] describes being tired out by newspaper photographers asking her to pose [*268*]:

Someday I'll put him la painting. Exhibition what they bin give me. What they bin do la me. What I bin see. I gotta make a painting out of that one. [The photographers had me] sittin' down la chair. Get up from chair. Walk that a way, walk back. Come back sit down la chair. Hand like a that [posing as 'The Thinker'] and talkin' like a that. Picture like a that and picture you goin' along walkin'. All the way they two fella talkin'. Knock-em up me properly.

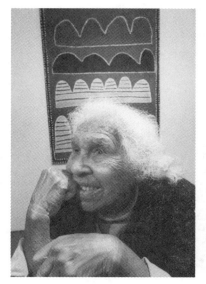

268. Queenie McKenzie posing for photographers in Melbourne, 1996.

They bin show me that newspaper [with my photo]. I bin look straight away this newspaper here now. Really good one. Puttin' the news on, you know. Everybody read-em from you. You gonna be there forever. You see that newspaper. It's good.

At exhibitions artists frequently recount the **Dreaming** or 'story' behind their paintings. Some motifs, however, are purely decorative. After repeatedly being questioned about decorative elements in a print, Allan **Griffiths** [*130*] reflected with amusement that Kartiya are obsessed with the idea that in Aboriginal art 'everything gotta have a meaning!' Shirley Purdie describes answering questions about her work and worries about its ultimate fate and the display of paintings by deceased artists:

I've bin to Melbourne and I've bin to Brisbane. We was doin' a bit of painting and they bin hang-em up and do exhibition. They was askin' what them painting what we used to do. If they got story and all that. Dreamtime story. They askin' all that. Well, painting was good, you know. Doin' the painting.

I don't know what they do with them after when they buy-em up here. They might be hang-em up la wall or I don't know what. I think he all right. But sometimes when Aboriginal people come down [to exhibitions]. Sometime we feel sorry. We say 'Oh, we bin do-em that country and he'll be goin' another place now.' We say that word, you know.

When we went to Melbourne in that big National Gallery. [We saw a painting by] that oldfella one really. That we lost here. We saw his one there. Bit worried what, you know. You can't help it his. You do your painting and painting he'll be still there [after you die]. Yeah, really we don't know. Can't help [it] really.

HECTOR JANDANY, JACK BRITTEN, FREDDIE TIMMS, QUEENIE MCKENZIE, AND SHIRLEY PURDIE
COMMENTARY AND INTERVIEWS SUPPLIED BY ERIC P. KJELLGREN

23. The way ahead

23.1 A balance in knowledge: Respecting difference

Mandawuy Yunupingu [see **Yunupingu family**] is renowned as the leader of the Aboriginal rock group **Yothu Yindi** which he founded in 1986. Before that he was the first Yolngu head teacher of the **Yirrkala** school. Recently, with his brother Galarrwuy Yunupingu [*39*], Chairman of the Northern Land Council, he has founded the Garma Cultural Studies Institute near Yirrkala which will provide an environment for teaching Yolngu culture to outsiders and aims to incorporate Yolngu knowledge systems with the Australian academic system. He has also developed his own recording studios and performance centre near his home at Gunyangara.

I guess I've been educated, and raised in both worlds ... but Yolngu culture—that's where my understanding of my roots are. I had a vision of helping Yolngu culture particularly in Yirrkala. Maintaining our culture whether it be language, whether it be *raŋga* (sacred objects), whether it be spirituality or whatever it may have been ... I made that part of my commitment for the future. I set a target, an objective, saying that after I leave school I want to train to become a teacher then go back help my people ... What I was searching for was a balance. A balance in knowledge. And that knowledge, that I had learnt when I was growing up as a boy, wasn't being put into the school curriculum. So I thought I'd make it additional to what was already there in place. We wanted to incorporate the many, many, many, many aspects of Aboriginal education that could be part of the school. My challenge was to fight the system and get them to accept the fact that we wanted to bring our knowledge system into the school. That was the challenge that made my people—particularly the many tribes from Yirrkala—come together in unity. My guiding principle was to maintain our language, so that our system of learning wasn't being overlooked, so that there was freedom to learn not only in the classroom but outside of the classroom situation. So therefore we had to take people out into the bush going back to the real roots of Yolngu ways and understanding. And that's basically what I did.

In the process in order to be intellectually accepted and recognised by wider academic society I undertook a formal education. That meant that I could compete with any non-Yolngu in Australia so I was part of the big institution of education out there. But in that forum I was able to challenge and say this is what I want to do—negotiate [the inclusion of Yolngu knowledge]. I took it to that mainstream level of tertiary education and I said 'this is what I want to negotiate, what can you do about it, how can you make it happen?'

I was able to go back to Yirrkala and put what has become known as the Aboriginalisation program in place. I then introduced changes in the curriculum, in the form of Garma Maths and Garma Education, based on principles of Yolngu knowledge. All this then becomes part of a prerequisite for the tertiary level. And our tertiary level is the knowledge associated with our ceremonies, with our sacred objects, with our land.

And then Yothu Yindi of course. Yothu Yindi was an influence from education really because I was trying to bring the balance you know—of Western culture and Aboriginal culture in order to meet and fuse two things, the end results of which can be recognised as one. So that's the way the influence came to me to form Yothu Yindi band. The band takes on the same agenda to what I did in teaching really. But I'm a musician instead of a teacher.

In the early 1970s Mandawuy Yunupingu was assisting European scientists like Neville White and Neville Scarlet who were interested in Yolngu science, in ethno-science, and the naming of plants and their uses. People from the outside were interested in Yolngu knowledge. Mandawuy reversed that by saying: 'Well this is already here as Yolngu science so this should be part of what we're teaching in our schools. So there's no reason why if Europeans are coming from outside to learn about this, we shouldn't see that as part of a valuable knowledge system that is our own'. Similarly with Yothu Yindi, there were musical forms coming from outside, that young Yolngu were interested in. Mandawuy Yunupingu did not see these things as opposed, but things that can be fused together.

Fused together, yeah, that's right. But that's basically what our view is. Our objective is to bring about balance and understanding—a true sense of equality. And that's basically what I think our next step is to do that because we know we're strong in the elements of our foundation. Our foundation is our *raŋa* (sacred objects), our foundation is our *madayin* (religious knowledge) our *likan* (clan connections), *larrakitj* (hollow-log mortuary ceremonies), and the philosophy that they carry. Those things and the songs—that's our foundation—we know we're secure. The challenge now is to enable the next generation to live a good quality of life that recognises difference more than what we've been experiencing in the past, because now it's time to think what difference contributes to a society. Because that's how society lives and that's why we don't want to lose our culture, it's the difference that we want to maintain not the sameness. The sameness can be classified as assimilation. That's what we don't want—we don't want to be assimilated—to think like a white man.

For Mandawuy the *raŋa* are like the foundation, but they're a foundation that you have to be prepared with and for, and to understand. So that in fact the knowledge that you get every day of the uses of the plants and their habitats—that is something that you need to know before you can then understand the foundation, and that's what often outsiders don't see. They see beautiful Yolngu art works and they imagine they come just like that from nothing, but they don't, they come from a long history of work.

That's right. When you're born you start to grow, and then you start to walk … You crawl in order to start to walk and we're then taught all those essentials you need to know what that tree is, what that plant is, what it is used for—for medicine, for sustaining abilities—for all those things that make us want to be part of the land. You have got to be able to know all these essentials in life. And then after that you start to learn all this abstract thinking that then becomes part of Yolngu culture. It's the moving living thing.

For Mandawuy the *raŋa*, the *larrakitj*, all stand for abstract thinking:

That's right of course that's what it is, it's all theirs. You know, you can see it, you can celebrate it. For example when you look at a painting of Ganbulabula [an ancestral being] in a *larrakitj*, you can see, you know, the yam climbing up [*269*]. The yam flower, it blossoms out, it represents nice people, because flower is unity. Just a simple yam, it's just nothing, but yet it's got something big there. Like *garma* (public religious knowledge), you know, you can't pull *garma* out, and say that it doesn't exist. You know, it's there, it's already—all these aspects of life that are so essential to Yolngu—Yolngu's ability to exist—it's so vital for the existence of Yolngu culture. And that's what teaches us to live in harmony. Because we live in harmony already, we relate to one another. But there's also a *gurruthu* (relationship) that we have with land; so it's a recursive thing—it keeps happening.

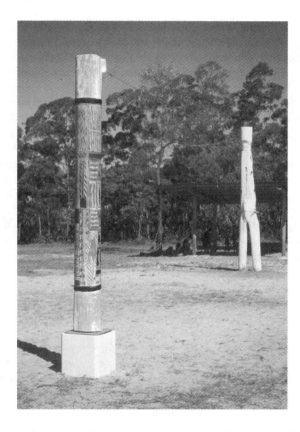

269. In the foreground is a *larrakitj* (hollow log coffin) painted at the inaugural seminar of the Garma Cultural Studies Institute at Gulkula, in 1999. The designs represent a number of clans of the Yirritja moiety. In the background is a sculpture of Ganbulabula by Galarrwuy Yunupingu, carved in 1998 but painted for the opening ceremony in 1999.

My learning took place around campfires and at my family's place of dwelling. That's basically where I got all my *manikay* (song) and my dancing and thinking straight. It provided the context in which we shared that information, whether it be singing, or dancing. We might be taking part in the preparation for a ceremony, or whatever you know—everyone's learning. And from there we took on a mixture of influences from Western influences, like country and western music, choirs, church choirs and then rock and roll of course came into being. That sparked in me a way of thinking ... Yothu Yindi gave me an insight into music and an insight into a network of genres that exist around the world. What I wanted to maintain is basically Yolngu and Balanda

(non-Aboriginal) elements that make up something that is one in the end. And that's what we've been able to do: fuse Yolngu and traditional—something that is sixty, eighty, a hundred thousand years old, with that of just two hundred years old. So that gives us a basis as to how strong and how powerful our side is because it gives the next generation an idea just where it's going to go, or where it's going to lead us—as long as you know that your roots are part of your foundation. My emphasis to younger generation is to say 'Don't forget your culture. We can be equal to any other—any other genres that exist around the world and still be recognised as a culture.'

<div align="right">

MANDAWUY YUNUPINGU

COMMENTARY BY HOWARD MORPHY

</div>

23.2 The *Ngurrara Canvas*

The National **Native Title** Tribunal held a plenary session for the Ngurrara Native Title Claim in July 1997. The Ngurrara claim covers land traditionally owned by Walmajarri, Wangkajunga, Mangala, and Martuwangka people. Hosted by the claimants, the meeting took place at Pirnini, a remote claypan on the edge of the Great Sandy Desert about 200 kilometres south-east of **Fitzroy Crossing** (WA). Centre stage was a painting measuring ten metres by eight metres, depicting a vast landscape and created by the artist claimants to demonstrate their connection to the country being discussed [*270*]. Around the canvas were assembled about seventy traditional owners and their families, Fred Chaney the tribunal's Deputy President, and a representative of the Western Australian State Government.

The claimants moved one by one to stand on their own area of the desert country represented in the painting, and spoke of their relationship to specific places within it. Pangkaylala Gail Smiler, one of the interpreters, describes her role at the meeting:

We moved around the canvas with each person giving their evidence in their own language. Then I told the story in English. Standing on and moving around the painting gives you the feeling that the country is nearby, as easy as putting your foot on the other side of the sandhill. That's how it felt when I was interpreting for the tribunal, standing right on the place we were talking about. But I know for the old people that it is a long way to their country. The painting makes it closer for people. As [Mona Skipper] Jukuna says, 'Painting brings my country up closer, true, it brings it closer to me.'

The *Ngurrara Canvas* was made by a group of about forty artists, who painted their own areas as well as those of other claimants who gave directions to them [see 10.2]. Some of those who painted had never done so before, while others were well-known artists, such as Jimmy **Pike** [*133, 369*], Pijaju Peter **Skipper** [*134*], Paji Honeychild **Yankarr**, Daisy **Andrews** [*283*], Dolly Snell, Maryanne Downs, and Stumpy Brown. This was not the first time that the **Mangkaja** artists had painted together. They had collaborated in 1991 on two large banners for the opening of their first exhibition at Tandanya in Adelaide. In 1993 they had produced a banner for the 'Images of Power' exhibition at the National Gallery of Victoria, and since then they had made many smaller joint works for gallery openings around the country.

When faced with the constraints imposed by language and the problem of being understood clearly when the time came to give evidence about their claim, the artists decided to make a composite canvas as visual testimony. As artist Tommy May says, 'If Kartiya can't believe our word, they can look at our painting, it all says the same thing.' In Pijaju Peter Skipper's words,

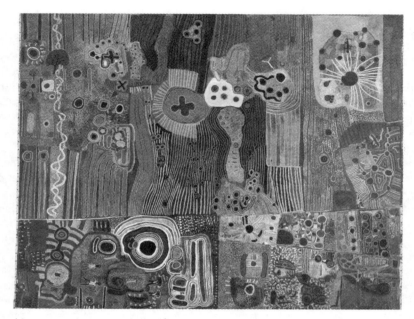

270. *The Ngurrara Canvas*, 1997.
Acrylic on canvas, 1000 x 800 cm.
The artists who contributed to the Ngurrura canvas are: Daisy Andrews, Manangu Huey Bent, Ngarta Jinny Bent, Biddy Bonny, Pulukarti Honey Boolgardie, Nyuju Stumpy Brown, Pajiman Wardford Budjiman, Parlun Harry Bullen, Junjarli John Charles, Jukuna Mona Chuguna, Peter Clancy, Kapi Lucy Cubby, Purlta Maryanne Downs, Sundown Ellery, Kurtiji Peter Goodije, Jewess James, Yilpara Jinny James, Jack Japarta, Willie Kew, Penny K-Lyon, Rosie Goodjie, Trixie Long, Doris May, Ngarralja Tommy May, Mawukura Jimmy Nerrimah, Yamapampa Hitler Pamba, Killer Pindan, Kuntika Jimmy Pike, Nada Rawlins, Lanyi Alec Rogers, Sweeney Nipper Rogers, Walka Molly Rogers, Pijaju Peter Skipper, Jukuja Dolly Snell, Nyilpirr Spider Snell, Scotty Surprise, Wakartu Cory Surprise, Myapu Elsie Thomas, Tuckerbox, Boxer Yankarr, Paji Honeychild Yankarr, and Gypsy Yata.

That big canvas is not an insignificant painting. It is very important. It is *wangarr* (shadow) and *mangi* (spirit or essence which remains when a person has gone). That's what we call it now. We painted all of our country. It is the same as all our smaller paintings. The stories and the bodies of our old people are in their country, our country. We wanted to make Kartiya understand our ownership of our country. Bulldozers come into our country and they grade the road right through these places, through those bodies. When the mining company takes the earth away they pull out the *mangi* and take it to another place, they take it away. That's why we are fighting for our country, to keep the *mangi* there in our country.

The significance of the work reaches beyond its use as evidence for the Ngurrara claim. The painting is relevant as documentation of the country and the stories for a large number of artists. It provides a base on which to locate many desert works, not only those from the Mangkaja Arts Resource Agency but also others held in State and national collections. A significant number of artists from **Balgo** [see 2.2, 9.5], **Wangkajungka, Warmun**, and Fitzroy Crossing communities paint sites which can be located on the large painting.

The work has now taken on a life of its own. It has regular showings in the carpark outside Mangkaja Arts and at land council meetings, prompting the eruption of lively discussion. It has travelled to the Parliament Houses in Canberra and Perth to coincide with ongoing debates on amendments to federal and State native title legislation. It travelled to France in June 2000 for the Lyon Biennale to form part of a major exhibition in conjunction with France 2000 celebrations. On return it toured nationally, before returning to Fitzroy Crossing to continue its role in the fight for the Ngurrara claimants' country. The case has now been referred to the Federal Court where it will be heard in 2001. This is a long time to wait, as Pijaju Peter Skipper said, 'Not worth, we'll all be dead.'

KAREN DAYMAN AND PAT LOWE

Mangkaja Arts & Kimberley Land Council, *Jila: Painted Waters of the Great Sandy Desert* [documentary film produced with assistance from SBS Independent], 1998; Lowe, P. et al., 'Painting up big: The Ngurrara Canvas', *KaltjaNow*, no. 1, September 2000.

23.3 The Natives are restless

There was song that haunted me all through the summer of '99 and one verse in particular: 'We are living in the mainstream'. **Yothu Yindi**'s CD, titled *One Blood,* travelled with me to places in various continents, including to South Africa, India, and Japan. The work that I was doing related to various theme exhibitions or installations in those countries. In each place I was asked to speak about my work, Aboriginal Australia, current matters relating to federal politics, **native title**, Indigenous language, and culture. Although these dialogues were initiated from a visual art springboard, the totality of our lives as Indigenous artists encompasses so much more.

In a similar way that Mandawuy Yunupingu [see 23.1; **Yunupingu family**] has made a commitment to living in his country and to a humanitarian approach to education and music, that commitment has also been a part of my life, consciously. Living in your own traditional country gives you a grounding that encompasses a past and a contemporary context for my generation of Badtjala. We are players in the mainstream, which encompasses the arts, as claimants for native title, and as spokespeople through the development of tourism [see 18.1], land management, health, and education.

In an ever increasing way, our voice, our aesthetic, which articulates Australia, is being sought out internationally. This expansion into the global village is made possible through the numerous publications on Aboriginal artists, the quantity of exhibitions that are travelling abroad from Australia, the use of new technology to access information on artists, and the means by which we can traverse continents in a relatively short span of time. However, alternative technology was first introduced to Australians well over 600 years ago by the Macassan people [see 6.4]. The Portuguese made brief visits to Australia 250 years before Captain Cook [see 4.2, 4.3]. Then came the Dutch, French, and British. Indigenous Australians have long incorporated new technology into their daily lives.

271. Installation view of 'World of Dreamings: Traditional and Contemporary Art from Aboriginal Australia' at the State Hermitage, St Petersburg, Russia, 2000.

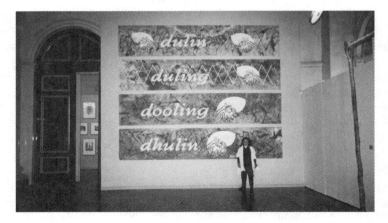

Although the direction for me currently is a duality that is both international and involved in regional Australia, it could be said this is the current direction for a number of Indigenous artists, musicians [see 15.1, 15.2], dancers [see 16.5, 16.6], writers [see 14.1], directors, and actors [see 16.1]. In the past decade, our lifestyle has led us all to meet offshore at various arts events, **festivals**, survey **exhibitions**, solo exhibitions, biennials, and triennials [see 21.1]. On more than one occasion, I have met the same Indigenous artist abroad, rather than in our native Australia [*271*].

This universality has opened up many more diverse opportunities for Indigenous artists that may not otherwise exist in the current narrowing of the Australian intellectual climate, where every scenario is a dichotomy between black and white. Dominant

post-colonial attitudes and behaviour are still well entrenched in Australian society and permeate all strata, releasing a pervasive stench. My work in recent times has led to collaborations, residencies, workshops, and dialogues with artists such as: Kelvin Yazzie, a Navajo ceramicist living in Flagstaff, Arizona, USA; Bernadette Searle, a photographer living and working in Cape Town, South Africa; Subba Ghosh, a painter and organiser on the KHOJ Committee, New Delhi, India; Anoli Perera, an installation artist from Colombo, Sri Lanka; and Olu Oguibe, an author, artist, and curator from Nigeria living and working in New York. These are but a few examples. In recent years, this space has allowed for a type of international networking. It is dynamic and at the cutting edge. It's not about positioning oneself in a dying European Centre which has relegated our Indigenous cultures and intellect to the periphery in past centuries. Engaging in alternative dialogues, strategies, and working models has been a breath of fresh air, challenging and inspirational.

At a local level, I live in my traditional country, in the State of Queensland [see 8.1, 8.2]. I belong to the Wondunna clan of the Badtjala nation, which traverses many sectors of society—this weighs heavily on us but is necessary because of our active participation at a regional level in the demands of native title claims. Badtjala traditional country encompasses all of Fraser Island and has four natural boundary markers on the mainland. We are still faced with ingrained ignorance about Badtjala people, our history, and our culture with continuous connections to country. Hervey Bay is currently represented by a member of the newly formed City Country Alliance political party (a split from One Nation). Despite this State's institutional racism we manage to work around those obstacles. As the *Native Title Act* was passed in 1993 and our Wondunna claim lodged in 1997, we see the mechanics of the process as unfolding over a long and drawn-out time frame, presently benefiting white-collar workers.

Having committed to living in Hervey Bay since the mid 1990s, a large proportion of my time during those years has been taken up with attending meetings about a multiplicity of issues. At times it seems my profession as an artist has had no bearing on my role as a community member and advocate. On the other hand, living in regional Queensland has brought home to me how centralised the art establishment is, with its various bureaucracies situated in the cities of Brisbane, Sydney, and Canberra—a nexus that has not motivated leading Queensland curators, gallery owners, art administrators, art historians, and art educators to travel the distance to Hervey Bay, even though there are five commercial flights per day. The new millennium is a time for new thinking.

My Indigenous peers have all embraced and are exploring the technological frontier available to us. These artists include, to list a few, Tracey **Moffatt** [*169, 244, 326*], **Rea** [*174, 276*], Karen **Casey** [*65*], Julie **Gough** [see 4.4, 11.5; *48*], and Arone Raymond **Meeks** [*64, 175*]. We are receptors to the times, technology, and geographical parameters that shadow our continuous growth. From Mandawuy Yunupingu to the artists of **Fitzroy Crossing** showing a connection to country through painting for their native title rights, from the time they are young to the time of their passing, Indigenous artists carry a responsibility much more integral to life than their non-Indigenous counterparts. We all have been much more than simply artists.

Over the past decade my work has taken me to many far-flung places, it is a responsibility that I view as being a cultural ambassador. At other times being a practising artist has been a solitary pursuit and yet rewarding for the education I have received purely through travel. No matter how many times I depart this colonial outpost (with its legal ties to the mother land) my very being is an unwritten accord. Like the various nations within Australia who also share this bond to country, we are the present day custodians with many voices of authenticity. FIONA FOLEY

Index to Part One

Part Two

Notes to readers of part two

In order to keep Part Two entries as concise as possible, abbreviations have been used to indicate commonly cited names of institutions, organisations, and the two most commonly cited visual art awards, hence: *Telstra presents* The National Aboriginal and Torres Strait Islander Art Award is cited as NATSIAA and the National Indigenous Heritage Art Award becomes NIHAA. A full abbreviations listing can be found on pp. xviii–xx.

Institutions and cultural organisations, have been cited, wherever possible, by the names they bore at the time of the publication of this *Companion*. For example, until 1992 the National Gallery of Australia (NGA) was called the Australian National Gallery, but within Part Two all exhibitions or citations of that institution within entries will appear as 'NGA'. The exception to this rule is bibliographic references made to material published by the institution; these will be cited using the name of the institution that was current at the time the material was published.

Titles of works and exhibitions
Works of art, series of works, and song and film titles are all given in italics. Where possible the dates of works are cited. For works of art citations take the form: *title*, date. In all other cases (e.g. book and film titles) they take the form: *title* (date).

Exhibitions held at institutions within Australia, or which had tours of Australia organised by Australian institutions or organisations, are always cited between single quotation marks. The exhibition's title is truncated, hence 'Flash Pictures by Aboriginal and Torres Strait Islander Artists' is simply cited as 'Flash Pictures'. The abbreviation for the venue or touring body follows, then the year(s) it was on display or toured, in brackets, thus: 'Flash Pictures' (NGA 1991). International exhibitions are cited slightly differently—again the truncated title appears between single quotation marks, but instead of the abbreviated title for institutions, the cities that played host to that exhibition are given within brackets followed by the dates, thus: 'Aṟatjara' (Düsseldorf, London, and Humlebaek 1993–94).

Cross-referencing
Almost all of the entries in Part Two are cross-referenced to other relevant sections of the *Companion*, in both Part One and Part Two. Within Part Two cross-referencing occurs at four levels. The first and second levels of cross-referencing appear in the A–Z sequence itself, to guide the reader through alternative forms of names for individuals, places, or topics. Thus a reader seeking out an entry on the artists of Yirrkala under the letter 'Y' will find a cross-reference of the following form: **Yirrkala artists**, see **Buku-Larrnggay Mulka**. Also within the alphabetical sequence are headword cross-references which define a major topic area that does not have a Part Two entry, pointing to other entries in the volume of relevance to that topic, thus: **architecture**, see 12.1, 1.3, 7.9.

The third level of cross-referencing occurs within the text of the entries: words which are themselves headwords of other Part Two entries appear in bold at first mention within the text, thus: ' … they called for administrative self-determination and a recognition of their **land rights**'. The fourth and final level of cross-referencing is found at the end of each entry, flagged by 'See also'. Here the reader is pointed to other parts of the *Companion* in the following order: Part One essays (indicated by section numbers: 1.1, 4.6, etc.); other Part Two entries (indicated by headword in bold); and images (indicated by image number in italics). Thus a complex set of cross-references might read as follows: See also: 12.1, 14.3; Albert **Namatjira, native title**; *7, 49*.

Types of entries
At the time of publication there were estimated to be around 10 000 practising Indigenous artists. Comprehensive coverage has therefore been impossible in a volume of this size. The biographies that appear here can be viewed only as a sample, selected to show readers the diversity of Australian Indigenous arts practice. Individual artists' dates of birth and death are given in brackets, where known, at the first mention of their name. However, if an individual has their own entry, then dates of birth and death are only given in that entry and do not appear elsewhere.

As the emphasis of the entire *Companion* has been weighted towards the visual arts, this is also reflected here in Part Two: the majority of biographies are devoted to visual arts practitioners. Individuals other than visual artists who have biographical entries are considered to be of enduring historical or cultural significance or, alternatively, to be leaders in other fields of artistic endeavour, such as literature or music.

Family and clan group entries are a means used to incorporate references to more artists than could be covered by the individual biographies. In many cases such entries are a particularly apt way to cover groups of remote-area artists who work in a distinctively collaborative way. Family and clan group entries are placed in the alphabetical sequence under the most commonly used 'surname' for that group.

Profiles of remote community art and craft centres have been included, and in some instances act as an alternative to individual artist biographies, through mention of artists in the context of the art centre and its activities. There are also regional summaries of the art of certain areas, or of stylistic movements. These entries may or may not be centred around particular art centres, and have also been a way to include artists who otherwise have not been addressed in the *Companion*.

Subject entries deal with significant Indigenous social and cultural issues or historical events that provide a background to the making of art, such as **land rights** or the **stolen generations**. There are also a number of entries that deal with the participation of Aboriginal people in the sporting arena. Finally, some modes of artistic production of particular relevance to Aboriginal art, such as **acrylic painting**, **bark painting**, and **printmaking** are given overview entries.

Entries on individuals

The short biographies feature significant aspects of their subject's career and are not intended to be comprehensive. The reader who seeks further details on a particular individual will find a list of up to four bibliographic references at the end of most entries.

In making the choice as to where an individual's entry will appear in the A–Z structure of Part Two, the editors have chosen the most commonly cited (in publications, or exhibitions) spelling of their name. Other commonly used alternatives very occasionally appear as cross-references within the A–Z sequence, thus: **NABAGEYO**, Bardayal, see Bardayal **Nadjamerrek**. Otherwise biographies are located in the A–Z under the English surname equivalent (if one exists) of an individual.

In Western cultures the naming system is one in which most individuals have first name(s) (which identify the individual) and a surname (which shows family membership). Aboriginal people's names often function to identify them as belonging to additional and broader social groupings, whether they be clan, subsection or moiety. Naming systems vary across the continent and conform to a greater or lesser extent to Western practices. For example north-eastern Arnhem Land people have a surname-like system, where members of a single clan share a surname (e.g. Yunupingu), whereas in desert regions people will nearly always have their subsection cited as part of their name, and may, in addition, have an English 'surname' (e.g. Turkey Tolson Tjupurrula). In such cases, the entry will be listed under the 'surname' (Tolson), but the reader may find a cross-reference within the A–Z listing under the subsection name (Tjupurrula).

The order in which Aboriginal names proceed also sometimes differs from Western systems. In the A–Z listing we have attempted to maintain the correct order of individuals' names, while still using the 'surname' as the headword in most instances. Thus Ginger Riley Munduwalawala is the correct order in which that artist's name should proceed, yet he appears in the A–Z listing under his English surname equivalent (Riley), thus: **RILEY MUNDUWALAWALA**, Ginger.

Structure of entries

Artist biographies begin with the artist's 'surname' in bold upper case, while non-biographical entry titles appear in bold upper and lower case. In the biographies, individuals' names are followed by date of birth and date of death, where known. Readers should note that for some individuals this information is difficult to obtain, and sources often contradict one another. In more traditionally oriented communities, birthdays may not be of great significance to Aboriginal people, who may place more emphasis on sites of conception. Yet, wherever possible approximate dates of birth and death have been given. Sources for these dates and other factual information include journals of early ethnographers, and government, mission, and art centre records.

The person's language affiliation or social group, or sometimes both, are cited next, if known. In Aboriginal societies language groups are often regional in character, and lower-level social groupings are contained within them. Where possible, a more localised affiliation is given first, followed by the language group, thus: Dhaḻwangu (Yolngu). In many instances, aligning someone with a particular group is not so easy because of the diaspora of Aboriginal peoples after white settlement in Australia. Moreover, for people who are members of the stolen generations, family history can often be a very sensitive matter. In some instances, artists may choose not to disclose certain personal details.

A designation of occupation follows these affiliation details, serving as a broad definition of the individual's field of artistic practice. From there the biography proceeds to tell of career highlights and to describe aspects of the artist's style, and usually culminates in a list of select exhibitions and collections which include the artist's work.

A

ABDULLA, Ian (Jo) William (1947–), Ngarrindjeri painter. When asked about his work, Ian Abdulla often replies: 'I can only paint what I know to be true.' Apart from a few years in Adelaide and northern South Australia, Abdulla has spent his life along the Murray River in South Australia. He was born at Swan Reach, and moved as a child with his family between Winkie and Cobdogla. As a teenager, he lived at the Gerard Aboriginal Mission near Berri.

Abdulla began painting in 1988 after attending a thirteen-week screen-printing workshop with Steve Fox in Berri (SA). Encouraged by Fox, he began to recreate his childhood in paint—a world of fishing, searching for swan eggs, yabbies, and frogs, trapping rabbits (for their meat and skins), picking grapes, and collecting wool from sheep carcases and from tufts caught on barbed wire fences, pieces of broken coloured glass, and even horse dung. Drawing from this lifetime of memories, Abdulla's paintings depict a wealth of enjoyment despite material hardship.

Created from a lively synergy of text and imagery, Abdulla's paintings are fresh and vivid; they are often peppered with humour or political barbs. 'Apart from their historical importance, Ian's paintings … affirm the culture of rural Aborigines throughout the country who, despite being dispossessed, have been determined to stay on their own land' (Kean 1993). His work has often been described as naive, and in the sense that he is untrained in Western paint-

ing techniques and ways of constructing 'realistic' pictures, this is true. But his narrative paintings have a disarming directness and probity that transcends such labels.

His career as an artist has led Abdulla to travel extensively throughout Australia. It has brought him numerous accolades: he was a prize winner at the 1996 NATSIAA, and South Australian Aboriginal Artist of the Year in 1991. He was awarded a full fellowship from the Australia Council in 1992. He has published two illustrated books through Omnibus Press: *As I Grew Older* (1993) and *Tucker* (1994). His work has been exhibited in art museums in Holland, Canada, Spain, Cuba, and Japan, and he is represented in all major Australian public collections. Despite this recognition, Abdulla remains a family man: 'My kids have been my inspiration, they kept me going. If not for them I wouldn't be where I am today.' His other concerns are for the environment: 'when we were kids the river was ours to collect swan eggs, catch fish or hunt; today it's polluted and we are meant to pay to camp', and for the continuities of storytelling: 'I like to teach my kids the things that were taught to me, I cannot paint what I have never seen or been involved in.'

PG

See also: 12.1; **art awards and prizes, Boomalli Aboriginal Artists Co-operative,** *282.*
Chryssides, H., *Local Heroes*, North Blackburn, Vic., 1993; Kean, J., *Murrundi: Three River Murray Stories*, Adelaide, 1993; Mundine, D. & Foley, F., *Tyerabarrbowaryaou II: I Shall Never Become a White Man*, Sydney, 1994.

Aboriginal and Torres Strait Islander Commission (ATSIC) is an independent statutory authority and the main Commonwealth agency concerned with the administration of Aboriginal and Torres Strait Islander affairs. It is a unique organisation both within the Australian Public Service and internationally, combining an elected arm of Indigenous politicians with an administration staffed by public servants. The ATSIC framework empowers Indigenous Australians, among other things, to act as advocates for their rights in relation to **land rights, native title** and the protection of culture and heritage.

ATSIC contributes to the preservation of Aboriginal and Torres Strait Islander art and culture through a number of

282. Ian Abdulla, *Lined up along the Banks of the Murray River*, 1998.
Acrylic on paper, 58.8 x 76 cm.

policies and programs. It provides funding for cultural **festivals**, ceremonial activities, dance performances and the preservation of cultural knowledge through national and regional programs. Its aims are to foster the practice and knowledge of Aboriginal and Torres Strait Islander art and culture within the Indigenous community, in order to preserve the **cultural heritage** of Indigenous Australians for future generations; to strengthen the social fabric of Indigenous communities; and to promote the general recognition of Aboriginal and Torres Strait Islander art and culture as vital elements of Australian culture.

ATSIC's Art and Culture Program, which complements those run by the Australia Council, has two distinct elements. The Regional Council Arts and Culture element allows ATSIC's Regional Councils to allocate discretionary funds to support Indigenous cultural and ceremonial activity; and the National Arts and Crafts Industry Support Strategy (NACISS) provides funds to Aboriginal and Torres Strait Islander community-based **art and craft centres** and regional support agencies. These art and craft centres assist visual artists and craftspeople with materials, space and facilities. They promote identification, preservation, and production of visual arts in their broader cultural context, assist with promotion and marketing, and help Indigenous artists and craftspeople to understand the nature of their industry.

ATSIC funded the National Indigenous Arts Advocacy Association (NIAAA) over a number of years for the development of a 'label of authenticity' which has now been launched as a certified trademark. ATSIC also produces the *Visual Arts and Crafts Resource Directory*—a reference and promotional tool for both artists and industry associated workers—published periodically in book form and on the Internet.

National Aboriginal and Islander Day Observance Committee (NAIDOC) Week, which is partly funded by ATSIC, is a cultural highlight of the year for many Aboriginal and Torres Strait Islander people and their supporters. In all capital cities and many regional communities, this week focuses on activities that celebrate culture, and increases awareness of a rich and diverse heritage. ATSIC also contributes partial funding to cultural activities such as dance, theatre, cultural festivals, literature and Indigenous documentaries through its Public Awareness Program. Through its support for Indigenous art and culture, ATSIC creates an important forum for dialogue, exchange. and reconciliation. MAG

See also: 21.2; **Aboriginal Arts Board**, **arts advocacy organisations**, **repatriation**, **reconciliation**.
Mercer, C., *Creative Country: Review of the ATSIC Arts and Crafts Industry Support Strategy*, Canberra, 1997; Aboriginal and Torres Strait Islander Commission, *Visual Arts and Crafts Resource Directory*, Canberra, 1998.

Aboriginal and Torres Strait Islander Arts Board (ATSIAB)

originally called the Aboriginal Arts Board (AAB), was part of the Australia Council—a Commonwealth statutory authority established in 1973 to allocate public money for the development of arts practitioners and their publics— until June 1989, when it was replaced by the Aboriginal Arts Committee. Commonwealth funding for Aboriginal arts began in February 1970 when the Australia Council's predecessor, the Australian Council for the Arts (ACFTA), established an Aboriginal Arts Advisory Committee chaired by a Lardil man, Dick **Roughsey**. By the end of 1972 Roughsey's committee had disbursed $300 000. In redesigning ACFTA to form the Australia Council, the Whitlam government upgraded the Committee to being one of the Council's seven founding boards. Roughsey remained chair in 1975–76, then was replaced by Wandjuk **Marika**, who served until June 1980. Subsequent chairs were Larry Lanley (1980–81), John Atkinson (1982–83), Chicka Dixon (1983–86) and Robert Merritt (1986–89).

All AAB members were Indigenous Australians and served short terms in order to rotate the representation of regions and art forms. The AAB autonomously allocated its budget (which averaged 6.4 per cent of the Australia Council's total 'assistance to the arts' in 1973–89) and selected its staff. Its first two directors were non-Indigenous—Bob Edwards (1973–80) and Alan West (1980–83). They were followed by Gary Foley (1984–87) and Gavin Andrews (1987–89). In 1983 the AAB sought to make all staff Indigenous, a goal achieved by 1985. The Board urged all the organisations it funded to emulate its policy of Indigenous control and staffing.

The AAB at first saw its charter as the conservation and repair of remnant artistic traditions in the remote communities of Australia's north and centre. In the late 1970s it began to note the importance of newer art practices in the cities and country towns of the longer-colonised regions. In the Australia Council's 1977–78 *Annual Report* such practitioners were poignantly evoked as being 'torn in different directions, by the tug of cultural memory, the magnetism of white pop culture and the demands of urban survival. Their identity is divided. For some, participation in the arts at all involves the difficult decision on where to belong.'

The surge of Indigenous pride elicited by the social policy shift from 'assimilation' to 'self-determination' helped to dissociate Indigenous 'identity' from any particular art practice, and the AAB recognised that any tradition is necessarily open-ended. Social policy goals gained new prominence in AAB rhetoric: 'The arts are now vital to Aboriginal people, both as a means of preserving cultural identity and as a way of gaining enough income to escape poverty and deprivation', it noted in the 1978–79 *Annual Report*. The following year's report stated that community arts grants, 'particularly those for young people, will use the arts in practical ways to combat the symptoms of social disorder—for example, alcohol and drug dependency—caused by the sense of cultural dereliction felt in many Aboriginal communities'.

The AAB made direct grants to relatively few artists, devoting the bulk of its funds to supporting specialist organisations that provided the infrastructure of arts practices. Indigenous visual arts have benefited particularly from the subsidy of touring exhibitions, from specialised exhibition and sales premises in towns and cities, and from some twenty regional art cooperatives and advisers. The latter became essential to the marketing of high quality visual arts produced in remote regions. Thus, in the beginning, as the ACFTA 1973–74 *Annual Report* stated: 'The Board has accepted as its main responsibility the preservation of what

remains of Indigenous Australian culture and seeks where possible to revive traditional music, song, dance, art and craft. Its objectives are to encourage pride in Aboriginal culture, to educate Aboriginal children in their cultural tradition and to bring to the wider community greater knowledge and appreciation of the wide range of Aboriginal arts and crafts.'

Words such as 'retain', 'revival', 'rebuilding', 're-establishing' and 'recreate' were characteristic of this emphasis on the 'traditional'. Announcing in 1977 that it would encourage commercial interest in Aboriginal art and craft, the AAB pointed out that this would not be 'contrary to tradition, because Aboriginals manufactured these objects for trade among themselves long before the white man came to Australia' (Australia Council, *Annual Report*, 1976–77). The person responsible for these words, Board Director Edwards, had a museum background. However, neither he nor the AAB sought to limit their clientele to those who produced the kinds of artefacts which museums had long collected. Appointments to the AAB included persons associated with Indigenous cultural practices that were not the 'traditional' arts of painting, woodcarving, weaving, and dance. Writing, dramatic performance, film-making, and ceramics and music of non-Indigenous inspiration were all supported by the AAB from the start. If the art practitioners were of Indigenous identity, then they could make a claim for support whatever their art practice.

Significant 'urban' developments included the Aboriginal and Islander Dance Theatre (growing out of Redfern's Black Theatre), established in 1975; the work of Brian Syron (acting), and Kevin **Gilbert** and **Mudrooroo** (Colin Johnson) (writing); and **country and western music**. By the early 1980s the terms in which the AAB expressed its aspirations privileged neither the old arts nor the new. TIR

See also: 16.5, 21.2; **arts advocacy organisations; art and craft centres, Mudrooroo.**

Aboriginal Arts Board (AAB), see **Aboriginal and Torres Strait Islander Arts Board (ATSIAB).**

Aboriginal English structure. Most Australian Aboriginal people nowadays speak some form of English. The varieties spoken range from English-as-a-second-language (AbE), which may be more or less influenced by people's first language, to English that is indistinguishable from colloquial Australian English (AusE), except in the use of some expressions unique to Aboriginal communities. In between are varieties that have been influenced by the Australian Aboriginal Pidgin (AAP) which developed in the early years of contact out of the mutual influence of English and Indigenous **languages** (especially those of south-eastern Australia). AAP spread with the moving frontier into most of the country, and developed in the north into a fully-fledged language which is now called Kriol. Early AAP, Kriol, and varieties of AbE spoken in remote areas of Australia have many linguistic features in common, although in AbE these are often freely mixed with features of AusE. There are a few salient features of AbE that are absent from AusE:

(a) a little word *bin* can be used before a verb to mark the past tense, instead of a past tense form of the verb;

(b) to indicate location, an AbE preposition *longa* may be used instead of English *at, in, on, to,* etc.;

(c) a preposition *blonga* (or *blonginto*) may be used in place of AusE *of, for,* and possessive *'s*;

(d) Forms that are object pronouns in AusE (*him, me*) may be used instead of *he, I*;

(e) Forms that are masculine pronouns in AusE (*him,* sometimes *he*) may be used in place of *she, her,* and *it.*

These features are illustrated in the Kriol example (1), with the AusE translation below:

(1) Him bin work longa station blonga Mr Brown.
'She worked on Mr Brown's station.'

(f) Other non-AusE pronouns include forms like *youfella* 'you' (more than one person), *mefella* 'we', *allabout* or *allgether* 'they';

(g) the form *-fella* (sometimes pronounced *pella*) may be included as part of numerals (*fourfella* 'four') or adjectives (*poorfella* 'poor, pitiable', *bigfella* 'big') without meaning 'fellows';

(h) an ending *-em* may be added to a transitive verb (one that takes an object)—this does not mean 'him' or 'them';

(i) a form *gottem* is sometimes used in the meaning 'with';

(j) a form *gotta* may be used to mark intention or futurity—it does not mean necessity as in AusE *'ve got to*;

(k) some words have meanings that are broader than in AusE, such as *kill(em)*, which may mean 'hit' as well as 'kill'.

Example (2) illustrates all these points:

(2) Allabout gotta killem poorfella puppy gottem bigfella stick.
'They will hit the poor puppy with big sticks.'

AbE and Kriol are also sometimes distinguished from AusE by the omission of things which are usually present in AusE. These include: the articles *a* and *the*; forms of the verb *be*; the *-s* ending of the plural, some uses of the possessive *'s*; the *-s* in verb forms such as *knows*; and prepositions such as *in, on, at*. These characteristics are illustrated in (2) above and in (3) and (4) below:

(3) Tide coming in and I frightened.
'The tide is coming in and I am frightened.'

(4) Joe father know good bogey hole down the river.
'Joe's father knows a good swimming hole down in the river.' HK

See also: 10.3, 11.7, 22.6; **Aboriginal English vocabulary.**

Eades, D., 'Aboriginal English', in D. Horton (ed.), *Encyclopaedia of Aboriginal Australia,* vol. 1, Canberra, 1994; Eades, D., 'Aboriginal English', in S. A. Wurm, P. Mühlhäusler & D. T. Tryon (eds), *Atlas of Languages of Intercultural Communication in the Pacific, Asia, and the Americas,* vol. 2, Berlin & New York, 1996; Harkins, J., *Bridging Two Worlds: Aboriginal English and Crosscultural Understanding,* St Lucia, Qld, 1994; Koch, H., 'On reading Aboriginal English', in G. Koch (compiler, ed.) & H. Koch (translator), *Kaytetye Country: An*

Aboriginal History of the Barrow Creek Area, Alice Springs, 1993; Koch, H., 'Non-standard English in an Aboriginal land claim', in J. B. Pride (ed.), *Cross-Cultural Encounters: Communication and Miscommunication*, Melbourne, 1985.

Aboriginal English vocabulary. Aboriginal English (AbE) is the newest linguistic variation in Aboriginal Australia and a major dialect of Australian English (AusE). Its origins lie partly in the pidgins that developed from the early nineteenth century onwards and, over time, became dialects in their own right. AbE differs from AusE in the use of expanded or altered word senses, in the formation of new word combinations, in the incorporation of Aboriginal words and grammatical structures based on those of Indigenous languages. Regional variations result from the retention of words from local languages within the dialect. For example, non-Aboriginal Australians are known as *Kartiya* in the Kimberley (WA), *Balanda* in Arnhem Land (NT), and *Gubba* in the south-east of the continent.

With its vocabularies of oppression, cultural continuity and change, and cultural creativity, AbE is a language of survival. In its lexicon are *dog tag* for 'exemption' certificate, *meat* for 'totem', *clever* for 'spiritually powerful', and **Day of Mourning** and *Survival Day* for 26 January. Indigenous grammatical forms sometimes use duplication for emphasis, as in *different-different* for 'very different'. Cultural variation is registered in names for regional groupings of Aboriginal people such as *Koori, Murri, Nyungar*, and *Palawa*.

Some AbE terms have become relatively familiar to the general community, such as *business* for 'secret–sacred concerns'. In areas like Darwin, where there is a large Aboriginal population, terms such as *gammon* meaning 'pretence' or 'lie' have been taken up by the wider community. *Gammon* is also an example of a nineteenth-century English word being retained in AbE.

AbE remains largely an oral language, but there is a growing body of written material or transcriptions of oral material. Until recently, it was identified as a form of broken or deficient English but is now acknowledged as part of Aboriginal culture. Editors of written and visual material are finding different ways to retain linguistic identity and general comprehensibility. AbE represents survival and creativity in the litany of language death that makes up much of the linguistic history of Aboriginal Australia. JA

See also: 10.3, 11.7, 22.6; **Aboriginal English structure**, **Aboriginality, languages**, *41, 66, 67*.
Arthur, J. M., *Aboriginal English*, South Melbourne, 1996; Harkins, J., *Bridging Two Worlds, Aboriginal English and Crosscultural Understanding*, St Lucia, Qld, 1994.

Aboriginality is now a widely accepted term in Australia. However, it was rarely used before the 1980s. It does not appear in most dictionaries, and when it does, as in the *Oxford English Dictionary* (1933, 1989), it is given an archaic nineteenth-century definition: 'the quality of being aboriginal'. This was its meaning in the regular column of the *Bulletin* at the turn of the century, titled 'Aboriginalities'. The column contained stories sent in by its readers from the bush. Very few of these included references to Indigenous Australians: rather the column aimed to promote a white nativist identity and nationalism. Only the *Macquarie Dictionary* (1981, 1987) and Oxford's *Australian National Dictionary* (1988) give the correct contemporary meaning, that Aboriginality refers to the cultural identity of Indigenous Australians.

The term Aboriginality is a key slogan in the identity politics that has characterised Aboriginal activism from the 1960s. Since the 1980s it has been pivotal in explaining Aboriginal art and politics. Often it is used to refer to an essentialised timeless identity shared by all Aborigines. However, strictly speaking, the term does not refer to pre-colonial practices, because they were organised around local affiliations, not an Australia-wide polity. Hence, correctly used, Aboriginality refers to modern cultural expressions, be they traditional or urban, all of which are influenced by the experience of colonialism.

The exact origins of the term (in its current meaning) are difficult to determine. It was probably first used by Black Power activists in south-eastern Australia following the decision by radical members of the Victorian Aborigines Advancement League to call themselves 'Koorie' (now generally spelt 'Koori') while agitating to make the League an all-black organisation. Across the world, black activists were seeking to develop a set of terms that expressed cultural pride which, they hoped, would replace words tainted with the racist and negative meanings of colonialism. By the mid 1970s Aboriginality had become a fashionable slogan among activists who believed it was imperative to articulate a pan-Aboriginal ideology. In this respect the term can be considered a verbal twin of the Aboriginal **flag**, designed by Harold Thomas in 1971.

Some Indigenous Australians have considered the term Aboriginality problematic because of its derivation from 'aborigine', a word imported by the colonists. Aborigine (from the Latin *ab origine*, from the beginning) is a near-synonym for indigenous. Originally it referred to the indigenous people of the Italian peninsula. In the eighteenth century it took on a particular colonialist derivation when used to refer to those peoples who inhabited a place before its colonisation. It became one of a family of words, such as 'savage', 'primitive' and 'native', used interchangeably by European colonists to name indigenous peoples around the world, without any acknowledgment of their own local and specific cultural differentiation. In the Australian vernacular it signified the Indigenous inhabitants of Australia, but it was only in the second half of the twentieth century that this usage spread to the rest of the English-speaking world. The *Oxford English Dictionary* did not acknowledge this particular usage until 1972. In Australia, however, it had become common practice in the second half of the nineteenth century to distinguish between 'aborigines' and 'natives'. The *Bulletin* aside, aborigines were Indigenous Australians; natives, as in the Australian Natives Association (formed in Melbourne in 1871), were the children of white colonists born in Australia.

Aboriginal activists, who were well aware of this history, nevertheless adopted the term Aboriginality as a slogan for

Black Power. Following World War II, the meaning of the word Aborigine had shifted. Colonisation is primarily a cultural war. In the lower case, 'aborigine' was a potent colonialist weapon against Indigenous peoples because of its association with the 'primitive' and the 'savage'. However, the word Aborigine was now increasingly capitalised in order to distinguish the specific cultural attributes of Indigenous Australians. This development was a result of a growing interest amongst white Australians in the cultural practices of Aborigines. For example, from the late 1930s, the influential anthropologist A. P. Elkin, had promoted the capitalising of the word Aborigine and the exhibition of Aboriginal art because, he believed, each increased the respect for Aborigines in the wider community and helped overcome racism. Capitalised, the word Aborigine had become a potent anti-colonial weapon.

'Aboriginality' was an archaic word that was rarely used in contemporary writing. Thus its meaning could readily be refashioned. And because it was not an Aboriginal word, or the name of any one Aboriginal group, it was a term under which all Indigenous Australians could unite.

The most important reason for the adoption of the term Aboriginality was the close ties developed by Aboriginal activists in the 1960s with Third World liberation movements, including Black and Red Power groups in Northern America that made cultural development the focus of their struggles. Like them, Aboriginal activists were schooled in the writings of Frantz Fanon. Fanon believed that because power was an ideological effect of language, the abusive slogans of colonialism and racism could, by inverse appropriation, become slogans for Black Power—as in his use of 'Negro-ism' and 'Negritude'. Like the term 'black', which Roberta (Bobbi) **Sykes** promoted, or 'blak' as devised by Destiny **Deacon**, Aboriginality was ironically turned against its former derogatory connotations in the interests of fermenting a new cultural identity and pride in Indigenous cultural practices.

In the 1980s Aboriginality became a widely accepted term for Aboriginal pride in cultural identity. From the beginning, the term—and the concepts underlying it—received widespread support in Indigenous and wider Australian communities. Since the 1980s it has proved extraordinarily effective, and in the last decade has appeared in virtually every publication designed to sell the products of Aboriginal culture.

Words count. The widespread adoption of the term 'Aboriginality' signals a paradigm shift in attitudes to Aborigines. Gone are the genetically driven notions contained in terms such as 'mixed blood' and 'half-caste', still widely used in the 1960s. In their place are culturally driven meanings that have been paramount in the success of the Aboriginal art movement. IMcL

See also: 4.1, 20.1.
Berndt, R. M., 'Introduction', in R. M. Berndt (ed.), *A Question of Choice*, Nedlands, WA, 1971; Fanon, F., *The Wretched of the Earth*, trans. C. Farrington, Harmondsworth, 1973; Gilbert, K., *Living Black: Blacks Talk to Kevin Gilbert*, Ringwood, 1978.

acrylic painting. Up until the early 1970s, when a group of mostly Pintupi men living at Papunya (NT) began painting murals on the school walls, almost all artistic renditions of the Tjukurpa (**Dreaming**) had been made on the human body, on the ground, on sacred or ceremonial objects, or in the context of the natural 'galleries' formed by cave walls or rocky escarpments. At the conclusion of a ceremony, ground paintings would be erased, body paint removed, and the ceremonial objects would be put away, to remain hidden from sight until the next ceremony. This is still the case in those places where Indigenous ceremonial life remains strong. Symbols or markings of the Tjukurpa were certainly never on permanent display, but were brought into existence in the context of ceremonial performance.

These symbols, called *kuruwarri* in the Warlpiri language, are visible patterns or manifestations of the spiritual forces which link their creators or bearers with the creative time known—inadequately—in English translation as the 'Dreaming'. The designs link people with specific tracts of land, or with particular flora and fauna or other natural features of that land, for example waterholes, rock holes or hills. The transition of these symbols, markings and designs from three-dimensional media to two-dimensional canvas has resulted inevitably in a number of stylistic changes. Most obviously, the application of acrylic paint to flat surfaces (canvas or board) allows for considerably more precision and detailed rendering of iconography than is possible with natural ochres and pigments that are affixed to natural surfaces with goanna fat. Similarly, bird down applied to the human body, with blood as the fixative, in men's ceremonies creates an impression of 'dotting' which is rather different from fine dots applied to canvas. Nevertheless there is a high level of structural continuity in artistic practice: while the materials and media may have changed, the fundamental rules have not.

The Western aesthetic, which abhors large areas of unfilled or 'empty' space in an artwork, has also had an influence in the transition from three to two dimensions. Canvases are usually painted right to the edges with imagery or other infill, and the pressure to fill the space has led to the ubiquity of the 'dot' which, for many, has become synonymous with Australian Indigenous art in general. In some cases then, the dots are simply there to act as space 'fillers' which are also pleasing to the eye. However, they have their origin in earlier practice, mimicking the effect achieved by affixing small clumps of white cockatoo down or emu down to the large sand sculptures created on the ground. This gave the work a dotted or even a mottled appearance particularly when seen from a distance. In contemporary acrylic painting dots have many forms and functions, as we shall see.

The genesis of the contemporary acrylic art movement at Papunya is mirrored in the larger history of acrylic painting in many Aboriginal settlements in the Central Desert and beyond. However each regional style should be seen in terms of its own unique historical development. The (mostly) non-Indigenous art advisers or coordinators have often exerted a strong influence on the development of distinctive regional styles. For example, at Papunya an influential non-Indigenous adviser believed that only 'traditional' or naturally occurring ochre colours should be used in artistic production, and this led to the characteristically restricted palette of many early Papunya works. By contrast, when people began

painting at the Warlpiri settlement of Lajamanu in 1986 there was no art coordinator to dispense advice about what colours they should or should not use or about the virtue of 'neatness'. The gender of the art adviser sometimes proved to be a significant factor: some white male art advisers believed—mistakenly—that only Aboriginal men were entitled to paint sacred Dreamings, and women were not encouraged to paint.

In the late 1970s a group of Anmatyerre and Alywarre women from the **Utopia** region (NT), whose land is situated about 280 kilometres north-east of Alice Springs, began learning the techniques of **batik** printmaking at a government-sponsored adult education course run by two non-Indigenous women. Many of these women were later to take up acrylic painting on canvas and became well known artists in the Australian and international art world: notably Emily Kame **Kngwarreye**, and also Kathleen **Petyarre** and her sisters Violet, Gloria, Nancy, Myrtle, and Ada **Bird Petyarre**. To this day women continue to dominate the acrylic art scene at Utopia. Their original training in the techniques of batik, which requires unremitting attention to detail, continues to be reflected in much of their work to this day, for example in Kathleen Petyarre's very fine, almost fastidious dotting.

The Anmatyerre and Alywarre women use elaborate screens of dots as an 'overlay' with the deliberate intention of obscuring secret–sacred aspects of their paintings which ought not to be revealed to, or shared with people outside of their immediate kin group. Underneath the dots, their Dreamings are shimmering, subterranean presences. This gives the Utopian work its distinctively regional feel. The use of dotting to conceal or hide sacred information is not, however, unique to the Utopia tradition: it is also in evidence in later Papunya paintings, and in the art of the Centre more generally.

In their often painstakingly careful renderings on canvas of the movements of ancestral figures of the Dreaming, Pintupi practitioners use dots to record the ancestors' travels both above and below the earth's surface. The puncturing of the earth's surface as they move between planes also may be signified by dotting. The ancestors' violations of social rules occasionally cause them to run amok, and their erratic movements may be represented as a series of broken lines or dots.

The Wirrimanu (**Balgo**, WA) artists, who began painting in the early 1980s, also sometimes use dots to record the journeys of ancestral figures. But their work is more frequently characterised by vast, flattened expanses or blocks of vibrant colour, evoking specific tracts of landscape or country. When Balgo artists do use dots, they tend to be large and bold. This, and the use of a wide range of vibrant colours, gives Balgo art a distinctive regional identity.

Dots thus have many functions in desert paintings, and the different dotting styles reflect regional variations in the acrylic painting tradition. The dot has now achieved iconic status as an expression of pan-Aboriginal identity, and has recently been appropriated as a generic identity marker by Indigenous groups and individuals outside the desert area.CN

See also: 2.2, 9.4, 9.5, 9.6; **Ikuntji Arts Centre, Warlukurlangu Artists.**

Maughan, J. & Zimmer, J., *Dot & Circle: A Retrospective Survey of the Aboriginal Acrylic Paintings of Central Australia*, Melbourne, 1986.

ALAMANHTHIN, see Rootsey

ANDREW, Brook (1970–), Wiradjuri visual artist and curator. Words and images displayed across billboards, flags, tea towels, and canvas epitomise the work of Brook Andrew. He is able to recast Indigenous and non-Indigenous language into a social commentary on being Aboriginal in contemporary Australia. *NGAJUU NGAAY NGINDUUGIR*, a flashing neon text exhibited in 'bLAK bABE(z) & KWEEER kAT(z)' at Gitte Weise Gallery, Sydney in 1998, enticed audiences to re-evaluate their understandings of representations of **Aboriginality**. Born in Sydney, university educated, with a kinship connection to his mother's country in Cowra, Andrew is able to weave postmodern notions of identity and language into powerful images of Indigenous Australian life. His solo exhibitions include 'Livin' It Up Series' (Artspace 1993), and 'Contention' (CACSA 1999).

Andrew's *Sexy and Dangerous* series, 1996, which was awarded the Monash University Art Prize and the 1998 Kate Challis RAKA award, is a powerful work that provides an opportunity to discover the beauty of indigenous male sexuality. *Chip on the Shoulder*, 1997 was an incisive and humorous reflection on understandings of racial difference during a confronting moment in Australian political history. Andrew does not retreat from piercing the armour of prejudice in his work and this extends into his portrayals of Indigenous sexuality.

As well as being an artist, Andrew is experienced as a curator, lecturer and writer. In 1999 he curated two **exhibitions** at the Australian Museum's Djamu Gallery, 'Menthen … Queue Here!' and 'BLAK*beauty*'. Both shows were selections of objects from the museum's Indigenous collections, including many historic works by unknown artists. Examples of his work are held in most Australian State galleries and he was exhibited in the 1999 Moët & Chandon Touring Exhibition as well as in 'Oltre il Mito' (1999), a satellite exhibition of the Venice Biennale. He received a professional development grant from the Australia Council in 1996. WB

See also: 12.3, 12.6; **Rea**; *170*.

Gellatly, K., 'Re-take: Contemporary Aboriginal and Torres Strait Islander photography', *Artonview*, no. 15, Spring 1998.

ANDREWS, Daisy (1934–), Walmajarri painter, has said: 'Nothing I say, this picture just makes me think.' The work of Daisy Andrews has made many people think. She paints Kimberley landscapes, in saturated colour, which belie the history she carries in her mind when she paints.

Andrews paints several places around an area called Lumpu Lumpu. She says that her early works make her sad—'when I paint I think of blood'—referring to the **massacre** in which her father died. Her brother, Boxer Yankarr, gave her the massacre story to paint; he was there swimming in the waterhole when the police opened fire on the men. The story was not new to her however: she learnt of it from her grandmother

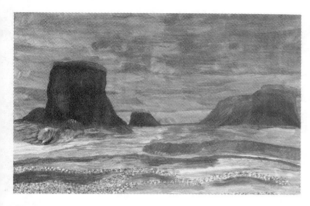

283. Daisy Andrews, *Untitled (Desert Landscape)*, c.1992. Watercolour and gouache on paper, 98.5 x 149 cm.

who taught Andrews a song for the country, the same song she sang when she witnessed the massacre. In recent times she has shifted away from the sadness to a celebration of the seasonal changes in her country. Her deft handling of pigment recreates the broad spectrum of atmospheric conditions, from *parranga* (hot weather time) to *yitilal* (the wet season).

Andrews does not stray from the location in her painting. She states, 'Only this one country I want to paint. I always go back to the same place.' She was born in that same place, at the creek on Cherrabun station in the Kimberley region. She grew up on the station and learnt to work in the house, cleaning and cooking. Her father worked on the station too; he had three wives, and regularly took the family out bush to get away. When this happened, the police would come and bring them all back into town, sometimes with the men in chains.

Eventually Andrews moved into town and married a Bunuba man. Since then she has lived in Fitzroy Crossing with her children and grandchildren. In the mid 1980s she attended classes at Karrayili Adult Education Centre where she started to paint. Her landscapes contrasted strongly with the more abstract images being produced at the time by artists such as Paji Honeychild **Yankarr**, Boxer Yankarr, Stumpy Brown, and others. She became conscious of the difference and attempted to emulate the freer style of these older artists. Eventually she gave up, announcing that 'this is my painting, it's not for anybody else', and she has maintained this strong sense of her uniqueness among the artists who work with her at **Mangkaja Arts**.

Since her inclusion in the 'Images of Power' **exhibition** (NGV 1993), Andrews' reputation has developed markedly. She won first prize in the 1994 NATSIAA and was commissioned by the Western Australian Opera to produce a major work for the set of their production of *Alcina* (1996). She is represented in the NGA and most State gallery collections.

KD

See also: 10.2; **art awards and prizes**; *283*.
Mangkaja Arts Resource Agency, *Ngarri muay ngindaji = Ngajukura ngurrara minyarti = Ngindaji ngarragi riwi = Ngayukunu ngurra ngaa: This is My Country*, Fitzroy Crossing, WA, 1994; Ryan, J., *Images of Power: Aboriginal Art of the Kimberley*, Melbourne, 1993.

ANNING, Boiyool Michael (1955–), Yidinjdji sculptor and wood carver, is one of a handful of artists who maintain near-forgotten traditions of the Queensland rainforest groups. His people, the Yidinjdji, once occupied the area between the Crater Lakes (Eacham, Barrine and Euramoo) at the eastern end of the Atherton Tableland, before most were removed to Mona Mona Mission. A few, like Anning's grandparents, remained on the tableland. Here his father subsequently undertook seasonal work such as cane cutting, tobacco picking and tin mining. By then people no longer used their traditional weapons—the decorated softwood shields and large swords—although knowledge of them remained with a few Yidinjdji, including Anning's father-in-law Sonny Fagan. He taught Anning how to make his first set of weapons for the Ravenshoe Dance Group in 1990.

In revitalising this art form Anning, who lives in Ravenshoe, uses the same rainforest timbers as his forebears. The ochre designs he applies to his artefacts, which also include cross-boomerangs and fire-stick 'dolls', are a combination of motifs copied from those seen in museum collections and those of his own invention. After winning the NATSIAA Wandjuk Marika Memorial Award for a set of his weapons in 1998, Anning undertook two solo exhibitions and several commissions in 1999. These have freed him substantially from the tourist market demand for miniaturised artefacts. A modest man, Anning is saddened by the fact that it is he, not the senior people, who is keeping this art alive. 'What I'm doing is supporting a culture that's just been made up, become hybrid over the past twenty years. I want to keep making shields and swords. I wanted them [the elders] to be doing what I am doing. Keep it alive as long as possible.' In 1999, Redback Gallery, Brisbane and Indigenart in Perth staged solo exhibitions of his work.

MW

See also: 8.1, 8.2, 18.1; **art awards and prizes**; *284*.
Museum and Art Gallery of the Northern Territory, *Telstra Presents the 15th National Aboriginal and Torres Strait Islander Art Award*, Darwin, 1998.

anthropology in Australia was for a long time almost synonymous with Aboriginal studies. The earliest Australian anthropologists, in the late nineteenth and early twentieth centuries, were men like Lorimer Fison, F. J. Gillen, A. W. Howitt, R. H. Matthews, W. B. Spencer and Carl Strehlow. They, and many others like them, wrote extensively about Aboriginal life, although they were usually amateurs whose main professions lay elsewhere. The first professionally trained anthropologist to work with Aboriginal people in Australia was the Englishman A. R. Radcliffe-Brown, who eventually set up Australia's first anthropology department at the University of Sydney in 1929. This department, particularly under the later leadership of A. P. Elkin, dominated Australian anthropology and Aboriginal studies for several decades, although there was also extensive research done by T. G. H. Strehlow (from Adelaide) and Donald Thomson (from Melbourne) during this time. Overseas anthropologists like W. Lloyd Warner also made important contributions. After the 1960s, anthropology broadened its professional base in Australia and came to be taught in most major universities. As the discipline has grown, the focus on Aboriginal Australia

has proportionally declined, although it remains important. Contributions from overseas (particularly American, British, and French) anthropologists have remained significant.

It is possible to distinguish three phases in anthropological work with regard to Aboriginal people. The early period of anthropology (up to *c*.1920) was dominated by an evolutionist paradigm in which Aboriginal life was seen as exemplifying one of the most primitive stages of human evolution. Even as late as 1927, Spencer and Gillen published a book titled *The Arunta: A Study of a Stone Age People*, in which Spencer referred to Aboriginal culture as crude and quaint and destined to fade away to make room for a more advanced civilisation. Anthropology was then largely concerned with the origins of human society and culture, so that Aboriginal clans, marriage rules, totemic beliefs, and the like were analysed as if they were contemporary versions of the past. Scholars like Radcliffe-Brown and Elkin later pushed this evolutionist perspective into the background by adopting what came to be known as functionalism. They dismissed evolutionism as conjectural history, preferring to place Aboriginal studies on a firmer empirical footing. Anthropologists became less interested in speculations about the primitive nature of Aboriginal life, and more interested in comparing systematic information about contemporary Aboriginal societies. To gather that information, they began to undertake more intensive fieldwork studies that built up comprehensive accounts of individual societies. Lloyd Warner's book on the Murngin (Yolngu) was published in 1937 and is one of the earliest and best known examples of a functionalist account portraying an Aboriginal society as an integrated system.

Functionalism dominated Aboriginal anthropology until the 1960s. While functionalist anthropology ostensibly rejected evolutionist thinking, it nevertheless concentrated its research efforts on so called traditional societies at the frontier of Euro-Australian settlement. The implicit assumption was that only 'remote' Aboriginal groups had 'pristine' societies and cultures worthy of scholarly attention, while Aboriginal people in 'settled' areas were thought to have lost much of their culture and to have assimilated to European forms of existence, however imperfectly. Elkin did sponsor early anthropological studies of these allegedly detribalised communities from the 1950s and notable studies were eventually undertaken by scholars like Jeremy Beckett (NSW) and Diane Barwick (Vic.). However, by the 1970s the social climate in which anthropology operated had shifted so dramatically that such studies ceased to be seen as marginal. Newer issues about Aboriginal people's relations with white Australia and their historical encounter with colonialism came to the fore. Anthropologists became less preoccupied with something they tended to call 'traditional' Aboriginal society and more engaged with issues deemed to be of more contemporary relevance.

At the present time, anthropologists continue to undertake intensive ethnographic studies with Aboriginal communities, but the research questions have changed. Topics like traditional religion or kinship and marriage have begun to look rather antiquarian when ranged alongside questions to do with issues like Aboriginal identity, land rights and the marketing of Aboriginal art in Australia and overseas. Anthropologists now tend to write about the *transformation* of 'traditional' societies and cultures in response to external pressures. They certainly remain interested in unpacking the cultural logic of Aboriginal systems of thought and practice, but such systems are now portrayed as more dynamic—as lending and borrowing cultural elements from each other and from the larger national and global systems in which they are enmeshed, and sometimes transforming them. So, for example, while Lloyd Warner wrote about the systemic characteristics of Yolngu society, recent studies of Yolngu life by Nancy Williams (1986), Ian Keen (1994) and Howard Morphy (1991) have related those characteristics to their political struggle for land rights, the accommodation of Christianity and the development of commercial art as an instrument of cultural survival. Similar examples could be drawn from all over Australia.

Other factors have also impacted on anthropology to break down the division between 'remote' and 'settled' Australia. Although many Aboriginal people remain wary of anthropology as a discipline that has allegedly been the handmaiden of colonialism and the Australian state, increasing numbers are studying the subject or becoming professional anthropologists themselves. Some, like Marcia Langton, have become key players in the creation of anthropological knowledge, and Aboriginal scholars, it is fair to say, tend to have a keener eye for issues of direct relevance to Aboriginal communities, wherever they may be in the continent. Also, in the last thirty years or so, anthropologists have become increasingly involved in the applied arena, particularly in relation to land claims and heritage protection. There has been an explosion of legislation in these areas, such that anthropological expertise has been constantly called for in the preparation of reports and the presentation of legal evidence. Anthropologists are also likely to be called upon in social impact studies (usually in relation to economic development) and as expert witnesses in legal cases involving Aboriginal people. While the relationship between anthropologists and Aboriginal people is probably more volatile

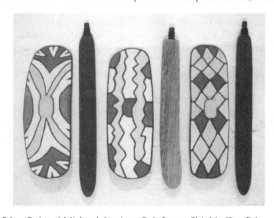

284. Boiyool Michael Anning, *Rainforest Shields (Starfish, Matchbox Beanpod Seed, Tree Grubs) and Swords*, 1998. Shields: natural pigments on wood, (*l. to r.*): 102 x 35 x 8 cm, 9 x 34 x 7 cm, 101 x 31 x 8 cm. Swords: wood, beeswax or resin, and vegetable oil, (*l. to r.*) 131 x 13 x 3 cm, 121.5 x 15 x 3 cm, 132 x 13 x 3 cm.

than it has ever been, it is also true that all these developments have brought about a huge increase in productive cooperation between anthropologists and Aboriginal communities and organisations. Anthropology at the dawn of the twenty-first century is a far cry from the discipline as it was at the dawn of the twentieth century, when anthropologists believed that Aboriginal societies were destined soon to become extinct. JOM

See also: 1.2, 4.1, 13.1, 21.1, 21.2; **Aboriginality, archaeology, cultural heritage, land rights.**

Keen, I., *Knowledge and Secrecy in an Aboriginal Religion: Yolngu of North-East Arnhem Land*, Oxford, 1994; Morphy, H., *Ancestral Connections: Art and an Aboriginal System of Knowledge*, Chicago, 1991; Warner, W. Lloyd, *A Black Civilization: A Social Study of an Australian Tribe*, New York, 1937; Williams, N.M., *The Yolngu and Their Land: A System of Land Tenure and the Fight for its Recognition*, Canberra, 1986.

APUATIMI family, Tiwi painters, printmakers, ceremonial singers, dancers, and sculptors. Declan Arakike Apuatimi (1930–1985), who lived at Nguiu, Bathurst Island (NT), was one of the most acclaimed exponents of Tiwi visual arts and a revered singer and dancer. The development of his distinctive, smaller and more realistic carvings for a European audience occurred in the 1950s. At this time he was one of only a few Tiwi producing for an outside market. The growth in appreciation and awareness of Aboriginal art in the 1970s created a high demand for his art. He was the first artist to carve figures with tiered heads, and to develop a distinct style of solid forms, with design broken up into dots and cross-hatching in vivid ochre colours. His work included fine ceremonial ornaments, spears and clubs. He also took on the role of mentor—teaching art and craft at the school, and recording oral **history**—as well as travelling to perform at various **festivals** and events. He attended a number of South Pacific arts festivals, and was a leader in ceremonial life.

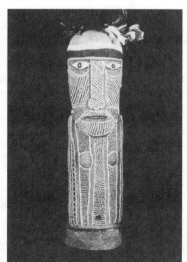

285. Declan Apuatimi, figure carving, undated. Natural pigments on carved ironwood, height 64 cm.

Declan's widow, Jean Baptiste Apuatimi (1940–) is also a painter; working on bark, she has become a significant artist of her generation. In the early 1980s both Declan's daughters, Maria Josette Orsto (1962–) and Carmelina Puantulura (1957–) were instructed in the arts of carving and painting by their father and became important collaborators in his later work when failing health prevented him from attempting more ambitious projects. Both women have continued their artistic pursuits; Maria Josette Orsto is perhaps one of the most versatile and innovative younger artists on the Bathurst and Melville Islands, prolific in all media. Unfortunately, Declan died before his work was exhibited, but as one of the most highly regarded Tiwi artists and educators, he left a legacy that is still discussed today. KAB

See also: 7.6; **Tiwi Design;** *285.*

Barnes, K., *Kiripapurajuwi Skills of Our Hands: Good Craftsmen and Tiwi Art*, Darwin, 1999; Bennett, J., 'Narrative and decoration in Tiwi painting: Tiwi representations of the Purukuparli story', *Art Bulletin of Victoria*, no. 33, 1993; West, M., *Declan: A Tiwi Artist*, Perth, 1987.

archaeology. The academic study of Aboriginal Australian archaeology, or 'Australian prehistory' as it was first known, started in the early 1960s. Unlike classical archaeology in Europe, Egypt, and the Middle East, where archaeologists studied 'treasures' such as jewellery, pottery, statues, scrolls, and coins, professional archaeology in Australia began with the classifying of stone tools from excavations. Archaeologists followed in the footsteps of amateur artefact collectors who were scavenging sites without any consideration of ethics or contemporary Aboriginal views. Australian archaeology initially focused on the determination of the regional and stratigraphic distribution of various stone tool types. Later, archaeologists started to examine evidence about what people ate and did with stone tools in an integrated economic system. The pioneering phase of Australian archaeology lasted until the 1980s when, simultaneously, the range of archaeological research diversified and Aboriginal people raised concerns about their lack of control over their **cultural heritage.**

An early archaeological aim, which persists today, is determining the antiquity of humans in Australia. While this idea is unimportant to most Aboriginal people who know they have always lived in Australia, it is of fundamental relevance to archaeologists seeking scientific evidence for migrations of humans to Australia. Other questions have emerged as archaeological investigations have become interrelated with scientific disciplines, **anthropology**, and ethnohistory.

The Aboriginal societies under investigation were not unchanging or conservative as was originally thought, but were highly sophisticated and complex. Intra-continental exchange networks of spears, stone tools, ochre, pituri, shells, and other objects were signs of multi-dimensional interactions between mobile, adaptable societies. The societies had prospered because of their flexibility and adaptability in the face of environmental, and internal and external cultural pressures. Signs of these complexities and diversities were evident in the record unearthed by archaeologists, but it required the blending of many academic disciplines to interpret and accommodate the challenging array of excavated data.

Organic materials are not very well preserved in occupation deposits and they were therefore initially less well known and studied than the stone tool assemblages. New techniques of microanalysis and identification of starch and pollen grains created opportunities to examine economic changes through time as well as climatic variations. Freshwater mussels, fish, and the bones of small animals, dating to more than 30 000 years ago in the Lake Mungo (NSW) area, were found in association with human occupation. The connections between the activities of contemporary Aboriginal people and the discarded food, stone tool, and bone remains that archaeologists found began to be made.

The history of **rock art** studies was similar. In the 1960s the prehistorians were indifferent to rock art; they were not able to understand or appreciate it, and this was reflected in the early, Eurocentric, studies. The classification of sequences of art into categories such as simple and complex figurative styles was devised on the basis of motif, character, technique, and form. Particular motifs were given European names; in the Kimberley, for instance, 'Bradshaw' replaced the traditional names *Gwion Gwion*, *Kiera-Kirow*, and *Jungardoo*. Regional diversity of Aboriginal painting traditions was evident, yet for the most part Europeans only saw the spectacular rock art. Even this they found incomprehensible and bewildering, yet to Indigenous people the paintings and engravings are culturally consistent and understandable.

Regional approaches to the study of archaeology began in the 1980s. It was Michael Morwood who first linked field survey, excavation, rock-art recording, and environmental analysis, and combined that information, using computerised data processing, with the exhaustive investigation of historical and ethnographic sources. Such a rounded approach provided a model for future studies and propelled archaeologists into working more with Aboriginal people. Since then greater efforts have been made by archaeologists to involve Aboriginal people in the recording of rock-art motifs and in documenting the stories, myths, and significance of the art. Australian archaeologists realised that they had previously missed the point of the art, and Aboriginal people affirmed that the art was their property and they should decide what happened to it.

For many years the research on Aboriginal cultural remains was viewed as the professional business of archaeologists, with no place for Indigenous participation. There was little contact or consultation with the traditional owners of land or custodians of sites, places, and objects. While Aboriginal people respected the knowledge gained by archaeologists they increasingly felt that they were equally or better qualified to speak about cultural matters, because they were Aboriginal. The excavation of sites became increasingly relevant to Aboriginal people, and as their knowledge about archaeology grew they realised that they could no longer be marginalised and ignored.

The issue of human skeletal remains proved a catalyst for debate and action. This complex issue, in which the pursuit of scientific knowledge clashed with ethical and moral considerations, had essentially been ignored for many years. Archaeologists' attitudes to human remains have changed dramatically, and are exemplified by the support of the local Indigenous people during excavations of a large burial ground at Roonka Flat, South Australia, in the mid 1980s and by the reburial of the Lake Mungo human remains in 1992. Such remains are no longer considered by archaeologists as the bone artefacts of a culture buried in the past, but as the relics of the sacred ancestors of a vibrant contemporary culture which, like their own, must be treated with sensitivity and respect.

Legislation to protect Aboriginal culture, sacred sites, artefacts, and heritage places was enacted more than a decade after the first professional archaeological studies were undertaken. In the early days of archaeological research, Aboriginal people had no control over their cultural heritage. That situation is changing as Aboriginal people become empowered to control decisions about the nature of archaeological research, the extent of conservation and the types of management required to protect their sacred places, lands, and **rock-art sites.**

Archaeological research now depends on the strength of the relationship between a researcher and the relevant Indigenous people, with expectations matching those involving kinship or partnership. These relationships offer scope for Aboriginal people to assert their rights and responsibilities. Today, Aboriginal people are joint management partners at Uluru–Kata Tjuṯa and Kakadu national parks and are actively contributing to the governance of these heritage areas. Some Indigenous people are now working as archaeologists and rock art specialists and are documenting their own history. AW

See also: 2.4, 5.3, 8.4, 11.2, 11.8, 22.1; **copyright, repatriation.**
Davidson, I., Lovell-Jones, C. & Bancroft, R., *Archaeologists and Aborigines Working Together*, Armidale, NSW, 1995; Morwood, M., Art and Stone, PhD thesis, Australian National University, 1980; Murray, T. (ed.), *Archaeology of Aboriginal Australia: A Reader*, St Leonards, NSW, 1998; Mulvaney, D. J. & Kamminga, J., *The Prehistory of Australia*, Sydney, 1999.

architecture, see 19.1, 19.2, 19.3, 19.4, 19.5.

art and craft centres. Scattered throughout remote Australia are a number of community art centres that support the work of more than 4500 Indigenous artists. They fulfil a diverse and complex variety of cultural, economic and social roles—as dealers, galleries, wholesalers, intercultural mediators, art schools and community art spaces. Art centres are the first point of contact for anybody seeking access to or information about artists and their communities. In buying and selling artworks they aim to maximise financial returns to the artists and to ensure that the artworks are presented with integrity and accurate documentation. Art centres have been involved in commercial and non-commercial exhibitions from Helsinki to New York, Cuba, and the Russian Federation, and dozens of cities and countries in between.

There is no standard model for art centres. The key factor that distinguishes them from any other organisation trading in Indigenous arts and crafts is that they are owned and controlled by local Indigenous people. They may be independently incorporated associations or function under the auspices of larger bodies such as community councils. Some

began life as women's centres and continue predominantly to support women's activities; in other places the majority of artists are men, or both men and women access the centre equally. A minority of art centres are located in towns, for example Ngunga Designs in Derby (WA), Jukurrpa and Papunya Tula in Alice Springs, Warba Mirdawaji in Roeburne (WA), Mimi in Katherine (NT). Most are in remote communities, as far as 800 kilometres from the nearest regional centre.

Art centres facilitate and encourage the production of a wide range of arts and crafts, in both traditional and introduced media. They provide artists with materials, information, and access to professional development. Purchasing art works or taking them on consignment, they market and promote artists and their works. More generally they affirm and promote the value of local culture and contribute to community life in a wide variety of ways, through special projects and through assisting their communities to document their past and present sociocultural activities. They provide employment and training for local staff; and give artists the opportunity to expand their knowledge and experience through travel beyond their community. They provide services to outside individuals and organisations such as arranging copyright clearances, responding to requests for information about artists and their work, and facilitating visits to the community.

Currently there are more than forty-five centres located in central Australia, the Top End (NT), and northern Western Australia. These centres are serviced by two peak organisations—Desart Inc. and the Association of Northern, Kimberley, and Arnhem Aboriginal Artists (ANKAAA)—which operate as regional resource centres for central and northern Australia respectively. Although art centres should not be judged or compared solely in financial terms, it is one way of broadly quantifying the scale of their activities. The smallest centres (Kaltjiti, Titjikala, Iwantja, Ngunga Designs, and Keringke) sell less than $100 000-worth of arts and crafts each year. Most sell between $100 000 and $350 000-worth of product annually (for example, **Ikuntji**, **Warlukurlangu**, **Warumpi**, **Tiwi Designs**, Jilamara, and Munupi). A small number of very large centres (**Injalak**, **Buku-Larrnggay Mulka**, and **Papunya Tula**) support more than 200 artists on a regular or occasional basis and have sales of more than $500 000 per annum. Variation in size is influenced by a range of factors: the size of the community in which the centre is located; the number of practising artists; the facilities and resources available to house the centre and service artists; and the economic value of the art centre product. For example paintings are generally sold for higher prices and generate greater returns than fibre-work and textiles, and some products require more capital investment or are more labour intensive than others.

For artists working with art centres, culture is inseparable from life and art. In nearly every community serviced by an art centre, unemployment for Indigenous residents is higher than 90 per cent, literacy and numeracy rates are low, and income comes primarily from government benefits, occasionally boosted by royalties from mining or tourism. The sale of arts and crafts provides both an avenue for cultural expression and an opportunity to earn income. Artists rarely perceive a conflict between commerce and culture. An art work may have been produced for the market, and is therefore 'public', but it is also a social artefact reflecting culture, aspirations and spirituality.

The first art centre was established by **Ernabella** mission in 1949, but the next did not follow until after 1970. In the 1970s and 1980s community councils and artists approached the Aboriginal Arts Board of the Australia Council or the Department of Aboriginal Affairs for funding to employ staff and establish buildings to act as centres for the artists. They met with varying degrees of success. In 1991 the newly formed **Aboriginal and Torres Strait Islander Commission** (ATSIC) took over responsibility for funding art centres and the Arts and Crafts Support Strategy (ACISS) program was established. ATSIC currently provides essential operational funding to more than thirty-five centres through NACISS (formerly ACISS), now a national program.

With changes in technology and an increasing world-wide interest in Indigenous cultures and products, art centres have had to become increasingly sophisticated in all aspects of service delivery, and mediation. Many art centres are now servicing an international market, soliciting commissions, forming partnerships to present exhibitions and projects, maintaining Web sites and promoting Aboriginal art and culture to a world-wide audience. In the 1990s art centres became increasingly proactive in developing projects to promote their artists and meet needs articulated by them, such as participation in **native title** claims.

Art centres have played a crucial role in facilitating communication and the flow of art works and cultural product between artists in remote Australia and the market in the wider world. Art centres allow Aboriginal artists to achieve equity, to make choices about what they produce, and to exert control over the representation of their work and their level of interaction with the market place. The art centre model has proved effective in supporting, through changing circumstances, the activities of thousands of artists in the bush. FW

See also: 13.5, 18.1, 21.1, 21.2; **arts advocacy organisations, ATSIAB, Lockhart River Arts and Cultural Centre, Mangkaja Arts, Maningrida Art and Culture, Maruku Arts and Crafts, Merrepen Arts, Ngukurr, Tiwi Pottery, Utopia, Wadeye, Wangkajungka Arts, Warburton Arts Centre, Waringarri Aboriginal Arts, Warlayirti Artists, Warmun Art Centre, Warnayaka Art Centre.**

Nugent, M., *Desert Art: The Desert Directory of Central Australian Aboriginal Art and Craft Centres*, Alice Springs, NT, 1998; Wright, F., *The Art and Craft Centre Story*, vol. 1, *Report*, Canberra, 1999; Wright, F. & Morphy, F., *The Art and Craft Centre Story*, vol. 2, *Summary and Recommendations*, Canberra, 2000.

art awards and prizes. In 1971 **Yirawala** won the International Cooperation Art Prize. Arguably, this was the first time an Aboriginal artist had won a significant competitive public award in the visual arts. Since then, Aboriginal and Torres Strait Islander artists have participated in ever-greater numbers in art awards, prizes, and have been the recipients of honours, grants and fellowships. These developments have been inextricably linked to the increasing prominence

of Aboriginal art in Australia and beyond. Awards include those dedicated specifically to art by Indigenous practitioners, awards open to all artists, and a number of other notable competitions and prizes in the visual arts.

Of the dedicated art awards, the first and most highly publicised is the National Aboriginal and Torres Strait Islander Art Award (NATSIAA), organised by MAGNT in Darwin. Over the years this annual award has undergone a number of changes in structure, sponsorship, and even title, but it has always been the case that work entered must have been completed in the year leading up to the award. When it was established in 1984 as the National Aboriginal Art Award, the first, second and third prizes were awarded in unspecified categories. In 1986 it was restructured to have one overall award and two media-based awards: work in a traditional medium (**bark painting**), and painting in introduced media. The following year saw the establishment of the Memorial Award for Mawalan's Eldest Son, an open media award that encompasses all media other than painting (i.e. fabric, sculpture and so on). In 1993 the award was renamed the Wandjuk **Marika** Memorial Award, signalling that the embargo on the use of the artist's name had been lifted, following a period of mourning. In 1995 the open media category was split into two different prizes. The first was for works on paper (photography, prints, and paintings on paper), and the Wandjuk Marika Memorial Award was then reserved for three-dimensional works. Since 1995 the prize categories have been stable. From 1989 to 1991 the award was sponsored by the Holmes à Court Collection. In 1992 Telecom began to sponsor the first prize, and in 1995 Telecom (now Telstra) became the major sponsor of all the prizes. In 1996 the award's name was changed to the National Aboriginal and Torres Strait Islander Art Award. Also in that year Telstra began an interstate tour of a selection of works, including the first prize winner from each year's award. Since NATSIAA's inception MAGNT has acquired the winning works in all the distinct categories. A nationally touring retrospective exhibition of past NATSIAA winners was held in 2000. Some significant past winners of the NATSIAA first prize include Daisy **Andrews** (1994), Jody **Broun** (1998), Les **Mirrikkuriya** (1992), Michael Jagamara **Nelson** (1984), Kathleen **Petyarre** (1996), and **Long Tom Tjapanangka** (1999).

The National Indigenous Heritage Art Award (NIHAA), formerly the National Aboriginal and Torres Strait Islander Heritage Art Award, is another dedicated art award which was established by the Australian Heritage Commission (AHC) in 1993 to coincide with the International Year for the World's Indigenous People. The second award was held in 1994, and since then it has been held biennially. The aim of this award is to draw attention to sites which are of heritage significance to the artists and their peoples. Judgements about inclusion depend upon the heritage significance of the sites as well as on artistic criteria. Like the NATSIAA, the structure of the NIHAA has altered since its inception. Every year the AHC acquires the work which has won first prize—in 1998 this was titled the 'Normandy Heritage Art Prize' after its sponsor, Normandy Mining Limited. In 1998 the other prize categories were the Lin Onus Youth Prize, the Works on Paper Prize, and the Ngunnawal Emerging Artists Prize—named in honour of the Indigenous people of the Canberra region who are the traditional owners of the site of Old Parliament House, where the Award is held. Finally, the Community Endeavour Prize is awarded to a group of artists who all come from a single Aboriginal community, and who have made a significant collective contribution to the visual arts in the two years leading up to the award. Winners of the first prize in the NIHAA since its inception have been Tapartji Bates (1988), Treahna **Hamm** (1996), Ginger **Riley Munduwalawala** (1993), and **Lin Onus** (1994)

The Ruth Adeney Koori Award, commonly known by its acronym—RAKA—is an annual award established in 1991 by Professor Emeritus Bernard Smith, the eminent Australian art historian, in honour of his late wife Kate Challis who in her childhood was known as Ruth Adeney. The word *raka* also signifies the number 'five' in Pintupi, while *radka* means 'hand' in Warlpiri—making RAKA an appropriate acronym for an award for artists whose hands are the tools of expression, and which is granted to five different areas of artistic endeavour on a five-year cycle. To carry the significance of the number five even further, works must be created in the five years leading up to the award in order to be eligible. The five award categories are creative prose, drama, the visual arts, script writing and poetry. Winners since RAKA's inception in 1991 include Bill Rosser (creative prose, 1991), Jack **Davis** (drama, 1992), Lin Onus (visual art, 1993), Tracey **Moffatt** (script writing, 1994), Kevin **Gilbert** (poetry, 1995), **Mudrooroo** (creative prose, 1996), John Harding (drama, 1997), Brook **Andrew** (visual art, 1998), and Rima Tamou (script-writing, 1999).

The ATSIAB of the Australia Council initiated the annual Red Ochre Award in 1993 for Indigenous artists who have made outstanding contributions to the recognition of Aboriginal and Torres Strait Islander art. Artists must be nominated for the award as opposed to being selected from an open field of entrants. Like RAKA, nominations are not restricted to the visual arts. Past winners include Jimmy Chi (playwright and songwriter, 1997), Justine Saunders (actor, 1999), and Maureen Watson (storyteller, writer, and performer, 1996).

Since the early 1970s, Indigenous artists have regularly participated in open art prizes and competitions, usually those restricted to a particular medium or genre, where artists compete regardless of cultural background. In 1971 **Kaapa Tjampitjinpa** entered the Alice Springs Caltex Golden Jubilee Award and shared first prize. The Alice Prize, another open award established in 1971 and held in Alice Springs (NT), showcases art on a national perspective and has had many Indigenous entrants and winners. The first of these was Clifford **Possum** Tjapaltjarri (1983), followed in quick succession by other Abori-ginal winners: Don Tjungarrayi (1986), **Ronnie Tjampitjinpa** (1988), Ginger **Riley Munduwalawala** (1992), Willie **Gudabi** (shared first prize 1993), Mick **Namarari Tjapaltjarri** (1994), Marlee Napurrula (1998) and Mitjili **Napurrula** (1999).

There are many other open art awards in Australia. They are often run under the auspices of State and regional galleries or museums, universities, city councils, local organisations and art societies. Among the most notable Indigenous winners of such prizes was Elizabeth **Djuttarra**, who won first prize in the VicHealth National Craft Award (1992).

On occasion, some longstanding open art awards dedicate a year solely to Indigenous entrants. In 1988, the year of Australia's bicentenary, AGSA's Maude Vizard-Wholohan Art Purchase Prize was only open to Indigenous artists. In 1993, the International Year of the World's Indigenous People, the Botany Prize (NSW), and the Gold Coast City Council Art Purchase Award (Qld), to name but two, were dedicated to Indigenous entrants in recognition of that year's significance.

The 1990s saw a proliferation of contemporary art awards. By far the most remunerative and prestigious of these is the Moët & Chandon Australian Art Fellowship, open to Australian artists between the ages of 20 to 35. The recipient is given the opportunity to live and work in Epernay in France for a year, with full financial support. Since the inception of the Fellowship in 1987 there have been two Indigenous Moët & Chandon Australian Art Fellows: Gordon **Bennett** (1991) and **Judy Watson** (1995).

The growing participation of Indigenous artists in art competitions reflects the increasing prominence of Aboriginal and Torres Strait Islander art within the mainstream. The existence of awards that are specifically dedicated to Aboriginal and Torres Strait Islander arts practitioners, and the ever increasing number of Indigenous winners of open awards, point to the upsurge in public awareness and appreciation of Indigenous arts practice in Australia. KR

Moët & Chandon Australian Art Foundation, *Moët & Chandon Touring Exhibition*, Sydney, 1991 & Victoria, 1995; Art Gallery Board of South Australia, *Recent Aboriginal Painting: Incorporating the Maude Vizard-Wholohan Art Prize Purchase Awards 1988*, Adelaide, 1988; Museum and Art Gallery of the Northern Territory, *Telstra Presents the National Aboriginal and Torres Strait Islander Art Award*, Darwin, 1996, 1997, 1998, 1999.

arts advocacy organisations have been key institutional forms since the early 1970s when public funding of Indigenous arts in Australia began in earnest. They were established to represent newly emerging Indigenous arts movements on two broad fronts: Indigenous producers—most of whom lived in remote areas—faced particular problems in marketing their art, and the question of the authenticity and cultural integrity of Indigenous art forms produced in new and old media required special attention. Initially, the Aboriginal Arts Board (AAB) was established as a separate element within the Australia Council, with statutory responsibilities to be an advocate for Indigenous artists nationwide. At the same time community-based arts organisations, mainly funded by the AAB, operated as local and regional collecting, marketing and advocacy agencies. In 1976, a non-profit organisation, the Aboriginal Artists Agency, was established as an Aboriginal copyright collection and advocacy agency. It was supported by the Australia Council until the early 1980s.

During the 1980s the Indigenous arts industry grew rapidly. In the late 1980s, a new genre of Indigenous arts advocacy agency emerged. This change was precipitated, in large measure, by the growing conflict of interest between the AAB's roles as both arts funder and advocacy agency. In particular, the AAB was the principal sponsor of commu-

nity-based **art and craft centres** and of the major retailing company Aboriginal Arts Australia. When long-standing tensions between many of the art centres and the company erupted in 1987 following political intervention by the federal government, the AAB was unable to play an effective mediating role. Subsequently, a number of art centres formed the Association of Northern and Central Australian Aboriginal Artists (ANCAAA), based in Darwin, as an independent indigenous arts advocacy agency. ANCAAA was instrumental in negotiating a major independent review of the industry in 1989 that resulted in enhanced government support and in facilitating legal action in landmark **copyright** infringement prosecutions.

Partly because ANCAAA represented Indigenous artists and art centres in remote regions, a number of urban art organisations with multiple functions also took on advocacy roles specifically for urban and rural artists. Foremost among these were the **Boomalli Aboriginal Artists Co-operative** in Sydney, Tandanya (the National Aboriginal Cultural Institute) in Adelaide, and Dumbartung Aboriginal Corporation in Perth.

In the late 1980s ANCAAA proposed that a National Aboriginal Arts Community Network be established as a loose confederation of Indigenous industry interests. This proposal was never formally acted on and subsequently a range of Indigenous arts advocacy organisations—ranging from the small, grass-roots, community-based to the regional or national representative organisations, like ATSIC—have emerged.

In the early 1990s ANCAAA divided into two regional organisations: Desart Inc., representing central Australian artists and based in Alice Springs, and the Association of Northern, Kimberley and Arnhem Aboriginal Artists (ANKAAA), based in Darwin. At the same time the Aboriginal Arts Management Agency (AAMA), purporting to be a national Indigenous advocacy agency, was established in Sydney. This organisation was relatively unsuccessful and was superseded by the National Indigenous Arts Advocacy Association (NIAAA), also based in Sydney. In the late 1990s, mainstream and specialist commercial galleries increasingly represented and promoted individual artists. In 1998, a new organisation, the Australian Indigenous Art Trade Association, was established to represent the commercial sector of the industry.

Advocacy agencies are viewed as having legitimate and important roles, and most are funded by government. They fulfil multiple advocacy, promotion, educative and industry support roles with variable degrees of success: a degree of political tension and disputation emerges when any organisation seeks to represent the wide-ranging and complex interests of all Indigenous artists. This is partly a reflection of the heterogeneity of Indigenous art movements in Australia and partly of the geographic distribution of artists, which is heavily skewed towards remote regions.

In the late 1990s, NIAAA made a concerted effort to play an industry leadership role and to establish an Indigenous national label of authenticity. There are ongoing debates about the appropriate jurisdictions of Indigenous arts advocacy organisations. Some believe that true representation of artists can only occur at the community or regional level;

others believe that effective arts advocacy and economies of scale require an organisation with national coverage. There is little doubt that historically these organisations have played important roles in providing support to Indigenous artists and in educating the general arts public about the complexities of indigenous intellectual and cultural property. The need for Indigenous arts advocacy in the early twenty-first century is likely to increase as the industry further expands; there is, arguably, a need for one agency to take a national and strategic leadership role in this domain. JCA

See also: 21.2, 22.1; **ATSIAB**.

ASHLEY, Djardi, see Dorothy **Djukulul**

athletics. Professional running—or pedestrianism, as it was referred to—came to the fore in Australia in the 1870s, having burgeoned in England during the 1800s. Gift races became prestigious events attracting huge crowds and wagers, and included those run at Stawell and Warracknabeal, the Melbourne Thousand (Vic.), the Bay Sheffield at Glenelg (SA) and the Carrington Cup at Botany (NSW). Prize money was extremely attractive with prizes ranging up to £1000.

Aborigines were both prominent and controversial athletes. Draconian state legislation prevented Aboriginal participation in virtually any economic enterprise, while simultaneously confining them to isolated missions and stations. The Queensland Amateur Athletics Association tried to disbar all Aborigines from athletics on the grounds that they either lacked moral character, had insufficient intelligence or couldn't resist white vice. In 1903, the Association deemed all Aboriginal athletes 'professional', and thereby ineligible. Despite such obstacles, Aborigines became so conspicuous in pedestrianism that from the 1880s to about 1912, official race programs indicated whether competitors were 'a' (Aboriginal), 'h.c.' (half-caste), or 'c.p.' (coloured person).

The first account of an Aboriginal 'ped' is that of Manuello from Victoria, who in 1851 beat Tom McLeod—then regarded as the fastest man in Australia—over 100 yards. Other prominent early Aboriginal runners included: Combardlo Billy, who ran 150 yards in fifteen seconds in 1882; Patrick Bowman, winner of the 1887 Carrington Cup; R. R. (Bobby) Williams, winner of the 1899 Carrington Cup; Fred Kingsmill; the Marsh brothers, Larry and Jack, who, apart from their cricketing achievements, were outstanding sprinters. Alec Henry also ran professionally while playing representative cricket for Queensland. Bobby Kinnear won the prestigious Stawell Gift in 1883—the first of three Aborigines to do so. Bob Anderson won the £100 Charters Towers (Qld) race in 1904, defeating the legendary sprinter Arthur Postle who was considered the world's fastest man in that era.

Perhaps the greatest of all Aboriginal runners was Charlie Samuels, who was begrudgingly accorded the title of 'the champion foot runner in Australia' by the *Referee* in 1886, after running 136 yards in 13.20 seconds and 300 yards in 30 seconds. In 1888 Samuels ran 100 yards in 9.10 seconds at Botany in Sydney—an astonishing time, possibly explained by the tendency for promoters to shorten the distances!

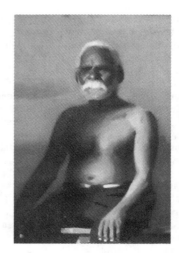

286. Percy Leason, *Robert Kinnear, (1851–1935)*, 1934. Oil on canvas, 102.2 x 75.0 cm, not signed.
This painting was no. 27 in the 1934 exhibition 'The Last of the Victorian Aborigines'.

Bobby McDonald, who won several gift races in the 1880s and 1890s invented the crouch start in running. He developed the 'sitting style' of start to counter the cold and the strong winds while awaiting the starter's gun. Tom Dancey from Hebel (Qld) won the Stawell Gift in 1910. Gift races offered social mobility and the opportunity to leave the abysmal government settlements and stations. Exemption certificates were often granted to 'half-castes'—known as dog tags, these certificates allowed at least temporary freedom from the oppressive and proscriptive state laws. Doug Nicholls won both the Nyah and the Warracknabeal Gifts in 1929 before going on to a magnificent career in **Australian Rules football**.

In 1928, desperate for money, Lynch Cooper sold his fishing boat, and with the remaining £20 backed himself at sixty-to-one to win the Stawell Easter Gift—which he did, covering the 130 yards in 11.93 seconds. Cooper was World Professional Sprint Champion in 1929 and his running provided security for his family during the Depression. After Cooper, Aboriginal interest in professional running abated. In part, this was due to the growing money and status of the stadium sports—**boxing**, Australian Rules football, and **Rugby League**, and also to the decline in major sprint events. Horse-racing had replaced pedestrianism as the premier gambling sport in the early part of the century, while growing involvement in the Olympic Games served to heighten the purity of amateur athletics.

There were, of course, notable exceptions. Norm McDonald was a remarkable athlete, Australian Rules football player—including 1952 State representative—professional boxer, and a champion sprinter who won the Wangaratta, Maryborough, and Lancefield Gifts, and runner-up at Stawell in 1948. Ken Hampton won the famous Bay Sheffield in 1961, as well as the Broken Hill and Murray Bridge Gifts. Percy Hobson was born in Bourke in 1943—in his prime as a high jumper, he was urged by athletics administrators not to broadcast his ancestry. At the 1962 Commonwealth Games in Perth,

Hobson became the first Aborigine to win a gold medal for Australia, with a leap of 6' 11".

Several Aboriginal sportsmen who went on to great success in other sports were outstanding athletes. Jim Murray from Cowra (NSW) won several Gifts, as well as boxing and playing both Australian Rules football and first-division rugby league. Wally MacArthur, a promising junior, turned professional and later enjoyed a sensational career as a rugby league winger in the UK.

The 1990s has ostensibly been a very positive decade for Aboriginal athletes. Karl Feifar and Beverley Champion have won a swag of gold medals at the World Championships for the Disabled and the Paralympics; Kyle Vander-Kuyp has consistently run world class 110 metre hurdle times, and was a finalist in Atlanta in 1996; Patrick Johnson is on the verge of becoming Australia's fastest 100 metre sprinter; Nova Peris-Kneebone has made the extraordinary transition from international hockey representative and Olympic gold-medallist to Commonwealth Games 200 metre champion; Cathy Freeman has won everything there is to win—except an Olympic individual gold medal—and is venerated as the apotheosis of **Aboriginality**.

And yet there is still the same lack of opportunity in many Aboriginal communities. To compete for places in sports institutes, Aboriginal kids have to run against others who have access to artificial tracks, running shoes, gymnasiums, coaches, physiotherapists, and swimming pools. The majority of remote Aboriginal communities have nothing. That there has been such a rich history of involvement—and success—in athletics is due to the simple fact that despite any laws, restrictions, forced removals or assimilation, people cannot be prevented from running. PAT

See also: 20.1, 20.2; **sport**; *41*, *281*, *286*.
Bull, J., *The Spiked Shoe*, Melbourne, 1959; Mason, P., *Professional Athletics in Australia*, Adelaide, 1985; Tatz, C. & Tatz, P., *Black Diamonds: The Aboriginal and Islander Sports Hall of Fame*, St Leonards, NSW, 2000; Tatz, C., *The Obstacle Race: Aborigines in Sport*, Sydney, 1995.

Australia Council, see ATSIAB

Australian Indigenous Cultural Network (AICN) is an innovative and challenging initiative that has been established to recognise the rights of, and to support, Indigenous Australians in reclaiming and consolidating their **cultural heritage**. An autonomous body supported in part by **AIATSIS**, it aims to empower Indigenous peoples by fostering the development of a national network of Indigenous cultural collections in Australia, and to help Indigenous communities to access cultural materials held in public and private collections within Australia and overseas. In the last twenty years Indigenous Australians have continually expressed the need for greater control over these cultural materials through a number of resolutions to international meetings, including many held under the auspices of the United Nations. Numerous Indigenous communities in Australia have been actively reclaiming their heritage through negotiations with collecting bodies, and by engaging in the lengthy process of locating, copying, recording, cataloguing and storing cultural materials. However, many collections in Australia and overseas still hold significant missing elements of the heritage of Indigenous Australians.

The major focus of the AICN is the development of a national network of regional Indigenous cultural collections that are effectively recorded, stored in appropriate conditions, and managed by local Indigenous peoples. The collections will be used by community groups for the consolidation, further development, and teaching of their cultural heritage. In the longer term, these collections can help Indigenous Australians to achieve economic independence by supporting the development of a range of business enterprises, including cultural tourism and educational initiatives. The effective establishment and maintenance of an electronic national network of Indigenous collections will require access to the appropriate technologies. The AICN is facilitating the production of a model digital archiving program that is culturally relevant to Indigenous requirements. This work is being undertaken in collaboration with the Pitjantjatjara Council in South Australia and the program is based upon the archiving software developed through the Aṟa Irititja Project. The program will support the archiving of the full range of cultural materials, including text, photographic, sound, and film records, cultural objects; artworks; and **family histories**. The model will be further developed and refined through testing in five regions, to ensure that it has the capacity to meet the diverse needs of Indigenous communities, and then it will be progressively introduced into other regions throughout Australia.

The AICN will develop a national information technology system on the Internet. The system will be capable of assisting Indigenous communities to identify and gain access to their cultural materials currently held in major public and private collections. The system will gradually link Indigenous cultural centres, **keeping places**, and other cultural organisations to museums, libraries, art galleries, archives, and universities. Appropriate material will also be published directly on the AICN web site. Publications will include discussion papers on issues such as the protection of cultural and intellectual property rights; information packages relevant to Indigenous cultural heritage and information technology, such as how to establish an electronic cultural collection, a national training strategy that provides information about relevant training opportunities and available resources, and a register of Indigenous cultural and IT projects.

Information technology presents many challenges, as well as opportunities. Indigenous peoples will be supported by the AICN to determine how they wish to participate in this era of information technology. The AICN is committed to promoting the maintenance of integrity in the representation of Indigenous peoples, histories and cultures in the digital domain. The vital importance of protocols, and the protection of Indigenous cultural and intellectual property rights, will be acknowledged by the production of a code of practice for the IT industry. The AICN will support Indigenous Australians to ensure that their cultural heritage survives in the long term, as well as promoting the richness of Indigenous cultures to the wider community in Australia and throughout the world. HLG

See also: 13.5, 22.1; **copyright**, **repatriation**.

Australian Institute of Aboriginal and Torres Strait Islander Studies (AIATSIS) was the first Commonwealth statutory body to concentrate research efforts on and about Australian Indigenous cultures. It was established in 1964 as the Australian Institute of Aboriginal Studies (AIAS); in 1989 its Act was changed, as was its title, to reflect the research work and resources held from the Torres Strait and to place it within the Commonwealth Public Service. AIATSIS provides grants to researchers through its research section, publishes results of funded projects, and maintains significant library and archival collections. Much of this material has been generated by research funded by the Institute.

A major shift in direction came in 1974 when a group of Aboriginal people identifying as 'Eaglehawk and Crow' sent a letter to the governing council requesting that Aboriginal people should participate in setting the policies of the institute. Since then, Australian Indigenous people have served on advisory committees, carried out research, and been employed in each section of AIATSIS. Some examples of collaborative work with Indigenous people are the 'After 200 Years' project that resulted in a book of photographs by Indigenous and non-Indigenous photographers portraying community life, and the publication of a number of auto-biographies by Indigenous authors.

The AIATSIS library is the major national collection of print sources about Australian Indigenous cultures. Some of its rare books date back to the eighteenth century. It also holds journals, manuscripts, theses, and other primary source material.

The archives hold major **media** collections: audio, photographs, video, and film. Archivists try to obtain copies of audiovisual materials documenting Australian Indigenous cultures from Australia and overseas. Collections copied include the 1898 Cambridge expedition to the Torres Strait, the Baldwin Spencer expeditions, and the Kerry–King photographic collection.

The recorded sound archive contains field recordings of **language** elicitation and texts, music, oral history, and a representative sample of commercial recordings. In 1985 AIATSIS archivists negotiated with depositors to clear access conditions to much of the recorded sound collection for Indigenous clients. The photographic archive holds over 500 000 images in various formats, **rock-art** tracings, and drawings. The film and video archive holds original film material from the former AIAS film unit, which operated from 1963 to 1990, as well as videos produced commercially and by Indigenous media associations, and copies of some of the earliest films made in Australia.

AIATSIS' most significant and enduring contribution to the visual arts has been the compilation of the National Aboriginal and Torres Strait Islander Visual Arts Database (NATSIVAD). This Internet-based resource makes available the biographical details of some 5500 Indigenous visual artists, and is updated on a regular basis.

GK

See also: 12.4, 13.1; **family history**.
Horton, D. (ed.), *The Encyclopaedia of Aboriginal Australia: Aboriginal and Torres Strait Islander History, Society and Culture*, Canberra, 1994; Taylor, P. (ed.) *After 200 Years: Photographic Essays of Aboriginal and Islander Australia Today*, Canberra, 1988; Taylor, P., *Telling It Like It Is: A Guide to Making Aboriginal and Torres Strait Islander History*, Canberra, 1992.

Australian Rules football (AFL) had been an important part of the Australian way of life for a hundred years. Yet on a Saturday afternoon in the winter of 1964—during a match between East Perth and Claremont—the Aboriginal player Syd Jackson broke in half the umbrella of a woman spectator who was racially taunting him. Jackson's cool and efficient act came out of a lifetime of coping in two worlds. His first few years had been spent with his family, east of Kalgoorlie (WA). As a small child, he was taken by 'welfare' to Roelands, a mission station in the State's cold south-west. In time Jackson became known locally as a fine footballer and won two Hayward Medals. He would later play brilliantly for East Perth and Western Australia and, still later, in Carlton's premiership teams of 1970 and 1972 in the Victorian Football League (VFL). On retirement he became an important public servant for the Department of Aboriginal Affairs, inspiring other sportsmen such as John McGuire who would also go on to play with East Perth, as well as captaining the national Aboriginal **cricket** team which toured England in 1988. Jackson was reunited with his mother only in 1981, after nearly four decades of separation.

By the 1990s, the problem of obstacles to the recognition of the talents of Indigenous footballers was acute. Within Australian Rules football there remained a culture of racial abuse which might have persisted beyond 2000 but for the actions of a player who had grown up in Pingelly in Western Australia's south-west. Neil 'Nicky' Winmar endured racial taunts until in 1993—while playing for St Kilda against Collingwood—he raised his jumper and pointed proudly to his dark-skinned chest. It was an act of anger and pride which resounded across the nation. Thereafter, the Australian Football League (AFL) sought to contain the worst excesses of racism in a national sport watched by millions weekly, and a code of conduct was agreed upon. But even as late as 1999, a St Kilda player racially abused Scott Chisholm and was only lightly penalised, and in the same year, well known Australian television entertainer and former Geelong player 'Sam' Newman, gave a hurtful on-air visual impersonation of an Aboriginal footballer—Nicky Winmar no less. These actions were condemned by many players and officials.

In 1999, out of sixteen teams competing in the AFL, there were enough Aboriginal footballers to field more than two teams. No other sport had such exceptional representation of talented Aboriginal sportsmen: Gavin Wanganeen (Brownlow Medallist in 1993), Andrew McLeod (Norm Smith Medallist in 1997 and 1998), and Michael Long, who received the Norm Smith Medal in 1993 from one of his heroes, fellow Tiwi and Richmond legend, Maurice Rioli. Chris Lewis, having played for the West Coast Eagles since 1987, reached 200 games. And Glenn James was a superb AFL umpire in the 1980s.

Why football? The answer to this question can be found in part in recent books by Colin Tatz. The Aboriginal game of *marngrook*, with its use of a stuffed possum-skin oblong 'ball', which was caught—and apparently kicked—was melded with the rules of Gaelic football and **rugby**, and

became Australian Rules football. Until the 1960s, few Aboriginal footballers were allowed to play in the senior colonial and State competitions. In the countryside it was different. Missions and reserves promoted football—perhaps seeing it as a means of encouraging assimilation—and formed local competitions, especially across Victoria, South Australia, and Western Australia. From the 1950s, with the relaxation of laws restricting the movements of Aboriginal people, more Aboriginal footballers joined country-town teams, and represented their regions in state-wide country carnivals.

From the 1970s this representation became a torrent, and country teams had become fertile ground for recruiting agents from the major league clubs. From Bunbury, Kojonup, and Mt Barker (WA) came Keith and Phil Narkle, Troy Ugle, and the Krakouer brothers. There was also Stephen Michael from Wagin in the south-west league; he was probably the greatest of his generation, and was to win All-Australian selection on several occasions, and play over 200 consecutive games for South Fremantle. In the Northern Territory, the Buffaloes and the St Mary's teams produced streams of footballers into the WA and SA Leagues. In the 1990s, with the formation of the AFL, they were joined by players from Queensland and New South Wales, where Aboriginal representation had previously been concentrated in the rugby codes.

Long before the breakthroughs of the last three decades, two great players had forced their way into football stardom and national awareness. In the 1930s, Doug Nicholls from Cummeragunja Mission—runner, boxer and footballer—made his mark in the VFL with Fitzroy, and represented Victoria on six occasions. In later life Nicholls was to be the first Aboriginal State Governor (in South Australia, from 1976 to 1982), after an outstanding career in public and community service. A second—and even greater—footballer who made his mark in the 1950s and 1960s, was Graham Farmer. For most of his childhood and teenage years Farmer was in Sister Kate's Orphanage in Perth, where he played local football with Kelmscott. By the end of 1956 Farmer had won a Sandover Medal, represented Western Australia, and was on the way to becoming the greatest footballer of all time. At Geelong he was regarded as the most innovative and charismatic VFL ruckman ever seen. He played over 350 games and also enjoyed success as a premiership coach with West Perth. Long after his retirement Farmer confided to his biographer, Steve Hawke, that he had been racially abused on a regular basis throughout his career. It was a sad but not unexpected revelation. Farmer's career stands as an inspiration to all Australians, as do those of players like Jackson and McGuire. Football has played host to their sporting genius, and we as a nation are the greater for it.

TS

See also: 20.2, **stolen generations**; *245*.

Hawke, S., *Polly Farmer: A Biography*, South Fremantle, WA, 1994; Holt, S., 'Go Nicky', in P. Craven (ed.), *The Best Australian Essays 1999*, Melbourne, 1999; Tatz, C., *The Obstacle Race*, Kensington, NSW, 1995.

autobiography, see life stories

B

BAKER, Nyukana (Daisy) (1943–), Pitjantjatjara **batik**-maker, painter, printmaker, and wood carver, joined the **Ernabella Arts** centre as a young girl in the late 1950s, where she learnt weaving and painting. She showed exceptional artistic ability. Her work is linked to her belief that 'Firstly, we keep our culture strong through our art. Secondly, this is a good way for our Tjukurpa to be documented and to make sure that the young people don't forget. We tell them Tjukurpa while we are painting.'

When batik was introduced to Ernabella in 1971 Nyukana Baker was among the first to experiment with the new medium and quickly developed her own style. Also known as a painter, printmaker and wood-carver, her greatest strength lies with batik; she specialises in scarves and cloths up to 5 metres long. Her flowing designs possess an outstanding rhythm and symmetry that make her work at once individually recognisable and at the same time characteristic of Ernabella design—a fluid, curvilinear abstract form known as the *Ernabellaku Walka*. She could confidently state in 1998: 'I have my own style now.'

Highlights of her career include a visit in 1975 to the Batik Research Institute in Jogjakarta, for a workshop on batik techniques, and a visit to Osaka, Japan in 1983, where she gave a number of technical demonstrations and was exhibited at the Museum of Ethnology. Nyukana Baker's work is widely represented in institutions and private collections in every State, as well as overseas. She has served as chairperson of Ernabella Arts Inc. LP

See also: **printmaking**, *293*.
Eickelkamp, U., *'Don't ask for stories': The Women from Ernabella and Their Art*, Canberra 1999; Partos, L., *Warka Irititja munu Kuwari Kutu: A Celebration of Fifty Years of Ernabella Arts*, Adelaide, 1998; Ryan, J. & Healy, R., *Raiki Wara: Long Cloth from Aboriginal Australia and the Torres Strait*, Melbourne, 1998.

BAKER, Rebecca, see Nellie **Nambayana**.

Balgo, see **Warlayirti**.

BANCROFT, Bronwyn M. (1958–), Bandjalang visual artist. Fundamental to the ideas and values expressed in Bronwyn Bancroft's images is her belief that 'it matters that you believe in your family and your heritage'. Bancroft always wanted to be an artist and one of her earliest childhood memories is of using refracted light to make patterns. She now works across a range of media including fabric design, fashion, painting in gouache and **acrylic**, collage, illustration, jewellery design, interior decoration, and sculpture. She has illustrated a number of books including **Oodgeroo Noonuccal**'s *Stradbroke Dreamtime* (1993) and Sally **Morgan**'s *Dan's Grandpa* (1996), and designed exhibition wall graphics and hand-painted body art for 'Ngamarang Bayumi' (PM 1997–99).

Born and raised at Tenterfield (NSW), Bancroft graduated from the Canberra School of Art (ANU) in 1980, having developed a unique style of photography using a process camera in which the still photograph was manipulated beyond its 'real' existence. She has since concentrated on painting and developed a glowing style reminiscent of stained glass windows. Although an instinctive colourist, she credits global indigenous cultures and the Western artists Kandinsky, Miro, and Georgia O'Keefe as influences.

In 1985 Bancroft established Designer Aboriginals to produce and sell her fabrics, fashion, and jewellery. Young Aboriginal women were employed and trained in design, production, and retailing. The 1985 Aboriginal Medical Service fashion parades in Sydney led to 'Aboriginal Design', a fashion parade at Printemps department store (Paris 1987),

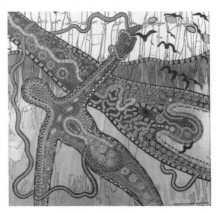

287. Bronwyn Bancroft, *My Land Escape*, 1993. Gouache on paper, 160 x 160 cm.

which was presented by Bancroft, Euphemia **Bostock** and Mini Heath, with a group of young Aboriginal models.

In 1987 Bancroft became a foundation member—and was later chairperson—of **Boomalli Aboriginal Artists Co-operative** in Sydney. In 1991 she was awarded damages when her painting *Eternal Eclipse* was reproduced commercially without permission. She was chairperson of the National Indigenous Arts Advocacy Association in 1993–96 and served on the Council of the NGA for nearly six years. In 1990 and 1991 she assisted in the coordination of public education programs about Aboriginal art at the AGNSW. The mother of three children, she supports young artists, conducting workshops for school children around Australia. KW

See also: 12.1, 17.1, 22.1; **arts advocacy associations, copyright**, *287*. Abouchar, B. & McFarland, R., *A Matter Of Identity* [video recording], Open Training and Education Network, Sydney, 1994; Isaacs, J., *Aboriginality: Contemporary Aboriginal Paintings and Prints*, St Lucia, Qld, 1989; Johnson, V., *Copyrites*, Sydney, 1996.

BANDAK, Nym (*c.*1910–1984), Murrinh-patha visual artist, of the Diminhin estate, was born in troubled times. The Murrinh-patha were engaged in a long-running conflict with inland groups and Nym gained a reputation as a clever spear fighter. At the time the region was not occupied by Europeans but was encircled by European interests which had dispossessed Aboriginal groups. Drawn by the excitement of new places, people and European goods, Bandak and his kinsmen travelled further than they had ever before, beyond the Victoria River to the Ord River region within the eastern Kimberley. There he witnessed and participated in ceremonies among other Aboriginal groups and was exposed to new ideas about cultural form, symbolism, and design.

The Port Keats mission was established on Bandak's land in 1935. By this time he was an initiated man with a number of wives. The missionaries wanted the Murrinh-patha to follow the teachings of the church and discouraged traditional practices. To appease them Bandak lived with one wife while in the mission, but lived with all of his wives and children outside the mission. He managed his cultural life in a similar fashion. Even though he and his contemporaries attended church they also secretly practised their own culture.

In an attempt to create cottage industries the missionaries encouraged Bandak and other artists such as Jarri, Mardigan, Birari, Indji and Tjimari to paint on bark and create artefacts for sale. Nym used **bark painting** to express ideas and describe cultural concepts found in Murrinh-patha high culture. His small bark paintings were in the shape of objects used within the discouraged ceremonies, while their content and themes were inspired by both secret and public Murrinh-patha cultural forms. These celebrated the **Dreamings** and the features of the land which gave meaning to the lives of Bandak and his kinsmen. In his paintings, both on bark and on board, Bandak synthesised Murrinh-patha cultural and artistic forms with those learnt in his travels within the eastern Kimberley, providing a cultural link between the eastern Kimberley and his own cultural milieu.

Bandak's paintings informed the work of anthropologist W. E. H. Stanner, and through him a generation of Australian anthropologists. They also adorn the walls of the Town Council office at Port Keats, where they continue to influence a new generation of Port Keats artists. Bandak's paintings have been shown at group exhibitions throughout the world, most recently in 'World of Dreamings' (St Petersburg 2000). His work is held by art galleries in most States of Australia as well as in the Kluge–Ruhe Collection at the University of Virginia, and the Musée Nationale des Arts d'Afrique et d'Océanie, Paris. KB

See also: 1,2, 10.1, 10.2; **Wadeye art**, *34*, *271*.
Barber, K., 'A History of Creation: A Discussion of the Art Gallery of New South Wales Collection of Port Keats Paintings' [unpublished manuscript], 1993; Barber, K., 'All The World: The 1958 and 1959 Paintings of Nym Bandak' in W. Caruana (ed.), *Aboriginal Art in Modern Worlds*, Canberra, in press; Stanner, W.E.H., *White Man Got No Dreaming: Essays 1938–73*, Canberra, 1979.

BANGGALA, England (*c.*1925–), Gun-nartpa painter, was born near Gochan Jiny-jirra, south east of Maningrida in Arnhem Land (NT). He married Mary Karlbirra, a Kuninjku woman. Like many of their contemporaries, Banggala and his wife travelled between their country and Darwin prior to the establishment of Maningrida in 1957, where they eventually lived and worked for several years.

In 1973 the family returned to Gochan Jiny-jirra where Banggala worked in the market garden. His return to

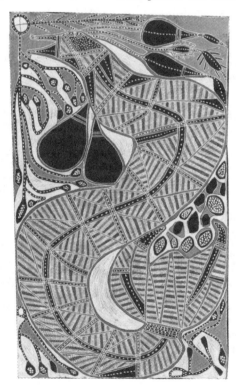

288. England Banggala, *Modj Rainbow Serpent*, 1988.
Natural pigments on bark, 143.5 x 83.5 cm.

country prompted him to start painting, as his subject matter is drawn directly from ceremonial designs associated with his clan estates. His two major motifs are *jingubardabiya* (pandanus skirt), associated with women and female water spirits, and *ji-japurn* (snake creator being). He has taught his children, including painter and weaver Dorothy **Galaledba**, about the **Dreamings** and ritual of their clan, and how to paint them.

With Johnny **Bulunbulun**, Banggala was one of the first Aboriginal artists to experiment with lithography at the Canberra School of Art, in 1983. His bark paintings, prints and carvings have been featured in major exhibitions, including 'The Continuing Tradition' (NGA 1989), and 'A̲ratjara' (Düsseldorf, London, and Humlebaek 1993–94).

MEJ & MC

See also: *288*.

Carew, M., *Men of High Degree*, Melbourne, 1997; Moon, D., 'England Banggala', in M. Eagle (ed.), *Adelaide Biennial of Australian Art 1990*, Adelaide, 1990; West, M., *Contemporary Territory*, Darwin, 1994.

BANI, Ephraim (1944–), artist, linguist and cultural historian, is recognised as an expert on the culture of the Torres Strait. He is a multi-talented artist who has promoted the Torres Strait both nationally and internationally. Born in 1944 on Mabuiag Island in the Western Island group of the Torres Strait into the Wagadagam tribe, he learnt directly from his grandfather and uncles as a boy, and became the proud recipient of a traditional knowledge that was quickly disappearing. At the age of sixteen he was able to assist Wolfgang Laade in cultural research on Mabuiag Island. It was during this time that he learnt that many of the traditional artefacts made by his ancestors had not been destroyed, but still existed in museums throughout the world.

As a young man Bani travelled to Canada to complete formal training in linguistics. During his research he developed the EPO ('Ephraim's Practical Orthography') which is now a recognised linguistic term. On returning to the Torres Strait, he worked hard to promote awareness of Torres Strait culture and established the Torres Strait Cultural Festival. He has produced many articles on his research into Torres Strait culture and language and has developed a perspective that offers a clear understanding of a complex area of cultural research.

His academic work aside, Bani is also a talented artist. Many of his early paintings were illustrations in Margaret Lawrie's book *Myths and Legends of Torres Strait* (1970). He has worked closely with the independent film-maker Frances Calvert on two films, *Talking Broken* (1991) and *Cracks in the Mask* (1997). The latter and most recent film promotes the need for Torres Strait Islander artefacts held in overseas collections to be returned to the Torres Strait.

Bani has worked all his life for the Torres Strait and is trying to establish a cultural centre in the area. His life has been full and there is much Torres Strait Islanders can learn from him. He once told me in reference to traditional knowledge: 'I am not trying to tell you something you don't know but helping you to understand what you already know.' Bani's statement does not set boundaries on what it is to be a Torres Strait Islander: rather, he is saying that being true to yourself is what it means to be a Torres Strait Islander. MB

See also: 7.1, 7.2, 7.4.

BARAK, William (*c.*1824–1903), Wurundjeri visual artist and ethnographer. There are four portraits of William Barak, all made in the last years of his life, which describe his position in late nineteenth century society. They emphasise his age, his dignified demeanour, his sadness, and his status as the 'Last Chief of the Yarra Yarra Tribe'. Barak was indeed a *ngurungaeta* (elder) of the Wurundjeri people, but he was not the 'last chief'—his position was passed to his nephew, Robert Wandin. His descendants still live in the Wurundjeri area of Victoria.

Barak was widely recognised as a remarkable survivor. It was considered significant that by the end of the nineteenth century, Barak was the only Wurundjeri person still living who had been present at the signing of John Batman's 1835 'treaty' with the Wurundjeri which led to the establishment of Melbourne. Barak estimated that he was eleven years old at that time. For anthropologists, his knowledge of the Aboriginal society and culture of pre-colonised Victoria was invaluable. He knew songs and stories, and was adept in the manufacture and use of hunting weapons and tools.

Barak's life was closely associated with the fortunes of the Coranderrk Aboriginal Station. Established in 1863, Coranderrk was settled by Aboriginal people from southern and central Victoria. Barak was one of its early inhabitants, and became a community leader. Government interference and mismanagement were endemic in the history of the station: there were continual threats of closure and relocation of the people. Barak petitioned the government for the retention of the settlement, leading deputations to Melbourne in July 1875 and February 1876. Coranderrk was gazetted as a permanent reserve in 1884.

Barak probably made most of his drawings in the last decades of his life. A photograph taken around 1898 shows him working on a drawing pinned to the slab-timber walls of a Coranderrk building. Beside him is his typical palette of watercolours and the pigments traditionally used for decoration in south-east Australia: charcoal and **ochre**. Almost all of Barak's drawings depict ceremonies. Aside from his unique blending of materials, his style is distinctive, taking its principal motif from the patterned possum-skin cloaks that were the traditional dress of the Wurundjeri.

Barak's drawings are not easy to date, except by the date of their collection. They formed a part of the tourist economy of Coranderrk and were bought by visitors to this, the closest Aboriginal settlement to Melbourne. Barak also gave his drawings as gifts—sometimes in lieu of performances of the traditional dances which were frowned upon at the settlement. In this context Barak's drawings were a means by which he recorded and reminded people of the shape of Aboriginal culture before the colonisation of his country.

In the late nineteenth and early twentieth centuries, Barak's drawings entered museum collections around the world; the largest concentrations of his work are held in the Museé d'Ethnographie in Neuchâtel, Switzerland, the Museum für Völkerkunde, Berlin and the Museum für Völkerkunde,

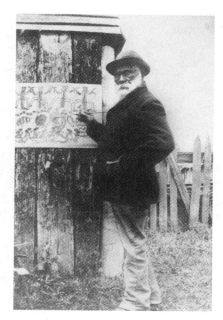

289. William Barak at work on a drawing at Coranderrk, c.1895.

Dresden. In recent years, Australian libraries, art galleries and museums have substantially increased their holdings of Barak's unique works. AS

See also: 11.1, 11.2, 14.2, 18.1; anthropology; 289.
Howitt, A. W., *The Native Tribes of South-East Australia*, London, 1904; Morphy, H., 'Documents of change: The art of William Barak and Tommy McRae', in H. Morphy, *Aboriginal Art*, London, 1998; Sayers, A., *Aboriginal Artists of the Nineteenth Century*, Melbourne, 1994.

bark painting. The practice of bark painting was once widespread among Aboriginal people. Unfortunately, because of the circumstances of the colonisation of the Australian continent, there are few surviving examples of the bark painting of the south-east. By contrast, bark painting flourishes in northern Australia: it is the basis of a major industry and works are eagerly sought in the contemporary world art market.

François Peron, the naturalist who accompanied the French explorer Nicholas Baudin, was the first European to record the practice of bark painting while on a visit to Maria Island, off the east coast of Tasmania, in 1802. He found designs resembling the scarification marks of the local landowning group of Aborigines painted on the inside of a bark shelter that covered a grave. Geometric and representational designs were common on bark shelters in Tasmania, and both women and men painted on bark. Some shelters were decorated with circular designs scratched into smoke-blackened bark with a forked stick. These patterns have been related to Tasmanian body scarification, which also featured circular designs representing the sun and moon, and which was believed to impart the power of these celestial bodies to the wearer. There are also reports from the mid-nineteenth century of charcoal drawings of species such as kangaroo, emu, and hunting and fighting scenes on bark shelters in Tasmania, and of a bark drawing at Mt Cleveland that depicted the bullock carts of the Van Diemen's Land Company.

Carol Cooper has reviewed the evidence for both naturalistic and geometric painting on bark in the Murray–Darling region in New South Wales and Victoria. The naturalistic art often takes the form of narrative scenes of animal figures, hunting, and scenes of contact with white men, or horses and carts. There are also reports of trees painted with designs resembling body paintings and designs engraved on weapons. Cooper makes the point that geometric designs on trees and weapons probably functioned in very much the same manner as geometric clan designs further north, that is, as the identity markings of local groups. Carved and painted sculptures made of bark were also carried in ceremony. Only two bark drawings from Victoria exist in museum collections. One, from the Murray River region, is now held by the Museum of Mankind, London; a second was collected at Lake Tyrrell in the Mallee district prior to 1874 and is now at MV.

From the available evidence, there appear to be strong similarities between the use of bark painting in south-east Australia and in Arnhem Land. In western Arnhem Land bark and rock shelters used for habitation were painted with narrative scenes and depictions of contact with Macassans or European settlers. Naturalistic and narrative works appear to have been associated with the relatively familial context of shelter painting, while geometric art is more generally associated with ceremony, particularly in body designs and related items such as bark belts, or on mortuary artefacts such as bark coffins.

Bark painting in northern Australia is found in the Kimberley (WA), and in the Top End of the Northern Territory, on Bathurst and Melville Islands, in Arnhem Land, and on **Groote Eylandt**. It was introduced relatively recently to **Wadeye** (Port Keats, NT), and to Mornington Island and Aurukun (Qld). In all of these regions, bark painting retains a role in the communication of values and cultural beliefs among local groups of Aborigines, as well as being a medium for cross-cultural exchange and communication. Contemporary bark painters work in two realms: training younger Aboriginal people in the cultural symbolism of paintings, and explaining their motivations in the broader non-Aboriginal market place. In Arnhem Land contemporary bark painting draws on both secular and ceremonial contexts of painting.

In eastern Arnhem Land centres such as **Yirrkala**, Milingimbi, and **Ramingining**, bark painting by Yolngu-speaking artists is closely articulated with the clan-based system of land ownership. Bark paintings provide a template of the relationship of ancestral beings to the lands they created. Contemporary bark paintings produced for sale are strongly related to body paintings worn at initiation and markings on the body or coffin at death. The paintings identify individuals with their ancestral lands. The effect of brilliance (*bir'yun*), achieved through the application of patterns of cross-hatching to ceremonial paintings,

is perceived as the emanation of the ancestral power (*märr*) of the design. The same marking when placed on the body communicates ancestral power to the wearer. Similarly, in bark painting, cross-hatched designs are considered appropriate to the representation of ancestral subjects and Aboriginal artists understand that non-Aboriginal audiences also respond to these brilliant patterns.

In western Arnhem Land, artists paint a variety of motifs common at **rock art sites**. Images of long, thin trickster spirits, called *mimih*, involved in hunting or ceremonial activity are common. These images relate to a very ancient style of rock painting, consisting of thin, red figures, that predates the development of contemporary estuarine conditions near the escarpment about 6000 years before the present. Other common secular subjects are x-ray paintings of animals (*mayt*). Artists depict the important cuts of meat of the animal and the internal organs, which are prized delicacies. Artists are careful to represent the features of the particular species accurately, but a common technique of representing the creative powers of ancestral beings (*djang*) is to reveal their transforming body shape. In western Arnhem Land artists also now incorporate the application of cross-hatched designs (*rarrk*) in paintings of ancestral beings. These could not be described as clan designs. Rather, cross-hatching has become one of a number of creative techniques that contemporary artists use to enliven their paintings.

On Melville and Bathurst Islands, Tiwi-speaking artists produced painted bark baskets in association with Pukumani mortuary ceremonies. The baskets were placed over the top of the carved sculptures made for the burial ground. Bark baskets are still occasionally made, although the art market has encouraged Tiwi artists to produce paintings on flattened pieces of bark, as is the practice on the mainland. Some Tiwi paintings relate to ancestral creation stories, although most works are not intended to be symbolic in the same sense as works from Arnhem Land. Rather, they are metonymically related to the designs of body scarification and elaborate body paintings in Pukumani.

At Wadeye, painting on bark by Murrinh-patha artists was stimulated by the work of the anthropologist W. E. H. Stanner in the late 1950s and these works were subsequently sought by collectors during the 1960s and 1970s. Their imagery derives from rock painting, body decoration, and the decoration of sacred objects. Bark paintings, in oval form, that closely resemble the shape of sacred objects were common during the 1960s and 1970s, although production has virtually ceased in the absence of a local arts centre. Some of the works reveal strong desert influences and are almost identical to paintings produced on canvas board at **Papunya** a decade later.

In the western Kimberley the most common subject of bark paintings is the Wanjina figure. Wanjina are creator figures who made the land and left their image and their continuing power in the caves at certain sites. Rock paintings of these figures focus on the details of the head and shoulders. The head is shown encircled by haloes of dots or dashed lines while only the eyes and nose of the face are shown. Often an oval representing the breast bone is depicted. The huge thunderclouds that sweep across the region in the wet season and the tall, cumulus clouds are manifestations of the Wanjina,

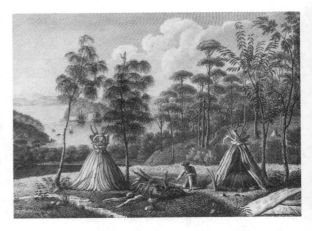

290. Victor Pillement, *Native Graves, Maria Island, Tasmania*, 1802.
Engraving, 24 x 31.2 cm.
Inside the graves, geometric designs similar to those found in body cicatrices and the rock art of the region have been scratched into two of the largest strips of bark. They indicated the deceased person's local clan affiliations.

and are captured in the solid forms of the figures. Repainting of these images is an essential responsibility of the Worrorra, Wunambal, and Ngarinyin Aboriginal landowners; bark paintings of Wanjina developed in response to the interest shown by European collectors in rock-painting motifs.

In Queensland, for a short period in the 1960s, Dick **Roughsey** (Goobalathaldin) and Lindsay Roughsey (Burrud) painted figurative images on bark at Mornington Island, and Peter Sutton (1991) describes a bark painting by Angus **Namponan** produced in 1976 at Aurukun. LT

See also: 1.5, 4.6, 5.2, 5.4, 6.1, 6.2, 6.3, 6.4, 7.6, 10.1, 10.2, 16.3; body adornment; *290*.

Cooper, C., 'Traditional visual culture in south-east Australia', in A. Sayers, *Aboriginal Artists of the Nineteenth Century*, Melbourne, 1994; Groger-Wurm, H., *Australian Aboriginal Bark Paintings and Their Mythological Interpretation*, Canberra, 1973; Morphy, H., *Ancestral Connections: Art and an Aboriginal System of Knowledge*, Chicago, 1991; Ruhe, E. L., 'The bark art of Tasmania', in A. Hanson & L. Hanson (eds), *Art and Identity in Oceania*, Bathurst, NSW, 1990; Sutton, P., 'Bark painting by Angus Namponan', *Memoirs of the Queensland Museum*, no. 30, 1991; Taylor, L., *Seeing the Inside: Bark Painting in Western Arnhem Land*, Oxford, 1996.

BARKER, Wayne (1957–), Yawaru–Djarbirr Djarbirr filmmaker and musician, was born in 1957 in Derby (WA). His parents' mixed marriage—Aboriginal mother and Scottish father—was looked upon unsympathetically by native welfare officials at the time. Barker has traditional ties to the Mangala people in the Fitzroy River region, where he was initiated. He spent three years at the Australian Institute of Aboriginal Studies (later **AIATSIS**), training in documentary film-making. This work took him to many Indigenous communities across Australia and gave him the opportunity to

write and direct his first documentary film, *Cass* (1983), about his pearl-diving grandfather.

Barker focuses on the painting of Mick **Gill Tjakamarra** in his short documentary, *Balgo Art* (1990), which accompanied the 'Yapa: Peintres Aborigènes de Balgo et Lajamanu' exhibition to Paris in 1991. His most creative work is *Milli Milli* (1993), a documentary portrait of the people and regions of the Kimberley. It won him the Andris Slapindish Award as International Filmmaker of the year in 1994 and has been broadcast on **television** globally. Barker's short dramatic film, *Strike Your Heart* (1996), was the first Indigenous drama to be made in the Kimberley region, capturing his childhood memories and played almost entirely by an Indigenous cast. He is also a musician, writing and performing all the songs that accompany his films.

Barker is now co-director of Strike Your Heart Films. He considers himself a storyteller first and foremost and takes seriously his responsibility to represent the artistry and dignity of Australian Indigenous people. IB

See also: 13.1.

BARKUS, Rosie (1959–), Muralag (Meriam Mir) visual artist, was born on Waiben (Thursday Island), the youngest of a large family. Her father's ancestral ties were to Moa (Banks Island) and her mother was from Mer (Murray Island). Through her mother Barkus learned the significance of maintaining cultural ties to the Torres Strait through daily activities—cooking, gardening, and weaving domestic objects, including mats, baskets, and fans. 'There were only a small number of [I]sland families living at Holloway's Beach [Qld] at the time and they would often get together, yarn, and *kai-kai* (eat together)', she says. She recalls well-known Australian artist Ron Edwards busily painting and printmaking in his beachside studio.

Barkus attended business college, travelled extensively, and worked for the Aboriginal and Torres Strait Island Legal Service. She established a craft store on Thursday Island in 1986 and began making jewellery from natural fibres and debris found on beachcombing expeditions, collecting black coral, pearl shell, seeds, and other natural fibres. She began experimenting with various forms of fabric printing, using innovated personal designs and cultural motifs.

Barkus also later experimented with other media, including ceramics, lino-block printing, and silk painting. Since 1996 she has exhibited widely: in 1997 she was represented in exhibitions at Savode Gallery in Brisbane, the CCCC in Perth, and at Customs House, Sydney. Her work is held in the collections of the ANMM and QM. BR

See also: 7.4; 91.

Mosby, T., with Robinson, B., *Ilan Pasin (This is Our Way): Torres Strait Art*, Cairns, Qld, 1998.

BARRA BARRA, Djambu (*c.*1946–), Wägilak (Yolngu) painter, began painting at **Ngukurr** (NT) in 1987. Just a few months later, his *Crocodile Story* was exhibited in the Fourth National Aboriginal Art Award (now NATSIAA) and earned critical acclaim for its bold colour and dynamic composition. In defiance of convention, the work refused to stay

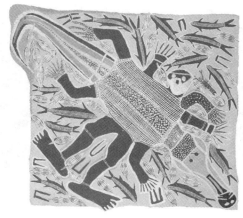

291. Djambu Barra Barra, *Crocodile Story*, 1987. Acrylic on cotton duck, 156 x 169.5 cm (irreg.).

within the usual square format; the tail of the huge saltwater crocodile broke through the edge of the picture plane.

After spending most of his early life at Ngilipidji in central Arnhem Land, Barra Barra moved in the 1970s to live at Ngukurr with his wife Amy Jirwulurr Johnson, also an artist. Encouraged by an adult education program, Barra Barra experimented with stencil printing in 1986, before beginning to paint. He has since become one of the leading Ngukurr-based artists, holding his first one-person exhibition in 1991. Since 1988 Barra Barra has participated regularly in group exhibitions, including 'Aboriginal Art and Spirituality' (HCA 1991), 'Crossroads' (Kyoto and Tokyo 1992), and 'Love Magic' (SHEG 1999). Examples of his work are held in the NGA and State gallery collections, and in the Holmes à Court Collection, Heytesbury (WA).

Barra Barra's figurative paintings have a strong narrative element and reflect his deep interest in ceremonial Law. He employs x-ray and cross-hatching styles derived from **bark painting** but reverses tradition by using bright primary colours on canvases of monumental scale. He now lives and works at Costello outstation (NT) and in 1998–99 began to make painted wooden sculptures, which were featured at a solo exhibition in 1999 at Alcaston Gallery, Melbourne.

 JUR

See also: *291.*

Crumlin, R. (ed.), *Aboriginal Art and Spirituality*, Melbourne, 1991.

basketry, see fibre

BATES, William Brian 'Badger' (1947–), Paakantji **emu egg** and wood carver and activist. As a young child, Badger Bates was taught the controlled sensibility of emu egg and wood carving by his grandmother, learning to work 'like a blind man that can see by feeling through the fingers'.

Born in Wilcannia (NSW), Badger has campaigned successfully for regional Indigenous heritage recognition. His conservation arguments are strongly advanced through his art: in 1993 a remarkable group of works were shown at Sydney University's Tin Sheds Gallery and, since then, his

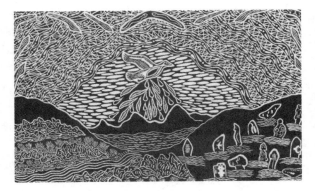

292. Badger Bates, *Marnpi Dreaming, Bronzewing Pigeon Story*, 1994. Linocut, 40 x 63 cm.

black and white linocuts and carvings regularly appear in State and national exhibitions. Linocuts such as *Bilyara Witalana Marnti (Eaglehawk looking after his country)*, 1993, and *Marnpi Dreaming, Bronze Wing Pigeon Story*, 1994 deal with cultural continuity. The former is dedicated to his son Bilyara and is about his mother's family totem; the latter puts the case to protect The Pinnacles from mining. The works explore the interdependence between the 'big river'—Paaka (the Darling River)—and its tributaries the Paroo and Warrego, the region's flora and fauna, and sites of significance to Aboriginal culture affected by mining, agriculture, and water regulation.

In other works, like the carved emu egg *Murra Yappa Handprints*, 1993, where the shell's many layers allow the creation of vivid highlight tones and shadows, or the large-scale stone carving made in 1996 for Broken Hill's Living Desert sculpture site, the artist's eye for drama recalls the rock art at Mutawintji, north-east of Broken Hill. In 1983 Badger was one of the 'Mutawintji Blockaders', demanding a lease-back management policy for Mutawintji National Park. In September 1998 the park was handed over to Mutawintji Local Aboriginal Land Council, headed by Badger's cousin William Charles Bates. Since this time Badger Bates has become a National Parks and Wildlife Service (NPWS) sites liaison officer.

Badger Bates has exhibited with his son—the painter and carver Phillip Bates—and has taught a TAFE linocut course to Wilcannia people, including his two nieces Feona and Kelly Bates. His young sons, William and Bilyara, have inherited the gift for seeing with the fingers.　　　JOH

See also: 18.1; printmaking; *229, 292*.

batik is a wax-resist dye technique for textiles that was introduced into remote Aboriginal communities in the early 1970s. The common use of the Indonesian loan word 'batik' reflects the influence of Javanese wax-resist methods, although the various styles that have evolved in this country are unique to Indigenous Australia.

Batik-making was introduced into Aboriginal communities in the context of a craft revival that commenced in Australia as a white urban phenomenon. In the early 1970s several communities, including Ernabella (SA), Papunya

(NT) and Weipa (Qld), experimented with wax-resist dyeing. At Ernabella, batik was taken up with enthusiasm within the structure of an existing craft centre. From 1974 production spread throughout the Pitjantjatjara lands to Fregon and Amata as well as neighbouring communities. In 1975 three Pitjantjatjara women, including Nyukana **Baker**, attended a three-week workshop at the Batik Research Institute in Jogjakarta, Central Java. Suitable materials were still difficult to procure in Australia at this time and the aim of the trip was to overcome difficulties in negotiating the newly-introduced medium. On their return the workshop participants passed on newly-acquired skills to other local artists. Ernabella artists gave workshops at **Utopia** in 1977, **Yuendumu** in 1984 and in Arnhem Land during this period. Ernabella and Utopia have provided important role models in batik production, such as when senior Utopia artists gave a workshop at Hamilton Downs in 1996 to women representing eight central Australian communities.

In central and northern Australian communities, batik-making has generally occurred in association with programs at women's centres. Batik is popular amongst women artists and is perceived as a means to gain economic independence as well as skills in small business management, literacy and bookkeeping.

Artists usually begin by experimenting with batik on wearable items such as T-shirts and they are often already familiar with more elementary methods of textile surface design. For example, tie-dyeing has allowed many artists to gain an understanding of resist-dyeing principles. Pigment painting on textile wall hangings formed a precedent at Ernabella for applying wax to dyed fabrics. Experiments in woodblock fabric printing created the context for the first explorations of the batik medium by Utopia artists.

Batik-making has been successful and popular with artists because it is flexible and suitable for the lifestyles of remote communities. Artists working in extended families are able to gather in groups and share skills and media; batik-making becomes as much a social event as an artistic activity. The contrast between working practices at the art and craft building, centrally located within the settlement of Ernabella, and open-air production on scattered Utopia outstations demonstrates its adaptability to a variety of environments.

In 1987–88, at Utopia, eighty-eight local batik artists participated in the project 'Utopia: A Picture Story'; the completed works were acquired for the Holmes à Court Collection. The subsequent international touring exhibition and documentation of this collection was a landmark for the promotion of Aboriginal batik. The accompanying artists' statements emphasised batik's role as an expression of Aboriginal identity. The challenge to white Australian preconceptions of medium hierarchies was accompanied by a growing interest in Indigenous craft demonstrated by the exhibitions such as: 'Crossing Borders' (USA tour 1995–97), 'Origins and New Perspectives' (Lödz, 1998), and the Thirteenth Tamworth Textile Biennale (TCG 1998).

It is commonly assumed that Javanese wax-resist traditions have stylistically influenced Aboriginal batik. In Aboriginal textiles the use of single motifs with 'filler' background patterns appears to replicate the decorative *isen-isen* patterns of Javanese batik, but this is an outcome of shared techniques,

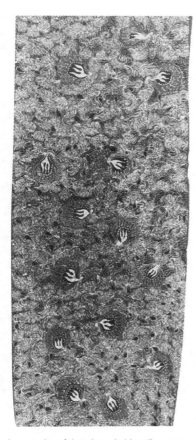

293. Nyukana Baker, fabric length (detail), 1995.
Batik on silk, 375 x 114 cm. Ernabella was one of the first
Aboriginal art centres to experiment with batik.

canting tends to blur in Aboriginal batik where many artists prefer to brush 'close' large areas of fabric in preparation for over-dyeing, especially when production is directed by economic imperatives.

In the late 1980s, Aboriginal batik artists participated in cultural exchange programs between Australia and Indonesia. An Ernabella artist, Yipati **Kuyata**, along with five other batik artists participated in the 'Australian Batik' exhibition that toured extensively throughout south-east Asia in 1988–89, and an exhibition of Ernabella batik at the National Museum Jakarta in 1993 was part of a major promotion of Australian trade and culture in Indonesia. The Indonesian batik technique of hand printing using a copper *cap* stamp was first studied by Nyungah batik students from Marribank (WA), at Brahma Tirta Sari Batik Studio in Jogjakarta in 1988. Since then the studio has hosted a number of workshops for Aboriginal batik artists. The most significant exchanges to date have been with Utopia artists, including Ada **Bird Petyarre**, Lena Pwerle, Myrtle Petyarre, and Hilda Pwerle. The 1994 workshop collection was acquired by MAGNT and subsequently toured as 'Hot Wax', the first joint exhibition of Aboriginal, Indonesian and non-Aboriginal Australian batik to be shown in either Australia or Indonesia.
JAB

See also: 7.6, 16.3, 17.5; **Apuatimi family, art and craft centres, Tiwi Designs**; *293, 390.*
Bennett, J., *Hot Wax: An Exhibition of Australian Aboriginal Indonesian Batik*, Darwin, 1995; Rowley, S., *Crossing Borders: Contemporary Australian Textile Art*, Wollongong, NSW, 1995; Ryan, J. & Healy, R., *Raiki Wara: Long Cloth from Aboriginal Australia and the Torres Strait*, Melbourne, 1998; Supangkat, J., 'Crossing borders: Brahma Tirta Sari Studio and Utopia Batik— towards cultural representation' in Queensland Art Gallery, *Beyond the Future: The Third Asia–Pacific Triennial of Contemporary Art*, Brisbane, 1999.

BAUMANN, Miriam-Rose, see Miriam-Rose Baumann **Ungunmerr**

BEDFORD, Paddy Nyunkuny (Kuwumji) (*c.*1922–), Kija painter, commonly known by his nickname 'Kuwumji' and also by his Kartiya name Paddy Bedford, is a Kija Law man of the Jawalyi subsection who was born at Bedford Downs station in the east Kimberley (WA). As a youth he worked as a stockman for the usual rations of tea, flour, and tobacco on old Greenvale and Bow River stations before returning to work on Bedford Downs. Eventually he and his family left Bedford Downs and moved to Warmun, a community near Fitzroy Crossing.

As a senior Law man Bedford has been involved in painting as part of ceremony all his life. He began painting on canvas for exhibition after Freddie **Timms** set up the Jirrawun Aboriginal Art group at Rugun (Crocodile Hole) in 1997, and is represented in several major collections including that of Parliament House in Canberra. His work in the 'Turkey Creek' style with its expanses of plain ochre and a few well-chosen shapes and sparse lines marked by white dots, depicts the bones of the landscape in which he has spent a lifetime.

and the nature of the medium. In Ernabella designs the depiction of leaves and plants emerging out of seemingly abstract configurations are already found in Pitjantjatjara drawings from the early 1950s. Botanical 'bush tucker' motifs of Utopia batik, identified by the artists as alluding to *awelye* Dreamings, developed in response to Western commercial floral fabric prints. The sources of inspiration for batik artists are diverse. Geometric patterns found on batiks by Tiwi artists such as Maria Josette Orsto directly derive from contemporary *mulypinyinni amintiya pwanga* (line and dot) motifs applied as ochre decoration to poles created for traditional Pukumani mourning rituals. **Jenuarrie**'s wall hangings reference the rock art of north Queensland, while the Torres Strait artist Ken Thaiday, Jr has created delicate works inspired by traditional dance costume designs.

It is the use of the Javanese *canting*, a pen-like implement for applying the hot wax, that most obviously establishes the relationship of Aboriginal to Indonesian batik. But in the subsequent development of a local Ernabella style the controlled line has been replaced with a spontaneous approach where even accidentally spilt and cracked wax are incorporated. The differentiation between the techniques of *klowong* (line) and *tembok* (wall) found in the Javanese use of the

His paintings combine important family **Dreamings** such as emu, turkey and cockatoo, with roads, rivers, the living areas for traditional life and stock camp life, stock yards and country visited while mustering. Bedford has been hailed as a 'new' **Rover Thomas**, although he was born a few years before that renowned artist. His work was included in the 'Blood on the Spinifex' exhibition at Martin Browne Gallery, Sydney in 2000. FK

See also: 10.1, 10.2, 10.3.
Ross, H. (ed.), *Impact Stories of the East Kimberley*, Canberra, 1989.

BELL, Richard (1953–), Gamilaraay visual artist. 'Our history has been sanitised and sterilised. I want to expose that,' says Richard Bell, who unashamedly uses his art as propaganda to confront the dominant culture and its negative stereotyping of Aboriginal people. In a combination of text and image he engages in debates about issues such as misappropriation, **land rights** and authenticity. In titles to his works like *Crisis: What To Do About This Half-Caste Thing*, 1991, or *This Black and White Thing*, 1991 he challenges colonialist attitudes to racial purity and the polarising of complex cultural conditions into simple oppositions with an uncompromising toughness. He uses his canvases to enact the viewer's worst fears, prejudices and projections with bristling irony and cynicism.

Born in Charleville (Qld) in 1953, Bell is a self-taught artist. He helped to form a number of Aboriginal artists' groups, including the **Campfire Group** in 1992. He was active in mounting QAG's landmark exhibition 'Balance 1990'.

Bell has held many solo exhibitions, and was selected for the 1992 Biennale of Sydney and 'Australian Perspecta' (AGNSW 1993). He has been included in national and international exhibitions such as 'Flash Pictures' (NGA 1991), and 'Commitments' (IMA 1993) and 'Aratjara' (Düsseldorf, London, and Humlebaek 1993–94). Represented in the NGA, State public art galleries, many museum art collections and collections in China and Indonesia, Bell has also been a recipient of a number of fellowships, commissions for postcards and prints. MN

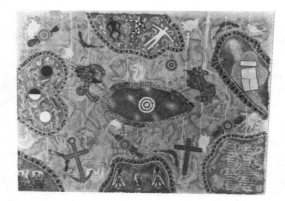

294. Richard Bell, *Crisis: What To Do About This Half-Caste Thing*, 1991.
Acrylic paint and collage on canvas, 180 x 250 cm.

See also: 12.1; *294*.
Bell, R., 'Artist statement', in E. Chambers, Institute of New International Visual Arts & Boomalli Aboriginal Artists Co-operative, *True Colours: Aboriginal and Torres Strait Islander Artists Raise the Flag*, Chippendale, NSW, 1994; Genocchio, B., 'Dreaming in urban areas: Activism and audience in urban Aboriginal art', *Eyeline*, no. 35, Summer 1997–98.

BENNETT, Gordon (1955–), visual artist. Although he is primarily a painter, Gordon Bennett also makes installations and videos, and writes eloquently on his own aesthetic strategies. With a unique postmodernist style of juxtaposed appropriated images, he pioneered a new internationalism in Aboriginal art that sought to redefine existing notions of identity. His pictures of multiple, historical and fluid narratives challenge the essentialist ideologies of both Aboriginalist and imperial discourses.

The son of an English migrant and an Aboriginal mother raised on Cherbourg mission, Bennett became acutely aware in his youth of being between two worlds, and located in neither. Moving around several locations—from Queensland country towns to the Melbourne outer suburb of Sunbury—the family finally settled at Nambour (Qld). Bennett left school at fifteen and completed a four-year fitting and turning Trade Certificate. He then worked with Telecom for eleven years. After graduating with distinction from the Queensland College of Art in 1988, he achieved rapid recognition in Australia and overseas for his paintings. *The Nine Ricochets (Fall Down Black Fella, Jump Up White Fella)*, 1990 was reproduced on the back cover of the third edition of Bernard Smith's *Australian Painting* (1991), and it won him the 1991 Moët & Chandon Australian Art Fellowship. Bennett was invited to participate in numerous group exhibitions throughout the 1990s, including 'Aratjara' (Düsseldorf, London, and Humlebaek 1993–94), 'Transculture' (a support exhibition for the Venice Biennale) (1995), a retrospective at the Canberra School of Art Gallery (1996), 'In Place (Out of Time)' (Oxford 1997). Ikon Gallery in Birmingham (UK) organised a travelling retrospective of his work in 1999–2000.

Bennett is well known for resisting the category 'Aboriginal'. This cannot be simply explained by his upbringing outside an Aboriginal community: rather, it is due to his heightened sense of aporia with respect to his own Aboriginality and the burden of representation carried by minority artists today. His aesthetic strategy is to put his own subjectivity—and the very notion of black or Aboriginal subjectivity—in question. Bennett treats the his-torical economy of Australian identities as a field in which to trace multiple subject positions. Thus he prefers a performative to an expressionist style, that is, he transparently acts out various roles through his work rather than reclaiming some inner centre or original lost identity. Employing an appropriation aesthetic, he pictures not his own 'authentic' voice but mobile and layered patterns of other voices. He repeats their aesthetic postures, but eccentrically, in different and unexpected ways. In his 1997 series *Home Decor (Preston + De Stijl = Citizen)* for instance, work in the style of early twentieth-century Australian modernist Margaret Preston jives to the syncopated beat of Mondrian grids, creating a new and rich

moment of dialogue in which Australian meets European, and modernist utopianism meets modernist primitivism. In this way Bennett deconstructs existing identities and histories rather than proposing another 'correct' one. If the pictorial logic of Australian colonialism is not overthrown, at least its ideological effects are decentred and dissipated by being disturbed, then repeated so differently and eccentrically. IMCL

See also: 12.1, 22.4, 22.5; *265, 267, 275.*
Bennett, G. & McLean, I., *The Art of Gordon Bennett*, Roseville East, NSW, 1996; Lingard, B. & Rizvi, F., '(Re)membering, (Dis)membering "Aboriginality" and the Art of Gordon Bennett', *Third Text*, no. 26, Spring 1994; Macgregor, E. A., *History and Memory in the Art of Gordon Bennett*, Birmingham & Oslo, 1999.

Bima Wear had its origins in a project initiated in 1969 by the Roman Catholic Church at Nguiu on Bathurst Island (NT). Sister Eucharia Pearce, a nun who had resided on the Tiwi Islands since 1936, taught a dedicated group of Tiwi women to sew, as a training project and to provide clothing for Tiwi. By the late 1970s Bima Wear was a growing enterprise, supplying many schools in the Top End with uniforms, and selling wall hangings, sarongs and place-mats through shops in Darwin. It used fabric that was screen-printed by men at **Tiwi Designs**, another enterprise based in Nguiu. Bima Wear continues to employ approximately twenty women, several of whom have worked there for many years. In 1986 Sister Eucharia left Bathurst Island and the organisation ceased to be a Catholic mission project. In 1982 screen-printing was introduced at Bima Wear itself. This move allowed the women a more creative outlet than simply sewing with commercial fabric. Most Bima Wear garments now featured Bima Wear designs, which were quite different from those produced by men at Tiwi Design. By the late 1980s the early motifs had been developed into 'all-over' designs for lengths of fabric, and the resulting garments were included in many fashion parades throughout the Northern Territory. In the late 1990s, Bima refocused its efforts on screen-printing and de-emphasised the manufacture of garments. It retains an important role within the community, supplying fabric and clothing for ceremonies, special occasions, and funerals, as well as continuing to supply a small number of outlets around Australia. KAB

See also: **Tiwi Pottery.**
Barnes, K., Kiripapurajuwi (Skills of Our Hands): Good Craftsmen and Tiwi Art, Darwin, 1999.

BINYINYIWUY (1928–1982), Djambarrpuyngu (Yolngu) painter, dancer, and ritual leader, was a senior elder of the Ngaladharr Djambarrpuyngu people. He lived at Milingimbi in north-east Arnhem Land for most of his adult life, but his own country was at Djarraya (Napier Peninsula), and the totemic ancestor (*waŋarr*) to which he had particular affiliation was *ḏärrpa* (king brown snake).

Binyinyiwuy had a reputation among Yolngu people of the Milingimbi region as a man of great knowledge. Together with his younger brother Djatjiwuy (c.1934–), he was very active in the ritual life at Milingimbi, as well as on the mainland at Nangalala outstation and Ramingining township.

The topics of Binyinyiwuy's **bark paintings** between 1960 and 1982 included *ḏärrpa*, *milkmilk* (mosquito) and *baṉumbirr* (morning star); the last of these appears to have been his favourite subject. The Baṉumbirr ceremony involves an exchange in which a decorated pole and string are given by one group to another, accompanied by—and in return for—other gifts. Binyinyiwuy also painted subjects belonging to his mother's group, including *birrkuḏa* (honeybee or sugar bag), Dhupiḏitj (a male ancestor), *wurrpaṉ* (emu), *waṉ'kurra* (bandicoot), and the Djaḻumbu Hollow Log ceremony. His maternal grandmother's clan also provided him with subjects for his work, including the Nguḻmarrk ceremony and *wititj* (olive python). His ceremonial activities included performance, and the making of sacred objects and sand-sculptures.

Binyinyiwuy's bark paintings have featured in many exhibitions including 'The Inspired Dream' (MAGNT 1988), and 'Aboriginal Art: The Continuing Tradition' (NGA 1989), and are represented in numerous public and private collections both in Australia and overseas, including the Musée National des Arts d'Afrique et d'Océanie (Paris) and the Kluge–Ruhe Collection at the University of Virginia. IK

See also: 3.1, 6.1.
Allen, L. A., *Time before Morning: Art and Myth of the Australian Aborigines*, New York, 1975; Wells, A. E., *Milingimbi: Ten Years in the Crocodile Islands of Arnhem Land*, Sydney, 1963; Art Gallery of New South Wales, *Gamarada: Friends*, Sydney 1996.

biography, see life stories

BIRD MPETYANE, Lyndsay (c.1945–), Anmatyerre painter, was born at Ungoola (NT). He mustered sheep on Bushy Park station and worked as a cattleman at Waite River and Woodgreen stations. In 1984 Lyndsay, who is married to Ada **Bird Petyarre**, moved with his family to Akaye (Mulga Bore). Lyndsay is an important member of the **Utopia** community.

Lyndsay Bird began his painting life in 1987 when he and a few other men at Akaye approached CAAMA, who managed Utopia Women's Batik Group, for painting materials. Notably, Lyndsay was the only man at Utopia to work in **batik**, which was regarded as the women's activity. He was also the first Utopia artist to have a solo exhibition, held in Sydney in 1989, which helped redefine public perceptions of contemporary Aboriginal art.

Lyndsay Bird's themes include *utnea* and *enmalu* (snakes), *ulkuta* (perentie lizard), and mulga seed. His paintings tell of significant ceremonial events through boldly rendered iconography and luscious painted surfaces. In 1992 he created an important series of mural-sized canvases which travelled to Italy and Japan. He has been represented in several group exhibitions including 'Utopia: A Picture Story' (Dublin, Cork, and Limerick 1990), 'A Summer Project' (SHEG 1989), 'Flash Pictures' (NGA 1991), and 'Aboriginal Art and Spirituality' (High Court of Australia, Canberra 1991). His work is held in the NGA, most Australian State galleries, the Holmes à Court Collection, Heytesbury (WA), and the Kelton Foundation, Santa Monica. CH

See also: 9.5.

Gooch, R., *Il Tempo del Sogno del Deserto*, Perth, 1992.

BIRD PETYARRE, Ada (*c.*1930–), Anmatyerre visual artist, is one of the senior women of **Utopia** (NT). Her strong character and lively personality make her an important member of her community. She is married to Lyndsay **Bird Mpetyane** and lives with her extended family a short distance from Akaye (Mulga Bore), south of Utopia.

In her work she draws inspiration from the traditional stories of her country, Anungara. Her major subjects include *arnkerrthe* (the mountain devil lizard) *arlatyeye* (pencil yam), *ntange* (grass seed), *ankerre* (emu), and *atnwerle* (green bean). She was a founding member of the Utopia Women's Batik Group (formed in 1977) and has consistently exhibited with the group. Her **batik** work is found in major collections throughout Australia and abroad. At the end of 1988, along with other women from Utopia, Ada Bird made her first paintings on canvas. With her usual enthusiasm, she made two striking and quite different works. One displayed breasts decorated with the ceremonial body painting for *arnkerrthe*, using a line and dot technique. The other work employed a strong linear pattern. In 1990 she made the first screen print by a Utopia artist and she has gone on to produce woodblock prints as well as more screen-printed images.

Ada Bird has had numerous solo exhibitions and has been included in many significant exhibitions of contemporary Aboriginal art including 'Aboriginal Women's Exhibition' (AGNSW 1991), 'Flash Pictures' (NGA 1991), and 'Aṟatjara' (Düsseldorf, London, and Humlebaek 1993–94). Examples of Ada Bird Petyarre's work can be seen in the NGA and most Australian State galleries. CH

See also: 9.5; *222*.

BISHOP, Mervyn (1945–), photographer. The work of Mervyn Bishop reflects the diversity of an extraordinary career. His period as a photographer with the Department of Aboriginal Affairs (DAA) in Canberra placed him in a unique position to document Aboriginal life Australia-wide, and it is through this vast archive of images that his warm and informal photographs are mostly known.

Mervyn Bishop was born in Brewarrina (NSW). At seventeen he commenced a photography cadetship with the *Sydney Morning Herald* (*SMH*)—where he worked for seventeen years—and became Australia's first Aboriginal press photographer. In 1971 he was made Press Photographer of the Year for his front page photograph *Life and Death Dash* (*SMH*, 22/1/1971). He was the only staff photographer to be denied promotion after receiving this award.

In 1974 Bishop started as a photographer with the DAA, a position he held for five years before returning to the *SMH*. In 1986 he worked as a photographic assistant and adviser for the National Geographic Society, and exhibited work in the 'NADOC '86 Exhibition of Aboriginal and Islander Photographers' at the Aboriginal Artists Gallery, Sydney. He completed an Associate Diploma of Adult Education (Aboriginal Education) in 1989, after which he taught photography at both Tranby College and the Eora Centre. His first solo exhibition 'In Dreams: Mervyn Bishop Thirty Years of Photography 1960–1990' (ACP 1991) toured widely and led to the wider public exposure and recognition that his work deserved.

Bishop's work has since been widely shown in group exhibitions, including 'Aṟatjara' (Düsseldorf, London, and Humlebaek 1993–94) and 'Re-take' (NGA 1998–99). He is represented in the collections of the NGA and PM. He now works as a freelance photographer. KG

See also: 12.4; *167, 340*.

McQuire, S., 'Signs of Ambivalence: Documentary Images', *Photofile*, no. 43, November 1994; Moffatt, T., (ed.), *In Dreams: Mervyn Bishop Thirty Years of Photography 1960–1990*, Sydney, 1991; Phillips, S. (ed.), *Racism, Representation and Photography*, Sydney, 1994.

BLAIR, Harold (1924–1976), concert artist, teacher, and political activist, was born at Cherbourg reserve. He and his mother were later moved to Purga mission in Queensland. He worked as a station hand and then as a cane-cutter, and in his twenties began to consider singing as a career. He was taken to his first audition in Brisbane by prominent fellow trade unionist Harry Green and sang for the soprano Marjorie Lawrence, who predicted that he would become 'one of the greatest ambassadors of his race'. In 1945 Blair appeared on radio, singing 'Macushla' on Dick Fair's *Amateur Hour*. This brought him national acclaim. In 1946 he began studying music at the Conservatorium of Music in Melbourne. Here he met and married fellow student Dorothy Eden, despite opposition from their families—at this time interracial marriages were still rare, if not taboo.

Blair studied in the USA with Sarah Lee—the teacher of Afro-American baritone Todd Duncan, as well as at the Julliard School, and his concerts received good reviews. He found his relatively unknown status liberating—he was no longer the 'token' Aborigine constantly thinking of himself as representing his people in white Australian society. In the USA he observed successful black doctors, lawyers and other professional people. This helped him to formulate his political beliefs: he realised that 'there was no divine and immutable law, which decreed that the dark races must always be subservient'. Harold Blair was feted by New York society with a farewell concert at the Town Hall, followed by a consular reception.

On his return to Australia to undertake the ABC's 1951 *Jubilee Concert Tour*, Blair was expected to maintain a punishing schedule—perhaps because of his popularity as the first Aboriginal concert artist. As a result his voice suffered permanent damage; although he continued with training, his career as a concert tenor had effectively ended.

Harold Blair continued to speak out against the treatment of Aboriginal people: he became involved in Aboriginal affairs and Moral Re-Armament, travelling throughout Europe in the 1950s in pursuit of social justice for Indigenous Australians. He also stood unsuccessfully for the Victorian State Parliament in the 1960s. In the 1970s he was persuaded to teach at Sunshine Technical School, Melbourne, and under his direction the school choir won a number of prizes.

DB & NB

Thomas, S. & Crooke, M., *Harold* [video recording], ABC Television, 1993.

BLANASI, David (*c*.1930–), Mayali musician, was born around 1930 near Katherine (NT) where his parents worked on a peanut farm. During his youth he learnt the traditional lore from his father, despite the prevailing assimilationist policies of the time.

In 1952 the Australian variety entertainer Rolf Harris recognised Blanasi's talent for Indigenous music, in particular his mastery of the **didjeridu**. Blanasi's numerous tours as a representative of Mayali culture, and then as a member of the White Cockatoo song and dance groups between 1952 and 1999—ensured that his reputation spread to all continents.

The songs Blanasi performs publicly come mainly from the repertoire of Djioli Liawonga (1925–98), along with his own didjeridu solos *Brolga* and *Kookaburra*. More important to him are the clan songs, performed only in ritual contexts. Artistically Blanasi's work has no contemporary influences; his didjeridu playing is always rhythm-ically ametric. While Blanasi's international reputation is based on his skill with the didjeridu, among his people he is held in high regard for his roles as a ceremonial leader, a song man, and family head.

Blanasi is also an artist, and was a contributor to the *Aboriginal Memorial*, 1987–88. He paints didjeridus and on board, using a fine *rarrk* style with **ochres** gathered in Arnhem Land. He lives at Wugullar community near Katherine with his wife Rosie, children, grandchildren and great-grandchildren.

CMcM

See also: 6.3.
McMahon, C., *Didjeridu* [video recording], Log Music, 1993; *Didjeridu Masters* [CD recording], MRA, 2000.

boab nuts from the Kimberley (WA), engraved or otherwise decorated, have long been minor collectibles sought by visitors to the region. Images of engraved nuts were published in 1897 and specimens in Australian museums date back to the 1870s.

The nuts are the fruit of the boab tree (*Adansonia gregorii*), a medium sized member of the *Bombacaceae* family that is found in the Kimberley and the adjacent Fitzmaurice and Victoria River basins of the Northern Territory. Aboriginal people have many uses for the tree and its fruit. The turnip-like taproot of the young boab is eaten, as is the pulp surrounding the seeds within the nut. The root fibres may be spun into a strong cord used for making belts and handles for bark containers, as well as for general lashing. Occasionally, living boab trees are carved with figures of humans or animals.

Boab nuts are generally globular, and range from elegantly symmetrical shapes to more contorted forms resulting from the effects of insect predation or other damage during their development. They vary in size, but grow up to 30 centimetres long and 22 centimetres in diameter. Mature nuts are prepared for carving by first removing the soft velvety fuzz that coats the hard, darker epidermis. Carving, usually executed with a pocketknife, may simply consist of incising the darker external skin to reveal the contrasting lighter interior.

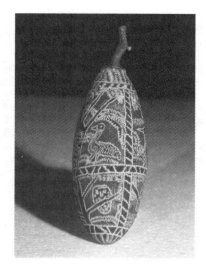

295. Boab nut, decorated and pigmented, from Mowanjum (WA). Nut, black and red pigment, 28 x 8 x 7 cm.

Alternatively, a zigzag line may be produced by a tremolo rocking action of the knife tip. The size of the zigzag can be controlled by modifying the speed and pressure used during the action. Occasionally engravings are accentuated with the use of paints. There are early examples too of nuts that have been painted but not engraved.

The earliest recorded carved boab nuts usually depict geometric figures, mazes, or apparently randomly-constructed, protean forms. Figurative motifs found on early nuts are in a style similar to the traditional engravings found on some early pearl shells; both resemble the figurative rock art of the same period. There are early references to the occasional use of engraved boab nuts as maracas to accompany singing during dances and other theatrical presentations.

By the early twentieth century, boab nuts were regularly engraved with naturalistic figures, which were often placed in a landscape. Many engravings depict aspects of traditional life and material culture. Depictions of the diverse terrestrial and marine fauna of the Kimberley are also common. Nuts carved with images relate to cross-cultural interaction of the times: those carved in hinterland areas associated with the developing pastoral industry often depict scenes of stock work, while those carved with maritime themes involving pearl luggers and divers reveal a coastal origin. There are nuts that show cattle-spearing raids and images of black–white conflict, and scenes of Aboriginal prisoners in chains. More recently, stylised carvings of Aboriginal women have been added to the general repertoire of motifs engraved on boab nuts.

From the 1960s to the 1980s the production and sale of carved boab nuts was an important economic activity practised by individual artists in a number of Kimberley communities. Although it is now practised by fewer Aboriginal people, it has been taken up by a growing number of non-Aboriginal artists of the region.

KA

See also: 10.1; *295*.

body adornment. For millennia Aboriginal artists have recorded, in **rock art**, the adornment worn by the people of their times. In western Arnhem Land the earliest of such paintings are characterised by men wearing elaborate head-dresses, sometimes embellished with feathers, pins, tassels, and strings. The people, engaged in hunting, fighting, and ritual activity, appear to wear nose pins, necklaces, pendants, and both simple and long, tasselled armbands. Later paintings show bustles, pubic coverings, breast girdles and small string pouches attached to headbands. The function and symbolism of many of the adornments shown in these paintings has been inferred from their modern equivalents.

Body adornment as an activity in Aboriginal society was, and still is, one of the ways by which groups and individuals renew and maintain connections with the ancestral realm. As an integral part of ritual activity, performers paint their bodies with clays and **ochre**, apply down with adhesives of tree sap or blood, and mask themselves from head to foot with a range of both found and constructed objects. In so doing they assume the forms and identities of the ancestral beings themselves. Many of these adornments are ephemeral, lasting no longer than the ceremony for which they are made. Others may be kept for repeated use, as the property of an individual or group. Like the ceremonies in which they are worn, such adornments may be restricted or may be viewed by all. For example, the long fur-string or feathered cords attached to armbands worn by the Yolngu in north-eastern Arnhem Land—are sacred, but unrestricted. They encode sacred meaning in the spatial arrangement of the different coloured feathers that form the cords, and are the public equivalents of *raŋga* (sacred objects) viewed only by men.

Adornments made predominantly for secular use often have a ceremonial basis or ancestral reference which dictates their form and application. The everyday wearing of these objects can be seen as a continuous connection between an individual, the ancestral realm, and all those who share in it. By their references to ancestral beings such objects frequently indicate clan, totem, or moiety membership. Thus, in the Northern Territory, Kaytej men of the rain **Dreaming** are entitled to wear teeth from the euro kangaroo suspended from their side-whiskers in reference to a particular ancestral event. Mourning practices and adornments vary widely across Australia. The Tiwi mourning armbands—*pamagini*—have no visual parallels elsewhere, nor do the Gagadju *kundama* mourning bracelets. Cross-shoulder mourning ornaments of strung shells were worn in parts of Cape York, yet in other areas where identical items are worn, they have no such significance. Styles of secular pubic adornments may also be unique to particular groups. The Pitta Pitta people made a miniature tassel of possum-fur twine 5 centimetres long and attached it directly to the pubic hair. The Diyari of the Lake Eyre region made a tasselled ornament, *thippa,* from up to 350 white tail-tips of the bilby, while in the south-east an apron of emu feathers was worn by women until the birth of their first child, after which it could be dispensed with.

The natural lustre of pearl shell made it especially valued as an adornment, and it was traded from the Kimberley coast as far south as the Great Australian Bight. While at its source it could be worn as a pubic adornment by children, at Ooldea, on the eastern edge of the Nullarbor Plain, it was one of the highly significant gifts presented to a novice immediately prior to his circumcision. Pipeclay, huntite, and powder from the bark of particular gum trees could be used to whiten adornments, particularly headbands and pubic tassels, to increase their lustre and power of attraction. The 'king plates' presented to Aboriginal 'chiefs' in the nineteenth century probably owed some of their acceptability to their polished brass surface, whatever other benefits they may have brought to their wearers by associating them with the non-Aboriginal realm.

Adornments could be both functional and symbolic. Human hair-string belts—the badge of an adult hunter over much of Australia—were presented to novices during the time of their transition from childhood to manhood. In south-eastern Australia a possum-skin belt held the same significance. The belts or girdles worn by men allowed small weapons and game to be carried around the waist, leaving the hands free. In central Australia hair-string belts are still symbolically presented to initiates; however their mundane functions have been superseded by purchased leather belts. Leather belts, in turn, with shiny decorative buckles, are part of the **country and western** paraphernalia worn by men whose former status as stockmen is an important aspect of their identity.

Adornments are often matters of personal choice based on individual aesthetic preferences, a whim, or a passing fashion. Piercing of the nasal septum for ritual adornment was once common throughout Australia; in the secular sphere it offered a site for individual decoration. Nose pins ranged in size and individuality from kangaroo fibulae 40 centimetres long, to small wooden pegs, kept in the septum as spare parts for a woomera. A popular ornament in central Australia at the start of the twentieth century consisted of the tibia or radius of a large bird, one end sealed off with resin, and a feather or bilby tail-tip inserted in the other. Spontaneous decorations for the septum included flowers and feathers; a paintbrush may similarly be used by older artists today.

In modern Australia, body adornment is frequently used to make important political statements. Red, black, and yellow which, together with white, have been the mainstay of the Aboriginal palette for millennia, were chosen as the colours for the Aboriginal **flag** in 1971. Adornments created in these colours, in the form of hatbands, headbands, necklaces, bracelets, pins, and tattoos are immediately recognisable by all Australians. Overcoming regional, geographic and cultural boundaries, such adornments have come to represent a national Aboriginal identity. ER

See also: 7.5, 10.4, 11.4, 17.1, 17.5; **shell necklaces.**

Isaacs, J., *Australia's Living Heritage: Arts of the Dreaming*, Sydney, 1984; Ride, E. (ed.), *Armlinks*, Darwin, 1998; Roth, W. E., 'North Queensland Ethnography, Bulletin no.15, Decoration, deformation, and clothing', *Records of the Australian Museum*, vol. 8, no. 1, 1910; Spencer, W. B., *Native Tribes of the Northern Territory of Australia*, London, 1914.

Boomalli Aboriginal Artists Co-operative was initiated by a group of urban Indigenous artists in 1987. Boomalli means

'to strike', or 'to make a mark' in the **languages** of at least three Aboriginal Nations—Bandjalang, Gamilaraay, and Wiradjuri. For over twelve years Boomalli has struggled to achieve status for Aboriginal people within mainstream society. Boomalli is controlled and managed by Aboriginal people. It exists to promote the teaching of the visual arts and to promote self-management and self-determination, to provide a gallery for the display of Aboriginal art, and support for Aboriginal artists, and to promote Aboriginal culture and independence through all visual art mediums. A number of important exhibitions which brought the founding artists together had taken place prior to the formation of Boomalli. The most important of these was 'Koori Art '84', held at Artspace, Sydney in 1984. Many of the early members of Boomalli participated in that exhibition, including Michael **Riley**, who has said that 'it was a milestone in gaining recognition for urban contemporary art'.

Since its inception, Boomalli has primarily provided artist members with a gallery space; however it offers other services as well, including administrative support, studio and art storage space, a slide archive, library resources, a retail outlet, and a publishing house for catalogues, and postcards and other ephemera. Since the establishment of Boomalli, its membership has grown and changed. It includes artists who are self-taught as well as those who are art-school trained. They work in a variety of media including painting, **printmaking**, photography, video, computer manipulated imagery, sculpture, drawing, fabric design, and mixed media. The range of media is ever-evolving, and Boomalli encourages members to take up new opportunities as they arise.

Since 1987 Boomalli has also provided services to the wider Aboriginal community, and to the broader community in general. The cooperative acts as an information and resource centre, and its extensive slide and publications archive is accessed by students, arts industry professionals and academic and commercial organisations throughout Australia.

Through its involvement in numerous exhibitions and projects over the past ten years, Boomalli has built an extensive network of artists. Collaborative projects between Boomalli artists and indigenous artists from overseas have placed Boomalli at the forefront of the creation and promotion of Indigenous art in Australia. Boomalli facilitates residencies locally, nationally and internationally. There are many important aspects to Boomalli today. It has gained international recognition, but more importantly Boomalli provides the first step for upcoming new artists, by showing and promoting their work. Key exhibitions have included 'True Colours' (1994–95), 'Blakness: Blak City Culture' (1994–95), and 'Flyblown' (1999). LS

See also: 12.1; Bronwyn **Bancroft**, Euphemia **Bostock**, Brenda L **Croft**. ·

Croft, B. L., 'Boomalli: From little things big things grow', in L. Taylor (ed.), *Painting the Land Story*, Canberra, 1999.

boomerangs. The origins of the boomerang—an Aboriginal invention—are well documented archaeologically, and in **rock art** thousands of years old. Boomerangs have great social and religious significance for Aboriginal people and feature in stories from the **Dreaming** which recount the journeys and exploits of ancestral heroes. Within Aboriginal culture the boomerang fulfils many different roles: as a hunting and fighting weapon, an object for exchange, a tool for cutting, digging, and fire-making, as a toy, in sporting competitions, and as a percussion instrument to accompany dancing and songs. While the basic generic form of the boomerang is instantly recognisable, the diversity of Aboriginal culture has resulted in distinctive regional differences. The light but strong returning boomerang—originally used for hunting wildfowl—is associated with the well-watered regions of south-eastern Australia and south-west Western Australia. Returning boomerangs are not associated today with Tasmania, Cape York (Qld), or the Kimberley coastal region (WA), but the documentation provided by rock art of the far north and Queensland suggests that it was known there in earlier times. By contrast, the heavy hooked boomerang used for hunting and killing game is found in all regions except Tasmania. Across the continent, regionally distinctive designs—expressive of individual and communal identity—imbue these finely crafted artefacts with power.

With colonisation the boomerang has assumed a wider range of meanings. Collectors greatly admired the aesthetic beauty, craftsmanship, and variety displayed in the wooden artefacts produced: institutions amassed vast collections and sent them overseas to international exhibitions. During the late nineteenth century, the boomerang came to assume a new importance, taking its place alongside the sprig of wattle, the kangaroo, and the swagman as a unique symbol of national identity for White Australia. Simultaneously, commercial interests appropriated the boomerang—as the emblem for Australian products to which the consumer would undoubtedly return. During the world wars (in which many Aboriginal soldiers served) the boomerang assumed even more profound meaning.

Through a long history of domestic tourism, Aboriginal people have contributed to the wider symbolic meanings generated by the boomerang. In the 1950s and 1960s, the **Timbery family** at **La Perouse** (NSW) and Yorta Yorta artist **Bill Onus** in Melbourne, gained renown for their boomerangs, regularly staging public displays. In keeping with the dynamic nature of Aboriginal society, designs and techniques changed in response to historical circumstances: shields and boomerangs produced by the Timbery family depict the arrival of Captain Cook, while Bill Onus encouraged the use of traditional forms. The distinctive boomerangs produced by the contemporary South Australian artist Bluey Roberts (1937–) draw upon his cultural heritage to depict ancestral figures and animals singed in black so they stand out in relief. He performs with the Ngarrindjeri-Narungga Dance Troupe and has exhibited in Japan, where he has given boomerang workshops.

In a brilliant riposte to colonial history, contemporary urban artists such as **Rea**, Richard **Bell**, and Fiona **Foley** reappropriate the boomerang, exploiting its association with kitsch and popular stereotypes of Aboriginality. In Rea's photographic triptych *for 100% Koori* from the *REA-PROBE Series*, 1998, boomerangs take flight through the repeated text in a bold assertion of identity. SK

See also: 11.1, 18.3; *228, 232, 276, 364, 377.*
Anderson, C. & Jones, P. *Boomerang*, Adelaide, 1992; Jones, P. *Boomerang: Behind an Australian Icon,* Adelaide, 1996.

BOOTJA BOOTJA NAPALTJARRI, Susie, see Mick **Gill Tjaka-marra**

BOPIRRI, Namiyal (*c.*1929–), L̲iyagalawumirr (Yolngu) painter and fibre artist, was born on the mainland near Yathalamarra in north central Arnhem Land (NT). She lived with her family on the island of Milingimbi until after World War II, when she married and moved to Galiwin'ku (**Elcho Island**) mission. In the 1960s following the death of her first husband she returned to Milingimbi and married Tony Djikululu, a bark painter who was highly regarded as a ritual singer and dancer.

At Ramingining in the early 1990s, Djikululu suffered a stroke that affected his painting arm, after which he would draw the compositional outline on a sheet of bark for Namiyal to finish the painting. With growing confidence Namiyal developed her own paintings in a free, expressionistic style, in contrast to the formal images favoured by her husband.

Namiyal's paintings are highly animated. Her subject matter is usually drawn from elements of the Wägilak sisters story: itchy caterpillars, bush foods, and snakes. Her country, Gurruwana on the Hutchinson Strait, is often painted as a minimalist design featuring sacred rocks and *wayanaka* (oyster beds).

Following a successful solo exhibition in Melbourne in 1991, Namiyal's paintings and painted hollow logs have been collected by major public institutions such as the NGA, the NGV, and the AGSA. They are also in private collections including the Kluge–Ruhe Collection at the University of Virginia. Her work has featured in major exhibitions such as 'Aboriginal Women's Exhibition' (AGNSW 1991), and 'Painters of the Wagilag Sisters Story' (NGA 1997). DJM

See also: 3.1, 6.1; **Bula'bula Arts.**
Caruana, W. & Lendon, N. (eds), *The Painters of the Wagilag Sisters Story 1937–1997*, Canberra, 1997.

BOSTOCK, Euphemia (1936–), Bandjalang–Munanjali sculptor, printmaker, textile artist, and activist, was born at Tweed Heads on the far north coast of New South Wales. She moved to Sydney as a young woman. In the 1970s, she and her brothers Gerald and Lester were founding members of the Aboriginal Black Theatre. She was present at the **Tent Embassy** in 1972, agitating for Indigenous rights. She was a founding member of **Boomalli Aboriginal Artists Co-operative** and she has been involved in the National Indigenous Arts Advocacy Association and the National Aboriginal Dance Council of Australia.

Bostock initially took up art as a hobby, attending classes at East Sydney Technical College, Sydney College of the Arts, and the Eora Centre, Redfern, where she taught for four years. As a sculptor, she has worked in soapstone, clay, and cement casting. Her textiles combine traditional and historical imagery, using silks and modern textile technology. She has exhibited extensively within Australia and overseas; a highlight of her career was an exhibition of her fashion garments with Minnie Heath and Bronwyn **Bancroft** at Printemps, Paris in 1987. More recently, she participated in 'Bamaradbanga (to make open)' (MoS 1999). She is represented in many Australian public collections including the NGA and NMA.

Euphemia Bostock epitomises all that is special about Aboriginal life—she the matriarch of an extended family, active in political life, working in many levels of artistic practice, and a mentor for her people. BB

See also: 12.1, 17.5.
Boomalli Aboriginal Artists Co-operative, *Boomalli Breaking Boundaries*, Sydney, 1989; Isaacs, J., *Aboriginality: Contemporary Aboriginal Paintings and Prints*, St Lucia, Qld, 1989; Sykes, R., *Murawina: Australian Women of High Achievement*, Sydney, 1994.

Boulia artists, see **Youngi.**

boxing can oppress and liberate. It produces violence and competition between individuals and groups, but also engenders personal growth and camaraderie among men. Boxing is a cultural artefact, if cultures are (following Clifford Geertz) the webs of meaning which people share about their world. Cultural ideas, particularly notions of class, race, and masculinity shape boxing. For centuries, labouring men and members of oppressed minorities have been drawn to this hard sport, which promised fame and money without the usual social prerequisites. Jews, Irishmen, West Indians, Black Americans, and Latins dominated boxing's world ranks over two centuries. Some forged this tough sport into a path to glory. Indigenous Australians, prominent in twentieth-century Australian boxing, experienced similar torments and triumphs from the sport.

Aboriginal involvement was first recorded at Sydney in 1833, but few boxed until the 1890s, when Thomas Palmer (Qld), fought as 'Midnight'. Aboriginal middleweights 'Black Paddy' (WA) and Jerry Jerome (Qld), were celebrated contemporaries. Jerome won the Australian middleweight title in 1912. A succession of Aboriginal titleholders, who emerged from the 1930s to the 1980s, won fifteen per cent of professional Australian titles: a remarkable achievement for just one per cent of the population. Most fought in eastern and southern Australia, although boxing emerged in the Northern Territory and Western Australia over time. A host of state titleholders, stadium fighters, and 'prelim' boys underpinned this Aboriginal sporting dominance. Beyond these, stretched ranks of Aboriginal fighting men and their Aboriginal challengers, who traded leather in the travelling boxing tents throughout the continent's settled areas.

Aboriginal communities were steeped in boxing. Reserves from Cherbourg (Qld) to Framlingham (Vic.), bred boxers who shaped up to sugar bags of sand slung from trees, their hands wrapped in rags. They fought in local tournaments and itinerant tent shows. Hosts of families boasted boxing siblings such as the six famous Sands (Ritchie) brothers from Newcastle (NSW), the five Landers brothers from Stradbroke Island (Qld), the Simpsons of Coonamble (NSW), and the Clay, Grogan, and Meredith brothers from Queensland. Others like Ron and Max Richards of Ipswich

(Qld) emulated their fighting fathers. Whole families, such as the Clarkes, Austins, and Cousens of the Warrnambool–Portland (Vic.) area, boxed as kin imitated kin. Some boxers became role models in a more general sense: George Bracken, the Australian lightweight title-holder in the mid 1950s boxed in emulation of former title-holder Jack Hassen. And in his boyhood, Lionel Rose travelled from Drouin to Melbourne to see Bracken fight at Festival Hall. Rose later became an Australian title-holder and world bantamweight champion (1968–69).

Boxing was at times oppressive for Aboriginal men. They entered a white world that was controlled by white managers, trainers, and boxing tent owners, who patronised them, as they did all the 'boys' they managed—black or white. But some managers were also racists. Sports writers were appreciative of Aboriginal talent, yet aired prevailing racial stereotypes: Aboriginal boxers, they opined, had quick eyes and reflexes, but lacked heart and dedication. The fight game was controlled by white match-makers and promoters such as John Wren of Stadiums Ltd. Top boxers had their substantial winnings eroded by their manager's twenty-five per cent and by their living, training, and travelling costs. The rest was spent on family or slipped through their fingers.

Boxing was also liberating. The world of gymnasiums, stadiums, and travelling boxing tents drew young Aboriginal men into new and exciting environments where they sometimes made equal wages. They mixed with white people and tasted the egalitarianism of sporting culture. Friendships formed and some Aboriginal boxers developed reputations across racial lines. Their managers praised their fighting abilities and they were photographed in the defiant and powerful pose of the boxer. Articles on them appeared in the press. Young Aboriginal boxers met fans, won girls, and went to parties—often across racial lines. Stars like Sands, Bracken, and Rose were cheered by whites fans and received fan mail from them. All these three formed enduring marriages with white Australian women.

Matches were often staged in terms of the drama of Black versus White. However, Aboriginal fighters encountered whites on equal terms in the ring and boxing tents, creating spaces where individual skills rather than racial discourses and structures dictated events. Aboriginal fighters often dominated those moments, and savoured them for years after. Boxing became a pathway to Aboriginal manhood and wisdom for many youths. They learned to be assertive, to confront the wider world of colonial Australia, and sometimes to win. Out of this experience came Aboriginal leaders. Many ex-boxers like Pastor Don Brady, 'Buster' Weir and Alf Clay (Qld), and Alf Bamblett, Bruce McGuinnea and 'Banjo' Clarke (Vic.), led community organisations. Sir Doug Nicholls, who enjoyed national stature, owed his prestige to boxing as well as football.

Boxing was deeply embedded in Aboriginal culture. Many Aboriginal boxers fought in a free, untrained, and open style which fans found attractive. At each country agricultural show, boxing tents were magnets for Aboriginal men and their families who barracked as they sought to gain a week's wages in nine minutes. The defeats and victories became the stuff of family stories, which enthused new generations of hopefuls. Aboriginal heroes were made in the ring and the names of Richards, Sands,

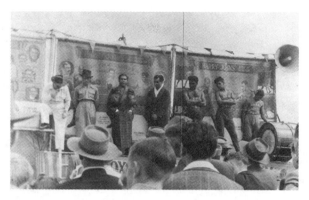

296. Harry Johns' boxing tent with Aboriginal boxers, Bombala Show, 1950s.

Hassen, Bracken, and Lionel Rose fell from awed lips. For communities with few heroes, boxing, from the Depression onwards, provided plenty.

The 1970s saw the rise to prominence of Tony Mundine, who is the only boxer in Australian history to have held national titles in four weight divisions. However in general the sport was collapsing in the face of other pastimes and with the demise of the ubiquitous travelling boxing tent, itself the victim of television and new restrictions. Some Aboriginal men still box, but the glory days are mostly conjured up in powerful memories. RIB

See also: **Australian Rules football**, **sport**, *296*.
Broome, R., 'Professional Aboriginal boxers in eastern Australia 1930–1979', *Aboriginal History*, vol. 4, no. 1, 1980; Broome, R., 'Theatres of power: Tent boxing circa 1930–1970', *Aboriginal History*, vol. 20, 1996; Broome, R. with Jackomos, A., *Sideshow Alley*, Sydney, 1998; Corris, P., *Lords of the Ring: A History of Prize-fighting in Australia*, Sydney, 1980.

BRITTEN, Jack Warnngayirriny 'Yalarrji' (*c*.1920–), Kija painter. Jack Britten's various names reflect the many layers of his life and involvement with country. His real Kija name—Warnngayirriny—relates to one of his **Dreamings**, the type of bush honey or 'ground sugar bag' found under rocks or at the base of trees. It describes the sound of swarming 'sugar-bag' bees moving over water: 'You can hear them for miles every hot time.' His Kartiya (European) name—Britten—was given by a white man called Ted Britten who adopted him when he was just a little boy to keep him safe at a time when many Aboriginal people were being killed. Ted Britten took him all over the place in a horse and buggy, delivering mail and stores around Fitzroy Crossing and Derby. His nick name 'Yalarrji' was given to him because after the death of Ted Britten he spent a number of years panning for gold and dingo trapping with his mother and sister in the undulating open *yalarre* (a Kija topographic term) country on Alice Downs.

Britten was born high in the hills to the north of Alice Downs at a place called Garndawarranginy, where his family had gone to hide from white people. Today he lives at Wurreranginy (Frog Hollow), his mother's birthplace, about 35 kilometres south of **Warmun** (Turkey Creek). Wurreranginy is

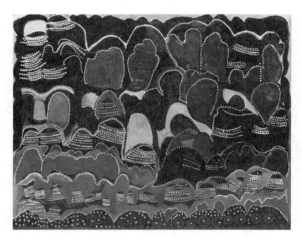

297. Jack Britten, *Purnululu (Bull Creek Country)*, 1988. Natural pigments and gum on canvas, 160 x 200 cm.

a small and beautiful outstation of which he is the chairman. He started painting on canvas in the mid 1980s and has been outstandingly successful with spectacular pictures of his country between Frog Hollow and Alice Downs, including Tickelara and Han Spring. His idiosyncratic style is characterised by lines of dark hills often decorated with traditional body designs in white. The paintings are a personal interpretation of a landscape characterised by numerous small round hills and large rocky boulders rising above meandering creek beds. Britten uses traditional **ochres**, sometimes with the addition of dark red bloodwood gum. He says that he paints '*ngarranggarnim thuwuthuwum kirli-ngarri wumperranype, ngarangarak-karri perrani ngarrangkarni perrempuwa* (all the things made by the travelling dreaming as it created the land)', and '*nhurr ngeniliyan ngayin* (the spirit urges me to do it)'. He is represented in all major collections in Australia and regularly appears in industry journal *Australian Art Collector* lists of the nation's fifty most collectable artists. FK

See also: 10.1, 10.2, 10.3; *297*.
Ross, H. (ed.) 'Impact stories of the East Kimberley', *East Kimberley Working Papers*, no. 28, CRES, ANU 1989; Ryan, J. with Akerman, K., *Images of Power: Aboriginal Art of the Kimberley*, Melbourne, 1993.

BROPHO, Robert (1930–), Nyungah writer and film-maker, writes: My mother gave birth to me on 9 February 1930 at a bag camp near the old Corringie wine saloon at Toodyay under stars on the Dreaming track of the Waugal the Rainbow Serpent. My mother was Isobel Bropho, born Layland. My father was Thomas Nyinda Bropho. I have lived along the Dreaming track, the Swan River, all my life.

I am a professor within my own right studying the living lifestyle of a fringe-dweller and the white man's government and lifestyle. I have seen the changes in and around and over our Sacred ancient land, and the trees and scrubs, now the Perth metropolitan area.

My main role is that I speak for my people, the Last of the River people living at Lockridge Campsite on our home-grounds. I am a Nyungah elder not an activist. I speak on behalf of the Aboriginal teenagers in Children's Courts and on behalf of our rights to our land.

I have had a lifetime of trying to bridge the gaps between Black and White. I am a book writer, *Fringedweller* (1980), a documentary film-maker, *Munda Nyuringu* (1984); *In the Name of the Crow* (1988) and *Always Was Always Will Be* (1989).

I am a time traveller across the breadth and length of Australia. I have crossed the Grandmother of all rivers and creeks, which is the sea, on Indigenous issues to meet with Indigenous Spiritual Elders of the World in Aotearoa New Zealand, and to reclaim Yagan's Head in England.

I am part of many happenings that occurred in the past along the laneways of yesterday with the experience and knowledge of encountering and talking to people from all walks of life to now.

That is some of my lifestyle that is written down here. I am who I am and I cannot change being that. RCB

See also: 2.5, 11.8, 13.1, 19.2; *149*.

BROUN, Jody (1963–), Yindjibarndi visual artist. The art of Jody Broun is best described as both vivacious and political, in a climate of increasing focus on urban Aboriginal art: 'My paintings celebrate Aboriginal culture and survival. People have adapted but maintain important strengths in family, community and culture and a pride in being Aboriginal.'

Born in Perth, Broun was heavily influenced by a family life which instilled a strong sense of pride. Unlike her mother—who did not see her family until she was an adult because she was taken away and brought up in an orphanage—Broun developed a close affinity with her Aboriginal relatives and her native Pilbara country. Regular visits to the area as a child instilled a love of country which is evident in her rich and powerful portrayal of the region. She paints powerful images of Aboriginal people coming to terms with changes in lifestyle and culture, and of their interrelationships with each other and the land.

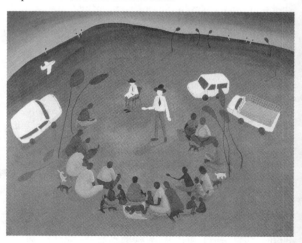

298. Jody Broun, *White Fellas Come to Talk 'bout Land*, 1998. Acrylic on canvas, 153 x 187 cm.

During the first ten years of her painting career, Broun exhibited in Perth; since 1997 she has also exhibited in London, Singapore, Milan, and Sydney. In 1998 she won the NATSIAA award for her work *White Fellas Come to Talk 'bout Land*, 1998. She was awarded an MPhil by UWA in 1992 for a study focusing on Aboriginal culture, and has been Executive Director of Aboriginal Housing Infrastructure with the Western Australian State Housing Commission since 1994.

<div align="right">DAM</div>

See also: 12.1; **art awards and prizes, stolen generations**; *298*.
Museum and Art Gallery of the Northern Territory, *Telstra Presents the 15th National Aboriginal and Torres Strait Islander Art Award*, Darwin, 1998.

BROWN, Jonathan Kumintjara (1960–1997), Pitjantjatjara painter and potter. Brown's greatest achievement was his *Ode to Maralinga Nullius* series (1994–95) of 'poison country' paintings about the devastation of his country, people, and culture that resulted from British nuclear testing at Maralinga (SA) in the 1950s. Despite images like *Sandridges—Ooldea*, a shimmer of undulating white lines on a red ochre ground exemplifying his belief that 'there is beauty as well as the other side of it. There is life', these large paintings include some of the most desolate images ever made in Australia.

Born in Yalata (SA), Brown was taken away from his parents as a baby. He grew up happily with foster parents Basil and Olive Brown and siblings, including an Aboriginal 'brother', in Adelaide, Melbourne and Scone (NSW), receiving a good education and attending Sydney Technical College. After six years working at Taronga Park Zoo, he returned to Adelaide to pursue Aboriginal Studies (including art) at Underdale College, and was reunited with his natural family. He discovered his true country—Oak Valley, Ooldea, and Maralinga—and was taught by uncles and brothers to paint his ancestral **Dreaming**.

He mostly exhibited in Melbourne, and his final exhibition 'Ooldea (Grandfather's Country)' at Flinders Lane

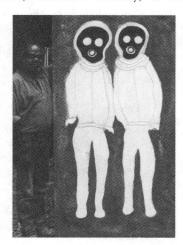

299. Jonathan Kumintjara Brown with his painting, *Frogmen at Maralinga*, 1994.
Natural pigment and acrylic on canvas, 180 x 90 cm.

Gallery in 1997 included pottery made from river-bed pipeclay, charcoal, and sand. In 1990 a large acrylic painting of his own *Milky Way Dreaming at Yalata* (1989) was included in 'Balance 1990' (QAG 1990). A second exhibit, *Cat on Nissan Dreaming* (1989–90), had a Nissan four-wheel drive car as its ground and was painted with his friend, **Lin Onus**.

In 1996 Brown was the star of the touring exhibition 'Native Titled Now' (Tandanya 1996). His *Maralinga Nullius* paintings, also recorded on a video *Heart of the Country—Maralinga* by the Indigenous curator Doreen Mellor, overwhelmed the contributions of the other forty invited artists. Jonathan Kumintjara Brown died prematurely in Melbourne on 11 September 1997, aged thirty-seven.

<div align="right">JAK</div>

See also: 20.5, 22.4; **stolen generations**; *299*.
Chryssides, H., 'Full Circle', *The Bulletin*, 7 May 1996; Mellor, D., *Native Titled Now*, Adelaide, 1996.

Buku-Larrnggay Mulka (Yirrkala Art Centre). The Revd Wilbur Chaseling founded Yirrkala as a Methodist mission in 1935, as part of the process of bringing the Yolngu region of north-east Arnhem Land under government control. In 1933 the Japanese crew of a boat had been killed at Caledon Bay, and later that year a policeman—Constable McColl—had been speared to death on Woodah Island. The government encouraged missionary activity to help create peaceful relations, and sent the anthropologist Donald Thomson to the region to investigate the conditions and concerns of the Aboriginal people.

Bark paintings and other material culture objects were produced for sale from the beginning of intensive European contact. Thomson made collections as part of his research and Chaseling encouraged the making of arts and craft for sale, using stick tobacco as currency. Beginning in 1936, Chaseling sent collections to museums in Melbourne, Sydney, and Brisbane. While some of the paintings he collected are 'traditional' clan paintings, many were invented for sale. The artists referred to these as 'anyhow' paintings since that was how Chaseling asked them to paint. The paintings Thomson collected reflected the regional religious and social organisation of the area. The subsequent history of the commercial production of art has involved a dialogue between cultural and economic interests: art has been used to communicate the values of Yolngu culture to outsiders, and simultaneously to earn money.

The sale of art received a boost during World War II through the military personnel stationed at Gove, whose presence stimulated the production of small carvings. In 1946 anthropologists Ronald and Catherine Berndt spent a year at Yirrkala and made large collections, and in 1948 the American–Australian Scientific Expedition to Arnhem Land under C. P. Mountford visited and collected there. These collections helped widen interest in Yolngu art and many works ended up in national institutions. Artists who painted for the Berndts included Mawalan, Mathaman and Wandjuk **Marika**, Munggurrawuy and Bununggu **Yunupingu**, Narritjin and Nänyin **Maymuru**, Wonggu and Mäw **Munung-gurr**, and many others who subsequently gained renown.

During the 1950s the marketing of art at Yirrkala was mainly the responsibility of Doug Tuffin. As Nancy Williams writes: 'the mission had assumed the function of art dealer.' Tuffin was in charge of marketing art from 1954 until his retirement in 1963. By the end of this period several significant developments had occurred. The technique of producing soft-wood carvings with finely incised surface hatching was invented and the size of bark paintings began to increase. Dr Stuart Scougall, a surgeon and patron of AGNSW visited Yirrkala first in 1959. He was accompanied by AGNSW curator Tony Tuckson. The collections they made for AGNSW included a number of very large barks representing connected sequences of mythic action associated with the artists' countries. Scougall also organised an exhibition of bark paintings for the opening of Qantas House in New York in March 1963. The payment of £1200 from this exhibition doubled the annual return for Yirrkala art. Scougall's secretary, Dorothy Bennett, subsequently moved to Darwin and became a dealer and promoter of Aboriginal art.

The Reverend Edgar Wells was superintendent of Yirrkala from 1962 to 1963, having previously spent ten years at Milingimbi. During his time two significant art works were produced: the Yirrkala Church Panels (1962) and the Bark Petition (1963). In 1962 the Melbourne-based businessman Jim Davidson made the first of his annual visits to Yirrkala. He established a continuing relationship with several of the artists and sold many works to the leading American collectors of the time, Ed Ruhe and Louis Allen. The Swiss ethnologist Karel Kupka also visited Yirrkala during Wells's time and his collections made a significant impact in Europe.

The marketing of art remained the responsibility of the mission until 1977. The income from art steadily increased, rising to over $100 000 in 1974. The homelands movement boosted production and the atmosphere created by the Whitlam government increased public interest in Aboriginal art. The mid 1970s saw the appointment of the first designated arts adviser, and Buku-Larrnggay Arts was incorporated in 1975. In 1988 a second art centre, Nambara Arts, was developed by Yirrkala Business Enterprises.

The arts adviser was Michael O'Ferrall, who subsequently became curator of Aboriginal Art at AGWA. He was followed by Steve Fox who worked tirelessly to promote Yirrkala art in two periods in the 1970s and 1980s. During his time, a new art centre was built; it included a museum to house the community's collection which was opened by Gough Whitlam in 1988. The 'chapel' to house the Church Panels was finally completed after Andrew Blake had taken over as arts adviser, and was opened in 1998 by Prime Minister John Howard. Blake has overseen a further expansion of Buku-Larrnggay Mulka's business, reaching a turnover of $A672 100 in 1997/8. With Will Stubbs, Blake has facilitated a series of well curated projects: two major collections of big barks representing the different clans of the region were commissioned by the NGV and the Kluge–Ruhe Collection of the University of Virginia, and in 1998 the *Saltwater* series was produced. Art production diversified with the development of a successful print venture involving mainly women artists, under the direction of Diane Blake and Marrnyula Munung-gurr, and facilitated by the printmaker Basil Hall of NTU. The centre has continued to collaborate with commercial galleries such as the Annandale Gallery in Sydney and the William Mora Gallery in Melbourne to put on exhibitions of the work of individual artists such as Gawirri<u>n</u> **Gumana**, Galuma Maymuru and Djambawa **Marawili**. The *Saltwater* series set a new direction for art centres, with a touring exhibition accompanied by a major catalogue. The paintings centred on the mythology and ownership of the coastal waters: Yolngu artists continue to combine commerce with the education of outsiders about their values and way of life. HM

See also: 3.1, 4.6, 21.2, 21.3; **art and craft centres, keeping places, printmaking.**

Buku-Larrnggay Mulka, *Saltwater: Yirrkala Bark Paintings of Sea Country*, Neutral Bay, NSW, 1999; Wells, A. E., *This Their Dreaming: Legends of the Panels of Aboriginal Art in the Yirrkala Church*, St Lucia, Qld, 1971; Williams, N., 'Australian Aboriginal Art at Yirrkala: Introduction and Development of Marketing', in N. H. H. Graburn (ed.), *Ethnic and Tourist Arts: Cultural Expressions from the Fourth World*, Berkeley, CA, 1976.

BUKULATJPI, George Liwukang, see **Elcho Island.**

Bula'bula Arts, is an Aboriginal artists' co-operative based at Ramingining township in north-central Arnhem Land (NT). It provides services to about 200 artist members who live in an area of about 500 square kilometres between Cape Stewart to the west and the Woollen River in the east.

A Methodist mission established on Milingimbi Island in the mid 1920s channelled all art and craft from the region to the outside world until the 1960s, when Ramingining, on the mainland, became the major town in the region. In 1977 the Australia Council funded the position of an arts and craft adviser for the newly formed Ramingining Arts Co-operative, under the umbrella of the town council.

In 1984, Ramingining Arts staged 'Objects and Representations from Ramingining' at the Power Gallery of Contemporary Art (University of Sydney). Many other exhibitions followed. The co-operative organised member artists to appear at the 1979, 1986, and 1988 Biennales of Sydney; the last of these featured the *Aboriginal Memorial*, 1987–88. In the 1990s Ramingining Arts undertook a major commission (now in the Kluge–Ruhe Collection at the University of Virginia) for the American collector John Kluge.

A period of acclaim for Ramingining artists followed, and in 1992 a meeting of artists formed a body independent of the town council, called Bula'bula Arts. The name was suggested by singer and painter Jimmy Djelminy: *bula'bula* is an old word referring to the tongue of the kangaroo ancestor who moved through the land and across to Milingimbi, and who appears in all Yirritja moiety song cycles. Thus, it is connected to all the groups of the area. DjM

See also: 6.2, 6.3, 17.1.

Morphy, H. & Mundine, D., 'Art co-ordinator: No ordinary job', in B. Lüthi (ed.) *A<u>r</u>atjara: Art of the First Australians*, Cologne, 1993; Mundine, D., 'The land is full of signs: Central north east Arnhem Land art', in H. Morphy & M. Smith Boles (eds), *Art from the Land: Dialogues with the Kluge–Ruhe Collection of Australian Aboriginal Art*, Charlottesville, VA, 1999; Musée Olympique Lausanne, *The*

Memorial: A Masterpiece of Aboriginal Art, Lausanne, 1999; Museum of Contemporary Art, *The Native Born: Objects and Representations from Ramingining, Arnhem Land*, Sydney, 2000.

BULL, Ronald (1943–1979), Gurnai painter, is a significant figure in the cultural heritage of south-eastern Australia, both as an important historical parallel to Albert **Namatjira** and as a pivotal influence on the young Melbourne artist **Lin Onus**. Born at Lake Tyers Aboriginal Station in Gippsland (Vic.) in 1943, Ronald Bull was removed from his family twice—first as an infant and again at the age of ten, when he entered the Tally Ho Boys Home, Burwood (Vic.) before being placed into foster care at the age of fifteen. He studied informally with Ernest Buckmaster and Hans Heysen, and drew inspiration from the landscapes of Constable, Turner and Streeton, whose work he saw at the NGV and in reproduction. During his lifetime, Ronald Bull gained considerable recognition. Like Dick **Roughsey** (Goobalathaldin), Bull was hailed as 'the new Namatjira'. His single most important surviving work is a mural painted in 1962 in Pentridge prison (now decommissioned), Melbourne, depicting a traditional camp scene.

Bull exhibited with leading Australian artists including Keith Namatjira in 1996–67 and Lin Onus in 1976. His work is represented in the Koorie Heritage Trust, Melbourne.
SK

See also: 11.1, 12.1; **prison art, stolen generations**; *142.*
Kleinert, S., '"Blood from a stone": Ronald Bull's mural in Pentridge Prison', *Australian Journal of Art*, vol. 14, no. 2, 1999; Kleinert, S. 'Aboriginal landscapes', in G. Levitus (ed.), *Lying about the Landscape*, Sydney, 1997.

BULUNBULUN, Johnny (1946–), Ganalbingu (Yolngu) painter and printmaker. In discussing his painting, Bulunbulun always makes reference to the importance of the culture and Law that underpin his work. This deep commitment to Ganalbingu Law is evident in the many roles he plays—ceremonial leader, songman, advocate for Aboriginal arts and **copyright**, and leading bark painter. He grew up at Milingimbi (NT) and at Bulman in southern Arnhem Land. He began to paint at Maningrida around 1970, where for a time he was also an arts adviser.

In 1979, Bulunbulun and his wife went to live with her family at Gamardi, together with the artist Djiwul 'Jack' **Wunuwun** and his family, they established an outstation. The two artists painted together for several years. During this time Bulunbulun was awarded two Professional Development grants, and a six-month Fellowship, from the Aboriginal Arts Board, and was on the Advisory Committee for the Arts at the Australian Institute of Aboriginal Studies (now **AIATSIS**).

Bulunbulun and David Milaybuma produced the first limited-edition prints by Aboriginal artists to be widely marketed, and, in 1983 he and England **Banggala** produced the first lithographs by Aboriginal artists, at the Canberra School of Art (ANU). In 1989 Bulunbulun successfully brought an action in the Federal Court against R & T Textiles regarding the unauthorised reproduction of one of his paintings on T-shirts. This case was a landmark in establishing the protection of the work of Aboriginal artists in Australian law.

In 1991 Bulunbulun was awarded a Professional Fellowship from the Australia Council. His work is represented in numerous national and international collections, and has appeared in many group exhibitions, including 'Keepers of the Secrets' (AGWA 1989), 'The Continuing Tradition' (NGA 1989), 'Balance 1990' (QAG 1990), 'Crossroads' (Kyoto and Tokyo 1993), and 'Aratjara' (Düsseldorf, London, and Humlebaek 1993–94).
MEJ

See also: 6.4, 22.1. 22.2; copyright, **Maningrida Arts and Culture**; *78, 263.*
Johnson, V., 'The case of the Flash T-shirts', in V. Johnson, *Copyrites: Aboriginal Art in the Age of Reproductive Technologies*, Sydney, 1996; Magin, P., 'John Bulunbulun: "I water my trees and I paint" ', in Annandale Galleries, *Mawurndjul and Bulunbulun*, Sydney, 1997; Queensland Art Gallery, *Balance 1990: Views, Visions, Influences*, Brisbane, 1990; Reser, J., '*Djakaldjirrparr*: Explanation of a mural painted by Johnny Bulun Bulun as told to Joseph Reser', *Australian Institute of Aboriginal Studies Newsletter*, no. 8, 1977.

BUNDUCK, Nym, see Nym **Bandak**.

BUNGAREE (?–1830), a Ku-ring-gai man, was a familiar figure in early Sydney town, wearing a series of cast-off military full-dress uniforms and a cocked hat. He is described in early texts as 'officially' welcoming every ship that visited Sydney Cove, and demanding a coin or two from the captain as tribute. The visitors laughed at what they took to be his delusions of grandeur, but treated him with mock courtesy and gave him the money and 'grog' he asked for. He was also a renowned mimic: 'The action, the voice, the bearing of *any* man, he could personate with astonishing minuteness.' Yet Bungaree is neither the figure of fun that his white contemporaries thought him to be, nor the passive victim that recent historians would have him be. His assumed role of pantomime king was a strategic one, allowing him to negotiate his position within the colonial situation, even while his behaviour subverted the pomposity of white authority.

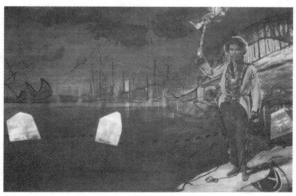

300. Clinton Nain, *Dream Run*, 1997.
Bubble-jet print, 38 x 58 cm.
Clinton Nain's contemporary portrait links past and present to reclaim recognition for the historical figure of Bungaree.

Bungaree stands as a highly visible example of how all colonised people must continually 'perform' for survival in their day-to-day life.

Bungaree's intelligence and reliability were remarked upon by Matthew Flinders, whom he accompanied in the *Norfolk* in 1799 and in the *Investigator* in 1802–03. During these voyages around the Australian continent he acted, with skill and discretion, as Flinders's mediator with Aboriginal people who were seeing Europeans for the first time. In 1815 Governor Macquarie granted Bungaree land at George's Head on the north shore of Sydney Harbour, in a misguided attempt to transform his family into settler–farmers. They were given houses, tools, orchards and gardens. Bungaree himself was given a breastplate proclaiming him as 'Bungaree: Chief of the Broken Bay Tribe'. More indicative of Bungaree's status than this meaningless honour, however, was Macquarie's assignment of white convicts to him—an arrangement of statuses that was publicly acknowledged at the time but that was inverted in many later texts, where the convicts became 'instructors'.

Such attempts to diminish Bungaree's significance and to write him out of the white history of early Sydney (as has happened with other Aboriginal notables) have not succeeded, because of his prominence in the records. He appeared in many published accounts of the settlement at Sydney (the earliest being David Collins's *Account of the English Colony in New South Wales*, 1798), and even as the subject of an article in Charles Dickens's *All the Year Round*. He was certainly the most commonly represented Aborigine in colonial imagery—if not the most commonly represented individual of all. Augustus Earle's circular panorama of Sydney town, exhibited in 1829 at Burford's in London, included only three identified figures: the governor, his *aide-de-camp*, and Bungaree. Seventeen portraits of Bungaree are known to survive. The best known is Earle's oil portrait of Bungaree in his signature uniform—a white heroic portrait often quoted by contemporary Aboriginal artists to allude to all Aboriginal heroes of the colonial past.

AC

See also: *300*.

Healy, J., *Literature and the Aborigine in Australia*, St Lucia, Qld, 1989; Lawrenson, A., From Tourist Attraction to Cultural Icon, BA (Hons) thesis, University of Western Sydney, 1999.

BURNUM BURNUM (Harry Penrith) (1936–1997), Woiworung–Yorta Yorta activist, writer, storyteller, and actor. A member of the **stolen generations**, Burnum Burnum used his personal experiences and remarkable abilities in the service of white and black alike. Born at Wallaga Lake (NSW), he was removed from his family as an infant. After spending his early childhood at the United Aboriginal mission home at Bomaderry, he was sent to the Kinchela Home near Kempsey. A great achiever, he played **rugby** for New South Wales, studied law at the University of Tasmania in the late 1960s, won a Churchill Scholarship in 1975, ran for the Senate, and worked as a manager of Aboriginal Hostels. He changed his name to Burnum Burnum in 1976 to honour his great-grandfather, the artist Tommy **McRae**, and as part of the search for his **Aboriginality**. He became involved in social and environmental issues: in one campaign in which he was involved **Trukanini**'s remains, on show in Hobart as 'the last Tasmanian', were cremated and scattered at sea in 1976. His most celebrated action was during the Bicentenary in 1988 when, in a symbolic invasion of England, he 'landed' at Dover and erected the Aboriginal **flag**—only to offer the British a negotiated peace. Burnum Burnum appeared in several films, and gained renown for his lectures and storytelling. In 1988 he wrote *Burnum Burnum's Aboriginal Australia: A Traveller's Guide*.

PR

Norst, M. J., *A Warrior for Peace: Burnum Burnum*, East Roseville, NSW, 1999; Read, P., 'Agent of change, from the outside', *The Australian*, 20 August 1997.

BURRUWAL, Bob (1952–), Rembarrnga sculptor, painter, and weaver, is an accomplished bark painter, but in recent years he has concentrated on making sculptures in fibre and wood. He is married to fibre artist Lena **Yarinkura**; together they work with a unique combination of innovative and traditional techniques and ideas.

Burruwal is particularly well known for his ceremonial dancing belts made from bark fibre adorned with **ochre**, feathers and beeswax, as well as armbands made from bark-fibre string and feathers. He also carves spirit figures, particularly the *wurlga* and *wurum* which he describes as dual manifestations of his **Dreaming**. These spirits reside at Bolkdjam where Burruwal lives, and are responsible for the regeneration of the abundant fish supply there. They are invoked ceremonially to ensure that the supply increases. These sculptures are painted and finished with pandanus-fibre hair, and various accessories—dillybags, dancing belts, grass skirts, and armbands. Some of these objects are evocative of spiritual power and ceremonial significance; others are everyday objects, such as dillybags for hunting.

Burruwal's work has appeared in a number of group exhibitions including 'Aboriginal Art at the Top' (MAGNT 1982), 'Maningrida: The Language of Weaving' (AETA 1995), and 'Armlinks' (DVAA 1998).

MEJ

See also: *17.1, 17.3*; **body adornment, Maningrida Arts and Culture.**

Australian Exhibitions Touring Agency, *Maningrida: The Language of Weaving*, South Melbourne, 1995; Garde, M. & Burruwal, B., 'The armband in Arnhem Land: An interview with Bob Burruwal', in E. Ride (ed.), *Armlinks: An Illustrated Exploration of Aboriginal and Non-Aboriginal Use of Arm Adornments*, Darwin, 1998.

C

Cairns College of TAFE, see Far North Queensland Institute of TAFE.

CAMPBELL, Robert Jr, (1944–1993), Ngaku painter and print-maker, was born at Kempsey in northern New South Wales. He first learnt to draw while still at primary school, by producing images of birds and animals in pencil on his father's carved **boomerangs**. His father would then trace over the young Robert's design with a red-hot wire, to burn it into the wood. As an adult, while toiling at various labouring jobs in Sydney and in seasonal work around Kempsey, Campbell continued to paint for tourists and local art shows, using whatever discarded materials he could lay his hands on.

Despite having neither traditional Aboriginal tutoring nor Western art-school training, he worked confidently to invent his own idiosyncratic visual devices and painting style, such as the 'x-ray' view of the oesophagus of his figures. In this respect he differed from the artists of the more urbanised Aboriginal art movements of the late 1970s, which were centred around a population of young Indigenous art students in Sydney. Rather, his patternings resemble designs on the insides of the traditional possum-skin cloaks of south-eastern Australia.

Campbell's subject matter ranged from the brutal history of racism and colonialism in Australia to the mundane existence that constituted life in postwar rural New South Wales. Bright and cartoon-like, his episodic snapshots of contemporary events merge his Aboriginal world-view with that of the wider Australian society (from which he was mostly excluded) in an often humorous but always insightful way. He is remembered for his wit and for his celebration of Aboriginal political events, which he saw as points of historical convergence with the outside 'white' Australian world.

Campbell had a number of solo exhibitions in private galleries, and his work has been included in numerous group exhibitions, significant among them being 'A Koori Perspective' (Artspace 1989), 'The Continuing Tradition' (NGA 1989), 'L'été Australien' (Montpellier 1990), 'Tagari Lia: My Family' (Glasgow, Swansea, and Manchester 1990), and 'Tyerabarrbowaryaou: I Shall Never Become a White Man' (MCA 1992). Examples of his work are held in the NGA and MCA, and in most Australian State galleries.

He has a following in his community: in 1995 the local Kempsey school held a pageant titled 'Living the Dreaming' that featured large Robert Campbell, Jr puppets in celebration of his work. DjM

See also: 12.1, 18.1; **Boomalli Aboriginal Artists Co-operative**; 49.
Isaacs, J., 'Robert Campbell Jnr', in *Aboriginality: Contemporary Aboriginal Paintings and Prints*, St Lucia, Qld, 1992; Mundine, D. and Foley, F., *Tyerabarrbowaryaou: I Shall Never Become a White Man*, Sydney, 1992.

Campfire Group. 'You and me: one campfire … Michael you tell your own story because that is all we do.' It was the philosophy behind these words, spoken by a senior Maningrida artist in 1986, that led to the formation of Campfire Consultancy in 1990 by Michael Eather and Marshall Bell. In 1992, they were joined by Richard **Bell**, Laurie Nilsen and Joanne Currie, and changed their name to the Campfire Group. The sharing of stories around one campfire symbolises welcome and mutual respect to Indigenous Australians, and that is the guiding idea behind this Brisbane-based collective. The Campfire Group has expanded to become a group of between twenty-five and thirty artists—mostly Indigenous Queenslanders—that tells its own stories of collaboration, exchange, journeys, and intersecting histories. In 1987, the emerging group was involved in the development of the landmark exhibition 'Balance 1990' (QAG 1990).

As art critic George Petelin observed, by exploring shared influences between black and white artists, and between urban-based and remote community artists, the group 'brought together values, traditions and people that had previously been separated'. Campfire's desire to provide exhibition space with studio and training opportunities for emerging artists, resulted in the creation of the Queensland Indigenous Artists Aboriginal Corporation (QIAAC). This in turn stimulated the establishment of Australia's first degree course in contemporary Indigenous art at the Queensland College of Art in 1995, coordinated by Campfire member and artist, Jennifer Herd.

The Campfire Group initiated cultural exchanges in Norway and Finland in 1993. Marshall Bell and Laurie Nilsen worked alongside indigenous Sami artists and exhibited at the Kerava and Rovaniemi Museums, for which they produced the *Finland Ground Painting* in the snow as a gesture of respect to their hosts. In the same year 'Stories from

301. Campfire Group, *Fish 'n' Chips*, 1998.
Mixed media: crumbed artefacts, bain-marie, type-c photograph, ochre, Pauline's canned products, newsprint, and postcards.

the Inner Circle' was shown in Amsterdam, and in 1994 exchanges took place at Santa Fe in New Mexico. In 1997 the 'Interference' exhibition was shown as part of the Edinburgh 'Fotofeis'.

Within Australia, the Campfire Group has participated in the 1992 Biennale of Sydney and the Second Asia–Pacific Triennial (QAG 1996). In commenting on the commodification of culture through the radical performance installation *All Stock Must Go!* with artists selling art from the back of a cattletruck, or on the white supremacist policies of Pauline Hanson through the satirical installation *Fish 'n' Chips*, 1998, where crumbed artefacts and canned ideologies are sold, their work exhibits a distinctive brand of Indigenous humour. MN

See also: 8.2, 12.1; *227, 248, 301*.
Petelin, G., *Campfire Group Australia*, Brisbane, 1997; Neale, M., 'Cultural brokerage in the Aboriginal stockmarket: Installation art as social metaphor', in C. Turner & R. Davenport (eds), *Present Encounters: Papers from the Conference—The Second Asia–Pacific Triennial of Contemporary Art*, Brisbane, 1997.

CARLTON, Paddy Gwambany Joolama (*c.*1926–) Gajerrong painter and printmaker, was born in the 1920s at Legune station (NT). He is a senior elder or 'Law man' in his community who remembers being taught rock and body painting techniques by his elders and participating in painting at cave sites around Legune and Bullo River Stations. With such an artistic apprenticeship it is not surprising to discover that the style and iconography of his work is closely linked to the **rock art** traditions of the East Kimberley, as well as to the painted men's ritual body designs of both the Gajerrong and Miriwung people.

Carlton represents ancestral beings figuratively, either sculpturally or on canvas, and often fills the remainder of the surface with large white dots. Sometimes this painted decora-

302. Paddy Carlton, *Ganjinganang*, 1992.
Natural pigments and binder on wood, 116 x 42 cm.

tion is supplemented by the application of 'sprayed' pigments: 'I finish off by putting in my mouth white ochre mixed with gum and water and then I spray it over my hand like I used to do a long time ago on the cave.' By continuing to use traditional techniques, but adapting them to articulate his own vision, he uses his knowledge to keep the culture of his father and grandfathers alive.

He has been exhibiting his work since 1990, and is represented in the collections of the NGA, NGV, and QAG. He has also participated in many group exhibitions, significant among which are 'Balance 1990' (QAG 1990), 'Images of Power' (NGV 1993) and 'Power of the Land' (NGV 1994) In recent times he has also become an active printmaker.

 CD

See also: 10.2; **printmaking, rock-art repainting, Waringarri Aboriginal Arts;** *302*.
Ryan, J., 'Bones of Country: The East Kimberley Aesthetic', in J. Ryan with K. Akerman, *Images of Power: Aboriginal Art of the Kimberley*, Melbourne, 1993.

CARMODY, Kevin (Kev) (1946–), singer, songwriter, and musician, is one of the outstanding contemporary Aboriginal voices in Australia. His hard-hitting lyrics take their inspiration from a truly oral tradition. His influences stem from his parents' Irish and Aboriginal origins, and the stories and songs told and taught to him by his Murri maternal grandparents and extended family. His first album, *Pillars of Society* (1989)—considered by some music critics to be one of the best albums ever released by an Australian musician—

helped to establish him as one of the most respected singer–songwriters in Australia.

Carmody was born in Cairns, moving at the age of four to live on a cattle station seventy kilometres west of Dalby in the Darling Downs area of south-eastern Queensland. His father was Irish and his mother was a Lama Lama woman from the Cape York area. Carmody left school at fifteen to work as a labourer in the wool industry. During his twenties he learned to play the guitar at the Music Centre of the Darling Downs Institute of Advanced Education. He returned to his studies at the University of South Queensland when he was thirty-three years old, progressing to a PhD on the history of the Darling Downs in the period 1830–60. It was while he was at university that music became the focus of his life and his career and, while he does not consider himself to be 'a musician' in the way most popular musicians see themselves, he has become an influential member of the Aboriginal community. He tours Australian prisons and plays to Aboriginal inmates, and he has also worked with street children as part of a community education program, using music and the arts as a means of developing their self-esteem and creativity.

His second album *Eulogy (for a Black person)* was released in 1991, again to critical acclaim. It was nominated for an ARIA award, as was his third album *Bloodlines* (1993). In 1995 he released *Images and Illusions*. He has performed around the world, touring in Europe and North America. While Carmody would reject the idea that he is a spokesperson for Aboriginal rights, asserting that he writes and performs only on his own account, he has become one of Aboriginal Australia's most visible ambassadors. The blunt yet eloquent message he brings has universal resonances which reach and touch audiences around the world.

BE

See also: 15.2; **prison art**.

CARROLL, Alison (Milyika) (1958–), Pitjantjatjara **batik** artist and printmaker, says of her work as an artist: 'I like working in the craft room doing batik. I draw all kinds of beautiful designs and sometimes I like to paint. It's a good way to work.' Alison Carroll is a qualified health worker as well as being a talented artist. She specialises in batik and increasingly in the medium of **printmaking** (both etching and lithography) which she has developed through attending workshops in Darwin, Alice Springs and Adelaide. Together with Nyukana **Baker** and Nyuwara **Tapaya**, she has also been a major factor in **Ernabella**'s recent successes in ceramics. Her intricate circular, yet fluid, designs adapt well to the form of terracotta plates, and these were enormously popular at the 1998 Ernabella Arts ceramic exhibition at Adelaide's Jam Factory Craft Centre.

Carroll is renowned for the intricacy and vitality of her designs, which move easily between textiles, ceramics and printmaking. Her work has been exhibited in Jakarta and Beijing, and extensively throughout Australia. In 1999 her batik work was shown throughout Australia and in Japan. She is represented in the NGA, PM, and most State gallery collections. With other younger artists, she represents the future of Ernabella Arts.

LP

Eickelkamp, U. (ed.), *'Don't ask for stories': The women of Ernabella and their Art*, Canberra, 1999; Art Gallery of South Australia, *Objects from the Dreaming: Aboriginal Decorated and Woven Objects*, Adelaide, 1996.

CARTER, Thelma, (née Pearce) (1910–1995), Gurnai fibre artist. An ancient Aboriginal basketry tradition continues in east Gippsland thanks almost entirely to the skills, enthusiasm and foresight of Thelma Carter. Recalling her funeral, her daughter, Elvie Bull, said: 'The day we said goodbye to mum we thought it appropriate that the grave should be covered with red and green basket grass. One of the baskets she had made was carried by family members filled with rose petals to sprinkle on the casket.'

'Family' and 'basket grass' are words that will always be associated with Thelma Carter, who spent most of her life in east Gippsland. Her family was always her central concern, but her basketry skills became widely known as a result of the 1979 film *The making of an Aboriginal Coiled Basket*, in which she demonstrated the traditional coiling technique used in Victoria, discussed her plant sources, and was shown collecting the 'grasses' (*Lomandra longifolia* and *Lepidosperma elatius*) and preparing them for use. Significantly, she was assisted by her granddaughter Rita, for she was always keen to pass on her knowledge to younger people.

Carter's mother-in-law, Clara Hunt (born 1872 at Ramahyuck) was a proficient basket maker, like most of her contemporaries. At Lake Tyers she taught her daughter-in-law the craft. In the 1930s and earlier, basketry had been an important cottage industry that supplemented the incomes of families at Lake Tyers. Tourist parties were encouraged to visit the reserve by boat and the men would demonstrate and sell **boomerangs**, clubs, and shields, while the women sold their baskets. Thelma Carter participated in the trade and became as adept as her teacher. Baskets were in common use at the time, probably more so than at present. Many an egg basket originated at Lake Tyers.

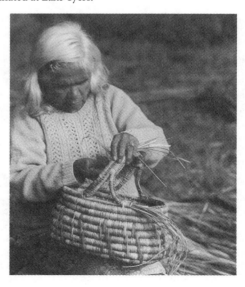

303. Thelma Carter making a coiled basket, c.1978.

Poor only in a material sense, Thelma Carter was always giving of her meagre resources to others, especially to members of her extended family. In the 1960s she felt the fear and insecurity of all those emotionally and physically attached to their home at the Lake Tyers reserve, at a time when the government's Welfare Board planned to dispose of the station and disperse the families throughout the wider community. A strong public outcry defeated the board; her son Charlie was at the forefront of the campaign. In 1971 freehold title was vested in a trust comprising all Lake Tyers residents.

Thelma Carter died at the age of eighty-five at Lakes Entrance. In old age, in her quiet, dignified way, she was proud to accept the accolades that her basket-making skills brought her. However, it was her status as the loved matriarch of a large and growing family that was her greatest joy.

ALW

See also: 17.1, 18.1; *303*.

Jackomos, A. & Fowell, D., *Living Aboriginal History of Victoria: Stories in the Oral Tradition*, Melbourne, 1991; West, A., *The Making of an Aboriginal Coiled Basket* [film], Museum of Victoria, 1979.

cartoonists. On 15 January 1992, a cartoon headed 'Eastwood comment' appeared in the fortnightly *Koori Mail* published from Lismore (NSW). Since then, cartoons by Danny Eastwood have appeared regularly, making him Australia's only Indigenous cartoonist with an established career on a national newspaper. Born in 1943 in the Sydney suburb of Waterloo, one of eight children, Danny left school at fourteen and worked as an unskilled factory labourer. Four years later, he won a scholarship to study art at East Sydney Technical College, but felt a misfit in the 'arty' scene and left after a year. His hopes of becoming a professional cartoonist were dashed in the 1970s when the Sydney *Daily Mirror* rejected his football gags (some are now in the SLNSW), though a similar series by a white cartoonist subsequently appeared in the paper. He was a fireman for twenty-two years. Only after his retirement did his artistic career take off.

Eastwood's *Koori Mail* cartoons range from very black drawings on bleak topics like *Death in Custody* (16 December 1992) to witty satires on contemporary Abori-ginal life. The cartoon of 22 October 1997, for instance, shows Aboriginal artists painting a council-sponsored traditional 'Dreamtime' mural that turns into emulations of Picasso and Botticelli. As a guide explains to the mayor: 'These two artists just returned from Paris.' In 1999 he became the first Aboriginal cartoonist to have work hung in the NMA's annual exhibition of political cartoons at Old Parliament House, Canberra.

Cartooning is a new profession for Indigenous Australians. Although witty drawings by early Aboriginal sketchers, notably Tommy **McRae**, were often appreciated as if they were cartoons, it was a different story if they tried to get published in the popular press. The vast collection of original *Bulletin* cartoons in the SLNSW includes a coloured pencil drawing of the champion racehorse Phar Lap by 'Noonie, Arunta Tribe Alice Springs' sent to Sydney from the Hermannsburg Lutheran mission in the early 1930s. Although Noonie exhibited drawings and painted theatrical scenery for white audiences, cartoons were governed by strict conventions that virtually guaranteed that any Indigenous offering would be rejected. An ink drawing of a stylish horse in a landscape by Reg Graham, 'a 14 yr old untaught half caste', sent on 2 February 1945 by an officer at 'Point Pearce Aborigines Reserve' (SA), fared no better. Despite being full of non-Indigenous cartoons, drawings, and 'pars' by freelance contributors, many self-taught and from similarly remote places, the *Bulletin* had no interest in Indigenous work. For decades its cartoons about Aboriginal Australians were confined to 'Jacky-Jacky' gags by white artists like Frank Mahony, B. E. Minns and Stan Cross.

In the 1950s Koori children contributed occasional cartoons to the Aboriginal newspaper *Dawn*, usually copying some popular international cartoon character. A few adults like Mark Wandin illustrated books with comic drawings in the late 1960s. But Indigenous artists only began publishing political cartoons on issues of direct concern to their people once they had their own news-papers in the 1970s. Most of the crude yet biting cartoons in Sydney's *Alchuringa* and *Black Australian News*, both edited by Kevin **Gilbert** in 1972, seem to have been drawn by the editor (apart from those in the latter taken from white publications). 'B. Jackson' was chief cartoonist on the *Aboriginal & Islander Forum* in 1975–79. Roberta Sykes drew a cartoon in the April 1977 issue of *Koori Bina: A Black Australian News Monthly* showing an official in the 'Australian Dept Immigration & Redneck Affairs' refusing a visa to a Nigerian (male) professor captioned, 'Professor?—Aw, yeah! Do you sing, dance, box, play football—or otherwise entertain?' Not only did the subject anticipate Sykes's own career, but this is also the first known published cartoon by a black Australian woman.

Although **Lin Onus** and his colleagues normally illustrated Melbourne's Black Power *Koorier* newspapers with serious Aboriginal designs and portraits, they added a few (pseudonymous or unsigned) cartoons in the 1980s. Onus's gouache and watercolour *Kaptn Koori* satirised the white comic-book superhero as part of an unrealised bicentennial project he 'tentatively titled' *Barinja's Big Black Comic Book: An Illustrated Alternative History of Australia*. In 1988 he ran a workshop for Indigenous cartoonists in association with the Melbourne Comedy Festival. The fourteen participants, from places as far apart as Milingimbi and Tasmania, included Ernie Dingo, with a gag about an Aboriginal–Japanese real estate swap in Queensland, and artist Donna Leslie showing whitefellas tanning on the beach in order to look Aboriginal.

Such cartoonists were mostly political guerrillas who disappeared or moved on to a 'higher' artistic plane after a brief skirmish over some controversial issue like the Bicentenary, **land rights**, or Pauline Hanson. Lacking access to the mass media, many chose to create witty visual satires in paintings or art prints or by publishing in 'little magazines'. Melbourne's *Overland* occasionally included a comic drawing by an Aboriginal artist among its numerous cartoons, for example *Two Pangkalangka have captured a bush man and intend to eat him* by the Papunya painter Tutuma Tjapangati, then sixty-five years old (issue 85, 1981). The vast majority of black cartoons appeared in Indigenous publications of the 1990s. In 1997–98 alone the *Aboriginal Independent Newspaper* (WA) published cartoons by Eastwood, 'Darryl',

'Gidge' (Ron **Gidgup**), Ben Laycock of Broome, Ron Martin, Chris Pease, and others.

The UNSW's *Aboriginal Law Bulletin* (*ALB*) gave some their career break. Frank McLeod, who drew the April 1993 cover cartoon, went on to do regular strips for the youth educational comic *Streetwize* (which has always employed Aboriginal cartoonists). For *Busted!* (1998)—'funded by the NSW Department of Juvenile Justice to inform young people, aged 10–18 years, of their rights and responsibilities whilst involved in the Juvenile Justice System'—he drew the strip *Buddy gets busted*, written by indigenous editor Gayle Kennedy. Gordon **Hookey** drew another *ALB* cover cartoon in 1993 (**Boomalli** holds the original) but was soon confining his ferocious attacks on white society to paintings and to lithographs like *Nigalu Mammon* (1996), a satire on post-**Mabo** white paranoia about blacks taking over suburban backyards. A cartoon by **Peter Yanada McKenzie**—now known as a photographer—of a Sydney policeman as a giant pig about to shoot a small cowering Aboriginal couple (*c.*1993) was deemed too inflammatory even for the *ALB*. Passionate polemic is expected of a cartoonist, but Indigenous ones can still go 'too far'.

Indigenous cartoonists are still to appear in the national daily newspapers, but they have produced memorable work in most media, including animated film and video. Many simultaneously exhibit in 'high art' shows. Gerard Scifo (1975–), who had two paintings and a pencil and aerosol drawing in the national touring exhibition 'Black Humour' (CCAS 1997), is known for his self-published urban comic *Smooth* (now *Bize Comix*). His strips frequently focus on **graffiti** art, since he began as a teenage graffiti artist. While graffiti mostly remains illegal, adult 'comix' like *Smooth*—cheap, cheeky and defiantly independent—offer the most accessible training grounds for professional cartoonists today. Until they can also offer adequate distribution, payment and visibility, gifted Indigenous artists will continue to favour other art forms. Even Danny Eastwood makes his living designing 'Dreamlike Australia' posters and T-shirts, and painting colourful pictures and murals. JAK

See also: *304*.

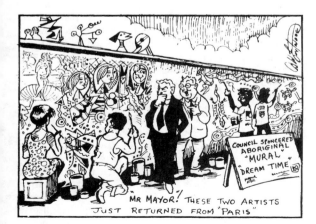

304. Danny Eastwood, *From Rock Art to Picasso*, 1997.

CASEY, Karen (1956–), Tasmanian visual artist, gained recognition in the late 1980s for her prints and posters on political, social and gender-based issues. She says of herself: 'My Aboriginality is spiritual rather than cultural, I draw inspiration from the land, but my themes are universal.' The 1987 touring exhibition 'Aboriginal Australian Views in Print and Poster' saw her first success. In 1989, with the assistance of an Australia Council Professional Development Grant, she commenced a full-time art practice in Melbourne, focusing on painting and **printmaking**.

Casey's early paintings were raw and confrontational, addressing themes of environmental imbalance, racism, and the inequality of women. Her 1990 series *War Buggers* highlighted the senselessness of war by imaging the plight of its innocent victims. *Got the Bastard*, 1991 confronted the persecution and annihilation of Casey's Indigenous ancestors in Tasmania, along with the continual degradation of the natural environment. This emotionally charged work was a release for Casey's resentment at a world controlled by 'redneck' values of ignorance, aggression and greed.

Polarity, 1991 shows her concern to balance masculine and feminine energies in a movement away from menacing paintings of protest. Her first sculptural installation, *Awakening*, 1992 was produced as part of a series of works on the theme of self-exploration and renewal. *Transformation*, 1993, exhibited at the Fifth Australian Sculpture Triennial (NGV 1993), led the viewer on a multi-sensory journey of initiation and rebirth within an archetypal cave.

Casey's paintings of the mid to late 1990s explored universal spiritual themes and alternative realities through representations of landscape. Inspiration drawn from a trip to the vast Arizona desert and her reconnection to her Celtic origins during a visit to Ireland, renewed Casey's links to her dual ancestry. Her *Guardians* and *Alchemy* series were the result. In 1997, she continued to investigate the landscape through a series of aerial and satellite perspectives. These 'earthscapes'—bearing her own fingerprint impressions—refer to her personal philosophical belief that the world is of our mind's making.

In attempting to unite Indigenous insights with those of modern science, Casey explores themes that question reality. *Dreaming Chamber*, 1999, an installation incorporating a soundscape, water, and lighting effects, was produced for the Third Asia–Pacific Triennial (QAG 1999). In this piece she managed to combine conventional materials and computer technology to produce a seemingly natural environment.

Casey has been included in many significant group exhibitions including 'The Continuing Tradition' (NGA 1989), 'Balance 1990' (QAG 1990), 'Power of the Land' (NGV 1994), and 'Crossroads' (Kyoto and Tokyo 1992). Her work is held in the NGA and most Australian State galleries. JUR

See also: 5.1, 5.6, 12.1; 65.

Samuels, J. & Watson, C., *Aboriginal Australian Views in Print and Poster*, West Melbourne, 1987; Neale, M. & Casey, K., 'Karen Casey: A moment out of time' in Queensland Art Gallery, *Beyond the Future: The Third Asia–Pacific Triennial of Contemporary Art*, Brisbane, 1999.

ceramics, see 9.2, 9.3; **Thancoupie, Tiwi Pottery.**

ceremony, see 1.1, 1.2, 1.6, 2.2, 3.2, 3.3, 6.2, 7.6, 9.5, 11.3, 15.1, 16.3.

CHEREL, Janangoo Butcher (*c.*1920–), Gooniyandi–Kija visual artist, has always been an industrious man. Now in his eighties, he still has a passion for work, although his present occupation is somewhat less strenuous than the labour he performed as one of the head stockmen on Fossil Downs station, to the east of Fitzroy Crossing (WA). He has taken painting on as a full time job, working every day at **Mangkaja Arts.** In his words:

With my eyes, my heart and with my brain I am thinking. When I sleep night-time, I might talk to myself, 'Ah, I might do [paint] that one tomorrow.' Not dreaming; I think about what to do next day. It's not easy, I have to think about what I am going to do. Thinking hard, thinking with my eye and body. Even if you have good hands, if you have a strong body, I am thinking it's still hard. You have to be happy to be doing it. What I am doing is for myself; I am working every day and I'm happy.

Butcher had already been painting for several years when Mangkaja began trading consistently in 1990. The stability which the centre offered, in terms of a ready supply of materials and a place to work, led to him setting up his own space within it. His first solo show was held at Birukmarri Gallery in Fremantle in 1993, and he has had regular exhibitions since this time, primarily through Artplace Gallery in Perth. In 1999 he was awarded an Australia Council Professional Development Grant in support of a project to highlight the threat to his country of the proposed damming of the Fitzroy River. Much of his country would be lost if the dam were to go ahead: 'I know that Ngarrangkarni (**Dreaming**) story from my mother's side. I know that country too from long time; like Manjoowa [a permanent waterhole on the Margaret River]. There's crocodile, fish, everything there. I know this country from long time. They can't change that river country; it's no good that idea.' Butcher's father was born in the desert, but he grew up and learnt the Law of his mother's country

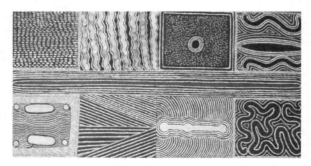

305. Janganoo Butcher Cherel, *Goongooloo*, 1996.
Acrylic on canvas, 60 x 120 cm.
The artist says of this painting: The red line in the centre is my *goongooloo* (blood). This is my dream. It is not Ngarrangkarni (Dreaming). This is my own dream, about *warlu* (fire), bush food, hunting, and the old people.

along the river to the east of Fitzroy Crossing. His sense of himself is drawn intrinsically from that river country.

Butcher works with paint on both canvas and paper, and he appreciates the specific qualities of each. His work has three main themes, microscopic views of his physical environment, Ngarrangkarni stories, and accounts of daily life on stations and in the bush. He has developed a broad range of ways to apply the paint, often inventing tools to use instead of brushes. He is also an accomplished printmaker, having had his first solo print exhibition in 1997. KD

See also: 10.2; **printmaking**; *305.*
Mangkaja Arts Resource Agency, *Ngarri muay ngindaji = Ngajukura ngurrara minyarti = Ngindaji ngarragi rirri = Ngayukunu ngurra ngaa: This is My Country*, Fitzroy Crossing, WA, 1994; Mangkaja Resource Agency, *Imanara: Big Country*, Fitzroy Crossing, WA, 1999.

child art. From the early 1930s Aboriginal children in various communities were encouraged by European visitors or teachers to draw with new materials—paper, pencils, crayons, and pastels. Many of these drawings were acquired for anthropological research, while others were obtained specifically to compare the intellectual and artistic development of Aboriginal and non-Aboriginal children. Collecting was also prompted by an educational and aesthetic interest in child art, and more recently by a desire on the part of the collectors to encourage pride in all areas of Aboriginal culture.

The degree of European influence in these early drawings depended upon the aims of, and enticements offered by, the teachers and collectors, the duration and nature of European involvement in the community, and the degree of respect shown for the children's traditionally-based visual language. Variations in the earliest known collected drawings (from the 1930s to 1950s) are particularly revealing. Whereas some evince a profound relationship to the distinct cultural history and physical environment of the artists, many others embody both traditional and introduced influences, while still others clearly reflect the strongly overlaid European structures and values in some communities.

European influence was least evident in drawings from relatively remote regions, including missions and government settlements in places like **Ernabella** and Ooldea (SA), the Central Desert, Hermannsburg (NT), Warburton and Carrolup (WA), and Aurukun in far north Queensland. European influence was most prominent in drawings collected from the mission schools in areas of denser European settlement, like Moore River and Mount Margaret (WA), Point Pearce and Raukkan (Point McLeay, SA), and Mona Mona, Yarrabah and Cherbourg (Qld). The majority of Aboriginal children's pictures collected in the 1960s and 1970s reveal European influence. Examples can be found in collections made by the **Aboriginal Arts Board** between 1973 and 1977, a number of which were shown in the NMA's touring exhibition 'Drawn from the Heart' (1994–95). However, quite recent pictures from a particular region may display more traditional characteristics than drawings made several decades earlier. Numerous mission-school drawings col-

lected in the 1930s feature images such as cars, boats, planes, flags, flowers, cowboys, and princesses, inspired by or copied from book illustrations, and mostly lack any reference to the children's Indigenous values and experience.

In contrast, pictures made in the late 1960s at the **Maningrida** School (NT) clearly reflect a different educational approach as well as the community environment. The young art teacher there, Dennis Schapel, valued highly the art produced by adults in the community and would ask his students to talk about their daily lives, encouraging them to depict personal experiences. In turn, the students introduced him to their favourite places, activities, and stories. This interaction resulted in lively and powerful representations of local fauna, landscapes, and hunting scenes. In 1971, Geoffrey Bardon, the newly appointed art teacher at **Papunya** (NT), observed children drawing designs in the sand and encouraged them to repeat them on paper in the classroom. The children were reluctant to use the designs in this more permanent way, however, as only adults were the rightful custodians of this traditional imagery.

The national touring exhibition 'Then and Now: Pitjantjatjara Artists and Aranda Artists 1930s–1990s' (AETA 1993) examined Pitjantjatjara and Arrernte children's drawings made in Ernabella and Hermannsburg from the early 1930s to 1950s. Significantly, the drawings made at Ernabella in the early 1930s differ from those made at Hermannsburg during the same period, demonstrating the dynamic relationship between traditional experience and the different forms and degrees of European influence. Ernabella remained one of Australia's most remote communities and experienced only minimal contact with Europeans prior to the establishment of a Presbyterian mission there in 1937. Mission authorities thought that the people of Ernabella should retain their language, customs and beliefs while at the same time being gradually prepared for contact with the world outside. On the other hand, the Lutheran mission at Hermannsburg had been established in 1877; by the 1930s there had been many decades of close contact with a European culture espousing a different philosophy, resulting in considerable suppression of Arrernte culture.

N. B. Tindale and C. P. Mountford collected and annotated children's drawings from Ernabella during anthropological expeditions conducted from Adelaide in 1933 and 1940. The 1933 drawings mostly depict animal or human tracks and are closely related to traditional Pitjantjatjara imagery. The numerous drawings from the 1940 Mountford collection show local plants and animals, with the occasional representation of people. Free juxtaposition of plan views and elevations, and the absence of a horizon are notable features of most Ernabella works. There is no noticeable stylistic difference between boys' and girls' drawings, and many incorporate symbolic images that are typical of traditional adult sand drawings, and cave and body painting. They are among the most traditional images to be found within the corpus of Aboriginal child art and were of great interest to Mountford, who wanted to assemble a collection of children's art that was free from the influence of other cultures.

In 1940 Ron Trudinger, Ernabella's newly appointed teacher from Adelaide, allotted time for art classes. He was determined not to impose European concepts or styles, and

the abstract designs which resulted are very different from the drawings collected the same year by Mountford. Trudinger asked the children to just draw 'anything'. They responded with colourful and lively abstract images using curvilinear and organic forms. Inventive and varied, these early works conveyed the children's extraordinary intuitive sense of colour and composition. A decade later these designs were taken up by women artists—several of whom had drawn the first such designs as children—and developed into the characteristic images and distinctive style for which their paintings, **batiks** and prints are recognised nationally and internationally.

Both Mountford's collection and these abstract designs showed ease and confidence in dealing with large sheets of paper, and reflect the children's strongly developed sense of spatial relationships. Perhaps this was because they were already comfortable with the unbounded sand surface onto which they traditionally drew. Books and illustrated material did not become available until much later.

The drawings acquired in Hermannsburg during the early 1930s by Melbourne artist Rex Battarbee and visiting art teacher Frances Derham, as well as those obtained by a succession of school teachers from 1938 onwards, contain images from the immediate environment of the mission. The subjects are landscapes, animals, hunting scenes, people, motor vehicles, and aircraft, as well as the mission buildings themselves. They are drawn as elevations with a distinct horizon line and only occasionally include a plan view. Hermannsburg children would have seen pictures on the walls of missionaries' houses. They had access to books from Europe and, in the church, they saw illustrations of Bible stories depicting European landscapes. The children used bright colours and patterning as well as a high viewpoint and flattened perspective, reflecting the competition between their own sense of space and the influence of European representation. Boys made detailed drawings showing a keen sense of observation, an ability to represent animals and people in motion, and a concern to render perspective. Girls showed they could also depict such scenes, but usually preferred to draw flowers, sometimes inspired by the local flora but often linked in style and subject to the introduced embroidery images taught to the women of the mission.

The children's familiarity with and considerable ability in pencil drawing may have resulted from the school's emphasis on copperplate writing. There is a distinct relationship of style and subject matter between the Hermannsburg children's landscapes and the works made at the same period by Albert **Namatjira** and several other local painters, following Rex Battarbee's earlier visits. A number of these children became watercolour artists in what was later known as the Hermannsburg School.

Questions about the personal, cultural, and political appropriateness of European influence over the children of Ernabella and Hermannsburg, as well as in other Aboriginal communities around Australia, remain un-answered. At the time of European contact, these children who would have, under other circumstances, continued thousands of years of local tradition, were immersed in an entirely new and highly challenging social order, established without warning or invitation. They made tangible visual sense of the

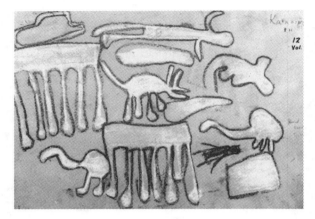

306. Kanarinya (Peter Kanari), *Untitled*, 1940.
Pastel on paper, 26 x 36 cm.
An example of Pitjantjatjara child art from 'Then and Now:
Pitjantjatjara Artists and Aranda Artists 1930s–1990s' (1993).

contradictions surrounding them and in so doing provided exceptional evidence of an experience of conflict, adaptation, growth, and survival. LF

See also: 9.1, 9.4, 11.6; Billy **Wara**; *148*, *306*, *397*.
Eickelkamp, U., '*Anapalaku walka*—Ernabella Design: A women's art movement ', in L. Taylor (ed.), *Painting the Land Story*, Canberra, 1999; Fontannaz, L., *Then and Now: Pitjantjatjara and Aranda Artists, 1930s–1990s*, South Melbourne, 1995; Piscitelli, B., White, M. & Ramsey, R., *Childhoods Past: Children's Art of the Twentieth Century*, Canberra, 1999.

circus life. Australia's first successful local circus enterprise dates from December 1847 in Tasmania, when a Launceston publican, Robert Avis Radford, opened his Royal Circus on ground adjoining the Horse and Jockey Inn. Successful circuses followed at Sydney in 1850 and at Melbourne in 1852. At first they were conducted in permanent buildings called 'amphitheatres', but within a few years the establishment of inland gold-rush communities and trade routes gave impetus to the development of a large travelling show industry, of which travelling circus companies formed a major part.

From the earliest days it was customary to induct young children—orphaned, illegitimate, or abandoned—into circus life, to complement a circus family or troupe. Aboriginal children, too, were occasionally 'apprenticed' or 'adopted' by companies and trained as performers; most circuses during the 'bush period' appear to have included at least a token Aboriginal performer. At first such performers were promoted as Aborigines, but by the 1870s it was fashionable to bill Aboriginal horsemen as South American, Brazilian, or 'Wild Indian'.

While performing on the goldfields around Bathurst early in 1852, the circus proprietor John Jones picked up two local Aboriginal boys for training as bareback riders. This appears to be the first recorded example of the induction of Aboriginal children. In May 1852, when Jones returned to Sydney to perform with his equestrian troupe, he proudly promoted

the pair. When the troupe opened in the York Street Circus on 21 May 1852, one of the lads, billed as 'Master Parello Frank', commenced the evening's entertainment. Called *The Young Turk*, his solo act of horsemanship is the first recorded appearance by an Aborigine in a circus arena. Thereafter, Aboriginal people were commonly regarded as a pool of potential talent for Australian circuses.

One of Jones's Aboriginal boys took his master's name and became Billy Jones, an all-round performer whose career in the Australian circus spanned some fifty years. In spite of being abnormally large, Jones accomplished some remarkable physical feats as an acrobat, tightrope walker, horse trainer, and equestrian. He was brought to Melbourne to perform in Noble's Circus in 1853, then joined the pre-eminent circus of Henry Burton the following year. In March 1866, as a member of Foley's Californian Circus, Billy Jones walked across Argyle Street, Hobart, on a rope stretched from the top of the circus pole to the Theatre Royal on the other side, at a height of about fifty feet, to resounding cheers from the people below. The performance made such an impression that Jones, having lost neither 'the flesh nor the agility', was recognised by members of his audience when he visited Hobart nearly twenty years later, in 1884, as ringmaster of St Leon's Circus. In the early 1900s he retired from an illustrious career to become a coach driver on Queensland's Mount Morgan Road, only to be brought out of retirement to appear again with the great FitzGerald Circus at Sydney in 1905. He died in Sydney the following year.

Ashton's Circus, founded in 1851, is Australia's oldest surviving circus and possibly the oldest continuously travelling circus in the English-speaking world. In 1854, when Ashton's Royal Olympic Circus visited the Hanging Rock diggings near Uralla (NSW), the troupe included Mongo Mongo, one of a group of Aborigines. A native of Tamworth (NSW), Mongo Mongo quickly developed as a circus rider under Ashton's tutelage and within two years was executing daring feats of horsemanship in Sydney. When the circus visited Beechworth (Vic.) in August 1857, it was recorded that the entertainment included 'trampoline performances by the whole of the male artistes throwing somersaults over twelve horses in the most rapid succession, led by an Aboriginal pupil of Mr. Ashton'. When the celebrated troupe appeared in Sydney in July 1863, the company included the Aboriginal riders Combo Combo and Master Callaghan, both pupils of Ashton. Callaghan was still a member of Ashton's company in 1879, when he performed a 'back somersault over a nine foot banner on a galloping horse' during a visit to Wilcannia in far west New South Wales.

In about 1887 a 'little darkie boy', Harry Dunn, was 'picked up' at Ullo (Qld) by the FitzGerald brothers. Harry's paternal grandfather William Dunn, who had arrived in New South Wales as a convict in 1818, was African, while his maternal grandmother, 'Caroline', the partner of a white squatter, was a Queensland Murri. By 1889 Harry had been trained as a bareback rider and was working in the FitzGerald Bros Circus under the name of Harry Cardella. He married 'a juggler girl', Sarah Burrell. After FitzGeralds' broke up, the Cardellas performed in India and the Far East before eventually returning to Australia.

Ernie Gilbert, an Aboriginal performer who served his apprenticeship with St Leon's Circus in the 1890s, travelled with Sole Bros Circus early in the twentieth century. In the recollections of one of the Sole family, Gilbert 'was a good bloke in the show … a good leaper, a good tumbler, a very good comedy man and the greatest worker you could meet.' He did not accompany the circus on its 1926 tour of South Africa however, 'because they treated the coloured people terrible [there]'.

There are occasional instances recorded of Aboriginal people being employed as general hands around circuses. In about 1915 the eight or nine tent hands in Gus St Leon's Great United Circus included two Aboriginal workers—a man nicknamed 'Tivoli', from a mining camp between Cloncurry and Mount Isa, and Tommy Rapp, called 'a good worker, and a clean, tidy fellow, a real gentle-man'. However, by this time circuses did not employ many Aboriginal people, partly because of restrictions placed on their free movement around the country.

The bareback rider Bob West—a native of Narrabri (NSW)—was the son of Bob Sooby, a London-born circus man who adopted the name of West for professional purposes, and an unknown Aboriginal mother. A daring horseman, the younger Bob West excelled in a bounding jockey act, jumping on and off his horse's back as it cantered around the circus ring at full speed, and sometimes gave a trick riding performance with his feet encased in wicker baskets. By 1905 West Bros Circus had taken to the road; it travelled around outback Australia for many years thereafter. In 1934 Bob West, his wife Mary, and their nine children were the last circus troupe to travel across the Nullarbor Plain to Western Australia by wagon, with horses, donkeys and mules tailing.

The most famous Aboriginal performers in Australian circus history were the Colleano family, who formed their own circus in 1910. Within a few years each of the ten children developed into an outstanding acrobatic performer, and Colleano's All-Star Circus became one of the largest and best in Australia. Leaving Australia in 1923, the family moved on to America where they became popular as circus and vaudeville artists. MStL

See also: **boxing**, Con **Colleano**; *309*.
St Leon, M., *The Circus in Australia: Spangle and Sawdust*, Richmond, Vic., 1983.

COCHRANE SMITH, Fanny (1834–1905), was born on Flinders Island in 1834 at Wybalenna, a prison set up to hold Palawa people after they were systematically removed from their homelands. At the age of five, she was taken from her parents to live with the prison catechist, Robert Clark. Three years later she was sent to the Queen's Orphan School in Hobart to be trained as a domestic servant. She was eventually returned to Wybalenna and placed in Clark's service, where she stayed until Wybalenna was closed in 1847.

Surviving Palawa were sent to Oyster Cove, an old convict station near Hobart where Fanny married an English sawyer named William Smith in 1854. She set up a boarding house in Hobart, but soon moved nearer to Oyster Cove where her mother, her sister Mary Anne, and her brother Adam were

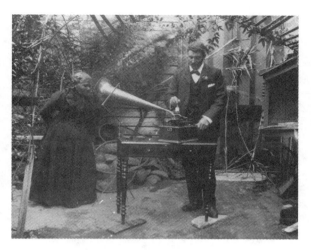

307. Fanny Cochrane Smith at her second recording session in 1903, with Horace Watson in his garden at Barton Hall, Sandy Bay.

still living. Fanny Cochrane Smith was given a grant of 100 acres by the government and settled at Nichols Rivulet. Her close friends, **Trukanini** and William Lanni, whom she had grown up with at Wybalenna, often visited. By 1889 she had been granted deeds to 600 acres. In 1899 a special concert was held in Hobart in her honour. At the event she spoke of the quality of her people and their love of honesty. The traditional songs she sang at this concert were recorded that same year; this was probably the first recording of Aboriginal song in Australia. The recordings are still held in the TMAG in Hobart. GRL

See also: 1.5; *307*.
Plomley, N. & Henley, K. A., *The Sealers of Bass Strait, and the Cape Barren Island Community*; Tasmania, 1990; Reynolds, H., *Fate of a Free People: A Radical Examination of the Tasmanian Wars*, Ringwood, Vic., 1995; Ryan, L., *The Aboriginal Tasmanians*, St Lucia, Qld, 1996.

COLE, Robert Ambrose (1959–1994), painter, described the varied sources of his art in this way:

I was born in Alice Springs, paint my mother's and my father's country. My mother's country is Banka Banka, Warramunga people, north of Tennant Creek. Most of my paintings are from around Aputula. Finke [is] my father's country. His country is south of Alice Springs the sandhills on the edge of the Simpson Desert … My images come from all over the place.

From the outset Cole's work had a unique subtlety. He explored the technical possibilities of acrylic paint on paper and canvas to develop a repertoire of dotting techniques that go far beyond the 'traditional'. He also experimented with wash and overlay techniques in European style landscapes, influenced by the watercolours of the Hermannsburg School.

His acrylic paintings fall into three distinguishable styles. In the first, a series of reductive and minimal works, forms

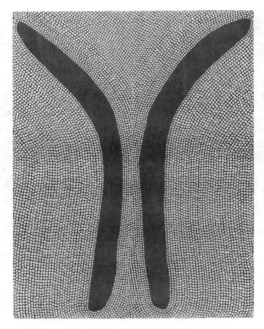

308. Robert Ambrose Cole, *Untitled*. 1993.
Synthetic polymer on paper and canvas, 76.5 x 56.5 cm.

309. Con Colleano limbering up for his performance on the tightwire, 1924.

are defined within and by a highly charged field of shimmering white dots on a coloured ground. In another style he experimented with fields of coloured dots in an almost pointillist mass, where the forms seem to ebb and flow before the eyes. In his final style, dramatic figurative forms are incorporated into the picture plane to produce a spirit-like presence within the painting.

Cole was not a prolific artist, but towards the end of his life he made a series of prints that made his work acces-sible to a wider audience. In 1991 and 1993 he had solo exhibitions at Utopia Art in Sydney, and he participated in several group exhibitions including 'Australian Perspecta' (AGNSW 1993) and, posthumously, 'Spirit + Place' (MCA 1996), and 'All This and Heaven too' (AGSA 1998). CH

See also: **acrylic painting**; *308*.
Perkins, H., 'Robert Ambrose Cole', in Art Gallery of South Australia, *All this and Heaven Too: Adelaide Biennial of Australian Art 1998*, Adelaide, 1998

COLLEANO, Con (1899–1973), acrobatic tightwire dancer, whose real name was Cornelius Sullivan, was born on 26 December 1899 at Lismore (NSW). He was third of the ten children of Cornelius Sullivan Sr—a boxing troupe showman—and Julia Robinson, an Aboriginal woman. The Sullivan family settled at Lightning Ridge (NSW) in about 1907, before starting out in 1910 with a circus of its own—the Collino Bros Circus. Young Con practised up to seven hours a day on the tightwire until, one summer afternoon at Sydney in 1919, he brought off the difficult trick of a forward somersault. This became the basis of an extraordinary wire act, developed for both circus and vaudeville performances.

In September 1924 he made a successful US debut at the Hippodrome, New York, and was soon engaged by Ringling Bros and Barnum and Bailey's Combined Circus as the 'Australian wizard of the wire'. Colleano remained Ringlings' principal star into the 1930s, drawing a salary of US$1000 a week. After an unsuccessful attempt to resettle in Australia in 1956, he returned to the USA and resumed working the wire. He gave his final performance, unheralded, at Honolulu in 1960, and died on 13 November 1973 at his home in Florida. His contribution to the circus performing arts is now internationally recognised. MStL

See also: **circus life**; *309*.
St Leon, M., *The Wizard of the Wire*, Canberra, 1993; St Leon, M., 'Colleano', in P. Parsons (ed.), *Companion to Theatre in Australia*, Paddington, NSW, 1995.

collections, see 21.1.

community museums, see art and craft centres, keeping places.

COOPER, Revel (1938–1983), Nyungah painter, grew up on the Carrolup Native Settlement (WA). Under the creative guidance of the headmaster, Noel White, and his wife, children at Carrolup gained renown for their drawing, painting and embroidery, which was exhibited in Perth in 1948 and overseas in the 1950s. Cooper subsequently worked as a railway fettler, before he left for south-eastern Australia. There he worked briefly for **Bill Onus** at Aboriginal Enterprises in Belgrave (Vic.) in the late 1950s. His work, reproduced in *Child Artists of the Australian Bush* (1952) had inspired a Carrolup style at Aboriginal Enterprises, which he continued to follow. Revel Cooper's formative influence on the young Melbourne artist **Lin Onus**, dates from this period.

Cooper exhibited regularly with the dealer and collector James (Jim) Davidson, and his work was seen alongside **bark paintings** from Arnhem Land and the watercolours of the Hermannsburg School. During a period in Fremantle prison (WA) in the 1960s, he continued to paint using art materials

supplied by Davidson. He is best known for his **corroboree** scenes and for his landscapes in two distinct styles: sombre, naturalistic scenes evocative of the south-west and those painted in raw, lurid colours. Revel Cooper is represented in the Berndt Collection (UWA). SK

See also: 11.6, 12.1; **prison art**, Vera **Wallam**; *148, 364, 397.*
Kleinert, S., 'Aboriginal landscapes', in G. Levitus (ed.), *Lying About the Landscape*, Sydney, 1997; Stanton, J. E., 'Nyungar landscapes, Aboriginal artists of the south-west: The heritage of Carrolup, Western Australia', *Berndt Museum of Anthropology Occasional Paper*, no. 3, 1992.

copyright. Art is at the heart of Indigenous culture. Painting, designs, songs and stories, like other forms of cultural expression, are a means by which Indigenous peoples express their identity. Many forms of Indigenous arts have been handed down through the generations and link Indigenous Australians to their homelands and cultural groups.

In the past thirty years, the Indigenous arts have been recognised as a viable, aesthetic cultural movement. But Indigenous people took a risk when they painted their **Dreamings** for public exhibition and told their narratives in public fora. Indigenous designs, seen as free for the taking, were copied onto tea-towels, T-shirts and carpets. Stories were appropriated by non-Indigenous writers and published widely. In 1976, Wandjuk **Marika**, the pioneer for copyright protection of Indigenous arts, made the following plea:

We have come to understand that we are going to need the same sort of protection that other artists and craftsworkers have in order to prevent their works being copied or reproduced in books and in other forms without their permission. We do not wish to prevent anybody from using our non-sacred designs, in books, magazines, postcards, calendars, even on tea-towels and table-cloths, for we are happy to see that people all over the world are interested in the Australian Aboriginal culture. We know that our people are in high demand as painters, potters, and craftsworkers, and it would be foolish to do anything that might prevent these people from getting money if they wish to take commercial advantage of their talents. We do, however, seek legal protection.

Copyright became an unlikely sword for the protection of Indigenous cultures. Copyright is the right granted to creators of artistic, literary, and musical works and to makers of sound recordings and films, which allows them, as owners, to exploit these works, recordings and films for economic reward. If the work of Indigenous artists met the criteria of copyright, then they could bring actions of infringement of their exclusive rights under the *Copyright Act 1968* and prevent the commercial exploitation of their designs. However, the circumstances of Indigenous ownership and production test the definitions under the Act. For copyright to exist in a work it must be original and, until recently, Indigenous traditional forms of art were not considered original. To obtain copyright protection, a work must be written down or recorded in some permanent, tangible form. Non-permanent forms of cultural expression, such as body painting, sand painting, and oral representations of a story do not

meet the requirement of material form. Further, it is the *expression* that is protected and not the idea, so clan designs, for example, are not protected in themselves. Under the terms of the Act, there must be an identifiable author, or authors, for copyright to exist in a work. Given the nature of Indigenous arts and cultural expression, an individual person or group of people will not always be identifiable: a design or style or image may have been developed over time and through generations. Communal ownership does not fit with copyright notions of protection. Moreover copyright only exists in a work from fifty years after the death of the artist. After this time, the work falls in the public domain, where it is considered free for all to use and reproduce without the need to seek consent or negotiate licence fees. Under existing copyright laws, ancient works such as **rock art** images can be copied or reproduced without the permission of the traditional custodians—as when a Wanjina figure copied from the Kimberley area was used as a surfboard logo. Another problem with copyright is that it caters for economic interests rather than moral or cultural interests. Currently neither moral rights nor rights of attribution and integrity are recognised under Australian copyright law. Issues of responsibility, which are central to Indigenous people's works, are not covered. Remedies under copyright do include the provision of damages for loss of profits, but Indigenous people want, in addition, the opportunity to set the record straight and seek rectification and apology.

Since the 1980s, there has been an increase in the number of Indigenous artists bringing actions in copyright, resulting in considerable shifts in the application of copyright to Indigenous arts. *Milpurrurru and Others v. Indofurn* (1993) (the 'Carpets Case') is perhaps the most significant case to date. This case involved the unauthorised reproduction of the artistic works of several Indigenous artists on carpets produced in Vietnam, where there is no copyright. Under Australian law, it is an infringement to import items which infringe copyright. Hence, the artists commenced action under these importation provisions. The artists were able to show that their works were original, and that the carpets were copies of these works. The judge ruled in favour of the artists, awarded damages and ordered the handing over of the unsold carpets. Part of the damages was awarded in respect of the cultural harm suffered by the artists in having their works reproduced in such a way.

Another notable Indigenous copyright case was *Bulun Bulun & Milpurrurru v. R & T Textiles*, in 1989. In this case Johnny **Bulunbulun**'s painting, *Magpie Geese and Waterlilies at the Waterhole*, 1980, was reproduced without permission on imported fabric. Bulunbulun was the artist and copyright owner in the painting, which embodied communally-owned designs of the Ganalbingu people. The issue of copyright infringement was not contested by the respondents. The Ganalbingu put forward the argument that under Indigenous customary law, they were the traditional owners of the ritual knowledge and the subject matter of the painting, and that therefore the Ganalbingu people were, as a group, the equitable owners of the copyright in the artistic work. The court did not agree however. It found that while Johnny Bulunbulun had the *right* to depict designs, he also had an *obligation* to the rest of the clan group to ensure that the

image was reproduced in ways that preserved the integrity of their cultural knowledge. This case illustrates how copyright laws have accommodated Indigenous interests, but it raises many legal points for further examination.

The question remains: can copyright laws be stretched to accommodate all possible eventualities? The parameters are in a state of flux in any case, as copyright adapts to meet the demands of advancing technology. Despite shifts in the application of copyright law, Indigenous interests are still struggling to gain real recognition and protection. Fundamental issues unaddressed include communal ownership of works, integrity, attribution, and appropriate remedies. Indigenous people continue to seek a comprehensive and coordinated approach for protection of their intellectual property, including new laws specifically protecting Indigenous cultural heritage. TJ

See also: 22.1, 22.2, 22.4; George **Milpurrurru**; *261, 262, 263*.
Marika, W., 'Aboriginal Copyright,' *Art and Australia*, March 1976; Janke, T., *Our Culture: Our Future: Report on Australian Indigenous Cultural and Intellectual Property Rights*, Canberra, 1999; Johnson, V., *Copyrites: Aboriginal Art in the Age of Reproductive Technologies*, Sydney, 1996.

corroborees. Performing daily since May 1987, the Tjapukai Aboriginal Dance Theatre has been Australia's most successful Aboriginal tourist product. The events it stages are contemporary examples of one of Australia's earliest Aboriginal tourist products. Corroborees were, originally, public dance events staged by Aboriginal people for a settler audience. The Dance Theatre promotes itself as 'not just a corroboree but an Aboriginal musical comedy which tells a **Dreamtime** legend'. The format—an acted-out play alluding to a traditional legend, involving singing, music, traditional Aboriginal dance

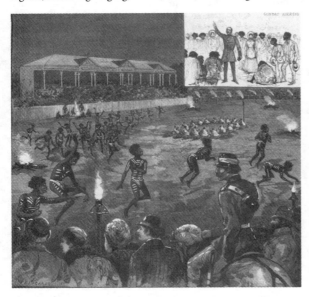

310. *Aboriginal Corroboree at Adelaide.*
Wood engraving, reproduced in the *Australasian Sketcher*, 29 June 1885.

movements, mime, and humour—closely follows the tradition set by nineteenth-century Aboriginal corroborees.

Soon after colonisation, corroborees were performed on a regular basis throughout south-eastern Australia for paying audiences. These staged performances, like Tjapukai's, were often jointly produced with private sector interests: performances were often scheduled and advertised. They were blatantly theatrical, using multicoloured lighting and special effects. Like the Tjapukai performers, early corroboree participants combined performance styles from European and Aboriginal traditions, incor-porating mimicry and mockery, and lampooning popular images of black–white relations. Thus it may be said that the Tjapukai Aboriginal Dance Theatre belongs to one of the longest traditions in Aboriginal tourist attractions.

Aborigines have a tradition of public entertainment, including songs, dances, and story-telling. Campfire songs and dances drew upon the richness of ceremonial life, but often omitted key words and actions in order to keep deeper 'inside' meanings hidden. Significant incidents would be commemorated, or day-to-day events commented upon, through pantomime that might draw upon totemic associations between animals and people to celebrate or lampoon the actions of particular individuals. Public performance was a major vehicle for appropriating the new. Songs and dances were exchanged between groups, often over long distances, and the arrival of the first settlers allowed the growth of a wider and more complex system of exchange. In the early days of settlement, performances directed to Aboriginal audiences were occasionally witnessed by non-Aboriginal observers, who popularised them in paintings, drawings, engravings, magazines, newspapers, and books. This reinforced the appeal of the corroboree as a spectacle not to be missed, particularly for the newly arrived. Early settler demands for entertainment, coupled with their curiosity to witness this unique type of spectacle, led Aborigines to adapt and tailor their performance to satisfy a new, non-Aboriginal audience. The term 'corroboree' (*garaabara* in the Dharuk language of the Sydney region, meaning a particular style of dance) came to be applied to these performances, and was subsequently carried by the settlers all over Australia.

During the nineteenth century, performances directed to non-Aboriginal audiences developed into a cultural artefact, jointly negotiated between the two cultures. Four major framings of corroborees of this period can be identified. The 'peace' corroboree was performed chiefly in association with diplomatic encounters, and symbolised cooperative relations between Aboriginal people and the Crown. The 'command performance' corroboree was orchestrated by the new occupiers as a joint act of homage to the Crown: it was often performed for vice-regal visitors. The 'gala' corroboree was the commoner's imitation of the vice-regal 'command performance' and marked significant social occasions. Finally, the 'commercial' or 'tourist' corroboree traded on the sense of exclusive occasion established by the other frames to increase its own value.

Sunday evening corroboree performances on the banks of the Yarra River in Melbourne pulled in such big crowds that Governor La Trobe banned them in April 1840. By 1845 the Aboriginal-organised 'Sunday corroboree' was a regular fea-

ture of Adelaide's social life. Aboriginal corroboree entrepreneurs were even approaching local newspapers to ensure advance promotion of visits by new dance groups.

From the 1850s settler-entrepreneurs increasingly assisted Aboriginal performers in staging 'tourist corroborees'. In 1856 a Murrumbidgee Aboriginal dance troupe performed corroborees to packed houses at the Queens Theatre in Melbourne, to critical acclaim in the *Argus* and *Age* newspapers. The performance of the corroboree on a stage reinforced a tendency to perceive Aboriginal performance through the settlers' own theatrical experience, which at that time included a great emphasis on spectacular effects. In 1867 a purveyor of pyrotechnic displays promoted an open-air corroboree on the Ballarat cricket ground. In 1872 Jack Fisherman and George Bennett were the first Aboriginal entrepreneurs to charge a set admission fee for corroboree performances in the Adelaide Parklands, advertising them in the local newspaper. In 1885 a corroboree staged on the Adelaide Oval attracted over 20 000 people—a sixth of Adelaide's population. Two performances on a single weekend earned the Aboriginal performers a half share in the net profit of £200. This so alarmed government and mission authorities that the police were instructed to prohibit a repetition in 1886, lest the policy of quarantining Aborigines on reserves be undermined. Critics compared these corroborees, which were illuminated by coloured lights or fireworks, to productions of Weber's celebrated opera *Der Freischutz*.

Corroboree performances had the potential to enter the domain of European mainstream theatre—or outdoor theatrical spectacular—as the standard 'tourism' package of the day. However the proscriptive policies of government and mission agencies generally denied Aboriginal performers any possibility of pursuing a mainstream theatrical career. In the late nineteenth and early twentieth century these restrictions diverted Aboriginal theatre into what was literally a sideshow tradition, paralleling the Aborigines' marginalised social position. Aboriginal football and cricket players, athletes, and corroboree performers found their niche in itinerant corroboree–minstrel troupes, often playing at rural fairs and sporting festivals. Some Aborigines pursued acrobatic careers in roving vaudeville or burlesque bush shows and circuses. These contexts provided an alternative forum of respectability, a locus of identity, and a measure of authenticity that was being denied to them by the advancing frontier. However the corroboree element of such performances was to diminish as these performers found their Aboriginality a disadvantage—one of Australia's greatest circus tightrope artists, Con Colleano, promoted himself as a 'Royal Hawaiian'.

Ironically, it was the residents and former residents of government settlements and mission stations who continued the corroboree tradition in the mid twentieth century. For Aborigines living in isolated government reserves under yoke of assimilationist policies, concerts staged for tourists represented an important means of cultural survival. In *Spinifex Walkabout*, tourists Coralie and Leslie Rees tell of corroborees performed for their benefit at Lombadina mission (WA) and Urapunga station (NT) in 1951. The same year striking Aboriginal workers in Darwin were supporting their jailed leaders by refusing to perform a corroboree for tourists on the visiting luxury ship, *Stella Polaris*.

Since the 1970s Aboriginal people have staged corroboree performances within their own contemporary cultural tourism venues, performing for local and international tourists. The mainstream stage has also been reclaimed, with the formation of contemporary professional theatre and dance companies. Performer Russell Page says in *Urban Clan*, that 'Bangarra Dance Theatre is a modern-day corroborree … building the bridges between traditional Aboriginality and urban Aboriginality because it has song, dance and storytelling in a more contemporary form.' During the bicentenary of white settlement in 1988, the corroboree appeared yet again at the Barunga Festival near Katherine (NT), framed in more political terms. In response to an Aboriginal performance that physically engulfed him, Prime Minister Bob Hawke made a public statement announcing his commitment to a negotiated treaty between Indigenous and non-Indigenous Australians. Though widely different in style, these various performances are all present day inheritors of Aboriginal 'settler-corroboree' performance traditions. MP

See also: 11.1, 18.1, 16.4, 16.5, 18.1; **festivals**; *310*.
Bruce, C. & Callaway, A., 'Dancing in the dark: Black corroboree or white spectacle?', *Australian Journal of Art*, vol. 9, 1991; Mahrer, M., *Urban Clan: A Portrait of the Page Brothers and the Bangarra Dance Theatre* [video], Ronin Films, 1997; Parsons, M., 'The tourist corroboree in South Australia to 1911', *Aboriginal History*, vol. 21, 1997; Rees, C. & Rees, L., *Spinifex Walkabout: Hitchhiking in Remote North Australia*, Sydney, 1953.

country and western music has been the dominant form of non-traditional Aboriginal music at least since the 1950s. Dougie Young (c.1935–1991), from Wilcannia (NSW), came to wider attention in the 1950s, but the maturity and ironic sophistication of his compositions reflected a longer Aboriginal history of the genre in Australia. His songs expressed the pain and despair of Aboriginal lives in rural Australia with humour and stoicism.

The 1950s saw the emergence of a more optimistic Aboriginal country singer and composer in Jimmy **Little**, who made a long career as a Sydney-based commercial entertainer with a religious bent. His song *Royal Telephone* (1964) was a huge commercial success, and at the turn of the twenty-first century Little was still active in the commercial music industry.

Roger Knox (1948–) represents a later generation of Aboriginal country singers and is recognised as a mainstream country music performer. His first album, *Give It a Go* was released in 1983. Knox might have been an even greater success if he had not been seriously injured in an accident that affected his guitar-playing ability.

Country Outcasts was an Aboriginal country music band formed by Harry and Wilga Williams and their children. Based in Melbourne, this band was immensely popular, among Aboriginal and white audiences alike, in the 1970s and 1980s. The band released several albums, including *Harry Williams and the Country Outcasts* (1979), and toured the South Pacific. Establishment of the annual National Aboriginal Country Music Festival in 1976 was one of Harry Williams major achievements.

cricket

Many other Aboriginal musicians, professional and non-professional, naturally turned to country music as a means of expression. Bob Randall, a member of the **stolen generations**, was born in central Australia and raised in Arnhem Land (NT). The pain of separation was immortalised in his song *My Brown Skin Baby* which became an anthem for the stolen generations.

Although country music became less dominant in relation to other forms of non-traditional Aboriginal music during the 1980s and 1990s, it remained an important influence. Indeed, country-rock was probably the dominant style in this period, as exemplified by such prominent bands as Coloured Stone and the Warumpi Band. Coloured Stone, from South Australia, was also influenced by reggae (as were many other Aboriginal bands), and its hit single *Black Boy* (1984) was an international success. Warumpi originated in the central Australian Aboriginal community of **Papunya** and was responsible for several innovations in popular Aboriginal music such as singing in an Aboriginal **language** and using paired **boomerangs** to create a percussion accompaniment (borrowed from traditional singing). Although Warumpi is predominantly a rock band, the country influence is very strong. It can be clearly heard in their song *Fitzroy Crossing* on their album *Big Name, No Blankets* (1985). SW

See also: 15.2; **radio**; *193, 342*.

Beckett, J., 'Aborigines make music', *Quandrant*, vol. 2, 1957–58; Breen, M., *Our Place Our Music*, Canberra. 1989.

CRAIGIE, Linda, see **Youngi**.

cricket. It is perhaps one of the great ironies of Australian history that, along with land-theft, disease and mayhem, British settlers brought with them the subtle, civil, and gentlemanly game of cricket. The earliest record of Aboriginal involvement in the game dates from 1835, when a Tasmanian named Shiney or Shinal appeared as an unsuccessful batsman in a match at Hobart Town. Following his premature death Shinal's skull was despatched as a scientific curio to an Irish museum.

Over subsequent decades British and Spanish missionaries introduced cricket as a 'civilising' vehicle to Aboriginal inmates at Poonindie (SA), Coranderrk (Vic.), New Norcia (WA) and Deebing Creek (Qld). In 1854, artist John Michael Crossland painted Nannultera, a young Poonindie male with cricket bat defiantly raised, his gaze focused and intent. Even at Cummeragunja (NSW), where missionary Daniel Matthews actively discouraged the game, Aboriginal residents took to it avidly. From the mid nineteenth century, evidence mounted of Aborigines excelling at the sport: the Poonindie team, which played irregularly, and the 'Invincibles' of New Norcia both won all but one of their matches against local white sides, while the Deebing Creek Aborigines carried off a major cricketing trophy in 1895.

The greatest example of cricketing prowess in the nineteenth century, however, was the performance of the Aboriginal cricket team that toured England between May and October 1868. They were the first Australian cricketers to play abroad and thus the first to meet the Marylebone Cricket Club (MCC) at Lord's—preceding the first white Australian team by more than a decade. During their gruelling five-month tour, during which one of their number, 'King Cole', died and two others were sent home seriously ill, they won as many games as they lost (fourteen), and drew a further nineteen. The two outstanding players of the 1868 tour were Unaarrimin (Johnny Mullagh) and the diminutive Yellanach (Johnny Cuzens), both stylish all-rounders, excelling at bowling, batting, fielding, and wicket-keeping. Mullagh, in particular, was the mainstay of the team, scoring 1698 runs and taking 257 wickets with a bowling average of 10.00.

Following the team's return to Victoria, all but Mullagh and Cuzens drifted into obscurity and even these two exceptional players found the going tough. With scientific racist theories burgeoning and the introduction of official 'protection' policies to segregate and control Aboriginal peoples, opportunities for sporting competition with white teams diminished considerably. Mainstream public opinion grew increasingly intolerant of Aborigines excelling at cricket and unduly sensitive towards the spectacle of white players and teams being humbled by Aboriginal ones. Nevertheless, Aboriginal teams continued to exist, such as two that comprised Jack Daylight's Barambah cricket club in the World War I years.

From the time of Federation, outstanding Aboriginal cricketers were isolated figures in a white sporting world, their talents only grudgingly accepted and their bowling prowess, in particular, viewed with intense suspicion. The three pre-eminent twentieth-century Aboriginal performers—Deebing Creek's Albert Henry, Yulgilbar's Jack Marsh, and Barambah's Eddie Gilbert—were all bowlers who were subjected to the allegation that they threw rather than bowled the ball. Of the eleven 'no-balling' incidents involving the charge of 'chucking' in Australian cricket between 1900 and 1940, four (or more than one-third) involved these three bowlers. Marsh, a right-arm fast bowler of exceptional speed and accuracy, was constantly no-balled while playing for New South Wales against Victoria in the 1900–01 season. The mercurial Henry was suspended from the game for a month after remonstrating with a Queensland umpire for no-balling him in 1904. Gilbert's whip-like bowling action was repeatedly questioned by Victorian umpire Andrew Barlow in December 1931. To vindicate their bowling actions, Marsh submitted to performing with a splinted arm and Gilbert was rigorously tested while being filmed by slow-motion cameras. Although nothing unacceptable was revealed, charges of 'suspect' bowling actions persisted.

Significantly, the campaigns against both Marsh and Gilbert were accelerated after they had humbled white Australian cricketing legends. In November 1900 Marsh had clean-bowled Australia's crown prince of cricket, Victor Trumper, for one. Umpire Barlow's humbling of Gilbert occurred only a month after Gilbert had dismissed Don Bradman for a duck at the Gabba on 6 November 1931. Gilbert's fiery four-ball spell that day is probably the most illustrious moment in Aboriginal cricketing history. His first ball, a bouncer, had opening batsman Wendell Bill caught behind for a duck. Bradman then took the crease, only to

566

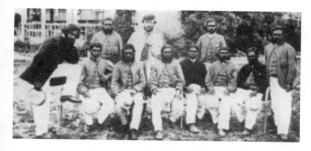

311. Australian Aboriginal Cricket Team, England, 1868. Standing (*l. to r.*) Bullocky, Tiger, T. W. Wills, Johnny Mullagh, Red Cap; sitting (*l. to r.*) Mosquito, Johnny Cuzens, Dick A Dick, Twopenny, Jim Crow, King Cole.

have his bat knocked from his hands by Gilbert's second delivery. Avoiding the third, Bradman fell awkwardly backwards onto the pitch. In attempting to play at Gilbert's fourth ball 'the Don' was caught behind by the wicket-keeper without scoring. Although he later rated this display as 'faster than anything seen from [Harold] Larwood or anyone else', at the time Bradman joined in a hue and cry against Gilbert's 'suspect' method of delivery.

Henry, Marsh, and Gilbert were all shamefully treated by white officialdom and all met tragic ends. Henry was imprisoned for insubordination upon Barambah reserve before being transported north to Yarrabah mission, where he died prematurely of tuberculosis in 1909. In 1916, Marsh was kicked to death by several white men after being knocked down in the street in Orange (NSW). A court subsequently acquitted his assailants of manslaughter, Judge Bevan having commented that Marsh 'had probably deserved' his fate. Gilbert was peremptorily retired from the game in 1936. Overall, he had taken 87 wickets in first-class cricket at an average of 28.97. While working at Cherbourg reserve (Qld) as a hospital orderly in the late 1940s he began to exhibit signs of increasing mental instability. Admitted to Goodna mental asylum in 1949, he died there in 1978.

During their short careers, leading Aboriginal cricketers received the highest sporting accolades—usually from visiting overseas sportsmen. Mullagh was rated one of the world's finest batsmen, while Henry, Marsh, and Gilbert were all accredited with some of the fastest bowling performances in first-class cricket. Only one Aboriginal cricketer, Faith Coulthart (later Thomas), has ever been selected to play for Australia, bowling six overs in a single Test match in 1958. Aboriginal cricketers have invariably been outstanding all-round sportsmen, excelling in athletics (Mullagh, Marsh, and Henry), basketball and **boxing** (Ian King), hockey (Coulthart), **Australian Rules football** (John McGuire), and soccer (Roger Brown).

Cricket has traditionally remained the most English of English sports and has been predominantly played in Australia by English and Anglo-Australian men and women, most often from middle-class backgrounds. Only a handful of Aboriginal cricketers have emerged into the first-class game, and their history has mainly been typified by discontinuity, exclusion, and thwarted hopes. Yet this overall narrative of unfair treatment has been illuminated by flashes of

individual triumph and grandeur, as incandescent and memorable as they are fleeting. RE

See also: 22.4, *311*, *313*, *331*.
Cashman, R., *The Oxford Companion to Australian Cricket*, Melbourne, 1996; Mulvaney, D. J. & Harcourt, R., *Cricket Walkabout: The Australian Aborigines in England*, 2nd edn, South Melbourne, 1988.

CROFT, Brenda L (1964–), Gurindji photographer, curator, administrator, and writer. In her equally successful roles as artist and curator, Brenda L Croft has carved out a unique position within the contemporary Indigenous art world. A member of the Gurindji nation, from Daguragu–Limbunya (NT), Croft was born in Perth and grew up in northern New South Wales. After completing her schooling in Canberra, she moved to Sydney in 1985 to attend Sydney College of the Arts, but dropped out after a year to focus on her art practice and her involvement with Indigenous and community media. In 1987 Croft was a founding member of **Boomalli Aboriginal Artists Co-operative** and in 1990–96 was employed as its general manager. In 1995 she was awarded a Master of Art Administration from the UNSW College of Fine Arts. She has contributed to numerous boards and advisory committees, and lectured widely on Indigenous art. In 1996–97, she and Hetti Perkins co-curated 'fluent', Australia's representation at the 1997 Venice Biennale. In 1999 she was appointed curator of Indigenous art at AGWA and guest curator of the Adelaide Biennial of Australian Art exhibition, 'Beyond the Pale'(AGSA 2000).

Croft's first published works were photographs taken at landmark rallies, like the Stop Black **Deaths in Custody** rally (1985) and the Long March of Freedom, Justice and Hope on **Survival Day** (1988). At the invitation of Kevin **Gilbert**, these photographs were included in the national touring exhibition, 'Inside Black Australia' (1988–89). *Conference Call*, her 1992–93 collaboration with African-American artist Adrian Piper, for the Biennale of Sydney, incorporated large-scale images of friends and acquaintances from Redfern looking directly at the viewer. *The Big Deal is Black*, 1993 and *Strange Fruit*, 1994, in the artist's words, 'focus on black women and friends and family and show through images the relationships that I've got with the people that I photographed' (quoted in Bellear 1993). Her 1998 series *In My Mother's Garden* and *In My Father's House* directly address her family history using colour slide images taken by her parents overlaid with text and other, more recent, photographs:

By placing myself behind the camera I am taking control of my self image and images of ourselves. I cannot, do not, take sole responsibility but challenge and attempt to reverse the expected. My mother marrying my father, white dress, black suit, the negative makes me laugh, the story makes me cry. Reverse roles. Look at me/us and do not see through me/us. Acknowledge me/us. I am right beside you (quoted in Perkins 1999).

Key group exhibitions in which her work has been represented include 'True Colours' (1994–96), 'Mistaken Identities'

at 'Africus '95' (Johannesburg Biennale), South Africa (1995), and 'Signs of Life' (1999) at the Melbourne International Biennial. Croft's work is held in national and State public collections. HF

See also: 12.1, 12.4; 46.
Bellear, L., 'The big deal is Black', *Photofile*, no. 40, 1993; Croft, Brenda L. (ed.), *Beyond the Pale: Contemporary Indigenous Art*, Adelaide, 2000; Perkins, H., 'Right Beside You: Brenda L Croft', in J. Kerr & J. Holder (eds), *Past Present: The National Women's Art Anthology*, Sydney, 1999.

cultural centres, see **art and craft centres, keeping places.**

cultural heritage. Aboriginal and Torres Strait Islander (Indigenous) cultural heritage is about who we are today, and about respect and recognition for those who came before us. It has both tangible and intangible elements. It includes the custodianship of stories, knowledge of country, language, kinship laws, songs, dance ceremonies, traditional practices, beliefs, sites, and objects.

The importance of Indigenous cultural heritage was recognised in the broader Australian community in the late 1970s, with the introduction of State and Commonwealth legislation protecting Aboriginal sites and relics. More recently, legislative and policy changes have recognised the significance of cultural heritage to contem-porary Indigenous people, and the primacy of our role in its identification, management, and protection. This has largely come about as a result of the actions of Indigenous people who have been successful in ensuring that the importance of many significant places is recognised, including places of contemporary cultural significance, such as the site of the Wave Hill walk-out in Northern Territory, the Aboriginal **Tent Embassy** in Canberra, and the Cyprus-Hellene Club in Sydney—the site of the **Day of Mourning** and Protest meeting in 1938.

The recognition of contemporary Indigenous people's relationship to their cultural heritage, and their right to be involved in its management is also reflected in diverse ways, such as the increasing **repatriation** of cultural material to Aboriginal communities by museums, and joint management of national parks.

CG

See also: 2.1, 2.3, 2.4, 2.5, 4.5, 5.4, 11.3, 18.4, 19.4; **Australian Indigenous Cultural Network, archaeology, languages.**
Birkhead, J., De Lacy, T. & Smith, L. (eds), *Aboriginal Involvement in Parks and Protected Areas*, Canberra, 1992; Evatt, E., 'Overview of State and Territory Aboriginal heritage', *Indigenous Law Bulletin*, vol. 4, no. 16, 1998.

D

Daly River artists, see Merrepen Arts.

dance, see 6.5, 7.3, 10.1, 10.2, 16.3, 16.5, 16.6.

DANIELS, Dolly Nampijinpa (*c.*1931–), Warlpiri painter, is a prominent member of Yuendumu (NT) community who has served on many community committees. She has been painting for **Warlukurlangu Artists** since the mid 1980s. Her ancestral country is Warlukurlangu (fire **Dreaming**), south-west of Yuendumu. A respected ritual leader of Yawulyu (women's ceremonies), she is also associated with and paints the following Dreamings: *ngapa* (water), *yankirri* (emu), *watiyawarnu* (acacia seed) and *yilyinkarri* (burrowing skink).

Her colourful works have been exhibited nationally and internationally in individual, collaborative, and group exhibitions. She was one of a group of Warlukurlangu artists who travelled to New York for the opening of 'Dreamings' (New York, Los Angeles, and Chicago 1988–89), and other exhibitions which have featured her work include 'Mythscapes' (NGV 1989), 'Tjukurrpa, Desert Dreamings' (AGWA 1993) and 'Aṟatjara' (Düsseldorf, London, and Humlebaek 1993–94). Dolly Nampijinpa's works are found in the major collections of the NGV, AM, and the Musée National des Arts d'Afrique et d'Océanie, Paris.

Daniels has worked and exhibited with non-Indigenous artist Anne Mosey, first in 'Frames of Reference' (1991), and again on an installation for the 1993 Biennale of Sydney. Another collaboration by these two artists was the subject of the 1994 exhibition 'ngurra (camp/home/country)' (USAAM 1994). LC

See also: 3.3.
Dussart, F., 'What an acrylic can mean: On the meta-ritualistic resonances of a Central Desert painting', in H. Morphy & M. Smith Boles (eds), *Art from the Land: Dialogues with the Kluge–Ruhe Collection of Australian Aboriginal Art*, Charlottesville, VA, 1999; Ryan, J., *Mythscapes: Aboriginal Art of the Desert*, Melbourne, 1989.

DAVIS, Jack (1917–2000), Nyungah writer, begins his autobiography *A Boy's Life* (1991) with a regret: 'I wish I could say I was born in the bush and delivered by Aboriginal women in the glow of a campfire. Instead, I was born in King Edward Memorial Hospital in a sanitized labour ward.' If the birth in March 1917 of the fourth child in a family of eleven was, in his view, 'nothing spectacular', the impact of this activist, actor, editor, poet and playwright has been anything but ordinary. And the subject of much of his work has been the divide between what is often constructed as traditional Aboriginal culture, and the urban realities that are so much a part of many Aboriginal lives today.

At the age of fourteen Davis was sent to live at the infamous Moore River Settlement (WA). In the 1930s he worked shooting kangaroos, and was imprisoned twice for protesting against curfews imposed under the Western Australian *Aborigines Protection Act 1905*. In the 1940s he married and returned to his country in south-western Western Australia, working as a mill hand and as a lay preacher.

In the late 1960s and early 1970s Davis began to assume leadership roles: in 1967 he became manager (and was later president) of the Aboriginal Advancement Council and in 1971 he became State secretary of **FCAATSI**. He was manager of the Aboriginal Centre in Perth, first Chairman of the Aboriginal Lands Trust in Western Australia, a committee member of **AIATSIS**, and a member of the **Aboriginal Arts Board** of the Australia Council. He was also editor of the journal *Identity*.

But it is as a writer that Davis is most celebrated. His first play, *Kullark*, was written in outrage at the exclusion of Aboriginal **history** from Western Australia's sesquicentennial celebrations in 1979. *The Dreamers* (1982) depicts the alcoholism and despair experienced by many Aboriginal families. But it also introduces the figure of the Dreamer, a dancer who represents Aboriginal heritage, and who signals hope and potential for the aged Worru and his great-nephew. The character of Worru was made particularly memorable by Davis himself, who assumed the role in several productions. His greatest success was the play *No Sugar* (1986), which was followed by *Barungin (Smell the Wind)* (1989) and *In Our Town* (1992). He also wrote **poetry**, and plays for children.

Davis was awarded the British Empire Medal (1977) and Order of Australia (1985). He was named Aboriginal Writer of the Year in 1981, and in 1984 received a Sidney Myer Performing Arts Award and an honorary doctorate from Murdoch University (WA). In an ironic moment surely not lost on Davis, he was elected a Citizen of the Year in 1985 in Western

Australia, where the elision of Aboriginal history had started him writing in the first place. GT

See also: 14.1; 14.1, 16.1; **arts awards and prizes, fiction, Survival Day**; *183*.
Turcotte, G. (ed.), *Jack Davis: The Maker of History*, Sydney, 1994.

DAWIDI Djulwarak (1921–70), Liyagalawumirr (Yolngu) bark painter and ritual leader, lived through a period of great social change with the coming of the Methodist missionaries to Milingimbi (NT). He was married to the noted weaver Nellie Ngarri'thun. After the death of his father's brother **Yilkari Kitani** in 1956, Dawidi became the senior ritual leader, at a relatively young age, of the Wägilak sisters suite of ceremonies, arguably the most important rituals in central Arnhem Land. Under the tutelage of Dhawadanygulili, his *djunggayi* (manager), he developed an innovative painting style and introduced new compositions to relate the various aspects of the Wägilak narrative.

In the 1950s and 1960s Dawidi formed a special relationship with Czech collector and anthropologist Karel Kupka and he figures prominently in Kupka's book *Dawn of Art* (1965). In the 1960s he was one of an inner circle of advisers to the art co-ordinator at Milingimbi, Alan Fidock. During this decade, possibly the 'golden age' of **bark painting**, he produced a large body of work and was widely collected. His work features in collections made by Ed Ruhe, Helen Groger-Wurm, J. A. (Jim) Davidson, Louis Allen, Dorothy Bennett and others. Dawidi's bark paintings and sculptures featured in the 'Painters of the Wagilag Sisters Story' exhibition (NGA 1997).

In the absence of a son old enough to take over his mantle, Dawidi taught his daughter Daisy Manybunharawuy (1950–) to paint the complete story of the Wägilak sisters narrative. Manybunharawuy had been taught to weave by her mother Nellie Ngarri'thun, and came to prominence as a bark painter in 1993 after the death Paddy **Dhathangu**, Dawidi's successor as owner of the Wägilak rituals. DJM

See also: 3.1; *150*.
Allen, L., *Time Before Morning: Art and Myth of the Australian Aborigines*, New York, 1975; Caruana, W. & Lendon, N. (eds), *The Painters of the Wagilag Sisters Story 1937–1997*, Canberra, 1997.

Day of Mourning and Protest was first held on 26 January 1938 in Sydney, after a decade of Aboriginal political activity in south-eastern Australia. Challenging the official celebration of Australia Day, about 100 Aboriginal people from New South Wales, Victoria, and Queensland gathered to express deeply felt anger at the suffering caused by invasion and colonial rule. The meeting passed a resolution that Aboriginal people everywhere should be immediately accorded full citizenship rights, defined as 'equality with the white man'; speakers stressed the effects of economic and civil discrimination in an era when the Depression had wiped out not only jobs but also recently-won civil rights such as family endowment payments. Their program of demands made it clear that they called for administrative self-determination and a recognition of their **land rights**, as well as legal, economic, and civil equality.

The Day of Mourning was initiated by William Cooper, then an elderly man from Cummeragunja, who had devoted his life to a courageous campaign for the restoration of land rights, the economic self-sufficiency of Aboriginal communities, the achievement of legal and political rights and the recognition of Aboriginal cultural values. He had a gift for conceiving political actions of great symbolic power, such as the 1937 petition to the King which had circulated around rural south-east Australia and Western Australia, providing a rallying point for Aboriginal people and sympathetic white Australians. The Day of Mourning was another such powerful and evocative focus.

The Aboriginal-only meeting was an assertion of autonomy and authority, with speeches from the main public figures of Aboriginal organisations of the day—the Victorian Australian Aborigines' League and the NSW Aborigines' Progressive Association (APA). An elderly speaker, Mr Johnson of Batemans Bay, had been an office-bearer of the earlier Australian Aboriginal Progressive Association, which fought during the 1920s to save Aboriginal farming lands from revocation and to save Aboriginal children from forced removal from their families.

Pearl Gibbs, a spokeswoman for the APA from western New South Wales, recalled that the day was organised to gain maximum attention from the general public. Aboriginal activists arranged media contacts, circulated their statement and demands to journalists and used the popular press to reach a wide audience. Photographs in *Man* (an illustrated general affairs magazine) showed Aboriginal men and women engrossed in the business of the meeting—images of Aboriginal assertiveness and purpose which challenged the prevailing representations of Aboriginal poverty and disorder.

The Day of Mourning drew public attention to Aboriginal demands, and demonstrated Aboriginal community support for a program of reforms which were taken to Prime Minister Joseph Lyons. Its significance has deepened over the decades: it offers a model, still relevant today, for the public assertion of rights, and a testimony to the tenacity and imaginative force of Aboriginal activism. HG

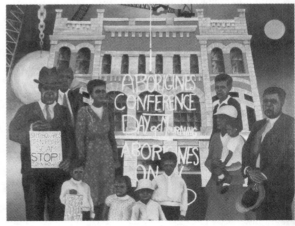

312. Gordon Hookey, *Day of Mourning*, 1997.
Oil on linen, 120 x 160 cm.

See also: 4.5; **stolen generations**; *186, 312*.
The Australian Abo Call, no. 1, April 1938; Markus, A. (ed.), *Blood From a Stone*, 2nd edn, Sydney, 1988; Goodall, H., 'Pearl Gibbs: Some memories', *Aboriginal History*, vol. 7, no. 1, 1983.

DAYPURRYUN, Mickey, see **Elcho Island.**

DEACON, Destiny (*c.*1956–), Erub–Mer–Kuku photographer, installation artist, video-maker, performer, broadcaster, writer, and teacher, has developed a widely intelligible visual language that employs bogus Aboriginal artefacts, kitsch souvenirs, domestic knick-knacks, dolls, toys, and human models in engagingly staged, but ambiguous, photographs, installations, and collaborative videos. She discovered early her preferred media—ready-made, low-intervention, fast-result technologies, including Polaroid photography, laser and bubble-jet printing, and domestic video. Mixing fantasy, reportage, humour, and political comment with mass and trash media forms, her work evokes—sometimes simultaneously—stereotypes of debased and trivialised subjects, the world that produced them, and invented parallel worlds only slightly removed. Deacon's coinage, 'Blak', first used in the *Blak lik mi* series (1991), denotes a contextualised, specifically Australian, Indigenous Blackness (**Aboriginality** plus **history**). This remains her primary prompt.

Marcia Langton has said of Deacon's work that it 'serves as a barometer of post-colonial anxiety, as a window of understanding [those] … seeking to establish a considered and meaningful grammar of images in an environment full of colonial memories.' Of Deacon herself, Langton notes that she has positioned herself as a public intellectual, playing 'hard ball with gender and hybridity stereotypes'.

Deacon earned a BA in politics (University of Melbourne 1979) and a Dip Ed (La Trobe University 1981). She has taught in the Victorian State secondary education system, devised and taught Aboriginal community courses, worked as a staff trainer in the Commonwealth public service, and tutored in the English department at the University of Melbourne. She has been actively involved in Indigenous communities and politics since she was 'a nipper'. In 1990, divining a new and entertaining way of entering public debates while expressing and interpreting herself, she used a borrowed camera and darkroom, to make her first exhibited photographs. These were *Koori Rocks, Gub Words*—nine small black and white pictures of a monumental, graffiti-covered rock formation in Victoria's Western District. Within a year, enlargements from this series were included in the touring 'Aboriginal Women's Exhibition' (AGNSW 1991–92).

The quick recognition and support given by other Indigenous artists, curators, and writers, notably Tracey **Moffat**, Hetti Perkins, Avril **Quaill**, Brenda L **Croft**, and Marcia Langton, and by **Boomalli Aboriginal Artists' Co-operative**, both predicted and developed a wider interest in her work. Deacon has since had numerous solo exhibitions in private and public galleries, and has participated in many group and major local and international exhibitions, including 'Australian Perspecta' (AGNSW 1993, 1999), 'Tyerabarrbowaryaou II' (Havana 1994), 'Africus 95' (Johannesburg 1995), and the Asia–Pacific Triennial (QAG 1996–97)—where she installed her living room. Her work is held in most Australian public gallery collections, and by other institutional and private collections inside and outside Australia.

VF

See also: 5.6, 12.1, 12.4; *66, 67, 277, 313, 314*.
Fraser, V., 'Destiny's Dollys', *Photofile* 40, November 1993; Langton, M., 'The Valley of the Dolls: Black humour in the art of Destiny Deacon', *Art and Australia*, vol. 35, no. 1, 1997.

313. John Michael Crossland, *Portrait of Nannultera: A Young Poonindie Cricketer*, 1854.
Oil on canvas, 99 x 78.8 cm.

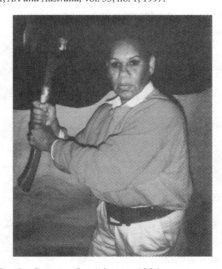

314. Destiny Deacon, *Eva Johnson*, 1994.
Colour bubble-jet print, 72.8 x 58.6 (image), 77.8 x 60.4 (sheet).
In her subversive, yet humorous portrait of Eva Johnson, Destiny Deacon parodies colonial representations and reclaims status for Nannultera, the subject of John Michael Crossland's painting.

deaths in custody. The Royal Commission into Aboriginal Deaths in Custody was a salient and profoundly symbolic event—a historical moment that branded itself upon the national consciousness and conscience. Its poignancy derived in part from its juxtaposition to the political and cultural events leading up to the Australian Bicentenary 'celebrations' in 1988, and to an ongoing review of Australia by the United Nations Working Committee on Indigenous People. The Royal Commission was both a statutory legal response to, and political and symbolic gesture towards, a set of Indigenous 'social problems' and 'underlying issues' which were increasingly finding dramatic and alarming expression in the hanging deaths of young Aboriginal men in custody. In the months immediately preceding Prime Minister Bob Hawke's announcement of the Commission, in August 1987, fourteen Aboriginal people had died in custody.

The ostensible purpose of the Commission was to examine the causes of forty-four Aboriginal deaths that had taken place in police and prison custody since 1980, and to ascertain responsibility and possible accountability. From an Aboriginal perspective, the Commission was to have been about correcting a system of injustice, and achieving some semblance of accountability, acknowledgment and justice. The nation and Aboriginal communities were deeply distressed and concerned by these deaths and were seeking a meaningful explanation, in particular for the apparent 'suicide' deaths of young people—a phenomenon previously unknown in traditional communities. Suicide deaths in custody anywhere in the world raise suspicions about institutional injustice and possible mistreatment of prisoners—even murder. Such deaths raise multiple issues relating to systems of justice and inprisonment, the link between alcohol and incarceration, and institutionalised racism.

The confrontational and disturbing impact of these deaths was keenly felt by Aboriginal artists, a number of whom had

315. Trevor Nickolls, *Deaths in Custody*, 1990.
Acrylic paint on canvas, 150 x 150 cm.

personal experience of being in custody, or knew of friends or family members who had died or spent much of their lives in custody. Artists like Mitch Dunnet and Michael Naden produced works on the theme of death in custody while themselves incarcerated, and exhibited them while still in prison. Other images have been produced by artists outside the prison system, as an expression of solidarity and protest: examples are found in the work of Robert **Campbell**, Jr, Fiona **Foley**, Trevor **Nickolls**, Arone Raymond **Meeks**, and Danny **Eastwood**. The symbolic power, character, and political currency of specific instances of youth 'suicide' and Indigenous death by hanging, projected in media images, created a highly charged, expressive, and multi-valenced symbolic vehicle which many artists explored. They captured and distilled the injustice of the justice system, the incarceration of a culture, the mix of desperation and defiance, anguish and anger, experienced at some level by both victim and viewer. The nature and circumstances of these deaths, as with their representations, was such as to suggest, rather than confirm, ultimate causes or social meanings. Were they suicide or murder, statement or sentence, symbolic expression or stereotype? And—a vexed question this—were the media images and the artistic response to these deaths themselves contributing to the emergent phenomenon of Aboriginal youth suicide? Did they provide elements of suggestion, identification, martyrdom, and an invitational sense of inevitability and self-fulfilling prophecy for particular viewers?

These images of deaths in custody—which so viscerally express and communicate the collective pain, loss and anger of Aboriginal people—provide a far more coherent, emotionally genuine, and culturally meaningful explanation than the *Final Report* of the Royal Commission and subsequent reviews of the same ilk. The works speak to a shared experience of incarceration, shame, loss, and injustice. They reach back through a devastating 200 years of contact to make cultural connections and continuities. These stark but fluid images seem to occupy a volatile space between art and popular culture, between politics and prejudice. They embody and mirror a strange collision of cultural stereotype and cultural affirmation—a refashioning and reinvesting of another culture's media image and moral tale, into a very different visual recounting and indictment.

These are clearly images for non-Aboriginal as well as Aboriginal audiences—perhaps primarily so. They exist at a complex intersection of texts, images, accounts, representations and meaning systems. In this context, the images become condensed and edited narratives, operating at many levels, offering very different explanations and invitations, and speaking to multiple audiences. And in their refraction through majority culture institutions and consumption practices they acquire greater evocative power, impact, and resonance—both individually and collectively—in Aboriginal communities.

It is likely that the symbolic, complex, and emotionally charged context of 'deaths in custody' will continue to provide a confronting touchstone and mirror to cultural chasms in art, and popular culture representations of Indigenous realities. The irony and continuing injustice of the current situation is that the suicide deaths of young Aboriginal men

and women, in and out of custody, continue at an alarming rate. JR

See also: 11.1; **prison art**; *315.*
Hunter, E., Reser, J. P., Baird, M. & Reser, P., *An Analysis of Suicide in Indigenous Communities of North Queensland: The Historical, Cultural and Symbolic Landscape*, Canberra, 2000; Johnson, E. F., *Royal Commission into Aboriginal Deaths in Custody*, 5 vols, Canberra, 2000.

DHATHANGU, Paddy (*c.*1914–1993), Liyagawumirr (Yolngu) painter, was one of the artists who contributed to the *Aboriginal Memorial*, 1987–88. He speaks of his life:

I was born in the bush on the mainland near Ramingining, maybe near Yathalamarra, near the paperbark inside the bush. I was born there but my country is really Gatatangurr or Gurgangurr and Mirarrmina. That billabong where Wititj is there. That Wititj met those two miyalk [women—the Wagilag Sisters] there; Wititj hunted from there. We went to Milingimbi when I was a little boy, before my dhapi (initiation). There were trepangers working there then. They were white men, not Japanese or Macassan, maybe from Darwin ...

There was no settlement at Milingimbi then and people used to travel around by lipalipa (dugout canoe). Then we saw Mr Webb [the missionary Revd T. T. Webb] come in a big boat [in 1924]. My father came out of the bush to meet them and then all the Yolngu came out of the bush, Mildjingi, Djinang and so on, and they all went to Milingimbi. Milingimbi little town, marrma (two) tin [sheds], a lot of warraw' (lean-tos). Rrulku, [a place on Milingimbi] there was a school and a

316. Paddy Dhathangu, *The Wagilag Sisters Story*, 1983.
Natural pigments on bark, 133 x 60 cm.

church house, and ... I went to school there and had my initiation there nearby a little after. There was a missionary there who taught me how to use a big whip. They speared him you know—it was a Sunday when he got speared. There was a lot of trouble then and my parents took me away from Milingimbi.

After a while we went back and worked with Mr Shepherdson in the gardens they had there, mangoes, coconuts, then when the war came these two Balandas [Mr Sweeney and Bill Harney] took us, Nakarra people, Burrarra people, Blyth River people to Mataranka and Katherine. I was a corporal you know, with stripes on my shirt. I worked near Mindil beach [in Darwin], shifting sand and in the mornings when the sirens would go off and the Japanese would come [overhead]. There was a lot of shooting and they dropped a lot of bombs and we'd all jump into the munatha (sand) until they'd left.

Returning to Milingimbi after the war, Dhathangu lived on the mainland at Gätji and took part in many ceremonies. Some time later he returned again to Milingimbi where he worked in the gardens and painted.

My father taught me to paint. He was one of the first men [to make barks for sale through the mission] ... Later, when they started a garden at Ngangalala I shifted there; this was before Ramingining was built, and did my painting there. When Ramingining was built up I shifted here.

Dhathangu participated in many group shows from the late 1960s onwards, including 'Australian Aboriginal Art' (Chicago 1972), 'Aboriginal Art' (AIATSIS 1984), 'My Country, My Story, My Painting' (NGA 1986), and 'The Continuing Tradition' (NGA 1989). He was a pivotal figure in 'The Painters of the Wagilag Sisters Story' (NGA 1997), and examples of his work are held in the NGA, MCA, most Australian State galleries, and the Holmes à Court Collection, Heytesbury (WA). INTERVIEW BY DjM

Reproduced with permission of the National Gallery of Australia from Caruana, W. & Lendon, N. (eds), *The Painters of the Wagilag Sisters Story 1937–1997*, Canberra, 1997.
See also: 6.3; **Bula'bula Arts**, *316.*
Mundine, D., 'The Land is full of signs', in H. Morphy & M. Smith Boles (eds), *Art from the Land: Dialogues with the Kluge–Ruhe Collection of Australian Aboriginal Art*, Charlottesville, VA, 1999; Museum of Contemporary Art, *The Native Born: Objects and Representations from Ramingining, Arnhem Land*, Sydney, 2000.

didjeridu. In the area of its origin in northern Australia, the didjeridu was probably in use at least 1500 years ago. In that area it was, and still is, used as accompaniment, usually in combination with clap sticks, to singing and dance, in both secular and secret–sacred contexts. There are regional variations in performance styles. In many secret–sacred contexts only men play the didjeridu, although researchers have documented some contemporary secular playing by women. Accomplished players are in demand as valued members of their communities, providing music that links past, present, and future, through religious, spiritual, and social practice.

The didjeridu is an aerophone: the player produces sound by blowing air into the hollow tube while buzzing the lips.

The combination of the resulting fundamental tone and overtones with vocalisations, diaphragmatic movements and continuous 'circular breathing', creates complex sounds and rhythms. In circular breathing. air is inhaled through the nose, while air held in the cheeks is simultaneously expelled into the instrument. In Australia, Indigenous makers usually cut a didjeridu from a termite-bored eucalyptus tree, clean it, and add a beeswax or resin mouthpiece. Decorations are sometimes added and the designs are often similar to those used in body decoration and on hollow log coffins and other ceremonial items. They commonly include inherited totemic symbols, animals, creation beings, and linear patterns such as *rarrk* (cross-hatching).

In recent decades, didjeridu playing has spread to the rest of Australia and has been adopted and adapted by both Aboriginal and non-Aboriginal musicians. It has become an aural and visual national icon and the basis of an international commercial industry. Outside its historic homeland areas it has become a pan-Aboriginal instrument, providing musical accompaniment to public ceremonies such as art exhibitions, graduations, and funerals. It is also an important component of Aboriginal popular music and cultural tourism. Non-Indigenous Australians also use the didjeridu in popular music and contexts of cultural tourism. It appears in film and documentary soundtracks and in advertising campaigns promoting mass tourism and major sporting events such as the Sydney 2000 Olympics.

The didjeridu-making industry encompasses both Indigenous and non-Indigenous producers. Outside Australia, construction materials include plastic pipes, brass, glass, and agave cactus. Didjeridus are sold (sometimes with instructional tapes and videos) directly to tourists, wholesalers, and retailers in Australia or exported to the USA and Europe. The sudden popularity of the instrument has had some adverse effects such as environmental stress through over-demand for the raw material, and the misappropriation of aspects of its use in ritual and ceremony, and of Aboriginal performance styles and songs, and decorative designs. Notwithstanding these challenges, a wide range of didjeridu recordings is now available and the demand for Aboriginal didjeridus, and for performance and teaching by Aboriginal masters of the instrument continues to grow. KN

See also: 15.1, 15.4; David **Blanasi**, David **Hudson**, Richard **Walley**; *191, 196, 330, 351*.
Neuenfeldt, K. (ed.), *The Didjeridu: From Arnhem Land to Internet*, Sydney, 1996.

DJIWADA, Albert, see Yilkari (Tjam) **Kitani.**

DJUKULUL, Dorothy (1942–) Ganalbingu (Yolngu) bark painter, was born into a prominent family of artists which includes her father Dick Ngulmarmar (1911–1979), brothers George **Milpurrurru**, Charlie Djurrutjini, and Jimmy Djelminy (1946–), and sisters, Djelirr (1938–), Elizabeth **Djuttarra**, and Robyn **Djunginy**. Djukulul was one of a small but significant number of young women who were taught to paint by their fathers in the 1960s. She worked as a stockwoman, cook, and labourer, as well as raising a family in the 1960s and 1970s. She married artist Buranday in the 1970s.

After his death she married Djardie Ashley (1950–), himself a painter.

Although influenced by the work of her father and brothers, Djukulul's painting style is formally different. Her imagery refers to ritual body designs. These feature a prominent space in the form of a square, usually black, into which she places images of a variety of beings—*garritjarr* (black-headed python), *biyarri* or *yalman* (water lily), and *garrtjambal* (kangaroo). The square (created by the ancestral dog spirit in the genesis) refers to the beginning of the world manifest as water flowing from a hole in the centre of a sacred rock in the Arafura Swamp (NT). As a body design in sacred ceremony this is an unadorned black space; in paintings for outside audiences, the square contains naturalistic depictions of animals and plants.

Djukulul danced with the Ramingining Performance Group for the 1986 Biennale of Sydney and has exhibited widely, often with her husband Djardie, with whom she has collaborated on several works. Both contributed to the *Aboriginal Memorial* (1987–88). Djukulul has been included in many group exhibitions including 'Aboriginal Women's Exhibition' (AGNSW 1991) and 'Painters of the Wagilag Sisters Story' (NGA 1997). In 1999 she received a Professional Development Grant from the **ATSIAB** of the Australia Council to prepare a body of work. DJM

See also: 6.3; **Bula'bula Arts**; *38, 74.*
Caruana, W. & Lendon, N. (eds), *The Painters of the Wagilag Sisters Story 1937–1997*, Canberra, 1997; Mundine, D. 'The land is full of signs: Central north east Arnhem Land art', in H. Morphy & M. Smith Boles (eds), *Art from the Land: Dialogues with the Kluge–Ruhe Collection of Australian Aboriginal Art*, Charlottesville, VA, 1999.

DJUMBURPUR, Tom (1920–), Wuduminy (Yolngu) bark painter, was born at Djilpin, at the top of the Goyder River in central Arnhem Land (NT). He lived in the area until his parents died in the early 1930s. He then went to live with his uncle nearby, who organised his *dap* (initiation) ceremony at Murrwangi in the heart of the Arafura Swamp. Although the area was, and is, surrounded by cattle stations, he seems never to have been drawn to them. Living on the mainland away from the Milingimbi mission or any other contact with Balanda, Tom never attended school. He lived a traditional life, only occasionally travelling to Milingimbi to sell crocodile skins. He attended his first Gunapipi ceremony at Djilpin—his birthplace—as a young man. He is recorded in one of Donald Thomson's classic 'goose hunter' photographs in the 1930s poling a stringybark canoe through the swamp to collect magpie goose eggs. Djumburpur has thirteen children. He and his wife, painter Clara Wubugwubuk (1950–), were recorded by anthropologist Nicolas Peterson as living at Mirrngatja on the eastern edge of the Arafura Swamp in the mid to late 1960s.

Taught to paint by his 'second' father, Charlie Warrgirr, Djumburpur has never been a 'star' painter in the public domain, although his name has always been on discerning collectors' lists. His work shows two distinct styles. One verges on the abstract, being based on traditional body designs concerning the Wägilak sisters story, where the sheet

of bark is often tapered like a shield. His other style features monumental and highly animated images of fauna, also related to the Wägilak narrative. He was one of the artists who contributed to the *Aboriginal Memorial*, 1987–88.

DjM

See also: 6.3; Robyn **Djunginy**; *38, 74.*

Caruana, W. & Lendon, N. (eds), *The Painters of the Wagilag Sisters Story 1937–1997*, Canberra, 1997; Mundine, D. 'The land is full of signs: Central north east Arnhem Land art', in H. Morphy & M. Smith Boles (eds), *Art from the Land: Dialogues with the Kluge–Ruhe Collection of Australian Aboriginal Art*, Charlottesville, VA, 1999.

DJUNGINY, Robyn (1947–), Ganalbingu (Yolngu) painter and fibre artist. Bottles with lids are everyday items, often overlooked. But when the bottles are Robyn Djunginy's the attention of the viewer becomes sharply focused. Bottles with no glass, twined from dyed pandanus, contrast with the basic forms of Arnhem Land baskets. The first, in the shape of a gin bottle, led to a series of bottle forms which were included in an exhibition of work from Mulgurram, where Djunginy then lived with her husband Tom **Djumburpur.** This exhibition, shown at the George Paton Gallery in Melbourne in 1983, was the beginning of Djunginy's professional practice.

It is not surprising that Robyn Djunginy is such an accomplished painter and fibre artist: she comes from a family of artists. Her brother George **Milpurrurru** was a renowned painter, her sister Dorothy **Djukulul** is also a bark painter, and her other sister, Elizabeth **Djuttarra**, is famous for her twined mats. Djunginy and her sisters are able to draw on the heritage of their mother's group, the Marrangu Djinang, who have strong connections to the water goanna and honey ancestors. Her work in painting and fibre-bottle forms, displayed in the 1998 Biennale of Sydney refers to a site of the honey ancestors near the airstrip at Ramingining.

Djunginy continues to employ the bottle form as well as water goannas in her work, which is held in the collections of NGA, MCA and the Holmes à Court Collection, Heytesbury (WA). She was one of the artists who contributed to the *Aboriginal Memorial*, 1987–88.

LH

See also: 6.3, 17.1; **Bula'bula Arts;** *38, 74, 210.*

Watkins, J. (ed.), *Every Day: The 11th Biennale of Sydney*, Sydney, 1998; Mundine, D. 'The land is full of signs: Central north east Arnhem Land art', in H. Morphy & M. Smith Boles (eds), *Art from the Land: Dialogues with the Kluge–Ruhe Collection of Australian Aboriginal Art*, Charlottesville, VA, 1999.

DJUTTARRA, Elizabeth (1942–), Ganalbingu (Yolngu) fibre artist, lives and works at **Ramingining** in central Arnhem Land (NT). She was born at nearby Djapididjapin waterhole and moved to the offshore Methodist mission on Milingimbi in the Crocodile Islands. Here she attended school, married and raised a family. She worked in the mission gardens, the preschool and the clinic before becoming a full-time weaver from the 1970s.

Traditional fibre practice has undergone many changes since contact with the Europeans. In 1929 the 'flat' mats first began to be produced in the Milingimbi region. Prior to this all mats were of a conical shape and were used to sit on, and under. Both styles of mat have connections with the major narrative cycles of the region. Djuttarra is one of a significant number of women in the community who is equally adept in traditional weaving forms and in recent innovatory forms. In her early years, her work was influenced by Trudy Marpundharr, an innovative weaver, a few years her senior. In later years she has maintained a strong working relationship with Nellie Ngarri'thun (1925–).

Djuttarra was a contributor to the *Aboriginal Memorial*, 1987–88. She left the Northern Territory for the first time in 1992, on a trip to Melbourne, when she won the VicHealth National Craft Award. Her conical mats appeared in the 1998 Biennale of Sydney.

DjM

See also: 6.2, 6.3, 17.1; **art awards and prizes, Bula'bula Arts,** Dorothy **Djukulul**, Robyn **Djunginy**, George **Milpurrurru**; *38, 74, 160.*

Watkins, J. (ed.), *Every Day: The 11th Biennale of Sydney*, Sydney, 1998.

DODO, 'Big' John (*c.*1910–) Karajarri sculptor, was born at Yilila near old Bohemia station about 32 kilometres east of the present Bidyadanga community (formerly LaGrange mission) and 186 kilometres south of Broome (WA). He is the senior elder of the Karajarri tribe. An experienced stockman, he worked on surrounding stations for many years till he finally retired to live with his family at Bidyadanga.

He first displayed his innate artistic ability in the 1960s by crafting heads out of mud and wood. It was then suggested he try stone as a medium. The results were so impressive that he was asked if he would craft a stone head of Christ for the mission church, using as his model the head outlined in the shroud of Turin. It was suggested he would encircle the head with a crown of thorns. The head has been placed above the tabernacle in the church.

In about 1984, Alistair, Lord McAlpine came to visit the mission. He was shown the head, met John Dodo and commissioned him to make one in stone. Thus began a friendship between Dodo and 'Mr Calpine' which lasted many years. Other commissions followed and he was joined by members of his family in crafting heads of stone.

The stone from which the heads were made comes from Mt Phyre (Payarr) a hillock about 96 kilometres south of Bidyadanga. Around the hillock pieces of stone lie scattered in great numbers. John Dodo has told the following story of how they got there:

A family from ancestral times … were hunting near Eighty Mile Beach, or Mt Payarr. The young son killed a female goanna heavy with eggs and ate them—an act which was taboo. This angered Pulanj, the rainbow serpent, who sought revenge first by unleashing violent storms and then by setting out to devour the boy. However the boy's father was a medicine man and had the power to seal the cave in which his family took refuge to withstand repeated attacks by the serpent. Enraged and with gaping jaws it attacked the mountain itself, biting off

large chunks of rock. This continued throughout the night whilst the petrified family huddled inside. Finally, at dawn, the Serpent withdrew and the rain stopped.

It is from these scattered chunks of rock that John Dodo carves the face of the 'doctor man' of Mt Payarr. His work has been included in a number of significant group exhibitions including 'The Continuing Tradition' (NGA 1989) and 'Paper, Stone, Tin' (Tandanya 1990). Examples of his carvings can be seen in the NGA, AGNSW and the Berndt Museum of Anthroplogy at UWA. KMcK

See also: 10.2; *132.*

Neale, M., *Yiribana: An Introduction to the Aboriginal and Torres Strait Islander Collection*, Sydney, 1994.

DORRNG, Micky (*c.*1940–), Liyagawumirr–Buyu'yukulmirr (Yolngu) bark painter. Dorrng's clan estate is located inland from Howard Island in north central Arnhem Land (NT), around a set of sacred freshwater springs created by the Djang'kawu ancestors. In his early years Dorrng worked as a fisherman operating out of Galiwin'ku (**Elcho Island**) Methodist mission on Yolngu-owned fishing boats. He contracted leprosy and was treated at East Arm Quarantine Station in Darwin.

Dorrng's art centres on the ancestral Djang'kawu who came to Gärriyak (on the Hutchinson Strait) and who created and gave the Buyu'yukulmirr people their *madayin* (sacred objects), songs, dance, and *rom* (Law). He rarely painted commercially until 1990, when he made a major breakthrough in painting the Djang'kawu sacred design using stripes of red, yellow, and white to create powerful, esoteric images, of a type not seen in public contexts before. He continues to invent variations on these designs, on bark and on hollow log coffins. Later in the 1990s he began to experiment with painting on canvas and paper.

Dorrng has exhibited widely in group exhibitions and held solo shows at private galleries. He was selected to participate in 'Australian Perspecta' (AGNSW 1993). As part of the 'Yolngu Science' exhibition (MCA 2000), he painted his *djirrdidi* (kingfisher body design) directly onto the walls of two rooms of the gallery space. This sacred design is normally painted on the bodies of participants and sacred objects in religious rituals connected to the Djang'kawu sisters story. Dorrng's work is held in the NGA, MCA and a number of State gallery collections. DjM

See also: 6.2; *73.*

Caruana, W., 'Wägilak and Djang'kawu: Ancestral paintings in the public domain', in H. Morphy & M. Smith Boles (eds), *Art from the Land: Dialogues with the Kluge–Ruhe Collection of Australian Aboriginal Art*, Charlottesville, VA, 1999; Museum of Contemporary Art, *The Native Born: Objects and Representations from Ramingining, Arnhem Land*, Sydney, 2000.

DOWLING, Julie (1969–), Yamatji–Badimaya visual artist, was raised in Perth in a strongly matriarchal family, and was the first Aboriginal woman to graduate from Fine Arts Painting at Curtin University. She is connected through her mother's family to the Yamatji–Badimaya people of central Western Australia. She and her twin sister Carol are fair-skinned, and Dowling has commented that they were considered the 'great white hope for the family'.

Dowling, who is primarily a portrait painter, has been painting and drawing since childhood. Her self-portraits explore the paradox of looking white yet being Aboriginal and the dualism of her Catholic upbringing and her Aboriginal culture. Defining her feelings of guilt, fear, confusion, and anger, her portraits are powerful and often confrontational. They combine two traditions: Renaissance art (in their stance and realism) and the Aboriginal oral tradition of story telling through which the artist records the history of her family. Her paintings individualise her subjects, their history, stories, triumphs, and suffering. With the exception of a series of paintings with black backgrounds, her portraits are surrounded by layers of symbols and images drawn from Catholic iconography, text, archival photographs, and Aboriginal motifs, dots, and patterning. This layering of images refers back to the art of her own people—to the sand drawings and cave paintings which were regularly repainted at ceremonial events. Julie Dowling's work honours and celebrates her family and community as survivors of Australian colonial history.

Dowling's work has been included in a number of significant group exhibitions including, 'Read My Lips' (FAC 1997), 'Daughters of the Dreaming' (AGWA 1997), and 'Beyond the Pale' (AGSA 2000). Examples of her work are held at the AGWA, the Kerry Stokes Collection, Perth and the Kelton Foundation, USA. AA

See also: 12.1; **family history**; *24.*

Croft, B. L. (ed.), *Beyond the Pale: Contemporary Indigenous Art*, Adelaide, 2000; Herriman, A., 'An Urban Aboriginal Artist and Her Sense of Family', *Periphery*, no. 28, 1996; Oakes, C., 'Julie Dowling: Cultural Communion', *Artlink*, vol. 15, nos 2–3, 1995; Ryan, L., 'Grandmother's Mob and the Stories', *Artlink*, vol. 18, no. 1, 1998.

DOWNS, Jarinyanu David (*c.*1925–1995), Wangka-junga–Walmajarri painter, printmaker, and preacher. In Jarinyanu's art, ancestral beings mostly appear as real personalities in tableaux representing episodes in story-cycles: they are explicitly human images that seize the imagination. No other Kimberley artist has combined figurative talent with a genius for theatrical revelation in quite this way. His inspiration derived from experience with traditional ceremony, and a deep involvement with Christianity which, he believed, protected him from any malign consequences in making such revelations of the sacred.

Jarinyanu was born in the Great Sandy Desert (WA), and lived a traditional life until his early manhood. He moved north some time in the late 1940s to join relatives, and for the next twenty years he drove cattle or mined for gold around Halls Creek, participating in seasonal ceremonies. Finally he settled at Christmas Creek station and started a family. Around 1965 Jarinyanu converted to Baptist Christianity, which preached the wholesale denunciation of traditional Law and ceremony. Shortly afterwards he moved his family into the mission at Go Go station and then to Fitzroy Cross-

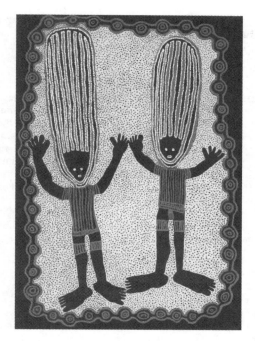

317. Jarinyanu David Downs, *Minijartu*, 1988.
Natural pigments and acrylic on linen, 152 x 106 cm.
This painting represents two lizard men from the Ngarrangkarni (Dreaming) with striped body-paint designs called *purnarra*.

ing, where he became a church elder. These changes drew Jarinyanu into the power structure of the mission, positioning him in oppositon to his older brothers and the authority structure inherent in Aboriginal Law. Later, he discerned resonances between biblical events and traditional story-cycles, and propounded linkages between the two systems, in effect fashioning his own personal cosmology. Being both a traditional Lawman and church elder, Jarinyanu felt authorised to paint both Ngarrangkarni (**Dreaming**) and Bible stories.

From the late 1960s Jarinyanu made shields, **boomerangs** and coolamons covered with incised designs and ochres. In the early 1980s he began painting figurative works on paper, shields, and canvas boards, using **ochres** and gum-resin adhesive. From the mid 1980s, he painted on stretched and unstretched canvas, using **acrylic** paints with ochres and gum adhesive. For his church he produced works which included Christian images. From the beginning of 1987 he painted for the fine art market, working in Fitzroy Crossing (WA) and Adelaide. Jarinyanu signed the reverse side or (rarely) the face of early paintings 'David Downs' or 'Jarinyanu'. He finally joined these into 'Jarinyanu David Downs', following the sequence these names were bestowed. 'Name from mother—"Jarinyanu"—from beginning! He gotta go front. And Kartiya (white) name after—"David Downs".'

Jarinyanu's images reveal the vision of a religious artist preaching the oneness of man. His paintings are auth-orised by sung verses from Ngarrangkarni story-cycles, by references to the Bible, and by personal experiences, with symbols and ideas from all these sources fusing together. Jarinyanu's

abiding concern was to transform society into a coherent unity—expressed in his simply stated conviction, 'Gotta make-em whole lot one family.' His work is held in the NGA and most State galleries. He has been represented in many group exhibitions including 'Aboriginal Art and Spirituality' (HCA 1991), 'Crossroads' (Kyoto and Tokyo 1995) and 'Images of Power' (NGV 1993). DK

See also: 1.1, 1.2, 10.2; *35, 317*.
Kentish, D., 'Jarinyanu David Downs', in A. M. Brody (ed.), *Stories: Eleven Aboriginal Artists*, Roseville East, NSW, 1997; Kentish, D., Downs, J. D., & von Sturmer, J., *You listen me!—An Angry Love: Writings in Honour of Jarinyanu David Downs on the Occasion of Southern Explorations, an Exhibition of his Paintings*, North Adelaide, 1995.

Dreaming can refer to three different, though closely related, aspects of Aboriginal culture. The best known usage is linked to the idea of the 'Dreaming' (synonymous with the 'Dream-time'), which usually refers to an archaic, but eternal, time of ancestral creation. Closely connected to this is the idea of 'Dreamings', which is used when referring to particular ancestral stories, totems, or any physical manifestations of these. Finally, 'dreaming' retains its usual English meaning with reference to nocturnal visions. The development of 'Dreaming' and 'Dreamings' as English glosses for Aboriginal concepts took the normal English meaning as its starting point. They have since gained some currency in both Aboriginal and non-Aboriginal communities.

The anthropologist Baldwin Spencer provided the first written record of the 'Dreamtime' in 1896. In central Australia, he said, Aboriginal morality 'is governed by rules of conduct [that come from] the "Alcheringa", which Mr [Frank] Gillen [then postmaster of the Alice Springs Telegraph Station and Spencer's collaborator] has aptly called the "Dream times".' Some doubt was cast on this being a correct translation of the Arrernte term 'Alcheringa', which prompted Spencer to write in 1927 that, in his and Gillen's experience:

ceremonies [are] all connected with the doings of the far past ancestors and the mythic times in which they lived. These mythic times ... were continually spoken of as Alchera ... The word Alchera was always ... used in reference to past times during which the ancestors of the different totemic groups ... lived and wandered over the country. In the ordinary language of today Alchera is used also for 'dream': to dream is alcherama—that is, to see a dream. As indicating a past period of a very vague and, as it seemed to us, 'dreamy' nature we adopted, to express as nearly as possible the meaning of the word alcheringa (alchera, a dream, and ringa, a suffix meaning 'of' or 'belonging to'), the term 'dream-times'.

This translation was readily received into Australian English and was then generalised to all Aboriginal religions as the 'Dreamtime' or the 'Dreaming'.

Many Aboriginal and non-Aboriginal people use the Dreaming to signify the ancestral creative period spoken of by Spencer, although it is often now stressed that it is not solely a thing of the past. Rather, it is the continuing origins of all

things, which makes it eternal in character (hence Strehlow gives alternative translations for 'Alcheringa': 'out of all eternity', 'from all eternity', and 'ever from the very beginning'). On the other hand, **Aboriginal English** tends not to favour the 'Dreaming' or the 'Dreamtime', preferring instead the term 'Dreamings'. In this sense, *a* Dreaming is any particular ancestral being, the story which recounts that being's actions, or the sacred objects, designs, and sites in the landscape which those actions brought about. A person usually speaks of their Dreamings, rather than the Dreaming as such. In as much as Aboriginal people seek to express a general form for the many and varied Dreamings that make up their worlds, they tend to speak of the Law, stressing the fact that the ancestors created a universe of rules and regulations—a kind of socio-political constitution. This perhaps supports T. G. H. Strehlow's contention that: 'The English 'dream time' is … a vague and inaccurate phrase; and though it has gained widespread currency among white Australians through its sentimentality and its suggestion of mysticism, it has never had any real meaning for the natives, who rarely, if ever, use it when speaking in English.'

While some Aboriginal languages are similar to Arrernte in making a linguistic connection between dreaming and the transcendental powers of ancestral beings, others do not. Also, while many Aboriginal groups see dreaming as a mode of ancestral revelation, so that new religious ceremonies and songs can be formulated through recollections and re-enactments of dream events, only some dreams are truly revelatory in this sense. Generally speaking, Aboriginal people draw a distinction between 'ordinary' and 'extraordinary' dreams. While the former are widely used in the diagnosis of events, only the latter deliver privileged contact with the ancestors.

Given that the Dreaming is such an inadequate translation of the idea of transcendental power in Aboriginal societies, it is worth asking why it has proved so popular in Australia and the wider world. Much hinges on the way in which Aboriginal people have been, and continue to be, consistently constructed as 'other' to an allegedly rational Western self, so that ideas that portray Aborigines as steeped in mysticism are readily acceptable to the popular imagination. The Dreaming strongly suggests that Aboriginal worlds are ruled by dreams rather than by reason. Time and time again, Aborigines are spoken of as if they dwell in the Dreamtime, or used to dwell there before Europeans came to interrupt their slumber. This mystical association can be viewed positively or negatively: Aboriginal people have been romanticised and celebrated in terms of their deep spirituality, but they have also been denigrated for being primitive and childlike. Either way, the Dreaming is largely, if not exclusively, a shadow that others have cast upon them.

JOM

See also: 1.1; **Aboriginality**; **anthropology**.
Spencer, W. B., 'Through Larapinta Land', in W. B. Spencer (ed.), *Report on the Work of the Horn Scientific Expedition to Central Australia*, Part 1, Melbourne, 1896; Spencer, W. B. & Gillen, F. J., *The Arunta: A Study of a Stone Age People*, 2 vols, London, 1927; Strehlow, T.G.H., *Songs of Central Australia*, Sydney, 1971; Wolfe, P. 'On being woken up: The Dreamtime in anthropology and in Australian settler culture', *Comparative Studies in Society and History* no. 33, 1991.

dress, see 17.5

E

EASTWOOD, Danny, see cartoonists.

EBATARINJA, Cordula (1919–1973), Western Arrernte watercolour painter, was born at Hermannsburg Lutheran mission (Ntaria), daughter of Hezekiel and Julia (Julanta) Malbunka. She was the first Arrernte woman to take up painting and exhibit as part of the Hermannsburg School of watercolour artists. Both her parents died before she was six years old, and she was raised by her uncle the renowned painter Albert **Namatjira**, and his wife Rubuntja.

It was not until she was thirty-one years old and married to another watercolour painter, Walter Ebatarinja (1915–1968), that she was persuaded by Namatjira to begin painting. By then she already had six children to care for (three more were to follow). Thereafter she painted regularly, and both of her sons—Joshua (1940–1973) and Desmond (1946–)—became painters.

Ebatarinja's work was exhibited along with that of other Arrernte watercolourists at Anthony Hordern's Gallery in Sydney, in 1952 and 1954. In July 1957 she featured in an article in *Woman's Day* magazine titled 'The Female Namatjira', which laid emphasis on the purchase of one of her paintings by Prince Philip at the Melbourne Olympic Village in 1956.

Ebatarinja is especially noted for the inclusion of figures—especially women and children—in her watercolour landscapes, and for her portraits. She and her husband did little painting after Albert Namatjira died in 1959, preferring to work for their community. HRM & JVSM

See also: 9.1; *113*.
Hardy, J., Megaw, J. V. S. & Megaw, M. R. (eds), *The Heritage of Namatjira*, Melbourne, 1992; Kerr, J. (ed.), *Heritage: The National Women's Art Book*, Roseville East, NSW, 1995.

education, see 3.1, 5.2, 6.5, 11.5, 13.3, 13.4, 13.5, 15.4, 23.1.

EDWARDS, Agnes (Aggie) (1873–1928), Wati Wati, maker of feather flowers, embroidery, and works in fibre and leather. For Aboriginal people in Swan Hill (Vic.) Aggie Edwards is 'a very important lady'. She was born at Mellool station, twenty kilometres south of Swan Hill (Vic.). At twenty she married Harry Edwards from the nearby Muti Muti group, and they lived at Nesbitt's Estate, several miles downstream from Swan Hill on the Murray River. Agnes Edwards attracted attention following her introduction to Governor Hopetoun in the 1890s. At her death in 1928, her status was such that the Australian Natives Association erected a memorial in the Swan Hill cemetery, eulogising her as the 'Last Queen of the Moolpa Tribe'.

After her husband's death in 1912, Agnes Edward lived independently on land formerly owned by her people. She fulfilled an important role as a midwife for the Aboriginal and non-Aboriginal community, supplementing her income by selling fish, eggs, rabbits, rabbit skins and wool collected from barbed wire fences. In her own lifetime she gained renown for the skilfully crafted objects she produced: feather lures, feather flowers, embroidery, rush baskets, and small draw-string purses made from the skin of water rats. Despite her position on the fringe of society, she maintained a circle of friends among women from the wider community, repaying their hospitality with gifts of produce and feather flowers.
SK

Penney, J., 'Queen Aggie: The last of her tribe', in M. Lake & F. Kelly (eds), *Double Time: Women in Victoria—150 years*, Ringwood, Vic., 1985.

Elcho Island was named for Lord Elcho, a British Naval Commander who had distinguished himself in the Caribbean. The name is serendipitously appropriate, for it sounds to Yolngu like an abbreviation for Galiwin'ku—the name of the island's major settlement—which honours the parrot fish, a significant ancestral being for the island's Dhuwa moiety land owners, the Liyagawumirr and Gunbirrtji.

The largest Aboriginal community in north-east Arnhem Land, Galiwin'ku was established as a Methodist mission in 1942. In 1974, in accordance with changing policies in Aboriginal affairs, the church withdrew and Yolngu took control of the administration. Situated by a lone hilltop (the eagle's nest in Yolngu mythology), Galiwin'ku is home to approximately 1500 out of a total Yolngu population of around 5000. The traditional land owners share their country with eleven closely related groups whose territories lie in the immediate vicinity of the island.

Galiwin'ku is known internationally for two reasons: the richness of the Yolngu cultural heritage, and the touring Aboriginal 'Black Crusade'. Many of Elcho Island's most revered traditional artists are also church leaders. Two events crystallised this coming together of an alien religion and the Yolngu world view: the 'adjustment movement' of 1957, and the later Christian revival. The 'Elcho Island Memorial' is a collection of carved and painted wooden posts on the beach at Galiwin'ku. Representing many **language** groups in north-eastern Arnhem Land, it was once arguably the best known and most photographed image in Australian Aboriginal art. Erected in 1957 as the culmination of efforts to reconcile Indigenous beliefs and practices with developments that were taking place on Yolngu land, the Memorial featured formerly concealed sacred emblems. One incorporated a Christian cross.

While the principal artists of this unique and influential beachside sculpture are no longer living, their descendants and close associates have gone on to become noted Arnhem Land artists. Gälpu leader John **Mandjuwi**, Warramiri elder George Liwukang Bukulatjpi (*c.*1927–), Gumatj artist Charlie Matjuwi Burarrwanga, and the Liyagawumirr and Galiwin'ku traditional owner, the late Micky Daypurryun (1929–1994), for instance, all have bark and canvas paintings in Australia's foremost museums and galleries. While Liwukang often lived in the shadow of his older brother, political strategist and 'adjustment movement' instigator David Burrumarra, he has distinguished himself through breathtaking depictions of Yirritja moiety and Warramiri aquatic **Dreamings**. Images of the ancestral whale, octopus, and flying fox contrast starkly with the land-based 'freshwater' images that feature so prominently in the works of Dhuwa moiety leaders Daypurryun and Mandjuwi. While these elders also draw inspiration from a bounteous cultural heritage, there is no overlap in iconography or style. Mandjuwi and Daypurryun both look to the legacy of the Djang'kawu ancestral beings as subject matter, but at the level of clan group, different motifs predominate. The rainbow serpent and yam often characterise Gälpu paintings, whereas the goanna and mudcrab are key symbols for the Liyagawumirr.

The work of Elcho Island artists continues to feature in contemporary art circles. In addition to **bark painting** Elcho Island is renowned for its sculpture and fibre art. IMcI

See also: 1.2, 1.4, 6.2, 6.4; Elsie **Milindirri**; *7, 75, 77*.
References: Berndt, R. M., *An Adjustment Movement in Arnhem Land, Northern Territory of Australia*, Paris, 1962.

emu eggs. The art of carving emu eggs became popular in the late nineteenth century both among Aboriginal artists and in the wider community. Various tools, including a pocket knife (or scalpel) and a file or emery board, are used to incise designs into the hard, layered and granulated surface of the egg, the colour of which may vary from grey to blue or green, depending on the bird's diet. Frequently the finished art work is mounted on a stand, together with miniature weapons, to form a decorative tableau. Subject matter typically centres around landscapes and flora and fauna, but earlier examples include Christian themes, events

from colonial history such as the landing of Captain Cook, and international events such as the world wars and the visits of royalty. Historically, it is possible to distinguish regionally distinctive styles. Amongst the Paakantji of far western New South Wales, the work of the contemporary artist Bluey Roberts (1948–), who carves away the background to create a positive bas-relief, follows the style established by earlier Paakandji artists such as Harry Mitchell and his family. More commonly, artists create a brilliant, cameo-like illusion of reality by carving through several layers to reveal the almost white shell beneath. The contemporary work of Esther Kirby (1950–), a Wiradjuri artist, reflects a more expressive style.

During the twentieth century the craft declined in popularity: eggs were protected by legislation, and only Aboriginal people continued to produce carved emu eggs as gifts and to supplement their income. Recently, carved and painted emu eggs have again become more popular with the commercial development of emu farms. SK

See also 11.1; Badger **Bates, boab nuts**; *141, 318*.
Ioannou, N., 'Bluey Roberts', *Artlink*, vol. 10, nos 1 & 2, 1990.

ERLIKILYIKA (Jim Kite) (*c.*1865–*c.*1945), Southern Arrernte sculptor, painter, and ethnographer, became the first recognised central Australian artist. Originally from Charlotte Waters, he worked in his youth for the staff of the Overland Telegraph Line. He excelled at tracking horses, and came to know the country from Oodnadatta to Tennant Creek. He was proficient in the Arrernte dialects, in English, and in Kaytej. This knowledge was of great assistance to the scientist Baldwin Spencer and ethnographer Frank Gillen, for whom he acted as guide and interpreter during their expedition of 1901–02.

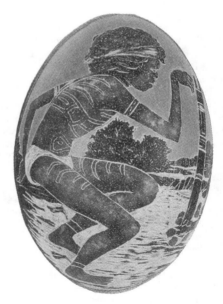

318. Esther Kirby, *A hunter on one side, and mother and child on the other,* 1985.
Carved emu egg 13.1 x 9.1 cm

A report in the *Register* (SA) on 18 July 1913 reads in part:

In an upstairs room at the Selborne Hotel I saw ... perhaps a score of valuable and diversified creations of ... extraordinary intellect ... I saw marsupial rats with life so realistically suggested that they appeared to be scampering away among the undergrowth or poised tense for attack ... Jim Kite's graphic knife had carved birds with such delicacy of form and such a superb sense of rhythm that they might have been flying in the trees ... and perhaps caught and imprisoned in kaolin.

By the 1890s Jim Kite, as he was widely known, was recognised for his carvings in pipeclay and, less often, in wood. His works were in local demand among telegraph-station and cattle-station hands. Over the next four decades they were acquired by collectors for the South Australian and Victorian museums, by increasing numbers of visitors to central Australia, and by many people in Adelaide when he resided there for a time.

Different collectors wanted different kinds of art. Many locals appreciated pipes with bowls carved in eagle-claw, horse-hoof, or busty women's shapes; decorative walking sticks were another favourite. Frieze-like works on slabs of pipeclay, and carvings in soft stone of wonderful likenesses of native animals were among the items collected by museums. Some were delicately painted using natural dyes and, later, manufactured paints. In Adelaide a favourite item was a cup-and-saucer set with naturalistic depictions of a hen and her chicks.

Gillen encouraged Erlikilyika to sketch in his 1901–02 journal and in at least one other sketchbook for his children. His naturalistic sketches of people, animals, and ritual activity give a sense of alertness, movement, and celebration, and

at times show fine details of foreground and background vegetation. A surviving sketchbook shows both young and mature trees, with particular emphasis on leaf-shape, upper branch form, patterning of bark, and occasionally fruit or galls. These sketches, which are stylised and naturalistic at the same time, appear to have been executed at a later date than the drawings in Gillen's diary; river red gums, ghost gums, and ironwood are among the identifiable trees. Erlikilyika remained a master artist for at least forty years.

RGK

See also: *319*.

Gillen, F. J., *Gillen's Diary: The Camp Jottings of F. J. Gillen on the Spencer and Gillen Expedition across Australia, 1901–1902*, Adelaide, 1968; Kimber, R. G., 'Erlikilyika', in D. Carment, R. Maynard, & A. Powell (eds), *Northern Territory Dictionary of Biography*, vol. 1, Darwin, 1990; Morphy, H., *Aboriginal Art*, London, 1998; Sayers, A., *Aboriginal Artists of the Nineteenth Century*, Melbourne, 1994.

Ernabella Arts Inc. Ernabella, or Pukatja, is a community of Pitjantjatjara and Yankunytjatjara speakers (who refer to themselves as Anangu) at the eastern end of the Musgrave Ranges in north-western South Australia. On a scientific expedition in 1933 anthropologist N. B. Tindale visited the area, and provided brown paper and coloured crayons, as well as clay, to people camped there. The resulting art works, held by the South Australian Museum, represent the first body of work by Anangu in those new media.

In 1937 Scottish surgeon Charles Duguid arranged the purchase of a sheep station to establish a Presbyterian mission. Ernabella was to be a place of non-coercive adaptation where the Indigenous culture, including language, religious beliefs, marriage customs, and ceremonial life, was to be respected and 'used' to facilitate the running of the station, preparation for life as members of the Australian nation state. Ernabella never had a dormitory, and the Anangu camps were on the other side of the creek, away from the white mission staff dwellings. In this way, a degree of privacy could be maintained for both parties. People came together for work.

The idea of producing marketable art and craft was conceived as a means to create a source of income for the mission, and as an occupation for the women that would allow for the continuation of existing cultural practices. The design for which Ernabella became famous originated in the early drawing classes of the mission school, opened in 1940. There, without having been given instruction, the children used coloured crayons to produce patterns on paper that displayed a striking stylistic coherence. This was noted by visiting anthropologist C. P. Mountford who arranged for Ernabella's men, women, and children to produce over 650 works, now held at the SLSA, Adelaide.

The handcraft industry for women was established in January 1949 after Mary Bennett, on a visit from Kalgoorlie, suggested that locally produced wool be spun, dyed, and woven into marketable items. Anangu women already spun rabbit fur and human hair, and Bennett showed them how to transfer the technique to wool. Another visitor, Lillian Muller, introduced the making of sea-grass baskets. Bennett, a school

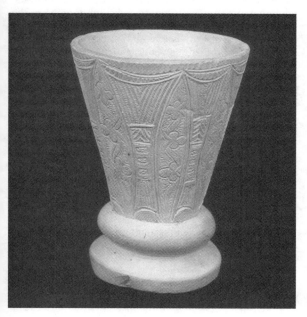

319. Meerschaum vase carved by Erlikilyika (Jimmy Kite) in 1922, at Charlotte Waters (SA).
16 x 11.5 cm

teacher from Adelaide, became Ernabella's first official craft adviser. After work at school in the morning, she organised handcraft for women and teenage girls in the afternoon. Her aim was to find a meaningful occupation for girls who had been through school and who were no longer used to a life in the bush. Craft production soon involved women and girls from three generations: the older women spun the wool out in the open at their fireplaces, the school leavers and middle-aged women wove on looms in and near the craft shed, and the schoolchildren provided the designs.

In 1950 the painting of greeting cards for sale began, with five young women painting on a voluntary basis. These cards have been partially preserved in the Enid Bowden Memorial Collection (NGV). The women also started to knit woollen jumpers. However, these were frequently unravelled by the men, who used the wool for headbands, signalling their status as initiated men. In 1951, Aboriginal women's work from Ernabella and from Mornington Island, another Presbyterian mission station, was exhibited in the assembly hall of the Australian Aboriginal Mission Auxiliary, Melbourne. Winifred Hilliard took over as craft adviser for Ernabella in 1954; she was to stay for thirty-two years. During the 1960s a number of other communities were established in the area. The women who moved to these new centres—Fregon and Amata in 1961, Indulkana in 1968—or to cattle stations owned by white pastoralists where Anangu had been working for decades, brought designs from Ernabella with them: 'Ernabella is the place number one, then we showed the Fregon women how to do it.'

From 1963 woven floor rugs incorporating Ernabella design were produced, and painted moccasins were sewn from kangaroo skin for tourists. A price list from Erna-bella Mission Handcrafts of the late 1960s lists floor rugs, knee rugs, scarves, cushion covers, spun wool, and spinning sticks. The designs appear on wall hangings, silk scarves, cards, gift tags, bookmarks, picture frames and pictures for framing. In 1971 New York artist Leo Brereton visited Ernabella for a month and taught the dyeing of **batik**. Since then, artists from Ernabella have travelled to Jogjakarta in Indonesia to further their studies at the Batik Research Centre and the Brahma Tirta Sari Workshop. They have also held workshops in other Aboriginal women's centres, including **Utopia**. In the mid 1980s women and some men began to paint in **acrylic** and gouache on canvas in the so-called dot-painting style. They explain that they have learnt the visual iconography needed to depict stories about ancestral creator beings and narratives about everyday life from other Aboriginal groups in central Australia.

The 1970s had been a decade of pervasive changes, culminating in the 1981 *Pitjantjatjara Land Rights Act* under which an area of 103 000 square kilometres came under freehold title. The church withdrew from the administration of the community during 1971 and 1972. The rapid structural and material changes that resulted had far-reaching consequences; within months an Indigenous council was formed, housing was provided for Anangu, Toyota vehicles were bought, and a new and lasting source of income was implemented with the Community Development and Employment Program (CDEP). The sheep industry had collapsed, and the craft centre, supported by CDEP, became the main employer in the community. Importantly, the women's art association has been operating independently from any other organisation in the community since it was first incorporated in 1974 as Ernabella and Fregon Arts Inc., changing to Ernabella Arts Inc. in the following year. Since 1971 production has concentrated on batik, the medium in which the Ernabella women artists have excelled. UE

See also: 9.5, 17.5; Nyukana **Baker**, Alison **Carroll**, **child art**, Atipalku **Intjalki**, Angkuna **Kulyuru**, Yipati **Kuyata**, Tjunkaya and Kanngitja **Tapaya**.

Eickelkamp, U. (ed.), *'Don't Ask for Stories': The Women of Ernabella and Their Art*, Canberra, 1999; Hilliard, W., *The People in Between: The Pitjantjatjara People of Ernabella*, New York, 1968; Partos, L. (ed.), *Warka Irititja Munu Kuwari Kutu (Work from the Past and Present): A Celebration of Fifty Years of Ernabella Arts*, Ernabella, SA, 1998.

exhibitions. 'Fifteen to twenty years ago few of us would have envisaged this meteoric rise in popularity, within Australia and overseas', wrote Ronald Berndt in 1964. He was particularly interested in the number of then recent, large institutional exhibitions of Aboriginal art. He cited five over a fifteen year period, culminating in 'Australian Aboriginal Art' which had toured State galleries around Australia during 1960 and 1961. Berndt's words are again wholly appropriate for describing the recent exhibition history of Aboriginal art. It is now impossible to make a list that is both brief and comprehensive; this short account will discuss a representative selection of significant moments.

Berndt was writing at a particular turning point: 'Australian Aboriginal Art' was a significant development in the exhibition of Aboriginal art in Australia. It was organised by Tony Tuckson, an artist and Deputy Director at AGNSW, who was particularly influential in shifting the exhibition of Aboriginal art from ethnographic museums to art galleries. Tuckson had first become interested in Aboriginal art as 'art' after seeing 'Arnhem Land Art', an exhibition selected by Ronald and Catherine Berndt, at the David Jones Art Gallery in Sydney in 1949; and regarded as a landmark for its attribution of the creation of works to individual artists. Tuckson's innovations at AGNSW included the exhibition of seventeen Melville Island grave posts in 1959. and culminated in the exhibition 'Aboriginal and Melanesian Art' in 1973.

The interplay between the work of anthropologists and the interests of artists, art historians, and curators is central to the development of exhibitions of Aboriginal art. The work of both groups has been transformed through this interplay, along with the shift in interpretation of Aboriginal art that they have brought about. Key moments in this development pivot on how and why Aboriginal art objects are valued in particular contexts.

Before the Berndt–Tuckson innovations Aboriginal art was exhibited either as a curiosity or under the rubric of 'primitive art', a reflection of the then current evolutionary social paradigm in which Indigenous works of art were considered to be 'less evolved' than Western art and the artists were viewed as anonymous producers bound by an

unchanging tradition. The first exhibition of Aboriginal art, 'The Dawn of Art', was held in the late 1880s, where figurative paintings and drawings by inmates and staff of Palmerston prison (Darwin) were shown as curiosities. 'Australian Aboriginal Art' (NMV 1929), regarded as the first major exhibition of Aboriginal art in Australia, showed the results of collecting by Baldwin Spencer in 1912. And Aboriginal art was prominent in the 'Primitive Art' exhibition (NGV and NMV 1943), which was a survey exhibition of indigenous art from around the globe.

Following the 1973 AGNSW exhibition, the next important set of exhibitions occurred at the end of the 1970s and into the 1980s. They included 'Aboriginal Australia' (AGDC and NGV 1981–82) and 'Art and Land' (SAM, 1986). For these exhibitions, anthropologists worked with the host institutions to deepen and develop the sense of Aboriginal art *as* art. During this time controversies developed over the inclusion of Aboriginal art in art-gallery contexts, and particularly in the context of contemporary art exhibitions. A related debate concerned just what kinds of Aboriginal art might be appropriate and even 'authentic' enough to include in such exhibitions. **Bark paintings** by David **Malangi**, Bungawuy, and George **Milpurrurru** were represented in the Biennale of Sydney, a survey exhibition of international contemporary art, for the first time in 1979 and performance and sand sculpture by Warlpiri people from Lajamanu was included in 1982. In 1988 it was the venue for the first exhibition of the *Aboriginal Memorial*—perhaps its most significant contribution to date. The inaugural 'Australian Perspecta' exhibition of 1981, a survey of contemporary Australian art, included Western Desert **acrylic paintings** on canvas by Clifford **Possum Tjapaltjarri**, Tim **Leura Tjapaltjarri** and Charlie Tjapangarti. 'Australian Perspecta 83' included the work of Arnhem Land artists in the form of bark paintings and other objects by David Malangi, photographs by Jimmy Barnabu, and work by a group of five artists (Joe Djimbungu, Jimmy Moduk, Ray Munyal, Andrew Marrgululu, and Don Gundinga) catalogued under the name *Guku* (honey).

By the late 1980s the rise to prominence of Western Desert acrylic painting was a particular feature of the extremely influential 'Dreamings' exhibition (New York, Chicago, Los Angeles, Adelaide, 1988–89). It became the focus of a heated debate over the relationship of the institutional success of Aboriginal art to Aboriginal political struggles in other areas. At this time an international group exhibition of particular significance, 'Magiciens de la terre' (Paris 1989), a survey of contemporary 'Western art' alongside a broad survey of non-Western and indigenous art from around the world included work of artists from **Yuendumu** and Arnhem Land.

In the 1990s international exhibitions of note included 'Aratjara' (Düsseldorf, London, and Humlebaek 1993– 94), a comprehensive survey exhibition significant for the even value it gave to a broad range of art, including work by urban Indigenous artists. Small groups of Aboriginal artists have twice exhibited at the Australian Pavilion at the Venice Biennale: in 1990 **Rover Thomas** and Trevor **Nickolls** (AGWA), and in 1997 Emily Kame **Kngwarreye**, Yvonne **Koolmatrie**, and Judy **Watson**, under the title 'fluent' (AGNSW).

The 1990s also saw the first retrospective of an individual Aboriginal artist at a major public gallery, 'The Art of George Milpurrurru' (NGA 1993). This was followed by 'Roads Cross: The Paintings of Rover Thomas' (NGA 1994). To date the most significant single artist show has been the extremely successful 'Emily Kame Kngwarreye—Alhalkere: Paintings from Utopia' (QAG 1998).

'The Painters of the Wagilag Sisters Story 1937–1997', (NGA 1997) set the current high-water mark for exhibitions of Aboriginal art in a number of respects: in the extensive consultation with artists and owners, in the display of the work with particular concern for clan and group relationships, and in the emphasis on diversity and development within tradition. GB

See also: 6.3, 21.1, 22.1, 22.6; **art awards and prizes**; *255, 256, 257, 271.*

Berndt, R. M. (ed.), *Australian Aboriginal Art*, Sydney, 1964; Mundine, J., 'Ramingining artists community: Aboriginal Memorial', in Biennale of Sydney, *From the Southern Cross: A View of World Art, c.1940–88*, Sydney, 1988; Sutton, P. (ed.), *Dreamings: The Art of Aboriginal Australia*, New York & Ringwood, Vic., 1988; Caruana, W. & Lendon, N. (eds), *The Painters of the Wagilag Sisters Story 1937–1977*, Canberra, 1997.

F

family history. By the late nineteenth and early twentieth centuries, Australian Indigenous people were marginalised in the white Australian account of the continent's **history**. Anthropologists, missionaries, and historians seldom mentioned the names of Indigenous individuals in their writing. Warriors from the past slipped into oblivion, occasionally referred to in a settler's diary, missionary's note, or explorer's report. The names of Indigenous people who worked for settlers and squatters were not recorded in most cases. As a result, scattered archival sources—church records, and documents housed in historical societies and country libraries—often provide the only chance an Indigenous person has to find information on their heritage before 1880.

In the late 1970s **AIATSIS** took a major step that was to redress this situation through the establishment of an Aboriginal biographical index, later to become the core of its Family History Unit. In the years that followed, some major sources were indexed, for example *Dawn Magazine* and *New Dawn Magazine*, which were popular Indigenous periodicals in the 1950s, 1960s and 1970s. These included photographs taken by Aboriginal Welfare Board photographers, and news stories from around New South Wales. Also indexed were the quarterly *Identity*, and missionary magazines such as *Australian Evangel, The Lutheran,* and the *Australian Board of Missions Review,* that recorded births, deaths and marriages, along with news stories, from all States and territories.

The index was originally a name list intended to assist academic researchers using the AIATSIS library's collection. However, there was a change of focus during the Australian bicentenary (1988) in response to the growing demands of Indigenous people for information on their own heritage; the success of the **referendum of 1967** had been a stimulus to people to reclaim their heritage and identity. The library actively sought new acquisitions as a growing number of Indigenous writers published their stories.

The Aboriginal biographical index was formally reconstituted as the Family History Unit in 1978. Following the inquiry into the **stolen generations**, demands on the unit increased further still. Registrations of births, deaths and marriages from each State and Territory were added to the rapidly growing family history collection. Although registrations for Indigenous people are more likely to be found in the twentieth century, early registrations do exist, especially for people who lived in the more populated areas of the country. Maori registrations have also been added, and the interaction between the two countries can be traced through surname lists. Lists of blanket distributions, which occurred on the King's birthday each year from the 1820s to the twentieth century, have been added. Also included in the unit's holdings are Aboriginal Protection Board minute books, which can help to place a person in an area and establish a starting point for inquiry.

The unit faced a number of problems in trying to assist people to trace their heritage. The use of European names to record Indigenous people as well as the policy of exemptions (introduced in the twentieth century) created considerable gaps in the record. Exemptions were given to Indigenous people who applied and who met assimilation criteria. An exemption certificate allowed an Indigenous person to live in town, and their children to go to the town school. A man could drink in a hotel and earn a wage equal to that of Europeans. In order to receive these benefits, an exempted person had to cut all ties with their Indigenous relations, causing major breaks in family networks which now impede heritage tracing.

As the demand for knowing and belonging continues, the Family History Unit will increase its networks and resources, and continue to add entries to its biographical index. In 1999, the unit received funding from **ATSIC**'s 'Bringing Them Home' task force to extend its service to support Link Up, a service that seeks to reunite people of the stolen generations with their living relatives. As a result, the unit organises workshops on tracing family history for Indigenous people doing research on their own heritage. Workshops have been run both within the unit and in many areas across Australia. They have helped people understand the potential of the existing records and the seemingly endless list of places to do research. KS

See also: **life stories.**

Taylor, P., *Telling It Like It Is: A Guide to Making Aboriginal and Torres Strait Islander History,* Canberra, 1992.

Far North Queensland Institute of TAFE. The contemporary Aboriginal and Torres Strait Islander art of north Queensland has received growing recognition within Aus-

tralia's Indigenous arts community. The staff and students of the Arts and Cultural Centre of the Far North Queensland Institute of TAFE (FNQIT) (formerly the Cairns College of TAFE) have been instrumental in the instruction, production and promotion of Indigenous art in the region.

Since the school opened in 1984 non-Indigenous art teachers and Indigenous elders and artists, including **Thancoupie** (Gloria Fletcher) and Arone Raymond **Meeks**, have instructed students in the techniques of **batik**, silk-screening, painting, ceramics, sculpture and **printmaking**. Printmaking, in particular, has been a key focus of activity at the school and under the direction of Anna Eglitis the students of the centre were among the earliest collectives of Indigenous artists specialising in this medium. The strong emphasis on printmaking has led to the production of richly textured and boldly designed images, evident in the works of Pooraar Bevan Hayward, Zane **Saunders**, **Jenuarrie** and Heather **Walker**.

In addition to the technical skills of art education the school offers a variety of units such as marketing, financial management and presentation techniques which are intended to provide students with the knowledge to manage their own art career. There is formal education in Indigenous art history and students are encouraged to develop their own artistic identity through an appreciation of their cultural heritage and the long history of Indigenous visual culture.

Early on in the history of the school the artistic direction of the students was fuelled by an enthusiasm for the rock art of far north Queensland. Annual excursions to Laura and Stanley Island gave students an opportunity to study, draw and photograph the traditional rock art of these areas. Students began to translate this rock art influence—the textures of the rock, the depth and layering of superimposed pigments and the distinctive shapes of the stencils and figurative forms—through a variety of contemporary art media. This work came to characterise the early Cairns TAFE 'style'.

The referential nature of this artistic approach was later criticised by some as culturally inappropriate borrowing of traditional imagery. It could be argued, however, that the students were engaged in a post-modern art practice, innovatively reinventing traditional Indigenous themes within a contemporary Western art practice. Nevertheless this critique came at a time when the central debate of Indigenous art circles revolved around issues of 'authenticity', 'appropriation', 'tradition' and 'innovation'. Historians, curators, collectors, critics and anthropologists of Indigenous art were concerned with identifying and contrasting the attributes of art generated within urban and outback contexts of production. There was considerably less interest in artwork which appeared to transgress or dissolve this dichotomy, such as that being produced at the innovative TAFE school.

This experience was instructive for the students and staff of the school and they are now operating from a position more informed by the complexities and sensitivities of cultural production. An Aboriginal and Torres Strait Islander Community Advisory Board (CAB) consisting of Indigenous artists, curators, teachers and elders plays an important role in the school's educational approach. The CAB work in conjunction with community elders to oversee the arts curriculum and activities to ensure that arts training is delivered

in culturally appropriate and effective ways. An awareness and commitment to cultural issues has become a key strength of the school's approach to arts education and has contributed to the development of a range of new courses and arts initiatives throughout the region, including the delivery of arts training to remote communities.

Through the implementation of video conferencing, online training and short-term residential courses, in coordination with local elders, FNQIT currently facilitates the development of arts education in a number of remote communities throughout Cape York, including the **Lockhart River** Community, Mornington Island and the Lotus Glen Correctional Centre.

At Lockhart River, the resources and teaching skills of FNQIT staff have been successfully combined with the knowledge and experience of local elders to produce an arts movement that is directed, generated, and managed by the community. This has had the effect of establishing strong cultural foundations for the local art practice, and has also reinforced the cultural links between the visual arts, music, dance and **language** within the community. Another arts development course delivered through FNQIT is the Inside Art Out Pilot Program within the Lotus Glen Correctional Centre. The program aims at assisting artist–inmates in their self-expression, and empowering them to become actively involved in the instruction, production, management and exhibition of their own art.

The distinctive influence of traditional themes, cultural objects and the natural environment continues to resonate throughout FNQIT. In recent years the art emerging from the Cairns campus has reflected the growing Torres Strait Islander presence. Prints, fabrics, and paintings link figurative representations of sea life enmeshed within a dense plane of intricate lines. The forms, patterns and raw materials displayed in these works evoke a continuity with the strong wood engraving, plaiting and sculptural traditions of the Torres Strait. Tatipai Barsa, Dennis **Nona**, Harry Nona, and Alick **Tipoti** are some of the students who have incorporated the myths and experiences of island life into print and painted works. The art of other students, for example Brian **Robinson** and Ken Thaiday, Jr, possess a more sculptural quality often combining wood, paint and other media in their constructions.

Many of the FNQIT students have gone on to develop professional careers in arts, some as practising artists, curators, arts administrators and teachers. Their success and the growing interest in the school is proof of the merits of balancing artistic experimentation with the enduring elements of an individual's personal and cultural history. The unique and transformative history of the FNQIT is clearly represented through the wealth and diversity of artistic expression with which it is associated, and also through an expanding network of individuals and communities working towards personal and community arts development.

UF

See also: Ken **Thaiday, Sr.**

Eglitis, A., 'A new art from the Torres Strait Islands', in T. Mosby with B. Robinson, *Ilan Pasin (This is Our Way): Torres Strait Art*, Caairns, 1998.

Federal Council for Advancement of Aborigines and Torres Strait Islanders (FCAATSI). Perth poet and playwright, Jack **Davis**, said that FCAATSI 'was able to bring together Aborigines from across Australia to discuss and formulate policies that would eventually have far-reaching effects on the Australian Aboriginal scene'.

The council began (as FCAA) at a small Adelaide conference in February 1958. Five general principles were agreed to as a basis for action: equal citizenship rights, good standards for health and housing, equal pay for equal work, free and compulsory education, and the retention of all reserve lands in Aboriginal ownership. FCAATSI campaigned for a national referendum to change the Commonwealth Constitution so as to include Aborigines in the national census, and for the Commonwealth government to be responsible for Aboriginal and Torres Strait Islander affairs. This was achieved on 27 May 1967, with a 90.77 per cent 'Yes' vote.

By 1967, FCAATSI was calling for Indigenous peoples to be recognised as distinct cultural groups, with their own customs, laws, and languages. Through annual conferences, held throughout Australia, campaigns were mounted for **land rights** (at Mapoon, **Yirrkala**, and Daguragu), equal wages, improved health, education, and housing, and the removal of legal discrimination. Initially, non-Indigenous people such as Dr Charles Duguid (the first president), Shirley Andrews, Stan Davey (general secretary), and Gordon Bryant, MP, were most active, and occupied official postions in what was a national, multiracial coordinating body, but Indigenous leaders, such as long-time president Joe McGinness, Faith Bandler, and Oodgeroo **Noonuccal** soon became prominent.

After the **referendum of 1967**, the influence of Indigenous people within the organisation increased, but other Indigenous political organisations also emerged. These began to deal with issues initially raised by FCAATSI, which was disbanded in 1978. JAH

FENCER, Lorna Napurrurla (Yulyulu) (*c.*1925–), Warlpiri painter, expresses her inner experience of Warlpiri culture, **Dreaming**, and country through her paintings. Born at Yarturlu Yarturlu, near the Granites mine in the Tanami Desert (NT), she is custodian for the sacred country of Yumurrupar and for the *luju* (caterpillar) and *yarla* (bush potato) Dreamings associated with this site. She has ancestral rights over seed, bush tomato, and plum Dreamings for the Napurrurla–Japurrurla, and Jakamarra–Nakamarra skin groups.

Napurrurla Fencer held her first solo exhibition at Alcaston Gallery in Melbourne in 1997, and subsequently has had solo exhibitions there annually. She has also participated in numerous group exhibitions at the **Warnayaka Art Centre**, where she is a member of the artist's cooperative. In 1997 Napurrurla won the Conrad Jupiters Art prize at the GCCAG for her *Yarla Dreaming,* 1996. Her contribution to contemporary Australian art was recognised in 1998 when she was invited to participate in the triennial John McCaughey Memorial Art Award at the NGV.

Napurrurla Fencer's use of paint differs from that of her peers at Lajamanu. She opts for striking and bold colours, constantly manipulating and reinventing her art through her application of colour. In her *Caterpillar Dreamings,* for example, she creates a flowered effect by applying pressure to her brush, forcing the bristles to fan out. Her diversion from the standard dotting infill can most readily be seen in her *Yarla Dreamings,* where the gestural brush strokes produce an effect of movement and fluidity. VMcR

See also: **art awards and prizes.**
Glowczewski, B., *Yapa: Peintres Aborigènes de Balgo et Lajamanu,* Paris, 1991.

festivals. Little attention has been paid to Aboriginal involvement in festivals, either in the historical or the contemporary context. Yet even during the protectionist era, while confined to missions and government reserves, Aboriginal peoples not only participated in festivals of various kinds—sports carnivals, rodeos, fairs, fetes, and Christian feast days—on the reserves, but also contributed to celebrations of the general community. For example, Aborigines sometimes competed at local eisteddfods, and dance troupes from the reserves performed regularly at annual agricultural shows held in urban and rural centres across the country. Such events provided Aboriginal people with the opportunity to stage their own 'fringe festivals'. For example, in north Queensland people would gather at the Mareeba rodeo, not just to compete in the rodeo itself, but also to meet for **corroboree**. Aboriginal peoples not only seized the opportunity to socialise with friends and relatives from whom they had been forcibly separated by the reserve system, but also embraced the performative potential of such festivals for political engagement with settler society.

Aboriginal peoples have contributed to many celebrations of Australian nationhood. Participation in festivals commemorating European colonisation, like the ceremonial performances by the Ngarrindjeri on the Murray River at the Sturt Re-enactment, and the theatrical performance, 'An Aboriginal Moomba', during the Jubilee celebrations of the State of Victoria in 1951, are examples of the 'creative response of Aborigines operating within the opportunities and limitations imposed by an assimilationist regime' (Kleinert 1999).

Today, festivals are a burgeoning phenomenon in Australia, partly due to support from the federal government under the Festivals Australia cultural grant program which 'provides assistance to regional and community Australian festivals for the presentation of quality cultural activities'. The grants awarded under this scheme are a good indicator of the increasing significance of Aboriginal art and culture in Australian identity politics. It is clear that Australian festivals provide an avenue for the expression and representation of Aboriginal culture. Yet, they do more than this. They are culturally situated performance events that allow Aboriginal peoples a means of political and economic engagement in both local and international arenas. Festivals involving Aboriginal peoples at the international level include such events as the Commonwealth and Olympic games, World Expositions, and Indigenous festivals such as the Festival of Pacific Arts and the Ainu Mosiri Festival, Japan.

Festivals are politically significant, and they may be repudiated as well as supported. Many Aborigines organised protest demonstrations at Australian bicentenary events

fiction

staged around the country in 1988, while others chose to participate in, rather than protest against, commemorative performances, recognising that performance itself may provide a powerful means of political interaction.

Festivals are generative of symbols of identity and difference that may be contested and negotiated. This is most clearly in evidence at festivals that celebrate 'New Age' values, for example ConFest, facilitated by the Victorian Down to Earth Co-operative, and the Woodford (formerly Maleny) Folk Festival in Queensland. Here Aborigines confront the appropriation of Indigenous cultural elements for use in the construction of alternative lifeworlds and environmentalist and youth subcultures. The Fire Event, performed on New Year's Eve at the 1999 Woodford Folk Festival, was one of Australia's contributions to the millennial celebrations televised internationally.

Festivals such as Woodford nevertheless provide an avenue for Aboriginal peoples to engage positively with the New Age movement. Although they are sites where Indigenous cultures are being appropriated, New Age agendas can also be pressed into the service of Aboriginal interests. The idea of 'traditional' culture has become a useful tool by which Aboriginal peoples can assert rights in the contemporary context of nation-state and inter-national politics.

As well as contributing to general community festivals, Aboriginal peoples are increasingly staging their own cultural festivals. These are not just displays of traditional culture; they are also celebrations of contemporary Aboriginal identities. They include various Christian Church events, music festivals, and sports carnivals such as the Yuendumu Sports Weekend in Central Australia, which began as an **Australian Rules football** carnival in 1963 but has since expanded to include many other cultural activities. Two other festivals of this type are the Barunga Sports and Cultural Festival, which takes place annually in a small Abori-ginal community near Katherine (NT), and the Laura Aboriginal Dance and Cultural Festival in Cape York (Qld). As well as highlighting traditional dance, music, and visual arts, these festivals also celebrate contemporary Aboriginality by showcasing a range of performance genres featuring Aboriginal artists. Concerts billing Aboriginal rock, reggae, blues, and **country and western** bands, among others, are popular events.

Aboriginal peoples, therefore, see festivals as an opportunity to display cultural vitality. Festivals provide them with an avenue for presenting their art and culture, but are also a means to a political engagement; they allow Aboriginal people to make themselves present to the world and to challenge a history which had rendered them absent.

RH

See also: 15.2, 16.4; history, Survival Day.
Barlow, A, 'Festivals', in G. Beed Davey & G. Seal (eds), *The Oxford Companion to Australian Folklore*, Melbourne, 1993; Henry, R., 'Performing place: Staging identity with the Kuranda amphitheatre', *Australian Journal of Anthropology*, vol. 10, no. 3, 1999; Kleinert, S., 'An Aboriginal Moomba: Remaking history', *Continuum: Journal of Media & Cultural Studies*, vol. 13, no. 3, 1999; Lewis, J. L. & Dowsey-Magog, P., 'The Maleny Fire Event: Rehearsals toward neo-liminality', *Australian Journal of Anthropology*, vol. 4, no. 3, 1993.

fibre-work, see 6.2, 8.1, 17.1, 17.2, 17.3, 17.4.

fiction. In the 1994 *Encyclopaedia of Aboriginal Australia*, an entry on novels listed only four authors: **Mudrooroo**, Archie Weller, Sam Watson, and Faith Bandler. Robert **Bropho**'s *Fringedweller* (1980) was mentioned, although it is not a novel, presumably to expand the entry. It is indicative of the richness of contemporary Aboriginal writing that a similar entry written today needs to cover much more ground.

Without doubt Mudrooroo and Weller were pioneers in the field. Mudrooroo (as Colin Johnson) is credited with the first Aboriginal novel, *Wild Cat Falling* (1965), and he has written eight further novels. They are complex and challenging—he has moved through a series of increasingly daring and unconventional works. He has consistently revisited his own texts, creating in the process complex narratives which undermine the traditional notion of how novels conventionally function. *Wild Cat Falling* was rewritten as *Doin' Wildcat* (1988) and then again as *Wildcat Screaming* (1992). *Doctor Wooreddy's Prescription for Enduring the Ending of the World* (1983) is loosely reconfigured as *Master of the Ghost Dreaming* (1991), which itself generated two sequels, *The Undying* (1998) and *Underground* (1999). In this series, readers were shown the unreliability of the historicising process not simply through Mudrooroo's blistering rendition of George Augustus Robinson's diaries, but also through his demonstration of how the account of colonial history and the genocide of the Tasmanian Aborigines could be deconstructed and retold.

Archie Weller's promising first novel *Day of the Dog* (1981), which was shortlisted for the *Australian*–Vogel award, and his superb collection of stories *Going Home* (1986) were followed by his 1998 futurist fantasy *Land of the Golden Clouds*. The publishers describe it as a cross between *Lord of the Rings* and *Watership Down*—mainstream publishers often attempt to articulate Aboriginal texts through European genealogies. This is an Aboriginal **Dreamtime** narrative set 3000 years in the future, a novel which rewrites notions of nomadism and solidarity, and even of genre fiction itself.

Both Mudrooroo and Weller have been the subject of sustained campaigns to question their Aboriginality. That such attacks are always turned towards established figures seems significant. The extent to which both men were socialised as Aboriginal, and have worked to define and express important dimensions of Aboriginal experience, should be kept in mind when judging the value of *ad hominem* attacks on their integrity.

Three other pioneering novels were Faith Bandler's *Wacvie* (1977) and *Welou, My Brother* (1984), and Monica Clare's *Karobran: The Story of an Aboriginal Girl* (1978)—possibly the first novel written by an Aboriginal woman. Although straightforward in style and technique, these books are important cultural markers: they tread the thin line between autobiographical, political, and fictional retellings.

The significant rise in the number of novels by Indigenous authors is certainly due in part to the efforts of the University of Queensland Press (QUP) and the success of the David **Unaipon** Award for Aboriginal and Torres Strait Islander

587

writers. Winners have included *Caprice: A Stockman's Daughter* (1991) by Doris Pilkington (Nugi Garimara), Philip McLaren's *Sweet Water—Stolen Land* (1993), John Muk Muk Burke's *Bridge of Triangles* (1994), and Steven McCarthy's *Black Angels—Red Blood* (1998). QUP's Black Australian Writers series has also published other novelists such as the remarkable Melissa Lucashenko, whose first novel, *Steam Pigs* (1997), won the Dobbie Award for women's fiction. Both this and her later novel, *Hard Yards* (1999), are characterised by tough, believable characters, and a dynamic use of idiom (which also describes her award-winning work for young readers, *Killing Darcy,* 1998)

Two other novels of note are Eric Willmot's *Pemulwuy: The Rainbow Warrior* (1987) and Sam Watson's *The Kadaitcha Sung* (1990). Watson's book is extraordinary for its frenetic narrative. In *The Kadaitcha Sung* the South Land has been devastatingly plundered and corrupted, and Aboriginal and non-Aboriginal people share in the villainy which such transgression generates. *Pemulwuy* is a more conventional though no less compelling historical novel, retelling the life and struggle of Pemulwuy against the British from 1788 until 1802.

Perhaps the most exciting voice in recent Aboriginal fiction is that of Kim Scott, a descendant of the Nyungah people. In 1993 he published *True Country*, which charts the important movement of a young Aboriginal man back to his heritage. His second book, *Benang: From the Heart* (1999), examines, in a unique and darkly comic way, the troubling question of 'half-caste' existence, and the white government's long-standing policies to breed out Aboriginal peoples.

The list of texts and authors presented above is not exhaustive. Aboriginal authors continue to write dynamic and challenging texts, often deliberately confounding expectations, so that their works do not fit comfortably into a single category. Other texts rewrite established genres, Aboriginalising and destabilising European categories. Philip McLaren's crime novels *Scream Black Murder* (1995) and *Lightning Mine* (1999), for example, like Mudrooroo's *The Kwinkwan* (1993) or Weller's *Land of the Golden Clouds*, have the potential to redefine, rather than reconfirm, European modes and forms. GT

See also: 14.1, 14.2; **life stories, poetry.**

Glass, C. & Weller, A. (eds), *Us Fellas: An Anthology of Aboriginal Writing*, Perth, 1987; Mudrooroo, *Milli Milli Wangka = The Indigenous Literature of Australia*, South Melbourne, 1997.

film, see 13.1.

Fitzroy Crossing artists, see Mangkaja.

flags, Aboriginal and Torres Strait Islander. The Aboriginal flag was designed in 1971 by Harold Thomas, a Luritja man and graduate of the South Australian School of Art. He was inspired to create the flag in July 1970, after attending a protest march in Adelaide, where he was struck by the fact that Indigenous people had no symbol of their own around which they could rally. His first design used **ochre** colours but he decided red, black, and yellow would be more eye-catching at protests. The colours of the flag are symbolic. The large yellow sphere in the centre represents the sun, the giver of all life. Black represents Aboriginal people, while the red of the flag represents the earth, the spiritual relationship of Aboriginal people with the land, and the blood of Aboriginal people shed at the hands of white invaders.

The flag was first flown on National Aborigines Day in July 1971 in Adelaide's Victoria Square. In 1972, when Aboriginal protesters and their supporters erected and defended the **Tent Embassy** outside Parliament House in Canberra, they chose Thomas's design from several others as the symbol of their movement. In 1987 NAIDOC honoured Thomas for creating the flag, but his authorship of the design (and hence **copyright**) was not accepted in the Federal Court until 1997, after white producers had profited from sale of the flag for over twenty-five years.

Since the Tent Embassy, Aboriginal people have continually harnessed the potency of the flag as a symbol of Aboriginal resistance and pride, perhaps most famously in 1994 when Cathy Freeman draped it around her shoulders as she ran her victory lap at the Commonwealth Games in Canada. In recent years, some Aboriginal cooperatives and land councils have incorporated the flag and its colours into logos to reflect their own distinctive identities while still referencing a common Aboriginal identity. In 1987 Harold Thomas was reported to say, in the *National Aboriginal Day Magazine*, that: 'It is a great joy to me that the flag has been adopted by Aboriginal people as their symbol ... It is the most powerful symbol in my life, and there is no greater reward than the fact that it is flying at Uluru, in the heart of Australia, where my people come from.'

The green, blue, white, and black flag of the Torres Strait was designed by fifteen-year-old Bernard Namok, and accepted in 1992 by the Island Coordinating Council on behalf of all Torres Strait Islanders. The green of the flag represents the land and the white *dari~dhoeri* (head-dress) symbolises all Torres Strait Islander people. As in the Aboriginal flag, black represents the people and the white, five-pointed star symbolises the five island groups: the Eastern Islands; Western Islands; Central Islands; the group consisting of Waiben (Thursday Island), Ngurupai (Horn Island), Muralag (Prince of Wales Island) and Kiriri (Hammond Island); and the northern peninsula area of Queensland, home of mainland Torres Strait Islanders. The white of the *dari* and of the star represents peace. The star itself is an important symbol for a seafaring people, who rely on the stars for navigation, as is the colour blue, representing the sea. The flag stands for the unity and identity of all Torres Strait Islanders and was first flown at the Torres Strait Cultural Festival at Thursday Island in May 1992.

The Aboriginal and Torres Strait Island flags have provided a focus for activism and for new art. In 1987 artist Tracey **Moffatt** was arrested after a confrontation with a white historian who had arranged for the Aboriginal flag to be flown without Aboriginal permission from the rigging of one of the ships in a First Fleet re-enactment flotilla. In 1994 **Boomalli Aboriginal Artists Co-operative** organised the touring exhibition 'True Colours: Aboriginal and Torres Strait Islanders Raise the Flag' (London, Liverpool, and Leicester 1994). LR

See also: 12.1, 20.2; **Survival Day;** *281.*

FLETCHER, Gloria, see **Thancoupie.**

FOGARTY, Lionel George (1958–), Wakka Wakka poet and activist, was born and grew up at Cherbourg Reserve, near Murgon, in southern Queensland, and attended high school in Murgon. Despite the detribalising and dehumanising effects of life at Cherbourg, he was able to learn from some of the elders there about Wakka Wakka **language** and culture. Fogarty himself is now one of the most important guardians of Wakka Wakka cultural traditions.

Fogarty left the reserve for Brisbane and in the early 1970s, with Sam Watson and Dennis Walker, became one of the young leaders of radical Aboriginal protest. He was charged with conspiracy, imprisoned in 1974, and later acquitted. He has been active in many Aboriginal causes, from setting up legal and health services to education and cultural issues. As a performer of poetry he has also worked with the Warumpi band and Bart Willoughby. The death of his brother, Daniel Yock, a gifted young Aboriginal dancer, in the back of a police van in Brisbane in 1993, re-ignited his campaign against racism and violence in Australia.

Fogarty published his first book of poems, *Kargun*, in 1980, with Cheryl Buchanan. Since then he has published another six collections of **poetry**, *Yoogum Yoogum* (1982), *Murrie Coo-ee* (1983), *Kudjela* (1983), *Ngutji* (1984), *Jagera* (1990) and *New and Selected Poems* (1995). His book for children, *Booyooburra* (1993), a spiritual story of the Wakka Wakka people at Barambah, written out of a desire to teach about his culture, is illustrated by Sharon Hodgson, a descendant of the Wiradjuri people. His poetry draws on the rhetoric of protest, but it has also opened up a wholly new and distinctive space for black Australian writing. PM

See also: 14.1.

FOLEY, Fiona (1964–), Badtjala visual artist, activist, curator, and writer. Through her art, Fiona Foley attempts to reassert the culture and history of the Badtjala people following their forced removal from Thoorgine (Fraser Island) and integration into the white community at the turn of the twentieth century. Born in Maryborough (Qld), she was raised on Fraser Island, as well as in the nearby town of Hervey Bay. While studying art at East Sydney Technical College in the early 1980s, Foley first experimented with Aboriginal motifs: 'I made some etchings with designs from Arnhem Land, but when I pulled the prints off the plate I realised the imagery had nothing to do with me. I then understood I had to be true to my own culture, even if the remnants were scant, in order to articulate my Aboriginal identity and ancestry.'

Since that time, Foley has gained international recognition for her brilliant pastels on paper as well as her intelligent and often humorous political photographs, prints, and installations. Many of her pastels draw on the distinctive fauna and flora of Fraser Island. Others recount personal experiences, family stories, and legends, or reinterpret historical events, as in her 1991–92 series on Eliza Fraser (the English woman shipwrecked on the island in 1836). Her photographs and installations are often based on the physical remnants of Badtjala culture, most of which are now held in museums. A photo-

graph from Brisbane's John Oxley Library of an unknown woman from Fraser Island formed the inspiration for her series of photos titled *Native Blood*, 1994. 'Lick My Black Art' (ACCA 1993) was a solo exhibition that dealt with issues of colonialism and its impact on Indigenous Australians.

Foley has also completed several important commissions, including a mural for the Darwin Post Office under the direction of Paddy **Dhathangu** in 1990, a collaborative installation with Janet Laurence, *Edge of the Trees*, 1994–95 at the Museum of Sydney, and *Lie of the Land*, 1997, a temporary installation outside Melbourne Town Hall concerned with the treaty signed between the Aboriginal people of Melbourne and John Batman in 1835. In 1999 she produced six designs for the pavement of Brisbane's City Mall. She is represented internationally and in Australian national and State galleries, museums and university collections.

Foley has also had a significant impact as a curator and as an advocate for Aboriginal rights. She was a founding member of **Boomalli Aboriginal Artists Co-operative,** and has served on the Visual Arts and Aboriginal and Torres Strait Islander Arts Boards of the Australia Council, and on the board of directors of Bangarra Dance Theatre. With Djon Mundine, she co-curated two major Aboriginal art exhibitions, 'Tyerabarrbowaryaou' (MCA 1992) and 'Tyerabarrbowaryaou II' (MCA 1994) which was also exhibited in Havana. Foley's work has been included in over fifty group exhibitions in Australia and overseas. In 1997 she and other members of her family spearheaded a **native title** claim for clan land on Fraser Island. BG

See also: 12.1, 22.4, 23.3; 2, 63, 164.
Koop, S., 'Fiona Foley: Bare bones', *Art AsiaPacific*, no. 22, June 1999; Foley, F., 'A blast from the past', in I. McNiven, L. Russell, & K. Schaffer (eds), *Constructions of Colonialism: Perspectives on Eliza Fraser's Shipwreck*, London, 1998; Oguibe, O., 'Medium and memory in the art of Fiona Foley', *Third Text*, no. 33, 1995–96; Losche, D., 'Reinventing the Nude: Fiona Foley's museology', in J. Kerr & J. Holder (eds), *Past Present: The National Women's Art Anthology*, Sydney, 1999.

football, see **Australian Rules football, rugby league.**

FORDHAM, Paddy, see **Wainburranga.**

Freedom Ride. A bus journey by approximately thirty students from the University of Sydney to protest against racial discrimination in New South Wales country towns has gone down in history as the Freedom Ride. It began on 12 February 1965 and ended two weeks later. Self-consciously based on freedom rides in the American South of the previous two years, it aimed to publicise the continuing prevalence of racial discrimination even after many of its legislative supports had been removed in the early 1960s. The participants also aimed to survey conditions on reserves and in towns. A leading figure in the Freedom Ride was Charles Perkins, the first Aboriginal student at the university; the other twenty-nine students were non-Indigenous, from a variety of political and class backgrounds. The Freedom Ride was strongly supported by the Reverend Ted Noffs, a mentor and supporter of Charles Perkins.

The bus travelled through Orange, Wellington, and Gulargambone. On 15 February the students demonstrated against racial segregation in the Walgett RSL club, where not even Aboriginal ex-servicemen were allowed membership. After the protest the bus was run off the road by angry white townsfolk, a threatening act that drew substantial media attention. It took another six years, however, before the Walgett RSL admitted Aboriginal members. In Moree, the students drew attention to the exclusion of Aboriginal people (except school children on formal school excursions) from the swimming pool and bore baths. After a large public meeting and demonstration, they left town thinking they had gained an agreement that the pool be desegregated. On hearing that Aboriginal children were still being denied access, they returned several days later, on 20 February. Hundreds of townsfolk came to the pool to oppose the students, and there were some violent clashes, in an ugly atmosphere. Eventually, the students left with a promise that the pool would be desegregated, which happened some months later. **Media** coverage of this event was extensive—on **television** and **radio**, and in the newspapers. The students also demonstrated against discrimination at the Bowraville cinema, confronting large angry groups of white townspeople, and at the Kempsey swimming pool.

The main significance of the Freedom Ride was its success in attracting sympathetic urban media attention to racial discrimination and inequality in country towns. It was also important as the occasion for the emergence of a new Aboriginal leader in Charles Perkins, who helped create the National Aboriginal Consultative Committee in 1972, became chair of the newly created Aboriginal Development Commission in 1980 and Secretary to the Department of Aboriginal Affairs in 1984–89. It inspired a new generation of Aboriginal political activists within New South Wales and, along with the work of many mixed-race organisations seeking Aboriginal advancement, helped quicken and strengthen opposition to the Aborigines Welfare Board and the reserve system it administered. At a national level it was a forerunner to the 1966 Gurindji strike at Daguragu and the **referendum of 1967**, and as such signalled a radical and long-lasting change in Aboriginal activism and non-Indigenous awareness of Aboriginal claims and demands. ANC

See also: 4.1, 12.1.
Perkins, C., *A Bastard Like Me,* Sydney, 1975; Read, P., *Charles Perkins: A Biography*, Ringwood, Vic., 1990.

funerary art, see 1.6, 6.3, 7.6, 8.4, 9.2, 10.3, 11.8.

furniture. Since colonisation, Aboriginal people have displayed remarkable ingenuity in devising their living spaces. Confronted with a changed historical reality they have

320. Maker unknown, pair of verandah chairs, Taree (NSW), 1903.
Hardwood (unidentified) and cabbage-tree palm (*Livistona australis*), 87 x 66 x 63 cm each.

adopted and adapted Western traditions of architecture and the domestic environment to serve their own culturally distinctive values. Oral histories from south-eastern Australia record how Aboriginal people improvised homes and furniture from canvas, scrap timber, and flattened four-gallon drums, and placed great store upon beautifying their homes with feather flowers and eucalyptus branches.

Building on this rich, vernacular tradition of improvisation, Aboriginal people put their skill and pleasure in craftsmanship to economic use. The collection of the NGA contains a pair of chairs made in the Aboriginal fishing community of Taree in northern New South Wales. Presumably modelled on the design of an English verandah chair, they have been creatively adapted to an Indigenous resource—the cabbage tree palm (*Livistona australis*). Men from the community were skilled carpenters: they made their own fishing boats and sold sets of furniture (usually two chairs and a sofa) to local farmers to supplement their income. Another set of furniture produced by the Taree community, painted black, is owned by the PM in Sydney. In a more recent development Bibdjool Craftwood, established in 1996 by the Narrogin Aboriginal community (WA), has produced a range of furniture in local jarrah and she-oak. The work has been exhibited at the Cullity Gallery at UWA, at many trade fairs, and at the Perth Royal Show. SK

See also 11.1, 19.1, 19.3; Agnes **Edwards, Riley sisters**; *320*.
Logan, J., *Everyday Art : Australian Folk Art*, Canberra, 1998.

G

GALALEDBA, Dorothy (1967–), Gun-nartpa fibre artist and bark painter, first established herself as a fibre artist and later began painting on bark. She was taught to paint by her father England **Banggala**, and by her late husband, the Rembarrnga painter Les **Mirrikkuriya**. Galaledba studied intensively with Mirrikkuriya, who taught her about the sacred sites on his land, the inspiration for much of their subject matter. Although men in Arnhem Land usually teach their junior male relatives to paint, it was then unusual for a woman to be taught in this way. After several years, Galaledba and Mirrikkuriya separated, and Banggala has since moved to Gunbalanya (Oenpelli). Without the authorisation of either of them Galaledba has not painted for some time, but is considering returning to her art in the future.

Galaledba's work has featured in many group exhibitions including the Adelaide Biennial of Australian Art (AGSA 1990) and 'Flash Pictures' (NGA 1991), and is also held in several major public institutions. MEJ

See also: 17.1; *321*.
Moon, D., 'Dorothy Galaledba', *Art and Australia*, vol. 28, no.3, 1991; Moon, D. 'Dorothy Galaledba' in M. Eagle (ed.), *Adelaide Biennial of Australian Art*, Adelaide, 1990.

Galiput, see Gyallipurt.

Galiwin'ku, see Elcho Island.

galleries, see 21.1.

GANAMBARR, Larrtjannga (*c.* 1932–), Ngaymil painter, is from Arnhem Bay in north-eastern Arnhem Land (NT). He was one of a group of young Dhuwa moiety artists, which also included Wandjuk Marika and Mithinari **Gurruwiwi**, who learnt painting from the renowned Rirratjingu artist Mawalan Marika. Many of Larrtjannga's paintings represent waterholes, such as those at Mathi and Guminyungbuy in his clan territory, which are associated with the journeys of the Djang'kawu sisters. His paintings are characterised by meticulous bands of cross-hatching which represent, in the form of Ngaymil clan designs, the dense surface vegetation of the waterholes and swamps, interspersed with lines of footprints marking the pathways of animals and birds. The bands

of colour contrast with the bold black forms of the figurative representations which are carefully placed to create an effect of dynamic symmetry. In the 1990s Larrtjannga produced a number of fine hollow coffins in the form of *warrukay* (barracuda), with the 'mouth' of the coffin carved to represent its jagged-toothed jaw. He was one of the artists who painted the Yirrkala Church Panels in 1962, and his work is represented in collections around the world including the Kluge–Ruhe Collection at the University of Virginia, the NGV, and the NMA. HM

See also: 6.2; **Buku-Larrnggay Mulka, Marika family;** *31*.
Buku-Larrnggay Mulka, *Saltwater: Yirrkala Bark paintings of Sea Country*, Neutral Bay, NSW, 1999.

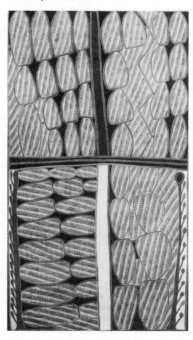

321. Dorothy Galaledba, *Djing-gubardabiya (triangular pandanus skirt)*, 1989.
Natural pigments and charcoal on bark, 168 x 92 cm.

Gapuwiyak fibre artists. Connections to the past are manifest in the work of a group of women fibre artists from Gapuwiyak, a small inland community on the shores of Lake Evella in north-eastern Arnhem Land (NT). Links to mothers and grandmothers are frequently expressed through statements like Lucy Ashley's, about working with her mother: 'I learn with my eyes.' Ties to the ancestral past are located not only in historical, traditional forms but also in innovative sculptural works, like the canoe forms of Ruby Gubiyarrawuy Guyula that hark back to the ancestors who once paddled in canoes. Brilliant dyed bunches of pandanus and bark fibre are the main materials the artists use. Bags, baskets, mats, and wearable items form the core of work from Gapuwiyak. Most of the artists are senior women, and most are of the Dhuwa moiety. The large group of Guyula Djambarrpuyngu women includes Djupuduwuy, Ngangiyawuy, Gubiyarrawuy, Dhawuluwul, Walinyawuy, Walawun, Yakarralawuy, and Guwtjingurawuy. There are two Wägilak practitioners—the sisters Lucy and Florence Ashley—and Djarrminydjarrminybuy represents the Liyagalawumirr. Yirritja moiety artists are mainly Bidingal Ritharrngu women: Minawala, Munguluma, Banbarrmiya, Milpuna, Guwatjingurawuy; and Mamuka; other Yirritja women are Nimanydjurru (Madarrpa) and Batumbil and Gunumunggu Ngurruwutthun (classificatory sister of Munyuku ritual expert Dula Ngurruwutthun). There are others, too many to mention here.

The work of a number of Gapuwiyak fibre artists was included in 'Australian Perspecta 1997' (AGNSW). Djarrminydjarrminypuy's work was exhibited in 'Fibre Art from Elcho Island' (UNSW 1994) and Djupuduwuy's work was included in the touring exhibition 'Circles About the Body' (UTAS 1997). The work of Gapuwiyak fibre artists is held in the collections of the AGNSW, NGA, and the Department of Archaeology and Anthropology, ANU. LH

See also: 17.1.
Hamby, L. (ed.), *Fibre Art from Elcho Island*, Sydney, 1994; Mellor, D. & Norman, R., *Circles About the Body*, Launceston, 1997.

GIDGUP, Ron (*c.*1959–), Nyungah fashion designer, was the first Aboriginal person in Western Australia to become successful in his field. He grew up in the wheat-belt town of Bruce Rock. One of many creative Aboriginal pioneers in textile design and production, he initiated his own label, Gidge Design Studio, in 1988. He has created award-winning gowns with hand-painted and embroidered animal motifs, using spiritual symbolic references and earth colours. Gidgup has competed in the Western Australian annual Aboriginal Gown of the Year Awards, and the 1997 and 1998 Australian Fashion Awards. His gowns have been exhibited at AGWA and at UWA's Lawrence Wilson Art Gallery, and are held in WAM and other public and private collections.

Gidgup has initiated and participated in Aboriginal youth and community projects, presenting art-based workshops that promote self-esteem, strengthen identity, and reinforce an understanding of cultural heritage. He won the 1997 Aboriginal of the Year award for Western Australia. Through self-determination, commitment, and creative talent, Gidgup—often referred to as *marr mooditji gnuni* (brother

with good hands)—has succeeded in an area once considered beyond the reach of Aboriginal artists. TJM

See also: 17.5; *218.*
Mia, T., 'Scrutiny: Mooditji gnuni yarka yel ngillelung gurlongga (good brother working with our kids)', *Artlink*, vol. 20, 2000.

GILBERT, Kevin (1933–1993), Wiradjuri painter, printmaker, sculptor, cartoonist, photographer, poet, writer, historian, and activist left a personal legacy of recorded speeches, art, and writing, which documents his involvement in the struggle for acceptance of Aboriginal sovereignty and the spirituality of the oldest culture in the world.

Gilbert was born on the banks of the Kalara (Lachlan River, NSW), on 10 July 1933, the youngest of eight children. His early years are lyrically encapsulated in *Me and Mary Kangaroo* (1994). Losing his parents at a very young age left him vulnerable to the harshest realities of the oppression being perpetrated against Aboriginal peoples, conveyed in *Massacre Mountain* (1965). Escaping from the orphanage, he returned to his country to live in fringe camps with extended family and Wiradjuri elders, protecting Wiradjuri language and culture—expressed in *Lineal Legends* (1965). *Burrawang* (1968) and *Mabung* (1967) are poems about two of his elders who kept alive the songlines he alluded to in *Eaglemen Legend* (1965).

Growing up close to country towns like Condobolin exposed Kevin to the racism perpetuated by police. To break the poverty cycle he worked his way to station manager, but his marriage ended in the tragedy for which he served fourteen years and seven months in Australia's harshest prisons. Strengthened by ancestors (*Corroboree Spirits* 1967, and *Eagles at Bay* 1967), his indomitable spirit survived the unspeakable physical and mental torture of the prison system.

Kevin was inspired by a demonstration of linocutting in Long Bay prison (Sydney), and became Australia's first Aboriginal **printmaker**. He used 'old brittle lino off the prison floor', and made his own tools 'from a spoon, Gem [razor] blades, and nails'. Left alone in the prison printing workshop, using printing inks and whatever base was available—paper, card, wrapping paper, and cloth—he used the back of a spoon to print uniquely vibrant and spiritual works, as in *Totality*, 1965, *My Father's Studio*, 1965, and *Bhoolbene Miggai Ritual*, 1969. His literary talents also flourished in poetry, essays and the play *The Cherry Pickers* (written in 1968 and produced in 1971).

Gilbert was freed in 1971. He immediately participated in the strike at Daguragu (Wattie Creek, NT) led by the Gurindji people. He was instrumental in establishing the **Tent Embassy** opposite Parliament House in Canberra in 1972. He crystallised the political struggle in *Because a Whiteman'll Never Do It* (1973) and exposed the reality of genocide in the oral history *Living Black* (1977), which won the National Book Council Award in 1978. The **poetry** of *The Blackside: People Are Legends and Other Poems* (1990) elucidates the humanity of survival. He travelled extensively, and put into practice his ideas for community development at Purfleet, near Taree, where he wrote *Child's Dreaming* (1992). In 1979 he spearheaded the national Aboriginal

protest on Capital Hill, Canberra, calling for official acceptance of Aboriginal sovereignty. Coordinating the Treaty '88 campaign, he defined the legal argument in *Aboriginal Sovereignty, Justice, the Law and Land* (1988).

Gilbert commissioned and exhibited in the groundbreaking group photographic travelling exhibition 'Inside Black Australia' (1988). The accompanying anthology *Inside Black Australia* won the 1988 Human Rights Award for literature, which he refused to accept. During the 1992 re-establishment of the Tent Embassy he produced a recording of the handing of the 'Declaration of Aboriginal Sovereignty' to a Minister of the Crown inside old Parliament House.

Gilbert's visual art has been exhibited nationally and internationally and is in many major collections. In 1992 he was awarded a four-year Australia Council Creative Arts Fellowship for his 'outstanding artistic contribution to the nation'. He died on 1 April 1993. In 1995 his collection of poems *Black from the Edge* (1994) won the Kate Challis RAKA award. The nationally touring exhibition 'Breath of Life' (CCAS 1996) highlighted the core of his struggle for justice. Koori-way, he remains 'the land rights man' and his aspirations for justice live on in his six children, and in his grandchildren, great-grandchildren, and friends. EGW

See also: 5.6, 12.1, 12.4, 14.1; **art awards and prizes, Survival Day, 62.**
Gilbert, K. & Williams, E., *Breath of Life: Moments in Transit towards Aboriginal Sovereignty*, Canberra, 1996.

GILES, Kerry (Kurwingie) (1959–1997), Ngarrindjeri visual artist and curator, known to the Ngarrindjeri as Kurwingie, was born at Waikerie of a Ngarrindjeri father and a mother of Irish–German descent. Educated in Adelaide, at the age of sixteen she went north to Katherine and Darwin (NT) where she met her husband and started painting. her first works were landscapes in the style of Albert **Namatjira.** On her return to Adelaide with her children in 1985, she began formal art education at the TAFE College in North Adelaide, and won the NADOC Aboriginal Artist of the Year Award in 1986. From late 1987 she began working in a range of media including graphic design, **printmaking,** photography, and fabric design using themes from Aboriginal history. In 1988 she curated her first exhibition, 'The Cutting Edge: Art from the Third and Fourth Worlds' (FUAM 1988). She said at that time: 'Our art is now widely recognised both in Australia and overseas. It is one area where we can have freedom of speech to teach the ignorant and prejudiced in Australia about our past and our present and our hopes for the future' (cited in Megaw 1988). Between 1989 and 1992 she was a trainee Exhibitions Officer at Tandanya, in Adelaide. Leaving Tandanya to spend more time on her art, she was for a period an artist in residence at Flinders University. She later went north to take her children to their father's country at Roper River (NT). She died tragically shortly after her return to Adelaide. Kurwingie's work has been included in many significant group exhibitions including, 'Balance 1990' (QAG 1990), 'Murrundi: Three River Murray Stories' (CACSA 1993), and 'Urban Focus' (NGA 1994). A retrospective of her work was held at FUAM in August 1997. MRM & JVSM
See also: 12.1, 17.1.

Megaw, M. R. (ed.), *The Cutting Edge: New Art of the Third and Fourth Worlds*, Adelaide, 1988; Megaw, J. V. S. & Megaw, M. R., 'Ngarrindjeri Soldier: Kerry Giles (Kurwingie) 1959–97', *Artlink*, vol. 17, no. 3, 1997; Kean, J. (ed.), *Murrundi: Three River Murray Stories*, Adelaide, 1993.

GILL TJAKAMARRA, Mick (1925–), Kukatja visual artist, was born in the area around Lake Wills and Lappi Lappi (Lake Hazlett, WA). Susie Bootja Bootja Napangarti (*c.*1936–) was born near Kurtal (Helena Spring), an important water **Dreaming** site south-west of **Balgo** (WA). They married at Old Balgo in the 1950s.

The couple became involved in the contemporary art movement in 1980 when Bootja Bootja was working in the mission dining room with Warwick Nieass, a Swiss-born artist who came to Balgo as a cook, and also taught cooking and art in the community. Following the return of Kenny Gibson Tjakamarra (1938–) from Papunya, where the **acrylic painting** movement was in full swing, senior Balgo men decided to paint, but not to market their work. Mick Gill, Bootja Bootja, their son Matthew Gill Tjupurrula (1960–), **Sunfly Tjampitjin,** and Jimmy Njamme (*c.* 1920–) were pioneers of Balgo's first painting movement. Mick and Matthew travelled to Perth for the opening of 'Art from the Great Sandy Desert' (AGWA 1987).

Water Dreaming designs are central to Mick Gill's paintings. His work is energetically charged, yet soft in execution, favouring black, blue, red, and green over the lighter-toned **ochre** colours. Bootja Bootja often assists Mick on these canvases. Her own painting style is varied. In the late 1980s she produced a series of joyously-coloured renditions of Kurtal waterhole, with schematised white-trunked gum trees. This tree motif continued in large expressionistic paintings in the early 1990s, when she began to develop a more geometrically structured style. By the late 1990s she had moved to producing paintings consisting of a series of dotted fields.

Mick Gill's work has appeared in a number of group exhibitions including 'Mythscapes' (NGV 1989), 'Songlines: Paintings from Balgo Hills' (London 1990), and 'Aratjara' (Düsseldorf, London, and Humlebaek 1993–94). Both Gill and Bootja Bootja participated in 'Yapa: Peintres Aborigènes de Balgo et Lajamanu' (Paris 1991), and Bootja Bootja's work was included in 'Daughters of the Dreaming' (AGWA 1997). CW

See also: 9.5; **Warlayirti Artists.**
Cowan, James, *Wirrimanu: Aboriginal Art from the Balgo Hills*, Roseville East, NSW, 1994; Mia, T., *Daughters of the Dreaming: Sisters Together Strong*, Perth, 1997.

GIMME NUNGURRAYAI, Ena, see Eubena **Nampitjin.**

GINIBI, Ruby Langford, Bandjalang writer, was born at Coraki on the north coast of New South Wales and raised in the little country town of Bonalbo. In her book *Real Deadly* (1992), Ginibi remembers searching for *bunihny* (porcupine) and *binging* (turtle). Ruby's mother would go into the water, wading around and feeling with her feet until she got a *binging* which her daughters would put into a chaff bag. When they got home they would cook the turtle on the fire.

Ginibi left the bush for Sydney when she was a teenager. 'I can't begin to tell you how many obstacles there were to overcome—you see I was a country girl born and bred, and besides that I was an Aboriginal to boot.' She qualified as a machinist and attended sewing classes at the Aboriginal Medical Centre in Sydney, as well as Indigenous Cultural classes at Tranby College. She has had nine children, whom she raised mostly by herself. Since the 1980s she has written three books about her life: *Don't Take Your Love to Town* (1988), *Real Deadly* (1992), and her family history, *Haunted by the Past: The Story of Nobby* (1999). She continues to express her concerns on issues of social justice and gives guest lectures at various colleges and universities. RB

See also: 3.4, 14.1; life stories; *30*.

GOOBALATHALDIN, see Dick **Roughsey.**

GORDON NAPALTJARRI, Elizabeth, see Tjumpo **Tjapanangka.**

GORRINGE, Jennie (1965–), artist, arts administrator, and activist grew up in rural Tasmania. Her high-school poem, with the lines 'White man devil from the sea, why did you take my land from me?' provides an insight into the thoughts and feelings of a young Aboriginal woman carving out her identity.

For Gorringe, studying for a BA in Fine Arts at the University of Tasmania gave flesh to the meaning of culture and identity. It also established her trademark design of totemic sculptural installations using clay, steel, and wood in symbolic carvings. Her 1991 postgraduate installation, *I'm Not a Half-Caste*, disputed racist assumptions that have contributed to the genocide of Indigenous people, and also celebrated her coming of age as an Aboriginal artist. She is best known for the installation she created in 1994 as artist in residence at Women's Karadi Aboriginal Corporation, Hobart. Six individually carved and painted totems placed among horizontal wood poles reminiscent of Tiwi burial sculptures explore themes of death and survival, oppression and resistance, and genocide and cultural identity. She has since returned to university to undertake a Masters degree. The centrepiece of her work *Warriors and Whalers*, 1999 explores the relationship between colonisation and Aboriginal resistance. One piece, entitled *Walyer*, which was exhibited in October 1999 at **Boomalli Aboriginal Artists Co-operative,** Sydney was inspired by a Tasmanian woman who was a key figure in Aboriginal resistance in the early part of the nineteenth century: 'I have received information respecting an amazon named ... Walyer, who is at the head of an Abor. Banditti ... and roams over a vast extent of country committing dire outrage' (George Augustus Robinson, quoted in Reynolds 1995).

In 1992 Jennie Gorringe was the first artist in residence at TMAG. In 1994 she facilitated the first Tasmanian Aboriginal women's fibre workshop. relearning traditional basketry skills and for the repatriation of cultural heritage. She has also worked in arts administration at the local council level. SKF

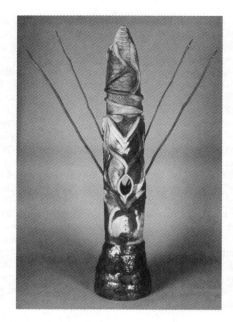

322. Jenny Gorringe, *Walyer*, 1999.
Ceramic, wood, ochre, steel (pit fired), tea-tree, 200 x 75 cm (irreg.).
See also: 1.5, 11.4; guerilla fighters; *322*.
Reynolds, H., *Fate of a Free People*, Ringwood, Vic., 1995.

GOUGH, Julie (1965–), Trawlwoolway visual artist, collects golliwogs, **shell necklaces,** breakfast-cereal trinkets, Kamahl and Rolf Harris records, kaftans, plastic rocks, coathangers, and Aboriginalia—kitsch objects from the 1950s, 1960s and 1970s, decorated with 'Aboriginal-inspired' designs. She rearranges these objects, and sometimes fabricates slightly altered facsimiles, in art works that question representations of Aboriginal people. Gough's work addresses a misrepresented and misremembered past, but also centres on an absence of memory: the knowledge of her Aboriginal heritage that was repressed during her childhood and adolescence, and the rupture in cultural memory particular to Tasmanian Aboriginal history. Yet she does not presume to represent ancestral memory: the memories that she invokes, and the language that she uses to describe them, are emphatically those of her own experience. She counts Luna Park (Melbourne), the films *The Sound of Music* and *Psycho*, and the television series *Magnum P.I.* among the imaginative sources of her art, and identifies with the figure of Kolchak, the reporter-turned-detective from the 1970s television show *Night Stalker*. As she wrote in 1996: 'Physically ... I work "undercover" collecting information by unintentionally eavesdropping as the "invisible Aboriginal" ... acknowledging the self I shouldn't be aware of—if Government assimilation policies had worked.'

Gough's work often addresses the trauma at the heart of recent Aboriginal history, in particular of Tasmanian history (she is descended on her mother's side from the Trawlwoolway people of north-eastern Tasmania). Her work draws attention to some of the more outrageous chapters of Aus-

tralian history and of **anthropological** practice. The ludicrous becomes an organising principle for things that make no sense—the outlandish, the unbelievable, the obscene—and in this respect her work is allied with the absurdist 'Blak' satire of Destiny **Deacon**.

Gough holds degrees from UWA (1986), Curtin University of Technology (1993), and UTAS (1994). In 1997 she was awarded a Samstag International Visual Arts Scholarship, with which she completed an MA in Fine Arts at Goldsmiths College, University of London, in 1998. In 1999 she was enrolled for a PhD at the Tasmanian School of Art, Hobart (UTAS). She has also completed courses in sign and ticket-card writing, floristry, and forensic pathology.

Gough was one of twenty-five emerging artists selected for exhibition by the jurors at 'Art Cologne' in 1996. Her work has been included in numerous group exhibitions, including 'Wijay Na? (Which Way Now?)' (24 Hr Art 1996), 'Black Humour' (CCAS 1997), and 'Trace' (Liverpool, UK 1999). She has held two solo exhibitions at Gallery Gabrielle Pizzi in Melbourne: 'Dark Secrets/ Home Truths' (1996) and 'Re-Collection' (1997). She is represented in the NGA, PM and most Australian State galleries. HF

See also: 4.4, 11.5; *48*.

Fink, H., 'Bad memory: Art, collecting, and the mercurial world of Julie Gough', *Siglo*, Winter 1998; Gough, J., *Dark Secrets/Home Truths*, Melbourne, 1996; Gough, J., 'Contemporary Aboriginal art in Tasmania today', *Art and Australia*, vol. 35, no.1, 1997.

graffiti usually constitute some kind of claim on social and cultural space. Indigenous graffiti, highly visible in many parts of Aboriginal Australia today, can be said to share a number of basic characteristics with Indigenous rock art. Peter Sutton notes that 'images of aggressive, erotic, or disintegrative energy are … very common' in ancient Australian rock engravings. The same may be said of contemporary Indigenous graffiti, which can be read as attempts at symbolic domination of, or assertion of ownership over a particular physical and social space.

Colonisation and the attendant marginalisation of many Indigenous Australians complicates this, particularly in urban centres like Katherine (NT), Alice Springs (NT), and Port Augusta (SA) where a significant minority of the Indigenous inhabitants have been pushed to the fringes into 'satellite' camps. The graffiti of young Indigenous people, prominently displayed on and in public buildings in the middle of such towns (places perceived as 'off-limits' by most Aboriginal people, as belonging to whites), not only proclaim survival but, in some cases, a consciously oppositional identity.

In Port Augusta, a predominantly white town, Aboriginal youths consistently defy high levels of police surveillance and council-imposed curfews by spray-painting the words 'Hard to Catch' or 'HTC' on public buildings. Other forms of graffiti found throughout Indigenous Australia show the persistence of associating person with place. The country on which Tennant Creek stands is recognised as belonging to the Warumungu people, but there is a good deal of rivalry (mostly friendly) with other groups, particularly the Warlpiri. So when the following graffiti was displayed

prominently on a wall of a public building in Tennant Creek in 1994 (its author's name has been changed):

JONATHAN ROBERTSON
FROM
TENNANT CREEK

a different hand responded:

YOU BULLSHITTER JONATHAN
YOU FROM
BARKLY SIDE

As a way of asserting and disputing territorial boundaries this does not differ fundamentally from one of the functions of pre-contact **rock art**. The exchange could be interpreted as a land claim and counterclaim in miniature.

As Deborah Bird Rose puts it: 'Everybody has the rights of ownership which include the right to exclude others.' It is precisely this exclusionary right that the unknown respondent to 'Jonathan's' graffiti is exercising. Hence it is possible to interpret both the structure and content of such graffiti as a testament to resilience, a contemporary re-inscription in which the idea of 'person as place' endures and takes precedence over Australia's dominant individualistic notions of self. Indigenous Australian graffiti which seem, on the surface, to be a dramatic rupture with 'tradition', may in fact exemplify cultural survival *par excellence*. CN

See also: 5.5, 5.6, 12.2.

Nicholls, C., 'The social construction of subjectivity: The graffiti of young Warlpiri Australians', in J. Docker & G. Fischer (eds), *Race, Colour, Identity*, Sydney, 1999; Rose, D. B., 'The saga of Captain Cook: Morality in Aboriginal and European law', *Journal of Australian Aboriginal Studies*, vol. 2, 1984; Sutton, P., *Dreamings: The Art of Aboriginal Australia*, New York & Ringwood, Vic., 1988.

graves of the post-invasion period in NSW. In the early years of the twentieth century, settlers in the Lachlan Valley used to see an old Aboriginal man sitting near the mounded grave of his father. The grave had originally been in secluded woodland, but was now exposed on land cleared for farming. For a few days every year the man would come to camp near the grave and sit beside it, alone. The image of him sitting beside his father's grave in a cleared field, exposed to the gaze of the settlers, gives us a sense of the suddenness with which dispossession occurred. The carved tree that stood beside the grave was eventually cut down and put on display at the local school. We do not know the fate of the grave.

In much of New South Wales and Queensland, Aboriginal people commemorated the graves of close relatives by carving particular designs on trees that were already standing at the spot chosen for the grave. In some ways these carved trees are the equivalent of headstones in the cemeteries of white settlers. Over the last 200 years Aboriginal people have occasionally erected headstones too, or placed a simple white cross with the name of the deceased at the head of the grave. Far more commonly, they have decorated the graves of relatives with coloured glass, seashells, and river pebbles. At Collarenebri in north-west New South Wales, Aboriginal

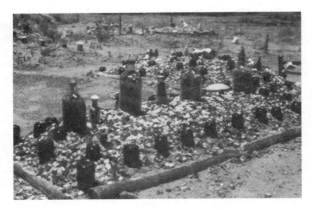

323. Grave decorated with broken glass and Vicks bottles, Collarenebri, 1978.

people use fragments of bottle glass to decorate the graves in their cemetery. In the late 1970s Isabel Flick described how this was done:

It happens at least every three years when everyone says, right, and we get out there and make sure that all of these graves are tended in some way … There's a lot of hard work in it. The bottles are mainly what we use; they're placed in hot ashes. We have to have a lot of fire and then we dip them quickly into the water, which gives them a crystallized effect. Young people just learn automatically, they see it done once or twice and older people like myself don't have to do that job any more … about 2000 bottles in the last four weeks, nearly every family saves them. It is a big procedure you know. Everything that's put on each grave, some member of the family thinks that's what I'd like to put there. We say this is a real labour of love, I think that's why we have such strong ties with this place.

In contrast to the stone monuments erected over many settler graves, these Aboriginal grave decorations lie very lightly upon the ground. But they are no less significant, for all that.
DEB

See also: 6.3, 7.6, 11.1; *115, 138, 139, 290, 323.*
Flick, I., Transcript of a late 1970s recording, in Creamer, H., *A Gift and a Dreaming* [unpublished ms], NSW National Parks and Wildlife Service, 1984.

GREENO, Lola (1946–), Palawa shell necklace and fibre object maker, has been a driving force in the retrieval of traditional Palawa cultural practices. Of particular visual interest are the water containers which Greeno and others make from bull kelp, a sea-harvested plant material. The kelp is collected only at certain times of the year from particular Tasmanian beaches, then selected for suitability of size and form. After being moulded and sun-dried over sand, it is threaded over tea-tree 'skewers', and the container is completed with handles of twined natural fibres. Greeno uses other non-native fibre materials such as grape-vine and flax to create both open-weave vessels of lively and irregular

structure, and more closely woven and delicate symmetrical forms.

Another of Greeno's important cultural contributions is her commitment to producing necklaces made from different kinds of Tasmanian shells—toothies, rice shells, cats' teeth and stripey button shells. Most significantly, she works with maireeners—small, blue-green, pearl-like shells, invested with profound cultural and historical meaning for the Palawa people. The practice of making **shell necklaces** has continued from Tasmania's pre-colonial days.

Greeno is a visual arts graduate of the University of Tasmania, where she studied as a mature student. Her subsequent activities reflect the skills garnered as part of her life experience. She is in demand as a focal member of the arts community in Tasmania, serving on Advisory Committees for Arts Tasmania, working as the Cultural Officer for Karadi Women's Centre, and researching oral histories which are published with printed materials as a kit for schools.

The 13th Tamworth Fibre Textile Biennial exhibition 'Many Voices' (TCG 1998) included Greeno's installation *The 10 … Plan* comprising small wooden boxes, sand and fibre balls. She has also used large-scale installation work to explore the political domain. A number of shell pieces by Greeno and other Palawa artists were exhibited in the touring exhibition 'Circles About the Body' (UTAS 1996–98). Her work was also featured in the Adelaide Biennial of Australian Art, 'Beyond the Pale' (AGSA 2000) and 'Keeping Culture' (NGA 2000–01), an exhibition that toured Aboriginal **keeping places** and cultural centres in south-eastern Australia. Examples of Greeno's work are held in the NGA, PM and many Australian State and regional galleries.
DOM

See also: 1,5, 11.4: **family history**, *147, 381.*
Mellor, D. & Norman, R., *Circles about the Body*, Launceston, 1996; Croft, B. L. (ed.), *Beyond the Pale: 2000 Adelaide Biennial of Australian Art*, Adelaide, 2000.

GRIFFITHS, Alan (1933–), Ngarinyman painter, printmaker, and dancer, began painting in 1981, after his retirement from a long life of stock and station work. His wife Peggy Griffiths (*c.*1955–) of the Miriuwung language group, began painting at **Waringarri Aboriginal Arts** in early 1985. These two artists often work collaboratively and base much of their imagery on dream cycles, painting to keep the **Dreaming** of their grandfathers alive. Most of their work is executed on canvas, but both possess strong carving skills and work with **boab nuts**, slate, and **didjeridus**. They are also active printmakers: Peggy Griffiths was awarded the non acquisitive award at the Western Australian 20th Annual Fremantle Print Award. Together and as individuals they have participated in many group exhibitions. They are also involved in traditional fibre craft and are the only producers of 'thread-cross' dance frames used in traditional ceremonies in the north-east Kimberley region (WA). Apart from their busy life as artists, they devote a lot of their time throughout the year to the age-old tradition of initiation for many young Aboriginal men and women in the Kununurra region.
CD

See also: 10.1, 10.2; **printmaking;** *130.*

Monger, K., *Printabout: Lithographs, Etchings and Lino Prints from the Northern Territory University Art Collection*, Darwin, 1996.

GRIFFITHS, Peggy, see Alan **Griffiths**.

GRIGGS, Leslie (Les) (1962–1993), Gunditjmara painter, was a member of the **stolen generations**, whose life was profoundly affected by the experience of institutionalisation. His work deals primarily with an expression of that experience. His tragic, premature death in 1993 left a legacy of paintings that portray a strong political consciousness.

Images of syringes, coffins, handcuffs, locks, keys, and prison bars—representing drug addiction and incarceration—are used symbolically in a painting style that is a visual declaration of the artist's cultural heritage. Griggs had a strong social conscience and he wished to help young people to transcend the cycle of institutionalisation and drug addiction. He was inspired by the guidance of Indigenous elders and by Indigenous Victorian material culture, and he wanted his work to be of benefit to the Indigenous community. The acquisition of a body of his work by the Koorie Heritage Trust (Melbourne) in 1987, and his attendance as a Victorian delegate at the 5th Festival of Pacific Arts in 1988 were key events in his life. For Griggs art was about 'painting your soul' and he wanted to 'hit people in the eye'.

Meeting artist **Lin Onus** was a turning point. Griggs realised then that art could be a new kind of personal empowerment, providing relief, release, and a voice. In 1986 he was awarded a Professional Development Grant by the Australia Council. He had no solo exhibitions during his brief artistic career, but his participation in group exhibitions included international exposure in 'Aratjara' (Düsseldorf, London, and Humlebaek, 1993–94). DL

See also: 12.1; **prison art.**
Griggs, M., 'Les Griggs', *Artlink*, vol. 10, nos 1 & 2, 1989; Isaacs, J., *Aboriginality: Contemporary Aboriginal Paintings and Prints*; St Lucia, Qld, 1992; Thompson, L., 'Les Griggs: Artist', in L. Thompson (ed.), *Aboriginal Voices: Contemporary Aboriginal Artists, Writers, and Performers*, Brookvale, NSW, 1990.

Groote Eylandt art. Groote Eylandt and its smaller neighbour Bickerton Island are part of an archipelago in the Gulf of Carpentaria off the north-eastern Arnhem Land coast (NT). As an island people, the Anindilyakwa differ from mainland groups in aspects of their social organisation, ceremonies, and style of painting. The earliest records of artistic expression in the area are the extensive galleries of rock paintings that were first commented upon by Matthew Flinders in 1814. Characteristic of these paintings is a predominance of maritime themes that include sea-going animals, fishing scenes, fishing paraphernalia and depictions of Macassan praus and European boats. These themes reflect the island's early contact history and the islanders' heavy reliance upon a maritime economy.

When N. B. Tindale visited Groote's Emerald River mission soon after its establishment in 1921, he recorded that the Anindilyakwa painted onto a range of surfaces including their bodies, ceremonial objects, paddles, spear-throwers, spears, and wet-weather bark shelters. He was one of a

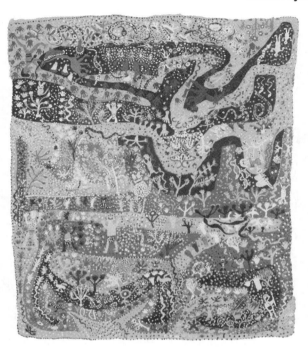

324. Willie Gudabi, *Singing Ready for Ceremony*, 1993. Acrylic on canvas, 154 x 133 cm.
This painting depicts men preparing for the Balginy ceremony, which is connected with the sacred site of Kewulyi on Roper Valley station. Gudabi painted it during a period of concern about the desecration of this site by the owners of the station.

number of people, including C. P. Mountford (1948) and Helen Groger-Wurm (1969), who subsequently put together collections of Groote Eylandt bark paintings destined for public institutions. Another of these collectors was Fred Grey, who initiated the marketing of Groote artefacts at the Port Langdon flying boat base (NT) between 1938 and 1948. When the base later became the Umbakumba Mission, the CMS mission took over the task of marketing artefacts from here and Angurugu via their Sydney outlets. This arrangement lasted until the 1970s. Apart from a consolidated period in the early eighties when work was sold via Mimi Arts and Crafts in Katherine, marketing has been intermittent. With no community-based art centre to assist, very few artists from either Groote or Bickerton Islands were producing art works for sale in the late 1990s.

Stylistically, Groote Eylandt art is quite distinctive, partiularly in the use of decorative detailing based upon dashes, parallel lines and herringbone motifs. The proportionally high use of black manganese backgrounds is characteristic of the classic Groote style, in which figurative motifs are painted onto monochromatic backgrounds. Anthropologist David Turner, however, has noted that there are subtle variations in style that reflect the cultural differences between the Groote Eylandters, who live predominantly at Umbakumba, and the people from Bickerton, who live mainly at Angurugu. As intermediaries between Groote and the

mainland, the Bickerton people had close ceremonial and mythological ties with the Nunggubuyu and Yolngu in north-eastern Arnhem Land. As a result, the overall configuration of the Bickerton Islanders' painting is closer to the north-eastern Arnhem Land style, with the use of feature blocks and all-over or partial background patterning.

Decorative embellishment has intensified over the years— a change that has been attributed to the rise in intermarriage and contact with mainland people. The increased use of decorative detail by many Groote Eylandt artists also shows the growing (probably market-driven) preference for ceremonial themes which are indicated in the use of the *alawudawara* **Dreaming** designs of cross-hatching, herringbone and so on. These contrast with the earlier Groote Eylandt paintings which more closely parallel the rock art.

Groote and Bickerton art depicts familiar environmental as well as mythologically significant themes. Some of the important totemic subjects associated with the various clan groups are depicted in their **bark paintings,** such as the north wind, north-west wind, south-east wind, curlew, Central Hill (a feature of the island), bark canoe, and sailing boat. Images of Macassan praus are also still commonly painted in the more recent work from the islands. There have been a number of highly regarded and prolific Anindilyakwa artists over the years: Minimini Mamarika, Nambaduba Maminyamanja, Bill Namiayangwa, Thomas Nanjiwara Amagula, Mangangina Wurramara, Peter Nangurama, Naj Wurramara, Jennifer Lalara, Trevor Maminyamanja, Larry Durilla, Nadjalgala Wurramara, Hilda Wurrawilya, Valerie Wurramara. Apart from bark painting, some of these artists have specialised in figure carving, shell-painting and the making of the now rare ceremonial barbed spears.　　MW

See also: 1.3, 6.4; **rock-art sites;** 6.
Mountford, C.P., 'The art of Groote Eylandt', in C. P. Mountford (ed.), *Records of the American–Australian Scientific Expedition to Arnhem Land*, vol. 1, *Art Myth and Symbolism*, Melbourne, 1956; Tindale, N., 'Natives of Groote Eylandt and of the west coast of the Gulf of Carpentaria', *Records of the South Australian Museum*, vol. 3, nos 1 & 2, 1925, 1926; Turner, D., 'The rock art of Bickerton Island in comparative perspective', *Oceania*, vol. 42, no. 4, 1973.

GUDABI, Willie (*c.*1917–1996), Alawa painter, was born at Nutwood Downs station (NT) and grew up in Alawa country, hunting and gathering on the margins of small cattle stations such as St Vidgeon, Bauhinia Downs, Nutwood Downs and Tanumbirini. Before he went to live at **Ngukurr**, Gudabi worked as a stockman at a number of these stations including Tanumbirini, where he was initiated and inducted into the mysteries of the complex sacred life of his people.

After a stint at **printmaking**, Gudabi took up **acrylic painting** with other Ngukurr artists in 1987. Often working collaboratively with his wife Moima Willie (*c.*1935–) of the Ngalakan people, Gudabi soon developed a distinctive style of painting. His works were vibrant, densely-painted narratives, sometimes gridded into a patchwork of vignettes relating to one or more of the interconnected stories about the characters, ceremonies, sites, plants, and animals of his country.

A character who recurs in Gudabi's work is Gurdang— one of the last survivors of the early contact period. He was a mysterious person who shunned any contact with the white settlers, preferring to live alone out bush. He left a legacy of rock art in Alawa country, with which Willie Gudabi was familiar, and was also associated with a secret ceremony central to Gudabi's paintings. For a long time Gudabi had wished to recover a cache of sacred items that Gurdang had secreted before his death in the labyrinthine stone country called Langgabayan. Aware of his own impending death, Gudabi enlisted the assistance of the Aboriginal Areas Protection Authority to relocate these items to a safe place. His art was informed by his spiritual life, and by the archetypal historic figure of Gurdang and Langgabayan country.

In his short painting career Gudabi achieved a high degree of recognition and is represented in most Australian art gallery collections. He featured in a number of group exhibitions including 'Aboriginal Art and Spirituality' (HCA 1991) and 'Flash Pictures' (NGA 1991) as well as in solo commercial exhibitions. In 1993, he was awarded the Gold Coast City Art Award, and won joint first prize at the Alice Prize.
　　JOA & MW

See also: **art awards and prizes;** *324.*
Crumlin, R., *Aboriginal Art and Spirituality*, North Blackburn, Vic., 1991; Wallace, D., Desmond, M. & Caruana, W., *Flash Pictures by Aboriginal and Torres Strait Islander Artists*, Canberra, 1991.

GUDTHAYKUDTHAY, Philip (1935–), Liyagalawumirr (Yolngu) bark painter, was born at Lirrabambitj, about ten kilometres from **Ramingining** (NT), and was initiated at Gätji in about 1949. During his youth he was raised by Paddy Lilipiyana, his classificatory brother. Over the years Gudthaykudthay has worked as a stockman, made fences, and shot crocodiles for their skins, which he sold at Milingimbi mission (he appears doing this in *Across the Top* (1965), a film by Malcolm Douglas). During the 1960s he also assisted in the construction of cattle yards at Ngangalala, on the Glyde River.

He started painting at Ngangalala in the 1960s under the tuition of his half-brother, Mirritja (Manbararra) and sold his work through the Milingimbi Methodist mission. He moved to Ramingining when the township was established on his mother's country. He lived in Maningrida for a period, but returned to Ramingining in the late 1980s.

Gudthaykudthay's paintings have always been focused either on the tuber called *munyigani* from his mother's group's imagery, or the optical landscape grid of his own country near the Woolen River. This is the site of the Milky Way **Dreaming**, where the ancestral crow man and glider possum man completed the first hollow log bone coffin ceremony for the possum's wives, the native cat women—from whom Gudthaykudthay gets his nickname 'Pussycat'. He contributed several hollow log coffins to the *Aboriginal Memorial* (1987–88).

Gudthaykudthay had his first solo exhibition at Garry Anderson Gallery, Sydney in 1983, followed by others at Roslyn Oxley9 Gallery in 1991 and at Aboriginal and South Pacific Gallery, Sydney in 1995. He has had two exhibitions

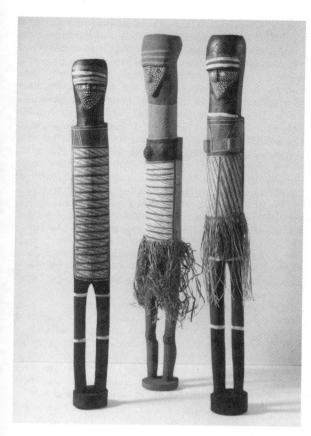

325. Philip Gudthaykudthay, *The Wagilag Sisters and Child*, 1994.
Wood, natural pigments, and fibre (sisters); elder sister, 160 x 18 x 16 cm; younger sister, 164 x 30 x 17 cm; child, 149 x 17 x 16 cm.

with Jimmy **Wululu** (ANU 1992), and (EAF 1993), where both artists completed individual sand sculptures as centre-pieces for the exhibitions. Gudthay-kudthay has been included in a number of significant group exhibitions including, 'Aratjara' (Düsseldorf, London, and Humlebaek, 1993–94), 'Canvassing' (24 Hr Art 1994), 'Power of the Land' (NGV 1994), and 'The Painters of the Wagilag Sisters Story' (NGA 1997). Examples of his work are held in the NGA, MCA and most Australian State galleries. DJM

See also: 6.3; *38, 74, 325.*
Mundine, D., 'Meetings with Remarkable Men and Women', in W. Caruana & N. Lendon (eds), *The Painters of the Wagilag Sisters Story 1937 –1997*, Canberra, 1997; Mundine, D. 'The land is full of signs: Central north east Arnhem Land art', in H. Morphy & M. Smith Boles (eds), *Art from the Land: Dialogues with the Kluge–Ruhe Collection of Australian Aboriginal Art*, Charlottesville, VA, 1999.

guerilla fighters. When the British invaders attempted to take over their land and its resources, Aboriginal people

resisted energetically. Port Jackson's convict settlement and its hinterland presented the earliest eastern Australian frontier. From 1788, the frontier rapidly extended south into Van Diemen's Land and Port Phillip, then more slowly through Western Australia and elsewhere to the north. Despite British efforts to colonise far northern outposts from the 1830s, the Aboriginal population dominated in such remote regions until as late as in the 1920s. While some Aboriginal groups initially welcomed individuals as spirit ancestors, when larger invading groups arrived and started to destroy resources and commit acts of violence and brutality, Aborigines implemented diverse guerilla tactics. While colonisers tended to see any violent actions against whites as anti-coloniser hostility, the historical record does not always allow us to distinguish between violence as a penalty for specific transgressions against local Indigenous Law, and broader guerilla strategies aimed at ending white invasion.

Aboriginal people are estimated to have killed at least 3000 Europeans in frontier attacks, and an equal number were wounded, but this hardly matches the devastating violence perpetrated by the British invaders. Guerilla strategies varied from malign sorcery, to attacking crops or stock animals, and even to spearing the leader of government—the first British Governor, Captain Arthur Phillip, was speared by the Eora (Yura) of Port Jackson in 1790. Phillip responded bravely to the attack on his own life, but when his gamekeeper was murdered, he was so incensed that he ordered a killing party. When settlers and convicts cleared Dharuk yam-bearing lands for farming on the Hawkesbury River, the Dharuk harassed settlers, consistently burning their cornfields. After surviving a number of engagements with troopers, one of their leaders, Pemulwuy, was shot and killed in 1802. Tasmanian Aborigines stole guns, shot and powder from invaders' camps, shouting abuse at them, demanding they leave their country. Walyer, or Mary-Ann, a six-foot tall tribal leader, murdered several whites and plotted the murders of her eventual captors. She swore at and taunted the white men to come out of their hiding places to meet the spears. In 1823, the exiled Musquito from New South Wales used his knowledge of European weaponry to gain an advantage, attacking after the muskets had fired. Tasmanian Aborigines were so effective in discouraging sheep farmers that in 1830 a well-armed 'black line' of white settlers was organised across the entire island to round them up. On the western Darling River, the Baagandji successfully drove stockholders off their river lands for ten years during the 1850s. In 1894, Jandamarra led a band in the Kimberley which carried out raids on sheep and cattle stock, evading capture several times. At the beginning of the twentieth century, in many northern regions of Australia, Aboriginal attacks on cattle, horses, and men caused pastoralists to desert their stations.

While Aboriginal resistance delayed colonialism in remoter regions, and Aboriginal weaponry and ingenuity often won out over by the muskets and gunpowder, guerilla tactics were increasingly impeded by the growing and better-equipped white population. Although access to more horses and to American imports such as the Winchester rifle further advantaged white men, Aborigines continued to use their close knowledge of the landscape and its resources, as well as their increasing knowledge of European behaviour, to effect

a significant impediment to colonisation of remoter areas. Other groups decided upon co-operative strategies such as providing labour for the introduced European enterprises, as a means of maintaining access to their country and ensuring community survival. If they did not gain the cultural outcomes or other benefits they sought from such arrangements, workers used walk-offs, strikes, and other methods of non-compliance to resist the colonisers. AMcG

See also: Jennie **Gorringe**, **history**, **Lin Onus**.

McGrath, A. (ed.), *Contested Ground: Australian Aborigines under the British Crown*, Sydney, 1995; Reynolds, H., *The Other Side of the Frontier*, Ringwood, Vic., 1981; Reynolds, H., *Fate of a Free People*, Ringwood, Vic., 1995; Reynolds, H., *Frontier*, Sydney, 1987; Loos, N., *Invasion and Resistance: Aboriginal–European Relations on the North Queensland Frontier 1861–1897*, Canberra, 1982.

GULPILIL, David (*c.*1953–), Mandalpingu (Yolngu), Australia's best known Aboriginal actor and dancer, lives at Meriyu, a homeland centre on the outskirts of **Ramingining** in north-eastern Arnhem Land (NT). His career in film, **television**, and sound recording spans some thirty years. The man who once danced for the Queen, whose performances won acclaim in Hollywood and Cannes, and who brought Aboriginal culture to the far reaches of the globe, has returned to his homeland. His love of the land is evident as he comments, 'my homeland is paradise … In the land of my forefathers, my mother's land, I can sleep under the cool shadow of trees … all I have is my spear and woomera. It's all I need.' However, Gulpilil's life has not always been so utopian and he has met with his fair share of hardship and alienation, born of the struggle to survive in two worlds and two economic and cultural systems which are so often at variance with each other.

He grew up near Maningrida, and was taught the songs, dances and ancestral Law of his people. In 1968, British director Nicholas Roeg went in search of Arnhem Land talent to play the leading role in his film *Walkabout* (1971). Gulpilil's skills in hunting, dancing, and singing, animated by his virtuosity and presence, made him an immediate

326. Tracey Moffatt, *The Movie Star: David Gulpilil on Bondi Beach*, 1985.
Direct positive colour photograph, 50.3 x 80.2 cm

choice. He remarked: 'Hunting is like acting and my acting is part of hunting.' His success in *Walk-about*, depicting the incongruities that arise in the meeting between black and white cultures, entranced the film-going public while also mirroring the tension that he was to experience in his own journey through life. Gulpilil has also acted in many other films including *The Morning Star Painter* (1974), *Storm Boy* (1976), *Luke's Kingdom* (1976), *Mad Dog Morgan* (1976), *The Last Wave* (1977), *Bill West* (1982), *The Right Stuff* (1983), *Crocodile Dundee* (1986), and *Dead Heart* (1996), but is concerned about exploitation, both of himself and of his people. For example, although the film *Crocodile Dundee* grossed more than $400 million, Gulpilil got paid $10 000 for his efforts. He commented, 'I was happy to represent Australia and Aboriginal culture, but I was exploited.' He has appeared on television in his own show *The Dreamtime*, and was the subject of the television program *This is Your Life* in 1979. He has made recordings such as *The David Gulpilil Dance Group—Music from Ramingining* and *Djurdjurdjane —Music From Arnhem Land and Christmas Hills* with Bobby Bunungurr in 1991. He was made a Member in the Order of Australia in 1987.

Nowadays, he is a volunteer for the clan homeland resettlement program and he finds occasional work mustering cattle. Despite his mixed experiences as a media star, Gulpilil remains optimistic about his people's and his children's future: 'I want to teach my people about the world and to bring a better life for them. My people don't know about the world, how the world spins. I want my children to know how to use the woomera and the spear and the knife and fork.'
FM

See also: *13.1*; *326*.

Baker, M., 'From where the wind blows', *The Age*, Sunday, 19 April 1998; 'David Gulpilil', *ICAM* [SBS, Indigenous Cultural Affairs Magazine], produced by Paul Fenech, 1999.

GUMANA family, Dhaḻwangu (Yolngu) visual artists. Photographs taken by anthropologist Donald Thomson in the mid 1930s depict a group of men at a camp on Blue Mud Bay. Among them was the warrior, later to become a renowned artist in the public domain, Birrikitji Gumana (1898–1982). Birrikitji's eldest son, Gawirriṉ Gumana (*c.* 1935–) is also a well known artist. Birrikitji's father, also called Gawirriṉ, had the 'special' name of Gumana. During the 1960s the Nungburundi group of the Dhaḻwangu clan took this as their family name.

After his early days living with his people around Blue Mud Bay, Birrikitji painted at the newly established missions at **Groote Eylandt** and Rose River before settling at **Yirrkala** in the late 1950s. By this time he was regarded as the most eminent Yirritja moiety Law man as well as being a noted warrior, dancer, and songman. He painted the lower section of the Yirritja side of the Yirrkala Church Panels, assisted by his son Gawirriṉ and Yanggarriny **Wunungmurra**, of the Narrkala Dhaḻwangu.

Birrikitji's art is steeped in Yolngu culture. He also painted to teach his sons. The barks he produced in the 1960s and 1970s have found their way into Australia's public and private

collections. Today they are often seen in the auction-house catalogues of important Aboriginal art.

Gawirrin too spent his early days living the semi-nomadic lifestyle of his father and family, travelling country and learning the Laws that govern it. Afflicted by leprosy in his late teens, he was sent to Darwin for treatment. There he first learnt his skills in English and began his self-education in Balanda ways. At the leprosarium he met his wife Miyalka-wuy (1930–1999).

Gawirrin had also spent time at Groote Eylandt with his father before the family moved to Yirrkala, and there had learned the fundamentals of Christianity. He became a lay preacher to his people at Yirrkala and **Ramingining**. He saw a compatibility between the philosophies of his own traditional culture and that of the Christian gospels—that people should respect one another. It was in the context of this new church that the senior men living at Yirrkala got together and designed the Yirrkala Church Panels. These priceless works now hang in the **Buku-Larrnggay Mulka** Centre at Yirrkala.

In the early 1970s the mining town of Nhulunbuy was built near Yirrkala, and many Yolngu found the impact of the mining community increasingly intolerable. Birrikitji and Gawirrin went to the Dhalwangu creation site at Gängan to establish their homeland. Gawirrin has lived at Gängan since then. In 1982 and 1988 he travelled overseas to the United States, London, Paris, and Singapore for exhibitions and with dance troupes. In 1991 he successfully put himself through a theology course at Nungalinya College in Darwin to be ordained as minister of the Uniting Church.

Gawirrin is an important spokesperson and ambassador for his people on the issues of Indigenous self-determination and rights. In 1997 alone, he featured in the SBS documentary *Copyrites*, led the Yolngu delegation to 'Nugget' Coombs's funeral, was instrumental in opening the 'Painters of the Wagilag Sisters Story' exhibition (NGA), and led the Yolngu at the 'Native Title' (MCA) exhibition opening in Sydney. At home he also has important roles in ceremony and homeland management, and plays an integral role in his art centre, Buku-Larrnggay Mulka.

When addressing a gathering for the opening of 'Miny'tji Buku-Larrnggay—Paintings from the East' (NGV 1995), Gawirrin expressed his intrinsic connection to his land: 'Hello, I'm Gawirrin, I am from the mud [at Gängan]—I am the mud.' AB

See also: 1.1, 1.2, 3.1, 4.6, 6.1, 22.1; *32, 257*.

Buku-Larrnggay Mulka, *Saltwater: Yirrkala Bark Paintings of Sea Country*, Neutral Bay, NSW, 1999.

Gunbalanya, see Injalak Arts and Crafts.

GURRUWIWI, Mithinari (1929–1976), Gälpu (Yolngu) bark painter, had a reputation among European buyers of Aboriginal art as a somewhat eccentric genius. This was partly because, unlike most of his contemporaries, he never spoke English and was reserved in his relationships with outsiders and Yolngu alike. It was also because of the way he painted—rapidly, fluently, at times almost expressionistically, in a unique style. He lived for the final years of his life camped on the beach at **Yirrkala** (NT), painting alone for much of the

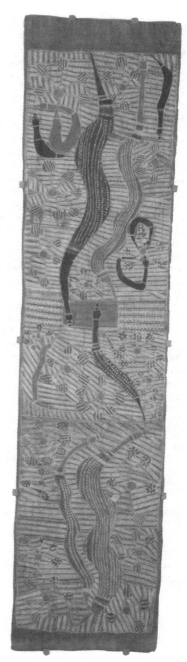

327. Mithinari Gurruwiwi, *File Snakes at Garrimala*, c.1959. Natural pigments on bark, 264.2 x 68.6 cm.
This painting was collected by Dr Stuart Scougall on one of his visits to Yirrkala.

day, shaded by palm fronds stuck in the sand. He never seemed to have access to a motor vehicle and would set off early in the morning on foot to collect sheets of bark. He was very much a professional artist painting to support his large family. And though reserved, he was a man of warmth and

tolerance who occasionally displayed his wry sense of humour.

Mithinari's paintings show great diversity of form, although all are characterised by a lightness of touch. Sometimes elements of form are reduced to give the appearance of abstraction, in other paintings figurative and geometric motifs are combined in ways characteristic of Yirrkala art. He learnt to paint with his age mates Wandjuk Marika and Larrtjannga **Ganambarr** under the tutelage of the great Rirratjingu artist Mawalan Marika. While Mithinari's paintings represent places in his own Gälpu clan country it is possible to see the influence of the older artist in his style. One of the most characteristic features of Mithinari's paintings is the integration of figurative representations with the geometric clan designs, creating a flowing overall composition.

From early on, his paintings had great market appeal. He painted superb large barks for Scougall in 1959; one is in the collection of the AGNSW. A second was sold in the USA, and in 1997 became the second-highest priced bark painting ever at a Sothebys auction in New York. The missionary Edgar Wells provides an interesting account of the purchase of one of Mithinari's paintings by a French psychiatrist in 1962. Mithinari had returned on a flight from Darwin, during which he appeared terrified. He subsequently produced a painting that conveyed his experience. It 'confirmed a Mission sister in her view that Mithinari was "possessed", but sent the psychiatrist into raptures ... he suggested ... that Mithinari in any other culture would be regarded as a genius.'

Mithinari was one of the contributors to the Yirrkala Church Panels, and his work has appeared in many significant group exhibitions including 'Australian Aboriginal Art' (Chicago 1972), 'Ancestors and Spirits' (NGA 1987) 'Spirit in Land' (NGV 1990), 'Keepers of the Secrets' (AGWA 1990) and 'Aratjara' (Düsseldorf, London, and Humlebaek 1993–94). He is represented in the NGA, MCA, all Australian State galleries, and the Kluge–Ruhe Collection at the University of Virginia. HM

See also: 1,2, 4.6, 6.1; **Buku-Larrnggay Mulka, Marika family**; *31, 327*.

Allen, L., *Time before Morning: Art and Myth of the Australian Aborigines*, New York, 1975; Morphy, H., *Ancestral Connections: Art and an Aboriginal System of Knowledge*, Chicago, 1991.

GYALLIPURT, Minang Nyungah sketcher, dancer, and diplomat, active in the mid nineteenth century. In 1833 Gyallipurt was a mature man of the King George Sound region of Western Australia where Europeans had established comparatively harmonious relationships with the local Aboriginal people. In February he and a compatriot, Maryate (Manyat), were taken from Albany to Perth on board the *Thistle* in what Neville Green has called 'a unique public relations exercise to advise the Swan River Aborigines how they should behave with Europeans'. They were met on arrival by the instigator of the visit Colonial Surgeon Alexander Collie, the former Government Resident at Albany for whom Maryate had acted as guide and interpreter. While staying in Perth with the government storekeeper John Morgan, Gyallipurt imitated his host's letter-writing activities by taking up a quill pen and drawing a sand-map—traditionally scratched with a stick on the ground—on a piece of parchment. The sketch, which depicted the layout of an Aboriginal camp and surrounding hunting places, is in the Public Record Office in London..

As well as having two amicable meetings at Mongers Lake with the Perth Nyungars, including Yellagonga and Yagan, the Albany men attended a soirée at the home of George Leake, merchant, pastoralist and MLC for Perth. Both encounters included dance. At Leake's party Gyallipurt danced a kangaroo dance, which another guest, the settler and diarist George Fletcher Moore, considered a clever imitation of 'the motions of the animal, and the panting and gestures of the persons in chase'. 'Afterwards', said Moore, the two men 'seated themselves in armchairs with the greatest self-complacency, and drank tea'. Moore was on board when Gyallipurt and Maryate were returned to King George Sound in the schooner *Ellen* and recorded the joyous reunion. He considered their brief visit to have been 'of great service, for many natives subsequently came into Perth and Fremantle and intimated their desire to live [with us] on friendly terms' JAK

See also: 11.7, 11.8.

Green, N., *Aborigines of the Albany Region 1821–1898*, vol. 6 of *The Bicentennial Dictionary of Western Australians*, Nedlands, WA, 1989; 'Gyallipurt', in J. Kerr (ed.), *The Dictionary of Australian Artists, Painters, Sketchers, Photographers, and Engravers to 1870*, Melbourne, 1992.

H

Haasts Bluff artists, see Ikuntji Arts Centre.

HAMM, Treahna (1965–), Yorta Yorta printmaker, and visual artist. On viewing the first exhibitions of 'urban' Aboriginal art in the 1980s, Treahna Hamm discovered a sense of connection with the art world: 'For the first time I found a group of artists with similar experiences. I was able to relate personally to what they were saying in their work. Identity, Aboriginality, and dispossession were major issues'.

Born in Melbourne, Hamm was adopted into a non-Koori family and grew up in a household with two other Koori children in Yarrawonga (Vic.). Her love for drawing seemed instinctive; in her late twenties she was not surprised to discover that three of her uncles were artists. She chose **print-making** as her medium because of the 'practicality of the techniques', a fascination with the tools, and the possibilities for seemingly limitless effects.

Manni Redlich at the Charles Sturt University furnished her with a formal art education, introducing her to the work of European and Australian modernists. Hamm has since favoured minimal colour, a flattened picture plane, and fluency of line. Later influences include 1960s psychedelic motifs, Rolf Harris, and traditional Indigenous landscapes. In her mature style she utilises reinterpreted landscape imagery and a layering of form and subject. Her themes revolve around family history and national political issues.

Hamm won the 1996 NIHAA for her three-panelled work *Remains to Be Seen*, 1996. She has had solo exhibitions at Sydney's Hogarth Gallery, and the Wagga Wagga and Albury regional galleries, and has given print workshops at various venues. Group shows include 'Can't See for Lookin'' (NGV 1993) and 'Urban Focus' (NGA 1994). She has undertaken commissions from the Charles Sturt University, Wagga Wagga City Council, and SOCOG. Her work is in collections as diverse as the NGA, Japan's National Museum of Ethnology, the Holmes à Court Collection, Heytesbury (WA), and Griffith Regional Art Gallery.

TM

See also: **art awards and prizes,** *328*.
Australian Heritage Commission, *The Third National Aboriginal & Torres Strait Islander Heritage Art Award: The Art of Place*, Canberra, 1996; Victorian Aboriginal Education Association and the Women's Art Register, *Can't see for lookin': Koori Women Artists Educating* [education kit], Melbourne, 1993.

HARGRAVES, Lily Nungarrayi (Yirdingali) (*c.*1930–), Warlpiri painter, is a senior Law woman and leader in the ritual lives of Warlpiri women, who supervises women's song and dance ceremonies with the great personal and spiritual strength that is evident in her paintings. Nungarrayi is custodian of *ngalyipi* (bush vine **Dreaming**). Her traditional country is Kulungalinpa (Duck Pond), situated 200 kilometres south-east of Lajamanu. She holds custodial rights to this country, singing the land and reproducing the ceremonies of the site in her paintings. She also holds ancestral rights over *mala* (wallaby) and *karnta* (women's Dreamings for the Nungarraiyi–Jungarraiyi, and Japaljarri–Napaljarri subsections. She works in bright, vivid patches of colour, employing the dotted line to create a background rather than the randomly-distributed single dots that are the trademark of many other Lajamanu artists. In this way she creates a heavily worked textural surface in which the graphic *yalwaya* (ancestral) designs are enclosed in a mosaic of colour.

Nungarrayi's work is held in a number of public and private collections throughout Australia. She was represented in the exhibition 'Paint up Big' (NGV 1990), and 'Aboriginal Art and Spirituality' (HCA 1991). She has exhibited in numerous group shows with the **Warnayaka Art Centre,** of which she is a member.

VMCR

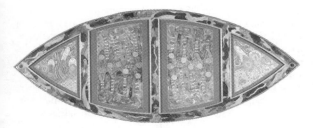

328. Treahna Hamm, *Remains to be Seen*, 1996.
Hand-coloured etching, 123 x 303.5 cm.

Ryan, J., *Paint up Big: Warlpiri Women's Art of Lajamanu*, Melbourne, 1990.

HARRIS, Alana (1966–), Wiradjuri–Ngunnawal visual artist. In 1986, while still a photography trainee at **AIATSIS,** Alana Harris was selected as one of the photographers for the Institute's *After 200 Years* project. Harris's work with the Indigenous community of Leeton marked an important period of personal growth as an artist that has subsequently helped to shape her career.

Harris was employed as Senior Photographer at AIATSIS from 1987 and completed a Diploma of Arts (Photography) at Canberra Institute of Technology (CIT) the following year. In 1988 she documented Sydney's Long March of Justice, Freedom and Hope, which resulted in the publication *Australia's too Old to Celebrate Birthdays.* Harris first exhibited her photographs in 1988, and was one of the participants in Kevin **Gilbert**'s landmark touring exhibition 'Inside Black Australia' of the same year.

Harris received the NAIDOC ACT Aboriginal Artist of the Year Award in 1990 (she was to receive it again in 1993, along with the NIHAA Award for Photography). Her first solo exhibition was 'Patterns of People and Place—Aboriginal Photographs in a New Decade' (HCA 1993). In 1992, her production of the *1993 Black Women's Calendar* was important in providing her with the opportunity of working with some of Australia's inspirational Indigenous women.

Harris was awarded a Professional Development Grant from the ATSIAB of the Australia Council in 1995, which enabled her to produce a series of landscape images of national parks in New South Wales. This marked a significant return to the subject matter of her youth, to the time before she had gained, through the *After 200 Years* project, the confidence and self-assurance necessary to photograph people. Harris's work is held in a number of public collections including the NGA and AIATSIS. KG

See also: 12.4; **art awards and prizes;** 387.
Harris, A., *Australia's too Old to Celebrate Birthdays,* Canberra, 1988; Phillips, S. (ed.), *Race, Representation, and Photography,* Sydney, 1994; Taylor, P. (ed.), *After 200 Years: Aboriginal and Torres Strait Islander Australia Today,* Canberra, 1988.

HELICOPTER TJUNGURRAYI, Joey, see Lucy Napanangka Yukenbarri.

history. The spaces given to Aborigines in Australian history books have reflected how white Australians defined themselves and what kind of nation they wanted to be. Historians of Australia, predominantly of Anglo-Celtic origin and of the coloniser class, have been in a powerful position to place Aborigines in—or displace them from—historical narratives. Mindful of a British audience, nineteenth-century historians exoticised the drama of colonial encounters with Indigenous peoples, adding excitement and tragedy to a narrative about a strange land. Late nineteenth-century historians like J. Bonwick (*First Twenty Years of Australia* 1882), H. G. Turner (*A History of the Colony of Victoria* 1904) and G.W. Rusden (*History of Australia* 1883) lamented the violent exit of Aboriginal people from places like Tasmania, and described frontier warfare between British settlers and Aborigines as poignant, often morally disturbing episodes. Although Rusden lumped Aborigines in his chapter with

'natural phenomena', he blamed Australians for denying Aboriginal rights, and for a 'century of contempt for justice', and held the whole community responsible for the frontier slaughter. In his study of Victoria, Turner took another tack, concluding that this colony's treatment of Aborigines should cause 'no serious stain'; it was more the stain of British convict ancestry that troubled his generation.

In the lead-up to Federation in 1901, and after it, historians launched their bid to shape a unifying narrative for the emergent nation, attempting to create a respectable story of progress and evolution towards self-government. Their metaphors and contrived paradigms created foundational mythologies of nationhood which artificially marginalised or excluded Aborigines. Bestselling historian Arthur Jose (*History of Australasia* 1899) thus imagined Australia as a blank map waiting to be discovered and explored, its spaces and places to be pencilled in. While New Zealand's colonisation was characterised by warfare, he dismissed Australian 'blackfellows' as being 'unfriendly', yet with populations 'so small and scattered' as to be powerless. Major studies of land 'settlement', such as S. H. Roberts' *History of Australian Land Settlement* (1924) mentioned Aborigines as 'ungovernable', with no understanding of 'the white man's laws of property', before rendering them invisible from his history of the taking over of the land.

National ideals were gaining the tonal quality of 'White Australia', so dark Australians did not fit neatly into the national future. Australia's histories became increasingly oriented to 'progress' and the future, with Aborigines relegated to the 'melancholy footnote' which became, in W. E. H. Stanner's words, the 'Great Australian Silence'. In school textbooks and popular histories, most Australians learnt that their nation was 'peacefully settled'; it was the 'quiet continent'. Aborigines only appeared as a past, primitive people, as a series of negatives; they had 'no houses', 'no clothing', 'no agriculture'. Conservative historians mentioned Aboriginal primitives as a prelude before getting onto the 'real' history of modern Australia. A more radical historian, W. K. Hancock (*Australia* 1930), referred to the 'economical tear' shed by humanitarians to mark the inevitable demise of Aborigines after pastoral takeover. In Russel Ward's search for the apotheosis of the 'unique' Australian bush (*The Australian Legend* 1958), he not only ignored frontier conflict but transposed white men as the truly 'Indigenous'—as the 'nomad tribe'.

Since the 1980s, historians have continued to play a key role in defining and reinventing the nation. A tidal change in history writing reflected the impact of post-1960s civil rights struggles in Asia, the USA, and elsewhere. Henry Reynolds' eye-opening *The Other Side of the Frontier* (1981) demonstrated that the story of Australian colonisation could be written from an entirely different cultural and experiential perspective. C. D. Rowley, Richard Broome, Andrew Markus, and Tim Rowse used the state as their focal points for analyses of Aboriginal policy and practice, while histories by Peter Read, Anna Haebich, Heather Goodall and Ann McGrath integrated first-hand stories of Aboriginal struggles. Bain Attwood's *The Making of the Aborigines* (1989) argued for more theorised approaches. Henry Reynolds' *With the White People* (1990) discussed Aboriginal people's

work for white colonisers, and his highly influential *Law of the Land* (1987) presented arguments about the legal premises of colonial dispossession.

Aboriginal protests at the 1988 bicentenary of the British landing at Port Jackson made Australians aware that Australia also had a black history. But in the public arena, a historical question like 'Was Australia invaded or settled?' is still likely to provoke discomfort for many white Australians. Increasing talk of a shameful past so upset conservative forces that, in the late 1990s, the Prime Minister, John Howard, slammed the 'black armband school of history' as a distortion of the national past. But Australian history-writing now acknowledges greater parity between Aboriginal and non-Aboriginal historiographical traditions. Land claims and **native title** claims, and the quest of the **stolen generations** to find their families, have led to an intensification of historical research. In response to Indigenous desires to claim back their history, several non-Indigenous historians have turned away from the study of white–black interactions to focus instead upon the early history of campaigners for Aboriginal rights. Historians Fiona Paisley, Marilyn Lake, and Alison Holland (in her *Saving the Aborigines* 1998) have analysed the work of white feminists who, in conjunction with Aboriginal women, struggled valiantly, though often mis-guidedly, for justice and human rights. By focusing more on the 'good colonisers', recent historical writing is not so much trying to scrub away the stains of the past, as to explore, and possibly gain heart from, the long struggle of those men and women who always saw those stains clearly.

Some would argue that only histories written by Aboriginal people can be truly classed as 'Aboriginal history'; for only they incorporate actual Aboriginal perspectives on the past. Lack of educational opportunities, and commitment to other priorities, mean that few Aboriginal historians practise in the academy. Reflecting their different perspective on the parameters of history and possibly of 'nation', Aboriginal historians are often community historians, focusing on family and community histories rather than general themes. Australian Aboriginal people who still retain their **languages** and land relationships continue to tell their own stories of colonial encounters in orally transmitted stories, dance, song, and art. Aboriginal history stories emerge out of ontological traditions very different from Western historiographical traditions. Intricately associated with landscape, they are best told on the land where things happened: the land is verification of the historical sequence. Stories are also specific to people and should be told by the person who is in the correct relationship to country, or to the kin and family concerned. Aboriginal traditional stories do not distinguish sharply between what happened in the storyteller's lifetime and stories known as '**Dreaming**'—creation stories where chronology is indeterminate. Such histories reflect a moral universe and its philosophical underpinnings, in the form of agreed narratives.

Child removal policies, severance of whole communities from their traditional lands, and cultural domination have disrupted the transmission of traditional history. Aboriginal autobiographical writing, most spectacularly Sally **Morgan**'s *My Place* (1987) and Ruby Langford **Ginibi**'s *Don't Take Your Love to Town* (1988), has greatly sharpened awareness of a dis-tinctive Aboriginal experience of twentieth-century Australia. The paintings of Gordon **Bennett**, Sally Morgan, Trevor **Nickolls**, and many other Aboriginal artists also deal with post-colonial historical and autobiographical themes, debunking historical givens with hard-hitting wit and clever juxtapositions. Indigenous academic historians like Jackie Huggins, Marcia Langton, and Noel Pearson have published valuable and innovative histories and also draw upon their historical knowledge to work as key political advisers to promote their people's future. AMcG

See also: 2.5, 3.4, 4.2, 4.3, 4.6, 8.3, 8.4, 8.5, 10.3, 11.2, 11.4, 12.2, 12.3, 14.5, 18.4, 19.2, 20.3, 20.4; **archaeology, cultural heritage, Day of Mourning, family history, Freedom Ride, guerilla fighters, Gyallipurt, land rights, life stories, Mabo, massacres, reconciliation, referendum of 1967, repatriation, Survival Day, Tent Embassy, Trukanini.**
Clendinnen, I., *True Stories*, Sydney, 1999; McGrath, A. (ed.), *Contested Ground*, St Leonards, NSW, 1995; Reynolds, H., *This Whispering in Our Hearts*, St Leonards, NSW, 1998; Stanner, W. E. H., *After the Dreaming*, Sydney, 1968.

HONEYCHILD, see Paji Honeychild **Yankarr.**

HOOKEY, Gordon (1961–), Waanyi visual artist, was born at Cloncurry (Qld). He has been making art since second grade, inspired by his cousin, who told him stories and drew pictures in the sand. His first paintings were on bark. However, 'even as a kid I would get frustrated painting, I always saw things differently.'

At home everyone was encouraged to get a trade, so after completing his school certificate in 1977, Hookey trained as a bricklayer (1981–84). He sees this as an advantage, particularly since his favourite medium is sculpture: 'Painting is like a waltz; sculpture to me is like heavy metal. Sculpture is more active and physical, it allows me to work more with my hands, get dirty.' His sculpture commissions include the Redfern Public Art Project, Lawson Square, begun in 1996.

In 1987 Hookey completed his BA at Queensland University. While in Sydney completing a BFA at UNSW's College of Fine Arts (1991–94), he joined **Boomalli Aboriginal Artists Co-operative** and in 1994 became its alternate director. The Sydney Road Transport Authority had employed him on the Gore Hill Freeway project in 1992, and the following year he was commissioned to paint several murals. He has never signed his name to a painting—'I would prefer people to buy my art for the art, not for the name'—and sees his work as non-commercial because of its political content and passionate subject matter: 'My art is located … where Aboriginal and non-Aboriginal cultures converge. A lot of concerns and issues still have to be addressed. There is no real accountability for the injustices on Aboriginal rights.'

Hookey had three solo shows less than eighteen months after graduation, and six by 1996. Examples of his work are in national and international collections: the NGA, ANU, SLNSW, Flinders University, and the AGWA, and in the Native Studies Collection, at the University of Alberta, Canada. In 1990 Hookey won the Maroochy Art Prize; and in 1992 was awarded a Ken Brindle Scholarship. In 1998 he won

the Ngunnawal Emerging Artists Prize in the NIHAA with his painting *Day of Mourning*. He has participated in a variety of group shows including the travelling exhibition 'Black Humour' (CCAS 1997–98), and 'Beyond the Pale' (AGSA 2000). BW

See also: 12.1; *312*.
O'Neill, N. J. & Barney, J., *Black Humour*, Canberra, 1997; Croft, B. L. (ed.), *Beyond the Pale: 2000 Adelaide Biennial of Australian Art*, Adelaide, 2000.

horse racing, see jockeys.

HUDDLESTON, Gertie (1933–), Mara–Yukul–Warndarang painter and needleworker, started painting in 1992. Her mentors were the late Willie **Gudabi** and his wife Moima Willie, who exerted some influence upon her exquisitely detailed landscapes and vibrant palette. However, when she reveals her past talents as a champion needleworker the origins of her intricate style and love of floral motifs becomes apparent:

Oh goodness [flowers] make me happy inside. Long time, when the missionaries were there [at Roper River] we used to do fancywork you know, table cloth and needlework: big flowers, Waratah flowers, all the bush flowers. I was champion for needlework and it looked like that [one of her paintings] (interview by Margie West, 1998).

Huddleston's bountiful landscapes, crammed with a plethora of animal and plant life, are eloquent depictions of the two ways of life she has lived; firstly as a hunter-gatherer 'footwalking' through her parents' countries between the Rose and Limmen rivers (NT), then as a young girl growing up at Roper River mission she tended the animals and the gardens, planting exotic vegetables and flowers in orderly rows. In addition,

Huddleston draws upon the various landscapes she has travelled through on her way to places like Darwin, Gunbalanya (Oenpelli), and Perth: 'I've seen a lot, everywhere I went. It's good to put something that you saw in your painting.'

Since beginning to paint for the market in 1992, Huddleston has had solo exhibitions in Darwin and Melbourne, and has participated in a number of group shows including 'Contemporary Territory' (MAGNT 1998) and 'Beyond the Pale' (AGSA 2000). In 1999 she won the General Painting Award at the NATSIAA for her work *Garden of Eden II*.

Huddleston shares her enjoyment of painting with her talented sisters, Eva Rogers, Dinah Kadjeri, Betty Roberts, and Angelena Gorge, and daughter-in-law Sheena Huddleston. Together they comprise the core of the women painters who are forging a distinctive form of landscape painting at **Ngukurr.** MW

See also: *329*.
Croft, B. L. (ed.), *Beyond the Pale: 2000 Adelaide Biennial of Australian Art*, Adelaide, 2000.

HUDSON, David (1962–), Ewamin–Yalangi musician, dancer, actor, visual artist, and producer, has also studied and worked in community recreation and Aboriginal health. He has taught many thousands of students of all ages about Aboriginal culture through music and dance. His career as an actor has included roles in television (*Frontline*) theatre, and in film, for example the short film *Black Man Down* (1996) and the feature film *The Isle of Dr Moreau* (1995). He has recorded twenty-one CDs featuring the **didjeridu**, and he co-founded the Tjapukai Dance Theatre, one of Australia's premier tourist attractions. He has toured internationally as a soloist and group member of Aboriginal cultural troupes, and with New Age musician Yanni, and has exhibited his art

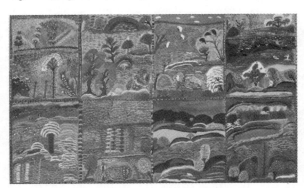

329. Gertie Huddleston, *Different Landscapes around Ngukurr*, 1997.
Acrylic on canvas, 122 x 199 cm.
The artist says of this painting:
'There are several places around Ngukurr that are special. The old vegetable gardens that we planted all in a row in the early mission days. The white and black cockatoos, egrets, and water birds feeding at the water's edge. The bush trees and shrubs provide us with many kinds of food and medicines. Flowers are in bloom, butterflies, beetles, insects fly everywhere. This is the wet season.'

330. David Hudson in performance, 1998.

works in Australia, Europe, and the USA. He has recently established a retail outlet in Cairns to market his own and other Aboriginal artists' arts and crafts.

Hudson has successfully diversified his creative talents into multimedia representations of contemporary Aboriginal culture. For example, he not only writes, produces and performs the music for his CDs, but also paints or designs the artwork used in their packaging. The artwork is then integrated into his Internet site and also used for T-shirt designs. As well as making and decorating didjeridus, he also produces instructional videos on how to play the instrument. This unique combination of musical and artistic talents and promotional skills mark David Hudson as one of Australia's most prolific and professional multimedia artists.

KN

See also: *330*.

HURLEY, Ron (1946–), Gurang Gurang–Munuunjali painter, printmaker, ceramicist, and sculptor. Ron Hurley's works are eloquent statements about the politics of dispossession. As a result of his city upbringing, he personally experienced the alienation of what he terms 'limboism'—of belonging to neither black nor white culture. This led him to explore the urban Aboriginal dilemma and to create his own heroic, urban mythology. Out of this came his first major series of paintings based on the tragic life of the gifted Indigenous cricketer, Eddie Gilbert.

Hurley's classical European art training strongly influenced his early work. By the 1990s his style was becoming more expressionistic, with a flattening of the picture plane and occasional use of traditional Gurang Gurang motifs—a change typified by his paintings shown in 'Tyerabarrbowaryaou II' (Havana 1994). Hurley has taught with the Australian Flying Art School and at the Queensland College of Art, and undertook an Australia Council residency in Paris in 1992. Since 1996 he has carried out numerous public sculpture commissions in Queensland.

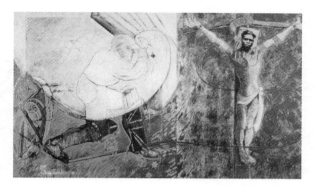

331. Ron Hurley, *Bradman Bowled Gilbert*, 1989.
Two panels, oil on canvas, 182.3 x 304.5 cm.

While partly autobiographical, Hurley's art is a conscious repositioning of Aboriginal people in the historical record. As he said in an interview with Margie West in 1993:

We should think about the fact that [Eddie] Gilbert and people like him, are a very integral part of not only white Australian history, but black Australia's history too. There's been a distinct lack of records by black people. The wonderful thing about paintings is that they are records of the state of play, according to the time in which they were produced, and hopefully address the shortcomings, imbalances and the deficiencies of that time. They are records that will be here a long time after their creators are gone.

Hurley has participated in a number of significant group exhibitions including 'Balance 1990' (QAG 1990), 'Aratjara' (Düsseldorf, London, and Humlebaek 1993–94), and 'Urban Focus' (NGA 1994). His work is held in the NGA, QAG, QM, and several university collections.

MW

See also:8.2, 12.1; **cricket**; *331*.
Mundine, D. & Foley, F., *Tyerabarrbowaryaou II: I Shall Never Become a White Man*, Sydney, 1994.

I

Ikuntji Arts Centre and its artists. Ikuntji, meaning 'a place where two creeks cross' is the local name for Haasts Bluff (NT). Fifty kilometres to the west of Hermannsburg and separated from Papunya by the spectacular Western MacDonnell Ranges, the community is made up of approximately 200 people, primarily Pintupi and Luritja speakers. In days gone by it was a Lutheran mission, rations depot, and finally a government cattle station. From the 1930s until 1955, when Papunya was established, there was a large population drawn from a variety of language groups, a result of drought and 'dispersals' (often the euphemism for **massacre**). Pastoral encroachment, particularly the fencing of waterholes also forced people off traditional lands.

In the 1970s a number of artists living at Haasts Bluff and nearby Browns Bore painted for the **Papunya Tula** company, including Timmy Tjungarrayi Jugadai, Two Bob Tjungarrayi and Barney Raggatt Tjupurrula. Arrernte watercolourists Kevin Morris Tjampitjinpa and Skipper Tjakamarra Raggatt also made Haasts Bluff their home. The individuals, mainly women, who would be instrumental in establishing the new art centre had sat down alongside these senior artists and assisted their work, and were now keen to paint in their own right and pass on their culture, to a wide audience. They set up the art centre, originally known as Ikuntji Women's Centre, with Marina Strocchi as coordinator.

Officially opened in August 1992, the centre became a major focus for the community. Screen-printed T-shirts gave way to an eclectic and exciting wave of paintings on rag paper and Belgian linen. The publication of *Ikuntji: Paintings from Haasts Bluff 1992–1994* helped promote the work on a national level, as did inclusion in high-profile exhibitions and awards such as the NATSIAA, NIHAA, and the Alice Prize.

A nationally touring retrospective, 'Ikuntji Tjuta' (CCBAG 1999) featured work by all the regular artists at Haasts Bluff. Their work continues to be exhibited in private and public galleries, and has been included in overseas survey shows.

In 1995 *Minyma Tjukurrpa*, a joint canvas project between Kintore and Haasts Bluff women, gave artists from both areas an opportunity to reaffirm family and country ties. Exhibited at Tandanya in Adelaide, and later in Singapore, the large-scale canvases inspired women at Kintore to continue painting for Papunya Tula.

Anyone living in or around Ikuntji is encouraged to paint. Collectively, Ikuntji paintings are recognisable through their bold colour and the inclusion of traditional motifs alongside figurative and naturalistic imagery. The key painters to have emerged are Long Tom **Tjapanangka**, Mitjili **Napurrula**, Marlee Napurrula, Narputta **Nangala**, Daisy **Napaltjarri Jugadai** and Alice Nampitjinpa. Individually these artists have developed their own sophisticated and innovative visual repertoire to record their Tjukurrpa (**Dreamings**), setting themselves apart by working intently with a strong sense of self expression.

Other artists associated with Ikuntji Art Centre include Eunice Napanangka, Anmanari Napanangka, Linda Napurrula, Coral Napurrula, Kevin Morris Tjampitjinpa, Inkitjili Nampitjinpa, Gideon Tjupurrula, Katarra Nampitjinpa, and Tjungupi Napaltjarri. UR

See also: 9.5; **art awards and prizes, art and craft centres**; *393*.
Strocchi, M. (ed.), *Ikuntji: Paintings from Haasts Bluff 1992–1994*, Alice Springs, 1995.

Injalak Arts and Crafts, Gunbalanya (Oenpelli). Art had been produced for sale for many years in western Arnhem Land (NT) before the establishment of Injalak, and a number of private dealers had long-standing relationships with, or were resident in, the Gunbalanya (Oenpelli) community. The establishment of a community-owned and controlled centre finally provided the opportunity for local people to take full responsibility for the marketing of their arts and crafts. Injalak Arts and Crafts was incorporated as an association in 1989, with an Aboriginal executive committee.

The centre began life in 1986 as a very modest screen-printing workshop in a tin shed, operating under the auspices of the Adult Education Centre. When the new purpose-built centre opened in 1989 it included a large screen-print workshop at the rear of the building and training in screenprinting was provided by a qualified teacher. The focus of the centre shifted rapidly as bark painters and weavers brought in ever increasing quantities of their work, but it was not until late in 1991 that the centre first employed a manager, with **ATSIC** funding. Injalak buys arts and crafts from more than 300 artists and craftspeople who work regularly or semi-regularly for the centre. It now carries a very broad range of products including bark and paper paintings, natural fibre products, jewellery, limited edition prints, screen-printed fabrics and T-shirts, artefacts, **didjeridus**, cards, and books.

Injalak has been able to achieve significant commercial success since trading began, capitalising on its proximity to Kakadu National Park. It also acts as a wholesaler and exhibits in galleries nationally and internationally.

Injalak has had major international successes. In 1991 it accepted a major commission from the American collector John W. Kluge. The commission—forty-five works on paper featuring a range of *djang* or creation stories, a full colour catalogue of the works, and an accompanying video—are now part of the Kluge–Ruhe Collection at the University of Virginia. The commission was executed on archival quality handmade rag paper which has since become a popular medium for the local artists. In 1994 the Department of Foreign Affairs and Trade bought the *Kunwinjku Seasons* calendar collection and toured it throughout Asia. Injalak has also entered into strategic partnerships to collaborate on a range of commercial and socio-cultural projects with the local community school, manufacturing and licensing companies, performing arts companies, and the Australian Nature Conservation Agency.

Although Injalak operates in difficult circumstances, its long-term future is passionately supported by its stakeholders. In the words of executive member Isaiah Nagurrgurrba: 'We want Injalak to help for cultural things, for the future. We want the art centre for the children's future.' FW

See also: 5.2, 21.3; **art and craft centres, printmaking**; *3, 55, 56, 57, 58, 152, 363.*
Morphy, H. & Smith Boles, M. (eds), *Art from the Land: Dialogues with the Kluge–Ruhe Collection of Australian Aboriginal Art*, Charlottesville, VA, 1999; Aboriginal Arts Board, *Oenpelli Bark Painting*, Sydney, 1979.

Internet, see 13.5, 15.4.

INTJALKI, Atipalku (1955–), Pitjantjatjara batik artist, is well known for her mastery of **batik** technique, which is constantly refined and expanded in her practice. An extremely skilled textile producer with an exquisite colour sense, she quickly adopted the characteristic *Ernabellaku walka* (a fluid, curvilinear, abstract form) and adapted it for medium and mood. Her designs are varied, yet all operate within this regional design base, distinctive across the Anangu Pitjantjatjara Lands (SA). The *Ernabellaku walka* operates as a signature for art from the region. Although the women consistently refuse to attach specific meanings to these designs, they acknowledge that they are inspired indirectly by the natural environment.

Many artists at the **Ernabella Art Centre** operate in a variety of media, but Atipalku concentrates on batik. She participated in the Shift Textile Symposium at Canberra in 1997 and exhibited widely in Canberra during this time. Her talent has been inherited by her three daughters—Langaliki (1973–), Lynette (1979– , who works in the art room), and Michelle (1983–). 'The girls seem to learn design in [the] way language is learnt: by "absorbing" the structure of images and shapes', noted Ute Eickelkamp in 1998. Atipalku's work was exhibited in Poland and London in 1998 as well as throughout Australia, and examples of her work are held in Australian national and State collections.

LP

Invasion Day, see Survival Day.

J

JAGAMARA NELSON, Michael, see Michael Jagamara Nelson.

JAMINJI, Paddy (Jampin) (1912–1996), Kija visual artist. Steeped as he was in traditional knowledge of his country, Paddy Jaminji produced paintings of great spiritual intensity. Despite the social upheavals that occurred in the Kimberley during his lifetime, he spent most of his life in and around his country near Bedford Downs station (WA). In 1975 he was one of the first people to move to **Warmun** on the fringes of the township of Turkey Creek, after Aboriginal people had been sacked from their cattle station jobs as a result of the granting of equal wages to Indigenous workers. Jaminji was instrumental in helping his people adjust to the new living conditions at Warmun.

As a classificatory uncle to **Rover Thomas**, and as a man of great religious knowledge, Jaminji was chiefly responsible, in 1977, for creating the paintings used in the first Kurirr Kurirr (Krill Krill) ceremony, which was owned by Rover. With Rover, he was one of the instigators of what is now commonly known as the East Kimberley School of painting. As interest in his work increased, Jaminji's subject matter expanded beyond the images of the Kurirr Kurirr. In the last years of his life, his painting output was curtailed by the onset of trachoma.

Although Jaminji is mostly known for his paintings in natural pigments on board, on occasion he also painted on canvas and made sculptures. His work is held in several major public and private collections and has been included in exhibitions such as 'The Continuing Tradition' (NGA 1989), 'Roads Cross' (NGA 1994), 'Images of Power' (NGV 1993), and 'Aratjara' (Düsseldorf, London, and Humlebaek 1993–94).

WC

See also: 10.1, 10.2, *332*.
Akerman, K., 'Western Australia: A focus on recent developments in the East Kimberley', in W. Caruana (ed.), *Windows on the Dreaming: Aboriginal Paintings in the Australian National Gallery*, Chippendale, NSW, 1989; Christensen, W., 'Paddy Jaminji and the Gurirr Gurirr', in J. Ryan with K. Akerman, *Images of Power: Aboriginal Art of the Kimberley*, Melbourne, 1993; Stanton, J. E., *Painting the Country: Contemporary Aboriginal Art from the Kimberley Region*, Nedlands, WA, 1989.

JANDANY, Hector (*c*.1929–), Kija visual artist, is a cultural and spiritual leader of the Warmun community (Turkey Creek, WA) in the East Kimberley. He has been committed to the 'two-way' education of Kija children in Warmun since he and fellow artist and elder George **Mung Mung** set up the Ngalangangpum bicultural Christian school in the 1970s. His paintings often reflect 'his own radical blend of Gija law and Catholicism interpreted in Gija terms' (Ryan 1993). He is a master with natural earth pigments, achieving rich and subtle surfaces derived directly from his intimate knowledge and inseparable relationship with his country. Through working at Warmun Art Centre, he continues to be an inspiration to many young, emerging Kija artists.

Jandany has participated in a number of significant group exhibitions including 'Images of Power' (NGV 1993) and 'Aboriginal Art and Spirituality' (HCA 1991), and his work is held in the NGA, NTU, many State gallery collections, and the Berndt Museum of Anthropology, UWA. JNK & AM

See also: 1.2, 10.1, 10.2.
Ryan, J., 'Bones of Country: The East Kimberley aesthetic', in J. Ryan with K. Akerman, *Images of Power: Aboriginal Art of the Kimberley*, Melbourne, 1993; Crumlin, R. & Knight, A. (eds), *Aboriginal Art and Spirituality*, Melbourne, 1991.

332. Paddy Jaminji, *Pukulmirri and Jukulmirri, Dreaming Hills from the Krill Krill ceremony series*, 1983.
Natural pigments on plywood, 60 x 120 cm.

JANGALA, Abie (Walpajirri) (*c*.1919–), Warlpiri painter, describes his painting as *junga nyarnyi* ('really true ones'). To the artist painting is a living reality rather than an abstract idea, part of an intricate ritual life which animates his

ancestral **Dreamings** and reinforces the power inherent in the landscape.

Born at Kurlpurlurna in the Tanami Desert (NT), Abie Jangala is a senior rainmaker and custodian of *ngapa* (water) Dreaming and the associated frog, emu, rainbow serpent and women's Dreaming for the Jangala–Nangala, Jampitjimpa–Nampitjimpa subsections. Jangala's first exposure to the international art world was in 1983, when he and eleven other men from Lajamanu installed a traditional ground painting at the exhibition, 'D'un autre continent: l'Australie, le Rêve et le Réel' (Paris 1983). At the time, members of the Lajamanu community were comfortable with this degree of public exposure of life, but reluctant to follow the example of other communities such as Papunya in incorporating **acrylic** painting into their artistic and cultural practice. In 1985, however, it was decided that ancestral designs could be painted in acrylics for commercial purposes without compromising the spiritual and cultural life of the community. Jangala played a pivotal role in this decision.

In his paintings Jangala employs the iconic designs of his *kuruwarri* (ancestral beings) and their tracks across the land. From the basis of a flat colour background, he brings forth his designs by the application of white dots, which serve to define the other forms through the interplay of light and dark. The *kuruwarri* are the areas of the canvas where the darker ground is allowed to show through (in the absence of dots), enlivened by the application of additional colours. According to Jangala, the choice of colour makes the *kuruwarri* 'really strong'. The white dots are the counterpoint against which the starkness of the *kuruwarri* come alive, seeming to jump off the canvas. Until 1997, Jangala preferred grounds of green, red, and black. In later works he opted for pale blue and mauve hues. Over his painting career, his depiction of ancestral forms has become increasingly symbolic; he is now less concerned with imparting cultural knowledge to an outside audience and more with strengthening and keeping his culture alive.

Jangala has established himself as an important figure in Indigenous art. He held his first solo exhibition in 1993, at Coo-ee Gallery in Sydney. More recently, he began to work in the print medium, contributing a limited-edition print for the 1997 *Origins* portfolio of prints by Aboriginal artists for the Festival of the Dreaming. Examples of his work are held in the NGA and most State galleries, and in private collections including the Holmes à Court Collection, Heytesbury (WA), and the Kelton Foundation, Santa Monica.

VMCR

See also: 9.5; **Warnayaka Art Centre**; *223*.

Brody, A. M. (ed.), *Stories: Eleven Aboriginal Artists*, Sydney, 1997.

JARINYANU, see Jarinyanu David **Downs**.

JENUARRIE (1944–), Koinjmal ceramicist, printmaker, painter, and textile artist. Judith Warrie adopted the professional name of Jenuarrie when she embarked on a career in the arts. For twelve years she worked with her sister Heather Walker (1942–); they shared resources and both earned success as Aboriginal printmakers and creative artists. Working together in their shared studio space in the 'family compound' was a practical solution that minimised setting up

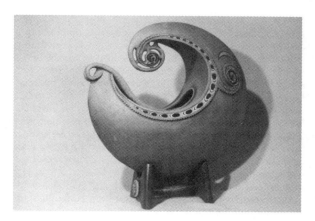

333. Jenuarrie, *Earth–Water–Fire: Idea–Object*, 1989. Low-fired terracotta, c.35 x 35 cm.

and running costs, and provided moral and physical support through the long working hours.

The two sisters are the eldest of seven children born to Dorothy Warrie (née Gray) whose cultural heritage is Koinjmal (Qld). Jenuarrie and Heather began their creative careers as mature-age students at the Cairns TAFE (now **Far North Queensland College of TAFE**). This foundation stage of their careers proved to be very enlightening, as the all-Indigenous student body came from a wide variety of different Aboriginal community backgrounds. Most were urban artists who had been taught in regional rural schools throughout Australia. As Jenuarrie said: 'We were more familiar with an educational system that upheld a colonial attitude and maintained Western philosophies and teachings.'

Both Jenuarrie and Heather Walker soon realised that many of these accepted practices conflicted with traditional Aboriginal and Torres Strait Islander cultural protocols and customs. This period of time spent bridging cultures was an awakening that was a guiding force in motivating Jenuarrie to pay tribute to her Aboriginal cultural heritage. Cairns TAFE proved to be a very exciting, inspirational, and productive environment for both sisters as their research gradually unfolded a history and assisted in establishing their connections to 'country'. Some of their best work was produced in this period.

Jenuarrie's work was purchased by both the NGA and QAG in the early stages of her career. Heather Walker's print *Watching*, 1988 won an award in the 1988 NATSIAA. This particular work holds the essence of spirituality and hints at constantly being observed and protected. Heather continues to live in Mackay (Qld) and teaches **printmaking** and pottery. Jenuarrie has returned to Cairns and has taken up a senior position with Arts Queensland.

J

See also: 8.2; **art awards and prizes**, *333*.

Samuels, J. & Watson, C., *Aboriginal Australian Views in Print and Poster*, Melbourne, 1987.

jockeys. It is commonly supposed that Aboriginal people have had minimal involvement with organised horse racing

in Australia. Many racing histories and studies of Indigenous sport concluded that racing was far too class-conscious and elitist to have allowed a significant Aboriginal presence, and that it was not until the 1960s, when 'Darby' McCarthy burst upon the scene, that the colour bar was broken. However, Aboriginal people were significantly involved from the very beginning of organised racing in Australia, a testament to the tenacity, resourcefulness, and burning desire of Aboriginal horsemen and women to follow their chosen pursuit regardless of obstacles. Many Aboriginal riders were forced to hide their **Aboriginality** to avoid stigma, stereotyping, and ostracism, or through genuine fear. In other sports too—**boxing** and football are two examples—Aboriginal athletes were forced to adopt another identity and nationality to pursue their careers and gain an income for their families. In the very class-structured 'Sport of Kings' this was accentuated tenfold.

There have been literally dozens of Aboriginal jockeys who have ridden winners at metropolitan tracks across Australia; some even ventured overseas and tasted success on the international stage. The first high-profile Aboriginal jockey was Peter St Albans. Mystery and intrigue surrounds his background, but he was undoubtedly Aboriginal and most probably the illegitimate son of wealthy stud owner and trainer James Wilson. He first burst onto the racing scene in the autumn of 1876 when, aged only twelve, he partnered Briseis to win the Doncaster Handicap and All Aged Stakes at Randwick. Several months later he and Briseis wrote themselves into the history books when they triumphed at Flemington in Australia's greatest race, the Melbourne Cup. St Albans came within a whisker of back-to-back Melbourne Cup victories when he finished second on Savanaka in 1877. He went on to record other notable victories including the Victoria Racing Club's St Leger, the Ascot Vale Stakes, the Sires Produce, the Geelong Cup, and the Hobart Town Cup. Illness, and serious injury from a fall in Sydney, were instrumental in forcing his early retirement. He became a horse trainer; his best horse was Forest King which ran second to G'naroo in the 1891 Caulfield Cup. St Albans died in 1898, aged only thirty-five.

Merv Maynard was another successful Aboriginal jockey. He was the son of the well known Aboriginal activist Fred Maynard, who had been at the forefront of the first united and organised Aboriginal political movement, the Australian Aboriginal Progressive Association, which formed in Sydney in 1924. Merv Maynard began his racing life at Newcastle during the 1948–49 season, and his career went on to span five decades. During that time he rode for Sir Frank Packer and the Sultan of Johore, and was introduced to Queen Elizabeth II. He was also internationally successful, riding winners in New Zealand, Singapore, and Malaysia. Maynard recorded several group and listed victories and rode over 1500 winning races, including more than fifty cup victories on country tracks throughout New South Wales.

Richard Lawrence 'Darby' McCarthy (1947–) was born at Cunnamulla (Qld), the son of an Aboriginal stockman and one of twelve children. McCarthy would prove to be one of the most naturally gifted jockeys to ever grace the Australian turf. He rode in France and Europe for the Wildensteins, Rothschilds, and Prince Aly Khan, and attended parties with the likes of Mia Farrow and Frank Sinatra. His career was punctuated by controversy: he fell foul of officialdom, and weight troubles, accidents, and personal heartache all added to the torment that stalled his career. He attempted numerous comebacks, but he was never able to regain his once lofty position. His all too short a span in the saddle saw him take the spoils in some of racing's greatest events, including three Stradbroke Handicaps, the Brisbane Cup, the Doomben 10 000 and, in the one afternoon at Randwick, the Australian Jockey Club Derby and Epsom.

The pursuit of a career as a jockey has not just been the dream of Aboriginal men. The skill of Aboriginal women, especially as stock-women, has been well documented from the very outset of Aboriginal contact with the horse. Women were denied any presence in organised racing until 1978. Since that point Aboriginal women have been noted as jockeys, especially in remote centres. However it was not until 1998, when Leigh-Ann Goodwin was successful on Getelion at Eagle Farm (Brisbane), that an Aboriginal female rider tasted success at a metropolitan track. Goodwin was extremely proud of her Aboriginal heritage and had overcome parental disapproval and industry bias against female riders, and juggled her role as a single mother of a young son to make her mark as a rider of great talent, potential, and commitment. Tragically, she was involved in a terrible fall during a race at Roma in Queensland on 5 December, 1998. She died two days later as a result of her severe injuries.

Aboriginal involvement and achievement in the very intense, competitive, and bodily demanding sport of racing needs to be recognised. Aboriginal jockeys have achieved great success and they have done so in the face of the added obstacles of oppression, racism, and prejudice. They have mixed it with the best of their profession, playing their part in the sheer exhilaration and excitement of Australian racing. Their vivid stories show them playing an active role in the pages of racing's colourful history.

JM

See also: **Australian Rules football, rugby league.**

Maynard, J., 'Aboriginal Stars of the Pigskin', *Aboriginal History*, vol. 21, 1997; Pierce, P. with Kirkwood, R., *From Go to Whoa: A Compendium of Australian Turf*, Crossbow, Vic., 1994; Hutchinson, G. (ed.), *They Are Racing: The Complete Story of Australian Racing*, Ringwood, Vic., 1999.

JOSÉ, Ellen (1951–), Nurapai–Erub–Mer painter, printmaker, photographer, and installation artist is one of the longest-practising professional artists of Torres Strait Islander descent. Through her art, she has recorded her personal struggle in discovering her cultural identity. Her style and approach to complex issues are a celebration of her newfound pride as a Torres Strait Islander woman in contemporary Australian society.

Her artistic career began at the age of fifteen in various jobs—ticket-writing, window dressing and layout work. After gaining a Certificate of Applied Art in 1976, José went on to complete a Diploma of Fine Art in 1978 and Diploma of Education at Melbourne State College in 1979. While raising four children, she worked professionally as a lecturer, painter, printmaker, photographer, and book illustrator.

With roots in Nurapai (Horn Island), Erub (Darnley Island), and Mer (in the Murray Island group) of the Torres Strait region, José identifies with all of her mixed cultural heritage. She once stated: 'The blood of four continents and many cultures courses through my veins, their struggles are my struggles, their past is my past, their strengths are my strengths, they are my family.'

In 1991, in a solo exhibition entitled 'In Search of Lost Innocence', José tackled the difficult issue of childhood sexual abuse. The seventeen watercolours contained bright tropical images, despite the darkness of the topic. Her next major solo exhibition was 'Black Diggers Ghost Fighters' (1994), a visual recognition of the role of Torres Strait Islander and Aboriginal servicemen in World War II, and in part a form of protest aimed at educating the broader public. José was also paying a personal tribute through this exhibition to her father's struggle through the war. In the exhibition 'Native Titled Now' (Tandanya 1996), José produced the installation piece *RIP Terra Nullius*. This depiction of a typical Torres Strait Islander Tombstone Opening signified the landmark decision of the **Mabo** Case but also the overturning of the concept of terra nullius that had justified the colonisation of Australia.

José's need for cultural fulfilment resulted in her first visit back to the Torres Strait in 1996. This was a turning point in her expression as a Torres Strait Islander artist. 'Ailan Notbuk (Island Notebook)' and 'Blo Em Diskain (It's Like That)' are two exciting exhibitions in which José has asserted her identity with a new vigour. The two titles in Torres Strait Creole celebrate her personal experiences in travelling back to the Torres Strait and accentuate the quintessential aspects of Torres Strait culture that many Islanders take for granted.

José's artistic history represents her life history. Her discovery of herself is expressed from both a personal perspective and within a broader global context. Having toured both nationally and internationally in solo and joint exhibitions, José has not limited her range of expression. Through her use of a variety of different artistic techniques, José expresses her respect for other cultures as well as her own. MB

See also: 1.6, 7.2, 7.4, 12.1; *158*.
José, E., 'Cultural identity', in T. Mosby with B. Robinson, 1988.
Mosby, T. with Robinson, B., *Ilan Pasin: This is Our Way, Torres Strait Art*, Cairns, Qld, 1998; Bani, M., 'Tradition in contemporary form', in L. Taylor (ed.), *Painting the Land Story*, Canberra, 1999.

JUGADAI, Daisy Napaltjarri (1955–), Pintupi–Luritja painter, printmaker, and fabric painter, is the daughter of Timmy Tjungarrayi Jugadai and **Narputta Nangala**. She was born at Haasts Bluff (NT), and attended enough school at Papunya and Haasts Bluff to gain the rudiments of literacy. It was there that she also learned to 'draw properly', that is, according to the conventions of Western art. She also cites the Hermannsburg watercolourists as an influence: artists such as Kevin Morris Tjampitjinpa and Skipper Tjakamarra Raggatt impressed her at an early age.

Jugadai played a key role in getting the Ikuntji Women's Centre (now **Ikuntji Art Centre**) established, and when it opened in 1992 she quickly moved from screen-printing T-shirts and hand-cut lino blocks to large format **acrylic** paintings on linen. Some of her most brilliant paintings were created between 1993 and 1995, when her love of colour and country combined to give rise to a desert landscape abundant with fruits and flowers. The only artist at Ikuntji to work standing 'at the easel', her work is vivid and highly descriptive of the lush, diverse 'bush garden' that springs to life after rain in apparently infertile lands.

Daisy paints her Tjukurrpa, her landscapes, and the landmarks of her late father's and late husband's country: Ulampuwarru, Anyali, Mereenie Range, Atji Creek, Mount Wedge, Browns Bore, and Muruntji. She has exhibited extensively since 1993 at private galleries, and has been included in the NATSIAA and NIHAA exhibitions. Her work is held in many collections in Australia and overseas. UR

See also: **art awards and prizes**.
Strocchi, M., *Ikuntji: Paintings from Haasts Bluff 1992–1994*, Alice Springs, 1995

JULI, Mabel (*c*.1933–), Kija visual artist and community elder, is a senior artist at **Warmun** (Turkey Creek, WA), in the east Kimberley region. She is committed to upholding traditional Law and culture and is an important ceremonial singer and dancer. She was born at Five Mile, near Moola Boola Station (south of Warmun) and was taken as a baby to Springvale station, her mother's country. She started work on the station as a little girl, and as a young woman moved to Bedford Downs and Bow River stations for work.

Juli started painting in the 1980s, at the same time as Warmun artists **Queenie McKenzie** and **Madigan Thomas**. The women used to watch **Rover Thomas** paint and one day he said to them: 'You try yourself, you might make good painting yourself.' As a result, Juli says, 'I started thinking about my country, I give it a try.' She is a dedicated and innovative artist who continues to work in natural earth pigments on canvas. She primarily paints the Ngarrangkarni (**Dreaming**) stories of her country Darrajayn, which is covered largely by Springvale station.

Exhibitions of her work have included a solo show at Gallery Gabrielle Pizzi, Melbourne in 2000, and group exhibitions in Australia and Germany. Collections which hold her work include the Edith Cowan University Art Collection, the Berndt Museum of Anthropology (UWA), the collection of the NTU, and the Kerry Stokes Collection. JNK & AM

See also: 10.2; Rusty **Peters**.

K

KALUNBA, Anchor (*c*.1915–1996), Kuninjku (Eastern Kunwinjku) conical fish-trap maker, song composer, and 'clever man', was born in the lower Mann River district of western Arnhem Land (NT). His father was Narraruk, one of a large number of Kurulk clan brothers including Wurrkidj, Nakarndja, Yankurdda, and Namadburrundul who lived in the rock shelters within Kurulk and neighbouring clan estates of the Liverpool and Mann Rivers district.

During World War II, Kalunba and his family camped on the middle Liverpool River at Yimayhyirud. After the war in the late 1940s he travelled by foot to Gunbalanya (Oenpelli) from time to time. Although Kalunba never saw Macassan seafarers, he was told about their visits by his parents and identified Macassan wells at Nagalarramba on the mouth of the Liverpool River. Kalunba had three wives, and was the father of artists Jimmy Njiminjuma, John **Mawurndjul** and James Iyuna.

Kalunba was an expert at making the conical fish trap known in Eastern Kunwinjku as *mandjabu*. The traps are woven from the vine of *Malaisia scandens* and placed into small tidal creeks in the early dry season on the Tomkinson River floodplain. Kalunba was also recognised as *nakordang* or *marrkidjbu*, a 'clever man' who had the power to discern the causes of illness and to heal people using traditional techniques. His family say this power to heal was given to him by *wayarra* (spirit beings) which inhabit the vine forests of the region. He was considered a patriarch of the Eastern Kunwinjku people and lived at his outstation, Mumeka, on the Mann River south of Maningrida until his death in 1996.

Kalunba's work was represented in a number of significant group exhibitions including 'Aboriginal Art at the Top' (MAGNT 1982) and 'Stories My Parents Sang' (ANMM 1995). His work is held in the ANMM, NGA, MCA, and most Australian State galleries.

MG

See also: 5.2, 5.3, 17.1; Nancy **Kaybbirama, Maningrida Arts and Culture**, *212*.

Altman, J. C., *Hunter–Gatherers Today: An Aboriginal Economy in North Australia*, Canberra, 1987.

KANNGITJA, Nyuwara, see Tjunkaya **Tapaya.**

KANTILLA, Kitty, see **Paru women artists**; *334.*

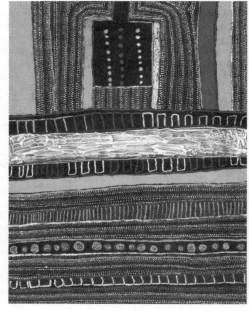

334. Kitty Kantilla, *Parlini Jilamara*, 1995.
Natural pigments on canvas, 122.5 x 92 cm.
The artist said of this painting: 'The shape at the top of the painting is a frying pan. There's lots of different foods. The red is buffalo, the white is fish and the yellow bits are eggs.'

KAREDADA family, Wunumbal painters. Among the most consistent and longest practising artists from Kalumburu (WA) in the far north Kimberley region, the Karedada family have maintained an association with the arts that spans more than thirty years. Jack Karedada and his brother Louis and their wives Lily (Mindildil) (*c*.1937–) and Rosie (Ngalirrman) (1927–) belong to the Wunumbal-speaking peoples whose country is in the north-west Kimberley between the Prince Regent River and the King Edward River. Another brother, Manila Karedada (Kutwit), was one of the foremost painters of Wanjina pictures in the mid 1970s. Lily's brother, the late Geoffrey Mangalamarra was the creator of the famous 'Cyclone Tracy' *balga*, a public ceremony that has had a great impact on contemporary developments in Kimberley art.

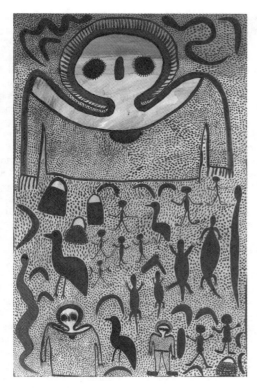

335. Lily Karedada, *Wanjina*, 1990.
Natural pigments and binder on canvas, 110 x 70 cm.

The clan lands of the Karedada family lie at Cape Voltaire (Wulangku). Its primary totemic affiliation is the *karedada* (butcherbird), hence the name of the clan. The Karedada patrilineal moiety affiliations are *wodoi* (spotted nightjar), and *kurangkul* (brolga). The totems of the other moiety, to which Lily and Rosie belong, are *jiringgun* (owlet nightjar) and *banar* (bustard).

During the 1970s the Karedadas augmented their income with the production of traditional artefacts and craft goods. As well as being accomplished in the arts of spinning fibre, hair, and fur string which was made up into belts and other articles of adornment, Lily and Rosie were skilled engravers of **boab nuts**. Jack was an expert knapper of the beautiful, serrated-edged Kimberley spear-points, made from glass and stone. Both Jack and Louis produced high quality artefacts, weapons, and implements that generally did not lend themselves to further embellishment. The exceptions were the broad-faced shields and the **didjeridus**, which both provided surfaces suitable for engraving and painting. In addition to these, the brothers carved boab nuts and, from the mid 1970s on, both families engraved small tablets of slate. Motifs engraved on the slates, nuts, and shields included totemic species, particularly bustard and brolga, the rainbow serpent, fruits and plants of economic importance, and Wanjina beings.

While artists such as Manilla Kutwit and Alex **Mingelmanganu** produced work aimed at the upper end of the art market, the Karedadas generally produced smaller works

painted on prepared slabs of wood. The small Wanjina plaque was to be a major addition to their already extensive range of creations. As an occasional break from the production line approach, all family members painted larger pictures on bark and later on canvas. Initially Jack and Lily produced more significant works than Rosie and Louis, and exhibited alongside Manila and Mingelmanganu at the first exhibition of Kalumburu art held in Perth in 1977.

Jack's Wanjinas can be distinguished from those of other artists by several features including the eyes. These generally abut each other, separated only by a nose that is reduced to a stroke of the brush. Their internally divided haloes are also usually totally bounded, unlike the free-ended rays seen on other Wanjina. By contrast, Lily Karedada's Wanjina are, in Judith Ryan's words, 'executed in a refined style, full of subtle tonal variations'. The figures are often seen to emerge from a ground of finely placed dots or dashes that appear to be an extension of the stippling that covers the body. Infilling the body, in this way, as well as developing the ground on which an image is placed, is a common feature of recent styles of Kimberley **rock art**. Rosie Karedada depicts her Wanjinas with a formal simplicity, depending for her primary effect on the hard contrasting tones of the red, white, and black colours. Louis Karedada has in the past drawn upon a wider range of themes in his art and has presented them in a far more naturalistic way. As well as drawing upon images based on the traditional lifestyle of his youth, he has also called upon his adult life experiences as a source of inspiration. Richard Karedada, Louis and Rosie's son, also paints, and exhibited with his parents in 'Images of Power' (NGV 1993). More recently both Rosie and Louis have turned their hand to **printmaking**.

As elders with extended experience in ways of the bush and its associated cosmology, the senior members of the Karedada family are a vital link between the past and the increasingly cosmopolitan Kalumburu population. KA

See also: 10.1, 10.2; **body adornment**; *335*.
Ryan, J. with Akerman, K., *Images of Power: Aboriginal Art from the Kimberley*, Melbourne, 1993.

KARLOAN, Albert (1863–1843), Ngarrindjeri (Kukabrak) custodian, craftsman, and artist, once spoke to anthropologist Ronald Berndt about the distinctiveness of his cultural tradition: 'When we say we are Kukabrak [Ngarrindjeri], we mean that out forebears belonged to a particular way of life; we did things that other people [other Aborigines] did not do; we spoke a language that was different. There was no need to identify who we were because we knew who we were.'

Albert Karloan was born at Raukkan (Point McLeay mission, SA). He was raised in camps around Lake Albert and went to school at the mission. He was married twice: first to Flora Kropindjeri and then to Eva Closs, a Wutaltinyeri woman. He was the last man to go through the full sequence of Yaraldi initiation ceremonies which ceased in 1892. He was an elder in the Point McLeay community and actively sought to improve the welfare of mission residents. In 1912 he and five other Ngarrindjeri men unsuccessfully applied for modest areas of land under the *Crown Lands Act*. In 1916 Karloan wrote to the Chief Protector of Aboriginals, Mr W. G.

South, for a loan to purchase a cinematograph so that he and his son Clement could set up a travelling show of songs and stories accompanied by slides. His request was rejected.

Karloan moved away from the mission to camp at Murray Bridge, where he first met the anthropologist Ronald Berndt in 1939. His serious concerns about the disappearance of the knowledge of his people and the obvious breadth and depth of his own knowledge, expressed freely at this meeting, were instrumental in Berndt's decision to pursue **anthropology**. Berndt met Karloan again in 1942, and he and his wife Catherine stayed at the Aboriginal camp at Murray Bridge with Karloan for six months. Karloan and Pinkie **Mack** provided Ronald and Catherine Berndt with information about Ngarrindjeri life and customs, and Karloan also assisted Berndt's research by producing drawings of ceremonies, weapons, canoe-making, net-making, and basket-making.

GMcC

See also: 17.1, 17.2, 20.3; *347*.

Berndt, R. M., & Berndt, C. H. with Stanton, J. E., *A World That Was: The Yaraldi of the Murray River and the Lakes, South Australia*, Carlton, Vic., 1993.

KAYBBIRAMA, Nancy (*c*.1930–), Kuninjku (Eastern Kunwinjku) fibre artist, is a much respected elder of the Kurulk clan in the Liverpool and Mann Rivers district of central and western Arnhem Land (NT). Kaybbirama was born at Korlng Karri on the banks of the Liverpool River long before there was any European influence in the region. The nearest mission stations were Gunbalanya (Oenpelli) some 150 kilometres to the west, and Milingimbi Island about 100 kilometres to the north-east. Kaybbirama grew up in the bush at Mumeka on the Mann River, and is the sister of the late Anchor **Kalunba**.

As a young woman Kaybbirama spent a brief time working at Gunbalanya mission in the gardens, but she always remained on the fringe of the mission's activities and she never had any dealings with Europeans in the region. As a result, she has never learnt to speak English. She lives today at Kakodbebuldi outstation, and visits the nearby Maningrida community only rarely. She remains a quietly spoken and shy traditional woman who has never travelled out of the western Arnhem Land region.

As an artist and craftswoman Kaybbirama is best known for her skill as a weaver of traditional conical baskets known as *kunmadj*, and knotted and looped string bags known as *djerrh*. She specialises in the production of feathered string and has extensive knowledge of the plants and animal products used in fibre art. Kaybbirama was taught to produce fibrecraft by her mother and female relatives in the traditional manner, and she is respected in her community as a teacher and senior authority on all aspects of traditional string-bag and basketry craft.

MC

See also: 6.1, 6.2, 17.1; **body adornment**.

Australian Exhibitions Touring Agency, *Maningrida: The Language of Weaving*, South Melbourne, 1995.

keeping places and cultural centres. In the late twentieth century Australian public museums and galleries were no longer just monolithic institutions in capital cities whose role, in relation to Indigenous peoples, was to collect and preserve cultural material. Attitudes had begun to change in the 1970s. Before that the emphasis had been on the objects themselves, with little or no attempt to place the collections within any context other than that of anthropological inquiry. There was little contact between museum staff and the Indigenous makers of the objects. The model that is now emerging emphasises Aboriginal involvement—in some cases in partnership with—museums in the preservation and interpretation of their material culture and through this, of their **history** and **cultural heritage**. A catalyst for action was the publication of *Previous Possessions, New Obligations* (1993), a policy document that articulated the desired relationship between large institutions and Indigenous peoples with regard to the objects held within museum collections. The Australian Museum (Sydney) was one institution which responded, through its pioneering 'Outreach' program, whereby objects are returned, either permanently or as loans, to keeping places and cultural centres run by local Indigenous communities. The staff of the Museum's Aboriginal Heritage Unit also often have a role in the planning and building of these keeping places, and training in museum practice is given to Indigenous community art workers.

Keeping places and Aboriginal cultural centres can be defined as the rural Australian equivalent of the **art and craft centre** in remote Aboriginal communities—as a cultural locus for the Aboriginal people. A keeping place can range in size and scope from a cabinet containing material culture or photographs housed in the local public library, to a free-standing purpose-built centre, such as Brewarrina Aboriginal Cultural Museum (NSW), that serves as a meeting place, study centre, repository for material culture and historical material, and encompasses a museum display for visitors and a retail outlet for locally-produced art. In response to the heightened interest in Aboriginal culture, many keeping places now also function as cultural tourism and education outlets, as at Minjungbal Cultural Centre in Tweed Heads and Umbarra Aboriginal Cultural Centre, Wallaga Lake (NSW). All of these keeping places are unique responses to community wishes and needs: the history of these facilities has shown that if there is a high degree of local Indigenous community input the venture is more likely to be of use to that community, and thus successful.

Another interesting initiative is 'Keeping Culture' (NGA 2000), a travelling exhibition and mentorship program organised in liaison with south-east Indigenous communities. Locally nominated Indigenous art workers first spent time at the NGA developing the exhibition and the accompanying catalogue—skills that can then be put into practice in their local centres. The exhibition then travelled to keeping places and cultural centres in rural New South Wales, Tasmania, and South Australia, where the objects from the NGA Collection were augmented by works from the local area.

PG

See also: 11.1, 11.3, 19.4, 21.1, *241*.

Council of Australian Museum Associations, *Previous Possessions, New Obligations: Policies for Museums in Australia and Aboriginal and Torres Strait Islander Peoples*, Melbourne, 1993; Jenkins, S.,

'Keeping Culture: Contemporary Aboriginal Art to Aboriginal Keeping Places', *Artonview*, no. 21, Autumn 2000.

KERINAUIA, Dolly (*c.*1924–1985), Tiwi carver. In 1954, when the Melville Island Tiwi woman Dolly Kerinauia was asked to carve and paint an ironwood pole (*tutini*) for the grave of her friend Ruby One, she enlisted the help of a visiting North American anthropologist, Jane Goodale. The grave posts made by the Tiwi people of Bathurst and Melville Islands for Pukumani ceremonies are unusual in Australian Aboriginal cultures in being made by women as well as men. As Goodale explains:

Pole cutting is usually men's work, but the workers' wives may help with the painting. Theoretically, women can also cut the poles, but they rarely do so because of the physical strength needed in handling the huge logs. One day, my good friend Dolly came to me and said that her husband had been commissioned to cut a pole for Ruby's pukamani, but he was unable to do so because he had to go to Darwin. The employers had asked her to cut the pole. Would I like to come and help her? And so I also was commissioned as a worker, although I did not fully realize this until the payoff, when I received a pound of tobacco and a pipe as payment …

The working men suggested that Dolly and I should make a very small pole, and that it should be very simple in carved design. Since this was the first pole for either of us, we took their suggestion. When it came to the painting, the men left us alone, and the result was perhaps the most unique pole of all. Dolly and I would discuss each row of design, and when agreed we would proceed to paint in opposite directions around the pole; by the time we met on the other side each of us had added our own variations. While I was doing my best to paint in Tiwi style, the working men kept exclaiming in apparent admiration at my 'true American Indian' design.

The pole appears in the right-hand foreground of a photograph taken by Goodale just after the final Pukumani rituals had been completed. It is small and squat with a round pair of

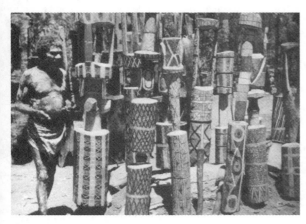

336. Pukumani grave posts, 1954.
The pole made by Dolly Kerinauia, assisted by the anthropologist Jane C. Goodale, is the small one with with the round 'eye' in the right-hand foreground of the photograph.

'eyes'. Although quite unpretentious, this pole is significant for being the earliest *tutini* made by a woman with an extant pictorial record. The pole itself has been destroyed, probably in the 1950s or 1960s when most of the old graves in the locale were bulldozed over the cliff.

Dolly Kerinauia died in 1985, survived by a daughter and six grandchildren. Goodale's full-length photograph of her cutting cycad palm nuts and carrying a bandicoot killed during the day's hunt appears in *Tiwi Wives*, while a close-up portrait adorns the cover of the 1994 reprint. JAK

See also: 7.6, 16.3; **anthropology, Paru women artists;** *336.*
Goodale, J. C., *Tiwi Wives*, Seattle, 1971; Kerr, J., 'Dolly Kirianua' and 'Jane Goodale', in J. Kerr (ed.), *Heritage: The National Women's Art Book*, Sydney, 1995.

Keringke Arts is an association of Eastern Arrernte women formed in 1989. The women initially forged a reputation in silk painting, but moved on to produce a range of hand-painted pottery, furniture and home wares, together with **acrylic paintings** on paper and canvas. Between ten and fifteen women paint every day at the Keringke Arts Centre, which is part of the Ltyentye Apurte community at Santa Teresa, eighty kilometres south-east of Alice Springs. Before its establishment as a Catholic mission in the early 1950s, Ltyentye Apurte was known as a sacred rainmaking place and Keringke, meaning 'kangaroo tracks', is related to a **Dreamtime** story.

The initial years of Keringke Arts saw a range of artistic styles emerge, incorporating both pictorial landscape painting and traditional symbolism associated with Dreaming stories. Pictorial depictions of local foods such as bush bananas, witchetty grubs and honey ants appeared in many paintings, usually within a field of symbolic patterns and colours. Over time, Western landscapes have given way to more colourful, complex, and detailed symbolic patterns. Keringke artists have developed their own personal style derived from ancestral rock carvings and paintings in the Santa Teresa area. However highly abstract in composition, their works always retain the basic 'dot' style. TR

See also: 9.1; Kathleen **Wallace.**
Keringke Arts, *Keringke: Contemporary Eastern Arrernte Art*, Alice Springs, 1999.

KING-SMITH, Leah (1957–), Gamilaraay–Koamu photographer. In the early 1990s, seemingly overnight, Leah King-Smith became known both nationally and inter-nationally, because of the success of her series of large Cibachrome photographs titled *Patterns of Connection*, 1991. Born to a Gamilaraay–Koamu mother, and a father of British descent, King-Smith is a photography graduate of Melbourne's Victoria College. *Patterns of Connection* was produced as a result of research into the historical photographs of Aboriginal people held in the SLV. King-Smith was overcome by the denigration implicit in these portraits, and the effect they had of reducing their subjects to classificatory types. King-Smith wrote in 1992 of the dual nature of her sources: 'For the Koori community in Victoria, the original photographs

are treasures, bearing a storehouse of stories and family history. For these people, they symbolise the knowledge of their Aboriginal heritage. Conversely, documentation of the collection in the library's records is in the form of classifications and captions which reflect 19th century ethnographical terminology and popularise attitudes from the British cultural viewpoint of the time.'

To come to terms with their negative impact on her own Aboriginal identity, King-Smith chose to re-work the images in a manner that would restore dignity and authority to the individuals portrayed and invite personal, intuitive responses from viewers. She did so by re-presenting the subjects of the original photographs, large and ghost-like, within her own hand-painted, fish-eye landscape format. The result is to reverse the relationship between viewer and subject — the figures in these large colour images check the viewer's gaze with their own.

After initial shows at the VCP and ACP in 1992, both accompanied by an evocative soundscape by Duncan King-Smith, *Patterns of Connection* toured the UK, USA, and Canada. Individual images from the series were included in group exhibitions in Japan, Germany, and Denmark, as well as throughout Australia. They are now held in many public collections in Australia.

King-Smith's latest work has synthesised her own colour photographs with historical imagery. In 1994 she collaborated with Lel Black and Indigenous historian and writer Jackie Huggins to produce *White Apron, Black Hands*, a project about Aboriginal women in domestic service. Drawn from the photographic collections of the SLQ, these large-scale colour composites, together with oral histories presented through text and sound, told stories, as she explained, of the 'strength and resilience on the part of the Murri women who cared for their white employers'.

Since then, King-Smith has increasingly avoided the political and the physical in order to explore inner landscapes of the psyche. She has moved into the realm of digital imaging, finding it a most appropriate medium for the articulation of the immaterial and the spiritual. CLW

See also: 4.4, 8.5, 12.1, 12.4; **family history, life stories**; *273*.
Victorian Centre for Photography, *Patterns of Connection: An Exhibition of Photo-Compositions by Leah King-Smith*, Melbourne, 1992; Brisbane City Hall Gallery, *White Apron, Black Hands: A Project on Aboriginal Women Domestics in Service*, Brisbane, 1994; Williamson, C., 'Patterns of connection: Leah King-Smith's subject', *Photofile*, no. 41, March 1994.

KITANI, Yilkari (Tjam) (1891–1956), Liyagalawumirr (Yolngu) bark painter. Around the time of Yilkari's birth, white people had finally arrived in central Arnhem Land (NT). They established a number of cattle stations in the Arafura Swamp region and violent clashes occurred as the Yolngu people tried to defend their lands. This war abated briefly in the first decades of the twentieth century before Methodist missionaries arrived in the 1920s.

Kitani lived a traditional lifestyle on the mainland near present day Ramingining township but spent time at the new Milingimbi mission. He travelled across the mainland with

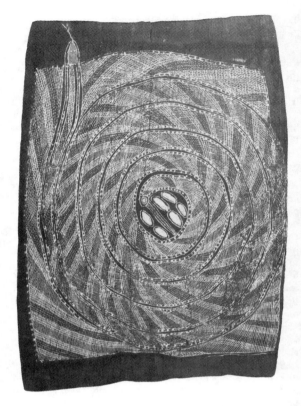

337. Yilkari Kitani, *Mapumirr Wititj (Wititj with Eggs)*, 1951. Natural pigments on bark, 85 x 57 cm.

the anthropologist Donald Thomson in the mid 1930s. In 1937 Kitani was photographed completing a bark painting of the Wägilak sisters story for Thomson. Until that time bark paintings of the more complex type were painted to be used as teaching boards in religious rituals, and for instruction and even amusement on the inside walls of bark huts in the wet season. Although not a prolific painter, Yilkari produced several paintings concerning the Wägilak sisters, which featured in 'Painters of the Wagilag Sisters Story 1937–1997' (NGA 1997).

In the 1940s Yilkari lived between the mainland and the mission on Milingimbi Island and was photographed painting at Milingimbi by Axel Poignant in the early 1950s. He was survived his by son, Paddy **Dhathangu,** and by **Dawidi** (his brother's son), who both went on to become important religious and ceremonial figures in the region. Albert Djiwada (1938–), his youngest son and a bark painter in his own right, is the current ceremonial leader of rituals connected with the Wägilak sisters. He provided the main liaison between the Yolngu communities of **Ramingining** and Milingimbi, and the NGA in the development of the 'Painters of the Wagilag Sisters Story 1937–1997'. DJM

See also: 1.4, 6.2, **anthropology**; *150, 257, 316, 325, 337*.
Caruana, W. & Lendon, N. (eds), *The Painters of the Wagilag Sisters Story 1937–1997*, Canberra, 1997.

KITE, Jim, see **Erlikilyika.**

KNGWARREYE, Emily Kame (*c.*1910–1996), Anmatyerre visual artist. Kngwarreye's art is inextricably linked with her country, Alhalkere: 'whole lot, that's all, whole lot. Awelye (my dreaming), Arlatyeye (pencil yam), Ankerthe (mountain devil lizard), Ntange (grass seed), Tingu (dingo puppy), Ankerre (emu), Intekwe (small plant-favourite food of emu), Atnwerle (green bean) and Kame (yam seed). That's what I paint, whole lot' (from an interview by Rodney Gooch translated by Kathleen Petyarre, 1990).

Kngwarreye grew up in a traditional way, learning her responsibilities to her country which inspired her art. Alhalkere was indeed the subject for all her art; the veils of dots, the bold striped *awelye* (body paint) or the underlying pattern of landscape, all these forms are part of the whole.

Kngwarreye commenced making public art in the late 1970s as a member of the **Utopia** Women's Batik Group, encouraged by the fact that her community had regained title to and returned to their traditional lands. Kngwarreye exhibited her first **acrylic paintings** on canvas in 'A Summer Project' (SHEG 1988–89). This led to her receiving the first CAAMA Fellowship in 1989, her first of many solo shows in 1990, and the award of an Australian Artists Creative Fellowship in 1992. Her work was exhibited in many group exhibitions including 'Aboriginal Art and Spirituality' (HCA 1991), 'Crossroads' (Kyoto and Tokyo 1992), 'Aratjara' (Düsseldorf, London, and Humlebaek 1993–94), 'The Eye of the Storm' (New Delhi 1996), and 'World of Dreamings' (St Petersburg 2000). Her work was included in 'fluent', the official Australian representation at the 1997 Venice Biennale. In the same year the Queensland Art Gallery curated a major survey exhibition 'Emily Kame Kngwarreye: Alhalkere—Paintings from Utopia'. Her work is now included in every major public, corporate and private collection in the country and increasingly abroad.

Emily Kame Kngwarreye's abstract images transcended her culture to speak to us all. This was her great gift. She showed us a new way to look at the world. CH

See also: 9.5, 9.6, 17.5, 21.1, 21.3; **batik**; *123, 216, 225.*
Caruana, W., 'Emily Kame Kngwarreye and the palimpsest of experience', in B. Carrigan (ed.), *Utopia: Ancient Cultures/New Forms*, Perth, 1999; Isaacs, J. (ed.), *Emily Kngwarreye Paintings*, North Ryde, NSW, 1998; Neale, M. (ed), *Emily Kame Kngwarreye: Alhalkere paintings from Utopia*, Brisbane, 1998.

KOO'EKKA, see Arthur **Pambegan.**

KOOLMATRIE, Yvonne (1944–), Ngarrindjeri fibre artist. Yvonne Koolmatrie's cool appraisal of the eels in the fish markets in Venice in 1997 underlines her position in contemporary Australian art as a 'woman of the land'. Her woven eel traps, when hung alongside paintings by Emily Kame Kngwarreye and Judy Watson in 'fluent'—Australia's official representation at that year's Venice Biennale—demonstrated the poetic resonance of these traditional Ngarrindjeri artefacts. Their trumpet-like forms were related to their function—the trapping of eels in flowing water—but in a contemporary art gallery they took on a symbolic role as vessels shaped from the fibre of the land itself.

Koolmatrie's mother, Connie, was Ngarrindjeri, born at Rabbit Island, Meningie (SA), while her father, Joe Roberts, a descendant of the Pitjantjatjara people of Yalata and Andamooka, was forcibly removed from his family at the age of eight and adopted. She married Chris Koolmatrie in 1963; they had seven children of their own and brought up twelve more.

Yvonne Koolmatrie first learnt rush basketry in a workshop given by Dorothy Kartinyeri (Auntie Dorrie) to Ngarrindjeri women in 1982. Weaving linked her to the land, to places where the spiny sedge (*Cyperus gymnocaulus*) was gathered, and to the continuation of ancient knowledge. Baskets, scoops, mats, traps, and nets for fishing in the waterways—all made from sedge—were used by both men and women in every aspect of hunting, gathering and ceremony, while coffin baskets provided their last covering.

Koolmatrie's woven *Biplane*, 1994, quoting a 1930s weaving by **Janet Watson**, and her *Turtle*, 1994 and *Echidna*, 1993 extend the Ngarrindjeri repertoire with the individuality and insight that has given her a national audience. Her weavings continue to explore and give new meaning to myths once widely known. *Coorong Dreaming*, 1996 provided a map of the river country, with significant baskets, scoops, turtle, fish, and a burial basket after Pinkie Mack, while *Prupi*, 1998 was another variation on the theme of traps. Although Prupi, wife of the fearful water spirit Mulgyewonk, who traps children in her cave is sometimes considered malignant, to Koolmatrie she is a **Dreaming** ancestor: 'We have not many elders left to tell us the Dreamtime stories, we don't have any carvings or rock paintings, so weaving is my creation to tell the stories. So many of the stories have gone from Lake Alexandrina, even the secret stories. I still have some, from my mother, since it has been given to me to carry on the weaving.'

Koolmatrie has participated in many major group exhibitions including the touring 'Aboriginal Women's Exhibition' (AGNSW 1991), 'Two Countries, One Weave'(Tandanya 1991), Yanada New Moon (IDG 1993), 'Murrundi: Three River Murray Stories' (CACSA 1993) 'Weave' (CPAC 1998), 'Beyond the Pale' (AGSA 2000), and most significantly, 'fluent' (Venice 1997) which toured Australia during 1998.
 DWC

See also: 12.1, 17.1, 17.2, 20.3, 21.1; **stolen generations,** Ellen **Trevorrow;** *159, 401.*
Pring, A., *Aboriginal Artists in South Australia*, Adelaide, 1998; Kean, J., *Murrundi: Three River Murray Stories*, Adelaide, 1993; Perkins, H., Croft, B. L. & Lynn, V., *fluent: Emily Kame Kngwarreye, Yvonne Koolmatrie, Judy Watson, 47th Venice Biennale*, Sydney, 1997; Croft, B. L. (ed.), *Beyond the Pale: 2000 Adelaide Biennial of Australian Art*, Adelaide, 2000.

KOOLPINYAH, (1941–), Larrakia painter. In one of the more extraordinary encounters in Aboriginal art history, Koolpinyah met Ian Fairweather when the famous artist was living in Darwin (NT). Even though Koolpinyah was just a boy of ten, Fairweather gave him lessons that were to profoundly affect his stylistic development as an adult artist. After producing landscapes, then Aboriginal camp scenes throughout the 1960s, Koolpinyah stopped painting for nearly twenty years. He started again in 1988 after enrolling

in a Fine Art degree course at NTU, where he completed his MFA in 1999. During this period his calligraphic, Fair-weather-influenced style developed into a more stylised mode of figurative painting. Since then he has undertaken a number of commissions in Darwin, including the Larrakia memorial sculpture at Mindil Beach, a work for Darwin Airport, and several sculpture installations for the annual Festival of Darwin.

As a senior traditional owner of the Darwin region, Koolpinyah is concerned with recording historic and contemporary aspects of Larrakia identity. He paints his totems of frog and rainbow serpent and other public ceremonial themes alongside images about dispossession and survival. He has drawn considerable inspiration from the Larrakia artifact collections he has visited in the museums of south-east Australia, incorporating their formal aesthetics with the powerful emotions of discovery and sadness they engendered. 'I have used these images and the feelings they invoked, along with my cultural knowledge to document my impressions of what happened long ago', he stated in 1998. MW

See also: 6.6; *81*.

West, M., 'Richard Barnes Koolpinyah', in D. Mendham (ed.), *Contemporary Territory: Sea Harvest, Earth Harvest: Third Biennial Exhibition of Northern Territory Art*, Darwin, 1998.

Kriol, see **Aboriginal English structure, Aboriginal English vocabulary**

KUBARKKU, Mick (*c.*1926–), Kuninjku (Eastern Kunwinjku) painter and sculptor, was born at Kukabarnka near Kungorabu billabong in the Marrinj clan estate about ten kilometres north of Mumeka outstation on the Mann River, western Arnhem Land. He was instructed in painting by two of his father's brothers, Nabulumo and Malankarra. Kubarkku spent his childhood and youth living a traditional hunting and gathering lifestyle in the Mann and Liverpool Rivers district. During World War II, he spent a couple of years at the Milingimbi Mission off the coast of central-north Arnhem Land.

Kubarkku first started painting **bark paintings** for non-Aboriginal people in the late 1960s, when the township of Maningrida was new. He recalls that the Revd Gowan Armstrong was one of the first Balanda (non-Aboriginal person) to buy his bark paintings for the fledgling art co-operative which later became **Maningrida Arts and Culture**. In the late 1970s Kubarkku and his two wives and children returned to his clan estate at Kubumi on the middle Mann River to set up an outstation at a site known as Yikarrakkal.

Kubarkku's bark painting and spirit-being sculptures focus on totemic subjects such as *yawkyawk* (female water spirits), *mimih* (mischievous rock spirits), *dird* (moon **Dreaming** site), *kodjok bamdjelk* (profane pandanus spirit), *ngalyod* (rainbow serpent) and numerous natural species such as *lambalk* (sugar glider), and *djaddi* (ornate burrowing frogs). Kubarkku's art is popular for its raw appeal and freedom from European influence, and is well described by the principle 'quality is not a neat straight line'. He himself says of his reasons for painting:

Ngarri-bukkan ngarri-djare Balanda ya, kabirri-bengkan wanjh
'We want to show [our culture] to non-Aboriginal people, so they will understand.'

Kubarkku's work has been included in many group exhibitions such as 'Aboriginal Art at the Top' (MAGNT 1982), 'Spirit in Land' (NGV 1990) and 'Aratjara' (Düsseldorf, London, and Humlebaek 1993–94). Most significant was his combined exhibition with Bardayal **Nadjamerrek**, 'Rainbow, Sugarbag and Moon' (MAGNT 1995). Examples of Kubarkku's work are held in the collections of the NGA, MCA and most Australian State galleries. MG

See also: 5.2, 5.3, 17.3; *59*.

Garde, M. & Taçon, P., '*Kunwardde Bim*: Rock Art from Western and Central Arnhem Land', in M. West (ed.), *Rainbow Sugarbag and Moon: Two Artists of the Stone Country—Bardayal Nadjamerrek and Mick Kubarkku*, Darwin, 1995.

KULYURU, Angkuna (1943–), Pitjantjatjara visual artist, began learning the method of **batik** in the 1970s, and over the next twenty years practised and refined her technique. Her batik lengths of up to four metres feature the distinctive **Ernabella** design (a fluid, curvilinear abstract form known as the *Ernabellaku walka*), but are also strongly individual. The women do not attach specific meanings to these designs, which occur across the Pitjantjatjara Lands, but they do acknowledge that they are indirectly inspired by their natural environment.

The artists in the Ernabella art room come from several generations, and artistic skills and traditions are passed down from one generation to the next. The Kulyuru family is no exception, and five of Angkuna's daughters, Unurupa (1962–), Amanda (1964–), Karen (1969–), Daisybell (1972–) and Tjulyata (1978–) have absorbed their mother's design sense and have worked in the Erna-bella craft room. Angkuna has now retired and spends her time either at Ernabella or on her homeland (Black Hill), some fifteen kilometres from Ernabella.

Angkuna Kulyuru's textiles have been represented in many exhibitions and festivals including 'Aboriginal Art' (AIATSIS 1984), 'The Continuing Tradition' (NGA 1989), 'Power of the Land' (NGV 1994) and the national touring exhibition 'Raiki Wara' (NGV 1998). Her work is represented in many collections including the Museum of Ethnology in Japan, the NGA and NGV, and many other public museum and gallery collections. LP

Eickelkamp, U., '*Anapalaku walka*—Ernabella Design: A women's art movement', in L. Taylor (ed.), *Painting the Land Story*, Canberra, 1999; Ryan, J. & Healy, R. (eds), *Raiki Wara: Long Cloth from Aboriginal Australia and the Torres Strait*, Melbourne, 1998.

KUMINTJARA, Jonathan Brown, see Jonathan Kumintjara Brown.

KUNINGBAL, Crusoe (*c.*1922–1986) Kuninjku (Eastern Kunwinjku) sculptor, singer, song composer, and dancer, was

born near the middle Liverpool River region. He belonged to the Dangkorlo clan from the Tomkinson River district of western Arnhem Land. Kuningbal spent his early life working in the buffalo shooters' camps in western Arnhem Land. This involved 'working with *djarrang* (horses)', as his son Kurddal explains it. Shortly before World War II, Kuningbal returned to the Maningrida region and once the war started he went to Milingimbi. Kuningbal was well known as a sculptor and composer–singer of the *kunborrk* song genre of western Arnhem Land. He composed a number of songs about his war experiences, some of which were recorded by anthropologist A. P. Elkin in the 1940s. After the war Kuningbal remained in his country around the Tomkinson River district and after a few years living in Maningrida in the 1960s, he returned to set up Barrihdjowkkeng outstation where his family remains today.

Kuningbal was known as a gentle and kind man who had a beautiful high-toned singing voice. He was a gifted composer of songs, and old recordings of his music are still much sought after by the Eastern Kunwinjku community. Kuningbal's sculptures of the tall slender *mimih* spirits provided the

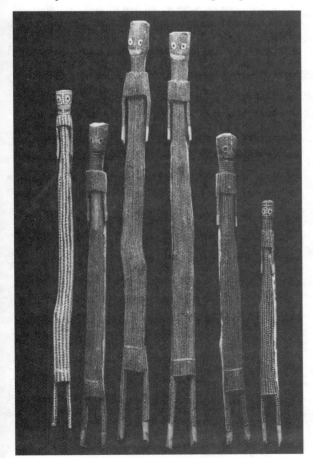

338. Crusoe Kuningbal, *Mimi Figures*, 1979.
Natural pigments on wood, 186.7cm, 168 cm, 221 cm, 216 cm, 164 cm, 129 cm (heights).

inspiration for much of the sculpture produced today by numerous Eastern Kunwinjku artists. His work has been included in many exhibitions including two significant early displays, 'Aboriginal Australia' (AGDC 1981–82) and 'Aboriginal Art at the Top' (MAGNT 1982).

Crusoe Kuningbal's second-born son is Crusoe Kurddal (1965–), who has become best known for continuing both the sculptural and musical traditions of his father. Kurddal is the only one of Kuningbal's three sons who performs his father's solo *mimih* style dance routine. Along with his elder brother, Owen Yalandja, Kurddal also continues to perform the singing of individually-owned *kunborrk* songs from his father's repertoire. In the early 1990s Kurddal started to produce very large versions of the sculpted *mimih* spirit figures which were made famous by his father. Large sculptures of other clan totems such as *yawkyawk* (mermaids) are also produced by both Kurddal and Yalandja.

Kurddal travels regularly between Maningrida, Oenpelli, Darwin, and Croker Island, and has performed as a dancer throughout Australia as well as on tours of North America and Europe. His work was included in the international exhibition 'Art and Aboriginality' (Portsmouth 1987). MG

See also: 6.1; *338*.
Taylor, L., 'Flesh, bone, and spirit: Western Arnhem Land bark painting', in H. Morphy & M. Smith Boles (eds), *Art from the Land: Dialogues with the Kluge–Ruhe Collection of Australian Aboriginal Art*, Charlottesville, VA, 1999.

KUNNYI, Mary, see Miriam-Rose Baumann **Ungunmerr.**
KURDDAL, Crusoe, see Crusoe **Kuningbal.**

KUYATA, Yipati (1943–1994), Pitjantjatjara visual artist, was a **batik** artist whose flowing fabric designs represented both her own individuality and the natural environment of her homeland in the Musgrave Ranges. Together with Nyukana **Baker,** she was one of the first **Ernabella** artists to take up batik. A visit in 1975 to the Jogjakarta Batik Institute, Indonesia, for a workshop on batik techniques was, for her, a highlight of her career. In 1972, she had spent three months training in weaving at the Sturt Workshops in Mittagong (NSW). Yipati also visited Osaka in 1983 and gave a number of technical demonstrations and exhibitions at the Museum of Ethnology there. In 1985 she travelled to Nairobi, where she participated in and demonstrated her skills at the 'Decade of Women' conference. Yipati was a wonderful ambassador both for women and for Aboriginal art and culture.

Apart from being a superb artist, Yipati's presence was important for the stability and strength of the Ernabella art centre. She was Anangu Mayatja (Anangu chairperson and main trainer and supervisor) for many years, having taken over from her older sisters. With Winifred Hilliard she helped to create an awareness of and respect for art from the Anangu Pitjantjatjara Lands. Continuing the family tradition, one of her daughters, Carol Williams (1977–) currently works in the Ernabella craft room. LP

Ryan, J. & Healy, R. (eds), *Raiki Wara: Long Cloth from Aboriginal Australia and the Torres Strait*, Melbourne, 1998.

L

La Perouse Aboriginal community is situated on the northern headland of Botany Bay (NSW), and lies within the northern boundary of the Dharawal tribal and **language** group. The Aboriginal people of La Perouse have strong links with the south coast of New South Wales. A number of them can trace their ancestry to the arrival of Captain Cook, or to the decades immediately following the establishment of the penal colony at Port Jackson. Throughout the nineteenth century, the area (known locally as Gooriwaal) was used as a base for fishing, and by the 1870s it had become the site of permanent settlement for about five Aboriginal families.

In the 1880s La Perouse was used by the colonial government for the relocation of Aboriginal people dispersed from the metropolitan area. Camps near the centre of the city, including those at Circular Quay and Darling Point, were closed down, while La Perouse was allowed to remain, being considered sufficiently isolated from the city for a segregated Aboriginal settlement. A Methodist mission was established in 1894 and remained there until 1931.

La Perouse was popular as a place for weekend tourism. Local Aboriginal people participated in the tourist trade in various ways; as early as 1891, the Board of Protection of Aborigines reported that 'some make native weapons and gather honey for sale. The women and children make shell ornaments and gather and sell wild flowers'. The making and selling of **boomerangs** and shell-work became the staple of the Aboriginal tourist industry, and La Perouse became well known for these tourist objects.

Aboriginal men made the boomerangs; popular designs for the decoration were native flora and fauna. The Harbour Bridge, opened in 1932, was also adopted as a motif. Shell-work was (and is) made by Aboriginal women. Gloria Ardler remembers that 'we travelled with our parents to Kurnell on the ferry and on foot across the sandhills to Cronulla to gather shells.' Different beaches were known for different shells: and muttonfish, starries, beachies, buttonies, couries, small cockles, and small pippies were all collected. Popular designs for the shell-work were baby shoes, heart-shaped boxes—and the Sydney Harbour Bridge.

As a place associated with the landing of Captain Cook in 1770, and the arrival of the First Fleet in 1788, La Perouse has also been the site of Aboriginal protest against the celebration of the colonial history of Australia. It is most well known for the **Survival Day** concerts held there on Australia Day, through which Aboriginal music, performance, and culture from around the country, rather than the white invasion of Australia, is celebrated. At the same time a number of local efforts have been made to record and promote the Aboriginal history and cultural significance of the site, including the publication of a collection of reminiscences in 1988, a display in the local museum and ongoing efforts to restore rock carvings within the Botany Bay National Park—which is also in the process of being renamed to reflect its significance to the local Aboriginal community. MAN

See also: 11.1, 18.1, 18.3; **family history**, Jane and Olive **Simms**, **Timbery family**; *232, 339*.
Australian Institute of Aboriginal Studies, *La Perouse: The Place, the People and the Sea: A Collection of Writings by Members of the Aboriginal Community*, Canberra, 1988.

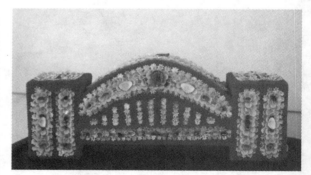

339. Esme Timbery, *Sydney Harbour Bridge*, 1998.. Cardboard, pink velvet, and assorted shells, 18 x 40 x 9 cm.

Lajamanu artists, see **Warnayaka Art Centre.**

land rights and land tenure. Since the 1960s 'land rights' has come to refer, principally, to the legal and political struggle by Indigenous people to recover some portion of the land taken from them by the arrival and settlement of the Australian continent by Europeans. Sometimes, but less and less

frequently, it is used to refer to the range of rights Indigenous people have in land under their own systems of land tenure. Land rights have been associated with statutory rights, that is rights granted by Acts of Parliament, as opposed to **native title**, which is recognised by the common law. The struggle for land rights is not just about land. It is also, importantly, about the restoration of some of the political autonomy and self-determination that existed prior to European colonisation. The quality of any land rights settlement is judged not simply in terms of the quantity of land restored to particular groups of Indigenous people but also by the range of rights and the levels of independence that go with it.

Although areas of land were set aside for the use and benefit of Aboriginal people from early on in the history of European colonisation, they were held by the government, or by one of a number of religious bodies that ministered to Aboriginal people, usually supported by government funding. John Batman signed a so-called treaty in June 1835 with Aboriginal people in the vicinity of present-day Melbourne when he tried to purchase blocks of land there, but this was an unauthorised act and was disallowed in August 1835. Indeed, no officially recognised treaties were negotiated with any Aboriginal people, since it was widely considered that peoples who lived by hunting and gathering did not, or could not, own land. Nor were there any obvious authorities with whom to negotiate; Australia was, therefore, treated as terra nullius—land owned by no-one.

While from the colonisers' point of view they were 'settling' the land, it is clear that from the Indigenous point of view they were taking it, and in many areas of eastern Australia, in particular, Aboriginal people became **guerilla fighters** in small-scale campaigns to defend their territory. By the 1890s such fighting was over in eastern Australia, heralding a period of protectionism in which land was set aside for many of the Aboriginal people that remained. The Federation of the Australian colonies in 1901 made no impact on Indigenous people, leaving the control of Indigenous affairs entirely to the States, with the exception that the Commonwealth took over the administration of the Northern Territory from South Australia in 1911. Thus, over the years, the regimes regulating the lives of Indigenous people, including the terms under which land was set aside for them, varied somewhat from State to State and in the Northern Territory.

It was really only when Indigenous people formally achieved citizenship that the land rights movement got under way. Land rights, as a rallying cry, emerged in the 1963 with the forced eviction of Aboriginal people from Mapoon in northern Queensland to make way for mining, and the Bark Petition to federal Parliament from the people of Yirrkala in north-eastern Arnhem Land protesting the unilateral authorising of mining on their hunting and gathering lands. The Gurindji strike and walk-off in 1966–67 at Wattie Creek in the Victoria River District (NT) added fuel to the fire.

At this same period, Indigenous issues in Australia started to become internationalised through the Black Power movement and the recognition, by international agencies, of a class of Indigenous rights. These influences, and others, led to the South Australian government setting up an Aboriginal-controlled trust in 1966 with the intention that it would hold the existing lands reserved for Aboriginal people in that State. Victoria passed legislation in 1970, Western Australia in 1972, and New South Wales in 1974. These pieces of State legislation related only to existing reserved lands, and varied very much in the quality of the rights granted, and on whom and how they were conferred.

The *Aboriginal Land Rights (Northern Territory) Act 1976 (Cth)*, a Commonwealth Act that resulted from the Royal Commission into Aboriginal Land Rights conducted by Mr Justice Woodward, was and remains the high-water mark for land rights. It has this status not only because it has resulted in the return of over 40 per cent of the Northern Territory to Indigenous people but because it also set in place structures and access to financial resources that have given Indigenous people in the Territory considerable autonomy.

Mr Justice Woodward was not asked to inquire into whether Aboriginal people *should* have land rights, but how best to *recognise* their rights in land. This, of course, raises the issue of land tenure and how to integrate two systems of law. The importance of ensuring some degree of congruence between existing Indigenous arrangements in respect of land and those embodied in the legislation granting land rights is made clear by the fact that the legislation in both South Australia and New South Wales had to be amended within a few years of being passed, because both States had originally failed to address the issue in their legislation.

Indigenous systems of land tenure vary considerably across the continent, not only because there was variation pre-colonially, but also because the impact of Europeans has been highly variable. Thus in remote Australia the present-day systems of tenure are recognisably linked to the pre-colonial forms, while in most areas of settled Australia any close links with the pre-colonial forms have become attenuated: people have had to adapt to radically changed economic, demographic and residential circumstances.

Generally speaking, the key to rights in land was knowledge of the associated religious patrimony. This took the form of songs, myths, dances, ceremonies, sacred objects, and designs associated with particular places, and with the heroic ancestors whose activities in the **Dreamtime** created the places and the landscape more generally, endowing it with ancestral power. Knowledge of these tended to be handed down in the male line everywhere outside of the drier desert regions, and to be distributed variably by age, gender and local cultural traditions. The senior people with this knowledge were the people who had the control over the associated places and areas, and were the ones who could authorise others to live there, use the resources, and generally make all decisions about the land and waters. There were, however, a range of other people whose views had to be taken into account in respect of any place, for a large variety of reasons that varied by region: because they had been conceived at the place; or born at the place; or their umbilical cord had fallen off at the place; or they had been initiated at the place; or they were named after the place; or their mother or father had been buried at the place; or because the place was linked to other places central to their own patrimony through the travels of their heroic ancestor in the Dreamtime; or because the place was associated with their mother's patrimony.

languages

This complex web of bases on which to make a claim—to be heard in respect of what happened in a particular place—is still highly significant in many remote areas. This is despite rapid social transformation whereby, for example, people are born in hospital and conceived in central villages. In settled Australia, drastic population decline, the fathering of many children by non-Aboriginal people, the decrease in marriage stability, and other factors, have all led to the emergence of the cognatic family, and of the 'tribe' (or 'nation') as the unit of land tenure. This is a new, but nevertheless perfectly logical and legitimate development: the tribe was often a linguistic (rather than political) identity pre-colonially.

Today Indigenous people own over 13 per cent of the continent, mainly as Aboriginal freehold. Almost all of this land has passed into Aboriginal hands through Acts of Parliament. Since 1992, as a result of the **Mabo** judgment, native title has been recognised. Native title arises from the fact that the Australian legal system now recognises that the land and coastal waters of the Australian continent were subject to an Indigenous system of tenure, which the common law recognises, where it has not been extinguished by legitimate acts of governments, or by loss of particular kinds of connection with the land. Native title gives rather different kinds of rights. It does not confer statutory rights. It reflects only the actual, transformed, pre-colonial rights and interests which Indigenous people can demonstrate to the courts that they have in land today, in terms of four quite demanding criteria. Statutory rights, on the other hand, can provide whatever rights, structures, and monies a parliament sees fit. In a sympathetic climate statutory rights, such as those that exist in the Northern Territory, are better than native title rights. But in an unsympathetic climate native title rights may be all that some groups of Aboriginal people can achieve. NP

340. Mervyn Bishop, *Prime Minister Gough Whitlam pours soil into hand of traditional land owner Vincent Lingiari, NT,* 1975.
Direct colour positive photograph, 76.2 x 50.8 cm.

See also: 1.1, 2.1, 2.3, 2.4, 2.5, 4.2, 4.5, 4.6, 10.3; **Day of Mourning, languages, rights in art, Survival Day**; *39, 49, 50, 206, 312, 340*.
Butt, P. & Eagleton, R., *Mabo, Wik, and Native Title*, Leichhardt, NSW, 1998; Maddock, K., *Your Land is Our Land: Aboriginal Land Rights*, Ringwood, Vic., 1983; Peterson, N. & Langton, M. (eds), *Aborigines, Land, and Land Rights*, Canberra, 1983; Reynolds, H., *The Law of the Land*, 2nd edn, Ringwood, Vic., 1992

LANGFORD, Ruby, see Ruby Langford **Ginibi.**

languages of Indigenous Australia. At the time of English colonisation there were over 200 distinct languages spoken in Australia. Most had a number of dialects, so that about 700 distinct language varieties were spoken. Dialect groupings were the significant units in respect of social organisation—particular dialect features provided speakers with a sense of social identification and solidarity. Each dialect was associated with a particular tract of land; a dialect and its territory were viewed as 'belonging' to each other, and people were expected, as far as possible, to adopt a dialect when living in or visiting its territory. People did not generally live in linguistic isolation. They tended rather to have extensive social and ceremonial contact with surrounding groups, and the custom of marrying across linguistic boundaries was common. Such protracted contact gave rise to widespread multilingualism and promoted much borrowing between language varieties of a range of linguistic features—vocabulary, grammatical structures, semantic concepts, and so on.

The amount of borrowing over the millennia, together with the absence of written historical records, has made it difficult for linguists to gain a clear picture of the way in which the languages of Australia originated and evolved. However, most now believe that nearly all the languages of Australia belong to a single family and have all descended from a single original ancestral language. But the age of that ancestor is unclear. While comparisons with other language families in the world suggest that the ancestral language could have been spoken no more than 10 000 years ago, some linguists have speculated on a much more ancient dating, proposing an age of 30 000 years or so. Similarly unclear is where the ancestral language itself came from. No clear family connections between the languages of Australia and languages elsewhere in the world have yet been established.

Australian languages are 'agglutinating': they tend to have complex words made up of a basic vocabulary item to which can be added a variety of meaningful segments. Virtually all Australian languages make extensive use of the technique of suffixing—adding segments at the end of a basic vocabulary item. For example in Pintupi, a language variety traditionally spoken in the desert to the west of Alice Springs, a basic word such as *ngurra* (camp) can be followed by suffixes such as *kutu* meaning (towards), *lpi* (finally) and *rna* (I) to make sentences like:

ngurra-kutu-lpi-rna yanu
camp-towards-finally-I went
'Finally I went to camp'

There is also a group of languages that employ prefixing as well as suffixing. In such languages a single multisyllabic

word can substitute for a whole sentence in English, as in the following example from Marrithiyel, a language from the north-western coastal area of the Northern Territory:

gu-nj-a-ningin-pirr-fini-ya
they-plural-stand-to me-throw-two-past tense
'Those two threw it to me'

Languages like this can develop very elaborate word structures, and can be difficult for foreigners to learn. Australian languages can be divided into two groups—'Pama-Nyungan' (PN) and 'non-Pama-Nyungan' (NPN)—largely on the basis of whether they construct their words using suffixing techniques only, or form their words using both prefixes and suffixes. NPN is the group that has prefixes; these languages are found in a single geographical bloc across the Kimberley region of Western Australia and eastwards into the Top End of the Northern Territory across to the western coast of the Gulf of Carpentaria. The PN group occupies the rest of the country, with an intrusion into otherwise NPN territory in the north-eastern corner of Arnhem Land (comprising the Yolngu group of languages).

While naturally lacking the array of technical jargon associated with industrialisation and technological development, Australian languages nevertheless have rich and diverse vocabularies, in particular in their wealth of kinship terminology. In many parts of the country, pronouns vary according to kinship relationships: the English 'we' or 'you' will have several equivalents, and the appropriate form to use will depend on how the people referred to, and perhaps also the speaker, are related to each other. Many languages also possess special 'respect' or 'avoidance' registers—polite forms of language that have to be used when talking to particular relatives. A respect register is required nearly everywhere when a man needs to communicate with his mother-in-law. Special socio-linguistic rules are associated with the use of respect registers: for example a man may not even be allowed to address his mother-in-law directly, instead having to direct his conversation via an acceptable intermediary.

The sound systems of Australian languages share a number of broad features. For example, they tend to have only a few significant vowels, with the majority of languages in the country distinguishing only three (*i*, *u* and *a*). At the same time they have noteworthy contrasts in their consonant series: many differentiate consonants made at six different points in the mouth (bilabial, dental, alveolar, retroflex, palatal, and velar).

The effect of English colonisation on this long and rich linguistic heritage has been devastating. Of the 200 or more languages spoken in Australia in the late eighteenth century more than half have been lost completely, while a further seventy or so face imminent extinction. Only about twenty languages—all in the north of the country—are spoken by sufficiently viable speech communities, and are being learnt by enough children as a first language, to be expected to survive the next few decades. Even these relatively robust languages are under considerable pressure as English-language media and Western cultural practices penetrate further into Aboriginal communities. Aboriginal culture had no tradition of literacy; and Aboriginal languages were so devalued

by the colonisers that it is only since the 1960s that the task of writing down, recording, and describing Aboriginal languages has gathered any momentum. But now most Aboriginal communities believe that documenting their language and culture, and thus having the material to conduct school education in their own languages, will help them resist the onslaught of English. Dictionaries in, and descriptions of, most extant Australian languages are now available. In central and northern Australia, particularly within the Northern Territory, bilingual education programs have been established in many schools. Regional language and culture centres have been set up, and at institutions such as Batchelor College and the Institute for Aboriginal Development speakers of Aboriginal languages are training as linguists and community language workers. How much impact these initiatives will have on the loss of Australia's Indigenous linguistic heritage remains to be seen. IG

See also: 2.3, 5.3, 5.4, 11.7; **Aboriginal English structure, Aboriginal English vocabulary**.
Dixon, R. M. W., *The Languages of Australia*, Cambridge, 1980;
Walsh, M. & Yallop, C. (eds), *Language and Culture in Aboriginal Australia*, Canberra, 1993.

LEE TJUPURRULA, Donkeyman (*c*.1925–1994), Kukatja painter, spent his early life at Tjula Rockholes (SA) near Kiwirrkura in the Great Sandy Desert. He did not encounter white people till after his first initiation in the late 1930s. He was later nicknamed Donkeyman by the Pallotine missionary Father Alphonse, because he looked after the donkeys, sheep, and goats which the mission brought to the area. Tjupurrula became a respected Law man, and worked with anthropologist Ronald Berndt over a considerable period.

Donkeyman learnt about the **acrylic painting** movement in the 1970s when he visited an older brother at **Papunya**. He started painting in the early 1980s when a number of the senior men at **Balgo** began transferring their traditional designs into acrylics on canvas, and also painted when the Adult Education Centre took up the movement in 1985. His subjects include men's Tingarri paintings, *Wati Kutjarra* (Two Men) which is held by both women and men, and the *Kanaputa* (Digging Stick women).

Donkeyman's work soon attracted the attention of public institutions, and was exhibited in the landmark exhibition 'Mythscapes' (NGV 1989), as well as in 'The Continuing Tradition' (NGA 1989). His paintings have been exhibited widely overseas: at 'L'été Australien' (Montpellier 1990), 'Yapa: Peintres Aborigènes de Balgo et Lajamanu' (Paris 1991), 'Aboriginal Paintings from the Desert' (Moscow and St Petersburg 1991); and 'Aratjara' (Düsseldorf, London, and Humlebaek 1993–94).

Donkeyman's paintings exhibit a versatility of conception ranging from bold compositions containing relatively few pictorial elements, to monumental works in which his flowing draughtsmanship unifies a plethora of design elements and different painting techniques. He is represented in the collections of the NGA, NGV, and AGSA, and in the Kelton Foundation in Santa Monica and the Kluge–Ruhe Collection of the University of Virginia. CW

See also: 9.5; *155*.
Watson, C., 'Touching the land: Towards an aesthetic of Balgo contemporary painting', in Morphy, H. & Smith Bowles, M. (eds), *Art from the Land: Dialogues with the Kluge–Ruhe Collection of Aboriginal Art*, Charlottesville, VA, 1999.

LEE, Georgia, see Dulcie **Pitt**.

LEE, Roque (Gullawan) Larrakia visual artist. As a young boy Roque Lee learned the skills for making spears, woomeras (spearthrowers) and **didjeridus**. He started painting in the late 1980s, influenced by the Larrakia stories passed on to him by his mother and his uncles and by his growing knowledge of his connection with Larrakia country. He paints with both natural **ochres** and **acrylics** on board, and canvas, and uses a variety of unusual surfaces and materials including saw-fish bills, bones, turtle shell, feathers, and vinyl briefcases. His work is characterised by a fine attention to detail, beautiful line work, and aesthetic beauty, and is bought by private collectors in Australia and overseas. His entry in the 1995 NATSIAA was purchased by MAGNT. He was one of the commissioned Larrakia artists who contributed to the Darwin City Council's heritage ceramic pathway project in 1996. In 1998 he co-curated the 'Spirits Of The Dreaming' exhibition for the Raintree Aboriginal Art Gallery at the National Aboriginal Cultural Centre in Sydney. He was one of the contributing artists in the exhibition 'Love Magic' (SHEG 1999). Since the 1980s Roque Lee has worked as an Aboriginal heritage guide and teacher while continuing to produce carvings and paintings celebrating contemporary Larrakia culture and society. GL

See also: 6.6.

LESLIE, Donna (1963–), Gamilaraay painter, children's book illustrator, writer, teacher, mosaicist, printmaker, and cartoonist writes:

My art is a celebration of spirituality. I like to dwell on the interconnectedness between people rather than the differences that divide us. My family once lived on Aboriginal reserves— Terry Hie Hie near Moree, Burra Bee Dee, and Gunnedah Hill outside Coonabarabran (NSW). My earliest memory is of light on gum leaves in the Warrumbungle mountains. Images and sounds of hundreds of cockatoos flying overhead are etched in my childhood memories and I often paint birds and leaf symbols, representative of an holistic, cyclical and sacred world. I completed a Postgraduate Diploma in Art Curatorship at the University of Melbourne in 1993, and I am currently a Doctoral candidate in Art History. My first exhibition 'Contemplations' was held in 1986 at the Aboriginal Artists Gallery in Melbourne. The following year I was awarded an Australia Council grant. I have held eight solo exhibitions and participated in numerous group exhibitions in public and private galleries—the most memorable for me being the exhibition of my illustrations for the book Alitji in Dreamland—Alitjinya Ngura Tjurkurmankuntjala *(a translation and adaptation of Lewis Carroll's* Alice in Wonderland*) at ACCA in 1992. These works won the Crichton Award for Children's Book Illustration in 1993. Other books I have illustrated include* Damper *(1998) and* A Mob of Kangaroos *(1998).* DL

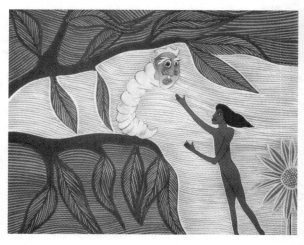

341. Donna Leslie, *Alitji Gazed up into a Tree and saw a Large Witchetty Grub*, 1992.
Watercolour 40 x 50 cm
An illustration from *Alitji in Dreamland,* an Aboriginal version of Lewis Carroll's *Alice's Adventures in Wonderland*. The book was adapted and translated by Nancy Shepherd, and published by Simon & Schuster, East Roseville, and Ten Speed Press, Berkeley, in 1992.

See also: cartoonists; *341*.
Isaacs, J., *Aboriginality: Contemporary Aboriginal Paintings and Prints*, St Lucia, Qld, 1992.

LEURA TJAPALTJARRI, Tim (*c*.1929–1984), Anmatyerre–Arrente painter and wood carver, grew up on Napperby station (NT) and worked as a stockman before moving to **Papunya** with his young family, when the settlement was established in the late 1950s. There he made carvings of wooden snakes and goannas renowned in central Australia for the brilliant quality of their craftsmanship. When painting began at Papunya in 1971, he quickly joined the group and became the close friend and assistant of the art teacher Geoffrey Bardon. He also enlisted his younger brother Clifford **Possum Tjapaltjarri**. In the mid 1970s the brothers collaborated on a series of large topographical paintings incorporating several **Dreaming** stories in a map-like configuration on one canvas. This was of considerable importance as it was one of the characteristics of painting from Papunya that appealed to European sensibilities. Leura became custodian of the country known as Nurta on Napperby Creek, and painted the possum, yam, blue tongue lizard, sun, moon and morning star Dreamings associated with this area. Always prolific, he had a delicacy of touch, and his translucent painterly effects are distinctive even in his earliest works. The sombre quality of his work reflects his profound sadness at the loss of the old ways of life.

Leura has participated in many group exhibitions including, 'Dot and Circle' (RMIT 1985), 'Mythscapes' (NGV 1989), 'The Continuing Tradition' (NGA 1989), 'The Painted Dream' (Auckland and Wellington 1991), 'Crossroads' (Kyoto and Tokyo 1992), and 'Aratjara' (Düsseldorf, London, and Humlebaek 1993–94). He served two terms as a member

of the AAB of the Australia Council (1973–74). Examples of his work are held in the NGA, SAM, and most Australian State galleries, as well as in the Holmes à Court Collection, Heytesbury (WA), and the Kelton Foundation, Santa Monica. VJ

See also: 9.4, 9.5; **acrylic painting**; *224, 262*.
Johnson, V., *The Painted Dream*, Auckland, 1991; Wolseley, J., 'Rock wallaby Dreaming: The power, the mood, and the scandal', *Art and Australia*, vol. 37, no. 3, 2000.

life stories have been one of the dominant literary forms of Aboriginal textual production to date. The imperative to record events, processes, and lives elided in white histories contributes to the centrality of life-story telling in post-invasion culture. It is widely acknowledged that **history** as a Eurocentric discipline has been slow to include Aboriginal perspectives of the processes of colonisation and modernisation in Australia. Aboriginal people have been denied the authority and political instrumentality of history, and their social memory has not been widely admitted into the official discursive realm of the 'true'.

The entry of Aboriginal life stories into the public sphere is a mediated process. Nonetheless, Aboriginal people have made these collaborations productive for their own political and professional purposes. It is clear from many comments made by Aboriginal tellers of life stories that they anticipate both an Aboriginal and a non-Aboriginal audience. It is important to take into account the oral nature of their narratives. The originary enunciative act of oral story telling from which many of the written texts evolve, is often framed by both Aboriginal and non-Aboriginal listeners and readers. In many cases the stories are pedagogic and archival; their tellers see themselves as custodians of knowledge that must be recorded and passed on. On the one hand, the stories are an 'education' for the contemporary generation of Aboriginal people, for the young people of the extended family as well as the wider Aboriginal community. On the other hand many Aboriginal writers are quite consciously aiming their texts at a white market with both educative and commercial interests in mind.

Life stories have been a representative genre in the growing visibility of Aboriginal culture. There were a small number of Aboriginal life stories published in the 1950s and 1960s. Among the earliest recorded examples are David **Unaipon**'s *My Life* (1951) and *Leaves of Memory* (1953). Most life stories of this period focused on men, for example Ronald Morgan (1952) and Lionel Rose (1969); it is difficult to determine what involvement Aboriginal people had in the production of a number of these texts. The 1970s and 1980s saw many more Abori-ginal men's life stories being produced by Aboriginal authors, covering a wide range of themes from traditional life, to cattle-station life and political activisim in the city. **Family history** was also an element.

The 1990s saw the continuation of station stories such as the tracker stories of Jack Bohemia (1995), and stockman and drover stories, notably those of Morndi Munro (1996) and Jack McPhee (1989, 1995). Landscape and sacred practices were also popular subjects, especially in coffee-table format, as in Wandjuk **Marika** (1995). Personal experience, for exam-

ple of station life, has been used as a basis for fiction, as in Herb Wharton's *Unbranded* (1992), and *Where Ya Been, Mate?* (1996). There were also a number of biography-like life stories of men prominent in the political arena published in the 1990s.

Following the publication of *Bringing Them Home* (1997)—the Report of the National Enquiry into the Separation of Aboriginal and TSI Children from their Families—and other State publications such as *Telling Our Story* (1995)—a Report by the Aboriginal Legal Service of WA on the removal of Aboriginal children from their families in WA—there have been a number of anthologies of historical testimonials including *The Stolen Children* (1998), which contains stories extracted from *Bringing Them Home*. These compilations of life stories consolidate the efforts of earlier publications such as *The Lost Children* (1989). Rosalie Fraser's (1998) book also focuses on this experience. In the 1980s several compilations of short life-stories with specific themes had been published including *The Sweetness of the Fig* (1980), *We are Bosses Ourselves* (1983), *Dreamtime Nightmares* (1985), *Fighters and Singers* (1985), *Countrymen* (1986), *Survival in Our Own Land* (1988), and *Reaching Back* (1989). The 1990s saw the appearance of further compilations and documentations of life stories which varied greatly in theme and genre, such as *Up Rode the Troopers* (1990), *Hidden Histories* (1991), *Cattle Camp* (1994), *Ngarrindjeri Anzacs* (1996), and *Voices From the Land* (1993), to name but a few. Some of these anthologies, such as *The Wailing* (1993) and Robert Hall's interviews with Aboriginal and Torres Strait Islander soldiers from World War II, *Fighters from the Fringe* (1995), foreground the interview format, of which *Living Black: Blacks talk to Kevin Gilbert* (1977) is an early example.

It could be argued that the life story genre has a special significance for women. Until the late 1980s, women have been comparatively less prolific as playwrights, fiction-writers and poets. There are very few early publications of women's life stories apart from Theresa Clements (*c.*1950). A wave of women's life stories began in the late 1970s and spanned the 1980s, notably those of Evonne Goolagong (1975), Kath Walker (Oodgeroo **Noonuccal**), and Labumore (Elsie Roughsey) (1984). This wave gained further momentum in the late 1980s with the publication of Sally **Morgan**'s *My Place* (1987). Morgan's success focused new attention on the genre; in Ruby Langford **Ginibi**'s words 'her book was the first to open the country up' (1994). From this point the genre proliferated giving rise to about twenty books in the following decade including Ginibi's own in 1998, and the collection of life stories, *The Sun Dancin'* (1994). More recently, we have seen the focus of Aboriginal women's life stories widen to include the histories of other family members.

The burgeoning of women's narratives from the 1980s onwards may be related to a change in the structure of Aboriginal society. Women in recent generations have come to occupy a more prominent role in communal and family life which have become, in Marcia Langton's words, 'matrifocal'. As heads of households, Aboriginal women have assumed responsibility for the continuation and transmission of Aboriginal values and practices, and act as a counter to

outside influences. In their affirmation of the family and a distinct way of life, Aboriginal women's life stories foreground gender-specific strategies of resistance to governmental coercion and specific structures of domination and assimilation. ANB

See also: Robert **Bropho**, Jack **Davis, family history, fiction**, Eddie Koiki **Mabo, poetry, stolen generations**.
Langford, G. R., 'Talking with Ruby Langford Ginibi: Interview with Janine Little', *Hecate*, vol. 20, no.1, 1994; Langton, M., 'Urbanising Aborigines: The social scientists' great deception', *Social Alternatives*, vol. 2, no. 2, 1981; Brewster, A., *Reading Aboriginal Women's Autobiography*, Sydney, 1996.

literature, see 3.4, 14.1, 14.2, 14.3; 14.5, 14.5; **fiction, poetry**.

LITTLE, Jimmy (1937–), Yorta Yorta singer and musician, is a true legend of the Australian music industry. Born on Cummeragunja mission on the Murray River (Vic.), Jimmy followed in his father's footsteps. Jimmy Little Sr, himself an Aboriginal legend, was a song and dance man who toured with vaudeville troupes across south-east Australia during the 1930s and 1940s. Jimmy Little Jr sought a more modern world. Starting out as a teenage hillbilly singer in the early fifties, he caused a sensation when he first appeared on the country music showboat in Sydney Harbour. By 1956, at the age of eighteen, he had cut his first Regal Zonophone 78, *Mysteries of Life*, with EMI, at a time when Aboriginal people were not yet counted as citizens of their own country. By 1963 Jimmy Little's recording of *Royal Telephone* had knocked the Beatles off the top of the Australian hit parade: it received two gold records and one gold album. The following year Little was voted by the Australian pop music magazine *Everybody* as Australia's star of the year. Over the following three decades, his all-Aboriginal band remained together recording *Baby Blue* in 1978 followed by the reggae single *Beautiful Woman* in 1983. Both made it to the Top Fifty.

After this time Jimmy Little reined in his career to spend more time with his family and community, and taught performing arts at the Aboriginal Community College, the Eora

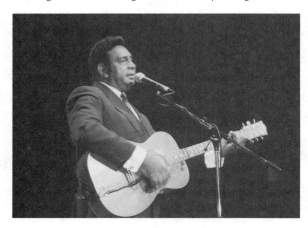

342. Jimmy Little playing at the 1999 Aboriginal and Torres Strait Islander Sports Awards, Hobart.

Centre, Sydney, where he made a triumphant theatre debut in *Black Cockatoos*. Subsequently he starred in several short dramas produced by Aboriginal filmmakers and in the Wim Wenders feature film *Until the End of the World* (1992). Although he made his acting debut as early as 1959 in Billy Graham's evangelical feature film *Shadow of the Boomerang*, for Jimmy Little 'acting in front of cameras doesn't compare to singing to a live audience', so in 1995 he released the independently-produced album, *Yorta Yorta Man*, the autobiography of his traditional Aboriginal roots. In 1999, at the age of 62, he returned to Festival Records to produce the album *Messenger*, which reached number 2 in the Australasian album charts. *Messenger* also won the ARIA award for Best Adult Contemporary Album.

In 1990 Jimmy Little won the NAIDOC award for Aboriginal of the Year. In 1994 he was inducted into Tamworth Country Music's Roll of Renown. In 1997 he won the Australian Entertainment Mo Awards' Industry Lifetime Achievement Award for his contribution to the Australian community, and in 1999, he was inducted into the Australian Recording Industry Association Hall of Fame. During 2000, he travelled to Europe and the USA for the Womad Festival.

The musical career of Jimmy Little, a Yorta Yorta elder, and Australian recording artist, touches all corners of the Australian music industry and the Aboriginal community— from country, to pop, dance hall, and cabaret, and everything else in between. He has always stayed true to himself: through his simplicity, sincerity, and understated elegance he has maintained his artistry after forty albums and a rich musical career spanning forty-five years, and rising. FP-L

See also: **country and western music;** *342*.

Lockhart River Aboriginal Community Arts and Cultural Centre Incorporated. In 1996, a group of elders of the Lockhart River community (Qld) (a former mission station) developed a strategic plan for a commercially viable art and culture centre which would provide professional working facilities and technical support to its artists. The centre contains print studio and a recording and archival facility for traditional language and culture. Every stage in the production of art prints, is carried out in the community, providing experience, training, and professional development for artists. Master printmakers have run special workshops to train artists to produce high-quality print editions.

The twenty-five members of the 'Art Gang', all under thirty years old, create a wide range of contemporary artworks including paintings on canvas and paper, and fine art prints. Their works depict elements of their natural environment and are a contemporary response to the culture and traditions of their community. They have had successful entries in major national print and art awards. In 1998 the Lockhart River Aboriginal Community won the Community Endeavour prize in the NIHAA. They have also had two major group exhibitions at Cairns Regional Gallery and Queensland Aboriginal Creations, Brisbane. In May 1999, Rosella Namok had a solo exhibition at Hogarth Galleries, Sydney.

Artists represented in Australian public collections include Patrick Butcher, Sammy Clarmont, Silas Hobson, Vanessa Macumboy, Rosella Namok, Richard O'Brien, Fiona

343. Rosella Namok, *Leaving the Community*, 1998.
Screen-print, 71 x 100 cm.
The artist's commentary on this work is as follows: This one is about people leaving the community and staying away for a while then coming back. People go out from Lockhart River to different places—Coen, Cairns, Bamaga, Weipa, Mossman, Napranum, Aurukun, Kowanyama, Pormpuraaw. They go for funerals, meetings, school, hospital, and to stop with relations. Some times they stay away for a long time then they come back. People always come back to where they belong. This shows the hills around
Lockhart River. That's the community in the middle. You can see the people going from the community and then coming back

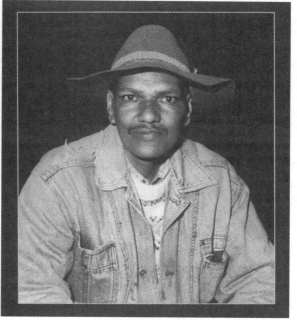

344. Agnes Love, *Greg Harald*, 1998.
Silver gelatin print, 60 x 50 cm.

Omeenyo, Gregory Omeenyo, Leroy Platt, Terry Platt, and Evelyn Sandy. The centre has given the community's young people optimism for the future: it provides them with employment opportunities in their own community and a chance to establish a viable career. The Art Gang's work has a freshness and strong market appeal: some artists have developed a following, and buyers eagerly await each new work.

FB

See also: **art awards and prizes, art and craft centres**; *343.*

LONG, Clarence, see **Milerum.**

LOVE, Agnes (1958–) Ngarrindjeri–Gaurna photographer. One of Agnes Love's cherished childhood memories is of receiving a Christmas present of a small Kodak camera from her mother. Delighted by the wonderful gift, she went around happily, if somewhat obsessively, 'snapping' members of her extended family—and has done so ever since. Love studied visual arts, and majored in photography at Port Adelaide's Indigenous Tauondi College. In 1998 she won the NATSIAA 'work on paper' award for a sensitive, discerning portrait of a fellow student, Greg Harald.

Love's work ranges from portraiture to hand-coloured photographs of natural phenomena, montage, and collage.

Her black and white photographs of theatrical performances—ethereal images that float in the darkness as if somehow cut loose from their social and cultural moorings—have further enhanced her reputation. *The White Protector*, 1997 makes a chilling visual statement through a skilful play of light and shade, creating an atmosphere of oppressive, psychologically-choking evil embodied in the masked and menacing figure of the inappropriately-named Protector of Aborigines.

She also creates hand-coloured, sepia-toned photographs of natural phenomena. Her series of fungi and shells titled *The Blossom, the Oyster and the Shell* are profoundly sensuous and poetic, strongly grounded in her Indigenous identity and sense of belonging to the land. Her beautifully made, strong photographs evoke a recent past that continues to inflect the present in important ways while avoiding the pitfalls of sentimentality and self-pity.

Love's work has been included in a number of group exhibitions such as '3 Views of Kaurna Territory Now' for the 1998 Adelaide Festival, and 'Karra' (Artspace SA 2000).　　CN

See also: *344.*

Kean, J., 'Exposing the "Aboriginal Location"', in *Three Views of Kaurna Territory Now*, Adelaide, 1998; Nicholls, C., 'The Look of Love', in *State of the Arts*, December 1998–April 1999.

M

MABO, Edward Koiki (1936–1992), Meriam cultural activist. The name Mabo is principally associated with the Murray Island (Mer) **land rights** case which, after eleven years, resulted in the overturning by the High Court of Australia of the doctrine of terra nullius, not merely for the Meriam people, but for all Indigenous Australians. Eddie Mabo's main concern, however, was with the Meriam people and their culture.

Mabo was born on the island of Mer, in the Torres Strait, the son of Robert and Paipe Sambo. His mother died soon after his birth, and her brother Benny Mabo and his wife Maiga made the boy their son through traditional adoption. The Mabo family were descended from the priests of the old cult of Malu-Bomai, and although this cult had been displaced by mission Christianity, the Meriam people remembered it. In later years, Eddie Mabo also remembered it, and it inspired him in his career as a cultural activist.

He spent his boyhood on Mer, but in his mid teens he committed a minor misdemeanour, prompting the island court to send him away from the island for a year. He was not to return for more than twenty years. At first he worked on a trochus lugger in the Strait, but eventually made his way to the mainland. He was among the first Meriam to make his home there, eventually marrying and settling in Townsville.

Incensed at the Queensland Government's treatment of both Islanders and Aborigines, Mabo became involved in radical politics; as a result the authorities in Torres Strait ordered that he not be allowed to return to Mer, even to visit his parents. He also made contacts with academics interested in Indigenous affairs at James Cook University, and through them gained access to the library and the various anthropological writings on Torres Strait culture. Realising that his children, attending a State school in Townsville, were not learning about their cultural heritage, he resolved to establish the Black Community School. He won a government grant for this project, and for a few years in the mid 1970s was able to include Islander culture—particularly dance and music—in the curriculum. The loss of the premises and the withdrawal of its funding brought this project to an end.

In his discussions with academics, Mabo had also discovered that the Meriam did not, as they believed, own their land: upon annexation it had become the property of the Crown. This discovery, combined with his own exclusion from Mer, was the genesis of the Mabo case which, with three other Meriam, he brought against the State of Queensland in 1981. The case dragged on through the decade. When it finally reached the High Court for determination, he was no longer included among the plaintiffs: he died in January 1991; five months before the High Court brought down its decision in their favour.

At this point, the attempts to discredit Mabo no longer mattered. The case became the Mabo Case, in recognition of Eddie Mabo's leading role. Trevor Graham's film, *Land bilong Islanders*, completed before the High Court's decision, made his face and his personality familiar to a wide public.

In 1994, when his family 'opened' his tombstone according to *Ailan Kastom* in the Townsville cemetery, the ceremony was attended by the Minister for Aboriginal and Islander Affairs, the wife of the Prime Minister, and numerous other dignitaries. But while the event was being celebrated with feasting and dancing, unknown persons vandalised the stone, daubing it with racist slurs. The RAAF brought the casket and the tombstone back to Mer in 1995. The reinterment was followed by a re-enactment of parts of the Malu-Bomai ceremony, which Eddie Mabo would undoubtedly have appreciated. Trevor Graham recorded these events in a second film, *Mabo: Life of an Island Man*. JB

See also: 1.1, 1.2, 7.3; **native title**.
Graham, T., *Mabo: Life of an Island Man*, Sydney, 1999; Graham, T. (director), Land Bilong Islanders [film], Yarra Bank Films, *c.* 1990; Loos, N., & Mabo, E., *Edward Koiki Mabo: His Life and Struggle for Land Rights*, St Lucia (Qld), 1996.

MCCARTHY, Nikki (1943–), Wiradjuri–Dabee sculptor and installation artist. In her most recent work, Nikki McCarthy plays with the metaphysical, and even with the possibility of extra-terrestrial visitors. Born in Sydney, she came to art through her involvement with the Newport Beach Surf Club. In 1993 she graduated with a BFA from CoFA, and in 1994 was awarded an MA. The same year her work was selected for the New South Wales Travelling Art Scholarship exhibition.

Nikki McCarthy's early works used elements of traditional netting and feathering, though even at this stage she was involved in the use of glass to create translucent, ambiguous

345. Nikki McCarthy, *Black Lightning*, 1988.
Ceiling installation, 450 individual clear and black glass rods from 10 to 200 cm long.

works. Since 1994 her installations have explored the surfaces and reflections produced by glass and sand. She has exhibited widely in Australia, including an exhibition with the **Campfire Group** at the 1992 Sydney Biennale, the 1995 NATSIAA exhibition, and the 1998 NIHAA exhibition.

JAM

See also: *345.*

MCGRATH, Victor (1948–), Muralag shell carver, craftsman, and administrator, was born on Waiben (Thursday Island), where he spent most of his childhood. He continues a long tradition in the Torres Strait of artistry in pearl shell, turtle shell, dugong bone and ivory. In his youth, he watched the Island men fashion objects from shell and other materials. He also learnt from them how to dive for the shell.

In using pearl shell, black coral, and turtle shell, McGrath acquired an acute feeling for the natural qualities of the materials. After a period of experimentation, he began etching into their surfaces with images of marine and terrestrial wildlife, as well as more stylised design work.

Upon completing his schooling, McGrath worked as a teacher's aide, fisherman, and leather craftsman. He has also held managerial and research positions in a variety of local and national government bodies and, as part of this work, has produced several reports on the arts and the environment of the Torres Strait. In 1991, he was awarded a travel grant to study Torres Strait cultural material in the UK and North America. He has also run art workshops in many communities on Cape York Peninsula.

BR

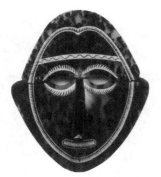

346. Victor McGrath, *Turtleshell Mask*, c.1991.
Etched turtle shell and white ink, length 24 cm.

See also: 7.1, 7.2, 7.4; *346.*
McGrath, V., 'Contemporary Torres Strait arts', in T. Mosby with B. Robinson, *Ilan Pasin—This is Our Way: Torres Strait Art*, Cairns, 1998; Wilson, L., *Kerkar Lu—Contemporary Artefacts of the Torres Strait Islanders*, Brisbane, Qld, 1993.

MACK, Pinkie (Maggie) (*c.*1864–1954), Yaraldi custodian, fibre artist, and singer. Pinkie Mack's father was George Mason, Sub-Protector of the East Murray Aborigines, and her mother was Louisa Karpenny. The anthropologist Ronald Berndt records that Pinkie Mack went through initiation, and therefore was very knowledgeable. She was married three times; to John Djelwara, Phillip Sumner, and later to John Cameron Jr.

Pinkie Mack worked with N. B. Tindale of the SAM in the 1930s, and collaborated closely with anthropologist Ronald Berndt. She had an intense interest in her culture's songs and ceremonies, and provided cultural material, recordings, and extensive genealogical information to Berndt, who wrote that she was 'an exceptional teacher, patient and painstaking in attention to detail'. He described her as 'a wonderful singer … the songs she sang encompassed both timeless traditional concerns and the impact of alien influences such as money, paddle steamers, alcohol, shepherding, and dresses with bustles', and recorded some of her singing on wax cylinders. In 1943, Pinkie Mack made Berndt a funeral mat—photographs of her with the mat at Raukkan (Point McLeay) show her as an active, sprightly woman.

In 1951, Pinkie Mack was a leading figure in the staging of a re-enactment of Charles Sturt's journey down the Murray River and his coming ashore at Raukkan. During the ceremony participants and audience moved to Hindmarsh Island where they danced the 'Big River' **corroboree**. Pinkie Mack provided information on the dance steps, songs, and body painting for the ceremony. The ABC recorded much of this celebration, including the singing of Pinkie Mack.

GMcC

See also: 17.1, 17.2; **anthropology**, Albert **Karloan**; *347.*
Berndt, R. M. & Berndt, C. H., with Stanton, J. E., *A World That Was: The Yaraldi of the Murray River and the Lakes, South Australia*, Melbourne, 1993.

347. Pinkie Mack with a mortuary mat made of sedge in the 'coiled bundle' technique, Raukkan (Point McLeay), 1943.

MCKENZIE, Peter Yanada (1944–), visual artist, was awarded a Commonwealth Department of Education Aboriginal Overseas Study Award in 1982. This enabled him to study photography, design, **printmaking** and commercial illustration in the USA at Clark University (MA). This course of study built upon his previous experience as a commercial artist, and cemented his commitment both to his own artistic practice and to continued involvement in Aboriginal affairs. He completed an MFA at the CoFA, UNSW in 1993.

McKenzie received a grant from the Australia Council in 1985 and was later employed as an Aboriginal liaison officer and project coordinator at the PM, Sydney, and Museums Australia. He has lectured at the CoFA, UNSW in post-contact Aboriginal history and Aboriginal Arts. He was selected as a photographer for the **AIATSIS** *After 200 Years* project, working with his own community of La Perouse. He also curated the exhibition 'What is Aboriginal Art?' (1997) at the Ivan Dougherty Gallery, Sydney (1997) as part of the Festival of the Dreaming, Olympic Arts Festival. In recognition of his success, McKenzie became the inaugural **ATSIC** Fulbright Scholar in 1994.

KG

See also: 12.4; *378.*

Taylor, P. (ed.), *After 200 Years: Aboriginal and Torres Strait Islander Australia Today*, Canberra, 1988.

MCKENZIE, Queenie (Nakarra), (*c.*1930–1998), Kija visual artist, was the first woman painter to gain prominence in the East Kimberley school of painting. A close and long-time friend of **Rover Thomas**, she worked with him on the cattle station at Texas Downs where she was born. She was daughter of an Aboriginal mother and a white father, and there were unsuccessful attempts by the authorities to separate her from her mother. As a young woman, McKenzie was a camp cook for the stockmen on the cattle station. She fondly remembered an incident which occurred about 1950, when she saved Rover's life. He had been thrown from a horse and had scalped himself. She sewed his scalp back on so expertly that, even though she had never done such a thing before, doctors were later amazed. In time, the incident became the subject of a number of her paintings.

McKenzie and her husband moved to **Warmun** in the 1970s. When Rover Thomas began painting for the public domain, his work inspired Queenie McKenzie to take up painting herself. She preferred using natural pigments and **ochres** rather than acrylic paint, and her palette often included distinctive powdery pink and pale violet colours made from ochres that she mined herself. As she said, these colours appealed to her sense of beauty. In her compositions, she usually placed images of geographic features in rows against monochrome grounds, and she combined plan and profile views to render the rugged landscape. Her paintings allowed her to teach others—black and white—the narratives associated with her traditional country. Late in life she was introduced to **printmaking**.

McKenzie participated in several group exhibitions including 'Aboriginal Women's Exhibition' (AGNSW 1991), 'Images of Power' (NGV 1993), 'Bush Women' (FAC 1994), and 'Power of the Land' (NGV 1994). Her work is found in several public collections including the NGA, AGWA and the Berndt Museum of Anthropology (UWA).

Queenie McKenzie was a woman of strong convictions and indomitable spirit, with a firm belief in the significance of her culture. She was lauded as an artist, and in 1998 the government of Western Australia declared her a State Living Treasure for her contribution to the arts and to the teaching of the Kija **language**.

KA & WC

See also: 10.1, 10.2, 10.3; *135, 268.*

Perkins, H., *Aboriginal Women's Exhibition*, Sydney, 1991; Ryan, J. with Akerman, K., *Images of Power: Aboriginal Art of the Kimberley*, Melbourne, 1993.

MCLEAN, Pantjiti Mary (*c.*1930–), Ngaatjatjarra painter. When Mary McLean visited her country for the first time as a contemporary painter in the spring of 1996, the Western Desert was a riot of wildflowers and bush tucker: 'See that's my paintings, that's the colour for my *parna* (land), my paintings are *murlapa* (true)'. The experience reinforced her growing ability to depict her country with vibrant flair.

Conceived along the song line of Kunkarankalpa (the Seven Sisters of the Pleiades), Mary McLean was brought up in her grandmother's country Kalkukutjara, then further west in her father's country of Papalungkuta, near Blackstone (WA). She worked for many years as a musterer on Eastern Goldfields sheep stations while her children were raised at Mount Margaret Mission. Today she resides at Ninga Mia Village in Kalgoorlie (WA).

Initially she painted small dot images, often of Wati Kutjara (two goanna men) or Kunkarangkalpa Tjukurpa (Seven Sisters **Dreaming**), and made carved pokerwork artefacts— emus, kangaroos, and trees decorated with burnt flowing lines—for the tourist market. In 1992 she became involved in the Street Art Project in Kalgoorlie. Stimulation and encour-

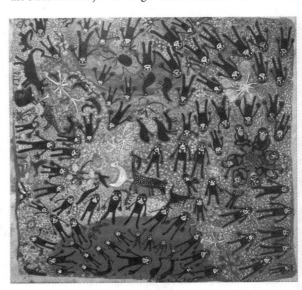

348. Pantjiti Mary McLean, *Ngura walkumunu (Being in a Good Camp)*, 1995.
Acrylic on canvas, 173 x 179 cm.

agement from Nalda Searles, and access to a broader range of materials, led her to develop the figurative style that is now her hallmark. Her paintings depict the everyday narratives of her childhood—men hunting for meat, women looking for bush tucker, children playing, and animals and birds tracking across the surface. Often daily life and historical events are combined with one of the religious epics, as in *Wanampi Kutjara at Kukerana (Two Water Snake Men at Kukerana Rock Hole)*. While the many figures that occupy a single canvas may appear uniform, subtle shifts in individual expressions and gestures are the key to understanding the richness of the unfolding drama. When describing her paintings, Mary McLean takes delight in mimicking those differences with great humour.

'Hunting Grounds' (FAC 1993), was her first exhibition. In 1995 she won the NATSIAA for *Ngura Walykumunu (Being in a Good Camp)*, and was given a survey show at Australia House, London. McLean was the commissioned artist for the 1996 Festival of Perth and a participant in the international indigenous artists' camp and exhibition 'Offshore: Onsite' (CPAC 1997). 'Mustering' (FAC 1999), was an exhibition of a series of anecdotal paintings and drawings about her life in the pastoral industry in the 1950s. NS

See also: 1.3, 2.2; *348*.

Kean, J., *Pantjiti Mary McLean*, Fremantle, WA, 1995; Laurie, V., 'The drover's girl', *The Weekend Australian*, 8–9 May, 1999.

MACNAMARA, Shirley Anne (1949–), Indjalandji fibre artist and mixed media artist, began her education at Camooweal State School. She subsequently studied by correspondence, due to her family's involvement in the cattle industry. She now lives at Mt Guide (Qld), where she and her son manage the family cattle station.

Since 1989 Macnamara has attended Queensland's Flying Art School workshops, working in watercolour. She has explored mixed media, installation, and sculpture. Following a period of grief, Macnamara sought solace through twining and weaving the plentiful local spinifex grass to make exciting organic forms. In working the spiky, hardy grass, she also drew personal strength from its tough resilience and reaffirmed her relationship with the land:

I could see myself in the same position as the spinifex. You belong to the area so your roots are there and you have to be strong enough to survive and keep going. I could see that in that plant. The seasons do not affect its survival. It manages to keep on going. It is fragile as well as strong. But you are fragile as well. To survive in the country is not an easy thing.

Her popular spinifex 'vessels' have been included in major collections and in the exhibitions 'Carried Lightly' (PTRG 1998) and 'Spinifex Runner' (CCBAG 1999). In 1999 Macnamara was awarded an Australia Council grant to create a body of work for the Centre for Contemporary Craft, Sydney. DIM

See also: 17.1; *349*.

Silver, A. 'Spinifex, ochres, and the land: Anneke Silver interviews Shirley Macnamara', *Periphery*, vol. 33, Summer 1997.

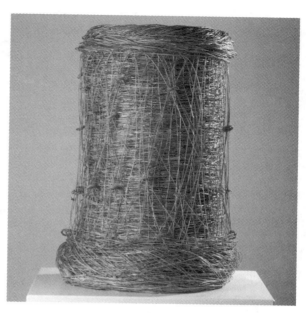

349. Shirley Macnamara, *Spinifex Vessel*, 1997. Spinifex grass runners, yellow ochre, waxed thread, and synthetic polymer fixative, 68 x 48 cm.

MCRAE, Tommy (*c.*1835–1901), Kwatkwat visual artist, was known at various points in his life by two other names: Yackaduna and Tommy Barnes. Tommy McRae was the name by which he was known in his later years, during which time he made most of his drawings. In his early life McRae worked as a stockman on stations around the upper Murray River. By the time he settled with his family on the shores of Lake Moodemere, near Wahgunyah (Vic.), in the early 1880s, he was, according to one account, 'a well known identity throughout the country from Albury to Yarrawonga'.

Although details of McRae's early life remain hazy, it is clear on the evidence of his drawings that he had considerable experience of traditional Aboriginal life before the European colonisation of Victoria. His earliest surviving drawings were made in 1864. They depict **corroborees**, hunting and fishing and ritual fighting—but they also include squatters and farmhouses. These continued to be McRae's principal themes and the coexistence of Aborigines and colonisers, including Chinese as well as European squatters—suggested in these drawings—was to become a recurring motif in his work. Another repeated theme was the story of William Buckley, the 'wild white man' who lived with Aboriginal people for thirty-three years, between 1803 and 1835.

Almost all of McRae's drawings are in sketchbooks. His compositions consist of predominantly silhouetted figures, animals and trees in a sparse landscape. It was a style that provided a remarkable range of possibilities and a vitality of expression—recognised even in McRae's lifetime. The sketchbooks are usually annotated, and the range of handwriting suggests that the people who commissioned them annotated the drawings with McRae's descriptions of the

subjects: 'Black-fellow practising for a fight', 'Echuca Tribe one song', 'Victorian Blacks. Melbourne Tribe, holding corroboree after seeing ships for the first time', and so on.

McRae worked on commission. Payments for a book of drawings varied, but with the proceeds McRae was eventually able to afford a buggy and horses; he was described in the late 1880s as an 'astute financier and something of a wag'. Through his friendly association with the Canadian-born telegraph master and vigneron Roderick Kilborn, whose property Goojung was close to Lake Moodemere, McRae gained a patron. Surrounded by the devastating effects of alcoholism, McRae was himself an ardent advocate of teetotalism.

During his last years McRae saw the destruction of his family group. Despite his protestations and appeals to Kilborn, his children were removed from the Lake Moodemere camp and sent to Aboriginal missions in other parts of Victoria. When McRae died in 1901 he was buried in a quiet ceremony in the Carlyle Cemetery outside Wahgunyah, on the shores of Lake Moodemere. His sketchbooks are now held in a number of Australian public institutions including the NLA, NMA, NGA, and MoV. AS

See also: 8.2, 11.1, 22.4; William **Barak**, **Mickey of Ulladulla**, **Oscar**; *140*.
Barrett, C., 'Tommy McRae, Aboriginal Artist', *Victorian Naturalist*, vol. 52, no. 5, 1935; Morphy, H., *Aboriginal Art*, London, 1998; Sayers, A., *Aboriginal Artists of the Nineteenth Century*, Melbourne, 1994.

MADDIGAN, Gayle (1957–), Wamba Wamba–Wertigkia visual artist. 'We are indeed a people of beauty and intellect, a people of honour and laughter, a people of profound simplicity, a people of sovereignty, a people of dreaming.' Gayle Maddigan wrote these words for her solo exhibition 'Burial Grounds' (Tandanya 1999). Sparked by the excavation of Aboriginal burial grounds near her birth-place on the Murray River, these large oil paintings resonate with a raw energy that seems to come straight from the earth itself. Spontaneous forms and symbols saturated in a range of pure colours convey a vivid story about her people's shared tragedies and ritual celebrations. Maddigan's palette and sense of form reflect the distinctive hues and shapes of Australia's landscape. In her paintings, deep blues adjoin rich reds, punctuated by blackened forms and splashes of intense white light. Yet despite their obvious link with the land, many of her compositions have little in common with traditional Aboriginal imagery—the artist's use of bold flat colours and improvised detail lends her work a rhythmic quality more reminiscent of international modernist abstraction.

Raised among her people, the Wamba Wamba and Wertigkia, at Red Cliffs (Vic.), Maddigan studied art at La Trobe University and, since the late 1970s, has parti-cipated in many solo and group exhibitions in Australia, the USA, and the UK. Her work features regularly in the NATSIAA and NIHAA where, in 1994, she won second prize in the open section. In 1993 she won the Heritage Commission Award, and the Inaugural Botany Aboriginal Art Award for landscape. Her work is held in both private and public collections.

350. Gayle Maddigan, *Burial Grounds*, 1997. Oil on canvas, 92 x 76 cm.

Maddigan has been a member of the North-West Nations Clan since its establishment in 1997 and remains actively concerned with Aboriginal rights. AAC

See also: 12.1; *350*.
Greenwood, N. 'Contemporary Australian Aboriginal Art', *Artlink*, vol. 10, 1990.

MALANGI, David Daymirringu (1927–1999), Djinang (Yolngu) bark painter, printer, and designer, was born at Mulanga, the land of the Manyarrngu people, at the mouth of the Glyde River in north-central Arnhem Land, just before the arrival of Christian missionaries on the nearby island of Milingimbi. He was initiated around 1941, and as an adult lived between Mulanga, Milingimbi, and his mother's land at Yathalamarra waterhole.

After painting for ritual purposes only for many years, he learnt from a group of older artists how to paint for the 'outside' market in the 1960s. He became famous when one of his paintings, which had been collected and displayed by Czech anthropologist and art collector Karel Kupka, was reproduced on the Australian one-dollar note—without his permission. He said of his work: 'The paintings are just like our sacred sites and dreamings. In doing paintings we are acting out our ancestral traditions. That's where they come from, our sacred dreamings. I only paint my land because it's mine. And Yirritja is my mother's land. And my grandmother's land. Each person—whether Dhuwa or Yirritja—have to look after their own land.'

Malangi's painting style is marked by large plots of bold blacks, reds, and yellows, usually fixed with a cross-panel of *rrarrk* cross-hatching at the base of the composition, representing the land itself. The lines are like his signature; the sequences of white bands, then red, then yellow, mirror the

array of similar colours that make up the Djang'kawu sacred design. His arrangements of figures are adventurous, monumental, and challenging. On several occasions he collaborated with urban Aboriginal artists, including Arone Raymond **Meeks**, Avril **Quaill**, and Fiona **Foley** to create murals in Surfers Paradise (Qld) and Darwin.

In 1979 Malangi, with fellow Ramingining artists George **Milpurrurru** and Johnny Bonguwuy, became the first Aboriginal artists to show their work at the Biennale of Sydney, in 'A European Dialogue'. In 1983 a suite of Malangi's paintings appeared in 'Australian Perspecta' (AGNSW) and his work appeared in the important 'Dreamings' exhibition at the Asia Society in New York in 1988. He travelled to the opening with fellow Ramingining artist Jimmy **Wululu**. The same year both were major contributors to the *Aboriginal Memorial*, first shown in 'Beneath the Southern Cross' at the 1988 Bicentenary Biennale of Sydney. In 1992 Aboriginal film-maker Michael **Riley** directed a film about David Malangi for the ABC.

Malangi received an Australia Council Award in 1997, and an honorary doctorate from the ANU in 1998. He died in 1999, leaving a large family, some of whom are also painters, and throughout his career inspired many Aboriginal artists across the continent.

DjM

See also: 6.1, 22.1; **copyright**; *38, 69, 74, 261.*
Jenkins, S. 'Dr David Daymirringu 1927–1999', *Artonview*, no. 19, Spring 1999; Johnson, V., *Copyrites: Aboriginal Art in the Age of Reproductive Technologies*, Sydney, 1996; Mundine, D., 'Glyde River Story: David Malangi', *Art Monthly Australia*, no. 89, May 1996; Museum of Contemporary Art, *The Native Born: Objects and Representations from Ramingining*, Arnhem Land, Sydney, 2000.

MANARRDJALA, Minnie (*c*.1929–), Nakkara fibre artist. The first Minnie Manarrdjala fibre piece I ever saw was a seductive introduction to her contemporary work. Purple pandanus swirled through a field of yellow, drawing my eye instantly to the centre of the mat. Her years of experience as a fibre artist were evident in her apparently effortless mastery of a technically difficult pattern.

Manarrdjala started to acquire her weaving skills as a very young girl, helping and watching as her mother and her mother's sisters prepared and produced fibre objects—everyday necessities when one must collect and carry food for a large family. In earlier times the women made utilitarian objects needed for food collecting such as baskets, fish traps, and long twined fish fences made from pandanus.

Manarrdjala married young, and four boys and four girls followed. Although her husband is deceased, her children are still living; most are still in the Maningrida (NT) area. She continues to produce a range of fibre objects for sale through **Maningrida Arts and Culture**. Her work was included in the major touring exhibition, 'Maningrida: The Language of Weaving' (AETA 1995). Her fibre pieces are in the permanent collections of the MCA, MV, and NGA.

LH

See also: 17.1.
West, M. & Carew, M., *Maningrida: The Language of Weaving*, South Melbourne, 1995.

MANDARRK, Wally (*c*.1915–1987), Kune–Dalabon rock painter and bark painter. Speaking of Wally Mandarrk, his son George Baydduna once said: 'He doesn't like living near Balandas [white people]. He doesn't like riding in trucks and planes. He prefers bush foods, but he is happy to get shotgun, bullets, and tobacco.'

Mandarrk was a profoundly independent artist who maintained continuous contact with his clan lands south of Maningrida at Benebenemdi, despite the incursions of settlement. His work in the collections of the American–Australian Scientific Expedition (1948) represents some of the earliest **bark painting** from central Arnhem Land. He is known to have painted a rock shelter in the Cadell River region with an image of Bolung the rainbow serpent in about 1965, and he described the meaning of this painting and others to Eric Brandl, who worked with him between 1968 and 1971. Mandarrk also produced bark paintings for Brandl to illustrate his style.

Rather than moving to Maningrida, Mandarrk preferred to live with his family closer to his own lands. He decorated some of their bark shelters with paintings, in a manner that

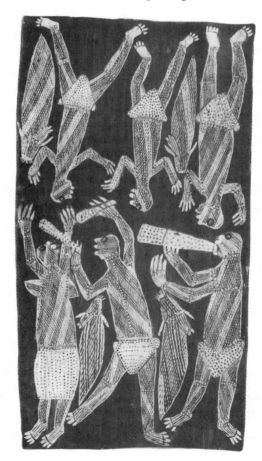

351. Wally Mandarrk, *Dancing Ceremony and Bikurr (Eel-Tailed Catfish)*, 1984.
Natural pigments on bark, 81 x 41 cm.

was first recorded by researchers in the late nineteenth and early twentieth centuries. One of Mandarrk's painted bark shelters is now held by the NMA. He regularly moved to new locations to take advantage of their specific food and ceremonial resources. He had a reputation as a powerful *marrkidjpu* ('clever man' or 'doctor') and it is clear that many in the region feared his powers. For example, he was believed to be able to send his 'shadow' on long journeys at night to look after his relatives, and to have a special relationship with *mimih* spirits.

Mandarrk also painted for the market during the 1970s. The arts adviser Peter Cooke made a number of collections of his work, one of which was purchased by MAGNT. His paintings are characterised by a soft, chalky, quality in the paint resulting from a very sparing use of fixative. Many works depict unique species of the rocky escarpment, such as *barrk* (black wallaroo), or *doddorok* (chestnut-quilled rock pigeon). Spirit figures include *mimih,* which are said to live in the cracks and caves, *ngalkunburriyaymi* (female water spirits), and the *wayarra* spirits of the dead. Mandarrk often paints these spirits surrounded by the bounty of food they had collected. The hands of the figures are often raised in expressive postures and the mouths are open to suggest the hunting activities in which they are engaged. Mandarrk remains best known for his rock painting, although the collection from 1979 held at MAGNT is a major expression of his skill as a bark painter. LT

See also: 5.2; *351.*

Brandl, E. J., *Australian Aboriginal Paintings in Western and Central Arnhem Land,* Canberra, 1973; Taylor, L., 'Flesh, bone, and spirit: Western Arnhem Land bark painting', in H. Morphy & M. Smith Boles (eds), *Art from the Land: Dialogues with the Kluge–Ruhe Collection of Australian Aboriginal Art,* Charlottesville, VA, 1999.

MANDJUWI, John (1935–), Gälpu (Yolngu) bark painter, is based at Galiwin'ku (**Elcho Island**) just off the coast of north-eastern Arnhem Land. Though well represented in public museums and art galleries, Mandjuwi, like other Elcho Island artists, has been underrepresented in exhibitions and catalogues because of the fluctuating fortunes of the Galiwin'ku artists' cooperative.

Much of the subject matter of his paintings relates to sacred sites on the mainland, and his style shares the brilliance of white cross-hatching that is the distinctive mark of several other Elcho Island painters. Stylistically, his work is divided between formal Dhuwa compositions relating to the Morning Star and Djang'kawu ceremonies, and more figuratively descriptive compositions relating to totemic aspects of the bush and the marine life surrounding the island and nearby mainland. The chevron-shaped patterns which appear in many of his paintings are a favourite device; they animate his barks, which are otherwise distinguished by serried rows of small animals, fish, or symbolic shapes. The complexity of Mandjuwi's white cross-hatching and the dazzling optical effect of his formal compositions are representative of north-eastern Arnhem Land art at its most powerful. MO'F

See also: 6.1, 6.2, 6.4.

West, M., *The Inspired Dream: Life as Art in Aboriginal Australia,* Darwin, 1988; O'Ferrall, M., *On the Edge: Five Contemporary Aboriginal Artists,* Perth, 1989.

Mangkaja Arts Resource Agency Aboriginal Corporation began its operation in Fitzroy Crossing in the mid 1980s with a small capital grant from the Australia Council. It took the name Mangkaja from a Walmajarri word for the wet-weather shelters which the artists built in the desert. In years prior to its incorporation in 1993 Mangkaja struggled to get going; it opened and closed several times.

Mangkaja provides training for both artists and staff, to encourage and increase active local participation in the Aboriginal art market. It has opened up national markets, and mounted exhibitions such as 'Karrayili: Ten Years On' (Tandanya 1991). Since 1993, Mangkaja has been run by a committee of twelve, made up of three representatives from each of the four local language groups—Bunuba, Gooniyandi, Walmajarri, and Wangkajunga.

Some of the key Mangkaja artists are Daisy **Andrews**, Janangoo Butcher **Cherel**, Jukuna Mona Chuguna, Pijaju Peter **Skipper**, Paji Honeychild **Yankarr**, Walka Molly Rogers, Wakartu Cory **Surprise**, Nada Rawlins, Yamapampa Hitler Pamba, Nyuju Stumpy Brown, Purlta Maryanne Downs, Jukuja Dolly Snell, Nyilpirr Spider **Snell**, Ngarralja Tommy May, and Dorothy May. KD

See also: 10.1, 10.2, 23.2; **art and craft centres**; *cover illustration, 270.*

Maningrida Arts and Culture. Maningrida (NT) was established as a trading post in 1949 by Sidney Kyle-Little and Jack Doolan. With the exchange of pandanus mats and baskets for supplies through this post, the evolution of Maningrida into a centre of art for commercial sale was set in train. The quest to encourage and develop the art trade was initiated in 1963 by the Revd Gowan Armstrong, who came to Maningrida as the Methodist minister. Under the banner of the 'Maningrida Social Club', bark paintings and works in fibre were bought and sold from beneath his house. A more permanent craft shop was set up in 1967; this grew to become Maningrida Arts and Culture as it is today. It is one of Australia's largest community-based art cooperatives, servicing over 300 artists from the Maningrida township and surrounding outstations in a region of about 10 000 square kilometres. Operating under the auspices of Bawinanga Aboriginal Corporation, the centre functions as an art-marketing and cultural research body. **Bark painting**, sculpture, fibre objects, and items of material culture, inspired by the region's unique heritage, are regularly exhibited and sold to commercial galleries, private collectors, and public institutions both nationally and internationally. Through its cultural research office, the centre documents artworks as well as the region's rock art, traditional music, and languages.

The style of Maningrida art, most notably in bark painting, is best described as 'heterogeneous'. This can be attributed to intense ceremonial and artistic interaction between members of the eight different language groups of the region. In surveying the work of past senior artists Wally **Mandarrk**, Jack **Wunuwun**, Les **Mirrikkurria**, and Crusoe **Kuningbal**, and that

of leading contemporary artists John **Mawurndjul**, Johnny **Bulunbulun**, England **Banggala**, Mick **Kubarkku**, and Lena **Yarinkura**, the continuation of artistic excellence and aesthetic diversity to the present day is evident, marking a robust and vital culture.

FS

See also: 5.1, 5.3, 6.1, 15.4, 13.5, 17.1, 17.3; **art and craft centres.**

MANYBUNHARRAWUY, Daisy, see **Dawidi.**

MARAWILI family, Madarrpa (Yolngu) painters. Wakuthi Marawili (c.1921–) was a youth when missionaries first arrived in north-eastern Arnhem Land during the 1930s. As a young teenager he travelled and lived with members of the **Gumana family** and his classificatory father Mundukul, whose paintings were collected by anthropologist Donald Thomson in the late 1930s. During the 1950s and 1960s, they all spent some time at the **Yirrkala** mission.

Wakuthi today is the patriarch of his large Madarrpa clan homeland at Yilpara (formerly known as Baniyala) outstation on Blue Mud Bay. Djambawa Marawili (1953–), the eldest son of Mayawuluk, a senior wife of Wakuthi, is his spokesman, and an artist. Marrirra Marawili (c.1937–), and Bakulangay Marawili (c.1944–) are artists and sons of Mundukul, and also reside at Yilpara as did his son Watjinbuy Marawili (c.1937–2000). Through their mothers, all these Yirritja moiety men 'come from' the same Dhuwa moiety clan, the Dhudi Djapu, whose homeland is at Dhuruputjpi.

Both Gawirrin **Gumana** and Wakuthi Marawili were established as artists in the late 1960s, when they spent time at Yirrkala. When living there became intolerable due to intrusive large-scale mining for bauxite, they moved back to clan estates and started the homeland movement. Wakuthi is known as 'the old blind one', but is far from lacking in vision. His simple but invigorating bark paintings illustrate fields of his saltwater and fire country at sacred Yathikpa and surrounds; he has also carved—by feel alone—ancestral totems out of local timbers. Wakuthi was filmed in 1974 at Yilpara by Ian Dunlop. In 1997 in the film *Copy Rights*, Wakuthi explained to the camera the meanings of country.

Djambawa, Wakuthi's son, is an artist who has experienced mainstream success. He won the NATSIAA prize for Best Bark Painting in 1996, and is represented widely in public and private collections in Australia and overseas. The production of art is a small part of a much bigger picture for Djambawa. His principal roles are as a leader of the Madarrpa clan, a caretaker for the spiritual well-being of his own and other related clans, and as an activist and administrator in the interface between non-Aboriginal people and the Yolngu (Aboriginal) people of north-eastern Arnhem Land. He was one of the artists who contributed to the Barunga Statement, and in 1997 was one of the elders who burned the Prime Minister's 'Ten point plan' at Timber Creek. He has contributed to the push for Yolgnu sea rights under **native title**, instigating the production of a series of eighty bark paintings for the major travelling exhibition 'Saltwater Country—Bark Paintings from Yirrkala', which opened at the Drill Hall Gallery, ANU, in 1999.

Marrirra is the oldest surviving son of Mundukul. His father was named for the ancestral lightning snake—the black headed python found at Burraltja on Madarrpa clan land—which is the subject of many of his paintings.

Watjinbuy carved as well as painted works that focused on *bäru*—the clan's totemic crocodile—and the country imbued by its power, until a crippling stroke stopped him painting. Then in 1997 he got caught up in the new wave of painting for public recognition of the Yolngu connection to land and sea. On three slabs of bark he painstakingly produced the all-important outline structures for paintings which his wives and daughters then completed.

Bakulangay spent most of his early life in south-eastern Arnhem Land, working cattle at Hodgson Downs station. The Madarrpa had connections in this area and at Rose River. He was part of the first reconnaissance party sent out to establish the homeland centre at Yilpara. He carves his clan's totems with elegance and grace.

Works by members of the Marawili family are found in most major national collections, as well as overseas, for example in the Kluge–Ruhe Collection at the University of Virginia.

AB

See also: 1.1, 1.2, 4.6; **Buku-Larrnggay Mulka;** *32, 39, 207.*
References: Buku-Larrnggay Mulka, *Saltwater: Yirrkala Bark Paintings of Sea Country*, Neutral Bay, NSW, 1999; Morphy, H., *Journey to the Crocodile's Nest*, Canberra, 1984.

MARIKA family, Rirratjingu (Yolngu) visual artists. Most members of the Marika family live at **Yirrkala** on the Gove Peninsula (NT). They are all descendants of five classificatory brothers, Mawalan (c.1908–1967), Mathaman (c.1920–1970), Milirrpum (c.1923–1983), Dadaynga (Roy) (c.1925–1992), and Dhunggala (1931–1989). All these men were born on or near their clan lands before the Revd Wilbur Chaseling established the mission at Yirrkala, on Rirratjingu land. Mawalan was the head of the Rirratjingu clan at the time.

When Chaseling arrived at Yirrkala, he observed that people were sometimes producing paintings on the inside of their bark shelters. The 1930s and 1940s saw the beginnings of the production of **bark paintings** and carvings for anthropologists such as Donald Thomson. The mission began to sell these—initially to museums—to produce cash income. Mawalan, and subsequently Mathaman, are perhaps the best known Rirratjingu artists of their generation and the most widely represented in galleries and museums. In succeeding generations, the works of Mawalan's son Wandjuk (1929–1987), and his daughter Banduk (1954–), and of Wandjuk's son Mawalan (1956–), as well as Mathaman's daughter Yalmay (1956–), are best known. A large bark painting of the Marwuyu site executed by Mathaman for Scougall in 1959 was sold in 1996 for US$71 250, the highest price ever paid for a bark painting.

In the mid 1950s Mawalan was the first artist in the Yolngu area to teach and encourage his daughters, including Banygul (1939–) and Dhuwarrwarr (1946–), to paint in a tradition that had previously been restricted to men. Mawalan's daughter Laklak (1943–) weaves pandanus mats and baskets, and her art has been exhibited in a number of galleries. Laklak is now the most senior member of the clan, and acknowledged as its head.

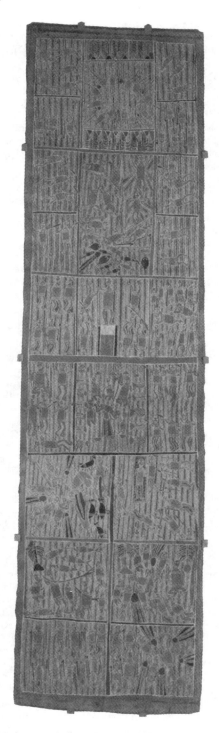

352. Mathaman Marika, *Marwuyu*, 1959.
Natural pigments on bark, 274.3 x 86.4 cm.
This painting was collected by Dr Stuart Scougall. In 1976 it was sold at Sotheby's in New York, fetching a near-record price of US$71 250.

Mawalan was the first of many Rirratjingu clan leaders, both men and women, to take on the education of missionaries and other outsiders in aspects of Yolngu culture—an ongoing clan responsibility. They often use the representations of clan heroes and creators in bark paintings as a basis of instruction. In 1963 Yolngu leaders used such visual means to convey a powerful message to the Commonwealth Parliament in the form of the Bark Petition, asserting their rights as land-owners to negotiate the terms of mining on their lands. Rirratjingu leaders were actively involved in initiating and prosecuting the first Aboriginal **land rights** case, which began as *Mathaman and others vs. Nabalco and the Commonwealth* and, following Mathaman's death, continued as *Milirrpum and others vs. Nabalco and the Commonwealth*. As an element of their case they revealed to the presiding Supreme Court judge a beautiful, symbolically decorated sacred object which validated their ownership of the lands at issue. They regarded this as most powerful and telling evidence, but its significance was not appreciated. In 1976 they again used a bark painting as the basis of their petition to retain the Yolngu name Nhulunbuy for the area where the new town was being constructed.

Mawalan's son Wandjuk became a founding member of the **Aboriginal Arts Board** and served as its chairman from 1979. Wandjuk began a campaign to secure **copyright** protection for Aboriginal artists, a campaign continued by his sister Banduk. In 1962, Mawalan, Mathaman, and Milirrpum had contributed sections to the Dhuwa moiety panel of the Yirrkala Church Panels, painted to portray the sacred endowment of the Yolngu clans. They were displayed on either side of the altar, with the Christian cross between them.

Along with other clan leaders, including Munggurrawuy Yunupingu, Wandjuk developed a style of representing myth episodes in large bark paintings. Paintings of the Djang'kawu and their creative activities remain important themes of Rirratjingu artists. The Wäwilak sisters narrative has also provided subjects for them since a historic exchange some time before 1918 between Mawalan's grandfather and men of the Manhdhalpuy clan of north-central Arnhem Land. The exchange involved ceremonies, stories, and paintings. The Rirratjingu are thus connected to the Manhdhalpuy, and as Mawalan and Mathaman painted themes related to the Wäwilak site Marwuyu, so their sons and daughters have continued to paint them.

Banduk Marika has been a leading figure in the development of **printmaking**. She first produced linocuts and studied with Theo Tremblay at the Canberra School of Art where she was an artist-in-residence in the early 1980s. She has continued to produce works in this medium, and her prints are held in many public and private galleries both in Australia and overseas. Dhuwarrwarr is renowned for her murals, one of which was commissioned for the Darwin Airport. In collaboration with Trevor van Weeren and students in the Yirrkala School, Dhuwarrwarr painted a series of large murals on the exterior of the school, in which Rirratjingu clan themes figure importantly. Dhuwarrwarr continues to produce bark paintings using the traditional palette, but in her murals she also uses non-traditional colours.

RM & NW

See also: 1.1, 1.2, 4.6, 6.1, 22.1; **anthropology, Buku Larrnggay, Yunupingu family;** *31, 50, 352.*

Caruana, W. & Lendon, N., *The Painters of the Wagilag Sisters Story 1937-1997,* Canberra, 1997; Hutcherson, G., *Gong-Wapitja: Women and Art from Yirrkala, Northeast Arnhem Land,* Canberra, 1998; Williams, N. M., 'Australian Aboriginal art at Yirrkala', in Graburn, N. H. H. (ed.), *Ethnic and Tourist Arts: Cultural Expressions from the Fourth World,* Berkeley, CA, 1976.

MARRALWANGA, Peter (Djakku) (*c.*1916–1987), Kuninjku (Eastern Kunwinjku) bark painter, was a senior ritual leader and bark painter of the Kuninjku language group of central Arnhem Land. Known as Djakku, a nickname which means 'left handed', he was encouraged to paint for the market relatively late in his life by another senior artist of this group Billy **Yirawala.** Yirawala and Marralwanga established an outstation at Marrkolidban, south-west of Maningrida, in the early 1970s, and painted regularly for the market from that date. Marralwanga was recognised locally to be very knowledgeable about ceremonies such as Wubarr, Mardayin, Kunabibi, and Yabbadurruwa, and was adept at painting subjects relating to these ceremonies, and in teaching a younger generation about them. He also painted subjects from the wide area he had grown to know during his lifetime. Because of his senior status, Marralwanga was confident in experimenting with new ways of depicting these subjects.

He was particularly skilful at representing spirit figures such as *ngalkunburriyaymi* (a female water spirit) which he

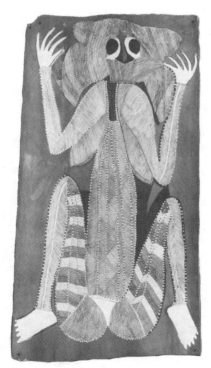

353. Peter Marralwanga, *Ngalkunburriyaymi, Daughter of Yingarna,* 1982.
Natural pigments on bark, 121.5 x 65 cm.

painted with long flowing hair and body decoration that sparkled with brilliant, dotted sections. He frequently varied the style of infill pattern in his paintings, contrasting blocks of full colour with multicoloured cross-hatching, and by varying the sequence of colours in the cross-hatching could achieve different effects within the one painting. These techniques contributed to a dynamic painting surface that departs from the more usual, ordered, cross-hatching style of the region. Marralwanga had a strong influence on other younger artists of the region such as Jimmy Njiminjuma, John **Mawurndjul,** and his own son Ivan Namirrki.

Marralwanga's best work was represented in two exhibitions at the Aboriginal Traditional Arts Gallery in Perth in 1981 and 1983. The NGA purchased a major series of his works from this period. LT

See also: 5.1, 5.2; *353.*

Taylor, L., 'West Arnhem Land: Figures of power', in Caruana, W. (ed), *Windows on the Dreaming: Aboriginal Paintings in the Australian National Gallery,* Chippendale, NSW, 1989; Taylor, L., *Seeing the Inside: Bark Painting in Western Arnhem Land,* Oxford, 1996.

MARTIN, Andrea Nungarrayi (1965–), Warlpiri painter, lives at Yuendumu (NT). She is associated with, and paints, many Dreamings, including: *wardapi* (goanna), *warlawurru* (eagle), *marlu* (kangaroo), *yarla* (bush yam), *janganpa* (possum), *jajirdi* (native cat), Ngarlu (Red Hill), *janmarda* (bush onion), *pingirri* (meat ant), and *ngatijirri* (budgerigar).

Martin has painted for **Warlukurlangu Artists** Aboriginal Association since 1986 and has served as its coordinator. She has also held positions in several Aboriginal **arts advocacy** associations. Among the younger group of emerging artists, she has been at the forefront of the development of style at Warlukurlangu Artists. While familiar with several different painting styles, she has consistently favoured a white dotted background that emphasises the design of the story elements.

Martin has exhibited extensively with Warlukurlangu Artists both nationally and internationally. She has travelled in the USA as an advocate of Warlukurlangu Artists and as an artist-in-residence. LC

MARTIN, Nyalgodi (Scotty) (*c.*1938–), Ngarinyin–Miwa *barnman* (dreamer of songs), is the pre-eminent living composer in the contemporary world of the Ngarinyin, Wunumbal and Worrorra peoples of the North Kimberley (WA). He was born near Kalumburu (WA) shortly before the commencement of World War II. His father, Mardanbu, and therefore Nyalgodi himself, are of the Brrewarrgu (Eagle-Hawk's Nest) clan, which holds country on present day Theda station. His mother, Wardijilan, was from Bararungarri clan country west of the King Edward River.

As a young boy of no more than seven, Nyalgodi was taken far from his country by a police party which had captured his father. This group was making its way—in chains—across Mt Elizabeth station when the owner of the station, Frank Lacy, asked for the release of the pair into his custody. Nyalgodi and his family have resided at Mt Elizabeth or nearby

ever since, forging a binding relationship with the Lacy family. Nyalgodi went on to become head stockman at the station and for some years has been chairman of Dodnun Aboriginal Community.

For a man who has remained physically close to his adopted childhood home all his life, Nyalgodi has nevertheless travelled extensively over the northern Kimberley in his dreamt compositions. This ability to fly in dreams over the landscape and to find songs from the country is regarded as a skill unique to the *barnman*. Nyalgodi was unaware of having this gift until 1973, when he was visited in a dream by his deceased mother's father, Bunuyu Galangyiali. In this dream Nyalgodi was taken to Dulugun, the land of the dead off the western coast, and shown a new song series by his deceased relations which he was able to shape into the Jadmi *junba*, an example of a traditional song genre which uses cone-shaped paperbark caps (*ngadari*) and sprays of green leaves attached at the knee and elbow. From the paperbark caps emerge *wurgugudugudu* (sticks to which corella feathers are fixed with gum). The bodies of the dancers are painted with *dalnga* (red **ochre**) and *onmal* (pipeclay).

Nyalgodi says of this song:

This song is from my old grandfather, mamingi (mother's father). He came to me in a dream and said 'You wouldn't mind keeping this song and keeping it going forever and ever. This is a sea-side song.'

I travelled [in dream] to sea-side and picked it up there. Mamingi said 'Wake up my grandchild, I'm going to give you this for everybody. This song will go forever and ever. Sing about all sorts of songs for the birds, mountains, river, sea. You must see countrymen in dreams—granny, father's uncles, grandfathers. You must think about this'. I didn't know I was a composer before that dream ... Whatever song you compose comes out of the life of the Wanjina. You take half of Wanjina life to go to the culture life of humans.

AJR

See also: 10.1, 10.2, 15.5.

Maruku Arts and Crafts. According to Nancy Miller, people have been carving on the Pitjantjatjara, Yankunytjatjara and Ngaanyatjarra lands since time immemorial:

In the Dreaming, before we were born, the creation ancestors were here. This is Tjukurpa. The women of the Tjukurpa had bowls, digging sticks and fire. Now our grandmothers and grandfathers have the bowls, spears, and spear throwers they brought into being. They have been held since the beginning when the original people had them.

Since contact with non-Aboriginal people, they have been making artefacts and craft for sale. Until the 1970s selling was done by the side of the road and along the path of the old Ghan railway line, or through various mission, pastoral, and government settlements. Then in 1981 a historic journey in the marketing of craft work from the far north of South Australia took place. Topsy Tjulyata and Pulya Taylor explain:

A long time ago we were living in Amata and one of the white people asked if we'd make some puṉu. So we thought about what we would make and began carving. At first it was really

rough work, we weren't very skilful in those days but we kept trying and trying, gradually improving. So after this we started talking about how best to make the craft and to take it to places where we could sell it. We came to Uluru bringing a great load of puṉu, all of it piled on a truck, to sell to the tourists. We brought it to where people climb the rock, and sold it at the base of the climb. We sat down there with a lot of our puṉu, making it and learning to sell to tourists. We've been selling and selling, learning all the time and now we have our Cultural Centre to display our work in.*

Anangu from the west had also been travelling to Uluru since the trickle of tourists began in the 1940s and following Amata's successful trip and another from Pipalyatjara, a series of meetings was held. In 1984 Maruku Arts and Crafts was established, setting up its base within the Muṯitjulu community. Created to sustain, promote, and market the work of its members, *Maruku* means 'belonging to black.' The founding communities of Amata, Muṯitjulu, Fregon, Mimili, Docker River, Pipalyatjara, Kalka, and Wingellina were joined later by **Ernabella** and Indulkana, Warakurna, Blackstone, Jamieson, Wanarn and Warburton. Maruku was incorporated in 1991 as Anangu Uwankaraku Puṉu Aboriginal Corporation, meaning literally 'the wood belonging to all Anangu'.

Senior spokesperson Tony Tjamiwa says Maruku and its Aboriginal governing committee is the eagle flying high in the desert skies, circling above to keep a vigilant eye over the country, swooping to attack and defend where necessary. He holds out his hands, gently interlocking and clasping his fingers to make a strong two-handed fist: 'This is how it's meant to be. All the Maruku communities and homelands linked, jointly represented, and the cultures work side by side.'

Running a commercially viable business which undertakes to buy all work of an appropriate standard is challenging.

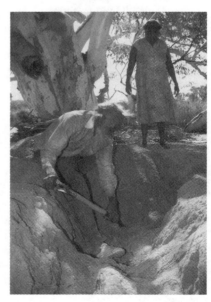

354. Pulya Taylor and Billy Wara digging out the roots of a river red gum for *puṉu*, 1994.

Maruku receives assistance from **ATSIC**, and some project funding through State and federal art and craft bodies. Sales through the Maruku Gallery in the Uluṟu–Kata Tjuṯa Cultural Centre, and wholesaling to other outlets, are the main sources of income. From early exhibitions in Sydney and Adelaide, artists have travelled the country and overseas. Maruku has won awards in tourism, retailing and fine art.

Its success must be credited to the hundreds of artists, craftspeople, and storytellers—those who hold a vision of working together—and also to the hard-working Piṟanpa (white) staff and to all those people who purchase the craft. In the hands of the old people, the *puṉu* work endures, like the Tjukurpa. To the young they say: *Puṉuku waaka wantiriyantja wiyajgku wantima!* (Never stop carving wood!)

© Maruku Arts and Crafts
KT & SF

See also: 2.3, 18.2; **art and craft centres**, Pulya **Taylor**, Billy **Wara**; *231, 354, 399.*

Isaacs, J., *Desert Crafts: Aṉangu Maruku Puṉu*, Sydney, 1992; Brokensha, P., *The Pitjantjatjara and Their Crafts*, Sydney, 1975.

massacres. In the nineteenth century the British government classified Aborigines as subjects of the Crown, but this was rarely enforced in the frontier situation, where the interests of the colonisers reigned supreme. Aborigines who resisted invasion were classed as outlaws, and often all Aborigines were regarded as enemies. As it was not legal to murder Aborigines, a code of secrecy prevailed, and written records disguised the gruesome realities of colonisation. In 1826 missionary Lancelot Threlkeld described in 1826 'a state of warfare up the country' where 'the blood of the blacks begins to flow'. Those who spoke out against atrocities were socially ostracised by the rest of the community. When J. B. Gribble exposed the killing and brutality against blacks on the Western Australian frontier in 1886, he was scathingly criticised and driven out of the colony. Although individual British colonisers agitated for humane treatment of Aboriginal people, violence—even massacres—were condoned as normal frontier practice.

The Myall Creek massacre of 1838 was one of the few where white men were brought to trial, and where they were testified against by other whites, resulting in the execution of the white murderers. In Queensland, Aboriginal attacks on Hornet Bank station in 1857 and Cullinlaringoe in 1861 resulted in private and State-backed punitive expeditions. In the 1870s, humanitarians voiced concern about 'deeds of blood', 'skirmishes' and 'wholesale butchery'.

In Queensland, the Native Police, a force manned by Aborigines, was instructed to 'disperse' large gatherings and enforce white law by the carbine. The effectiveness of the Native Police in conducting large-scale 'dispersals' or massacres, and the advanced weaponry of the later nineteenth century, made Queensland an especially bloody frontier. Native police also operated in Victoria and Western Australia, and their tracking skills, and knowledge of the country and culture made them a highly effective and fatal force.

As late as the 1920s a police-led massacre occurred at Coniston in Central Australia, and another at Forrest River in Western Australia. Although both resulted in government inquiries, the exact numbers killed were never determined. Police disguised massacres by burning and pulverising bones, burying remains, and using coded phrases in their reports. Henry Reynolds estimates that over 20 000 Aborigines died directly at the hands of Europeans on the Australian frontier. AMCG

See also: 10.2, 10.3; *135, 136, 391.*

Gribble, E., *A Despised Race: The Vanishing Aboriginals of Australia*, Sydney, 1933; McGrath, A. (ed.), *Contested Ground: Australian Aborigines under the British Crown*, Sydney, 1995; Reynolds, H., *Frontier*, Sydney, 1987; Reynolds, H., *This Whispering in Our Hearts*, Sydney, 1998.

MAWURNDJUL, John (1952–), Kuninjku (Eastern Kunwinjku) bark painter and hollow log coffin maker. 'Sometimes that Ngalyod gets inside my head and makes me go mad', John Mawurndjul once said. Mawurndjul is one of the leading exponents of contemporary **bark painting** in western Arnhem Land. Over the last twenty years he has moved from painting relatively small paintings of animals to large and complex works that reveal the creative actions of ancestral beings who reside in the country near Mumeka, south-west of Maningrida, where he lives. Mawurndjul was tutored in painting by his brother, Jimmy Njiminjuma and uncle, Peter **Marralwanga**. It was from Marralwanga in particular that he learned to use cross-hatched infill of paintings in new and exciting ways.

Mawurndjul is adept at painting Ngalyod, the rainbow serpent that guards sacred sites, called *djang* in western Arnhem Land. In early works Mawurndjul painted Ngalyod more as a snake, sometimes entwined around another figure. More recent works reveal such elaborate compositions of interlaced figures that it is difficult to discern the main characters. Instead the bark becomes a complex field of squares of cross-hatching, the visual surface moving with the optical effects produced by bands of multicoloured lines. The patterns suggest the rainbow patterning of snakeskin and the dynamism of the work as a whole evokes Ngalyod's power. The complex interaction of figures suggests Ngalyod's struggle to encircle and devour its victim. Mawurndjul also paints more abstract works deriving the body paintings of the Mardayin ceremony relating to sites near his home. These can be large barks completely filled with swathes of cross-hatching.

The market for Aboriginal art has developed to the point where a relatively young artist like Mawurndjul can receive world recognition in a way that was not possible for an earlier generation of bark painters. His work has travelled throughout Australia and was featured in the 'Dreamings' exhibition (New York and Chicago 1988), 'Magiciens de la Terre' (Paris 1989), 'L'été Australien' (Montpellier 1990), 'Crossroads' (Kyoto and Tokyo 1992), 'Aṟatjara' (Düsseldorf, London, and Humlebaek 1993–94), 'Eye of the Storm' (New Delhi 1996), 'In Place (Out of Time)' (Oxford 1997), and 'World of Dreamings' (St Petersburg 2000). In 1988 he won first prize at the Barunga Festival Art Exhibition and the Rothmans Foundation Award for best painting in traditional media at the NAAA; in 1991 he received a Professional Development Grant from the Aboriginal Arts Unit of the Australia Council and most recently he was the recipient of

the Telstra Bark Painting Award at the 1999 NATSIAA. Mawurndjul's work is held in Australian national and State galleries, and he was a contributor to the *Aboriginal Memorial*, 1997–98. LT

See also: 5.2; *151*.

Morphy, H. & Coates, R. (eds), *In Place (Out of Time): Contemporary art in Australia*, Oxford, 1997; Taylor, L. 'West Arnhem Land figures of power', in Caruana, W. (ed), *Windows on the Dreaming: Aboriginal Paintings in the Australian National Gallery*, Chippendale, NSW, 1989; Taylor, L. in National Gallery of Australia, *The Eye of the Storm: Eight Contemporary Indigenous Artists*, Canberra, 1996.

MAYMURU family, Manggalili (Yolngu) bark painters, print-makers, sculptors and cultural ambassadors. The Manggalili are a clan of some fifty members whose main areas of land are in the region of Cape Shield in eastern Arnhem Land. The present clan members are the descendants of three classificatory brothers Nänyin Maymuru (*c.*1914–1969), Narritjin Maymuru (*c.*1916–1981) and Bokarra Maymuru (*c.*1932–1981). Narritjin and Nanyin were close in age and had the same mother and father; Bokarra was more distantly related to them. Narritjin in particular played an important role in the development of relationships between the Yolngu and outsiders. In the 1930s and 1940s he worked at different times for Fred Gray, an English pearler who was based in Caledon Bay, and for Wilbur Chaseling, the missionary who established **Yirrkala** mission in 1935. The earliest documented paintings by Narritjin and Nänyin were produced for anthropologist Ronald Berndt in 1946, and are today in the Berndt Museum (UWA) and in the McLeay Museum in the University of Sydney. However they certainly made paintings earlier for sale through the mission. Narritjin was a more prolific and more innovative artist than his brother. Some of the crayon drawings that he made for Berndt prefigure later developments in Yolngu bark painting, in particular the combination of a number of designs associated with adjacent areas of land in a single painting. His paintings are known for their variety and the complex nature of their symbolism; many of them represent myths in narrative form. With Mawalan Marika and Munggurrawuy Yunupingu he helped develop a mode of representing myths in episodic form in large complex paintings, which, although based on the traditional art, involved a considerable elaboration of the figurative component. Later he developed a series of paintings illustrating public myths, in particular the Bamabama (trickster spirits) and *djeṭ* (sea eagle) paintings. In the 1950s Narritjin lived in Darwin for some time and won prizes in the Aboriginal Art category at the Darwin Eisteddfod. In 1963 he travelled with an Aboriginal dance group to perform in the southern States of Australia, where he became determined that Aboriginal art should gain the same recognition in Australia as European art.

Narritjin frequently used art as a means of widening understanding of Yolngu culture. In 1962 Nänyin and Narritjin were two of the painters of the Yirritja moiety panel for the Yirrkala Church Panels. The panels were an important syncretic gesture and part of a continuing dialogue between Yolngu and Europeans over the value of the Yolngu way of life. In 1963 Narritjin helped paint the Bark Petition that was sent to the Commonwealth Parliament to secure, among other things, recognition of Yolngu rights in land. After the mining town of Nhulunbuy was established in 1971, Narritjin worked hard to educate its inhabitants by opening up some of his brother Nänyin's mortuary rituals to the population of the township. At about the same time, Narritjin and some other Yolngu began working with the film-maker Ian Dunlop to produce a series of films that documented Yolngu life at this moment of change, and to make a record for future generations. The films of Narritjin and his relatives living at Djarrakpi on Cape Shield provide an intimate portrait of family life in north-eastern Arnhem Land. By the 1970s Narritjin's paintings were highly sought after by collectors and in 1978, with his son Banapana (1944–1986), he was jointly awarded a Visiting Artistic Fellowship at the ANU. They were the first Aboriginal artists from Northern Australia to be awarded such a position and their Fellowships culminated in an exhibition of their work.

Bokarra Maymuru was a less prolific artist than his older brothers, but was a leading ritual painter for his mother's clan, the Marrakulu. Some of his finest paintings in public collections represent Marrakulu rather than Manggalili themes. Most of Narritjin's and Nänyin's children have at times made paintings, and several have become well known artists. Narritjin's two eldest sons Manydjilnga (1939–1976) and Banapana were both fine artists whose lives were tragically cut short. Nänyin's eldest son Baluka (1947–) is both a painter and a sculptor. Nyapililngu (1937–), Nänyin's eldest daughter and one of the signatories of the Bark Petition, periodically produced paintings in an individualistic figurative style. Like Mawalan Marika, Narritjin played a major role in encouraging women to produce sacred paintings. His own daughters Bumiti (1948–1996) and Galuma (1951–) became well known painters. Galuma's works include fine figurative sculptures and intricately painted scenes from everyday life set in a mythological framework. In 1999 a solo exhibition of her work was held at the William Mora Gallery in Melbourne. Narritjin also taught Nänyin's daughter Naminapu Maymuru-White (1952–), whose work in a variety of different media is represented in a number of Australian public collections. Her print, *Nyapililngu Wapitja* won the 1996 NATSIAA work on paper category, and her large bark painting *Djarrakpi* was runner-up in the 1998 NIHAA awards. HM

See also: 1.1, 1.2, 6.1, 4.6; **Buku-Larrnggay Mulka, Marika family, Yunupingu family;** *32, 50, 68.*
Hutcherson, G., *Gong-Wapitja: Women and Art from Yirrkala, Northeast Arnhem Land*, Canberra, 1998; Morphy, H., *Manggalili Art: Paintings by the Aboriginal Artists Narritjin and Banapana Maymuru*, Canberra, 1978; Morphy, H. 'Manggalili art and the Promised Land', in L. Taylor (ed.), *Painting the Land Story*, Canberra, 1999.

MAYNARD, Ricky (1953–), documentary photographer, was born in Launceston (Tas.), and began taking photographs as a teenager. While working for **AIATSIS** in the 1980s he catalogued vast numbers of photographs taken of Aboriginal people since colonisation: 'I saw every picture. I looked

into the faces of all those Aboriginal people and it was so sad. I started questioning the photographer's role. It changed my life and the way I viewed pictures.' Moved by decades of colonial image making, Maynard embraced 'the serious art of documentary photography' that challenges the stereotypes.

In 1985 he returned to the Bass Strait Islands to picture his community during the mutton-bird season. *Moonbird People*, 1985, a series photographed on Babel, Big Dog and Trefoil Islands, depicts the everyday realities of life that connect land, people, place, and history. *No More Than What You See*, 1993, an essay on Indigenous prisoners in South Australian prisons, won the Mother Jones International Prize for Documentary Photography and the 1997 Human Rights Commission Photography Award.

In 1990–91 Maynard received an Aboriginal Overseas Studies Award to study documentary photography at the International Centre for Photography in New York. A subsequent series, *Urban Diary*, 1997, focuses on the interior space of Galiamble—a Koori recovery and rehabilitation centre. Commissioned for publication by the Black Photographers Association of the UK, his images ask the viewer to appreciate the experience of Indigenous people. Also in 1997, with funding from the Australia Council, Maynard began a folio of portraits of Aboriginal elders. LIH

See also: 11.5, 12.4; prison art; *168*.
Gellatly, K., 'Re-take: Contemporary Aboriginal and Torres Strait Islander photography', *artonview*, no. 15, Spring 1998; Taylor, P. (ed.), *After 200 Years: Photographic Essays of Aboriginal and Torres Strait Islander Australia Today*, Canberra, 1988.

media associations oversee the delivery of **radio, television,** and other media services to particular localities. They operate at local community, regional, and national levels, in both remote and urban areas. Working at the interface between local communities and the wider society, media associations are also often advocates on behalf of their constituencies across a range of public arenas.

The first Aboriginal media association to be established was the Central Australian Aboriginal Media Association (CAAMA), founded in 1980 in Alice Springs. Originally broadcasting a radio service throughout central Australia via the ABC, then later 8CCC (Kin FM), CAAMA secured its own broadcasting licence in 1985. In the following decade it steadily expanded and diversified its production base, moving into the areas of video production and music recording. In 1986 it was successful in a bid to secure the Remote Commercial Television Service licence for the central Australian zone. CAAMA's Imparja Television went to air in 1987, broadcasting to an area encompassing all of the Northern Territory, the north of South Australia, and small parts of Queensland.

The establishment of media associations in remote areas of Australia occurred as part of a broader Indigenous response to developments taking place at a national level. In the early 1980s, residents of the Yuendumu and Ernabella communities in central Australia began experimenting with video production. In 1984 both communities incorporated their own media associations—the Warlpiri Media Association (WMA) at Yuendumu, and Pitjantjatjara Yankunytja-

tjara Media Association (PY Media) at Ernabella. In April the following year they both launched 'pirate' television stations.

This activity preceded the implementation of government guidelines for remote broadcasting as well as the launch of AUSSAT. This satellite was to bring national television to much of remote Australia for the first time, prompting Aboriginal concerns about the maintenance of local languages and ongoing integrity of cultural practices. While remote communities made it clear that they wanted to have access to the incoming satellite signal, they also wanted to retain some degree of control over programming. The federal government launched an inquiry, the findings of which were published in *Out Of the Silent Land* (1984), and prompted the establishment of the Broadcasting for Remote Aboriginal Communities Scheme (BRACS) in 1987. Eighty-two communities received an equipment package allowing each of them to receive one ABC radio service, ABC TV, and a remote commercial television service via satellite. BRACS equipment has an interruptibility capacity which allows the incoming signal to be intercepted and alternative material inserted in its place. This mechanism was built into the equipment to encourage community residents to produce and broadcast their own material, which might focus on issues of local interest and be conducted in the **language** of the community's choice. In practice, the interruptibility function has not been used very extensively. About half the communities with BRACS equipment have produced and broadcast their own material at some stage.

WMA and PY Media were the first media associations to be established in remote communities. Subsequently more than fifty media associations have been established across the country. These range from: the National Indigenous Media Association of Australia (NIMAA), set up in 1991 as an umbrella organisation to administer the distribution of **ATSIC** funding and to act as national advocate on behalf of media associations; through to multi-functional regional organisations such as the original CAAMA in Alice Springs (NT), and Goolari Media Enterprises in Broome; and organisations which broadcast to discrete communities within a transmission area confined to one square kilometre.

Urban media associations differ from their remote counterparts in terms of the size and composition of their constituencies, as well as in the nature of the issues they must address. There are major media associations in most capital cities, and in some regional centres such as Townsville and Thursday Island. The potential audience of urban associations tends to be larger and more diverse. For example, Gadigal Information Services in Sydney broadcasts to a potential Indigenous audience of 30 000, as well as to a non-Indigenous audience many times this size.

While many media associations have shown an interest in pursuing Internet and multimedia applications, the majority continue to favour radio as their primary operating medium. It is the easiest form of electronic communication to operate, and has proven to be the most robust in the harsh conditions of remote Australia. In the face of funding limitations, radio also remains the most financially viable medium for most media associations. It continues to be the preferred mode of communication between Aboriginal people across distance. MH

See also: 13.3, 13.4.
Aboriginal and Torres Strait Islander Commission, *Digital Dreaming: A National review of Indigenous Media and Communications*, Canberra, 1999; Langton, M., 'Well I Heard It on the Radio and I Saw It on the Television ...' An Essay for the Australian Film Commission on the Politics and Aesthetics of Filmmaking by and about Aboriginal People and Things, North Sydney, 1993; Michaels, E., *Bad Aboriginal Art: Tradition, Media, and Technological Horizons*, Minneapolis, 1994; Turner, N., National Report on the Broadcasting for Aboriginal Communities Scheme [unpublished report to ATSIC], Canberra, 1998.

MEEKS, Raymond (Arone) (1957–), visual artist, is a Murri from far north Queensland. He is a pioneer of urban contemporary Aboriginal art, and a noted writer and illustrator of children's books which explore stories and imagery of Cape York (Qld). Arone studied art in both Queensland and Sydney, and came to prominence in Sydney in the mid 1980s. In 1987 he helped form **Boomalli Aboriginal Artists Cooperative**.

Although he is primarily a painter, Arone's adaptability and broad professional training underscores much of the technical excellence evident in his etchings and prints. These reveal themes of cultural interaction—between black and white in Australia, and between Indigenous cultures. Following collaborative work at Santa Fe with Native American artists he said 'it still shines through that their cultural heritage is such a spiritual part of their total makeup. You can compare that to Aboriginality in Australia' (quoted in Sever 1997). Arone's early work employed imagery from ancient Aboriginal sources such as Queensland cave paintings in a synchronistic approach which paralleled post-modernist contemporary art practice in the 1980s.

He studied with the Lardil people of Mornington Island, and was adopted by **Thancoupie**, the celebrated ceramicist, who gave him the tribal name of Arone (Black Crane), and with it the right to express culture and legends of the people of Cape York in his art. This connection was to culminate in the publication of his book, *Enora the Black Crane* (1992), which won the UNICEF Best International Children's Book Award in 1993.

Arone then began to explore the psychological dimensions of place, dreams, and gender. The death of his partner John Darling, and the threat of the AIDS epidemic underscored his courageous prints and paintings in which phallic forms metamorphose into Cape York landscape icons. He shows a mastery of a diverse range of techniques, moving easily from fluid painted figurative drawings to bold prints exhibiting inventive and strong geometric pattern-making. The textured surfaces of his paintings on paper and canvas are organic, and layered like eroding rocks.

Arone has exhibited nationally and internationally, and is represented in most national and State public collections. Highlight exhibitions include 'Koori Art '84' (Artspace, Sydney), 'Art and Aboriginality' (Portsmouth 1987), 'Perspecta: A Koori Perspective' (Artspace, Sydney 1989), and 'Balance 1990' (QAG). His solo exhibitions have included 'Paris Dreaming' (1989), 'Ensueños—Dreams', (Buenos Aires 1990); 'La Rêve' (Paris 1992), and a survey exhibition of his work at the Drill Hall Gallery, ANU, Canberra in 1997. JI

See also: 5.6, 12.1, 12.6; *64, 175.*
Isaacs, J., *Aboriginality: Contemporary Aboriginal Paintings and Prints*, Brisbane, 1989; Sever, N., *Common Ground*, Canberra, 1997; Riley, M., *Boomalli, Five Koori Artists* [video], Film Australia, 1988.

Merrepen Arts is located at the former Catholic Mission of Nauiyu Nambiyu on the banks of the Daly River (NT), about 200 kilometres south-west of Darwin. It was established largely through the efforts of educator and artist Miriam-Rose Baumann **Ungunmerr**, who was instrumental in setting up the Uniting Church Women's Resource Centre in Darwin. She was keen to provide the women from her home community with the same educational and recreational resources and, together with some of the senior women, helped establish the Magellan House Women's Centre in 1986. A year later, due to the rapid expansion of art and craft activity within the adult education programs, Eileen Farrelly was employed as the first art coordinator. Since then the artists have undertaken a series of training workshops in **batik**, silk painting, silk-screen fabric printing, tie-dying, and papier-mâché making, as sidelines to their **acrylic painting**. The name Merrepen, which honours the sand palm used for the women's basketry, was officially adopted for the first exhibition at MAGNT in October 1987.

Some decorative elements used by the Nauiyu artists—like wavy lines, dots and circles—indicate ceremonial links with the 'desert' cultures to the south-west. In this respect, Merrepen art has iconographic similarities with that of its **Wadeye** (Port Keats) neighbours. The highly decorative, figurative style of Nauiyu acrylic painting is, however, quite distinctive and owes much to the formative influence of Ungunmerr, who taught many of the younger artists when they were at school. As well as stylistic influences, her particular type of religious synchronism, blending Christian and Indigenous imagery, has also provided a powerful model for other painters. Thematically, the unusual mix of **Dreaming** stories and bush tucker scenes together with Christian subjects sets Merrepen paintings apart from those of other Top End groups.

The paintings are marketed though gallery exhibitions, though the majority are sold locally at the Merrepen Arts Festival, held at the community each year since 1988. Most of the sixty or so artists who paint for the art centre belong to the Ngan'gukurunggurr, Ngan'giwumirri, Marrithyel, Maringarr and Malak-Malak language groups. The best known are Miriam-Rose Baumann Ungunmerr and her mother Mary Kunnyi, Henry and Marita Sambono, Louise Pandella, Anne Carmel Mulvien, Topsy Gumunerrin, Margaret Gilbert, Dominica Mullens, Mona Burns, Molly Yawalminy, Mercia Wowal, Biddy Lindsay, Dianne Tchumut, and sisters Patricia Marrfurra McTaggart, Christina Yambeing, Benigna Ngulfundi, and Grace Kumbi.

When the floods of 1998 destroyed the centre's paintings and archival records, the artists worked extremely hard to resurrect Merrepen Arts because by then it was an important focus for over a third of the small community's population. As Miriam-Rose said when interviewed by the author in 1995: 'many of them are well known artists and recognised all over the country. It's good because the painting gives

people dignity and shows that they are just as good as anyone else.' MW

See also: 1.2.

MICKEY of Ulladulla (c.1820–1891), Dhurga visual artist. Very little is known about the life of Mickey of Ulladulla—also known as Mickey the Cripple. The majority of the details are contained in inscriptions on his drawings or can be deduced from the circumstances of Aboriginal people living on the south coast of New South Wales in the nineteenth century.

Mickey's earliest dated drawings were originally bound—along with a Tommy **McRae** sketchbook—into an album in the Mitchell Library (SLNSW). They are dated 1875 and the artist, described as 'Mickie, an old crippled blackfellow', is recorded as living at Nelligen on the Clyde River. The subjects of these are ones to which he returned constantly in subsequent drawings: fish, native birds and animals, sailing vessels and steamships, and depictions of Aboriginal people hunting and working.

At some point in the 1880s Mickey moved to the Aboriginal reserve at the small south-coast port of Ulladulla. Most of his drawings appear to have been made there during the 1880s. His medium was a mixture of pencil, watercolour and coloured crayons, materials which he possibly obtained from the wife of the Ulladulla lighthouse keeper and friend of the local Aboriginal population, Mary Ann Gambell. Mickey's drawings were, for the most part, conceived as pairs—typically with one image of a corroboree and a second image showing fishing activity. The repeated composition of the **corroboree** subject always includes a central figure, in European dress, supporting himself on two sticks; there is evidence which points to this being a depiction of the artist himself. In his unique drawings of fishing, the artist depicted the fish below the water and the boats above—the boats being identified as the fishing skiffs provided by the Board for the Protection of Aborigines, and the steamer, *Peterborough*, a coastal vessel which regularly berthed at Ulladulla. All of his drawings celebrate the abundance of the animal and marine life of coastal New South Wales.

After his death at Ulladulla on 13 October 1891, Mickey's drawings entered a number of library and museum collections in Australia. Collections in which his works are now held include the NGA, AIATSIS, SLNSW, and NLA. Five of his drawings were included in the 1893 Columbian World's Fair in Chicago, two of them winning a bronze medal for their exhibitor, George Ilett of Milton. AS

See also: 8.2, 11.1; William **Barak**, *Oscar*; *272*.
Sayers, A., *Aboriginal Artists of the Nineteenth Century*, Melbourne, 1994; Mundine, D., 'First Koori', *Art Monthly Australia*, no. 76, December 1994.

MIDIKKURIA, Les, see Les **Mirrikkuriya**.

MIDJAWMIDJAW, Jimmy (1897–1985), Kunwingku bark painter and clay sculptor, belonged to the Mirarr clan and lived between Croker Island (Minjilang) and Gunbalanya (Oenpelli, NT). He and fellow artists on Croker Island—

Namatbara, Nangunyari, and Billy **Yirriwala**—created dynamic, raw work in which sexual imagery is often made overt as well as is reference to malevolent sorcery. Midjaw-midjaw produced ceremonial and sorcery themes as well as sculpted clay figures for the anthropologists Ronald and Catherine Berndt during their visits to Oenpelli in 1947 and 1949–50. In 1963, when the Czech art collector and anthropologist Karel Kupka collected his work, he was living at Croker Island. Helen Groger-Wurm collected one of Midjawmidjaw's bark paintings at Croker Island in 1966, and A. G. Spence and J. A. Donaldson collected his work in the late 1960s. Midjawmidjaw began painting for the market in the 1960s. Common subjects and themes include *mimih* (rock country spirits), sorcery figures, Nadulmi (the principal figure of the Ubarr ceremony), barramundi, arrow fish, black kangaroo, crocodile, ring-tailed possum and red-eye pigeon. He has also painted the lightning man Namarragon. A feature of Midjawmidjaw's style is the depiction of multi-limbed figures using only two or three colours, with blocking in of parts of the design (often in white), leaving them bare of ornament.

Midjawmidjaw is represented in collections in France, Switzerland, and the USA (including the Kluge–Ruhe Collection, University of Virginia) as well as throughout Australia. His work, which was sold through **Injalak Arts and Crafts** Association, has been exhibited consistently since 1957. VH

See also: 5.2, 6.1; *70*.
Taylor, L., 'Flesh, bone, and spirit: Western Arnhem Land bark painting', in H. Morphy & M. Smith Boles (eds), *Art from the Land: Dialogues with the Kluge–Ruhe Collection of Aboriginal Art*, Charlottesville, VA, 1999.

MILERUM (Clarence Long) (1869–1941), Milmeindjeri (Ngarrindjeri) custodian, craftsman, and singer, was born near the Coorong (SA), south of the Murray River mouth, and did not see white people until 1875 when his parents took him to Kingston. His first wife was Lydia Bull, with whom he had one son, Banks Long. His second wife was Polly Beck (or Becks), and one of their children was Annie Rankine, known as a basket maker. As an adult, Milerum mostly worked on cattle and sheep stations, and was a champion blade-shearer. As he grew older he became concerned at the loss of knowledge about his people, and began working with anthropologist N. B. Tindale at the South Australian Museum.

Milerum is important as a great transmitter of traditional knowledge. He retained his language, was able to recall the stories and traditions he had learned as a youth, and possessed a detailed knowledge of native foods and the social organisation of his own and other Ngarrindjeri clans. He made shields and canoes from the river red gums, burning in the design of an owl—his *ngatji* (totem). By the 1930s he spent increasing amounts of time at the museum as a volunteer, working under the shade of an old grapevine, making baskets, singing songs, and telling stories. He told Tindale that 'sometimes when you are dreaming, half asleep and half awake, a song comes to you. When it comes like this you must sing it straight away, that is how we find new songs.' Milerum

recorded two Yaraldi songs and seventeen Tangani songs on wax cylinders, and later on more modern equipment.

He sang in his own language and that of his mother who was a Potaruwutj woman from the interior of the Coorong area. He also made a film with Tindale, demonstrating the process of Ngarrindjeri basket-making, which has become an invaluable resource to the Ngarrindjeri fibre artists of the present day.　　　　　　　　　　　　　　　　GMCC

See also: 17.1, 17.2; Yvonne **Koolmatrie**, Ellen **Trevorrow**; *213*.
Tindale, N. B., 'Milerum', in B. Nairn & G. Serle (eds), *Australian Dictionary of Biography*, vol. 10, Melbourne, 1986; Tindale, N. B., 'Native songs of the south-east of South Australia', *Transactions of the Royal Society of the South Australian Museum*, vol. 61, 1937.

MILIKA, see Milika Darryl **Pfitzner**.

MILINDIRRI, Elsie (1935–), Wolkarra (Yolngu) fibre artist. On the surface, the singer Madonna and fibre artist Elsie Milindirri have little in common. Yet people on **Elcho Island** (NT) have given the name 'Madonna basket' to one particular type of fibre work that she makes: its conical side-forms bear an uncanny resemblance to the bras worn by Madonna in stage performances of the early 1990s. The connection, however, stops at the physical form. Milindirri's Madonna baskets draw upon Arnhem Land weaving traditions that incorporate both relatively new influences from the south, and centuries-old knowledge. Milindirri was taught fibre processes and techniques by her mother when she was a young girl living on the island of Milingimbi. While still young she moved to Elcho Island, where she married into the Gurrawarra family (her husband is now deceased). Elsie works full time in Galiwin'ku on Elcho Island, with a women's home-maker program which assists women in the organisation of their home responsibilities. Previously she

worked for Shepherdson College in Galiwin'ku as a teacher's aide. Her spare time is spent in gathering, dyeing, and preparing the material for the construction of her coiled fibre forms. Her Madonna baskets were included in 'Australian Perspecta' (AGNSW 1997) and the touring exhibition 'Spinifex Runner' (CCBAG 1999).　　　　　　　　LH

See also: 17.1; *355*.
Hamby, L. (ed.), *Fibre Art from Elcho Island*, Sydney, 1994; Moon, D., *Spinifex Runner: A Collection of Contemporary Aboriginal and Torres Strait Islander Fibre Art*, Campbelltown, NSW, 1999.

MILPURRURRU, George (1934–1998), Ganalbingu (Yolngu) bark painter, was born to the Gurrumba Gurrumba clan of the Ganalbingu people at the Arafura Swamp in central Arnhem Land. He became one of the most important bark painters in the twentieth century. After initially working as a stockman, he began to paint regularly from the late 1960s. He was taught to paint by his father, the renowned bark painter Dick Ngulmarrmar (1911–*c*.1977), and his sister is

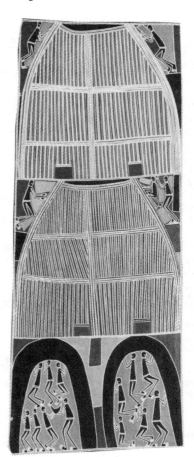

356.　George Milpurrurru, *Liya Dhamala (Mosquito House)*, 1990.
Natural pigments on bark, 261 x 98.5 cm.

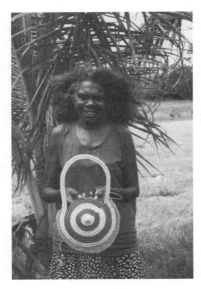

355.　Elsie Milindirri with her *Madonna Basket*, 1997.
Dyed pandanus and hand-spun string, 42 x 25 x 8 cm.

the artist Dorothy **Djukulul**. His work reflects continuity with tradition, and innovation: he paints the clan lands of Ganalbingu country, the magpie goose, and the ecology of swamp lands. Of his work he said: 'I was taught to paint by my father Ngulmarmar on sheets of bark. Some paintings I do very much the way my father did. The pictures I paint are based on the ones I have been taught, but I also think of making my own pictures like the magpie goose paintings.'

Milpurrurru's works form part of major national and State collections, including the collection of Helen Groger-Wurm. In 1979, he and David **Malangi** were the first Indigenous artists to be featured at the Biennale of Sydney, in 'A European Dialogue'. Milpurrurru has contributed to several important group exhibitions. In 1983 the members of his outstation on the edge of the Arafura Swamp created an entire exhibition, 'Mulgurrum (Outstation) Exhibition', at the Ewing–Paton Gallery in Melbourne. He also contributed to 'The Native Born' (MCA 1996) and 'The Eye of the Storm' (NGA and New Delhi 1996).

During his career, he participated in two more Sydney Biennales: in 1986 he led the Ramingining Performance Group; and constructed a sand sculpture to perform a cleansing ceremony for 'Origins, Originality and Beyond'. For the bicentenary year he was one of the senior artists who contributed to the *Aboriginal Memorial* which was first officially shown at the 1988 Biennale of Sydney in 'Beneath the Southern Cross'. Recognition for Milpurrurru has extended to two solo shows. In 1985 his art formed the opening exhibition, 'George Milpurrurru', for the government-sponsored 'Aboriginal Artists Gallery' in Sydney and in 1993 he became the first living artist to be honoured by an individual show; 'The Art of George Milpurrurru' (NGA). In the 1990s he began to work more with paper and painting on canvas. Since his death Milpurrurru has remained an extremely sought-after artist.

DJM

See also: 6.1, 6.3; *38, 74, 356*.

Milpurrurru, G., 'Bark painting: A personal view', in W. Caruana (ed.), *Windows on the Dreaming: Aboriginal Paintings in the Australian National Gallery*, Sydney, 1989; Milpurrurru, G., Getjpulu, G., Mundine, D., Reser, J. & Caruana, W., *The Art of George Milpurrurru*, Canberra, 1993; Museum of Contemporary Art, *The Native Born: Objects and Representations from Ramingining, Arnhem Land*, Sydney, 2000.

MINGELMANGANU, Alex (Alec) (*c.*1910–1981), Wunumbal visual artist, is renowned for his robust but sublime paintings of ancestral Wanjina beings. He began painting on a regular basis for the public domain at Kalumburu (WA) in the mid 1970s, with a group of artists which included Manila Kutwit and Geoffrey Mangalmarra, and later the **Karedada family** of artists. In late 1974 or early 1975, Mingelmanganu made a painting of a Wanjina on bark, which he discarded. However, the painting found its way into the 1975 Derby Boab Week art show under the title 'Austral Gothic'. The interest it aroused encouraged others at Kalumburu to take up painting in the public domain.

Mingelmanganu continued to paint on bark, and on occasion, he engraved pieces of ochre and resin-covered slate with images of Wanjina. These rare works show, in the rock-

ing motion of the engraving tool, the evidence of techniques associated with the carving of **boab nuts** and pearl shell.

In 1979, the artists at Kalumburu were introduced to the techniques of painting in natural pigments on canvas. The medium allowed Mingelmanganu to escape the restrictions imposed by the size of barks to create monumental images of Wanjina, on a scale similar to those found in rock paintings. His main influences were the rock paintings at Lawley River with their distinctive high and pointed shoulders. Mingelmanganu's images are also characterised by layers of dots which make the figures sparkle as if with ancestral forces.

In executing these paintings, Mingelmanganu found the opportunity to continue his traditional duty of perpetuating the presence of the ancestral Wanjina, just as Kimberley people protect and preserve the **rock art** which is considered to have been placed there by the Wanjina themselves.

Mingelmanganu's work has featured in several major exhibitions including 'Flash Pictures' (NGA 1991), 'Images of Power' (NGV 1993), and 'Aratjara' (Düsseldorf, London, and Humlebaek 1993–94).

KA & WC

See also: 10.1, 10.2, 10.4; *60, 153, 154*.

Ryan, J., with Akerman, K., *Images of Power: Aboriginal Art of the Kimberley*, Melbourne, 1993; Stanton, J., *Painting the Country: Contemporary Aboriginal Art from the Kimberley Region*, Western Australia, Nedlands, WA, 1989.

MINUTJUKUR, Makinti, see Tjunkaya **Tapaya**.

MIRRIKKURIYA, Les (*c.*1943–1995), Rembarrnga–Kune painter, was born near Bolkdjam (NT), an outstation of the Rembarrnga-speaking people, about forty kilometres southeast of **Maningrida** in central Arnhem Land. He lived in Maningrida during the early days of this government welfare station, which was established in 1957, and did his army training in Darwin. Afterwards he moved around the Northern Territory, droving cattle at Barunga and Borroloola. On his return to Maningrida he settled in 1983 at Cadell (Gochan Jiny-jirra) in his mother's country, where he married artist Dorothy **Galaledba**.

Mirrikkuriya was a renowned songman of the *bongolinj-bongolinj* song genre, as well as a dancer and ceremonial leader. He specialised in **bark painting** that focused on subjects of totemic significance relating to an important site in his clan estate known as Kndjangkarr. He expanded the traditional palette of red and yellow **ochre**, white, and black, by mixing ochres to produce new hues. His style fused western Arnhem Land figurative work with the geometric clan designs typical of north-eastern Arnhem Land.

His work was included in many national and international exhibitions, including 'Bulawirri/Bugaja' (NGV 1988), a collaboration between Maningrida artists and **Lin Onus**, at the inaugural Adelaide Biennial (1993), and 'Aratjara' (Düsseldorf, London, and Humlebaek 1993–94). In 1992 he won the NAAA (now NATSIAA) for a traditional work, and in 1993 he received a full Fellowship from the **Australia Council**. His paintings are represented widely in national and State public collections.

MG

See also: 6.1, 12.1, 20.6; **art awards and prizes**; *254*.

MOFFATT, Tracey (1960–), photographer and film-maker. Ten years after her first overseas exhibition, Tracey Moffatt's solo exhibition, 'Free-Falling', at New York's prestigious Dia Center for the Arts (1997–98) confirmed her as an artist of major international standing. 'Free-Falling' incorporated all major strands of Moffatt's practice: photography, film, and video.

Moffatt was born in Brisbane, where she was raised by adoptive white parents while maintaining contact with her Aboriginal mother. Throughout her childhood and adolescence she was fascinated by the imagery of popular culture. This interest was extended by studies at Queensland College of Art and continues to underpin her work, with its density of reference to histories of film and photography. Working across the media of photography and moving image, she not only explores and exploits their illusionary qualities but also evokes, and at times calls into question, the historical and socio-political agency of the mass-media contexts with which they are aligned.

Moffatt moved to Sydney in the early 1980s. Early work there included *Some Lads*, 1986, a series of black and white portraits of male Aboriginal and Torres Strait Islander dancers, echoed somewhat later by the more aestheticised pair of male Aboriginal colour portraits, *Beauty*, 1994. She held her first major solo exhibition at the ACP in 1989. The nine photographs in *Something More*, 1989 presented an edgy film-like narrative involving a young woman of mixed race and her futile attempt to break out of a harsh and clearly violent rural existence for life in the city. Subsequent photographic series have included *Pet Thang*, 1992, *Scarred for Life*, 1994, *GUAPA (Goodlooking)*, 1995, *Up in the Sky*, 1997, and *Laudanum*, 1998. *GUAPA* and *Laudanum* concentrated on relationships between women as mediated by period-specific visual tropes, while *Scarred for Life* worked with the image and text forms of picture magazines to create taut vignettes conveying the barely suppressed violence of childhood and adolescent socialisation. *Up in the Sky* evoked strange goings-on at the fringes of an outback town.

Moffatt is also a film and video-maker of renown. *Nice Coloured Girls* (1987)—a short film depicting a group of urban, streetwise 'coloured girls' using and triumphing at the expense of white masculinity—was followed by the celebrated *Night Cries: A Rural Tragedy* (1989) which fused fractured narrative with a sensitive realism to chart the changing relationship between a white mother and adopted Aboriginal daughter. Her first feature film, *Bedevil* (1993), was an official selection at the Cannes Film Festival. In addition to a number of music video clips Moffatt produced the video *Heaven* (1997)—a hilarious, but cutting, female take on male exhibitionism—for the 'Free-Falling' exhibition.

Moffatt has held over thirty solo exhibitions worldwide since the late 1980s, and has been included in numerous international group exhibitions of note. Two major solo survey exhibitions toured Western Europe during 1998 and 1999, and another toured North Asia in 1999 and 2000.

BF

See also: 4.1, 12.1, 12.4, 13.1; *169, 244, 326.*
Hentschel, M. & Matt, G. (eds), *Tracey Moffatt*, Stuttgart, 1998; Newton, G. & Moffatt, T. (eds), *Tracey Moffatt: Fever Pitch*, Annandale, NSW, 1995; Cooke, L. & Kelly, K., *Tracey Moffatt: Free-Falling*, New York, 1998; Snelling, M. (ed), *Tracey Moffatt*, Brisbane, 1999.

MORGAN, Sally (1951–), Palku–Nyamal visual artist and writer, was born in Perth in 1951. She belongs to the Palku people of the Pilbara through her grandmother and to the Nyamal people of the Pilbara through her grand-father. She holds a Bachelor of Arts Degree from UWA, and a Graduate Diploma in Counselling and a Graduate Diploma in Library Studies from Curtin University. Currently she is the Director of the Centre for Indigenous History and the Arts at the University of Western Australia. Morgan feels equally at home with writing and painting, and readily switches between them. As she says: 'I need to paint and to write; I can express things in different ways and perhaps reach different audiences. I paint so I don't have to explain. When I want to fill in the details, I write.'

Morgan had made drawings throughout her school years, but took up art in earnest in 1986 on the eve of the publication of *My Place* (1987), for which she painted the cover image. After a few years working solely in acrylic on canvas she began **printmaking** in both black and white and colour. The change of medium enabled her to achieve the flat, bright colour that she is now renowned for. Black and white prints such as *Citizenship*, 1988 allowed her to make stark, dramatic, and often political statements.

She held her first solo exhibition at Birruk Marri Gallery, Fremantle (WA) in 1989. She has also been included in many significant group exhibitions, such as 'Art and Aboriginality' (Portsmouth 1987), 'A Koori Perspective' (Artspace 1989), 'Aboriginal Women's Exhibition' (AGNSW 1991), and 'Beyond the Picket Fence' (NLA 1995). Her work is represented in national and international collections including the NGA, the Dobel Foundation, the Kelton Foundation, Santa Monica, USA, and the Holmes à Court Collection, Heytesbury (WA).

Morgan's publications include *My Place* (1987), *Wanamurraganya: The Story of Jack McPhee* (1989), *The Flying Emu* (1992), *Hurry Up Oscar* (1993), *Pet Problem* (1994), *Dan's Grandpa* (1996), *Just a Little Brown Dog* (1997), and *In Your Dreams* (1997). She has been the recipient of a number of awards including: United Nations Human Rights Stamp Series (1994), the Order of Australia Book Prize (1990), and Braille Book of the Year (1998).

SAM

See also: 12.1, 14.1, 14.5; life stories; *41, 384.*
Davis, J. (ed.), *Paperbark: A Collection of Black Australain Writings*, St Lucia (Qld), 1990; Laurie, V., 'Chasing pale shadows', *The Australian Magazine*, 23–24 October 1999; Morgan, S., *The Art of Sally Morgan*, Ringwood, Vic., 1996; Samuels, J. & Watson, C., *Aboriginal Australian Views in Print and Poster*, West Melbourne, 1987.

MOWALJARLAI, David Banggal (*c*.1925–1997), Ngarinyin activist, cultural recorder, storyteller, artist, and musician. 'That country is our own living body, flesh and blood. How can we be smashing up our own body? Can't do it.' These are the words of David Mowaljarlai, a North Kimberley man descended from Ngarinyin on his father's side and from

Worrorra on his mother's side. He was born at Kunmunya (WA) on the north-western Kimberley coast, and belonged to the first generation of North Kimberley Aborigines to experience regular contact with Europeans. He attended the mission school of the Presbyterian missionary Revd J. R. B. Love, and learnt to play various Western musical instruments, including violin and harmonica. His musical skills were honed during his childhood sojourn at Derby Leprosarium. The young Mowaljarlai is depicted in the photographs of German anthropologist Andreas Lommel, who visited Kunmunya on the 1938 Frobenius Expedition.

In 1956 the Kunmunya population was shifted to a site near Derby, remote from their traditional countries. This station became known as **Mowanjum**. From this refugee camp Mowaljarlai, under the tutelage of senior men such as Sam Umbagai, Albert Barunga and Sam Woolagoodja, emerged as an important spokesman for the Worrorra, Wunumbal and Ngarinyin people.

During the period of resettlement at Mowanjum, Mowaljarlai was strongly affiliated with the Presbyterian (later Uniting) Church. He was proposed for membership in the lay clergy, but the General Synod rejected his candidature. Mowaljarlai experienced this rejection as demeaning to his **Aboriginality** and as a personal insult, and had nothing or very little to do with organised Western religion thereafter.

Mowaljarlai's expertise and facility in cross-cultural communication were recognised by various non-Indigenous institutions: he was appointed to membership of the WA government's Aboriginal Cultural Material Committee, the Australia Council's **Aboriginal Arts Board**, and **AIATSIS**.

In 1991, Mowaljarlai was named Aboriginal Australian of the Year. At that time he was working towards the **repatriation** of skeletal remains held by overseas museums. He was awarded the Order of Australia in 1993. He was central to the Ngarinyin Aboriginal Corporation and Pathways Project, recording significant places in the western Kimberley and taking a film to Paris for UNESCO officials and scholars. Mowaljarlai's determination to inform the wider community about Ngarinyin ways is seen in his development of the 'Bush University' in the Kimberley.

Mowaljarlai championed the rights of the traditional owners in the infamous Noonkanbah dispute, and became one of the founding members of the Kimberley Land Council. In 1984 he was one of the senior keepers of the Law who helped establish the Kamali Land Council. With the passing of the *Native Title Act* in 1993, Mowaljarlai played a major role in the research and development of the Ngarinyin **native title** case.

In the 1990s Mowaljarlai discovered a new medium for expressing his vision, painting with traditional materials on canvas. He built up an important body of work of more than seventy canvases and also works on paper, and had a solo exhibition at Chapman Gallery, Canberra, in 1977. Examples of his work are held at the Berndt Museum (UWA).

AJR & GW

See also: 5.4, 10.1, 10.2, 15.5; **cultural heritage, rock-art repainting**.
Kamali Land Council, 'Mowaljarlai', and 'Mowaljarlai talks to Ulli Beier', *Art and Australia*, vol. 35, no. 3, 1998; Mowaljarlai, D. & Watchman, A. L., 'An Aboriginal view of rock art management', *Rock*

Art Research, vol. 6, 1989; Mowaljarlai, D. & Malnič, J. *Yorro Yorro: Everything Standing Up Alive*, Broome, WA, 1993; Lommel, A. & Mowaljarlai, D. 'Shamanism in northwest Australia', *Oceania*, vol 64, no. 4, 1994; Riemenschneider, D. & Davis, G. V. (eds), *Aratjara: Aboriginal Culture and Literature in Australia*, Amsterdam & Atlanta, GA, 1997.

Mowanjum. In 1997, after many years in which collective artistic endeavour in the Wanjina culture-area had been dormant anywhere outside Kalumburu (WA), a particular set of circumstances prompted a move to recreate Wanjina imagery on canvas and board at Mowanjum and in the Ngarinyin station communities. There had been a deep reluctance among many older people to produce portable Wanjina imagery because the Wanjina are so much 'spirits of place', but **Mowaljarlai** had been engaged in painting the Wanjina theme for some years, working in collaboration with metropolitan galleries in south-eastern Australia. In the last few months of his life, in his role as a principal of the Kamali Land Council, and drawing upon a strong desire for autonomy from regional funding bodies, he suggested that evoking the Wanjina on canvas was one way in which the community might fund their struggle for **land rights**, simultaneously affirming their traditional knowledge of country and working towards political and economic independence.

Many Ngarinyin adults of all ages began to participate in this activity and special care was taken to ensure that only people with specific attachments to specific images and countries would paint and narrate the stories. The **ochres** were collected from Ngarinyin country or via the traditional trade routes which have always supplied particular colours. Older Ngarinyin people saw this as an opportunity to teach the younger generation the stories of the Wanjina pertaining to their own particular countries, how to gather and prepare ochres and ultimately (approaching the subject with great caution) how to preserve the imagery of their traditional cave-painting galleries.

The Ngarinyin elder Laurie Gowanulli Jedman, of the Brrejalngga clan on the Moran River, has been one of the most prolific of the artists and his work is always accompanied by lengthy dissertations on the major features in his paintings. For this reason his work has been much sought after by curators. Gowanulli's life experience embraces the whole period of transition from the pre-contact era, through to the first government settlement in the area at Munja, incarceration in the Derby Leprosarium, relocation to Mowanjum. Gowanulli remains an astonishing fount of cultural knowledge, and his parti-cipation is considered vital to the continuing ceremonial life of the West Kimberley. His most active colleagues in the Wanjina Art Project include Paddy Neowarra, Paul Chapman, Jack and Biddy Dale, Pansy Nulgit and Dicky Tataya.

In 1998, a parallel painting project, initiated at Mowanjum through a local TAFE teacher, concentrated on teaching various Western etching and painting techniques, such as water-based colours on canvas and paper, using traditional Wanjina imagery. This project has had the middle-aged and younger generations as its prime participants. The most prolific painters from this group currently include Donny Woolagoodja, Derek Oobagooma, Mabel King and Jessica

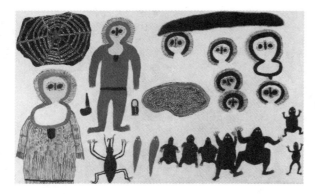

357. Laurie Gowanulli Jedman, *Frog Life Cycle*, 1977. Natural pigments on canvas, 200 x 300 cm.

Nenowatt. This group exhibited in Melbourne, Perth, and Sydney in 1998 and 1999. The original Ngarinyin Aboriginal Corporation project has exhibited work in Melbourne and Perth, concentrating on curated exhibitions and sales to large personal and corporate collections rather than to commercial galleries.

Much community discussion precedes and follows the production of these images by Ngarinyin, Worrorra and Wunambal people. In these discussions the affiliations of individuals and their rights in country are central, and the process contributes to the maintenance of traditional knowledge in a shifting socio-economic context. The arrival of rain storms following exhibitions or production of works in the communities is often attributed to the power of Wanjina; tradition holds that evoking their image also evokes rain and storms. AJR

See also: 5.4, 10.1, 10.2; *357*.

MPETYANE, Lyndsay Bird, see Lyndsay **Bird Mpetanye.**

MUDROOROO (born Colin Johnson), (1938–), writer, has also published under the names Colin Johnson, Mudrooroo Nyoongah and Mudrooroo Narogin [sic]. He changed his name from Colin Johnson to Mudrooroo in protest at the Australian bicentennial celebrations of 1988, and variously appended Nyoongah (an alternative spelling for Nyungah, the south-western language group) and Narrogin (the town near which he was born) to it. He made a reputation as the first published Aboriginal novelist with the publication of *Wildcat Falling* in 1965. His literary output—**fiction, poetry,** and literary criticism—is considerable: *Wildcat Falling* was followed by *Long Live Sandawara* (1979), *Dr. Wooreddy's Prescription for Enduring the Ending of the World* (1983), *Doin' Wild Cat* (1988), *Master of the Ghost Dreaming* (1991), *Wildcat Screaming* (1992), *The Kwinkan* (1993), *The Undying* (1998), *Underground* (1999), and a number of short stories published in magazines and anthologies. His published poetry includes *The Song Circle of Jacky and Selected Poems* (1986), *Dalwurra, the Black Bittern: A Poem Cycle* (1988), *The Garden of Gethsemane* (1991) and *Pacific Highway Boo-Blooz: Country Poems* (1996). His works of non-fiction are

Writing from the Fringe: A Study of Modern Aboriginal literature (1990), *Aboriginal Mythology* (1994), *Us Mob* (1995), *Indigenous Literature of Australia: Milli Milli Wangka* (1997). He has also published a play—*The Mudrooroo/Muller Project* (1993)—and many articles, reviews, forewords and essays.

In July 1996 a public debate over his identity, instigated by his sister, erupted in the *Australian* and subsequently in numerous State newspapers, most notably the *West Australian*. It was in Western Australia, and specifically among the Nyungah people from whom he claimed descent and affiliation, that the sense of injustice and outrage was felt—and continues to be felt—most keenly. Among the Nyungah people, for whom exploitation and appropriation have been a common historical experience, Johnson/Mudrooroo was seen as a 'renegade spiritual thief' by Robert Eggington of the Dumbartung Aboriginal Corporation. While choosing not to respond to invitations from Nyungah elders to discuss the situation, Johnson/Mudrooroo published his response in *Race Matters*.

The wider literary community has to some extent been isolated from the intensity of the outrage in the Nyungah and Western Australian community. Outside the Nyungah community Johnson/Mudrooroo's identity has remained problematic and the reception of his work ambivalent. His literary output, in particular *Wildcat Falling* (1965) and *Writing from the Fringe* (1989), had an undisputably major role in shaping the development of the study of Aboriginal literature from the mid 1960s to the mid 1990s, focusing attention on issues such as essentialism, genre and resistance. It would seem that attention to the historical formation of the field of 'Aboriginal literature' in the 1960s, and to the social conditions that allow some writers to acquire mobility while others are relegated to the margins is urgently required. ANB

See also: 4.1, 4.2.

Dixon, G., Little, T., & Little, L., 'The Mudrooroo Dilemma', *Westerly*, vol. 41, 1996; Little, L. & Little, T., 'Brick Walls: A Comment on the Challenges', in A. Brewster, A. O'Neill, & R. van den Berg (eds), *An Anthology of Western Australian Writing*, Perth, 2000; Mudrooroo, 'Tell them you're Indian', in G. Cowlishaw & B. Morris (eds), *Race Matters: Indigenous Australians and 'Our' Society*, Canberra, 1997; Oxenham, D., 'Politics of Identity', in Curtin Indigenous Research Centre, *A Dialogue On Indigenous Identity: Warts 'n' All*, Perth, 2000; van den Berg, R., 'Intellectual property rights for Aboriginal people', in K. Reed-Gilbert (ed.), *The Strength of Us as Women: Black Women Speak*, Charnwood, ACT, 2000.

MUNDARRG, Wally, see Wally **Mandarrk.**

MUNDUWALAWALA, Ginger Riley, see Ginger **Riley Munduwalawala.**

MUNG MUNG, George (c.1920–1991), Kija visual artist, was a great cultural leader, artist and teacher at **Warmun** Community (Turkey Creek, WA), in the East Kimberley district. A strong Law man and elder, Mung Mung began painting in the early 1980s. Using **ochres** and natural gum binders, he painted the inseparable relationship between land and life. Many of his works embody both traditional Kija and Christ-

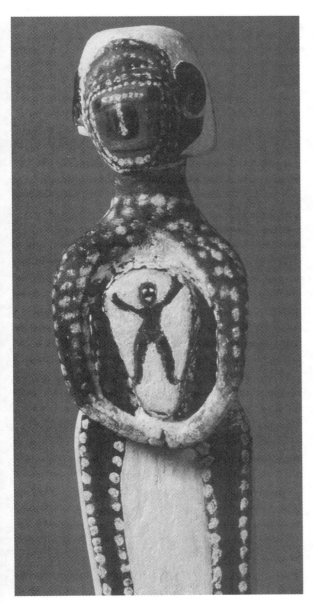

358. George Mung Mung, *Mary of Warmun (The Pregnant Mary)*, c.1983.
Carved wood and natural pigments, height 64 cm.

ian beliefs. One of his most important is his carving *Mary of Warmun (The Pregnant Mary)*, c.1983. In the 1970s he set up the Ngalangangpum bicultural Christian school with his friend, fellow artist and elder Hector **Jandany**, who said of his friend: 'He was looking forward to a blackfella way and a Kartiya [whitefella] way. He was a two-way man. He was a very clever man for the Dreaming' (quoted in Crumlin 1998). Both men taught the stories and songs of their country to the children in the school, using paintings as an educational tool.

Mung Mung won the 1990 NATSIAA (Paintings in Introduced Media) for *Tarrajayan Country*. He has been included in exhibitions such as 'Beyond Belief' (NGV 1998), 'Images of Power' (NGV 1993), and 'Aboriginal Art and Spirituality' (HCA 1991), and his work is represented in the NGA and NGV.

Patrick Mung Mung (c.1944–), son of George Mung Mung, is a senior artist and elder. When his father died in 1991 Patrick accompanied his father's carving *Mary of Warmun* to Canberra for the exhibition 'Aboriginal Art and Spirituality'. This occasion marked the beginning of a journey for Patrick, which was to see him take on his father's role of senior artist, Law and culture man. Like his father, he worked as a stockman for many years on Texas Downs, and other nearby stations. He started painting in 1991, shortly before his father passed away. He was instrumental in establishing the first artist and community-owned art centre at Warmun in 1998, and has been chairperson of the Warmun Art Centre Committee. Patrick Mung Mung continues to use natural pigments on canvas. Through his painting, his knowledge of his country and his cultural memory of family, land, and work are powerfully related. It is often said that his work is reminiscent of his father's, in the way that it frequently draws on figurative elements to narrate a Ngarrangkarni (**Dreaming**) story. His painting is also influenced by the previous generation of Warmun artists including **Rover Thomas** and Paddy **Jaminji**, in its raw directness and composition.

Like his father, he was included in 'Images of Power' (NGV 1993). In 1999 he was winner of the East Kimberley Art Award, and he has had a solo show at Gallery Gabrielle Pizzi, Melbourne (2000) as well as representation in various group exhibitions in Australia and Germany. Collections of his work are held in the NGV, Artbank and the Kerry Stokes Collection, Perth.

JNK & AM

See also: 10.1, 10.2; *358*.

Crumlin, R., *Beyond Belief: Modern Art and the Religious Imagination*, Melbourne, 1998; Ryan, J. with Akerman, K., *Images of Power: Aboriginal Art of the Kimberley*, Melbourne, 1993; Crumlin, R. & Knight, A. (eds), *Aboriginal Art and Spirituality*, Collins Dove, Melbourne, 1991.

MUNG MUNG, Patrick, see George **Mung Mung.**

MUNUNGGURR family. The 300 or so present members of the Djapu clan are all descendants of Wonggu Mununggurr (c.1880–1959), the famous Yolngu clan leader. Wonggu led the resistance to outside colonisation of Yolngu lands in the 1930s and three of his sons were imprisoned in Darwin as a result of the killing of the Japanese crew of a pearling vessel in Caledon Bay in 1933. Later, Wonggu developed good relations with a number of Europeans, and with his sons produced many paintings and objects for the anthropologist Donald Thomson and for sale through **Yirrkala** mission. For Thomson he painted detailed representations of Macassan boats and in 1942 he and his sons produced the first famous large **bark painting**, *Wet Season Painting*, which is now in the Melbourne University Collection on loan to MV.

In 1946–47 Wonggu produced many paintings and crayon drawings for Ronald and Catherine Berndt. These, together with paintings by his sons Mawunbuy and Mäw (*c.*1910–1976), are in the Berndt Museum at the University of Western Australia. Mäw was a renowned songman and dancer and painted until his death. Mawunbuy died tragically in the 1950s when his canoe was lost at sea. His series of paintings and drawings evoking the estuarine fish trap near Dhuruputjpi in Blue Mud Bay reveal an artist of enormous potential. His younger brother Mutitjpuy (1932–1993) developed into perhaps the finest Djapu clan artist, and he was one of the members of the Dhuwa moiety who contributed to the Yirrkala Church Panels. His paintings are characterised by the elegance of the figurative representations of animals and plants and by the way in which figures are interwoven with one another and integrated into the overall design. As well as paintings of the Djapu clan Mutitjpuy produced many designs from his mother's clan, Maḏarrpa. The last of Wonggu's sons to gain renown as an artist was Djutjatjutja Mununggurr (1934–1999), who was well known for his hollow log coffins. Much of his painting was strongly geometric, consisting of the rectangular pattern of the Djapu cloud design. In 1997 one of his paintings won the NATSIAA for the best bark painting. Many younger artists continue the Djapu clan's tradition including Tjutjatjutja's daughter Marrnyula (1964–), who has become a leading printmaker, and Mutitjpuy's daughter Yananymul (1962–) who is a bark painter and printmaker. In 1995 Yananymul was awarded the prize for the best bark painting at the NATSIAA; her father had won the overall prize at the same event in 1990.

HM

See also: 1.2, 4.6, 6.1; **anthropology, art awards and prizes, Buku-Larrnggay Mulka**; *31, 359.*

Buku-Larrnggay Mulka, *Saltwater: Yirrkala Bark Paintings of Sea Country*, Neutral Bay, NSW, 1999; Morphy, H., *Ancestral Connections: Art and an Aboriginal System of Knowledge*, Chicago, 1991.

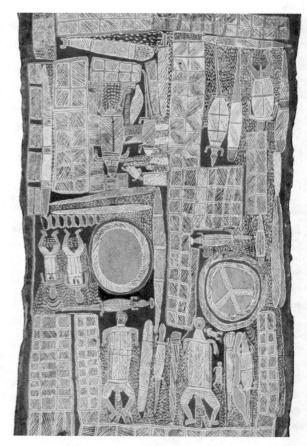

359. Wonggu Mununggurr, *Wet Season Painting, c.*1942. Natural pigments on bark, 188 x 110 cm.

music, see **country and western music; didjeridu.**

N

NABAGEYO, Bardayal, see Bardayal **Nadjamerrek.**

NADJAMERREK, Bardayal (*c.*1926–), Kundedjnjenghmi painter, began his art career as a youth, painting on rocks in the region of the headwaters of the Liverpool River, south of Maningrida (NT). He has excelled in **bark painting** over a period of at least thirty years, and now at Gunbalanya (Oenpelli) also produces work on paper of exceptional quality. He is one of the foremost exponents of the x-ray style of painting of the region. His rock paintings of a kangaroo, emu, goats, and a horse and rider survive in shelters at Kodwalehwaleh in the Djordi clan estate.

As opposed to many other artists in western Arnhem Land who now make use of multi-coloured cross-hatching to infill their works, Bardayal prefers to use x-ray details in association with parallel line hatching in red—a feature of his rock-country heritage. Bardayal was initiated to the full complement of western Arnhem Land ceremonies and is now widely recognised as a leader in a number of them.

He began painting for the market at Oenpelli in 1969. His works depict in intricate detail a wide variety of different animal species and more lately, in the works on paper, tableaux of the major western Arnhem Land ceremonies. Bardayal is particularly well known for his images of Yingarna and Ngalyod the rainbow serpents, and the paintings emphasise the transformational powers of these beings. A commissioned mural of the subject adorns the foyer of Darwin Airport. In 1982 Bardayal was commissioned to produce a painting for use on the Australian forty cent stamp.

His work has toured nationally and internationally. Major collections are held at the NMA and MAGNT. His works were featured in 'Rainbow, Sugarbag and Moon' (MAGNT 1995). Bardayal is currently the leader of a group of artists painting on Arches paper at Gunbalanya and a number of his major works were purchased for the J. W. Kluge Collection (now part of the Kluge–Ruhe Collection at the University of Virginia). LT

See also: 5.1, 5.2, 5.3, 6.1; **rock art**; *55.*
Aboriginal Arts Board of the Australia Council, *An Exhibition of Oenpelli Bark Paintings,* Sydney, 1978; West, M. (ed.), *Rainbow, Sugarbag and Moon,* Darwin, 1995.

NADJOMBOLMI (*c.*1895–1967), Jawony–Kundedjnjenghmi rock painter, is the artist responsible for some of the most beautiful **rock art** in Kakadu National Park (NT). His Bardmardi clan lands at Deaf Adder Creek are in the south of the park. In his early years he hunted game throughout the rock country and floodplains of the entire park area. After World War I he hunted buffalo for settlers and later in the 1950s and 1960s he provided game to safari operators. During this period he camped at different sites along the Nourlangie escarpment and produced new paintings or touched up old paintings at the sites. He saw this as a necessary aspect of looking after his country.

His most well known paintings are the lower frieze of figures at the Anbangbang shelter at Nourlangie Rock. These figures show women and men with rayed hair and body designs consisting of chevron Mardayin-style motifs on their thighs. A number of the women are shown with marks suggesting milk in their breasts. There are contradictory reports that Nadjombolmi was also responsible for repainting the other main figures at this gallery and for producing the so called 'Blue Paintings' nearby, which feature washing blue pigment.

Nadjombolmi is reported to have painted at another forty-six sites in the Kakadu region. There are a number of friezes of large human figures in the same style as those at Anbangbang. Animal figures such as fish and birds are shown with the details of the most tasty portions of fat and flesh, vital organs, and skeletal elements. Nadjombolmi's paintings are a major contribution to the rock art landscape of the Kakadu region. He is known to have painted a few works on bark and some of these are held in the Dorothy Bennett Collection at the NMA. LT

See also: 5.1, 5.2; **bark painting, rock-art repainting;** *152.*
Chaloupka, G., *Journey in Time: The World's Longest Continuing Art Tradition,* Chatswood, NSW, 1993; Haskovec, I. P. & Sullivan, H., 'Reflections and rejections of an Aboriginal artist', in H. Morphy (ed.), *Animals into Art,* 1989.

NADJUNDANGA, Njabangarda Daisy (*c.*1935–), a Kunibidji woman, has been an active fibre artist for many years. The Kunibidji are the traditional owners of the country in and around the **Maningrida** on the eastern shore of the Liverpool

River estuary (NT). Their language is called Ndjebbana. Nadjundanga is a member of the Warrkwarrk clan, and a speaker of 'hard' Ndjebbana.

She was born in her father's country on the floodplain at Warrangala Kanora. She grew to young adulthood before Maningrida was established as a welfare settlement in 1957. During her youth there were 'no Balanda, no town, only Aboriginal people'. She learnt weaving as a child from her mother, Njawakadj Margaret Waykkuma, who taught her traditional techniques of fibre processing, weaving, and knotting which are used to make *beya* (dillybags), *barlangunngun* (string bags), *namewaya* (fishing nets), and so on. She also learnt to make *njarriwana* (mats) and *karrurru* (sails): the *njarriwana* weaving technique, originally used to make conical containers and body coverings, was adapted to make sails for dugout canoes following contact with the Macassans. Once a commercial interest was shown in Kunibidji weaving, the technique was further adapted for mats.

In her youth Nadjundanga sometimes travelled with her family and other Kunibidji and Nakkara people to Martpalk (Goulburn Island) to visit the mission settlement at Warruwi. At Martpalk the missionary women had introduced a new technique of weaving using pandanus fibre to make coil baskets. They also introduced the use of dye to impart colour to the fibres. New equipment was involved; darning needles are used to make coil baskets and metal cooking vessels are used to boil or 'cook' the fibre in the dye solution.

Today, Nadjundanga is a core member of a group of Kunibidji and Nakkara women renowned for their technical skill in the making of these introduced coil baskets and for their innovative use of colour. She said: 'Before, my mother made mats with no colour, just raw ones.' Her daughter Nora added, 'then a long time ago Aboriginal women came from Goulburn Island and showed them this colour, brown and yellow'. The yellow and brown colours introduced by the women of Goulburn Island come from the root of the cork-wood tree (*Pogonolobus reticulatus*). The modern Ndjebbana name for this plant reflects its importance as a dye plant and also the role of the missionaries in establishing this function. Originally named *molorr* and *njanamalabba-njameyameya* (different speakers used different names), today everybody calls it *kala*, from the English word 'colour'.

The use of yellow dye by the Mawng women inspired the young Nadjundanga to experiment further with colour, and her current reputation owes much to her knowledge of dye plants and her mastery of dyeing techniques. Some of the dyeing recipes she uses are general knowledge among central Arnhem Land weavers; others are closely guarded trade secrets. In contrast to her innovative use of colour, her approach to form is conservative. She deliberately eschews experimentation in which different weaving styles and fibres may be mixed in a single object, typical of the Burarra weavers farther east. Instead she takes pride in maintaining the techniques for fibre processing and weaving taught her by her mother. Her work displays a propensity for technical precision, a personal aesthetic of symmetry, and a regularity of form.

In 1987 Nadjundanga was awarded first prize for weaving at the Barunga Festival Art Exhibition (NT). She has participated in several group exhibitions: 'Kunmadj Rowk' (CCV

1993), the touring 'Maningrida: The Language of Weaving' (AETA 1995), and 'Marking Our Times' (NGA 1996). In 1995 she and other Kunibidji weavers travelled to West Timor to participate in a cultural exchange with textile and basket makers from Timor's Biboki region. Examples of her weaving are held in the MCA, NGA and NGV.　　　MC & CC

See also: 17.1.
Australian Exhibitions Touring Agency, *Maningrida: The Language of Weaving*, South Melbourne, 1995; Quaill, A., *Marking Our Times: Selected Works of Art from the Aboriginal and Torres Strait Islander Collection at the National Gallery of Australia*, Canberra, 1996.

NAIN (Petersen), Clinton (1971–), Meriam Mer–Ku Ku visual, installation, and performance artist. Art commentators describe Clinton Nain as a 'political artist'. But this definition does not do justice to the way in which he plunges into the depths of our collective psyche, producing evidence of the way we think in the manner of a magician pulling a rabbit out of a hat. In a 1999 exhibition entitled 'White King, Blak Queen', the accompanying text to one of his mottled calligraphies read: 'We have a fear of stains. They must be removed, bleached out with White King. But the shadows, the memories remain. Bleach usually turns things white, but whitewashing Blackness—chaotically—makes only stains and shadows.' A reference to our **stolen generations**? Perhaps.

Nain began his career as a post-secondary student in Melbourne in 1992, determined to pursue a fine arts degree. While he was still a student he was asked to contribute to an NGV exhibition entitled 'Power of the Land'. He also contributed to the touring exhibition 'Blakness: Blak City Culture' (ACCA 1994). After graduating he participated in 'New Faces New Directions' (1995) at Gallery Gabrielle Pizzi, Melbourne.

Nain received commissions in 1996 from the Hogarth Galleries in Sydney (*Wonder White, Wonder What You Are*), the Linden Gallery in Melbourne (*Island Magic*), and the Jean-Marie Tijbou Cultural Centre in New Caledonia. He has since had several exhibitions at Gallery Gabrielle Pizzi and at the Hogarth Galleries, Sydney, and contributed to several touring exhibitions. The most notable of these has been 'Ilan Pasin' (CRG 1998), the first collection of work from traditional and contemporary Torres Strait Islander artists to be mounted and toured nationally.　　　JH

See also: 7.2, 7.4, 12.1, 12.6; *173, 300*.
Lee, G., 'Clinton Nain', in B. L. Croft (ed.), *Beyond the Pale: 2000 Adelaide Biennial of Australian Art*, Adelaide, 2000; Mosby, T. with Robinson, B., *Ilan Pasin (This is our Way): Torres Strait Art*, Cairns, Qld, 1998; Williamson, C. & Perkins, H., *Blakness: Black City Culture!* South Yarra, Vic., 1994.

NAMARARI TJAPALTJARRI, Mick (*c.*1926–1998), Pintupi painter. In 1989, Daphne Williams, the longest serving arts adviser at Papunya Tula, considered that Mick Namarari 'has been consistently the best of the **Papunya Tula** artists'. This is no small claim, for these artists from the Western Desert changed the face of Australian painting.

Mick Namarari Tjapaltjarri was conceived at Marnpi, a soakage site deep in sandhill country. As a small boy he

360. Mick Namarari Tjapaltjarri, *Untitled*, 1987. Acrylic on canvas, 149 x 35 cm.

witnessed the death of his parents at the hands of a party of assassins. He was then taken east by relatives to Putarti spring, and later to Hermannsburg mission by Pastor Paul Albrecht. He was initiated at Untartiti before working as a stockman at Tempe Downs. In the 1950s he moved to Haasts Bluff where he married for the first time. He and many other Pintupi people moved to Papunya in the early 1960s, and it was there, under Geoff Bardon's influence, that Namarari and other men established the Papunya Tula art movement.

Namarari continued to create new images throughout his long career as a professional artist, often changing his approach to space and composition from one work to the next. Much of his earliest work is dominated by powerful, sinuous, and often interlocking lines. During the same period he created several emblematic figurative works. His middle years were characterised by the subtle reworking of detailed aspects of his **Dreamings**; he created some of the first minimal works, such as the dotted fields of hailstorms at Karriltingi, or the evocation of subtle impressions left in the earth by a resting wallaby, or the scratchings of a bandicoot.

Namarari came to national prominence as an artist in the last decade of his life. In 1991 he won the NAAA (now NATSIAA), in 1991 and 1992 he presented solo shows at Gallery Gabrielle Pizzi, Melbourne, and in 1994 he won the Red Ochre Award and was awarded a Keating Fellowship. He has participated in many significant group exhibitions including 'Dot and Circle' (RMIT 1985), 'Circle Path meander' (NGV 1987), 'Dreamings' (New York, Los Angeles, and San Francisco 1988–89), 'East to West' (Tandanya 1990), 'Mythscapes' (NGV 1989), 'Canvas and Bark' (SAM 1991), 'Crossroads' (Kyoto and Tokyo 1992), and 'Tjukurrpa, Desert Dreamings' (AGWA 1993). His works are represented in all major Australian public galleries, the Holmes à Court Collection, Heytesbury (WA), and the Kelton Foundation, Santa Monica. JK

See also: 1.1, 6.1, 9.1, 9.5, 9.6; **acrylic painting, art awards and prizes**; *360*.

Bardon, G., *Aboriginal Art of the Western Desert*, Adelaide, 1979; Bardon, G,. *Papunya Tula: Art of the Western Desert*, Ringwood, Vic., 1991; Bardon, G., James, P. & Falkenmire, J., *Mick and the Moon* [documentary film]; Hodges, C., 'Founding member of Papunya art school', *The Australian*, 26 August 1998.

NAMATJIRA, Albert (Elea) (1902–1959), Western Arrernte watercolour painter and craftsman. In 1936, Albert Namatjira painted *Amphitheatre, Palm Valley* of which his mentor, Rex Battarbee wrote, 'I know that I could not do anything like as good at so early a stage of water colour painting.' Namatjira went on to become the most celebrated Indigenous person of his day in Australia. He led the way, not only for Arrernte artists but also for the revitalisation of artistic traditions in the Western Desert and elsewhere in Australia. Born at Hermannsburg Lutheran mission (Ntaria) south-east of Alice Springs, he was first named Elea, but renamed Albert when his father was baptised in 1905. He attended the mission school and lived in the boys' dormitory, segregated from his family. At the age of twelve, he returned to the bush for initiation. Namatjira left Hermannsburg again with his wife Ilkalita (later baptised Rubina) in 1919,

and did not return until 1923. He and Rubina had ten children, of whom two died in infancy. All five of his sons—Enos (1920–1966), Oscar (1922–1991), Ewald, (1930–1984), Keith (1937–1977), and Maurice (1939–1979)—also became painters.

Namatjira worked as a stockman, blacksmith, and camel driver, and produced artefacts such as mulga-wood plaques and **boomerangs** for sale in the mission shop. Astounded by an exhibition at Hermannsburg by the visiting Victorian artists Rex Battarbee and John Gardner, he seized the opportunity to learn watercolour technique. Thereafter he painted the country that he knew and loved. Namatjira held his first solo exhibition at the Fine Art Society Gallery in Melbourne in 1938, and after World War II he exhibited in Melbourne, Adelaide, Perth, Sydney, and Alice Springs. His watercolour landscapes, sold in exhibitions and to the tourist market in Alice Springs, proved more popular with the general public than with critics and art institutions. They largely ignored his work, or denigrated it as evidence of his assimilation. More recently Namatjira's art has undergone extensive re-evaluation. Links have been drawn between the high-keyed colour, multiple perspectives and mosaic-like surface patterning characteristic of his work, and later developments in the Western Desert.

In 1944 Albert Namatjira became the first Aboriginal person to be listed in *Who's Who in Australia*. In 1946 he was presented to the Duke and Dutchess of Gloucester. In 1953 he was awarded the Queen's Coronation Medal, and in 1954 he was presented to the Queen in Canberra. In 1957 Namatjira was given Australian citizenship, an honour which subjected him to pressures that caused conflict between his traditional and legal obligations. He was sentenced to six months' imprisonment for making alcohol available to family members. He served a reduced sentence of two months at **Papunya**, and died on 8 August 1959, probably of heart disease. JVSM & MRM

See also: 9.1, 9.1, 9.3; *36, 42, 111, 115*.
Amadio, N. (ed.), *Albert Namatjira: The Life and Work of an Australian Painter*, South Melbourne, 1986; Hardy, J., Megaw, J. V. S. & Megaw, M. R. (eds), *The Heritage of Namatjira*, Port Melbourne, 1992.

NAMBAYANA, Nellie (*c*.1934–), Burarra fibre artist. It is not unusual to see mother and daughter working together, sometimes on the same fibre object, in Arnhem Land (NT), but Nellie Nambayana and her daughter Rebecca Baker (1967–), of the Yanhangu language group, also collaborate on the ideas behind the work. An example of such collaboration is a large complex twined piece in the collection of **Maningrida Arts and Culture** that represents the coastal landscape of Yilan, east of Maningrida, where they both live. In this basket, Baker twined the open section and Nambayana twined the compact closed areas. Each area's pattern calls up particular shapes and textures in the environment. Baker calls the open twined areas *marlirli* (sandbars), and the closely twined areas represent the water between the sandbars.

Nambayana grew up at Yilan, where she received a thoroughgoing traditional education. Trips to Maningrida in her early life were only for supplies not obtainable in the bush.

Her mother and aunts taught her the skills necessary for fibre production in the same way that she, in turn, taught her daughter Rebecca Baker. Baker grew up in Maningrida and attended the local school. She continued her education by boarding for three years at Kormilda College in Darwin. She has lived at Yurrwi and Galiwin'ku (**Elcho Island**) but currently lives at Yilan with her husband and three children. Nellie Nambayana's work was included in the exhibition 'Maningrida: The Language of Weaving' (AETA 1995). LH

See also: 17.1.
Australian Exhibitions Touring Agency, *Maningrida: The Language of Weaving*, South Melbourne, 1995.

NAMPITJIN, Eubena (Yupinya) (*c*.1929–), Wangkajunga artist, was born at Yalantjiri, north of Kiwirrkurra (WA); her country runs down the Canning Stock Route to Nyilla and other sites in the area of Well 33, some 650 kilometres from **Balgo**. Wimmitji (*c*.1924–2000), Eubena's second husband, was born at Kutakurtal, and his country centres on Lirrwarti, about 150 kilometres south of Balgo.

Eubena travelled to Balgo mission with her first husband and their children in about 1948, a little over a decade after the mission was established, at Rockhole. They accompanied a number of Walmajarri and Wangkajunga people who were forced out of their homelands when introduced cattle greatly reduced the water resources of their country along the Canning Stock Route. Wimmitji came to Balgo mission in the late 1940s because all his relatives had moved there.

From within their then separate families, Eubena and Wimmitji began working with anthropologists Ronald and Catherine Berndt, recording **Dreaming** stories and ceremonies of the region. During the 1950s Eubena spent time travelling back to her country and to the Jigalong area, so as not to 'sit down' at the mission for too long. Eubena and Wimmitji married in the 1970s, after Eubena's first husband died. Wimmitji was a major informant for Father Anthony Peile in his research on Aboriginal concepts of the body and healing, and made an important contribution to the Kukatja dictionary. In 1981–82, Wimmitji and a small group of senior men painted their traditional designs. In this, the first stages of the art movement in Balgo, women were not included. Eubena, with eight children, still found time to teach Kukatja in the school and the St John's Adult Education Centre.

Eubena began painting in 1986 when the art centre prepared the first exhibition of Balgo paintings, 'Art from the Great Sandy Desert' (AGWA 1986). The stimulus for both Eubena and Wimmitji to resume painting came with the 1988 appointment of a new coordinator of **Warlayirti Artists**, Michael Rae. The multi-faceted, spontaneous works of the Wangkajunga artists became an important new style within the rich panoply of Balgo art. Soon Eubena, Wimmitji, and five daughters from her first marriage, most notably Ena Gimme Nungurrayi (1955–1992) and Nyula Mutji Nungurrayi (1945–1993), were painting together in their family camp. Eubena and Wimmitji often worked on the same canvas, painting sites from her country, sometimes from his, sometimes from land to which they both had rights. They developed a unique style of complex dotting, often seeming to reflect the textures of the ground and low-growing foliage,

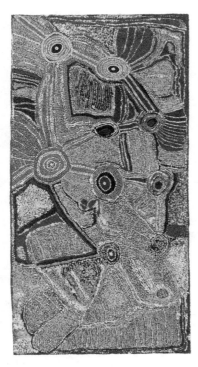

361. Eubena Nampitjin, *Minyulpa*, 1991.
Acrylic on cotton duck, 120 x 60 cm.

combined with complex webs of larger icons. Ena Gimme's short painting career, during which she had attracted the attention of the NGV, the Holmes à Court Collection, and other major collectors of Balgo art in Australia, was cut short by her untimely death in 1992 at the age of thirty-seven.

In 1998, Eubena was awarded second prize for painting in NATSIAA. Eubena and Wimmitji continued to paint together for a time, becoming perhaps the most famous artist-couple from Balgo, until late 1993 when their partnership ended. Although Wimmitji stopped painting then, Eubena has gone on to become one of the major practising artists in the Balgo community. The works of Eubena, Wimmitji, and Ena Gimme have been seen in many exhibitions: Eubena and Wimmitji's in 'Mythscapes' (NGV 1989), the works of all three in 'Images of Power' (NGV 1993), and Eubena's in the 'Aboriginal Women's Exhibition' (AGNSW 1991) and 'In Place (Out of Time)' (Oxford 1997). Works by Eubena and Wimmitji are held in major Australian collections at the NGA, NGV, and HCC, and Eubena is represented in the Kluge–Ruhe Collection at the University of Virginia. Works by Ena Gimme are held in the collections of the NGV and HCC. CW

See also: 1.1, 1.2, 9.5; *361*.
Berndt, R. M. & Berndt, C. H., *The Speaking Land: Myth and Story in Aboriginal Australia*, Ringwood, Vic., 1989; Watson, C., 'Eubena Nampitjin and Wimmitji Tjapangarti', in A. M. Brody (ed.), *Stories: Eleven Aboriginal Artists*, Sydney, 1997; Watson, C., 'Eubena Nampitjin: Animating landforms, enlivening the palette', in R. Coates & H. Morphy (eds), *In Place (Out of Time): Contemporary Art in Australia*, Oxford, 1997.

NAMPONAN, Angus (1930–1994), Wik-Ngatharr wood carver and bark painter. Angus Poonkamelya Koo'alkan Namponan (also known as Kuuchenm) belonged to the Wik-Ngatharr Bush Rat clan of the coastal Wik people of western Cape York Peninsula (Qld). His clan estate lay in the Cape Keerweer area south of Aurukun, where he lived most of his life. Arguably his best known work is *The Two Young Women of Cape Keerweer*, 1987, which he produced with Peter Peemuggina and Nelson Wolmby to release the spirit of a young man who had died in Aurukun jail. The sculpture symbolises the reconciliation between different clans.

Later in his life, Namponan produced a series of finely detailed and innovative carved crocodiles for sale to visitors to Aurukun. These carvings were a significant departure from the totemic images for which he and other Wik artists had hitherto been known. Namponan was not a prolific artist in the public domain, but his work is found, nevertheless, in the MV, NMA, and the QM. DM

See also: 8.1, 8.2; **deaths in custody**, Arthur Koo'ekka **Pambegan**, Sr; *26*.
Sutton, P., 'Bark Painting by Angus Namponan of Aurukun', *Memoirs of the Queensland Museum*, vol. 30, no. 3, 1991; Sutton, P. (ed.), *Dreamings: The Art of Aboriginal Australia*, New York & Ringwood, Vic., 1988.

NANGALA, Narputta (*c.*1933–), Pintupi–Pitjantjatjara painter, was born in the desert near the salt lake Karrkurutinytja (Lake MacDonald, on the NT–WA border). She travelled with her father, Tjalakunya Tjampitjinpa, to Hermannsburg and Jay Creek, where she attended school before settling at Haasts Bluff. Narputta became the recognised matriarch there, having married the head stockman and **Papunya Tula** artist Timmy Tjungarrayi Jugadai, and raised a large family.

Narputta is an active and prolific painter and avid storyteller, concerned that her history be preserved for future generations. She talks about her early days as a cook and stock hand, and witness to the many Pintupi who passed away not long after 'coming in' from the desert.

Narputta often produces bodies of work on a theme, such as the paintings she made following a visit to her birthplace in 1996. The key work *Karrkurutinytja* (winner of the NATSIAA open painting category, 1997) featured a thin white salt lake surrounded by *tali* (sandhills) in orange, sienna, and ochre, a painterly vision showing no trace of the detailed dotting of her earlier works.

Another of her favourite subjects relates to Kutunkgu, a mythological female giant who travelled through Muruntji to the south-west of Haasts Bluff. In this narrative the figure sometimes presides, in other examples a lush plain of wild figs or rolling sandhills and crater-like escarpment suggests the primordial story. The sand goanna Tjukurrpa (near Docker River) is also regularly painted in her eclectic style. Narputta's work is held in numerous public and private collections in Australia and overseas. As well as participating in the NATSIAA and NIHAA exhibitions, she has exhibited

with other Haasts Bluff artists in two exhibitions at Gallery Gabrielle Pizzi, Melbourne, in 1994. UR

See also: 9.5; **art awards and prizes, Ikuntji Arts Centre.**
Gartrell, M., *Dear Primitive: A Nurse Among the Aborigines*, Sydney, 1957; Strocchi, M., *Ikuntji: Paintings from Haasts Bluff 1992–1994*, Alice Springs, 1995.

NANGALA, Ningie, see Tjumpo **Tjapanangka.**

NANGAN, Butcher Joe (*c.*1902–1989), Nyigina Law man, *jalngka* (healer), and artist, was born at Kanen (Fisherman's Bend), Broome (WA). His own country was to the east, in the area now covered by Dampier Downs station. He received his nickname 'Butcher Joe' in the 1930s when he was employed in the Beagle Bay mission butcher shop, and was known throughout the West Kimberley and adjacent Pilbara region by this name. As a young man he had regularly experienced spirit visitations in the course of his dreams, and a focus on the esoteric and the spiritual was always part of his nature. During one such visitation the spirit of his dead 'aunt' Kintimayi bestowed the pelican being *mayata* upon him and taught him the *marinji-rinji nulu*, a public ceremony which relates the transformational processes by which spirits of the dead may reveal themselves to the living. A photograph published in 1928 shows Nangan dressed in the pelican headdress shown to him by Kintimayi and accompanied by two other dancers dressed as *balangan* (spirits of the dead). Joe performed the *mayata nulu* (dance of the pelican) that recreated the original visitation until 1985, and the distinctive *niwalki* thread-cross pelican head-dress became a local icon of Aboriginal culture.

By 1960 Butcher Joe Nangan was noted for his skilful engraving of **boab nuts** and pearl shell and, his work was collected sporadically by both locals and tourists. His brilliantly executed pencil and watercolour pictures of flora and fauna, spirit beings, and mythological and historical events were less well known. By 1955 he had begun drawing in the Western figurative or naturalistic style, and his drawings were collected by anthropologists in the 1960s. In 1974 Western Australian author Hugh Edwards worked with him recording a series of stories; they produced *Joe Nangan's Dreaming* (1976), with twenty legends illustrated by Nangan.

Butcher Joe Nangan recorded and transmitted a vast body of cultural knowledge. He was acutely aware of the increasingly rapid loss of historical and other cultural information in the late twentieth century. Primarily, he illustrated the legends of the Bugarigara (**Dreaming**), that formative period when beings with the ability to transform from human to animal or other form walked the earth. He also drew from a range of historical events in which elements of the supernatural and spirit worlds were thought to have entered the lives of known mortals. *Rai* (spirit beings), guardians of the plants and animals, bearers of the spirits of children, were also a favourite topic. The Aboriginal community believed that Nangan interacted with these little, somewhat mischievous, yet helpful, beings, and that they were the source of his vast store of spiritual knowledge and power.

In the 1970s and 1980s Butcher Joe Nangan fulfilled regular commissions for Mary Mácha, who assisted with three

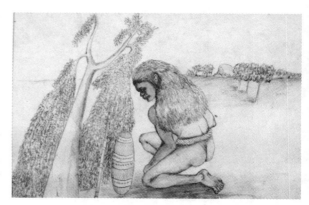

362. Butcher Joe Nangan, *Wirrawirra woman*, 1997. Pencil and watercolour, 30 x 42 cm.
These women lived alone in the bush where they transformed themselves into the bush mistletoe, hanging in the trees. When hungry they would reveal themselves as beautiful young women to men who were hunting alone. These they would seduce in return for game that they had captured. Butcher Joe Nangan stated that he had seen the Wirrawirra but his own *mabarn* power had protected him from their wiles. Usually he would depict the Wirrawirra as young women with flowing tresses (the mistletoe) crouched beneath or beside a mistletoe-infested tree.

exhibitions of his work, at the Aboriginal Traditional Arts Gallery (Perth 1981), Broome Arts Centre (1982) and—in conjunction with a season of *The Dreamers* by playwright Jack **Davis**—at the Theatre Royal (Hobart 1983). His works were also exhibited in 'Paper, Stone, Tin' (Tandanya 1990) and 'Images of Power' (NGV 1993).

In the last fifteen years of his life, Nangan produced about 600 works on paper and possibly twenty or thirty engraved pearl shells. Significant collections of his work are now held by the NGA, Edith Cowan University, and the Berndt Collection (UWA). Some are also in private collections: about 300 works are owned by the Cable Beach Club, Broome. In his lifetime Butcher Joe Nangan probably produced several thousand objects—works on paper, complex thread-cross ceremonial paraphernalia, carved boab nuts, and engraved pearl shells. KA

See also: 10.1, 10.2, 10.4; *362.*
Akerman, K., 'From boab nuts to Ilma: Kimberley art and material culture', in J. Ryan with K. Akerman, *Images of Power*, Melbourne, 1993; Stanton, J., *Painting the Country*, Nedlands, WA, 1989; Tandanya Aboriginal Cultural Institute, *Paper, Stone, Tin*, Adelaide, 1990.

NAPANGARTI, Bai Bai, see Sunfly **Tjampitjin.**

NAPURRULA, Mitjili (*c.*1945–), Pintupi painter, is one of a small group of artists who were promoted through the **Ikuntji Art Centre** at Haasts Bluff from 1992 until 1999. Some of her first paintings were derivative of the **Papunya** dot paintings which she observed as a young woman. However she gained wide recognition for very different work in exhibitions, awards, and commissions in the late 1990s.

Mitjili was born at Haasts Bluff, half-sister to Turkey **Tolson Tjupurrula** and daughter of Tjunkayi Napaltjarri and Tupa Tjakamarra. She married Long Tom **Tjapanangka** at Papunya in the 1960s. They later lived at Haasts Bluff and she developed a distinctively individual painting style. Mitjili experimented with rich decorative colours, portraying bush flowers and nulla nullas, combining dots with solid areas of colour and line. Gradually her imagery became more and simplified and refined, reflective of her country but unlike the work of her peers.

The *Watiya Tjuta* became her most recognised painting subject—wiry generic tree forms in arresting colours inspired by her father's country at Uwalki in the Gibson Desert south of Kintore. In 1999 she won the Alice Prize and was selected to appear in 'Beyond the Pale' (AGSA 2000). Her work is held in public and private collections in Australia and overseas including the NGA, NGV, MAGNT and Artbank, Sydney. UR

See also: 9.5; **art awards and prizes.**

Croft, B. L. (ed.), *Beyond the Pale: 2000 Adelaide Biennial of Australian Art*, Adelaide, 2000; Strocchi, M. (ed.), *Ikuntji: Paintings from Haasts Bluff 1992–1994*, Alice Springs, 1995.

NATHAN, Nora, see **Youngi.**

native title. Colonial Australia was founded on the myth of terra nullius; that is, the early settlers recognised no system of pre-existing law by which the Aboriginal groups they encountered held title to land, or rights to its resources. This foundation myth not only served to legiti-mate the actions of the early colonists in their dispossession of Aboriginal people; it also continued to underpin the settler nation's view of itself, as conquering unoccupied wilderness and utilising its resources for economic, and therefore social, progress. This myth legitimated a collective denial of, or at best amnesia about, the harsh reality faced by Indigenous people: denigration, exclusion, dispossession, and systematic attempts to destroy their beliefs and practices.

Over the last three decades of the twentieth century there was a gradual, if uneven, political recognition of the centrality of land to Aboriginal societies and of the historical wrongs which underlay their dispossession. This recognition ultimately resulted in **land rights** legislation for particular States and Territories which provided for mechanisms to enable the grant of lands to eligible Indigenous groups. The lead was taken by the Commonwealth government, which in 1976 passed legislation allowing for certain categories of land in the Northern Territory to be granted to or claimed by Aboriginal groups for whom it was their traditional lands.

Subsequently, a number of State parliaments passed legislation which provided for generally limited areas of land to be granted to or (in some jurisdictions) claimed by Indigenous groups. Since most of these 'land rights' schemes related to lands in rural or remote regions, they addressed neither the pervasive construction of Indigenous identity through connection to ancestral lands, nor the deeply felt sense of historical injustice of an increasingly urbanised Indigenous population. Neither were these legislative schemes predicated upon the recognition of systems of tra-

ditional law and custom which pre-dated the introduction of the common law to Australia by the colonists. Rather, they involved the grant of an interest in land established under the general Australian law to Indigenous groups who could satisfy criteria instituted by the particular legislature.

The Queensland and Western Australian State governments, however, were adamantly opposed to land rights. In 1985, the Queensland government attempted to extinguish certain indigenous entitlements to land. A number of individuals from Mer (Murray Island) in the north-eastern Torres Strait, led by Eddie Koiki **Mabo**, initiated action in the courts in response to this attempt. Ultimately, in a landmark decision in 1993, the High Court of Australia rejected the doctrine that Australia was terra nullius at the time of European settlement. The 'Mabo' judgment overturned the established view that whatever indigenous systems may have existed prior to European settlement, they were automatically and instantaneously extinguished by the acquisition of sovereignty by the British monarch. The judgment held that the Australian common law recognises a form of 'native title' that reflects the entitlement of Indigenous people to their traditional lands, in accordance with their traditional laws and customs. However, the Court also found that native title could be extinguished by valid government acts that are inconsistent with the continued existence of native title rights and interests (such as the grant of freehold interest).

Native title can therefore be seen to lie in a 'recognition space' between two systems of law; Indigenous systems of traditional Law and custom on the one hand, and the general Australian law on the other. Native title therefore is not a title created under the Australian legal system (such as freehold or leasehold). Its content does not *derive* from the Australian common law; rather it derives from the laws and customs of the particular group of Indigenous people, but is (following Mabo) *recognised* by the common law. In 1993, the Keating Labor Government introduced the *Native Title Act* which provided mechanisms to bring the recognition of native title into the general Australian land and resource management regime, including procedures through which native title claims could be settled by mediation, rather than litigation, by agreement of all the parties.

In a second landmark decision arising as the result of claims over certain pastoral leases by the Wik peoples of western Cape York, the High Court in 1996 found that the grant of pastoral leases did not necessarily extinguish native title. Native title therefore can, under certain circumstances, coexist with other interests in land, such as particular forms of leasehold. The Mabo and Wik decisions caused an immense furore in Australia, despite the fact that, in comparison with other common law countries such as Canada and New Zealand, the High Court's Mabo and Wik decisions were relatively cautious and limited. Conservative political forces, including those representing interests such as pastoralists and resource industries, mounted strong campaigns against the recognition of native title, arguing that it posed a basic threat to the nation's capacity to do business. In response to the 'Wik' decision, the Howard Government developed the 'Ten Point Plan' which was implemented amidst immense controversy through amendments to the *Native Title Act* in 1998. Indigenous leaders and many other

commentators argued that the amended Act severely curtailed the rights of Indigenous people, and infringed the *Racial Discrimination Act*.

The meanings attributed to the 'recognition space' of native title are thus highly contested. From a purely legal perspective, the Australian common law now recognises a limited set of Indigenous relations to country. This limited recognition however does not correspond to an acknowledgment of Indigenous sovereignty. From the point of view of many conservative politicians, native title represents the 'politics of symbolism', offering few tangible benefits to Indigenous people, and miring crucial resource industries in costly and time-consuming administrative and legal processes which threaten their viability. For many in the wider Australian public, whose sources of information are the popular media and conservative commentators, native title is yet another instance of selective favourable government treatment of Indigenous people, and arouses considerable hostility. For Indigenous people, however, native title provides the first recognition by the Australian political and legal system of the existence and validity of their systems of traditional Law, and thus of their distinctive histories, cultures, and identities.

DM

Brennan, F, *The Wik Debate: Its Impact on Aborigines, Pastoralists and Miners*, Sydney, 1998; National Native Title Tribunal, *Native Title; An Opportunity for Understanding*, Perth, 1994; Pearson, N., 'From remnant title to social justice', in Goot, M. & Rowse, T. (eds), *Make a Better Offer: The Politics of Mabo*, Leichhardt, NSW, 1994.

NATSIVAD, see AIATSIS.

NELSON, Michael Jagamara (*c*.1949–), Warlpiri visual artist. In 1988 Michael Jagamara Nelson was introduced to the Queen and the Australian people as the designer of the vast Aboriginal mosaic set into the forecourt of the national Parliament House in Canberra. A controversy erupted at the opening ceremony over wild claims by Indigenous protestors that the **Dreaming** designs of his painting, set in granite, had placed a historic curse on White Australia. In 1993 Michael Nelson was again at the centre of Indigenous protests over the stalled Mabo **native title** negotiations, declaring himself 'an artist, not a politician', and issuing a dramatic threat to take the mosaic back to central Australia if the Australian Parliament did not 'stop insulting my people and my painting'.

Born 'in the bush' at Pikilyi (Vaughan Springs), west of Yuendumu (NT), Michael Nelson was a young boy when his family group 'came in' to the mission settlement at Haasts Bluff, later shifting to **Yuendumu** so the children could attend school. Michael Nelson came from a powerful Warlpiri family. His father and grandfather were important 'clever men' in the Yuendumu community. After his initiation at thirteen, his formal (Western) education ended and he worked across the Top End buffalo shooting, driving trucks, and droving cattle. Finally, he returned to Yuendumu. After his father's death in 1976, Nelson married and moved to Papunya, where he observed the work of the older **Papunya Tula** artists before himself beginning to paint in 1983. In 1984 he won the inaugural NAAA (now NATSIAA)

in Darwin, and commenced one of the most illustrious careers in Western Desert art. He was instrumental in producing the current recognition of Indigenous artists from traditional tribal backgrounds as contemporary artists.

In 1986 Nelson became the first desert artist to exhibit at the Biennale of Sydney, at the time Australia's only international contemporary art forum, appearing in a British art documentary *State of the Art* alongside such luminaries as Andy Warhol and Joseph Beuys. His 1985 painting *Five Stories*, which has been described as the most reproduced work of Australian art of the 1980s, appeared on the cover of the catalogue for 'Dreamings: Art of Aboriginal Australia' (New York, Los Angeles, and Chicago 1988–90). Michael Nelson and Billy **Stockman Tjapaltjarri** travelled to New York for the opening, and created the first central Australian ground paintings on American soil. In 1989 Nelson became one of the first desert artists to have a solo exhibition and also participated in the BMW 'Art Car' project by hand-painting a racing car. In 1993, he received the Order of Australia for services to Aboriginal Art, and in 1994 was awarded an Artist's Fellowship from the Visual Arts Board of the **Australia Council** for the Arts. He paints flying ant, possum, snake, kangaroo, banana, witchetty grub and yam Dreamings from his mother's country around Pikilyi and his father's and grandfather's country around Wapurtarli (Mt Singleton).

VJ

See also: 1.1, 1.2, 6.1, 9.4, 9.5, 22.1, 22.3; art awards and prizes; *226, 227, 264.*

Johnson, V., *Aboriginal Artists of the Western Desert: A Biographical Dictionary*, Roseville, NSW, 1994; Johnson, V., *Michael Jagamara Nelson*, Roseville, NSW, 1997.

NGANJMIRRA brothers, Kunwinjku painters. Bobby Barrdjaray Nganjmirra (*c*.1915–1992) was one of the most proficient and well-known bark painters working at Gunbalanya (Oenpelli, NT) from the 1940s to the 1990s. He and his younger brother, Jimmy Nakkuridjdjilmi Nganjmirra (*c*.1919–1982), also a painter, grew up near Djalama clan country in the Goomadeer River region in western Arnhem Land. The family group visited the mission at Oenpelli a number of times. On one occasion Bobby Barrdjaray was taught to paint on rock by his father, Kurlamarrmarr. These paintings of kangaroos with x-ray details can be seen at Injalak rock shelter. Barrdjaray said that he painted for the market sporadically before the late 1960s. Both he and his brother became key artists in the period of strong growth of the art industry at Gunbalanya.

Bobby Barrdjaray's paintings are characterised by a black painted background, whereas other Kunwinjku artists favour red. Human and animal figures are finely drawn and x-ray details rarely shown. During the 1970s Barrdjaray introduced very fine bands of multicoloured cross-hatching as a way of enlivening his works. Likanaya and Marrayka, two dreaming women from Malworn in Djalama clan country, were an important subject. These figures were often painted with fish tails instead of legs, and with long hair representing water weed. Jimmy Nakkuridjdjilmi's common subjects, executed in the x-ray style (unlike his brother's work), were *mimih* spirits, Ngalyod (rainbow serpent), and kangaroo. He also painted Namarrkon, the lightning spirit.

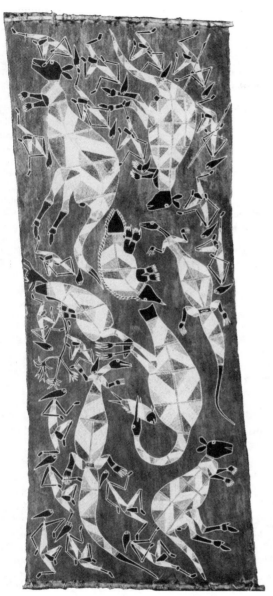

363. Bobby Barrdjaray Nganjmirra, *Animals and Mimi Figures*, 1985.
Natural pigments on bark, 64.5 x 164 cm.

Examples of the work of both brothers were included in major collections made by Dorothy Bennett, Louis Allen, Helen Groger-Wurm, and the Aboriginal Arts Board—of which Bobby Barrdjaray became a member in 1975. The Nganjmirra brothers' work has toured nationally and been included in exhibitions in Britain, Japan, the USA and Mexico, and is held in most Australian national and State art institutions.

In his later years Bobby Barrdjaray was active in producing works on paper. This led him, along with other close members of the family—his son Alexander, and Lawrence, Luke,

Ralph, Thompson, and Wesley Nganjmira—to become very active participants in the rebirth at Oenpelli of **Injalak Arts**, a centre specialising in the production of works in ochre on Arches art paper. LT

See also: 5.1, 5.2; **arts advocacy organisations, bark painting**; *363*. Dyer, C. A. (ed.) *Kunwinjku Art from Injalak 1991–92*, North Adelaide, 1994; Nganjmirra, N., *Kunwinjku Spirit: Creation Stories from Western Arnhem Land*, Melbourne, 1997; Taylor, L., 'Flesh, bone and spirit: Western Arnhem Land bark painting', in H. Morphy and M. Smith Boles (eds), *Art from the Land: Dialogues with the Kluge–Ruhe Collection of Australian Aboriginal Art*, Charlottesville, VA, 1999.

Ngukurr artists. Ngukurr is located on the Roper River in south-eastern Arnhem Land (NT). The community grew out of the Roper River mission, set up in 1908 by the Church Missionary Society; by the end of its first year, over 200 people had moved there. Despite a long history of frontier violence and an extended period of mission protection and control, Ngukurr has emerged as a strong and vibrant community with its own dynamic art style.

The first paintings from Ngukurr date from March 1987. A group of artists were allocated the old hospital building as a painting studio. A simple barn-shaped structure with two verandahs and a galvanised iron roof, it had fallen into disrepair and been covered both inside and out with **graffiti** by young people, earning it the name Beat Street, after the words plastered on one side: 'Let's Rap Dance, Beat Street, 1985'. Beat Street lacked running water, appropriate tables, lockable storage racks, and proper artists' facilities, so many artists preferred to take canvas and **acrylic** back to camp where they could work at their own pace, often in the cooler parts of the day or at night.

For the first time the artists, who included Ginger **Riley Munduwalawala**, Willie **Gudabi**, Moima **Willie**, Holly Daniels, Djambu **Barra Barra**, Amy Johnson, Charlie Munur, and Ngalandarra Wilfred, were given acrylic paints, brushes, canvas, and paper. Some continued to make artefacts for sale through Mimi Arts and Crafts at Katherine; others opted to paint with **ochres**. But most of the work was raw, bold and bright in colour. As in Abori-ginal desert communities, the introduction of acrylic paints—fast drying, intense of hue, permanent—provided the essential catalyst. The ease of the medium, its brilliance and shininess, fired the imagination of the artists to experiment, innovate, and transform ideas absorbed from their culture. The first paintings by both men and women reflect the range of cultural groups that contribute to the rich fabric of Ngukurr society. In its explosion of primary colours and unhinged pictorial imagery, early Ngukurr art defied preconceptions about Aboriginal painting. The work was quickly painted and spontaneous. Patterning was boldly and crookedly applied in pink, green, blue—anything but the tasteful autumnal palette contrived to please the Munanga (white) collectors of 'authentic' Indigenous merchandise.

As with other Aboriginal painting enterprises, an immense effort was needed to secure continuous funding and establish a market before Ngukurr art could be put on the map. By mid August 1987 nothing had been exhibited,

and a stack of canvases languished unsold. The first real breakthrough occurred in September 1987, when a number of works were entered in the NAAA (now NATSIAA) in Darwin. The Ngukurr paintings burst on the scene like something out of left field. Nothing was familiar; there were no meticulous fields of dots, natural ochres or detailed cross-hatching. At the end of the exhibition, the artists were encouraged when they heard the news, via short-wave **radio**, that paintings by Barra Barra and Ginger Riley had been purchased for the Holmes à Court Collection.

In March 1988 the first Ngukurr group exhibition was held at Gallery Gabrielle Pizzi, Melbourne. Works sold well to private collectors and some State galleries, and created an upsurge of interest. One successful group show, however, was not enough to ensure continual funding and long-term success for the group. From late 1987 the artists sought to form their own corporation, separate from the community council. Only then would they have a solid base from which to lobby for government funding, organise distribution, pricing and marketing of works, manage moneys from sales, purchase materials, and control expenditure. In May 1988, they incorporated as the 'Ngundungunya Association of Artists, Ngukurr'.

Within a few weeks Abstudy funding was secured for eight of the artists to make a field trip to Alice Springs, **Yuendumu**, and **Santa Teresa**, where they met artists and administrators in desert Aboriginal communities. The journey ended with a visit to the annual Barunga Festival and Art Prize in which one of Barra Barra's paintings won equal first prize. The tour broadened the artists' exposure to forms of contemporary Aboriginal art made with introduced materials, enabling them to see art being produced in and marketed through established communal art centres. It reinforced their understanding of where their art fitted into the wider picture.

The Ngukurr artists, then as now, were hampered by the lack of sustained government backing. Efforts to set up an art centre in the community along the lines of those established elsewhere in the Northern Territory failed, leaving the artists to fend for themselves. In 1989 some of them, notably Ginger Riley and Willie Gudabi (past winners of the Alice Prize), Djambu Barra Barra and Amy Johnson, were included in a Ngukurr group show at Alcaston Gallery, Melbourne. During the 1990s more artists began painting, including Barney Ellaga, Maureen Thompson, Norma Joshua, and a family of artists: Eva and Betty Rogers, Dinah Garragi, Angelina George, Gertie **Huddleston** and Sheena Huddleston Wilfred. Some have held successful solo exhibitions.

Artists from Ngukurr produce vibrant, pictorial works that stand apart from many other known forms of Aboriginal art. Their tapestries of light and colour reveal a close familiarity with the wet and dry seasons of the Roper River region and with particular sites in this country. Their images of plants, flowers, insects, animals, and birds evoke in the viewer a sense of wonder and innocence. Features of the land—rivers, hills, trees, grasses—burst into view as bright, textured and luxuriant images.

JUR

See also: **art awards and prizes**.

Roberts, B., 'Alawa and Roper Creole Story', in L. Hercus & P. Sutton (eds), *This is What Happened: Historical Narratives by Aborigines*, Canberra, 1986.

NGULEINGULEI MURRUMURRU, Dick (*c.*1920–1988), Dangbon bark painter, grew up in the rock country at the headwaters of the Liverpool River (NT) and his style of bark painting remained true to his origins throughout his life. He became a key figure among the bark painters who worked for Peter Carroll at Gunbalanya (**Oenpelli**) during the late 1960s and 1970s. In 1982 he was commissioned to produce a work of art for the Australian 75 cent stamp. His works toured internationally in exhibitions organised by the American collector Louis Allen and the Aboriginal Arts Board of the Australia Council, and one was included in the 'Dreamings' exhibition (New York, Los Angeles, and Chicago 1988). During the 1980s Nguleingulei lived at Malgawo outstation, close to his own Bularlhdja clan lands. He died there in tragic circumstances in 1988. Some of his last work, painted on a bark shelter at Malgawo for George Chaloupka, is recorded in Penny Taylor's *After 200 Years*.

Nguleingulei maintained superb control of the balance and dynamism of his figures within the outlining frame of the bark. For example, he painted a beautiful and animated set of works showing how the *mimih* spirits hunt and butcher their game. Ronald Berndt collected a dynamic work that shows the creative moment of an ancestral being emerging from the body of Ngalyod, the rainbow serpent. Nguleingulei rarely used cross-hatching in his paintings, preferring an infill style composed of fine red parallel lines, and he was able to impart visual activity to his paintings by making very fine variations in their thickness. His works stand out in contrast to works by other artists, who use much more precise and regular hatching styles. LT

See also: 5.1, 5.2, 6.1.

Aboriginal Arts Board of the Australia Council, *An Exhibition of Oenpelli Bark Paintings*, Sydney, 1978; Berndt, R. M. & Berndt, C. H. with Stanton, J. E., *Aboriginal Australian Art: A Visual Perspective*, Port Melbourne, 1992; Carroll, P., 'Mimi from western Arnhem Land', in P. J. Ucko (ed.), *Form in Indigenous Art*, Canberra, 1977; Taylor, P. (ed.), *After 200 Years: Photographic Essays of Aboriginal and Islander Australia Today*, Canberra, 1988.

NGURRUWUTTHUN, Ḏula (*c.*1936–), Munyuku (Yolngu) painter and ritual expert. Ḏula and his brother Gambali (Djewiny) (*c.*1940–) are leaders of the Munyuku clan of north-eastern Arnhem Land (NT). They are sons of Djimbarryun, who worked with the anthropologist Donald Thomson in the 1930s and 1940s, and share the inherited title of *djirrikay*. An authority on sacred forms, the *djirrikay* is a ceremonial leader who knows the sacred names belonging to all the Yirritja moiety clans of the region, and calls them out in ceremony. Ḏula in particular is a powerful singer and dancer. He can be seen leading ritual performances in films by Ian Dunlop, notably in *Mardarrpa Funeral at Gurka'wuy*. There is no better expression of the poetry of Yolngu art than in his contribution to *Saltwater: Yirrkala Paintings of the Sea Country*, where he describes the ways in which designs evoke the sense of being in the landscape:

'[This] sacred design has the tantalising taste of the Green Turtle. It has the pattern etched by the sea around Walirra … the sound of the moving waters is called Wulamba. The wide open sea has huge waves, water that roars. This water existed in ancestral times and the cycle continues. It is massive, ancient, endless.'

Dula's paintings are represented in institutions around the world including the Museum of Modern Art in Seattle, the Kluge–Ruhe Collection at the University of Virginia, and the NGA. Dula and Gambali paint, in a similar style, ancestral designs from the floodplains of Maywunydji and the rocky waters off Yarrinya in the North of Blue Mud Bay. The strong sharp-edged clan designs of Munyuku paintings seem to reflect their subject matter—the sharp edges of the swamp grass, the angled forms of the saltwater crayfish, and the curved blade of the Macassan knife used to cut through the flesh of the whale. In other paintings the designs evoke the swirling waters as they wash around the coral rocks.

Dula is an artist whose life is devoted to the continuity of Yolngu culture. Reflecting on the brush of *marwat* (human hair) that Yolngu use to paint the fine cross-hatched lines drawn across the surface of their paintings he states: 'it is for the Yolngu that we paint … We are working on our law. This is interpreting our wisdom, our foundation, and the sinews of the Yolngu. This is a true story, not lies. And this hair on my head is true. The truth comes out of this hair brush.'

HM

See also: 6.1, 6.4; **Buku-Larrnggay Mulka**; *39*.
Buku-Larrnggay Mulka Centre, *Saltwater: Yirrkala Bark Paintings of Sea Country*, Neutral Bay, NSW, 1999; Dunlop, I. (director), *Mardarrpa Funeral at Gurka'wuy* [film], Film Australia, 1979; Morphy, H., *Ancestral Connections: Art and an Aboriginal System of Knowledge*, Chicago, 1991.

NICKOLLS, Trevor (1949–), painter, was born in Adelaide of Aboriginal and Irish parents. At school he found solace in art, as a means to express his identity. Extensive formal art education in Adelaide, Melbourne and Canberra exposed him to European artistic traditions and techniques. In the mid 1970s his repertoire expanded to include the visual symbols of his Aboriginal inheritance, and the cross-hatched designs of Arnhem Land began to appear in his work alongside European motifs. The most direct Aboriginal influence on his work came from his meeting in 1979 with **Papunya** artist Dinny Nolan Tjampitjinpa, who introduced Nickolls to the artistic lexicon of the desert.

His major themes between 1978 and 1981 were an exploration of the duality of his mixed ancestry, and the wider disjunction between 'Dreamtime' and 'Machinetime' as seen in the painting series *Dreamtime Machinetime* (NGA 1981) which explores the visual differences between 'Dreamtime'—the fundamental Aboriginal connection with natural forces of the land—and 'Machinetime'—a notion which encompasses the alienating effects of a modern society based on money, machines, noise, and urban claustrophobia. Referring to those works he once said: 'My work is a balancing act, like walking a tightrope between my dreams and my life when I'm awake—from Dreamtime to Machinetime.'

In the early 1980s Nickolls sought to deepen his understanding of traditional Aboriginal culture by spending a number of years in Darwin. At first the works from this period presented the landscape as a Garden of Eden, a symbiosis of Aboriginal and biblical themes. This mood changed when Nickolls was unable to reconcile the celebratory nature of these paintings with the reality of Aboriginal settlement life. Since the mid 1980s Nickolls has also experimented with the formal qualities of landscape, and, like many Indigenous artists, acknowledges the example of Albert **Namatjira** in his series of works titled *Namatjira Dreamings*, 1990.

In the late 1980s and into the 1990s his work continued to entwine Dreamtime and Machinetime themes—but with a more barbed, political edge, as seen in one of his most powerful images, *Deaths in Custody*, 1990. Nickolls continues to display an uncanny ability to switch between artistic styles, or to blend what would seem to be disparate visual elements into a cohesive whole.

In 1990 Trevor Nickolls and **Rover Thomas** were the first Indigenous Australian artists to be exhibited at the Venice Biennale. Individual commissions include a painted Melbourne tram (1984) and a painted costume for Australia's entrant in the 'Miss Universe' pageant (1984). Significant group exhibitions include 'Koori Art '84' (Artspace 1984), 'On the Edge' (AGWA 1989) and 'Aṟatjara' (Düsseldorf, London, and Humlebaek 1993–94). He is represented at the NGA and in all Australian State galleries.

MRM & JVSM

See also: 10.2; 11.1, 12.1; **deaths in custody**; *315*.
Beier, U., *Dream Time—Machine Time: The Art of Trevor Nickolls*, Robert Brown & Associates, Bathurst, 1985; O'Ferrall, M. A., *Rover Thomas, Trevor Nickolls: 1990 Venice Biennale*, Art Gallery of Western Australia, Perth, 1990.

NJINAWANGA (Nyinawanga), Brian (1935–), Rembarrnga painter, printmaker, and sculptor, works and lives at Malyanganak in central Arnhem Land (NT). He was born on his land on the western edge of the Arafura Swamp and as a teenager moved south to work as a stockman on various cattle stations on the fringe of the Arnhem Land reserve and south to the township of Katherine. In the 1970s Njinawanga moved to Maningrida where he started painting and carving wooden animal figures for the public domain.

His early **bark painting** style, like that of many Rembarrnga artists, was similar to western Arnhem Land paintings— a single figure or number of figures laid out on a bare background. By the end of the 1970s the skeleton form had begun to appear in his sculptures.In the 1980s he moved to filling the background with realistic vegetation or cross-hatched design.

By the end of the 1970s Njinawanga and his brothers began to create a new form of idiosyncratic sculpture in wood which included renditions of human skulls, bones, complete skeleton animal figures, and wooden versions of everyday objects such as woven baskets and fibre sieves. From these sculptures developed the series of painted wooden bone bundles wrapped in paperbark. These bundle sculptures imitate bone carriers and, presented in a fully

wrapped or partially unwrapped state, comment on the parallel nature of the physical and spiritual worlds.

Njinawanga is an innovator in terms of media and subject matter. He has made screenprints depicting his impression of the city of Sydney (*Sydney City Landscape*, 1992) and stockyards in memory of his early working life as a stockman, and in honour of the Gurindji stockmen's strike at Daguragu in the 1960s. Njinawanga has also painted on canvas: his *Kava Story*, 1996 comments on the deleterious effects of kava on traditional life. DJM

See also: 6.1; **printmaking**.
Mundine, D., 'Brian Nyinawanga', in National Gallery of Australia, *The Eye of the Storm: Eight Contemporary Indigenous Australian Artists*, Canberra, 1996.

NONA, Dennis (1973–), printmaker, is an established Torres Strait Islander artist who has set the standard for the development of the new contemporary Torres Strait Islander art movement. He was born on Thursday Island, and lives on Badu Island in the Western Islands group of the Torres Strait. He was one of the first young Torres Strait Islander artists to move away from the Torres Strait to develop his artistic skills: in 1993 he completed an Associate Diploma of Arts at the **Far North Queensland Institute of TAFE.**

Nona first exhibited his works in the Cairns Art Society Exhibition (CRG 1991). His work has also been displayed in the USA and Japan and throughout Australia, and is represented in the collections of the NGA, and State and regional galleries. He has contributed to catalogues, and has illustrated the children's book by Selena Solomon, *Dabu the Baby Dugong* (1992).

Nona favours linocutting for his prints, which may include spiritual figures, totems, or traditional artefacts. Spaces surrounding the main motifs are often filled with decorative designs similar to those traditionally used on artefacts. Works such as *Ubirikubiri* and *Mal Lag Ar Dapparr-aw Ar Idal* tell traditional stories relating to islander life in the Torres Strait. *Ubirikubiri*, 1991 illustrates a traditional story about a pet crocodile and an important totem in the Western Island group of the Torres Strait. The print *Naath*, 1995 depicts a figure with a *wap* or traditional hunting spear jumping off a dugong-hunting platform.

Nona has developed his career through learning Western techniques in art, but his subject matter, as with many other Torres Strait Islander artists, is the stories and images that are central to his identity. MB

See also: 7.2, 7.4, 12.1.
McGrath, V., 'Contemporary Torres Strait Arts: An Overview', in T. Mosby with B. Robinson, *Ilan Pasin (This is Our Way): Torres Strait Art*, Cairns, 1998.

NOONUCCAL, Oodgeroo (Kath Walker) (1920–93), poet and writer. The opening lines of Oodgeroo's poem *Aboriginal Charter of Rights*, which she read at the 1962 Easter conference of **FCAATSI**, run as follows:

We want hope, not racialism,
Brotherhood, not ostracism,

Black advance, not white ascendance:
Make us equals, not dependants.

Written for the occasion, it illustrates how impossible it is to separate the poet from the activist for Aboriginal rights.

Born Kathleen Ruska on 3 November 1920, Oodgeroo's childhood was spent in the family home on Stradbroke Island, an attachment reflected in her book *Stradbroke Dreamtime* (1972). She left school at thirteen to become a domestic servant, but was rescued from this drudgery by the outbreak of World War II. She joined the Australian Women's Army Service and learnt new skills. In 1942 she married Aboriginal Bruce Walker and they bought a modest house in Buranda, but soon after the war she was left with responsibility for two sons.

The need to speak out for her people had become urgent. She sought support from the Communist Party, the Realist Writers, and later from Aboriginal Advancement groups such as the Queensland Council for the Advancement of Aborigines and Torres Strait Islanders, and the Queensland Aboriginal Advancement League. Assistance with her development as a poet came from James Devaney, and from Judith Wright, then a reader for Jacaranda Press, who wrote that when a collection of poems by Kath Walker came in, 'the poems rang out and commanded attention'. *We are Going* (1964) brought instant fame. *The Dawn is at Hand* followed in 1966, and in 1967 Walker won the Jessie Litchfield award. When *My People* (1970) appeared, she was acclaimed worldwide, as a poet and as an advocate for her people's rights. In 1969 she was Australian delegate to the World Council of Churches consultation on racism in London. Lecture tours to New Zealand, Fiji, Malaysia, and Nigeria followed. In 1978 she won a Fulbright Scholarship and a Myer travel grant, then was poet in residence at Bloomsburg State College, Pennsylvania. A visit to China in 1984 resulted in her final collection of poems, *Kath Walker in China* (1988). In 1986 she attended the International Forum for a Nuclear-Free World in Moscow.

She established Moongalba on North Stradbroke Island, where she arranged holiday camps for underprivileged children of all races. She taught them Aboriginal food-gathering, survival, and self-sufficiency skills. Between 1972 and 1977 more than 8000 children visited Moongalba.

When Australians celebrated 200 years of white occupation in 1988, she signalled her disapproval in two important ways. She returned the MBE she had been awarded in 1970, and changed her name to Oodgeroo of the Noonuccal Tribe. In 1988 Oodgeroo and her son Vivian wrote the script for *The Rainbow Serpent*. The Master of the Queen's Music, Malcolm Williamson, used the words of *The Dawn is at Hand* in an oratorio which had its world premiere at Brisbane in October 1989. One of the plaques outside the Sydney Opera House bears Oodgeroo's name and her poem *Son of Mine*. Three Australian universities honoured her with doctorates. KC

See also: 14.1, 14.3.
Cochrane, K., *Oodgeroo*, St Lucia, Qld, 1994.

novels, see **fiction**.

O

ochres are natural earthy red or yellow pigments, containing iron oxides or hydrated iron oxides. Originally the term referred to yellow ochres alone (Greek ōkhros, 'pale yellow') but is now used more broadly. Colour ranges from yellow through shades of brown to red, depending on the proportions of impurities and iron oxide, and the type of iron mineral present. Yellow ochres are goethite or limonite. In red ochre the pigment is the iron mineral haematite, from the Greek haimatites 'blood-like'. Yellow goethite dehydrates to red haematite on weathering or heating. Aboriginal people roasted dull brown or yellow earths to produce a deep red pigment. Most ochres occur as mixtures of iron minerals and other substances, typically quartz grains, mica, feldspars, and clays. White pigments are kaolin, gypseous clays or carbonates, without significant iron oxide content.

Ochre is found in ancient marine sedimentary formations, hydrothermal lodes or veins, or in Tertiary-age laterites. The best known ochre mines—Bookartoo (SA), Wilgie Mia (WA), Karrku (NT), and Toolumbunner (Tas.)—are discrete deposits where Aboriginal people use open-cut pits or tunnels to follow an ochre seam. Many red ochre deposits are associated mythologically with the blood of totemic beings—typically kangaroos, emus, dogs, or menstruating women—mirroring European use of the term 'haematite'.

High-grade red ochre is a valued commodity in Aboriginal Australia, and was once exchanged over hundreds of kilometres, in a trading system that sometimes involved organised expeditions. In the 1860s, Diyari people travelled from Coopers Creek to obtain red ochre from the Bookartoo mine in the northern Flinders Ranges, 300 kilometres to the south. The antiquity of the major mines and associated exchange systems is not known. However, ochres from different sources have characteristic chemical or mineralogical 'fingerprints'. Fragments of red ochre found in archaeological excavations in western central Australia, are sourced to the Karrku mine, still operating in Warlpiri country 125 kilometres to the north. Use of the ochre seam at Karrku appears to have continued over thirty millennia. Europeans have also exploited some Aboriginal ochre mines, such as Wilgie Mia, as sources of commercial pigments.

Aboriginal people use ochres as body paint (for decoration and to make people feel cool), as a preservative coating covering balls of desiccated fruit, as a coating on wooden implements, as paint in ground paintings, on bark paintings, or in rock art. Ochres are ground and rubbed onto the body either directly as a dry powder or after rubbing the body with grease. Red ochre is daubed on novices during initiation ceremonies. Both men and women use ochre as a ritual cleanser during ceremonies. The most desirable ochres are those with a deep red colour, good covering qualities, and a metallic sheen (small flakes of crystalline haematite give these pigments their distinctive lustre). In prehistory, the use of ochres in mortuary rites is shown by the burial of a man covered in red ochre at Lake Mungo, dating to more than 40 000 years ago. Pieces of red ochre are ubiquitous in early archaeological sites across Australia. Ground crayons of heavy crystalline haematite have been found in the earliest levels of archaeological sites in western Arnhem Land, dating to 50 000–60 000 years ago.

Rock paintings were produced by using ground ochre mixed with water, usually without the addition of organic binders such as blood or grease. Red ochre bonds to rock surfaces more successfully than other ochres, possibly because the platform of haematite gives it strong adhesive qualities. Clay-rich pigments are subject to alternate swelling and shrinking, causing rapid flaking of painted surfaces. An ochre-stained rock slab excavated at Carpenters Gap rock shelter, Kimberley region (WA), dates to 39 000 years ago and may be part of ancient wall paintings. The earliest surviving rock paintings are red ochre 'Bradshaw' designs and hand stencils in the Kimberley region, some dating to at least 17 000 years ago. Some of the rock art in Kakadu is thought to be of similar age. Red-ochre hand-stencils made about 11 000 years ago have survived in limestone caves in south-western Tasmania. Contemporary Aboriginal artists in northern and central Australia continue to use natural ochres, mixed with wood glue as a binder, in paintings on bark or on canvas.

MS

See also: body adornment.

Rosenfeld, A., *Rock Art Conservation in Australia*, 2nd edn, Canberra, 1988; Sagona, A. (ed.), *Bruising the Red Earth*, Melbourne, 1994; Smith, M. A., Fankhauser, B. & Jercher, M., 'The changing provenance of red ochre at Puritjarra rock shelter, Central Australia: Late Pleistocene to Present', *Proceedings of the Prehistoric*

Society, vol. 64, 1998; Walsh, G. L., *Bradshaws Ancient Rock Paintings of North-West Australia*, Carouge-Geneva, 1994.

Oenpelli, see Injalak.

ONUS, Bill (William) Townsend (1906–1968), Yorta Yorta craftsman, actor, film-maker, writer, entrepreneur, activist, was born at Moama (NSW), grew up on the Cummeragunja Aboriginal Reserve, and at twelve went droving with his family in the Riverina. At sixteen he left home to work as a shearer and in 1928 he married Bella Patten. The next year he moved to Sydney where he worked for several Aboriginal agencies organising dances to provide legal assistance for Aboriginal people migrating to the city. After the war, Bill Onus joined his parents in Melbourne and in 1947 married Scotswoman Mary McLintock Kelly. Their only child, (William McLintock) **Lin Onus** was born the following year. With his brother Eric, and Doug Nicholls, Bill Onus revived the Australian Aborigines League. In his political activism Onus used every available platform—clubs, community groups and the media—to fight for Aboriginal equality and justice. He became the first Aboriginal Justice of the Peace, the first president in 1967 of the Aborigines Advancement League (Victoria) and before his death on 10 January 1968, he played a major role in the campaign for the **referendum of 1967**. Alma Toomath said of him in 1992: 'Bill gave you determination and a good cultural way, and in those negative times he made you think positively.'

Onus was also a fine craftsman and a champion **boomerang** thrower. Trading from his home in Deepdene, a Melbourne suburb, Onus gained renown for his displays of boomerang throwing at venues such as Station Pier and St Kilda in Melbourne and the Colin Mackenzie Sanctuary, Healesville. In 1952 he established Aboriginal Enterprises, a tourist outlet for Aboriginal art in Belgrave (Vic.). Funding for this venture came from compensation Onus received for injuries sustained in a traffic accident, which left him an invalid for a year. Unable to return to his former employment as a wharf tally clerk, Onus sought an alternative means of income. Aboriginal Enterprises offered a wide range of merchandise: **bark paintings** from Arnhem Land and locally-made artefacts, **furniture**, textiles, and pottery decorated with motifs from traditional Aboriginal art. With additional branches at Narbethong (Vic.) and Port Augusta (SA), Bill Onus provided employment and training and fostered a strong sense of cultural pride among a new generation of urban Aborigines.

With Doug Nicholls, Bill Onus organised several highly successful theatrical performances: *Corroboree* in April 1949 at Wirth's Olympia, and *An Aboriginal Moomba: Out of the Dark* in June 1951 at the Princess Theatre, Melbourne—the latter staged in protest against the exclusion of Aborigines from the Melbourne Jubilee celebrations. In 1954, Bill Onus gave the name 'Moomba' to Melbourne's new autumn festival. Onus acted in several Australian films, and in 1962 he compered the prize-winning *Alcheringa*, a twelve-part ABC **television** series recreating a traditional Aboriginal lifestyle. In 1967 he featured with Doug Nicholls in *Forgotten People*, a film about Aboriginal people in the Murray–Goulburn Valley of Victoria.　　　　　　　　　　　　　　　SK

See also: 11.1, 12.1, 13.1; **festivals**; *364*.

Howie-Willis, I., 'William (Bill) Townsend Onus', in Ritchie, J. (ed.), *Australian Dictionary of Biography*, vol. 15, Melbourne, 2000; Kleinert, S., 'An Aboriginal Moomba: Remaking History,' *Continuum*, vol. 13, no. 3 1999.

ONUS, Lin (William McLintock) (1948–1996), Yorta Yorta painter, sculptor, activist, and administrator, is widely acknowledged as a pioneer of the Aboriginal art movement in urban Australia. The only child of **Bill Onus** and Scottish mother, Mary McLintock Kelly, Onus acknowledged and reconciled his mixed ancestry in his art. He grew up in Melbourne and left school at fourteen because of the racism he experienced. With time on his hands, and having discovered a set of children's watercolours, he began painting in the early 1970s. Being self-taught gave him the freedom to study a diversity of artists. His 'masters' ranged from Nyungah artist Revel **Cooper**, Koori artist Ronald **Bull**, and Arrernte artist Albert **Namatjira**, to Ainslie Roberts, illustrator of Aboriginal legends, and the surrealist elements in the early works of Sidney Nolan and Albert Tucker. Another training ground of profound significance was Aboriginal Enterprises, his father's business.

As Victorian representative of the **Aboriginal Arts Board** of the Australia Council in 1986, Onus had the opportunity

364.　Revel Cooper (*l.*) and Bill Onus with a boomerang in the 'Carrolup style' produced by Aboriginal Enterprises, *c.*1955.

to visit **Maningrida** in Arnhem Land and meet traditional elders such as Jack **Wunuwun**, who became his adoptive father and mentor. Through his interaction with Wunuwun and his extended family, maintained over sixteen years, he developed a distinctive visual language from a combination of traditional and contemporary Aboriginal imagery, and photorealist landscapes. From 1988 Onus worked predominantly in sculpture, the medium in which he could best combine his wide range of manual skills from previous occupations as a panel beater, motor mechanic and carver, and which provided the interaction with his viewers that he desired.

He was the recipient of many awards. These included the introduced media section in the 1998 NAAA (now NATSIAA), and the 1993 Kate Challis RAKA Award; he received the Order of Australia the same year. He was overall winner of the 1994 NIHAA as well as of the People's Choice Award. Appointed a member of the Aboriginal Arts Board of the Australia Council in 1986, he became Chairman of the Board from 1989 to 1992, was co-founder of the Aboriginal Artist Management Association in 1990 and a founding member and director of Viscopy in 1995.

He mounted his first exhibition at the Aborigines Advancement League in 1975 and had another seventeen solo exhibitions in Melbourne, Canberra and Sydney, which, together with group shows, made a total of about eighty exhibitions in Australian and international venues. Overseas exhibitions included 'Tagari Lia: My Family' (Glasgow 1990) and 'Aratjara' (Düsseldorf, London, and Humlebaek 1993–94). Onus is represented in major public, private and corporate collections. Reflecting on his own life in 1990, Onus said: 'I kind of hope that history may see me as some sort of bridge between cultures, between technology and ideas.' MN

See also: 11.1, 12.1; **art awards and prizes, cartoonists**; *163, 254, 266, 274*.

Neale, M. (ed.), *Urban Dingo: Lin Onus Retrospective*, Sydney, 2000; Onus, L., 'Southwest, southeast Australia and Tasmania', in B. Lüthi (ed.), *Aratjara, Art of the First Australians: Traditional and Contemporary Works by Aboriginal and Torres Strait Islander Artists*, Cologne, 1993; Ryan, J., 'Lin Onus', *Art and Australia*, vol. 35, no. 1, 1997.

OODGEROO, see Oodgeroo **Noonuccal.**

oral history, see **family histories.**

ORSTO, Maria Josette, see **Apuatimi family.**

OSCAR of Cooktown (*c*.1878–?), possibly Gugu Yalanji. The work of 'Oscar' is known from a single, small sketchbook in the collection of the NMA. It contains forty drawings, and a letter taped inside the front of the book gives what little information exists on the life of the artist. The letter indicates that 'Oscar' was an Aboriginal boy of nine or ten when he was taken from Cooktown in 1887 and brought by police to work for A. H. Glissan, manager of the Rocklands cattle

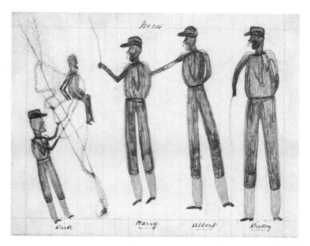

365. Oscar, *Police Boys Doing Duty (Lynch Law)*, 1890s. Pencil and coloured pencil on paper, 16 x 20.4 cm.

station, near Camooweal in north-western Queensland. The letter, written by Glissan when he sent the book to a friend in March 1899, concludes with captions for each of the drawings: 'The index will give you all the information, this the boy gave me in his own way, & I have put it as well as I can.'

Glissan's captions give some place names (Cooktown, Maytown, the Palmer River, Camooweal), but they also capture his sense of what Oscar was trying to communicate, for example 'Cooktown Swells'. However, analysis of the drawings reveals a level of story-telling within the drawings which goes beyond their captioning by Glissan.

The book itself is a small (15 x 20 cm) lined notebook, and the materials used by Oscar are lead and coloured pencils. The drawings depict a range of subjects including traditional hunting and dancing scenes, figures from town and station life, and drawings of the Queensland Native Police. The Palmer River in north-eastern Queensland was the centre of a major gold rush in the 1870s and saw tens of thousands of miners invade an area which had hitherto been scarcely visited by non-Aboriginal people. Most were Chinese, and the sketchbook includes drawings of them, of mining officials and successful merchants of the goldfield towns.

Narrative is evident within the drawings, and they are also, at some level, autobiographical in that they trace his movement from the Palmer River and Cooktown to the inland of western Queensland. Oscar's drawings, especially those of the Native Police, are a rare document from the Aboriginal side of the frontier. Little is known of his life after 1899, when Glissan dispatched the notebook. By a curious route the tiny book was finally deposited at the Institute of Anatomy in Canberra, and was transferred from there to the collections of the NMA. KMCK & CAC

See also: 8.1, 8.2, 11.1; *365*.

Sayers, A., *Aboriginal Artists of the Nineteenth Century*, Melbourne, 1994.

P

PAMBEGAN, Arthur Koo'ekka Sr (1895–1972), Wik-Mungkan sculptor, was a leader of the Winchanam ceremony who lived at Aurukun in the western Cape York Peninsula (Qld). His totem was the willy wagtail. Pambegan was a major informant for the anthropologist Ursula McConnel in the 1950s. His sculptures were usually made for ceremonial purposes and he was not prolific as an artist in the public domain. His most famous works, made in collaboration with his son Arthur Koo'ekka Pambegan, Jr (1936–)—*Flying Foxes*, and *Bonefish*—were created for a public ceremony at Aurukun in 1962. The ceremony was filmed by Ian Dunlop.

The two works incorporate the traditional fork stick and cross-beam structure. The entire ceremonial group of sculptures was collected by F. D. McCarthy and is now housed in the NMA. Pieces were exhibited in the touring exhibition 'Aboriginal Australia' (AGDC 1981–82), 'The Continuing Tradition' (NGA 1989) and 'World of Dreamings' (St Petersburg 2000). DM

See also: 9.1, 9.2; Angus **Namponan**; *366*.

Cooper, C., Morphy, H., Mulvaney, J. & Peterson, N., *Aboriginal Australia*, Sydney, 1981; Sutton, P. (ed.), 1988, *Dreamings: The Art of Aboriginal Australia*, New York & Ringwood, Vic., 1988.

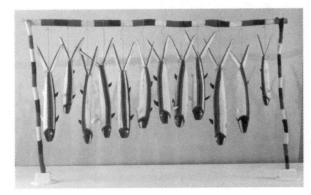

366. Arthur Pambegan, *Bonefish*, 1962.
Paint on wood, 140 x 216.5 cm.
The rack of fish formed the centrepiece of a dance which represented bonefish being hunted at night by spear fishermen in canoes.

Papunya Tula Artists is one of the most successful Aboriginal-owned and directed businesses in Australia, having operated without government assistance for close to two decades. Its member artists were the founders of the Western Desert art movement.

The Papunya Tula Artists company was incorporated in 1972 in the wake of art teacher Geoffrey Bardon's successful work in 1971–72 establishing a professional painting enterprise with the senior men of the numerous Western Desert groups living at the remote government settlement of Papunya. Many of the founding artists subsequently became some of the best known names in desert art. They included Old Mick Tjakamarra (c.1900–1996), Old Walter Tjampitjinpa (c.1910–1981), **Kaapa Mbitjana Tjampitjinpa**, Tim **Leura Tjapaltjarri**, David Corby Tjapaltjarri (c.1945–1980), Mick **Namarari Tjapaltjarri**, Old Tutuma Tjapangarti (c.1915–1987), Uta Uta **Tjangala**, Anatjari Tjakamarra (c.1932–1992), Charlie **Tjararu Tjungurrayi**, Tim **Payungka Tjapangarti**, Johnny **Warangkula Tjupurrula**, Long Jack Phillipus Tjakamarra (c.1932–), Billy **Stockman Tjapaltjarri**, Turkey **Tolson Tjupurrula**, Yala Yala Gibbs Tjungurrayi (c.1925–1998), Charlie Egalie Tjapaltjarri (c.1940–), John Tjakamarra (c.1933–), Shorty Lungkarda Tjungurrayi (c.1920–1987), and Clifford **Possum Tjapaltjarri**.

During the difficult years of the 1970s, this core group laboured in obscurity, inventing a secular painting language based on the circles, lines, and tracks of ceremonial sand and body painting, in which hundreds of desert artists have since painted their **Dreamings** for the art market. During this decade they were joined by a few others, notably Paddy Carroll Tjungarrayi (c.1927–), Dinny Nolan Tjampitjinpa (c.1922–), Tommy Lowry Tjapaltjarri (c.1935–1987), Anatjari Tjampitjinpa (c.1932–), Limpi Tjapangati (c.1930–1985), Willy Tjungurrayi (c.1930–), and Freddy West Tjakamarra (c.1942–1994). A succession of devoted and overworked art coordinators including Peter Fannin, Dick Kimber, Janet Wilson, John Kean, and Andrew Crocker—and, since 1982, the inimitable Daphne Williams AM—managed the day-to-day running of the company.

Not until the early 1980s did the Australian art world—and the art market—begin to show any interest in the work of the Papunya Tula artists. At this time a group of younger painters was added to the company's books, including Maxie

Tjampitjinpa and Michael **Nelson** Tjakamarra (later Jaga-marra). Their accomplished works in the mature Papunya Tula style assisted the recognition of Papunya Tula painting as contemporary art—and, simultaneously, as the expression of the ancient cultural traditions of which the painters, and the peoples of the Western Desert, were custodians. This direction was signalled by the company's first group show featuring named individuals (Uta Uta Tjangala, Clifford Possum Tjapaltjarri, and Paddy Carroll Tjungarrayi), at the Adelaide Arts Festival in 1984.

Meanwhile the homelands movement was gathering momentum, fuelled by the money from steadily increasing painting sales. Pintupi 'outstations' of Papunya had previously been established by the authorities in an effort to relieve pressures at the troubled settlement, for example at Brown's Bore and Yayayi. Kintore, established in 1981, was an entirely Pintupi initiative. The township, 300 strong, spear-headed the re-settlement of the lands from which the Pintupi had been variously frightened, cajoled and driven over the preceding generation. The success of this courageous act of self-determination was in large part made possible by Papunya Tula, which continued its support of the painting enterprise, despite the arduous travel involved, especially when the Pintupi pushed a further 250 kilometres west across the Western Australian border to establish Kiwirrkura in 1985.

The market for Western Desert painting expanded rapidly, following the acquisition of Papunya Tula works by major public galleries and museums and some high profile private collectors. 'Face of the Centre' (NGV 1985) and 'Dreamings' (New York, Los Angeles, and Chicago 1988–89), helped to bring the work of the pioneer desert painters before national and international audiences. Solo exhibitions of the company's artists and survey shows of Papunya Tula Artists in North America, New Zealand, Japan, and Russia followed in the early 1990s, cementing its high profile in the Indigenous art movement.

The number of artists painting for Papunya Tuka increased markedly in the 1990s. The artist body finally included women, many of whom had become highly proficient in the Western Desert style through helping on the backgrounds of their husbands' and other male relatives' paintings before beginning to paint in their own right. The senior Pintupi women of Kintore, who began painting for the company in the mid 1990s, have emerged as a distinctive group of artists whose richly textured and often vibrantly coloured work is increasingly gaining attention. In general, the traditional Papunya Tula palette of red ochre, yellow ochre, black, and white steadily expanded to include brighter colours and a broader range of tones.

Papunya Tula Artists has remained strong. Oriented to the needs of the communities it serves, it remains true to its original objectives, eloquently expressed in a statement from a meeting of its artists in 1986:

We are not 'turning our heritage into cash'—we want the whole world to know our culture ... Now our art is recognised world-wide for itself. We keep our 'sacred heritage' for ourselves, for our ceremonies, and for our children. We Papunya Tula artists have our culture and we want to pass it on to our children ... The style has changed but not the message. VJ

See also: 9.4, 9.5, 9.7.

Bardon, G., *Papunya Tula*, Ringwood, Vic., 1991; Brody, A. (ed.), *The Face of the Centre: Papunya Tula Paintings 1971–84*, Melbourne, 1985; Johnson, V., *Aboriginal Artists of the Western Desert: A Biographical Dictionary*, Roseville, NSW, 1994, Myers, F., 'Aesthetic function and practice: A local art history of Pintupi painting', in H. Morphy & M. Smith Boles (eds), *Art from the Land: Dialogues with the Kluge–Ruhe Collection of Australian Aboriginal Art*, Charlottesville, VA, 1999.

PAREROULTJA brothers, Otto (1914–1973), Reuben (1916–1984), and Edwin (1918–1986), Western Arrernte watercolour painters. Writing in 1951, the Victorian artist Rex Battarbee hailed the work of the first formative group of ten Hermannsburg artists as a new art historical movement—a *Modern Australian Aboriginal Art*. Foremost among a new generation of emerging young artists, he identified the three Pareroultja brothers as a 'breakaway group' who displayed great individuality. Influenced by **Namatjira**, but radically departing from his more representational style, the Pareroultja brothers painted brilliantly coloured, densely patterned, and rhythmically pulsing landscapes that demonstrably asserted their **Aboriginality**.

Battarbee initially admired the work of Edwin Pareroultja, the youngest in the family and the first to take up painting. Like his brothers, Edwin had worked around the mission as a stockman, carpenter, shearer and gardener, but he was also a champion athlete and a musician of note. His style is remarkable for its combination of detailed patterning within a perspectival landscape. Already in 1938 Reuben Pareroultja had produced a finger-painting of a pair of emus for visiting art teacher Frances Derham, and Battarbee later commented upon the veracity of the animals he depicted. While many commentators likened Otto Pareroultja's artistic expression to the work of European modernists such as Vincent van Gogh and Paul Gaugin, the anthropologist T. G. H. Strehlow and Rex Battarbee himself drew connections between the swirling parallel lines and concentric circles of Otto's work and the designs found on the *tjuringa* (sacred boards) associated with ceremonial life.

The Pareroultja brothers exhibited widely from 1947 and their work was purchased by several State galleries, but they never gained the same recognition or popularity as the leader of the Hermannsburg School, Albert Namatjira. Exhibitions mounted since 1984 have begun to redress the balance, and the work of Otto Pareroultja was included with Albert Namatjira's in 'The Great Australian Art Exhibition 1788–1988' (AGSA 1988). SK

See also: 9.1; 112.

Battarbee R., *Modern Australian Aboriginal Art*, Sydney, 1951; Thomas, D. (ed.), *Creating Australia: 200 Years of Art 1788–1988*, Sydney, 1988.

Paru women artists, Tiwi bark painters and sculptors. Paru is situated on Melville Island, directly across the Apsley Strait from Nguiu on Bathurst Island (NT). Over the decades it has been a camp for older Tiwi who have chosen to reside there rather than in the main communities. Many artists have lived here over the decades, particularly up to the 1960s, as artistic

pursuits and ceremonies were not encouraged by the Catholic Mission at Nguiu. In the 1970s and 1980s Kitty Kutulumi Kantilla (1928–) and several other Tiwi women lived at Paru, producing art for sale at Nguiu. Their style was quite distinct from that of the women artists at Nguiu, in part because they were older women, but also because of their isolated life. Other women living at Paru included Rachel Warlapinni (1931–), Mary Tupalatu Puraminni (1924–), Topsy Kitampumeiu Kerinauia (1930–1991), Marjorie Tipuwangipila Woneaemirri (1920–1990), and Marie Celine Purrakijipiyiti Porkalari (1926–1993). As a result of the proliferation of their work, a significant exhibition, 'Carved Wooden Sculptures by Tiwi Women from Paru' was held at Aboriginal Arts Australia, Sydney in 1988. It was a powerful and energetic display of bold carving with coarse and subdued, but carefully decorative, painting. These artists were not using the contemporary tools for sculpture, such as chainsaws and grinders, glue and brushes. Instead they continued to make their own brushes and glue (from the sap of trees) and to finely chisel their sculpture. By the early 1990s many of these women had passed away or wished to be closer to family members in the communities. After many years Kitty Kantilla moved to join her family at Milikapiti on Melville Island. She commenced painting at Jilamara Arts and Crafts, but by this time she had ceased carving. As the oldest female artist at Milikapiti and because of her use of the traditional geometric designs, Kitty Kantilla came to be one of the most acclaimed artists of her generation. The young Tiwi are always impressed with all she produces. Her work has been included in many group exhibitions and events in the 1990s, including two solo exhibitions at the Aboriginal and South Pacific Gallery, Sydney (1993, 1995).

KAB

See also: 7.6, **art and craft centres**, **Tiwi Design**, *334*, *371*.
Barnes, K., *Kiripapurajuwi (Skills of Our Hands): Good Craftsmen and Tiwi Art*, Darwin, 1999; Bennett, J., 'Narrative and decoration in Tiwi painting: Tiwi representations of the Purukuparli story', *Art Bulletin of Victoria*, no. 33, 1993; Croft, B. L. (ed.), *Beyond the Pale: 2000 Adelaide Biennial of Australian Art*, Adelaide, 2000.

PAYUNGKA TJAPANGARTI, Tim (c.1942–), Pintupi visual artist, was one of three living artists who were applicants in the landmark Aboriginal Carpet Case (*Milpurrurru et al. vs Indofurn Pty Ltd*) of 1995, the first case involving **copyright** infringement of Aboriginal art works to go to full trial. His affidavit speaks from a lifetime's passionate involvement with country and **Dreaming** heritage: 'I wish the court to know that I am very upset and angry about the copying of my painting onto carpets … I am old and unwell from a kidney complaint and the actions of the respondents … are insulting to me as an artist, and seriously offend my cultural traditions and those of the Pintupi tribe, of which I am an elder.'

Payungka Tjapangarti was born just west of Central Lake Mackay. He and his family had already walked hundreds of kilometres into Haasts Bluff to sample 'whitefella' tea and flour, and gone back to Pintupi country to continue their nomadic lifestyle, when they were picked up by the Northern Territory Welfare Branch patrols in the early 1960s and

brought into **Papunya**. Part of the original 1971 painting group at the settlement, Payungka joined the Pintupi exodus to Kintore in 1981 and moved further west in the mid 1980s to Kiwirrkura, in the establishment of which he was a key figure. The painting *Kangaroo and Shield People Dreaming*, 1980, illegally copied by the carpet manufacturers, was featured in 'Dreamings' (New York, Chicago, and Los Angeles 1988–89). Other significant group exhibitions in which Payungka has participated include 'L'été Australien' (Montpellier 1990), 'Tjukurrpa Desert Dreamings' (AGWA 1993), and 'Power of the Land' (NGV 1994). Examples of his work may be found in the NGA, SAM, most State gallery collections, the Holmes à Court Collection, Heytesbury (WA), and the Kelton Foundation, Santa Monica.

VJ

See also: 9.4, 22.1; *262*.
Bardon, G., *Papunya Tula*, Ringwood, Vic., 1991; Johnson, V., *Copyrites: Aboriginal Art in the Age of Reproductive Technologies*, Sydney, 1996; O'Ferrall, M., *Tjukurrpa Desert Dreamings: Aboriginal Art from Central Australia 1971–1993*, Perth, 1993.

PENRITH, Harry, see **Burnum Burnum**.

PERKINS, Charles, see **Freedom Ride**.

PERKINS, Rachel (1969–), Eastern Arrernte–Kalkadoon film-maker, was born in Canberra in 1969 to an Aboriginal father and German mother. She travelled Australia with her parents until she was seventeen. Her father is the activist and bureaucrat Charles Perkins. She decided to settle in Alice Springs, where she began a traineeship in **television** production at the Central Australian Aboriginal **Media Association** (CAAMA). During her three years at CAAMA, she produced and directed programs for the Aboriginal-owned television station Imparja. She moved to Sydney to work as a producer, and established a unit for Indigenous production at the Special Broadcasting Service (SBS). There she produced and directed the four-part series *Blood Brothers* (1993) which won the inaugural Tudawali Award for excellence in Indigenous film and television. She was also the producer of *Manyu Wana* in 1991, a ten-part children's television program. While at SBS, Perkins established Blackfella Films with Michael **Riley**, and produced the international series about Indigenous peoples, *From Spirit to Spirit* (1993).

Perkins then worked independently in the film industry and also organised finance for the series *Sand to Celluloid* for the Australian Film Commission's Indigenous Branch. In 1995 she completed a one-year degree in producing at the Australian Film, Television and Radio School and worked as a producer with the Indigenous Programs Unit at the ABC. She produced the series *Songlines* and directed and produced *Crim TV* (1997), a documentary film about Indigenous prisoners and their production of a video aimed at making young offenders aware of the realities of prison life. She left the ABC in 1998 to direct her first dramatic feature, *Radiance* (1998), which forced her to reconceptualise her film-making and focused her energy on making Indigenous films accessible to mainstream audiences. *Radiance* was nominated for six Australian Film Institute awards, including best picture and best director, and won Deborah Mailman the AFI's Best

Actress award for her part as Nona. Rachel Perkins is a strong advocate of the Indigenous film industry, having served on the board of the National Indigenous Media Association of Australia and being a founding member of Indigenous Screen Australia. She has continued her support through the compilation of the *Black Book Directory 2000*, a directory of Aboriginal and Torres Strait Islander arts and media workers. IB

See also: 13.1; *178*.

PETERS, Rusty (Dirrji) (1935–), Kija painter, was born under a *warlagarri* (supplejack) tree on Springvale station southwest of Turkey Creek, on the same day as his *jimarri* (age mate) Charlie McAdam. His 'bush' name, Dirrji, refers to dingo pups looking out of a hole at the sunrise. His conception spirit came from a crocodile his father had killed. He grew up on Springvale learning traditional Law and working as a stockman. When his father was killed in a tragic riding accident at Roses Yard, the family moved to Mabel Downs where he became renowned as a horse-breaker. He lived for some time at Nine Mile reserve at Wyndham after the introduction of award wages had forced people off the stations, but then moved to Turkey Creek where, with other senior Kija artists such as Hector **Jandany** and George **Mung Mung**, he helped start the school. As part of the Kija cultural program, he took groups of boys out bush, showed them how to make spears and hunt, and how to make a camp without matches or blankets, in the traditional way. He also worked in the Kija language maintenance program.

In 1989 he moved to Kununurra, where he was employed at **Waringarri Aboriginal Arts** as an assistant. He was a long-time friend of **Rover Thomas**, and cared for him on most of the trips he made in the later part of his life. He made prints and did some painting while working for Waringarri Arts. He moved to Crocodile Hole when Freddie Timms based the Jirrawun Aboriginal Arts group there in 1997, and began to paint on large canvases. His detailed knowledge of the land and stories from Springvale and neighbouring Moolabulla stations is reflected in distinctive paintings in traditional red and yellow ochres and black charcoal. While his work is recognisably in the 'Turkey Creek' style, the intricate curves which map the country and the dark caves and rivers are particular to his work. FK

See also: 10.1, 10.2; Mabel **Juli**.
McAdam, Charlie and family, as told to Elizabeth Tregenza, *Boundary Lines*, Ringwood, Victoria, 1995; William Mora Galleries, *Rusty Peters, Kimberley Stories*, Melbourne, 1999.

PETERSEN, Clinton, see Clinton **Nain** (Petersen)

PETERS-LITTLE, Frances Claire (1958–), Gamilaraay singer–songwriter, documentary film-maker, and author was brought up in Balmain, and her early life was caught up in Sydney's emerging black activist politics. She was greatly influenced by her parents, Marjorie and Jimmy **Little**. As a poet, actor, and singer for theatre and **television** during the 1970s and early 1980s, her creative work echoed the concerns of other urban black activists; her voice joined others in the demand for **land rights** and social justice.

By the mid 1980s Peters-Little had become aware that her perspective on black politics was intensely personal, diverging significantly from the general rhetoric that defines it: 'Your politics have to be personal, otherwise you're just fighting someone else's battles.'

In the 1990s she performed as lead singer with country n' blues bands All In Vain and Preferred Models, working simultaneously as a radio journalist for 2RSR FM and studying at the University of Technology, Sydney. After graduating in 1991 she worked with the ABC as a director, producer, and writer, producing films for the *Blackout* series and a number of documentaries, including four in the *Storytellers of the Pacific* series, and *Tent Embassy*. She was a Rockefeller Fellow at New York University in 1994, and is currently working towards an MPhil in History at the ANU. She continues to write. SC

See also: 13.1, 13.2; *180*.

PETYARRE, Ada Bird, see Ada **Bird Petyarre**.

PETYARRE, Gloria Tamerre (*c.*1945–), Anmatyerre visual artist, has emerged from the remote **Utopia** (NT) community to become one of the most dynamic forces in contemporary Australian art. Petyarre's country, Anungara, is the inspiration for all her art. 'I paint *awelye*', she has stated, referring to the body paint applied for ceremonies that celebrate the elements that constitute Anungara. The marks symbolise the whole concept of women's knowledge for this land, and their importance in Petyarre's works is fundamental.

At the end of the 1970s Gloria Petyarre was a founding member of Utopia Women's **Batik** Group. She merged the stories for *arnkerrthe* (the mountain devil lizard), *arlatyeye* (pencil yam), *ntange* (grass seed), *ankerre* (emu), and *atnwerle* (green bean) into dramatic lengths of silk. The work she created over the next decade was a significant contribution to the group, and she travelled to Ireland, England, India, France, and Thailand as its representative. In early 1989 Petyarre made her first painting on canvas. She soon developed a unique style—one that continues to evolve. Traditional motifs rapidly became absorbed into abstract fields, though she is quick to link specific marks with leaves, grasses, and body paint. The substance of her paintings is her country: 'People have to use their imagination', she states.

In 1993 Petyarre collaborated with the Victorian Tapestry Workshop on several large tapestries, one for the Brisbane Law Courts; she also travelled to Kansas to paint a mural for the City Zoo. In 1995–96 she received an **ATSIAB** Fellowship Grant, leading to a survey exhibition at CCAG in 1998. Petyarre has been an ambassador for her art and her country through regular solo exhibitions and inclusion in significant touring exhibitions of contemporary Aboriginal art such as 'The Continuing Tradition' (NGA 1989), 'Utopia—A Picture Story' (Dublin, Cork, and Limerick 1990), 'Aboriginal Women's Exhibition' (AGNSW 1991), and 'Power of the Land' (NGV 1994). Her work is held in every major Australian public collection. Her ability to communicate to a wide audience was no better illustrated than when she opened the Emily Kame **Kngwarreye** exhibition at QAG in 1998. Her haunting song and acknowledgment of the

deceased artist's presence united everyone present. This is her gift. CH

See also: 9.5, 9.6; *216, 367*.
Brody, A. M. with Gooch, R., *Utopia—A Picture Story: 88 Silk Batiks from the Robert Holmes à Court Collection*, Perth, 1990; Garside, S. (ed.), *Gloria Tamerre Petyarre*, Sydney, 1998.

PETYARRE, Kathleen (*c.*1940–), Eastern Anmatyerre painter, travelled as a child with her extended family around her father's and grandfather's country Atnangkere, about 275 kilometres north-east of Alice Springs (NT), developing an encyclopedic knowledge of its flora, fauna, rock holes, soaks, and other significant sites. Petyarre estimates that she would have been about seven or eight when the family first came across a white person.

In the late 1970s, with other Anmatyerre and some Alyawerre women from the **Utopia** region, she began learning **batik** techniques at an adult education course. About the same time she became a key claimant in a claim for Anmatyerre freehold title over the Utopia pastoral lease.

Since then Petyarre's artistic career has blossomed. Working full-time as a professional artist, she has won several major prizes and commissions, including the 1996 NATSIAA and the 1997 VisyBoard Art Prize. She was commissioned for the John McCaughey Memorial Art Prize in 1997. She has had many solo and group exhibitions in Australia and overseas.

In 1997 Petyarre's estranged, white, de facto husband claimed he had painted the lion's share of *Storm in Atnangkere Country,* her winning NATSIAA painting. His claims were investigated by the board of MAGNT, which eventually cleared Petyarre's name.

One of seven sisters, all of whom are artists, Petyarre is the senior custodian of the *arnkerrth* (thorny devil) **Dreaming.** A small, timid lizard with alarming-looking spikes on its head and back, *arnkerrth* typically moves in a quasi-circular fashion leaving an exquisite pattern of tiny, not-quite-concentric tracks. These have become something of a trademark in Petyarre's work. Petyarre recreates the journeys of *arnkerrth* through sandstorms, over sand dunes, across mountains, through watercourses, and even underground. The creature survives in harsh terrain largely because of its modest dietary and water requirements and its chameleon-like camouflage. This is reflected in Petyarre's use of a limited palette of colours. In some paintings a central square or rectangle represents the initiation ground, a section of which is reserved for women's initiations. There is, therefore, a secret–sacred, gender-specific dimension to these paintings, which the artist deliberately obscures by means of an elaborate dot cover.

Petyarre now mostly works in Adelaide. When she returns home she spends time schooling younger Anmatyerre women in the correct preparation of canvases and painting techniques. Her painstakingly precise application of tiny dots means that each painting can take days, sometimes weeks to complete. In her persistence and patience Kathleen Petyarre resembles her Dreaming ancestor, *arnkerrth,* more than a little.
CN

See also: 9.5, 9.6, 21.3; **art awards and prizes**; *259*.

367. Gloria Petyarre. *Untitled*, 1990.
Acrylic on canvas, 239 x 60 cm.

Mellor, D., 'Kathleen Petyarre', in Museum of Contemporary Art, *Seppelt Contemporary Art Award Catalogue*, 1998; Nicholls, C., 'Kathleen Petyarre and the heroic odyssey of Arnkerrth', *Art Monthly Australia*, October 1998; North, I., *Expanse: Aboriginalities, Spatialities and the Politics of Ecstasy*, Adelaide, 1998.

PFITZNER, Milika Darryl (1949–), Kokatha visual artist. Darryl Pfitzner's Kokatha grandmother was brought to Adelaide as a servant in the late nineteenth century, and he and his mother were born there. As an adult he has travelled widely, working at various manual jobs. The turning point in his life came when staff at the Adelaide Community Centre introduced him to the Adelaide Aboriginal College of TAFE in the early 1980s. Pfitzner taught himself metalwork and jewellery making; he has worked as a **printmaker** (and cultural educator), but more recently he has produced some large-scale installations.

Pfitzner exploits the potential of found materials to create works which often address critical social issues—but he does so with 'black humour'. His jewellery is also characterised by its attention to detail: rather than precious stones, he casts small-scale works in materials such as cuttlefish, combining Indigenous and non-Indigenous techniques. Pfitzner was included in the touring Indigenous exhibition 'Black Humour' (CCAS 1997). One of his major commissions was *Yerrikartarta*, 1998, a ground sculpture and murals outside the Hyatt Hotel on North Terrace, Adelaide, in collaboration with Ngarrindjeri–Kaurna artist Muriel Van der Byl. In 1999 Pfitzner held a solo exhibition, 'Same Story, Different Places' at the City of Unley Museum (SA). MRM & JVSM

368. Darryl Pfitzner, *Beguiled (pastoral letter)*, 2000.
Bone (sheep skull) fragments and acrylic on marine ply, diameter 120 cm.
This piece was exhibited in '3SPACE-21st Century Indigenous Explorers' (Tandanya Cultural Institute 2000).

See also: 12.1; *368*.
Mellor, D. & Norman, R., *Circles About the Body*, Launceston, 1997; Pring, A., *Aboriginal Artists in South Australia*, Adelaide, 1998; Pfitzner, D., *Same Story, Different Places: An Urban Dreaming*, Adelaide, 1999.

photography, see 8.5, 12.1, 12.4.

PIKE, Jimmy (*c*.1940–), Walmajarri visual artist. A fellow prisoner awaiting trial at Canning Vale Remand Centre gave Jimmy Pike the idea of taking up painting and earning his living through art. 'I thought about it', says Pike, 'but I didn't try it out till I went to Fremantle'.

Pike spent his early years in a semi-nomadic family group in the Great Sandy Desert (WA). He learnt skills needed to earn a living and find his way confidently around the vast sandhill country of his people. He memorised the position and the attributes of hundreds of small waterholes, and the stories and ceremonies that give his country meaning. Pike's exposure to art, in a country with few materials, was slight. People painted their bodies for ceremonies, carved tools and containers for food and water, and incised wooden boards with intricate designs. There were few rock paintings in Walmajarri country. After leaving the desert with one of the last groups of his people, he worked on Cherrabun station as a stockman. He continued wood carving and when he moved to Fitzroy Crossing sold his work to tourists.

While serving a sentence in Fremantle prison in the early 1980s, Pike joined art classes. 'I started off doing landscapes like the other blokes', he says, 'then I thought, I'll try painting stories from my country. I did paintings on paper first. Then I did linocuts and paintings on boards and canvas.' Such his skill and confidence that his teachers, Steve Culley and David Wroth, immediately recognised his artistic potential. His first work sold at prison exhibitions. By his release in 1986 Pike had a growing reputation in art circles. Culley and Wroth formed a company to apply Pike's designs, and later those of other artists, to textiles and household goods, and devised the 'Desert Designs' label. Pike continues to supply work under licence to the company.

Pike's art is instantly recognisable, featuring abstract designs drawn from wood carving and body painting to depict his country and traditional stories; and modern themes as in *Prison Dining Room*, 1992. Even more characteristic are the active, occasionally grotesque, silhouette figures and animals of more representational works. Less interested in detail than in overall effect, Pike has a gift for capturing the essence of his subject. The felt-pen drawings he favours for designs and book illustrations are uninhibited in their use of colour, and often humorous.

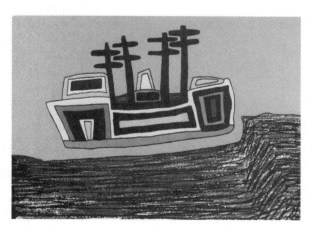

369. Jimmy Pike, *Kartiya Boat*, 1987.
Colour screen-print, 48.6 x 67.8 cm.

After leaving prison, Pike set up camp near Kurlku on the edge of the Great Sandy Desert and continued to paint. With others he visited and revived the waterholes of his country, and became active in the Walmajarri **native title** claim. He now spends most of his time between Broome and Fitzroy Crossing. His work has been exhibited in major galleries across Australia, and in Japan, Hong Kong, France, Germany, the UK, the Philippines, and the People's Republic of China. Pike has collaborated with his partner, writer Pat Lowe, on four books: *Jilji* (1990), *Yinti* (1992), *Desert Dog* (1997), and *Jimmy and Pat Meet the Queen* (1997). PL

See also: 10.1, 10.2, 23.2; *133, 270, 369*.
Christensen Fund, *Jimmy Pike: Graphics from the Christensen Fund Collection*, Perth, 1988; O'Ferrall, M. A., *Jimmy Pike: Desert Designs 1981–1995*, Perth, 1995.

PIRARD, Debra (1955–), jeweller, was born in Cloncurry, Queensland, and has lived in and around Mt Isa for most of her life. She is one of a few Aboriginal artists working with precious metals and related materials to make jewellery. Her life and work centre on the mining of metals from the Mt Isa region, part of her own country. Before her independent work as an artist, she worked in the design department of Mt Isa Mines, and often refers to industrial mining issues through her work. Her husband's employment with the mine has continued the association.

Pirard's relationship with the materials she uses began early, with copper gouging expeditions out bush with her family. She often uses the technique of *mokume gane*, the swirls created by beating silver and copper together becoming part of the vocabulary of cultural narrative constructed around the personal symbolism she ascribes to different metals. Living in Colombia for four years with her husband, a Belgian national born in the (then) Belgian Congo, awakened her interest in the symbology of different societies and cultures. This perspective was brought to workshops she conducted on Darnley Island in 1997, where her silversmithing skills were combined with traditional Torres Strait shell and seed necklace construction.

Since 1994, Pirard's work has been included in many exhibitions, including 'Circles About the Body', which toured nationally in 1997–99. She is active in Mt Isa's contemporary visual arts community, as a board member of a number of regional arts organisations. DOM

See also: 12.1; *370*.
Mellor, D. & Norman, R., *Circles About the Body*, Launceston, 1997.

PITT, Dulcie Ramer Lyra (Georgia Lee) (1921–), was born in Cairns and grew up in an extended family in Malay Town (in Cairns), where music and dance were important family and community activities. She combined early Torres Strait Islander and Aboriginal musical influences with later formal training to build a successful national and international career in live-performance, **television**, **radio**, and recordings as Georgia Lee. Her repertoire included Torres Strait Islander songs, blues, ballads, jazz and show-tunes, delivered in a sophisticated and dramatic style praised by audiences, critics and other musicians and singers.

Highlights of her long and varied career included tent-show performances in Queensland in the 1930s, Red Cross entertainments for military and civilian audiences during World War II, and lengthy seasons at Sydney's Tivoli Theatre, Melbourne's Ciro's Theatre-Restaurant and with Colgate-Palmolive Radio Shows after World War II. As an experienced and adventurous entertainer she performed overseas in Sri Lanka, and in the West End of London in the 1950s. In Australia she made numerous appearances on television, radio, and the concert platform in the period from the 1950s to the 1970s. Her Australian performances included several recordings, and lead roles in stage shows as varied as *An Aboriginal Moomba: Out of the Dark* (1951), *Burst of Summer* (1961), and *The Wiz* (1976).

She performed with many well-known singers, musicians and personalities including Graeme Bell, Harold **Blair**, Jack Brokensha, Nat King Cole, Geraldo, the Aboriginal actor and star of *Jedda* Robert Tudawali, John Wayne, and Candy Williams. She ranks as one of the most accomplished and multi-skilled Indigenous performers of her generation.

KN

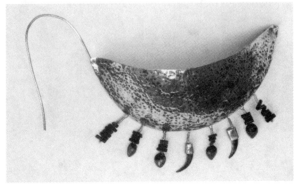

370. Debra Pirard, *Cheekpiece*, 1996.
Fine silver, kite claws, and black coral, 5.5 x 8 cm.

poetry. Indigenous poetry has a rich and complex heritage as well as an extensive variety of contemporary practices and styles. As the art form most intimately associated with **language** (and the land), poetry for Aboriginals and Torres Strait Islanders expresses the complexities of histories, as well as of contemporary Indigenous identities.

Traditional Aboriginal poetry still flourishes today in some of the many ancestral languages and dialects of Indigenous Australia, particularly in regions remote from the urban centres. Its important social, spiritual, educative, and ritual roles in Aboriginal culture continue as they have done for thousands of years. This is, though, a fragment of what must have been an immense universe of Aboriginal oral culture before white invasion. Ancestral songs are not merely traditional: they are sacred in that they stem from the **Dreaming** ancestors. Something of the place, colour, and ritual value of this poetry can be glimpsed in this exerpt from Ronald Berndt's translation of a Wuradilagu Song Cycle of north-eastern Arnhem Land:

Blowing from Rose River places, Snake places, wind swirling.
Southeast wind blowing from Rose River places:
Blowing from those places,
Blowing from the chest of the cloud, swirling.
Blowing from the black-girdled cloud, from the extended hands:
Flecked wind-blown clouds, from the chest of the yellow cloud.

The uneasy relations of oral-performative forms to white-settler literary knowledge and traditions have contributed to misunderstandings about the nature of Abori-ginal poetry. In 1964 when Oodgeroo **Noonuccal** (Kath Walker) published *We Are Going*, the first collection of original poetry in English by an Aboriginal, it was a popular success. But it was read by (white) critics within the then narrow and often unsympathetic context of Australia national traditions of poetry. When Jack **Davis** (*The First-Born and Other Poems*, 1970), Aileen Corpus (in *Identity* magazine in the 1970s), Kevin **Gilbert** (*People Are Legends*, 1978), Bobbi (Roberta) **Sykes** (*Love Poems and Other Revolutionary Actions*, 1979) and Lionel **Fogarty** (*Kargun*, 1980) published their first poetic works, it was within the context of language genocide. These were all aggressive and complex outbursts against the violence of dispossession as it was carried out through and by language. But they could be sidelined as the poetry of 'protest.' When Gilbert published his anthology of Aboriginal poetry in the year of the bicentenary (1988), it was prefaced with his anguished cry for recognition of Aboriginal poetry as part of a larger political struggle: 'Aboriginal poets ... can be identified with the freedom poets of the lately decolonised countries and as a new phenomenon upon the Australian scene, demanding a new perception of life around us, a Presence within the earth and all life forms throughout the universe.'

Over the past thirty or more years, the diversity and unique traditions of Aboriginal poetry have become more widely known. Readers are beginning to understand Indigenous poetic expression within the context of the institutions of Aboriginal and Torres Strait Islander literary production. These include surviving and reformulated elements of traditional Aboriginal song cycles (like **Mudrooroo**'s *The Song Circle of Jacky*), the appropriation and adaptation of popular 'white' forms like the hymn, the ballad, rock, and **country and western**, collaborative authorship, the discourse of 1970s protest and subsequent forms of activism, communal performance, fast-developing and adaptive creoles like Kriol and Broken, and hybrid generic forms like 'life-narratives' and 'sayings.' At the same time as understanding of the unique uses of oral forms in Aboriginal culture has progressed, there is also a recognition of the ways in which Aboriginal people use modern technology and media for their own communicative and artistic purposes. The literary-historical beginnings of Aboriginal use of (English) print culture are generally thought to be David **Unaipon**'s *Native Legends* (1929) and Oodgeroo's *We Are Going*. This view is challenged by Penny van Toorn: 'At least as far back as 1796 Aboriginal people have utilised a broad range of written and printed textual forms.' Magabala Books, the Indigenous publishing house based in Broome which publishes the work of poets like Alf Taylor (*Singer Songwriter*, 1992) and Mudrooroo (*Pacific Highway Boo-Blooz: Country Poems*, 1996), is at the contemporary end of that Aboriginal appropriation of the institution of publishing.

While Aboriginal literature began, in Mudrooroo's words, as 'a cry from the heart directed at the whiteman', and while poetry continues to voice the individual and collective humanity of an oppressed people, it is also being used increasingly by Aboriginal people to speak about identity, culture and politics among themselves. With the **Mabo** (1992) and Wik (1996) decisions and the subsequent restructuring of political institutions in Australia in relation to race, and the **stolen generations** report and subsequent Australia-wide movements towards **reconciliation**, race relations in Australia are moving into a new era. It will remain one in which Abori-ginal people are oppressed, but it will also be one in which Aboriginal people themselves own a discourse of poetry and poetics that is sustainingly rich in its historical value as well as diverse and increasingly powerful in its contemporary expressions.

Some important texts of ancestral Aboriginal song cycles include R. M. Berndt's *Love Songs of Arnhem Land* (1976), his 1948 translation of another Arnhem Land song cycle published in *Oceania*, and T. G. H. Strehlow's *Songs of Central Australia* (1971). Important statements of poetics by Aboriginal writers and critical accounts of Aboriginal poetry include Kevin Gilbert's introduction to his 1988 anthology *Inside Black Australia*, Mudrooroo's *Indigenous Literature of Australia = Milli Milli Wangka* (1997), Cliff Watego's essay 'Aboriginal poetry and white criticism' in Jack Davis and Bob Hodge's edited collection *Aboriginal Writing Today* (1985), and Adam Shoemaker's *Black Words, White Page* (1989). The work of contem-porary Aboriginal poets is available in publications like *Message Stick* (compiled by Kerry Reed-Gilbert) and *Voices from the Heart* (edited by Roger Bennett), and in individual volumes like Jack Davis's *Black Life* and Lisa Bellear's *Dreaming in Urban Areas* (1996). 'Mura', the on-line catalogue of the **AIATSIS** library, is also an invaluable resource for researching Aboriginal poetry and poets. PM

See also: 14.1, 14,2, 14.3, 14.4; **Aboriginal English**.
Berndt, R. M., 'The Wuradilagu song cycle of northeastern Arnhem Land: Content and style', *Journal of American Folklore*, January–March 1966; Gilbert, K., 'Introduction', in K. Gilbert (ed.), *Inside Black Australia*, Ringwood, Vic., 1988; Head, L., 'Headlines and songlines', *Meanjin*, vol. 55, no. 4, 1996; Narogin, M., *Writing from the Fringe*, South Yarra, Vic., 1990; van Toorn, P., 'Early Aboriginal writing and the discipline of literary studies', *Meanjin*, vol. 55, no. 4, 1996.

politics, see 1.1, 1.2, 2.1, 2.4, 3.3, 4.1, 4.6, 6.3, 12.2, 20.1, 20.2, 20.3, 22.1, 23.1, 23.2, 23.3.

Port Keats artists, see **Wadeye**.

POSSUM TJAPALTJARRI, Clifford (*c.*1932–), Anmatyerre painter. The face of Clifford Possum's father, a senior Anmatyerre tribesman widely respected in Western Desert circles for his knowledge of the **Dreaming**, was one of the best known Aboriginal countenances in the world half a century ago, appearing on 99 million Australian stamps. Now his son is one of the best known and most respected names

in contemporary Aboriginal art—and among its most widely travelled artists.

Born on Napperby station, not long after his family had been driven from their traditional camping places around the site of the Coniston **massacre**, Clifford Possum grew up in the bush and then at Jay Creek Aboriginal settlement in the late 1940s. Encouraged by his older brother, Tim **Leura Tjapaltjarri**, he joined Geoffrey Bardon's founding group of artists at Papunya in the early 1970s. Clifford Possum had already made a name for himself as a woodcarver—an occupation he combined with stock work. He rose to a position of pre-eminence among the painters, succeeding Billy **Stockman** as chairman of **Papunya Tula** Artists in the late 1970s. In 1976, assisted by Tim Leura, he produced the painting *Warlugulong* for the cameras of a BBC film crew making one of the first documentaries about the **acrylic** art movement, *Desert Dreamers* (1976). This canvas was the first of a series of large 'map paintings' he created in the late 1970s, setting out his Dreaming sites and tracks like deeds of title to his ancestral lands.

Clifford Possum's father was born at Ngarlu, west of Mount Allan, site of the 'Man's Love Story', which the artist has painted throughout his career. In 1980 the AGSA caused a mini-furore in the Australian art world by hanging a large canvas depicting Clifford Possum's signature spindle motif for this Dreaming in its contemporary Australian art gallery, the first institutional acknowledgment of Western Desert art's emerging status as fine art. In 1981, *Warlugulong* was exhibited in the Papunya Tula artists' display at the inaugural 'Australian Perspecta', AGNSW's prestigious biennial survey of contemporary Australian art—another landmark in the acceptance of Aboriginal artists into the mainstream.

During the late 1970s and early 1980s Clifford Possum shifted regularly between Papunya, Napperby Station and Mbunghara, before moving his family into Alice Springs and establishing himself as an independent producer; he was one of the first Papunya Tula artists to take this step. Following a retrospective at ICA (London 1988), he had his first solo exhibition—also in London—in 1990. He has since spent increasing amounts of time in Europe, North America and the eastern Australian capital cities, only rarely visiting his country around Mt Wedge (Kerrinyarra), Napperby station (Tjuirri) and Mount Allan to renew his connections with his extensive repertoire of Dreamings. In 1994 he became the first Aboriginal artist to be the subject of a scholarly monograph on his work. VJ

See also: 9.4, 9.5, 21.1, 21.3; *45, 220, 227*.

Johnson, V., *The Art of Clifford Possum Tjapaltjarri*, Roseville East, NSW, 1994.

PRINCE OF WALES (Mitbul) (*c.*1935–), Larrakia visual artist, is a senior *daribah* (old man), clan elder, ceremonial custodian, lead dancer, and song leader who was born in Darwin at Kah'lin (Cullen) Beach. Previously resident at Belyuen on the Cox Peninsula where he had grown up and had been living with his family, Prince of Wales retired to Kullaluk after suffering a stroke several years ago. Initially he began painting on wood and cardboard but now works primarily with **acrylics** on canvas. Prince of Wales paints

Larrakia body designs belonging to the ceremonies, songs and dances for which he is one of the principal custodians. He first exhibited in a group show at the Karen Brown Gallery in Darwin in 1996 and in the following year had his first solo exhibition at Gallery Gabrielle Pizzi in Melbourne. In 1997 he and Larrakia artist Duwun exhibited together for the first time at Hogarth Gallery in Sydney in a joint exhibition. Prince of Wales has had works selected for consideration in the NATSIAA in 1997 and 1998, and his 1999 entry was purchased by MAGNT. He continues to exhibit regularly in Darwin and Sydney despite some difficulty with his physical movement and speech. He is represented in the collections of MAGNT, NGV, the Wollongong Art Gallery, and the Kerry Stokes Collection. GL

See also: 6.1, 6.6; *82*.

printmaking. Indigenous printmaking emerged in the late 1960s and early 1970s at a time of radical change in politics, society, and the arts. Australia's Indigenous people had no tradition in printmaking practices, other than the stencilled images (usually of hands) that are to be found on cave walls throughout Australia. But many Aboriginal artists have found printmaking a natural extension to their painting and sculpture. The engraving of wood and linoleum blocks is a similar process to the incising of designs in stone, **boab nuts** or shells, or the carving of wooden sculpture and utilitarian objects. The sequential overprinting of colours in screenprinting is paralleled in the way traditional **bark paintings** are realised, and the same chalky opaque colours can be obtained.

The first prints were produced in the late 1960s by the artist, writer, and activist Kevin **Gilbert**. The linocuts he produced in Long Bay prison did not become widely known until a decade later. They can now be seen as a forerunner of his poetry, plays, photographs, and political writings.

There are a number of other isolated examples of early prints, produced with techniques demonstrated by schoolteachers, craft advisers, or white artists. At Nguiu, Bathurst Island (NT), Bede **Tungutalum** learnt the rudiments of woodblock cutting and printing from Madeline Clair and in 1970, with Giovanni Tipungwuti, established **Tiwi Designs**. A year later John Rudder, who worked at the local mission on Galiwin'ku (Elcho Island), provided artists Monydjirri, Charlie Matjuwi and Botu with lino blocks, on which they engraved designs that traditionally would have been cut to decorate wooden pipes. The blocks were not printed until the 1980s and printmaking did not develop in the community.

In 1976, while visiting Arnhem Land, Jörg Schmeisser, then head of printmaking at the Canberra School of Art, traded information with an Aboriginal of the area named Albert. Schmeisser demonstrated how prints were produced, and Albert demonstrated the preparation of bark for painting. This exchange resulted in Albert's production of a small drypoint. In 1978 Schmeisser worked with Narritjin **Maymuru** and his son Banapana while they were artists-in-residence at the ANU.

The publication of prints was fostered by commissions given to already successful painters. In 1978 the Canadian Government commissioned Dinny Nolan Jampijinpa, a leading member of the Anmatyerre, to produce a print for the

Commonwealth Print Portfolio, which also included a print by Kenojuah, an Inuit (Canadian Eskimo) artist. Like the Australian Indigenous people, the Inuit had no tradition of printmaking but, since 1958, they have rediscovered through printmaking their artistic heritage of stories and images. A strong market for Inuit art developed, enabling many of the artists to achieve financial independence.

The success of the Inuit influenced the Aboriginal Artists Agency to produce a set of six screenprints by artists from the Western Desert. David Rankin, director of the print publishers Port Jackson Press, and Anthony Wallis, manager of the agency, initiated the project. The artists selected for the 1979 project were Johnny **Bulunbulun** and David Milaybuma, both from **Maningrida** in Arnhem Land. These were the first prints produced by Aboriginal artists to be marketed widely, being offered to 22 000 American Express card-holders. Only fifty-four prints sold; the rest were then distributed through regular Port Jackson Press outlets and the agency.

The Second Biennial Conference of the Australian Institute of Aboriginal Studies (now **AIATSIS**) in 1982, at the NGA, discussed Indigenous printmaking and offered support to artists such as Banduk **Marika**, who first exhibited her linocuts at the Women's Art Festival in Sydney in the same year. Women's venues were important: the first exhibition of prints from the Indulkana Community was held at the Women's Art Movement Gallery, Adelaide, in 1993.

Until the 1990s almost all prints by Aboriginal artists were produced in southern cities, far from the northern community population centres. Many of the projects carried out by these workshops were facilitated by government funding organisations. The early prints of Kevin Gilbert and Jimmy **Pike** had been executed in Sydney and Fremantle prison workshops respectively. The lithograph by Dinny Nolan Jampinjimpa for the 1972 Commonwealth Games had been printed at the Victorian College of the Arts in Melbourne. The 1979 screenprints by Johnny Bulunbulun and David Milayburna were drawn and printed in the Melbourne studio of Larry Rawlings; many prints were produced at the Canberra School of Art printmaking workshop (from 1976), at Studio One, Canberra (from 1989), and at the Australian Printmaking Workshop, Melbourne from 1988.

There were forays to Aboriginal communities by artists and printers such as Theo Tremblay, who from 1989 has taken his small lithographic press to the Tiwi Islands, central Arnhem Land and South Australia; Helen Eager, who in 1990 initiated the *Utopia Suite* of woodcuts; and Martin King, who has regularly taken a small etching press into the Kimberley.

The 'Getting Into Prints' symposium at the School of Fine Arts, NTU, in 1993 was a watershed for Indigenous printmaking in northern Australia. It led directly to the opening of the university's facilities to Aboriginal communities and the eventual establishment of Northern Editions, with Basil Hall as director. Red Hand Prints, established in 1997 by Franck Gohier and Shaun Poustie, also operates from Darwin. In Western Australia Edith Cowan University established the Open Bite Access Workshop in 1998, which is utilised by local Aboriginal artists.

Today many communities have access to printmaking equipment. Among those that have facilities for screenprinting, etching, or linocuts are Tiwi Designs on Bathurst Island,

Munupi Arts at Pularumpi on Melville Island (from 1989), and Iwantja Arts and Crafts, Indulkana (SA) (from 1981). More recently, workshops have been established at **Yirrkala** and **Injalak** (Oenpelli), while others are planned for **Warmun** (Turkey Creek) and Kalumburu. Neville Field introduced printmaking at Wilu Arts with the Kulpitarra Community at Alice Springs in 1993, and the **Lockhart River** Aboriginal Community has produced prints since late 1996, supported by Geoff Barker. Many other communities, while not producing limited edition prints, have facilities for fabric and T-shirt printing.

With the opening up of such print workshops, Abori-ginal artists from the Top End now have the option of exploring many forms of printmaking. Screen, wood and linoblock printing remain the most popular techniques. The equipment needed is inexpensive and easy to maintain, and the processes are simple to teach. Etching is practised in some communities, and lithography, due to technical difficulties, hardly ever. Collograph printing, introduced recently, is also proving popular.

The exhibition 'Old Tracks New Land' (1992) organised by the Aboriginal Arts Management Association in conjunction with the Massachusetts College of Art, Boston, resulted in unprecedented sales and has led to a dramatic increase in the number of artists working in the medium. The promotion of Aboriginal and Torres Strait Islander prints, both in Australia and overseas, is now facilitated by the Australian Art Print Network established in Sydney in 1996.

Many prominent print artists, such as Arone Raymond **Meeks** and Ellen José, began working in the 1980s. Some have turned to other media. Fiona **Foley** is now making installations, and **Judy Watson**, Karen **Casey** and Ian **Abdulla** have concentrated on painting. Of more recent practitioners, Treahna **Hamm**'s detailed decorative prints have been awarded major prizes, while Gordon **Bennett**'s postcolonial appropriations have created new directions for Aboriginal art.

A significant area of expansion in recent years has been the production of prints by Torres Strait Islanders. Activity has centred on the printmaking department at FNQIT, Cairns established by Anna Eglitis in 1984. Graduates Dennis **Nona**, Zane **Saunders** and Alick **Tipoti** have later worked at the Canberra School of Art (ANU). The distinctive linocuts produced by the Islanders show their cultural connections to Papua New Guinea. Aboriginal and Torres Strait Islanders have longstanding connections with other indigenous peoples of the Asia–Pacific region who produce prints. Bede Tungutalum visited Canada in 1978, as did Bevan Hayward Pooaraar in 1991. The second Western Pacific Print Biennale, organised by the Print Council of Australia in 1978, exhibited prints by Aboriginal artists alongside works by Indonesians, Thais and printmakers from other neighbouring countries. In 1984 Jimmy Pike and other Aboriginal artists were included in the Indian Ocean Arts Festival. Collaborations with Aotearoa New Zealand are also expanding. Muka Studio, Auckland, has produced lithographs for Maori artists as well as Aboriginal artists such as Paddy Fordham **Wainburranga** (1991). The Torres Strait Islander artist Brian **Robinson** has worked with artists from Samoa while Michel Tuffery, an Aotearoa New Zealand artist of Samoan descent, has been

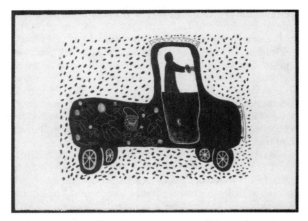

371. Fatima Kantilla, *This Mob Going Hunting*, 1990. Lithograph, 36 x 48 cm.

artist in residence at the Aboriginal and Torres Strait Islander Art Centre, Cairns. The Asia–Pacific Triennial, organised by QAG since 1993, has acted as a catalyst for Aboriginal and Asian collaborations. The Australasian Print Project—The Meeting of Waters—organised by the Printmaking Workshop at NTU in 1997 resulted in a number of large prints with artists from Indonesia, the Philippines, Arnhem Land and Darwin all participating to produce the images.

Compared to the large number of Aboriginal artists producing paintings on bark, canvas, or paper, there are relatively few who have so far worked as printmakers. However, the very nature of printmaking—its potential for replicating an image—has enabled Aboriginal practitioners to reach a wide audience. Prints, whether they employ traditional or urban images, are a means of contributing to the increasing self-determination of Aboriginal and Torres Strait Islander people. ROB

See also: 6.1, 12.3; *371*.

Butler, R., *The Streets as Art Galleries—Walls Sometimes Speak: Poster Art in Australia*, Canberra, 1993; 'Prints by Australian Aborigines', *Imprint: A Journal about Australian Printmaking* [special edition], vol. 21, nos 3–4, 1986; Watson, C. & Samuels, J., *Aboriginal Australian Views in Print and Poster*, West Melbourne, 1987.

prison art. With colonisation, Aboriginal people were incorporated within a European legal system designed to uphold the rights of a settler society and supplant traditional law. To this day, relations between Aborigines and police officers remain a central arena for racial prejudice, and the high rate of Aboriginal imprisonment reflects the despair and resentment this breeds. Despite the greater understanding resulting from the recent Royal Commission into Aboriginal Deaths in Custody, Aboriginal rates of imprisonment have increased; in 1997 the Australian Bureau of Statistics reported a rate eighteen times that of non-Aborigines. Prisons are thus a site of colonial authority, but the powerful and compelling history of Aboriginal prison art reveals that it has been possible for Aboriginal inmates to intervene in their particular circumstances.

One of the earliest surviving examples of prison art is the Aborigines' cell at the Old Gaol, Albany (WA), established in 1872–75 and now a museum. Incised into the wood-lined walls of the cell by an unknown artist or series of artists are a rainbow serpent, a goanna, a kangaroo, and geometric forms divided by intricate designs. Ironically incarceration probably served to focus attention on the wealth of Aboriginal artistic expression. Andrew Sayers records that in 1888 the Deputy-Sheriff at Palmerston, (Darwin), J. G. Knight, assembled a group of eighteen annotated drawings by five Aboriginal artists, four of whom (Davie, Jemmy Miller, Paddy and Wandy Wandy) were prisoners at Fannie Bay Gaol, Palmerston, while the fifth, Billiamook, was employed at the police station as an interpreter for the Larrakia of the Darwin region. Included as part of the Northern Territory display for the Centennial International Exhibition in Melbourne, under the title 'The Dawn of Art', the drawings attracted considerable interest both as evidence of Aborigines' intellectual capacities and as a source of ethnographic, geographic, and narrative information. In style and content the detailed depictions of animals, birds, fish, and figures in ceremonial regalia bear a close resemblance to the **rock art** of Arnhem Land and to the drawings of the south-eastern artists, William **Barak** and Tommy **McRae**. Two drawings of murals in the jail, probably produced by the same group of artists, were later reproduced in Thomas Worsnop's study, *The Aborigines of Australia* (1897).

The subject matter of these drawings is expressive of an Aboriginal world view concerned with spiritual connections to country. By contrast, those of another prisoner in the same gaol, Charlie Flannigan, are primarily concerned with recording his particular experiences as a young Aborigine who had worked initially as a groom and **jockey** and later as a stockman and station hand in the Northern Territory and Queensland. Flannigan's drawings, made in 1892, use the imagery and text of the popular illustrated press to relay descriptive and sometimes witty narratives that recall the itinerant lifestyle of stockmen in pastoral homesteads and outback towns. Although little is known about the lives of these artists, Sayers records that the executions of Flannigan (1893) and Wandy Wandy created some controversy, drawing attention to the evident inequalities confronted by Aboriginal people in relation to white law.

For most of the twentieth century Aborigines were 'locked away' on isolated missions and reserves. Rates of incarceration escalated when assimilation policies of the 1950s encouraged or forced Aboriginal people to move into urban centres, thereby making them more visible to the police. In one notable instance, public controversy resulted when a prison sentence was imposed in 1958 on the Arrernte artist Albert **Namatjira** for supplying alcohol to members of his family—who unlike him were not citizens. Against this background of coercion and oppression, a new generation of urban Aboriginal youth emerged who bore the brunt of government policies aimed at the eradication of Indigenous culture: removal from their families, transferral to institutions and cumulative racial discrimination which began with police hostility and ended with incarceration.

Contemporary wisdom acknowledges that producing art in prison is a means of regaining self esteem, and can operate

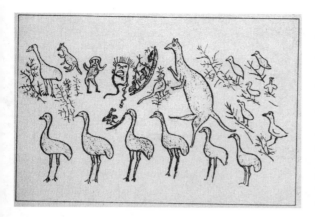

372. Artist unknown, drawing of a mural in Fannie Bay Gaol, Palmerston (Darwin).
Reproduced in Thomas Worsnop, *The Prehistoric Arts, Manufactures, Works, Weapons etc. of the Aborigines of Australia*, Government Printer, Adelaide, 1897.

cathartically to channel tension. The extraordinary mural produced by the young Gurnai artist Ronald **Bull** in 1962 in Melbourne's Pentridge prison (since decommissioned) is one such example. Painted at the invitation of a senior prison officer, the mural depicts a classic tribal scene of three Aboriginal men in a desert landscape grouped around a central symbolic fire. The Nyungah artist Revel **Cooper**, already known to members of the public as one of the child artists from the Carrolup mission (WA), also painted in prison. During the 1960s, he was assisted in his career by the collector and expert on Aboriginal art, Jim Davidson, who supplied him with art materials, and included his dark, brooding landscapes and **corroboree** scenes in a series of exhibitions alongside more familiar **bark paintings** from Arnhem Land and watercolour landscapes of the Hermannsburg School.

With self-determination and hard-won citizenship came greater freedom for Aborigines to express more public and politicised affirmations of Aboriginality. Self-educated within the prison system, Wiradjuri artist and writer Kevin **Gilbert** produced his first series of linocuts in the late 1960s as an inmate of Long Bay prison, Sydney, using improvised tools and materials collected from his prison environment: floor linoleum, razor blades, nails, spoons, and bed linen. Gilbert's prison experiences, described in *Breath of Life*, were a catalyst for his art: 'Going into a prison I saw the prisoners … given better conditions than Aboriginal People had … [and] of course, that rankled with me quite a lot and … motivated me to do the carving of *Christmas Eve in the Land of the Dispossessed*.' The print depicts an Aboriginal family under a southern night sky flecked and whorled with radiating lines—emblematic of both the spiritual strength of Aboriginal culture and the alienation of Aboriginal people within a settler colonial society.

For contemporary Indigenous artists such as Gordon **Syron** and Walmajarri artist Jimmy **Pike**, prison workshops have provided the opportunity for an artistic career. Growing recognition for the importance of Aboriginal prison art is reflected in recent exhibitions: 'Postcards from the Bay'

(1993) by Aboriginal inmates of Long Bay at **Boomalli Aboriginal Artists Co-operative**; the Campbelltown City Art Gallery exhibition 'Doing Time, Doing Dreamtime' (1995) which showed work by boys at the Reibey Juvenile Justice Centre produced at workshops conducted by the Aboriginal artists-in-residence, Mark Leon, Anthony Leslie, and Janice Shipley; and the Aboriginal murals commissioned for the former Fremantle Gaol (WA). SK

See also: 10.2, 11.1, 12.1; **deaths in custody**; *372*.
Australian Bureau of Statistics, *Australian Social Trends*, Canberra, 1997; Gilbert, K. & Williams, E. *Breath of Life*, Canberra, 1996; Johnston, E. F., *Royal Commission into Aboriginal Deaths in Custody*, 5 vols, Canberra, 1991; Sayers, A., *Aboriginal Artists of the Nineteenth Century*, Melbourne, 1994.

PUANTULURA, see Apuatimi family.

PURDIE, Shirley (*c.*1949–), Kija visual artist, singer, and dancer, is a senior member of **Warmun** community (Turkey Creek, WA), in the East Kimberley. She was born on Gilbun (Mabel Downs station). As a young woman she worked on Mabel Downs and Texas Downs stations and returned to Warmun to work in the school. She is a strong Law and culture woman and an important ceremonial singer and dancer. In the early 1990s she began to paint her country, inspired by older Warmun artists including her mother **Madigan Thomas**, **Rover Thomas**, and **Queenie McKenzie**. Purdie's uncle, artist Jack **Britten**, said to her: 'Why don't you try yourself for painting, you might be all right.' Purdie views painting as an important cultural educational tool. She says: 'It's good to learn from old people. They keep saying [when you paint] you can remember that country, just like to take a photo, but there's the Ngarrangkarni (Dreaming) and everything. Good to put it in painting, your country, so kids can know and understand. When the old people die, young people can read the stories from the paintings. They can learn from the paintings and maybe they want to start painting.' She is well known for her use of richly textured natural earth pigments on canvas—**ochres** which are collected from, and imbue her paintings with, the spirit of her country. Her paintings have featured in numerous group exhibitions in Australia and overseas. Her work is held in the collections of Edith Cowan University (WA), NTU, and the Kerry Stokes Collection, Perth. JNK & AM

See also: 10.2.

PURUNTATAMERI family, Tiwi carvers, painters, and designers. Tiwi artists place great emphasis on individual creativity and fine workmanship. Often the knowledge and experience of older artists are passed on to younger family members in a situation that resembles a contemporary 'studio', where generations of a family work together.

No artistic pursuit is solely the domain of men or of women, either in the visual or in the performing arts. Blanche Puruntatameri (1920–), her daughters Gemma Munkara (1955–), Juanita Wumulah Tipiloura (1957–), Concepta Tupukwitanu Kantilla (1945–), and Jeanette Tupukweilau Mungatopi (1941–1999), and Concepta's

daughter, Mary Jo Kantilla (1972–), are a close-knit family working together in **bark painting** at their 'studio' at Nguiu. Until the late 1970s few women produced paintings for sale, because the local mission encouraged the women to learn European skills such as weaving and needlework. Until the early 1980s artists who were female tended to be older, often assisting their husbands in decorating work, or producing art for ceremonies. This group of women began to paint with the endorsement of their father Patrick Puruntatameri (1918–1986), a highly regarded and recognised artist working in the early 1950s, and with encouragement from art advisers interested in women's work. Probably because the women work consistently together, their styles are similar. High quality craftsmanship is evident in their bark paintings, *tunga* (painted bark baskets) and ceremonial ornaments. In 1996, a major exhibition of their work on bark, 'From Body Painting to Bark Painting', was held at Gallery Gabrielle Pizzi, Melbourne. KB

See also: **Tiwi Design, Tiwi Pottery,** *204.*

Barnes, K., *Kiripapurajuwi (Skills of Our Hands): Good Craftsmen and Tiwi Art*, Darwin, 1999.

PWERLE, Angelina (*c.*1952–), Alyawarre visual artist, lives at Mosquito Bore (NT), and has been exhibiting with the vibrant artistic community of **Utopia** for over ten years. In 1986 she was introduced to **batik**; however, in recent years she has primarily focused on sculpture and painting. The representation of *awelye* (**Dreaming**) bush plum, *arrkere* (night owl), bush foods, and flowers remain the central concerns of her work. Along with the other women artists of Utopia, Pwerle was first given canvas and **acrylic** paint in the late 1980s. Her canvases characteristically feature an intense concentration of dots which produce the effect of movement, or shadows, across the surface. Her work is distinct from that of other artists of her community in the clarity of her colour schemes. Placed on dark backgrounds, the dots take on a pure, ephemeral quality.

There is a strong heritage of carving amongst the men and women of Utopia, although until the 1980s women made only non-traditional sculptural work. It was in this context that Pwerle's bold, whimsical animals and figures were first produced. The artist gives her creatures and little people bright-eyed, startled faces, and adorns their bodies in green, grey, and blue, as well as traditional **ochres.**

Since 1996 Pwerle has been represented by Melbourne's Niagara Galleries, where she regularly holds solo exhibitions. She has been included in group exhibitions such as 'The Oval Board Collection' (Hawaii 1994) and 'Utopia Women' (MCA 1993). Private and public collections around the world hold examples of her work. WN

See also: 9.5.

Boulter, M., *The Art of Utopia*, Roseville East, NSW, 1991.

Q

QUAILL, Avril (1958–), Nunugal–Goenpul artist and curator. Avril Quaill's career has been shaped by her twin desires: to paint, and to create change through educating the wider community about the impact of colonisation on her people. She established herself as an artist in the early 1980s. Her first piece, *Trespassers Keep Out!* 1992, was a screen-print poster produced at the Tin Sheds Workshop under tutelage of members of the Lucifoil poster collective, at the University of Sydney. The poster signified the exclusion of Indigenous Australians from Australian political and social life, and became a visual symbol in the Indigenous political struggle during the lead-up to the bicentennial celebrations in 1988.

Quaill completed a BA at the Sydney College of Arts in 1985. Working mostly in the print medium, her works reflect Indigenous cultural and spiritual values and document the Australian Indigenous political struggle. During her art school training she assisted on several inner-city murals and mosaics in Sydney. She collaborated with fellow student Glen Hennessey (1958–1996) on a mural for Carnivale at Central Railway Station. Her work has featured in 'Aboriginal Women's Exhibition' (AGNSW 1991) and 'Urban Focus' (NGA 1994).

In 1987, Quaill was awarded a Visual Arts Fellowship by the **Australia Council** and travelled to **Ramingining** (NT), where she participated in a screen-print workshop and assisted in managing the local craft shop. At Ramingining she met bark painter David **Malangi**, with whom she later collaborated on a mural at the GCCAG with Arone Raymond **Meeks**.

Avril Quaill was a founding member of **Boomalli Aboriginal Artists Co-operative** in 1987 and its chairperson in 1989. Her involvement in Boomalli led to her interest in curating exhibitions. In 1989 she curated her first major show, the travelling exhibition 'A Koori Perspective' (Artspace 1989). This and later exhibitions aimed to bring public attention to the art of urban Aboriginal artists.

Since 1994, Avril has been employed as a curator in the Department of Aboriginal and Torres Strait Islander Art, NGA. She curated 'Papunya Pictures: The First Ten Years' (NGA 1996). KM

See also: 5.6, 12.3; **printmaking**; *63, 161.*

Isaacs, J., *Aboriginality: Contemporary Aboriginal Paintings and Prints,* St Lucia, Qld, 1989; Quaill, A., *Marking Our Times,* Canberra, 1996.

R

radio forms the largest part of the Indigenous media sector. As relatively accessible and inexpensive technology for entertainment and exchanging information, and for 'linking up' across the country, radio has been embraced by Aboriginal and Torres Strait Islander people who recognise its significance in promoting Indigenous **languages** and culture, as well as Indigenous social and political agendas.

Indigenous groups began gaining regular access to the airwaves through community radio and ABC regional stations in the late 1970s and early 1980s. These early radio shows proved extremely significant for local Abori-ginal and Islander audiences who had previously been denied a significant presence in the Australian media. Inspired by community enthusiasm in centres such as Townsville and Alice Springs, broadcasters began forming **media associations**, campaigning for greater access to the airwaves and for the establishment of Indigenous-controlled radio stations. In 1980 the Central Australian Aboriginal Media Association (CAAMA) was founded in Alice Springs. Five years later CAAMA launched 8KIN FM, Australia's first Aboriginal radio station. Up to seven local Aboriginal languages were regularly broadcast over CAAMA's broadcast 'footprint' which reached communities beyond Alice Springs via shortwave and later, after satellite radio became available in remote communities in the late 1980s, on local FM stations. Programming included community news and information, traditional stories and music, local bands, and request shows.

Following CAAMA's success, Aboriginal radio became the fastest growing sector in Australian broadcasting. There are now over 120 licensed Aboriginal radio stations broadcasting across the country in remote communities and urban centres. In 1988 the establishment of Broadcasting in Remote Aboriginal Communities Scheme (BRACS) led to the development of more than 100 community radio and television stations which often broadcast local programs several hours a day. Regional Aboriginal stations include 4KIG Townsville, 4TSI Torres Strait, 4AAA Brisbane, 4MOB FM Mount Isa, 4US Rockhampton, 4USM Cherbourg, 5UMA Radio Port Augusta, 6AR Perth, Radio Goolarie Broome, Wangki Yupurnanupurra Radio Fitzroy Crossing, Puranyangu-Rangka Kerrem (PRK) Radio Halls Creek, Warringari Radio (Kununurra), Larrakia Radio Darwin, Mid-North Coast Indigenous Broadcasting Inc. Taree, Majunji Aboriginal

Resource Association Borroloola, 2CUZ Bourke, and TEABBA Radio NT. Radio 6LN Carnarvon is the only commercial Aboriginal radio station in Australia. In addition, there are more than thirty-five groups applying for licences, especially throughout the eastern States. There are, as yet, no licensed Indigenous radio stations in Adelaide, Hobart, Melbourne and Sydney. Gadigal, the aspirant Indigenous broadcaster in Sydney, is the successor to Koori Radio which broadcast for many years on Radio Skid Row, a non-Indigenous radio station. In its test broadcasts across greater Sydney, Gadigal links a geographically dispersed Koori population of 30 000, the largest Indigenous audience in Australia.

During the 1990s satellite technology enabled Indi-genous broadcasters to reach a wider audience. In 1994 Top End Aboriginal Bush Broadcasting Association (TEABBA) radio began test broadcasts from BRACS communities in Arnhem Land. Using the telephone line to send programs back to the main studio in Darwin, 'remote' bush communities now broadcast their programs live via satellite to twenty-nine communities and a number of outstations across the Top End of the Northern Territory. In defiance of mainstream models of centralised broadcasting from capital cities, this form of innovative, low-cost networking allows Aboriginal people to broadcast from their country in their own languages, and give impetus to grass-roots participation and self-representation. This model was applied in central Australia via 8KIN FM, in the Anangu–Pitjantjatjara Lands (SA and NT) via the 5NPY network, and via the PAKAM radio network across the Kimberley and Pilbara (WA). The National Indigenous Radio Service (NIRS), launched in February 1997, enhances these links by giving individual radio stations the capacity to receive and re-broadcast programs from stations in other parts of the country via satellite. Recent NIRS developments include a national Indigenous news service available on the Internet or through satellite links.

There is no single Aboriginal radio 'sound' in terms of style and content. Station play lists include Australian Indigenous music in genres that range from **country and western**, rock, reggae, and heavy metal, to more traditional clan songs. Whereas Brisbane's 4AAA *Murri Country* format leans towards country and traditional music, broadcasters at

Gadigal in Sydney or Radio Gularri in Broome favour hip-hop, blues, and reggae. In the course of a single program a BRACS operator in the bush might play local rock bands, contemporary pop songs, and Christian and traditional music.

Apart from providing an outlet for musicians seldom given airtime on mainstream radio, stations broadcast Indigenous news and current affairs, community information, and educational material. Broadcasters speak in local languages, dialects and slang, encouraging their audiences to send a message or dedication on talkback and request shows. Complementing Indigenous community station programming is the rebroadcasting of specialist arts and current affairs programs originally produced by Indigenous staff at ABC and SBS radio.

In these ways Aboriginal and Islander broadcasters are contributing to a diverse contemporary Indigenous radio soundscape, from remote BRACS stations to capital city studios. Ideas, information, and experiences are exchanged, contributing to the production of an emerging national Indigenous identity as well as consolidating local and regional affiliations. As satellite and digital communications expand the possibilities of radio networking and convergence with other media via the Internet, the Indigenous broadcasting sector will continue to increase its range and profile. The National Indigenous Media Association of Australia (NIMAA), based in Brisbane, assists and advises broadcasters with policy, licensing, and funding issues as well as representing them in negotiations with government at national and regional levels. As local stations begin to expand their traditional signals with webcasts on the Internet, NIMMA is lobbying for the expansion and consolidation of the sector through the establishment of a national broadcasting authority known as Indigenous Communications Australia (ICA). This initiative, if successful, would officially recognise the role of Indigenous broadcasting by establishing ICA as the third national public broadcaster in Australia. In addition to its significance for Indigenous audiences, this would increase the ability of Aboriginal broadcasters to reach a non-Indigenous audience, facilitating cross-cultural understanding and respect through the blend of music, information and humour offered by this very personal medium.　　　　　　　　　　　　　　　　　　JD

See also: 13.3, 13.4, 15.2; *181*.

ATSIC, *Digital Dreaming: A National Review of Indigenous Media and Communications*, Canberra, 1999; Ginsburg, F., 'Aboriginal media and the Australian imaginary', *Public Culture*, vol. 5, no. 3, 1993; Molnar, H., 'Aboriginal broadcasting in Australia', *Howard Journal of Communications*, vol. 2, no. 2, 1990.

Ramingining artists, see Bula'bula Arts.

REA (1962–), Gamilaroi (Gamilaraay)–Wailwan visual artist. Rea's connection with photography began with a biscuit tin that contained family photos kept by her mother. Rea took the opportunity to explore the stories behind the photographs by 'drawing together family photos, new technology and language to produce my writing through the lens'. Through this combination of elements she produces works that contain intricate paths of meaning.

Rea was born in Coonabarabran (NSW) and later lived in Sydney, where she began her visual arts studies at Sydney's Eora Centre in 1990. She then went on to complete a BFA at UNSW in 1993. During this course, Rea sought an understanding of herself and her family through investigating the past. The result was her first self-portrait, *Highly Coloured: My Life is Coloured By My Colour I–VI*, 1993–94, and the theme was further developed in the *RIP Blak Body series I–VI*, 1995. This remains a continuing process. Her *Blue Print Landscape: Blood & Bone I–VI*, 1995 is a series of Cibachrome digital prints that wrap the observer in the past to represent seizures of Aboriginal body parts and skeletal remains.

Residencies at the Laura Aboriginal Dance and Cultural Festival in Queensland (1997), and exhibitions such as the 'Pop, Mass 'n' Sub Cultures' at the Banff Centre for Arts in Alberta, Canada (1996) and 'ARX4 torque' (PICA 1995) have enabled Rea to make connections with artists of different cultural backgrounds. Her solo shows have included 'Ripped into Pieces' (TPS 1995) and 'EYE/I'MMABLAKPIECE' (CACSA 1996). Rea's ability to forge new understandings of Aboriginality, colonised society, and history can be seen in her works included in group exhibitions such as 'True Colours' (Liverpool and London 1994) and 'Blakness: Blak City Culture!' (ACCA 1994). Works in her *REA-PROBE* series (1997) shown at 'Australian Perspecta 97' (AGNSW 1997), illustrate the striking colours of Indigenous symbols intersected with the reclaimed language of invasion society in a double-sided lightbox and billboard. This work was joint runner-up at NIHAA (1998). Rea's work is represented in collections at the NGA and in many State galleries.

Rea uses computer technology to push back the boundaries that limit the expression of Indigenous identity and female sexuality. In 1998, in the 'bLAK bABE(Z) & KWEER kAT(Z)' exhibition at the Gitte Weise Gallery, she included her own body in her work to remind viewers that she will uncover layer upon layer of meaning written there. Rea articulates her artistic vision with the question: 'Why do I feel I can't be who I really am? And who am I anyway?' In response, she demands that her audience ask themselves: 'Who are we?'　　　　　　　　　　　　　　　　　　WB

See also: 12.4, 12.6; *174*, *276*.

Gellatly, K., 'Retake: contemporary Aboriginal and Torres Strait Islander photography', in *artonview*, no. 15, Spring 1998; Rea, *EYE/I'MMA BLAK PIECE*, Chippendale, NSW, 1997; Williamson, C. & Perkins, H., *Blakness: Blak City Culture!* Melbourne, 1994.

reconciliation. In May 1997, 1800 participants at the Australian Reconciliation Convention issued a 'Call to the Nation', affirming that 'reconciliation between Australia's Indigenous peoples and other Australians is central to the renewal of this nation as a harmonious and just society which lives out its national ethos of a fair go for all; and that until we achieve such reconciliation, this nation will remain diminished.'

The convention further declared that 'reconciliation and the renewal of the nation can be achieved only through a people's movement which obtains the commitment of

Australians in all their diversity to make reconciliation a living reality in their communities, workplaces, institutions, organisations and in all expressions of our common citizenship.'

The 1997 convention, convened by the Council for Aboriginal Reconciliation, was a landmark event in the formal process of reconciliation which had been established by a unanimous vote of the Commonwealth Parliament in 1991.

However, the story of reconciliation really begins with the establishment of the British colony at Sydney Cove on 26 January 1788, and the rapid colonisation of the continent that followed. Aboriginal people were dispossessed and displaced from their lands, herded into reserves, killed in battles and **massacres**, or by the poisoning of their waterholes, or they died from introduced diseases. Later, Torres Strait Islanders also lost their independence when the Queensland Government annexed the islands. From the late nineteenth century until the 1960s, Indigenous communities also suffered from a range of policies such as those which condoned the removal of Aboriginal and Torres Strait Islander children from their families, and their placement in institutions run by governments or churches.

Through all of these developments, the colonial power and its local administrators ignored the established law and organisation of the Indigenous societies occupying the continent, and failed to recognise the deep spiritual connection between Aboriginal and Torres Strait Islander peoples and their lands and waters. Alone among British Commonwealth countries, the Australian colonial authorities and successive governments never attempted to negotiate a formal treaty with the original Indigenous inhabitants.

Sporadic dissenting voices from this general policy included the first Attorney-General of New South Wales, Saxe Bannister, who in 1837 submitted an argument to a House of Commons Select Committee that treaties should be entered into and that the rights of Aboriginal people to land should be respected. No action was taken.

With their numbers depleted and their traditional lifestyles and cultures disrupted, many Aboriginal people became cultural and economic fringe-dwellers. They were no longer allowed to live as they had done for tens of thousands of years, but they were restrained from participating as citizens and equals in the wider society which had taken their land.

When the Australian colonies federated in 1901, the new Commonwealth Constitution referred to Aboriginal people only to say that the Commonwealth Parliament would not have power to make laws for them, and that they need not be counted in the official census of the population. That was the constitutional position until the historic **referendum of 1967**, when more than 90 per cent of voters affirmed that both those references be struck out.

This referendum is often regarded as a turning point for Aboriginal and Torres Strait Islander people, and the ten-year campaign which preceded the vote brought together Indigenous and wider-community activists in large numbers. Yet the stark social disadvantages of Indigenous peoples remained. Among many other reports and commentaries on these issues, in 1991 the Royal Commission into Aboriginal **Deaths in Custody** reported to the Commonwealth Govern-

ment. In its last recommendation, the commission, having analysed the historical and cultural reasons behind the high level of Indigenous deaths in Australian jails, recommended that the nation should undertake a formal process of reconciliation.

That same year, the Parliament unanimously passed the *Council for Aboriginal Reconciliation Act 1991*, establishing the council as a cross-party statutory body charged with the task of promoting a process of reconciliation, with functions which included promoting a renewed national commitment to overcoming Aboriginal and Torres Strait Islander disadvantage, consulting widely to determine whether a formal document or documents would advance reconciliation and, if so, making recommendations on the form and content of such documents. The council adopted a vision which guided all its endeavours: 'A united Australia which respects this land of ours, values the Aboriginal and Torres Strait Islander heritage; and provides justice and equity for all.'

In its first and second terms (1991–94 and 1995–97) the council undertook, supported, or encouraged a wide range of local, regional and national initiatives and projects, including community meetings, negotiated agreements, cross-cultural awareness and cooperation, consultations with Indigenous communities (organised jointly with **ATSIC**) about social-justice issues, and working with education authorities to incorporate reconciliation ideals in their curricula, with special emphasis on teaching Indigenous perspectives in Australian history.

The council drew on the outcomes of the May 1997 Australian Reconciliation Convention to set its agenda for its final term, with three goals: first, a national document of reconciliation and acknowledgment of Aboriginal and Torres Strait Islander peoples within Australia's Constitution; second, commitments of governments and key sectors of society to form partnerships which will achieve social and economic equality for Indigenous peoples; and third, a people's movement for reconciliation to ensure that the work of reconciliation would continue beyond the life of the council.

Throughout 1999–2000, the council devoted much of its time to consultations on and preparation of a National Document for Reconciliation, to be ready for the nation's consideration and possible endorsement before council ended its work on 1 January 2001, the centenary of Federation. Recognising that whatever might be achieved by that date, much would remain to be done, the council hoped that its work would set a framework for an ongoing process, and stressed that Australians would need to continue 'walking together' for some time along the path towards true reconciliation.

CAR

See also: **prison art, stolen generations.**
Council for Aboriginal Reconciliation, *Going Forward: Social Justice for the First Australians*, Canberra, 1995; Council for Aboriginal Reconciliation, *Proceedings of the Australian Reconciliation Convention*, Books 1–5, Melbourne, 1997; Huggins, J., *Sister Girl*, St Lucia, Qld, 1998; Reynolds, H., *Why Weren't We Told*, Ringwood, Vic., 1999; Reynolds, H., *This Whispering in Our Hearts*, St Leonards, NSW, 1998.

referendum of 1967. The 1967 referendum is one of the best known yet most widely misunderstood events in modern Australian history. It is commonly represented by journalists, political leaders, Aborigines, and scholars alike as a historic event when Aborigines were granted Australian citizenship rights and the Commonwealth gained the power to legislate for Aborigines and assumed control of Aboriginal affairs. These claims are unfounded, although the historical importance of the referendum is, nevertheless, undeniable. It entailed two amendments to the Australian Constitution: repeal of section 127 whereby 'aboriginal natives' were not counted in national censuses; and amendment of section 51 (xxvi), which denied the Commonwealth the powers to make 'laws … with respect of any race, *other than the aboriginal race in any State*, for whom it is necessary to make special laws', by deleting the italicised words. Neither of these changes has the significance attributed to them by the popular myth.

Campaigners for Aboriginal reform had long believed a greater Commonwealth role was fundamentally necessary and had sought amendment of section 51 (xxvi) because successive federal governments claimed it prevented them taking control of Aboriginal affairs. Repeal of section 127 was a more recent demand, dating from 1957. Beginning the following year, constitutional change was central to the fight for Aboriginal rights and 'advancement' conducted by a national multiracial organisation, the Federal Council for the Advancement of Aborigines (later the **Federal Council for the Advancement of Aborigines and Torres Strait Islanders, FCAATSI**); in petition campaigns in 1958 and 1962 it drew attention to the panoply of discriminatory State laws and to Aborigines' economic and social disadvantage. During this period federal and State administrations began to repeal their discriminatory legislation—for example, the Commonwealth restored the vote to all Aborigines in 1962—but FCAATSI saw no reason to change its calls for a referendum. In a richly symbolic campaign in 1967 the council and its supporters (which included the labour movement and the churches) represented sections 51 (xxvi) and 127 as racially discriminatory and called for a 'yes' vote as a matter of citizenship for Aborigines and federal control of Aboriginal affairs. Placards and leaflets called on electors to 'Vote Yes for Aboriginal rights' and grant 'the Commonwealth Government … the power to take action on behalf of Aborigines'. Consequently most people understood the referendum in this way and voted accordingly. The 90.77% vote, the highest in any such referendum in Australia's history, brought little immediate change but it did provide a mandate for those in the conservative Coalition government calling for change and, eventually, for the Whitlam government in 1972. At the same time, the apparent achievement of equal rights for Aborigines seemed to hasten demands among Aboriginal campaigners for indigenous rights, which culminated in the **Tent Embassy**.

In recent years the referendum has again been 'talked up' by a broad range of political players who invoke its surrounding mythology in the course of trying to deflect calls for Indigenous rather than equal rights, or for upholding the rights of Aboriginal people. BA

See also: **Day of Mourning, Survival Day.**

Attwood, B., Markus, A., Edwards, D. & Schilling, K., *The 1967 Referendum, or When Aborigines Didn't Get the Vote*, Canberra, 1997; Attwood, B. & Markus, M., '(The) 1967 (referendum) and all that: Narrative and myth, Aborigines and Australia', *Australian Historical Studies*, vol. 29, 1998; Bennett, S., 'The 1967 referendum', *Australian Aboriginal Studies*, no. 2, 1985; Chesterman, J. & Galligan, B., *Citizens Without Rights: Aborigines and Australian Citizenship*, Melbourne, 1997.

repatriation. During the first two centuries of European invasion many ancestral burial places were plundered, and the bones procured for metropolitan and colonial museums and anatomy schools. The records of frontier conflict reveal numerous instances where the bodies of Aboriginal men and women who had been killed in punitive raids mounted by settlers and colonial militia were mutilated for their skulls. In north Queensland between 1862 and the late 1880s a small number of settlers boasted they had killed Aboriginal people to acquire anatomical specimens. By the late nineteenth century it was not uncommon for skulls and soft tissues to be removed from the bodies of Aboriginal people who died in hospitals or benevolent asylums. As a result of widespread scientific trafficking in remains, by the 1920s the skulls of over 2000 men and women had been dispersed amongst scientific institutions in Australia and around the world.

The success of campaigns for repatriation since the 1970s owes much to the efforts of elders and younger Aboriginal activists, working through organisations such as UNESCO and the World Archaeological Congress (WAC). Aboriginal people, for example, have been instrumental in the formulation and adoption by the UN and WAC of policies recognising the world's indigenous communities' right to ownership and control of remains. Contrary to what some commentators maintain, there is nothing new in the determination of Aboriginal people to see remains repatriated from scientific collections, and their fate determined in accordance with community wishes. Historical records show Aboriginal communities have striven to protect burial places from desecration since the early years of invasion. Demands for repatriation of remains from museums can be traced back to the late nineteenth century.

Belatedly appreciating the anguish caused by the collection and preservation of remains, Australia's museums and many scientific institutions have worked closely with community elders over the past decade, deaccessioning remains for reburial in ancestral country, or transferring them to **keeping places** under strict control until communities conclude the lengthy deliberations required to satisfy themselves that they have acted in accordance with customary law. Tragically, the problem for many communities is that State governments, fearing adverse international publicity, have demanded that remains be handed over to communities as quickly as possible. This has placed elders and Indigenous museum personnel in a morally difficult situation.

Central to repatriation has been the need to determine as accurately as possible the identity of remains and the circumstances in which they were procured. The information, slowly brought to light, has profoundly affected all Australians. But for Aboriginal historians, writers, and visual artists it has been a powerful source of inspiration. Historians, notably Henrietta

Fourmile, Jackie Huggins and Lyndon Ormond-Parker, have offered challenging critiques of the role of western biomedical sciences in legitimating the dispossession of Australia's Indigenous peoples. Similarly, contemporary artists such as Gordon **Bennett** have vividly interrogated the interrelationship between European ways of knowing and colonial ambition.

However, repatriation has also been a source of joyous reflection. The prominent role in securing the return of remains to ancestral country over the past two decades undertaken by David **Mowaljarlai**, Oodgeroo **Noonuccal**, Monty Pryor, and many others has shown the continuing strength of Aboriginal religion and customary law in contemporary Australia.

Though repatriation has been a sad encounter with the colonial past, it has brought home to non-Aboriginal Australians the need to temper the quest for scientific knowledge with respect for Aboriginal culture. Indeed, there is every cause to be optimistic about scientific research involving ancestral remains, provided that Aboriginal rights in respect of ownership, participation, and direction of research are fundamental elements of future scientific practice. PUT

See also: 1.5, 8.4, 11.8; **Trukanini**; *105, 149, 290*.
Bennett, G. & McLean, I., *The Art of Gordon Bennett*, Roseville East, NSW, 1996; Fourmile, H., 'Museums and Aborigines: A case study in scientific colonialism', in B. Wright, D. Moody & L. Petchkovsky (eds), *Contemporary Issues in Aboriginal Studies 2: Proceedings of the Second National Conference on Aboriginal Studies*, Sydney, 1988; Langford, R., 'Our heritage—your playground', *Australian Archaeology*, vol. 16, 1983; Turnbull, P., 'Body and soul snatchers', *Eureka Street* vol. 7, no. 7, 1997.

rights in art. The issue of rights in art has been a topic of some importance, and one of the areas in which Aboriginal art has made a significant contribution to more general art discourse. Under Indigenous Law rights in art are distributed in accordance with more general descent-based rights in land and sacra. This is because paintings, song and dance are part of a society's ancestral inheritance. The exercising of rights thus involves a complex intersection of group and individual rights. The pattern of ownership varies regionally and is integral to the local system of kinship and group organisation. Frequently the rights are vested in groups of people rather than individuals, and age and gender, as well as ability, determine the exercising of rights.

Within a community, permission to produce a painting is usually implicit: people are able to exercise their individual rights without constant reference to others since they know what they are allowed to produce. However, the widespread nature of the rights means that they have to be exercised with caution, since many people can be affected by breach of **copyright**. While some have argued that there may need to be special laws to protect Aboriginal rights in cultural property, significant protection has been provided by existing copyright laws where cases have been brought forward. The exercising of rights not only concerns the sale and reproduction of works of art, but also affects their exhibition or performance. Artists and their communities are concerned that works are displayed appropriately and that Indigenous protocol is followed, even when the works are distant from home.

For example, following the death of an artist works may be withdrawn from view for a while or the artist's name may need to be held back. While requirements are often negotiable, right-holders expect to be asked. The maintenance of control and the exercise of custodial rights have also been an important issue in **cultural heritage** management.

HM

See also: 3.1, 22.1, 22.2.
Johnson, V., *Copyrites: Aboriginal Art in the Age of Reproductive Technologies*, Sydney, 1996.

RILEY MUNDUWALAWALA, Ginger (*c.*1937–), Mara painter, encountered the great Arrernte watercolourist Albert **Namatjira** in the 1950s, and resolved thereupon to be an artist. As he put it, he saw Namatjira 'painting his colour country', admired the 'nice paint' and 'saw my colour country'. But it would be over three decades before he had access to paints other than natural **ochres**. The breakthrough occurred in March 1987 when the Northern Territory Education Department set up a painting course at **Ngukurr**. Here Riley began to paint in earnest, as he remembers: 'When I first did them, red, blue, I thought they looked very good. I chased around again, blue, black—very good. I saw in my mind from my grandfather, my father.' His artistic vision reflected his 'proper bush' education in the business of Mara law, which included art. As he explains, 'my grandfather showed me how to paint on woomera and spear'.

Later that year, Riley began to exhibit his work with other Ngukurr artists but he dreamt of becoming independent. He held his first commercial solo exhibition in 1990, followed by four more in 1991. In 1992–93 his reputation was established when he won the Alice Prize and the first NIHAA, and received important commissions for Australia Post and for the Australian Embassy in Beijing.

In 1993–94 his work gained international exposure with representation in two major exhibitions, 'Aratjara' (Düsseldorf, London, and Humlebaek 1993–94), and 'Tyerabarrbowaryaou II' (Havana 1994). He began to sign his paintings after seeing signed works by Picasso and Van Gogh in London. Further recognition came with an Australia Council Fellowship and a solo exhibition at the NGV in 1997–98. Riley's work is held in many collections including the NGA and most State galleries.

Ginger Riley's vision of his mother country, identified by the important landmarks of the Limmen Bight River and the Four Archers, is uniquely experessed. The bright iconic landscape of his imagination is presented as a mythical space in which the sea eagle *ngak ngak* and the dual serpent-creator *garimala* are ever-present. An image-maker rather than a mark-maker of abstract sensibility, Riley is a great colourist, constantly 'building up colours' in order to 'build up country'. In thinking of his art, he says, 'I see my country when I wake up, think what I'm going to do—sometimes one colour, sometimes three. Same country—coming to one place, Limmen Bight—blue down, green, red. My mother country is in my mind … You must see it, it must be bright … I do not look backward, but look forward.' JUR

See also: *156*.

Mundine, D., 'Ginger Riley Munduwalawala', in A. M. Brody (ed.), *Stories: Eleven Aboriginal Artists*, Sydney, 1997; Ryan, J., *Ginger Riley*, Melbourne, 1997.

RILEY, Michael (1960–), Wiradjuri photographer and film-maker, says of his photography: 'I do what I do because I like doing it, I'm not chasing fame … Photography is just a medium for me, a way of putting across my views and images to the world. There's no big deal.'

Riley was born in Dubbo, central western NSW, and as a child lived on Talbragar mission, just east of Dubbo. His interest in photography began in 1982 with a Koori photography workshop at the Tin Sheds, University of Sydney. He worked as a darkroom technician at Sydney College of the Arts and as a freelance photographer until offered a training position at Film Australia in 1987, where he wrote and directed his first film, *Boomalli: Five Artists* (1988).

His most enduring images—and those closest to his heart—are of family and friends with whom he grew up. Since participating in the first exhibition of contemporary Aboriginal photography in Sydney in 1986, Riley has always privileged an aesthetic concern with tone and space over the overtly political. He has held several solo exhibitions: 'Portraits by a Window' (Sydney 1990), 'A Common Place: Portraits of Moree Murries' (Sydney and London 1991), 'Sacrifice' (Sydney 1992), 'Fence Sitting' (Sydney 1994), and 'They Call Me Nigger' (Sydney 1995). The last-mentioned toured internationally in 1996 as part of the exhibition 'Abstracts: New Aboriginalities and Yarns from Talbragar'. Riley considers 'Sacrifice' to have been his first conceptual exhibition. Focused on Christianity, mission life, and rationing, the photographs shift between the literal and the allegorical, exploring the experience of dispossession by replacing people with symbolic images of poppies, fish, and crucifixes.

In 1996 Riley was commissioned by MoS to direct an audiovisual display on the Eora people of the Sydney region, and in 1996–97 he directed *Guwanyi: Stories of the Redfern Community* for MoS, a video interpretative display based on snapshots taken in the previous decade. His documentary film *Empire* (1997) explored issues of land, culture, and destruction, and imagery from it formed the basis of 'Flyblown' (Gallery Gabrielle Pizzi 1998). This exhibition of large-format photographs examined the decay and destruction of rural Australia through abstract images of dead animals and barren landscape—a subliminal reference to the history of Aboriginal Australia. Riley has also participated in group exhibitions including 'Koori Art '84' (Artspace 1984), 'A Koori perspective' (Artspace 1987), 'Aratjara' (Düsseldorf, London, and Humlebaek 1993–94), and 'Urban Focus' (NGA 1994).

BW

See also: 12.1, 12.4; *373*.

Dewdney, A. & Phillips, S., 'Liking what I do: Michael Riley', in S. Phillips (ed.), *Racism, Representation and Photography*, Sydney, 1994; de Lorenzo, C., 'Delayed Exposure', *Art and Australia* vol. 31, no. 1, 1993; Riley, M., *Yarns from the Talbragar Reserve*, Dubbo, 1999.

373. Michael Riley, *A Dying Wetland*, 1997. Cibachrome photograph, 112 x 50 cm.

RILEY sisters, Nyungah fibre artists. When the Riley sisters—Jean (1948–), Lizzie (1951–), Gillian (1964–), Leslie (1978–) and Wanda (?–)—made a group of fifty multi-coloured, hand-stitched fabric dolls (now in the Edith Cowan University Collection) for the exhibition 'Re-coverings' in the 1997 Festival of Perth, they represented both traditional and contemporary Nyungah life. Recycled clothes are used to

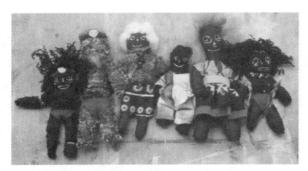

374. Jean and Lizzie Riley, *Fabric Dolls*, 1998.
Recycled clothing and buttons, 12–18 cm (variable).

make the predominantly black bodies and coloured clothing: 'I dress them how I would like young Noongars, teenagers, to dress instead of in this [tracksuit]', one of the artists, Leslie Riley, commented in 1998. Each doll is different, and close attention is given to details such as facial features, hair, headbands, and bush jewellery.

The women live and work in Narrogin (WA). They did workshops with Nalda Searles and Pantjiti Mary **McLean** in 1993. Jean Riley is represented in the NGA, and all five sisters are represented in the Berndt Collection (UWA).　　　　NS

See also: 17.1, 17.5; *374*.

ROACH, Archibald (Archie) William (1955–), poet, singer–songwriter, and storyteller. Roach's first album *Charcoal Lane* (1990) featured *Took The Children Away* and *Down City Streets*, songs which explored the difficult times in his life and the emotional chaos which engulfed him after he discovered he was a child of the **stolen generations.**

Archie Roach was removed from his family at Framlingham, Victoria, with his brothers and sisters, and was separated from his siblings. When he was ten he was placed with a white couple, Alec and Dulcie Cox, in Lilydale, Melbourne. He had been led to believe that his family was dead. He became interested in music, playing acoustic guitar, and listened to the stories told to him by his Scottish foster father. At fifteen he received a letter from his sister telling him that his mother had died. This was the beginning of a chaotic life on the streets of Sydney, and his search for his Aboriginal roots and his family. His subsequent partnership with Ruby Hunter gave him the impetus to stop drinking and start writing his own songs.

Roach's first album won both national and international acclaim, winning Best Indigenous Album and Best New Talent in the 1991 ARIA awards. He was the first songwriter to win the Human Rights Achievement Award, for *Took The Children Away*. *Jamu Dreaming* (1993) was nominated for a 1994 ARIA Best Indigenous Record award, and in 1997 *Looking for Butter Boy* was released to critical acclaim. RAB & ND

See also: 15.2; *193*.

ROBERTS, Bluey see boomerangs, emu eggs.

ROBINSON, Brian, (1974–), artist, curator, and arts administrator. Confidence in the enduring identity of the Torres Strait Island people in the context of their strengthening ties with other cultures is central to Brian Robinson's life and art. As an experienced curator and arts administrator, he brings to projects involving fellow Torres Strait and Pacific Island artists a broad understanding of cultural issues across the region. In 1997 he embarked on formal museum training through a Museums Australia internship at CRG (Qld,), which culminated in his co-curating the 1998–2000 touring exhibition, 'Ilan Pasin (This is Our Way): Torres Strait Art'.

Enthusiasm for expanding the boundaries of a given visual art technique gives an exuberant freshness to Robinson's **printmaking** practice. Milestones in his career include the group exhibitions 'Pacific Dreams' (Perc Tucker Regional Gallery 1995, while he was artist-in-residence); 'Our Inspirations' (Honiara 1996, while he was artist-in-residence), 'Art or Artifice Torres Strait Exhibition' (Noumea 1996, while he was artist-in-residence), 'Local Colour' (CRG 1996), and 'Raiki Wara' (NGV touring exhibition 1998–99). He is represented in several major collections including the NGA, NGV, QAG, QM and ANMM, and the Jean-Marie Tjibaou Cultural Centre (New Caledonia).　　　　IH

See also : 17.2, 17.4; *90*.

Mosby, T. with Robinson, B., *Ilan Pasin (This is Our Way): Torres Strait Art*, Cairns, Qld., 1998.

rock-art dating, or rock-mark dating. Rock paintings, carvings, stencils, and prints are found throughout Australia, with major concentrations in the north and centre of the continent. The age of these rock markings has been the subject of scholarly and popular interest since the initial reports of rock carvings by the Sydney colonists. Australia is unique in that rock marking is a cultural practice that continues to the present day.

The first attempts at dating rock markings relied on the development of chronologies based on stylistic changes in art over time. A number of models were used to compare the relative ages of rock markings, but no one model gained general acceptance. Conventional radiocarbon analysis was later applied to the dating of rock paintings. This technique dates organic material such as charcoal, which is generally excavated from sites directly underneath the paintings. It is difficult to prove a direct relationship between the paintings and such organic material. Other techniques have recently emerged for dating the paint itself, or the rocks. These techniques include accelerator mass spectrometry and optically stimulated luminescence (OSL).

Some techniques involve obtaining samples of the paint. Sampling of rock markings—many of which are of special cultural significance to Indigenous Australians—in order to apply the new techniques has therefore raised ethical questions. Sophisticated sampling techniques which minimise the size of the sample have been developed in an attempt to address such concerns, and also to minimise the possibility of contamination of organic materials across the layers of pigments and encrustations, and of introducing materials not related to the original act of painting.

The results of recent research using these techniques have been most encouraging. At sites in the Kimberley region (WA), OSL has been used to date a wasp's nest overlying a

375. Contact paintings from near the East Alligator River, Arnhem Land (NT).
These paintings date from the late nineteenth or early twentieth century. The hand and arm stencil is infilled with clan designs.

Drysdale River Wanjina figure to at least 600 years ago, and and another overlying a Bradshaw *(Gwion Gwion)* figure near the Edwards River Crossing to about 20 000 years ago. Luminescence and radiocarbon results from Deaf Adder Gorge (NT) suggest that the use of ochre for markings dates back about 60 000 years.

The application of these techniques to rock markings is new, and caution is required. For example, some results have been questioned on the basis that the samples being tested include material from more than one source and, therefore, potentially more than one period.

Researchers recognise that there are other interests involved in the materials and the results, especially those of Indigenous Australians. A critical appraisal of research design and the interpretation of results, and protocols that take into account the concerns of all parties, are being developed. GW

See also: 5.1, 5.2, 5.3, 5.4; rock-art repainting, rock-art dating; *375*.
Roberts, R. G., Jones, R. & Smith, M. A., 'Beyond the radiocarbon barrier in Australian prehistory', *Antiquity,* vol. 68, no. 260, 1994; Rosenfeld, A. & Smith, C., 'Recent developments in radiocarbon and stylistic methods of dating rock-art', *Antiquity,* vol. 71, no. 272, 1997.

rock-art repainting, or rock re-marking. Archaeological studies of some painted images in Western Australia have demonstrated that more than thirty layers of pigment have been placed one over the other. Recent research in Queensland has shown that more than ten superimposed layers of paintings, laminated within encrustations rich in organic materials, might be defined in a depth of twenty millimetres, and represent a period of 30 000 years. Because only minute areas of paintings have been studied in this intensive way, it is not possible to conclude that the same image has been reproduced in the same place, or to follow changes over time in the form of markings.

It is clear from ethnographic studies and the testimony of Indigenous custodians, that re-marking is a culturally approved and even necessary practice, and one that continues today. Indigenous custodians in some areas might use the terms 'freshening-up' or 'brightening', since they have the appropriate connotation of revitalising the motif for a ritual purpose. For many Indigenous Australians, marks on rock faces are not 'art works', but expressive representations of their dynamic relationship with the natural and spiritual worlds.

Moreover, many marks are considered to have been left on rocks by the ancestral beings of the **Dreaming** during their journeys across a region, concentrating their power at certain places. People might say that the ancestral beings 'painted themselves into the rock'. Such places are powerful representations of various elements of the Dreaming—of sacred knowledge, cosmology and ceremonies—through which the initiated might connect with the Dreaming. One way that this might be done, is by 'brightening' the figures, by re-marking them.

In northern areas of the continent, custodians of significant sites may view re-marking as a continuation of traditional practice. Among the Kimberley peoples, for example with repainting of the Wanjina figures, re-marking might be undertaken to encourage seasonal rains, and thus ensure continuity of the life cycle—to replenish flora and fauna and to ensure the well-being of the human population. Various clans are responsible to others in the region for the maintenance of particular representations of species so that all may benefit. Sorcery might be a motive in the Victoria River District and the Cape York Peninsula. In southern Australia, re-marking may be undertaken as part of a process of revival of culture. Throughout the continent, whether in Arnhem Land or in south-eastern Australia, re-marking is part of a process of reinforcing a group's relationship to country, and strengthening social networks and cultural identity.

The significance of re-marking to many Indigenous Australians has not always been understood by some non-Indigenous observers. In the mid 1980s a controversy arose when custodians of sites in the Kimberley, a group of Ngarinyin people, obtained Community Employment Program funding to assist them to train young people in aspects of their culture heritage. This involved visiting painted sites, listening to traditional stories and using traditional materials to re-mark faded images in order to ensure the continuing spiritual value of the places. Much of the initial reaction to news of this cultural continuity project, including newspaper and television current affairs reporting and commentary, was ill-considered and ill-informed—a pastoralist wrote that sites had been 'desecrated'.

At an academic forum provided by the first Australian Rock Art Research Association Congress in Darwin in 1988, the Kimberley re-painting controversy was discussed. In response to various criticisms made mainly from 'national heritage' and conservation perspectives, David **Mowaljarlai** stressed custodianship by Ngarinyin people, the continuing value of these places to their way of life, and the great importance that they placed on the maintenance of their sites. Repainting is a necessary part of that process by which Mowaljarlai's people manifest their obligation to their country. 'Conservation' of painted imagery was not an issue; if the places were part of a continuing cultural process, an expression of belief, then they needed to be treated in an appropriate—although not necessarily static—adaptation of traditional process.

The conference debates suggested divergent discourses and competing ideologies. As a footnote to the debate, it is worth noting that the Australian Archaeological Association adopted in 1994 a 'Code of Ethics' among the Principles of which is acknowledgment that 'the indigenous cultural heritage rightfully belongs to the indigenous descendants of that heritage'. GW

See also: 5.1, 5.2, 5.3, 5.4, 18.1; **rock-art dating, rock-art sites**; *60, 154.*

Anon., 'Code of ethics of the Australian Archaeological Association (Members' obligations to Australian Aboriginal and Torres Strait Islander people)', *Australian Archaeology*, vol. 39, 1994; Bowdler, S., 'Repainting Australian rock art', *Antiquity*, vol. 62, 1988; Mowaljarlai, D., Vinnicombe, P., Ward, G. K. & Chippindale, C., 'Repainting of images on rock in Australia and the maintenance of Aboriginal culture', *Antiquity*, vol. 62, 1988; Ward, G. K. (ed.), *Retouch: Maintenance and Conservation of Aboriginal Rock Imagery*, Occasional AURA Publication no. 5, Melbourne, 1992.

rock-art sites. Australia is rich in rock paintings and engravings—richer than any other continent. There are well over 100 000 individual rock-art sites, ranging in size from a handful of images to galleries containing hundreds of individual motifs, overlapping in elaborate and lengthy sequences. Hand stencils, detailed pictures of animals, human figures in a range of poses and scenes, striking depictions of ancestral beings, clusters of cup-marks ('cupules'), and many other images cover shelter walls, ceilings, boulders, and platforms of rock. They range in age from at least 40 000 years to less than 15 years old (some of the last rock paintings were done by artists in Arnhem Land in the mid 1980s), but most surviving imagery is less than 10 000 years old. Incredibly, dozens of previously undocumented sites are still found each year, many with stunning imagery. This is particularly true in northern Australia, where rich concentrations of rock art are scattered across the Pilbara, Kimberley, Arnhem Land, and Cape York. But there are other focal points with hundreds or thousands of sites in central and southern Australia, including in cities such as Sydney.

Pictures from the past, whatever their age, are very important for Aboriginal people. Aboriginal art is primarily of and about the land: its creation, its people, and relationships between its creatures. This is particularly true of rock art, a long-lasting form that is literally on, or in, the land, transcending the ages.

Rock paintings and engravings can be found almost everywhere that suitable surfaces occur. At least thirty key regions are identifiable on the basis of style, geography, and cultural history. In most regions either paintings or engravings predominate, but in some, such as greater Sydney, dual systems of painted and engraved art operated simultaneously for thousands of years. There have been many attempts to classify this extraordinary art body, at national, regional and local levels, and chronologies have been worked out for each region. In parts of northern and central Australia, Aboriginal elders have recently been consulted to provide Indigenous insight into meaning and significance. Across the country, there is a shared concern for better conservation and protection of, and education about, Australia's unique rock-art heritage.

The diversity of Australian rock art can best be appreciated by visiting a range of regions and sites, remembering also that within each region there is diversity over time, and often between neighbouring areas. Australia's north is dominated by elaborate polychrome paintings but there also are stencils, figurative engravings, tracks, and cup-marks. Different sorts of rock art are associated with different eras of the past; in some areas there are six or more separate styles.

If we were to travel from west to east across Australia's north we would begin our journey among the grand engraved animals of the Pilbara, and move next to the red and mulberry painted Bradshaw (*Gwion Gwion, Kiera Kirow, Jungardoo*) human figures, enormous polychrome Wandjina paintings, painted animals, hand prints, and stencils of the Kimberley. A sweep through the Keep and Victoria River regions would introduce us to new ancestral beings—such as the Lightning Brothers of the Wardaman people—and a mix of engraved or painted animals, rows of hundreds of abraded grooves, and shelters full of hand-stencil arrangements. Kakadu National Park and western Arnhem Land would reveal not only Dynamic and x-ray art but also fantastic depictions of rainbow serpents, *mimih* figures engaged in battle, and stencils infilled with elaborate clan designs. Further east we would see depictions of Macassans and the great fishing traditions of Groote Eylandt. Near Laura, in northern Queensland, we would see Quinkan spirit figures, huge polychrome animals, and several forms of engraving. In the Torres Strait we would see images of sea life and maritime encounters. All across the top of Australia we would see pictures recording the arrival of Europeans, on horseback, and by ship, automobile, and aeroplane.

Our journey to central Australia would be a contrast: engraved tracks, circles, and other geometric designs are common, while paintings are rare. This form of art has been labelled Panaramitee, after a site near Olary in South Australia. Panaramitee motifs are usually less than twenty centimetres long, and are generally pecked, but sometimes abraded. Tracks and circles are common, with bird, macropod, and human tracks most frequent. Today these tracks are common features of **acrylic paintings**. Some Panaramitee art dates to the late Pleistocene, over 10 000 years ago, some motifs were made last century. Particularly spectacular sites can be found at places such as Ewaninga (NT), Sturt Meadows (WA), Mutawintji, Olary (SA), and Karolta (SA). Occasionally, we might find engraved animals, such as an emu with a clutch of eggs, a large goanna as seen from above, or an ancestral being with an enormous rayed head-dress. Haunting clusters of deeply engraved faces may also be encountered.

Across the southern portion of the continent the rock art is different again, with distinctive traditions found in the south-west of Western Australia, the Flinders Ranges, Tasmania, and various parts of Victoria and New South Wales. Deep caves on the Nullarbor and near Mt Gambier (SA), can be explored for their intricate finger flutings and markings. Complexes of large circles can be seen in Tasmania, mostly near the coast but also at a recently discovered site in the interior. Engravings of ancestral beings Baiaimi and

Daramulan can be viewed across the greater Sydney region, while painted stick figures may be found in the Grampians. But this lightning tour is just skimming the surface of Australia's rock-art richness and diversity: each pocket of this vast continent has a story to tell—in art, archaeology, and Aboriginal history.　　　　　　　　　　　　　　PT

See also: 5.1, 5.2, 5.3, 5.4, 5.5, 5.6; **rock-art dating, rock-art repainting**; *51, 52, 53, 54, 59, 60, 152, 154, 375.*
Chaloupka, G., *Journey in time*, Sydney, 1993; Chippindale, C. & Taçon, P. S. C., *The Archaeology of Rock-Art*, Cambridge, 1998; Flood, J., *Rock Art of the Dreamtime*, Sydney, 1997; Layton, R., *Australian Rock Art: A New Synthesis*, Cambridge, 1992.

ROOTSEY, Joe Alamanhthin (1918–1963), Wuuriingu painter. Joe Alamanhthin Rootsey's painting career began unexpectedly in 1954 after he was diagnosed with tuberculosis. During his two-year confinement in Cairns hospital he started sketching and, with encouragement from a medical social worker, began painting in watercolours. For his inspiration, Alamanhthin drew upon the tropical landforms around Cooktown (Qld) and his birthplace at Barrow Point, the clan land of the Wuuriingu. (Wuuriingu was his father Albert's surname before they both adopted the surname Barrow Point, then Rootsey). After his release from hospital, he had assembled enough work to stage solo exhibitions in Cooktown and then Brisbane by 1958.

It is not known if Alamanhthin was aware of the Hermannsburg School at the time; nevertheless he was promoted in the local press, predictably, as the 'second **Namatjira**'. While his landscapes had more in common with Otto **Pareroultja's** expressionism, Alamanhthin's career did have some parallels with Namatjira's; his work had strong popular appeal although it was dismissed by the local art establishment. In 1958 Robert Haines, Director of QAG, considered his works charming but unworthy of purchase, and advised against Alamanhthin receiving formal tuition, in case it destroyed his 'innocence of vision'.

Alamanhthin was undeterred, and his wish to further his career was fostered by the Queensland Department of Native Affairs, which assisted his tuition at the Brisbane Central Technical Art College for six months in 1958. The Department then marketed his work through their George Street art and craft shop, Aboriginal Creations, with individual works priced at between ten and twenty-five guineas. Alamanhthin also exhibited at the Finneys' art gallery in Sydney, and was included in an Australian art promotion in Johannesburg by the Australian High Commission. Alamanhthin died five years later from tuberculosis, the disease indirectly responsible for launching him as an artist. Because of his short career, he was then largely forgotten. This neglect was redressed in 1993, when QAG purchased some of his watercolours in belated recognition of his significance to contemporary Indigenous art. Since then, three more of his works have been added to the gallery's collection.　　　　　MW

See also: 8.2, 9.1; *101.*
Haviland, J. B. with Hart, R., *Old Man Fog and the Last Aborigines of Barrow Point*, Washington, 1998.

Roper River Artists, see Ngukurr.

ROSS, Darby Jampijinpa (*c.*1910–), Warlpiri painter, was born at Wakurlpa, north of Yuendumu (NT). He is associated with and paints a large number of **Dreamings**, including *pamapardu* (flying ant), *yankirri* (emu), *liwirringki* (burrowing skink), *ngapa* (water), *wardilyka* (bush turkey), *yakajirri* (desert raisin), and *watiyawarnu* (acacia seed).

Ross spent his early years travelling with his family through the length and breadth of Warlpiri country, living a 'traditional' lifestyle. After the Coniston **massacre** of 1928, in which several of his family were killed, he travelled extensively throughout the Northern Territory and outback Queensland working with camels, droving cattle, and mining wolfram during World War II. On his return to **Yuendumu**, he became well known for his extensive knowledge of flora and fuana, and of Warlpiri Law, and for his strong support of the Baptist church. Darby Ross is fluent in several languages and possesses a near-unique ability to communicate effectively and with good humour across social, cultural, and language barriers with both Aboriginal and non-Aboriginal people.

Darby Jampijinpa Ross is one of the founding members and strongest supporters of **Warlukurlangu Artists Aboriginal Association**. He has been painting on canvas since 1985, and his works are bold, colourful paintings with a strong grounding in Jukurrpa (Dreaming). He is among the most highly acclaimed artists of Yuendumu, and has exhibited extensively nationally and internationally since 1985. His work was included in 'Dreamings' (New York, Chicago, and Los Angeles 1988), 'Mythscapes' (NGV 1989) and 'Aboriginal Art and Spirituality' (HCA 1991). Major collections in which he is represented include the NGA, NGV, AGNSW, AM and the Musée National des Arts d'Afrique et d'Océanie, Paris.　　　　　LC

See also: 9.5; *121, 221.*
Crumlin, R. (ed.), *Aboriginal Art and Spirituality*, North Blackburn, Vic., 1991; Dussart, F., 'What an acrylic can mean: The meta-ritualistic resonances of a Central Desert painting', in H. Morphy & M. Smith Boles (eds), *Art from the Land: Dialogues with the Kluge–Ruhe Collection of Australian Aboriginal Art*, Charlottesville, VA, 1999.

ROSS, Jack Jakamarra (*c.*1922–), Warlpiri painter, was born at Wapurtali, west of Yuendumu (NT). He is associated with and paints many **Dreamings** from this area of Warlpiri country, including: *yarla* (big yam) and *wapirti* (small yam), *ngarlayiyi* (bush carrot), *pamapardu* (flying ant), *liwirringki* (burrowing skink), *marlu* (kangaroo) and *janganpa* (possum).

As a young man, Jack Ross travelled extensively throughout Warlpiri country and surrounding areas. As a senior Warlpiri custodian, he is respected for his knowledge of and enthusiasm for Tjukurrpa (Dreamings) and the maintenance of Warlpiri Law. He is a long-term committee member of **Warlukurlangu Artists Aboriginal Association**. He is well known for the production of 'traditional' artefacts, and is also a successful artist on canvas.

Jack Ross started painting for Warlukurlangu Artists Aboriginal Association in 1985, and his works have since

been exhibited regularly nationally and internationally. He has worked on seven large collaborative canvas commissions for Warlukurlangu Artists and created ground installations at major Aboriginal art exhibitions. Among the group exhibitions in which he has participated are 'Yuendumu: Paintings Out of the Desert' (SAM 1988), 'Awake to the Dreamtime' (San Diego Museum of Man 1993) and 'Spirit Country' (Fine Arts Museums of San Francisco 1999). He is represented in major collections in the SAM, the AGNSW and the Gantner Myer Collection, San Francisco. LC

See also: *121*, *221*.
Dussart, F., 'What an acrylic can mean: The meta-ritualistic resonances of a Central Desert painting', in H. Morphy & M. Smith Boles (eds), *Art from the Land: Dialogues with the Kluge–Ruhe Collection of Australian Aboriginal Art*, Charlottesville, VA, 1999; Isaacs, J., *Spirit Country: Contemporary Aboriginal Art*, South Yarra, Vic. & San Francisco, 1999.

ROUGHSEY, Dick (Goobalathaldin) OBE, (*c.*1920–1985), Lardil painter, children's book author and illustrator, and explorer, was born on Mornington Island (Qld). The birth names given to him by his parents Kiwalpija and Jathagin were Garagara (pandanus nut) and Goobalathaldin. When they were about nine and eleven years old respectively, he and his older brother were separated from their parents and brought to a dormitory school. The missionaries there called him Dick Roughsey—the translation of Goobalathaldin is 'weather standing on its end', or 'rough sea'. At sixteen he left the mission to work as a stockman and deckhand, making frequent trips home to Mornington Island. He married Elsie Wilson in his early twenties and they had six children.

During his school years Roughsey contracted 'cattle blight' (trachoma) which badly affected many Lardil people on Mornington Island. His eyes remained weak, appearing half-closed in strong light. Yet his vision of the landscape and of the figures moving through it, as evinced in his later paintings, shows a love of bright colour, particularly in people's

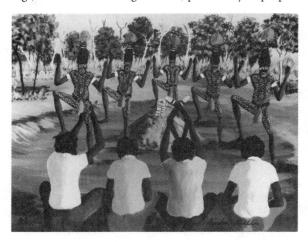

376. Dick Roughsey (Goobalathaldin), *Rainbow Serpent, Thwiathu Dance, Mornington Island*, 1972.
Acrylic paint on canvas on cardboard, 47.7 x 57.4 cm.

clothing, or in the strong contrasts of red and green, as in pandanus nuts against green foliage.

In 1962 Dick Roughsey met the pilot and explorer Percy Trezise at Karumba Lodge, where Trezise was painting a mural on the swimming pool. Roughsey asked to be taught painting, and so began his career as an artist and a partnership with Trezise which was to continue all his life.

In common with his later acrylic and oil paintings, Roughsey's bark paintings feature many traditional ceremonial scenes in which the naive figures bear the full repertoire of Lardil body paint designs and wear cere-monial or, as Roughsey termed it, '**corroboree**' cockatoo-feather headbands and woven armbands. In silhouette or profile, often in 'shake-a-leg' dance position or poised to hurl weapons, the figures are arranged in tiers, sometimes with an inventory of Lardil artefacts and weapons.

Roughsey depicted life using strong form, rounded dark figures, and sensuous tropical colour. He developed his own unique themes from the Aboriginal cultural background of Cape York, often positioning the viewer behind the action of his paintings, so that most figures have their backs to the viewer. From 1965 until his death, he held numerous exhibitions with mentor and manager Trezise, with whom he discovered hundreds of rock art galleries in the escarpments of Cape York and the Laura region. The pair also exhibited with **Thancoupie** (Gloria Fletcher) in her first exhibition of bark paintings in Cairns. Roughsey also exhibited at the Upstairs Gallery (Cairns), Artarmon, Holdsworth and Macquarie Galleries (Sydney), Australian Galleries (Melbourne), Bonython Gallery (Adelaide) and regional centres including the Anvil Gallery, Albury.

After the publication of *Giant Devil Dingo* (1973), his writing and illustrating career blossomed. Roughsey and Trezise combined their illustrating and story-telling skills in many publications, including *Turramulli the Giant Quinkan* (1982). Children's writer Walter McVitty wrote in Roughsey's obituary in 1985: 'He introduced millions of children, all round the world, to the creation myths and legends of Aborigines of the Cape York Peninsula.' Two of Roughsey's books—*The Rainbow Serpent* (1976) and *The Quinkans* (1979)—won Children's Picture Book of the Year Awards. His seminal autobiography *Moon and Rainbow* (1971) pioneered the genre of Aboriginal **life stories**.

In 1970 Roughsey was appointed to the Aboriginal Arts Advisory Committee for the Australia Council, and was later chairman of the **Aboriginal Arts Board**. A pioneer of contemporary Australian art and a great supporter and patron of Aboriginal people, he is a well remembered and immensely important figure in Australian Aboriginal art history. He was awarded the OBE in 1978 for his services to Aboriginal art.
 JI

See also: 8.2; *102*, *376*.
Cadzow, J., 'Dick and Percy—An enduring act', *The Australian*, 24 November 1983; McVitty, W., 'Black man of the Moon, white man of the Sun', *The Age*, 14 July 1984; Trezise, P., *Dream Road: A Journey of Discovery*, St Leonards, NSW, 1993.

RUBUNTJA, Wenten (*c.*1926–), Arrernte artist and activist, is a remarkable man, well known as an artist and as a

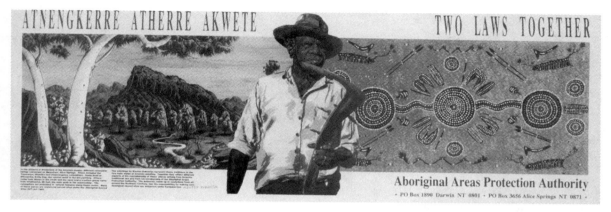

ATNENGKERRE ATHERRE AKWETE — TWO LAWS TOGETHER

Aboriginal Areas Protection Authority

• PO Box 1890 Darwin NT 0801 • PO Box 3656 Alice Springs NT 0871 •

377. Wenten Rubuntja and Chips Mackinolty, *Atnengkerre Atherre Akwete, Two Laws Together*, 1990. Poster (Aboriginal Areas Protection Authority), from watercolour paintings by Wenten Rubuntja, 50 x 123 cm.
In the Altyerre or Dreamtime of the Arrernte people, different caterpillar beings converged on Mparntwe (Alice Springs). These included the Yeperenye, Ntyarlke and Utnerrengatye caterpillars. Some lived at Nthwerrke (Emily Gap), the central motif in the painting. Others came from places in the south and in the east; and a western group came from Urlatherrke (Mt Zeil), the peak illustrated in the paintings. The caterpillars are embodied in the natural features along these routes. The original paintings by Wenten Rubuntja represent the two main styles of Arrernte painting. Together they reflect different aspects of his custodianship of these places arising from Arrernte Law.

spokesperson, negotiator, and ambassador for Aboriginal Australia. He has been a central figure in the **land rights** movement since its formative days, and continues to be involved in issues such as **reconciliation** and the protection of sacred sites.

Rubuntja was born at Burt Creek (NT). His parents worked on cattle stations around Alice Springs, and he spent his early years in that country. Later, he worked as a brickmaker, drover, butcher and cook. He came to be a key figure in the events which led to land rights legislation in the Northern Territory. In 1976 he headed a major demonstration through the streets of Alice Springs, then a deputation which campaigned for land rights across the country, culminating in a meeting with Prime Minister Malcolm Fraser in Canberra. He played a leading role in the subsequent establishment of Aboriginal organisations in central Australia— the Central Australian Aboriginal Congress, Tangentyere Council, Yipirinya school and the Central Land Council, of which he was twice Chairman (in 1976–80 and 1985–88). In 1991 he became a member of the Aboriginal Reconciliation Council, and he has worked for many years with the Aboriginal Areas Protection Authority.

His work, which is represented in many collections, spans both the watercolour landscape style of the Hermannsburg School of painters, and the Western Desert style which began at **Papunya**. His father's cousin, Albert **Namatjira**, provided the catalyst for Wenten's long artistic career:

I went with my father and saw old Namatjira painting. I wanted to learn. He gave me a little board, little half board and

I went back to the Telegraph Station, and started painting there. I went and hid myself behind a rock to paint. I was remembering how that old man was painting; his handwork, his mixing and his ideas. After that I brought the painting up and showed it to old Namatjira and he said, 'Eh, who taught you? You've got good ideas.'

In the 1970s Rubuntja began to use acrylics as well as watercolour, and he continues to alternate between the two, while still rendering themes of country and **Dreaming**. In 1986 he was commissioned to paint a large canvas for presentation to Pope John Paul when he visited Alice Springs. In 1988 Wenten Rubuntja and the chair of the Northern Land Council, Galarrwuy Yunupingu, presented Prime Minister Bob Hawke with the Barunga Statement, seeking government recognition of Aboriginal prior ownership of Australia and calling for a treaty. As he once put it, with considerable eloquence and power: 'The town [Alice Springs] grew up dancing and still the dancing is there under the town. Subdivisions spread, but we still keep going. We still have the culture, still sing the song. It's the same story we have from the old people, from the beginning here in the Centre' (quoted in Brooks et al. 1994).

JG

See also: 4.6, 9.1, 9.5; **printmaking, Yunupingu family**; *39, 377.*
Brooks, D., Rhodes, J., & Ruff, C., *Site Seeing*, Sydney, 1994; Eames, G., 'The Central Land Council: The politics of change', in N. Peterson & M. Langton (eds), *Aborigines, Land and Land Rights*, Canberra, 1983; Green, J. (compiler), *Pmere, Country in Mind: Arrernte Landscape Painters*, Alice Springs, 1988.

rugby league has probably been kinder to Aborigines and Islanders than any other sport. This 'working class' game —played almost solely in Queensland and New South Wales—has required little from its players in the way of class, income, schooling, clothing or equipment. It has, however, offered much—especially in the 1980s and 1990s—by way of financial and status rewards for the elusive, the creative, the fast, the tough, and the exciting.

It wasn't always so. The first 'dusky' players (to use the language of the time) were George Green and Paul Tranquille between 1909 and 1922. George, who may well have been of Islander descent, played sixteen games for Eastern Suburbs between 1908 and 1913 and then joined North Sydney's

693

378. Peter Yanada McKenzie, *The Dressing Room of La Perouse United 'A' Grade Football Club*, 1991. Gelatin silver photographic print, 30.5 x 54 cm.

'shoremen' in 1918 as their hooker. He was in North's only premiership sides in 1921 and 1922. George went on to lecture, to awaken interest in the sport in North Sydney and to coach Norths. Historian Andrew Moore believes there was no racism involved at this time: in 1923 the NSW Rugby League recognised Green's pioneer status and arranged a testimonial match in his honour. Paul Tranquille, the New South Wales 220 yard sprint champion, was another 'public favourite' who played for Norths in the early 1920s. He had a Mauritian father and possibly an Aboriginal mother. In 1925 the first Aboriginal footballer to tour abroad in any code was Glen (Paddy) Crouch of Queensland. He was a member of a successful state side that toured New Zealand.

There was to be a long break between this pioneering period and full Aboriginal and Islander access to the game. New South Wales government policy was to move Aborigines from towns back to remote missions, and to declare all youth wards of the State. Most Aboriginal children were excluded from the State public school system: the policy of 'exclusion on demand' meant that head-masters could and did exempt any or all Aboriginal children from attending before they reached the compulsory school-attendance age, on the grounds that white parents objected to their presence in the classroom! There was also social exclusion—a refusal by local white teams to have Aborigines in their sides. These factors made an Aboriginal presence almost impossible.

That there were any players in the 1930s, 1940s and early 1950s is remarkable. However, six men of note emerged in the game which its fervid supporters claim is tougher, more spectacular and more intellectually satisfying than rugby union. Frankie ('Big Shot') Fisher was Cathy Freeman's grandfather. A regular member of the famous Cherbourg teams, he played five-eighth for Wide Bay against the visiting British teams in 1932 and 1936. So impressed was the English captain, the legendary Gus Risman, that he wrote to Fisher suggesting that he come to England for a career. Fisher, then a 'controlled' Aborigine under the restrictive Queensland special legislation, applied to the Sub-Department of Health and Home Affairs for permission to apply for a passport. This was refused, allegedly on the ground that one sports star

from Cherbourg—namely cricketer Eddie Gilbert—was enough! A happier story, though only marginally so, is that of Arthur ('Stokel' or 'Stoker') Currie. In 1937 he played for the NSW Country side that beat Sydney City, a rare victory in that series. He was a member of the top-ranking Tweed Heads All Blacks side, which was created because local white teams wouldn't include Aboriginal players. The famous Redfern All Blacks and the Moree Boomerangs were formed in these eras of rejection, exclusion and segregation. Stoker's grandson Tony Currie is a celebrated international.

The brothers Lin and Dick Johnson hailed from Currabubula, near Tamworth. Both played full-back: Lin for Canterbury Bankstown and Dick for South Sydney, Cessnock, Western Suburbs and finally Canterbury. In 1941 the brothers were opposing full-backs in the City *versus* Country fixture. Walter Mussing, an immensely popular South Sea Islander, played 37 games for St George immediately after World War II. Wally McArthur, who was born in the Northern Territory and removed as a child to an assimilation home in Adelaide, began his sporting life as a junior sprinter. Alleging that a colour bar was hindering him, he went to England and there had a remarkable rugby league career, amassing a total of 165 games for four different clubs between 1953 and 1959.

The 1960s can be described as the 'decade of opportunity'. Certainly this was the case in a few sports: Evonne Goolagong in tennis; Polly Farmer in Australian football; Lionel Rose in boxing; John Kinsella in wrestling; Cheryl Mullett in badminton; and Michael Ahmatt in basketball. But it was in league that Aborigines really found their niche. Lionel Morgan became the first Aborigine to play for Australia, in 1960. The uncompromising Newtown and New South Wales prop Bruce Olive played at this time. Artie Beetson says that the first time he encountered racial sledging on the field was from Bruce. He yelled back to Bruce: 'you're two shades darker than midnight than I am'! Ron Saddler captained and coached New South Wales and toured with the Kangaroos. Eric Simms broke all kicking records, played for New South Wales and eight World Cup matches for Australia. Other notables were Kevin Yow Yeh, Eric Pitt, Bruce 'Larpa' Stewart (the uncle of the Ella brothers), Eric Robinson and Kevin Longbottom.

The 'daddy' of them all was Arthur (Artie) Beetson who came from Roma in Queensland in 1966. Regarded as possibly the greatest ball-playing forward of all time, he played 28 matches for his country, as captain on two occasions. He led Eastern Suburbs to two premierships and was the undoubted hero of the first State of Origin match in 1980. He once said: 'I consider myself an Australian first, a Queenslander second and part-Aboriginal third'. Yet in his post-career as player and as a state and national selector, he gives every appearance of being Aboriginal first. His influence and the amount of time he has put into the game have helped develop Aboriginal players enormously.

In the early 1970s George Ambrum played two Tests for Australia in a period that saw a huge increase in the number of first grade players. The trickle was now a full-flowing stream with spectacular performances from Ray Blacklock, Eric Ferguson, Larry Corowa (who was the glamour player of the time), Ross Gigg, David Grant (Beetson's cousin), Percy Knight, Terry Wickey and Mark Wright.

The State of Origin series, which began in 1980, provided for greater involvement of Queenslanders and eventually to the presence of three teams in the Sydney competition. The stars, in the real sense of that overused word, were Sam Backo, Tony Currie, Colin Scott, Dale Shearer and Mal Meninga.

The Queensland *versus* New South Wales rivalry was also the spur to some outstanding southern players: Mal Cochrane, Steve Ella (a cousin of the famous rugby union trio), John (Chicka) Ferguson, Ron Gibbs, Cliff Lyons and Ricky Walford.

Since the 1980s the number of Aboriginal and Islander players has increased to the point where they now constitute over ten per cent of the Sydney first grade players. Given that Aborigines and Islanders constitute less than two per cent of the New South Wales and Queensland populations, this is indeed an amazing over-representation. The only comparable figures are in Australian football and, by way of sharp contrast, darts! One match doesn't make a statistical truth but the 1987 grand final between Canberra and Manly was both freakish and normal: there were seven Aboriginal and Islander players on the field!

The 1990s has brought about a veritable flood of great Aboriginal and Islander talents, some of whom will undoubtedly become members of this Hall of Fame: Nathan Blacklock, Tony Carroll, Owen Craigie, Ashley Gordon, Jeff Hardy, Lee Hookey, Ken and Kevin McGuiness, Ewan McGrady, Chris McKenna, Anthony Mundine, Ken Nagas, David Peachey, Wendell Sailor, Craig Salvatori, Rod Silva, John Simon, Matt Sing, Gorden Tallis, Darrell Trindall, Steve Renouf, Andrew Walker, Craig Wing and not least, the incomparable Laurie Daley.

This magnificent parade doesn't mean that all is honey and light. In 1999 a Canterbury player racially vilified Anthony Mundine. His startling defence was that he wasn't racially abusing Mundine but another player nearby, Aboriginal Robbie Simpson! Despite efforts to keep the matter 'in house' and dealt with 'inside'—which is typical of football officialdom in all codes—Mundine insisted on pursuing the matter. He had the satisfaction of seeing the Australian Rugby League fine the offender $10 000, despite Canterbury's indignation that it was all 'unfair and un-Australian'! The ARL, which doesn't have the same formal code of conduct as introduced by the Australian Football League has, in effect, introduced an important precedent by this heavy sentence.

CT & PAT

See also: 20.2; *378*.

Reprinted with permission of the authors from Tatz, C. & Tatz, P., *Black Gold: The Aboriginal and Islander Sports Hall of Fame*, Aboriginal Studies Press, Canberra, 2000.

S

SAMUELS, Jeffrey (1956–), painter, printmaker, and installation artist, was born in Bourke (NSW), and spent his childhood on sheep properties near Carinda. After completing school at Grafton High in 1973, he obtained an Aboriginal Study Grant, completing a Diploma in Fine Art in 1978. In 1983 he was awarded a fellowship from **ATSIAB** to study traditional Aboriginal painting and culture under Lardil elder Lyndsey Roughsey from Mornington Island (Qld). During this period he converted his diploma to a BFA at the City Art Institute, Sydney. Samuels has taught painting, silkscreen printing, and mural-making in private and public schools, in the tertiary system, and within the prison system. He was a founding member of **Boomalli Aboriginal Artists Co-operative**. His works are represented in private collections and in national and regional art galleries in Australia and overseas.

Samuels has been involved with and contributed to many exhibitions including 'Koori Art '84' (Artspace 1984), 'Artists for Aboriginal Land Rights', 'A Koori Perspective' (Artspace 1989), and 'Blackroots: Indigenous Gay and Lesbian Artists' (1999). His work was also included in 'Aṟatjara' (Düsseldorf, London, and Humlebaek 1993–94). He has lectured on contemporary Aboriginal art at the University of Copenhagen. His professional career includes arts administration: he was program officer with the **Australia Council** for the 1996–97 **Survival Day** concerts.

His firm commitment to community is demonstrated through his donation of paintings to fund-raising events. His artworks are at once contemporary and influenced and inspired by traditional Aboriginal culture, Aboriginal politics, and the Australian landscape. BW

See also: 12.1; *162*.
Croft, B. L.. 'Boomalli: From little things big things grow', in Taylor, L. (ed.), *Painting the Land Story*, Canberra, 1999; Watson, C. & Samuels, J., *Aboriginal Australian Views in Print and Poster*, West Melbourne, 1987.

Santa Teresa artists, see Keringke.

SAUNDERS, Zane (1971–), Badtjala painter and printmaker, was born in Cairns (Qld) and spent most of his life in nearby Kuranda with family and relatives. He spent his childhood exploring the surrounding rainforest country, and swimming and fishing in the rivers and reef waters around Cairns. His mother's family is from Sandy Cape, from the Badtjala people of Fraser Island, and his father was born in Cherbourg. As a student in the Visual Arts Course at the **Far North Queensland Institute of TAFE** in the late 1980s, he experimented with different techniques, finding his strengths in painting and linocuts. Journeys to Laura, Cooktown, and other areas of Cape York were opportunities to meet new friends and family, and to learn something of the traditional laws and lifestyles that continue in the people's contemporary way of living.

Saunders takes as his themes animals, figures, and patterns from his surroundings. His work is mainly inspired by what he sees while camping, fishing, and hunting in the bush, and through gathering life events and stories from elders. His public commissions include the curtain for the original Tjapukai Dance Theatre in Kuranda, a rock painting for the Stockman's Hall of Fame at Longreach (Qld), a poster design in 1993 for the Year of the World's Indigenous People AIDS campaign, two canvas paintings which form part of a mural at Brisbane Airport commissioned in 1995, and two linocuts for the Cairns Convention.

He has exhibited almost annually since 1987 both nationally and internationally, as part of many group and touring exhibitions including 'Balance 1990' (QAG 1990), 'You Came to My Country and You Didn't Turn Black' (QM 1990), 'Epama, Epam!' (Alberta, 1994, 'Urban Focus' (NGA 1994), and 'Lingo Getting the Picture' (QAG 1995). He held a solo exhibition at the Bauhaus Gallery, Brisbane, in 1995, and a two-man show at the Hogarth Galleries in Sydney with Andrew Williams in 1990.

His work is included in many important national and international collections including the NGA, NGV, HCC, QAG, Alice Springs Art Foundation, James Cook University Fibre Art Collection, CRG, and the Dreamspeakers Conference Collection, Canada. AE

See also: 12.1; **corroborees**; *51, 379*.
Eglitis, A. (ed.), *Contemporary Aboriginal and Torres Strait Islander Art*, Rockhampton, Qld, 2000; Hill, P., *Shadows in the Dust: A Contemporary Portrait of Aboriginal Station Life*, Glebe, NSW, 1997; Isaacs, J., *Aboriginality: Contemporary Aboriginal Paintings & Prints*, St Lucia, Qld, 1989; Queensland Art Gallery, *Balance 1990: Views, Visions, Influences*, Brisbane, 1990.

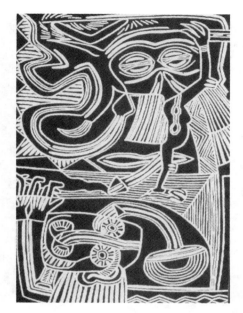

379. Zane Saunders, *Make Way We Come Strong*, 1994. Linocut, 42.5 x 27.5 cm.

sculpture, see 1.6, 4.4, 6.3, 7.5, 7.6, 10.1, 10.4, 12.1, 16.3, 17.3, 23.1.

SEN, Ivan (1972–), writer and director, was born in Nambour (Qld) in 1972. His mixed parentage—Aboriginal mother and Hungarian–German father—activated his thinking about identity during his youth in Tamworth and Inverell (NSW). As he grew older, identity became less of an issue in his thinking and in his film-making. He first studied photography in an Associate Diploma course at Griffith University, and this knowledge of photography has been pivotal in the development of his individual style as a filmmaker. He developed his skills further at the Australian Film, Television and Radio School where he completed a Bachelor of Arts in Directing in 1998.

He had entered the film school on the strength of an experimental documentary *Unheard Colours* (1994), and went on to work for the ABC as a director on the music series *Songlines*, as well as writing and directing the documentary *Shifting Shelter* (1997). An individual style became apparent in Sen's film-making with *Journey* (1997), made for the Festival of the Dreaming short-film compilation *Three for the Lucky Country* and in his short film *Tears* (1998), made for the Australian Film Commission's second Indigenous Drama Initiative compilation, *Shifting Sands* (1998). These films are about the unpredictable and uncontrollable nature of youth. In his short film *Wind* (1999), he moved away from this theme but consolidated his technical usage of close-up wide-angle, giving his subjects dimensionality. Through wide-angle close-ups, Sen is able to reflect the surrounding landscape through the framed face of the subject: 'There is a magic moment of a lens just after wide angle and before standard. The audience is close to the person but there is

dimension in the frame, things bounce off their face back at the audience.' Sen is an award-winning filmmaker and scriptwriter whose films have been screened internationally. In 2000 he completed another short dialogue-based film for the ABC, *Dust*, and was developing a cinema feature called *Beneath Clouds*. IB

See also: 13.1; *177*.

SERICO, Vincent (1946–), Wakka Wakka–Kabi Kabi visual artist, was born in southern Queensland and grew up on Baramba mission, later known as Cherbourg Aboriginal Reserve, in south-eastern Queensland. His father was born in the Carnarvon Ranges and his mother came from Palm Island. As a child he was separated from his family and placed in a segregated boys' dormitory to 'learn white ways'. His work reflects separation and reintegration through the juxtaposition of Aboriginal influences from many regions and non-Aboriginal systems of representation. The enforced movement of people and later artistic exchanges between regions created a distinctive Cherbourg style, and Serico is its best-known exponent. He draws on motifs and cross-hatching from Arnhem Land, figurative elements from Mornington Island where he was taught by local artists Lindsey and Dick **Roughsey** in 1974, and graphic and illustrative elements from Western sources.

The Road to Cherbourg, 1995, his signature work and the retrospective exhibition of the same title (GAL 1999), explores his vision and sociopolitical commentary on journeys and change from the perspective of a 'mission black'. While he deals with the despair of dispossession he also celebrates Aboriginal cultural identity, adaptation, and survival, having much in common with other community-based artists Gordon **Syron** and HJ **Wedge**.

Serico has been included in State and national exhibitions such as 'Urban Focus' (NGA 1994), the regional touring exhibition, 'Ancient Land, Modern Art' (QAG 1995) and had a solo exhibition, 'Baramba Visions' (Armidale Cultural Centre 1994). He is represented in a diverse range of public

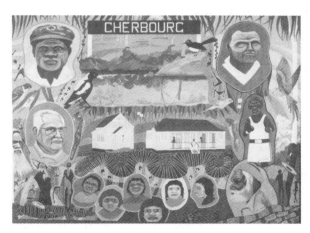

380. Vincent Serico, *Cherbourg*, 1993. Acrylic on canvas, 120 x 150 cm.

collections including the NGA, QAG, GAL, and the Singapore Art Museum. MN

See also: 8.2, 12.1; **Campfire Group, stolen generations**; *380.*

SHEARER, Heather Kemarre (1959–), Arrernte painter, is a member of the **stolen generations** of Aboriginal children who, like many others, has attempted to reclaim her Indigenous heritage. Taken from her mother at birth, she was adopted into the Shearer family and brought up and educated in Adelaide. At the age of twenty-four, she traced her mother's homeland to Ntaria (Hermannsburg) in central Australia but found that her mother had already died. From 1988 to 1992 she lived in central Australia, spending the period from 1990 at her father's homeland at Atitjere (Harts Range).

Contact with her birth family, and stories taught to her by her surviving senior relatives, inspired Shearer to start painting in 1991; her work encompasses theatre sets, poster and book-cover design and **acrylic paintings**. In 1992 she won the national NAIDOC poster competition and the NAIDOC Artist of the Year Award for Alice Springs. In 1995–97 she chaired the Indigenous Arts Advisory Committee of Arts SA. She worked in Northern Ireland in 1996 and held a residency at Limoges, France, in 1997. A gifted and dedicated teacher, and now an Indigenous Arts development officer with Arts SA, Shearer uses her art to express her Indigenous ancestry, as well as her own tumultuous journey through life, by combining the 'dot' style painting traditions of the desert, the sinuous forms of **Ernabella** art and her own personal story.
 MRM & JVSM

See also: 9.1, 9.2, 9.3.
Pring, A., *Aboriginal Artists in South Australia*, Adelaide, 1998.

shell necklaces. Early settlers noted that Tasmanian Aborginal women wore necklaces of a continuing spiral pattern, consisting of many layers of strung pearly-blue shells. The traditional wearers of shell necklaces, such as **Trukanini** and Fanny **Cochrane Smith**, have been photo-graphed wearing the layers of shells that form an entire *maireener* necklace. The design of the necklaces identified the individual Palawa women who were involved in the process of shell stringing. Our women say they watched elder family members make the necklaces and were included in collecting and sorting the shells at a young age. Recent interviews by the Palawa women record how most have continued a family tradition in making shell necklaces. Late in the nineteenth century a number of women aimed to keep this part of their traditional culture alive in order to allow their daughters and grand-daughters to participate in their cultural heritage. My mother, Val MacSween, says that in her earlier days on Cape Barren Island, few women went out anywhere without wearing a necklace—it meant they were properly dressed. In the nineteenth century and beyond, traditional Palawa necklaces were collected and traded for what my mother recalls as 'a few shillings'.

Ideally, the necklace makers like to collect *maireener* shells, a common shell used in the necklaces, on a low spring tide, as most are gathered by hand while walking knee deep in sea-

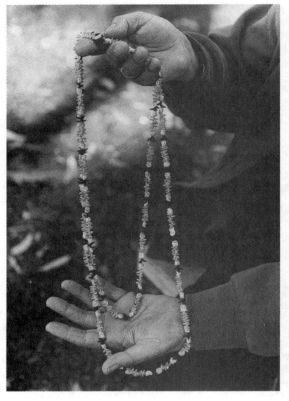

381. *Maireener* shell necklace, 1999.
This necklace was made by Joan Brown of Cape Barren Island. It represents an unbroken cultural tradition in Tasmania which is probably thousands of years old.

water. This part of the process requires days of painstaking work to gather enough for one string of shells. The shells then undergo a series of cleaning, drying and polishing processes until they are spread out to dry. Once dried they are pierced with a sharp tool—originally Palawa used the eye tooth of a kangaroo.

The final stage of preparation is to string the shells using a length of double strength thread which is then doubled again for even more strength. Traditionally the women threaded the shells on the fine sinew from the tail of the kangaroo. *Maireener* shells are often strung as a repeat pattern alone, or threaded with a mixture of other shells to make intricate patterns. The method of stringing and polishing the shells varies slightly from one woman to another. During the past ten years the shells have become more difficult to find. As a majority of necklace makers now live away from the islands where the shells are found, they make every effort to travel back at least once a year to collect enough shells to replenish their shell stocks to last until another journey is possible.

Palawa women making shell necklaces today are Val MacSween, Joan Brown, Muriel Maynard, Dulcie Greeno, Corrie Fullard and Lola **Greeno**. These necklace makers are now encouraging the younger generation to continue this significant women's cultural practice. LG

See also: 11.5; **body adornment**; *9, 381*.
Norman, R., 'Black histories', *Object*, no. 4, 1998.

SIMMS sisters, Jane and Olive (both *c.*1890–1950), workers of shell, are remembered for their dedication, professionalism and expertise. Little has survived of their shell-work, which was produced primarily for a tourist market in the period 1930–50. Museums did not collect such work, being interested only in 'traditional' Aboriginal objects at that time.

Olive and Jane Simms were members of an Aboriginal family within the **La Perouse** community (NSW) renowned for their skill in producing artefacts. Their grandmother was 'Queen' Emma **Timbery** whose shell-work was admired, both locally and overseas, when exhibited by mission organisations in the early 1900s. The production of artefacts was seen by the missions as a means of providing some form of economic base for Aboriginal communities in New South Wales, with the men working wood into **boomerangs** and the women creating shell-work. The first references to Aboriginal women selling shell baskets at Circular Quay and at La Perouse appear in the 1880s.

When shell-work is spoken about it is always as a social activity: 'When we were young our mothers would take us to the beach to collect the shells. The women would sit around in a circle sorting the shells into sizes and colours. The different shells they used were mutton-fish, starries, beachies, buttonies, cowrie pearl, fan, conk, small cockle and small pippies.' Collecting shellfish has always been a part of the lives of coastal peoples, but the Simms sisters' 'La Per shell-work' does not resemble any pre-contact form. Its shapes adapt European souvenirs: little boxes in the shape of hearts, miniature shoes, or the Sydney Harbour Bridge. Because of the ephemeral character of these objects, Olive and Jane Simms' work now exists mainly as a memory, as does their reputation as some of the best 'shellers' from the Aboriginal community at La Perouse.

ANS

See also: 11.1, 18.1, 18.3.
Stephen, A., 'Jane Simms and Olive Simms', in J. Kerr (ed.), *Heritage: The National Women's Art Book*, Roseville East, NSW, 1995.

SIMS, Bessie Nakamarra (*c.*1932–), painter, is a senior Warlpiri woman from **Yuendumu** (NT). Her main **Dreamings** are *ngarlajiyi* (small yam), *janganpa* (possum), *pamapardu* (flying ant), *Karntajarra* (Two Women), *yarla* (bush yam) and *mukaki* (bush plum). She is married to Paddy Japaljarri **Sims**, with whom she occasionally collaborates on larger pieces. She has been painting for **Warlukurlangu Artists Aboriginal Association** since the mid 1980s, and her works have been exhibited nationally and internationally. Major exhibitions in which she has been represented include 'Aratjara' (Düsseldorf, London, and Humlebaek 1993–94), 'Jukurrpa: Desert Dreamings' (AGWA 1993) and 'Desert Tracks' (Amsterdam 1994). Her work is represented in the collections of the NGA, AGWA, SAM and Art Gallery and Museums, Glasgow. LC

See also: 9.5.

Lauraine Diggins Fine Art, *A Myriad of Dreamings*, Melbourne, 1989.

SIMS, Paddy Japaljarri (*c.*1917–), Warlpiri painter, was born at Kunajarrayi (Mt Nicker) west of **Yuendumu** (NT). He is associated with and paints a large number of **Dreamings**, including *witi* (ceremonial pole), *yanjilyipiri* (star), *yiwarra* (Milky Way), *ngarlkirdi* (witchetty grub), *liwirringki* (burrowing skink), *jungunypa* (marsupial mouse), *mala* (hare wallaby), *wakulyarri* (banded rock wallaby), *warlu* (fire), *wanakiji* (bush tomato) and *ngalyipi* (snake vine).

While maintaining a strong connection to his ancestral country, Paddy Japaljarri Sims has lived in Yuendumu since the community was established in 1947. He is well known for his role in painting the *Yuendumu Doors* in 1983. Painting consistently since 1985, Sims has worked on eight of the large collaborative canvases produced by **Warlukurlangu Artists** for museums and private collections. In 1989, he was one of the few Warlpiri men selected to create a significant ground painting installation for the 'Magiciens de la Terre' exhibition in Paris.

He has developed a distinctive painting style that has established him as one of the leading Warlukurlangu artists. He is a long-term committee member of Warlukurlangu Artists, and encourages his children and grandchildren to paint for the association. He strongly supports the association's community focus. He has exhibited in over eighty group exhibitions since 1985, including 'Dreamings' (New York, Chicago, and Los Angeles 1988–89), 'Mythscapes' (NGV 1989), 'Aratjara' (Düsseldorf, London, and Humlebaek 1993–94) and the touring exhibition of the *Yuendumu Doors*, 'Unhinged' (SAM 1999–2000). Major collections holding his work include the NGA, NGV, most Australian State galleries, and Musée National des Arts d'Afrique et d'Océanie, Paris. LC

See also: 9.5, 21.1; Bessie Nakamarra **Sims**, Paddy Japaljarri **Stewart**, *221*.
Warlukurlangu Artists, *Yuendumu Doors: Kurruwarri*, Canberra, 1987.

SIWES, Darren (1968–), photographer and painter, born in Adelaide, has cultural links to the people of Barunga, near Katherine (NT). After completing his apprenticeship and working as a fitter and turner, his lifelong artistic aspirations, encouraged when very young by family member and well known Aboriginal artist Harold Thomas, led him first to the Central School of Art in Adelaide, then to the University of South Australia. In 1996 he graduated with an Honours degree in Visual Arts, majoring in painting and photography. He is currently a Lecturer in Painting and Drawing at Tauondi, the Aboriginal College in Port Adelaide (SA).

Although his innovative work as a photographer is most well known, he describes himself as 'a painter at heart'. However, the photographic medium seems to align itself with his conceptual approach, and much of his exhibition work is photography. But it is informed by his training as a painter, and his respect for the work of Jeffrey Smart and Piero della Francesca, among others.

His work came to public attention when he was included in an exhibition of work by three Aboriginal photographers,

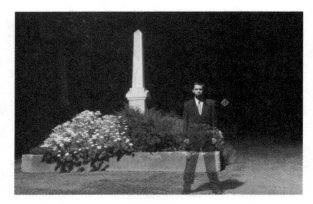

382. Darren Siwes, *Stand (Monument)*, 1999.
Cibachrome print mounted on aluminium, with a supergloss laminate, 100 x 120 cm.

'Three Views of Kaurna Territory: Then and Now' (Art-spaceSA 1998). In recent years his work has featured in major exhibitions, including 'Australian Perspecta' (AGNSW 1999) and 'Beyond the Pale' (AGSA 2000). DOM

See also: 12.4; **flags**; *382.*
Croft, B. L. (ed.), *Beyond the Pale: 2000 Adelaide Biennial of Australian Art*, Adelaide, 2000.

SKEEN, Millie (Milkitjungu) (1932–), Kukatja visual artist, was born in her grandparents' country near Kiwirrkura, some 300 kilometres to the south of **Balgo**. She travelled to the Balgo area as a young girl with her sister, Rita Kunintji Nampitjin (c.1936–), and Rita's husband, Albert Nagomarra (1924–1995), both of whom were important Balgo artists. Millie later married Tommy Skeen Tjakamarra (c.1930–), a Ngardi man who is one of the owners of the country immediately to the south of Balgo.

Millie Skeen began painting in 1986, some time before Tommy, and has remained the more prolific artist of the two. Her work covers subjects such as the emu **Dreaming**, the making of *tjimari* (stone knives), the Tjipari women's song cycle, and sites related to the Nakarra Nakarra song cycle in the Balgo area. Tommy's work became known and celebrated from 1992. Tommy paints sites from the Manga Manga area of Ngardi country, associated with the travels of the Nakarra Nakarra women.

To Western eyes, the paintings of Millie and Tommy Skeen have a celebratory air through their combination of bold, broad, freely drawn icons, and a decorative dotting style featuring random colour dotting which seems sometimes to glow like the stars. Areas of single-colour dotting (often in white or yellow) and outlining of icons in double rows of white dotting add an air of lightness to the paintings, which are also memorable for their gentleness of touch.

Important exhibitions in which Millie Skeen's work has featured include 'Aboriginal Art and Spirituality' (HCA 1991) and '65e Salon du Sud-Est' (Lyon 1993). The work of both Millie and Tommy Skeen is included in the Kluge–Ruhe Collection at the University of Virginia. CW

See also: 2.2, 9.5; **Warlayirti Artists**
Peter, S. & Lofts, P. (eds), *Yarrtji: Six Women's Stories from the Great Sandy Desert*, Canberra, 1997; Watson, C., 'Touching the Land: Towards an aesthetic of contemporary Balgo painting', in H. Morphy & M. Smith Boles (eds), *Art from the Land: Dialogues with the Kluge–Ruhe Collection of Australian Aboriginal Art*, Charlottesville, VA, 1999.

SKEEN, Tommy, see Millie **Skeen.**

SKIPPER, Peter (Kurrapa Pijaju) (c.1929–), Juwaliny–Walmajarri visual artist, was born in the Great Sandy Desert (WA) at a place called Payinjarra. He was a young man before he had any contact with Kartiya (white people). In the 1950s he travelled north with his wife Jukuna and other relations as they were drawn away from their countries to cattle stations in the southern Kimberley. He worked as a stockman on Old Cherrabun station until the early 1970s, then moved with his family to Fitzroy Crossing. He learnt to read and write his own language as well as English and he worked extensively as an informant on the development of the Walmajarri dictionary.

In the mid 1980s Peter Skipper was introduced to painting; at first he produced small-scale works primarily for the local tourist trade. In the late 1980s he met Duncan Kentish, an art dealer who has worked with a number of Fitzroy Crossing artists. Kentish commissioned works from him, providing him with quality linen and acrylics. He painted what he calls 'easy' paintings at first and then he started thinking about his country at Japirnka: 'I started painting roughly. I painted patterns. They were easy paintings, no Ngarrangkarni (**Dreaming**) stories, just patterns like *punarrapunarra* (patterns in sand made by the wind and symbolic carving on artefacts). From there I started thinking about Japirnka. I painted Japirnka *jila* (waterhole) next on a very big canvas. I am still painting the same thing. I still paint all of my country today.'

He repeats this motif regularly, either as a single image or with the full complement of the sixty or more waterholes in the Japirnka area. As Skipper calls the names of these waterholes he takes the viewer on a journey through his country, from waterhole to waterhole, following the journeys he made as a younger man. Skipper also paints the spirit figures who inhabit his desert landscape. Other works tell of epic journeys made by creation spirits in the form of men, women, snakes, and lizards which are painted either as whole narratives or as excerpts.

Skipper's first solo show was held at the Craft Centre Gallery, Sydney in September 1989. His work was included in 'Dreamings' (New York, Chicago, and Los Angeles 1988–89), and he has continued to exhibit both nationally and internationally since then. His work is included in most major national collections. He is one of the key artist claimants in the Ngurrara **native title** claim and he contributed significantly to the development of the *Ngurrara Canvas*.

KD

See also: 10.2, 18.1, 23.2; *134, 270.*
Isaacs, J., *Spirit Country: Contemporary Aboriginal Art*, Melbourne, 1999; Kentish, D., 'Peter Skipper', in A.M. Brodie (ed.), *Stories : Eleven Aboriginal Artists*, Roseville East, NSW, 1997; Sutton, P. (ed.),

Dreamings: The Art of Aboriginal Australia, New York & Ringwood, Vic., 1988.

SNELL, Nyilpirr Spider (*c.*1925–), Wangkajunga dancer and visual artist, was born in about 1925 at Yurramaral, a *pirnti* (billabong water) on the south-eastern side of the Canning Stock Route in the Great Sandy Desert. He came into the station country when he was already a young man. He quickly developed strong skills in handling horses and cattle, and worked as a stockman on Christmas Creek station for a long time. His most significant education however came much earlier as he learnt to dance cere-monies which he still practises today. The key dance which he performs is centred around an important permanent waterhole in the Great Sandy Desert known as Kurtal. Spider recalls the first time he performed this ceremony, as a young apprentice under the guidance of three old men, at a billabong called Pinypingka. He said that they danced all night after hunting during the day for meat for the three senior men. In his words: 'we were dancing now, we tired ourselves out; we danced all night for the whole night. Then we danced another night.' Spider is still dancing today. He has a strong sense of his responsibility to pass on his dance to the younger people and he has been teaching his grandsons for the past five years. He makes large sculptural headdresses for his dances, and is one of the few men still making them. They are constructed of human hair, grass string and wool and he maintains and repairs them, spending several days before a ceremony to get them ready. Spider's energy for performing extends into the public domain as well. He performed in Canberra, dancing on the *Ngurrara Canvas* in May 1998. In 1997 he was awarded an Australia Council Fellowship from the Dance Fund. He also paints, and his work is represented in major public collections around Australia. KD

See also: 10.2, 23.2; **Mangkaja Arts;** *cover illustration, 270.*
Mangkaja Arts Resource Agency, *Ngarri muay ngindaji = Ngajukura ngurrara minyarti = Ngindaji ngarragi riwi = Ngayukunu ngurra ngaa = This is My Country*, Fitzroy Crossing, WA, 1994; Mangkaja Arts & Kimberley Land Council, *Jila, Painted Waters of the Great Sandy Desert* [documentary film], SBS Independent, 1998.

SOLOMON, Yertebrida, Ngarrindjeri sketcher, appears briefly in the diaries of the Revd George Taplin, who established the Congregationalist mission at Raukkan (Point McLeay) in South Australia. Six of her drawings are reproduced in Taplin's book *Folklore, Manners, Customs and Languages of the South Australian Aborigines*, published in 1879. In that book Taplin describes Yertebrida thus: 'she was never in any school in her life, and never received any instruction.' He used her drawings as evidence of the 'natural talent for drawing' displayed by Aboriginal people. The drawings reproduced in his book depict animals and women's camp-life on the Coorong. A watercolour drawing in the SAM, depicting a group of figures, somewhat biblically dressed but carrying characteristic Lower Murray shields, is possibly her work, in which case it would be her only surviving drawing in the original.

The elusiveness of the artist in Taplin's records suggest that Yertebrida may not have had a long life. Although in 1867 Taplin recorded her living at Milang with a newborn child,

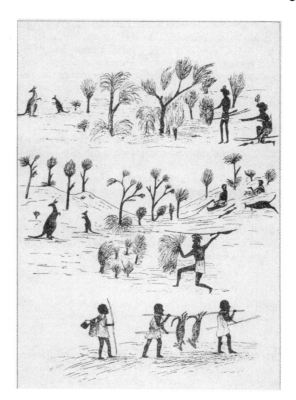

383. Yertebrida Solomon, *Hunting Party After Game*, 1876. Photolithograph from the original drawing.

her name does not appear subsequently in his diaries nor in his 1876 census of the 'Milang clan' of the Ngarrindjeri. Yertebrida Solomon is significant in that she remains the only identified woman artist of Aboriginal descent who is known to have produced drawings in the nineteenth century. AS

See also: 11.1; William **Barak**, Tommy **McRae**, Mickey of Ulladulla; *383.*
Sayers, A., *Aboriginal Artists of the Nineteenth Century*, Melbourne, 1994; Taplin, G., *The Folklore, Manners, Customs, and Languages of the South Australian Aborigines* [facsimile of 1879 original], New York, 1967; Worsnop, T., *The Prehistoric Arts, Manufactures, Works, Weapons, etc., of the Aborigines of Australia*, Government Printer, South Australia, 1897.

sport, see 20.1, 20.2; **athletics, Australian Rules football, boxing, cricket, jockeys, rugby league, surfing.**

STEWART, Paddy 'Cookie' Japaljarri (*c.*1940–), Warlpiri–Anmatyerre painter, is from Mungapunju south of **Yuendumu** (NT). He is associated with and paints a large number of **Dreamings:** *marlu* (kangaroo), *janganpa* (possum), *yarla* (bush yam), *warlawurru* (eagle), *wardapi* (goanna), *yajukurlu* (bush cabbage), *jarlji* (frog), *jajirdi* (native cat), *ngatijirri* (budgerigar), *wakulyarri* (banded rock wallaby), *yanyilingi* (native fuschia), and *pingirri* (meat ant).

As a young man, Stewart worked and travelled extensively in the Northern Territory. He was among the men who painted the original **Papunya** school murals. In 1983, he painted twenty of the thirty-six *Yuendumu Doors* and has been a strong supporter of cultural programs in the Yuendumu school since. He is among the most consistent and best-informed members of **Warlukurlangu Artists Aboriginal Association** and currently serves as chairman of the committee.

In 1989, Stewart was one of the few Warlpiri men selected to create a significant ground painting installation for the 'Magiciens de la Terre' exhibition in Paris. He has exhibited both nationally and internationally since 1985, and his paintings have been included in many major exhibitions including 'Dreamings' (New York, Chicago, and Los Angeles 1988–89), 'Aboriginal Art and Spirituality' (HCA 1991) and 'Aṟatjara', (Düsseldorf, London, and Humlebaek 1993–94). Major collections in which his work is held include the NGA, SAM and Art Gallery and Museums, Glasgow.

LC

See also: 9.5, 21.1; Paddy Japaltjarri **Sims**; *221*.
Crumlin, R. (ed), *Aboriginal Art and Spirituality*, Melbourne, 1991; Warlukurlangu Artists, *Yuendumu Doors: Kurruwarri*, Canberra, 1987.

STOCKMAN TJAPALTJARRI, Billy (*c*.1927–), Anmatyerre–Western Arrente visual artist, describes his first contact with white people: 'All the people were running. I was a little one—in a coolamon. My mother put me under a bush. My father had gone hunting—for rabbit and goanna. They killed my mother. I was grown up by her sister—Clifford Possum's mother.'

Born at Ilpitirri, north-west of Papunya (NT), he was an infant survivor of the 1928 Coniston **massacre**. He grew up at Napperby station and was a stockman there for many years before moving to Papunya. He was an accomplished wood carver before he took up painting: he assisted **Kaapa Mbitjana Tjampitjinpa** with the honey ant **Dreaming** design on the Papunya school wall in 1971. An energetic campaigner in the outstation movement, he was one of the first to shift to his own outstation at Illili west of Papunya, where he has continued to paint prolifically the budgerigar, snake and wild potato Dreamings for his country around Mt Denison, Ilpitirri, and Yuendumu. He was a Central Australian delegate to the NAC during the 1970s; an **Aboriginal Arts Board** member from 1975 to 1979; and Chairman of **Papunya Tula** Artists during the mid 1970s. He visited the USA several times, most recently for the opening of the 'Dreamings' exhibition in New York in 1988. He has also travelled to Papua New Guinea, New Zealand, and the 'All Black Festival' in South Africa. He has participated in many significant group exhibitions including 'Dot and Circle' (RMIT 1985), 'Canvas and Bark' (SAM 1991), and 'Tjukurrpa, Desert Dreamings' (AGWA 1993), and his work is held in the NGA, most State galleries, the Holmes à Court Collection, Heytesbury (WA), and the Kelton Foundation, Santa Monica.

VJ

See also: 9.1, 9.5, 9.6; **acrylic painting**, Clifford **Possum Tjapaltjarri**; *118*.

Bardon, G., *Papunya Tula: Art of the Western Desert*, Ringwood, Vic., 1991; Johnson, V., *Aboriginal Artists of the Western Desert: A Biographical Dictionary*, Roseville East, NSW, 1994.

stolen generations. The separation of Aboriginal children from their parents and communities began almost with the invasion, and ended officially in the 1970s. Within this period perhaps 50 000 children were removed by governments, churches, and individuals and placed in private homes as adopted or foster children or, more commonly before 1950, in institutions. Very many, perhaps most, of the children, did not return to their communities, and of those who did almost none were able to resume a life as if untouched by trauma. Many relinquishing parents died without the knowledge of what had happened to their children. The Link-Up agencies are today the principal means by which separated adults can again make contact with their natural family, and their **Aboriginality**.

The most remarkable characteristic of the artistic response of those individuals personally affected by separation is its diversity of opinion and sensibility. This variety can be traced clearly through song. While outsiders sometimes expect the 'stolen generations' to dwell upon their own pain and loss, singers often adopt other themes. The first modern expression of the pain of separation was probably Bob Randall's mid 1960s song *Brown Skin Baby* which, significantly, lamented the plight both of mother and child. Another central Australian singer, Herbie Laughton, sang quite sentimentally about his days in the Alice Springs institution, the Bungalow. In the 1990s the best known of all Aboriginal separated musicians, Archie Roach, wrote songs about his own separation, the effects on his family, and on a relinquishing mother.

Personal responses by Aboriginal people to Randall's lament of the 1960s did not emerge until a decade later in the mid 1970s with the publication of Charles Perkins's autobiographical *A Bastard Like Me* (1975) and Margaret Tucker's *If Everyone Cared* (1977). These authors understandably did not realise the extent to which national policy was implicated in their separation, and this led them to emphasise the role of individuals rather than the agency of the state. Equally significantly, they regarded their separation and institutionalisation merely as an unfortunate incident demanding no more than a couple of chapters. A new interpretation of the meaning of forced deculturation was set by Sally **Morgan's** *My Place* (1987). Morgan, although not 'stolen', presented the story of her family's concealed identity as an implicit consequence of the same pressures of forced assimilation. In presenting the search for an Aboriginal identity as a theme worthy of a complete book, she pioneered a model that has been followed by several other Aboriginal autobiographers such as Connie Nungulla McDonald, in *When You Grow Up* (1996).

The use of film as a means to express the personal grief of separation began in the early 1980s. The first autobiographical film was made by Coral Edwards, co-founder of the first Link-Up organisation. In *It's a Long Road Back* (1981) Edwards focused on the threats to girls' Aboriginality in the Cootamundra Domestic Training Home, where Aboriginal girls from New South Wales who were forcibly removed from

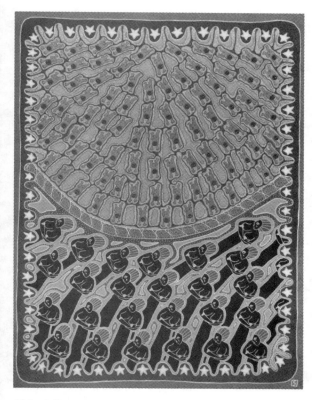

384. Sally Morgan, *Taken Away*, 1989.
Acrylic on canvas, 122 x 92 cm.

their parents under the *Aborigines Protection Act* of 1909 were sent. Anne Pratten, who was formally adopted, focused more on abuse within her adoptive family in her short film *Terra Nullius* (1993). In her powerful short film of 1989, *Night Cries: A Rural Tragedy,* Tracey **Moffatt** takes up the theme of the effects of separation for both the Aboriginal child and the adoptive white parent in much later life, when the responsibility of care is reversed.

Poetry is the most accessible medium through which those who endured the experience can respond artistically. Again, the responses of the poets are not always those expected by outsiders. Among the first to reveal her feelings in poetry was Pauline McLeod, whose poem *The Fortunate One* appeared in Edwards and Read's *The Lost Children* (1989). It was a demand to her own people to take returning adults like herself seriously. Many other recent poets have lamented their inability to re-establish meaningful contact with their community of origin.

In the visual arts, probably the first widely known representation of separated individuals were Sally Morgan's works in acrylic and screen-print, depicting figures of community members and children seeking each other against a variety of urban and rural backgrounds. Again the most distinctive and original voices came from the separated. In a commentary on her art depicting her search for Aboriginality, printmaker Treahna **Hamm** pointed out that she grew up in a caring environment that did not deny her origin.

Responses by Aboriginal artists who were not separated have been rather more uniform, concentrating on the act of separation rather than on later events. An exceptional example is **Lin Onus**'s haunting sculpture, *They Took the Children Away*, 1992, of two policemen, one leading a child by the elbow, while the other stands with arms crossed authoritatively over the distraught mother on the ground. In 1982, Lillian Crombie of AIDT performed to a reading of a Maureen Watson poem that dealt with the anxiety of an Aboriginal mother who had given up her child. Tiddas' song *Malcolm Smith* (1993) is about one of the deaths investigated by the Royal Commission into Aboriginal **Deaths in Custody**. Two of the four excellent films in the joint Aboriginal and non-Aboriginal television production *Women of the Sun* (1982), *Nerida Anderson* and *Lo-Arna,* took separation as their theme.

While the historians have been very active, artistic response by non-Aborigines to separation has been surprisingly muted. Milestones were films such as Alec Morgan and Gerry Bostock's *Lousy Little Sixpence* (1983), David McDougall's *Link-Up Diary* (1985), and Paul Kelly's song *Special Treatment* (1992). *Sorry,* a 1998 song by the band Goanna, addresses and apologises to, rather than sings about, the late Margaret Tucker, a member of the stolen generations and later a prominent Aboriginal activist. Works such as these may mark a new direction of innovative and respectful responses. The publication of *Bringing Them Home* (1997), the Report of the Human Rights and Equal Opportunity Commission into the history of separation, laid out clearly the very wide parameters of the agency of church and state, and the gross abuses which the children had suffered while in care. A number of artists, writers and filmmakers, stimulated by the publicity, and to an extent, by the catharsis of emotion evoked by such fresh and raw testimony, are currently working on themes of separation.

PR

See also: 11.1, 12.1, 13.1; *193, 384.*

Bird, C. (ed), *The Stolen Children: Their Stories*, Milsons Point, NSW, 1998; Human Rights and Equal Opportunity Commission, *Bringing Them Home: Report of the National Inquiry into the Separation of Aboriginal and Torres Strait Islander Children from Their Families,* Sydney, 1997; Read, P., *A Rape of the Soul so Profound: The Return of the Stolen Generations,* St Leonards, NSW, 1999.

SUMNER, Polly (Sumner Dodd) (1952–), Ngarrindjeri photographer, was born at Point McLeay, now Raukkan, (SA). When asked to describe her work, she responds with characteristically wicked wit: 'Well, I'm definitely not just your ordinary, run-of-the-mill, dot-painting Aborigine.' Eschewing what she considers to be pretentious experimental photo-graphy, she prefers to show what is 'real': 'to me, the drunk sitting in the park is real. I'm simply not interested in making euphemistic statements in my photography.' She attributes a good deal of her current success, both as Chief Executive Officer of Nunkuwarrin Yunti—an Aboriginal community-controlled health organisation in Adelaide— and as a photographer, to her decision in 1981 to become sober.

385. Polly Sumner, *Mitch Dunnett, Adelaide Jail*, 1987.
Silver gelatin photographic print, 22.3 x 34.0 cm.

Polly Sumner loves to photograph faces. Most often they are the faces of ordinary Indigenous Australians placed in the contexts in which they feel most comfortable, and sometimes doing what they enjoy most—whether that be fishing off a Port Augusta jetty, proudly showing off a newly-polished motor vehicle, sitting quietly in a chair bathed in the afternoon light, or drinking with family members or friends in a park.

Apart from her gift for capturing the ordinary, the everyday, the unadorned, Sumner is immensely skilled in the way that she uses both line and direction to create photographs of great equilibrium. She never places herself above or below the people she photographs; she never uses her camera to pass judgement. In her photography, as in life, Polly Sumner is always on the level. She is represented in the collections of the SAM and Flinders University (SA). CN

See also: 12.4; *385*.

Pring, A. 'Polly Sumner', in A. Pring (ed.), *Aboriginal Artists in South Australia*, South Australia, 1998; Sumner, P. 'Port Augusta, photographs by Polly Sumner' in P. Taylor (ed.), *After 200 Years: Photographic Essays of Aboriginal and Islander Australia Today*, Canberra, 1988.

surfing. When Kenny Dann, a Yamatji man from Geraldton (WA), was narrowly beaten into second place in the 1998 Australian open surfing titles at Cronulla beach in Sydney, it sent shock waves through the spectators on the sand dunes. One middle-aged man was overheard to remark to his wife: 'I didn't know Aboriginal people could really swim, let alone surf like that!' Dann was no stranger to excellence, however, having previously placed sixth in the world amateur titles as a junior, and having won the national Indigenous titles the year before. These results represent the pinnacle of surfing achievement to date for Aboriginal people in this country. They are also part of what well might be one of the best kept secrets in Australian sports: the depth of talent in the Aboriginal surfing community.

An indigenous Hawaiian prince, Duke Kahanamoku, introduced the sport of surfing to the Australian shores at Freshwater beach Sydney, on 15 January 1915. Another indigenous Polynesian, Tommy Tanner, was the first to body surf in this country. Since that day when the Duke demonstrated surfboard riding in front of a huge crowd, surfing has become one of the most popular and defining of national pastimes. Although the stereotypical media image of the surfer is of a blond, tanned Anglo man, since the 1950s a small but growing number of Aboriginal people have adopted traditional surfing techniques, and modern fibreglass technology, to make surfing their own. Aboriginal participation in surfing has gone largely unnoticed by mainstream society, and until very recent times by the surfing and sporting press.

Coastal communities along the east coast of the country were most likely the breeding grounds for the first Indigenous surfers. The people there had the greatest access to the broader surfing community and to equipment, as well as to countless generations of practical knowledge of fishing, tides, and local ocean conditions. The communities of Fingal, Coffs Harbour, **La Perouse**, Wreck Bay and Moruya (NSW) were among those that produced small but dedicated 'crews' of surfers in the early long-board days of the late 1950s and early 1960s. Kevin Slabb from Fingal remembers using fence posts and driftwood to ride the waves before he had access to or could afford real surfboards. Aboriginal surfers of that era remember feeling isolated—often never really knowing that other Aboriginal surfers existed outside their area.

From the mid 1960s rumours of 'red hot' Aboriginal surfers being spotted at their local breaks began to filter through to the mainstream surfers. Some began to join the established surfing clubs: Barry Paulson and John Nobbs joined the Snapper Rocks club on the Gold Coast in 1964–65. The first article concerning Aboriginal surfers in popular surf magazines appeared in 1972, with *Tracks* magazine's feature on the surfers from Wreck Bay community near Nowra. For locals Steve Williams and Ray Ardler, the article probably proved more troublesome than helpful, as many 'tourist' surfers came to the area and overcrowding resulted. Since that time, helped by its hosting of the first two national Indigenous surfing contests, (in 1993 and 1994), the Wreck Bay community has enjoyed something of a reputation as the cradle of black surfing in Australia.

The local heroes of the Indigenous surfing communities from the 1960s and 1970s—Barry Paulson, Todd Roberts, Paul Dann, Steve Williams, Mervin Brieley, Eric Mercy, John Nobbs, and the Nye brothers—were men who rode the waves for their own pleasure and enjoyment. They largely eschewed the contest and mainstream areas of the sport; they espoused the 'soul surfer' tradition, where riding the waves was seen as an art form, not a sport. They rarely had equipment sponsors from the surf industry. It was not until the 1990s that major surf labels and equipment manufacturers first ventured to sponsor Aboriginal surfers in any significant way. In the most visible of these associations, Quicksilver contracted Kenny Dann, and Billabong sponsored Andrew Ferguson. Ferguson was nicknamed 'The Black Occy' by the surfing periodical *Australian Surfing Life* (after the popular Australian world surfing champion of the late 1990s, Mark Occilupo—seemingly the highest compliment that could be paid by surfing journalists). Dann enjoyed something of a reputation as a 'bad boy' of surfing—as brilliant, but unpredictable. Both

men's relationships with their sponsors proved testy, and their sponsorships remained at a minor level.

From these early beginnings of a career path for Aboriginal surfers, momentum has slowly been gaining in the field. In 1993 the Billabong clothing company started to sponsor a national Indigenous surf competition. This event, being held variously at Wreck Bay, North Stradbroke Island (Qld), and Fingal, has proved most significant for the Indigenous surfing community. It is a unique event where families come together to share and promote Indigenous culture, to rekindle family and kinship ties, and to elevate a healthy lifestyle and sport to a community ravaged by colonial exploitation and oppression: it is likened to a 'modern day **corroboree**' by current president of the Indigenous Surfing Association, Kevin Slabb. In recent years, as the contest has grown, teams from other indigenous surfing cultures have also been invited, including Hawaii, Fiji, Bali, and New Zealand.

Past winners of the event have gone on to forge a part or full time career in surfing. Among these are two-time winner Gavin Dickinson, Kenny Dann, Scotty Rotumah, also a two-time winner, Paul Evans, Ty Arnold, Josh Slabb, and Lucas Proudfoot. The Aboriginal 'crew' are generally accepted as being among some of the most explosive and innovative surfers in the professional ranks today. Ken Dann thinks the motivation among Indigenous surfers lies beyond the love of riding waves: 'we want to prove that we can surf well too, that you know, that white people just can't do everything.' HB

Benjamin, H. & Burns, T., *Surfing: The Healing Wave* [video recording], Ronin Films, 1999.

SURPRISE, Wakartu Cory (*c.*1929–), Walmajarri visual artist, explains: 'When I sit down and paint I am thinking about law from a long time ago. I think about everyone, all of the Law women and men. At first I sat down here with nothing, no corroboree, nothing. We had nothing here (on the station). Then that Kurungal (Christmas Creek) mob brought that corroboree. That was a long time ago. I woke up when I heard that word.'

Wakartu was born at a *jila* (sacred waterhole) called Tapu, about 200 kilometres south-east of Fitzroy Crossing (WA). In the Ngarrangkarni, (**Dreamtime**) a huge fire killed all of the people who were living there. Wakartu's father died in the desert and her mother went to Noonkanbah station when she was still a young child, so she does not remember them. She stayed in her parents' country around Tapu and was given her first promised husband when she was a young girl. She was taken with her uncle to the police station in Fitzroy Crossing where the policeman's wife taught her how to do housework, and she worked in the yard looking after the chickens. Eventually she went back to Christmas Creek station. Her promised husband sent for her and they went back into the bush. Her first two children were born in the desert and she had seven others—only the last was born in the hospital.

Like many of the artists who work through **Mangkaja Arts**, Wakartu began painting at Karrayili Adult Education Centre in Fitzroy Crossing. Her paintings make strong reference to Law in two ways. She paints in a style which mimics the marks made on men and women's bodies for ceremony.

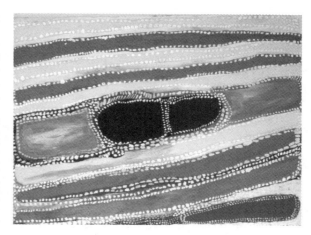

386. Wakartu Cory Surprise, *Wayampajarti*, 2000. Acrylic on cotton duck, 91 x 121 cm.

Her work is characterised by broad bands of colour, applied to the paper in much the same manner as fingers shifting pigments across skin. These images are often reduced to three or four bands of colour spread horizontally across the paper. The other reference point is actual ceremonial sites— places where large groups gathered. At times she uses dots, albeit sparingly, to add emphasis. She paints primarily on paper, but was a contributor to the *Ngurrara Canvas*. She is represented in many private and public collections, notably the NGA, AGNSW, and NGV.

KD

See also: 10.2, 23.2; *270, 386.*

Mangkaja Arts Resource Agency, *Ngarri muay ngindaji = Ngajukura ngurrara minyarti = Ngindaji ngarragi riwi = Ngayukunu ngurra ngaa = This is My Country*, Fitzroy Crossing, WA, 1994; Ryan, J., *Images of Power: Aboriginal Art of the Kimberley*, Melbourne, 1993; Perkins, H., *Aboriginal Women's Exhibition*, Sydney, 1991.

Survival Day is now widely used among Aboriginal people to name 26 January, the day marked as Australia Day. The most ostentatious Anglo-Australian displays of celebration over the beginning of the British invasion have been staged in Sydney, often with re-enactments of the first British landings (in 1770 and 1788) which denigrate Aboriginal people and deny the violence of the invasion. It is in Sydney, therefore, that Aboriginal people have felt it most urgent to confront this colonial perspective, to force white Australians to recognise that what they think of as 'peaceful settlement' was in fact an invasion. During the early 1970s, young activists were becoming increasingly aware of the 1938 **Day of Mourning**, when an earlier generation of Aboriginal people had come to Sydney from three States to challenge the white Australian interpretation of the meaning of 'Australia Day'. This determination to reinterpret celebrations of colonialism found renewed expression, beginning with the solemn vigil at **La Perouse** in 1970 to challenge the Cook's landing bicentennial. The two most common phrases circulating among Aboriginal activists as reinterpretations of the Australia Day

date were the 'Day of Mourning' and the more aggressively assertive 'Invasion Day'.

The struggle for **land rights** in the late 1970s and the 1980s emphasised the endurance of Aboriginal people, even in the areas of the earliest and most violent invasion. Alongside the desire to make white Australia recognise their 'settlement' as an invasion, Aboriginal people increasingly wanted recognition of the tenacity and vitality of Aboriginal people and their cultures. Cultural expressions like art and contemporary music became an important way to intervene in popular ideas and real relationships between white and black Australians. Tranby Aboriginal College (NSW) initiated a collaboration between Aboriginal and white musicians which emerged in 1986 as the first 'Building Bridges' concert, held mid year during NADOC (now NAIDOC) Week in the Bondi Pavilion in Sydney, with a powerful poster by Chips Mackinolty, which had the phrase 'We have survived' blazoned across it. Organised by Karen Flick, Gary Foley, and Jaqui Katona, this was the first in a series of concerts where Aboriginal performers like Kev **Carmody**, **Yothu Yindi**, Maroochy Barambah and Sharon Carpenter appeared with Paul Kelly and Midnight Oil, drawing together many young people and stressing the dynamic continuation of Aboriginal culture. In 1988, the year of the bicentennial of formal British rule, Aboriginal people from all over Australia came to Sydney in a 'Long March' to confront the official celebrations. Their protest drew on each of the themes that had emerged during the previous decades of political action: the 'Day of Mourning' and the assertive 'Invasion' and the triumphant 'Survival' themes. Their actions took the form of a massive street march and a concert on the Building Bridges model, in which traditional and contemporary Aboriginal performers appeared on stage with non-Aboriginal artists, to a huge crowd of Aboriginal people and non-Aboriginal supporters.

The day ended in an even more important demonstration of Aboriginal survival and continuity. Aborigines from remote, rural and urban communities, along with non-Aboriginal supporters, came together at La Perouse, because there, with Cook's landing, 'the story had really begun'. Through that night, Aboriginal people from the traditionally-oriented areas which had been less severely affected by the invasion, danced the stories which tell of legendary heroes

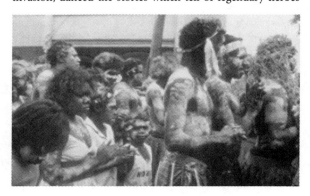

387. Alana Harris, *The March for Freedom, Hope and Justice, 26 January 1988, Sydney NSW.*
35mm slide transparency.

who travel across the continent. Wenten **Rubuntja** from Central Australia explained:

When the English people found our country and Aboriginal people, they put their cities and their culture all over our country. But underneath this, all the time, Aboriginal culture and laws stay alive. The Aboriginal people living along the coast where the white people took over first, they might not know their language any more, but the emu story and the snake story goes all over Australia ... When they see us dance we can celebrate that we all belong to the songs that go across the whole of this country (reported in Land Rights News, *January 1988).*

As dawn broke, Aboriginal people from Sydney and the coast, hosts of the night of celebration, spoke of what the invasion had meant to them. Then they gravely ushered everyone there through the smoke of smouldering green branches, a ritual cleansing and protection, to release people from the sadness of so many past deaths and pain and to protect everyone there from the powerful forces now able to move again in the land.

After 1988, the desire to celebrate continuity has remained, along with the demand that the magnitude of the invasion be recognised, as well as the need to mourn. Each year since then, Aboriginal people in Sydney have marked 26 January as Survival Day, with a day-long concert at La Perouse or more recently at Waverley. The Survival Day concert draws in Aboriginal and non-Aboriginal performers, all expressing the many faces of Aboriginal cultural continuity and hopes for a creative and peaceful future. HG
See also: 4.1, 4.2, 4.3; **flags**; *46, 387.*

Goodall, H., *Invasion to Embassy: Land in Aboriginal Politics in New South Wales 1770–1972*, St Leonards, NSW, 1996.

SYDDICK, Tjungkiya Wukula Linda (1941–), Pintupi painter. In the late 1980s Tjungkiya Wukula Linda Syddick broke dramatically with the inherent conservatism of Western Desert classicism by incorporating a range of contemporary and highly personal themes into her art. Like other senior Pintupi, she was profoundly influenced by her encounters with the 'other' kind, experienced after leaving her desert homeland for settlement life. Here, her introduction to money, European food, and even her uncle's frightening first encounter with a Southern Cross windmill have provided a rich source of commentary for her recent work.

Tjungkiya was also profoundly influenced by the fundamental aspects of Christianity she encountered as a young woman at Haasts Bluff (NT). As part of her innovative development she began to fuse aspects of Christianity with her ancestral mythologies to produce highly original works on the theme of religious syncretism. Her fascination with new experiences and ideas turned an unexpected corner when she embarked upon her series on the Steven Spielberg film character ET.

Her very first works in the ET series were begun in 1992 after she had viewed the video more than twenty times. The impact of this lost creature's desire to return home had obvious parallels with the artist's own experiences so she continues to paint ET intermittently to this day. At a more profound level the ET character also has resonances with

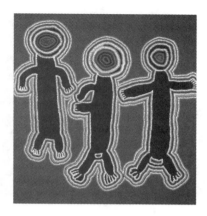

388. Linda Syddick, *ET and Friends*, 1992.
Acrylic on canvas, 82 x 76 cm.

Tjungkiya's religious beliefs which fuse Christian and Pintupi notions of death and the soul. Tjungkiya believes that a deceased Pintupi's spirit, *kurrunpa,* ascends to heaven in the same way as the Christian Jesus—a belief that was reinforced by her childhood recollections of her grandfather's death. She says he went to heaven, because the day after his burial the family returned to the grave to find that the body had disappeared. The concept of the ascension that features in many of her religious paintings was therefore easily extended to embrace ET. She often likens him to Jesus and in her depictions of ET ascending to heaven in his spaceship the analogy is often made explicit through the placement of a cross at the craft's apex.

The Pintupi ontology that the Dreaming is enduring and ever-incorporating, or ever-revealing of new experience, has allowed Tjungkiya to integrate her diverse experiences and beliefs into a unified world view. In this, her grandfather, *kurrunpa,* Jesus, and ET are all facets of the same cosmological belief concerning the spirit's sublimation and transference to its spiritual home. As an extension of this world view, ET has also been incorporated into the artist's socialised world and is often depicted with the family she has invented for him. In doing this Tjungkiya reverses the Western notion of the alien by reclaiming ET as a person with close kin or *walytja,* to show how the white people he encountered during his earthly adventure are really the ones who are the *munuka,* or outsiders. MW

See also: 1.2, 9.5, 22.4; *388.*

West, M., 'Linda Syddick Napaltjarri: Encounters with the other Kind', in Art Gallery of South Australia, *All This and Heaven too: 1998 Adelaide Biennial of Australian Art,* Adelaide, 1998.

SYKES, Roberta (1943–), author, educator, and community activist, earned her PhD from Harvard University. She has published nine books, including two poetry anthologies, *Love Poems and Other Revolutionary Actions* (1988) and *Eclipse* (1996), as well as two important educational texts, *Black Majority* (1989) and *Murawina: Australian Women of High Achievement* (1993). Her most recent works, the autobiographical *Snake Dreaming* trilogy (1997–1999), won,

among other awards, the *Age* Book of the Year, the National Biography Award and the Kibble Award for Women Writers. Sykes has worked in a wide variety of occupations including health educator and columnist, Chairperson of the Australian Broadcasting Corporation's Promotion Appeals Tribunal, and as consultant to numerous government departments such as the Royal Commission into Aboriginal **Deaths in Custody,** the Commonwealth Office of the Aged and the New South Wales Department of Corrective Services.

Sykes is the Founder and National Executive Officer of Black Women's Action in Education Foundation, and an internationally renowned public speaker. She has been the recipient of many community service awards, including Avon Spirit of Achievement Award and the Australian Human Rights Medal. RS

See also: 12.2; **life stories.**

SYRON, Gordon (1942–) painter and printmaker, was introduced to art in Long Bay prison in the mid 1970s. He taught himself to paint from art history books with a view to making a living after his release, which came some nine years later. He developed a distinctive raw and energetic expressionist style which earned him a reputation as 'the pioneer of a westernised, overtly political urban Aboriginal art' according to Vivien Johnson. With his potent assaults on injustice, oppression, and racial discrimination, laced with an acerbic wit, his work was generally too confrontational for the art establishment, ensuring him a kind of 'visible invisibility' as a lone but known maverick. While his work is represented widely in private collections and some museums, to date no mainstream public art gallery yet holds one of his works.

Syron believes he has done his time and has a right to call to account, through his art, those guilty of social crimes against humanity. He deals with historic and contemporary events with titles like *Capital Punishment—Here comes the Judge,* 1995, *MABO, The Black Bastards are Coming,* 1997, *Howard's Way,* 1997, and *Terror Nullius,* 1997. His iconic work, *Judgment by his Peers,* 1978, first exhibited at Murraweena, Redfern while he was still in prison, is widely published. His solo exhibitions in Sydney have included 'Aboriginal Deaths in Custody' (Parliament House 1996) and 'A Perspective: The Art of Gordon Syron' (DQ Art on Oxford 1997), and his work was included in the landmark exhibition 'Koori Art '84' (Artspace 1984) and 'A Changing Relationship' (SHEG 1998).

Syron grew up on a dairy farm at Minimbah on the north coast of New South Wales, one of sixteen children. From 1982–86 he was head teacher (visual arts) at the Eora College of Aboriginal Arts, which he co-founded, and he later lectured in fine art at the Aboriginal Education Unit at the University of Sydney (1987–88). He was official artist and later president of the Aboriginal **Deaths in Custody** Watch Committee and entered two portraits into the Archibald Prize: *David Gulpilil* in 1988 and *Mum Shirl* in 1998. Neither was hung. MN

See also: 12.1, 12.2; **prison art;** *165.*

De Lorenzo, C. & Dysart, D., *A Changing Relationship: Aboriginal Themes in Australian Art c.1938–1988,* Sydney, 1988.

T

TABUAI, Allson Edrick (1933–), visual artist and craftsman, and choreographer, was born on Saibai Island, the most northerly island in the Torres Strait, and is leader of Suruil Tituil (Shooting Star), a professional dance troupe based in Cairns. Under his guidance, Suruil Tituil has performed to acclaim in many parts of Australia. The troupe grew from his extended family, and even today family cohesiveness remains the foundation of its success.

Tabuai was born into a large family that held and practised traditional values. During an idyllic childhood and adolescence on Saibai he learnt the full cultural complex of his people—ceremony, dance and music, **language**, mythology, and the arts and crafts. His father, Tabuai Jaum, was a highly skilled craftsman and taught Tabuai respect for his materials and a love of detail and precision. By the age of seventeen, he had developed such a high standard of proficiency with his tools that he was commissioned to build clinker dinghies for use in the trochus and pearlshell fisheries.

During World War II, many of the islands in Torres Strait were evacuated, and many young Islanders sought opportunities away from their homelands. By this stage, Tabuai's highly developed skills had earned him employment aboard a trochus lugger, and for several years he dived the waters throughout the Straits and along the Barrier Reef. He eventually settled in Mackay (Qld). Even though he was quite some distance from his island home, Tabuai still managed to maintain his dance practice to a certain extent.

In the late 1960s, as the need to rediscover his cultural roots become increasingly important to him, he returned to Saibai, only to encounter a depressed society and economy. He moved again, this time to Cairns. With an increasing commitment to his dance practice, Tabuai motivated family members to form a small dance troupe which began performing Saibai Island dancing at **festivals** and Tombstone Openings in and around Cairns. In 1985 the group caught the eye of managing personnel at the developing Kewarra Beach Resort who, for the opening of the establishment, contracted Tabuai and his troupe to perform. They received great reviews for their style of dance and accompanying apparel, and the troupe was then contracted to perform on a regular basis at the resort.

This was the beginnings of the Suruil Tituil dance troupe. Their spectacular style of dance performance demanded equally spectacular dance paraphernalia, and Tabuai began

developing innovative artefacts that would complement his skilled and energetic choreography, much of which portrayed warfare, and related ceremonial practice, between Saibai and Papua New Guinea. The troupe now performs at many resort venues along the Queensland coast as well as making appearances on national **television** and at cultural festivals and other events.

Tabuai is a consummate artist and craftsman. His understanding of the visually spectacular is instinctive, yet his artefacts are above all else functional, and superbly designed for his rigorous style of dance and the venues where his dancers

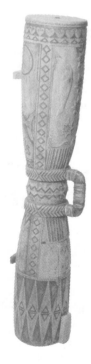

389. Allson Edrick Tabuai, *Buruburu (Island Drum)*, 1980. Carved wood and cassowary feathers, 137 x 37 cm, with handle.

perform. They are recognisably Saibai in origin and, to those who know their Island Dance, obviously based in *Ailan Kastom*. But Tabuai stamps his personality on his art, and shows few scruples about side-stepping tradition where it hinders creativity.

Tabuai is represented in several State and regional collections including the QM, CCBAG, CRC, and the Perc Tucker Regional Gallery, as well as in many private collections.

These days he sits at home in Cairns among his dance instruments, which clutter the living room, covering all available wall-space. His workshop is the garage, and on the surrounding walls and floor are unfinished art works: drums, masks, bows and arrows, clubs, and headdresses. The floor is covered with wooden shavings, paint spills and drops, cassowary and duck feathers, and strands of horse hair. On most days he can be seen sitting cross-legged on the floor of his workshop, with blocks of hard and soft wood, partially carved, in front of him. In a week's time these will be finished head-dresses adorned with feathers and bright colours. His ten-year-old grandson Binibin (Theo) is often to be found sitting beside him, looking intensely for the slightest movements in Tabuai's hands as he carves. He has been chosen by Tabuai to maintain cultural ties to Saibai Island and the Torres Strait through dance, music, mythology, and the arts and crafts. BR

See also: 7.2, 7.3, 7.4, 12.1; *389*.

Wilson, L., *Kerkar Lu: Contemporary Artefacts of the Torres Strait Islanders*, Brisbane, 1993.

TAPAYA, Tjunkaya (1943–), Pitjantjatjara visual artist, first exhibited her **batik** works at Sydney's Argyle Arts Centre in 1971. She continued to exhibit throughout the 1970s and 1980s, and in 1992 one of her batiks was selected for 'Lizards, Snakes, and Cattledogs', an exhibition of contemporary Australian textiles which travelled to Krefeld in Germany. In 1993–94 Tjunkaya and other **Ernabella** artists were featured in major exhibitions in Chicago, at Bendigo Regional Gallery—in an exhibition which travelled throughout Victoria—and in Jakarta, Brisbane, Adelaide, Melbourne, and Sydney.

Tjunkaya has also worked in the office and as a teacher's aide at the Ernabella school. Her entire family is extremely talented. Her older sister Mayawara Ukula (*c.*1938–), a craftworker in the early 1950s, was, as Mary Bennett states, 'outstanding in her ability as a leader in the craft room. All teaching was done in Pitjantjatjara and Mayawara quickly became a competent overseer to assist the new manager-supervisor'. Mayawara's daughter Makinti Minutjukur (1957–) has also been an integral member of the art centre. Examples of her popular batiks and paintings are in the MV, AGSA, QAG, and NMA.

Tjunkaya's daughter Nyuwara Kanngitja (1971–) began working at the art centre in 1989. A talented artist, Nyuwara specialises in batik, **printmaking** on paper, and painting. She has had two trips to Indonesia (in 1992 and 1997) to study batik methods and regularly participates in artists' residencies in Australia. She began printmaking in 1993 and her etchings and lithographs have since been widely exhibited and collected. In 1998 Nyuwara won a Professional Develop-

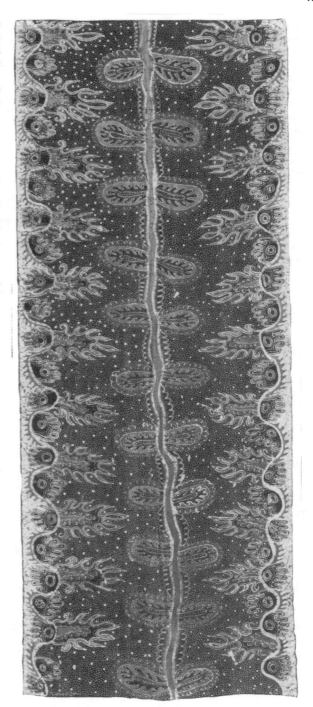

390. Tjunkaya Tapaya, *Raiki Wara*, 1994.
Batik on silk, 295.5 x 117.5 cm.

ment Scholarship which enabled her to hold her first solo exhibition in Adelaide at Gallerie Australis the following year. Her work represents the continuing evolution of art

from Ernabella in the form of textiles, ceramics, and prints on paper. LP

See also: 9.5; **batik, Ernabella**; *390*.
Bennett, M., 'Early days of art and craft at Ernabella 1949–1954', in L. Partos, 1998; Partos, L., *Walka Irititja munu Kuwari Kutu: A Celebration of Fifty Years of Ernabella Arts*, Adelaide, 1998.

TASMAN, Rosie Napurrurla (Mungu) (*c.*1935–), Warlpiri painter, was born at Pawarla, north of the Granites area in the Tanami Desert (NT). She has ancestral rights over the *wampana* (wallaby), *janganpa* (possum), *ngurlu* (seed), and wild pigeon **Dreamings**, which were passed from her father, Wayipurlungu.

Tasman's traditional country, Miya Miya and Pawarla, and the Dreamings associated with these particular sites, provide the inspiration and imagery for her distinctive paintings. She says that painting provides her with a 'happy way' in which to make her culture strong.

Rosie Napurrurla Tasman was first introduced to the medium of **acrylic paint** in 1986 when the first works from Lajamanu were created for a public audience. Since then, painting has played a fundamental role in the ritual and ceremonial life of her family. Both of her siblings, Teddy Japurrurla Morrison and Molly Napurrurla Tasman are established artists in the Lajamanu community, and her daughter Denise Napangardi Robertson is one of the younger generation of Warlpiri artists.

Tasman's work alternates between intricate dotted circular motifs and bold gestural brush strokes. Her palette oscillates from traditional ochre colours to a freer application of bright yellows, reds, and blues. In her *janganpa* (possum) Dreaming, she employs a technique of a white monochrome background to enhance the *kuruwarri* (ancestral designs) of the *janganpa* ancestor and his travels across the country. Her *ngurlu* (seed) Dreamings employ a technique where the iconography of the seed is mirrored in a background circular pattern of dots. This reinforces the essential circular elements of the seed Dreaming. VMcR

See also: 9.5; **Warnayaka Art Centre**.
Ryan, J., *Paint up Big: Warlpiri Women's Art of Lajamanu*, Melbourne, 1989.

TAYLOR, Pulya (*c.*1931–), Pitjantjatjara carver. 'I am the daughter of the Perentie lizard and a Perentie lizard carver', says Pulya Taylor, who was born in her ancestral country, Waltjitjata (NT), and was raised on bush tucker—grass-seed dampers, bush plums, and sweet flower nectars. Travelling and learning the Tjukurpa (**Dreamings**) she closely observed the movements and habits of the animals that she would later carve in wood.

At **Ernabella** mission in the 1940s she began carving in the 'craft room', using red-hot fencing wire to burn the *walka* (design, or pattern) in the wood. Forty years later Pulya moved to Mutitjulu in the Uluru-Kata Tjuta National Park. After first selling her craft to tourists at the base of Uluru, Pulya and her husband, Tony Tjamiwa, were instrumental in the formation of **Maruku Arts and Crafts**, where she is a member of the governing body.

Taking her *punu* (wooden artefacts) out to the world from the dry and beautiful Pitjantjatjara creek beds, she says it is important that people are learning about Anangu country and culture. Pulya's work stems from narratives of creation, of country, family, and Law cycles—Tjukurpa.

She is known particularly for her beautiful carved birds. In 1992 she created a collection for the Museum of Ethnology in Osaka. Since 1987 she has been included in the NATSIAA, has held a solo exhibition at aGOG in Canberra in 1998, and is represented in national, State and regional gallery and museum collections. © Maruku Arts and Crafts KT

See also: 2.4, 18.1, 18.2; Billy **Wara**; *231, 354, 399*.
Isaacs, J., *Desert Crafts: Anangu Maruku Punu*, Sydney, 1992.

television. In the 1950s and 1960s portrayals of Aboriginal people on television tended to reflect and reinforce stereotypes prevalent in the wider society. Productions by film makers, notably Charles Chauvel's *Jedda* (1955), and various newsreels made in this period depicted Aboriginal people either as 'savages' or as 'caught between two worlds'. Reflecting government policy of the time, successful assimilation into the white, mainstream society was portrayed as the only option.

In the 1970s, urban-based (predominantly Sydney-based) Aboriginal people began to demonstrate against what they saw as the stereotypical, and in many cases racist, depictions of Aboriginal lives on television. They called for more culturally sensitive and sympathetic representations, and greater control by Aboriginal practitioners of public images of **Aboriginality**. A notable early television program which attempted to address the issue of racist misrepresentation was *Basically Black* (1973), a comedy-satire produced by the ABC and written and performed by a number of Indigenous actors including Gary Foley and Bob Maza. Nine years later, the series *Women of the Sun* also screened on the ABC. In its time, this program was unique: it involved Aboriginal actors speaking their own **language**, with English subtitles. In 1986 the ABC broadcast another satire titled *Babakieuria*—a pun on the quintessential Australian social event, the barbecue — with Indigenous performers, including Michelle Tauhini and Bob Maza, acting out the roles of colonisers of Australia.

From the late 1970s onwards there was a rapid increase in the involvement of Aboriginal people in broadcasting industries including **radio**, video, and **film** production. The greatest support for this involvement came from the community sector. In the 1980s community television stations such as Metro in Sydney gave airtime and production control to the Aboriginal producers of programs such as *The Black and White Breakfast Show*, *Black on Black*, and *Which Way Now?*

During the 1980s Aboriginal people in both urban and remote areas fought to have the issue of 'Aboriginal content' placed on the federal government's broadcasting policy agenda. Whereas urban-based Aborigines were calling for greater involvement in the television industry, the majority of Aboriginal people living in remote communities did not even have access to television until after AUSSAT—the first Australian satellite—was launched in 1987. While Aboriginal people living in these areas were keen to gain access to national television transmissions, in the lead-up to the launch

of the satellite there concerns were raised about the impact that mainstream television might have in remote Australia, where Indigenous peoples continued to enjoy cultural and linguistic distinctiveness. In 1985 two 'pirate' television stations were launched simultaneously at the remote communities of **Yuendumu** (Warlpiri Media Association) and **Ernabella** (EVTV) in Central Australia. These community-based initiatives involved the production and broadcast of locally-produced video and television programs for consumption by a local, predominantly Aboriginal, audience. Broadcasts often occurred in the dominant local Aboriginal language. For remote-based Aboriginal video-makers and their **media associations**, such broadcasting activity was, and con-tinues to be, viewed as a critical aspect of Aboriginal people's wider attempt to ensure the continuing survival of their cultural and linguistic distinctiveness. Programs produced by remote media associations have included recordings of ceremonies open to the public, sporting events, community meetings, and oral histories.

The 'pirate' activity of the Warlpiri Media Association and EVTV became the model upon which a national policy approach to remote Aboriginal broadcasting was developed. The Broadcasting for Remote Aboriginal Communities Scheme (BRACS) was implemented from 1987, as a result of recommendations arising from the 1994 Report of the Task Force on Aboriginal and Islander Broadcasting and Communications, *Out of the Silent Land*. A critical component of the equipment, which was delivered to 101 Indigenous communities across remote Australia in subsequent years, was its 'interruptibility capacity', allowing community representatives to control retransmission and insert their own programming as desired. The same year, the Central Australian Aboriginal Media Association (CAAMA) sought and acquired the Remote Commercial Television Service licence for the Central Australian satellite zone. CAAMA's Imparja television went to air in late 1997. While it is Aboriginal owned and controlled, with its own television and video production house (CAAMA Productions), 99 per cent of Imparja's content is rebroadcast from commercial television networks. In 1994 and 1995 CAAMA Productions produced *Nganampa Anwernekenhe*, a series of Aboriginal language programs profiling a range of cultural and social issues, which was later sold on to SBS. Imparja also produces its own local news and current affairs programs. Fifty per cent of Imparja's staff are Aboriginal. CAAMA–Imparja has been a training ground for a number of high profile Indigenous film-makers including Rachel **Perkins**.

Indigenous communities have had changeable relationships with Australia's two national broadcasters, the ABC and SBS. Both stations have at times come under criticism for having insufficient levels of Aboriginal content in their programming schedules, for failing to respect Indigenous protocols regarding the treatment of culturally sensitive audiovisual materials, and for failing to provide a supportive forum for Indigenous practitioners to show their works. Partly in response to such criticism, both stations established Aboriginal Program Units in 1987, with the dual aim of producing programs and establishing a training ground for Indigenous people working in all aspects of the industry. Early productions of the ABC Unit included *Is there Anything*

to Celebrate in 1988? a forum for discussion of Aboriginal social issues in the context of the bicentenary, and the documentary about Sydney's first Aboriginal community radio station, *88.9 Radio Redfern*, directed by Sharon Bell and Geoff Burton. From 1989 the ABC produced *Blackout*—a magazine-style program whose presenters over the seven years it ran included Clayton Lewis, Michelle Tuahine and Aaron Pedersen. *Tent Embassy* was produced by Frances **Peters-Little** in 1992. *Heartland*, a drama series which screened on the ABC in 1994, was acclaimed for its complex exploration of relationships between Aboriginal and non-Aboriginal people, and for the involvement of senior Aboriginal actors as cultural consultants to the writers of the program. *Kam Yam* (1995–96) profiled 'ordinary people' from Indigenous communities across the nation, and *Songlines,* an Indigenous music series, screened in 1997.

Similar developments occurred concurrently at SBS. *First in Line*, a magazine-style program anchored by Rhoda Roberts went to air in 1989. In 1993 the *Blood Brothers* series showcased a series of documentary films about prominent Aboriginal men, including *Jardiwarnpa—A Warlpiri Fire Ceremony*, a co-production of the Warlpiri Media Association, and Rachel Perkins and Ned Lander of City Pictures. SBS went on to purchase the rights to screen the nine-part *Sesame Street*-style language program by David Batty and the Warlpiri Media Association entitled *Manyu Wana* (Just For Fun). From 1996 *Indigenous Cultural Affairs Magazine* (*ICAM*), hosted by Frances Rings, became the broadcaster's signature Indigenous program.

Difficulty in attracting funding is an ongoing issue. For a number of years **ATSIC** funded the production of *Aboriginal Australia*, a magazine program which it distributed to commercial stations. It was produced by a non-Indigenous production house, and in the face of criticism, production funding for the program was transferred to CAAMA. However, like its predecessor, this new series failed to reach a wide audience and in 1996 it was wound up. In the 1990s, the Open Learning series *Aboriginal Studies* helped promote understanding in the wider community of the issues facing Indigenous people. From 1997 ATSIC split this allocation between funds it committed to SBS for the production of *ICAM,* and the establishment of a National Indigenous Documentary Fund. In 1997–98 ten half-hour documentaries were made with the support of this fund, with CAAMA acting as series producer and Rachel Perkins (at the Indigenous Program Unit of the ABC) as executive producer. The productions, broadcast on the ABC, ranged from works by individual film makers such as Michael **Riley** (*Blacktracker),* to collaborative ventures between remote media associations and urban-based professionals, such as the Warlpiri Media Association's *Munga Wardingki Patu* (Night Patrol). The series was so successful that a second series of ten documentaries was commissioned in 1998–99. In the same period the Indigenous Drama Initiative sponsored by the Australian Film Commission enabled the production of the *Sand to Celluloid* series in 1995 and *Shifting Sands* in 1998, which again put indigenously produced short films on national television, on SBS. SBS Independent have subsequently collaborated with CAAMA to fund the production of a series of Indigenous documentaries which commenced screening in 1999.

In the late 1990s the screening of works by Indigenous producers on national television occurred at an unprecedented rate. At the same time, lack of funding continued to restrict the potential of Indigenous practitioners' participation in the television industry. This is still particularly the case in remote areas, where media associations have in recent years shifted their focus away from television-based production and towards radio broadcasting. A lack of coordinated training programs and insufficient funding continue to be the key restrictions on the potential expansion of Indigenous people's involvement in the industry. MH

See also: 4.1, 13.1, 13.2.
Aboriginal and Torres Strait Islander Commission, *Digital Dreaming: A National Review of Indigenous Media and Communications*, Canberra; Langton, M., '*Well I Heard It On The Radio and I Saw It On The Television…* ': *An Essay for the Australian Film Commission on the Politics and Aesthetics of Filmmaking by and about Aboriginal People and Things*, North Sydney, 1993; Michaels, E., *Bad Aboriginal Art: Tradition, Media, and Technological Horizons*, Minneapolis, 1994; Perkins, R., 'Aboriginal television', in Moran, A. (ed.), *Film Policy: An Australian Reader*, Brisbane, 1994.

Tent Embassy. The Aboriginal Tent Embassy was one of the most important protests in post-war Australian history, and has since acquired a legendary status. It was first seen on the lawns in front of Parliament House in the national capital on 26 January 1972, following an Australia Day statement on Aborigines released the previous day in which Prime Minister William McMahon reaffirmed his government's commitment to assimilation, and rejected **land rights** on the terms demanded by Aboriginal and non-Aboriginal campaigners.

The protest was apparently first mounted by a handful of young Aboriginal men from Redfern—Michael Anderson, Bill Craigie, Bertie Williams, Tony Coorey, and Gary Williams—who came from communities that had strong memories of being dispossessed or forced away from their reserve lands.

They were soon joined by other blacks, the most prominent among whom were Kevin **Gilbert** (one of those who first suggested the idea of the embassy), Gary Foley, Paul Coe and Roberta (Bobbi) **Sykes**. Others like John Newfong, Denis Walker, and Bruce McGuinness also played a role, as did students at the ANU who provided much-needed support.

Most of the embassy's demands were not new—ownership of Aboriginal reserves, mining rights, and compensation for alienated land had been the staple of Aboriginal political demands since 1968. But the call for a treaty and an Aboriginal state was novel, and implied a demand for recognition of Aboriginal sovereignty. The style of the protest was not completely new; the **Freedom Ride** of 1965, for example had also used direct action, and later protests (such as the **Day of Mourning** on the Cook bicentenary in 1970) had similarly emulated the techniques of marches and vigils made popular by radical political movements in the United States and Europe in the late 1960s.

The form of the protest was, however, highly original. The embassy—which echoed the 'resurrection city', a shanty town which African-American protesters had erected in Washington in 1969—became a richly symbolic and ironic

statement. On the one hand the tents evoked the many impoverished Aboriginal fringe camps across Australia; on the other the embassy represented Aboriginal protesters' sense of being foreigners in their own land, as well as their claim to be an autonomous nation (eventually reflected by flying the Aboriginal **flag**).

The spectacle of the embassy attracted considerable media coverage, both nationally and overseas. This, and especially the reportage of the heavy-handed destruction of the embassy by the Commonwealth police, and the resultant clashes with protesters on two occasions later in the year, helped draw political attention to Aboriginal demands. Consequently the major political parties were, perhaps, forced to consider Aboriginal matters more seriously. The Labor Party, which formed government later in the year and subsequently introduced the first substantive land rights legislation, had already pledged itself to reform.

Since 1972 the Tent Embassy has been either recreated or commemorated on several occasions. Since 1997 it has remained continuously in front of Old Parliament House as the most obvious and most persistent expression of Aboriginal demands for sovereignty. BA

See also: 4.1, 4.5; **referendum of 1967**; *49, 206.*
Attwood, B., and Markus, A., *The Struggle for Aboriginal Rights: A Documentary History*, Sydney, 1999; Goodall, H., *Invasion to Embassy: Land in Aboriginal Politics, 1770–1972*, Sydney, 1996; Robinson, S., 'The Aboriginal Embassy: An Account of the Protests of 1972', in V. Chapman & P. Read (eds), *Terrible Hard Biscuits: A Reader in Aboriginal History*, St Leonards, NSW, 1996.

textiles, see 17.5; **batik, Bima Wear, Tiwi Design.**

THAIDAY, Ken Sr, (1950–), dance performer and dance artefact constructor, is an expert creator and designer of dance equipment for contemporary Torres Strait dance. Born on Erub (Darnley Island) in the Torres Strait, he now lives in Cairns (Qld) with his family. He began his art career in 1987 by constructing dance artefacts for the Darnley Island Dance Troupe. Over the years he has actively experimented in the construction of masks, dance machines, and musical instruments.

As a child Thaiday enjoyed growing up on his home island. His training began early, encompassing living skills such as gardening and fishing, and cultural skills such as art, dance, and **language**. The traditional values of Erub, and a respect for its culture were instilled in him as he was growing up. His father Tat Thaiday had a great influence on his life. An expert composer of songs and dance, and the Chairman of Darnley Island Community for many years, Tat Thaiday gained much respect within his community. Ken Thaiday had a standard and tradition to uphold.

Dance is the most popular form of cultural expression for Torres Strait Islanders, and today there is often strong competition between Island groups and mainland communities living in north Queensland. Traditional dances associated with ceremonial practices were serious events, enacted in the privacy of the initiated male's domain. Elaborate masks of finely carved wood and composite turtle shell symbolised totemic figures, and were instruments to bridge the gap

between the material and spiritual worlds. Public secular performances are often lighthearted and the playfulness of onlookers reinforces the feeling of community. But a competitive streak is apparent, not only in the accentuated movements of the performers, but further exaggerated and emphasised by the use of dance paraphernalia.

Thaiday's artefacts of dance represent the strength of tradition and the creativity of the secular. As a dancer himself, Thaiday knew first-hand the symbolism of dance and the appropriate way to complement dance performances. His ingenious innovations in dance regalia have set a new standard. The use of articulated parts in masks and dance machines are the main characterisitics of his designs. He maintains the integrity of Islander symbolism while developing a new sense of reality. The moving parts of his machines allow performers to represent physically the movement of animals and natural events.

Thaiday's *Beizam* (shark dance headdress) epitomises his art. Consisting of a hammerhead shark on top of a large shark's jaw, it is articulated so that the jaws can open and close and the head can move back and forth, imitating the shark's feeding action. The movements of the head-dress combined with the gyrations of the performers make for a spectacular, hair-raising, performance. The shark is an important totem in Torres Strait Islander culture, and one of many that signify the deep connection Islanders have with the sea. A symbol of order, the shark represents the strength of the seas of Torres Strait and demands respect. Shark symbolism was central to the Malu-Bomai cult of precolonial times; the continued use of sharks in Thaiday's masks confirms the relevance of traditional beliefs in contemporary Torres Strait Islander society.

MB

See also: 7.1, 7.2, 7.3, 7.4, 7.5, 12.1; *157*.
National Gallery of Australia, *The Eye of the Storm: Eight Contemporary Indigenous Australian Artists*, Canberra, 1997; Mosby, T. with Robinson, B., *Ilan Pasin (This is Our Way): Torres Strait Art*, Cairns, Qld, 1998.

THANCOUPIE (Gloria Fletcher) (1937–), Thanaquith ceramic artist, community worker, elder, and spokesperson. In 1970, the young Gloria Fletcher visited East Sydney Technical College, hoping to enrol in a painting course. She had spent formative creative years painting with north Queensland artists including Dick **Roughsey** (Goobalathaldin), with whom she held her first exhibition of paintings in Cairns (Qld) in 1968. She passed the college pottery and, entering its stone walls, became entranced:

Clay at Weipa was sacred. We only used it for ceremonial purposes and each colour had a meaning. Red, black, yellow and white. The men used to keep the clay in a special storehouse and we kids were not allowed to touch it. We used it only for decoration, of our bodies and special spears and woomerahs, not to make things. We didn't need pottery because we had shells to drink water and leaves to wrap and cook food in. The idea of having my hands in clay and working with it making art was somehow strange but exciting—it was only much later I realised that clay would be my art, and also my legends (quoted in Isaacs 1982).

Following a three-year certificate in ceramics, Thancoupie became the first Australian Aboriginal solo ceramic artist. She has been the foremost Aboriginal potter for thirty years. Through the use of clay she has expressed herself and her intricate relationship with the land and all living things, and with the elements—earth, fire, and water.

After a short period of making wheel-thrown bottles, mugs, and domestic bowls, Thancoupie was encouraged by Albert Barunga from **Mowanjum**, to express the old people's stories from Weipa where she had grown up in the dormitory system run by the Presbyterian mission. She began to use her totemic name of Thancoupie (wattle flower) publicly in 1972. She is, essentially, a ceramic sculptor; both her forms and her surface images are symbolic. Egg shapes suggesting emus are fertility symbols, spheres are the earth and the cycle of life. Seaforms and free-form shapes suggest rocks and rock holes. Clay surfaces are covered with linear designs, the surface glazes changing over the years from highly glazed stoneware using *tenmoku*, celadon, and dry feldspathic effects—to the work of the last two decades—chalk-like effects with dark linear drawings of kangaroos, possums, emus, dugong, barramundi, ibis and other characters and figures who created the land around Weipa, Aurukun and the coastal areas of Cape York. Other themes are plants and seafoods, seaweeds, vines and tendrils. The form of some of her recent work suggests yams and seed pods. Encouraged occasionally by curators or gallerists eager for innovations, she has held firm, remarking 'No, this is *the* work.'

Thancoupie has held sixteen solo exhibitions and numerous combined exhibitions throughout Australia and abroad. From her first exhibition in 1972 at Volta, the communal house she shared in Sydney with writer Jennifer Isaacs, photographer Jon Rhodes, and dancer Carole Johnson, she was determined to be an independent creative artist. She resolved to exhibit with the best contemporary artists, sculptors and craft-workers in Australia rather than show her work with other Aboriginal artists in contexts in which it might be regarded as 'ethnographic' or 'folk' art. This prescient decision and subsequent critical acclaim have established her prominent career. She exhibited throughout the 1980s in Sydney and Melbourne, with other exhibitions in Adelaide, Cairns, Townsville, and other cities.

Highlights of her career include her appointment in 1986 as Australian Cultural Commissioner to the Biennale of São Paulo (Brazil), and her solo exhibitions which toured throughout South America and to Houston, Texas. She has designed fabrics, murals and terrazzo works for public institutions.

Thancoupie founded the Weipa **Festival** and has run the Holiday Program in Weipa since 1988 with other family members, teaching bush knowledge and art and craft skills to the children of Weipa. She is a mentor for young north Queensland artists but also continues the pressing work of family support, and **reconciliation**. In 1998 she received an honorary PhD from the University of Queensland for her achievements and services to Aboriginal Arts.

JI

See also: 8.2, 12.1, 16.5; Arone Raymond **Meeks**; *103*.
Isaacs, J., *Thancoupie the Potter*, Brisbane, 1982.

theatre, see 14.1, 16.1, 16.2.

THOMAS, Madigan (*c.*1932–), Kija visual artist and community elder, is a senior artist at **Warmun** community (Turkey Creek, WA), in the East Kimberley region. She began to paint in the 1980s, inspired by artists **Rover Thomas** and **Queenie McKenzie**. Madigan and Rover Thomas were the first Warmun artists to combine natural earth pigments to achieve a range of colours. Madigan says:

I seen-em kartiya (white people's) paint la (at the) shop; blue one, green one, pink one. I was thinking, OK, we can make something like that using our bush paint [ochre]. One time we bin try-em, me and oldfella [Rover Thomas]. Old man and me bin work together and mix-em up. Old woman [Queenie McKenzie] yell out to me 'how you bin do that?' Ah well, after that old girl [Queenie] bin start-em up and never stop mix-em colour.'

Madigan Thomas continues to paint with natural **ochres** and pigments on canvas. Her paintings tell the Ngarrangkarni (**Dreaming**) stories of her country and refer to historical events, particularly early interaction between white and Kija people. In 1998 she was a driving force behind the establishment of Warmun Art Centre, the first artist and community-owned art centre at Warmun. Her work continues to be an inspiration to many young, emerging Kija artists.

Madigan Thomas's paintings have featured in numerous group exhibitions in Australia and overseas. Her work is included in the collections of the NGV, AGWA, and NTU, the Edith Cowan University Art Collection, Perth and the Kerry Stokes Collection, Perth. JnK & AM

See also: 10.2, 10.3, 22.6.

THOMAS, Phyllis (*c.* 1940–), Kija painter, was born at a place called Riya on the Turner River, south-east of the Bungle Bungle Range (WA). When young she worked on Turner station looking after poultry, gardening, grinding salt, and carting water from the well, but often preferred to join the old women on trips out into the bush. She loved walking all over the country with her mother's mother and the other old women, hunting, collecting dingo scalps, and looking for gold. She married Joe Thomas from Rukun (Crocodile Hole) and lived there for many years. She began painting when Freddie **Timms** set up the Jirrawun Aboriginal Arts group there.

Her work depicting **Dreaming** places and bush tucker from the Crocodile Hole area, as well as the country around the middle reaches of the Ord and Turner rivers where she was born, achieved almost immediate success. She was represented in NATSIAA exhibition in 1999 with a stunning picture *Boornbem Goorlem, Hot Water Spring II*, done in black and a pinkish-red colour made by mixing red **ochre** and white pipeclay. The spring in question is in a gorge, with the open sky shown as a plain expanse of paint above the water and rock faces. Other works include *Bush Honey—'Sugarbag' Dreaming at Dry Swamp*, in which the dark cells of the hives float on a plain ground, and *Loomookool Blue Tongue Lizard Dreaming*, in which a prominent landscape feature is seen from the side. Her work has been acquired by a number of collectors and galleries including a special focus purchase of five paintings by the AGWA. FK

See also: 10.2, 10.3, 22.6.

THOMAS, Rover (1926–1998), Kukatja–Wangkajunga visual artist, occupies a unique place in the history of modern Australian art. His paintings received major critical acclaim in Australia and overseas, and he was the leading light in the emerging school of painting in the East Kimberley (WA) in the 1980s. But he also became part of the **history** of the Kimberley country.

Rover Thomas was born at Gunawaggi (Well 33 on the Canning Stock Route) in the Great Sandy Desert (WA). When he was young, his family moved to Billiluna in the Kimberley and he grew up working as a stockman and fencer on various cattle stations. The enforced exodus of Indigenous station workers saw him move to Warmun in 1975. There he received a dream visitation from the spirit of a classificatory mother who had died as a result of injuries received in a car crash on a road flooded by the rains of Cyclone Tracy, which destroyed Darwin on Christmas Eve in 1974. The cyclone was interpreted by Aboriginal elders in the Kimberley as a warning by an ancestral rainbow serpent to Aboriginal people to maintain their culture. The spirit of the dead woman revealed to Rover Thomas its journey from the west across the Kimberley to her home in the east, where it witnessed the destruction of Darwin by the rainbow serpent. The spirit of the woman also revealed to him details of a ceremony—the Kurirr Kurirr (Krill Krill)—with its associated narrative, songs, choreography, and graphic images.

The rituals featured boards painted with images from the spirit's journey. As is customary in Kimberley ceremonies, these boards were carried across the shoulders of the performers. In the first years of the ritual, Thomas supervised the painting of the boards by Paddy **Jaminji**, but did not paint any himself until he began painting on a regular basis in about 1981.

Rover Thomas's first paintings were associated with the Kurirr Kurirr, but he soon began to paint other subjects in which he revealed his perceptions of the ancestral and modern histories of the East Kimberley, where the landscape becomes an allegory for the course of history. Among his most frequently painted subjects are the **massacres** of Aboriginal people in the years just prior to his birth, and images of the East Kimberley landscape which reveal its ancestral origins.

His painting style incorporated traditional techniques common in the region, such as the description of shapes by lines of dots, and the combination of planar and profile views of the landscape. To these he added his unique gestural style of paint application and drawing. He used paint made from natural pigments bound by a variety of native resins and gums to produce tactile visual surfaces. His compositions are intuitive and spectacularly unconventional, but nonetheless convincing and resolved.

Rover Thomas and Trevor **Nickolls** were the first Aboriginal artists to represent Australia officially at the Venice Biennale, in 1990. A major retrospective exhibition of his work, 'Roads Cross', was mounted at the NGA in 1994, and

he has been represented in major exhibitions both in Australia and abroad, including the Adelaide Biennial (1990), 'Crossroads' (Kyoto and Tokyo 1992), 'Images of Power' (NGV 1993), 'Aṟatjara' (Düsseldorf, London, and Humlebaek 1993–94), 'The Eye of the Storm' (New Delhi 1996), and 'World of Dreamings' (St Petersburg 2000). WC

See also: 10.2, 10.3, 21.1, 22.6; *136*, *219*.
National Gallery of Australia, *The Eye of the Storm: Eight Contemporary Indigenous Artists*, Canberra, 1996; Ryan, J, with Akerman, K., *Images of Power: Aboriginal Art of the Kimberley*, 1993; Thomas, R., with Akerman, K., Mácha, M., Christensen, W. & Caruana, W., *Roads Cross: The Paintings of Rover Thomas*, Canberra 1994.

THORNTON, Warwick (1970–) Kaytej cinematographer, was born in Alice Springs. Son of Freda Glynn, photographer and creator of the Central Australian Aboriginal **Media Association** (CAAMA), he grew up surrounded by images of the social and sporting life of local Aboriginal people. At the age of twelve he was a DJ on CAAMA's **radio** program, *Black Kids*, and at seventeen he took up a camera operator traineeship at CAAMA. He shot hundreds of hours of **television** for CAAMA which was broadcast on Imparja and the ABC, while also making commercial corporate videos as a source of income for CAAMA. Between 1993 and 1996 he worked towards his BA in Cinematography at AFTRS in Sydney, which he undertook to break out of documentary and to learn cinematic techniques for drama. During this period, he wrote and directed his first short drama *Payback* (1996) as part of the first Indigenous Drama Initiative compilation *Sand to Celluloid*.

After graduating Thornton returned to freelance work and shot parts of *Songlines* (1997), an Indigenous music series, for the ABC. During 1998 he shot the short drama *My Bed Your Bed* (1998) for his sister, the director Erica Glynn. In this film, his style of shooting through doors and windows to give contrast and depth gelled with his sister's intentions, and a warm and beautiful film evolved. It was also during this year that he shot his first dramatic feature film, *Radiance* (1998). His love for photography is evident in his documentary *Photographic Memory* (1998), a portrait of the Aboriginal photographer Mervyn **Bishop** written and directed by him for the second series of films funded through the National Indigenous Documentary Fund. IB

See also: 13.1; *178*.

TIMBERY family. According to Timbery folklore, the family was fishing in Botany Bay when James Cook sailed in. Today visitors to **La Perouse** (NSW) are still met by a Timbery, namely Laddie, who, following his family's tradition, sells arts and crafts at a stall at the Loop. The Protection Board Report for 1891 records that the men at La Perouse were fishermen and also made weapons for sale, while the women sold shell-works and wildflowers. Laddie's great-great-grandmother, Queen Emma Timbery, exhibited her shell-work in London in 1910. Laddie's grandfather, Hubert, was a 'lookout man' who could tell the species of fish from the ripple on the water: he used to sit on the shore to spot the fish

and signal to the men on the boats. While waiting he would carve **boomerangs** and nulla nullas, which he sold throughout the 1940s at the Loop. His brother John, who had been the first postman at Wreck Bay, was a fisherman too, and also used to sell artefacts with his wife Marjorie at the stall in the 1950s. Rose and Esme Timbery, Hubert's daughters, started to sell their shell-work at about that time. In the 1950s Joe Timbery—the champion boomerang thrower who had performed on top of the Eiffel Tower and in front of Queen Elizabeth in 1954—opened a shop at La Perouse, where he produced and sold boomerangs, shields, and other wooden objects. The shop was near the family home, which had been built by his grandfather, Joseph 'Dooka' Timbery. In the 1950s and the 1960s the Timberys had stalls at the Royal Easter Show, following a tradition started at the beginning of the century by Queen Emma.

Today the Timberys' workshop, the Bidjigal Aboriginal Corporation, is based at Huskisson, Jervis Bay, from where Laddie travels to La Perouse on the weekends following the travelling route of his ancestors, the Bidjigal people. At the shop he is helped by other family members. Rose Timbery, his mother, is a boomerang designer: she learnt the art of 'burning in' images from John. Esme Timbery, who still lives at La Perouse, contributes to the business with her unique shell-works. Jeff Timbery, Laddie's son, is a visual artist and a dancer. Since 1991 he has been the coordinator of Bidjigal Dancers, who regularly perform in Australia and overseas, for example in 1997 at the Indigenous Games in Canada. Their success and the subsequent demand for Timbery-made objects was such that the family opened a Canadian outlet in British Columbia which, together with the email catalogue available through their web site, serves an international clientele. IV

See also: 18.1, 18.3; **Simms sisters**; *232*, *339*.
La Perouse—The Place, the People, and the Sea: A Collection of Writing by Members of the Aboriginal Community, Canberra, 1988; Timbery Family & Moore, L., *Timbery Tales* [interactive CD Rom], Pelicanvideo@fastrac.net.au.

TIMMS, Freddie Ngarrmaliny (1946–), Kija painter, was born at the place he is named for—Ngarrmaliny (Police Hole, near Foal Creek) on Bedford Downs station southwest of **Warmun** (WA). He spent his childhood on Bow River and Lissadell stations then worked as a stockman, handyman, and fencer on several stations in the East Kimberley. He knew **Rover Thomas** when they both worked at Bow River and Texas Downs, and danced and helped to paint boards for early performances of the Kurirr Kurirr ceremony.

Joel Smoker of **Waringarri Arts** brought canvases to Jack **Britten**, Rover Thomas, Hector **Jandany**, and his father-in-law George **Mung-Mung** when Timms was living with them at Frog Hollow, south of Turkey Creek. Timms asked for canvases as well, and he has not stopped painting since. His style is reminiscent of Thomas's, but recognisably his own, with expanses of plain paint lined with white dots. Many of his pictures are like aerial maps of the bones of the country where he has lived and worked all his life. Much of the country where he worked on Lissadell, a frequent painting

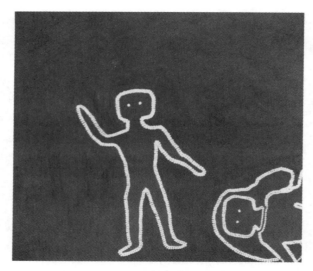

391. Freddie Timms, *The Death of Major at Ninemile*, 1991. Natural pigments on linen, 122 x 135 cm.

subject, is now under the water of Lake Argyle, formed by the damming of the Ord River. He says, 'I think about the country where I was walking and camping, all the main water holes, all the camping areas. I remember the places where I used to go mustering and I follow them up with my painting.'

Freddie Timms occasionally seeks to make a political statement in his work. A striking example is *Whitefella–Blackfella*, 1999 which describes the position of Aboriginal people in Australia. In a large black canvas four symbolic figures are strategically placed, with the 'whitefella' at the top, the yellow Chinaman under him, then the African, then the 'blackfella right down at the bottom'. He tells of the tragic **history** of the first fifty years after the arrival of Europeans in the East Kimberley, when many Aboriginal people were murdered.

While in Melbourne in 1996, Timms met Tony Oliver, who used to own a gallery there. Oliver introduced him to Sydney gallery owner Frank Watters who agreed to show his work on equal terms with European artists, with paintings sold on consignment. Solo exhibitions at Watters Gallery followed, and in 1998 he participated in a combined show there with non-Aboriginal artist Ken Whisson, described by reviewer John McDonald in the *Sydney Morning Herald* of 18 July as 'a wonderfully fertile "compare and contrast" exhibition of landscapes'. Timms proceeded to set up Jirrawun Aboriginal Art Corporation to market work on a consignment basis for an increasingly wide group of Kimberley artists including Paddy **Bedford**, Churchill Cann, Goody Barrett, **Phyllis Thomas**, and his father's brother Timmy Timms.

The work of Freddie Timms is represented in all major public collections in Australia and has been shown in group exhibitions including 'Aratjara' (Düsseldorf, London, and Humlebaek 1993–94).

FK

See also: 10.2, 10.3, 21.2, 22.6; *391*.
Ross, H. (ed.) *Impact Stories of the East Kimberley*, East Kimberley Working Paper, no. 28, CRES, ANU, 1989; Ryan, J., *Images of Power: Aboriginal Art of the Kimberley*, Melbourne 1993.

TIPOTI, Alick Seriba (1975–), printmaker, was born on Thursday Island, but his family originates from Saibai and Badu, also in the Torres Strait. Alick always liked to draw as a child and since his career has taken off he has reflected that: 'Art has always been a part of myself, a natural expression of my personality.' He was one of a number of Indigenous students to complete the Associate Diploma of Aboriginal and Torres Strait Islander Art at the **Far North Queensland Institute of TAFE**. He then moved on to complete a Bachelor of Visual Arts at the Canberra School of Art (CSA, ANU) in 1994.

While he was still a student at the CSA Tipoti gained international recognition through exhibitions and cultural exchanges. His prints are in demand not only for their quality but also because they depict a rich, but little-known, cultural tradition. In the print *Mura Uruiau Danaka*, 1996, the title of which translates from the Kala Lagaw Ya (KLY) **language** as 'For the eyes of every creature', the imagery and underlying theme express the artist's pride in his heritage. The work re-ignites traditional mythology in the form of the triumphant headhunter who draws strength from his totem (*augud*) as he prepares to revenge the death of his six brothers in a previous battle. Tipoti's choice of the linoprint technique allows him to express his identity physically through a carving process that he likens to the style of carving and etching practised by traditional artisans. Many of Tipoti's works draw from the myths and legends symbolic of the older, darker times. Images of warriors recall fighting and headhunting traditions, representing a past in which islanders were in control of their destiny, before the disruption of European contact.

Tipoti has recently moved into children's literature, publishing traditional stories such as *Kuiku Mabaigal*, a tale of two brothers, Waii and Sobai, from Badu Island which was first told to Tipoti by an elder, Aidan Laza. Tipoti translated the story from KLY and also drew the many detailed and realistic illustrations.

In 1998 Tipoti was awarded the **Lin Onus** Youth Award category in the NIHAA for his work *Aralpaia ar Zenikula*. He has always wanted to be a leader in cultural activities, and hopes to make people more generally aware of the traditional customs and religious beliefs of the Torres Strait Islanders; he has participated in cultural exchanges to Japan and New Caledonia. Despite the many external influences in his life Tipoti maintains a strong hold on his culture, and on the traditions that underlie his Torres Strait Islander heritage.

MB

See also: 7.2, 7.4; **printmaking**; *88*.
Bani, M., 'Tradition in contemporary form', in L. Taylor (ed.), *Painting the Land Story*, Canberra, 1999; Mosby, T. with Robinson, B., *Ilan Pasin (This is Our Way): Torres Strait Art*, Cairns, Qld, 1998.

Tiwi Design Aboriginal Corporation is the art centre at Nguiu on Bathurst Island (NT). Established in 1969, it was

one of the first art centres in a remote community. It incorporates Tiwi Design (textile printing), **Tiwi Pottery** (ceramics), Tiwi Pima Art (material culture), and Tiwi Poster Printing (limited-edition works on paper). Printing activities on Bathurst Island began as a rudimentary training program organised by Madeline Clear, a schoolteacher. Two young men, Bede **Tungutalum** and Eddie Puruntatameri (1948–1995) had showed an interest in wood-block printing, and a small space was set aside underneath the presbytery for producing works on paper and, subsequently, prints on fabric. Eddie Puruntatameri stayed only a few months before pursuing his preferred career of pottery. Giovanni Tipungwuti (1953–1993) designed wood-blocks in mid 1969, and by the end of the year sixty single-motif prints had been produced. The artists were building on skills acquired in the Tiwi wood-sculpting tradition.

In 1970 Tiwi Design was awarded a good design label by the Industrial Design Council of Australia. This was to be the first of many awards, exhibitions and commissions for the artists over the next two decades. Bede Tungutalum and Giovanni Tipungwuti remained with Tiwi Design until the late 1980s, and were the inspiration behind such textile designs as the Tiwi Bird, Pukumani Pole, Sea-life, Yam, and Kulama designs, which continue to be printed to this day. They also encouraged young artists such as Angelo Munkara (1958–), Danny Munkara (1957–), Michael Munkara (1962–), Edwin Fernando (1961–), Osmond Kantilla (1966–), and Alan John Kerinauia (1964–), who all began their careers as designers and screen printers at Tiwi Design. All have worked consistently as artists since the late 1970s. Tiwi Design became a significant role model for other screen-printing studios in remote communities, at **Injalak**, **Ernabella**, Nauiyu Nambiyu, and Munupi.

Many of the designs both for fabric and paper over the past three decades have juxtaposed realistic with traditional motifs. The early designs were all worked in wood-blocks before being transferred to silk screens with water-based dyes. Products included sarongs, calendars, table linen, scarves, T-shirts, and printed cards and, more recently, silk items. Production of **batik**, etching, and lithography have also commenced over the past few years, allowing further creativity and experimentation in the print media. In 1996 a limited edition of thirty-two original wood-blocks was printed; along with many other works they were included in the retrospective exhibition 'Tiwi Prints: A Commemorative Exhibition 1969–1997' (MCA 1997). This show included prints produced twenty-five years apart, and clearly showed the undiminished talent of the Tiwi printmakers. KAB

See also: 16.3; **printmaking**; *334, 371, 395*.
Barnes, K., *Kiripapurajuwi (Skills of Our Hands): Good Craftsmen and Tiwi Art*, Darwin, 1999.

Tiwi Pottery. The dedication of Tiwi artists to working in clay has been the basis for the success and longevity of the Tiwi Pottery. Several professional non-Tiwi potters with a belief in the talent and perseverance of the Tiwi have also contributed to its success. The Tiwi tradition of three-dimensional carved sculpture, with its distinctive decoration, has allowed for an easy transition to the introduced medium of ceramics. In 1969, Eddie Puruntatameri (1948–1995) decided to pursue a career in pottery, having worked with limited-edition woodblocks for a year at **Tiwi Design**. With John Bosco Tipiloura (1952–) he undertook training at the Bagot Ceramic Training Unit in Darwin in 1970. Late in 1970 a small exhibition of the pottery produced at Bagot was held at the Museum of Arts and Sciences, Darwin. As a result of the enthusiasm generated by this exhibition, a feasibility study was undertaken to investigate the availability of ceramic raw materials on the Tiwi islands in 1971. In 1972, with the support of Catholic Missions, a small pottery was built by Puruntatameri and Tipiloura under the guidance of Ivan McMeekin at Nguiu (Tiwi Design was built next to the pottery in 1974).

The pottery remained a mission project until the late 1970s. John Patrick Kelantumama (1952–) joined Tiwi Pottery in 1976 as an apprentice, and Jock Puautjimi (1962–) started in late 1979. Over the years these four potters have also been highly regarded as wood carvers. Throughout the 1970s and 1980s local clay, glazes, and pigments were used, and the pots were fired in a single firing in a two-chambered wood-burning kiln. In 1990 a new training project expanded the Tiwi Pottery: several young Tiwi trained as apprentices in clay preparation and decoration. With the increased demand for their work, the potters began to use a commercial porcellanous stoneware clay, underglaze colours, and a gas-fired, down-draft fibre kiln.

The first exhibition of Tiwi pottery was held in 1977 at the Aladdin Gallery, Sydney, with subsequent exhibitions at Arnhemland Art Gallery, Darwin (1979), the Potters Gallery, Sydney (1980), the Meat Market Craft Centre, Melbourne (1982), and Birrukmarri Gallery, Fremantle (1987). Commissions, exhibitions and workshops continued into the 1990s. The reputation of the four original Tiwi potters, the high quality of their technical skills, and the fact that demand has far exceeded supply over many years, are all factors contributing to the ongoing enthusiasm of the artists for this introduced art form. KAB

See also: **Puruntatameri family**.
Barnes, K., *Kiripapurajuwi (Skills of Our Hands): Good Craftsmen and Tiwi Art*, Darwin, 1999.

TJAMPITJIN, Sunfly (1916–1996), Kukatja visual artist, was conceived at Murranpa (the Alec Ross Range, WA). His country encompassed Mankayi and Lake Mackay in Kukatja country some 250 kilometres south of **Balgo**. He was an important Law man, and supported the entry of the Christian church into the Balgo area.

His wife Bai Bai Napangarti (*c*.1934–) was born near Point Moody. As for many senior Balgo artists, incidents of great cruelty which occurred as Aboriginal and Kartiya (non-Aboriginal) society met in the desert were part of her world as she grew up. Despite these experiences, her mother encouraged her to share her knowledge. She has since applied this advice in her painting, which she sees as a medium for educating Kartiya about Aboriginal culture.

Bai Bai and Sunfly's work was exhibited in 'Art from the Great Sandy Desert ' (AGWA 1986–87). The clarity and power of Sunfly's paintings soon attracted the attention of private and public galleries in Perth, Melbourne and

Canberra. His work was included in 'Mythscapes' (NGV 1989), and 'The Continuing Tradition' (NGA 1989). Gabrielle Pizzi took his paintings to 'L'été Australien' (Montpellier 1990), and to the USSR for the 'Aboriginal Paintings from the Desert' (Moscow and St Petersburg 1991). Both Sunfly's and Bai Bai's work was shown in 'Yapa: Peintres Aborigènes de Balgo et Lajamanu' (Paris 1991), and Sunfly's painting was included in 'Aratjara' (Düsseldorf, London, and Humlebaek 1993–94).

Sunfly's work is classic in its minimalist perfection, balancing large icons with fine detail to create monumental effects within moderately sized canvases. It is measured, and restrained, and imparts an unfailing atmosphere of authority. Bai Bai's style is somewhat bolder and more experimental. Her early work has the informality of public sand drawing, used as an aid to story-telling by the peoples of the desert. Over the late 1980s and early 1990s she established herself as an artist able to produce measured, harmonious compositions, and also works with idiosyncratically-shaped icons and unusual linear rhythms. Her style has become progressively looser and more expressionistic, and more energetically charged.

Pauline Sunfly (1963–), one of Sunfly and Bai Bai's children, has inherited the wealth of stories from her parents' countries. She began to paint for the market in the late 1990s. Dynamic graphics, unencumbered by details, dominate the canvas. Her work, effortless and bold, is punctuated by white dotting, stark shapes, and areas of straight colour, and combines the painterly strengths of both her parents.

Sunfly Tjampitjin's work is held in the NGA, AGWA, NGV, and the Holmes à Court Collection, Heytesbury (WA), while Bai Bai's is held in the AGWA, NGV, and the Kluge–Ruhe Collection at the University of Virginia. CW

See Also: 9.5; **Warlayirti Artists**.
Cowan, J., *Wirrimanu: Aboriginal Art from the Balgo Hills*, Roseville East, NSW, 1994; Peter, S. & Lofts, P., *Yarrtji: Six Women's Stories from the Great Sandy Desert*, Canberra, 1997; Ryan, J. with Akerman, K., *Images of Power: Aboriginal Art from the Kimberley*, Melbourne, 1993; Stanton, J. E., *Painting the Country: Contemporary Aboriginal Art from the Kimberley Region, Western Australia*, Nedlands, WA, 1989.

TJAMPITJINPA, Kaapa Mbitjana (*c*.1920–1989), Anmatyerre painter. Kaapa's exceptional skill with a paintbrush was acknowledged by the old men of Papunya when they chose him to paint a mural of honey ant **Dreaming** on the Papunya school wall in 1971. That year he won equal first prize in the Alice Springs Caltex Golden Jubilee Award, the first public recognition the Papunya artists had received for their work. In 1972, his fellow painters appointed this forceful and intelligent man as the first Chairman of **Papunya Tula Artists**, the founding desert art enterprise.

Born at Lurumbu on Napperby station in his mother's birth country, Kaapa lived, for most of his youth and adulthood, the hard dangerous life of a Central Australian stockman, maintaining close contact with his country while working on the various pastoral leases among which it had been divided. One of his principal sites was Mikanji, a rainmaking place near Mt Denison which he frequently painted.

Other common subjects were owl, shield, witchetty grub, pelican, snake, black goanna, emu, and yam Dreamings. Kaapa gave his **language** affiliation as Anmatyerre, though his father was born at Warlugulong in what is now Warlpiri territory, and the name 'Mbitjana' is the Arrernte equivalent of the Western Desert subsection name 'Tjampitjinpa'. His influence among the Papunya-based artists remained strong until his death in October 1989. His work was seen in several group exhibitions including 'The Inspired Dream' (MAGNT 1998), 'Aboriginal Art and Spirituality' (HCA 1991), and 'Tjukurrpa: Desert Dreaming' (AGWA 1993), and is represented in major public collections throughout Australia. VJ

See also: 9.4, 9.5, 9.6; **art awards and prizes**; *120*.
Johnson, V., *Aboriginal Artists of the Western Desert: A Biographical Dictionary*, Roseville East, NSW, 1994.

TJAMPITJINPA, Maxie (*c*.1948–1997), Warlpiri visual artist. The personal highlight of Maxie Tjampitjinpa's art career was flying from Australia to Germany in a private jet for the opening of 'Stories: Eine Reise zu den Großen Dingen (A Journey Around Big Things)' in 1995. This major exhibition, drawn from the Holmes à Court Collection, featured the work of eleven leading contemporary Aboriginal painters, and toured museums in Europe for eight months.

Maxie Tjampitjinpa was born at Haasts Bluff (NT), and moved to **Papunya** with his family in the early 1960s to attend school. He worked in a variety of jobs across the Top

392. Maxie Tjampitjinpa, *Flying Ant Dreaming*, 1985. Acrylic on cotton duck, 132.5 x 97.5 cm.

End before returning to Papunya in the mid 1970s, where he was police tracker and school bus driver before taking up painting in 1980. His teacher was Old Mick Tjakamarra, one of the senior artists of the Papunya movement, who instilled his own love of painting in his pupil. Tjampitjinpa won the Alice Prize in 1984 and a few years later moved into Alice Springs where he began developing the flicked style of background brushwork which was to become the hallmark of his style. In the early 1990s he began producing canvases consisting entirely of more and more refined versions of this technique, signifying variously the wings of flying ants, heat haze, the dust kicked up by dancing feet, or fires in the landscape, depending on which of his **Dreamings** was being represented. When asked if he was aware of creating great contemporary art, he would insist, like Emily Kame **Kngwarreye**, whose abstract-looking canvases also rely on painterly effects to evoke ancestral forces in the landscape, 'No, I am making Aboriginal art. You see we got stories, might be water Dreaming or kangaroo Dreaming or bushfire Dreaming. You know.'

Tjampitjinpa has been a part of many group exhibitions including 'Papunya and Beyond' at the Araluen Centre, Alice Springs, in 1984, and examples of his work are held in most major Australian public art collections.

VJ

See also: 9.4, 9.5, 9.6, 21.1; *392*.
Brody, A. M. (ed.), *Stories: Eleven Aboriginal Artists*, Roseville East, NSW, 1997; Johnson, V., *Aboriginal Artists of the Western Desert: A Biographical Dictionary*, Roseville East, NSW, 1994.

TJAMPITJINPA, Ronnie (*c.*1943–1997), Pintupi visual artist. Ronnie Tjampitjinpa's dream of returning to the Pintupi homelands where he was born and grew to manhood was realised after an absence of nearly twenty years when a Pintupi township was established at Kintore in 1981. He moved his family there in the early 1980s and established an outstation at Redbank (Ininti). He became Chairman of the Kintore Outstations Council and resumed painting for **Papunya Tula Artists** after a break of several years. He won the Alice Prize in 1988, and emerged as one of the company's leading artists. As the demand for his work grew, linked dotting replaced the more laborious individually placed dots on his scaled-up drawings of Pintupi designs, evolving into the bold and increasingly expressionistic line drawing which characterised his style in the late 1990s. This painterliness, applied to the traditional Western Desert subject matter of his **Dreaming** heritage, has proven a winning combination with contemporary art audiences, and brought him widespread acclaim and a string of solo exhibitions. These started with the 1989 showing of his work at the Gallery Gabrielle Pizzi in Melbourne, providing his first trip outside Central Australia. He participated in many group exhibitions including 'The Continuing Tradition' (NGA 1989), 'Aboriginal Art and Spirituality' (HCA 1991), 'Aboriginal Paintings from the Desert' (Moscow and St Petersburg 1991), and 'Tjukurrpa: Desert Dreamings' (AGWA 1993). His work is included in most major public and private collections in Australia and the Musée National des Arts d'Afrique et d'Oceanie, Paris.

VJ

See also: 9.4, 9.5, 9.6.
Johnson, V., *Aboriginal Artists of the Western Desert: A Biographical Dictionary*, Roseville East, NSW, 1994.

TJANGALA, Uta Uta (Wuta Wuta) (*c.*1920–1990), Pintupi painter, was conceived at Ngurra Palangu when his mother ate the seeds from the succulent plant *mungilpa*. He is thereby associated with the Old Man Dreaming and the nearby site of Yumari (Mother-in-Law). He lived the first half of his life in the Gibson Desert (WA). When he and his family were faced with the extreme hardship of an extended period of drought, they determined to make the epic journey from Pintupi country to Haasts Bluff (NT) on foot, surviving on a meagre ration of bush fruits and travelling over country that he knew only from 'songlines'.

Uta Uta was among the first Pintupi men to begin painting at Papunya in 1971. He continued to produce powerful and enduring images until his death in 1990. His smaller works often strain at the edge of the hard board with expansive energy. His larger canvases are epic statements of country and radiate personal authority. While much of his work conforms to the Pintipi pictorial conventions, it is distinguished by a restless bustling energy and a passionate immediacy of application.

Uta Uta spent most of the last two decades of his life at small outstations such as Yayayi, Warawiya, and Inyalingi to the west of Papunya. In the late 1970s he travelled extensively across the Western Desert and together with other leaders, developed a strategy to return to his homelands. By 1984 he had established an outstation at Muyin in the heart of his ancestral country.

Uta Uta was one of the first **Papunya Tula** artists to be widely acknowledged. In 1985 his painting *Tjanangkamurramurra* won the NAAA (now NATSIAA). He is best known for a series of huge canvases he painted in the 1980s: *Yumari*, 1981 was exhibited in the Australian representation at the XVII Biennale de São Paulo (São Paulo 1983), and was later exhibited with *Yumari*, 1983 in 'Dreamings' (New York, Los Angeles, and Chicago 1988–89). Uta Uta's work has been included in numerous other group exhibitions, both internationally and within Australia, and examples of his work are held in Australian national and State gallery collections, and in the Kluge–Ruhe Collection at the University of Virginia. JK

See also: 1.1, 9.4, 9.5, 9.6; **acrylic painting**; *1*.
Myers, F., 'Aesthetics and practice: A local art history of Pintupi painting', in H. Morphy & M. Smith Boles (eds), *Art from the Land: Dialogues with the Kluge–Ruhe Collection of Australian Aboriginal Art*, Charlottesville, VA, 1999; Sutton, P. (ed.) *Dreamings: The Art of Aboriginal Australia*, New York & Ringwood, Vic., 1988; Bardon, G., *Papunya Tula: Art of the Western Desert*, Ringwood, Vic., 1991.

TJAPALTJARRI, Billy Stockman, see Billy **Stockman Tjapaltjarri**.

TJAPALTJARRI, Clifford Possum, see Clifford **Possum Tjapaltjara**.

TJAPALTJARRI, Mick Namarari, see Mick **Namarari Tjapaltjarri**.

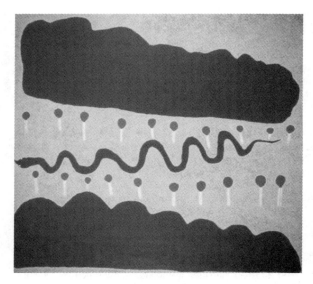

393. Long Tom Tjapanangka, *Ulampuwarru*, 1999.
Acrylic on canvas, 182 x 199 cm.

TJAPALTJARRI, Tim Leura, see Tim **Leura Tjapaltjarri.**

TJAPANGARTI Tim Payungka, see Tim **Payungka Tjapangarti.**

TJAPANGARTI, Wimmitji, see Eubena **Nampitjin.**

TJAPANANGKA, Long Tom (*c.*1930–), Pintupi–Ngaatjatjarra painter. As a child Long Tom Tjapanangka walked from his birthplace at Lupul in the Frederick Range to Haasts Bluff (NT). During the 1930s and 1940s many Pintupi were following the same route, encouraged by stories of permanent water and ration depots. During the 1950s he worked as a stockman at Haasts Bluff, where he married his first wife Marlee Napurrula and started a family. This was of course poorly paid work, rewarded with rations and the occasional token payment. It is evident that he travelled extensively in his lifetime. He worked as a police tracker based at Harts Range and later in Alice Springs, and also lived in Queensland at some stage.

He started painting only on his return to Haasts Bluff in 1993, and was one of the few male painters at **Ikuntji Art Centre.** His striking minimalist landscapes and lyrical paintings of emu, perentie, camels, and camp dogs were instantly recognisable. Country around Ikuntji, including Mereenie, Ulampuwarrru (Haasts Bluff Mountain), Winparrku and Mount Liebig are depicted in reds, yellows, brown, and white. Uluru and Kata Tjuta appear, as do broad desert sandhills which 'could be anywhere', inspired by his early years in rolling sandhill country.

While he achieved high acclaim almost instantly, Long Tom Tjapanangka has never been a regular painter. In 1999 he won the NATSIAA for his painting *Ulampuwarru,* and most recently featured with twenty-five contemporary Indigenous artists in 'Beyond the Pale' (AGSA 2000). Almost ambivalent in regard to his achievements, he is reluctant to divulge any 'secret business' through painting, and instead reminds viewers that he looks around, 'not making story, just pictures'. UR

See also: 9.5; Mitjili **Napurrula;** *393.*
Croft, B. L. (ed.), *Beyond the Pale: 2000 Adelaide Biennial of Australian Art*, Adelaide, 2000;

TJAPANANGKA, Tjumpo (*c.*1930–), Kukatja visual artist, is a senior Kukatja Law man whose country is Kanapir, between Kiwirrkura and Pippar, some 300 kilometres south of **Balgo** (WA). His group came to Balgo as a result of the actions of the local priest, Father Alphonse, who sent people out into the bush with supplies of flour, sugar, and tea to attract Aboriginal people to the mission. Shortly afterwards, in 1948, groups of people came from all directions to live at the Old Mission, then situated at Tjumuntora.

Tjumpo began painting in 1986. His ex-wife, Ningie Nangala (*c.*1930–), a Kukatja–Wangkajunga woman, was born in the same area as Tjumpo. Her mother had died when she was very young. She came to the mission when her family group was camped at Lirrwati close to Balgo, on the invitation of Aboriginal people living there. As a young girl she tended the mission goats, gathering bush food for them to eat. Like many people at that time, she returned to her own country before settling more permanently at the Old Mission. She married a Kukatja man and had four children, including Elizabeth Napaltjarri Gordon (1956–). After her first husband passed away, she married Tjumpo and had five more children. Elizabeth Gordon was born at the Old Mission when it was at Tjalyiwarn. She began painting in 1988, following her mother and stepfather. Tjumpo taught Gordon a number of his **Dreamings,** and there are similarities in the work of the three artists.

Tjumpo is an inventive painter whose work has varied from monumental pieces incorporating contrasting visual motifs, to more tightly woven smaller pieces. His paintings of the late 1980s often featured tight lines of energy-charged dotting around interlinked roundels. Ningie's work shows a greater fluidity of line, softer colours, and is usually on a more intimate scale. Gordon's early work was influenced by Wangkajunga artist Lucy **Yukenbarri**'s compositions with their *kinti-kinti* (close-close) style of dotting. For a short period in 1992 she used washes of colour rather than dotting in sections of her canvases, and for a time her canvases and those of her mother showed evidence of an interest in creating unusual effects by combining different textures.

Tjumpo's work is held in the NGV, AGWA, the Holmes à Court Collection, Heytesbury (WA), and the Kluge–Ruhe Collection at the University of Virginia. Ningie's work is also held in the Kluge–Ruhe Collection and Gordon's work is represented in the Holmes à Court and Kluge–Ruhe Collections.

CW

See also: 9.5; **Warlayirti Artists.**
Crugnale, J. (ed.), *Footprints across Our Land: Short Stories by Senior Western Desert Women*, Broome, WA, 1995; Watson, C., 'Touching the land: Towards an aesthetic of Balgo contemporary painting', in H. Morphy & M. Smith Boles (eds), *Art from the Land: Dialogues*

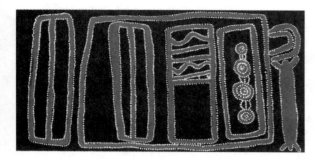

394. Charlie Tjaruru Tjungurrayi, *Mitukatjirri*, 1972.
Gouache on composition board, 32.8 x 65.1 cm.

with the Kluge–Ruhe Collection of Australian Aboriginal Art,
Charlottesville, VA, 1999.

TJARURU TJUNGURRAYI, Charlie (Tarawa) (*c.*1921–),
Pintupi visual artist, was given the name Charlie by Dr
Charles Duguid, who encountered his family group living
around the missions at Haasts Bluff and Hermannsburg
(NT) before World War II. He described the young man as
'the most intelligent human being' he had ever encountered.

Born at a rocky hill called Tjitururrnga, west of the Kintore
Ranges, Tjaruru's first contact with white people was an
encounter with the Adelaide University expedition of 1932 at
Mt Liebig. He worked with the army around Adelaide River
during World War II, then as a dogger out of Haasts Bluff,
travelling by camel team in journeys westward to the Pintupi
homelands. He took rations out to his countrymen still living
in the desert, some of whom rode back east on his camels to
see the newcomers for themselves. Because of his extensive
experience with Europeans, he became the spokesman for the
younger Pintupi men in the early years of the painting move-
ment. Later he became a friend of the late Andrew Crocker,
who managed **Papunya Tula** Artists in 1980–81. He travelled
to England with him in the early 1980s. Crocker organised a
major retrospective of Tjaruru's work, which toured four
Australian States. Tjaruru's group exhibitions include 'Dot
and Circle' (NGA 1989), 'Mythscapes' (NGV 1989), and 'L'été
Australien' (Montpellier 1990). His paintings are included in
many major public and private collections in Australia and
the Burke Museum, University of Washington. VJ

See also: 9.4, 9.5, 9.6; *394*.
Crocker, A., *Charlie Tjaruru Tjungurrayi: A Retrospective
1970–1986*, Orange, NSW, 1987; Johnson, V., *Aboriginal Artists of
the Western Desert: A Biographical Dictionary*, Roseville East, NSW,
1994.

TJUNGURRAYAI, Helicopter, see Lucy Napanangka **Yuken-
barri**.

TJUPURRULA, Donkeyman Lee, see Donkeyman **Lee Tjupur-
rula**.

TOLSON TJUPURRULA, Turkey (*c.*1942–), Pintupi– Luritja
painter, was born at Yalyalpi, near Haasts Bluff (NT). Just
prior to Tjupurrula's birth his family had migrated east to

the new settlement at Haasts Bluff. Tjupurrula learned the
sacred designs of his country by watching his father and
other men during post-initiatory instruction ceremonies,
and while travelling around the Western MacDonnell Ranges
with his father, collecting dingo scalps. In the early 1960s he
moved to Papunya. He was the youngest of the artists
involved at the inception of the **Papunya Tula** painting
movement in the early 1970s.

For much of that decade Tjupurrula lived with his family
at the outstation of Kungkayurnti, where George Tjangala,
Mick **Namarari Tjapaltjarri** and Ray Inkamala Tjampitjinpa
were his main influences. In the early 1980s he visited his
ancestral country for the first time, and in 1984 he shifted to
Kintore. With the death of his older relatives he has assumed
ritual responsibility for his father's country. For several years
he was the chairman of Papunya Tula Artists and was a key
point of contact in the community for visiting academics,
curators, film-makers and art dealers. He has maintained an
outstation at Yuwalki to the south of Kintore.

Of his work Turkey Tolson says: 'When I paint I always
think about the country, every place of mine.' His early work
is characterised by meticulous opaque paint application, and
strong symmetrical compositions. His move to Kintore and
increasing ceremonial authority coincided with a more indi-
vidualistic approach to his subjects. Notable in this period
are the stylised portraits of his patrilineal ancestor
Mitukatjirri Warrior, and *Straightening Spears at Illyingaun-
gau*, 1990.

In 1999 Turkey Tolson appeared on the front page of the
Weekend Australian newspaper after revealing he had signed
a work he did not paint. The story revealed the tensions that
exist between community-based arts organisations and art
dealers who elicit pot-boilers from established artists.

Turkey Tolson has been represented in many group exhibi-
tions including 'Koori Art' (Artspace 1984), 'The Face of the
Centre' (NGV 1985), 'Mythscapes' (NGV 1989), and 'East to
West' (Tandanya 1990). Examples of his work are held in the
NGA and most Australian State galleries. JK

See also: 9.4, 9.5, 9.6.
tourism, see 11.1, 18.1, 18.2, 18.3, 18.4.

TREVORROW, Ellen (1955–), Ngarrindjeri fibre artist. Since
1982, when the South Australian Museum organised a
Ngarrindjeri weaving workshop with Dorothy Kartinyeri,
Ellen Trevorrow has been weaving and demonstrating rush
baskets: 'Auntie Dorrie [Kartinyeri] must have felt herself
going and she just said that there should be a workshop or
else. She showed us where to get particular types of rushes
and how to go about preparing the rushes before weaving.'

The culture was all around her as a child in Raukkan (Point
McLeay, SA). The first piece Trevorrow made was an exact
replica of Kartinyeri's basket, but the imitation was uncon-
scious. The renowned Ngarrindjeri repertoire of basket forms,
as seen in museum collections, has inspired Trevorrow to
make 'Sister' baskets and circular mats which have a contem-
porary simplicity and elegance. Although knowledge of their
use is largely lost, in the old days all woven objects contributed
to survival on the land. Sister baskets, made of two identical
flat pieces joined together as one, were used to collect herbs.

Rushes for weaving are gathered from the edge of Lake Alexandrina, near Poltalloch, an old sheep-grazing property with family connections. For Trevorrow, family and culture are inseparable and the ancient technique links a vital contemporary craft to a pre-European past. Married to Tom Trevorrow in 1976 and mother of six children, the artist describes herself as primarily a 'cultural weaver' and teacher.

Ellen Trevorrow's work has been seen in several group exhibitions including the touring 'Aboriginal Women's Exhibition' (AGNSW 1991), 'Two Countries One Weave' (Tandanya 1991), 'Talking Listening' (ArtspaceSA 1994), the touring exhibition 'Below the Surface' (GRAG 1995–96), and 'The Somatic Object' (IDG 1997), which travelled to Taipei.

DWC

See also: 17.1, 17.2; **Janet Watson**, Yvonne **Koolmatrie**; *211*.
Pring, A., *Aboriginal Artists in South Australia*, Adelaide, 1998;
Rowley, S. (ed), *The Somatic Object*, Sydney, 1997.

TRUKANINI (1812–1876), was the daughter of Mangana, leader of the Nuenone nation. She grew up on Bruny Island, one of the first places in Tasmania invaded by Europeans. By the time she was seventeen she had seen her mother stabbed to death, her sisters captured by sealers, and her husband-to-be drowned while attempting to save her from abduction. Something of her story is recorded in most Tasmanian **history** books; she is undoubtedly the most famous Tasmanian Aborigine ever to have lived.

But there is irony in her fame. During her later years she was celebrated as 'Queen of her race' and paraded before visiting royalty. Today, her piercing eyes gaze forth from bronze plaques and medallions, her youthful beauty is admired in French engravings, and her haunting photographs have an obligatory place in historical texts. She has become the face of her people. But that face is also the face of genocide. She is the principal character in a totalising narrative of extinction.

Trukanini is cherished by today's Tasmanian Aboriginal community as a woman who displayed strength and diplomacy in her struggle to find a way for her people to endure the savage impact of Europeans on her land. She was one of the last of our tribal ancestors to pass away at the end of a long war which resulted in the deaths of thousands of Indigenous Palawa people in Tasmania. She is, for us, an icon of survival. Even though she had no children, Trukanini is a mother for our people; just as the land is our mother because it gives life and meaning to each of us, so Trukanini's spirit nurtures strength and pride in us as a people.

However, for most non-Aborigines, Trukanini is a symbol of the extinction of a race. The Tasmanian government's *Aboriginal Relics Act* of 1976 uses the year of her death to demarcate the authenticity of Palawa cultural material. Accordingly, items produced after 1876 are neither recognised as being made by Aborigines nor considered worthy of protection. Thus is the fame of a person so important to us used to deny us our identity, and our very existence. Yet the elders in our community continue to pass on the oral history and traditions which have preserved our identity, and our cultural practices. **Shell-necklace** making, gathering native foods and materials, and basket making were all handed on by Trukanini's contemporaries to their children. Their decision to pass on Palawa culture, even though the children's fathers were white, ensured our cultural survival.

As is so often the case, indigenous history has been distorted by imperialism. There has been little awareness of the complexity of Trukanini's life. She is often seen as a passive figure in Tasmanian history, or perhaps a sad victim who should be mourned. Worse still, some writers have chillingly implied she was complicit in the bloody defeat of her people. Rae-Ellis and later writers like Conrad and Hughes characterise Trukanini as a promiscuous 'gin' or 'bimbo', the counterpoint to Walyer, known and feared as an active **guerilla fighter**, who led an armed band of Palawa men in raids against white settlers in the remote north-west during the 1820s. But Trukanini too was active in the Aboriginal paramilitary resistance, abandoning her white captors while on a trip to the Victorian colony to undertake an armed pursuit of two sealers who had committed atrocities against Palawa women. In 1842 she narrowly escaped the gallows for her part in this. Her greatest achievement was probably her diplomatic success in guiding those who negotiated a range of treaties with Palawa nations, thus bringing about an end to the Black War.

Although Trukanini and her companion Lanne (William Lanney) had been presented to the Duke of Edinburgh in 1868 as fellow royals, this did not prevent irreverent treatment of her remains after her death. Trukanini's body was exhumed and her skeleton displayed in Royal Society of Tasmania's museum for over forty years, an obscene trophy of colonial conquest masquerading as a scientific curio. In 1976, one hundred years after her death, the remains finally cremated as a result of a highly public campaign by the Aboriginal community. The action was pivotal in reasserting the survival and transformation of Tasmanian Aboriginal identity, countering the government's neat dismissal of any need for further engagement with native rights in Tasmania. The reclamation of Trukanini's remains clearly demonstrated that Aborigines were still to be reckoned with and could not be contained by the past.

GRL

See also: 1.5, 11.1, 11.5, 17.1; **Burnum Burnum**, Fanny **Cochrane Smith**; *9*.
Rae-Ellis, V., *Trucanini: Queen or Traitor?* Canberra, 1981; Ryan, L. 'The Struggle for Trukanini 1830–1997', *Papers and Proceedings, Tasmanian Historical Research Association*, vol. 44, no. 3, 1997.

TUNGUTALUM, Bede (1952–), Tiwi printmaker began his artistic career at the young age of sixteen by undertaking a ceramics course at the Bagot Training Centre, Darwin. With Giovanni Tipungwuti and Eddie Purantatameri he established a ceramic workshop and kiln at Nguiu on Bathurst Island in 1969. All three young artists had also, by this time, become involved in the small screen-print workshop set up under the **Tiwi Design** Cooperative. This workshop initially produced single colour wood-block prints on paper and for wall hangings and other small domestic textile items. It subsequently adopted the more versatile screen-printing process to expand its range of commercial items.

By 1974 the screen-printing workshop had expanded into full colour production of both wall-hanging lengths and fin-

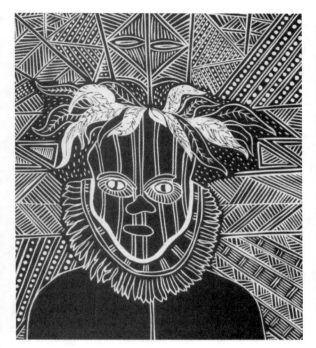

395. Bede Tungutalum, *Self Portrait, 'Purrikinni' (Owl Man)*, 1988.
Linocut, 50 x 40.5 cm (print), 76 x 56 (sheet).

ished casual clothing. Tungutalum provided a substantial number of the original graphic designs. Throughout the 1970s he developed a wide range of reusable screen designs based around traditional Tiwi cross-hatching and other patterns used on Pukumani poles. Separately, however, he also developed a range of individual figurative screen designs of fish, birds, and animals, as well as human figures and the 'sun disk'. These were increasingly integrated into the earlier non-figurative patterns, producing dense compositions.

By the 1980s Tungutalum's work showed a distinctive shift into large narrative compositions combining single screened images and hand-painted sections. The subjects covered several of the major Tiwi creation narratives such as Bima and Purukupali, and the Kulama yam ceremony In the 1980s his single framed works were included in several major commercial and non-commercial exhibitions either as part of Tiwi Islands exhibitions, or alongside paintings from other parts of Aboriginal Australia. Among these exhibitions were 'On the Edge' (AGWA 1989), 'The Continuing Tradition' (NGA 1989), and 'Balance 1990' (QAG 1990).

Though his early artistic development was predominantly in clay and screen printing Tungutalum was born during the heyday of the postwar wood-carving movement on Melville and Bathurst Islands. Although he has never been a prolific wood carver, his poles and bird figures reflect in their style the solidity of the carvings produced during the 1950s and 1960s by an older generation of Tiwi carvers. MO'F

See also: 7.6, 16.3; **printmaking**; *395*.

Conroy, D., 'Tiwi Designs: An Aboriginal silk-screen printing workshop', *Art and Australia*, vol.13, no. 3, 1976; O'Ferrall, M., *On the Edge: Five Contemporary Aboriginal Artists*, Perth, 1989; Ryan, J. & Healy, R. *Raiki Wara: Long Cloth from Aboriginal Australia and the Torres Straits*, Melbourne, 1998.

U

UNAIPON, David (1872–1967), Yaraldi (Ngarindjerri) writer, preacher, inventor, musician, and lobbyist. 'Look at me and you will see what the Bible can do,' said David Unaipon, the son of the first convert at the Congregationalist mission at Raukkan (Point McLeay) in the Lower Murray (SA). At the mission school he was singled out for his intelligence and skills, and was educated in Adelaide by C. B. Young and the Aborigines' Friends Association (AFA). As his interest in philosophy, science, music, and languages developed in his early years, he found it frustrating to be able to work only as a bootmaker, accountant, and storeman. He participated in the Gleeclub, a choir from Point McLeay that had been active from 1894, playing the organ and using his performances as a vehicle for earnest, persuasive speeches on behalf of his people's advancement. While he explained Aboriginal civilisation, he also sought assimilation to Christian and European values. In 1910 he travelled to Tasmania with eleven other Ngarindjerri to participate in Australia's first major historic pageant, one of many interstate trips he was to undertake as a lay preacher. His studies of the Aboriginal mythology of his own people and other South Australian tribal groups, combined with his study of the English classics, led him to publish pamphlets such as *Native Legends* (1929), which he sold door-to-door on behalf of the AFA. He often spent time with the families of the ministers he visited in over fifty years of this peripatetic life.

By the 1920s Unaipon was at the height of his powers, and was Australia's best-known Aborigine. His lifelong interest in perpetual motion, aerodynamics, and mechanics resulted in several patent applications, including one for a modified handpiece for mechanical shearing (1909). These, along with his other skills and achievements, thrust upon him the reputation of being an Aboriginal 'Leonardo'. He was also the first significant Aboriginal writer. His major manuscript, *Legendary Tales of the Australian Aborigines,* held at the Mitchell Library (SLNSW), is to be republished by Melbourne University Press in 2001 in its original form, rather than as appropriated and edited by William Ramsay Smith in *Myths & Legends of the Australian Aboriginals.*

In the 1920s and 1930s Unaipon made important interventions in government policy, and assisted Rev J. H. Sexton, Dr Herbert Basedow, Sir George Murray, and Dr Charles Duguid in submissions and research regarding his people. He testified before two Royal Commissions into the treatment of Aborigines, and in 1926 petitioned the federal government with a plan to set up an autonomous Aboriginal State in Northern Australia. His political style, which advocated reform and education of Aborigines in the broader society, contrasted with the more contestatory style of the Australian Aborigines League and its plans for the 1938 Aboriginal **Day of Mourning.** Despite his rhetorical skills and austere lifestyle, he was nonetheless charged with vagrancy in 1926 and struggled to gain support for his various projects.

Unaipon died in the year of the **referendum of 1967,** poor and somewhat bitter, survived by a son. He is buried at Raukkan and his closest surviving descendants are Melva Kropinyeri and her children. The Coronation Medal was bestowed on him in 1953, and he appeared in 1995 on the Australian fifty-dollar note. In 1988 the David Unaipon Award for Aboriginal and Torres Strait Islander writers was established by the University of Queensland Press, and the first annual lecture in his name was delivered at the University of South Australia. Even so, his multiple contributions to Australian Indigenous literature, art, and scientific invention are only beginning to be recognised by the wider community, both in Australia and overseas. STM & ADS

See also: 1.1, 1.2, 11.1, 17.2.
Alexander, J., 'Following David Unaipon's Footprints', *Australian Literary Studies,* vol. 54, 1998; Jones, P., 'David Unaipon', in *Australian Dictionary of Biography*, vol. 12, Canberra, 1996; Muecke, S., '"Between the church and the stage": David Unaipon at the Hobart Carnival, 1910', *UJS Review,* vol. 6, no. 1, 2000; Shoemaker, A., *Black Words, White Page: Aboriginal Literature 1929–1988,* St Lucia, Qld, 1989.

UNGUNMERR, Miriam-Rose Baumann (1950–), Ngangikurrunggurr painter, has had a profound impact on her home community at Nauiyu Nambiyu (**Daly River,** NT) through her work as an educator, school principal, writer, and active community and church member. As a painter, she has attempted to reconcile her belief in both Indigenous and Catholic spirituality through an individual style of religious synchronism. After painting a school mural in 1971, she undertook her first major work, the fourteen Stations of the Cross, at Daly River church, in 1974. This launched her as a

serious painter and led to her first commission, illustrating mythological themes in Alan Marshall's book *People of the Dreaming*.

In developing her painting style in **acrylics**, Ungunmerr consciously avoided any direct references to men's ceremonial art. The result was what she calls her 'symbolic art' of stylised figures with decorative detailing: dashes, wavy lines, dots, and circles that operate as personal icons to express particular ideas and emotions. When she assisted in the establishment of **Merrepen Arts** in 1987 many of the artists used her way of painting as the basis for their own stylistic development. Among the painters who first started working for Merrepen were a number of senior women, including Ungunmerr's mother, Mary Kunnyi (1925–). After executing a religious work very similar to her daughter's 'eucharist' painting, Kunnyi began developing her own style, starting with intricately dotted figure compositions that later evolved into the gestural, abstract works that she is known for today. Sometimes she explicitly depicts her **Dreamings**, such as water snake and pelican, though most works are vignettes of the various plant and animals species from her home country, Ngambu Ngambu. Kunnyi's unique style of painting is highly sought after and she is one of the few Merrepen artists to have had a number of solo exhibitions. Her daughter's paintings are also in demand, especially those on religious themes, though her responsibilities as Community Council President and school principal currently allow her little time to paint. MW

See also: 1.2.
Ungunmerr, M.-R., 'Autobiographical Reflections', *Nelen Yubu* no. 28, 1986; Ungunmerr, M.-R. with Gutsjahr, V., 'We Would Like You to Learn from Us Too', *Northern Perspective*, vol. 3, no. 1, 1980.

Utopia art. The Aboriginal community of Utopia is situated 240 kilometres north-east of Alice Springs. It is on the land of the Anmatyerre and Alyawarre-speaking peoples who have been making important visual images for thousands of years on their bodies, on the ground, and on ceremonial objects. In 1977 these images leapt onto lengths of silk **batik**. The women of Utopia went on to establish a reputation for themselves in this medium with their powerful images and distinctive style.

The subjects for the art come from the land: lengths of silk and canvas are covered with plants, lizards, snakes, centipedes, and fat goannas. Ceremony too is important and body-paint designs and dancing paths are often seen. Footprints, animal tracks, sites, and implements also feature in a rich variety of creative styles.

During the 1980s the women exhibited their batik across Australia and overseas, with notable exhibitions at the Adelaide Festival, Araluen Arts Centre, Alice Springs, MAGNT, and the Jogjakarta Fine Art Academy in Indonesia, culminating with the travelling exhibition of the Holmes à Court Collection of Utopia batik 'Utopia: A Picture Story' (Cork, Dublin, and Limerick 1990). The women of Utopia have had their work included in a number of museum and public gallery exhibitions and it has been acquired by collectors and institutions across the country. In all this they were assisted by a number of art and craft advisers who served as the link between the market place, art suppliers, exhibiting venues and the community.

A shift away from batik occurred in the late 1980s when some men at Utopia began painting on canvas. The women, too, quickly took up painting on linen. Utopia paintings were exhibited for the first time in 'A Summer Project' (SHEG 1988–189). Some of the artists simply translated their batik images into acrylics, but others immediately grasped the new technical possibilities of the medium and produced striking new images.

Utopia artists were also adept carvers. The men were well known, even before the advent of batik and **acrylic painting**, for their fine fluted **boomerangs** and shields and the women were equally known for their carved animals and dancing sticks, sometimes with poker-work designs. Acrylic paint is now applied to all these objects, and Utopia now produces a range of vivid lizards, coolamons, dancing sticks, and most notably, carved and painted human figures. CH

See also: 9.5, 9.6; Ada **Bird Petyarre**, Lyndsey **Bird Mpetyane**, Emily Kame **Kngwarreye**, Gloria **Petyarre**.
Boulter, M., *The Art of Utopia: A New Direction in Contemporary Aboriginal Art*, Roseville East, NSW, 1991; Brody, A. M. with Gooch, R., *Utopia—A Picture Story: 88 Silk Batiks from the Robert Holmes à Court Collection*, Perth, 1990; Carrigan, B. (ed.), *Utopia: Ancient Cultures/New Forms*, Perth, 1999.

W

Wadeye art. Wadeye, the former Catholic mission of Port Keats, is located south-west of Darwin in the sub-tropical region sandwiched between the Victoria and Daly River headwaters (NT). The scattered sandstone outcrops here contain a diverse body of **rock art**, including schematised Wanjina-like zoomorphs, linear motifs, and geometric symbols that indicate prehistoric links with desert groups to the south and through to the Kimberley region. These cultural and ceremonial ties are still evident in the contemporary paintings produced by the Murrinh-patha, Marringarr, Marrisjevin, Matike and Marri Ammu artists residing at Wadeye today.

The exact genesis of commercial art activity is not well documented, although **bark paintings** were apparently being produced just after World War II and were being marketed through the mission shop by the late 1940s. Up to this point the church had banned all overt ceremonial activity, so bark painting became an important vehicle for what was essentially a form of religious revival. Artists like Tjimari, Nym **Bandak**, Indji, Jarri, and Birari, used this medium to combine their **Dreamings** designs with those they had learnt from direct ceremonial engagement with desert groups further south. The application of their ritual designs onto shaped pieces of bark was a reference to the sacred ritual boards destroyed by the mission after its establishment in 1935.

Some of the most significant works undertaken during this time were the authoritative mythological narratives painted by Nym Bandak at the behest of anthropologist W. E. H. Stanner in 1959. These *ngakumarl* or Dreaming maps were painted onto large pieces of Masonite. With their strong rhythmic compositions, fusing figurative and symbolic elements, these paintings anticipated the stylistic developments that occurred nearly thirty years later at **Warmun**, especially in the descriptive landscapes of George Mung Mung. Using dense symbolic configurations, Bandak went on to complete 185 square metres of Masonite panels for the mission church in 1961. Along with other contemporaries including Charles Mardigan and Charles Ngumbe, Bandak helped create the style that came to be associated with the Wadeye region.

After decades of erratic production and sales, which even included a failed attempt to establish a pottery, the Adult Education branch of Wadeye School helped establish the first artists' co-operative, Wadeye Art and Craft, in 1993. This was finally consolidated in 1998 when the local store backed the establishment of retail outlets at Wadeye and Darwin. As a result of the intensification of artistic activity that ensued, close to a quarter of the 1200 or so Wadeye residents are now engaged in art production, including many women, who are painting as well as producing string bags and plaited mats. The men produce for the lucrative **didjeridu** market as well as making most of the art works. Some of the better known practitioners include Timothy Dumoo—one of the more experimental artists—along with Francis Mardigan, William and Richard Parmbuk, Leo and Leon Melpi, Claver Dumoo, Frank Jinjar, Gerald and Kate Longmar, Virgil Warnir, Alex Nilco, Helena Warnir, Anthony Nemarlu, Aileen Warnin, and Basil Parmbuk.

The early Wadeye style consisted of cryptic symbolic 'desert' designs painted alternately, or often in combination, with lively figure narratives onto monochromatic backgrounds. The paintings have become more decorative over the years, with a self-conscious realism apparent in the figurative and landscape compositions. On the other hand, the structural symmetry that Stanner observed in the early ceremonial designs is still a quintessential aspect of the symbolic art. Symmetry is also apparent in many of the figurative works, where devices like crossed diagonal lines are used to bisect the painting into repeat feature blocks. Even though the majority of these paintings are now executed with acrylics onto paper and canvas, the artists retain a preference for the basic **ochre** colours. When barks are produced, they are often still oval-shaped like the earlier ones, although the sacred content is now omitted.

MW

See also: 1.1, 1.2, 10.1, 10.2; **anthropology**; *34*.

Barber, K., A History of Creation: A Discussion of the Art Gallery of New South Wales Collection of Port Keats Paintings [unpublished manuscript], 1993; Walsh, G., *Australia's Greatest Rock Art*, Bathurst, NSW, 1988; Stanner, W. E. H., 'On Aboriginal Religion: Symbolism in the Higher Rites', *Oceania*, vol. 31, no. 2, 1960; Martin, J. H., 'Nineteenth-century Wadeye-Port Keats art work identified', *Australian Aboriginal Studies*, no. 2, 1994.

WAINBURRANGA, Paddy Fordham (*c.*1932–), Rembarrnga painter, sculptor, printmaker, and dancer. There is a sense in which Wainburranga, best known as a painter, would be better described as a historian—a teller of his people's stories in pictures, ranging from the traditional, where he says 'I'm painting this story from a million years ago', to the contemporary where he says 'I paint history for everybody else'.

He was born at Bambdibu in central Arnhem Land, and lived in the bush with his extended family until they moved to Maranboy, where he saw white people for the first time. In his youth he worked as a stockman, travelling from station to station in the Victoria River District and Murranji area (NT). At Gorrie the station owners gave him the name 'Fordham'. In the 1960s he lived at **Maningrida** and also helped to establish Guyun, one of the early outstations.

Wainburranga did not start painting until 1983, yet quickly gained acclaim for his innovative style, with its distinctive, elongated figures and narrative sequences. At first his art was primarily a vehicle for traditional themes. Some paintings were explications of traditional Law or the relationships between the animal kingdom and the clan structures of central Arnhem Land. Immediately prior to Australia's bicentenary of European settlement, Wainburranga expanded his subject matter to include the interactions between black and white Australians. One of his paintings of 1987 tells the Captain Cook story of the Rembarrnga–Ngalkbon people, which combines European history with Indigenous and Christian cosmology. It was subsequently recorded in the film, *Too Many Captain Cooks* (1988). Another work shows the Rembarrnga people's interpretation of the outbreak of World War II in the Pacific, mediated through their dealings with Japanese pearlers and fishermen. Wainburranga's most notable artistic statement regarding black–white relations is the twenty-three painted hollow log coffins he contributed to the *Aboriginal Memorial* (1987–88), which commemorates all the Aboriginal people who have lost their lives defending their land against Europeans since 1788. Wainburranga said of the *Memorial*: 'This is a serious thing, that's why the *lorrkon* (hollow log) is made, to make you remember, for many, many years … That's why we're making this *lorrkon*, we're afraid we're going to lose our culture, lose our Dreamtime. We are not book men we are letter-stick men … That's why we make this *lorrkon*.'

Working on the hollow logs provided the impetus for Wainburranga to make other wood sculptures, primarily *balanyjarrnngalany* spirit figures, one of which won the Memorial Award for Mawalan's Eldest Son at the 1989 NATSIAA. In the early 1990s he made his first foray into **printmaking**. The new degree of public exposure that Wainburranga received through his major works of the 1980s led to his inclusion in significant group exhibitions including 'Tyerabarrbowaryaou' (MCA 1992), 'Tyerabarrbowaryaou II' (Havana 1994), 'Contemporary Territory' (MAGNT 1994), and 'A̱ratjara' (Düsseldorf, London, and Humlebaek 1993–94). His works are now held in major collections across Australia.

CM

See also: 1.1, 1.2, 4.2, 4.3, 6.1, 6.3; *38*, *47*, *74*.

McDonald, P., *Too Many Captain Cooks* [video recording], Ronin Films, 1988; Mundine, D. & Foley, F., *Tyerabarrbowaryaou II: I Shall Never Become a White Man*, Sydney, 1994.

WALKER, Heather, see **Jenuarrie**.

WALKER, Kath, see Oodgeroo **Noonuccal**.

WALLACE, Kathleen (1948–), Eastern Arrernte visual artist, trained as a teaching assistant, working at the Ltyentye Apurte community school where, as a student, she had earlier learnt to paint watercolour landscapes. Some of these are in the Flinders University Collection. But it was not until the opening of the **Keringke Arts Centre** in 1989 that Wallace really began to work as an artist.

She first began to illustrate the stories of her country in silk painting, a technique introduced by Cait Wait, the first Keringke Arts coordinator. With their finely detailed lines and dots, her paintings have a lyrical layering of colours and motifs. The central features of her works are the spirit figures *irrernte-arenye* (belonging to the cold). According to Wallace: 'The *irrernte-arenye* look after the place where they live, watching out for and guiding the people from their families.' Other elements in her work are inspired by the rock paintings and carvings found throughout her country, and by the many stories told by her grandfather: 'I remember my grandfather used to teach me to draw on sand by telling stories and songs. He used … to show us the drawings in caves and tell us stories about them. That's how I learnt to draw.'

In 1996 Kathleen Wallace received an honourable mention for her silk painting *Grandfather's Tracks*, exhibited as part of the 1996 NIHAA. In 1997 the NGV purchased two of her

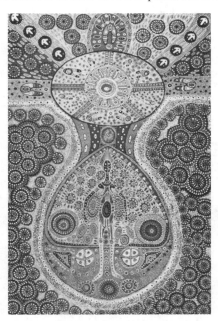

396. Kathleen Wallace, *Arelhe Altyerrenge Alhe Aneke (Woman from the Dreamtime)*, 1988.
Acrylic on canvas, 76 x 50 cm.

large silk paintings, and another one went to the Kelton Foundation, Santa Monica.

TR

See also: 9.1; *396*.
Keringke Arts, *Keringke: Contemporary Eastern Arrernte Art*, Jukurrpa Books, Alice Springs, 1999.

WALLAM, Vera (*c.*1934–), Nyungah embroiderer, attended school at the Carrolup Native Settlement (Marribank) near Katanning (WA). In the late 1940s, with the sympathetic encouragement of teachers Noel and Lily White, a group of young Nyungah children aged between twelve and fourteen developed a highly original interpretation of their rural environment.

The children painted and drew the world they knew from their own experience. Their works ranged from subtle and subdued perceptions of the night to the dramatic rendering of unbelievably rich sunsets. The animals of the bush and the images of body-painted Aboriginal men and spirits compete for prominence in many of the boys' drawings. Imagined corroborees, far removed from the institutional life of Carrolup, reflect a yearning for home.

The Education Department of the day encouraged the boys in the expectation that a few of them might become commercial artists. The girls, however, were being trained as domestic servants and were directed away from art. As a result the boys' pastel landscapes are better known, but the girls were also prolific artists, creating a wide variety of abstract designs which were worked as tapestries for cushion and chair covers and given as gifts, to charity, or to staff when they left the school.

Boy and girls alike considered the tapestries to be very important and quite precious. The only surviving example of these unique and beautiful tapestries is Vera Wallam's *Corroboree Scene, c.*1948 from a design by Revel **Cooper**, one of the most gifted and well known of the child artists. It was presented to the Whites when they left Carrolup in 1951 and was used as the cover of their piano stool until it was donated to the Berndt Museum of Anthropology (UWA).

JES

397. Vera Wallam, *Corroboree Scene, c.*1948.
Embroidery, after Revel Cooper design, 30 x 40 cm.

See also: 11.1, 11.6; *397*.
Durack-Miller, M. & Rutter, F., *Child Artists of the Australian Bush*, London, 1952; Stanton, J. E. 'Vera Wallam', in Kerr, J. (ed.), *Heritage: The National Women's Art Book*, Roseville East, NSW, 1995.

WALLEY, Richard (1953–), Nyungar **didjeridu** player, was born in Meekatharra (WA) and raised near Pinjarra. He had a keen interest in Aboriginal culture from an early age, and was an active sportsman. He chaired the Aboriginal Advisory Board in Western Australia, and contributed to other key Aboriginal community organisations. This experience afforded him an overview of community conditions and concerns and valuable administrative experience.

One of Walley's early artistic successes was as a co-founder of the Middar Aboriginal Theatre, which performed to over ten million people worldwide. Moving on from this solid grounding in music, dance, and theatre, his accomplishments have since included recording didjeridu CDs, writing and directing stage productions, and promoting Aboriginal and Australian culture to national and international audiences of all ages.

Projects such as the *Mooditj Multimedia CD-ROM* (1996) and the theatre production *Earth Dance* (1999) have further enhanced his reputation as an innovative and eclectic artist. Arts administration remains important. He was Chairperson of **ATSIAB** in 1992, and a Councillor with the Australia Council for the Arts in 1992 and with the Centenary of Federation Council in 1997.

Walley received the NAIDOC Aboriginal Artist of the Year Award in 1991 and the Medal of the Order of Australia in 1993 for services to the performing arts and his promotion of Aboriginal culture. Such awards are public acknowledgment of his many skills and his commitment to using performing arts to entertain, educate, and empower people of all heritages.

KN

See also: 16.1.

WANAMBI, Dundiwuy (*c.*1936–1996), Marrakulu painter and sculptor. One day in 1976 Dundiwuy Wanambi was walking along the beach with me at Gurka'wuy, his small Marrakulu clan settlement in north-eastern Arnhem Land. He stopped by a mangrove tree and drew in the wet sand a '**bark painting**' of two great ancestral beings who had come ashore at that very spot. It was his clan's title deeds to that land. That painting, like all Dundiwuy's art, was based on his knowledge of and right to use the sacred clan designs of his ancestors. His art may be appreciated on a purely aesthetic level, but an understanding of the many meanings of each element, each pattern, transforms them into sacred text, clan **history**, map, as well as art.

Dundiwuy was born in the bush in the mid 1930s. As a young teenager he moved with his father to **Yirrkala** mission. Later he spent time in Darwin and other places before settling at Yirrkala in the 1960s. In 1968 his bark painting of the ancestral being Wuyal standing on Nhulun hill formed part of a petition to Federal Parliament by the Yolngu of Yirrkala, who were protesting at the desecration of this sacred hill by works associated with the newly developing Gove bauxite

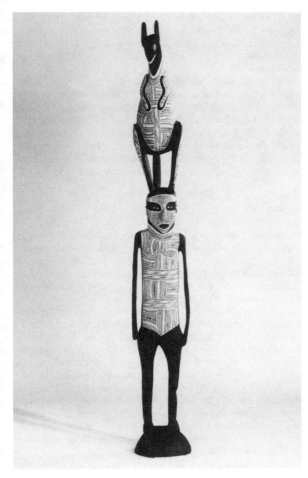

398. Dundiwuy Wanambi (with Wolpa Wanambi and Motu
Yunupingu), *Wuyal and Dhulaku (Euro)*, 1997.
Natural pigments on wood, 193 x 24.5 x 19 cm.

At the end of the film, he says: 'This [film] is a history for new
generation and for new generation … and in other end
Balanda or European … can see and understand which is
Yolngu culture.'

Dundiwuy died in November 1996, shortly after *Conversations with Dundiwuy Wanambi* (1995) won the Royal Anthropological Institute Film Prize. At his sad but splendid funeral ceremony at Gurka'wuy, his youngest daughter Wolpa received a copy of the prize certificate. During his later years, when his eyesight was fading, Wolpa helped him with the fine brushwork. Now she carries on his work.

ID

See also: 1.1, 4.6, 6.1, 13.1; **rights in art**; *398*.
Caruana, W. & Lendon, N. (eds), *The Painters of the Wagilag Sisters Story 1937–1997*, Canberra, 1997; Dunlop. I. (director), *Djungguwan at Gurka'wuy* [film], Film Australia, 1989; Dunlop. I. (director) with Deveson, P., *Conversations with Dundiwuy Wanambi* [film], Film Australia, 1995.

Wangkajunga Artists. George Tuckerbox is one of the figures in a group of around fifteen artists who paint at the Wangkajunga annex of the Karrayili Adult Education Centre (Fitzroy Crossing, WA). In response to the expressed wishes of the community, the centre was established in 1994 to assist the elders with literacy and numeracy skills. Painting has been a core component of these classes. Concurrently, the establishment, through **Mangkaja Arts**, of a wider profile for Fitzroy Crossing art, has paved the way for these painters to emerge as a distinct group of Kimberley artists: 'We paint to keep-em strong you know.'

Although they are not all from the same country, they share a common **language**, Wangkajunga, and they have very similar histories. Most were born in the desert to the east of the Canning Stock Route and then shifted into the stations with their parents and grandparents. As Tuckerbox explained, they all knew each other; even though they walked around in small groups, they would come together for large ceremonies. The first paintings the artists remember producing were done in Fitzroy Crossing at the old mission before many of them moved back to out to Jitapuru community. In March 1991, Ingrid Hoffman ran painting workshops with the women at Jitapuru as part of a health awareness program. They produced small works using natural pigments collected from the area around the community. A strong characteristic of these works was the deep red of the local *pirlji* (red **ochre**), favoured in the region for ceremony. In addition to the earth pigments, artist's **acrylics** were also used. These early works were sold at small exhibitions at Jitapuru with the works suspended from the wire security fence which surrounds the community office. The energy for painting continued and with the establishment of Karrayili, the artists began exhibiting further afield. Their paintings document sites in the desert to the south-east of Fitzroy Crossing along and around the Canning Stock Route. Many of the artists have strong ties to **Balgo** so it is not surprising that their work is similar to Balgo art: the colours are used directly from the tubes, not mixed on a palette as in other Fitzroy Crossing works, and the favoured method of applying the paint is by dotting. Unlike the Balgo painters,

mine. It is still on display in Parliament House. During the 1980s and early 1990s he became one of the best known artists of north-eastern Arnhem Land. In 1994 he won first prize for bark painting in the NATSIAA; this huge painting and many later works are monumental representations of his clan's Law. Examples are in galleries throughout Australia and overseas. Several were featured prominently in the important exhibition, 'Painters of the Wagilag Sisters Story' (NGA 1997).

With the establishment of a mine on Yirrkala's doorstep in the early 1970s, Dundiwuy became a regular visitor to the Walkabout Hotel in the new mining town of Nhulunbuy. But in 1973 he had a dream, in which a voice told him to change his life and establish a clan homeland settlement at Gurka'wuy on Trial Bay. From 1970 he was collaborating with me on a long-term ethnographic film project for Film Australia and when in 1976 he held a major ceremony at Gurka'wuy he invited me to film it. In *Djungguwan at Gurka'wuy* (1989) Dundiwuy reveals a great deal about the spiritual connections between his art, song, dance, and land.

however, these artists work on paper, a practice which had been established by the town-based Karrayili artists.

Their works have been exhibited extensively both nationally and internationally through Indigenart Gallery in Perth. The artists in this group are George Tuckerbox, Myapu Elsie Thomas, Peter Kurtiji, Lurn Willie Kew, Penny K-Lyon, Jukuja Nora Benny, Jijaja Molly Dededar, Kurtiji Rosie Goodjie, Biddie Baadjo, Gracie Green, Jakapa Dora Kwiller, Junpirr Trixie Long, Wanina Biddy Bonny and Jewess James. Many of these artists contributed to the *Ngurrara Canvas*.

KD

See also: 10.2, 23.2; *270*.

WARA, Billy (*c*.1918–), Pitjantjatjara wood carver, was born at Aran, in the south-west of the Northern Territory. Brought up in the bush, he travelled and learnt the Tjukurpa (**Dreaming**) at Waltjitjata, Umutju, Mantapailka, and Piltati, and holds many of the stories for these places. As a young man he met non-Aboriginal people, and began working at **Ernabella** mission. His drawings from this era, now in the SAM collection were included in the touring exhibition, 'Then and Now' (AETA 1996–97). He travelled the country fencing, droving, shearing, and digging wells—'*waaka pulka* (hard work)'.

Billy Wara is one of the most senior wood carvers in central Australia. He began making *punu* (wooden artefacts) in earnest when **Maruku Arts and Crafts** was formed in 1984. He later established an outstation at Umutju in order to work closer to his homelands. Wara's wooden *ngintaka* (perentie lizard) announce his senior responsibility for this Tjukurpa. He relates and celebrates the story of the creation ancestor, *Wati Ngintaka* (Perentie Lizard Man):

Ngayuku nguranguru Ngintaka pulka, number one.
The Perentie Lizard from my country is very powerful.

Ngayuku Tjukurpa pulka ngura Aranta.
My Law is very strong at Aran.

At the place where Billy Wara was born, the *ngintaka* was searched, after escaping from the east with a stolen grind-

399. Billy Wara, *Ngintaka (Goannas)*, 1989.
Wood (river red gum), lengths variable.

stone hidden in his tail. Some of Wara's carvings also cunningly conceal a grindstone and sometimes the footprints of the pursuers of *Wati Ngintaka* are branded into the carved lizard's body. Wara also carves *kulata* and *miru* (spear and spearthrower).

Billy Wara's work has been included in many exhibitions, both in Australia and overseas. He divides his time between Ernabella, his homelands, and Mutitjulu in the Uluru–Kata Tjuta National Park, carving slowly and patiently wherever he sits down. Examples of his work are held in national and State gallery and museum collections as well as the Kelton Foundation, Santa Monica, and the Museum of Ethnology, Osaka.
© Maruku Arts and Crafts KT

See also: 18.1, 18.2; child art; *231, 354, 399*.
Fontannaz, L., *Then and Now: Pitjantjatjara and Aranda Artists 1930s–1990s*, South Melbourne, 1995; Hilliard, W., *The People in Between: The Pitjantjatjara People of Ernabella*, 2nd edn, Adelaide, 1976; Isaacs, J., *Desert Crafts: Anangu Maruku Punu*, Sydney, 1992.

WARANGKULA TJUPURRULA, Johnny, Luritja visual artist, spent his early life in the sandhill country from Ilypili (Ehrenberg Ranges) to Wilkinkarra (Lake Mackay, NT). In 1930, when he was about eight years old, a rough airstrip had been constructed by the advance party of the Mackay Expedition. An aeroplane approaching the strip seemed to Warangkula's family like a devil. Soon after this event Warangkula made his first contact with Europeans and migrated to Hermannsburg mission. Later he travelled his own country on camel before settling at **Papunya**. After the construction of a windmill at Ilypili in the late 1970s, Warangkula moved there; at that time it was the most westerly of Papunya's outstations. The outstation was abandoned after the death of his brother in 1983, and since then Warangkula has lived in Papunya and Alice Springs town camps.

Warangkula is a story teller of spellbinding intensity, who has often worked at Papunya School where his stories are recorded in several publications. By 1972 he grasped the expressive potential of contemporary **acrylic painting**. His compositions are invariably fluid and his brushwork spontaneous. The dotting and overdotting that is characteristic of his work refers to the richness of his country and the ephemeral qualities of rainfall, fire, and vegetation. He was the first of the desert artists to explore the potential of the dot to produce explicit landscape representations.

In 1983 his *Yala Wild Potato Dreaming*, 1981 was the first Central Desert acrylic to be acquired into the NGA Collection. By the 1990s old age and poor eyesight had caused him virtually to abandon painting. In June 2000 his *Water Dreaming at Kalipinypa*, 1972 sold at Sotheby's for $486 000 setting a record for a second time. Since the sale the market demand has led Warangkula to paint on canvas again. His work has been seen in many group exhibitions, including 'The Face of the Centre' (NGV 1985), 'Dreamings' (New York, Los Angeles, and Chicago 1988–89), 'L'été Australien' (Montpellier 1990), 'East to West' (Tandanya 1990), 'Aboriginal Art and Spirituality' (HCA 1991), and 'Crossroads' (Kyoto and Tokyo 1992).
JK

See also: 9.1, 9.4, 9.5, 9.6; *37*.

Tjupurrula J. W., *Ngayulu Kulinu Mamu (I Thought It Was A Devil)*, Papunya, 1987; Green, I., '"Make 'im flash, poor bugger": Talking about men's painting in Papunya', in M. West (ed.), *The Inspired Dream: Life as Art in Aboriginal Australia*, South Brisbane, 1988.

Warburton Arts Project was established in 1990 in the remote Warburton Range community (SA) to maintain and strengthen contemporary Ngaanyatjarra arts. From the outset the project operated within the framework of a disjunction between Aboriginal 'place' and wider dominant cultural 'space'. Warburton Ranges lies on the single direct road between Perth and Alice Springs, a conduit for ever-increasing traffic through the Ngaanyatjarra Lands. Public perceptions of Warburton, generally negative in the 1950s and 1960s, have changed in recent years, reflecting the development of its infrastructure and self-management by the Ngaanyatjarra Council and community executives. Exposure to non-Aboriginal material and social systems has created a sea change in the social, cultural, political and economic mix and, for many, a tangible sense of cultural dislocation. To be effective, this cultural project had to re-work the definitions of words such as 'art' or 'aesthetics', develop a work practice in line with Aboriginal protocols, and acknowledge that Aboriginal people conceive meaningful productivity in terms very different from those of non-Aboriginals.

Ngaanyatjarra people have a strong sense of their identity. They maintain their culture and their common interests and, very importantly, they live on their traditional lands. The nomadic lifestyle is still well within living memory for many. The Warburton Arts Project has both long and short-term objectives. In the short term, there is a need to gather and store information that records collective and individual cultural knowledge and views. In the long term, the possible needs of future generations of Aboriginal people are considered crucial. This has led to the establishment of an archive of mixed media material owned and kept by the Warburton community.

The archive includes genealogies, site locations, personal narratives, video and magnetic tape recordings, text, photographs, and an **acrylic painting** program that provided Aboriginal artists with free access to good quality materials. The community purchased paintings from its members and a permanent collection was established, with men's and women's paintings separately curated. By 1998 there were over 250 works in the Warburton acrylic collection, reflecting a shift in the values ascribed to such work by the Ngaanyatjarra people. Previously made for sale in a non-Aboriginal art market, painting was now recast as a depository for cultural knowledge and a container for shifting power relations. Both government policy and the art market exert very considerable pressure on Ngaanyatjarra communities to embrace a business approach to cultural production, which in Warburton usually meant the sale of acrylic paintings or wooden artefacts: the commodification of culture. Paintings during this period, however, were nearly all, in effect, registers of a sacred domain. These works are to remain in Warburton as a collection of 'letters' to the future, supporting the archive as another level of cultural maintenance.

The need for a more culturally appropriate economic base in this remote community has, nevertheless, remained a concern to be addressed. In 1995 an art-glass facility was established in Warburton. The art glass, designed and made by community members, has both architectural and domestic applications. These engage the wider environment in a very different manner to the self-reflective space of sacred paintings. The fluid transition from painting to art glass has produced work of great beauty and complexity, which has been highly acclaimed. Taparti Bates won the Normandy Heritage Art Prize in 1998 NIHAA for her large glass panel *Kungkarrangkalpa*, and is represented in the collection of the ANMM. The artists Elizabeth Holland and Pulpurru Davies have completed eight large panels for the Geraldton Museum (WA), and the artist Arthur Robertson is represented in the PM collection.

Other initiatives over the years have included a **rock-art** program and assistance with *inma* (singing and dancing) and ceremonies, publications, and touring exhibitions. The project operates as much as possible within the definitions of productivity held by Aboriginal people, within their time frames, and in ways that make the technology and resources equally accessible to all. Its programs have been conducted primarily with Aboriginal people resident at Warburton and Karilwara (Patjarr). Over one hundred people have work in the acrylic collection—approximately one in five community members. Ngaanyatjarra artists from the communities at Irrunytju (Wingellina), Papulankutja (Blackstone), Kiwirrkura, Mantamaru (Jameson), Tjirrkarli, Tjukurla, Tjun Tjuntjarra, Wanarn, and Warakurna (Giles) have also been involved in the painting collection or other of the project's programs.

400. Taparti Bates, *Tjukurrpa Kungkarangalpa*, 1998.
Glass panel, 200 x 120 x 10 cm.

The artists of Warburton are represented in numerous private and public collections, including those at the Araluen Centre in Alice Springs, the Australian Heritage Commission, the Australian High Commission in Malaysia, Arts WA, the Chase Manhattan Bank, Curtin University, MAGNT, and WAM. The Arts Project has curated several exhibitions from the community: 'Minymalu Kanyirrantja: A Western Desert Women's Aesthetic' (Street Level Gallery, Sydney, 1989), 'Yarnangu Ngaanya' (Goldfields Arts Board, 1991), 'Yarnangu Ngaanya—Our Land Our Body' (PICA and SHEG, 1993), and 'Ngayululatju Palyantja: We Made These Things' (Australian High Commission, Kuala Lumpur 1998, CPAC and Djamu Gallery, Customs House Australian Museum, Sydney, and AGWA 1999). All these exhibitions aimed to present a lived, contemporary culture in which people negotiate exhibition spaces on their own terms. They often involved residencies of large numbers of Aboriginal people. Ngaanyatjarra artists have also participated in group exhibitions: 'Bush Women' (FAC 1994), 'Tjukurrpa: Desert Dreamings' (AGWA 1994), 'Bowled Over' (Savode Gallery, Brisbane 1997), 'Desert Mob Art Show' (Araluen Arts Centre, Alice Springs 1997–98), and 'Groundwork' (FAC 1998).

The Warburton Arts Project works as a register of cultural markers which disclose relationships between people. In another sense it is a history of fragments, always incomplete, remade continually by the people who contribute to it daily. As a cultural project, it endeavours to create an environment for the arts where transformations of Aboriginal space are controlled by the Ngaanyatjarra people themselves. Its efforts over the years have had the strong support of the Community Executive Council and the Ngaanyatjarra Council. GP

See also: 9.5, 21.2; **art awards and prizes**; *400*.
O'Ferrall, M., *Tjukurrpa—Desert Dreamings: Aboriginal Art from Central Australia*, Perth, 1993; Perth Institute of Contemporary Arts, *Yarnangu Ngaanya = Our Body*, Perth, 1993; Proctor, G., *Ngayulu-latju Palyantja = We Made These Things: From the Ngaanyatjarra Lands/Warburton Community*, Alice Springs, 1999.

Waringarri Aboriginal Arts Gallery was initiated in 1985 and officially opened in Kununurra (WA) as an art and craft outlet in August 1988. The gallery formed as a response to requests from Aboriginal artists and communities in the region, that a shop be set up to provide employment and empowerment through art. The project's aims were to provide an efficient, successful retail and wholesale outlet for artefacts produced by Aboriginal people in Kununurra and neighbouring communities in the East Kimberley region. Waringarri was instrumental in fostering and publicising the work of artists of the calibre of **Rover Thomas**, **Queenie McKenzie**, Jack **Britten**, Paddy **Carlton**, and Freddie **Timms**, intoducing to the world the unique painting traditions of East Kimberley artists. Waringarri Arts is owned and governed by local Aboriginal people. It has become an incorporated body, and is now known as Waringarri Arts Aboriginal Corporation. Artists are supported in various ways: they are supplied with art materials, and the gallery establishes contacts with the art world, both nationally and internationally, to sell and exhibit their work. Staff also provide advice and

support on copyright issues, and protect the interests of the artists. Waringarri Arts stocks a wide range of art and craft: works on canvas and paper, **didjeridus**, sculptures, fibrecraft, native-seed jewellery, carved slate, and **boab nuts**.

CD

See also: 10.1, 10.2; **art and craft centres, Karedada family,** Alan **Griffiths**.

Warlayirti Artists in Balgo (WA), the community-based organisation which markets Balgo art, was established in 1987. The process of Balgo people revealing their traditional designs began in the mid 1940s when the anthropologist Ronald Berndt worked with senior men. In the late 1950s people began producing artefacts for the ethnographic art market, an activity which they resumed in the 1970s and early 1980s.

News of the **Papunya Tula** painting movement reached Balgo in late 1971 when Pintupi people visited Balgo in the course of a ceremonial exchange. For some time thereafter the Balgo community remained wary about committing their traditional designs to a public medium, especially following a furore in the mid 1970s when some Papunya painters included secret ceremonial designs in canvases for the art market. But by the late 1970s, the old men were sporadically painting on materials lying around in the community, and in 1979 some paintings were marketed through the Balgo store. Then, in late 1980, Warwick Nieass, a Swiss-born artist, came to Balgo mission as a cook. In his free time, he went out into the bush with people while they produced stone carvings for the ethnographic art market. This group comprised a number of Kukatja elders who were foundational to the Balgo art movement and who have since become important artists—Bai Bai **Napangarti** and Nellie Njamme Napangarti, with their husbands, Sunfly **Tjampitjin** and Jimmy Njamme; together with Wangkajunga elders Susie **Bootja Bootja Napaltjarri** and her Kukatja husband, Mick **Gill Tjakamarra**, and John Mosquito Tjapaltjarri and his late wife, Muntja Nungurrayai.

An interest in art was also growing among mission staff. In early 1981 the Church revived its adult education classes in Balgo, appointing Sister Alice Dempsey to head the St John's Adult Education Centre. Nieass took on the job of teaching the traditional and modern (Western) art classes, and in April obtained funding from the **AAB** of the Australia Council to operate an art centre for six months. At this stage the male elders painted at Nieass's house, but were unwilling to paint commercially. A first community-based Balgo art exhibition took place in August 1981 in Broome, showing stone carvings and Western landscape painting. A few months later, at the celebration of the twenty-five year jubilee of Father Peile in Balgo, the male elders publicly revealed four banners bearing traditional icons, while the younger men produced two banners using a combination of traditional and Christian-based iconography.

Although the infant art centre collapsed in 1982, rising enthusiasm for painting during the next few years convinced Sister Dempsey that a public exhibition should be held. With the help of Ronald Berndt, she organised an exhibition at the AGWA to launch Balgo as a new Aboriginal painting com-

munity. The ensuing exhibition, 'Aboriginal Art from the Great Sandy Desert' (1986–87), received wide publicity.

It was time for a specialist community art centre to be established. The founding co-ordinator of Warlayirti Artists, Andrew Hughes, oversaw the development of the new organisation, and encouraged the artists to achieve a high quality of professional painting practice. The minimalist painting style and **ochre** palette of Balgo work during this period was influenced by the example of Papunya Tula. Then in 1988 a new co-ordinator, Michael Rae, responded to the desire of some artists to apply to their paintings of country the vibrant red, green, blue, and yellow that had been in use in the modern painting class. Australian art viewers were astonished at the diversity of styles and opulence of expression that resulted. The work of artists such as Eubena **Nampitjin**, **Wimmitji Tjapangarti**, Bridget Mudgidell, Elizabeth Nyumi, Alan Winderoo, Sam Tjampitjin, Michael Mutji, Johnny Cotchilli, Boxer Milner, Ena **Gimme** and Milliga became much sought after.

Balgo art made its mark in the eastern States in the landmark exhibition 'Mythscapes' (NGV 1989). Inclusion in international exhibitions such as 'Songlines' (London 1990) and 'Yapa, Peintres Aborigènes de Lajamanu et Balgo' (Paris 1991), and 'Aratjara' (Düsseldorf, London, and Humlebaek 1993–94) followed.

Balgo has now consolidated its reputation as a vibrant, creative centre of Aboriginal artistic expression. Many of the original artists responsible for establishing Balgo's reputation continue to paint: Eubena, Lucy **Yukenbarri**, **Helicopter**, Bai Bai Napangarti, Sam Tjampitjin, Tjumpo **Tjapanangka**, Bridget Mudgidell and Ningie **Nangala**. Some like Elizabeth Nyumi, Michael Mutji, Gracie Greene, Joan Nagomarra, Nellie Njamme and Johnny Cotchilli have recently achieved a new level of recognition. After a period of comparative isolation in the mid 1990s a group of Billiluna artists gathered around Elizabeth Nyumi, including Kathleen Padoon and Tjarmia Samuels, are creating something of a Billiluna school of art. And most importantly, a second generation of Balgo artists—Elizabeth **Gordon**, Pauline Sunfly, Maree Mudgidell, John Lee, Stella Gimme, Anitta Greene, Stuart Baadjo, Lindsay Rose, and Cathy, Carmel and Christine Yukenbarri—is rising to continue the work of their renowned parents.

CW

See also: 1.2, 9.5.

Ryan., J,. *Mythscapes: Aboriginal Art of the Desert from the National Gallery of Victoria*, Melbourne, 1989; Watson, C., 'Touching the land: Towards an aesthetic of contemporary Balgo painting', in H. Morphy and M. Smith-Bowles (eds), *Art from the Land: Dialogues with the Kluge–Ruhe Collection of Aboriginal Art*, Charlottesville, VA, 1999.

Warlukurlangu Artists Aboriginal Association, established in 1985, is renowned as one of the most significant and successful art centres in the Northern Territory. It is based in Yuendumu, which lies 300 kilometres north-west of Alice Springs, and is home for around 1000 people. The name 'Warlukurlangu' derives from an important Jukurrpa (**Dreaming**) and means 'place of fire'. It was chosen by a number of older men and women who saw the need for an organisation that represented their interests as artists but also recognised the importance of the cultural laws which are inseparable from the stories depicted in paint. Warlukurlangu is an Aboriginal owned and governed association with almost 200 Warlpiri and Anmatyerre-speaking members.

From its inception, the art centre has sought to encourage a better understanding of Warlpiri and Anmatyerre culture. The driving force behind its establishment was the desire to maintain control of the paintings within the community through an independent association of local artists. As a result Warlukurlangu was officially incorporated in 1985, with the directive that the interests of the community took precedence over everything else. Membership was drawn from the whole community and was open to all Warlpiri and Anmatyerre people from Yuendumu, and priority was given to group shows.

Paddy Japaljarri **Stewart** was a key figure in these events. In the early 1970s he had been involved in the painting of the now famous mural on the **Papunya** school wall and in 1983 he was instrumental in yet another community based project, the painting of the Yuendumu school doors. Altogether thirty doors were painted with the major Jukurrpa of the region: twenty were installed on to school buildings and six were placed in teachers' houses around the community. Paddy Japaljarri Stewart painted twenty of the doors himself and the others were painted by Paddy Japaljarri **Sims**, Larry Jungarrayi Spencer, Paddy Jupurrurla **Nelson** and Roy Jupurrurla Curtis. The artists stated their aim was to ensure that children were brought up with appropriate knowledge of the Jukurrpa. In Paddy Japaljarri Sims' words they were trying to 'make a memory of these stories' for their children. In 1987, with the assistance of AIAS (now **AIATSIS**), Warlukurlangu Artists published a book, *Yuendumu Doors: Kurruwarri*, which included colour photographs of the doors and accompanying stories in Warlpiri and English. The doors have since undergone extensive restoration and have toured Australia in an exhibition entitled 'Unhinged' (SAM 1999–2000).

The work produced at Warlukurlangu is characterised by its flamboyant use of colour and strong design elements. *Kurruwarri* (ritual design) forms the template for all the paintings and traditional rules are strictly adhered to. Individual creativity and artistry can nevertheless be seen in the handling of paint, arrangement of the *kurruwarri* and the execution of the dots. Warlukurlangu is famous for the large canvases which have been commissioned by public galleries in Australia, Europe and the USA. They have formed the focus of major exhibitions around the world and have also been purchased by private collectors. Measuring up to three by seven metres, these gigantic works of art give the artists room fully to express the sheer size and scope of Jukurrpa narratives and the country associated with them. These projects provide the artists with the opportunity to work together in a manner that reflects Warlpiri social practices and resembles traditional ceremonies. Many younger painters are given their first opportunity to gain experience in the process of painting and express their knowledge of Jukurrpa. There is a marked willingness to work together and a shared sense of obligation to represent the Jukurrpa as accurately and comprehensively as possible.

Warlukurlangu Artists has proven over the years that community control of an organisation can ensure artists' rights are recognised, and that the culture of Warlpiri and Anmatyerre people can be appropriately represented in the public arena. SUC

See also: 9.5; Dolly Nampijinpa **Daniels**, Andrea Nungarrayi **Martin**, Darby Jampijinpa **Ross**, Jack Jakamarra **Ross**, Bessie Nakamarra **Sims, Judy Napangarti Watson**; *121, 221*.
Congreve, S., 'Painting up big: Community painting at Yuendumu', *Art and Australia*, vol. 35, no. 1, 1997; Dussart, F., 'What an acrylic can mean: Meta-ritualistic resonances of a Central Desert painting', in H. Morphy & M. Smith Boles (eds), *Art from the Land: Dialogues with the Kluge–Ruhe Collection of Australian Aboriginal Art*, Charlottesville, VA, 1999; Warlukurlangu Artists, *Yuendumu Doors: Kurruwarri*, Canberra, 1987; Warlukurlangu Artists, *Warlukurlangu Artists of Yuendumu* [documentary video], Yuendumu, 1991; Warlukurlangu Artists, *Yanardilyi: Cockatoo Creek* [CD-Rom], Yuendumu & Tanami Tetwork, 1998.

Warmun Art Centre was established in August 1998, to represent Warmun artists (Kija people) and market their work to collectors, museums and galleries world-wide. It is wholly owned and controlled by Warmun artists and Warmun community (Turkey Creek, WA), in the East Kimberley Region. Jonathan Kimberley and Anna Moulton were employed as art coordinators to establish Warmun Art Centre in August 1998. In its first eighteen months of operation Warmun Art Centre organised and assisted artists to participate in more than fifteen exhibitions both in Australia and overseas.

Warmun art has an enviable national and international reputation thanks to a handful of highly successful artists. The community was home to **Rover Thomas** and **Queenie McKenzie**, and counts George **Mung Mung** and Paddy **Jaminji** among its members. Warmun artists are renowned for their use of natural **ochre** and pigments on canvas. Their art is an inseparable and celebratory part of Kija culture and country, and draws on traditional Ngarrangkarni (**Dreaming**) stories as well as contemporary events and life experiences of the artists. The next generation of Warmun artists are still working with natural ochre and earth pigments; in its freshness, style and scope this exciting new work transcends cultural boundaries and places many Warmun artists at the forefront of contemporary art in Australia.

Warmun Art Centre represents established artists including Hector **Jandany**, Patrick **Mung Mung**, Shirley **Purdie**, Churchill Cann, **Madigan Thomas**, Mabel **Juli**, as well as an ever-growing number of exciting emerging artists (ranging in age from their early 20s to their late 60s). They include Mona Ramsay, Gordon Barney, Lena Nyadbi, Charlene Carrington, Nora Nagarra, Colleen Carter, Katie Cox, Mary Thomas, Lorraine Daylight, Betty Carrington, and Shirley Bray. JNK & AM

See also: 10.2.

Warnayaka Art Centre, Lajamanu (NT), was founded in 1991, several years after the inception of the Lajamanu art movement. Before that time, the Warlpiri at Lajamanu had been reluctant to embrace the medium of acrylic on canvas.

That feeling was strongly expressed by members of the community when on a trip to Paris in 1983 to install a traditional ground painting for the exhibition 'D'un autre continent: L'Australie le Rêve et le Réel' at the Musée d'Art Moderne. In the words of Maurice Japurrurla Luther: 'We are not, and do not ever want to become, professional painters.'

Two years later, economic and educational considerations led the Lajamanu men to reconsider their stance and they granted approval for a painting course to be organised the following year. Ancestral designs, once used only for ceremonial purposes, began to be painted for public consumption. The Lajamanu women also began to paint in 1986, producing a series of works for the school that comprehensively documented their **Dreamings**. Later acquired by the NGV, it is the largest collection by a single community in the gallery's collection.

As with many other community-based art centres, a lack of secure funding has seen Warnayaka operate sporadically. Despite this, it holds a series of exhibitions in State capitals each year. Significant artist–members, like Abie **Jangala** and Lorna Napurrurla **Fencer**, have contributed to contemporary art both in Australia and internationally through their unique vision of Warlpiri culture. VMcR

See also: 9.5; *122, 223*.
Brody, A. M. (ed.), *Stories: Eleven Aboriginal Artists*, Roseville East, 1997; Ryan, J., *Mythscapes: Aboriginal Art of the Desert*, Melbourne, 1989.

WATSON, Janet (1910–*c*.1992), Moandik weaver, was an artist adept in the coiled basketry technique of the women of the Kingston area of the lower Murray River (SA). She learnt her weaving skills from older female relatives, and produced traditional baskets, but also adapted the style to create her own unique contemporary objects. The traditional technique is a coiled bundle with a simple loop stitch. What distinguishes the baskets of the Kingston area is the use of red coloured sedges (*Lepidosperma canescens*) which, when

401. Janet Watson, *Airplane in the Coiled-Bundle Style*, 1930s. Sedge, 32 x 68 cm.

incorporated into the weave process, create both a spiral pattern and a speckled effect. Historically, lower Murray River basketry took many forms: carrying containers, fish scoops, coffins, mats, and other utilitarian objects. Inspired by childhood memories of seeing an aeroplane for the first time, Watson created an innovative new woven form in the traditional manner of her people, simultaneously adapting her technique to meet the requirements of the irregular shape of the aeroplane. Watson's monoplane, in which sedge bundles are woven over a wire frame and the windows are made of celluloid, is now in the SAM collection. This piece was exhibited in the touring 'Aboriginal Women's Exhibition' (AGNSW 1991), where it inspired other weavers of the region to continue the development of the Kingston weaving tradition. In homage to Watson, Ngarrindjeri artist Yvonne **Koolmatrie** wove a biplane on a much larger scale that is now in the NGA collection. FC

See also: 17.1, 17.2, 22.4; **Pinkie Mack**; *401*.
Cubillo-Alberts, F. 'Janet Watson', in Kerr, J. (ed.), *Heritage: The National Women's Art Book*, Roseville East, NSW, 1995; Sutton, P., Jones, P. & Hemming, S., 'Survival, regeneration and impact', in P. Sutton (ed.), *Dreamings: The Art of Aboriginal Australia*, New York & Ringwood, Vic., 1988.

WATSON, Judy (1959–), Waanyi painter, printmaker, sculptor, and installation artist. In 1990 Judy Watson travelled with members of her family to the birthplace of her grandmother and her great-grandmother near Lawn Hill Gorge in northwestern Queensland, a seminal experience of country which the artist describes as 'learning from the ground up'. In her exhibition 'groundwork' (IMA 1990), the different strands of Watson's work—her feminism, environmentalism, and **Aboriginality**—came together in an exploration of her matrilineal heritage in the form of the guardian figure, an enduring image in her oeuvre.

Watson's earliest studies were in **printmaking**, and her paintings, installations, and drawings carry the hallmarks of a printmaker's sensibilities. Her work is characterised by a dynamic of presence and absence, whether through use of relief and resist methods of print or mark-making, depiction of the motifs of shells, fossils, vessels and islands, or allusion to the relation of past and present, remembrance and forgetting. The body is usually present only in absence, whether shrouded, as in her guardian figures, or drawn in hollow outline. The self is insistently subjective, depicted as if from inside the skin—at once a comment on the invisibility of Aboriginal people in Australian society and a reclamation of the historical pathologising of the black body. Watson's work invokes as much a celebration of late twentieth-century Aboriginality—of cultural repatriation and renascence—as the haunting of an Aboriginal history unrealised. It is an affirmative art but one shot with mourning—with 'residues of grief', as the artist describes it—for that which has been damaged or lost irretrievably:

I listen and hear these words a hundred years away
that is my Grandmother's Mother's Country
it seeps down through blood and memory and soaks into the
ground

Watson's Australian group exhibitions include 'A Koori Perspective' (Artspace 1989) and the 'Aboriginal Women's Exhibition' (AGNSW 1991). International exhibitions in which her work has been represented include 'Aṟatjara' (Düsseldorf, London, and Humlebaek 1993–94), 'True Colours' (Liverpool and London 1994–96), 'Antipodean Currents' (New York 1995), and 'In Place (Out of Time)' (Oxford 1997).

In 1995 Watson won the Moët & Chandon Australian Art Fellowship and in 1997 represented Australia, alongside Emily Kame **Kngwarreye** and Yvonne **Koolmatrie**, in 'fluent' at the Venice Biennale. Her major commissions include *Koori Floor* (CPAC 1994), and *Warreka*—a fifty-metre long etched zinc wall for the entrance of Bunjilaka, the Aboriginal Centre at Melbourne Museum (1999). She has held solo exhibitions throughout Australia and in India, France and New Zealand. She is a veteran of Indigenous artists' camps and of artists' residencies within Australia and in Canada, France, India, Italy, New Caledonia and Western Samoa, and has taught in Australian and overseas tertiary institutions.

HF

See also: 8.2, 12.1, 21.1; **art awards and prizes**; *40, 402*.
Fink, H., Lynn, V. & Perkins, H., *Judy Watson*, Epernay, 1996; Perkins, H., 'Judy Watson: Our skeletons in our closets', in R. Coates & H. Morphy (eds), *In Place (Out of Time) Contemporary Art in Australia*, Oxford, 1997.

WATSON, Judy Napangardi (*c.*1925–), Warlpiri painter. Judy Napangardi Watson's country is Mina Mina, a women's **Dreaming** site 200 kilometres west of **Yuendumu** (NT), where she now lives. Most of her works depict Mina Mina or dreamings connected to it: *Karnta* (Women), *kanakurlangu* (digging stick), *ngarlyipi* (snake vine), *yunkaranyi* (honey ant), *jintiparnta* (native truffle), and *majardi* (hair-string belt).

She has painted for **Warlukurlangu Artists** since 1986. With her sister, Maggie Napangardi Watson, she has developed a popular and distinctive style, employing contrasting lines of colour and richly textured surfaces. She is a committee

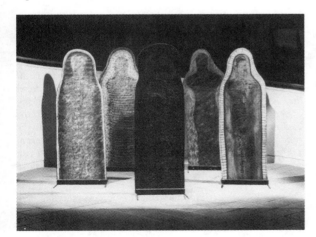

402. Judy Watson, *The Guardians,* 1986–87.
Powder pigment on plywood, each figure 180 x 58 cm (irreg.).

member of Warlukurlangu Artists and has exhibited at many group exhibitions including 'Chicago International New Art Forms Exposition' (Chicago 1993) and 'Echoes of the Dreamtime' (Japan 1994).

LC

See also: 9.5.

WEDGE, HJ (Harry) (c.1958–), Wiradjuri painter, grew up on Erambie mission at Cowra (NSW). After working as an occasional drover and fruit-picker, he moved to Sydney and in 1989 enrolled in photography at the Eora Centre for Aboriginal Studies, Redfern. He soon switched to painting, and his work swiftly attracted attention. After seeing his work in Eora's annual end of year show in 1990, curator and artist Brenda L **Croft** introduced Wedge to **Boomalli Aboriginal Artists Co-operative** and the following year he held his first exhibition, a joint show with Ngarrindjeri artist, Ian **Abdulla**. His subsequent flowering as an artist was closely associated with the activities of Boomalli in the period between 1991 and 1995. Wedge's colourful narrative art is founded on his experiences growing up on the mission, and is informed equally by current affairs, biblical stories, and Aboriginal lore:

We might have lost some of it but now, through our dreams, we are sharing the past, the present, and the future.

In 1993 Wedge was Aboriginal artist-in-residence at AGNSW, travelled to Hungary to participate in the 25th Budapest Autumn Festival, and was awarded a NSW Ministry for the Arts Indigenous Arts Fellowship. In 1995 he participated in the fourth Australia and Regions Artists' Exchange (ARX4), a process-based residency, and in the resultant exhibition, 'torque' (PICA 1995). His group exhibitions include 'Wiyana/Perisferia (Periphery)' (TPS 1993), 'Urban Focus' (NGA 1994) and 'True Colours' (Boomalli 1994). In Sydney he has held solo exhibitions at Coo-ee and Boomalli and in Melbourne at Gallery Gabrielle Pizzi. His work is in the collections of NGA, AGNSW, NGV, Campbelltown City Art Gallery, Cowra Council, Moree Plains Regional Gallery, and Boomalli, Sydney.

HF

See also: 12.1, 12.5; *171.*
Croft, B. L., 'Boomalli: From little things big things grow', in L. Taylor (ed.), *Painting the Land Story*, Canberra, 1999; Wedge, H. J., *Wiradjuri Spirit Man*, Roseville East, NSW, 1996.

WEIR, Barbara (Atnwengerrp) (c.1945–), Alyawarre visual artist, was born at Bundy River station near **Utopia** (NT), of an Aboriginal mother and Irish father. She was 'hidden' from the age of two at Utopia where she was 'grown up' by her aunt, the painter Emily Kame **Kngwarreye**. While out collecting water at the age of nine, she was taken by Native Welfare, and her family believed she had been killed. Thirteen years later, in the late 1960s, she was reunited with her family at Utopia and had to relearn her native **language**. She stayed until late 1997, always maintaining a close relationship with Kngwarreye. In 1974 she played a major role in a successful **land rights** claim and in 1985 was honoured for her work by being made the first woman President of Urapuntja Council.

403. Barbara Weir with her painting, *My Mother's Country*, 1998.
Acrylic on linen, 90 x 120 cm

A mother of six with thirteen grandchildren, she lives in Adelaide.

As part of the original group of women **batik** artists at Utopia who were given **acrylics** and canvas by Rodney Gooch in 1989, Weir has developed a highly sophisticated, contemporary, yet traditional, painting style. Whether referring to her earliest paintings of bush tucker and women's business or to recent intricate work, she says: 'Everything is about my mother's country.' Resplendent with night skies, the Milky Way, sunsets, rivers, and hills, her paintings use an extremely delicate technique of dotting and complex layering of visual and narrative elements. Others employ fine linear detail and bold *awelye* patterns.

In 1994 Barbara Weir was one of ten Utopia women artists invited to Indonesia to study batik. On her return her paintings on canvas became stronger than ever and much sought after. In 1996 she travelled to Europe and received many painting commissions. She has exhibited widely in Australia and overseas, with solo shows in Brisbane, Adelaide, Sydney, Canberra, and Zurich.

VK

See also: 9.5, 9.6; **stolen generations**; *216, 403.*

WIGGAN, Roy (Bagayi) (1930–) Bardi sculptor, explained the origins of his *ilma* in 1997:

Dad passed away on 3 December 1963, but his spirit is still coming back to us. Wherever Dad went, and whatever he done, [he] is producing all that thing onto ilma. History is being passed on to us. It's a story about himself and a story about the land he was brought up in. Yeah. He comes out with how he paddled his catamaran, how the birds flew around, what sort of dangers, how the spirits helped him. He comes out with trees, flowers, coral, whirlpool, fish, everything he knew, you know. It's all to do with his life and how he lived his life.'

Ilma are visually striking hand-held emblems characteristic of Bardi public dances. Roy Wiggan has constructed many hundreds of these brilliantly coloured images, and his work is now represented in many public and private collections as well as most of the major Australian museums and art galleries. The largest assemblage is in the ANMM, Sydney.

404. Roy Wiggan, *The Shovel*, 1992 (*l.*), and *Where Father Walked*, 1992 (*r.*).
Wood, paint, wool, and cotton, 96 x 30 cm, and 78 x 37 cm.

His father, a respected elder of the Bardi tribe in the Kimberley region (WA), appears to Roy in dreams, shows him the designs and colours to be used, and brings, with the identity of the totemic being, the associated songs and dances which combine inextricably to represent a powerful spiritual reality. Roy then constructs the *ilma* by cutting out a framework of plywood around which he weaves bands of coloured wool. The visual effect, especially when lit by firelight during a dance, is dramatic in the extreme.

Roy was born on Sunday Island, part of the Buccaneer Archipelago, where his father, Henry Wiggan, skippered luggers for the local mission. He grew up imbued with the traditional pattern of living, essentially oriented to the sea, depending entirely on an expert understanding of the capricious weather and massive tides which created dangerous rips and whirlpools. The Bardi people negotiated their notoriously treacherous seas in flimsy rafts made from mangrove logs, using their knowledge of the tides to reach their desired destinations. Propitious judgment based on a detailed knowledge of the elements, as well as of the life cycle and habits of marine creatures great and small, was essential to survival.

The Bardi lifestyle is, however, changing rapidly, with powered technologies and an accent on Western consumerism supplanting the wisdom of the old people. Ceremonial life is diminishing, and the *ilma* dances are now practised principally for commercial gain rather than for social cohesion. Witnessing the richness of their culture slip away distresses the Bardi elders, but Roy Wiggan, with inspiration from his father, is ensuring that detailed knowledge of their former way of life is enshrined in the objects that he makes for the world to enjoy.

Wiggan, who now lives in Broome with his wife and ten children, is a highly talented and astute man. The work ethic of the Sunday Island mission induced him to earn his living at such diverse occupations as shopkeeper, meatworks labourer, transport driver, pearl diver, crocodile hunter, station hand, horse trainer and medical orderly. He has also represented Aboriginal people on missions to the USA and to Japan.

Currently, he distributes his art works through an agent in Perth with whom he has had a long association. The patterns and colour combinations of his now purely decorative *ilma* are endlessly creative, and the meanings they encode are a veritable encyclopedia of Bardi cultural traditions. PV

See also: 10.2; *404*.
Caruana, W., 'Roy Wiggan' in *The Eye of the Storm: Eight Contemporary Indigenous Australian Artists*, Canberra, 1997.

Wik decision, see Native title.

WILLIE, Moima, see Willie **Gudabi.**

WINSLEY, Joyce (1938–), Nyungah fibre artist, says of her principal raw material: 'I like the feel of it, even seeing the grass makes me happy, knowing there is plenty of it around. When I see it I want to pick it. When I look at them [grass figures] after they are done then I name them.' Her grass figures are made from the introduced 'guildfordgrass' (*Romula roseata*) which she crushes and forms into shape through intensive stitching. A **stolen generations** child, Winsley was raised at Gnowangerup mission. Today she lives in Narrogin (WA), where the grass she uses grows abundantly along the

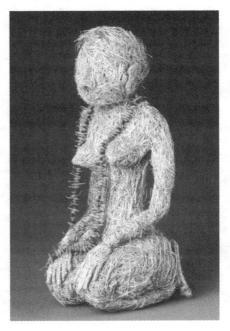

405. Joyce Winsley, *Granny Bass*, 1998.
Grass, threads, and seeds, 40 x 20 cm.

wheat-belt fence-lines. She attended fibre workshops run by visual artist Nalda Searles between 1993 and 1995. Among the works in her first solo exhibition at Narrogin were baskets and animals combining grass and wood, and an innovative sculpture, *Arthritic Arm*. Her first major piece, *Mamarie Man* (now in the Berndt Museum, UWA) was shown in the 1996 Festival of Perth exhibition, 'Re-coverings'. It represented a shift into portraying the spirit world. More recent pieces, *Granny Bass*, shown at 'Past Tense/Future Perfect' (CCCC 1998) and 'Beyond the Pale' (AGSA 2000), and *Church Lady*, included in the 1998 Tamworth Biennale 'Many Voices', show her engagement in social portraiture. NS

See also: 17.1; *405*.

Craftwest Centre for Contemporary Craft, *Past Tense/Future Perfect: A National Exhibition of Emerging Contemporary Craft Featuring the Work of 73 Craft Practitioners*, Perth, 1998; Mellor, D., 'Joyce Winsley', in B. L. Croft (ed.), *Beyond the Pale: 2000 Adelaide Biennial of Australian Art*, Adelaide, 2000.

WULULU, Jimmy (1936–) Gupapuyngu (Yolngu) painter and sculptor, was conceived at Malwanatharra, a site associated with the dingo ancestor on the coast of the Arafura Sea

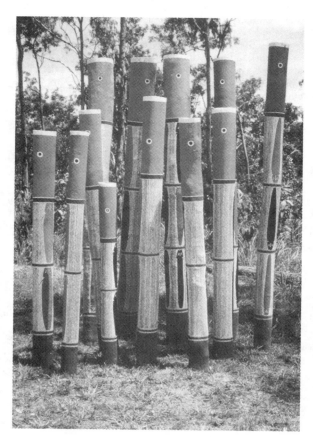

406. Jimmy Wululu, *Hollow Log Poles*, 1989.
Natural pigments on wood, group of twelve, various dimensions.

in Arnhem Land (NT). He spent his childhood at Milingimbi Methodist mission, and attended the mission school for a short period. He was initiated during a Mandiyala ceremony on Milingimbi. Later he worked on the mission in the piggery and went to Darwin where he worked as a labourer at the Qantas air base.

On returning to the Yolngu area, he moved in 1965 to Ngangalala on the mainland to build the store, stockyards and the wharf. In the late 1970s he started to paint on bark professionally, employing the plan-drawing skills learnt in the building trade to produce geometrically precise images. Working by day as a builder and with the livestock herd, he painted after work in the company of David **Malangi**.

After the death of his older brothers in the early 1980s Wululu became the major painter for his Gupapuyngu group both in the ritual and public domains. Subsequently his work was chosen for the important 'Dreamings' exhibition (New York, Los Angeles, and Chicago 1988). In that year he also contributed to the *Aboriginal Memorial* exhibited at the Bicentenary Sydney Biennale in 'Under a Southern Cross'. In the following year fifteen of his poles, now in the Holmes à Court Collection, were shown in the 'Magiciens de la Terre' (Paris 1989).

Wululu has since completed a number of low-relief sand sculptures as part of a number of individual and group shows. The last of these occasions was the inclusion of his *Bonggu Waterhole* installation at the 1998 Biennale of Sydney exhibition, 'Every Day'.

Though now unable to travel because of illness Wululu continues to produce a steady stream of fine herringbone paintings on bark, paper and canvas, as well as directing installations of his sculptures from afar.

 DjM

See also: 6.1, 6.3; **38**, *74*, *406*.

Mundine, D., 'Jimmy Wululu', in A. M. Brody (ed.), *Stories: Eleven Aboriginal Artists, Works from the Holmes à Court Collection*, Roseville East, NSW, 1997.

WUNUNGMURRA, Yangarriny (*c*.1932–), Dhaḻwangu (Yolngu) painter, was born at Bayapula in north-eastern Arnhem Land (NT) and spent his youth walking the country, receiving the traditional education which entitles him to paint the sacred designs in his keeping in accordance with the restrictions laid down by earlier generations of bark painters and clan elders. After minimal schooling ('a month') at Yirrkala mission, he worked as a labourer until he became involved in the historic Yirrkala Church Panels project of 1962–63. He then continued painting his clan designs on bark for the art market, and he was one of the first to join the homeland movement to resettle clan lands after the Northern Territory Supreme Court declared them 'terra nullius'. His commitment to the survival of his clan law and lands made him one of the first to break with tradition and teach his daughters as well as sons to carry on the work of painting the sacred designs. In 1983 he became the first Aboriginal artist successfully to sue for breach of **copyright** over unauthorised reproduction of one of his designs. His affadavit to the court was the clearest possible statement of the Yolngu view on copyright and **rights in art**:

This is our foundation. That painting comes from Barama. Barama is the first person for Yirritja people; he gave us our singing, dancing, our country and all our places. He taught us laws, and one law he taught us is to behave ourselves—not to steal other people's paintings: we must first ask older people for their permission. Part of that painting belongs to the land … It is one of the most important things people could paint.

On winning the 1997 NATSIAA, Yangarriny remarked, 'Hope they don't steal this one too'. With assistance from some of his ten children, he still paints and carves with undiminished intensity.

VJ

See also: 1.1, 1.2, 4.6, 6.1, 22.1; *32.*
Cooper, C., Morphy, H. & Peterson, N., *Aboriginal Australia*, Sydney, 1981; Johnson, V., *Copyrites: Aboriginal Art in the Age of Reproductive Technologies*, Sydney, 1996.

WUNUWUN, Djiwul 'Jack' (*c.*1930–1990), Djinang (Yolngu) painter and sculptor. When Wunuwun began painting in the 1960s, artists usually received between $3 and $40 for a bark painting. Three years before his death, his *Banumbirr the Morning Star*, 1987 was bought for the record price of $10 000 by the NGA; the then director, James Mollison, compared it to Michelangelo's *Last Judgement*. Wunuwun was an active participant in an era which saw important changes in the world of Aboriginal art.

Wunuwun grew up on Milingimbi (NT) at the Methodist mission, worked in Darwin after World War II, and returned to Arnhem Land in the 1960s where he commenced painting for the public domain. He was involved in the homelands movement and established an outstation with his brother-in-law Johnny **Bulunbulun** at Gamardi in 1979. Both artists worked and painted there for several years.

Wunuwun was a significant figure in the broader arts community, and a pioneer in the world of Aboriginal art. From 1979–81 he was a member of the Aboriginal Arts Board (now **ATSIAB**) of the Australia Council. He won second prize in the inaugural NAAA (now NATSIAA) in 1984. He was awarded a professional development grant from the Aboriginal Arts Board of the Australia Council, which enabled him to concentrate on painting a series on the Morning Star ceremony (Baṉumbirr), for which his clan has custodianship. Wunuwun was named Aboriginal Artist of the Year in the same year.

407. Jack Wunuwun, *Banumbirr, the Morning Star*, 1987. Natural pigments on bark, 178 x 125 cm.

Predominantly a bark painter, Wunuwun also experimented with canvas and sculpture. His work has appeared in several important exhibitions including 'Bulawirri/ Bugaja' (NGV 1988), 'The Continuing Tradition' (NGA 1989), 'Magiciens de la terre' (Paris 1989), and 'Aṟatjara' (Düsseldorf, London, and Humlebaek 1993–94). MEJ

See also: 6.1, *407.*
Moon, D. 'Jack Wunuwun', in A. M. Brody (ed.), *Stories: Eleven Aboriginal Artists, Works from the Holmes à Court Collection*, Roseville East, 1997; Caruana, W. (ed.), *Windows on the Dreaming: Aboriginal Paintings in the Australian National Gallery*, Canberra, 1989.

X, Y

x-ray art, see 5.1, 5.2, 5.3.

YANKARR, Paji Honeychild (*c*.1920–), Walmajarri visual artist. In 1995 Paji Honeychild travelled back to a major waterhole called Japirnka in the heart of the Great Sandy Desert, in order to record evidence for the Ngurrara native title claim. She got out of the car at one of the sandhills, a place distinct for its stand of *tutujarti* (desert walnut) trees. Without hesitation she moved to one spot and quietly told the group that this was her grinding stone, that she had sat here and ground seed around thirty years earlier. The stone was there, just as it had been left.

Grinding stones, seeds, and the bush meats that Honeychild grew up on in the desert are features of her work, although her most characteristic images are the waterholes in her country, the places where she walked around as a young woman. In her words, 'I put water in my paintings.' She works on paper with artist's **acrylic,** and uses broad brushstrokes with a vibrant, full palette. There is usually one single motif—the waterhole—which spreads to the edge of the paper in semicircular bands of colour. Bush seeds and meats are added afterwards, usually designating the type of food which was plentiful at particular sites. Honeychild was born at Jupurr in the Great Sandy Desert (WA). It is a *jila* (sacred waterhole) set among a stand of desert paperbarks, about 300 kilometres to the south of Fitzroy Crossing and slightly south of a major *jila* called Japirnka. Nearby is another waterhole called Yirtil. This is where smaller groups camped. As her nephew Jimmy **Pike** describes it, Jupurr was the city and Yirtil, the small town. These two places are key sites for Honeychild: she spent most of her early life living in the Jupurr area. She was given to her first husband at Yirtil, she took part in ceremony here, she hunted. When her husband got sick she stayed with him until he died and walked alone for four days back to Japirnka. Eventually she settled at Cherrabun station where she worked as a domestic. Her Kartiya name, Honeychild, was given to her by the station manager at Cherrabun.

She did not start painting until the mid 1980s when she attended classes at Karrayili Adult Education Centre with her second husband, Boxer Yankarr (1930–1999). Since she started painting, her work has been included in many major collections. She is one of the key senior artists working through **Mangkaja Arts** Resource Agency based in Fitzroy Crossing. She is also one of the artist claimants who contributed to the *Ngurrara Canvas.* KD

See also: 10.2, 23.2; *270.*

Mangkaja Arts Resource Agency, *Ngarri muay ngindaji = Ngajukura ngurrara minyarti = Ngindaji ngarragi riwi = Ngayukunu ngurra ngaa = This is My Country,* Fitzroy Crossing, WA, 1994; Ryan, J. with Akerman, K., *Images of Power: Aboriginal Art of the Kimberley,* Melbourne, 1993.

YARINKURA, Lena (1961–), Rembarrnga–Kune fibre artist. Lena Yarinkura's innovative, woven sculptures have taken Arnhem Land (NT) fibre-work in a totally new direction. Originally she learnt how to make the con-ventional range of twined basketry from her mother, but soon began experimenting with different shapes and stitch combinations. Later, through her collaborative partner-ship with artist-husband Bob **Burruwal,** Yarinkura developed her bark painting and carving skills, which stimulated her work with fibre. By 1994 she was producing life-size figures of paperbark over-bound with string, and the first major installation of this type was awarded the Wandjuk Marika Memorial Three-Dimensional Award at the 1995 NATSIAA. A second group was highly com-mended at the NIHAA (Canberra, 1995).

The manufacture of decorated bark sculpture does have a precedent in the men's bark *raŋga* (sacred objects) and the small spirit dolls held by women in Mularra ceremonies. How-ever Yarinkura's large mythological sculptures are unique. With continued experimentation Yarinkura has adapted twined basketry techniques to the crafting of sculptural forms.

In 1997 Yarinkura was again awarded the NATSIAA Wandjuk Marika Memorial Award and has since created a variety of pandanus sculptures in a range of forms—spirit figures, mermaids, dogs, and crocodiles—to illustrate the stories that belong to her and her husband. Her works have been included in many group exhibitions, including the touring exhibitions 'Aboriginal Women's Exhibition' (AGNSW 1991) and 'Maningrida—The Language of Weaving' (AETA 1995). Her works are also held in major Australian public collections including the AGNSW, MCA, NGA, NGV, and ANMM.

MW

See also: 17.1, 17.3; art awards and prizes; *214*.
Evans, J., 'New Directions: Lena Yarinkura's Yawkyawk Spirits', *artonview*, no. 20, Summer 1999–2000.

YIRAWALA, Billy (1903–1978), Kunwinjku bark painter. Yirawala's art represents the apex of the achievement of western Arnhem Land bark painters. One of the most prolific and inventive of Arnhem Land artists, he grew up in a traditional manner on his clan lands at the mouth of the Liverpool River in the Marrkolidban region and on the lands of adjoining clans. Later he spent time at Minjilang (Croker Island), at Gunbalanya (**Oenpelli**), and at **Maningrida**. His early work was collected by Karel Kupka, who visited Croker Island in the early 1960s when a school of artists were painting images of *mimih* spirits, sorcery, and love-magic subjects there. Yirawala's paintings of this time are very similar to those by artists such as **Midjawmidjaw** and Namatbara. They show lithe stick figures in dynamic poses, dancing or making love. The love-magic paintings often involve the enlargement of sexual organs, exaggeration of limbs, and entwined poses that local people find very funny. Yirawala's distinguishing feature is his skill with figures. The interior infill is relatively plain, consisting mainly of thin red lines that depict skeletal elements of the figures, joint marks, or areas of simple red hatched decoration.

From the late 1960s Yirawala had a close association with the collector Sandra Le Brun Holmes. In 1971, with Holmes's assistance, he was offered a solo exhibition at the University of Sydney, which then toured other Australian venues. In the same year he was awarded an MBE and received the International Co-operation Art Prize. Holmes's collection of Yirawala's work reveals his genius in depicting the full range of stories of the western Arnhem Land region in new and exciting ways. Yirawala wanted his paintings to allow a white audience to understand the powers of the region's ancestral beings and the depth of contemporary Aboriginal ceremonial life.

Yirawala's extensive series of paintings referring to the Mardayin, Lorrkkon, and Wubarr ceremonies is innovative in combining depictions of the subjects of the works with infill patterns taken from body designs worn by the dancers who act these beings in ceremony. For example, his paintings of Mardayin subjects such as Lumaluma or Mardayin initiates include the multicoloured cross-hatched designs called *rarrk* which are worn in these ceremonies, while his painting of Wubarr initiates includes the dotted circles called *kunmed* worn in this ceremony. Yirawala went on to enliven his paintings with variations in *rarrk* patterning. His best works crackle with the visual dynamism and energy evoked through surprising combinations of different coloured cross-hatching, dotted sections, and shapes infilled in full colour. He inspired artists like Peter **Marralwanga** to make use of *rarrk* designs in the same way, so that multicoloured cross-hatching is now the common decorative style in western Arnhem Land painting.

Late in his life Sandra Le Brun Holmes helped Yirawala establish an outstation at Marrkolidban. Following Yirawala's wishes, the Holmes collection, which she documented in two major publications, was kept together as a record of western Arnhem Land traditions and purchased as a whole by the NGA after Yirawala's death. In 1982 one of these bark paintings was chosen for the Australian 27 cent stamp commemorating the NGA's official opening. Reproductions of Yirawala's work can be seen in Le Brun Holmes's two monographs on the artist. Yirawala's paintings are held in the NGA and Australian State galleries as well as in the Kluge–Ruhe Collection at the University of Virginia. LT

See also: 5.2; bark painting.
Le Brun Holmes, S., *Yirawala: Artist and Man*, Milton, Qld., 1972;
Le Brun Holmes, S., *Yirawala: Painter of the Dreaming*, Sydney, 1992.

Yirrkala artists, see Buku-Larrnggay Mulka.

Yothu Yindi is a kinship-related term meaning 'child–mother' in the *matha* (**languages**) of Yolngu people of northeastern Arnhem Land (NT). It signifies not only a particular relationship of people to each other but also more inclusively it signifies the relationships of people to their social, cultural, physical, and spiritual environments. Basing itself philosophically on the recognition of such multi-layered and interrelated relationships, the popular music group Yothu Yindi has had a lengthy and successful international career. Its members are, at one and the same time, recording artists, cultural ambassadors, live performers, and entrepreneurs.

The group has also become a symbol of complex and often contentious political issues in contemporary Australian society, such as the role and value of Aboriginal perspectives on land, lore, and language. Although sometimes stereotyped by mainstream media as representing a kind of pan-Aboriginal culture or perspective, it has always been rooted in quite specific local and regional concerns arising from the early involvement of Yolgnu peoples in **land rights** issues in the Northern Territory and also the specific and long-standing involvement of key members of Yothu Yindi in Aboriginal and non-Aboriginal politics and law.

The music (and stage performance) of Yothu Yindi can be characterised as imaginative and diverse. Musically, they combine Aboriginal song forms (such as *djatpaŋarri*), *biḻma* (clap sticks) and *yidaki* (**didjeridu**) with Western forms and instrumentation. Thematically, they write songs about where they live, about community concerns, and more global notions of what it is to be an Indigenous person. Linguistically, they sing in Yolgnu *matha* and Australian English. They tour extensively and are featured on **television** and **radio,** and in the print media in Australia and overseas. Ideologically, they promote the potential for Aboriginal and non-Aboriginal Australians to work together by drawing on the strengths of each while recognising and respecting differences.

The notion of mutually beneficial collaboration is lived out: Yothu Yindi has always had both Aboriginal and non-Aboriginal members. Along with Yolgnu and other Aboriginal members, Anglo-Australians, Papua New Guineans, and an Afro-American have made key contributions to shaping an identifiable musical sound to complement Yothu Yindi's distinctive visual image. Similarly, they have collaborated with Anglo-Australian songwriters. They work with experienced non-Indigenous music producers who help to present their music in the latest styles and technology.

408. Yothu Yindi, 1998.
Centre: Mandawuy Yunupingu. Clockwise from top right: Malngay Yunupingu, Stuart Kellaway, Makuma Yunupingu, Jodie Cockatoo, Yomunu Yunupingu.

Importantly, they have embraced every technology or medium that can assist their goal of presenting Aboriginal culture through performing and visual arts.

Yothu Yindi has released albums and numerous singles, moving from the tentative musical and thematic explorations of *Homeland Movement* (1989) to the progressively more assured polish and focus of *Tribal Voice* (1991), *Freedom* (1993), and *Birrkuta-Wild Honey* (1996). Songs such as *Treaty*, *Tribal Voice*, *Djapana*, *Timeless Land*, and *Our Generation* are presented in varied popular musical styles. However, the combination of identifiably Aboriginal instrumentation and themes, and the distinctive vocals of lead singer and spokesman Mandawuy Yunupingu, creates consistency rather than repetitiousness in the songs and the albums. Traditional songs have always been included in recordings and stage shows and their presence has helped introduce non-Aboriginal audiences to the aesthetics of Yolngu forms of traditional Aboriginal vocal and instrumental music.

The packaging of Yothu Yindi products is sophisticated, with award-winning design work and informative liner notes. The music, artwork, and marketing of Yothu Yindi recordings and live performances have set the benchmark for other Australian Indigenous musicians. They have also done remixes, filmed videos, contributed to documentaries, and marketed themselves on the Internet. They have realised and exploited the cross-marketing potential of the world music market. They also have a strong commitment to foster artistic expression in the Yolngu community. The Yothu Yindi Foundation is an explicit example of that commitment.

Yothu Yindi has arguably been the most successful Aboriginal group to date in combining the business of music and the business of culture. A cultural agenda has been facilitated by a musical one, and vice versa. Its arrival at a particular moment in Australian history, when Indigenous rights were being publicly debated and some gains had been made, is an accident of history it was able to exploit to further its members' various agendas and aspirations. Their long-term and well-organised commitment to Indigenous rights, and their considerable accomplishments in the often fickle and fleet-ing world of the international entertainment industry, mark them as true pioneers. They have successfully presented a wide range of Aboriginal culture to the nation and the world while at the same time creatively presenting music (and dance) full of meaning, dignity, and depth. KN

See also: 1.2, 4.6, 6.1, 15.1, 15.2, 23.1 **Yunupingu family**; *269*, *408*.

YOUNGI, Kalboori (*c.*1900–?) Pitta Pitta sculptor. According to the scientist R. H. Goddard, who acquired a collection of Kalboori Youngi's sculptures when visiting a cattle station near Boulia on a trip to Queensland in 1936, the artist, then aged about thirty-two, was a genius of international significance. Yet, he added, this member of the Pitta Pitta ('virtually a tribe of hereditary artists') had never left her home in far west Channel Country nor seen any art that could have influenced her style before she began carving in about 1930. Her only link with white society was through occasional visits to station properties for supplies, he claimed, unaware that her carvings had been on sale in the bar of the Boulia Hotel from about 1934. Dr F. W. Whitehouse acquired two from the publican in 1937. Youngi was then living alone in a 'lean-to shelter of bark and tin on a cattle station in the Boulia district' and seemed 'of indefinite age' to F. P. Woolston, who purchased 'a small sphinx-like figure' from her for two shillings (later accidentally smashed). She was perhaps close to death; all her known work was made before 1939.

Extant examples of Youngi's remarkable little clay and stone sculptures are approximately fifteen centimetres high and include animals, a stockman with his horse (unusual in its depiction of a non-Aboriginal subject), a man holding a cockatoo walking between a horse and a dog, and many female figures, both as individuals and in groups. Her full-length figures stand, sit, or kneel in a variety of poses, including—to cite but a few of the kneelers—a man holding a goanna in a container, a woman rocking her baby, and a very thin, mournful old woman. The groups display lively social

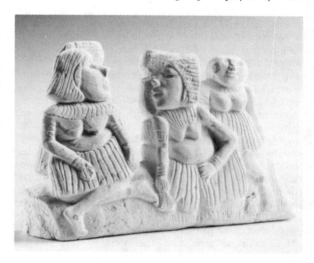

409. Kalboori Youngi, *Five Women*, c.1936.
Painted limestone, 20.5 x 8 x 14.5 cm height 13 cm.

interaction with minimal means. One of her most elaborate works is only thirteen centimetres high but brings to life a highly individualistic party of five women relaxing while out hunting for food. This piece is now in the NMA Collection. This is not ceremonial art but witty memorialising of people, events, and animals from Youngi's everyday life.

When Goddard exhibited his collection at Rubery Bennett's Sydney art gallery in November–December 1936, anthropologists and art critics alike hailed the sculptures as 'work of creative genius'. Melbourne University's Dr Leonhard Adam compared them to early Chinese sculptures. Their 'primitive, formalised style' recalled the art of ancient Egypt and Assyria to the *Sydney Morning Herald*'s art critic: 'they attain an emotional force and sincerity which twentieth century artists have often sought to imitate, in turning back to primitive sources for inspiration, but ... have never entirely recreated.' Even the cynical, racist *Bulletin*, highly amused that 'a middle-aged lady' who did carvings for 'baccy' could be linked to modernists like Epstein and the 'primitive' arts of Babylon and Egypt, 'unhesitatingly' acclaimed her 'the most essentially Australian artist it has yet struck'.

Youngi thus disrupted conventional ideas about the abilities and repertoire of Aboriginal women artists, and her success seems to have inspired other Pitta Pitta. In 1939 Mrs Watts of Ardmore station at Dajarra, south-west of Cloncurry, donated 'Two carvings in stone, using a penknife, executed by Nora Nathan (née Craigie, a half-caste Aboriginal woman—the wife of Byram Nathan' to the Royal Historical Society of Queensland. Three other sculptures closely comparable to Youngi's were presented to the AGNSW in 1948 by artist Margaret Preston, who reportedly purchased them from a station near Dajarra, probably during her extensive Australian tour of 1940–44. Two were by Nathan and one was by her mother, Linda Craigie, who may have been Youngi's cousin. In 1941, when Arthur Douglas of Cloncurry was presented with a collection of Nathan's work, the artist was known to be at Dajarra.

Interviewed in extreme old age when living at Mount Isa with her family, Craigie spoke of being Pitta Pitta but not of any artistic activities. Even Youngi's work was soon forgotten, except by Roman Black who featured examples from the Goddard collection in his 1964 book. This inspired Colliver and Woolston to make casts in 'Dental Stone' of a collection of similar figures in a private Brisbane collection said to be by a lesser Youngi emulator, 'Boulia Bob'. Apparently a contemporary of Nathan's, Bob's carvings were also made from the local gypsum, or kopi, but his works are less inventive in design and coarser in technique than known works by any of the women sculptors. Some of these casts are in the Colliver Collection at the QM along with the two Youngi figures from the Boulia Hotel. In 1976 Mel Ward donated seven Boulia figures to the AM that had been in his private museum in the Blue Mountains of New South Wales for years. They also look like Boulia Bob's work.

Public interest in such innovative Aboriginal art really only began to emerge after Peter Sutton included Youngi works from the SAM in his 1988 'Dreamings' exhibition and book. Today they are, once again, valued as internationally significant art. Goddard's collection has been transferred to the NMA from the Australian Institute of Anatomy, where his son lodged it in 1985, while QAG acquired the Historical Society's Nathan sculptures on permanent loan in 1999.

JAK

See also: 8.2; *409*.

Black, R., *Old and New Australian Aboriginal Art*, Sydney, 1964; Colliver, F. S. & Woolston, F. P., 'Anthropological Notes from Queensland—II', *Queensland Naturalist*, vol.18, nos 3–4, June 1967; Goddard, R. H., 'Aboriginal sculpture', *ANZAAS Report*, vol. 24, January 1939; Kerr, J., 'Kalboori Youngi' and 'Nora Nathan', in J. Kerr (ed.), *Heritage: The National Women's Art Book*, Sydney, 1995.

Yuendumu artists, see **Warlukurlangu.**

YUKENBARRI, Lucy Napanangka (*c.*1934–), Wangkajunga artist, comes from country that extends along the area now known as the Canning Stock Route to Jupiter Well and Well 33, including such sites as Mappar, Piyulpa, Winpupulla and Wirtjinti. Her husband is Joey Helicopter Tjungurrayi (*c.*1937–). His country includes Kurtal (White Hills), Wallawarra and Manga Manga, south-west of **Balgo**. Helicopter painted under his own name of Joey Tjungurrayi in the early years of Balgo art. In the early 1990s he painted with his wife, in those years not seeking acknowledgment of his hand in the canvases.

Yukenbarri is known among the Balgo artists for having invented a new style of dotting called *kinti-kinti* (close-close) in 1990, soon after she began to paint. Her early works followed the standard Balgo methods of forming lines by means of rows of dotting, and of outlining icons in a similar way. A quietly creative artist, she then moved to another technique in use by other Balgo painters at that time—single colour fields of dotting—but she alone made a next step of moving the dots so closely together that they converged, creating dense masses of pigment on the surface of the canvas. This, together with her exploration of the visual possibilities of black icons for waterholes and soaks, and her use of dark green and blue pigments, gave her work a distinctive style, producing effects unique in desert Aboriginal art. As a result, her work became sought after in the market place. It was exhibited at Birrukmarri Gallery in Fremantle in 1990, at the Aboriginal Arts Australia Gallery in Sydney, and featured prominently in 'Images of Power' (NGV 1993).

By 1994, Helicopter was painting on his own once more. He now has a major following for his works. He has continued to use the *kinti-kinti* style of dotting pioneered by his wife, but works in a different palette of colours to produce bold compositions based on flowing linear elements. These contrast with Yukenbarri's compositions, with their greater use of blocks of colour.

Yukenbarri's works are held in the collections of the NGV, and the Holmes à Court Collection, Heytesbury (WA). The work of both artists is held in the Kluge–Ruhe Collection of Aboriginal Art at the University of Virginia.

CW

See also: 9.5; **Warlayirti Artists.**

Cowan, J., *Wirrimanu: Aboriginal Art from the Balgo Hills*, Roseville East, 1994; Ryan, J. with Akerman, K., *Images of Power: Aboriginal Art of the Kimberley*, Melbourne, 1993.

YULIDJIRRI, Thompson (*c*.1930–) Kunwinjku painter, is one of the most senior artists working at Gunbalanya (**Oenpelli,** NT). He became prominent in the 1970s and 1980s, particularly for his paintings of the brolgas that frequent the freshwater floodplains surrounding Oenpelli. Yulidjirri captured the sinuous forms of these majestic birds as they bent down to eat the corms of the rushes that are their primary food. His wider skills became especially apparent in 1991–92, after the American collector John W. Kluge commissioned Oenpelli artists to produce works on paper. Yulidjirri depicted major ceremonies, such as Wubarr, that are no longer performed, and important sites where he had lived in his youth.

For example, his painting *Nimbuwah: The Sacred Dreaming,* 1991 depicts a story associated with a towering rock feature east of Oenpelli. Yulidjirri had lived in caves at its base, and was taught to represent the actions of Nimbuwah, Warramundud, and Djiribidj—the spirit beings that created the features of the site. In this creation story, Nimbuwah rock is understood to be the transformed body of Nimbuwah who was decapitated in a fight with Djiribidj. Yulidjirri painted the forms of the landscape in elevation and used the x-ray technique to show the ancestral beings inside the rock in order to suggest the site's spiritual associations. Another painting in the group, *The Ubar (Wubarr) Ceremony,* 1991 is a major work depicting the multitude of dancers, ancestral species, and sacred objects associated with the performance. The Kluge commission led a generation of younger artists to paint on paper, and through Yulidjirri's participation they came to understand the details of Wubarr, although they had never seen a performance. The works from the Kluge commission are now in the Kluge–Ruhe Collection at the University of Virginia. LT

See also: 5.2; **Injalak Arts and Crafts.**
Dyer, A. (ed.), *Kunwinjku Art from Injalak 1991–92: The John. W. Kluge Commission,* North Adelaide, 1994.

YUNUPINGU family, artists, musicians, and cultural ambassadors. Yunupingu is the family name of one of the Gumatj (Yolngu) clans of north-eastern Arnhem land (NT). It is the only family in Australia to number two Australians of the Year among its members: the award went to Galarrwuy Yunupingu (1948–) in 1978, and to his younger brother Mandawuy (1956–) in 1992. Their father, Munggurrawuy Yunupingu (*c*.1907–1978), was the senior elder of the clan during a critical period in the history of the Yolngu-speaking peoples. He was one of their leaders in their fight for **land rights** when tenure of their land was threatened by mining interests in the 1960s and 1970s, and was a contributor to the Yirrkala Bark Petition. Munggurrawuy was one of the first artists to produce **bark paintings** for sale to the missionary Wilbur Chaseling in 1935, and later contributed to Stuart Scougall's Collection for AGNSW. He helped to develop the episodic-narrative style of paintings characteristic of Yolngu art from the 1960s to the 1980s, and was one of the Yirritja moiety artists who contributed to the Yirrkala Church panels. He was a prolific painter until the end of his life, and established a productive relationship with the Melbourne art dealer James (Jim) Davidson who sold many of his paintings.

Munggurrawuy was also a significant carver, in particular of Wuraymu mortuary figures, and collections of these are in the NMA and the Berndt Museum (UWA).

Galarrwuy Yunupingu is one of Australia's leading Aboriginal politicians and Chairman of the Northern Land Council. He was one of the painters of the Barunga Statement. Mandawuy Yunupingu is the founder and lead singer of the rock group **Yothu Yindi.** Their sister Gaymala Yunupingu (*c*.1935–) is a renowned artist. While her use of colour in her paintings remains close to her father's practice, Gaymala has developed a bold and expressionistic style of figurative representation which makes her work easily recognisable. She has become one of the leading printmakers at **Buku-Larrnggay Mulka** Arts.

Munggurrawuy's younger brother Bununggu (*c*.1919–1969) was less prolific as an artist. He is best known for works done jointly with his brother such as *Lanytjung Story No. 1* in the collections of the AGNSW. However perhaps his most extraordinary achievement is the series of crayon drawings on butcher's paper that he produced for anthropologists Ronald and Catherine Berndt in 1946–47, now in the Berndt Museum (UWA). These works, many of which explore the Yirritja moiety Macassan mythology, reveal a strong sense of colour and compositional balance. Two of his sons Lumaluma Yunupingu (1941–1985) and Miniyawany Yunupingu (1948–) became well known artists. Lumaluma produced intricate and detailed composite carvings exemplified by *The Spirit's Journey* 1984 trilogy, comprising two sculptures and a bark painting now held in the NGA. Miniyawany has produced a number of very large bark paintings and hollow log coffins. His *From Biranybirany,* included in the touring 'Saltwater' exhibition (1999–2001) typifies his finest work, with its intricate combination of figurative representations and Gumatj clan diamond patterns. HM

See also: 1.1, 1.2, 4.6, 6.1, 23.1; *32, 39, 50, 76, 269, 408, 410.*
Groger-Wurm, H., *Australian Aboriginal Bark Paintings and Their Mythological Interpretations,* vol. 1, *Eastern Arnhem Land,* Canberra, 1973; Buku-Larrnggay Mulka Centre, *Saltwater: Yirrkala Bark Paintings of Sea Country,* Neutral Bay, NSW, 1999.

410. Gaymala Yunupingu, *Djirikitj Wanga,* 1997. Linocut, 26 x 38 cm print, 38 x 59 cm sheet.

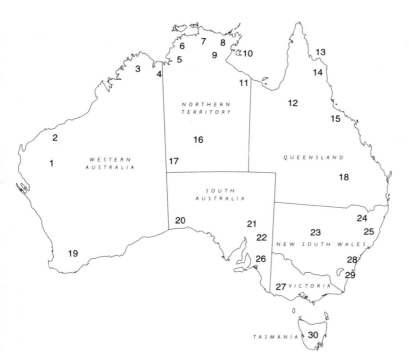

Map 1 Australia

Regional Maps

1. Ashburton / Lyons / Gasgoyne
2. Pilbara
3. Western Kimberley
4. Eastern Kimberley
5. Victoria River
6. Litchfield / Daly River
7. Kakadu / Western Arnhem Land
8. Central / North-eastern Arnhem Land
9. Southern Arnhem land
10. Groote Eylandt
11. Gulf Country
12. North Queensland Highlands
13. Princess Charlotte Bay
14. Laura
15. Mid-North Queensland Coast
16. Central Desert
17. Western Desert
18. Central Queensland Highlands
19. South-west Australia
20. Nullarbor
21. Flinders Ranges
22. Olary
23. Cobar
24. New South Wales Western Slopes
25. New South Wales Northern Tablelands
26. South-east South Australia
27. Grampians
28. Sydney-Hawkesbury
29. Shoalhaven
30. Tasmania

Regional Maps

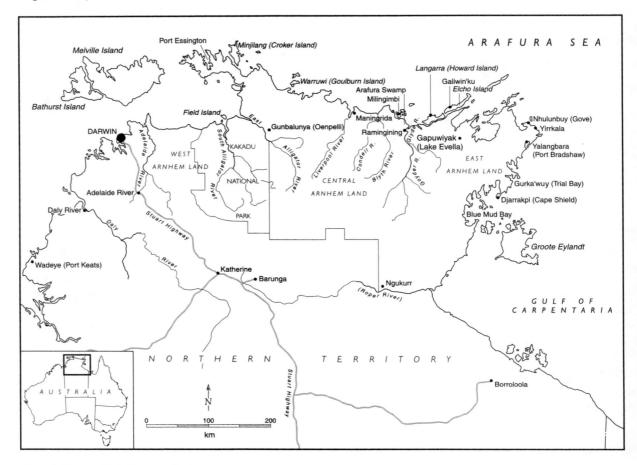

Map 2 The 'Top End' (Northern Territory)

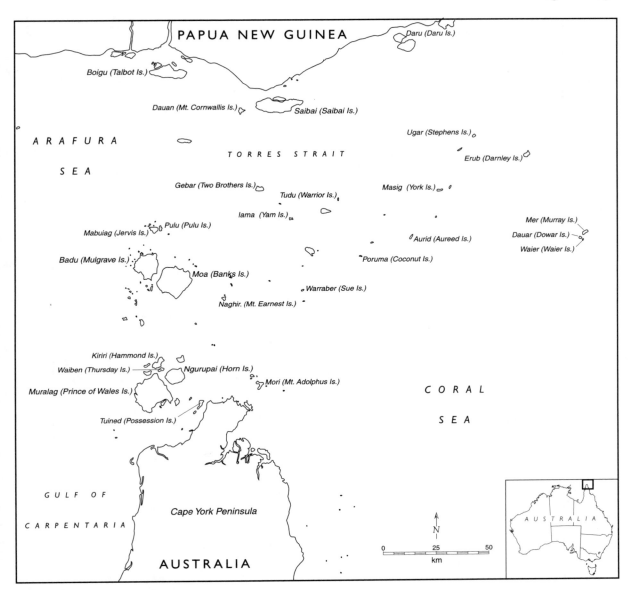

PAPUA NEW GUINEA

Daru (Daru Is.)

Boigu (Talbot Is.)

Dauan (Mt. Cornwallis Is.)　　Saibai (Saibai Is.)

A R A F U R A

S E A

Ugar (Stephens Is.)

T O R R E S　S T R A I T

Erub (Darnley Is.)

Gebar (Two Brothers Is.)

Masig (York Is.)

Tudu (Warrior Is.)

Iama (Yam Is.)

Mer (Murray Is.)

Pulu (Pulu Is.)

Mabuiag (Jervis Is.)

Aurid (Aureed Is.)

Dauar (Dowar Is.)

Waier (Waier Is.)

Badu (Mulgrave Is.)

Poruma (Coconut Is.)

Moa (Banks Is.)

Warraber (Sue Is.)

Naghir. (Mt. Earnest Is.)

Kiriri (Hammond Is.)

Waiben (Thursday Is.)　　Ngurupai (Horn Is.)

Mori (Mt. Adolphus Is.)

Muralag (Prince of Wales Is.)

C O R A L

S E A

Tuined (Possession Is.)

G U L F　O F

C A R P E N T A R I A

Cape York Peninsula

N

AUSTRALIA

0　　25　　50
km

A U S T R A L I A

Map 3　Torres Strait

747

Regional Maps

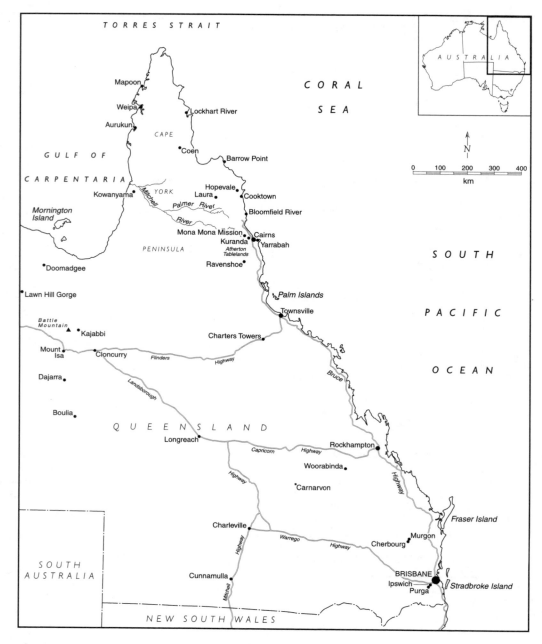

TORRES STRAIT

CORAL SEA

Mapoon

Weipa

Lockhart River

Aurukun

CAPE

Coen

GULF OF

Barrow Point

CARPENTARIA

YORK

Hopevale

Laura

Cooktown

Kowanyama

Mitchell

Palmer River

Bloomfield River

River

Mornington
Island

PENINSULA

Mona Mona Mission

Kuranda

Cairns

Yarrabah

Atherton
Tablelands

Ravenshoe

Doomadgee

Palm Islands

Lawn Hill Gorge

Townsville

Battle
Mountain

Kajabbi

Charters Towers

Mount
Isa

Cloncurry

Flinders

Highway

Bruce

Dajarra

Landsborough

Boulia

QUEENSLAND

Longreach

Capricorn

Highway

Rockhampton

Woorabinda

Carnarvon

Highway

Fraser Island

Charleville

Murgon

Highway

Warrego

Highway

Cherbourg

SOUTH
AUSTRALIA

BRISBANE

Cunnamulla

Mitchell

Ipswich

Purga

Stradbroke Island

NEW SOUTH WALES

AUSTRALIA

SOUTH

PACIFIC

OCEAN

N

0 100 200 300 400
km

Map 4 Queensland

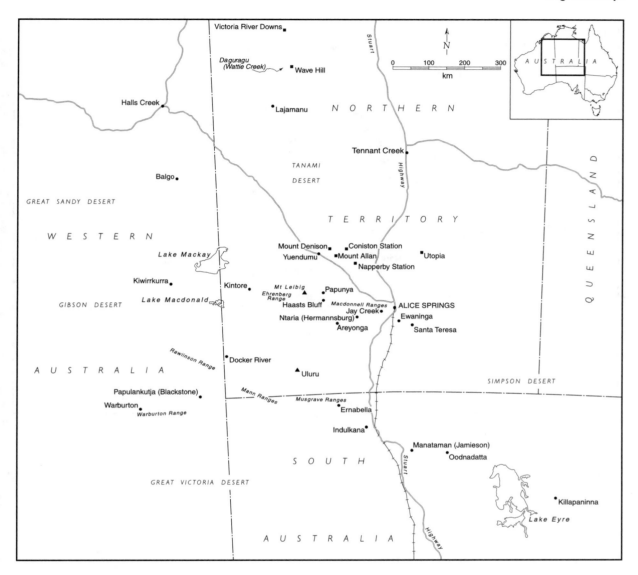

Map 5 Central Australia

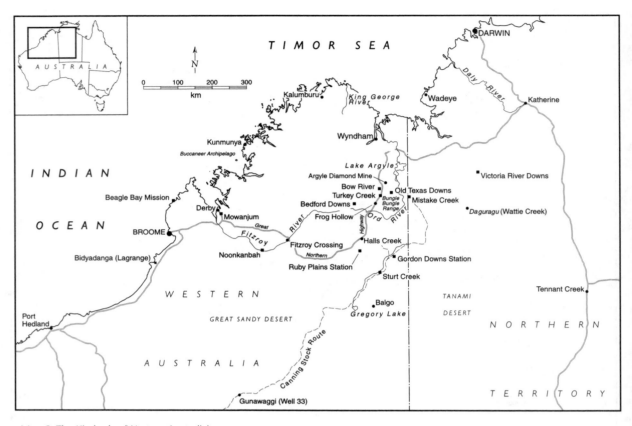

Map 6 The Kimberley (Western Australia)

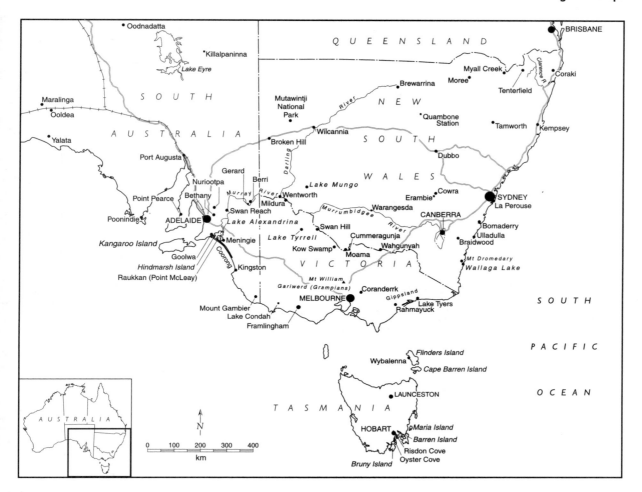

Map 7 South-east and South Australia

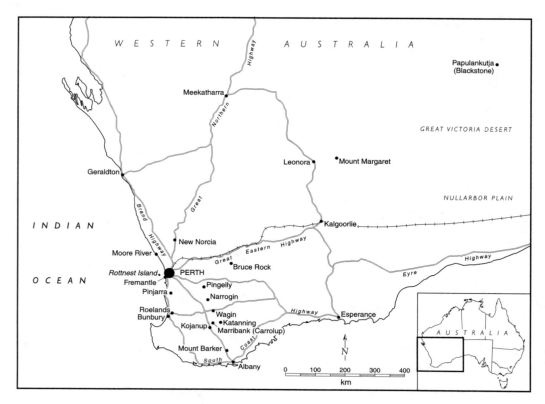

Map 8 The south-west (Western Australia)

Illustration Acknowledgments

The authors and publisher would like to thank the following individuals, institutions and companies for giving us permission to reproduce their material.

Photo credits
1. C+ BUS-The Construction and Building Industry Super Fund, 'Friendly Country—Friendly People' exhibition collection, on loan to Museum Victoria. 2. National Gallery of Australia. Courtesy Roslyn Oxley9 Gallery. 3. National Museum of Australia. Photo: Matt Kelso. Reproduced with permission of Injalak Arts and Crafts Association Inc. Oenpelli. 4. Hagenauer papers, MS 9556, Australian Manuscripts Collection, State Library of Victoria. 5. Lutheran Church of Australia, Archives and Research Centre, Adelaide. Reproduced with permission of the artist's family. 6. South Australian Government Grant 1957 578PA35 and 701PA46. Art Gallery of South Australia, Adelaide. Reproduced with permission of Aboriginal Artists Agency. 7. Photo: Ronald Berndt. Courtesy the Berndt Museum of Anthropology, The University of Western Australia. Reproduced with permission of Elcho Island Art and Craft, Galiwin'ku. 8. Reproduced from Michael Archer and Tim Flannery, *Kangaroos*, Kevin Weldon, McMahon's Point, NSW 1985. Photo: Jean-Paul Ferrero, Auspace. 9. Tasmanian Museum and Art Gallery. 10. A.C. Haddon *Reports of the Cambridge Anthropological Expedition to Torres Strait* 1904. vol V: p. 249. fig.32. Reproduced with permission of Torres Strait Regional Authority, Thursday Island. 11. Photo: Judith Fitzpatrick. 12. Photo: Judith Fitzpatrick. 13. Photo: Judith Fitzpatrick. 14. Photo: Darrell Lewis. 15. Photo: Deborah Bird Rose. 16. Photo: Peter Read. 17. Photo: Christine Watson. 18. Photo: Christine Watson. 19. Based on a drawing by Christine Watson. 20. Private collection. Reproduced with permission of Warlayirti Artists, Balgo. 21. Photo: Catherine Rogers. 22. National Gallery of Australia, Canberra. Reproduced with permission of Mutijulu Community Inc. Uluṟu–Kata Tjuṯa National Park. 23. *West Australian*, 18 April 1989. 24. Private collection. Reproduced with permission of Artplace, Perth. 25. Based on Howard Morphy, *Ancestral Connections: Art and an Aboriginal System of Knowledge*, Chicago, 1991, fig. 8.16. 26. Queensland Museum. 27. Photo: Annette Hamilton. Reproduced with permission of Maningrida Arts & Culture, Maningrida. 28. Photo: Annette Hamilton. Reproduced with permission of the Central Land Council, Alice Springs. 29. Installation © South Australian Museum and Warlukurlangu Artists Association. 30. Reproduced with permission of the National Library of Australia. 31. Reproduced with permission of Buku-Larrnggay Mulka Art Centre, Yirrkala. 32. Reproduced with permission of Buku-Larrnggay Mulka Art Centre, Yirrkala. 33. Photo: Franca Tamisari. 34. Gift of Patricia Stanner, in memory of W. E. H. Stanner, to the Stanner Collection, University House, The Australian National University, Canberra. 35. Courtesy The Holmes à Court Collection, Heytesbury. Reproduced with permission of Duncan Kentish Fine Art, Adelaide. 36. Museum and Art Gallery of the Northern Territory, Darwin. Reproduced courtesy Legend Press, Sydney. 37. Private collection. Courtesy Sotheby's Australia. Reproduced with permission of Abori-ginal Artists Agency. 38. Purchased with the assistance of funds from National Gallery admission charges and commissioned 1987. National Gallery of Australia, Canberra. Reproduced with permission of Bula'Bula Arts, Ramingining. 39. Photograph courtesy of the Parliament House Art Collection, Joint House Department, Canberra. Reproduced with permission of Northern Land Council, Darwin and the Central Land Council, Alice Springs. 40. Courtesy Mori Gallery, Sydney. © Judy Watson 1997/Licensed by VISCOPY, Sydney 2000. 41. Purchased from Gallery admission charges 1988. National Gallery of Australia, Canberra. Reproduced with permission of the artist. 42. Reproduced with permission of Caltex Australia Petroleum Pty Ltd. 43. Photo: Screensound Australia, Canberra. Reproduced with permission of Susanne Carlson and the H. C. McIntyre Trust c/- Curtis Brown (Aust) Pty Ltd. Sydney. 44. Photo: A/V Archives, AIATSIS. Reproduced with permission of the Young family. 45. Reproduced with permission of the National Philatelic Collection, Australia Post. 46. National Gallery of Australia, Canberra. Courtesy Brenda L Croft. ©Brenda L Croft 1988/Licensed by VISCOPY, Sydney 2000 47. Private collection. Reproduced with permission of the artist. 48. Courtesy the artist. Reproduced with permission of the artist. 49. National Gallery of Australia, Canberra. Courtesy Roslyn Oxley9 Gallery. 50. Original document of the House of Representatives. Photograph courtesy of the Parliament House Art Collection, Joint House Department, Canberra, ACT. Reproduced with permission of Buku-Larrnggay Mulka Art Centre, Yirrkala. 51. Photo: Noelene Cole. 52. Photo: Anthony Redmond. Reproduced with permission of Jervis/Ngarinyin Aboriginal Corporation. 53. Photo: Paul Taçon. 54. Photo: N. Paton © National Parks and Wildlife Service. 55. Kluge–Ruhe Collection, University of Virginia. Reproduced with permission of Injalak Arts and Crafts Association Inc. Oenpelli. 56. Aboriginal Arts Board. Reproduced with permission of Injalak Arts and Crafts Association Inc., Oenpelli. 57. Photo: Howard Morphy. 58. Photo: Axel Poignant Archive. 59.

Photo: Margie West, 1994. Reproduced with permission of Maningrida Arts and Culture, Maningrida. 60. Photo: Redmond/Ngarinyin Aboriginal Corporation. Reproduced with permission of Jervis/Ngarinyin Aboriginal Corporation. 61. Photo: Richard G. Kimber. 62. Gordon Darling Fund 1990. National Gallery of Australia, Canberra. Reproduced with permission of the artist's family. 63. Reproduced with permission of Avril Quaill. Courtesy Roslyn Oxley9 Gallery. 64. Gordon Darling Fund 1990. National Gallery of Australia, Canberra. Reproduced with permission of the artist. 65. Collection of the artist. Reproduced with permission of the artist. 66. Collection of the artist. Reproduced with permission of the artist. 67. Collection of the artist. Reproduced with permission of the artist. 68. Private collection. Reproduced with permission of Buku-Larrnggay Mulka Art Centre, Yirrkala. 69. Courtesy Mobil Yathalamarra Collection, Museum and Art Gallery of the Northern Territory, Darwin. Reproduced with permission of Bula'Bula Arts, Ramingining. 70. Courtesy the Berndt Museum of Anthropology, the University of Western Australia. Reproduced with permission of Aboriginal Artists Agency. 71. Purchased from Gallery admission charges 1983. National Gallery of Australia, Canberra. Reproduced with permission of Aboriginal Artists Agency. 72. Photo: D. F. Thomson. Courtesy Mrs D. M. Thomson, Museum Victoria. 73. Kluge-Ruhe Collection, University of Virginia. Reproduced with permission of Bula'Bula Arts, Ramingining. 74. Photo: J. Lewis. Reproduced with permission of the photo-grapher and Bula'Bula Arts, Ramingining. 75. Museum and Art Gallery of the Northern Territory, Darwin. Reproduced with permission of Elcho Island Art and Craft, Galiwin'ku. 76. Gift of the Commonwealth Government 1956. Art Gallery of New South Wales, Sydney. Photo: Ray Woodbury for AGNSW. Reproduced with permission of Buku-Larrnggay Mulka Art Centre, Yirrkala. 77. The University of New South Wales. Reproduced with permission from John Cawte, *The Universe of the Warramirri*, University of New South Wales Press, Sydney, 1993, p. 69 and Elcho Island Art and Craft, Galiwin'ku. 78. National Maritime Museum, Sydney. Reproduced with permission of Maningrida Arts and Culture, Maningrida. 79. Photo: Franca Tamisari. 80. Photo: Franca Tamisari. 81. Telstra Collection, Museum and Art Gallery of the Northern Territory, Darwin. Reproduced with permission of the artist. 82. Reproduced with permission of Karen Brown Gallery, Darwin. 83. University of Cambridge Museum of Archaeology and Anthropology. Reproduced with permission of Torres Strait Regional Authority, Thursday Island. 84. Reproduced from A. C. Haddon. (ed.), *Reports of the Cambridge Anthropological Expedition to the Torres Strait*, Cambridge University Press, Cambridge, vol IV, 1912, pp. 384-5. Reproduced with permission of Torres Strait Regional Authority, Thursday Island. 85. © The British Museum. Reproduced with permission of Torres Strait Regional Authority, Thursday Island. 86. University of Cambridge Museum of Archaeology and Anthropology. Reproduced with permission of Torres Strait Regional Authority, Thursday Island. 87. University of Cambridge Museum of Archaeology and Anthropology. Reproduced with permission of Torres Strait Regional Authority, Thursday Island. 88. Collection: Centre Culturel Jean-Marie Tjibaou, Nouméa. Reproduced with permission of the artist. 89. Photo: Jeremy Beckett. Reproduced with permission of the Saibai Island Community Council, Saibai Island. 90. Centre Culturel Jean-Marie Tjibaou, Nouméa. Reproduced with permission of the artist. 91. Collection of the artist. Reproduced with permission of the artist. 92. Private collection. Reproduced with permission of the artist. 93. Private collection. Reproduced with permission of the artist. 94. Collection of the artist. Reproduced with permission of the artist. 95. Travis Teske Collection, Queensland Museum. Reproduced with permission of the artist. 96. Gift of Dr Stuart Scougall 1959, Art Gallery of New South Wales, Sydney. Photo: Jenni Carter for AGNSW. Reproduced with permission of Munupi Arts & Crafts Association, Pirlangimpi/ Pularampi. 97. Nature Focus, Australian Museum 98. Photo: A. Atkinson, courtesy Cairns Historical Society Collection, A/V Archives, AIATSIS. 99. Courtesy Mrs D. M. Thomson, Museum Victoria. Reproduced with permission of Aurukun Shire Council, Aurukun. 100. © South Australian Museum and National Museum of Australia, Canberra. Reproduced with permission of the Aurukun Shire Council, Aurukun. 101. Purchased 1983 Queensland Art Gallery Society, Queensland Art Gallery. Reproduced with permission of the artist's family. 102. The Australian National University, Canberra. Reproduced with permission of the artist's family. 103. Photo: Peter Hohermuth. Reproduced with permission of Jennifer Isaacs. 104. Photo: E. Furniss. 105. Courtesy of the Public Record Office, London, and reproduced by permission of the National Library of Australia, Canberra. 106. Courtesy Public Record Office, London and reproduced by permission of the National Library of Australia, Canberra. 107. Courtesy Doris Yuke Collection. 108. Queensland Museum, Brisbane. 109. Queensland Museum, Brisbane. 110. Courtesy Bob Anderson. 111. Ngurratjuta/Pmara Ntjarra Aboriginal Corporation, Alice Springs. Courtesy of Legend Press, Sydney. 112. Museum and Art Gallery of the Northern Territory, Darwin. Reproduced with permission of the artist's family. 113. Museum and Art Gallery of the Northern Territory, Darwin. ©Cordula Ebatarinja, ND/Licensed by VISCOPY, Sydney, 2000. 114. © South Australian Museum and the artist's family. 115. Photo: Greg Weight. Reproduced with permission of the artist. 116. Photo: Greg Weight. Reproduced with permission of the artist. 117. Collection: Geoffrey Bardon. 118. Photo: Geoffrey Bardon. 119. Photo: Geoffrey Bardon. 120. Private collection. Courtesy Sotheby's Australia. Reproduced with permission of the Aboriginal Artists Agency. 121. © South Australian Museum, Adelaide and Warlukurlangu Artists Association. 122. Purchased through The Art Foundation of Victoria with assistance of CRA Limited 1989. National Gallery of Victoria, Melbourne. Reproduced with permission of Warnayaka Art Centre, Lajamanu. 123. Commissioned 1996 by QAG with funds from the Andrew Thyne Charitable Trust through and with assistance of the Queensland Art Gallery Association. Queensland Art Gallery, Brisbane. Reproduced with permission of Aboriginal Artists Agency. 124. Photo: Philip Batty. Reproduced with permission of the photographer. 125. Berndt Museum of Anthropology, University of Western Australia. 126. Berndt Museum of Anthropology, University of Western Australia. 127. Berndt Museum of Anthropology, University of Western Australia. 128. Berndt Museum of Anthropology, University of Western Australia. 129. Photo: Kim Akerman. 130. Purchased with the assistance of the VAC Fund of the Australia Council. Campbelltown City Bicentennial Art Gallery. Photo: Diane Moon. Reproduced with permission of

Waringarri Arts, Kununurra. 131. Photo: Kim Akerman. 132. Gift of Dr Ronald and Allison Fine 1994, Art Gallery of New South Wales, Sydney. Photo: Christopher Snee for AGNSW. Reproduced with permission of the artist. 133. Gordon Darling Fund 1991. National Gallery of Australia, Canberra. Reproduced with permission of the artist. 134. The Holmes à Court Collection, Heytesbury. Reproduced with permission of Mangkaja Arts, Fitzroy Crossing. 135. Private collection. Photo: courtesy Eric Kjellgren. Reproduced with permission of Red Rock Art, Kununurra. 136. National Gallery of Australia, Canberra. Reproduced with permission of Red Rock Art, Kununurra. 137. Photo: Kim Akerman. 138. Nature Focus, Australian Museum, Sydney. 139. Museum Victoria, Melbourne. Photo: Courtesy Museum Victoria Council. 140. Reproduced with permission of the State Library of New South Wales, Sydney. 141. Presented through the Art Foundation of Victoria by John and Jan Altmann, Founder Benefactors,˙ 1986. National Gallery of Victoria, Melbourne. 142. Private collection. Reproduced with permission of the artist's family. 143. Photo: Isabel McBryde. 144. Tyrell Collection, Powerhouse Museum, Sydney. 145. Tyrell Collection, Powerhouse Museum, Sydney. 146. © South Australian Museum. 147. Tasmanian Museum and Art Gallery, Hobart. Reproduced with permission of the artist. 148 Stan, Melvie and Gael Philips Collection, 1947-80. The Berndt Museum of Anthropology, University of Western Australia. 149. Design Christopher Pease. Photo: Ken Boase © *Aboriginal Independent Newspaper*, 3 September 1997. 150. Acquired by the Australian Government before 1970. National Gallery of Australia, Canberra. Reproduced with permission of Aboriginal Artists Agency. 151. National Gallery of Australia, Canberra. Reproduced with permission of Maningrida Arts and Culture, Maningrida. 152. Photo P. Taçon. 153. National Gallery of Australia, Canberra. Reproduced with permission of Mary Mácha, Subiaco. 154. Photo: Redmond/Ngarinyin Aboriginal Corporation, 1997. 155. Morven/Ruhe Collection, University of Virginia. ©Donkey Lee Tjupurrula Yata Yata Tjarinjpa, 1991/Licensed by VISCOPY, Sydney, 2000. 156. Presented through the Art Foundation of Victoria by Ginger Riley, Fellow 1999. National Gallery of Victoria, Melbourne. Reproduced with permission of Alcaston Gallery, Melbourne. 157. Photo: David Campbell. Reproduced with permission of Cairns Regional Gallery. 158. Collection of the artist. Photo: Tandanya Aboriginal Cultural Institute, Adelaide. Reproduced with permission of the artist. 159. Purchased with assistance of the VAC Fund of the Australia Council. Campbelltown City Bicentennial Art Gallery. Photo: Diane Moon. 1997. Reproduced with permission of the artist. 160. Purchased with the assistance of the Lou and Mary Seninni Fund, 1992. National Gallery of Victoria, Melbourne. Reproduced with permission of Maningrida Arts and Culture, Maningrida. 161. National Gallery of Australia, Canberra. Reproduced with permission of Boomalli Aboriginal Artists Cooperative, Annandale. 162. Photo: Franc Saule. Reproduced with permission of Boomalli Aboriginal Artists Cooperative, Annandale. 163. Art Gallery of New South Wales, Sydney. Photo Jenni Carter for AGNSW. © Lin Onus, 1991/Licensed by VISCOPY, Sydney 2000. 164. Museum Victoria, Melbourne. Courtesy Roslyn Oxley9 Gallery. 165. Collection the artist. Reproduced with permission of the artist. 166. Flinders University Art Museum, Adelaide. Reproduced with permission of the artist. 167 National Gallery of Australia, Canberra. © Mervyn Bishop, 1975/ Licensed by VISCOPY, Sydney 2000. 168. KODAK (Australasia) Pty Ltd. Fund 1990. National Gallery of Australia, Canberra. Reproduced with permission of the artist. 169. KODAK (Australasia) Pty Ltd. Fund 1997. National Gallery of Australia, Canberra. Courtesy Roslyn Oxley9 Gallery. 170. Purchased 1999. National Gallery of Victoria, Melbourne. Reproduced with permission of the artist. 171. Private collection. Reproduced with permission of Boomalli Aboriginal Artists Cooperative, Annandale. 172. *Sydney Morning Herald*, 28 January 2000. Photo. William Yang. Reproduced with permission of the photographer. 173. Centre Culturel Jean-Marie Tjibaou, Nouméa. Reproduced with permission of the artist. 174. Collection the artist. Reproduced with permission of the artist. 175. The Australian National University, Canberra. Reproduced with permission of the artist 176. Photo: Bob Tonkinson. Courtesy Ian Dunlop. 177. Courtesy Australian Film Institute, Melbourne. 178. Courtesy Blackfella Films. 179. Courtesy Warlpiri Media Association. 180. Photo: Juno Gemes. 181. see caption. 182. Reproduced with permission of Maningrida Arts and Culture, Maningrida. 183. Photographer unknown. Courtesy His Majesty's Theatre, Perth 184. Photo: Stephen Muecke. Reproduced with permission of the photographer from K. Benterrak, S. Muecke, & P. Roe (eds), *Reading the Country: An Introduction to Nomadology*, Fremantle Arts Centre Press, Fremantle, 1996 185. VPRS 1226/P Box 4 Item 4 W2858, 82/x, x1857. Reproduced with permission of the Keeper of Public Records. Public Record Office, Victoria. 186. Photo: Heather Goodall 187. Photo: Stephen Davis. 188. Photo: Allan Marett 189. Photo: Linda Barwick. Reproduced with permission of the artist. 190. Photo: Linda Barwick 191. Photo: Sarah Ogilvie 192. Photo: Bill Green 193. Photo: Chris Pavlich. 194. Photo: David Ellis. 195. Photo: Frank York 196. Private collection. Reproduced with permission of Maningrida Arts and Culture, Maningrida. 197. Photo: Allan Marett. 198. Photo: Allan Marett. 199. Photo: courtesy Kooemba Jdarra Theatre Company, Perth. 200. Photo: Heidrun Lohr. 201. Photo: Tracy Schramm. Courtesy Kooemba Jdarra Theatre Company, Perth 202. Photographer unknown. Courtesy His Majesty's Theatre, Perth. 203. Photo: Dominique Bernard 204. Courtesy: Munupi Arts & Crafts, Pirlangimpi/Pularampi. © Thecla Puruntatameri 1991. 205. Photo: Margaret Tuckson. Reproduced with permission of Munupi Arts & Crafts, Pirlangimpi/Pularampi. 206. Courtesy Australian Film Institute, Melbourne. Film still from Alessandro Cavadini and Carolyn Strachan, *Ningla a-Na!* (1972). Reproduced with permission of Alessandro Cavadini. 207. Photo Elaine Kitchener 208. Photo Greg Barrett. 209. Museum and Art Gallery of the Northern Territory, Darwin. Reproduced with permission of Maningrida Arts and Culture, Maningrida. 210. Photo: Louise Hamby. Reproduced with permission of Maningrida Arts and Culture, Maningrida. 211. Collection of the artist. Reproduced from *Below the Surface,* Goulburn Regional Art Gallery, 1996. Photo: Lesley Goldacre. Reproduced with permission of the artist. 212. Photo Jon Altman. Reproduced with permission of Maningrida Arts and Culture, Maningrida. 213. Photo: N. B. Tindale, 1937. South Australian Museum, Adelaide. 214. Telstra Collection, Museum and Art Gallery of the Northern Territory, Darwin. 215. Photo: Thisbe Purich. 216. Reproduced with permission of the Austral Gallery, St Louis. 217. © Peta Hill, 1996. 218. Photo: George France Photography. 219. National Gallery of Aus-

tralia, Canberra. Reproduced with permission of Red Rock Art, Kununurra. 220. Photograph courtesy of The Kelton Foundation, Santa Monica. Reproduced with permission of Aboriginal Artists Agency. 221. Designer: David Kerr. © South Australian Museum and Warlukurlangu Artists Association. 222. National Gallery of Australia, Canberra. Reproduced with permission of Utopia Art, Sydney. 223. The Holmes à Court Collection, Heytesbury. Reproduced with permission of Warnayaka Art Centre, Lajamanu. 224. Purchased from Admission Funds 1987. National Gallery of Victoria, Melbourne. Reproduced with permission of Aboriginal Artists Agency. 225. Felton Bequest 1990. National Gallery of Victoria, Melbourne. © Emily Kame Kngwarreye, 1990/Licensed by VISCOPY, Sydney 2000. 226. Queensland Art Gallery, Brisbane. Reproduced with permission of Aboriginal Artists Agency. 227. Queensland Art Gallery, Brisbane. Reproduced with permission of Fire-Works Gallery, Brisbane. 228. Peterson Collection 229. © National Parks and Wildlife Service. Photo: Steve Garland. 230. Photo: Diana James. 231. Reproduced with permission of Maruku Arts and Crafts, Uluru. Photo: Geoff Mason. 232. Photo: Ilaria Vanni. 233. Photo: Donna Leslie. © Megan Evans, 1994/Licensed by VISCOPY, Sydney, 2000. © Ray Thomas 1994/Licensed by VISCOPY, Sydney, 2000. 234. Photo: E. Myoberg. Courtesy Oxley Library. 235. Courtesy Paul Memmott and Tim O'Rourke. 236. Courtesy Kathy Keyes. 237. Photo: T. O'Rourke. 238. Photo: James Rickertson. 239. Postcard c. 1899. 240. Photo: Helen Ross. 241. Photo: Greg Burgess Architects. 242. Sydney Morning Herald, 27 December, 1997. Photo: Nick Moir. 243. Canberra Times, 2 January 1994. Reproduced with permission of the artist. 244. Commissioned by the Albury Regional Art Centre with assistance from the Visual Arts/Crafts Board of the Australia Council and the Exhibitions Development Fund of the Regional Galleries Association of NSW. National Gallery of Australia, Canberra. Courtesy Roslyn Oxley9 Gallery. 245. Photo: Wayne Ludby. Courtesy The Age. 246. Courtesy Australian Heritage Commission, Canberra, Reproduced with permission of the artist. 247. Angus & Robertson, Sydney, 1933. Reproduced with permission of the National Library of Australia, Canberra. 248. Collection: the artists. Reproduced with permission of Fire-Works Gallery, Brisbane. 249 National Gallery of Australia, Canberra. Reproduced with permission of Utopia Art, Sydney. 250. Courtesy D. Devanesan 251. Reproduced with permission of Christine Franks, Alice Springs. 252. Reproduced with permission of Michael Callaghan. 253. Redback Graphix and Commonwealth Department of Community Services and Health 1987. Reproduced with permission of Michael Callaghan. 254. The Holmes à Court Collection, Heytesbury. Reproduced with permission of Maningrida Arts and Culture, Maningrida. 255. Museum Victoria, Melbourne. 256. Reproduced with permission of the Museum of Contemporary Art, Sydney and Bula'Bula Arts, Ramingining. 257. Photo: National Gallery of Australia, Canberra. 258. Photo: Jon Altman. 259. Telstra Collection, Museum and Art Gallery of the Northern Territory, Darwin. Reproduced with permission of Gallery Australis, Hindmarsh. 260. Reproduced with permission of the National Library of Australia, Canberra. 261. Reproduced with permission of Bula'Bula Arts, Ramingining. 262. Photograph courtesy of the Parliament House Art Collection, Joint House Department, Canberra, ACT. Reproduced with permission of Aboriginal Artists Agency. 263. Courtesy Museum and Art Gallery of the Northern Territory, Darwin. Reproduced with permission of Maningrida Arts and Culture, Maningrida. 264. Reproduced with permission of the Aboriginal Artists Agency. 265. Collection: University of Melbourne. Photo: Kenneth Pleban. Courtesy Bellas, Sherman and Sutton Galleries. 266. Queensland Art Gallery, Brisbane. © Lin Onus 1994/Licensed by VISCOPY, Sydney 2000. 267. Private collection. Photo: Kenneth Pleban. Courtesy Bellas, Sherman and Sutton Galleries. 268. The Age, June 1996, Photo: Brett Faulkner, Courtesy News Ltd. 269. Photo: Howard Morphy. Reproduced with permission of Galarrwuy Yunupingu. 270. Reproduced with permission of Mangkaja Arts, Fitzroy Crossing. 271. Photo: courtesy Fiona Foley. 272. Reproduced with permission of A/V Archives, AIATSIS. 273. National Gallery of Australia, Canberra. Reproduced with permission of the artist. 274. Courtesy of Australian Heritage Commission, Canberra. © Lin Onus, 1994/Licensed by VISCOPY, Sydney 2000. 275. Private collection. Photo Philip Andrews. Courtesy Bellas, Sherman and Sutton Galleries. 276. Courtesy of Australian Heritage Commission, Canberra. Reproduced with permission of the artist. 277. Reproduced with permission of the artist. 278. Photo: Greg Barrett. 279. Photo: Djon Mundine. 280. Reproduced with permission of Balarinji Studios, Sydney and Qantas. 281. Photo: Sport the Library, Melbourne. 282. The Australian National University, Canberra. Reproduced with permission of the artist. 283. The Australian National University, Canberra. Reproduced with permission of Mangkaja Arts, Fitzroy Crossing. 284. Telstra Collection, Museum and Art Gallery of the Northern Territory, Darwin. Reproduced with permission of the artist. 285. National Gallery of Australia, Canberra. Reproduced with permission of Aboriginal Artists Agency. 286. Gift of Mrs Everard Baillieu. LaTrobe Picture Collection. State Library of Victoria. 287. National Gallery of Australia, Canberra. © Bronwyn Bancroft, 1993/Licensed by VISCOPY, Sydney, 2000. 288. National Gallery of Australia, Canberra. Reproduced with permission of Injalak Arts and Crafts Association Inc. Oenpelli. 289. Latrobe Picture Collection, State Library of Victoria. 290. First published in Voyage de Découvertes aux Terres Australes, Atlas by François Peron, Paris, 1807. Rex Nan Kivell Collection NK660. Reproduced with permission of the National Library of Australia, Canberra, U3128. 291. The Holmes à Court Collection, Heytesbury. Reproduced with permission of Alcaston House, Melbourne. 292. Broken Hill City Art Gallery. Reproduced with permission of the artist. 293. Maude Vizard-Wholohan Art Purchase Award 1996 Acc. No 967A103A. Art Gallery of South Australia, Adelaide. © Nyukuna Baker, 1995/Licensed by VISCOPY, Sydney 2000. 294. National Gallery of Australia, Canberra. Reproduced with permission of the artist. 295. National Museum of Australia, Canberra. Photo: David Featherstone. Reproduced with permission of Kimberley Culture and Law Centre, Fitzroy Crossing. 296. Photo courtesy Richard Broome. Reproduced with permission of Merle Jackomos. 297. National Gallery of Australia, Canberra. Reproduced with permission of Maxine Taylor. 298. Museum and Art Gallery of the Northern Territory, Darwin. Reproduced with permission of Indigenart, Perth. 299. Reproduced with permission of Neil McLeod Fine Art, Melbourne. 300. Reproduced with permission of Hogarth Galleries, Sydney. 301. Photo courtesy: Canberra Contemporary Art Space. Reproduced with

permission of Fire-Works Gallery, Brisbane. **302.** Purchased from Admission Funds 1992. National Gallery of Victoria. Reproduced with permission of Mary Mácha, Subiaco. **303.** Photo: Alan West. Courtesy Museum of Victoria. **304.** *Koori Mail*, 22 October 1997. Reproduced with permission of the artist. **305.** Private collection. Photo courtesy Mangkaja Arts. Reproduced with permission of Mangkaja Arts, Fitzroy Crossing. **306.** Mountford-Sheard Collection, State Library of South Australia, Adelaide. **307.** Tasmanian Museum and Art Gallery, Hobart. Photo: Howard & Rollings. **308.** Mollie Gowing Acquisition Fund for Contemporary Aboriginal Art 1993. Art Gallery of New South Wales, Sydney. Photo: Christopher Snee for AGNSW. Reproduced with permission of Utopia Art, Sydney. **309.** Photo courtesy Mark St Leon. **310.** La Trobe Picture Collection, State Library of Victoria. **311.** Photo: Courtesy Aldo Massola Collection. A/V Archives, AIATSIS. **312.** Courtesy Australian Heritage Commission, Canberra. Reproduced with permission of Boomalli Aboriginal Artists Cooperative, Annandale. **313.** Rex Nan Kivell Collection, NK 6295. Reproduced with permission of the National Library of Australia, Canberra, T386. **314.** National Gallery of Australia, Canberra. Reproduced with permission of the artist. **315.** National Gallery of Australia, Canberra. Reproduced with permission of the artist. **316.** National Gallery of Australia, Canberra. Reproduced with permission of Bula'Bula Arts, Ramingining. **317.** The Holmes à Court Collection, Heytesbury. Reproduced with permission of Duncan Kentish Fine Art, Adelaide. **318.** Museum Victoria. Reproduced with permission of the artist. **319.** South Australian Museum, Adelaide. **320.** National Gallery of Australia, Canberra. **321.** National Gallery of Australia, Canberra. Reproduced with permission of Maningrida Arts and Culture, Maningrida. **322.** Collection: the artist. Reproduced with permission of the artist. **323.** Photo: Howard Creamer. **324.** Museum and Art Gallery of the Northern Territory, Darwin. Reproduced with permission of Alcaston Gallery, Melbourne. **325.** National Gallery of Australia, Canberra. Reproduced with permission of Bula'Bula Arts, Ramingining. **326.** National Gallery of Australia, Canberra. KODAK Australasia Pty Ltd Fund 1993. Courtesy Roslyn Oxley9 Gallery. **327.** Private collection. Courtesy Sotheby's, New York. Reproduced with permission of Buku-Larrnggay Mulka Art Centre, Yirrkala. **328.** Courtesy Australian Heritage Commission, Canberra. Reproduced with permission of the artist. **329.** Telstra Collection, Museum and Art Gallery of the Northern Territory, Darwin. Reproduced with permission of Karen Brown Gallery, Darwin. **330.** Reproduced with permission of the artist. Photo: J. Trost. **331.** Collection of the artist. Reproduced with permission of the artist. **332.** National Gallery of Australia, Canberra. Reproduced with permission of Mary Mácha, Subiaco. **333.** Private collection. Reproduced with permission of the artist. **334.** Telstra Collection, Museum and Art Gallery of the Northern Territory, Darwin. Reproduced with permission of Jilamara Arts & Crafts, Milikapiti. **335.** Purchased through The Art Foundation of Victoria with the assistance of the Alex and Marjory Lynch Endowment, Governor, 1990. National Gallery of Victoria, Melbourne. Reproduced with permission of Waringarri Arts, Kununurra. **336.** Collection: Jane C. Goodale. Reproduced with permission of Jilamara Arts & Crafts, Milikapiti. **337.** The Museum of Anthropology. University of Queensland, Brisbane. Reproduced with permission of Bula'Bula Arts, Ramingining. **338.** National Gallery of Australia, Canberra. Reproduced with permission of Maningrida Arts and Culture, Maningrida. **339.** Photo: Ilaria Vanni. Reproduced with permission of the artist. **340.** National Gallery of Australia, Canberra. © Mervyn Bishop, 1975/Licensed by VISCOPY, Sydney 2000. **341.** Reproduced with permission of the artist. **342.** Photo courtesy Jimmy Little. **343.** Private collection. Photo: courtesy Museum and Art Gallery of the Northern Territory, Darwin. Reproduced with permission of Lockhart River Arts & Culture Centre, Lockhart. **344.** Museum and Art Gallery of the Northern Territory, Darwin. Reproduced with permission of the artist. **345.** Collection of the artist. Reproduced with permission of the artist. **346** Collection of the artist. Reproduced with permission of the artist. **347.** © South Australian Museum, Adelaide. **348.** Museum and Art Gallery of the Northern Territory, Darwin. Reproduced with permission of the artist. **349.** Purchased with assistance of the VAC Fund of the Australia Council. Courtesy Campbelltown City Bicentennial Art Gallery. Reproduced with permission of the artist. **350.** Private collection. Reproduced with permission of the artist. **351.** National Gallery of Australia, Canberra. Reproduced with permission of Maningrida Arts and Culture, Maningrida. **352.** Private collection. Courtesy Sotheby's, New York. Reproduced with permission of Buku-Larrnggay Mulka Art Centre, Yirrkala. **353.** Purchased from Gallery admission charges 1983. National Gallery of Australia, Canberra. Reproduced with permission of Maningrida Arts and Culture, Maningrida. **354.** Photo David Haigh. **355.** Private collection. Reproduced with permission of Elcho Island Art & Craft, Galiwin'ku. **356.** National Gallery of Australia, Canberra. Reproduced with permission of Bula'Bula Arts, Ramingining. **357.** Private collection. Reproduced with permission of Ngarinyin Aboriginal Corporation. **358.** Reproduced with permission of Warmun Art Centre, Turkey Creek. **359.** Donald Thomson University of Melbourne Collection on loan to the Museum of Victoria. Courtesy Mrs D. M. Thomson. **360.** Private collection. Reproduced with permission of Aboriginal Artists Agency. **361.** The Holmes à Court Collection, Heytesbury. © Eubena Nampitjin, 1991/Licensed by VISCOPY, Sydney 2000. **362.** Private collection. Reproduced with permission of Mary Mácha, Subiaco. **363.** National Gallery of Australia, Canberra. Reproduced with permission of Injalak Arts and Crafts Association, Inc. Oenpelli. **364.** Alick Jackomos Collection, Australian Institute of Aboriginal and Torres Strait Islander Studies, Canberra. **365.** National Museum of Australia, Canberra. **366.** National Museum of Australia, Canberra. Photo: Matt Kelso. Reproduced with permission from Aurukun Shire Council, Aurukun. **367.** Private collection. Reproduced with permission of Utopia Art, Sydney. **368.** Collection of the artist. Reproduced with permission of the artist. **369.** National Gallery of Australia, Canberra. Purchased from Gallery admission charges 1998. Reproduced with permission of the artist. **370.** Collection of the artist. Reproduced with permission of the artist. **371.** National Gallery of Australia, Canberra. Reproduced with permission of Ngaruwanajirrie, Winnellie. **372.** see caption. **373.** Photo: Nalda Searles. Reproduced with permission of the artists. **374.** Courtesy Australian Heritage Commission, Canberra. Reproduced with permission of Boomalli Aboriginal Artists Cooperative, Annanadale. **375.** Photo: Paul Taçon. **376.** National Gallery of Australia, Canberra. Reproduced with permission of the artist's family. **377.** Courtesy Aboriginal

Illustration Acknowledgments

Areas Protection Authority. Reproduced with permission of the artists. **378.** Courtesy the artist. Reproduced with permission of the artist. **379.** Cairns Regional Gallery. Reproduced with permission of the artist. **380.** Courtesy: Cherbourg Community Council. Reproduced with permission of Fire-Works Gallery, Brisbane. **381.** Photo: Simon Cuthbert. **382.** Art Gallery of South Australia, Adelaide. **383.** Reproduced from Thomas Worsnop. *The Prehistoric Arts, Manufactures, Works, Weapons etc. of the Abori-gines of Australia,* Adelaide 1897. **384.** Art Gallery of Western Australia, Perth. Reproduced with permission of the artist. **385.** Flinders University Art Museum, Adelaide. Reproduced with permission of the artist. **386.** Photo courtesy Mangkaja Arts. Reproduced with the permission of Mangkaja Arts, Fitzroy Crossing. **387.** Photo: Alana Harris. Reproduced with permission of the artist. **388.** Private collection. Reproduced with permission of the artist. **389.** Collection of the artist. Reproduced with permission of the artist. **390.** Purchased with the assistance of the Commonwealth Government, through the Australia Council, its arts funding and advisory body, 1995. National Gallery of Victoria, Melbourne. © Tjungkaya Tapaya, 1994/Licensed by VISCOPY, Sydney 2000. **391.** Courtesy Watters Gallery, Sydney. **392.** The Holmes à Court Collection, Heytesbury. Reproduced with permission of Aboriginal Artists Agency. **393.** Telstra Collection, Museum and Art Gallery of the Northern Territory, Darwin. Reproduced with permission of Ikuntji Art Centre, Haasts Bluff. **394.** Gift of Mrs Douglas Carnegie OAM, 1988. National Gallery of Victoria, Melbourne. Reproduced with permission of Aboriginal Artists Agency. **395.** Collection: Canberra School of Art. Reproduced with permission of Tiwi Designs, Nguiu. **396.** Private collection, Belgium. Reproduced with permission of Keringke Arts, Santa Terese. **397.** White Collection. The Berndt Museum of Anthropology, University of Western Australia. **398.** National Gallery of Australia, Canberra. Reproduced with permission of Buku-Larrnggay Mulka Art Centre, Yirrkala. **399.** Reproduced with permission of Maruku Arts and Crafts, Uluru. Photo: Steve Fox. **400.** Courtesy Australian Heritage Commission, Canberra. Reproduced with permission of Warburton Arts Project, Warburton Community. **401.** © South Australian Museum, Adelaide. **402.** Art Gallery of New South Wales, Sydney. Photo: Ray Woodbury for AGNSW © Judy Watson, 1986/7/Licensed by VISCOPY, Sydney 2000. **403.** Photo: DACOU Aboriginal Gallery. Reproduced with permission of the artist. **404.** Purchased from admission funds, 1992. National Gallery of Victoria, Melbourne. Reproduced with permission of Mary Mácha, Subiaco. **405.** Photo: Bill Shaylor. Reproduced with permission of the artist. **406.** The Holmes à Court Collection, Heytesbury. Reproduced with permission of Bula'Bula Arts, Ramingining. **407.** Purchased from Gallery admission charges 1987. National Gallery of Australia, Canberra. Reproduced with permission of Maningrida Arts & Culture, Maningrida. **408.** Courtesy: Mushroom Records. **409.** Keith Goddard Collection, National Museum of Australia, Canberra. **410.** Reproduced with permission of Buku-Larrnggay Mulka Art Centre, Yirrkala.

Reproduction Credits

Aboriginal Studies Press for the extracts from the *Aboriginal Encyclopaedia* (1994) by David Horton (ed.) and *Auntie Rita* (1994) by Rita Huggins and Jackie Huggins.

Michael Anderson for the extracts from 'Aboriginal Philosophy of the Land,' *Empire Times,* vol.19, no 11, 1987.

Beverly Dudley for an extract from *Just Me* (1997) by Maisie Chettle.

Macmillian Education Australia for an extract from *Shift of Sands* (South Melbourne, 1976: 96) by Roland Robinson

New South Wales University Press for an extract from *The Mudrooroo/Muller Project* (1993) by Gerhardt Fischer (ed).

Penguin Australia for an extract from *An Aboriginal Mother Tells of the Old and the New* (1984) by Elsie Roughesey.

Reed Educational & Professional Publishing Australia for an extract from *The Heritage of Namatjira,* (1992) by Jane Hardy, J.V.S. Megaw and M. Ruth Megaw (eds).

Thames and Hudson for extracts from *Ancestral Connections* (1991) by Howard Morphy.

Every effort has been made to contact copyright holders. Where the attempt has been unsuccessful, the publisher would be pleased to hear from the person concerned.

INDIAN OCEAN

TIMOR SEA

Tiwi Islands Melville I
Bathurst Van Croker I
Diemen Cobourg Pen
Gulf

Darwin

ARN

Mt Evely
.366

Pine Creek

Katherine

Ashmore Reef

Joseph
Bonaparte
Gulf

Daly R

East Alligator R

Rope

Scott Reef

Bigge I

Augustus I

Collier
Bay

KIMBERLEY

Drysdale R

Durack R

Ord R

L Argyle

KING LEOPOLD RANGES

Mt Remarkable
748

L Woods

Rowley Shoals

Derby

Mt Ord
937

Fitzroy Crossing

Broome

Fitzroy

Sturt Cr

Tennant Cree

TANAMI DESERT

GREAT SANDY DESERT

NORTHERN T

Port Hedland

De Grey R

L Auld

L Mackay

L Lewis

Dampier

Barrow I

Fortescue R

Oakover R

HAMERSLEY RANGE

PILBARA

Mt Meharry
1251

GIBSON DESERT

L Macdonald

Mt Zeil
1531

Ashburton R

LITTLE SANDY DESERT

L Disappointment

WESTERN
AUSTRALIA

MACDONNELL

Palmer R

Fin

L Macleod

Gascoyne R

Carnarvon

Wooramel R

Shark Bay

Dirk Hartog I

Murchison

L Carnegie

L Wells

Kata Tjuta

Uluru
867

L Amadeus

Mt Squires
705

MUSGRAVE

Mt Woodroffe
1435

RANGES

L Austin

L Barlee

L Moore

L Carey

L Ballard

L Rebecca

GREAT VICTORIA DESERT

SOUTH AUST

Coolgardie

Kalgoorlie–Boulder

L Cowan

NULLARBOR PLAIN

Eucla

L Eve

Perth

Fremantle

Swan R

Johnston
Lakes

L Dundas

INDIAN OCEAN

Bunbury

Blackwood R

Esperance

GREAT AUSTRALIAN BIGHT

Albany

King George Sound

SOUTHERN OCEAN

AUSTRALIA

GENERAL REFERENCE MAP

Simple Conic Projection

0 200 400

Metres above/below sea level

2000 1500 1000 500 2

• Cities and Towns

.1277 Spot elevation

— State boundary

Reef